HENRY M. SAY[...]

Oregon State University

The Humanities

Culture, Continuity & Change

VOLUME II

1600 TO THE PRESENT

PEARSON

Prentice Hall

Upper Saddle River, New Jersey 07458

Library of Congress Cataloging-in-Publication Data

Sayre, Henry M.

The humanities : culture, continuity & change / Henry M. Sayre.

p. cm.

Includes index.

ISBN 0-13-086264-9

1. Civilization—History. 2. Humanities—History. 3. Social change—History. I. Title.

CB69.S29 2008

909—dc22 2007016065

For Bud Therien, art publisher and editor par excellence, and a good friend

Editor-in-Chief: Sarah Touborg
Senior Editor: Amber Mackey
Editor-in-Chief Development: Rochelle Diogenes
Senior Development Editor: Roberta Meyer
Development Editor: Karen Dubno
Assistant Editor: Alexandra Huggins
Editorial Assistant: Carla Worner
Media Editor: Alison Lorber
Director of Marketing: Brandy Dawson
Executive Marketing Manager: Marissa Feliberty
Senior Managing Editor: Mary Rottino
Project Manager: Barbara Marttine Cappuccio
Production Editor: Assunta Petrone
Production Assistant: Marlene Gassler
Senior Operations Specialists: Sherry Lewis and Brian Mackey
Senior Art Director: Nancy Wells
Interior and Cover Design: Ximena Tamvakopoulos
Layout Specialists: Gail Cocker-Bogusz and Wanda España
Line Art and Map Program Management: Gail Cocker-Bogusz
 and Mirella Signoretto
Fine Line Art: Peter Bull Art Studio
Cartographer: Peter Bull Art Studio
Line Art Studio: Precision Graphics
Pearson Imaging Center
Site Supervisor: Joe Conti
Project Coordinator: Corin Skidds
Scanner Operators: Corin Skidds, Robert Uibelhoer, Ron Walko

Photo Research: Image Research Editorial Services/Francelle
 Carapetyan and Rebecca Harris
Director, Image Resource Center: Melinda Reo
Manager, Rights and Permissions: Zina Arabia
Manager, Visual Research: Beth Brenzel
Manager, Cover Visual Research and Permissions:
 Karen Sanatar
Image Permissions Coordinator: Debbie Latronica
Text Permissions: Warren Drabek, ExpressPermissions
Text Research: John Sisson
Copy Editor: Karen Verde
Proofreaders: Barbara DeVries and Nancy Stevenson
Composition: Preparé, Inc.
Cover Printer: Phoenix Color Corp.
Printer/Binder: Courier Kendallville
Cover Photo: (Top) Detail of *The Young Bacchus*, c. 1589 (oil
 on canvas) (see also 9648), Caravaggio, Michelangelo Merisi
 da (1571–1610)/ Galleria degli Uffizi, Florence, Italy, Alinari/
 The Bridgeman Art Library. (Center): Detail of *Olympia*, 1863
 (oil on canvas), Manet, Édouard (1832–83)/Musée d'Orsay,
 Paris, France, Giraudon/The Bridgeman Art Library. (Bottom)
 Detail of Pablo Picasso (1881–1973) *Girl Before a Mirror*.
 Boisgeloup, March 1932. Oil on canvas 64 x 51 1/4". Gift of
 Mrs. Simon Guggenheim (2.1938). Digital Image © The
 Museum of Modern Art/Licensed by SCALA/Art Resource, NY.
 © ARS Artists Rights Society, NY.

Credits and acknowledgments borrowed from other sources and reproduced, with permission, in this textbook appear on appropriate pages within text and beginning on page Credits-1.

Pearson Education LTD.
Pearson Education Singapore, Pte. Ltd.
Pearson Education, Canada, Ltd.
Pearson Education–Japan
Pearson Education, Upper Saddle River, New Jersey

Pearson Education Australia PTY, Limited
Pearson Education North Asia Ltd
Pearson Educación de Mexico, S.A. de C.V.
Pearson Education Malaysia, Pte. Ltd

10 9 8 7 6 5 4 3 2
ISBN 10: 0-13-086261-4
ISBN 13: 978-0-13-086261-7

Series Contents

Book 1 The Ancient World and the Classical Past: Prehistory to 200 CE

1 From Forest to Farm: The Rise of Culture

2 Mesopotamia: Power and Social Order in the Fertile Crescent

3 The Stability of Ancient Egypt: Flood and Sun

4 China, India, and Africa: Early Civilizations

5 Bronze Age Culture in the Aegean World: The Great Traders

6 The Rise of Greek City-States: War and Victory

7 Golden Age Athens: The School of Hellas

8 Rome: Urban Life and Imperial Majesty

Book 2 Medieval Europe and the Shaping of World Cultures: 200 CE to 1400

9 The Late Roman Empire, Judaism, and the Rise of Christianity: Power and Faith

10 Byzantium: Constantinople and the Byzantine Empire

11 The Rise and Spread of Islam: A New Religion

12 Fiefdom and Monastery: The Merging of Germanic and Roman Cultures

13 The Romanesque Tradition: Pilgrimage and Crusade

14 The Gothic Style: Faith and Knowledge in an Age of Inquiry

15 Siena and Florence in the Fourteenth Century: Toward a New Humanism

16 China, India, Japan, Africa, and the Americas before 1400

Book 3 The Renaissance and the Age of Encounter: 1400 to 1600

17 Florence and the Early Renaissance: Humanism in Italy

18 The High Renaissance in Rome: Papal Patronage

19 The Venetian Renaissance: Palace and Lagoon

20 The Renaissance in the North: Between Wealth and Want

21 The Reformation: A New Church and the Arts

22 The Early Counter-Reformation and Mannerism: Restraint and Invention

23 The Age of Encounter: West Africa, China, and Japan

24 England in the Tudor Age: "This Other Eden"

Book 4 Excess, Inquiry, and Restraint: 1600 to 1800

25 The Baroque in Italy: The Church and Its Appeal

26 The Secular Baroque in the North: The Art of Observation

27 The Baroque Court: Absolute Power and Royal Patronage

28 The Rise of the Enlightenment in England: The Claims of Reason

29 The Rococo and the Enlightenment on the Continent: Privilege and Reason

30 Cross-Cultural Encounter: Exploration and Trade in the Enlightenment

31 The Rights of Man: Revolution in America

32 A Culture of Change in France: Neoclassicism and Revolution

Book 5 Romanticism, Realism, and Empire: 1800 to 1900

33 The Self in Nature: The Rise of Romanticism

34 A Darker World: Napoleon and the Romantic Imagination

35 Industry and the Working Class: A New Realism

36 Revolution and Civil War: The Conditions of Modern Life

37 The Rise of Bourgeois Culture: Living the Good Life

38 The Gilded Age in America: Expansion and Conflict

39 Global Confrontations: The Challenge to Cultural Identity

40 From Realism to Symbolism: The Fin de Siècle

Book 6 Modernism and the Globalization of Cultures: 1900 to the Present

41 The Era of Invention: Paris and the Rise of Modernism

42 The Great War and Its Impact: A Lost Generation

43 New York and Skyscraper Culture: Making it New

44 Between the Wars: The Age of Anxiety

45 World War II and Its Aftermath: Devastation and Recovery

46 The Turbulent 1960s: Decade of Change

47 The Postmodern Era: Multiple Meanings in a Changing World

48 Blurring The Boundaries: The Global Village in the Information Age

Contents

Preface xv

Excess, Inquiry, and Restraint: 1600 to 1800 801

25 The Baroque in Italy
The Church and Its Appeal 805

Baroque Style and the Counter-Reformation 808
Sculpture and Architecture: Bernini and His Followers 809
READING 25.1 from Teresa of Ávila, "Visions," Chapter 29 of *The Life of Teresa of Ávila* (before 1567) 810

The Drama of Painting: Caravaggio and the Caravaggisti 815
Master of Light and Dark: Caravaggio 815
READING 25.2 John Donne, "Batter My Heart" (1618) 817
Elisabetta Sirani and Artemisia Gentileschi: Caravaggisti Women 817
Ceiling Painting: The Illusion of Heaven 819
READING 25.4 from Ignatius Loyola, *Spiritual Exercises*, Fifth Exercise (1548) 822

Venice and Baroque Music 822
Giovanni Gabrieli and the Drama of Harmony 822
Claudio Monteverdi and the Birth of Opera 823
READING 25.5 from Giulio Caccini, *New Works of Music* (1602) 824
Arcangelo Corelli and the Sonata 825
Antonio Vivaldi and the Concerto 826

Reading
READING 25.3 John Donne, "The Flea" (1633) 828

SPECIAL FEATURES
MATERIALS & TECHNIQUES The Facade from Renaissance to Baroque 814
FOCUS Caravaggio's *The Supper at Emmaus* 820
CULTURAL PARALLELS Large-Scale Paintings in Rome and Japan 822
VOICES Claudio Monteverdi Appeals for His Salary 824
CULTURAL PARALLELS Virtuosity in Venice and Amsterdam 825

Continuity & Change The End of Italian Ascendency 831

26 The Secular Baroque in the North
The Art of Observation 833

Calvinist Amsterdam: City of Contradictions 835
Gaining Independence from Spain 836
Tulipomania 836
The Dutch Reformed Church: Strict Doctrine and White-washed Spaces 838

The Science of Observation 839
Francis Bacon and the Empirical Method 839
René Descartes and the Deductive Method 839
READING 26.2 from René Descartes, *Meditations* (1641) 840
Johannes Kepler, Galileo Galilei, and the Telescope 840
Antoni van Leeuwenhoek, Robert Hooke, and the Microscope 842

Dutch Vernacular Painting: Art of the Familiar 842
New Imagery: Still Life, Landscape, and Genre Painting 842
Johannes Vermeer and Domestic Interiors 846
Frans Hals and the Group Portrait 848
Rembrandt van Rijn and the Drama of Light 848

The Baroque Keyboard 854
Jan Pieterszoon Sweelinck's Fantasies for the Organ 854
The North German School: Johann Sebastian Bach 854

Readings
READING 26.1 from Francis Bacon, *Novum Organum Scientiarum, (The New Method of Science)* (1620) 857
READING 26.3 from René Descartes, *Discourse on Method* (Part IV) (1637) 858

SPECIAL FEATURES
CULTURAL PARALLELS Scientific Inquiry in Northern Europe and China 841
FOCUS Rembrandt's *The Anatomy Lesson of Dr. Tulp* 852

Continuity & Change Tension between Populace and Court 861

27 The Baroque Court
Absolute Power and Royal Patronage 863

Versailles and the Rise of Absolutism 864
The Arts of the French Court 869
The Painting of Peter Paul Rubens: Color and Sensuality 869
The Painting of Nicolas Poussin: Classical Decorum 872
Music and Dance at the Court of Louis XIV 873
Theater at the French Court 874
READING 27.1a from Molière, *Tartuffe*, Act V (1664) 875

The Art and Politics of the English Court 876
Anthony van Dyck: Court Painter 877
Portraiture in the American Colonies 878
Puritan and Cavalier Literature 878
READING 27.2a Anne Bradstreet, "To My Dear and Loving Husband" (1667) 879
READING 27.3 Robert Herrick, "To the Virgins, To Make Much of Time" (1648) 879

Henry Purcell and English Opera 880

The Arts of the Spanish Court 880
Diego Velázquez and the Royal Portrait 880
The Literature of the Spanish Court 884

The Baroque in the Americas 885
The Cuzco School 885
Baroque Music in the Americas: Sor Juana Inés de la Cruz 886
READING 27.4 Sor Juana Inés de la Cruz, "To Her Self-Portrait" (posthumous publication 1700) 887
The Churrigueresque Style: *Retablos* and Portals in New Spain 887

Readings
READING 27.1 from Molière, *Tartuffe*, Act III, scenes 2 and 3 (1664) 890
READING 27.2 Anne Bradstreet, "Here Follows Some Verses upon the Burning of Our House, July 10th, 1666" (1667) 892

SPECIAL FEATURES
VOICES Life for the Other French 867
CULTURAL PARALLELS A Shogun's Power in Japan 868
CULTURAL PARALLELS Kabuki Theater in Japan 880
FOCUS Velázquez's *Las Meninas* 882

 Continuity & Change Excess and Restraint 895

28 The Rise of the Enlightenment in England
The Claims of Reason 897

The New London: Toward the Enlightenment 900
READING 28.1 from John Dryden, "Annus Mirabilis," 1667 900
Absolutism Versus Liberalism: Thomas Hobbes and John Locke 901
READING 28.3 from Locke's *Essay on Human Understanding* (1690) 904
John Milton's *Paradise Lost* 904
READING 28.5a-b from John Milton, *Paradise Lost*, Book 5 (1667) 905

The English Enlightenment 905
Satire: Enlightenment Wit 906
READING 28.7 from Jonathan Swift, *Gulliver's Travels*, Book IV, Chapter VI (1726) 909
READING 28.8 from Alexander Pope, *An Essay on Man* (1732) 909
Isaac Newton: The Laws of Physics 910
The Industrial Revolution 910
Handel and the English Oratorio 913

Literacy and the New Print Culture 913
The Tatler and *The Spectator* 913
READING 28.9 from Joseph Addison, *The Spectator*, No. 10, Monday, March 12, 1711 915
The Rise of the English Novel 915
READING 28.10 from Samuel Richardson's *Pamela* (1740) 916
READING 28.11 from Henry Fielding, *Shamela* (1741) 917
READING 28.12a from Jane Austen, *Pride and Prejudice*, Chapter 1 (1813) 917
READING 28.12b from Jane Austen, *Pride and Prejudice*, Chapter 43 (1813) 918

READING 28.13 from Samuel Johnson, *The Rambler*, No. 4, Saturday, March 31, 1750 919

Readings
READING 28.2 from Thomas Hobbes, *Leviathan* (1651) 920
READING 28.4 from John Locke, *The Second Treatise of Government* (1690) 922
READING 28.5 from John Milton, *Paradise Lost*, Book 6, (1667) 923
READING 28.6 from Jonathan Swift, *A Modest Proposal* (1729) 925

SPECIAL FEATURES
CULTURAL PARALLELS Growth and Commerce in London and China 900
FOCUS Christopher Wren's Saint Paul's Cathedral 902
CULTURAL PARALLELS Crisis in Holland 904
VOICES Rules for Behaviour in Company 914

 Continuity & Change Signboard of a New World 931

29 The Rococo and the Enlightenment on the Continent
Privilege and Reason 933

The Rococo 936
Rococo Painting in France: The *Fête Galante* and the Art of Love 937
Rococo Architecture and Landscape Design in Central Europe and England 940

The *Philosophes* 946
Denis Diderot and the *Encyclopédie* 946
READING 29.1 from "Law of Nature or Natural Law," from the *Encyclopédie* (1751–1772) 947
Jean-Jacques Rousseau and the Cost of the Social Contract 948
READING 29.3 from Jean-Jacques Rousseau, *The Social Contract*, Book 1, Chapter 4 ("Slavery") (1762) 948
READING 29.4 from Jean-Jacques Rousseau, *Discourse on the Origin of Inequality among Men* (1755) 949
Voltaire and French Satire 949
Art Criticism and Theory 950

Rococo and Classical Music 952
The Symphonic Orchestra 952
Symphonic Form 953
The String Quartets of Joseph Haydn 955
Wolfgang Amadeus Mozart: Music to Chew On 955
The Popularization of Opera 956

Readings
READING 29.2 from Jean-Jacques Rousseau, *Confessions*, Book 1 (completed 1770, published 1780) 961
READING 29.5 from Voltaire, *Candide* (1758) 962

SPECIAL FEATURES
CULTURAL PARALLELS Gardens in England and Japan 944
FOCUS Mozart's *Symphony No. 40 in G Minor* (K. 550), First Movement: *Molto Allegro* 958

 Continuity & Change The End of the Rococo 967

30 Cross-Cultural Encounter
Exploration and Trade in the Enlightenment 969

The South Pacific: The Cultures Captain Cook Encountered 971
Polynesia 971
Melanesia 974
Australia 975

China and Europe: Cross-Cultural Contact 976
The Arts in the Qing Dynasty (1644–1911) 977
Celebrating Tradition: The Great Jade Carving 980

India and Europe: Cross-Cultural Connections 982
Islamic India: The Taste for Western Art 982
Mogul Architecture: The Taj Mahal 983
READING 30.1 Shah Jahan, inscription on the Taj Mahal, ca. 1658 984

Native American Traditions 986
The Pueblo Cultures of New Spain 986
Weaving and Basketry 986
The Northeast Woodlands Tribes 988

Reading
READING 30.2 Logan, Speech at the End of Lord Dunmore's War, from Thomas Jefferson, *Notes on the State of Virginia* (1784) 992

SPECIAL FEATURES
VOICES James Cook Interprets Tahitian Behavior 972
CULTURAL PARALLELS The Voyages of Captain Cook on French Wallpaper 973
FOCUS Europe's *Chinoiserie* Craze 978
CULTURAL PARALLELS Two Islamic Rulers 985
Continuity & Change The Growing Crisis of the Slave Trade 995

31 The Rights of Man
Revolution in America 997

The American Revolution 998
The Road to Revolt: War and Taxation 999
The Declaration of Independence 1000
READING 31.1 from The Declaration of Independence (1776) 1001

Neoclassicism in Britain and America 1001
The British Influence: Robert Adam and Josiah Wedgwood 1003
American Neoclassical Architecture 1004
Neoclassical Sculpture in America 1006

The Issue of Slavery 1008
Autobiographical and Fictional Accounts of Slavery 1008
READING 31.3a from Olaudah Equiano, *The Interesting Narrative of the Life of Olaudah Equiano, or Gustavus Vassa the African* (1789) 1009
READING 31.4 Phyllis Wheatley, "'Twas mercy brought me from my Pagan land" (1773) 1011
The Economic Argument for Slavery and Revolution: Free Trade 1014

The Abolitionist Movement in Britain and America 1014
The African Diaspora 1015

Readings
READING 31.2 James Madison, *Federalist No. 10* (1787) 1016
READING 31.3 from *The Interesting Narrative of the Life of Olaudah Equiano* (1789) 1017
READING 31.5 from Aphra Behn, *Oroonoko, or The Royal Slave* (1688) 1019

SPECIAL FEATURES
VOICES Former Slaves Petition for Tax Relief 1009
CULTURAL PARALLELS The Dream of Freedom 1011
FOCUS Blake's "The Little Black Boy" and "The Chimney Sweeper" 1012
Continuity & Change The Rise of Neoclassicism in France 1021

32 A Culture of Change in France
Neoclassicism and Revolution 1023

Jacques-Louis David and the Neoclassical Style 1026
Three Paintings of 1787 1030
Angelica Kauffmann and Neoclassical Motherhood 1032

The French Revolution 1032
The Estates General of 1789 and the National Assembly 1032
The Great Fear and the October Days 1034
The Declaration of the Rights of Man and the Constitution of 1791 1034
READING 32.1 from The Declaration of the Rights of Man and Citizen (1789) 1034
Robespierre and the Reign of Terror 1035

The Rights of Woman 1037
Olympe de Gouges: The Call for Universal Rights 1037
READING 32.2 from Olympe de Gouges, *Declaration of the Rights of Woman and the Female Citizen* (1791) 1037
Mary Wollstonecraft: An Englishwoman's Response to the French Revolution 1038
READING 32.3a from Mary Wollstonecraft, Introduction to *A Vindication of the Rights of Woman* (1792) 1038

Napoleon and Neoclassical Paris 1038
The Consulate and the Napoleonic Empire: 1799–1814 1038
Art as Propaganda: Painting, Architecture, Sculpture 1041

Reading
READING 32.3 from Mary Wollstonecraft, *A Vindication of the Rights of Woman* (1792) 1044

SPECIAL FEATURES
FOCUS David's *The Lictors Returning to Brutus the Bodies of His Sons* 1028
CULTURAL PARALLELS Napoleon's Influence in Egypt 1039
VOICES The Perils of the Parisian Streets 1043
Continuity & Change Neoclassicism and Romanticism 1047

Romanticism, Realism, and Empire: 1800 to 1900 1049

33 The Self in Nature
The Rise of Romanticism 1053

The Early Romantic Imagination 1056
The Idea of the Romantic: William Wordsworth's "Tintern Abbey" 1056
A Romantic Experiment: *Lyrical Ballads* 1056
READING 33.2 from William Wordsworth, "Preface" to *Lyrical Ballads* (1800) 1057
Romanticism as a Voyage of Discovery: Samuel Taylor Coleridge 1057
READING 33.3a from Samuel Taylor Coleridge, "Rime of the Ancient Mariner," Part II (1797) 1057
READING 33.3b from Samuel Taylor Coleridge, "Rime of the Ancient Mariner," Part IV (1797) 1057
READING 33.3c from Samuel Taylor Coleridge, "Rime of the Ancient Mariner," Part IV (1797) 1060
Classical versus Romantic: The Odes of John Keats 1060
READING 33.4 from John Keats, "Ode to a Nightingale" (1819) 1060
READING 33.5 from John Keats, "Ode on a Grecian Urn" (1819) 1061

The Romantic Landscape 1061
John Constable: Painter of the English Countryside 1062
Joseph Mallord William Turner: Colorist of the Imagination 1064
The Romantic in Germany: Friedrich and Kant 1066
The American Romantic Landscape 1066

Transcendentalism and the American Romantics 1069
The Philosophy of Romantic Idealism: Emerson and Thoreau 1069
READING 33.6 from Ralph Waldo Emerson, *Nature*, Chapter 1 (1836) 1070
READING 33.7 from Henry David Thoreau, *Walden, or Life in the Woods*, Chapter 2 (1854) 1070
READING 33.8 from Henry David Thoreau, "Life without Principle" (1854) 1071
Herman Melville: The Uncertain World of *Moby Dick* 1071
READING 33.9 from Herman Melville, *Moby Dick*, Chapter 3, "The Spouter Inn" (1851) 1071
READING 33.10 from Herman Melville, *Moby Dick*, Chapter 35, "The Master-Head" (1851) 1073

Readings
READING 33.1 from William Wordsworth, "Lines Composed a Few Miles above Tintern Abbey, on Revisiting the Banks of the Wye during a Tour, July 13, 1798" (1798) 1074
READING 33.3 from Samuel Taylor Coleridge, "Rime of the Ancient Mariner," Part I (1798) 1076

SPECIAL FEATURES
CULTURAL PARALLELS Polish Nationalism 1056
FOCUS Wordsworth's "The Rainbow" 1058

 The Romantics and Napoleon 1079

34 A Darker World
Napoleon and the Romantic Imagination 1081

Napoleon and the Romantic Hero 1084
The Hegelian Dialectic and the "Great Man" Theory of History 1084
READING 34.1 from Georg Wilhelm Friedrich Hegel, *Philosophy of History* (1805–1806) 1085
The Promethean Hero in England 1085
READING 34.2 from George Gordon, Lord Byron, "Prometheus" (1816) 1085
READING 34.3a from George Gordon, Lord Byron, *Childe Harold's Pilgrimage*, Canto III, stanzas 37, 42 (1812) 1086
READING 34.3b from George Gordon, Lord Byron, *Childe Harold's Pilgrimage*, Canto II (1812) 1086
READING 34.4 from Percy Bysshe Shelley, *Prometheus Unbound* (1820) 1087
READING 34.5a from Percy Bysshe Shelley, "Ode to the West Wind" (1819) 1087
The Romantic Hero in Germany: Johann Wolfgang von Goethe's *Werther* and *Faust* 1088
READING 34.6 from Johann Wolfgang von Goethe, *The Sorrows of Young Werther* (1774) 1089
READING 34.7a from Johann Wolfgang von Goethe, *Faust*, Part I (1808) 1089
READING 34.7b from Johann Wolfgang von Goethe, *Faust*, Part II (1832) 1090
READING 34.7c from Johann Wolfgang von Goethe, *Faust*, Part II (1832) 1090

Beethoven and the Rise of Romantic Music 1091
Early Years in Vienna: From Classicism to Romanticism 1091
The Heroic Decade: 1802–1812 1092
READING 34.8 from Ludwig van Beethoven, *Heiligenstadt Testament* (1802) 1092
The Late Period: The Romantic in Music 1093
Romantic Music after Beethoven 1094

Goya's Tragic Vision 1097
The Third of May, 1808: Napoleon's Spanish Legacy 1097
Goya before Napoleon: Social Satire 1098
The Black Paintings 1099

French Painting after Napoleon: The Classic and Romantic Revisited 1102
Théodore Géricault: Rejecting Classicism 1103
The Aesthetic Expression of Politics: Delacroix versus Ingres 1104

Reading
READING 34.5 from Mary Shelley, *Frankenstein*, chapter 5 (1818) 1108

SPECIAL FEATURES
CULTURAL PARALLELS Volcanic Eruption 1084
VOICES An Englishman in Vienna Attends a Beethoven Premier 1094
FOCUS Goya's *The Family of Charles IV* 1100

 From Romanticism to Realism 1111

35 Industry and the Working Class
A New Realism 1113

The Industrial City: Conditions in London 1115
READING 35.1 from Dickens, *Sketches by Boz* (1836) 1116
READING 35.2 from Thomas Carlyle, *Past and Present* (1843) 1116
Water and Housing 1116
Labor and Family Life 1117
Reformists Respond: Utopian Socialism, Medievalism, and Christian Reform 1118
Utopian Socialism 1119
A.W. N. Pugin, Architecture, and the Medieval Model 1119
Literary Realism 1121
READING 35.3 from Dickens, *Dombey and Son* (1846–1848) 1121
Dickens's *Hard Times* 1122
READING 35.4 from Dickens, *Hard Times* (1854) 1123
French Literary Realism 1123
READING 35.6 from Flaubert, *Madame Bovary* (1856) 1125
The Russian Realists under Nicholas I 1125
READING 35.7 from Pushkin, *The Bronze Horseman* (1833) 1126
Literary Realism in the United States: The Issue of Slavery 1127
READING 35.8a from *Narrative of the Life of Frederick Douglass* (1845) 1127
READING 35.9 from Sojourner Truth, "Ain't I a Woman?" (1851) 1128
READING 35.10 letter from Harriet Beecher, Stowe to Eliza Cabot Follen, December 16, 1852 1129
READING 35.11 from Harriet Beecher Stowe, *Uncle Tom's Cabin* (1852) 1129
READING 35.12 from Mark Twain, *Huckleberry Finn* (1885) 1130
READING 35.13 from Mark Twain, *Huckleberry Finn* (1885) 1131
The New French Realism in Painting 1131
Caricature and Illustration: Honoré Daumier 1133
Realist Painting: The Worker as Subject 1134
Gustave Courbet: Against Idealism 1137
Photography: Realism's Pencil of Light 1140
Charles Darwin: The Science of Objective Observation 1142
READING 35.14 from Darwin, *Voyage of the Beagle* (1839) 1142
Readings
READING 35.5 from Balzac, *Father Goriot* (1834) 1144
READING 35.8 from the *Narrative of the Life of Frederick Douglass: An American Slave*, Chapter 1 (1845) 1146
SPECIAL FEATURES
VOICES A Recipe for Domestic Harmony 1118
CULTURAL PARALLELS A Gold Rush in Australia 1123
MATERIALS & TECHNIQUES Litography 1135
FOCUS Courbet's *A Burial at Ornans* 1138
 Continuity & Change Painting Modern Life 1151

36 Revolution and Civil War
The Conditions of Modern Life 1153

The Revolutions of 1848: From the Streets of Paris to Vienna 1154
Marxism 1155
The Streets of Paris 1155
READING 36.2 from Alphonse de Lamartine, *History of the Revolution of 1848* (1849) 1155
The June Days in Paris: Worker Defeat and Rise of Louis-Napoleon 1156
Revolution across Europe: The Rise of Nationalism 1157
In Pursuit of Modernity: Paris in the 1850s and '60s 1158
READING 36.3 from Charles Baudelaire, "To the Bourgeoisie," in *Salon of 1846* (1846) 1159
Charles Baudelaire and the Poetry of Modern Life 1159
READING 36.4 Charles Baudelaire, "Carrion," in *Les Fleurs du mal* (1857) (translation by Richard Howard) 1160
READING 36.5 Charles Baudelaire, "The Head of Hair," in *Les Fleurs du mal* (1857) (translation by Richard Howard) 1160
Édouard Manet: The Painter of Modern Life 1160
READING 36.6 from Charles Baudelaire, "The Painter of Modern Life" (1863) 1161
Émile Zola and the Naturalist Novel 1163
READING 36.7 from Émile Zola, *Édouard Manet* (1867) 1163
READING 36.8 from Émile Zola, "The Moment in Art" (1867) 1163
READING 36.9 from Émile Zola, Preface to *Thérèse Raquin*, 2nd edition (1868) 1167
READING 36.10a from Émile Zola, *Germinal* (1885) 1167
Nationalism and the Politics of Opera 1167
The American Civil War 1172
Romanticizing Slavery in Antebellum American Art and Music 1172
Representing the War 1174
Readings
READING 36.1 Karl Marx and Friedrich Engels, *The Communist Manifesto*, Part I, from "Bourgeois and Proletarians" (1848; English edition 1888; trans. Samuel Morse) 1179
READING 36.10 from Émile Zola, *Germinal* (1885) 1181
READING 36.11 from Abraham Lincoln, Address Delivered at the Dedication of the Cemetery at Gettysburg (1863) 1183
SPECIAL FEATURES
VOICES Italian Nationalists Struggle for Liberty 1158
CULTURAL PARALLELS The Rise of Bahá'í 1159
FOCUS Manet's *Olympia* 1164
Continuity & Change Impressionist Paris 1185

37 The Rise of Bourgeois Culture
Living the Good Life 1187

The Haussmannization of Paris 1189

The 1870s: From the Commune to Impressionism 1192

The Commune 1192

Impressionism 1194

Russian Realism and the Quest for the Russian Soul 1206

The Writer and Artist under the Tsars 1206

READING 37.1a from Fyodor Dostoyevsky *Crime and Punishment*, Part I, Chapter 7 (1866) 1207

READING 37.2 from Leo Tolstoy, *War and Peace*, Part I, Chapter 11 (1869) 1208

Russian Nationalist Music and Ballet 1209

Britain and the Design of Social Reform 1210

Morris, the Guild Movement, and the Pre-Raphaelites 1211

READING 37.3 from John Ruskin, "On the Nature of Gothic," in *The Stones of Venice* (1851–1853) 1211

READING 37.4 from Algernon Charles Swinburne, "Laus Veneris" (1866) 1213

The Fight for Women's Rights: Mill's *Subjection of Women* 1214

READING 37.5 from John Stuart Mill, *The Subjection of Women* (1869) 1214

Reading

READING 37.1 from Fyodor Dostoyevsky, *Crime and Punishment*, Part 3, Chapter 5 (1866) 1215

SPECIAL FEATURES

VOICES Where Are the Roses? 1190

CULTURAL PARALLELS The Modernization of Tokyo 1191

FOCUS Monet's *Water Lilies* 1198

 The Prospect of America 1217

38 The Gilded Age in America
Expansion and Conflict 1219

Walt Whitman's America 1220

READING 38.1 from Walt Whitman, "Crossing Brooklyn Ferry" (1856) 1221

READING 38.2a from Walt Whitman, "Song of Myself," in *Leaves of Grass* (1867) 1221

READING 38.2b from Walt Whitman, "Song of Myself," in *Leaves of Grass* (1867) 1223

READING 38.3 from Walt Whitman, *Democratic Vistas* (1871) 1223

In the Interest of Liberty: An Era of Contradictions 1223

The American Woman 1225

READING 38.4 Emily Dickinson, "Wild Nights" (as published in 1953) 1231

READING 38.6a from Kate Chopin, *The Awakening*, Chapter I (1899) 1231

READING 38.6b from Kate Chopin, *The Awakening*, Chapter VI (1899) 1231

Ragtime and the Beginnings of Jazz 1232

The American Abroad 1232

Henry James and the International Novel 1233

READING 38.7 from Henry James, *The Ambassadors*, Chapter 11 (1903) 1233

Painters Abroad: The Expatriate Vision 1233

Chicago and the Columbian Exposition of 1893 1236

Louis Sullivan and the Chicago School of Architecture 1239

Frederick Law Olmsted and the Invention of Suburbia 1241

Readings

READING 38.2 from Walt Whitman, "Song of Myself," in *Leaves of Grass* (1867) 1242

READING 38.5 from Emily Dickinson, *Poems* (as published in *The Complete Poems of Emily Dickinson*, ed. T. H. Johnson, 1953) 1243

SPECIAL FEATURES

CULTURAL PARALLELS Famine in India 1224

FOCUS Eakins's *Gross Clinic* and *Agnew Clinic* 1228

VOICES Saturday Night in San Francisco 1238

 The "Frontier Thesis" of Frederick Jackson Turner 1247

39 Global Confrontations
The Challenge to Cultural Identity 1249

The Native American in Myth and Reality 1251

The Indian Removal Act 1254

The Fate of the Native Americans: Cooper's *Leatherstocking Tales* 1255

READING 39.1a from James Fenimore Cooper, *The Pioneers* (1823) 1255

Recording and Mythologizing Native Americans: Catlin's Ethnographic Enterprise 1257

Plains Narrative Painting: Picturing Personal History and Change 1258

Women's Arts on the Plains: Quillwork and Beadwork 1259

The End of an Era 1262

The British in China and India 1263

China and the Opium War 1263

Indentured Labor and Mass Migration 1265

Company School Painting in India 1266

The Opening of Japan 1266

Industrialization: The Shifting Climate of Society 1267

Japanese Printmaking 1267

Africa and Empire 1269

European Imperialism 1269

Social Darwinism: The Theoretical Justification for Imperialism 1271

Imperialism and the Arts 1271

Reading

READING 39.1 from James Fenimore Cooper, *The Pioneers*, Chapter XII (1823) 1273

SPECIAL FEATURES

VOICES A Choctaw Festival 1252
FOCUS Howling Wolf's *Treaty Signingat Medicine Lodge Creek* 1260
CULTURAL PARALLELS The Rise of the Zulu 1269

 Continuity & Change The African Mask 1279

40 From Realism to Symbolism
The Fin de Siècle 1281

A Fair to Remember: The Paris Exposition of 1889 1283

The Fin de Siècle: From Naturalism to Symbolism 1284
Art Nouveau 1284
Exposing Society's Secrets: The Plays of Henrik Ibsen 1286
READING 40.1 from Henrik Ibsen, *A Doll's House*, Act III (1878) 1286
The Symbolist Imagination in the Arts 1287
READING 40.2a from Stéphane Mallarmé, "L'Après-midi d'un faune" ("Afternoon of a Faun") (1876) 1290

Post-Impressionist Painting 1291
Pointillism: Seurat and the Harmonies of Color 1291
Symbolic Color: Van Gogh 1293
The Structure of Color: Cézanne 1296
Escape to Far Tahiti: Gauguin 1300

Toward the Modern 1302
The New Moral World of Nietzsche 1302
READING 40.3 from Friedrich Nietzsche, *The Birth of Tragedy*, section 1 (1872) 1302
On the Cusp of Modern Music: Mahler and Brahms 1303
The Painting of Isolation: Munch 1303
The Vienna Secession: Klimt 1305

Readings

READING 40.2 from Stéphane Mallarmé, "L'Après-midi d'un faune" ("Afternoon of a Faun") (1876) 1307

READING 40.4 from Friedrich Nietzsche, *The Gay Science*, "The Madman" (1882), and *Beyond Good and Evil*, section 212 (1888) 1308

SPECIAL FEATURES

CULTURAL PARALLELS Revival of the Olympics 1283
FOCUS Cézanne's *Still Life with Plaster Cast* 1298
VOICES A Visitor in Vienna 1304

 Continuity & Change Freud and the Unconscious 1311

Modernism and the Globalization of Cultures: 1900 to the Present 1313

41 The Era of Invention
Paris and the Rise of Modernism 1317

Pablo Picasso's Paris: At the Heart of the Modern 1319
READING 41.1 from Gertrude Stein, *The Autobiography of Alice B. Toklas* (1932) 1320
The Aggressive New Modern Art: *Les Demoiselles d'Avignon* 1320
Matisse and the Fauves: A New Color 1322
The Invention of Cubism: Braque's Partnership with Picasso 1324
Futurism: The Cult of Speed 1328
Modernist Music and Dance: Stravinsky and the Ballets Russes 1329

The Expressionist Movement: Modernism in Germany and Austria 1330
Die Brücke: The Art of Deliberate Crudeness 1330
Der Blaue Reiter: The Spirituality of Color 1331
A Diversity of Sound: Schoenberg's New Atonal Music versus Puccini's Lyricism 1333

Early Twentieth-Century Literature 1334
Guillaume Apollinaire and Cubist Poetics 1334
READING 41.3 from Guillaume Apollinaire, "Lundi, rue Christine" (1913) 1335
READING 41.4 from Guillaume Apollinaire, "Il Pleut" (1914) 1335
Words in Relation: The Language of Gertrude Stein 1336
READING 41.5 from Gertrude Stein, *Tender Buttons* (1914) 1336

Modernism Comes to America 1336
Ezra Pound and the Imagists 1336
READING 41.6 from Ezra Pound, "In a Station of the Metro" (1913) 1336
READING 41.7 from Ezra Pound, "A Pact" (1913) 1337
Stieglitz, Gallery 291, and *Camera Work* 1337
The Armory Show and Marcel Duchamp 1338

The Origins of Cinema 1341
The Lumière Brothers' Celluloid Film Movie Projector 1341
The Nickelodeon: Movies for the Masses 1342
D. W. Griffith and Cinematic Space 1342

Reading

READING 41.2 from Filippo Marinetti, *Founding and Manifesto of Futurism* (1909) 1344

SPECIAL FEATURES

CULTURAL PARALLELS The Birth of Jazz in New Orleans 1320
FOCUS Picasso's Collages 1326
VOICES Interviewing a Cubist 1340

 Continuity & Change The Prospect of War 1347

42 The Great War and Its Impact
A Lost Generation 1349

Trench Warfare and the Literary Imagination 1352
READING 42.1 from Alfred, Lord Tennyson, "Charge of the Light Brigade" (1854) 1352
Wilfred Owen: "The Pity of War" 1352
READING 42.2 Wilfred Owen, "Dulce et Decorum Est" (1918) 1352
In the Trenches: Remarque's *All Quiet on the Western Front* 1353
READING 42.3 from Erich Maria Remarque, *All Quiet on the Western Front* (1928) 1353
William Butler Yeats and the Specter of Collapse 1353
READING 42.4 William Butler Yeats, "The Lake Isle of Innisfree" (1893) 1354
READING 42.5 William Butler Yeats, "The Second Coming" (1919) 1354
T. S. Eliot: The Landscape of Desolation 1354
READING 42.6a from T. S. Eliot, *The Waste Land* (1921) 1354

Escape from Despair: Dada in the Capitals 1355
READING 42.7 from Hugo Ball, "Gadji beri bimba" (1916) 1355
READING 42.8 from Tristan Tzara, "To Make a Dadaist Poem" (1920) 1356

Russia: Art and Revolution 1359
Vladimir Lenin and the Soviet State 1359
The Arts of the Revolution 1359

Freud, Jung, and the Art of the Unconscious 1364
Freud's *Civilization and Its Discontents* 1365
The Jungian Archetype 1365
The Dreamwork of Surrealism 1366
READING 42.10 from André Breton, *Surrealist Manifesto* (1924) 1366

Experimentation and the Literary Life 1370
Hemingway in Paris: "One True Sentence" 1370
The Stream-of-Consciousness Novel 1371
READING 42.12 from Virginia Woolf, *Mrs. Dalloway* (1925) 1373
READING 42.13 from Marcel Proust, *Swann's Way* (1913) 1374

Readings
READING 42.6 from T. S. Eliot, *The Waste Land*, Part III, "The Fire Sermon" (1921) 1375
READING 42.9 from Sigmund Freud, *Civilization and Its Discontents* (1930) 1375
READING 42.11 from Ernest Hemingway, "Big Two-Hearted River" (1925) 1377

SPECIAL FEATURES
CULTURAL PARALLELS Revolution in Russia and China 1359
FOCUS Eisenstein's *The Battleship Potemkin*, "Odessa Steps Sequence" 1362
VOICES Parisian Nightlife 1371

 Harlem and the Great Migration 1383

43 New York and Skyscraper Culture
Making it New 1385

Skyscraper and Machine: Architecture in New York 1386

The Harlem Renaissance 1388
The Origins of the Harlem Renaissance 1388
READING 43.1 from W. E. B. Dubois, *The Souls of Black Folk* (1903) 1389
READING 43.2 Claude McKay, "If We Must Die" (1919) 1389
"The New Negro" 1389
READING 43.3 Alain Locke, *The New Negro* (1925) 1392
Langston Hughes and the Poetry of Jazz 1393
READING 43.5a from Langston Hughes, "Jazz Band in a Parisian Cabaret" (1925) 1393
Zora Neale Hurston and the Voices of Folklore 1394
READING 43.7 from Zora Neale Hurston, "The Gilded Six-Bits" (1933) 1394
All That Jazz 1394
The Visual Arts in Harlem 1397
READING 43.8 from James Weldon Johnson, "The Prodigal Son" (1927) 1397

Making It New: The Art of Place 1398
Fitzgerald and *The Great Gatsby* 1398
READING 43.9a from F. Scott Fitzgerald, *The Great Gatsby* (1925) 1398
READING 43.9b from F. Scott Fitzgerald, *The Great Gatsby* (1925) 1399
The New American Poetry and the Machine Aesthetic 1399
READING 43.10 William Carlos Williams, "The Red Wheelbarrow," from *Spring and All* (1923) 1400
READING 43.11 William Carlos Williams, "The Great Figure," from *Sour Grapes* (1921) 1400
READING 43.12 E. E. Cummings, "she being Brand" (1926) 1401
READING 43.13 from Hart Crane, "To Brooklyn Bridge," *The Bridge* (1930) 1401
The New American Painting: "That, Madam . . . is paint." 1403
READING 43.14 from William Carlos Williams, *The Autobiography of William Carlos Williams* (1948) 1403
The American Stage: Eugene O'Neill 1407

The Golden Age of Silent Film: Hollywood in the 1920s 1407
The Americanization of a Medium 1407
The Studios and the Star System 1408
Audience and Expectation: Hollywood's Genres 1410
Cinema in Europe 1410

Readings
READING 43.4 Countee Cullen, "Heritage" (1925) 1412
READING 43.5 Langston Hughes, Selected Poems 1413
READING 43.6 Zora Neale Hurston, "How It Feels to Be Colored Me" (1928) 1414

SPECIAL FEATURES
FOCUS William van Alen's Chrysler Building 1390
VOICES The Jazz Capital of the World 1393
CULTURAL PARALLELS Shanghai and New York 1396

 The Rise of Fascism 1419

44 Between the Wars
The Age of Anxiety 1421

The Glitter and Angst of Berlin 1422
Kafka's Nightmare Worlds 1423
READING 44.1 from Franz Kafka, *The Trial* (1925) 1424

Brecht and the Berlin Stage 1424
READING 44.3 from Bertolt Brecht, "Theater for Pleasure or Theater for Imagination" (ca. 1935) 1425
Kollwitz and the Expressionist Print 1425

The Rise of Fascism 1425
Hitler in Germany 1427
READING 44.4 from Adolf Hitler, *Mein Kampf* (1925) 1427
Stalin in Russia 1433
Mussolini in Italy 1434
READING 44.5a from Ezra Pound, Canto 120 1435
Franco in Spain 1435

Revolution in Mexico 1436
The Mexican Mural Movement 1436
The Private World of Frida Kahlo 1440

The Great Depression in America 1440
The Road to Recovery: The New Deal 1440
READING 44.6a from Woody Guthrie, "This Land Is Your Land" (1940) 1445
READING 44.6b from Woody Guthrie, "This Land Is Your Land" (1940) 1446
The Rise of Regional Art 1446
READING 44.7 from William Faulkner, *The Sound and the Fury* (1929) 1446

Cinema: The Talkies and Color 1448
Sound and Language 1448
Disney's Color Animation 1449
1939: The Great Year 1450
Orson Welles and *Citizen Kane* 1451

Readings
READING 44.2 from Franz Kafka, *The Metamorphosis* (1915) 1453
READING 44.5 Ezra Pound, Canto 49 ("The Seven Lakes Canto") (1937) from *The Cantos* (1922–1972) 1454

SPECIAL FEATURES
CULTURAL PARALLELS The Rape of Nanjing 1436
FOCUS Picasso's *Guernica* 1438

 Continuity & Change The Bauhaus in America 1457

45 **World War II and Its Aftermath**
Devastation and Recovery 1459

World War II 1460
The War in Europe 1460
The War in the Pacific 1462
The Allied Victory 1463
Decolonization and Liberation 1463
Bearing Witness: Reactions to the War 1465
READING 45.1 from Elie Wiesel, *Night* (1958) 1466

Europe after the War: The Existential Quest 1467
Christian Existentialism: Kierkegaard, Niebuhr, and Tillich 1467
The Philosophy of Sartre: Atheistic Existentialism 1468
READING 45.2 from Jean-Paul Sartre, *No Exit* (1944) 1468

De Beauvoir and Existential Feminism 1468
READING 45.3 from Simone de Beauvoir, *The Second Sex* (1949) 1469
The Literature of Existentialism 1469
READING 45.4 from Albert Camus, Preface to *The Stranger* (1955) 1469
READING 45.5a from Samuel Beckett, *Waiting for Godot*, Act I (1954) 1470
READING 45.5b from Samuel Beckett *Waiting for Godot*, Act II (1954) 1470
The Art of Existentialism 1470

America after the War: Triumph and Doubt 1471
The Literature of Irony: Heller's *Catch-22* 1474
READING 45.6a from Joseph Heller, *Catch-22*, Chapter 5 (1961) 1474
READING 45.6b from Joseph Heller, *Catch-22*, Chapter 24 (1961) 1474
The Triumph of American Art: Abstract Expressionism 1474
The Beat Generation 1482
READING 45.7 from Allen Ginsberg, "Howl" (1956) 1483
Cage and the Aesthetics of Chance 1483
READING 45.8 from Allan Kaprow, "The Legacy of Jackson Pollock" (1958) 1486
Architecture in the 1950s 1486

Reading
READING 45.6 from Joseph Heller, *Catch-22*, Chapter 22, "Milo the Mayor" (1961) 1488

SPECIAL FEATURES
VOICES Racial and Ethnic Identity in the U.S. Military 1464
FOCUS Hamilton's *Just What Is It That Makes Today's Homes So Different, So Appealing?* 1472

 Continuity & Change The Return of the Reichstag 1491

46 **The Turbulent 1960s**
Decade of Change 1493

The Ongoing Fight for Civil Rights 1495
Martin Luther King's Message of Resistance 1495
READING 46.1 from Martin Luther King, "Letter from Birmingham Jail" (1963) 1496
Black Identity 1496
READING 46.3a from Ralph Ellison, *Invisible Man* (1952) 1497
READING 46.3b from Ralph Ellison, *Invisible Man* (1952) 1498
READING 46.4 Amiri Baraka, "Ka'Ba" (1969) 1500
READING 46.5 from Gil Scott-Heron, "The Revolution Will Not Be Televised" (1970) 1501

Mass Media and the Culture of Consumption 1501
Pop Art 1501

Minimalism in Art and Music 1504
György Ligeti and Minimalist Music 1505

The Vietnam War: Rebellion and the Arts 1506
Kurt Vonnegut's *Slaughterhouse-Five* 1507
READING 46.6 from Kurt Vonnegut, *Slaughterhouse-Five* (1969) 1507
Artists Against the War 1507
Conceptual Art 1511

The Music of Youth and Rebellion 1512
READING 46.7 from Joni Mitchell, "Woodstock" (1970) 1514

High and Low: The Example of Music 1514

The Birth of the Feminist Era 1515
The Theoretical Framework: Betty Friedan and NOW 1515
READING 46.8 from Betty Friedan, *The Feminine Mystique* (1963) 1516
Feminist Poetry 1516
READING 46.10 Anne Sexton, "Her Kind" (1960) 1516
Feminist Art 1517

Readings
READING 46.2 from James Baldwin, "Sonny's Blues" (1957) 1520
READING 46.9 Sylvia Plath, "Lady Lazarus" (1962) 1521
READING 46.11 Adrienne Rich, "Diving into the Wreck" (1973) 1522

SPECIAL FEATURES
FOCUS Rosenquist's *F-111* 1508
VOICES San Francisco in the 1960s 1513
CULTURAL PARALLELS Fusing Rock and Japanese Musical Traditions 1514

 Feminist Artists Fight Back 1525

47 The Postmodern Era
Multiple Meanings in a Changing World 1527

Complexity and Contradiction in Postmodern Architecture 1530
The University of Houston College of Architecture 1531
The Gehry House 1532
The Guggenheim Museum Bilbao 1532

Pluralism in the Visual Arts 1533
New Directions in Painting 1533
New Directions in Sculpture 1540
New Media 1541

Multiplicity and Postmodern Literature 1544
READING 47.1 from Michel Foucault, *The Order of Things* (1966) 1544
Postmodern Fiction 1545
READING 47.3a from Paul Auster, *City of Glass* (1985) 1545
READING 47.3b from Paul Auster, *City of Glass* (1985) 1546
The Plural Self and Magical Realism: Latino and Hispanic Literatures of the Americas 1546
READING 47.4 Aurora Levins Morales, "Child of the Americas" (1986) 1546
Postmodern Poetry 1547
READING 47.5a David Antin, "If We Get It" (1987–1988) 1547
READING 47.5b David Antin, "If We Make It" (1987–1988) 1547
READING 47.6 from John Ashbery, "On the Towpath" (1977) 1547

The Theatrical and the New *Gesamtkunstwerk* 1548
Robert Wilson and Postmodern Opera 1548
Laurie Anderson and Rock Postmodern 1550

Reading
READING 47.2 from Jorge Luis Borges, "Borges and I" (1967) 1551

SPECIAL FEATURES
CULTURAL PARALLELS *Miami Vice* and Postmodern Style 1530
FOCUS Basquiat's *Charles the First* 1534
VOICES Bohemia Upside Down 1549

 Toward a World Without Boundaries 1553

48 Blurring the Boundaries
The Global Village in the Information Age 1555

Architecture in the Information Age 1558

East/West: Power and Appropriation 1562

Global Perspectives: The African Double-Bind 1565
The African Experience in Art 1565
The African Experience in Literature 1566
READING 48.1 from Wole Soyinka, *A Dance in the Forests* (1960) 1566

The AIDS Pandemic and the Arts 1567

Multiple Identities in a Global World 1568
The Asian Worldview 1569
Imaging Islam 1571
The Latino and Hispanic Presence in the United States 1573
READING 48.3 from Luis Valdez, *Zoot Suit* (1978) 1574
The "World Music" Movement 1574

Recovering Tradition: Contemporary Native American Art 1575
The Potters of the Southwest 1578
The Revival of Northwest Coast Traditions 1578

Reading
READING 48.2 Véronique Tadjo, "The Betrayal" (1992) 1580

SPECIAL FEATURES
VOICES A Canadian in Tokyo 1563
CULTURAL PARALLELS Decoding the Human Genome 1569
FOCUS Bradley's *Indian Country Today* 1576

 Toward the Future 1583

Index Index-1

Photo and Text Credits Credits-1

Dear Reader,

You might be asking yourself, why should I be interested in the Humanities? Why do I care about ancient Egypt, medieval France, or the Qing Dynasty of China?

I asked myself the same question when I was a sophomore in college. I was required to take a year long survey of the Humanities, and I soon realized that I was beginning an extraordinary journey. That course taught me where it was that I stood in the world, and why and how I had come to find myself there. My goal in this book is to help you take the same journey of discovery. Exploring the humanities will help you develop your abilities to look, listen, and read closely; and to analyze, connect, and question. In the end, this will help you navigate your world and come to a better understanding of your place in it.

What we see reflected in different cultures is something of ourselves, the objects of beauty and delight, the weapons and wars, the melodies and harmonies, the sometimes troubling but always penetrating thought from which we spring. To explore the humanities is to explore ourselves, to understand how and why we have changed over time, even as we have, in so many ways, remained the same.

About the Author

Henry M. Sayre is Distinguished Professor of Art History at Oregon State University–Cascades Campus in Bend, Oregon. He earned his Ph.D. in American Literature from the University of Washington. He is producer and creator of the 10-part television series, *A World of Art: Works in Progress*, aired on PBS in the fall of 1997; and author of seven books, including *A World of Art, The Visual Text of William Carlos Williams, The Object of Performance: The American Avant-Garde since 1970*; and an art history book for children, *Cave Paintings to Picasso*.

See Context and Make Connections...

The Humanities: *Culture, Continuity, and Change* shows the humanities in context and helps readers make connections—among disciplines, cultures, and time periods. Each chapter centers on a specific geographic location and time period and includes integrated coverage of all disciplines of the humanities. Using an engaging storytelling approach, author Henry Sayre clearly explains the influence of time and place upon the humanities.

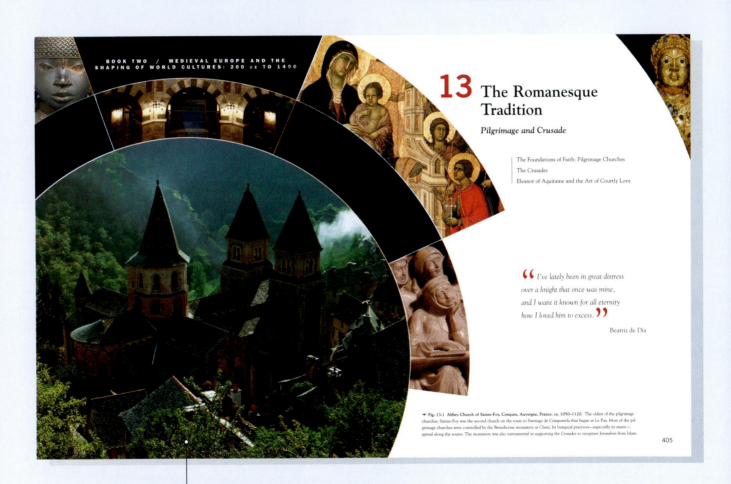

BOOK TWO / MEDIEVAL EUROPE AND THE
SHAPING OF WORLD CULTURES: 200 CE TO 1400

13 The Romanesque Tradition

Pilgrimage and Crusade

The Foundations of Faith: Pilgrimage Churches
The Crusades
Eleanor of Aquitaine and the Art of Courtly Love

*❝ I've lately been in great distress
over a knight that once was mine,
and I want it known for all eternity
how I loved him to excess. ❞*

Beatriz de Dia

◄ **Fig. 13.1 Abbey Church of Sainte-Foy, Conques, Auvergne, France. ca. 1050–1120.** The oldest of the pilgrimage churches, Sainte-Foy was the second church on the route to Santiago de Compostela that began at Le Puy. Most of the pilgrimage churches were controlled by the Benedictine monastery at Cluny. In liturgical practices—especially its music—spread along the routes. The monastery was also instrumental in supporting the Crusades to recapture Jerusalem from Islam.

405

CHAPTER OPENERS Each chapter begins with a compelling chapter opener that serves as a snapshot of the chapter. These visual introductions feature a central image from the location covered in the chapter. Several smaller images represent the breadth of disciplines and cultures covered throughout the book. An engaging quote drawn from one of the chapter's readings and a brief list of the chapter's major topics are also included.

Across the Humanities

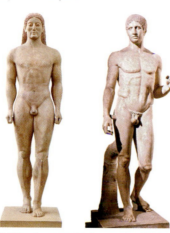

Egyptian and Greek Sculpture

Continuity & Change

Freestanding Greek sculpture of the Archaic period—that is, sculpture dating from about 600–480 BCE—is notable for its stylistic connections to 2,000 years of Egyptian tradition. The Late Period statue of *Mentuemhet* [men-too-em-het] (Fig. **6.18**), from Thebes, dating from around 2500 BCE, differs hardly at all from Old Kingdom sculpture at Giza (see Figs. 3.8–3.9), and even though the *Anavysos* [ah-NAH-vee-sus] *Kouros* (Fig. **6.19**), from a cemetery near Athens, represents a significant advance in relative naturalism over the Greek sculpture of just a few years before, it still resembles its Egyptian ancestors. Remarkably, since it follows upon the *Anavysos Kouros* by only 75 years, the *Doryphoros* [dor-IF-uh-ros] (*Spear Bearer*) (Fig. **6.20**) is significantly more naturalistic. Although this is a

Roman copy of a lost fifth-century BCE bronze Greek statue, we can assume it reflects the original's naturalism, since the original's sculptor, Polyclitus [pol-ih-KLY-tus], was renowned for his ability to render the human body realistically. But this advance, characteristic of Golden Age Athens, represents more than just a cultural taste for naturalism. As we will see in the next chapter, it also represents a heightened cultural sensitivity to the worth of the individual, a belief that as much as we value what we have in common with one another—the bond that creates the city-state—our *individual* contributions are at least of equal value. By the fifth century BCE, the Greeks clearly understood that individual genius and achievement could be a matter of civic pride. ∎

Fig. 6.18 *Mentuemhet*, from Karnak, Thebes. ca. 660 BCE. Granite, height 54". Egyptian Museum, Cairo.

Fig. 6.19 *Anavysos Kouros*, perhaps young Kroisos, from a cemetery at Anavysos [ah-NAH-vee-sus], near Athens. ca. 525 BCE. Marble with remnants of paint, height 6' 4". National Archaeological Museum, Athens; Fig. 6.20 *Doryphoros* (*Spear Bearer*), Roman copy after the original bronze by Polyclitus of ca. 450–440 BCE. Marble, height 6' 6". Museo Archeológico Nazionale, Naples.

185

CONTINUITY & CHANGE
Full-page essays at the end of each chapter illustrate the influence of one culture upon another and show cultural changes over time.

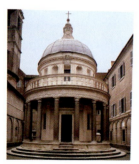

In his plan for a new Saint Peter's (Fig. 18.7a), Bramante adopted the Vitruvian square, as illustrated in Leonardo's drawing, p. 260 placing inside it a **Greek cross** (a cross in which the upright and transverse shafts are of equal length and intersect at their middles) topped by a central dome purposely reminiscent of the giant dome of the Pantheon (see Fig. 8.25). The resultant central plan is essentially a circle inscribed within a square. In Renaissance thinking, the central plan and dome symbolized the perfection of God. Construction began in 1506.

Continuity & Change

The Pantheon

Julius II financed the project through the sale of **indulgences**, dispensations granted by the Church to shorten an individual's stay in purgatory. This was the place where, in Catholic belief, individuals temporarily reside after death as punishment for their sins. Those wanting to enter heaven faster than they otherwise might could shorten their stay in purgatory by purchasing an indulgence. The Church had been selling these documents since the twelfth century, and Julius's building campaign intensified the practice (see *Voices*, page 588). (In protest against the sale of indulgences, Martin Luther would launch the Protestant Reformation in Germany in 1517; see chapter 21.) The New Saint Peter's would be a very expensive project, but there were also very many sinners willing to help pay for it. With the deaths of both pope and architect, in 1513 and 1514 respectively, the project came to a temporary halt. Its final plan would be developed in 1546 by Michelangelo (Fig. 18.7b).

Fig. 18.6 Donato Bramante, Tempietto. 1502. San Pietro in Montorio, Rome. This chapel was certainly modeled after a classical temple. It was commissioned by King Ferdinand and Queen Isabella of Spain, financiers of Christopher Columbus's voyages to America. It was undertaken in support of Pope Alexander VI, who was himself Spanish.

CONTINUITY & CHANGE references provide a window into the past. These eye-catching icons enable students to refer to material in other chapters that is relevant to the topic at hand.

CRITICAL THINKING questions at the end of each chapter prompt readers to synthesize material from the chapter.

 Critical Thinking Questions

1. What was the relationship of the Anglo-Saxon lord or chief to his followers and subjects?

2. How does the *Song of Roland* reflect feudal values? How do these values differ from those found in *Beowulf*?

3. What is the Rule of St. Benedict and how did it affect monastic life?

4. What role did music play in Charlemagne's drive to standardize the liturgy?

See Context and Make Connections...

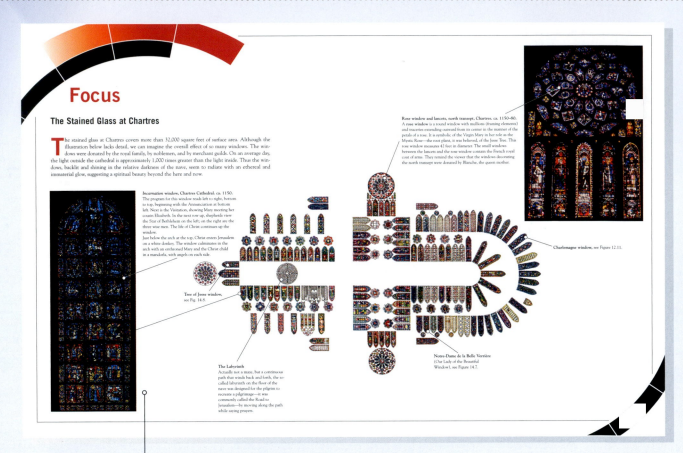

Focus

The Stained Glass at Chartres

The stained glass at Chartres covers more than 32,000 square feet of surface area. Although the illustration below lacks detail, we can imagine the overall effect of so many windows. The windows were donated by the royal family, by noblemen, and by merchant guilds. On an average day, the light outside the cathedral is approximately 1,000 times greater than the light inside. Thus the windows, backlit and shining in the relative darkness of the nave, seem to radiate with an ethereal and immaterial glow, suggesting a spiritual beauty beyond the here and now.

Rose window and lancets, north transept, Chartres. ca. 1150–80. A rose window is a round window with mullions (framing elements) and traceries extending outward from its center in the manner of the petals of a rose. It is symbolic of the Virgin Mary in her role as the Mystic Rose—the root plant, it was believed, of the Jesse Tree. This rose window measures 42 feet in diameter. The small windows between the lancets and the rose window contain the French royal coat of arms. They remind the viewer that the windows decorating the north transept were donated by Blanche, the queen mother.

Incarnation window, Chartres Cathedral. ca. 1150. The program for this window reads left to right, bottom to top, beginning with the Annunciation at bottom left. Next is the Visitation, showing Mary meeting her cousin Elizabeth. In the next row up, shepherds view the Star of Bethlehem on the left; on the right are the three wise men. The life of Christ continues up the window.
Just below the arch at the top, Christ enters Jerusalem on a white donkey. The window culminates in the arch with an enthroned Mary and the Christ child in a mandorla, with angels on each side.

Charlemagne window, see Figure 12.11.

Tree of Jesse window, see Fig. 14.8.

The Labyrinth
Actually not a maze, but a continuous path that winds back and forth, the so-called labyrinth on the floor of the nave was designed for the pilgrim to recreate a pilgrimage—it was commonly called the Road to Jerusalem—by moving along the path while saying prayers.

Notre-Dame de la Belle Verrière (Our Lady of the Beautiful Window), see Figure 14.7.

FOCUS Highly visual Focus features offer an in-depth look at a particular work from one of the disciplines of the humanities. These annotated discussions give students a personal tour of the work—with informative captions and labels—to help students understand its meaning.

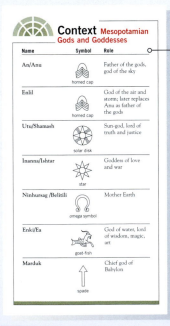

Context Mesopotamian Gods and Goddesses

Name	Symbol	Role
An/Anu	horned cap	Father of the gods, god of the sky
Enlil	horned cap	God of the air and storm; later replaces Anu as father of the gods
Utu/Shamash	solar disk	Sun-god, lord of truth and justice
Inanna/Ishtar	star	Goddess of love and war
Ninhursag /Belitili	omega symbol	Mother Earth
Enki/Ea	goat-fish	God of water, lord of wisdom, magic, art
Marduk	spade	Chief god of Babylon

CONTEXT boxes summarize important background information in an easy-to-read format.

MATERIALS AND TECHNIQUES boxes explain and illustrate the methods artists and architects use to produce their work.

Materials & Techniques
Tapestry

Tapestries are heavy textiles hand-woven on looms. The looms range in size from small, hand-held models to large, freestanding structures. They serve as frames, holding in tension supporting threads, called the **warp**, so that striking threads, called the **weft**, can be interwoven between them. Warp threads are made of strong fibers, usually wool or linen, while weft threads are brightly colored strands of silk or wool, spun gold, or spun silver. Once the warp threads are stretched on the loom, the weaver places a **cartoon**, or full-scale drawing, below or behind the loom. The weaver then works on the back side of the tapestry, pushing the weft threads under and over the warp threads, knotting alternating colors together in a single strand, to match the cartoon's design. So the front side of the tapestry reproduces the design in reverse. The design can approach painting in its compositional complexity, refinement, and the three-dimensional rendering of forms.

warp

weft

The vertical warp threads of a tapestry are interwoven with horizontal weft threads

Through Special Features and Primary Sources

Each chapter of *The Humanities* includes **PRIMARY SOURCE READINGS** in two formats. Brief readings from important works are included within the body of the text. Longer readings located at the end of each chapter allow for a more in-depth study of particular works. This organization offers great flexibility in teaching the course.

END-OF-CHAPTER READINGS

BRIEF READINGS

[Sample page — End-of-Chapter Readings]

READINGS

READING 17.4

from Baldassare Castiglione, *The Book of the Courtier*, Book 1 (1513–18; published 1528)

Castiglione spent his life in the service of princes, first in the courts of Mantua and Urbino, and then in Rome, where he served the papacy. His Book of the Courtier was translated into most European languages and remained popular for two centuries. It takes the form of a series of fictional conversations between the courtiers of the duke of Urbino in 1507 and included the duchess. In the excerpt below, the separate speakers have not been identified to facilitate ease of reading. The work is a celebration of the ideal character of the Renaissance humanist and the ethical behavior associated with that ideal.

[The Perfect Courtier]

Within myself I have long doubted, dearest messer Alfonso, which of two things were the harder for me: to deny you what you have often begged of me so urgently, or to do it. For while it seemed to me very hard to deny anything (and especially a thing in the highest degree laudable) to one whom I love most dearly and by whom I feel myself to be most dearly loved, yet to set about an enterprise that I am not sure of being able to finish, seemed to me ill befitting a man who esteems just censure as it ought to be esteemed. . . .

You ask me then to write what is to my thinking the form of Courtiership most befitting a gentleman who lives at the court of princes, by which he may have the ability and knowledge perfectly to serve them in every reasonable thing, winning from them favor, and praise from other men; in short, what manner of man he ought to be who may deserve to be called a perfect Courtier without flaw. . . .

So now let us make a beginning of our subject, and if possible let us form such a Courtier that any prince worthy to be served by him, although of but small estate, might still be called a very great lord.

I wish then, that this Courtier of ours should be nobly born and of gentle race; . . . for noble birth is like a bright lamp that manifests and makes visible good and evil deeds, and kindles and stimulates to virtue both by fear of shame and by hope of praise. . . . And this it nearly always happens that both in the profession of arms and in other worthy pursuits the most famous men have been of noble birth, because nature has implanted in everything that hidden seed which gives a certain force and quality of its own essence to all things that are derived from it, and makes them like itself: as we see not only in the breeds of horses and of other animals, but also in trees, the shoots of which nearly always resemble the trunk; and if they sometimes degenerate, it arises from poor cultivation. And so it is with men, who if rightly trained are nearly always like those from whom they spring, and often

It is true that, by favor of the stars or of nature, some men are endowed at birth with such graces that they seem not to have been born, but rather as if some god had formed them with his very hands and adorned them with every excellence of mind and body. So too there are many men so foolish and rude that one cannot but think that nature brought them into the world out of contempt or mockery. Just as these can usually accomplish little even with constant diligence and good training, so with slight pains these others reach the highest summit of excellence. . . .

Besides this noble birth, then, I would have the Courtier favored in this regard also, and endowed by nature not only with talent and beauty of person and feature, but with a certain grace and (as we say) air that shall make him at first sight pleasing and agreeable to all who see him; and I would have this an ornament that should dispose and unite all his actions, and in his outward aspect give promise of whatever is worthy the society and favor of every great lord.

But to come to some details, I am of opinion that the principal and true profession of the Courtier ought to be that of arms; which I would have him follow actively above all else, and be known among others as bold and strong, and loyal to whomsoever he serves. And he will win a reputation for these good qualities by exercising them at all times and in all places, since one may never fail in this without severest censure. And just as among women, their fair fame once sullied never recovers its first lustre, so the reputation of a gentleman who bears arms, if once it be in the least tarnished with cowardice or other disgrace, remains forever infamous before the world and full of ignominy. Therefore the more our Courtier excels in this art, the more he will be worthy of praise . . .

And of such sort I would have our Courtier's aspect; not so soft and effeminate as is sought by many, who not only curl their hair and pluck their brows, but gloss their faces with all those arts employed by the most wanton and unchaste women in the world; and in their walk, posture and every act, they seem so limp and languid that their limbs like to fall apart; and they pronounce their words so mourn-

[Sample page — Brief Readings]

The poem, in short, demonstrates that traditional chivalric virtues—those that Castiglione was outlining in *The Book of the Courtier* (see chapter 17) even as Ariosto was writing his poem—had little or no relevance to the modern Italian court, just as armor, swords, and lances had been made irrelevant by the invention of gunpowder. On the subject of gunpowder, the poem makes the following lament (Reading 19.2b):

READING 19.2b from Ludovico Ariosto, *Orlando Furioso, Canto XI*

XXVI
How, foul and pestilent discovery,
Didst thou find place within the human heart?
Through thee is martial glory lost, through thee
The trade of arms become a worthless art;
And at such ebb are worth and chivalry,
That the base often plays the better part.
Through thee no more shall gallantry, no more
Shall valour prove their prowess as of yore.

Love is never ennobling in the poem—and rarely chivalric—but leads only to insult, rejection, madness, and death. The only way to save oneself is not to love at all. But however unsympathetic the poem is to the chivalric code, Ariosto's ability to create an exciting narrative of nonstop action that moves across the globe in large part accounts for his poem's extraordinary success. Throughout the sixteenth century, new readers discovered the poem as the printing press (see chapter 21) made it more widely available, especially to a popular audience that had little use for the conventions of chivalry.

Lucretia Marinella's *The Nobility and Excellence of Women*

Not surprisingly, Renaissance women also attacked the chivalric, or rather pseudo-chivalric, attitudes and behavior of Renaissance males. One such attack was *The Nobility and Excellence of Women and the Defects and Vices of Men* by the Venetian writer Lucretia Marinella [loo-CREE-sha mah-ree-NEL-lah] (1571–1653), published in Venice around 1600 and widely circulated. (See **Reading 19.3a**.) Marinella was one of the most prolific writers of her day. She published many works, including a pastoral drama, musical compositions, religious verse, and an epic poem celebrating Venice's role in the Fourth Crusade, but her sometimes vitriolic polemic against men is unique in the literature of the time. *The Nobility and Excellence of Women* is a response to a contemporary diatribe, *The Defects of Women*, written by her Venetian contemporary, Giuseppe Passi [PAHS-see].

It is clear enough to Marinella, who had received a humanistic education, that any man who denigrates women

is motivated by such reasons as anger and envy (see Reading 19.3, pages 631–632, for an extended excerpt).

READING 19.3a from Lucretia Marinella, *The Nobility and Excellence of Women*

When a man wishes to fulfill his unbridled desires and is unable to because of the temperance and continence of a woman, he immediately becomes angry and disdainful, and in his rage says every bad thing he can think of, as if the woman were something evil and hateful. . . . When a man sees that a woman is superior to him, both in virtue and in beauty, and that she is justly honored and loved even by him, he tortures himself and is consumed with envy. Not being able to give vent to his emotions in any other way, he resorts with sharp and biting tongue to false and specious vituperation and reproof. . . . But if with a subtle intelligence, men should consider their own imperfections, oh how humble and low they would become! Perhaps one day, God willing, they will perceive it.

From Marinella's point of view, Renaissance women possess the fullest measure of Castiglione's moral virtue and humanist individualism, not the courtiers themselves. The second part of the book, on the *defects and vices of men*, is a stunning and sometimes amusing reversal of Passi's arguments, crediting men with all the vices he attributes to women.

For Marinella, Ariosto's *Orlando Furioso*, with its many exemplary female characters, was a rich mine of opinions, episodes, and characters that suggest women's moral and intellectual eminence. She makes use of the Neoplatonic argument that beauty is a reflection of goodness, arguing that women's souls must be preeminent because of "the beauty of their bodies." But perhaps Marinella's most important distinction is her insistence that women are autonomous beings, who should not be defined only in relation to men. (See *Voices*, page 627.)

Music of the Venetian High Renaissance

Almost without exception, women of literary accomplishment in the Renaissance were musically accomplished as well. As we have seen, Isabella d'Este played both the lute and the *lira da braccio*, the precursor to the modern violin (see Fig. 18.18). Through her patronage, she and her sister-in-law Lucrezia Borgia, duchess of Ferrara, competed for musicians and encouraged the cultivation of the *frottola*, (see chapter 17). Courtesans such as Veronica Franco could both sing and play. And both Isabella and Elisabetta Gon-

Mankind in Leonardo da Vinci, in whom, besides a beauty of body never sufficiently extolled, there was an infinite grace in all his actions, and so great was his genius, and such its growth, that to whatever difficulties he turned his mind, he

been so variable and distasteful, for she himself many things, and then, after having begun them, ab... them. Thus, in arithmetic, during the few months studied it, he made so much progress, that, by co...

[Voices feature box]

(((**V o i c e s**)))

A Young Woman's Perspective on Venetian Society

Against her will, the parents of Arcangela Tarabotti (1604–1652) sent her to a Benedictine convent near Venice for her education. Here she expresses her passionate anger at her family, the convent system, and the hierarchy of Venetian society. This excerpt is from her first work, Parental Tyranny. Her next work was an even more searing indictment (never published) entitled Convent Hell.

Compares the plight of young girls in the convent to captured birds:

Whenever I see one of these hapless young girls, betrayed by their very own parents, I am reminded of what happens to a pretty little bird: from within the tree's foliage or along riverbanks, it delights the ear with sweet chirping and charming song, soothing the hearts of its audience—when suddenly it's trapped in a treacherous net, robbed of precious liberty.

Discussing education, Tarabotti focuses on her own experiences:

So shameless are you that while reproaching women for stupidity you strive with all your power to bring

"As soon as you men catch sight of a woman with pen in hand, you start ranting and raving; you order them under penalty of death to put aside their scribbling and attend to "feminine" tasks like needlework and spinning. . . ."

them up and educate them as if they were witless and insensitive. You give them as a governess another woman, also unlettered, who can barely instruct them in the rudiments of reading, to say nothing of anything to do with philosophy, law, and theology. In short, they learn nothing but the ABC, and even that is poorly taught. (I know from experience, so I can bear witness at length.)

As soon as you men catch sight of a woman with pen in hand, you start ranting and raving; you order them under penalty of death to put aside their scribbling and attend to "feminine" tasks like needlework and spinning. . . . (As if our intellects could find no more appropriate occupation than spinning!)

zaga, duchess of Urbino, were well known for their ability to improvise songs. By the last decades of the sixteenth century, we know that women were composing music as well. The most famous of these was the Venetian Madalena Casulana [mah-dah-LAY-nah kah-soo-LAH-nah].

Madalena Casulana's Madrigals

Madalena Casulana was the first professional woman composer to see her own compositions in print. In 1566, her anthology entitled *The Desire* was published in Venice. Two years later, she dedicated her first book of songs to Isabella

chapter 17), the madrigal is **through-composed**—that is, each line of text is set to new music. This allows for **word painting**, where the musical elements imitate the meaning of the text in mood or action. Anguish, for example, is conveyed with an unusually low pitch, as in Casulana's *Morir non può il mio cuore* [moh-REER nohn pwo eel MEE-oh KWOR-eh] ("My Heart Cannot Die") **(CD-Track 19.1**). The song laments a relationship gone bad, and the narrator contemplates driving a stake through her heart because it is in so much pain. When she says that her suicide might kill her beloved—*so che morreste voi* [so keh mor-EH-stay VOY] ("I know that you would die")—

Included in every chapter, **VOICES** features offer vivid first person accounts of the experiences of ordinary people during the period covered in the chapter. These primary source readings offer a glimpse of what life was like in the past and help students understand the social context of a particular culture.

A **CD ICON** calls out musical selections discussed in the text that are found on the supplemental CDs available for use with *The Humanities*.

See Context and Make Connections... Across Cultures

The Humanities: Culture, Continuity, and Change provides the most comprehensive coverage of various cultures including Asia, Africa, the Americas, and Europe.

Included in every chapter, **CULTURAL PARALLELS** highlight historical and artistic developments occurring in different locations during the period covered in the chapter. This feature helps students understand parallel developments in the humanities across the globe.

Detailed **MAPS** in each chapter orient the reader to the locations discussed in the chapter.

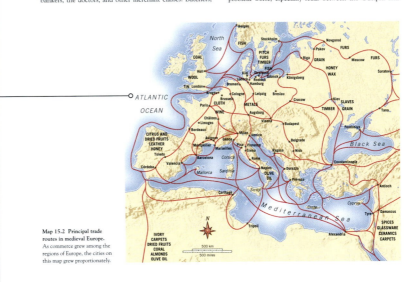

464 **BOOK TWO** MEDIEVAL EUROPE AND THE SHAPING OF WORLD CULTURES

CULTURAL PARALLELS

Textiles in Florence and Peru

Florence was the center of textile production in the West, but 7,000 miles farther west, the Inca culture of the Peruvian highlands also produced abundant supplies of high-quality textiles. The Inca valued these woolen products even more than gold, and weavers encoded complex symbolism into the fabric (see chapter 16).

The Guilds and Florentine Politics Only two other cities in all of Italy—Lucca and Venice—could boast that they were republics like Siena and Florence, and governing a republic was no easy task. As in Siena, in Florence the guilds controlled the commune. By the end of the twelfth century there were seven major guilds and fourteen minor ones. The most prestigious was the lawyers' guild (the Arte dei Giudici), followed closely by the wool guild (the Arte della Lana), the silk guild (the Arte di Seta), and the cloth merchants' guild (the Arte di Calimala). Also among the major guilds were the bankers, the doctors, and other merchant classes. Butchers, bakers, carpenters, and masons composed the bulk of the minor guilds.

As in Siena, too, the merchants, especially the Arte della Lana, controlled the government. They were known as the *Popolo Grasso* (literally, "the fat people"), as opposed to *Popolo Minuto*, the ordinary workers, who comprised probably 75 percent of the population and had no voice in government. Only guild members could serve in the government. Their names were written down, the writing was placed in leather bags (*borse*) in the Church of Santa Croce, and nine names were drawn every two months in a public ceremony. (The period of service was short to reduce the chance of corruption.) Those *signori* selected were known as the *Priori*, and their government was known as the *Signoria*—hence the name of the Piazza della Signoria, the plaza in front of the Palazzo Vecchio. There were generally nine Priori—six from the major guilds, two from the minor guilds, and one standard-bearer.

The Florentine republic might have resembled a true democracy except for two details: First, the guilds were very close-knit so that, in general, selecting one or the other of their membership made little or no political difference; and second, the available names in the *borse* could be easily manipulated. However, conflict inevitably arose, and throughout the thirteenth century other tensions made the problem worse, especially feuds between the Guelphs and

Map 15.2 Principal trade routes in medieval Europe. As commerce grew among the regions of Europe, the cities on this map grew proportionately.

See Context and Make Connections...
with Teaching and Learning Resources

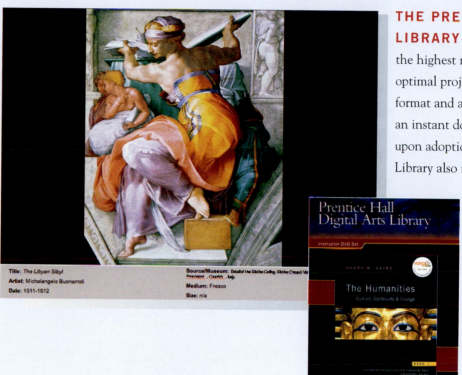

Title: *The Libyan Sibyl*
Artist: Michelangelo Buonarroti
Date: 1511-1512
Source/Museum: Detail of the Sistine Ceiling, Sistine Chapel Vatican, Rome, Italy.
Medium: Fresco
Size: n/a

Prentice Hall
Digital Arts Library
Instructor DVD Set

The Humanities
Culture, Continuity & Change

THE PRENTICE HALL DIGITAL ARTS LIBRARY contains every image in *The Humanities* in the highest resolution and pixellation possible for optimal projection. Each image is available in jpeg format and as a customizable PowerPoint® slide with an instant download function. Available to instructors upon adoption of *The Humanities*, the Digital Arts Library also includes video and audio clips for use in classroom presentations.

DVD Set: 978-0-13-615298-9
CD Set: 978-0-13-615299-6

myhumanitieslab

MYHUMANITIESLAB is a dynamic online resource that provides opportunities for practice, assessment, and instruction—including digital flashcards of every image in the text. Easy to use and easy to integrate into the classroom, it engages students as it builds confidence and enhances students' learning experience.

Visit **www.myhumanitieslab.com** to begin.

Instructor's Manual and Test Item File
978-0-13-182727-1

Test Generator
978-0-13-182730-1
www.prenhall.com/irc

Companion Website
www.prenhall.com/sayre

Student Study Guide
Volume I: 978-0-13-615316-0
Volume II: 978-0-13-615317-7

VangoNotes Audio Study Guides
www.vangonotes.com

Music CDs
Music CD to Accompany Volume I: 978-0-13-601736-3
Music CD to Accompany Volume II: 978-0-13-601737-0

The Prentice Hall Atlas of the Humanities
978-0-13-238628-9

Package Penguin titles at a significant discount
Visit **www.prenhall.com/art** for information.

Developing *The Humanities*

The Humanities: *Culture, Continuity, and Change* is the result of an extensive development process involving the contributions of over one hundred instructors and their students. We are grateful to all who participated in shaping the content, clarity, and design of this text. Manuscript reviewers and focus group participants include:

Kathryn S. Amerson, *Craven Community College*
Helen Barnes, *Butler County Community College*
Bryan H. Barrows III, *North Harris College*
Amanda Bell, *University of North Carolina, Asheville*
Sherry R. Blum, *Austin Community College*
Edward T. Bonahue, *Santa Fe Community College*
James Boswell Jr., *Harrisburg Area Community College–Wildwood*
Diane Boze, *Northeastern State University*
Robert E. Brill, *Santa Fe Community College*
Daniel J. Brooks, *Aquinas College*
Farrel R. Broslawsky, *Los Angeles Valley College*
Benjamin Brotemarkle, *Brevard Community College–Titusville*
Peggy A. Brown, *Collin County Community College*
Robert W. Brown, *University of North Carolina –Pembroke*
David J. Califf, *The Academy of Notre Dame*
Gricelle E. Cano, *Houston Community College–Southeast*
Martha Carreon, *Rio Hondo College*
Charles E. Carroll, *Lake City Community College*
Margaret Carroll, *Albany College of Pharmacy of Union University*
Beverly H. Carter, *Grove City College*
Michael Channing, *Saddleback Community College*
Patricia J. Chauvin, *St. Petersburg College*
Cyndia Clegg, *Pepperdine University*
Jennie Congleton, *College Misericordia*
Ron L. Cooper, *Central Florida Community College*
Similih M. Cordor, *Florida Community College*
Laurel Corona, *San Diego City College*
Michael W. Coste, *Front Range Community College–Westminster*
Harry S. Coverston, *University of Central Florida*
David H. Darst, *Florida State University*
Gareth Davies-Morris, *Grossmont College*
James Doan, *Nova Southeastern University*
Jeffery R. W. Donley, *Valencia Community College*
William G. Doty, *University of Alabama*
Scott Douglass, *Chattanooga State Technical Community College*
May Du Bois, *West Los Angeles College*
Tiffany Engel, *Tulsa Community College*
Walter Evans, *Augusta State University*
Douglas K. Evans, *University of Central Florida*
Arthur Feinsod, *Indiana State University*
Kimberly Felos, *St. Petersburg College–Tarpon Springs*
Jane Fiske, *Fitchburg College*
Brian Fitzpatrick, *Endicott College*
Lindy Forrester, *Southern New Hampshire University*
Barbara Gallardo, *Los Angeles Harbor College*
Cynthia D. Gobatie, *Riverside Community College*
Blue Greenberg, *Meredith College*
Richard Grego, *Daytona Beach Community College–Daytona*
Linda Hasley, *Redlands Community College*

Dawn Marie Hayes, *Montclair State University*
Arlene C. Hilfer, *Ursuline College*
Clayton G. Holloway, *Hampton University*
Marion S. Jacobson, *Albany College of Pharmacy of Union University*
Bruce Janz, *University of Central Florida*
Steve Jones, *Bethune-Cookman College*
Charlene Kalinoski, *Roanoke College*
Robert S. Katz, *Tulsa Community College*
Alice Kingsnorth, *American River College*
Connie LaMarca-Frankel, *Pasco-Hernando Community College*
Leslie A. Lambert, *Santa Fe Community College*
Sandi Landis, *St. Johns River Community College–Orange Park*
Vonya Lewis, *Sinclair Community College*
David Luther, *Edison Community College, Collier*
Michael Mackey, *Community College of Denver*
Janet Madden, *El Camino College*
Ann Marie Malloy, *Tulsa Community College–Southeast*
James Massey, *Polk Community College*
John Mathews, *Central Florida Community College*
Susan McClung, *Hillsborough Community College–Ybor City*
Joseph McDade, *Houston Community College, Northeast*
Brian E. Michaels, *St. Johns River Community College*
Maureen Moore, *Cosumnes River College*
Nan Morelli-White, *St. Petersburg College–Clearwater*
Jenny W. Ohayon, *Florida Community College*
Beth Ann O'Rourke, *University of Central Florida*
Elizabeth Pennington, *St. Petersburg College–Gibbs*
Nathan M. Poage, *Houston Community College–Central*
Norman Prinsky, *Augusta State University*
Jay D. Raskin, *University of Central Florida*
Sharon Rooks, *Edison Community College*
Douglas B. Rosentrater, *Bucks County Community College*
Grant Shafer, *Washtenaw Community College*
Mary Beth Schillaci, *Houston Community College–Southeast*
Tom Shields, *Bucks County Community College*
Frederick Smith, *Lake City Community College*
Sonia Sorrell, *Pepperdine University*
Jonathan Steele, *St. Petersburg Junior College*
Elisabeth Stein, *Tallahassee Community College*
Lisa Odham Stokes, *Seminole Community College*
Alice Taylor, *West Los Angeles College*
Trent Tomengo, *Seminole Community College*
Cordell M. Waldron, *University of Northern Iowa*
Robin Wallace, *Baylor University*
Daniel R. White, *Florida Atlantic University*
Naomi Yavneh, *University of South Florida*
John M. Yozzo, *East Central University*
James Zaharek, *Rio Hondo College*
Kenneth Zimmerman, *Tallahassee Community College*

Acknowledgments

No project of this scope could ever come into being without the hard work and perseverance of many more people than its author. In fact, this author has been humbled by a team at Pearson Prentice Hall that never wavered in its confidence in my ability to finish this enormous undertaking (or if they did, they had the good sense not to let me know); never hesitated to cajole, prod, and massage me to complete the project in something close to on time; and always gave me the freedom to explore new approaches to the materials at hand. At the down-and-dirty level, I am especially grateful to fact checker, George Kosar; to historian Frank Karpiel, who helped develop the timelines, the Cultural Parallels, and the Voices features of the book; to Mary Ellen Wilson for the pronunciation guides; as well as the more specialized pronunciations offered by David Atwill (Chinese and Japanese); Jonathan Reynolds (African); Nayla Muntasser (Greek and Latin); and Mark Watson (Native American); to John Sisson for tracking down the readings; to Laurel Corona for her extraordinary help with Africa; to Arnold Bradford for help with critical thinking questions; and to Francelle Carapetyan and her assistant Rebecca Harris for their remarkable photo research. The maps and some of the line art are the work of cartographer and artist, Peter Bull, with Precision Graphic drafting a large portion of the line art for the book. I find both in every way extraordinary.

In fact, I couldn't be more pleased with the look of the book, which is the work of Leslie Osher, associate director of design, Nancy Wells, senior art director, and Ximena Tamvakopoulos, designer. The artistic layout of the book was created by Gail Cocker-Bogusz and Wanda España. Gail Cocker-Bogusz coordinated the map and line art program with the help of Mirella Signoretto. The production of the book was coordinated by Barbara Kittle, director of operations; Lisa Iarkowski, associate director of team-based project management; Mary Rottino, senior managing editor; and by Barbara Cappuccio, project manager; who oversaw with good humor and patience the day-to-day, hour-to-hour crises that arose. Brian Mackey, operations manager, ensured that this project progressed smoothly through its production route.

The marketing and editorial teams at Prentice Hall are beyond compare. On the marketing side, Brandy Dawson, director of marketing; Marissa Feliberty, executive marketing manager; and Irene Fraga, marketing assistant; helped us all to understand just what students want and need. On the editorial side, my thanks to Yolanda de Rooy, president of the Humanities and Social Science division; to Sarah Touborg, editor-in-chief; Amber Mackey, senior editor; Bud Therien, special projects manager; Alex Huggins, assistant editor; and Carla Worner, editorial assistant. The combined human hours that this group has put into this project are staggering. Deserving of special mention is my development team, Rochelle Diogenes, editor-in-chief of development; Roberta Meyer, senior development editor; Karen Dubno; and Elaine Silverstein. Roberta may be the best in the business, and I feel extremely fortunate to have worked with her.

Finally, I want to thank, with all my love, my beautiful wife, Sandy Brooke, who has supported this project in every way. She continued to teach, paint, and write, while urging me on, listening to my struggles, humoring me when I didn't deserve it, and being a far better wife than I was the husband. I was often oblivious, and might at any moment disappear into the massive pile of books beside my desk that she never made me pick up. To say the least, I promise to pick up.

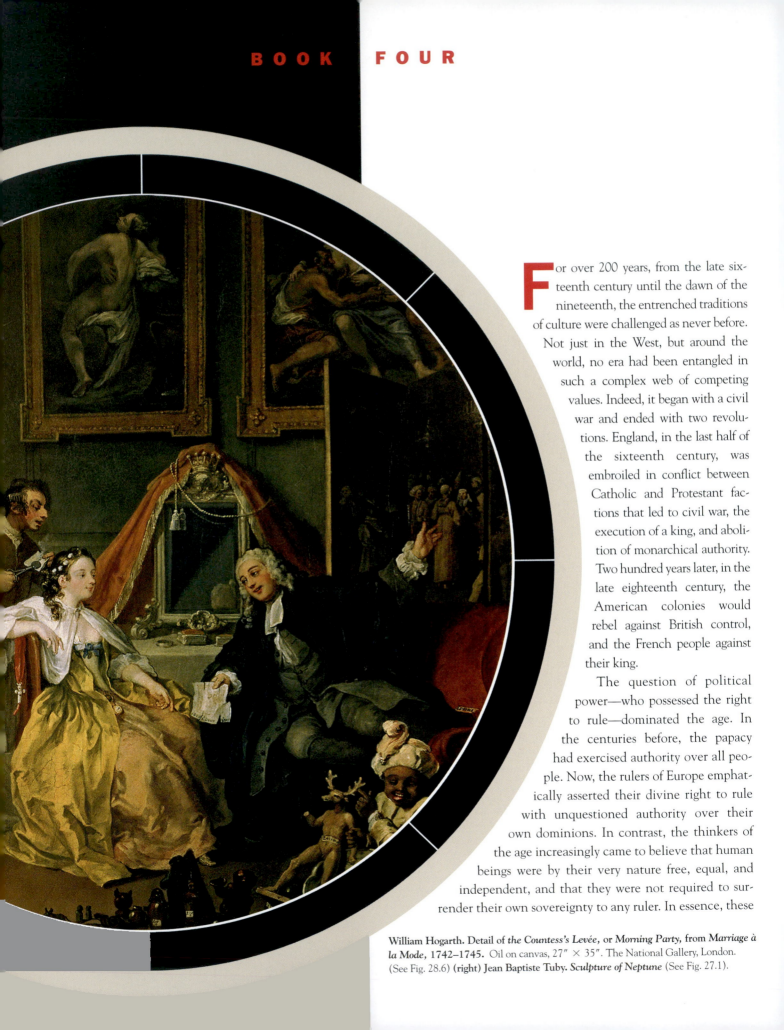

BOOK FOUR

For over 200 years, from the late sixteenth century until the dawn of the nineteenth, the entrenched traditions of culture were challenged as never before. Not just in the West, but around the world, no era had been entangled in such a complex web of competing values. Indeed, it began with a civil war and ended with two revolutions. England, in the last half of the sixteenth century, was embroiled in conflict between Catholic and Protestant factions that led to civil war, the execution of a king, and abolition of monarchical authority. Two hundred years later, in the late eighteenth century, the American colonies would rebel against British control, and the French people against their king.

The question of political power—who possessed the right to rule—dominated the age. In the centuries before, the papacy had exercised authority over all people. Now, the rulers of Europe emphatically asserted their divine right to rule with unquestioned authority over their own dominions. In contrast, the thinkers of the age increasingly came to believe that human beings were by their very nature free, equal, and independent, and that they were not required to surrender their own sovereignty to any ruler. In essence, these

William Hogarth. Detail of *the Countess's Levée,* or *Morning Party,* from *Marriage à la Mode,* 1742–1745. Oil on canvas, 27″ × 35″. The National Gallery, London. (See Fig. 28.6) **(right) Jean Baptiste Tuby. *Sculpture of Neptune*** (See Fig. 27.1).

Excess, Inquiry, and Restraint: 1600 to 1800

thinkers developed a secularized version of the contest between Catholicism and Protestantism that had defined the sixteenth century after the Reformation. Protestant churches had freed themselves from what they believed to be a tyrannical and extravagant papacy. In fact, many people found strong similarities between the extravagances of the European monarchies and the extravagance of Rome. Now, many believed, individuals should free themselves from the tyrannical and profligate rule of any government of which they did not freely choose to submit.

At the beginning of the era, the Counter-Reformation was in full swing, and the Church, out to win back the hearts and minds of all whom the Reformation had drawn away, appealed not just to the intellect, but to the full range of human emotion and feeling. In Rome, it constructed theatrical, even monumental, spaces—not just churches, but avenues, fountains, and plazas—richly decorated in an exuberant style that we have come to call "the Baroque." The other arts followed suit. Painters utilized the play of light and dark to create paintings of stunning drama and energy that reveal, as well, a new Baroque taste for vividly realistic detail. Musicians employed similar dynamic contrasts, mirroring the light and dark in painting. Even in the North, where Protestantism prevailed, artists and musicians employed Baroque techniques. Painters developed a new vernacular art concentrating on domestic scenes, still life, and portraiture, while composers wrote in a new dramatic and emotional style demanding great musical virtuosity, especially on the keyboard.

The courts of Europe readily adapted the Baroque to their own ends. In France, Louis XIII never missed an opportunity to use art and architecture to impress his grandeur and power upon the French people (and the other courts of Europe). In the arts, the stylistic tensions of the French court were most fully expressed. The rational clarity and moral uprightness of the Classical contrasted with the emotional drama and flamboyant sensuality of the Baroque. In music, for example, we find the clarity of the classical symphony and the spectacle of opera. Scientific and philosophical investigation— the invention, for instance, of new tools of observation like the telescope and microscope—had helped to sustain a new-found trust in the power of the rational mind to understand the world. When Isaac Newton demonstrated in 1687, to the satisfaction of just about everyone, that the universe was an intelligible system, well ordered in its operations and guiding principles, it seemed possible that the operations of human society—the production and consumption of manufactured goods, the social organization of families and towns, the operations of national governments, to say nothing of its arts—might be governed by analogous universal laws. The pursuit of these laws is the defining characteristic of the eighteenth century, the period we have come to call the Enlightenment.

Thus, the age developed into a contest between those who sought to establish a new social order forged by individual freedom and responsibility, and those whose taste favored a decorative and erotic excess—primarily the French court. But even the high-minded champions of freedom found themselves caught up in morally complex dilemmas. Americans championed liberty, but they also defended the institution of slavery. The French would overthrow their dissolute monarch, only to see their society descend into chaos, requiring, in the end, a return to imperial rule. And, when the Europeans encountered other cultures—in the South Pacific, China, India, and, most devastatingly, in the American West—they tended to impose their own values on cultures that were, in many ways, not even remotely like their own. But if the balance of power fell heavily to the West, increasingly the dynamics of global encounter resulted in the exchange of ideas and values.

Timeline Book Four: 1600 to 1800

1600–1700	1700–1750

HISTORY AND CULTURE

1600–1700: rise of Amsterdam as center of commerce

1605–1627: reign of Jahangir, Mogul India

1618–1648: Thirty Years' War in Europe

1643–1715: reign of Louis XIV, France

1644: Manchus conquer China, establish Qing dynasty

1665–1666: Great Plague and fire devastate London

1682–1725: Peter the Great rules Russia

1688–1689: William of Orange invades Britain: Parliament enacts Bill of Rights

Rigaud, *Louis XIV*

1703: Saint Petersburg, Russia founded by Peter the Great

1715–1774: reign of Louis XV, France

1736–1795: reign of Qianlong emperor, China

1740–1786: Frederick II (the Great) rules Prussia

RELIGION AND PHILOSOPHY

1600: Giordano Bruno burned at the stake for heresy

1601: Jesuits establish mission in China

1680–1696: Pueblo peoples of New Mexico revolt against Spanish rule and Catholic missions

TECHNOLOGY AND SCIENCE

1609–1610: Galileo Galilei observes moon's craters

1620: Francis Bacon outlines scientific method using inductive reasoning

1637: René Descartes's *Discourse on Method* argues for deductive reasoning

1651: Thomas Hobbes's *Leviathan*

1660: Royal Society in London founded to promote scientific inquiry

1687: Isaac Newton's *Principia Mathematica*

1689: John Locke's *Essay on Human Understanding*, *Two Treatises of Government*

1733: John Kay improves textile manufacturing through invention of flying shuttle

1743: Benjamin Franklin founds American Philosophical Society to study advances in science, medicine, and technology

ART AND ARCHITECTURE

1600–1700: Baroque art

1610: Peter Paul Rubens's *Elevation of the Cross*

1624–1633: Gian Lorenzo Bernini's canopy for altar of Saint Peter's

1623: Diego Velazquez appointed court painter to Philip IV of Spain

1625: Artemisia Gentileschi's *Judith and Maidservant with Head of Holofernes*

1632–1648: Shah Jahan constructs Taj Mahal

1641: Anthony Van Dyck, English court painter, creates *cavalier style*, conveying aristocratic ideal

1668: Jan Vermeer paints *Geographer*, using *camera obscura*

1678: Charles Le Brun creates Hall of Mirrors at Versailles

1717–1721: Jean-Antoine Watteau paints *fetes galantes* (amorous parties) using Rococo style

1730–1760: Luis Nino incorporates brocadeado in church paintings in Peru

1737–1791: Paris Salons, official art exhibitions of French Academy, create discipline of art criticism

1741–1807: painter Angelica Kauffmann

1747: Giovanni Canaletto's *London: Thames and City of London* illustrates idealized view of city

Fragonard, *The Swing*

LITERATURE AND MUSIC

1605–1616: Cervantes's *Don Quixote*

1622–1673: Molière, French comic playwright

1639–1699: Jean Racine, French dramatist

1667: John Milton's *Paradise Lost*

1678–1741: composer Antonio Vivaldi

1680: Comédie Française established

1685–1750: Johann Sebastian Bach, composer of cantatas using counterpoint

1711: *The Spectator*, daily newspaper in London, pioneers journalistic essay

1719: Daniel Defoe's *Robinson Crusoe*

1726: Jonathan Swift's *Gulliver's Travels*

1740: Samuel Richardson's *Pamela*, first epistolary novel

1740s: Johann Stamitz develops symphonic orchestra

1742: George Frederick Handel's oratorio *Messiah*

1749–1802: active career of composer Franz Joseph Haydn

1750–1772: Denis Diderot and Jean d'Alembert edit *Encyclopedie*

HISTORY AND CULTURE

1756–1763: Seven Years' War between France and Britain
1762–1796: Catherine the Great rules Russia
1770: Captain James Cook encounters aboriginal cultures in Australia
1774–1792: reign of Louis XVI, France
1776: U.S. Declaration of Independence
1789: Estates General convenes, French Revolution begins with fall of the Bastille
1793–1794: "Reign of Terror," France
1799–1814: Napoleon rules France
1810: Kamehameha I unites Hawaiian islands

RELIGION AND PHILOSOPHY

1776: Adam Smith's *Wealth of Nations*
1781: Immanuel Kant's *Critique of Pure Reason*
1789: French National Assembly issues *Declaration of the Rights of Man and Citizen*
1792: Mary Wollstonecraft's *Vindication of the Rights of Women*

TECHNOLOGY AND SCIENCE

1759: Josiah Wedgewood invents mass production at ceramics factory
1769: Richard Arkwright patents water wheel to power clothing looms
1776: James Watt improves steam engine

Flaxman, Vase

ART AND ARCHITECTURE

1751: William Hogarth's *Gin Lane*
1758–1789: Pantheon, Paris, designed by Jacques-Germain Soufflot, is built
1765–1774: Giuseppe Castiglione paints *Presentation of Uigar Captives* for Qing court, China
1767: Jean-Honore Fragonard's *Progress of Love* series
1768–1809: Monticello, VA designed by Thomas Jefferson, influenced by Palladio
1770: Benjamin West's *Death of General Wolfe*
1784: Jacques-Louis David's *Oath of the Horatii*
1788: Jean-Antoine Houdon's statue of George Washington as Cincinnatus
1791–1792: Pierre Charles L'Enfant designs Washington, D.C. in neoclassical style

Houdon,
George Washington

LITERATURE AND MUSIC

1755: Samuel Johnson's *Dictionary of English Language*
1756–1791: Wolfgang Amadeus Mozart
1759: Voltaire's *Candide*
1762: Jean-Jacques Rousseau's *Emile*
1789: Olaudah Equiano's autobiography describes slave living conditions
1789–1794: William Blake's *Songs of Innocence and Songs of Experience*

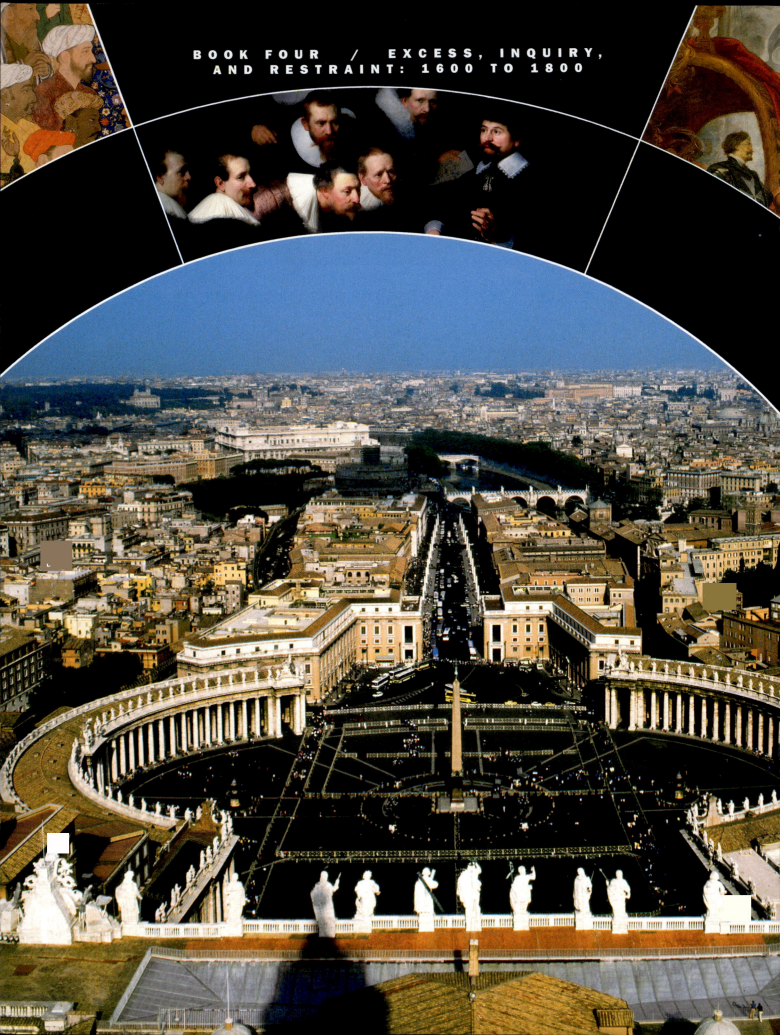

25 The Baroque in Italy

The Church and Its Appeal

Baroque Style and the Counter-Reformation

The Drama of Painting: Caravaggio and the Caravaggisti

Venice and Baroque Music

" I would see beside me, on my left hand, an angel in bodily form. . . . In his hands I saw a long golden spear and at the end of the iron tip I seemed to see a point of fire. With this he seemed to pierce my heart. . . . "

Teresa of Ávila, "Visions"

◄ **Fig. 25.1 Vatican Square as seen from Michelangelo's dome, looking east toward the Tiber.** The long, straight street leading to the Tiber is the Via della Conciliazione, cut by the Fascist dictator Benito Mussolini in the 1930s. Previously, visitors to the Vatican wandered through twisting medieval streets until suddenly they found themselves in the vast, open expanse of the Vatican Square. To the left of the bridge at the Tiber is the Castel Sant'Angelo (see Fig. 25.9), guarding the entrance to the Vatican. The oval colonnade defining the square is considered one of Gian Lorenzo Bernini's greatest works, and it fully captures the grandeur and drama of the Baroque style.

A

S THE SEVENTEENTH CENTURY BEGAN, THE CATHOLIC CHURCH was struggling to win back those who had been drawn away by the Protestant Reformation. To wage its campaign, the Church took what can best be described as a sensual turn, an appeal not just to the intellect but to the range of human

emotion and feeling. This appeal was embodied in an increasingly ornate and grandiose form of expression that came to be known as the Baroque [bah-ROAK] style. Its focal point was the Vatican City, in Rome (Fig. **25.1** and Map **25.1**).

Just as in the sixteenth century Pope Julius II (r. 1503–1513) had attempted to revitalize Rome as the center of the Christian world by constructing a new Saint Peter's Basilica, so at the beginning of the seventeenth century Pope Paul V (r. 1605–1621) began his own monumental changes of Saint Peter's, which represented the seat of Roman Catholicism. He commissioned the leading architect of his day, Carlo Maderno [mah-DAIR-noh] (1556–1629), to

design a new facade for the building (Fig. **25.2**). The columns on the facade "step out" in three progressively projecting planes: At each corner two flat, rectangular, engaged columns surround the arched side entrances; inside these, two more sets of fully rounded columns step forward from the wall and flank the rectangular side doors of the portico; and finally four majestic columns, two on each side, support the projecting triangular pediment above the main entrance. Maderno also transformed Michelangelo's central Greek-cross plan into a basilican Latin-cross design, extending the length of the nave to just over 636 feet in order to accommodate the large congregations that gathered to celebrate the elaborate ritual of the

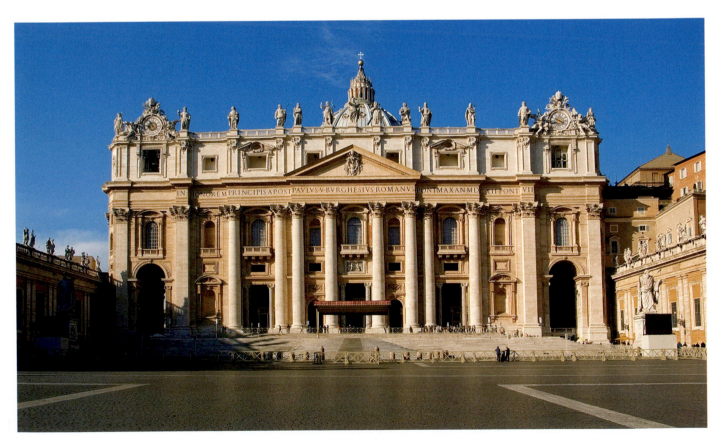

Fig. 25.2 Carlo Maderno. Facade of Saint Peter's Basilica, Vatican, Rome. 1607–1615. Originally the end bays of the facade had bell towers, but because Saint Peter's stood on marshy ground, with underground springs, the towers cracked, and they had to be demolished.

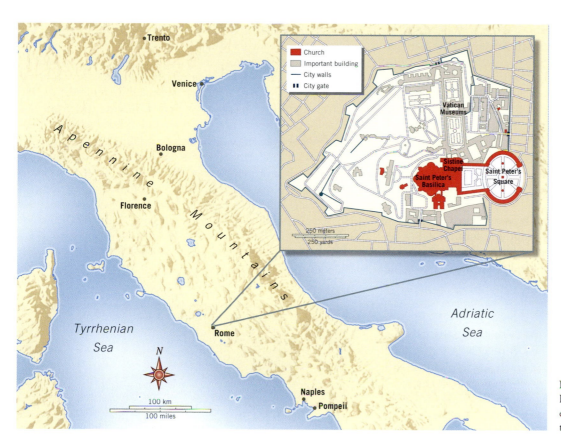

Map 25.1 Vatican City. ca. 1600.
From Vatican City, the pope exercised authority over Rome and the Papal States.

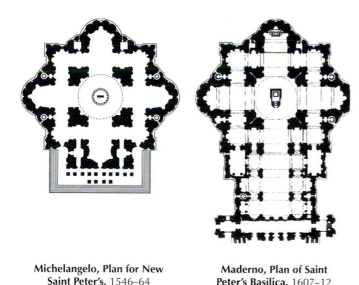

Michelangelo, Plan for New Saint Peter's. 1546–64

Maderno, Plan of Saint Peter's Basilica. 1607–12

Fig. 25.3 Left: Michelangelo. Plan for New Saint Peter's. 1546–1564; Right: Carlo Maderno. Plan of Saint Peter's Basilica. 1607–1612.
Maderno's plan was motivated by Pope Paul V's belief that Saint Peter's should occupy the footprint of the original wooden basilica that had stood in the spot until Pope Julius II tore it down in 1506.

new Counter-Reformation liturgy (Fig. **25.3**). The visual impact of this facade, extending across the front of the church to the entire width of Michelangelo's original Greek-cross plan, was carefully conceived to leave viewers in a state of awe. As one writer described the effect in 1652, "Anyone contemplating the new church's majesty and grandeur has to admit . . . that its beauty must be the work of angels or its immensity the work of giants. Because its magnificent proportions are such that . . . neither the Greeks, the Egyptians nor the Jews, nor even the mighty Romans ever produced a building as excellent and vast as this one." It was, in short, an embodiment—and an announcement—of the Church's own triumph over the Protestant threat.

The visual impact of the facade was heightened even more when, at Maderno's death, Gian Lorenzo Bernini [JAHN lor-EN-zoh bair-NEE-nee] (1598–1680) was appointed chief Vatican architect. He would serve eight popes before his death, but his most important contribution to Vatican architecture is his design for a colonnade to enclose Saint Peter's Square (see Fig. 25.1), the space in front of the main facade of the basilica. Bernini's curved porticoes, composed of 284 huge Doric columns placed in rows of four, create a vast open space—nearly 800 feet across—designed specifically for its dramatic effect. Bernini considered the colonnade enclosing the square to symbolize "the motherly arms of the church" embracing its flock. Here, as crowds gathered to receive the blessing of the pope, the architecture dramatized the blessing itself.

Attention to the way viewers would emotionally experience a work of art is a defining characteristic of the Baroque, a term many believe takes its name from the Portuguese *barroco* [bah-roh-koh], literally a large, irregularly shaped pearl. It was originally used in a derogatory way to imply a style so heavily ornate and strange that it verges on bad taste. The rise of the Baroque is the subject of this chapter. We look at it first as it developed in Rome, and at the Vatican in particular, as a conscious style of art and architecture dedicated to furthering the aims of the Counter-Reformation, then in Venice, which in the seventeenth century was the center of musical activity in Europe.

As Bernini conceived it, the Baroque was a compromise between Mannerist exuberance and religious propriety. He fully supported the edicts of the Council of Trent (see chapter 22) and the teachings of the Society of Jesus founded by the Spanish nobleman Ignatius [ig-NAY-shuhs] of Loyola [loy-OH-luh] (1491–1556). From their headquarters at the Church of Il Gesù [eel jay-ZOO] in Rome, the Jesuits [JEZ-uh-wits], as they were known, led the Counter-Reformation and the revival of the Catholic Church worldwide. All agreed that the purpose of religious art was to teach and inspire the faithful, that it should always be intelligible and realistic, and that it should be an emotional stimulus to piety. In Venice, these religious goals at first motivated developments in music, and the music reflected the same liveliness, energy, and emotional intensity that Bernini realized in his sculpture and architecture. But the city's composers and musicians were relatively free of papal authority and enjoyed a certain freedom to experiment, and they developed in the new secular form of opera, the monumental theatricality of which would soon rival any architectural scheme of Bernini's.

Baroque Style and the Counter-Reformation

As early as the 1540s, the Catholic Church had begun a program of reform and renewal designed to mitigate the appeal of Protestantism that came to be known as the Counter-Reformation (see chapter 22). The building and decoration programs that developed in response to this religious program gradually evolved into the style known as Baroque. During the Renaissance, composition had tended to be frontal, creating a visual space that moved away from the viewer in parallel planes, following the rules of scientific perspective. This produced a sense of calm and balance or symmetry. In the Baroque period, elements usually are placed on a diagonal and seem to swirl and flow into one another, producing a sense of action, excitement, and sensuality. Dramatic contrasts of light and dark often serve to create theatrical effects designed to move viewers and draw them into the emotional orbit of the composition. A profound, sometimes brutally direct, naturalism prevails, as well as a taste for increasingly elaborate and decorative effects, testifying to the Baroque artist's technical skill and mastery of the media used.

In Rome, the patronage of the papal court at the Vatican was most responsible for creating the Baroque style. Pope Sixtus V (r. 1585–1590) inaugurated the renewal of the city. He cut long, straight avenues through it, linking the major pilgrimage churches to one another, and ordered a **piazza** [pee-AHT-sah]—a space surrounded by buildings—to be opened in front of each church and decorated with an Egyptian obelisk salvaged from Roman times. In his brief reign, Sixtus also began to renovate the Vatican, completing the dome of Saint Peter's Basilica, building numerous palaces throughout the city, and successfully reopening one of the city's ancient aqueducts to stabilize the water supply. Over the course of the next century, subsequent popes followed his example with building and art programs of their own.

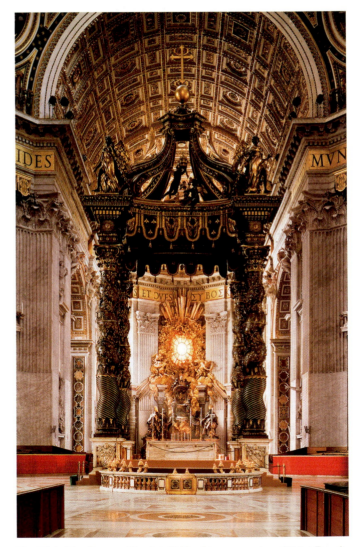

Fig. 25.4 Gian Lorenzo Bernini. Baldacchino at crossing of Saint Peter's Basilica, Vatican, Rome. 1624–1633. Gilt bronze, height approx. 100'. So grand is the space, and so well does Bernini's baldacchino fit in it, that the viewer can scarcely recognize that the structure is the height of the tallest apartment buildings in seventeenth-century Rome.

Sculpture and Architecture: Bernini and His Followers

The new interior space of Saint Peter's Basilica inspired the same feelings of vastness and grandeur as did Carlo Maderno's new facade. The crossing, under Michelangelo's dome, was immense, and its enormity dwarfed the main altar. When Urban VIII (r. 1623–1644) became pope, he commissioned the young Bernini to design a cast bronze **baldacchino** [bahl-da-KEE-noh], or canopy, to help define the altar space (Fig. **25.4**). Part architecture, part sculpture, Bernini's baldacchino consists of four twisted columns decorated with spiraling grooves and bronze vines. This undulating, spiraling, decorative effect symbolized the union of the Old and New Testaments, the vine of the Eucharist [YOO-kuh-rist] climbing the columns of the Temple of Solomon. Elements that combine both the Ionic and Corinthian orders top the columns. Figures of angels and putti [POOT-ee] stand along the entablature, which is decorated with tasseled panels of bronze that imitate cloth. Above the entablature, the baldacchino rises crownlike to an orb, symbolizing the universe, and is topped by a cross, symbolizing the reign of Christ. In its immense size, its realization of an architectural plan in sculptural terms, and its synthesis of a wide variety of symbolic elements in a single form, the baldacchino is uniquely Baroque in spirit.

The Cornaro Chapel Probably no image sums up the Baroque movement better than Bernini's sculptural program for the Cornaro [kor-NAH-roh] Chapel. Located in Carlo Maderno's Church of Santa Maria della Vittoria in Rome (Fig. **25.5**), it was a commission from the Cornaro family and executed by Bernini in the middle of the century, at about the same time he was working on the colonnade for Saint Peter's Square. Bernini's theme is a pivotal moment in the life of Teresa of Ávila [AH-vih-la] (1515–1582), a Spanish nun, eventually made a saint, who at the age of 40 began to experience mystical religious visions (see chapter 22). She was by no means the first woman to experience such visions—Hildegard of Bingen had recorded similar visions in her *Scivias* in the twelfth century (see chapter 12). However, Teresa's own *converso* background—her father was a Jew who had con-

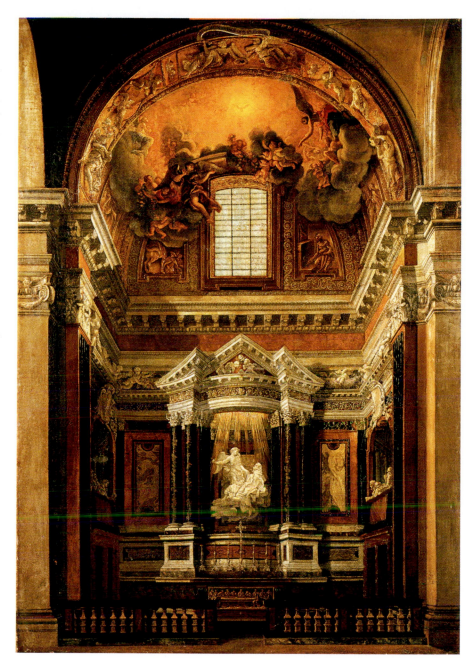

Fig. 25.5 Anonymous. Cornaro Chapel. ca. 1654. Oil on canvas, 5′6¼″ × 3′1¼″. Staatliches Museum, Schwerin, Germany. This seventeenth-century painting reproduces the relatively shallow and narrow space of the actual chapel and reveals the Cornaro family portraits at each side of the space.

verted to Catholicism—adds another dimension to her faith. Teresa was steeped in the mystical tradition of the Jewish Kabbalah [kuh-BAH-luh], the brand of mystical Jewish thought that seeks to attain the perfection of Heaven while still living in this world by transcending the boundaries of time and space. Bernini illustrates the vision she describes in the following passage (**Reading 25.1**):

READING 25.1 **from Teresa of Ávila, "Visions," Chapter 29 of *The Life of Teresa of Ávila* (before 1567)**

It pleased the Lord that I should sometimes see the following vision. I would see beside me, on my left hand, an angel in bodily form. . . . He was not tall, but short, and very beautiful, his face so aflame that he appeared to be one of the highest types of angel who seem to be all afire. They must be those who are called cherubim; they do not tell me their names but I am well aware that there is a great difference between certain angels and others, and between these and others still, of a kind that I could not possibly explain. In his

hands I saw a long golden spear and at the end of the iron tip I seemed to see a point of fire. With this he seemed to pierce my heart several times so that it penetrated to my entrails. When he drew it out, I thought he was drawing them out with it and he left me completely afire with a great love for God. The pain was so sharp that it made me utter several moans; and so excessive was the sweetness caused me by this intense pain that one can never wish to lose it, nor will one's soul be content with anything less than God. It is not bodily pain, but spiritual, though the body has a share in it—indeed, a great share. So sweet are the colloquies of love which pass between the soul and god that if anyone thinks I am lying I beseech God, in His goodness, to give him the same experience.

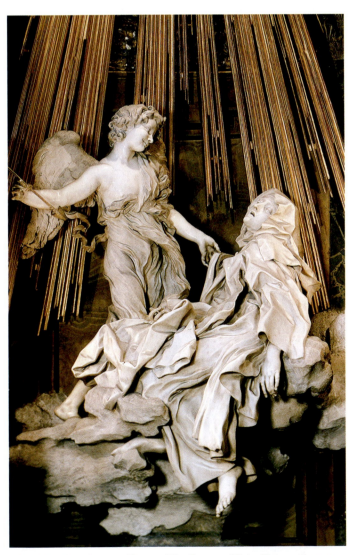

Fig. 25.6 Gian Lorenzo Bernini. *The Ecstasy of Saint Teresa*, Cornaro Chapel, Santa Maria della Vittoria, Rome. 1645–1652. Marble, height of group, 11′ 6″.

Bernini recognized in Teresa's words a thinly veiled description of sexual orgasm. And he recognized as well that the sexuality that Protestantism and the Catholic Counter-Reformation had deemed inappropriate to religious art, but which had survived in Mannerism, had found, in Saint Teresa's vision, a properly religious context, uniting the physical and the spiritual. Thus, the sculptural centerpiece of his chapel decoration is Teresa's implicitly erotic swoon, the angel standing over her, having just withdrawn his penetrating arrow from her "entrails," as Teresa throws her head back in ecstasy (Fig. **25.6**).

Bernini's program is far more elaborate than just its sculptural centerpiece. The angel and Teresa are positioned beneath a marble canopy from which gilded rays of light radiate, following the path of the real light entering the chapel from the glazed yellow panes of a window hidden from view behind the canopy pediment. Painted angels, sculpted in stucco relief, descend across the ceiling, bathed in a similarly yellow light that appears to emanate from the dove of Christ at the top center of the composition. On each side of the chapel, life-size marble recreations of the Cornaro family lean out of what appear to be theater boxes into the chapel proper, as if witnessing the vision of Saint Teresa for themselves. Indeed, Bernini's chapel is nothing less than high drama, the stage space of not merely religious vision, but visionary spectacle. Here is an art designed to appeal to the feelings and emotions of its audience and draw them emotionally into the theatrical space of the work.

Bernini's *David* The Cornaro Chapel program suggests that the Baroque style is fundamentally theatrical in character, and the space it creates is theatrical space. It also demonstrates how central action was to Baroque representation. Bernini's *David* (Fig. **25.7**), commissioned by a nephew of Pope Paul V, appears to be an intentional contrast to Michelangelo's sculpture of the same subject (see Fig. 17.30). Michelangelo's hero is at rest, in a moment of calm anticipation before confronting Goliath. In contrast, Bernini's sculpture captures the young hero in the midst of action. David's

body twists in an elaborate spiral, creating dramatic contrasts of light and shadow. His teeth are clenched, and his muscles strain as he prepares to launch the fatal rock. So real is his intensity that viewers tend to avoid standing directly in front of the sculpture, moving to one side or the other in order, apparently, to avoid being caught in the path of David's shot.

In part, David's action defines Bernini's Baroque style. Whereas Michelangelo's David seems to contemplate his own prowess, his mind turned inward, Bernini's David turns outward, into the viewer's space as if Goliath were a presence, although unseen, in the sculpture. In other words, the sculpture is not self-contained, and its active relationship with the space surrounding it—often referred to as its **invisible complement**—is an important feature of Baroque art. (The light source in his Cornaro Chapel Saint Teresa is another invisible complement.)

Bernini's Fountains Bernini is responsible for a series of figurative fountains that changed the face of Rome. One of the most celebrated is the *Four Rivers Fountain* in the Piazza Navona [nah-VOH-nuh] (Fig. **25.8**). Bernini designed the fountain for Pope Innocent X, who commissioned it in 1648 to celebrate his diversion of the water from one of Rome's oldest sources of drinking water, the Acqua Vergine [ak-wuh ver-ghin-ee] aqueduct, to the square in front of the Palazzo Pamphili [PAHM-fee-lee], his principle family residence. Rising above the fountain is an Egyptian obelisk that had lain in pieces in the Circus Maxentius [mak-SEN-shus] until restored and reerected for use

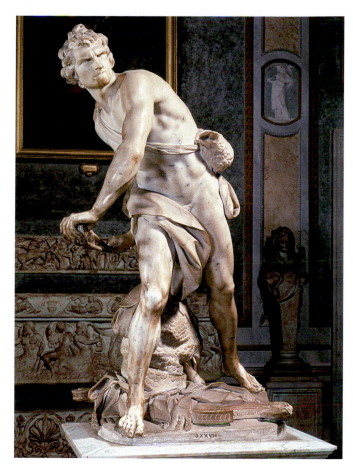

Fig. 25.7 Gian Lorenzo Bernini. *David*, 1623. Marble, height 5′ 7″. Galleria Borghese, Rome. Bernini carved this work when he was 25 years old, but he was already carving sculptures of remarkable quality by age 8.

Continuity & Change
p. 93

Obelisk

Fig. 25.8 Gian Lorenzo Bernini. *The Four Rivers Fountain*, Rome. 1648–1651. Each major figure was sculpted by a different artist in Bernini's workshop: the Nile, representing Africa, by Jacopo Antonio Fancelli; the Danube, representing Europe, by Antonio Raggi; the Ganges, representing Asia, by Claude Poussin; and the Plata, representing the Americas, by Francesco Baratta.

Fig. 25.9 Ambrogio Brambilla. *Firework Display at the Castel Sant'Angelo, Rome.* 1579. Engraving. Biblioteca Apostolica Vaticana, Rome. Ris.S.6, Fig. 112. At once beautiful and suggesting military might, the firework displays in Rome were designed to delight the populace and assert the Church's power and authority.

Fireworks and Theatrical Displays

Bernini's interest in theatrical action manifests itself in other ways than fountains, sculpture, and architecture. Under his direction, the annual fireworks display at the Castel Sant' Angelo [kah-STEL sahnt AHN-juh-loh], the fortress that guards the approach to the Vatican from the city, reached its zenith (Fig. **25.9**). The event was known as the *Girandola* [ghir-ahn-doh-la], literally "whirler," a type of firework. A manual by Vanoccio Biringuccio [van-OH-choh beer-in-GOO-chee-oh] on the use of fireworks, which was published in 1540, describes the festivities:

They make use of the whole castle, which is indeed a very pleasing shape. They ornament it by placing in each embrasure and on top of each merion [or parapet] two small lanterns made of a sheet of white paper over a mound of clay in which a tallow candle is put. When they are lit at night it is a very beautiful thing to see that shining and transparent whiteness in many rows as far as the eye can reach. As soon as the lanterns are lighted, two salutes are fired from a large number of short guns, all of which hurl into the air balls of fire. . . these make a clear fire in the air that appears like stars finally bursting. At the third round they shoot many rockets [which] hold three to four ounces of powder each. They are constructed so that after they have moved upwards with a long tail and seem to be finished they burst and each one sends forth anew six or eight rockets. Fire tubes are also made and small girandoles, flames, and lights, and even the coat of arms of the Pope is composed in fire. Up on the highest peak of the castle where the angel is attached to the flagpole the shape of a great star containing many rays is erected.

here. The sculptor intended the obelisk to represent the triumph of the Roman Catholic Church over the rivers of the world, represented by the four large figures lying on the stones below—the Danube for Europe, the Nile for Africa, the Ganges for Asia, and the Plata for the Americas.

Bernini's fountain was executed by a large group of coworkers under his supervision. In fact, it became commonplace during the Baroque era for leading artists to employ numbers of skilled artists in their studios. This allowed an artist of great stature to turn out massive quantities of work without any apparent loss in quality. Bernini and other Baroque artists like him were admired not so much for the actual finished work, but for the originality of their concepts or designs.

As elaborate as the display described by Biringuccio was, those that Bernini designed for the Girandola far exceeded it. He was especially fond of set-piece displays—arrangements of slow-burning fireworks forming a design or image when lighted—that were reflected in the Tiber River at the base of the castle. His carefully contrived choreography of pyrotechnics left viewers in total awe. The ephemeral, self-consuming nature of such displays must have appealed to Bernini—works of art that were not so much objects as events or experiences.

In fact, Bernini spent much of his time writing plays and designing stage sets for them. Only one of his theatrical works survives, a farcical comedy, but we have descriptions of others that suggest his complete dedication to involving the audience in the theatrical event. In a play entitled *Inundation*

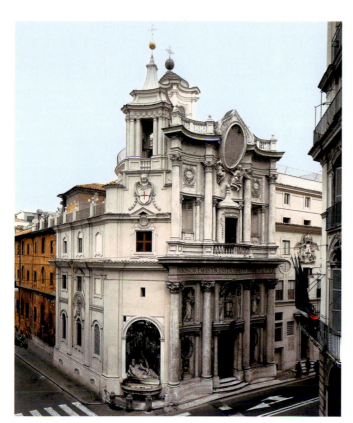

Fig. 25.10 **Francesco Borromini. Façade of San Carlo alle Quattro Fontane, Rome. 1665–1667.** Borromini's innovative church had little impact on Italian architecture, but across the rest of Europe, it freed architecture from the rigors of Renaissance symmetry and balance.

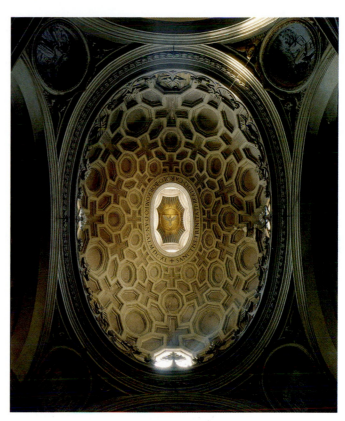

Fig. 25.12 **Francesco Borromini. Dome of San Carlo alle Quattro Fontane. 1638–1641.** At the top of the dome is a golden dove. A symbol of the Holy Spirit. It seems about to fly out the roof to the heavens above.

Fig. 25.11 **Francesco Borromini. Plan of San Carlo alle Quattro Fontane, Rome. 1638.**

of the Tiber, he constructed an elaborate set of dikes and dams that seemed to give way as the flooding Tiber advanced from the back of the stage toward the audience. "When the water broke through the last dike," Bernini's biographer tells us, "it flowed forward with such a rush and spread so much terror among the spectators that there was no one, not even among the most knowledgeable, who did not quickly get up to leave in the fear of an actual flood. Then, suddenly, with the opening of a sluice gate, all the water was drained away."

San Carlo alle Quattro Fontane The grandiose, the elaborate, the ornate—all used to involve the audience in a dramatic action—these are characteristics of the Baroque. Bernini's set for the *Inundation of the Tiber* suggests yet another characteristic—*surprise*. Perhaps the most stunning demonstration of this principle is the Church of San Carlo alle Quattro Fontane (Saint Charles at the Four Fountains) (Fig. **25.10**), the work of Bernini's pupil Francesco Borromini [bor-roh-MEE-nee] (1599–1667). In undertaking this church Borromini was challenged by a narrow piece of property, its corner cut off for one of the four fountains from which the church takes its name. The nave is a long, oval space—unique in church design—with curved walls and chapels that create an uncanny feeling of movement, as if the walls are breathing in and out (Fig. **25.11**). The dome seems to float above the space. Borromini achieved this effect by inserting windows, partially hidden, at the base of the dome. Light coming through illuminates coffers of alternating hexagons, octagons, and crosses growing smaller in size as they approach the apex so that they appear visually to ascend to a much greater height than they actually do (Fig. **25.12**).

Materials & Techniques The Facade from Renaissance to Baroque

The facade [fuh-SAHD] of a building is its front. Typically the facade carries architectural embellishment that announces its style. One of the most influential facades in Renaissance architecture is Leon Battista Alberti's for Santa Maria Novella in Florence. Limited only by the existing portal, doors, and rose window, Alberti designed the facade independently of the structure behind it. He composed it of three squares, two flanking the portal at the bottom and a third set centrally above them. A mezzanine [MEZ-uh-neen], or low intermediate story, separates them, at once seemingly supported by four large engaged Corinthian columns and serving as the base of the top square. The pediment at the top actually floats free of the structure behind it. Perhaps Alberti's most innovative and influential additions are the two scrolled **volutes** [vuh-LOOTS], or counter-curves. They hide the clerestory structure of the church behind, masking the difference in height of the nave and the much lower side-aisle roofs.

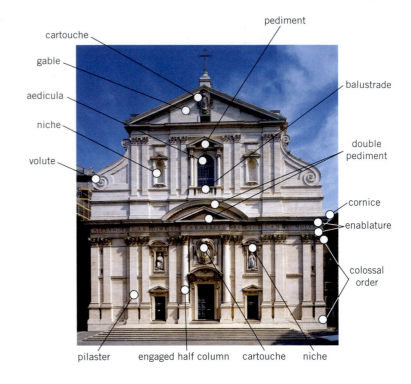

Giacomo della Porta. Facade of Il Gesù, Rome. ca. 1575–1584.

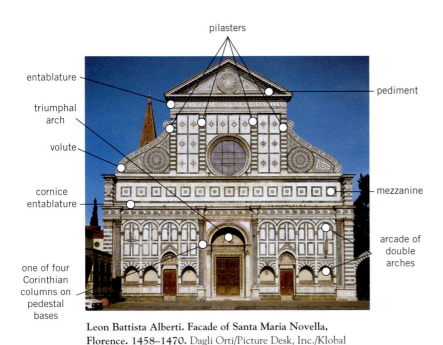

Leon Battista Alberti. Facade of Santa Maria Novella, Florence. 1458–1470. Dagli Orti/Picture Desk, Inc./Klobal Collection.

The Mannerist facade for the church of Il Gesù in Rome was designed by Giacomo della Porta, (ca. 1533–1602), and constructed over 100 years later. It is still recognizably indebted to Alberti's church, retaining the classic proportions of Renaissance architecture: The height of the structure equals the width. However, it has many more architectural features, and the portal is especially emphasized. Notice that the architect adds dimensionality to the facade by a projecting entablature and supporting pairs of engaged **pilasters** [pih-LASS-turz] (rectangular columns) that move forward in steps. These culminate in engaged circular columns on each side of the portal. A double pediment, one traditional and triangular, the other curved, crowns the portal itself. Together with the framing column, the double pediment draws attention to the portal, the effect of which is repeated in miniature in the **aedicula** [e-DIK-yoo-luh] **window** (composed of an entablature and pediment supported by columns or pilasters) above.

The church facade is equally bold (see Fig. 25.10). Increasingly in Baroque church architecture, the facade would leave the Renaissance traditions of architecture behind, replacing the clarity and balance of someone like Alberti with increasingly elaborate ornamentation (see *Materials and Techniques,* page 814). San Carlo's facade is distinguished by colossal columns and concave niches, oval windows on the first floor and square ones above, all topped by a decorative railing, or **balustrade** [BAL-uh-strade], that peaks over a giant **cartouche** [car-TOOCH] (oval frame) supported by angels who seem to hover free of the wall. One four-sided and pointed tower sits oddly at the corner above the fountain; another tower, five-sided, rounded, and slightly taller, stands over the middle of the structure. The balance and symmetry that dominated Church architecture since the early Renaissance are banished. In its stead is a new sense of the building as a living thing, as an opportunity for innovation and freedom. So liberating, in fact, was the design of San Carlo Quattro Fontane that Church fathers answered requests for its plan from all over Europe.

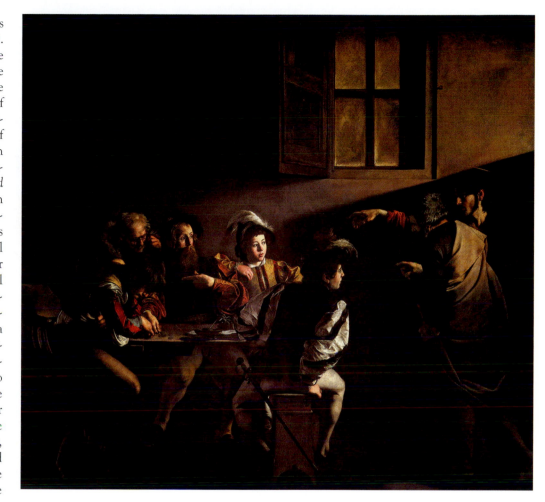

Fig. 25.13 Caravaggio. *The Calling of Saint Matthew.* **ca. 1599–1600.** Oil on canvas, 11′ 1″ × 11′ 5″. Contarelli Chapel, San Luigi dei Francesi, Rome. The window at the top of the painting is covered by parchment, often used by painters to diffuse light in their studios. This makes the intensity of light entering the room from the right especially remarkable.

The Drama of Painting: Caravaggio and the Caravaggisti

One of the characteristics of San Carlo alle Quattro Fontane is the play of light and dark that its irregular walls and geometries create. Ever since the Middle Ages, when Abbot Suger [soo-ZHAY] of Saint-Denis [san duh-NEE], Paris, had insisted on the power of light to heighten spiritual feeling in the congregation, particularly through the use of stained glass, light had played an important role in church architecture (see chapter 14). Bernini used it to great effect in his *Ecstasy of Saint Theresa* (see Fig. 25.6), and Baroque painters, seeking to intensify the viewer's experience of their paintings, sought to manipulate light and dark to great advantage as well. The acknowledged master of light and dark, and perhaps the most influential painter of his day, was Michelangelo Merisi, known as Caravaggio [kah-rah-VAH-gee-oh] (1571–1610), after the town in northern Italy where he was born. His work inspired many followers, who were called the Caravaggisti [kah-rah-vah-GEE-stee].

Master of Light and Dark: Caravaggio

Caravaggio arrived in Rome in about 1593 and began a career of revolutionary painting and public scandal. His first major commission in Rome was *The Calling of Saint Matthew* (Fig. **25.13**), arranged for by his influential patron Cardinal del Monte and painted about 1599–1600 for the Contarelli [con-tah-RAY-lee] Chapel in the Church of San Luigi dei Francesi [sahn LWEE-gee day frahn-CHAY-zee], the church of the French community (dei Francesi) in Rome. The most dramatic element in this work is light. This light that streams in from an unseen window at the upper right of the painting is almost palpable. It falls onto the table where the tax collector Levi (Saint Matthew's name before becoming one of

Jesus' apostles) and his four assistants count the day's take, highlighting their faces and gestures. They are dressed not of Jesus' time, but of Caravaggio's, making it more possible for his audience to identify with them. With Saint Peter at his side, Christ enters from the right, a halo barely visible above his head. He reaches out with his index finger extended in a gesture derived from Adam's gesture toward God in the Sistine Chapel ceiling *Creation*—an homage, doubtless, by the painter to his namesake (see Fig. 18.11). One of the figures at the table—it is surely Levi, given his central place in the composition—points with his left hand, perhaps at himself, as if to say, "Who me?" or perhaps at the young man bent over at the corner of the table intently counting money, as if to say, "You mean him?" All in all, he seems to find the arrival of Jesus uninteresting. In fact, the assembled group is so ordinary—reminiscent of gamblers seated around a table—that the transformation of Levi into Saint Matthew, which is imminent, takes on the aspect of a miracle, just as the light flooding the scene is reminiscent of the original miracle of creation: "And God said, 'Let there be light: and there was light'" (Gen. 1:3). The scene also echoes the New Testament, specifically John 8:12, where Christ says: "I am the light of the world; he that followeth me shall not walk in darkness, but shall have the light of life."

Caravaggio's insistence on the reality of his scene is thus twofold: He only depicts real people of his own day engaged in real tasks (by implication Christ himself assumes a human reality as well), but he also insists on the reality of its psychological drama. The revelatory power of light—its ability to reveal the world in all its detail—is analogous, in Caravaggio's painting, to the transformative power of faith. Faith, for Caravaggio, fundamentally changes the way we *see* the world, and the way we *act* in it. Time and again his paintings dramatize this moment of conversion through use of the technique known as **tenebrism** [TEN-uh-briz-um]. As opposed to **chiaroscuro** [key-AH-roh-SKYOOR-oh], which many artists employ to create spatial depth and volumetric forms through slight gradations of light and dark, a tenebrist style is not necessarily connected to modeling at all. Tenebrism makes use of large areas of dark contrasting sharply with smaller brightly illuminated areas. Another good example of Caravaggio's tenebrism is in his *Supper at Emmaus* (see *Focus*, page 820). In *The Calling of Saint Matthew*, Christ's hand and face rise up out of the darkness, as if his very gesture creates light itself—and by extension Matthew's salvation.

One of the clearest instances of Caravaggio's use of light to dramatize moments of conversion is the *Conversion of Saint Paul*, painted around 1601 (Fig. **25.14**). Though painted nearly 50 years before Bernini's *Ecstasy of Saint Teresa* (see Fig. 25.6), its theme is essentially the same, as is its implied sexuality. Here, Caravaggio portrays the moment when the Roman legionnaire Saul (who will become Saint Paul) has fallen off his horse and hears the words, "Saul, Saul, why persecutest thou me?" (Acts 9:4). Neither Saul's servant nor his horse hears a thing. Light, the visible manifestation of Christ's words, falls on the foreshortened soldier. Saul reaches into the air in both a shock of recognition and a gesture of embrace. A sonnet, "Batter My Heart," by the English metaphysical poet John Donne [dun] (1572–1631), published in 1618 in his *Holy Sonnets*, captures Saul's experience in words (**Reading 25.2**):

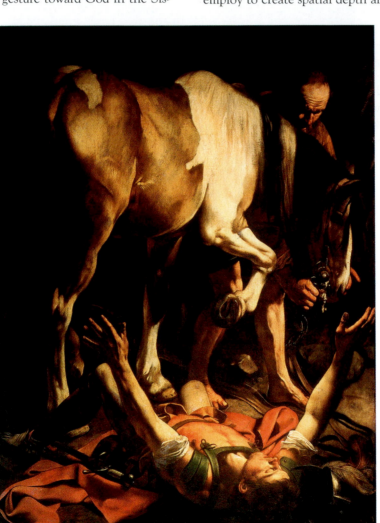

Fig. 25.14 Caravaggio. *Conversion of Saint Paul*. ca. 1601. Oil on canvas, 90$\frac{1}{2}$″ × 68$\frac{7}{8}$″. Santa Maria del Popolo, Rome. This painting was designed to fill the right wall of the narrow Carasi family chapel in Santa Maria del Popolo. Caravaggio had to paint it to be seen at angle of about 45 degrees, a viewpoint that can be replicated by turning this page about half open to an angle of 45 degrees to the reader's face. The resulting space is even more dramatic and dynamic.

READING 25.2 — John Donne, "Batter My Heart" (1618)

Batter my heart, three-person'd God, for you
As yet but knock, breathe, shine, and seek to mend;
That I may rise and stand, o'erthrow me, and bend
Your force to break, blow, burn, and make me new.
I, like an usurp'd town to'another due,
Labor to'admit you, but oh, to no end;
Reason, your viceroy in me, me should defend,
But is captiv'd, and proves weak or untrue.
Yet dearly' I love you, and would be lov'd fain,
But am betroth'd unto your enemy;
Divorce me,'untie or break that knot again,
Take me to you, imprison me, for I,
Except you'enthrall me, never shall be free,
Nor ever chaste, except you ravish me.

Elisabetta Sirani and Artemisia Gentileschi: Caravaggisti Women

Caravaggio had a profound influence on other artists of the seventeenth century. Two of these were women. Like her sixteenth-century Bolognese [boh-loh-NEEZ] predecessor. Lavinia Fontana (see chapter 22), Elisabetta Sirani [sih-RAH-nee] (1638–1665) was the daughter of a painter. Although trained in the refined, classical tradition, Sirani developed a taste for realism much like Caravaggio's and shared his willingness to depict the miracles of Christianity as if they were everyday events. Most of her paintings were for private patrons, and she produced more than 190 works before her early death at age 27; by then she had become a cultural hero and tourist attraction in Bologna for the easy way she could dash off a picture. She painted portraits, religious works, allegorical works, and occasionally mythological works and stories from ancient history.

There is no reason to believe the English poet knew the Italian's painting, but the fact that the two men share so completely in the ecstasy of the moment of conversion, imaged as physical ravishment, suggests how widespread such conceits were in the seventeenth century. Both share with Teresa of Ávila a profound mysticism, the pursuit of achieving communion or identity with the divine through direct experience, intuition, or insight. All three believe that such experience is the ultimate source of knowledge or understanding, and they seek to convey that in their art. Such mystical experience, in its extreme physicality and naturalistic representation, also suggests how deeply the Baroque as a style was committed to sensual experience.

Caravaggio would openly pursue this theme in a series of homoerotic paintings commissioned by the same Cardinal del Monte [MON-tay] who arranged for the painting of *The Calling of Saint Matthew*. These paintings depict seminude young men, quite clearly youths from the streets of Rome, dressed in Bacchic [BAK-ik] costume. In his *Bacchus* (Fig. **25.15**), the slightly plump but also attractively muscular boy offers the viewer a glass of wine at the same time that he seems, with his right hand, to be undoing the belt of his robe. This is not the mythic Bacchus, but a boy dressed up as Bacchus, probably pulled off the street by Caravaggio to pose, as the dirt beneath his fingernails attests. The bowl of fruit in the foreground is a still life that suggests not only Caravaggio's virtuosity as a naturalistic painter, but, along with the wine, the pleasures of indulging the sensual appetites and, with them, carnal pleasure. In fact, paintings such as this one suggest that Caravaggio transformed the religious paintings for which he received commissions into images that he preferred to paint—scenes of everyday people, of erotic and dramatic appeal, and physical (not spiritual) beauty. These same appetites are openly celebrated, in the same spirit, in many of John Donne's poems, such as "The Flea" (see **Reading 25.3**, page 828).

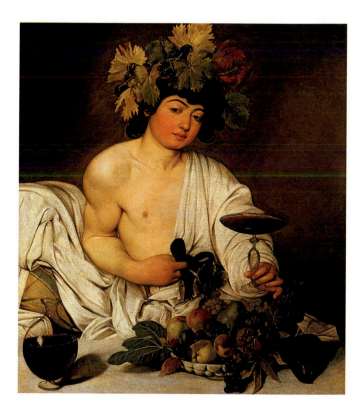

Fig. 25.15 Caravaggio. *Bacchus.* ca. 1597. Oil on canvas, 37 ³/₈″ × 33 ½″. Galleria degli Uffizi, Florence. One of the ways in which Caravaggio exhibits his skill in this painting is the handle of the wine goblet held by the boy. It is at once volumetric and transparent.

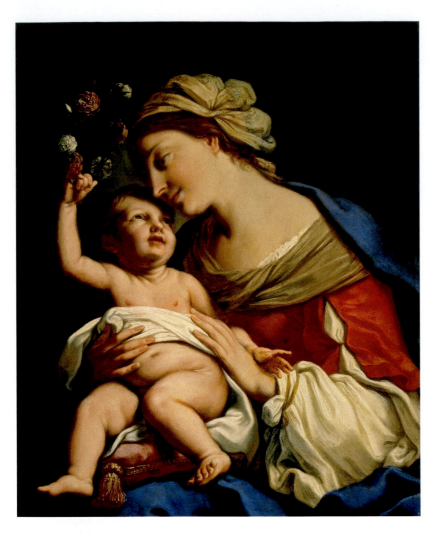

Fig. 25.16 Elisabetta Sirani. *Virgin and Child.* **1663.** Oil on canvas, 34″ × 27¹/₂″. National Museum of Women in the Arts, Washington, D.C. Gift of Wallace and Wilhelmina Holladay. Conservation funds generously provided by the Southern California State Committee of the National Museum of Women in the Arts. The artist signed and dated this picture in gold letters as if sewn into the horizontal seam of the pillow.

Sirani's *Virgin and Child* of 1663 portrays Mary as a young Italian mother, wearing a turban of the kind favored by Bolognese peasant women (Fig. **25.16**). The Virgin's white sleeve, thickly painted to emphasize the rough texture of homespun wool, is consistent with the lack of ornamentation in the painting as a whole. The only decorative elements are the pillow on which the baby sits and the garland with which he is about to crown his mother, in a gesture that seems nothing more than playful.

One of Caravaggio's most important followers, and one of the first woman artists to achieve an international reputation, was Artemisia Gentileschi [jen-tee-LESS-key] (1593–1652/53). Born in Rome, she was raised by her father, Orazio, himself a painter and Caravaggisto. Orazio was among Caravaggio's closest friends. As a young girl, Artemisia could not have helped but hear of Caravaggio's frequent run-ins with the law—for throwing a plate of artichokes at a waiter, for street brawling, for carrying weapons

illegally, and, ultimately, in 1606, for murdering a referee in a tennis match. Artemisia's own scandal would follow. It and much of her painting must be understood within the context of this social milieu—the loosely renegade world of Roman artists at the start of the seventeenth century. In 1612, when she was 19, she was raped by Agostino Tassi, a Florentine artist who worked in her father's studio and served as her teacher. Orazio filed suit against Tassi for injury and damage to his daughter. The transcript of the seven-month trial survives. Artemisia accused Tassi of repeatedly trying to meet with her alone in her bedroom and, when he finally succeeded, of raping her. When he subsequently promised to marry her, she freely accepted his continued advances, naïvely assuming marriage would follow. When he refused to marry her, the lawsuit followed.

At trial, Tassi accused her of having slept with many others before him. Gentileschi was tortured with thumbscrews to "prove" the validity of her testimony, and was examined by midwives to ascertain how recently she had lost her virginity. Tassi further humiliated her by claiming that Artemisia was an unskilled artist who did not even understand the laws of perspective. Finally, a former friend of Tassi's testified that Tassi had boasted about his exploits with Artemisia. Ultimately, he was convicted of rape and served only a year in prison. Soon after the long trial ended, Artemesia married an artist and moved with him to Florence. In 1616, she was admitted to the Florentine Academy of Design.

Beginning in 1612, Artemisia painted five separate versions of the biblical story of Judith and Holofernes [hol-uh-FUR-neez]. The subject was especially popular in Florence, which identified with both the Jewish hero David and the Jewish heroine Judith (both of whom had been celebrated in sculptures by Donatello and Michelangelo). When Artemisia moved there, her personal investment in the subject found ready patronage in the city. Nevertheless, it is nearly impossible to see the paintings outside the context of her biography. She painted her first version of the theme during and just after the trial itself, and the last, *Judith and Maidservant with Head of Holofernes*, in about 1625 (Fig. **25.17**), suggesting that in this series she transforms her personal tragedy in her painting. In all of them, Judith is a self-portrait of the artist. In the Hebrew Bible's Book of Judith, the Jewish heroine enters the enemy Assyrian camp intending to seduce their lustful leader, Holofernes, who has laid siege to her people. When Holofernes falls asleep, she beheads him with his own sword and carries her trophy back to her people in a bag. The Jews then go on to defeat the leaderless Assyrians.

Gentileschi lights the scene by a single candle, dramatically accentuating the Caravaggesque [kah-rah-vah-JESK]

tenebrism of the presentation. Judith shades her eyes from its light, presumably in order to look out into the darkness that surrounds her. Her hand also invokes our silence, as if danger lurks nearby. The maid stops wrapping Holofernes's head in a towel, looking on alertly herself. Together, mistress and maid, larger than life-size and heroic, have taken their revenge on not only the Assyrians, but on lust-driven men in general. As is so often the case in Baroque painting, the space of the drama is larger than the space of the frame. The same invisible complement outside Bernini's *David* (see Fig. 25.7) hovers in the darkness beyond reach of our vision here.

Gentileschi was not attracted to traditional subjects like the Annunciation. She preferred biblical and mythological heroines and women who played major roles. In addition to Judith, she dramatized the stories of Susannah, Bathsheba, Lucretia, Cleopatra, Esther, Diana, and Potiphar. A good business woman, Gentileschi also knew how to exploit the taste for paintings of female nudes.

Ceiling Painting: The Illusion of Heaven

One of the most notable characteristics of Caravaggio's painting is his elaborate use of foreshortening—in the hand of the disciple in *Supper at Emmaus* [em-AY-us] (see *Focus*, page 820, for instance, or Saul's pose in the *Conversion of Saint Paul* (see Fig. 25.14). By the middle of the seventeenth century, foreshortening was widely used on the ceilings of many Roman churches and palaces. With this technique, artists could make the ceiling appear larger than it actually was. To create the illusion of greater space, the artist would paint representations of architectural elements—such as vaults or arches or niches—and then fill the remaining space with foreshortened figures that seem to fly out of the top of the building into the heavens above. One of the most dramatic instances was painted by a Jesuit lay brother, Fra Andrea Pozzo [POH-tzoh] (1642–1709), for the Church of Sant'Ignazio [sahnt-ig-NAH-tzee-oh]. Its subject is the *Triumph of Saint Ignatius of Loyola* (Fig. **25.18**).

It is difficult for a visitor to Sant'Ignazio to tell that the space above the nave is a barrel vault. Pozzo painted it over with a rising architecture that seems to extend the interior walls an extra story. A white marble square in the pavement below indicates to the viewer just where to stand to appreciate the perspective properly. On each side of the space overhead are allegorical figures representing the four continents. America is at the upper left, crowned by a feathered headdress of red, white, and blue. At the lower right, in black robes, Ignatius Loyola, founder of the Jesuit order, is transported on a cloud toward the waiting Christ, in the center of the composition. Other Jesuit saints rise to meet them.

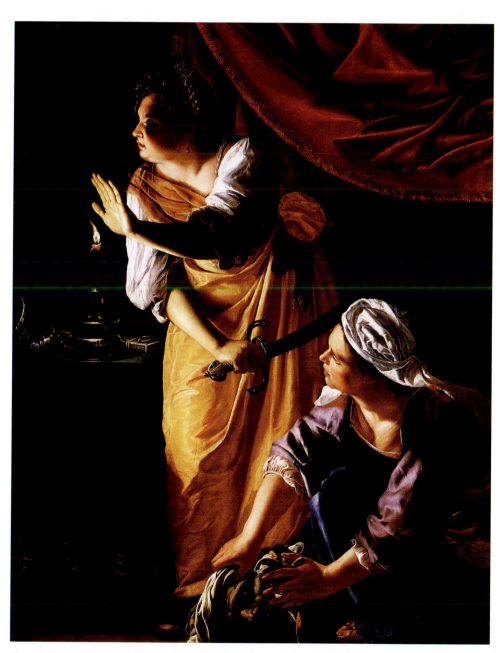

Fig. 25.17 Artemisia Gentileschi. *Judith and Maidservant with Head of Holofernes.* **ca. 1625.** Oil on canvas, 72½″ × 55¾″. The Detroit Institute of Arts. Gift of Leslie H. Green. 52.253. Photo © 1984 Detroit Institute of Art. Judith is a traditional symbol of fortitude, a virtue with which Artemisia surely identified.

Focus

Caravaggio's *The Supper at Emmaus*

In this painting, Caravaggio captures one of the most dramatic moments of the New Testament (Luke 14) and a perfect one for his Baroque instincts. The crucified Christ has risen from the dead and joins two of his disciples as they walk to the village of Emmaus, in ancient Palestine. Neither disciple recognizes the stranger, but all three wayfarers stop at an inn and sit down to a meal. The moment that Christ blesses the bread, just as he had done at the Last Supper, the disciples realize who he is. As the innkeeper looks on, a disciple pushes back in his chair, and the other spreads his arms in astonishment. Caravaggio makes great use of tenebrism and color to convey the emotional and symbolic content of the scene.

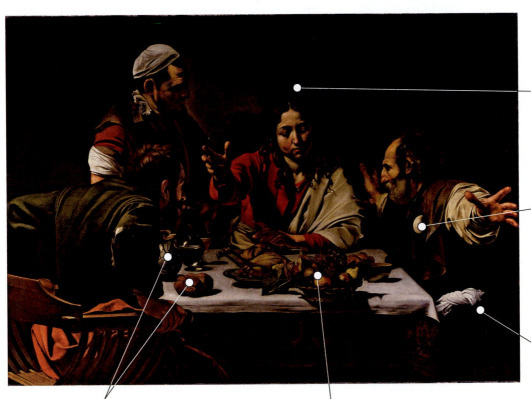

Caravaggio implies the traditional halo over Christ's head by means of the shadow that Christ's head casts behind him on the wall. This shadow gives the risen Christ a physical presence, underscoring for the viewer the reality of his Resurrection.

The cockleshell on the disciple's tunic is the traditional emblem of the pilgrim. The Bible names only one of the two disciples at Emmaus—Cleopas (Luke 24:18). The other may be Peter or perhaps Simon.

The contrast between the dark garment of the disciple and the smaller area of bright white scarf on his lap is a perfect example of tenebrism.

The wine and bread represent the blood and body of Christ as traditionally employed in the Eucharist, the Christian sacrament of Holy Communion. The two disciples are literally reunited with Christ in this story, just as, in taking Communion, Christians are symbolically reunited with Christ.

The fruit basket is charged with symbolism. The blemishes on the apple, as well as the cracking figs, refer to the original sin of Adam and Eve in the Garden of Eden, and the mortality that results from their partaking of the Garden's fruit. The grapes are the source of wine, or Christ's blood, used in the Eucharist. The deep red fruit of the pomegranate refers to the Resurrection and Christ's triumph over sin.

Caravaggio. *The Supper at Emmaus.* ca. 1600. Oil on canvas, 55″ × 77½″. The National Gallery Company Ltd.

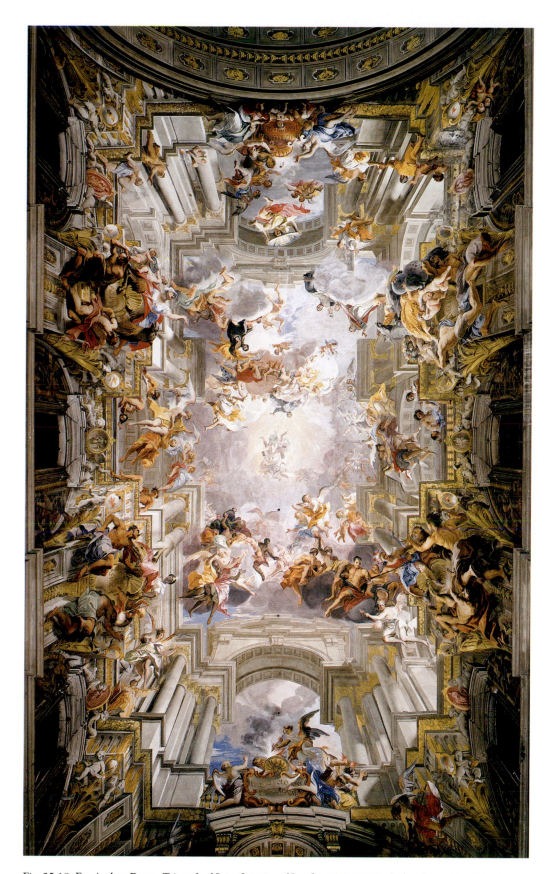

Fig. 25.18 Fra Andrea Pozzo. *Triumph of Saint Ignatius of Loyola.* **1691–1694.** Ceiling fresco, Sant'Ignazio, Rome. Allegorical works in each corner represent the four continents—Europe, Asia, Africa, and America—where the Society of Jesus carried out its missionary work.

CULTURAL PARALLELS

Large-Scale Paintings in Rome and Japan

During the Baroque era, artists decorated ceilings in Roman churches and palaces with painted representations of architecture to enhance the illusion of space and to create dramatic scenes with figures from the Christian religion. Far to the east, in Japan during the same period, large-scale paintings were also used as an architectural element in palaces, using screens instead of ceilings, and with a wider range of subjects including landscapes, mythological scenes, and cityscapes.

Such elaborate design is consistent with Jesuit doctrine. In his *Spiritual Exercises*, published in 1548, Loyola had called on Jesuits to develop all of their senses—an idea that surely influenced the many and richly diverse elements of the Baroque style. For instance, in the Fifth Exercise, a meditation on the meaning of Hell, Loyola invokes all five senses (**Reading 25.4**):

READING 25.4 from Ignatius Loyola, *Spiritual Exercises,* Fifth Exercise (1548)

FIRST POINT: This will be to see in imagination the vast fires, and the souls enclosed, as it were, in bodies of fire.
SECOND POINT: To hear the wailing, the howling, cries, and blasphemies against Christ our Lord and against His saints.
THIRD POINT: With the sense of smell to perceive the smoke, the sulphur, the filth, and corruption.
FOURTH POINT: To taste the bitterness of tears, sadness, and remorse of conscience.
FIFTH POINT: With the sense of touch to feel the flames which envelop and burn the souls.

Loyola's invocation of the senses helps explain Pozzo's remarkable ceiling. In it the faithful are invited to see not Hell but Heaven, hear "in imagination" not wailing but hosannahs, smell not smoke but perfume, taste not bitter tears but sweet tears of joy, and touch not flames but the glorious light of God. We can also understand how Caravaggio's and Gentileschi's dramatic use of light and dark and their appeal to the emotional truth of their representations satisfied the Jesuits' invocation of the senses. Jesuit doctrine also influenced Bernini's art—from the theatrical effects of *The Ecstasy of Saint Teresa* to his firework displays and stage designs, and helps to explain the widespread appeal of the Baroque style in general.

Venice and Baroque Music

In the sixteenth century, the Council of Trent had recognized the power of music to convey moral and spiritual ideals. "The whole plan of singing," it wrote in an edict issued in 1552,

> should be constituted not to give empty pleasure to the ear, but in such a way that the words be clearly understood by all, and thus the hearts of the listeners be drawn to the desire of heavenly harmonies, in the contemplation of the joys of the blessed. . . . They shall also banish from church all music that contains, whether in the singing or in the organ playing, things that are lascivious or impure.

In other words, the Council rejected the use of secular music, which by definition it deemed lascivious and impure, as a model for sacred compositions. Renaissance composers such as Guillaume Dufay and Josquin des Prez (see chapters 17 and 18) had routinely used secular music in composing their masses, and Protestants had adapted the chorales of their liturgy from existing melodies, both religious and secular.

The division between secular and religious music was far less pronounced in Venice, a city that had traditionally chafed at papal authority. As a result, Venetian composers felt freer to experiment and work in a variety of forms, so much so that in the seventeenth century the city became the center of musical innovation and practice in Europe.

Giovanni Gabrieli and the Drama of Harmony

Venice earned its place at the center of the musical world largely through the efforts of Giovanni Gabrieli [gah-bree-AY-lee] (1556–1612), the principal organist at Saint Mark's Cathedral. Gabrieli composed many secular madrigals, but he also responded to the Counter-Reformation's edict to make church music more emotionally engaging. To do this, he expanded on the polychoral style that Adrian Willaert had developed at Saint Marks in the mid-1500s (see chapter 19). Gabrieli located contrasting bodies of sound in different areas of the cathedral's interior, which already had two organs, one on each side of the chancel (the space containing the altar and seats for the clergy and choir). Playing them off against one another, he was able to produce effects of stunning sonority. Four choirs—perhaps a boy's choir, a women's ensemble, basses and baritones, and tenors in another group—sang from separate balconies above the nave. Positioned in the alcoves were brass instruments, including trombones and cornets. (A cornett was a hybrid wind instrument, combining a brass mouthpiece with woodwind finger technique. The nineteenth-century band instrument has a similar name but is spelled with a single "t.") Both the trombone and the cornett were staples of Venetian street processions. And the street processions of the Venetian confraternities or *scuole* (see chapter 19) are in many ways responsible for the development of instrumental music in Venice. By 1570 there were approximately 40 street processions a year, with each of the six confraternities participating.

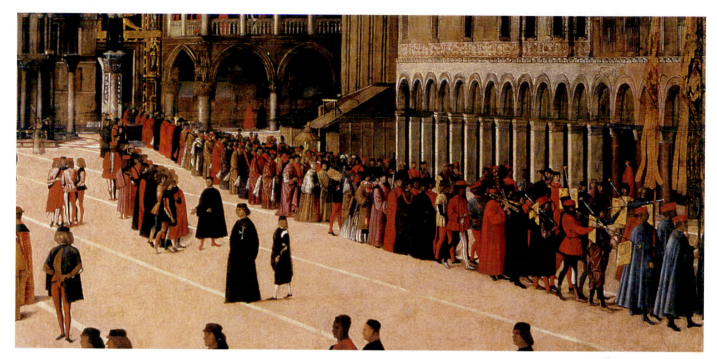

Fig. 25.19 Detail of Gentile Bellini. *Procession of the Reliquary of the True Cross in Piazza San Marco.* 1496. Oil on canvas, 12′1½″ × 24′5¼″. Gallerie dell'Accademia, Venice. (See Fig. 19.6.) The procession here includes six *trombe lunghe,* or long silver trumpets, followed by three shawms, and two trombonists.

Each *scuola* was accompanied through the streets by singers, bagpipes, shawms (a double reed instrument similar to a bagpipe, but without the bag), drums, recorders, viols, flutes, and *pifarri,* or ensembles of wind instruments often composed of cornetts and trombones (two or three of each) (Fig. **25.19**). The Venetian love for these ensembles quickly led to the adaptation from secular ceremonies to religious ones (many of the *scuole* processions were associated with religious feast days in the first place).

Gabrieli was among the first to write religious music intended specifically for wind ensemble—music that was independent of song and that could not, in fact, be easily sung. One such piece is his 1597 *Canzona Duodecimi Toni* [kan-ZOH-na doo-oh-DAY-chee-me TOH-nee] (*Canzona in C Major*), in which two brass ensembles create a musical dialogue (**CD- Track 25.1**). A **canzona** is a type of instrumental contra- puntal work, derived from Renaissance secular song, like the madrigral, which was increasingly performed in the seventeenth century in church settings. It is particularly notable for its dominant rhythm, LONG-short-short, known as the "canzona rhythm." In Saint Mark's, the two ensembles would have been placed across from one another in separate lofts. The alternating sounds of cornett and trombone or, in other compositions, brass ensemble, choir, and organ coming from various parts of the cathedral at different degrees of loudness and softness create a total effect similar to stereo "surround sound."

For each part of his composition Gabrieli chose to designate a specific voice or instrument, a practice we have come to call **orchestration**. Furthermore, he controlled the **dynamics** (variations and contrast in force or intensity) of the composition by indicating, at least occasionally, the words *piano* ("soft") or *forte* ("loud"). In fact, he is the first known composer to specify dynamics. The dynamic contrasts of loud and soft in the *Canzona Duodecimi Toni,* mirroring the taste for tenebristic contrasts of light and dark in Baroque painting, is a perfect example of Gabrieli's use of dynamic variety. As composers from across Europe came to Venice to study, they took these terms back with them, and Italian became the international language of music.

Finally, and perhaps most important, Gabrieli organized his compositions around a central note, called the **tonic note** (usually referred to as the **tonality** or **key** of the composition). This tonic note provides a focus for the composition. The ultimate resolution of the composition into the tonic, as in the *Canzona Duodecimi Toni,* where the tonic note is C, provides the heightened sense of harmonic drama that typifies the Baroque.

Claudio Monteverdi and the Birth of Opera

A year after Gabrieli's death, Claudio Monteverdi [KLAU- dee-oh mohn-tay-VAIR-dee] (1567–1643) was appointed musical director at Saint Mark's in Venice. A violinist,

Voices

Claudio Monteverdi Appeals for His Salary

Although Claudio Monteverdi was one of the giants of the music world of the seventeenth century (and remains so), he lived in an era that offered composers and musicians few material rewards. Like Mozart and many other great composers, Monteverdi worked for aristocrats who were often distant and/or unappreciative. In this plaintive letter, Monteverdi cites the difficulties of obtaining his contracted salary from the official charged with paying him (Benintendi). It offers insights into the hardships faced by a talented composer and musician even at the height of his powers.

Mantua 27 October 1604; to Duke Vincenzo Gonzaga, at Casale Monferrato

Most Serene Lord, my Most Respected Master,

For the most important provision [salary] it is indeed proper that I appeal to Your Highness's infinite virtue, since it is that which in the last resort directs your will concerning the salary granted to me by your kindness. I therefore kneel before you with the greatest possible humility, and beg you to be so good as to cast your gaze not upon my boldness in writing this letter, but rather upon my great distress, which is the reason for my writing; not upon the Lord

> **"This humble petition of mine comes to you with no other aim but to beg Your Highness to kindly direct that I receive wages amounting to a total of five months . . ."**

President who on numerous occasions has given an affirmative order so very kindly and politely, but rather upon Belintento [Ottavio Benintendi] who never wanted to carry it out except when it pleased him

This humble petition of mine comes to you with no other aim but to beg Your Highness to kindly direct that I receive wages amounting to a total of five months, in which situation my wife Claudia and my father-in-law also find themselves, and this sum grows even larger since we do not see any hope of being able to get hold of future payments save by the express command of Your Highness, without which support all my work will be ruined and undone, since misfortunes continue to overwhelm me day in and day out, and I have not the means to remedy them. . . .

Monteverdi had been the music director at the court of Mantua. In Venice, Monteverdi proposed a new relation of text (words) and music. Where traditionalists favored the subservience of text to music—"Harmony is the ruler of the text," proclaimed Giovanni Artusi, the most ardent defendant of the conservative position—Monteverdi proclaimed just the opposite: "Text is the ruler of harmony!" Monteverdi's position led him to master a new, text-based musical form, the **opera**, a term that is the plural of *opus*, or "work." Operas are works consisting of many smaller works. (The term *opus* is used, incidentally, to catalogue the musical compositions of a given composer, usually abbreviated *op.*, so that "*op.* 8" would mean the eighth work in the composer's repertoire.)

The form itself was first suggested by a group known as the Camerata of Florence (*camerata* means "club " or "society"), a group dedicated to discovering the style of singing used by the ancient Greeks in their drama, which had united poetry and music but was known only through written accounts. The group's discussions stimulated the composer Giulio Caccini to write *New Works of Music*. Here, he describes what the Camerata considered the ancient Greek ideal of music (**Reading 25.5**):

READING 25.5 **from Giulio Caccini, *New Works of Music* (1602)**

At the time . . . the most excellent *camerata* of the Most Illustrious Signor Giovanni Bardi, Count of Vernio, flourished in Florence. . . . I can truly say, since I attended well, that I learned more from their learned discussions than I did in more than thirty years of studying counterpoint. This is because these discerning gentlemen always encouraged me and convinced me with the clearest arguments not to value the kind of music which does not allow the words to be understood well and which spoils the meaning and the poetic meter by now lengthening and now cutting the syllables short to fit the counterpoint, and thereby lacerating the poetry. And so I thought to follow that style so praised by Plato and the other philosophers who maintained music to be nothing other than rhythmic speech with pitch added (and not the reverse!), designed to enter the minds of others and to create those wonderful effects that writers admire, which is something that cannot be achieved with the counterpoint of modern music.

Over the course of the 1580s and 1590s, Caccini and others began to write works that placed a solo vocal line above an instrumental line, known as the **basso continuo**, or "continuous bass," usually composed of a keyboard instrument (organ, harpsichord, etc.) and melody instrument (usually a cello), that was conceived as a supporting accompaniment, not as the polyphonic equivalent, to the vocal line. This combination of solo voice and basso continuo came to be known as **monody**.

The inspiration for Monteverdi's first opera, *Orfeo* [or-FAY-oh] (1607), was the musical drama of ancient Greek theater. The **libretto** [lih-BRET-toh] (or "little book") for Monteverdi's opera was based on the Greek myth of Orpheus [OR-fee-us] and Eurydice [yoor-ID-ih-see]. In the opera, shepherds and nymphs celebrate the love of Orpheus and Eurydice in a dance that is interrupted by the news that Eurydice has died of a snake bite. The grieving Orpheus, a great musician and poet, travels to the underworld to bring Eurydice back. His plea for her return so moves the god of the underworld that he grants it, but only if Orpheus does not look back at Eurydice as they leave. But anxious for her safety, he does glance back and loses her forever. Monteverdi did, however, offer his audience some consolation: [not really a happy ending] Orfeo's father, Apollo, comes down to take his son back to the heavens where he can behold the image of Eurydice forever in the stars.

Although *Orfeo* is by no means the first opera, it is generally accepted as the first to successfully integrate music and drama. Monteverdi tells the story through a variety of musical forms—choruses, dances, and instrumental interludes. Two particular forms stand out—the **recitativo** [ray-chee-tah-TEE-voh] and the **aria** [AH-ree-uh]. *Recitativo* is a style of singing that imitates very closely the rhythms of speech. Used for dialogue, it allows for a more rapid telling of the story than might be possible otherwise. The *aria* would eventually develop into an elaborate solo or duet song that expresses the singer's emotions and feelings, expanding on the dialogue of the recitative (in Monteverdi's hands, the aria could still be sung in recitative style). "The modern composer," Monteverdi wrote, "builds his works on the basis of truth," and he means by this, most of all, the emotional truth that we have come to expect of the Baroque in general. Orfeo's recitativo after learning of the death of Eurydice is one of the most moving scenes in this opera (**CD-Track 25.2**). He sings passionately first of his grief:

Tu se' morta, se' morta	You are dead, my life,
mia vita ed	and I am still breathing?
io respiro?	
Tu se' de me partita, se'	You have left me, left me,
da me partitat per mai piu,	
mia piu non tonare,	Never more to return, and I
ed io rimango?	remain here?

The melody imitates speech by rising at the end of each question. Then, when Orfeo decides to go back to the underworld and plead for Eurydice's return, the music reflects his

CULTURAL PARALLELS

Virtuosity in Venice and Amsterdam

The drama and virtuosity embodied in the music of Giovanni Gabrieli in Venice was mirrored 500 miles to the north by the sometimes astonishing church music played at Calvinist Sunday services in Amsterdam.

shift from despair to determination. But even in this second section, as he expresses his dream of freeing Eurydice, when he sings of the "lowest depths" (*profundi abissi* [pro-FOHN-dee ah-BEE-see]) of the underworld or of "death" (*morte* [MOR-tay]) itself, the melody descends to low notes in harmony with the words. Moment by moment, Monteverdi's music mirrors the emotional state of the character.

Orfeo required an orchestra of three dozen instruments—including ten viols, three trombones, and four trumpets—to perform the overture, interludes, and dance sequences, but generally only a harpsichord or lute accompanied the arias and recitatives so that the voice would remain predominant. For the age, this was an astonishingly large orchestra, financed together with elaborate staging by the Mantuan court where it was composed and first performed, and it provided Monteverdi with a distinct advantage over previous opera composers. He could achieve what his operatic predecessors could only imagine—a work that was both musically and dramatically satisfying, one that could explore the full range of sound and, with it, the full range of psychological complexity.

Arcangelo Corelli and the Sonata

The *basso continuo* developed by Caccini and others to support the solo voice also influenced purely instrumental music, especially in the sonatas of the Roman composer and violinist Arcangelo Corelli (1653–1713). The term **sonata** as we use it today, did not develop until the last half of the eighteenth century. In the Baroque era, it had a much more general meaning. In Italian, *sonata* simply means "that which is sounded," or played by instruments, as opposed to that which is sung, the *cantata*. By the end of the seventeenth century, the **trio sonata**, had developed a distinctive form. As the word "trio" suggests, it consists of three parts, two higher voices, usually written for violins, but often performed by two flutes, or two oboes, or any combination of these, that play above a basso continuo. One of the results of this arrangement is that the basso continuo harmonizes with the higher voices, resulting in distinct chord clusters that often provide a dense textural richness to the composition.

There were two main types of sonata, a secular form, the **sonata da camera** (chamber sonata), and a religious form, the **sonata da chiesa** (church sonata). Corelli wrote both. The *sonata da camera* consists of a suite of dances, and the sonata da chiesa generally consists of four **movements**, or independent

sections, beginning with a slow, dignified movement, followed by a fast, imitative movement, then slow and fast again.

Corelli quickly adopted the form because it allowed him, as a virtuoso violinist, to compose pieces for himself that showcased his talents. It was further expected that virtuoso violinists would embellish their musical lines. The following, from a single piece of sheet music from Corelli's Opus no. 5, shows the basso continuo in the bass clef and the complex violin part, filled with intricate runs of musical notes, as Corelli actually played it in the treble clef:

From Arcangelo Corelli, Opus no. 5. Dagli Orti/Picture Desk, Inc./Klobal Collection.

Thus, against the clear statement of the melody, the solo voice performs with rhythmic extravagance.

Antonio Vivaldi and the Concerto

Corelli's instrumental flair deeply influenced Venice's most important composer of the early eighteenth century, Antonio Vivaldi [vee-VAHL-dee] (1678–1741). Vivaldi, son of the leading violinist at Saint Mark's, assumed the post of musical director at the Ospedale della Pietà [oh-spay-DAH-lay DAY-lah pee-ay-TAH] in 1703, one of four orphanages in Venice that specialized in music instruction for girls. (Boys at the orphanages were not trained in music since it was assumed they would enter the labor force.) As a result, many of the most talented harpsichordists, lutists, and other musicians in Venice were female, and many of Vivaldi's works were written specifically for performance by Ospedali [oh-spay-DAH-lee] girl choirs and instrumental ensembles (Fig. 25.20). By and large, the Ospedali musicians were young girls who would subsequently go on to either a religious life or marriage, but several were middle-aged women

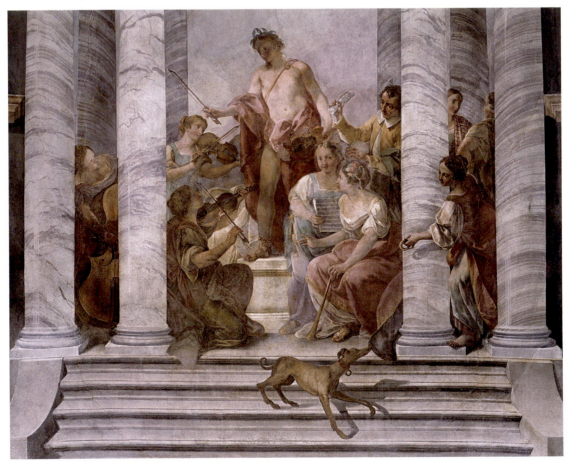

Fig. 25.20 Jacopo Guarana. *Apollo Conducting a Choir of Maidens*. 1776. Oil on canvas. Ospedaletto, Salla della Musica, Venice. The Ospedaletto church was the performance space for the girls of the orphanage of Santa Maria dei Derelitti. Although Apollo conducts in this painting, the ensemble director can be seen in yellow, just behind the right column, score in hand.

who remained in the Ospedali, often as teachers, for their entire lives. The directors of the Ospedali hoped that wealthy members of the audience would be so dazzled by the performances that they would donate money to the orphanages. Audiences from across Europe attended these concerts, which were among the first in the history of Western music that took place outside a church or theater and were open to the public. And they were, in fact, dazzled by the talent of these female musicians; by all accounts, they were as skilled and professional as any of their male counterparts in Europe.

Vivaldi specialized in composing **concertos** [kun-CHAIR-tohs], a three-movement secular form of instrumental music, popular at court, which had already been established, largely by Corelli. Vivaldi systematized its form. The first movement of a concerto is usually *allegro* (quick and cheerful), the second slower and more expressive, like the pace of an opera aria, and the third a little livelier and faster than the first. Concertos usually feature one or more solo instruments that, in the first and third movements particularly, perform passages of material, called episodes, that contrast back and forth with the orchestral score—a form known as **ritornello** [re-tor-NEL-loh], "something that returns" (i.e., returning thematic material). At the outset, the entire orchestra performs the ritornello in the tonic—the specific home pitch around which the composition is organized. Solo episodes interrupt alternating with the ritornello, performed in partial form and in different keys, back and forth, until the ritornello returns again in its entirety in the tonic in the concluding section.

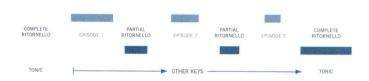

Ritornello

In the course of his career, Vivaldi composed nearly 600 concertos—for violin, cello, flute, piccolo, oboe, bassoon, trumpet, guitar, and even recorder. Most of these were performed by the Ospedale ensemble. The most famous is a group of four violin concertos, one for each season of the year, called *The Four Seasons*. It is an example of what would later come to be known as **program music**, or purely instrumental music in some way connected to a story or idea. The program of the first of these concertos, *Spring* (**CD-Track 25.3**) is supplied by a sonnet, written by Vivaldi himself, at the top of the score. The first eight lines suggest the text for the first movement, and the last six lines, divided into two groups of three, the text for its second and third movements:

Spring has arrived, and full of joy
The birds greet it with their happy song.
The streams, swept by gentle breezes,
Flow along with a sweet murmur.
Covering the sky with a black cloak,
Thunder and lightning come to announce the season.
When all is quiet again, the little birds
Return to their lovely song.

The ritornello in this concerto is an exuberant melody played by the whole ensemble. It opens the movement, and corresponds to the poem's first line. Three solo violins respond in their first episode—"the birds greet it with their happy song"—imitating the song of birds. In the second episode, they imitate "streams swept by gentle breezes," then, in the third, "thunder and lightning," and finally the birds again, which "Return to their lovely song." The whole culminates with the ritornello, once again resolved in the tonic.

In its great rhythmic freedom (the virtuoso passages given to the solo violin, recalling the improvisational embellishments of Corelli) and the polarity between orchestra and solo instruments (the contrasts of high and low timbres, or sounds, such as happy bird song and clashing thunder), Vivaldi's concerto captures much of what differentiates Baroque music from its Renaissance predecessors. Gone are the balanced and flowing rhythms of the *prima prattica* and the polyphonic composition in which all voices are of equal importance. Perhaps most of all, the drama of beginning a composition in a tonic key, moving to different keys and then returning to the tonic—a pattern known as **modulation**—could be said to distinguish Baroque composition from what had come earlier. The dramatic effect of this modulation, together with the rich texture of the composition's chord clusters, parallels the dramatic lighting of Baroque painting, just as the embellishment of the solo voice finds its equivalent in the ornamentation of Baroque architecture.

As an instrumental composition, *The Four Seasons* naturally foregoes the other great innovation of the Baroque, the *secunda prattica*'s emphasis on an actual text, as found particularly in opera. Even in Rome, where sacred music dominated the scene, opera began to take hold. In 1632, an opera by Stefano Landi (1590–1639), with stage designs by Gian Lorenzo Bernini, premiered at a theater seating no fewer than 3,000 spectators inside the walls of the Barberini [bar-buh-REE-nee] palace, home of the Barberini pope Urban VIII (r. 1622–1623). Like many of the Roman operas that followed, its subject was sacred, *Sant'Alessio* [sahnt-ah-LESS-ee-oh] (Saint Alexander), and it convinced the Church that sung theater could convey moral and spiritual ideas. This conviction would shortly give rise to a new form of vocal music, the **oratorio** [or-uh-TOR-ee-oh]. Generally based on religious themes, the oratorio shared some of opera's musical elements, including the basso continuo, the aria, and the recitative, but it was performed without the dazzle of staging and costume. This development of Baroque music will be discussed in chapter 27.

John Donne, "The Flea" (1633)

Donne's poetry is often labeled "metaphysical" because it borrowed words and images from seventeenth-century science. It reflects a Baroque taste for dramatic contrast and the ability to synthesize discordant images. This last is reflected particularly in the elaborate metaphor, or "conceit," of the following poem, first published posthumously, in which a flea is taken for the image of love's consummation.

Mark but this flea, and mark in this,
How little that which thou deny'st me is;
Me it sucked first, and now sucks thee,
And in this flea, our two bloods mingled be;[1]
Confess it, this cannot be said
A sin, or shame, or loss of maidenhead,
 Yet this enjoys before it woo,
 And pampered swells with one blood made of two,
 And this, alas, is more than we would do.
Oh stay, three lives in one flea spare,[2] 10
Where we almost, nay more than married are,
This flea is you and I, and this
Our marriage bed, and marriage temple is;
 Though parents grudge, and you, we are met,
And cloistered in these living walls of jet.[3]
Though use make you apt to kill me,
Let not to this, self murder added be,
 And sacrilege,[4] three sins in killing three.

Cruel and sudden, has thou since
Purpled thy nail, in blood of innocence? 20
In what could this flea guilty be,
Except in that drop which it sucked from thee?
Yet thou triumph'st, and say'st that thou
Find'st not thyself, nor me the weaker now;
 'Tis true, then learn how false, fears be;
 Just so much honour, when thou yield'st to me,
 Will waste, as this flea's death took life from thee. ■

Reading Question

How would you describe the tone of this poem? Is it sincere? playful? How does this tone affect how we understand its argument?

[1] United in the flea are the flea itself, the lover, and the mistress, thus echoing the Trinity, an elaborate metaphor that continues on throughout the poem.
[2] The mistress is about to kill the flea.
[3] Jet: black; in other words, the living body of the flea.
[4] Sacrilege because the flea is portrayed as a "marriage temple."

Summary

■ **Baroque Style and the Counter-Reformation** As part of its strategy to respond to the Protestant Reformation, the Catholic Church in Rome championed a new Baroque style of art that appealed to the range of human emotion and feeling, not just the intellect. Bernini's majestic new colonnade for the square in front of Saint Peter's in Rome helped to reveal the grandeur of the basilica itself, creating the dramatic effect of the Church embracing its flock. His sculptural program for the Cornaro Chapel in Rome, with its celebration of the mystical revelations of Teresa of Ávila, epitomizes the Baroque. The drama of revelation and experience is also evident in his sculpture of the biblical hero David, who is caught in the midst of action, and in the artist's other public works, such as fountains, fireworks, and theatrical displays.

One of the most influential pieces of Baroque architecture is Francesco Borromini's Church of San Carlo alle Quattro Fontane in Rome. Borromini replaces the traditions of Renaissance architecture with a facade of dramatic oppositions and visual surprises.

■ **The Drama of Painting: Caravaggio and the Caravaggisti** Caravaggio utilized the play of light and dark to create paintings of stunning drama and energy that reveal a new Baroque taste for vividly realistic detail. His followers,

among them Elisabetta Sirani and Artemisia Gentileschi, inherited his interest in realism and the dramatic. Other artists took special interest in Caravaggio's use of dramatic foreshortening, especially ceiling painters such as Fra Andrea Pozzo, whose ceiling for the Church of Sant'Ignazio seems to extend the chapel into the space of the heavens above.

■ **Venice and Baroque Music** If Rome was the center of Baroque art and architecture, Venice was the center of Baroque music. Giovanni Gabrieli took advantage of the sonority of Saint Mark's Cathedral to create madrigals in which he carefully controlled the dynamics (loud/soft) of the composition and its tempo. The dynamics mirror the Baroque painting's contrast of light and dark and help to create musical compositions of stunning range and effect. It was in Venice that a new form of musical drama known as opera was born in the hands of Claudio Monteverdi, who gave text precedence over harmony for the first time in the history of Western music. His opera *Orfeo* successfully married music and drama. The sonata form, popularized by virtuoso violinist Arcangelo Corelli, provided a model for instrumental music. Finally, Antonio Vivaldi perfected the concerto form, and many of his concertos were performed by the women at the Ospedale della Pietà, where he was musical director.

Glossary

aedicula window A window composed of an entablature and pediment supported by columns or pilasters.

aria An elaborate solo or duet song that expresses the singer's emotions and feelings.

baldacchino A canopy.

balustrade A decorative railing.

basso continuo A "continuous bass" line that serves as the supporting accompaniment to the solo or vocal line above it; also, the performers playing that part.

canzona A type of instrumental contrapuntal work increasingly performed in the seventeenth century in church settings.

cartouche An oval frame.

chiaroscuro The use of slight gradations of light and dark to create spatial depth and volumetric forms.

concerto A three-movement secular form of instrumental music.

dynamics Variations and contrast in force or intensity.

facade The front of a building or structure.

invisible complement The space surrounding a sculpture, with which it often has an active relationship.

key The central note of a musical composition; also called **tonic note**.

libretto The text of a musical work such as an opera.

modulation The pattern of beginning a composition in a tonic key, moving to different keys and then returning to the tonic.

monody A work consisting of a solo voice supported by a **basso continuo**.

movements The independent sections of a composition.

opera A drama presented entirely or primarily in music.

orchestration A musical arrangement in which each part of the composition has been designated with a specific voice or instrument.

oratorio A form of vocal music, generally on religious themes, without stage action.

piazza A space surrounded by buildings.

pilaster A rectangular column.

program music Purely instrumental music connected in some way to a story or idea.

recitativo A style of singing that imitates very closely the rhythms of speech.

ritornello A musical passage in which an instrument performs preceding or following major concerto episodes.

sonata Literally, "that which is sounded," referring in the broadest sense to a work for an instrument or instruments in any combination.

sonata da camera Literally, a "sonata of the chamber," usually featuring dance-related movements.

sonata da chiesa Literally, a "sonata of the church," often composed of four movements, slow-fast-slow-fast.

tenebrism An exaggerated form of **chiaroscuro**.

tonality The harmonic coherence of a composition.

tonic note The central note of a musical composition; also called the **key**.

trio sonata A sonata for two instruments of a high range and a basso continuo.

volute A counter-curve.

 ## Critical Thinking Questions

1. How do action, excitement, and sensuality fulfill the Counter-Reformation objectives in Baroque religious art?

2. How does the architecture of Bernini and Borromini express the theatrical urge to draw the viewer into the drama?

3. What social conditions and aesthetic values of the Italian Baroque particularly interested the artists Elisabetta Sirani and Artemisia Gentileschi?

4. What features of Venetian Baroque music parallel the drama and contrasts of Baroque painting and sculpture?

The End of Italian Ascendency

Continuity & Change

In France, the finance minister to King Louis [loo-EE] XIV was wise in matters far beyond finance. John-Baptiste Colbert [kohl-BAIR] counseled the king that "apart from striking actions in warfare, nothing is so well able to show the greatness and spirit of princes than buildings; and all posterity will judge them by the measure of those superb habitations which they have built during their lives." The king was looking for an architect to design a new east facade for the Palais du Louvre [pah-LAY dew loov] in Paris, which would house the new royal apartments. For such grand plans, the world's most famous—and original—architect, Gian Lorenzo Bernini, was the obvious choice. With the pope's permission, Bernini departed for Paris. Large and adoring crowds greeted him in every city through which he passed.

In Paris, he received a royal welcome, but the king was far from happy with Bernini's plans for the Louvre (Fig. 25.21). Although he accepted the plans, and foundations were poured, he concluded, after Bernini returned to Rome, that the Italian's design was too elaborate and ornate. Furthermore, French architects were protesting the award of such an important commission to a foreigner. The architect Louis Le Vau [loo-EE leh voh], the painter Charles Le Brun [sharl leh brun], and the physician, mathematician, and architectural historian Claude Perrault [peh-ROH] together designed a simpler, more classically inspired facade (Fig. 25.22),

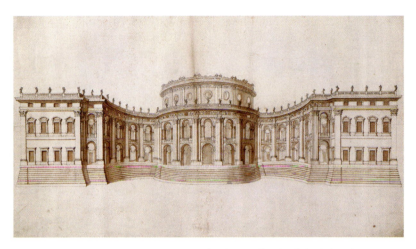

Fig. 25.21 Gian Lorenzo Bernini. Design for the east facade of the Palais du Louvre, Paris. 1664. Musée du Louvre, Paris.

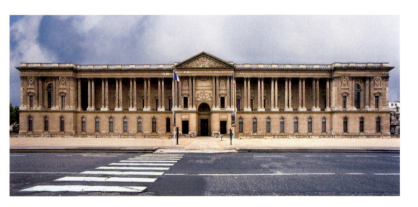

Fig. 25.22 Louis Le Vau, Claude Perrault, and Charles Le Brun. East facade, Palais du Louvre, Paris. 1667–1670.

consisting of five units, centered by a triangular pediment and paired Corinthian colonnades. Louis was so pleased that he added paired colonnades to the other facades of the palace.

This debate between the ornate and the classical, the sensuous and the austere, would define the art of the eighteenth century. Baroque ornamentation, epitomized in the seventeenth century by Bernini, would become even more exaggerated in the eighteenth, transformed into the fanciful and playful decoration of the so-called Rococo style. Ironically, this happened especially at the French court. The forms of classical Greek and Roman architecture offered a clear alternative, countering what seemed to many an art of self-indulgence, even moral depravity. Painting, too, could abandon the emotional theatrics of the Baroque and appeal instead to the intellect and reason, assuming a solidity of form as stable as architecture.

Louis XIV's rejection of Bernini's plan marks the end of the ascendency of Italian art and architecture in European culture. From 1665 on, the dominant artists of Europe would be northern in origin. Even in the field of music, northerners like Bach [bahk] and Handel, then Mozart [MOH-tzart] and Beethoven [BAY-toh-vun], were about to triumph. In Holland, France, and England the Baroque would become an especially potent cultural force, permanently redefining the centers of European culture. ∎

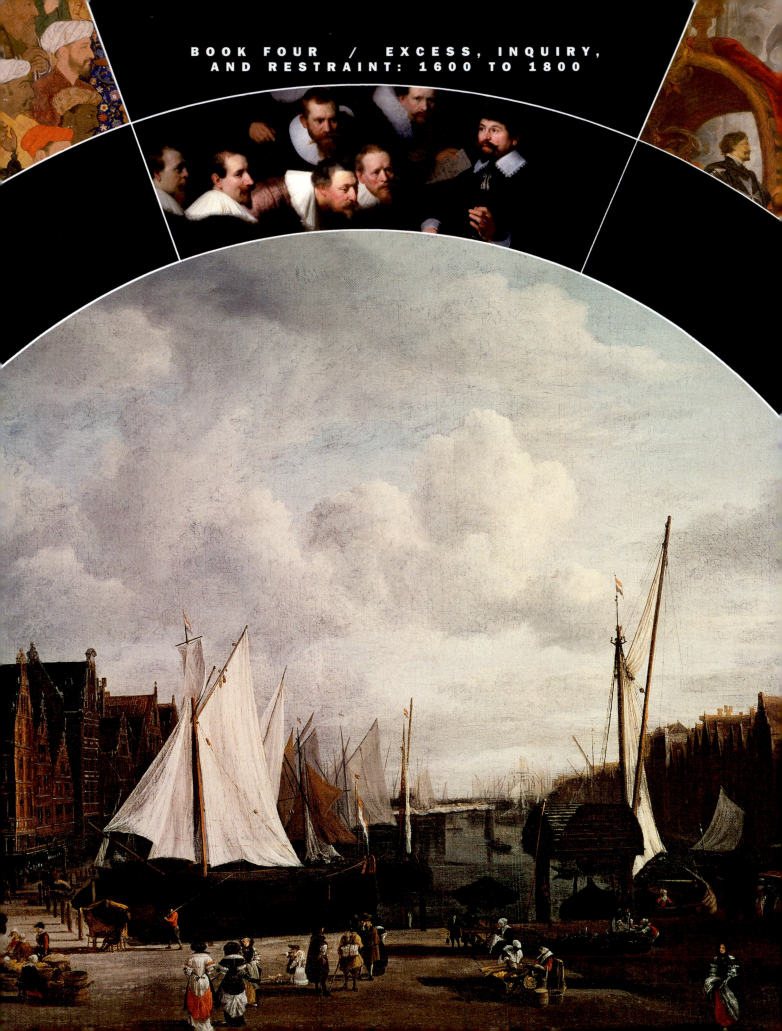

26 The Secular Baroque in the North

The Art of Observation

Calvinist Amsterdam: City of Contradictions

The Science of Observation

Dutch Vernacular Painting: Art of the Familiar

The Baroque Keyboard

❝ *One method of delivery alone remains to us, which is simply this: we must lead men to the particulars themselves, and their series and order; while men on their side must force themselves for a while to lay their notions by and begin to familiarize themselves with facts.* **❞**

Francis Bacon, *New Method of Science*

◄ **Fig. 26.1 Jakob van Ruisdael.** *Quay at Amsterdam,* **detail. ca. 1670.** Oil on canvas, $20\frac{3}{4}'' \times 26''$. Private Collection. Erich Lessing/Art Resource, NY. In the seventeenth century, the port of Amsterdam was the busiest in the world. The Dutch traded in everything from tulip bulbs to paintings.

SEVENTEENTH-CENTURY AMSTERDAM WAS ARGUABLY THE

best-known city in the world. In Europe, it might have competed for pre-eminence with Rome, Paris, Venice, and London, but in the far regions of the Pacific and Indian oceans, in Asia, Africa, and even South America, if you knew of Europe,

you had heard of Amsterdam. No city was more heavily invested in commerce. No port was busier (Fig. **26.1** and Fig. **26.2**). The city's businessmen traded in Indian spices and Muscovy furs, grain from the Baltic, sugar from the Americas, Persian silk, Turkish carpets, Venetian mirrors, Italian majolica, Japanese lacquerware, saffron, lavender, and tobacco. Tea from China, coffee from the Middle East, and chocolate from South America introduced the West to caffeine, the stimulant that would play a key role in igniting the Industrial Revolution a century later. And yet, for all its wealth and knowledge of foreign lands, Amsterdam remained somewhat conservative, as if the very flatness of the landscape, recovered from the sea, led the Netherlandish mind to a condition of restraint. Between 1590 and 1640, nearly 200,000 acres of land intersected by canals and dikes were created by windmills that

pumped water out of the shallows and into the sea. The resulting landscape was an austere geometry of right angles and straight lines (see Map **26.1**). The homes of the rich merchants of Amsterdam were distinguished by this same geometric understatement (see Fig. 26.1), their facades typically avoiding Baroque asymmetry and ornamentation. In life as in architecture, in Calvinist Holland, the values of a middle class intent on living well but not making too public a show of it eclipsed the values of European court culture elsewhere. Especially avoided were what the Dutch deemed the lavish Baroque excesses of the Vatican in Rome.

This chapter outlines the forces that defined Amsterdam as the center of the more austere Baroque style that dominated northern Europe in the seventeenth century. Having pushed Spain out of the north, Amsterdam block-

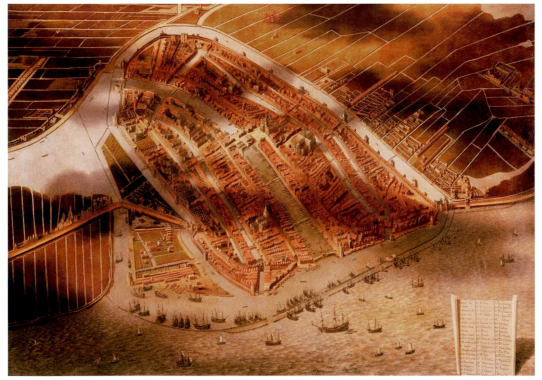

Fig. 26.2 Jan Christaensz-Micker. *View of Amsterdam.* **ca. 1630.** Oil on canvas, 39³⁄₈″ × 54″. Collection Amsterdam Historical Museum, Amsterdam. By 1640, the city would expand well into the fields on both sides of this image and continue expanding throughout the century. Note the realism of the shadows of passing clouds falling over the city.

Map 26.1 Map of Amsterdam. Published by Homan Ergen, Nürnberg, Germany, 1727. Hand-colored, 18″ × 22½″. Library of Congress Geography and Map Division, Washington, D.C.

aded the river Scheldt [skelt], denying Antwerp, with its Spanish Catholic leanings, access to the sea. Its own port was soon established as the new center of commerce in the north. The city's economy thrived, sometimes too hotly, as when mad speculation sent the market in tulip bulbs skyrocketing. But this tendency to excess was balanced by the conservatism of the Dutch Reformed Church. The Calvinist fathers of the Dutch Reformed Church found no place for art in the Calvinist liturgy, by and large banning art from its churches.

The populace as a whole, however, embraced a new vernacular art, depicting not only religious subjects but the material reality and everyday activities of middle-class Dutch society. The Dutch developed a cultural taste for the close observation of nature. They supported this by scientific and philosophical investigation—the invention of new tools of observation like the telescope and microscope, as well as new ways of reasoning designed to come to conclusions about the nature of the world and their own existence. The art of portraiture was especially popular, as average citizens increasingly sought to affirm their well-being in art. In the hands of the

era's greatest painters, portraits were soon endowed with a new psychological realism. And though the Calvinists ceased commissioning works of art to decorate their churches, liturgical music was a different matter. Music of sometimes outstanding virtuosity was performed on the organ before and after the Sunday service.

Calvinist Amsterdam: City of Contradictions

Seventeenth-century Amsterdam was a city of contradictions. It was a society at once obsessed with the acquisition of goods of all kinds, yet rigidly austere in its spiritual life. It was intolerant of what it deemed religious heresy among Protestants, but tolerant of Catholics and Jews; its people avidly collected art for their homes but forswore art in the church. The city was also the curious beneficiary of its sworn enemy, Catholic Spain. Throughout the first three-quarters of the sixteenth century, the provinces of the Netherlands, which correspond roughly to modern-day Belgium and Holland, had

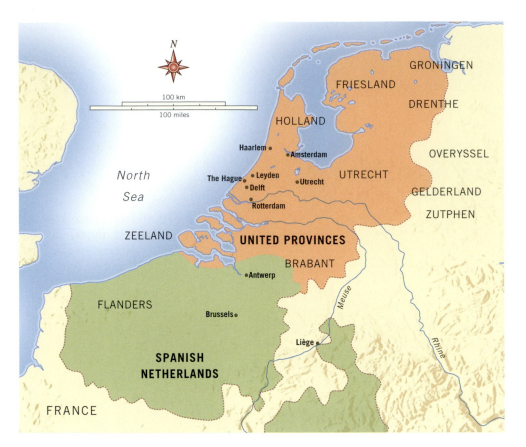

Map 26.2 The United Provinces of the Netherlands in 1648.

centered at Amsterdam. Ten thousand mercenaries led by the duke of Alba arrived in 1567 to force the Calvinist resistance into cooperation, but the Dutch opened their dikes, flooding the countryside in order to repulse the Spanish. Finally, in 1576, Spanish soldiers, rioting over lack of pay, killed 7,000 citizens in the streets of Antwerp in a four-day battle that became known as the Spanish Fury. Appalled at the slaughter, the southern ten provinces of the Netherlands, which had remained Catholic up to this point, united with the north to form the United Provinces of the Netherlands (see Map **26.2**). The union lasted only three years, at which point five southern provinces made peace with Spain. Throughout this period, Protestants migrated in mass numbers out of the south, and out of Antwerp particularly, to the north. So did intellectuals and merchants. Of Antwerp's 100,000 inhabitants in 1570, no more than about 40,000 remained by 1590.

been ruled by Charles I of Spain and then his son, Philip II, as part of their Habsburg kingdom (see chapter 22). Antwerp was their banking center (see chapter 20), and through its port passed much of the colonial bounty of the Western Hemisphere, especially from the great silver mines of Potosí, Bolivia, and Zatatecas, Mexico (see chapter 22). At Potosí alone, a minimum of 7.6 million pesos, minted into coins near the mine, were produced annually between 1580 and 1650, all destined to pay off the ever-increasing debt of the Spanish royal family.

Gaining Independence from Spain

Charles I had been born in Flanders and spoke no Spanish when he assumed the Spanish throne in 1519 (see chapter 22). But Philip II was born in Spain, and, in 1559, he left the Netherlands permanently for his native land, entrusting the northern provinces to the regency of Margaret of Parma, his half-sister. From Spain, Philip tried unsuccessfully to impose Catholic rule on the north by breaking down the traditional autonomy of the 17 Netherlands provinces and asserting rule from Madrid. To this end, he imposed the edicts of the Council of Trent (see chapter 22) throughout the Netherlands and reorganized its churches under Catholic hierarchy. The Calvinists roundly rejected both moves, especially in the northern seven provinces of Holland

Meanwhile, in 1581 the northern provinces declared their independence from Spain, even as Philip reinvigorated his efforts to reconquer them. In 1584–1585, when the Spanish under Alessandro of Farnese captured Antwerp after a 14-month siege, the city's fate was sealed. To the northern provinces Antwerp was too closely associated with the Spanish for comfort. Thus, at the end of the Thirty Years' War, when the Treaty of Westphalia in 1648 permanently excluded Spain from meddling in Netherlands affairs, Amsterdam closed the port of Antwerp by closing off the river Scheldt to commerce. As Amsterdam clearly understood, no viable commercial enterprise could remain in the city. The wealth that had flowed through the port at Antwerp would thereafter flow through the port of Amsterdam. Amsterdam's prize of war was largely this: What Antwerp had been to the sixteenth century, Amsterdam would be to the seventeenth.

Tulipomania

No single incident captures Amsterdam's commercial success and the wealth at its disposal better than the great tulip "madness" of 1634–1637. During those three years, frenzied speculation in tulip bulbs nearly ruined the entire Dutch economy. The tulip had arrived in Europe in 1554, when

the Austrian Habsburg ambassador to the court of Süleyman the Magnificent (1494–1566) in Constantinople shipped home a load of bulbs for the enjoyment of the royal court. Its Turkish origin lent the flower a certain exotic flavor (the word *tulip*, in fact, derives from the Turkish word for "turban"), and soon the tulip became the flower of fashion throughout northern Europe. The more flamboyant and extravagant a tulip's color, the more it was prized.

Especially valued were examples of what the Dutch called a "broken" tulip. Tulips, by nature, are a single color—red or yellow, for instance—but in any planting of several hundred bulbs, a single flower might contain feathers or flames of a contrasting hue. Offsets of these "broken" flowers would retain the pattern of the parent bulb, but they produced fewer and smaller offsets than ordinary tulips. Soon, the bulbs of certain strains—most notably the *Semper Augustus* [SEM-per aw-GUS-tus], with its red flames on white petals—became the closely guarded treasures of individual botanists.

We know, today, that a virus spread from tulip to tulip by the peach potato aphid causes the phenomenon of "breaking." The flower produces fewer and smaller offsets because it is diseased. As a result of this deterioration, by 1636 there were reportedly only two of the red-flamed *Semper Augustus* root bulbs in all of Holland. The one in Amsterdam sold for 4,600 florins [FLOR-inz] (fifteen or twenty times the annual income of a skilled craftsman), a new carriage and harness, and two gray horses. Some idea of what value these prices represent can be understood by looking at some of the "in-kind" dealings that transpired in the tulip trade. In his history of the Dutch seventeenth century, *The Embarrassment of Riches*, Simon Schama reports that one man, presumably a farmer leaping into the market, paid two *last* (approx. 4,000 pounds) of wheat, four of rye, four fat oxen, eight pigs, a dozen sheep, two oxheads of wine, four tons of butter, a

thousand pounds of cheese, a bed, some clothing, and a silver beaker, for a single Viceroy bulb, valued at 2,500 guilders [GILL-durz]. Presumably the farmer planned on planting it and selling its offsets for 2,500 guilders each.

We can't know for certain what caused the burst of speculation in "broken" flowers, although the Dutch taste for beauty certainly contributed to the madness. Tulip books, illustrated nursery catalogues of available bulbs and the flowers they produced, added to the frenzy (Fig. 26.3). But by the autumn of 1635, trade in actual bulbs had given way to trade in promissory notes, listing what flowers would be delivered and at what price. At the stock exchange in Amsterdam and elsewhere in Holland, special markets were established for their sale. Suddenly, good citizens sold all their possessions, mortgaged their homes, and invested their entire savings in "futures"—bulbs not yet even lifted from the ground. In a matter of months, the price of a single Switsers bulb, a yellow tulip with red feathers, soared from 60 to 1,800 guilders. Speculation was so frenzied that the paper "futures" began to be traded, not the bulbs themselves, and when in the winter of 1637 the tulip market faced the prospect of fulfilling paper promissory notes with actual bulbs, it collapsed. Suddenly no one could sell a tulip bulb in Holland for any price.

In Amsterdam, the assembled deputies declared any debt incurred in the tulip market before November 1636 null and void, and the debt of any purchaser whose obligation was incurred after that date to be considered met upon payment of 10 percent. Those holding debts were outraged, but the court in Amsterdam unanimously ruled that any debt contracted in gambling, which they deemed the tulip market to be, was no debt at all under the law.

Fig. 26.3 From the Tulip Book of P. Cos. 1637. Wageningen University and Research Center Library, The Netherlands. In the first half of the seventeenth century, thirty-four "tulip books," cataloguing the flower's many varieties, were published in Holland.

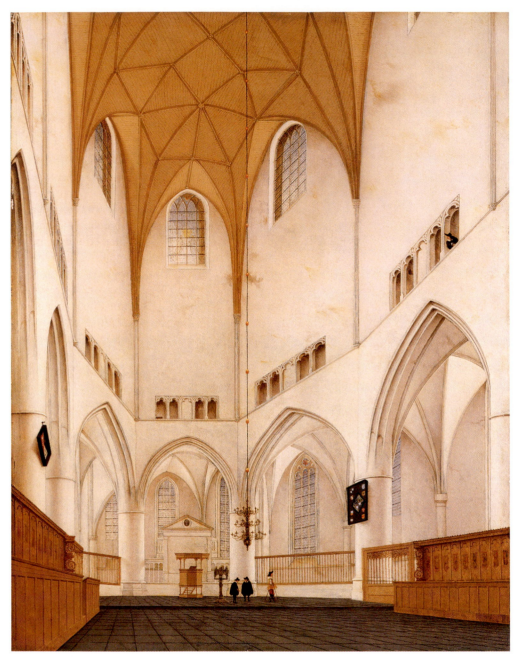

Fig. 26.4 Pieter Saenredam. *Interior of the Choir of Saint Bavo's Church at Haarlem*. 1660. Oil on panel, 27⁷⁄₈″ × 21⁵⁄₈″. Worcester Art Museum, Worcester, MA. The Bridgeman Art Library, NY. Charlotte E. W. Buffington Fund. 1951.29. The only adornments of the space are an escutcheon, bearing the coat of arms of Saint Bavo, hanging on the left wall, and a memorial tablet on the right.

country. Finally, in October 1571, 23 of these Calvinist leaders gathered in Emden, Germany, and proclaimed the creation of the Dutch Reformed Church. By 1578, they had returned to Holland.

This strict Calvinist sect did not become, as many believe, an official state religion, but the state did require that any person in public service be a member of the Dutch Reformed Church. The Church was itself split over questions of doctrine: In the saving of souls, could good deeds overcome predestination? On one side were those who held that the faith and good deeds of the believer might to some extent affect the bestowal of grace and their ultimate salvation. Opposing them were those who believed that salvation was predestined by God. The elect (those who would ascend to heaven) were numbered from the moment of birth, and no good works could affect the outcome of the damned. By 1618, this doctrinal conflict would erupt into what narrowly escaped becoming civil war, and those who believed in good works were soon expelled from the Reformed Church, their leader tried for treason and beheaded, and others imprisoned.

The doctrinal rigidity of the Reformed Church is reflected in the austerity of its churches. Ever since the Calvinist's iconoclastic destruction of religious imagery in 1566 (see chapter 21), when van Eyck's *Ghent Altarpiece* at Saint Bavo Cathedral in Ghent (Fig. 20.9, Fig. 20.10) was dismantled and hidden away, Dutch churches had remained devoid of paintings. A depiction of a different church dedicated to Saint Bavo, in Haarlem [HAR-lum] (Fig. 26.4), painted by Pieter Saenredam [SAHN-ruh-dahm] (1597–1665) nearly a century after the removal of the *Ghent Altarpiece*, shows a typical Dutch Reformed interior stripped of all furnishings, its walls whitewashed by Calvinist iconoclasts. A single three-tiered chandelier hangs from the ceiling above three gentlemen whom Saenredam includes in the composition in order to

The Dutch Reformed Church: Strict Doctrine and Whitewashed Spaces

The excesses of Dutch society so evident in the tulip craze were strongly countered by the conservatism of the Calvinist Dutch Reformed Church, which actively opposed speculation in the tulip market. In the 1560s, as the Spanish had tried to impose Catholicism upon the region, many Dutch religious leaders, almost all of them Calvinist (see chapter 21), fled the

establish the almost spiritual vastness of the medieval church's interior. This stripped-down, white space is meant to reflect the purity and propriety of the Reformed Church and its flock.

The Science of Observation

As stark and almost barren as Saenredam's painting is, it nevertheless reveals an astonishing attention to detail, capturing even the texture of the whitewashed walls with geometric precision. This attention to detail, typical of Northern Baroque art, reflects both religious belief and scientific discovery. Protestants believed that all things had an inherent spiritual quality, and the visual detail in Northern art was understood as the worldly manifestation of the divine. But perhaps more significantly, new methods of scientific and philosophical investigation focused on the world in increasing detail. In the seventeenth century, newly invented instruments allowed scientists to observe and measure natural phenomena with increasing accuracy. Catholics and Protestants were equally appalled at many of the discoveries, since they seemed to challenge the authority of Scripture. Also problematic for both religions were new methods of reasoning that challenged the place of faith in arriving at an understanding of the universe. According to these new ways of reasoning, *Scientia*, the Latin word for "knowledge," was to be found in the world, not in religious belief.

Francis Bacon and the Empirical Method

One of the most fundamental principles guiding the new science was the proposition that, through the direct and careful observation of natural phenomena, one could draw general conclusions from particular examples. This process is known as **inductive reasoning**, and with it, scientists believed they could predict the workings of nature as a whole. When inductive reasoning was combined with scientific experimentation, it produced a manner of inquiry that we call the **empirical method**. The leading advocate of the empirical method in the seventeenth century was the English scientist Francis Bacon (1561–1626). His *Novum Organum Scientiarum* (*New Method of Science*), published in 1620, is the most passionate plea for its use. "One method of delivery alone remains to us," he wrote, "which is simply this: we must lead men to the particulars themselves, and their series and order; while men on their side must force themselves for a while to lay their notions by and begin to familiarize themselves with facts." The greatest obstacle to human understanding, Bacon believed, was "superstition, and the blind and immoderate zeal of religion." For Bacon, Aristotle represented a perfect example (see chapter 7). While he valued Aristotle's emphasis on the study of natural phenomena, he rejected as false doctrine Aristotle's belief that the experience coming to us by means of our senses

Continuity & Change
p. 214

Aristotle

(things as they *appear*) automatically presents to our understanding things as they *are*. Indeed, he felt that reliance on the senses frequently led to fundamental errors.

A proper understanding of the world could only be achieved, Bacon believed, if we eliminate the errors in reasoning developed through our unwitting adherence to the false notions that every age has worshiped. He identified four major categories of false notion, which he termed Idols, all described in his *Novum Organum Scientiarum* (The New Method of Science) (see **Reading 26.1,** page 857). The first of these, the Idols of the Tribe, are the common fallacies of all human nature, derived from the fact that we trust, wrongly, in our senses. The second, the Idols of the Cave, derive from our particular education, upbringing, and environment—an individual's religious faith or sense of his or her ethnic or gender superiority or inferiority would be examples. The third, the Idols of the Market Place, are errors that occur as a result of miscommunication, words that cause confusion by containing, as it were, hidden assumptions. For instance, the contemporary use of "man" or "mankind" to refer to people in general (common well into the twentieth century), connotes a worldview in which hierarchical structures of gender are already assumed. Finally, there are the Idols of the Theater, the false dogmas of philosophy—not only those of the ancients but those that "may yet be composed." The object of the empirical method is the destruction of these four Idols through intellectual objectivity. Bacon argued that rather than falling back on the preconceived notions and opinions produced by the four Idols, "Man, [using the last idol] being the servant and interpreter of Nature, can do and understand so much and so much only as he has observed in fact or in thought of the course of Nature; beyond this he neither knows anything nor can do anything."

Bacon's insistence on the scientific observation of natural phenomena led, in the mid-1640s, to the formation in England of a group of men who met regularly to discuss his new philosophy. After a lecture on November 28, 1660, by Christopher Wren, the Gresham College Professor of Astronomy and architect of Saint Paul's Cathedral in London (see chapter 28), they officially founded "a College for the Promoting of Physico-Mathematicall Experimentall Learning." It met weekly to witness experiments and discuss scientific topics. Within a couple of years, the group became known as "The Royal Society of London for Improving Natural Knowledge," an organization that continues to the present day as the Royal Society. It is one of the leading forces in international science, dedicated to the recognition of excellence in science and the support of leading-edge scientific research and its applications.

René Descartes and the Deductive Method

Bacon's works circulated widely in Holland, where they were received with enthusiasm. As one seventeenth-century Dutch painter, Constantijm Huygens [HOY-guns] (1596–1687), put it in his *Autobiography*, Bacon offered the Dutch "most excellent criticism of the useless ideas, theorems, and axioms which, as I have said, the ancients possessed." But equally influential

were the writings of the French-born René Descartes [day-CART] (1596–1650). Descartes (Fig. **26.5**), in fact, lived in Holland for over 20 years, from 1628 to 1649, moving between 13 different cities, including Amsterdam, and 24 different residences. It was in Holland that he wrote and published his *Discourse on the Method of Rightly Conducting the Reason and Seeking for Truth in the Sciences* (1637). As opposed to Bacon's inductive reasoning, Descartes proceeded to his conclusions by the opposite method of **deductive reasoning**. He began with clearly established general principles and moved from those to the establishment of particular truths.

Like Bacon, Descartes distrusted almost everything, believing that both our thought and our observational senses can and do deceive us. In his *Meditations on the First Philosophy*, he draws an analogy between his own method and that of an architect (**Reading 26.2**):

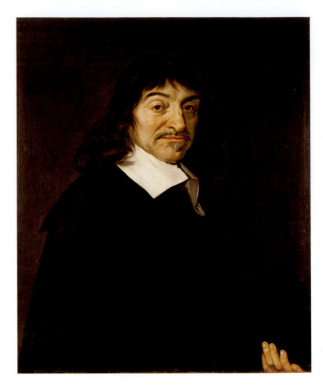

Fig. 26.5 Frans Hals. *Portrait of René Descartes*. 1649. Oil on wood, 7³/₈″ × 5¹/₂″. Musée du Louvre/RMN Réunion des Musées Nationaux, France. Erich Lessing/Art Resource, NY. Hals was renowned for his portraiture. Here he seems to reveal the very essence of Descartes. The philosopher appears to be thinking, with some evident amusement, perhaps about the prospect of any painter "capturing" his essence on canvas.

READING 26.2 **from René Descartes,** *Meditations* **(1641)**

Throughout my writings I have made it clear that my method imitates that of the architect. When an architect wants to build a house which is stable on ground where there is a sandy topsoil over underlying rock, or clay, or some other firm base, he begins by digging out a set of trenches from which he removes the sand, and anything resting on or mixed in with the sand, so that he can lay his foundations on firm soil. In the same way, I began by taking everything that was doubtful and throwing it out, like sand.

He wants, he says, "to reach certainty—to cast aside the loose earth and sand so as to come upon rock and clay." The first thing, in fact, that he could not doubt was that he was thinking, which led him to the inevitable conclusion that he must actually exist in order to generate thoughts about his own existence as a thinking individual, which he famously expressed in *Discourse on Method* in the Latin phrase "*Cogito, ergo sum*" [KOH-guh-toh er-goh sum] ("I think, therefore I am").

The remarkable result of this approach is that, beginning with this one "first principle" in his *Discourse on Method*, Descartes comes to prove, at least to his own satisfaction, the existence of God (see **Reading 26.3**, page 858). As a result, he is one of the most important founders of **deism** (from the Latin *dues* [DAY-us], "god"), the brand of faith that argues that the basis of belief in God is reason and logic rather than revelation or tradition. Descartes did not believe that God was at all interested in interfering in human affairs. Nor was God endowed, particularly, with human character. He was, in Descartes' words, "the mathematical order of nature." Descartes was himself a mathematician of considerable inventiveness, founding analytic geometry, the bridge between algebra and geometry crucial to the invention of calculus. The same year that he published *Discourse on Method*, Descartes also published a treatise entitled *Optics*. There, among other things, he used geometry to calculate the angular radius of a rainbow (42 degrees). But his entire project was built upon the earlier discoveries in optics of the German mathematician Johannes Kepler [KEP-lur] (1571–1630). Descartes was so taken with Kepler's insights that he included Kepler's illustration of the working of the human eye in his *Optics* (Fig. **26.6**).

Johannes Kepler, Galileo Galilei, and the Telescope

Kepler had made detailed records of the movements of the planets, substantiating Copernicus's theory that the planets orbited the sun, not the earth (see chapter 24). The long-standing tradition of a **geocentric** (earth-centered) cosmos was definitively replaced with a **heliocentric** (sun-centered) theory. Kepler also challenged the traditional belief that the orbits of the planets were spherical, showing that the five known planets moved around the sun in elliptical paths determined by the magnetic force of the sun and their relative distance from it. His interest in optics was spurred on when he recognized that the apparent diameter of the moon differed when observed directly and when observed using a **camera obscura** [ob-SKYOOR-uh], a device that temporarily reproduces an image on a screen or wall (Fig. **26.7**).

Meanwhile, in Italy, Kepler's friend Galileo Galilei [gal-uh-LAY] had improved the design and magnification of the telescope (invented by a Dutch eyeglass-maker, Hans Lippershey; see chapter 24). Through the improved telescope, Galileo saw and described the craters of the moon, the phases of Venus, sunspots, and the moons of Jupiter. Galileo also theorized that light takes a

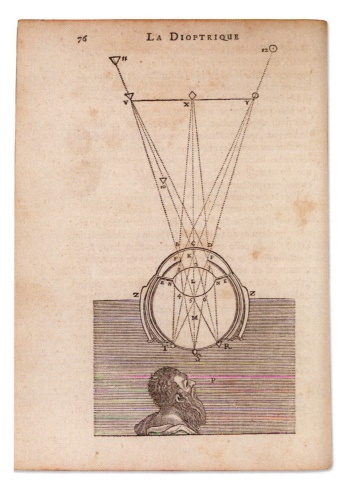

Fig. 26.6 Illustration of the theory of the retinal image as described by Johannes Kepler. From René Descartes, Optics (La Dioptrique) (Leiden, 1637). Bancroft Library, Berkeley, CA. Descartes was more interested in what happened to the image in the brain after it registered itself on the retina, while Kepler was interested in the physical optics of the process itself.

certain amount of time to travel from one place to the next, and that either as a particle or as a wave, it travels at a measurable uniform speed. He proposed, too, that all objects, regardless of shape, size, or density, fall at the same rate of acceleration—the law of falling bodies, or gravity. Inspired by Galileo's discoveries, Kepler wrote a study on the optical properties of lenses, in which he detailed a design for a telescope that became standard in astronomical research. Kepler's and Galileo's work did not meet with universal approval. The Church still officially believed that the earth was the center of the universe and that the sun revolved around it. Protestant churches were equally skeptical. The theories of Kepler and Galileo contradicted certain passages in the Bible. Joshua, for instance, is described in the Old Testament as making the sun stand still, a feat that would be impossible unless the sun normally moved around the earth: "So the sun stood still in the midst of the heaven, and hasted not to go down about a whole day. And there was no day like that before it or after it" (Joshua 10:13–14). Furthermore, it seemed to many that the new theories relegated humankind to a marginal space in God's plan. Thus, in 1615, when Galileo was required to defend his ideas before Pope Paul V in Rome, he failed to convince the pontiff.

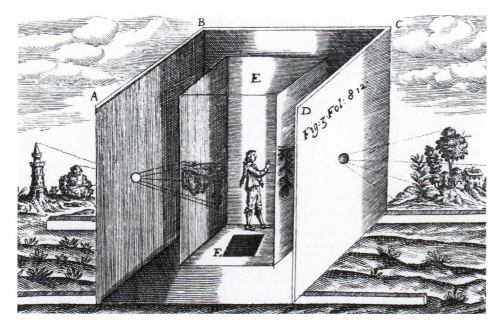

Fig. 26.7 An artist drawing in a large camera obscura. Courtesy George Eastman House, Buffalo, NY. The camera obscura works by admitting a ray of light through a small hole that projects a scene, upside down, directly across from the hole. Recent studies have shown that Vermeer made extensive use of such a device.

He was banned from both publishing and teaching his findings. When his old friend Pope Urban VIII was elected pope, Galileo appealed Paul's verdict, but Urban went even further. He demanded that Galileo admit his error in public and sentenced him to life in prison. Through the intervention of friends, the sentence was reduced to banishment to a villa outside Florence. Galileo was lucky. In 1600, when the astronomer Giordano Bruno had asserted that the universe was infinite and without center and that other solar systems might exist in space, he was burned at the stake.

Antoni van Leeuwenhoek, Robert Hooke, and the Microscope

In the last decade of the sixteenth century, two Dutch eyeglass-makers, Hans Lippershey and Zaccharias Janssen, discovered that if one looked through several lenses in a single tube, nearby objects appeared greatly magnified. This discovery led to the compound microscope (a microscope that uses more than one lens). Early compound microscopes were able to magnify objects only about twenty or thirty times their natural size. Another Dutch lens maker, Antoni van Leeuwenhoek [vahn LAY-ven-hook] (1632–1723), was able to grind a lens that magnified over 200 times. The microscope itself was a simple instrument, consisting of two plates with a lens between, which was focused by tightening or loosening screws running through the plates. Two inches long and one inch across, it could easily fit in the palm of one's hand. Leeuwenhoek was inspired by the publication of English Royal Society Curator of Experiments Robert Hooke's *Micrographia* in 1665. It was illustrated by drawings of Hooke's observations with his compound microscope: a flea that he said was "adorn'd with a curiously polish'd suite of sable Armour, neatly jointed," and a thin slice of cork, in which he observed "a Honey-comb [of] . . . pores, or cells"—actually, cell walls (Fig. **26.8**).

Leeuwenhoek wrote letters to the Royal Society of London to keep them informed about his observations. In his first letter, of 1673, he described the stings of bees. Then, in 1678, he wrote to the Royal Society with a report of discovering "little animals"—actually, bacteria and protozoa—and the society asked Hooke to confirm Leeuwenhoek's findings, which he successfully did. For the next 50 years, Leeuwenhoek's regular letters to the Royal Society, describing, for the first time, sperm cells, blood cells, and many other microscopic organisms, were printed in the society's *Philosophical Transactions*, and often reprinted separately. In 1680, Leeuwenhoek was elected a full member of the Society.

Fig. 26.8 Robert Hooke. Illustrations from *Micrographia*: a flea (top), and a slice of cork (bottom). London. 1665. Courtesy the University of Virginia Library. Hooke was the first person to use the word *cell* to describe the basic structural unit of plant and animal life.

Dutch Vernacular Painting: Art of the Familiar

Many scholars believe that Leeuwenhoek served as the model for the 1668–1669 painting by Jan Vermeer (1632–1675), *The Geographer* (Fig. 26.9). Leeuwenhoek was interested in more than microscopes. A biographer described him six years after his death as equally interested in "navigation, astronomy, mathematics, philosophy, and natural science." He would serve as trustee for Vermeer's estate in 1676, and we know that Vermeer actively used a *camera obscura* to plan his canvases, so the painter shared something of Leeuwenhoek's fascination with lenses. In this picture, Vermeer surrounds the young scientist with the tools of the geographer's trade. A sea chart on the back wall shows "all the Sea coasts of Europe," a map published in Amsterdam. The globe above his head was also produced in Amsterdam. (So detailed is this painting that the viewer can read the dates and names of the manufacturers of the map and the globe.) He holds a set of dividers, used to mark distances on what must be a chart or map on the table in front of him; the table covering is bunched up behind it as if he has pushed it out of his way. With his left hand resting on a book, he stares intently to his right, as if caught up in a profound intellectual problem.

Vermeer's *Geographer* not only embodies the intellectual fervor of the age, but also many of the themes and strategies of Dutch vernacular painting in the seventeenth century. It reveals, first of all, a Baconian attention to detailed observation, which is why we can readily identify the originals of things like the map and globe. It actively seeks to capture something of the personality of the figure, increasingly the aim of Dutch portraiture. It represents a domestic interior—a favorite theme in Dutch painting—even as it suggests an interest, through the practice of geography, in the natural **landscape**. (The word "landscape" derives, in fact, from the Dutch *landschap*—that is, "land form.") And, in all likelihood, the painting possesses an allegorical or symbolic meaning in keeping with the strict Dutch Calvinist discipline: The geographer not only charts the landscape but, as he looks forward into the light of revelation, the proper course in life itself. The *Geographer* is also a simple expression of joy in the world of things—carpets, globes, even pictures—and the Dutch desire to possess them.

New Imagery: Still Life, Landscape, and Genre Painting

The prosperous Dutch avidly collected pictures. A visiting Englishman John Evelyn explained their passion for art this way, in 1641: "The reason of this store of pictures and their cheapness proceeds

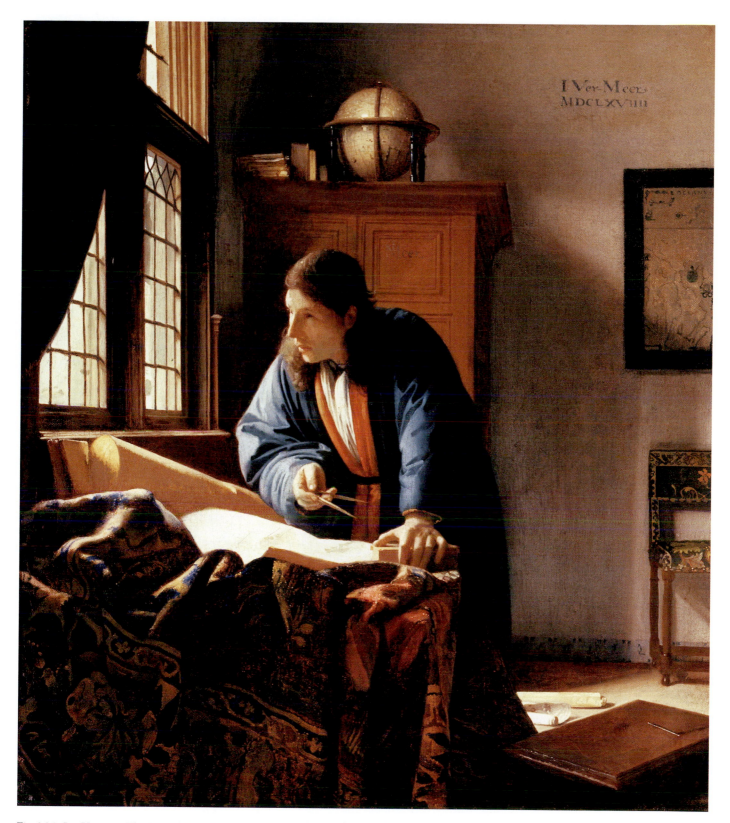

Fig. 26.9 Jan Vermeer. ***The Geographer.*** **1668–1669.** Oil on canvas, 20$\frac{1}{8}$″ × 18$\frac{1}{4}$″. Städelsches Kunstinstitut, Frankfurt. Courtesy Blauel/Gramm–ARTHOTEK, Peissenberg. The Granger Collection, NY. One of the details supporting the notion that Leeuwenhoek served as a model for this image is the carpet draped across the front of the desk on which he works. Leeuwenhoek worked in the textile industry.

from want of land to employ their stock [wealth], so that it is an ordinary thing to find a common farmer lay out two or three thousand pounds in this commodity. Their houses are full of them and they vend them at their fairs to very great gains." If Evelyn exaggerates the sums invested in art—a typical landscape painting sold for only three or four guilders, still the equivalent of two or three days' wages for a Delft clothworker—he was accurate in his sense that almost everyone owned at least a few prints and a painting or two.

Despite Dutch Reformed distaste for religious history painting—commissions from the Church had dried up almost completely by 1620—about a third of privately owned paintings in the city of Leiden (one of the most iconoclastic in Holland) during the first 30 years of the seventeenth century represented religious themes. But other, more secular forms of painting thrived. Most Calvinists did not object to sitting for their portraits, as long as the resulting image reflected their Protestant faith. And most institutions wanted visual documentation of their activities, resulting in a thriving industry in group portraiture. Painting also came to reflect the matter-of-fact materialism of the Dutch character—its interest in all manner of things, from carpets, to furnishings, to clothing, collectibles, food-

Continuity & Change
p. 815

The Calling of St. Matthew

stuffs, and everyday activities. And the Dutch artists themselves were particularly interested in technical developments in the arts, particularly Caravaggio's dramatic lighting (see Fig. 25.13). To accommodate the taste of the buying public, Dutch artists developed a new visual vocabulary that was largely vernacular, reflecting the actual time and place in which they lived.

Still Lifes Among the most popular subjects were **still lifes**, paintings dedicated to the representation of common household objects and food. At first glance, they seem nothing more than a celebration of abundance and pleasure. But their subject is also the foolishness of believing in such apparent ease of life. Johannes Goedaert's *Flowers in a Wan-li Vase with Blue-Tit* (Fig. **26.10**) is, on the one hand, an image of pure floral exuberance. The arrangement contains four varieties of tulip—somewhat ominously, given the memories of tulipomania—and a wide variety of other flowers, including a Spanish iris, nasturtiums from Peru, fritalleries [FRIT-ul-er-eez] from Persia, a stripped York and Lancaster Rose—a whole empire's worth of blossoms. The worldliness of the blooms is underscored by the Wan-li vase in which they are placed, a type of Ming dynasty porcelain (see Fig. 23.12) that became popular with Dutch traders around the turn of the century. The short life of the blooms is suggested by the yellowing leaves; the impermanance of the scene by the fly perched on one of the tulips. But perhaps the most telling detail is the bird at the bottom left of the painting, a blue-tit depicted in the act of consuming a moth. Dutch artists of this period used such details to remind the viewer of the frivolous quality of human existence, our vanity in thinking only of the pleasures of the everyday. Such *vanitas* [VAN-ih-tahss] **paintings**, as they are called, remind us that pleasurable things in life inevitably fade, that the material world is not as long-lived as the spiritual, and that the spiritual should command our attention. They are, in short, examples of the *momento mori*—reminders that we will die. Paintings such as Goedaert's were extremely popular. Displayed in the owner's home, they were both decorative and imbued with a moral sensibility that announced to a visitor the owner's upright Protestant sensibility.

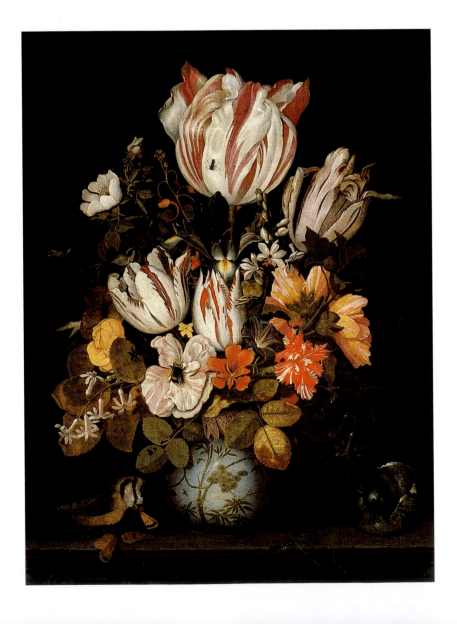

Fig. 26.10 Johannes Goedaert. *Flowers in a Wan-li Vase with Blue-Tit*. ca. 1660. Private collection, Middleburg, Germany. The shell in the lower right corner is a symbol of worldly wealth, but as it is broken and empty, it is also a reminder of our vanity and mortality.

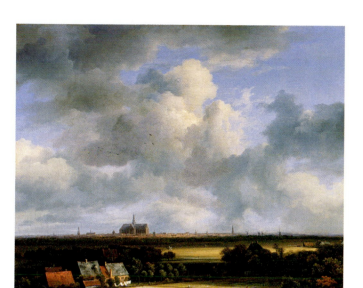

Fig. 26.11 Jacob van Ruisdael. *View of Haarlem from the Dunes at Overveen*. ca. 1670. Oil on canvas, 22″ × 24⅜″. Mauritshuis, The Hague. The play of light and dark across the landscape can be understood in terms of the rhythms of life itself.

Landscapes Another popular subject was landscapes. Landscape paintings such as Jacob van Ruisdael's [vahn ROYS-dahl] *View of Haarlem from the Dunes at Overveen* reflect national pride in the country's reclamation of its land from the sea (Fig. **26.11**). The English referred to the United Provinces as the "united bogs," and the French constantly poked fun at the baseness of what they called the *Pays-Bas* [PAY-ee bah] (the "Low Countries"). But the Dutch themselves considered their transformation of the landscape from hostile sea to tame farmland, in the century from 1550 to 1650, as analogous to God's recreation of the world after the Great Flood.

In Ruisdael's landscape painting, this religious undertone is symbolized by the great Gothic church of Saint Bavo at Haarlem, which rises over a flat, reclaimed landscape where figures toil in a field lit by an almost celestial light. (See Fig. 26.4 for Pieter Saenredam's depiction of the interior of the church.) It is no accident that two-thirds of Ruisdael's landscape is devoted to sky, the infinite heavens. In flatlands, the sky and horizon are simply more evident, but more symbolically, the Dutch thought of themselves as *Nederkindren*, the "children below," looked after by an almighty God with whom they had made an eternal covenant.

Genre Scenes Paintings that depict events from everyday life were another favorite of the Dutch public. *The Dancing Couple* (Fig. **26.12**) by Jan Steen (1626–1679) is typical of

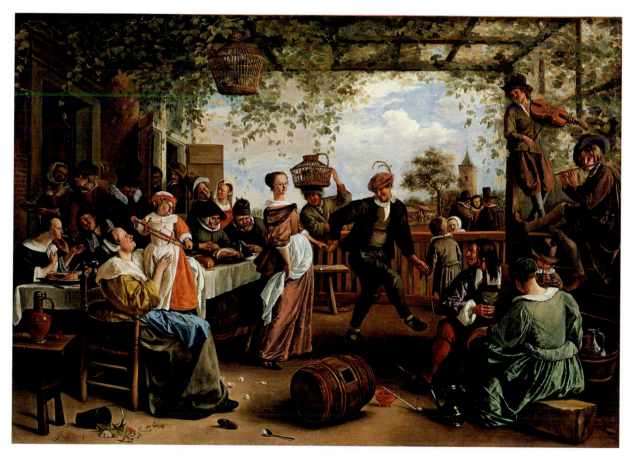

Fig. 26.12 Jan Steen. *The Dancing Couple*. 1663. Oil on canvas, 40⅜″ × 56⅛″. National Gallery of Art, Washington, D.C., Widener Collection. 1942.9.81. Photograph © 2007 Board of Trustees, National Gallery of Art, Washington, D.C. Steen's paintings, whatever their moralizing undercurrents, remind us that the Dutch were a people of great humor and happiness. They enjoyed life.

such **genre scenes**. Like many of Steen's paintings, it depicts festivities surrounding some sort of holiday or celebration. Steen was both a painter and a tavern keeper, and the scene here is most likely a tavern patio in midsummer. An erotic flavor permeates the scene, an atmosphere of flirtation and licentiousness. To the right, musicians play as a seated couple drunkenly watch the dancers. To the left, two men enjoy food at the table, a woman lifts a glass of wine to her lips, and a gentleman—a self-portrait of the artist—gently touches her chin. Steen thus portrays his own—and, by extension, the Dutch—penchant for merrymaking, but in typical Dutch fashion he also admonishes himself for taking such license. On the tavern floor lie an overturned pitcher of cut flowers and a pile of broken eggshells, both *vanitas* symbols. Together with the church spire in the distance, they remind us of the fleeting nature of human life as well as the hellfire that awaits those who have fallen into the vices so openly displayed in the rest of the painting.

One of the most popular genre painters of the day—and, incidentally, illustrator of a favorite tulip catalogue as well—was Judith Leyster [LY-ster] of Haarlem (see Fig. 26.3). We do not know much about her life, but she was admitted to the Haarlem painter's guild in 1633, in her early twenties, and married another genre painter, Jan Miense Molenaer, in 1636. The

moral severity of her 1631 painting *The Proposition* is unmistakable (Fig. **26.13**). Taking advantage of the contrast of light and dark, a Baroque technique probably learned from the example of Caravaggio (see Figs. 25.13, 25.14), Leyster creates a small drama of considerable tension and opposition. A woman sits quietly, intent on her needlework, as a lusty man leans over her, grinning. His left hand rests on her shoulder and his right offers her a handful of coins. Even as she ignores his clear proposition, her virtue is compromised. Perhaps her physical safety is in jeopardy as well, for the man's good humor will probably crumble under her rejection of him—a premonition signaled by the tension, even pain, evident in her concentration. The painting is, furthermore, remarkable for contrasting the domestic world of women with the commercial world of men, associating the former with virtue and the latter with lust and greed. *The Proposition* stops short of submission, but Leyster frankly depicts the polarity of gender roles in Dutch society: the tension between private and social space, the awkward collision of domesticity and sexuality.

Johannes Vermeer and Domestic Interiors

As his painting *The Geographer* (see Fig. 26.9) suggests, Johannes Vermeer was, above all, a keen observer of his world. His paintings illuminate—and celebrate—the material reality of Dutch life. We know very little of Vermeer's life, and his painting was largely forgotten until the middle of the nineteenth century. But today he is recognized as one of the great masters of the Dutch seventeenth century. Vermeer painted only 34 works that modern scholars accept as authentic, and most depict intimate genre scenes that reveal a moment in the domestic world of women.

The example here is *Woman with a Pearl Necklace* (Fig. **26.14**). Light floods the room from a window at the left, where a yellow curtain has been drawn back, allowing the young woman to see herself better in a small mirror beside the window. She is richly dressed, wearing an ermine-trimmed yellow satin jacket. On the table before her are a basin and a powder brush; she has evidently completed the process of putting on makeup and arranging her hair as she draws the ribbons of her pearl necklace together and admires herself in the mirror. From her ear hangs a pearl earring, glistening in the light. The woman brims with self-confidence, and nothing in the painting suggests that Vermeer intends a moralistic message of some sort. While the woman's pearls might suggest her vanity—to say nothing of pride because of the way she gazes at them—they also traditionally symbolize truth, purity, even virginity. This latter reading is supported by the great, empty, and white stretch of wall that extends between her and the mirror. It is as if this young woman is a *tabula rasa* [TAB-yuh-luh RAHZ-uh], a blank slate, whose moral history remains to be written.

Vermeer's paintings of interiors are, for many art historians, a celebration of Dutch domestic culture. As much as anything else they extol the comforts of home. In fact, the home is the chief form of Dutch architecture. Decorated with paintings and maps, furnished with comfortable furniture and carpets, its larder filled with foodstuffs from around the world, the home was the center of Dutch life.

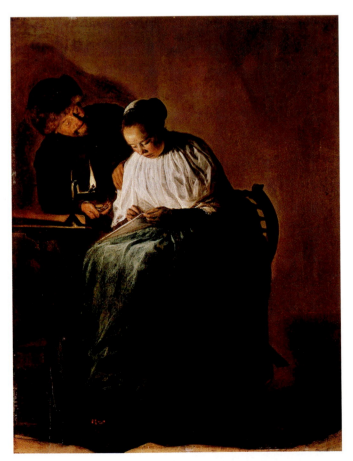

Fig. 26.13 Judith Leyster. *The Proposition*. 1631. Oil on canvas, 11⁷⁄₈″ × 9¹⁄₂″. Mauritshuis, The Hague. The Netherlands. SCALA/Art Resource, NY. The small size of the work underscores the intimacy of the scene, its detail almost as precise as the woman's needlework.

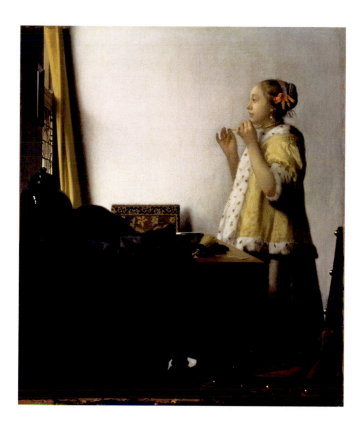

Fig. 26.14 Jan Vermeer. *Woman with a Pearl Necklace.* ca. 1664. Oil on canvas, 22⁵/₃₂″ × 17³/₄″. Post-restoration. Inv.: 912 B. Photo: Joerg P. Anders. Gemäldegalerie, Staatliche Museen zu Berlin, Berlin, Germany. Bildarchiv Preussischer Kulturbesitz/Art Resource, NY. The mirror can symbolize both vanity—self-love—and truth, the accurate reflection of the world.

formly suggested, was expected to be a true partner in her husband's affairs. She counseled him, encouraged him, and shared equally with him his burdens and successes. Probably the most popular of the marriage manuals was Jacob Cats's *Houwelick* (*Marriage*), first published in 1625, which devoted one chapter to each of six different roles in a woman's life: maiden, sweetheart, bride, housewife, mother, and widow. The book preached piety and virtue, but it also described, in tantalizing detail, the carnal acts that would inevitably lead to dire consequences. *Marriage* was, in short, a thinly disguised sex manual. Much like Dutch still-life painting, it was full of succulent treats and delicious morsels, but couched in the moral rhetoric of *vanitas*.

Still, the Dutch emphasis on familial harmony cannot be overstated. In fact, Vermeer's several paintings of young women playing the virginal, a keyboard instrument, such as his *Lady at the Virginal with a Gentleman*, also known as *The Music Lesson* (Fig. **26.15**), are emblems of domestic harmony. One of the primary forms of entertainment at Dutch family gatherings was the performance of keyboard music by the lady of the house, and indeed most of the surviving compositions from the period are

The basic household consisted of a husband and wife, who married late, compared to the custom in other European countries: Men were generally over 26 and women over 23. Almost all families had at least one servant, usually a young woman who helped with domestic chores. She often was of the same social status as her employer and might stay on for eight to ten years, or until her own marriage. By working, she could accumulate a dowry large enough to contribute to the establishment of her own household when she married.

The marriage manuals of the day were extremely popular, even bestsellers. All advocated friendship between husband and wife as a major goal of a good marriage. The man was head of the household, his authority was absolute, and all external affairs were his responsibility. The woman maintained a certain status. She not only ruled over the workings of the house itself, but, as the marriage manuals uni-

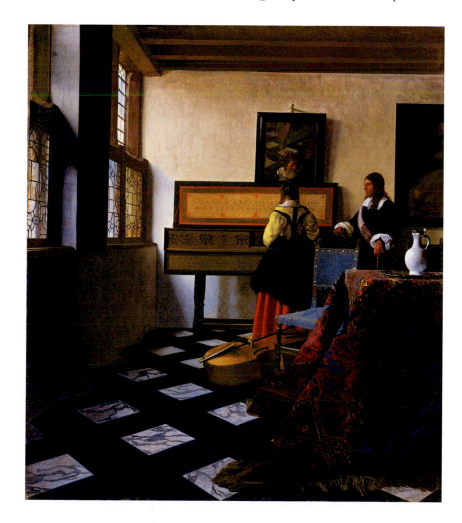

Fig. 26.15 Jan Vermeer. *Lady at the Virginal with a Gentleman (The Music Lesson).* ca. 1662–1664. Oil on canvas, 29¹/₈″ × 25³/₈″. Courtesy of Her Majesty Queen Elizabeth II. In the manner of van Eyck's *Giovanni Arnolfini and His Wife Giovanna Cenami* (see Fig. 20.11), Vermeer includes himself, or at least his easel, reflected in the mirror at the back of the painting.

scores made for home use. In Vermeer's painting, the idea of harmony is further asserted by the empty chair and bass viol behind the young woman, which, we can assume, the young gentleman will soon take up in a duet. Inscribed on the lid of the virginal are the words "MVSICA LETITIAE CO[ME]S MEDICINA DOLOR[VM]" ("Music is the companion of joy and balm for sorrow"). In the context of Dutch domestic life, it would not be far-fetched to substitute *marriage* for *music*, so close is the analogy.

Frans Hals and the Group Portrait

The leading portrait painter of early seventeenth-century Holland was Frans Hals (1581–1666) of Haarlem. Hals worked quickly, probably without preliminary sketches (none survive), with the loose and gestural brushstrokes apparent in his lively portrait of Descartes (see Fig. 26.5). He avoided flattering his sitters by softening or altering their features, seeking instead to convey their vitality and personality. Hals was particularly successful at the **group portrait**, a large canvas commissioned by a civic institution to document or commemorate its membership at a particular time.

Between 1616 and 1639, Hals painted five enormous group portraits for the two Haarlem militias: the Civic Guard of Saint George and the Cluveniers, who were also known as the Civic Guard of Saint Adrian. This was a mammoth task, because the five canvases alone contain 68 portraits of 61 different prominent Haarlem citizens, plus one dog. Group portraits of the civic guards had been commissioned before, but these set a new standard. Until this series, such group portraits had tended to be little more than formal rows of individual portraits. In the first of these paintings, *Banquet of the Officers of the St. George Civic Guard,* Hals turns the group portrait into a lively social event, capturing in specific detail a fleeting moment at the farewell banquet for the officers who had completed their three-year stint (Fig. **26.16**). Despite the casualness of the scene, Hals shows the hierarchy of the company by arranging its highest officers under the tip of the flag that tops an imaginary pyramid of figures. Alone at the head of the table and closest to the viewer sits the colonel, with the

provost marshal, the second in command, on his right. They are the highest-ranking officers. Three captains sit down along the side of the table to the colonel's left, and three lieutenants sit at the far end of the table between the colonel and the provost. Three ensigns, not technically part of the officers' corps, stand at the right. Holding the flag at the back of the composition is a servant. So vigorous are Hals's portraits that this painting quickly became a symbol of the strength and healthy optimism of the men who established the new Dutch Republic.

Rembrandt van Rijn and the Drama of Light

If anyone could compete with Hals as a portrait painter, it was Rembrandt van Rijn (1606–1669), the leading painter in Amsterdam. Twenty-five years Hals's junior, Rembrandt learned much from the elder Dutchman. Not least of all was how to build up the figure with short dashes of paint or, alternately, long fluid lines of loose, gestural brushwork. The result, paradoxically, is an image of extreme clarity. Consider Rembrandt's portrait of Amsterdam fur-trader Nicolaes Ruts, commissioned by the merchant in 1631 (Fig. **26.17**).

Ruts is dressed in the stuff of his trade, sable fur, the most sought-after and finest of all materials. In one hand he holds a note—perhaps a letter of credit—while the other rests firmly on the corner of a table or chair. His eyes gaze out of the picture—not at the viewer, but as if inward—with an almost ferocious intensity of thought. The picture is a piece of self-propaganda, commissioned to evoke the sitter's business acumen and success, the reliability and soundness of his enterprise. It accomplishes this by juxtaposing his wealth—captured in Rembrandt's rendering of the fur, each hair on the right sleeve realized with a single, minute stroke of oil paint—with the plainness and austerity of the painting's brown colors and setting. Devoid of the red, blue, and green draperies that mark Italian painting (see Fig. 25.18 for example), and purged of all architectural ornament, this painting announces the *economy* of its means in both senses of the word: the prosperity and wealth of the man and the thrift and frugality of their management. What Rembrandt brought to his portrait paintings, beyond the require-

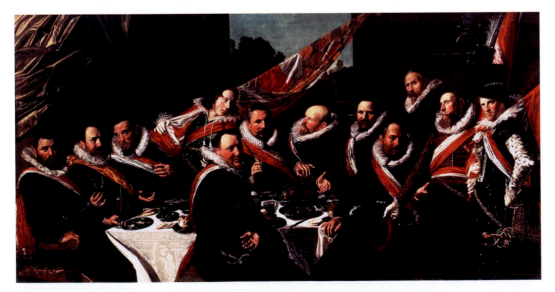

Fig. 26.16 Frans Hals. *Banquet of the Officers of the St. George Civic Guard.* 1616. Oil on canvas, $68\frac{7}{8}'' \times 137\frac{1}{2}''$. Frans Halsmuseum, Haarlem. The enormous scale of this painting reflects the Baroque taste for colossal theatrical settings. It is, in effect, the northern vernacular equivalent in painting of Bernini's architectural colonnade for Vatican square (see Fig. 25.1)—both conceived essentially to consume the viewer within their space.

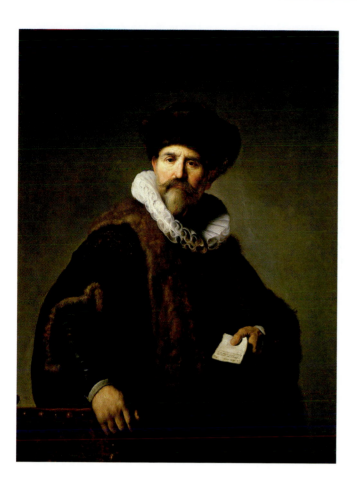

Fig. 26.17 Rembrandt van Rijn. *Portrait of Nicolaes Ruts.* **1631.** Oil on mahogany, 46″ × 34 ³/₈″. Frick Collection, NY. That Rembrandt painted this work on mahogany, instead of the usual oak, speaks to the sitter's wealth and taste for fine objects.

ment that they look like their sitters, is what Simon Schama in his biography *Rembrandt's Eyes* terms "the urgency and energy of characters caught in a personal drama—their own."

The painting also reveals one of Rembrandt's important contributions to the art of portraiture—his use of light to animate the figure. Where light falls through the windows of Vermeer's paintings onto his figures, it seems to emanate from the figures themselves in Rembrandt's. It is as if light is a symbol for life itself. In one of his most famous group portraits, *The Anatomy Lesson of Dr. Tulp* (see *Focus*, pages 852–853), Rembrandt would use this symbolic light for ironic effect. But in his religious works, especially, it would come to stand for the redemption offered to humankind by the example of Christ.

The master of such lighting effects was Caravaggio, and Rembrandt may have consciously tried to outdo the master. His use of chiaroscuro and tenebrism is even more dramatic than Caravaggio's. Compare Rembrandt's *The Supper at Emmaus* (Fig. **26.18**) with Caravaggio's version of the same scene (see *Focus*, page 820) to see the difference. Rembrandt has chosen to paint the moment just after the one Caravaggio depicts; that is, the moment just after the recognition: "And their eyes were opened, and they knew him, and he vanished out of their sight" (Luke 24:31). Rembrandt's Christ seems to dissolve into the shadows beneath him, while the glow behind, which seems to emanate from his head like some spiritual force, will in the next moment be extinguished and Christ will be gone. In Caravaggio's painting, the play between light and dark reinforces the dramatic tension of the moment. In Rembrandt's, the transformation of light to dark *is* the drama.

Rembrandt's love of the play of light and dark drew him to printmaking, a medium where the contrast between rich darks and brilliant lights could be exploited to great effect.

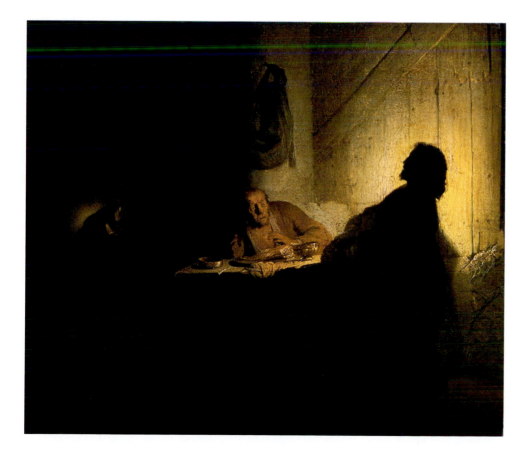

Fig. 26.18 Rembrandt van Rijn. *The Supper at Emmaus.* **ca. 1628.** Oil on paper placed on panel, 14 ³/₄″ × 16 ⁵/₈″. Musée Jacquemart-André, Paris. Erich Lessing/Art Resource, NY. While the subject of this painting overtly recalls Caravaggio's earlier work of the same name, the structure echoes another Caravaggio painting, *The Calling of Saint Matthew* (see Fig. 25.13).

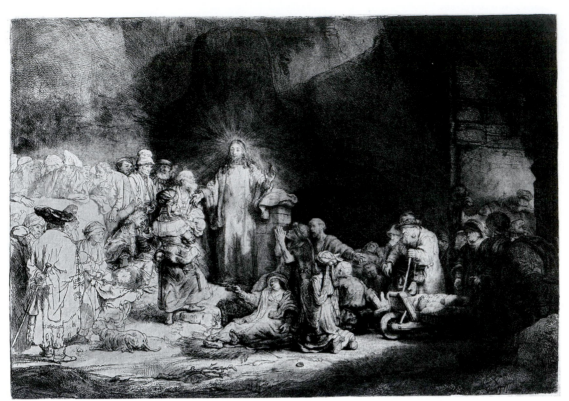

Fig. 26.19 Rembrandt van Rijn. *Christ Preaching* (the "Hundred-Guilder Print"). ca. 1648–1650. Etching, 11″ × 15½″. Rijksmuseum, Amsterdam. Many of the figures in this etching were suggested by Spanish and Jewish refugees who crowded the streets of Amsterdam and whom Rembrandt regularly sketched.

Among the greatest of his many prints is *Christ Preaching* (Fig. **26.19**), also known as the "Hundred-Guilder Print" because it sold for 100 guilders at a seventeenth-century auction, at that time an unheard-of price for a print. The image illustrates the Gospel of Matthew, showing Christ addressing the sick and the lame, grouped at his feet and at his left, and the Pharisees, at his right. Always aware of Albrecht Dürer's great achievements in the medium (see Figs. 21.7, 21.8), Rembrandt here constructs a triangle of light that seems to emanate from the figure of Christ himself, which seems to burst from the deep black gloom of the night. What the light is meant to offer, of course, is hope—and life.

Of all the artists of his era, Rembrandt was certainly the most interested in self-portraiture. A painter's own face is always freely available for study, and the self-portrait offered Rembrandt the opportunity to explore technical and compositional problems using himself as a means to do it. Over 60 self-portraits survive, most of them imbued with the same drama of light and dark that characterizes his other work. Beginning in 1640, he endured a series of tragedies, beginning with the death of his mother. Two years later, Rembrandt's wife Saskia died shortly after giving birth to Titus, the only one of their four children to survive to adulthood. Furthermore, Rembrandt lived notoriously beyond his means. In 1656 he was forced to declare bankruptcy, a public humiliation. The inventory of the collection he had put together to satisfy his eclectic taste is astonishing. There were South American Indian costumes, shells, sponges, and coral from around the world's oceans, a stuffed New Guinea

bird of paradise, Chinese ceramics, Turkish and Persian textiles, musical instruments of all kinds and from all periods, Javanese shadow puppets, and arms and armor. Works of art included sculpture busts of the Roman emperors from Augustus through Marcus Aurelius, "a little child by Michelangelo," and a huge collection of works on paper, including examples by Bruegel and Rubens, and a "precious book" (perhaps a collection of drawings) by Mantegna. He had used many of these items in his paintings. Suddenly he found himself without his things.

It is tempting to read his *Slaughtered Ox* of 1655, painted just before his bankruptcy, as a psychological self-portrait, reflecting the artist's anguish as he saw ruin approaching (Fig. **26.20**). Disemboweled and lashed to a wooden frame, its hind legs spread in some grotesque parody of the Crucifixion, the carcass is an exercise in the furious brushwork, the signature "rough style," for which Rembrandt was by now famous. At this point, he was over 13,000 guilders in debt, creditors were threatening to take his home, and he had spent all of Titus's inheritance from Saskia—another 20,000 guilders. Within the context of these difficulties, he must have identified with the flayed body of the ox. Yet the image is also one of plenty and well-being—suggesting a feast to come. This reading is supported by the emergence from the doorway behind the crossbeams of a kitchen maid, bathed in a soft light. A similar optimism pervades all of Rembrandt's late work, perhaps because he saw light, a requirement of the painter's act of seeing, as inherently imbued with divine goodness, or at least its promise.

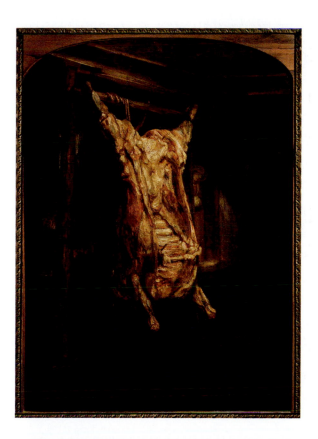

Fig. 26.20 Rembrandt van Rijn. *Slaughtered Ox*. 1655. Oil on panel, 37″ × 27 1/8″. Musée du Louvre/RMN Réunion des Musées Nationaux, France. Erich Lessing/Art Resource, NY. The painting lies fully within the tradition of Dutch still life (see Fig. 21.13), though it is much more starkly realistic than the norm.

His *Self-Portrait* of 1658 tends to confirm this reading of the *Slaughtered Ox* as a kind of self-portrait. (Fig. **26.21**). Here Rembrandt sits kinglike, dressed in rich robes, leaning forward in his chair, his legs wide apart, scepter or staff in hand, bathed in light. His hands, especially the left one (Fig. **26.22**), show the same ferocity and rough brushwork as the *Slaughtered Ox* and look quite meaty. In this painting Rembrandt seems to rise above his impoverished condition long enough to play the part of the victor, not the vanquished. The ferocity of Rembrandt's brushwork suggests that the function of art is to transform mere flesh by the stroke of imagination, to wrest from the inevitable misfortune of humanity a certain dignity, even a kind of triumph. In the drama of light that pervades his art, he asserted both the psychological complexity of a profoundly individual personality and a more general, but deeply felt, compassion for humanity.

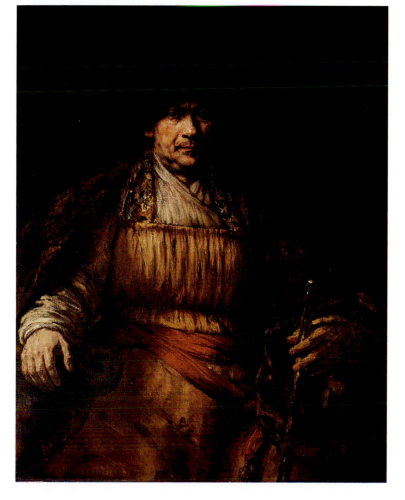

Fig. 26.21 Rembrandt van Rijn. *Self-Portrait*. 1658. Oil on panel, 52 5/8″ × 40 7/8″. Signed and dated on the arm of the chair at right: Rembrandt/f.1658. Purchased in 1906. Acc #06.1.97. The Frick Collection. Looking past the viewer, Rembrandt's gaze removes him from the cares of everyday life, and transports him into an almost

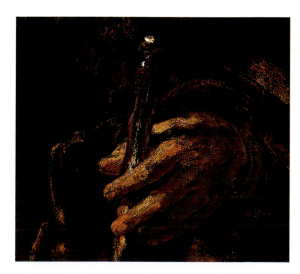

Fig. 26.22 Rembrandt van Rijn. Detail of *Self-Portrait*. **1658.** Frick Collection, NY. Rembrandt's hand seems painted with a scalpel or a butcher's knife rather than a brush.

Focus

Rembrandt's *The Anatomy Lesson of Dr. Tulp*

The Anatomy Lesson of Dr. Tulp was commissioned by Dr. Tulp to celebrate his second public anatomy demonstration performed in Amsterdam on January 31, 1632. Public dissections were always performed in the winter months in order to better preserve the cadaver from deterioration. The body generally was that of a recently executed prisoner. The object of these demonstrations was purely educational—how better to understand the human body than to inspect its innermost workings? By understanding the human body, the Dutch believed, one could come to understand God. As the Dutch poet Barlaeus put it in 1639, in a poem dedicated to Rembrandt's painting:

> *Listener, learn yourself! And while you proceed through the parts, believe that, even in the smallest, God lies hid.*

Public anatomies, or dissections, were extremely popular events. Town dignitaries would generally attend, and a ticket-paying public filled the amphitheater. As sobering as the lessons of an anatomy might be, the event was also an entertaining spectacle. An example of the Dutch group portrait, this one was designed to celebrate Tulp's medical knowledge as well as his following. He is surrounded by his students, all of whom are identified on the sheet of paper held by the figure standing behind the doctor. Their curiosity underscores Tulp's prestige and the scientific inquisitiveness of the age.

Like Frans Hals's group portrait *Banquet of the Officers of the St. George Civic Guard* (see Fig. 26.16), the figures are arranged in a triangle. Dr. Tulp, in the bottom right corner, holds a scalpel that is the focus of almost everyone's attention. As is characteristic of Rembrandt's work, light plays a highly symbolic role. It shines across the room, from left to right, directly lighting the faces of the three most inquisitive students, suggesting the light of revelation and learning. And it terminates at Tulp's face, almost as if he himself is the source of their light. Ironically, the best-lit figure in the scene is the corpse. Whereas light in Rembrandt's work almost always suggests the kind of lively animation we see on the students' brightly lit faces, here it illuminates death.

Dr. Frans van Loenen points at the corpse with his index finger as he engages the viewer's eyes. The gesture is meant to remind us that we are all mortal.

The pale, almost bluish skin tone of the cadaver contrasts dramatically with the rosy complexions of the surgeons. Typically, the cadaver's face was covered during the anatomy, but Rembrandt unmasked the cadaver's face for his painting. In fact, we know the identity of the cadaver. He is Adriaen Adriaenszoon, also known as "Aris Kindt"—"the Kid"—a criminal with a long history of thievery and assault who was hanged for beating an Amsterdam merchant while trying to steal his cape. Dr. Tulp and his colleagues retrieved the body from the gallows. In another context, a partly draped nude body so well lit would immediately evoke the entombment of Christ with its promise of Resurrection. It is the very impossibility of that fate for Adriaen Adriaenszoon that the lighting seems to underscore here.

Dr. Tulp is displaying the flexor muscles of the arm and hand and demonstrating their action by activating various muscles and tendons. It is the manual dexterity enabled by these muscles that physically distinguishes man from beast.

Dr. Hartman Hartmanszoon holds in his hand a drawing of a flayed body upon which someone later added the names of all the figures in the scene.

Dr. Tulp was born Claes Pieterszoon but took the name *Tulp*—Dutch for "tulip"—sometime between 1611 and 1614 when still a medical student in Leiden, where he encountered the flower in the botanical gardens of the university. Throughout his career, a signboard painted with a single golden yellow tulip on an azure ground hung outside his house.

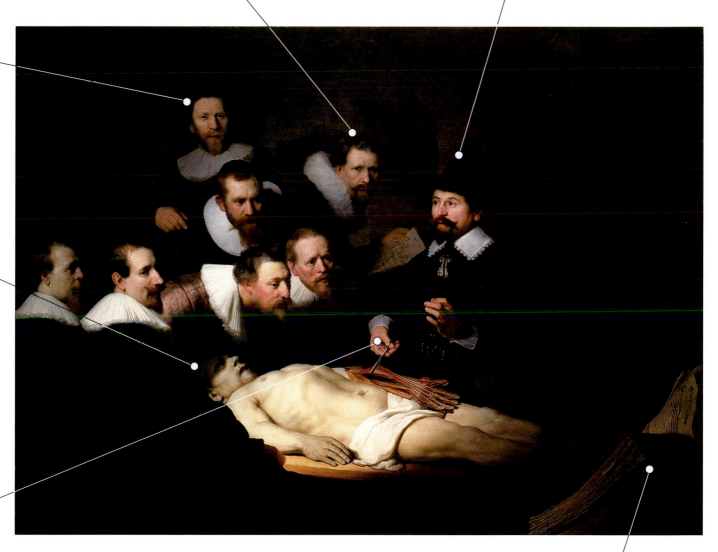

This large book may be the *De humani corporis fabrica,* the first thorough anatomy, published in 1543 by the Dutch scientist Andreis van Wesel (1514–1564), known as Vesalius, who had taught anatomy at the University of Padua. Tulp thought of himself as *Vesalius redivivus,* "Vesalius revived."

Rembrandt van Rijn. *The Anatomy Lesson of Dr. Tulp. 1632.* Oil on canvas, $66\frac{3}{4}''\times85\frac{1}{4}''$. Royal Cabinet of Paintings Maurithsuis Foundation, The Hague, Netherlands.

The Baroque Keyboard

In the late eighteenth century, the philosopher and sometimes composer Jean-Jacques Rousseau [roo-SOH] (whose work will be discussed in chapter 29) described Baroque music in the most unflattering terms: "A baroque music is that in which the harmony is confused, charged with modulation and dissonances, the melody is harsh and little natural, the intonation difficult, and the movement constrained." In many ways, the description is accurate, although Rousseau's negative reaction to these characteristics reveals more about the musical taste of his own later age than it does the quality of music in the Baroque era itself. Stylistically, the music of the Baroque era is as varied as the Baroque art of Rome and Amsterdam. Like the art created in both centers, it is purposefully dramatic and committed to arousing emotion in the listener. Religious music, particularly, was devoted to evoking the passion of Christ. Also like Baroque art in both cities, Baroque music sought to be new and original, as Catholic and Protestant churches, north and south, constantly demanded new music for their services. At the same time, Baroque musicians created new secular forms of music as well. (See the discussion of Corelli and the *sonata da camera* in chapter 25.) Perhaps most significant of all, the Baroque era produced more new instruments than any other. Additionally, even traditional instruments were almost totally transformed. This was the golden age of the organ. The deep intonations of this very ancient instrument, dating from the third century BCE, reached new heights as it commanded the emotions of both Catholic and Protestant churchgoers alike. By the first half of the eighteenth century, the piano began to emerge as a vital instrument even as the harpsichord was perfected technically. And for the first time in the history of music, instrumental virtuosos, especially on violin and keyboard, began to rival vocalists in popularity.

Jan Pieterszoon Sweelinck's Fantasies for the Organ

Amsterdam was home to one of the greatest keyboard masters of the seventeenth century, Jan Pieterszoon Sweelinck [SWAY-lingk] (1562–1621). As the official organist of Amsterdam, he performed on the great organ at the Oude Kerk (Old Church) for 40 years. Calvinist doctrine required that, at church services, he play standard hymns from the early years of the Reformation. Nevertheless, he was famous for his preludes and postludes to the services, which were virtuoso improvisations. These helped to draw large congregations on Sundays, and he routinely gave public concerts during the week as well. Students from all over Europe flocked to Amsterdam to study with Sweelinck, and, by the time of his death in 1621, he had transformed keyboard composition, especially in Germany. A long line of his pupils came to be regarded as members of the north German school.

Sweelinck was especially noted for his **fantasias**, keyboard works that lack a conventional structure but follow, or at least give the impression of following, the composer's free flight of fantasy. In fact, by the 1620s, when Sweelinck's compositions were in wide circulation, the terms *fantasia* and *prelude* were used interchangeably to refer to this purely instrumental form.

In his 1597 *Plain and Easy Introduction to Practical Music*, the English composer Thomas Morley (1558–1602) described fantasias as follows:

> The most principal and chiefest kind of music which is made without a ditty [i.e., without words to be sung] is the Fantasy, that is when a musician taketh a point [i.e., a theme] at his pleasure and wresteth and turneth it as he list [chooses], making either much or little of it according as shall seem best in his own conceit. In this may more art be shown than in any other music because the composer is tied to nothing, but that he may add, diminish, and alter at his pleasure.

Sweelinck's displays of virtuosity were heightened by his use of the pedalboard. (The organ normally had two keyboards playable by the hands, and a third keyboard playable by the feet.) Using the pedalboard as an independent part of the composition allowed Sweelinck, and the many composers who followed his lead, to create highly dramatic works that, in Morley's words, "wresteth and turneth" in surprisingly original ways. In their variety of forms— "discords, quick motions, slow motions"—in the composer's ability "to add, diminish, and alter at his pleasure," but above all in their ability to surprise their audience, Sweelink's compositions were the musical equivalent of the Baroque architecture embodied in Francesco Borromini's Church of San Carlo alle Quattro Fontane (see Fig. 25.10).

The North German School: Johann Sebastian Bach

Perhaps the greatest heir to Sweelinck's innovations was Johann Sebastian Bach [bakh] (1685–1750). Born 60 years after Sweelinck's death and at the end of the seventeenth century, Bach was very much a master of the keyboard in Sweelinck's Baroque tradition. Like Sweelinck, Bach sought to convey the devotional piety of the Protestant tradition through his religious music. And like Sweelinck, he was an organist, first in the churches of small German towns, then in the courts of the Duke of Weimar [VY-mahr] and the Prince of Cöthen, and finally at Saint Thomas's Lutheran Church in Leipzig [LIPE-zig]. There he wrote most of the music for the Lutheran church services, which were much more elaborate than the Calvinist services in Amsterdam.

Vocal Music For each Sunday service, Bach also composed a **cantata**, a multimovement musical commentary on the chosen text of the day sung by soloists and chorus accompanied by one or more instruments, usually the organ. The first half of the cantata was performed after the scriptural lesson and the second half after the sermon, concluding with a chorale, a hymn sung in the vernacular by the entire congregation. Like operas, cantatas include both recitative parts and arias.

Bach's cantatas are usually based on the simple melodies of Lutheran chorales, but are transformed by his genius for **counterpoint**, the addition of one or more independent melodies above or below the main melody, in this case the line of the Lutheran chorale. The result is an ornate musical texture that is characteristically Baroque. *Jesu, der du meine Seele* ("Jesus, It Is By You That My Soul") provides a perfect example, and it reveals the extraordinary productivity of Bach as a composer, driven as he was by the Baroque demand for the new and the original. He wrote it in

1724, a week after writing another entirely new cantata, and a week before writing yet another. (Bach was compelled to write them in time for his choir and orchestra to rehearse.) The opening chorus (**CD-Track 26.1**) is based on the words and melody of a chorale that would have been familiar to all parishioners. That melody is always presented by the soprano, and is first heard 21 measures into the composition after an extended passage for the orchestra. Even the untrained ear can appreciate the play between this melody and the others introduced in counterpoint to it.

Over the course of his career Bach composed more than 300 cantatas, or five complete sets, one for each Sunday and feast day of the church calendar. In addition, he composed large-scale **oratorios**. These are lengthy choral works, either sacred or secular, but without action or scenery, performed by a narrator, soloists, chorus, and orchestra (see chapter 25) for Christmas and Easter. Bach's *Christmas Oratorio* is a unique example of the form. It consists of six cantatas, written to be sung on six separate days over the course of the Christmas season 1734–1735, beginning on Christmas Day and ending on Epiphany (January 6). Based on the gospels of Saint Luke and Saint Matthew, the story is narrated by a tenor soloist in the role of an Evangelist. Other soloists include an Angel, in the second cantata, and Herod, in the sixth. The chorus itself assumes several roles: the heavenly host singing "Glory to God" in the second cantata; the shepherds singing "Let us, even now, got to Bethlehem" in the third; and, in the fifth, the Wise Men, singing "Where is this new-born child; the king of the Jews?" Solo arias interrupt the narrative in order to reflect upon the meanings of the story.

One of Bach's greatest achievements in vocal music is the *The Passion According to Saint Matthew*, written for the Good Friday service in Leipzig in 1727. A **passion** is similar to an oratorio in form but tells the story from the Gospels of the death and resurrection of Jesus. Based on the sung texts of chapters 26 and 27 of the Gospel of Matthew, it narrates the events between the Last Supper and the Resurrection. It is a huge work, over three hours long. A double chorus assisted by a boys' choir alternates with soloists (representing Matthew, Jesus, Judas, and others) who sing arias and recitatives, all accompanied by a double orchestra and two organs. As in the

Christmas Oratorio, the story is narrated by a tenor Evangelist. The words of Jesus are surrounded by a lush string accompaniment, Bach's way of creating a musical halo around them. All told, in the *Passion of Saint Matthew* Bach seems to have captured the entire range of human emotion, from terror and grief to the highest joy.

Instrumental Music Bach wrote instrumental music for almost all occasions, including funerals, marriages, and civic celebrations. Among his most famous instrumental works are the six *Brandenburg* concertos, dedicated to the Margrave of Brandenburg in 1721. (A margrave was a German title, of lesser rank than a duke.) Each of the six is scored differently, and in fact Bach seems to have been intent on exploring the widest possible range of orchestral instruments in often daring combinations. Technically, concertos number one, two, four, and five are examples of the **concerto grosso**, which feature several solo instruments accompanied by a **ripieno** (Italian for "full") ensemble. The second, for instance, is scored for trumpet, recorder (often performed by a flute today), oboe, and violin as soloists. In the third movement of the second concerto, the main melody is stated by the solo trumpet and subsequently imitated in counterpoint by all the other soloists, and subsequently restated by both the violin and oboe, until at the conclusion the trumpet makes a final statement accompanied by all the soloists and the orchestra (**CD-Track 26.2**). The third concerto is a **ripieno** concerto, a form which features no solo instruments at all and is scored for strings. The sixth is unique, calling for low strings (no violins or violas) to accompany two solo violas and two solo viola da gambas (a bass stringed instrument slightly smaller than a cello).

One of Bach's great contributions to secular instrumental musical history is his *Well-Tempered Clavier*. It is an attempt to popularize the idea of **equal temperament** in musical tuning, especially the tuning of keyboard instruments like the harpsichord, the virginal (a smaller harpsichord), and the clavichord. The harpsichord is a piano-like instrument whose strings are plucked rather than struck as with a piano. A clavichord's brass or metal strings are struck by metal blades (Fig. **26.23**). Equal temperament consists in dividing the

Fig. 26.23 Clavichord with painted images, Dirk Stoop (painter). ca. 1660–1680. Painted musical instrument, $4'' \times 32\frac{1}{2}'' \times 10\frac{3}{4}''$. Collection Rijksmuseum, Amsterdam. Item # NM -9487. Clavichords were built as early as the fifteenth century, perhaps even earlier. It was at once the most personal and quietest of European keyboard instruments, perfect for the household chamber.

octave into twelve half-steps of equal size. *The Well-Tempered Clavier* is a two-part collection of musical compositions, the first part completed in 1722, and the second around 1740. Each part consists of 24 preludes and fugues, one prelude and one fugue in each of the 12 major and minor keys.

The **fugue** is a genre that carries a single thematic idea for the entire length of the work. As Bach wrote on the title page to the first part, the pieces were intended "for the profit and use of musical youth desirous of learning and especially for the pastime of those already skilled in this study." Bach's fugues, of which the *Fugue in D major* from Part II of *The Well-Tempered Clavier* is a remarkable example, consist of four independent parts (or occasionally three), one part, or *voice*, of which states a theme or melody—called a *subject*—and is then imitated by a succession of the other voices. The parts constantly overlap as the first voice continues playing in counterpoint, using material other than the main subject, while the second takes up the subject, and so on. The trick is to give each voice a distinctly independent line and to play all four voices simultaneously with two hands on a single instrument (**CD-Track 26.3**). In the end, the fugues in *The Well-Tempered Clavier* are almost sublime examples of Cartesian rationalism. In his 1649 *The Passions of the Soul*, Descartes had argued that human emotions—love, hate, joy, sadness, or exaltation—were objective in nature and susceptible to rational description, particularly in the language of music. Bach's fugues are a demonstration of this, laying out a range of feeling with a virtually mathematical clarity.

READING 26.1

from Francis Bacon, *Novum Organum Scientiarum, (The New Method of Science)* (1620)

As a lawyer, member of Parliament and Queen's Counsel, the Englishman Francis Bacon wrote on questions of law, state, and religion, as well as on contemporary politics, but he is best known for his empirical essays on natural philosophy, including the Novum Organum Scientiarum (The New Method of Science). *In that work, he presents the following theory of "Idols," the false notions that must be purged from the mind before it can properly engage in the acquisition of knowledge. Empiricism is, in fact, the "new method of science" that will restore the senses by freeing them from the Idols.*

36 One method of delivery alone remains to us which is simply this: we must lead men to the particulars themselves, and their series and order; while men on their side must force themselves for a while to lay their notions by and begin to familiarize themselves with facts.

38 The idols and false notions which are now in possession of the human understanding, and have taken deep root therein, not only so beset men's minds that truth can hardly find entrance, but even after entrance is obtained, they will again in the very instauration[1] of the sciences meet and trouble us, unless men being forewarned of the danger fortify themselves as far as may be against their assaults.

39 There are four classes of Idols which beset men's minds. To these for distinction's sake I have assigned names, calling the first class *Idols of the Tribe*; the second, *Idols of the Cave*; the third, *Idols of the Market Place*; the fourth, *Idols of the Theater*.

41 The Idols of the Tribe have their foundation in human nature itself, and in the tribe or race of men. For it is a false assertion that the sense of man is the measure of things. On the contrary, all perceptions as well of the sense as of the mind are according to the measure of the individual and not according to the measure of the universe. And the human understanding is like a false mirror, which, receiving rays irregularly, distorts and discolors the nature of things by mingling its own nature with it.

42 The Idols of the Cave are the idols of the individual man. For everyone (besides the errors common to human nature in general) has a cave or den of his own, which refracts and discolors the light of nature, owing either to his own proper and peculiar nature; or to his education and conversation with others; or to the reading of books, and the authority of those whom he esteems and admires; or to the differences of impressions, accordingly as they take place in a mind preoccupied and predisposed or in a mind indifferent and settled; or the like. So that the spirit of man (according as it is meted out to different individuals) is in fact a thing variable and full of perturbation, and governed as it were by chance. Whence it was well observed by Heraclitus[2] that men look for sciences in their own lesser worlds, and not in the greater or common world.

43 There are also Idols formed by the intercourse and association of men with each other, which I call Idols of the Market Place, on account of the commerce and consort of men there. For it is by discourse that men associate, and words are imposed according to the apprehension of the vulgar. And therefore the ill and unfit choice of words wonderfully obstructs the understanding. Nor do the definitions or explanations wherewith in some things learned men are wont to guard and defend themselves, by any means set the matter right. But words plainly force and overrule the understanding, and throw all into confusion, and lead men away into numberless empty controversies and idle fancies.

44 Lastly, there are Idols which have immigrated into men's minds from the various dogmas of philosophies, and also from wrong laws of demonstration. These I call Idols of the Theater, because in my judgment all the received systems are but so many stage plays, representing worlds of their own creation after an unreal and scenic fashion. Nor is it only of the systems now in vogue, or only of the ancient sects and philosophies, that I speak; for many more plays of the same kind may yet be composed and in like artificial manner set forth; seeing that errors the most widely different have nevertheless causes for the most part alike. Neither again do I mean this only of entire systems, but also of many principles and axioms in science, which by tradition, credulity, and negligence have come to be received. ■

Reading Question

Can you identify, in your own place and time, an example of each of Bacon's "Idols" playing itself out and determining the way people think fallaciously?

[1] Reorganization or renewal.

[2] A Greek philosopher, ca. 500 BCE, who taught that nature was in a state of flux.

READING 26.3

from René Descartes, *Discourse on Method* (Part IV) (1637)

Descartes' Discourse on Method was published in 1737 in Holland, accompanied by three books designed to serve as appendices and examples of the method at work—a Geometry, an Optics, and a Meteorology. The following is an example of the line of reasoning that would take him from his "first principle"—"I think, therefore I am"—to a logically deduced argument for the existence of God. He would repeat this argument many times, most formally in his 1641 Meditations, but the logic, simply stated, is as follows: (1) I think and I possess an idea of God (that is, the idea exists in me and I can be aware of it as an object of my understanding); (2) The idea of God is the idea of an actually infinite perfect being; (3) Such an idea could only be caused by an actually infinite perfect being; and (4) Therefore, there is an infinitely perfect being, which we call God.

I do not know that I ought to tell you of the first meditations there made by me, for they are so metaphysical and so unusual that they may perhaps not be acceptable to everyone. And yet at same time, in order that one may judge whether the foundations which I have laid are sufficiently secure, I find myself constrained in some measure to refer to them. For a long time I had remarked that it is sometimes requisite in common life to follow opinions which one knows to be most uncertain, exactly as though they were indisputable, as has been said above. But because in this case I wished to give myself entirely to the search after Truth, I thought that it was necessary for me to take an apparently opposite course, and to reject as absolutely false everything as to which I could imagine the least ground of doubt, in order to see if afterwards there remained anything in my belief that was entirely certain. Thus, because our senses sometimes deceive us, I wished to suppose that nothing is just as they cause us to imagine it to be; and because there are men who deceive themselves in their reasoning and fall into paralogisms, even concerning the simplest matters of geometry, and judging that I was as subject to error as was any other, I rejected as false all the reasons formerly accepted by me as demonstrations. And since all the same thoughts and conceptions which we have while awake may also come to us in sleep, without any of them being at that time true, I resolved to assume that everything that ever entered into my mind was no more true than the illusions of my dreams. But immediately afterwards I noticed that whilst I thus wished to think all things false, it was absolutely essential that the 'I' who thought this should be somewhat, and remarking that this truth *I think, therefore I am* was so certain and so assured that all the most extravagant suppositions brought forward by the sceptics were incapable of shaking it, I came to the conclusion that I could receive it without scruple as the first principle of the Philosophy for which I was seeking.

And then, examining attentively that which I was, I saw that I could conceive that I had no body, and that there was no world nor place where I might be; but yet that I could not for all that conceive that I was not. On the contrary, I saw from the very fact that I thought of doubting the truth of other things, it very evidently and certainly followed that I was; on the other hand if I had only ceased from thinking, even if all the rest of what I had ever imagined had really existed, I should have no reason for thinking that I had existed. From that I knew that I was a substance the whole essence or nature of which is to think, and that for its existence there is no need of any place, nor does it depend on any material thing; so that this 'me,' that is to say, the soul by which I am what I am, is entirely distinct from body, and is even more easy to know than is the latter; and even if body were not, the soul would not cease to be what it is.

After this I considered generally what in a proposition is requisite in order to be true and certain; for since I had just discovered one which I knew to be such, I thought that I ought also to know in what this certainly consisted. And having remarked that there was nothing at all in the statement "*I think, therefore I am*" which assures me of having thereby made a true assertion, excepting that I see very clearly that to think it is necessary to be, I came to the conclusion that I might assume, as a general rule, that the things which we conceive very clearly and distinctly are all true—remembering, however, that there is some difficulty in ascertaining which are those that we distinctly conceive.

Following upon this, and reflecting on the fact that I doubted, and that consequently my existence was not quite perfect (for I saw clearly that it was a greater perfection to know than to doubt), I resolved to inquire whence I had learnt to think of anything more perfect than I myself was; and I recognized very clearly that this conception must proceed from some nature which was really more perfect. As to the thoughts which I had of many other things outside of me, like the heavens, the earth, light, heat, and a thousand others, I had not so much difficulty in knowing whence they came, because, remarking nothing in them which seemed to render them superior to me, I could believe that, if they were true, they were dependencies upon my nature, in so far as it possessed some perfection; and if they were not true, that I held them from nought, that is to say, that they were in me because I had something lacking in my nature. But this could not apply to the idea of a Being more perfect than my own, for to hold it from nought would be manifestly impossible; and because it is no less contradictory to say of the more perfect that it is what results from and depends on the less perfect, than to say that there is something which proceeds from nothing, it was equally impossible that I should hold it from myself. In this way it could but follow that it had been placed in me by a Nature which was really more perfect than mine could be, and which even had within itself all the perfections of which I could form any idea—that is to say, to put it in a word, which was God. ■

Reading Question

Later in the seventeenth century, the English philosopher Thomas Hobbes would claim that there was nothing special about Descartes's *Cogito* ("I think"), saying it could as easily be "I walk, therefore I am." But after reading this brief selection from Descartes, what is it that makes thinking, as opposed to walking, more compelling?

Summary

■ Calvinist Amsterdam: City of Contradictions As Holland asserted its independence from Spain at the end of the sixteenth century, Amsterdam replaced Antwerp as the center of culture and commerce in the north. Its commercial ascendancy was underscored by the wealth at the city's disposal during the tulipomania, or tulip madness, of 1634–1637, when speculators drove the price of tulip bulbs to unheard-of heights. The excess evident in the tulip craze was, however, balanced by the conservatism of the Dutch Reformed Church, the doctrinal rigidity of which is evident in the plain, whitewashed interiors of its churches.

■ The Science of Observation New developments in philosophy and science soon challenged the authority of both the Catholic and Protestant churches. In England, Francis Bacon developed the empirical method, a process of inductive reasoning, and argued, in his *Novum Organum*, that in order to observe the world with any accuracy, we must eliminate the errors in reasoning developed through our unwitting adherence to false notions—what he calls Idols. Bacon's works circulated widely in Holland, where, for over 20 years, René Descartes developed his own brand of philosophy based on deductive reasoning. From his "first principle"—"I think, therefore I am"—Descartes was able to deduce, at least to his own satisfaction, the existence of God, albeit a deist God, neither interested in human affairs nor endowed with human character.

Scientific discoveries supported the philosophies of Bacon and Descartes. Johannes Kepler described functional properties of the human eye, the optical properties of lenses, and the movement of the planets in the solar system. His friend Galileo Galilei perfected the telescope, described the forces of gravity, and theorized the speed of light. The Church still officially believed that the earth was the center of the universe, and Galileo was sentenced to life in prison for insisting that

it was not. Meanwhile, in Holland, the microscope had been developed, and soon Antoni van Leeuwenhoek began to describe, for the first time, "little animals"—bacteria and protozoa—sperm cells, blood cells, and many other organisms.

■ Dutch Vernacular Painting: Art of the Familiar Dutch painting of the period reflects a Baconian attention to detailed observation, especially everyday objects and activities. Still lifes, landscapes, and genre paintings, including many like Vermeer's that depict domestic life, were especially popular. Most popular of all, however, were portrait paintings, including large-scale group portraits, such as those by Hals, commemorating the achievements of community leaders, civic militia, and the like. Rembrandt van Rijn's portraits are especially notable for his ability to imbue his sitters—including himself in his many self-portraits—with a dramatic sense of life; an effect achieved in no small part by his mastery of light and dark.

■ The Baroque Keyboard In Amsterdam, Jan Pieterszoon Sweelinck, organist for 40 years at the Oude Kerk (Old Church), developed the distinctly Baroque brand of keyboard work known as the fantasy, or alternately, the prelude. These works, designed to follow the free flight of the composer's imagination, were widely imitated across Europe, reaching a height in the composition of Johann Sebastian Bach in Germany. Bach's many compositions reflect one of the distinct features of Baroque music, the drive to create new and original compositions at a sometimes unheard-of pace. His vocal music for Christmas and Easter, including *The Passion of Saint Matthew*, are among the most moving works ever composed. His *Well-Tempered Clavier*, an attempt to popularize the idea of equal temperament in musical tuning, dividing the octave into 12 half-steps of equal size, is an important contribution to secular musical history.

Glossary

camera obscura A device that anticipates the modern camera but lacks the means of capturing an image on film.

cantata A multimovement musical commentary on the chosen text of the day sung by soloists and chorus accompanied by one or more instruments, most often the organ.

concerto grosso A Baroque concerto featuring both soloists and a larger ensemble (the **ripieno**).

counterpoint The addition of one or more independent melodies above or below the main melody.

deism The brand of faith that argues that the basis of belief in God is reason and logic rather than revelation or tradition.

deductive reasoning A method that begins with clearly established general principles and proceeds to the establishment of particular truths.

empirical method A manner of inquiry that combines inductive reasoning and scientific experimentation.

equal temperament A system of tuning that consists of dividing the octave into twelve half-steps of equal size.

fantasias A keyboard work that possesses no conventional structure but follows, or at least gives the impression of following, the composer's free flight of fantasy.

fugue A contrapuntal work in which a musical theme is played by a series of musical lines, each in turn, until all the lines are playing at once.

genre scene A painting that depicts events from everyday life.

geocentric Earth-centered.

group portrait A large canvas commissioned by a civic institution to document or commemorate its membership at a particular time.

heliocentric Sun-centered.

inductive reasoning A process in which, through the direct and careful observation of natural phenomena, one can draw general conclusions from particular examples and predict the operations of nature as a whole.

landscape A painting that shows natural scenery.

oratorio A lengthy choral work of a sacred or secular nature but without action or scenery and performed by a narrator, soloists, chorus, and orchestra.

passion A musical setting, similar to an **oratorio**, that recounts the last days of the life of Jesus.

ripieno In Baroque music, the name for the large ensemble within a concerto grosso.

ripieno A concerto for a large ensemble in which all instruments participate together and soloistically.

still life A painting dedicated to the representation of common household objects and food.

***vanitas* painting** A type of painting that reminds the viewer that pleasurable things in life inevitably fade, that the material world is not as long-lived as the spiritual, and that the spiritual should command our attention.

Critical Thinking Questions

1. What is the difference between inductive and deductive reasoning?

2. Why would the Church—Catholic and Protestant alike—feel threatened by the philosophies of both Francis Bacon and René Descartes?

3. How would you describe the idea of the "vernacular" in Dutch painting? How might you connect it to Francis Bacon's philosophical principles?

4. How do you account for the popularity of portraiture in Dutch society? How might you connect it to Descartes'

Tension between Populace and Court

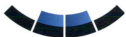

Continuity & Change

If, as many believe, Rembrandt was the leading painter of the vernacular in Baroque Amsterdam, then the leading court painter of the period is Peter Paul Rubens (1577–1640). Rubens's career in Antwerp, the Catholic city in the Spanish Netherlands, overlapped Rembrandt's in Amsterdam. Rubens was 30 years older than Rembrandt and had long been an international sensation by the time Rembrandt left Leiden for Amsterdam in 1631. The list of Rubens's accomplishments is long and impressive: chief painter to the Habsburg governors of Flanders, then in the 1620s to the Queen Mother of France, Marie de' Medici, and to Charles I of England; knighted in Brussels, London, and Madrid; successful diplomat who negotiated the treaty of peace between England and Spain in 1629–1630; and owner of what many considered the greatest collection of antique sculpture in the world, housed in what was also arguably the finest house in all Antwerp.

Across Europe in the seventeenth century, Rubens's exuberant style would dominate. It was a style more attuned to the lavish, even sensual lifestyle of the royal courts. The Dutch Reformists had managed to expel the excesses of Baroque style from Holland, but still, Rubens was the artist that every young painter sought to emulate in the early seventeenth century.

Rembrandt, despite his far more conservative and Protestant leanings, was no exception. What distinguished him was that he possessed the talent to compete with the master.

In 1633, at age 27, Rembrandt painted a *Descent from the Cross* (Fig. **26.24**) based directly on an engraving of Rubens's own *Descent from the Cross* in Antwerp Cathedral (Fig. **26.25**), painted 20 years earlier. The differences are more revealing than the similarities. For one thing, the scale of Rembrandt's intimate painting is much smaller than Rubens's original altarpiece, probably the result of Rembrandt's working from the etching. Furthermore, Rembrandt pushes the scene deeper into the space of the canvas, filling the foreground with shadow and deepening the picture plane so that viewers are more removed from the action. Many of his figures, too, are removed from the action, helplessly looking on, whereas in the Rubens everyone is engaged in the scene. The greatest difference, however, is that Rubens's *Descent* luxuriates in color and sensually curving line. Rembrandt's painting seems positively austere beside it. Nowhere in the seventeenth century can we more plainly see the tension between the art of the people, embodied in the taste of the middle-class Dutch, and the art of the royal courts of France, Spain, and England, the subject of the next chapter. ■

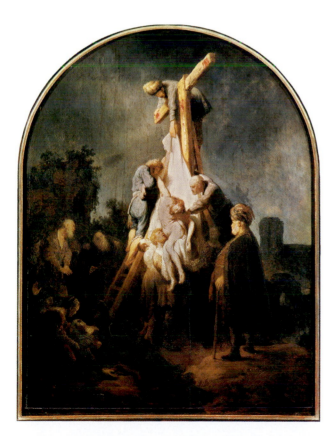

Fig. 26.24 Rembrandt van Rijn. *Descent from the Cross.* **ca. 1633.** Oil on panel, 35¼″ × 25⅝″. Alte Pinakothek, Munich, Germany. SCALA/Art Resource, NY.

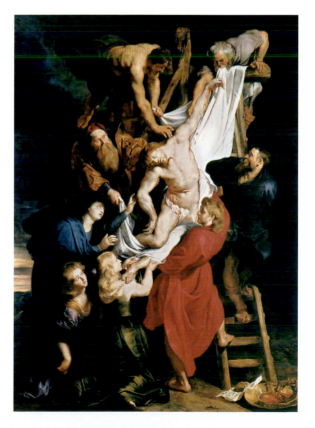

Fig. 26.25 Peter Paul Rubens. *Descent from the Cross,* **1611–1614.** Oil on panel, 13′9⅝″ × 10′2″. Antwerp Cathedral, Belgium. SCALA/Art Resource, NY.

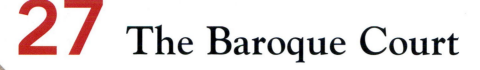

27 The Baroque Court

Absolute Power and Royal Patronage

Versailles and the Rise of Absolutism

The Arts of the French Court

The Art and Politics of the English Court

The Arts of the Spanish Court

The Baroque in the Americas

" *We serve a Prince to whom all sham is hateful,*

A Prince who sees into our inmost hearts,

And can't be fooled by any trickster's arts.

His royal soul, though generous and human,

Views all things with discernment and acumen . . . **"**

Molière, *Tartuffe*

◄ **Fig. 27.1 Grand facade, Palace of Versailles, France. 1669–1685.** Louis XIV planned Versailles as the grandest royal palace in Europe, the very image of his absolute power and might. It could house over 10,000 people—servants, members of the court, and ambitious aristocrats on the rise. Like Baroque architecture in other royal courts of Europe, it is a giant stage upon which the drama of the aristocratic sensibilities of the seventeenth century could be played out.

LOUIS XIV (r. 1643–1715) DETESTED THE LOUVRE, THE ROYAL palace in Paris that had been the seat of French government and home to French kings since the Middle Ages. In 1661 he began construction of a new residence in the small town of Versailles [vair-SIGH], 12 miles southeast of Paris. For 20 years,

some 36,000 workers labored to make Versailles the most magnificent royal residence in the world (Fig. **27.1**). When Louis permanently moved his court and governmental offices there in 1682, Versailles became the unofficial capital of France and symbol of Louis's absolute power and authority.

By the start of the eighteenth century, almost every royal court in Europe modeled itself on Louis XIV's court at Versailles. Louis so successfully asserted his authority over the French people, the aristocracy, and Church that the era in which he ruled has become known as the Age of Absolutism. **Absolutism** is a term applied to strong centralized monarchies that exert royal power over their dominions, usually on the grounds of divine right. The principle had its roots in the Middle Ages, when the pope crowned Europe's kings, and went back even further to the man/god kings of ancient Mesopotamia and Egypt. But by the seventeenth century, the divine right of kings was assumed to exist even without papal acknowledgment. The most famous description of the nature of absolutism is by Bishop Jacques-Bénigne Bossuet [BOS-sway] (1627–1704), Louis's court preacher and tutor to his son. While training the young dauphin for a future role as king, Bossuet wrote *Politics Drawn from the Very Words of Holy Scripture*, a book dedicated to describing the source and proper exercise of political power. In it he says the following:

> God is infinite, God is all. The prince, as prince, is not regarded as a private person: he is a public personage, all the state is in him; the will of all the people is included in his. As all perfection and all strength are united in God, so all the power of individuals is united in the person of the prince. What grandeur that a single man should embody so much! . . .
>
> Behold an immense people united in a single person; behold this holy power, paternal and absolute; behold the secret cause which governs the whole body of the state, contained in a single head: you see the image of God in the king, and you have the idea of royal majesty. God is holiness itself, goodness itself, and power itself. In these things lies the majesty of God. In the image of these things lies the majesty of the prince.

The role of absolutism in defining and controlling developments in the arts in the seventeenth century is the subject of this chapter. Although the monarchs of Europe were often at war with one another, they were united in their belief in the power of the throne and the role of the arts in sustaining their authority. In France, Louis XIV never missed an opportunity to use the arts to impress upon the French people (and the other courts of Europe) his grandeur and power. In England, the monarchy struggled to assert its divine right to rule as it fought for power against Puritan factions that denied absolutism. Royalist and Puritan factions each developed distinctive styles of art and literature. In Spain, the absolute rule of the monarchy was deeply troubled by the financial insolvency of the state. Nevertheless, royal patronage brought about what has been called the Golden Age of Spanish arts and letters. Finally, in the Americas, the Spanish monarch asserted his absolute authority by encouraging the creation of art and architecture as symbols of his divine right to rule over the two continents. In the Americas, the European Baroque merged with Native American decorative tastes to produce what is possibly the era's most elaborate expression of the Baroque.

Versailles and the Rise of Absolutism

More than any other art, French architecture was designed to convey the absolute power of the monarchy. From the moment that Louis XIV initiated the project at Versailles, it was understood that the new palace must be unequaled in grandeur, unparalleled in scale and size, and unsurpassed in lavish decoration and ornament. It would be the very image of the king, in whose majesty, according to the bishop, "lies the majesty of God."

In many ways, Versailles was visible proof of the monarchy's triumph over the French nobility, who had rebelled against a policy designed to centralize government in a strong ruler rather than share it with provincial governors and local aristocrats. Louis XIV was 5 years old when Louis XIII died, and during his childhood, Cardinal Mazarin [mah-zah-RAN] (1602–1661) controlled the government. Rebellions led by nobility and townspeople sought to maintain local autonomy. In 1649, when Louis XIV was only 6 years old, the *Parlement* [PAR-luh-mahn] of Paris, a political body, initiated a revolt, urged on by the wives of the many princes whom Mazarin had imprisoned. The young king was forced to flee Paris after an angry mob broke into the Louvre and demanded to see

their king. (Louis in his bedchamber feigned sleep, and the mob left after simply looking at him.)

The episode made Louis feel unsafe in the Louvre and planted seeds of distrust for the nobility and the mob. It also helped convince him that the heavy-handed tactics of Mazarin did not strengthen the monarchy but actually endangered it. When Louis assumed the throne at age 18 upon Mazarin's death, he asserted control over the nobility in more subtle ways. First, he made sure that the nobility benefited from the exercise of his own authority. He soon created the largest army in Europe, numbering a quarter of a million men, and modernized it as well. Where previously local recruits and mercenaries had lived off the land, draining the resources of the nobility and pillaging and stealing to obtain their everyday needs, now Louis's forces were well-supplied, regularly paid, and extremely disciplined. The people admired them, understanding that this new army was not merely powerful, but also designed to protect them and guarantee their well-being—another benefit of centralized, absolute authority. However, as the army was always a present threat, Louis made no effort to limit the authority of regional *parlements*, and he generally made at least a pretense of consulting with these provincial governmental bodies before making decisions that would affect them. He also consulted with the nobility at court. In fact, he required their presence in court in order to prevent them from developing regional power bases of their own that might undermine his centralized rule. He barred them from holding high government positions as well, even as he cultivated them socially and encouraged them to approach him directly.

At court, Louis fully regulated the lives of the nobility. He thought of himself as *Le Roi Soleil* [leh wah so-LAY], "the Sun King," because like the sun (associated with Apollo, god of peace and the arts) he saw himself dispensing bounty across the land. His ritual risings and retirings (the *levée du roi* [leh-VAY dew wah] and the *couchée du roi* [koo-SHAY]) symbolized

the actual rising and setting of the sun. They were essentially state occasions, attended by either the entire court or a select group of fawning aristocrats who eagerly entered their names on waiting lists. Louis encouraged the noble-women at court to consider it something of an honor to sleep with him; he had many mistresses and many illegitimate children. Life in his court was entirely formal, governed by custom and rule, so etiquette became a way of social advancement. He required the use of a fork at meal times instead of using one's fingers. Where one sat at dinner was determined by rank. In fact, rank determined whether footmen opened one or two of Versailles's glass-paneled "French doors" for each guest passing through the palace. Louis's control over the lives of his courtiers had the political benefit of making them financially dependent on him. According to the memoirs of the duc de Saint Simon, Louis de Rouvroy (1675–1755):

He loved splendour, magnificence, and profusion in all things, and encouraged similar tastes in his Court; to spend money freely on equipages and buildings, on feasting and at cards, was a sure way to gain his favour, perhaps to obtain the honour of a word from him. Motives of policy had something to do with this; by making expensive habits the fashion, and, for people in a certain position, a necessity, he compelled his courtiers to live beyond their income, and gradually reduced them to depend on his bounty for the means of subsistence.

Louis's sense of his own authority—to say nothing of his notorious vanity—is wonderfully captured in Hyacinthe Rigaud's [ree-GOH] official state portrait of 1701 (Fig. 27.2). The king has flung his robes over his shoulder in order to reveal his white stockings and red high-heeled shoes. He designed the shoes himself to compensate for his five-foot-four-inch height. He is 63 years old in this portrait, but he means to make it clear that he is still a dashing courtier.

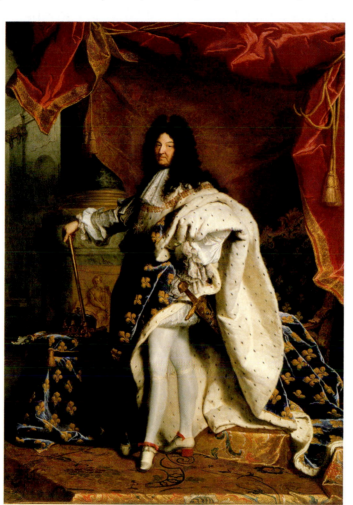

Fig. 27.2 Hyacinthe Rigaud. *Louis XIV, King of France*. (1638–1715). 1701. Oil on canvas, 9'1" × 6'4⅜". Musée du Louvre/RMN Réunion des Musées Nationaux, France. Herve Lewandowski/Art Resource, NY. In his ermine coronation robes, his feet adorned in red high-heeled shoes, Louis both literally and figuratively looks down his nose at the viewer, his sense of superiority fully captured by Rigaud.

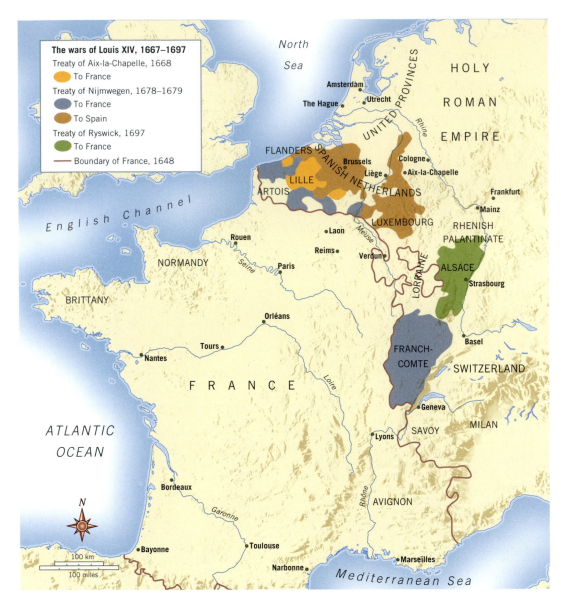

Map 27.1 The wars of Louis XIV. This map shows the territorial additions to eastern and northeastern France during Louis's reign. In 1700, Charles II of Spain died, leaving his entire inheritance and the Spanish throne to Philip of Anjou, Louis's grandson.

The elaborate design of the palace was intended to leave the attending nobility in awe. Charles Le Brun, who had participated in designing the new east facade of the Louvre (see Fig. 25.22), now served as chief painter to the king, and directed the team of artists who decorated the palace's interior. The Hall of Mirrors (Fig. **27.3**) was begun in 1678 to celebrate the high point of Louis XIV's political career, the end of six years of war with Holland. With the signing of the Treaty of Nijmegen [NY-may-gun], France gained control of the Franche-Comté [frahnsh-cohn-tay] region of eastern France (see Map **27.1**).

Louis asked Le Brun to depict his government's accomplishments on the ceiling of the hall in 30 paintings, framed by stuccowork, showing the monarch as a Roman emperor,

astute administrator, and military genius. Le Brun balanced the 17 windows that stretch the length of the hall and overlook the garden with 17 arcaded mirrors along the interior wall, all made in a Paris workshop founded to compete with Venice's famous glass factories. Originally, solid silver tables, lamp holders, and orange-tree pots adorned the gallery. Louis later had them all melted down to finance his ongoing war efforts. Such luxury was in stark contrast to how the common people lived throughout France. Louis's centralized government did not address the enemies of their daily lives: drought, famine, and plague (see *Voices*, page 867).

Landscape architect André Le Nôtre [leh NOHT] was in charge of the grounds at Versailles. He believed in the formal garden, and his methodical, geometrical design has

Voices

Life for the Other French

The lavish life of the French royal court in Paris and Versailles was a stark contrast to the life of the vast majority of French citizens who lived in the countryside. Frequent episodes of drought, pestilence, epidemics, and famine alternated with periods of relative prosperity. But the inhabitants of the royal court had little interest in the lifestyle of the peasants. The report excerpted below describes Saint-Quentin, a region less than 50 miles from Paris, in 1651.

Of the 450 sick persons whom the inhabitants were unable to relieve, 200 were turned out, and these we saw die one by one as they lay on the roadside. A large number still remain, and to each of them it is only possible to dole out the least scrap of bread. We only give bread to those who would otherwise die. The staple dish here consists of mice, which the inhabitants hunt, so desperate are they from hunger. They devour roots which the animals cannot eat; one can, in fact, not put into words the things one sees. . . . This narrative, far from exaggerating, rather understates the horror of the case, for it does not record the hundredth part of the misery in this district.

> **"Not a day passes but at least 200 people die of famine in the two provinces."**

Those who have not witnessed it with their own eyes cannot imagine how great it is. Not a day passes but at least 200 people die of famine in the two provinces. We certify to having ourselves seen herds, not of cattle, but of men and women, wandering about the fields between Rheims and Rhétel, turning up the earth like pigs to find a few roots; and as they can only find rotten ones, and not half enough of them, they become so weak that they have not strength left to seek food. The parish priest at Boult, whose letter we enclose, tells us he has buried three of his parishioners who died of hunger. The rest subsisted on chopped straw mixed with earth, of which they composed a food which cannot be called bread. Other persons in the same place lived on the bodies of animals which had died of disease, and which the curé, otherwise unable to help his people, allowed them to roast at the presbytery fire.

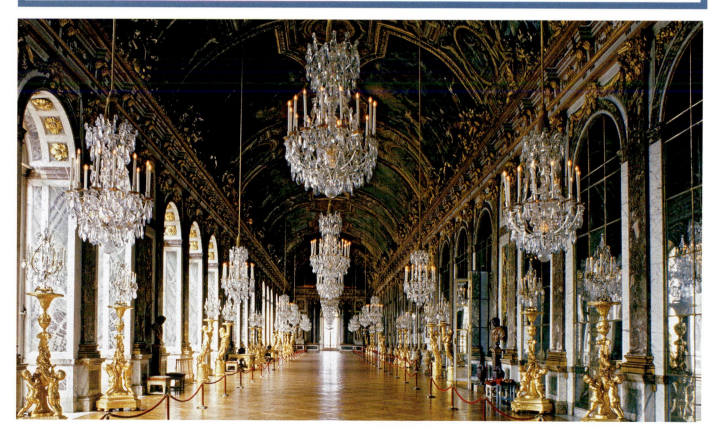

Fig. 27.3 Jules Hardouin-Mansart and Charles Le Brun. Galerie des Glaces (Hall of Mirrors), Palace of Versailles. Versailles. Begun 1678. The Galerie des Glaces is 233 feet long and served as a reception space for state occasions. It gets its name from the Venetian mirrors—extraordinarily expensive at the time—that line the wall opposite windows of the same shape and size, creating by their reflection a sense of space even vaster than it actually is.

CULTURAL PARALLELS

A Shogun's Power in Japan

Even as Louis XIV maintained tight control over French nobility at Versailles, the Tokugawa shogunate in Japan used similar methods to limit the power of its regional warlords. By requiring warlords to spend alternate years at the Tokugawa court at Edo (present-day Tokyo) and maintaining the power to transform their domains, the shoguns helped centralize their island nation that had been prone to chaotic civil wars among competing factions.

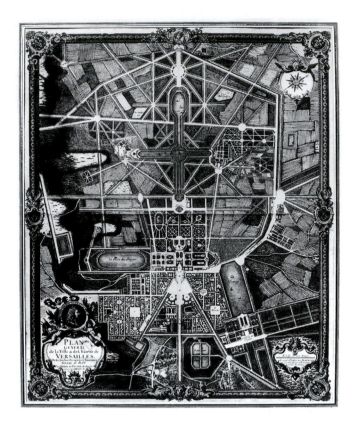

come to be known as the **French garden**. (See chapter 29 for its counterpart, the English garden.) The grounds were laid out around a main axis, emphasized by the giant cross-shaped Grand Canal, which stretched to the west of the palace (Figs. 27.4, 27.5). Pathways radiated from this central axis, circular pools and basins surrounded it, and both trees and shrubbery were groomed into abstract shapes to match the geometry of the overall site. The king himself took great interest in Le Nôtre's work, even writing a guide to the grounds for visitors. Neat boxwood hedges lined the flowerbeds near the chateau, and a greenhouse provided fresh flowers to be planted in the gardens as the seasons changed. Over 4 million tulip bulbs, imported from Holland, bloomed each spring.

Fig. 27.4 André Le Nôtre. Plan of the gardens and park, Versailles. Designed 1661–1668, executed 1662–1690. Drawing by Leland Roth after Delagive's engraving of 1746. To the right are the main streets of the town of Versailles. Three grand boulevards cut through it to converge on the palace itself.

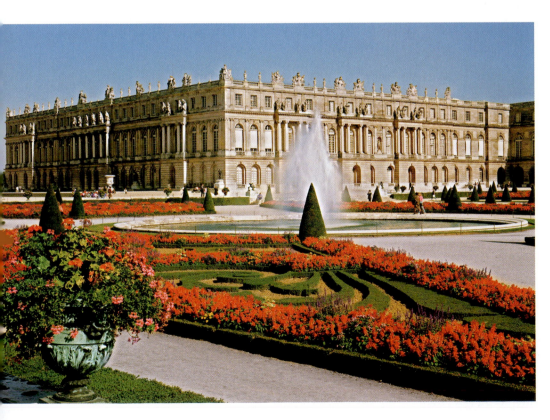

Fig. 27.5 André Le Nôtre. North flowerbed, formal French gardens, Versailles. 1669–1685. The gardens are most formal near the palace and become increasingly less elaborate further out in the park. Louis's gardener had more than 2 million flowerpots at his disposal.

The Arts of the French Court

Louis was the absolute judge of taste at the French court and a great patron of the arts. He inherited some 200 paintings from his father but increased the royal collection tenfold during his reign. Over the course of his career he established the national academies of painting and sculpture, dance, music, and architecture. His motives were simple enough: Championing the greatest in art would establish him as the greatest of kings. "Gentlemen," he is reputed to have said to a group of academicians, "I entrust to you the most precious thing on earth—my fame."

Louis's aesthetic standards modulated between the balance, harmony, and proportions of Classical art and the decorative exuberance of the Italian Baroque. Both the new east facade of the Louvre (see Fig. 25.22) and the geometric symmetry and clarity of Versailles and its grounds reflect his identification with Classical precedent, and by extension, the order, regularity, and rational organization of the Roman Empire. On the other hand, he fully understood the attractions of Baroque scale and decorative effect, its power to move, even awe, its audience. So Louis promoted an essentially Classical architecture with Baroque dramatic effects, in the process creating a style that is something of a contradiction, the Classical Baroque.

It was in painting that the stylistic tensions of the French court found their most complete expression. These tensions—which by extension were philosophical and even moral—were between the rational clarity of the Classical and the emotional drama of the Baroque, the rule of law and the rule of the heart. These styles shared the common ground of grandeur and magnificence. Furthermore, in private, the court tended to prefer the frank sensuality of the Baroque, but in public, for political reasons, it chose the rationality and clarity of the Classical in order to present an image of moderation as opposed to excess.

The Painting of Peter Paul Rubens: Color and Sensuality

One of Louis's favorite artists was the Flemish painter Peter Paul Rubens (1577–1640). Louis's grandmother, Marie de' Medici [deh-MED-ih-chee], had commissioned Rubens in 1621 to celebrate her life in a series of 21 monumental paintings. This series was to be paired with a similar (but never completed) series extolling Henry IV, her late husband. She was, by this time, serving as regent of France for her young son, Louis XIII, and the cycle was conceived to decorate the Luxembourg Palace in Paris, which today houses the French Senate. Rubens was 44 years old, had spent eight formative years (1600–1608) in Italy in the service of the duke of Mantua, and had already provided paintings for numerous patrons in his native Flanders, especially altarpieces for Catholic churches in Antwerp (see Fig.

26.25). He had spent time in most of Europe's royal or princely courts fulfilling commissions for large-scale paintings and gaining an international reputation. The cycle took four years (1621–1625) to complete with the help of studio assistants.

Rubens's pictorial approach to such self-promoting biographical commissions was through lifelike allegory. *The Arrival and Reception of Marie de' Medici at Marseilles* depicts the day Marie arrived in France from her native Italy on route to her marriage to King Henry IV (Fig. **27.6**). The figure of Fame flies above her, blowing a trumpet, while Neptune, god of the sea, and his son Triton, accompanied by three water nymphs, rise from the waves to welcome her. A helmeted allegorical figure of France, wearing a *fleur-de-lis* robe like that worn by Louis XIV in his 1701 portrait, bows before her. Marie herself, not known for her beauty, is so enveloped by rich textures, extraordinary colors, and sensuous brushwork, that she seems transformed into a vision as extraordinary as the scene itself.

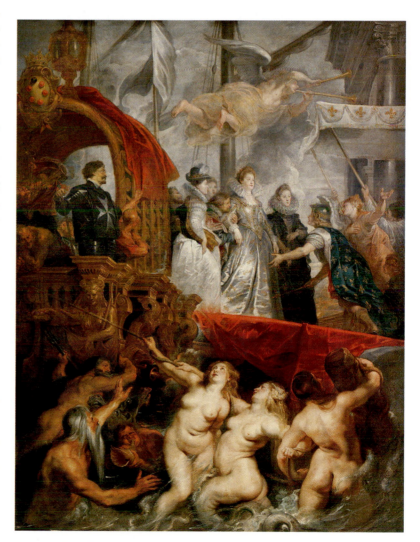

Fig. 27.6 Peter Paul Rubens and his workshop. *The Arrival and Reception of Marie de' Medici at Marseilles.* **1621–1625.** Oil on canvas, 13′ × 10′. Musée du Louvre/ RMN Réunion des Musées Nationaux, France. Erich Lessing/Art Resource, NY. The point of view here is daringly low, perhaps even in the water, beside the nymphs. This creates a completely novel relationship between viewer and painting.

Fig. 27.7 Peter Paul Rubens. *The Kermis (La Kermesse).* **ca. 1635.** Oil on canvas, 56 ⅝″ × 102 ¾″. Musée du Louvre/RMN Réunion des Musées Nationaux, France. Erich Lessing/Art Resource, NY. In this painting Rubens reveals his Flemish heritage, taking up the traditional subject matter of Bruegel and others, a genre scene of everyday life.

The fleshy bodies of the nymphs in this painting are a signature stylistic component of Rubens's work In fact, Rubens's style is almost literally a "fleshing out" of the late Italian Renaissance tradition. It is so distinctive that it came be known as "Rubenesque." His nudes, which often startle contemporary viewers because we have developed almost entirely different standards of beauty, are notable for the way in which their flesh folds and drapes across their bodies. Their beauty rests in the sensuality of this flesh, which in some measure symbolizes the sensual life of self-indulgence and excess. Rubens pushed to new extremes the Mannerist sensibilities of Michelangelo's *Last Judgment* and Bronzino's *Allegory with Venus and Cupid,* the color and textures of the Venetian school as embodied in Titian's *Rape of Europa,* (see chapter 22 for all) and the play of

moves diagonally back into space from either the front left or right corner of the composition. Rubens's 1611–1614 *Descent from the Cross*, created for Antwerp Cathedral, is an early example of these features (see Fig. 26.25).

In a painting like *The Kermis* [ker-miss], or *Peasant Wedding*, Rubens transforms a simple tavern gathering—a genre common to northern painting (see Fig. 26.12)—into a monumental celebration (Fig. 27.7). *The Kermis* is over 8 feet wide. Its wedding celebration spills in a diagonal out of the confines of the tavern into the panoramic space of the Flemish countryside. At the pinnacle of this sideways pyramid of entwined flesh a young man and a disheveled woman, her blouse fallen fully from her shoulders, run off across the bridge, presumably to indulge their appetites behind some hedge. Like the Hall of Mirrors at Versailles, with its mathematical regularity overlaid with sumptuously rich ornamentation, Rubens's painting seems at once moralistic and libertine. Arms and legs interlace in a swirling, twirling riot that can be interpreted as either a descent into debauchery or a celebration of sensual pleasure, readings that Rubens seems to have believed were not mutually exclusive.

Such frank sensuality is a celebration of the simple joy of living in a world where prosperity and peace extend even to the lowest rungs of society. Yet in keeping with his northern roots, Rubens gave the painting moralistic overtones. The posture of the dog with its nose in the cloth-draped tub at the bottom center of the canvas echoes the form of the kissing couple directly behind it and the dancing couples above it and, once more, represents the base, animal instincts that dominate the scene. The nursing babes at breast throughout the painting do not so much imply abundance as animal hunger, the desire to be fulfilled. Rubens knew full well that the bacchanal was not merely an image of prosperity but also of excess. In his later years, excess enthralled him, and *The Kermis* is a product of this sensibility.

Some 50 years later, in April 1685, Louis XIV purchased *The Kermis* for Versailles. What did the monarch who turned down Bernini's design for the new east wing of the Louvre (see Fig. 25.21) because he found it too extravagant see in this painting? For one thing, it was probably important to the man who considered himself Europe's greatest king to possess the work of the artist widely considered to be Europe's greatest painter. For another, Louis must have appreciated the painting's frank sexuality, which the artist emphasized by his sensual brushwork and color. It recalled the king's own sexual exploits.

light and dark of the Caravaggisti [kah-rah-vah-GEE-stee] (see chapter 25). He brought to the Italian tradition a northern appreciation for observed nature—in particular, the realities of human flesh—and an altogether inventive and innovative sense of space and scale. Only rarely are Rubens's paintings what might be called frontal, where the viewer's position parallels the depicted action. Rather, the action

The Painting of Nicolas Poussin: Classical Decorum

By the beginning of the eighteenth century, 14 other Rubens paintings had found their way to the court of Louis XIV. Armand-Jean du Plessis [dewplay-SEE], duc de Richelieu [duh REESH-uh-lee-yuh] (1629–1715), the great-nephew of Cardinal Richelieu (1585–1642), who had served as artistic advisor to Marie de' Medici and Louis XIII, purchased *The Kermis* and 13 other paintings that had remained in Rubens's personal collection after his death in 1640. Before he acquired his own collection of Rubens's work, Richelieu had wagered and lost his entire collection of paintings by Nicolas Poussin [poo-SEHN] (1594–1665) against Louis's own collection of works by Rubens in a tennis match between the two. A debate had long raged at court as to who was the better painter—Poussin or Rubens. Charles Le Brun had gone so far as to declare Poussin the greatest painter of the seventeenth century. Although a Frenchman, Poussin had spent most of his life in Rome. He particularly admired the work of Raphael and, following Raphael's example, advocated a classical approach to painting. A painting's subject matter, he believed, should be drawn from classical mythology or Christian tradition, not everyday life. There was no place in his theory of painting for a genre scene like Rubens's *Kermis*, even if portrayed on a monumental scale. Painting technique itself should be controlled and refined. There could be no loose brushwork, no "rough style." Restraint and decorum had to govern all aspects of pictorial composition.

This *poussiniste* [poo-sehn-EEST] style is clearly evident in *The Shepherds of Arcadia* of 1638–1639 (Fig. **27.8**). Three shepherds trace out the inscription on a tomb, *Et ego in Arcadia*, "I too once dwelled in Arcadia," suggesting that death comes to us all. The Muse of History, standing to the right, affirms this message. Compared to the often exaggerated physiques of figures in Rubens's paintings, the muscular shepherds seem positively understated. Color, while sometimes brilliant, as in the yellow mantle robe of History, is muted by the evening light. But it is the compositional geometry of horizontals and verticals that is most typically *poussiniste*. Note how the arms of the two central figures form right angles and how they all fit within the cubical space suggested by the tomb itself. This cubic geometry finds its counterpoint in the way the lighted blue fold of History's dress parallels both the red-draped shepherd's lower leg and the leftmost shepherd's staff. These lines suggest a diagonal parallelogram working both against and with the central cube.

Louis XIV was delighted when he defeated the duc de Richelieu at tennis and acquired his Poussins. But to Louis's surprise, Richelieu quickly rebuilt his collection by purchasing

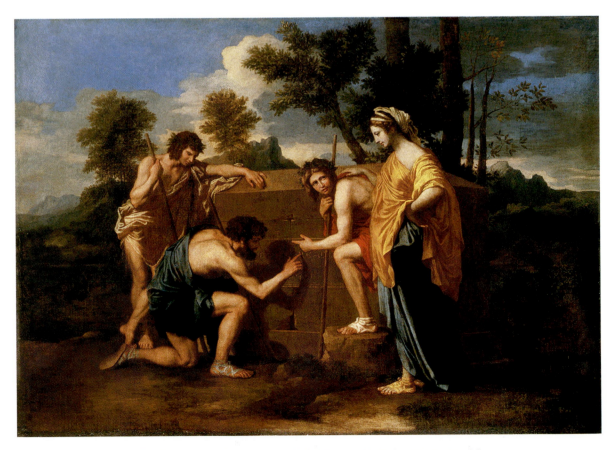

Fig. 27.8 Nicolas Poussin. *The Shepherds of Arcadia* (also called *Et in Arcadia Ego*). **1638–1639.** Oil on canvas, 33 1/2″ × 47 5/8″. INV7300. Photo: Renè-Gabriel Ojèda. Musée du Louvre/RMN Réunion des Musées Nationaux, France. Art Resource, NY. Note how even the bands on the shepherds' sandals parallel other lines in the painting.

Continuity & Change
p. 595

School of Athens

the 14 Rubens paintings and then commissioning Roger de Piles [deh peel] to write a catalogue describing his acquisitions. De Piles was a *rubeniste* [roobayn-EEST]. He argued that color was the essence of painting. Color is to painting as reason is to man, as he put it. The *poussinistes*, by contrast, were dedicated to drawing, what Vasari called *disegno*, particularly the art of Raphael (see *Focus*, page 595).

Poussin's paintings addressed the intellect, Rubens's the senses. For Poussin, subject matter, the connection of the picture to a classical narrative tradition, was paramount; for Rubens, the expressive capabilities of paint itself were primary. In 1708, de Piles scored each painter on his relative merits. Rubens received 18 points for composition, 13 for design, 17 for color, and 17 for expression. Poussin earned 15 points for composition, 17 for design, 6 for color, and 15 for expression. By de Piles's count, Rubens won 65 to 53. In essence, Rubens represented Baroque decorative expressionism and Poussin, Classical restraint—the two sides of the Classical Baroque. Both would have their supporters in the Academy over the course of the following decades.

Music and Dance at the Court of Louis XIV

Louis XIV loved the pomp and ceremony of his court and the art forms that allowed him to most thoroughly engage this taste: dance and music. The man largely responsible for entertaining the king at court was Jean-Baptiste Lully [lew-LEE] (1632–1687), who was born in Florence but moved to France in 1646 to pursue his musical education.

Jean-Baptiste Lully Lully composed a number of popular songs, including the famous "Au Clair de la lune." By the 1660s he had become a favorite of the king, who admired in particular his **comédie-ballets** [koh-may-DEE bah-LAY], performances that were part opera (see chapter 25) and part ballet and that often featured Louis's own considerable talents as a dancer (Fig. **27.9**). Louis commissioned many ballets that required increasingly difficult movements of the dancers. As a result, his Royal Academy of Dance soon established the rules for the five positions of ballet that became the basis of classical dance. They valued, above all, clarity of line in the dancer's movement, balance, and, in the performance of the troop as a whole, symmetry. But in true Baroque fashion, the individual soloist was encouraged to elaborate upon the classical foundations of the ballet in exuberant, even surprising expressions of virtuosity.

Lully used his connections to the king to become head of the newly established Royal Academy of Music, a position that gave him exclusive rights to produce all sung dramas in France. In this role he created yet another new operatic genre, the **tragédie en musique** [trah-zhay-DEE on moo-ZEEK], also known as the *tragédie lyrique* [leer-EEK]. Supported and financed by the court, Lully composed and staged one of these *tragédies* each year from 1673 until 1687, when he

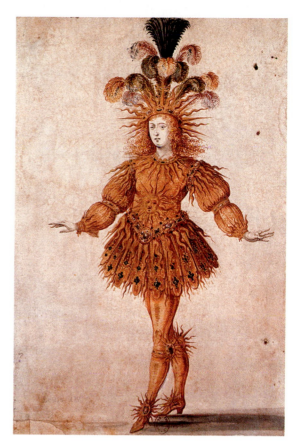

Fig. 27.9 Louis XIV as the sun in the *Ballet de la Nuit*. 1653. Bibliothèque Nationale, Paris. Louis, who was 15 years old at the time, appeared as himself wearing this costume during the ballet's intermezzo, a short musical entertainment between the main acts.

died of gangrene after hitting his foot with the cane he used to pound out the beat while conducting.

Lully's *tragédies en musique* generally consist of:

- an overture, distinguished by a slow, homophonic melody (associated with the royal dignity) that built to a faster contrapuntal section, a form today known as the **French overture**
- an allegorical prologue, which established the drama's connection to recent events at court, always flattering to the king
- five acts of sung drama, subdivided into several scenes
- a multitude of **intermezzi**—called **divertissements** [deever-tees-MOHN] in France—short displays of dance, song, or instrumental music

Lully's *tragédies* seamlessly blended words and music. The meter of the music constantly shifts, but the rhythms closely follow the natural rhythms of the French language.

One of the most powerful scenes in Lully's repertoire occurs at the end of Act II of *Armide* [ar-MEED], first performed in Paris in 1686 and the last of his *tragédies*. Based on *Jerusalem Liberate*, an epic poem by Torquato Tasso [TAHS-so] (1544–1595), the story concerns the crusader knight Renaud [ruh-NOH], whose virtue, according to the allegorical

prologue, is like that of Louis XIV. Renaud is desperately trying to resist the temptations of the sorceress Armida. But in a ballet sequence, demons disguised as satyrs and shepherds put him under a spell. Armida enters, intending to kill Renaud as he sleeps. But she is overcome by her love for him and decides, instead, to hold him forever in her power and to make him love her through the wiles of her sorcery. Her recitative monologue, *Enfin, il est en ma puissance* [en-fan eel ay-t-on mah pwee-SAHNSS] ("At last, he is in my power"), is considered among the greatest of Lully's works (**CD-Track 27.1**). One contemporary of Lully's, a French nobleman who saw the tragédie many times, recalls the scene's effect on its audience: "I have twenty times seen the entire audience in the grip of fear, neither breathing nor moving, their whole attention in their ears and eyes, until the instrumental air which concludes the scene allowed them to draw breath again, after which they exhaled with a murmur of pleasure and admiration." Lully's music, with its ever-intensifying repetitions, creates a dramatic tension fully in keeping with Baroque theatricality.

Dance Forms Louis's love of the dance promoted another new musical form at his court, the **suite**, a series of dances, or dance-inspired movements, usually all in the same key, though varying between major and minor modes. Most suites consist of four to six dances of different tempos and meters. These might include the following:

- Allemande [ah-luh-MAHND], a dance of continuous motion in duple meter (marked by two or a multiple of two beats per measure) and moderate tempo
- Bourrée [boo-RAY], a dance of short, distinct phrasing, in duple meter and moderate to fast in tempo
- Courante [koo-RAHNT], a dance often in running scales, in triple meter, and moderate to fast in tempo
- Gavotte [gah-VOT], a "bouncy" dance, in duple meter, and moderate to fast in tempo
- Gigue [zheeg], a very lively dance, fast in tempo, and usually employing a 6/8 meter
- Sarabande [sah-rah-BAHND], a slow and stately dance, with accent on the second beat, in triple meter

In a suite, two moderately fast dances—say, an allemande and a courante—might precede a slower, more elegant dance—perhaps a sarabande—and then conclude with an exuberant gigue. The structure is closely related to the *sonata da camera* (see chapter 25). Although it did not commonly occur in the dance suites themselves, the most important of the new dance forms was the **minuet**, an elegant triple-time dance of moderate tempo. It quickly became the most popular dance form of the age.

To help the courtiers learn the fashionable dances, members of Louis's court developed a system of dance notation – a way of putting the steps of a dance down on paper. The notation system facilitated the adoption of French dances in other courts across Europe. The 1700 publication of *Choreography, or the Art of Describing Dance in Characters*, by Raoul-Auger Feuillet [oh-ZHAY foy-YAY] (ca. 1653–ca. 1710) catalogued

the entire repertoire of dance steps. It was widely imitated across Europe. As a general rule, Feuillet noted, dancers should perform a *plié* [plee-AY], or bend, on the upbeats of the music, and a *élevé* [ay-luh-VAY], or rise, on the downbeats.

Elisabeth-Claude Jacquet de la Guerre One of Louis's favorite composers of dance suites was Elisabeth-Claude Jacquet de la Guerre [deh la ghair] (1665–1729), who performed for him beginning at age 5. Her *Pièces de clavecin* [pee-ESS deh klav-SEHN] ("Pieces for the Harpsichord") was published in 1687, when she was just 22 years old. The courante in Jacquet de la Guerre's suite is, like most dances, in **binary form**—it has a two-part structure—and both sections are repeated (**CD-Track 27.2**). This repetition derives from the primary function of social dance, which is not to challenge the dancer but to provide for interaction with one's partner. It consists of a prescribed pattern of dance steps repeated over and over. In addition, Jacquet de la Guerre's courante features what the French called a double—a second dance based on the first and essentially a variation on it. Always a court favorite for her skill at improvising on the harpsichord, Jacquet de la Guerre would become the first French woman to compose an opera: *Cephale et Procris* [say-FAHL ay pro-KREE] (1694).

Theater at the French Court

When, in 1629, Louis XIII appointed Cardinal Richelieu as his minister of state, he coincidentally inaugurated a great tradition of French theater. This tradition would culminate in 1680 with the establishment of the *Comédie Française* [koh-may-DEE frahn-SEZ], the French national theater (Fig. 27.10). It was created as a cooperative under a charter granted by Louis XIV to merge three existing companies, including the troupe of the playwright Molière [moh-lee-AIR].

Pierre Corneille Cardinal Richelieu loved the theater. When a comedy by Rouen lawyer Pierre Corneille [COR-nay] (1606–1684) was first performed in Paris soon after the cardinal's appointment, Richelieu urged the company to settle in Paris's Marais Theater, a former indoor tennis court. There, under Richelieu's direction, Corneille dedicated himself to writing tragedies in the classical manner based on Greek or Roman themes that alluded to contemporary events. Richelieu exerted a great deal of control over the plays. He outlined each idea and then asked his author to fill in the dialogue. But Corneille resisted Richelieu's direction and took liberties that the cardinal found to be appalling lapses of taste, and so the playwright struck out on his own.

In 1637, Corneille opened a new play, *Le Cid*. It was based on the legend of El Cid, a Spanish nobleman who conquered and governed the city of Valencia in the eleventh century. The play was an immediate hit, moving Louis XIII to send his compliments. But Richelieu was furious. Corneille had ignored the **classical unities**, a notion derived from Aristotle's *Poetics* that requires a play to have only one action

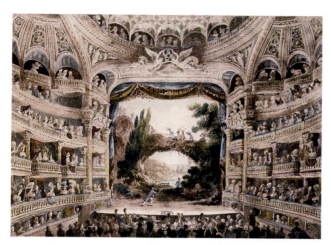

Fig. 27.10 The Comédie Française. Interior of the Comédie Française Theatre in 1791, after an original watercolour (colour litho), French School, (19th century)/Bibliothèque Nationale, Paris, France, Archives Charmet / The Bridgeman Art Library. The feuding that marked the Parisian theater world led Louis XIV to establish the Comédie Française in 1680 as a cooperative venture among the three major companies.

Continuity & Change
p. 214
Poetics

that occurs in one place and within one day. At Richelieu's insistence, the Académie Française [ah-kah-day-MEE frahn-SEZ] officially condemned the play as "dramatically implausible and morally defective." Although deeply hurt by this censure, Corneille followed with three masterpieces: *Horace* [or-AHSS] (1640), which dramatizes the conflict between the ancient Romans and their Alban neighbors; *Cinna* (1641), which tells the story of a conspiracy against the first Roman emperor, Augustus Caesar; and *Polyeucte* (1643), perhaps his greatest work, telling the story of an Armenian nobleman newly converted to Christianity who finds that his wife is in love with another man. Twenty-one more plays followed. In their allusion to antiquity, Corneille's plays embrace the classical side of the French Classical Baroque. And while Richelieu found their highly complex plots dramatically implausible, the plays embrace the Baroque love for elaborate moral and emotional range and possibility.

Molière Meanwhile, comedy had taken center stage in Paris, pushing the moral vision of Corneille to the wings. The son of a court upholsterer, Molière had been touring France for 13 years with a troupe of actors when he was asked, in 1658, to perform Corneille's tragedy *Nicomède* [nee-koh-MED] before the young king Louis XIV. The performance was a miserable failure, but Molière asked if he might perform a farce of his own, *Le Docteur Amoureux* [leh DOK-ter ah-moo-REH] ("The Amorous Doctor"). The king was delighted with this comedy, and Molière's company was given what was intended to be a permanent home.

Molière's first play to be performed was *Les Précieuses Ridicules* [lay PRAY-see-erz ree-dee-KEWL] ("The Pretentious Ladies"), in 1659. It satirized a member of the French court named Madame de Rambouillet [deh RAHM-boo-yeh],

who fancied herself the chief guardian of good taste and manners in Parisian society. The success of the play soon led Molière to double the admission price, and the king himself was so delighted that he honored the playwright with a large monetary reward. But not so, Madame de Rambouillet. Outraged, she tried to drive Molière from the city but succeeded only in having the company's theater demolished. The king struck back by immediately granting Molière the right to perform in the Théâtre du Palais Royal [tay-AT-ruh dew pah-LAY roy-AHL], in Richelieu's former palace, and there he staged his production for the rest of his life.

Molière spared no one his ridicule, attacking religious hypocrisy, misers, hypochondriacs, pretentious doctors, aging men who marry younger women, the gullible, and all social parasites. (Ironically, he himself was capable of the most audacious flattery.) His play *Tartuffe* [tar-TEWF], or *The Hypocrite* (1664), concludes, for instance, with an officer praising the ability of the king to recognize hypocrisy of the kind displayed by Tartuffe in earlier scenes from the play (**Reading 27.1a**):

READING 27.1a from Molière, *Tartuffe*, Act V (1664)

We serve a Prince to whom all sham is hateful,
A Prince who sees into our inmost hearts,
And can't be fooled by any trickster's arts.
His royal soul, though generous and human,
Views all things with discernment and acumen;
His sovereign reason is not lightly swayed,
And all his judgments are discreetly weighed.
He honors righteous men of every kind,
And yet his zeal for virtue is not blind,
Nor does his love of piety numb his wits 10
And make him tolerant of hypocrites.
'Twas hardly likely that this man could cozen
A King who's foiled such liars by the dozen.

These words undoubtedly warmed the heart of the king, described here as if he were a god. But until Molière's sudden death of an aneurysm during a coughing fit onstage, the playwright remained in disfavor with many in Louis's court who felt threatened by his considerable insight and piercing wit. They recognized what perhaps the king could not—the irony of flattering the king by saying he is above flattery.

The plot of *Tartuffe*, like most of Molière's plays, is relatively simple. Character, not plot, is its chief concern. Tartuffe himself is a great ego who disguises his massive appetites behind a mask of piety. He is completely amoral, and his false morality makes a mockery of all it touches. (For a selection from the play, in which Tartuffe tries to seduce Orgon's wife Elmire [el-MEER], see **Reading 27.1**, pages 890–891). While the hypocrite Tartuffe is himself a great comic creation, the naïve Orgon is almost as interesting. Why, the audience

wonders, is he so blind to Tartuffe's true nature? What drives human beings to ignore the evil that surrounds them?

Jean Racine In 1664, Molière befriended the struggling young playwright Jean Racine [rah-SEEN] (1639–1699) and offered to stage his first play to be performed in Paris, a tragedy. Racine was disappointed in the quality of the production that Molière's comedic company was able to muster, so he offered his next play to another company after seducing Molière's leading actress and convincing her to join him. Molière was deeply offended and never spoke to Racine again.

Racine went on to write a string of successful tragedies, to the dismay of the aging and increasingly disfavored Corneille. The feud between those two reached its height in 1670, when, unknown to each other, both were asked to write a play on the subject of Bérénice , an empress from Cilicia, in love with the Roman emperor Titus. Well aware that Rome opposes Berenice, Titus chooses to reject her. Corneille's play was unenthusiastically received, but Racine's proved a triumph. Of all his plays, it thoroughly embraces the classical unities, which Corneille had rejected. There is only one action in Racine's play—Titus's announcement to Bérénice that he is leaving her—but it takes place over five acts in the course of a single day. The audience knows his intentions from the outset, and the play reaches its climax at the end of the fourth act, when Titus explains that he must forsake his love for the good of the state. Bérénice at first rejects his decision, but in the fifth act they both come to terms with their duty—and their tragic fate.

Such successes made Racine the first French playwright to live entirely on earnings from his plays. But he had also acquired a large number of powerful enemies, many of whom were offended by his seeming humiliation of Corneille and Molière. Determined to destroy Racine's career, these enemies conspired to buy tickets for the opening night of *Phèdre* [FED-ruh] (1677) and leave their seats unoccupied. This and the other intrigues of the court so depressed Racine that he retired from the theater altogether in that year and accepted a post as royal historiographer, chronicling the reign of Louis XIV.

The Art and Politics of the English Court

The arts in England were dramatically affected by tensions between the absolutist monarchy of the English Stuarts and the much more conservative Protestant population. As in France, throughout the seventeenth century the English monarchy sought to assert its absolute authority, although it did not ultimately manage to do so. The first Stuart monarch, James I (1566–1625), succeeded Queen Elizabeth I in 1603. "There are no privileges and immunities which can stand against a divinely appointed King," he quickly insisted. His son, Charles I (1600–1649), shared these absolutist convictions, but Charles's reign was beset by religious controversy. Although technically head of the Church of England, he married a Catholic, Henrietta Maria, sister of the French

king Louis XIII. Charles proposed changes in the Church's liturgy that brought it, in the opinion of many, dangerously close to Roman Catholicism. Puritans (English Calvinists) increasingly dominated the English Parliament and strongly opposed any government that even remotely appeared to accept Catholic doctrine.

Parliament raised an army to oppose Charles, and civil war resulted, lasting from 1642 to 1648. The key political question was, Who should rule the country—the king or the Parliament? Led by Oliver Cromwell (1599–1658), the Puritans defeated the king in 1645, and, while peace talks dragged on for three years, Charles made a secret pact with the Scots. Cromwell retaliated by suppressing the Scots, along with other royalist brigades, in 1648. Charles was executed for treason on January 30, 1649, a severe blow to the divine right of kings, and hardly lost on young Louis XIV across the Channel in France.

Initially, Cromwell tried to lead a commonwealth—a republic dedicated to the common well-being of the people—but he soon dissolved the Parliament and assumed the role of Lord Protector. His protectorate occasionally called the Parliament into session, but only to ratify his own decisions. Cromwell's greatest difficulty was requiring the people to

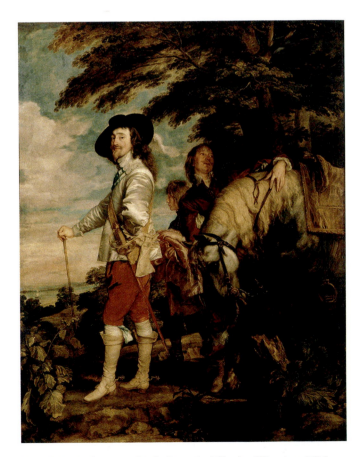

Fig. 27.11 Anthony van Dyck. ***Portrait of Charles I Hunting.*** **1635.** Oil on canvas, 8'11" × 6'11". Inv 1236. Musée du Louvre/RMN Réunion des Musées Nationaux, France. SCALA/Art Resource, NY. Charles's posture, his left hand on his hip, and his right extended outward where it is supported by a cane, adopts the positions of the arms in court dance.

obey "godly" laws—in other words, Puritan doctrine. He forbade swearing, drunkenness, and cockfighting. No shops or inns could do business on Sunday. The country, used to the idea of a freely elected parliamentary government, could not tolerate such restriction, and when, in September 1658, Cromwell died, his system of government died with him. A new Parliament was convened, which issued an invitation to Prince Charles (1630–1685), who was exiled in the Netherlands, to return to his kingdom as Charles II.

The new king landed in Dover in May 1660. A predominantly royalist Parliament was elected, somewhat easing the king's relations with the people. The threat of the monarchy adopting Catholicism, however, continued to cause dissension among Puritans, especially after Charles's brother, James, converted to Catholicism in 1667. James became king (James II) in 1685, and quickly antagonized the Puritans by appointing Roman Catholics to the highest government posts and establishing a large standing army with Roman Catholics heading several key regiments. Finally, in September 1688, William of Orange, married to the Protestant daughter of James II, invaded Britain from Holland at the invitation of the Puritan population. James II fled, and what has come to be called the Glorious Revolution ensued. Parliament enacted a Bill of Rights endorsing religious tolerance and prohibiting the king from annulling parliamentary law. Constitutional monarchy was reestablished once and for all in Britain, and the divine right of kings permanently suspended. Yet tensions between those who believed in the absolute power of the monarchy and those who believed in the self-determination of the people were by no means diffused.

Fig. 27.12 Anthony van Dyck. *Alexander Henderson, Presbyterian divine and diplomatist.* **ca. 1641.** Oil on canvas, 50″ × 41 ½″. National Galleries of Scotland. PG 2227. Van Dyck probably came to paint this portrait because Charles I admired Henderson for his forthrightness and honesty in their troubled negotiations over the liturgy.

Anthony van Dyck: Court Painter

The tension between the Catholic-leaning English monarchy and the more Puritan-oriented Parliament is clearly visible in two portraits by Flemish artist Anthony van Dyck [dike] (1599–1641), court painter to Charles I. Sometime in his teens, van Dyck went to work in Rubens's workshop in Antwerp and led the studio by the time he was 17. Van Dyck's great talent was portraiture. After working in Italy in the 1620s, in 1632 he accepted the invitation of Charles I of England to come to London as court painter. He was knighted there in 1633. Van Dyck's *Portrait of Charles I Hunting* is typical of the work that occupied him (Fig. **27.11**). He often flattered his subjects by elongating their features and portraying them from below to increase their stature. In the case of the painting shown here, van Dyck positioned Charles so that he stands a full head higher than the grooms behind him, lit in a brilliant light that glimmers off his silvery doublet. The angle of his jauntily cocked cavalier's hat is echoed in the trees above his head and the neck of his horse, which seems to bow to him in respect. He is, in fact, the very embodiment of the **Cavalier** [kav-uh-LEER] (from the

French *chevalier* [shuh-vahl-YAY], meaning "knight"), as his royalist supporters were known. Like the king here, Cavaliers were famous for their style of dress—long, flowing hair, elaborate clothing, and large, sometimes feathered hats.

Cavaliers are the very opposite in style and demeanor from the so-called **Roundheads**, supporters of the Puritan Parliament who cropped their hair short and dressed as plainly as possible. Just before his death in 1641, van Dyck painted one such Roundhead, Alexander Henderson, one of the most important figures in the Church of Scotland in the early seventeenth century (Fig. **27.12**). Henderson was one of the authors of the National Covenant, a document that pledged to maintain the "true reformed religion" against the policies of Charles I. This portrait was probably painted when Henderson was in London negotiating with Charles I. Henderson's short-cropped hair and dark, simple clothing contrast dramatically with van Dyck's portrait of Charles I, as does the shadowy interior of the setting. Henderson's finger holds his place in his Bible, seeming to announce that here is a man of the Book, little interested in things of this world.

Fig. 27.13 **Artist unknown.** *John Freake.* **ca. 1671–1674.** Oil on canvas, 42$\frac{1}{2}$″ × 36$\frac{3}{4}$″. American School, 17th century/Worcester Art Museum, Massachusetts, USA/The Bridgeman Art Library. John's portrait lacks objects, as if to understate his wealth and underscore his Puritan moderation.

Fig. 27.14 **Artist unknown.** *Elizabeth Freake and Baby Mary.* **ca. 1671–1674.** Oil on canvas, 42$\frac{1}{2}$″ × 36$\frac{3}{4}$″. American School, 17th century/Worcester Art Museum, Massachusetts, USA/The Bridgeman Art Library. Almost everything in this image was imported, suggesting the scope of the merchant trade in seventeenth-century Boston.

Portraiture in the American Colonies

The Puritans who arrived in America in the seventeenth century did not think of themselves as Americans but as subjects of the crown and Parliament. They brought with them the prejudices against ostentation that are embodied in van Dyck's portrait of Alexander Henderson. But as these Puritan immigrants achieved a measure of prosperity, they celebrated their success in portraits commissioned from a growing group of portrait painters, most of whom remain anonymous. Prosperity was, after all, the reward a good Calvinist could expect in fulfilling his Christian duties in the world. Worldly effort—what we have come to call the Protestant work ethic —was a way to praise God, and prosperity was a sign that God was looking on one's effort with favor. (The term "Protestant work ethic" is a twentieth-century invention. German sociologist Max Weber used it to describe the forces that motivated individuals to acquire wealth in the Protestant West.)

We see something of this sensibility in a pair of portraits of John and Elizabeth Freake and their child Mary painted in Boston in the early 1770s (Figs. **27.13, 27.14**). John Freake was born in England and came to America in 1658. He was a merchant and lawyer, and owned a brewery, a mill, an interest in six ships, and two homes, including one of the city's finest. His wife Elizabeth was the daughter of another Boston

merchant. While avoiding ostentation, the Freake portraits are careful to suggest their sitters' wealth. John's collar, of imported Spanish or Italian lace, is set off against a rich brown—not black—velvet coat. He holds a pair of gloves, symbolizing his status as a gentleman, and with his left hand, decorated with a large gold ring, he touches an ornate brooch that tops a row of silver buttons. His hair is Cavalier length, perhaps suggesting aristocratic sympathies but certainly aristocratic taste. Elizabeth's dress is made of French satin trimmed with rich brocade and topped by a beautiful lace collar. She wears three strands of pearls around her neck, a garnet bracelet, and a gold ring. She sits on what is known as a "Turkey-work" chair, so named because its upholstery imitates the designs of Turkish carpets. John owned over a dozen such chairs, the finest known in Boston in the seventeenth century. In this context, the child Mary, born after the paintings were begun and added late in the painting process, is another sign of the Freakes' prosperity, a sign of God's grace being bestowed upon them.

Puritan and Cavalier Literature

The debate between the monarchy and the Puritans had distinct literary ramifications. As the flamboyant style of Cavalier dress suggests, writers of a Cavalier bent were sensualists and often wrote frankly erotic works. These contrasted

strongly with the moral uprightness of even the most emotional Puritan writing.

One of the most moving Puritan writers of the day was Anne Bradstreet (ca. 1612–1672), who was born in Northampton, England, but migrated to Massachusetts in 1630 to avoid religious persecution. In order to entertain herself in the wilderness of rural Massachusetts, she took to composing epic poetry, eventually publishing in England *The Tenth Muse Lately Sprung Up in America* (1650), the first volume of poetry written by an English colonist. But it is her personal poetry, most of it published after her death, for which she is renowned. Consider, for instance, "To My Dear and Loving Husband" (**Reading 27.2a**):

READING 27.2a **Anne Bradstreet, "To My Dear and Loving Husband" (1667)**

If ever two were one, then surely we.
If ever man were loved by wife, then thee;
If ever wife was happy in a man,
Compare with me, ye women, if you can.
I prize thy love more than whole mines of gold
Or all the riches that the East doth hold.
My love is such that rivers cannot quench,
Nor ought but love from thee, give recompense.
Thy love is such I can no way repay,
The heavens reward thee manifold, I pray. 10
Then while we live, in love let's so persevere
That when we live no more, we may live ever.

This poem is a pious and direct statement of true affection from a devoted wife. While only the last line suggests its author's religious foundation, in its reference to an afterlife, Bradstreet's Puritan faith is a constant theme in many of her other poems, such as "Here Follows Some Verses upon the Burning of Our House" (see **Reading 27.2**, page 892). The poem narrates Bradstreet's conviction that she must give up all her worldly goods in order to pursue the path to salvation.

In its sense of progressing from the material world to spiritual redemption, Bradstreet's "Here Follows Some Verses . . ." anticipates what is perhaps the most influential Puritan text of the era, *The Pilgrim's Progress* by John Bunyan (1628–1688). After the Restoration of the monarchy in 1660, Bunyan spent 12 years in prison for his fiery preaching, during which time he wrote an autobiography, *Grace Abounding*. But it is *The Pilgrim's Progress*, first published in 1678, that established the symbolism of the Puritan quest for salvation. It narrates the allegorical story of Christian who, with friends Hopeful and Faithful, journeys to the Celestial City. On the way, they learn to resist the temptations of Worldly-Wiseman and Vanity Fair. They also navigate the Slough of Despond and endure a long dark night in the Doubting Castle. Their faith

is tested at every turn. Eventually they realize they must deny the joys of family and society, all earthly security, and even physical well-being, to attain "Life, life, eternal life."

Except for the clarity of their diction, and their rejection of complicated metaphor, Bradstreet and Bunyan share almost nothing with the Cavalier poets of their generation. All were admirers of Ben Jonson (1572–1637), a playwright and poet who flourished during the reign of James I. His comedies *Volpone* (1605) and *The Alchemist* (1610) were immediate hits. Collaborating with the designer and architect Inigo Jones (1573–1652), Jonson also wrote a series of **masques** [masks], a type of performance that combined speech, dance, and spectacle. These were performed for James's court, and they are closely related to the *comedies en musique* composed by Lully for Louis XIV's court. The Cavalier poets of the next generation appreciated especially the erudition and wit of his lyric poetry. Robert Herrick's Cavalier poem "To the Virgins, To Make Much of Time," descends directly from Jonson's example (**Reading 27.3**):

READING 27.3 **Robert Herrick, "To the Virgins, To Make Much of Time" (1648)**

Gather ye Rose-buds while ye may,
Old Time is still a flying:
And this same flower that smiles to day,
To morrow will be dying.

The glorious Lamp of Heaven, the Sun,
The higher he's a getting;
The sooner will his Race be run,
And neerer he's to Setting.

That Age is best, which is the first,
When Youth and Blood are warmer; 10
But being spent, the worse, and worst
Times, still succeed the former.

Then be not coy, but use your time;
And while ye may goe marry:
For having lost but once your prime,
You may for ever tarry.

First published in 1648 in a 1,200-poem volume called *Hesperides* [hess-PER-ih-deez], the poem addresses not merely young women but youth generally and is an example of a *carpe diem* [CAR-peh DEE-em] (Latin for "seize the day") poem admonishing the reader to make merry while one can. The poem is a forthright argument for making love. There is nothing of the traditional Renaissance conceit portraying the poet's love for his mistress as a metaphor for his higher love of God. Some Puritans saw Herrick's poem as a call to fornication, but it ends with a more traditional call to "marry." The poem's *carpe diem* argument is here turned to the purpose of Christian orthodoxy (although when

heard out loud, "marry" would have been impossible to distinguish from a more high-spirited "merry").

The ribald Cavalier sensibility is most pronounced in Restoration drama. Here the sensual, "fleshy" spirit of Rubens's paintings was expressed on stage, in a theater made possible by the Restoration of the monarchy in 1660. For 18 years, under Cromwell and the Puritan Parliament, theater had been banned in England, but when Charles II lifted the ban, a lewd anti-Puritanical theater ascended to the stage. The most notorious of these plays is *The Country Wife*, written by William Wycherley (1640–1716) in 1675. For the first time in British history, women were allowed on stage. Like many of his Cavalier colleagues, Wycherley stunned audiences by having his female characters cross-dress as males, in tight-fitting breeches, and engage their male counterparts in sexual banter. *The Country Wife* itself revolves around the exploits of Harry Horner (the name is suggestive) who has spread a rumor throughout London male society that he is impotent so that he may more easily seduce respectable ladies. The play consists of a series of Horner's seductions, in which he is always at the brink of being found out but just manages to escape detection. In keeping with its libertine spirit, the play is totally unrepentant; even at the end, it is clear that Horner's behavior will never change.

Henry Purcell and English Opera

Just as they were of the theater, Puritans were suspicious of secular music in all its forms, and special contempt was reserved for opera. Even after the Restoration, the English resisted drama that consisted entirely of singing, preferring plays and masques that combined drama, song, and dance. One of the very few operas of its time is *Dido* [DY-doh] *and Aeneas* [uh-NEE-us], the work of Henry Purcell [PUR-sul] (ca. 1659–1695). *Dido and Aeneas* was first performed in 1689 by students at a school for young ladies in Chelsea, west of London, but was not performed again until 1700, after Purcell's death. King William, the foreign king, and Queen Mary, the native daughter of Charles I, may have suppressed it, finding the alliance of Aeneas and Dido a story too close to their own. But the opera's Roman subject is in keeping with the Classical Baroque. It is the same story that Virgil tells in the *Aeneid* (see

Continuity & Change
p. 266
Aeneid

chapter 8). There, Aeneas falls in love with Dido, queen of Carthage, but knowing he must continue his journey and found Rome, he abandons her and she commits suicide. The final piece in Purcell's opera, known as "Dido's Lament," begins with a recitative, moves to an emotional aria, followed by a short orchestral conclusion. The lament itself is a ground bass aria, in which the melody is set over a repeated pattern in the bass (see **CD-Track 27.3**). The opening recitative moves steadily downward, setting the stage for the grief-stricken Dido's aria. Then the ground bass by itself descends by half steps, like some slowly accumulating sadness. It repeats 11 times during the course of the aria. Over it, Dido's words repeat themselves for dramatic effect, and convey her increasingly despairing emotional state. At the lament's conclusion, Dido dies. Despite its ability to move the listener, Purcell's opera did not capture the English imagination until 1711, when it helped to inaugurate an English passion for opera as a form.

The Arts of the Spanish Court

Even as England endured its divisive religious wars, Spain remained dogmatically Catholic. Yet after the death of Philip II (see chapter 22), and despite the wealth flowing into the country from its American empire, Spain entered a period of decline during which deteriorating economic and social conditions threatened the absolutist authority of its king. Severe inflation, a shift of population away from the countryside and into the cities, and a loss of population and tax revenue brought the absolutist Spanish court to bankruptcy. To make matters worse, if the reign of Philip III (r. 1598–1621) was marked by the corruption of his inner court, the regime of Philip IV (r. 1621–1665) was marked by disastrous, highly costly military campaigns. These culminated in 1659 when Spain accepted a humiliating peace with France and, in 1668, agreed to total independence for Portugal. As early as 1628, the Dutch had captured the entire Spanish treasure fleet in the Caribbean, taking 177,537 pounds of gold and silver valued at 4.8 million silver pesos. One might have suspected Spanish citizens to be angry with the Dutch, but in fact, they were delighted. As the painter Peter Paul Rubens, at work on a commission for Philip IV, reported, "Almost everyone here is very glad about it, feeling that this public calamity can be set down as a disgrace to their rulers." Nevertheless, even as the Spanish throne seemed to crumble, the arts flourished under the patronage of a court that recklessly indulged itself. So remarkable was the outpouring of Spanish arts and letters in the seventeenth century that the era is commonly referred to as the Spanish Golden Age.

Diego Velázquez and the Royal Portrait

The Spanish court understood that in order to assert its absolutist authority it needed to impress the people through its patronage of the arts. So when Philip IV assumed the Spanish throne at the age of 16, his principal advisor, suggested that his

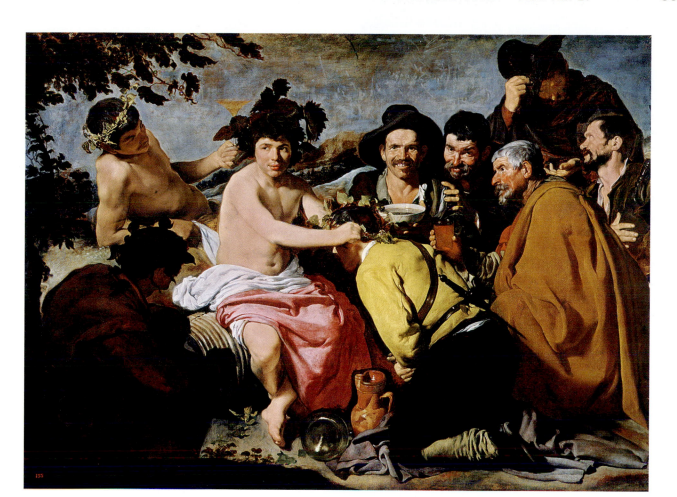

Fig. 27.15 Diego Velázquez. *El Triumfo de Baco, or Los Borrachos (The Triumph of Bacchus, or The Drunkards).* **1628–1629.** Oil on canvas, 65 ⅛″ × 87 ½″. Museo del Prado, Madrid, Spain. SCALA/Art Resource, NY. Velázquez's canvases consist of loosely painted layers of paint that appear totally coherent from even a few feet away, but which dissolve into a seemingly random amalgamation of individual brushstrokes when studied at close range. Dashes of white, lemon, and pale orange give the effect of light reflecting off the surface of his forms.

court should strive to rival all the others of Europe by employing the greatest painters of the day. The king agreed, hiring Rubens in the 1630s to paint a cycle of 112 mythologies for his hunting lodge. But when the 24-year-old Diego Rodríguez de Silva y Velázquez [vah-LASS-kez] (1599–1660) was summoned to paint a portrait of the king in the spring of 1623, both the king and his advisor recognized that one of the great painters of seventeenth-century Europe was homegrown. An appointment as court painter quickly followed, and Velázquez became the only artist permitted to paint the king.

In 1628, when Rubens visited the Spanish court, Velázquez alone among artists in Madrid was permitted to visit with the master at work. And Velázquez guided Rubens through the royal collection, which included Bosch's *Garden of Earthly Delights* (see *Focus,* chapter 20) and, most especially, Titian's *The Rape of Europa* (see Fig. 22.11), which had been painted expressly for Philip II. Rubens copied both. He also persuaded Velázquez to go to Italy in 1629–1630, where he studied the work of Titian in Venice. In Florence and Rome, Velázquez disliked the paintings of Raphael, whose linear style he found cold and inexpressive.

By the time Rubens met the young painter, he was already deeply affected by Caravaggio. The figure of Bacchus in *The Triumph of Bacchus,* also known as *Los Borrachos* [bor-RAH-chohs] (*The Drunkards*) (Fig. **27.15**), painted around the time of Rubens's visit, is directly indebted to Caravaggio's realistic and tightly painted treatments of the same mythological figure. And the peasants gathered around the youth are reminiscent of the ruddy working-class types that populate Caravaggio's canvases. But Rubens's own taste for bacchanalian themes was at work as well.

Velázquez's chief occupation as painter to Philip IV was painting court portraits and supervising the decoration of rooms in the various royal palaces and retreats. Most were portraits of individuals, but *Las Meninas* [las may-NEE-nahss] (*The Maids of Honor*) is a life-size group portrait and his last great royal commission. It elevates the portrait to a level of complexity almost unmatched in the history of art. The source of this complexity is the competing focal points of the composition (see *Focus,* pages 882–883). This work, with its unusual spatial scheme that includes a likeness of the painter and permits us into his studio, continues to inspire later artists.

Focus

Velázquez's *Las Meninas*

Diego Velázquez's *Las Meninas*, or *The Maids of Honor*, is a painting remarkable in conception and extraordinary in execution. This group portrait captures in a passing moment ten individuals in the vast room that was the painter's studio in the royal palace of Spain. The competing focal points of the composition are the source of the work's complexity. At the very center of the painting, bathed in light, is the Infanta Margarita, beloved daughter of King Philip IV and Queen Mariana. In one sense, the painting is the Infanta's portrait, as she seems the primary focus. Yet the title *Las Meninas*, "The Maids of Honor," implies that her attendants are the painting's real subject. However, Velázquez has painted himself into the composition at work on a canvas, so the painting is, at least partly, also a self-portrait. The artist's gaze, as well as the gaze of the Infanta and her dwarf lady-in-waiting, and perhaps also of the courtier who has turned around in the doorway at the back of the painting, is focused on a spot outside the painting, in front of it, where we as viewers stand. The mirror at the back of the room, in which Philip and Mariana are reflected, suggests that the king and queen also occupy this position, acknowledging their role as Velázquez's patrons.

Difficult to see even in person, this painting on the back wall is a reproduction of Rubens's *Pallas and Arachne* of 1636–1637, commissioned by Philip IV and is thus, an homage to that painter.

The **red cross** on the artist's breast is the symbol of the Order of Santiago, to which the painter was nominated in 1658. Formerly, the order had banned membership to those who worked with their hands. In winning his nomination, Velázquez affirmed not only his own nobility, but also that of his craft. Philip IV ordered the addition of the cross in the painting after Velázquez's death in 1660.

No other Veláquez painting is as tall as *Las Meninas*, which suggests that the back of the canvas in the foreground is, in fact, *Las Meninas* itself. Velázquez thus paints himself painting this painting.

One of two **maids of honor** who give the painting its title. The other stands just to the Infanta's left. This one hands the Infanta a terracotta jug on a gold plate. The jug probably contained cold scented water.

Diego Velázquez. ***Las Meninas (The Maids of Honor)***. 1656.
Oil on canvas, 10′ 3/4″ × 9′ 3/4″. Museo del Prado, Madrid.

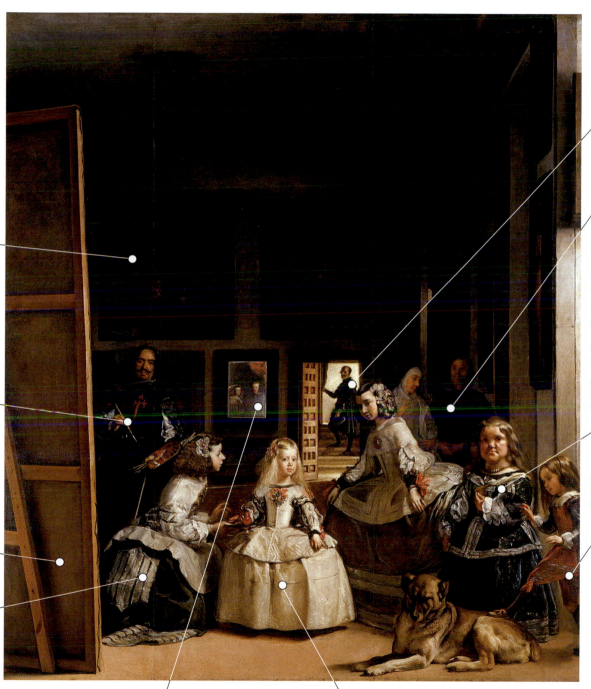

José Nieto, the queen's chamberlain, responsible for the day-to-day operations of the royal household. His gesture and the light that surrounds him draw attention to the mirror reflecting the king and queen.

The **nun and priest** emphasize the importance of the Catholic faith in the Spanish court.

Dwarfs were a common feature in the royal courts of Europe, a source of entertainment and amusement. They were dressed in fine costume, lavished with jewelry and gold, and shown off at court ceremonies and festivals. Often, they were presented as gifts to court dignitaries. Velázquez paints them with compassion, for their status in court was not much better than his own.

Court Jester Nicolasito, shown tormenting the huge dog in front of him by stepping on its back.

If the king and queen were really situated where the viewer stands, their reflection in the mirror at the back of the room would be much smaller. Velázquez is playing games with the space of the painting.

Infanta Margarita, 5 years old at the time of the painting, was heir to the Spanish throne.

Fig. 27.16 Baccio del Bianco. Drawing of his setting for *Andromeda y Perseo* by Calderón, First Scene with Fall of Discord. 1653. Department of Printing and Graphic Arts, MS Typ 258, Hughton Library, Harvard College Library. This is a drawing for one of 11 sets designed by Bianco, a Florentine engineer whom Philip had borrowed from the grand duke of Tuscany in 1651, originally to design waterworks for Philip's palaces. This scene would have utilized the full depth of the stage to show a rustic village as well as the Fall of Discord, driven from the heavens (apparently on a rope). In the performance, Discord apparently fell much faster than planned, and almost fractured her neck.

The Literature of the Spanish Court

Under Philip III and Philip IV, the literary arts in Spain flourished as never before. Cervantes's great novel *Don Quixote* appeared in two parts, the first in 1605 and the second in 1615 (see chapter 22). A transitional text, it represents the culmination of Renaissance thought even as it announces the beginning of an age of great innovation and originality. Especially influential was Cervantes's willingness to criticize, by means of good humor and satire, the social structures of Spanish society, particularly its aristocracy and religious institutions. Above all, the example of Cervantes freed Spanish writers to be entertaining.

The Plays of Lope de Vega and Calderón The Golden Age of Spanish drama lasted for nearly one hundred years, spanning the years when Lope Félix de Vega [LOH-pay FAY-leeks day VAY-gah] (1562–1635) produced his first play in 1592, and 1681, when the playwright who succeeded him as the favorite of the Spanish court, Pedro Calderón de la Barca [PAY-droh kahl-day-ROHN day la BAR-kah] (1600–1681), died. Literally thousands of plays were written and produced in these years, an estimated 1,800 by Lope de Vega alone (only 500 of these are considered authentic), a pace of some 42 plays a year, or one every eight or nine days. As a rule, plays in Golden Age

Spain were intended for a single performance, and yet despite the pace at which they were produced, which would tend to encourage formulaic and repetitive strategies, inventiveness was highly prized. Actors struggled to learn their lines and often begged forgiveness of their audiences for errors they committed. Set designers, many of them engineers imported from Italy, were encouraged to create as many changeable scenes as possible, and playwrights obliged them by creating plays of ten or more scene changes (Fig. **27.16**).

So extensive are Lope's writings in every genre—novels, short stories, epistles, epic poems, and lyric poetry in addition to plays—that a complete edition of his works has never been assembled. But beyond his extraordinary energy, his innovative approach to drama sets him apart. Before Lope, Spanish drama had been governed by strict observance of the classical unities. He offered instead a new model, the *comedia nueva* [koh-MAY-dee-ah noo-WAY-vah] ("new comedy"), fast-paced, romantic treatments taking as their themes national history or everyday Spanish life. According to Lope, the classical unities were to be abandoned. Furthermore, comedy and tragedy should be mixed in the same play, and noble and base characters intermingled. Puns, disguises, mistaken identities, and fixed types or caricatures should facilitate the plot. Finally, any theme was admissible. Lope's new comedies were a smashing success, performed again and again for both Philip III and Philip IV.

Calderón's temperament was very different from Lope's. He lived a quiet life dedicated to his books and thoughts. He wrote almost exclusively for the court, not the public, and produced some 120 plays, most of which followed models established by Lope. Some of them even recast Lope's original works. But it would be a mistake to think of Calderón as unoriginal. He was more philosophical and profound than Lope, and the beauty of his poetry far exceeded his mentor's. His so-called court-and-sword plays are especially interesting. His theme is the conflict between love and honor.

The point of honor (*pundonor* [poon-doh-NOR]) in Spanish society was based primarily on a notion of marital fidelity that extended to a man's entire household, including all women in the house, married or unmarried. Any violation of female honor had to be avenged as a matter of reputation and self-respect. In actual practice, the *pundonor* often led to horrific

outcomes. If a wife was even suspected of infidelity, her husband was permitted to kill her and had to murder her suspected lover as well. Calderón's plays take full advantage of the dramatic possibilities of such a social code. He weaves the intrigues of lovers—and the accompanying disguises, mistaken identities, false accusations, and humiliating loss of honor—into complex and entangled plots that capture the sometimes horrid depths and sometimes glorious heights of Spanish passion.

The Satires of Francisco de Quevedo No writer of Golden Age Spain understood so well or confronted so thoroughly the country's political, economic, and moral bankruptcy as Francisco de Quevedo y Villegas [day kay-VAY-doh ee veel-YAY-gahss] (1580–1645). Most of his literary life was dedicated to exposing the corruption and weakness of the Spanish court, the foolish ways and misplaced values of his contemporaries, and especially the dishonesty and deceit of Spain's professional and merchant classes—lawyers, doctors, judges, barbers, tailors, and actors. His greatest work along these lines is *Sueños* [soo-AYN-yohss] (*Visions*). The work consists of five visions written between 1606 and 1622. In the first, *El Sueño del juicio final* [el soo-AY-noh del hoo-EE-see-oh fee-NAHL] (*The Vision of the Last Judgment*), Quevedo recalls a dream in which on the day of the Last Judgment the dead rise from their graves. Their bones detached and scattered, the dead must reassemble themselves. While every soul finally gets it right, Quevedo witnesses considerable procrastination. A scribe pretends his own soul is not his own in order to be rid of it. Slanderers are slow to find their tongues, and the lustful fear to find their eyes lest these organs bear witness against them. Thieves and murderers spend hours trying to avoid their hands. Among the dead, Adam, Herod, Pilate, Judas, Mohammed, and Martin Luther are all tried and condemned until an astrologer arrives and declares that there is a great mistake—it is not Judgment Day at all. Devils promptly carry him off to Hell.

The other *Sueños* follow this same pattern. They are plotless catalogs of social types and historical characters, each exposed in succession to Quevedo's biting wit. Seeing themselves and their neighbors in Quevedo's sketches, and apparently capable of laughing at his often sardonic vision, Spaniards responded enthusiastically to the *Sueños*. Philip IV was less enthused. Perhaps that explains why Quevedo was arrested in 1639. He remained in prison until 1643 and died profoundly pessimistic that Spain would long remain a force in world politics.

The Baroque in the Americas

Don Quixote, Cervantes's great character (see chapter 22), is in part a spoof of the Spanish conquistador mentality that had taken control of the Americas and whose chivalry both Lope de Vega and Quevedo later likewise spoofed. The Americas were Spain's greatest source of wealth, and Spanish culture quickly took hold in both North and South America. This was a politically important enterprise, because it underscored that the absolute authority in the Americas was the Spanish monarchy. In Cuzco [KOOS-koh], Peru, the Spanish adopted the structures of the Inca to their own purposes, constructing their own buildings, as we saw in chapter 16, on original Inca foundations. They even converted the most magnificent of the Inca sacred sites, the Temple of the Sun, into a Dominican church and monastery. Over time, Spanish leaders and missionaries believed, the distinction between worshiping the Inca gods and worshiping the sacred in general would become increasingly less clear, and Christianization of the native population would occur naturally.

The Cuzco School

In truth, the indigenous native populations Indianized the Christian art imposed upon them, creating a unique visual culture, part Baroque, part Indian. A case in point is the city of Lima, founded by the conquistador Francisco Pizarro in 1535 as capitol of the Viceroyalty of Peru (see Map **27.2**) on the coast, convenient to harbor and trade. As opposed to Cuzco, with its narrow, winding streets, Lima was laid out in a formal grid, with wide, open vistas, the very image of imperial order. By the start of the seventeenth century, the city was a fully Baroque testament to the Spanish culture of its founders. The stones for its mansions were shipped in from Panama as ballast for ships that carried gold from the

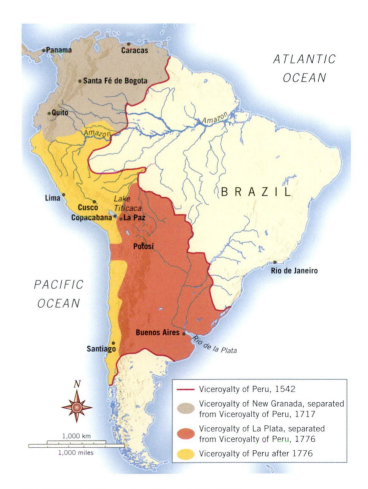

Map 27.2 **The Viceroyalty of Peru, 1542–1824.**

Fig. 27.17 Palacio Tore Tagle. Lima, Peru. 1735. Today the Palacio houses the Peruvian Foreign Ministry. Such ornately carved Baroque balconies were part of the facades of many colonial mansions in Lima.

highlands and silver from Potosí [pote-uh-SEE] (see chapter 22) to Mexico and then on to Spain. The wood for its mansions, with their elaborately carved Baroque balconies (Fig. 27.17), was imported oak and cedar.

The artisans who carved these Baroque panels were increasingly native, as were the metalworkers who created fine objects to satisfy colonists' tastes and the painters who decorated their churches. Especially in Cuzco, they brought to their work techniques and motifs from their Inca background. *Our Lady of the Victory of Malága* (Fig. 27.18) by Luis Niño (active 1730–1760) employs **brocateado** [broh-kah-tay-AH-doh], the application of gold leaf to canvas, a technique extremely popular among the Cuzco painters, especially for creating elaborate brocadelike effects on saints' garments. Here the Virgin stands on a silver crescent moon above the tiled roofs and trees of the Cuzco countryside, recalling the Inca association of silver with religious worship of the moon, while the flat symmetry of the *brocateado* evokes the flat patterns of Inca textile design (see Fig. 16.30) and the Inca association of gold with worship of the sun. In fact, some scholars argue that the crescent at the virgin's

feet, together with the two vertical red lines that rise straight up from its center, take the shape of the curved blade and handle of the Inca ceremonial knife used in traditional sacrifices, a shape also worn as a pin by Inca princesses as a symbol of good luck. Thus Catholic and native traditions are compounded in a single image, a syncretism mirrored in the increasingly mestizo fabric of the population as a whole (see chapter 23).

Baroque Music in the Americas: Sor Juana Inés de la Cruz

The syncretism in the work of the Cuzco artists is also evident in Baroque music as it developed in New Spain. As the Church sought to convert native populations to the Catholic faith, the musical liturgy became a powerful tool. As early as 1523, Spanish monks created a school for Native Americans

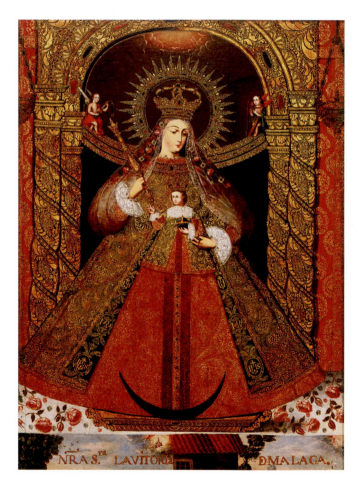

Fig. 27.18 Luis Niño. *Our Lady of the Victory of Málaga.* Southern Cuzco school, Potosí, Bolivia. ca. 1737. Oil on canvas overlaid with gold and silver, 59 1/2″ × 43 3/4″. Gift of John C. Freyer for the Frank Barrows Freyer Collection. Denver Art Museum, CO. This particular manifestation of the Virgin is associated with the Minimi order of the Catholic Church, founded in the fifteenth century by Francis of Paula (Italy). He was present at the Spanish victory over the Moors at Málaga in 1487, and claimed to have seen the Virgin appear. He was eventually sanctified by the pope, and was the patron saint of travelers, sailors, and navigators. A Minimi monastery was established in Peru in the seventeenth century.

in Texcoco, Mexico (just east of Mexico City), and began teaching music, including Gregorian chant, the principles of polyphony, and composition, on an imported organ. Throughout the sixteenth century missionaries used music, dance, and religious dramas to attract and convert the indigenous population to Christianity. These forms were sometimes adapted to local conditions. For example, the religious drama *Battle of the Christians and Moors* became the *Battle of Pizarro and Atahualpa* (see chapter 22), a dance-drama still performed in Peru.

An interesting example of syncretism in the cultures of New Spain is in the work of Sor Juana Inés de la Cruz (1648–1695). The illegitimate daughter of an America-born mother of pure Spanish descent and a Basque father, she was recognized as a prodigy at an early age, and at 16 was named lady-in-waiting to the wife of the Spanish viceroy. Four years later, seeking freedom to pursue her education, she entered the Convent of San Jerónimo in Mexico City, where she spent the rest of her life. She is remembered today largely as the author of an important tract, *Reply to Sor Philotea* (1691), in which she defended the rights of women to pursue any form of education they might desire, and as a poet. Her sonnet "To Her Self-Portrait" is representative of her work (**Reading 27.4**):

READING 27.4 Sor Juana Inés de la Cruz, "To Her Self-Portrait" (posthumous publication 1700)

What you see here is colorful illusion,
an art boasting of beauty and its skill,
which in false reasoning of color will
pervert the mind in delicate delusion.
Here where the flatteries of paint engage
to vitiate the horrors of the years,
where softening the rust of time appears
to triumph over oblivion and age,
all is a vain, careful disguise of clothing,
it is a slender blossom in the gale, 10
it is a futile port for doom reserved,
it is a foolish labor that can only fail;
it is a wasting zeal and, well observed,
is corpse, is dust, is shadow, and is nothing.

The poem expresses the poet's profound distrust in what is apparent in the self-portrait only through the observational senses. If "well observed," she concludes, one should see there the inevitable fact of death, which the color, beauty, and skill of the portrait masks. The poem is a profound example of Baroque self-awareness, the product of a mind that loves beauty even as it recognizes its fleeting nature.

Many of Sor Juana's poems were originally songs written to be accompanied by music, the notation to which is now lost. Nevertheless, they tell us much about music in Baroque New Spain. Her hymn *Tocatîn*, written in the Aztec language of Nahuatl, in which she was fluent, aligns the Virgin Mary with the Aztec Earth Mother and was probably sung to the tune of a popular Spanish folk tune. Among her most popular musical productions are several collections of *villancicos*. The *villancico* is a form similar to the Italian *frottola* (see chapter 17), and it developed in fifteenth- and sixteenth-century Spain. Simple polyphonic songs, on a light, rustic, or pastoral theme, in which the upper voice dominates while the lower voices fill in the polyphony, many early *villancicos* were originally written for voice and guitar. In New Spain, the form developed over the course of the next hundred years into a religious genre that made increasing use of recitative and aria, often employing as many as five solo voices. Because the New World *villancico* made use of vernacular texts and told popular stories, it was a particularly effective means of addressing the native populations.

In Sor Juana's hands, the *villancico* was a means to dramatize the diversity of language and culture in New Spain. In her suite of eight *villancicos* known as *San Pedro Nolasco* (1677), the story of a Mexican saint known for freeing slaves of both African and Indian descent, her soloists sang in three languages. An Aztec sang in Nahuatl. A female poet introduced and narrated the performance in proper Spanish. A common man of the street sang in less refined Spanish. An African-American slave also sang in Spanish, but in a very colloquial and African-inflected dialect. Finally, a student sang in Latin. All of these voices came together in a story of profound miscommunication about the possibilities of salvation. What the music might have sounded like is open to question, but it is likely that the different languages would have been sung in different rhythms with accents falling in different places. For instance, we know because the female poet narrator says so when she introduces him that the African-American slave's opening refrain was sung "to the music of a calabazo song," that is, a song accompanied by a percussive gourd. The introduction of a folk instrument into the religious *villancico* speaks to the heterogeneous complexity of Mexican Baroque music.

The Churrigueresque Style: *Retablos* and Portals in New Spain

The taste for elaborate decorative effects and complexity evident in the Cuzco Madonna and the Lima balconies as well as in Sor Juana's *villancicos* found its most extraordinary expression in large altarpiece ensembles, known as **retablos** [ray-TAH-blohs], which began to appear in the churches of Mexico in the late seventeenth century. In Spain, a family of architects and sculptors known as the Churriguera [choor-ree GAY-rah] had introduced and given their name to an extremely lavish Baroque style called Churrigueresque [choor-ree gay-RESK], used to decorate *retablos* and church portals. (These Baroque *retablos* are distinct from the folk art *retablos* that originated in the late nineteenth century as devotional

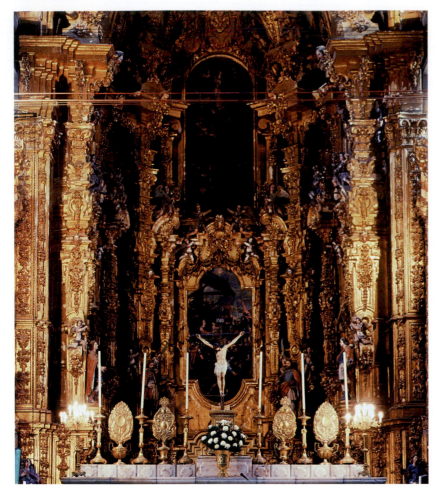

oil paintings sold to devout believers who displayed them in home altars to honor their patron saints.) In the Viceroyalty of New Spain, comprising most of modern Mexico, Central America, and the American Southwest (**see** Map **27.3**), Baroque *retablos* were at first the work of teams of European artists, then later *criollos* [kree-OHL-yoh], Mexican-born descendants of Spaniards. These *retablos* were generally designed to frame, in the most extravagant style, paintings and sculptures brought to the Americas from Europe.

A good example of the Churrigueresque *retablo* is the vast Altar of the Kings, designed by Jerónimo de Balbás [day bahl-BAHSS] (ca. 1680–1748) for the cathedral in Mexico City (Fig. **27.19**). Here artisans used gold leaf unsparingly in a radical vertical design distinguished by a new form of engaged column, narrow at the base and top, wider in the middle, known as the **estípite** [es-TEE-pee-tay] **column**. The column is constructed of segmented,

Fig. 27.19 Jerónimo de Balbás. Altar of the Kings, principal *retablo* of the Cathedral, Mexico City. 1718–1737. Polychrome and gilded wood, height 85'. Balbás was the first architect to employ the distinctive *estípite* column in Spanish-colonial America. Before coming to Mexico in 1717, Balbás had been a leading *retablo* maker in Seville.

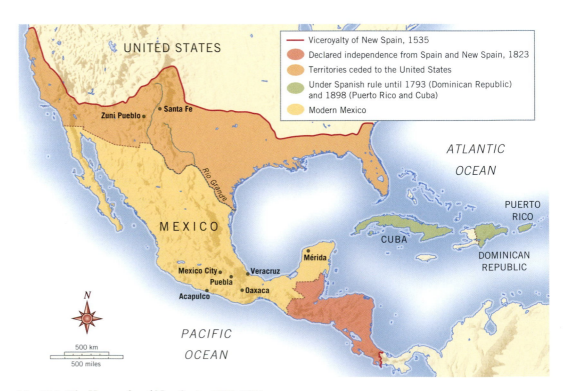

Map 27.3 The Viceroyalty of New Spain, 1535–1821.

upside-down and tapered pyramids and other sculpted forms of the kind previously found only on the finials of furniture. Surrounded by decorative scrolls, garlands, and sculptures of angels and saints, all gilded and flickering in the candlelight, these *estípite* columns rise column upon column to an awe-inspiring height of 85 feet!

The extravagance of the Mexico City *retablo* is hardly unique. On the one hand, *retablos* were designed to impress the indigenous population, which the Spanish missionaries were intent on converting to Christianity. Thus nearly every church of any size in New Spain possessed a *retablo* that aspired to the magnificence of the one in the Mexico City Cathedral. On the other hand, *retablos* were a manifestation of the extraordinary wealth that Mexico enjoyed as the center of a trade for precious metals. It coordinated a network of sources and outlets that through its Atlantic and Pacific ports linked the silver mines of Peru in the south, its own silver mines in the Sierra Madre of central Mexico, and other mining towns in the north, to Spain, the Philippines, and China. Thus, as far north as New Mexico and Arizona new missionary churches built in the seventeenth and eighteenth centuries were modeled on churches built in the same era to the south.

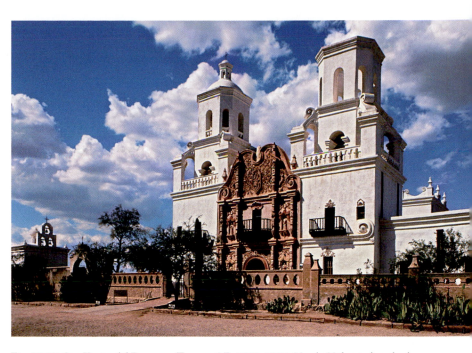

Fig. 27.20 **San Xavier del Bac, near Tucson, AZ. 1783–1797.** Nearly 99 feet in length, the church is made of brick and mortar, instead of adobe (earth and straw), the usual building material of the Southwest. The material was probably chosen to assert the Church's permanence.

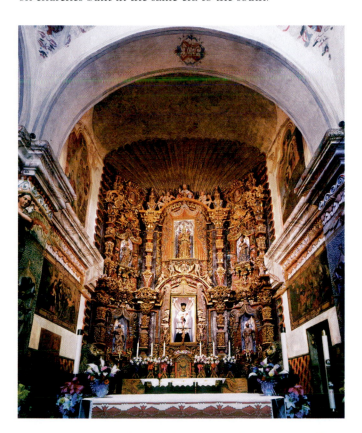

Fig. 27.21 **Nave of San Xavier del Bac with *retablo*. 1783–1797.** The *retablo* was restored in 1992–1997, a project that included the delicate cleaning of its gold and silver leaf.

One of the most beautiful of these northern churches is San Xavier del Bac [sahn KSAH-vee-ay del bahk], just south of present-day Tucson, built in 1783–1797. The mission was founded in the early eighteenth century to serve the Tohono O'odham, or "Desert People," and the settlement these people called Bac, "place where the water appears." The name of the settlement refers to the fact that the Santa Cruz River, which runs underground for some distance, reappears on the surface nearby. Surrounding the church's portal are niches framed by *estípite* columns (Fig. **27.20**). Elaborate Mannerist scrolls, probably deliberate echoes of Michelangelo's staircase for the Laurentian Library in Rome (see chapter 18), decorate the facade and support the two towers (one of which was mysteriously never completed). The magnificent *retablo* inside has unusual twin *estípite* columns that rise from floor to ceiling (Fig. **27.21**).

Despite Spain's program to convert Native Americans to Christianity, the Native American cultures of the Southwest never comfortably assimilated Western religion. In August 1680, the Pueblo peoples of present-day New Mexico and Arizona simultaneously revolted under the leadership of a San Juan Indian named Popé [POH-pay]. They killed 21 of the province's 33 Franciscans and 308 Spanish settlers, including men, women, and children. Survivors fled south to El Paso del Norte [el–PAH-soh del NOR-tay]. Not until 1692 would the Spanish reassert control of the region. However, the Native American peoples of the region had won from the Spanish a degree of freedom from the threat of the Christian mission. Thereafter the Church sought to work side by side with native traditions rather than attempt to eradicate them.

READINGS

from Molière, *Tartuffe*, Act III, scenes 2 and 3 (1664)

A remarkable feature of Molière's play is that its central character, Tartuffe, does not come on stage until Act III, scene 2. Up to that point, however, he has been the focus of all conversation, and the family maid Dorine has tried valiantly to expose his calumny. In these two scenes, the perceptive Dorine mocks his hypocrisy even as she announces the arrival of Orgon's wife, Elmire, whom Tartuffe attempts to seduce.

Scene II

Tartuffe, Laurent, Dorine

Tartuffe [*Observing Dorine and calling to his manservant off stage*]
Hang up my hair shirt, put my scourge in place,
And pray, Laurent, for Heaven's perpetual grace.
I'm going to the prison now, to share
My last few coins with the poor wretches there.

Dorine [*Aside:*] Dear God, what affectation! What a fake!

Tartuffe You wished to see me?

Dorine Yes . . .

Tartuffe [*Taking a handkerchief from his pocket*]
For mercy's sake,
Please take this handkerchief, before you speak.

Dorine What? 10

Tartuffe Cover that bosom, girl. The flesh is weak,
And unclean thoughts are difficult to control.
Such sights as that can undermine the soul.

Dorine Your soul, it seems, has very poor defenses,
And flesh makes quite an impact on your senses.
It's strange that you're so easily excited;
My own desires are not so soon ignited,
And if I saw you naked as a beast,
Not all your hide would tempt me in the least.

Tartuffe Girl, speak more modestly; unless you do, 20
I shall be forced to take my leave of you.

Dorine Oh, no, it's I who must be on my way;
I've just one little message to convey.
Madame is coming down, and begs you, Sir,
To wait and have a word or two with her.

Tartuffe Gladly.

Dorine (*Aside*) *That* had a softening effect!
I think my guess about him was correct.

Tartuffe Will she be long?

Dorine No: that's her step I hear. 30
Ah, here she is, and I shall disappear.

Scene III

Elmire, Tartuffe

Tartuffe May Heaven, whose infinite goodness we adore,
Preserve your body and soul forevermore,
And bless your days, and answer thus the plea

Of one who is its humblest votary.

Elmire I thank you for that pious wish. But please,
Do take a chair and let's be more at ease.
[*They sit down.*]

Tartuffe I trust that you are once more well and strong?

Elmire Oh, yes: the fever didn't last for long.

Tartuffe My prayers are too unworthy, I am sure, 40
To have gained from Heaven this most gracious cure;
But lately, Madam, my every supplication
Has had for object your recuperation.

Elmire You shouldn't have troubled so. I don't deserve it.

Tartuffe Your health is priceless, Madam, and to
preserve it
I'd gladly give my own, in all sincerity.

Elmire Sir, you outdo us all in Christian charity.
You've been most kind. I count myself your debtor.

Tartuffe It was nothing. Madam. I long to serve you better. 50

Elmire There's a private matter I'm anxious to discuss.
I'm glad there's no one here to hinder us.

Tartuffe I too am glad: it floods my heart with bliss
To find myself alone with you like this.
For just this chance I've prayed with all my power—
But prayed in vain, until this happy hour.

Elmire This won't take long, Sir, and I hope you'll be
Entirely frank and unconstrained with me.

Tartuffe Indeed, there's nothing I had rather do
Than bare my inmost heart and soul to you. 60
First, let me say that what remarks I've made
About the constant visits you are paid
Were prompted not by any mean emotion.
But rather by a pure and deep devotion.
A fervent zeal . . .

Elmire No need for explanation.
Your sole concern, I'm sure, was my salvation.

Tartuffe [*Taking Elmire's hand and pressing her fingertips*] Quite so:
and such great fervor do I feel . . .

Elmire Ooh! Please! You're pinching!

Tartuffe 'T was from excess of zeal. 70
I never meant to cause you pain, I swear.
I'd rather . . .
[*He places his hand on Elmire's knee.*]

Elmire What can your hand be doing there?

Tartuffe Feeling your gown; what soft, fine-woven stuff!

ELMIRE Please, I'm extremely ticklish. That's enough.
 [She draws her chair away; Tartuffe pulls his after her.]

TARTUFFE *[Fondling the lace collar of her gown]* My, my, what
 lovely lacework on your dress!
 The workmanship's miraculous, no less.
 I've not seen anything to equal it.

ELMIRE Yes, quite. But let's talk business for a bit. 80
 They say my husband means to break his word
 And give his daughter to you, Sir. Had you heard?

TARTUFFE He did once mention it. But I confess
 I dream of quite a different happiness.
 It's elsewhere, Madam, that my eyes discern
 The promise of that bliss for which I yearn.

ELMIRE I see: you care for nothing here below.

TARTUFFE Ah, well—my heart's not made of stone, you know.

ELMIRE All your desires mount heavenward, I'm sure,
 In scorn of all that's earthly and impure. 90

TARTUFFE A love of heavenly beauty does not preclude
 A proper love for earthly pulchritude;
 Our senses are quite rightly captivated
 By perfect works our Maker has created.
 Some glory clings to all that Heaven had made;
 In you, all Heaven's marvels are displayed.
 On that fair face, such beauties have been lavished.
 The eyes are dazzled and the heart is ravished;
 How could I look on you, O flawless creature,
 And not adore the Author of all Nature, 100
 Feeling a love both passionate and pure
 For you, his triumph of self-portraiture?
 At first, I trembled lest that love should be
 A subtle snare that Hell had laid for me;
 I vowed to flee the sight of you, eschewing
 A rapture that might prove my soul's undoing;
 But soon, fair being, I became aware
 That my deep passion could be made to square
 With rectitude, and with my bounden duty.
 I thereupon surrendered to your beauty. 110
 It is, I know, presumptuous on my part
 To bring you this poor offering of my heart,
 And it is not my merit, Heaven knows,
 But your compassion on which my hopes repose.
 You are my peace, my solace, my salvation;
 On you depends my bliss—or desolation;
 I bide your judgment and, as you think best,
 I shall be either miserable or blest.

ELMIRE Your declaration is most gallant, Sir.
 But don't you think it's out of character? 120
 You'd have done better to restrain your passion
 And think before you spoke in such a fashion.
 It ill becomes a pious man like you . . .

TARTUFFE I may be pious, but I'm human too:
 With your celestial charms before his eyes,
 A man has not the power to be wise.
 I know such words sound strangely, coming from me,
 But I'm no angel, nor was meant to be,
 And if you blame my passion, you must needs

Reproach as well the charms on which it feeds. 130
Your loveliness I had no sooner seen
Than you became my soul's unrivaled queen;
Before your seraph glance, divinely sweet,
My heart's defenses crumbled in defeat,
And nothing fasting, prayers, or tears might do
Could stay my spirit from adoring you.
My eyes my sighs have told you in the past
What now my lips make bold to say at last,
And if, in your great goodness, you will deign
To look upon your slave, and ease his pain,— 140
If in compassion for my soul's distress,
You'll stoop to comfort my unworthiness,
I'll raise to you, in thanks for that sweet manna,
An endless hymn, an infinite hosanna.
With me, of course, there need be no anxiety.
No fear of scandal or of notoriety.
These young court gallants, whom all the ladies fancy,
Are vain in speech, in action rash and chancy;
When they succeed in love, the world soon knows it;
No favor's granted them but they disclose it 150
And by the looseness of their tongue profane
The very altar where their hearts have lain.
Men of my sort, however, love discreetly,
And one may trust our reticence completely.
My keen concern for my good name insures
The absolute security or yours;
In short, I offer you, my dear Elmire,
Love without scandal, pleasure without fear.

ELMIRE I've heard your well-turned speeches to the end,
 And what you urge I clearly apprehend. 160
 Aren't you afraid that I may take a notion
 To tell my husband of your warm devotion,
 And that, supposing he were duly told,
 His feelings toward you might grow rather cold?

TARTUFFE I know, dear lady, that your exceeding charity
 Will lead your heart to pardon my temerity;
 That you'll excuse my violent affection
 As human weakness, human imperfection;
 And that—O fairest!—you will bear in mind
 That I'm but flesh and blood, and am not blind. 170

ELMIRE Some women might do otherwise, perhaps,
 But I shall be discreet about your lapse;
 I'll tell my husband nothing of what's occurred
 If, in return, you'll give your solemn word
 To advocate as forcefully as you can
 The marriage of Valère and Mariane,
 Renouncing all desire to dispossess
 Another of his rightful happiness,
 And . . . ■

Reading Question

Why do you suppose that Molière leaves it to the maid of the house to see through Tartuffe's hypocrisy, while the more educated members of the household seem blind to it?

READING 27.2

Anne Bradstreet, "Here Follows Some Verses upon the Burning of Our House, July 10th, 1666" (1667)

This poem is a poignant statement of the author's Puritan faith in the face of terrible personal tragedy. The opening lines, in which Bradstreet confesses her attraction to fire, refer not to the actual burning of her house, but to the day of judgment and the second coming of Christ. The poem then goes on to explore the tension between worldly desires and spiritual salvation.

In silent night when rest I took
For sorrow near I did not look
I wakened was with thund'ring noise
And piteous shrieks of dreadful voice.
That fearful sound of "Fire!" and "Fire!"
Let no man know is my desire.
I, starting up, the light did spy,
And to my God my heart did cry
To strengthen me in my distress
And not to leave me succorless. 10
Then, coming out, beheld a space
The flame consume my dwelling place.
And when I could no longer look,
I blest His name that gave and took,
That laid my goods now in the dust.
Yea, so it was, and so 'twas just.
It was His own, it was not mine,
Far be it that I should repine;
He might of all justly bereft
But yet sufficient for us left. 20
When by the ruins oft I past
My sorrowing eyes aside did cast,
And here and there the places spy
Where oft I sat and long did lie:
Here stood that trunk, and there that chest,
There lay that store I counted best.
My pleasant things in ashes lie,
And them behold no more shall I.
Under thy roof no guest shall sit,
Nor at thy table eat a bit. 30

No pleasant tale shall e'er be told,
Nor things recounted done of old.
No candle e'er shall shine in thee,
Nor bridegroom's voice e'er heard shall
In silence ever shall thou lie,
Adieu, Adieu, all's vanity.
Then straight I 'gin my heart to chide,
And did thy wealth on earth abide?
Didst fix thy hope on mold'ring dust?
The arm of flesh didst make thy trust? 40
Raise up thy thoughts above the sky
That dunghill mists away may fly.
Thou hast an house on high erect,
Framed by that mighty Architect,
With glory richly furnished,
Stands permanent though this be fled.
It's purchased and paid for too
By Him who hath enough to do.
A price so vast as is unknown
Yet by His gift is made thine own; 50
There's wealth enough, I need no more,
Farewell, my pelf, farewell my store.
The world no longer let me love,
My hope and treasure lies above. ∎

Reading Question

In the middle of the poem, Bradstreet points to the places where her former possessions used to rest—"here" and "there." How is the "here" and "there" of the poem transformed in its second half?

Summary

■ **Versailles and the Rise of Absolutism** The court and government of Louis XIV of France were centered at Versailles, the magnificent palace outside Paris designed by Charles Le Brun. André le Nôtre laid out the grounds in the geometric style called the French garden. Both reflected Louis's sense of his own greatness, his absolute authority, and his self-defined position as *Le Roi Soleil*, "the Sun King." He considered himself the embodiment of Apollo, god of the arts, and thus as the supreme patron of the arts, and a ruler by divine right.

■ **The Arts of the French Court** Various members of the court favored one or the other of two competing styles of art, represented by the lush color, loose brushwork, and diagonal compositions of Peter Paul Rubens and by the classical, linear style of Nicolas Poussin. Rubens's paintings, particularly his genre scenes, were frankly sexual, a fact emphasized by his sensual brushwork and color. Poussin, by way of contrast, drew his themes from classical mythology or Christian tradition, and organized his compositions frontally around a vigorous geometry of horizontals and verticals.

Louis indulged his taste for pomp and ceremony in music and dance, and especially entertainments written by Jean-Baptiste Lully. Lully's dramatic operas, or *tragédies en musique*, are notable for seamlessly blending words and music in the rhythms of the French language. Louis also strongly promoted dance, the most important form of which was the minuet.

The classical style of Poussin found expression as well in the French theater with the establishment of the *Comèdie Française*, the French national theater, under a charter granted by Louis. Pierre Corneille dedicated himself to writing "classical" tragedy, based on Greek and Roman themes that alluded to contemporary events. Molière's comedies, such as *Tartuffe*, spared no one from ridicule. Jean Racine wrote such successful tragedies that he became the first French playwright to live entirely on the earnings from his plays.

■ **The Art and Politics of the English Court** The greatest artist of the English court was Anthony van Dyck, who had worked in Rubens's studio as his chief assistant. His great talent was portraiture, but his career as a court painter was complicated by the political climate. Anglican fought Puritan in a civil war led by Oliver Cromwell that overthrew the monarchy. Cromwell ruled England with an iron hand, requiring everyone to obey the "godly laws" of Puritan doctrine. Upon Cromwell's death, the monarchy was restored, but when James II converted to Catholicism, the Puritan population invited William of Orange to invade from Holland and his "Glorious Revolution" established constitutional monarchy in England. The rivalry between "Roundhead" Puritan factions and "Cavalier" royalists did not abate and appeared, especially, in the poetry of the day, as well as in the ribald theater of Wycherley and others.

■ **The Arts of the Spanish Court** Philip IV of Spain strove to rival the other great courts of Europe by employing the greatest painters of the day, including Peter Paul Rubens. The young court painter Diego Velázquez, already deeply influenced by Caravaggio, visited Rubens at work. Velázquez's greatest work is *Las Meninas*, ostensibly a portrait of the royal princess, but a self-portrait as well, and a complex realization of space. Under Philip III and Philip IV, the literary arts thrived, especially in the drama of Lope de Vega and Calderón, as well as in the satires of Quevedo.

■ **The Baroque in the Americas** By the start of the seventeenth century, Lima, Peru, was a fully Baroque city. Inspired by their Inca heritage, native painters decorated their paintings of saints with elaborate *brocateado*. The poet Sor Juana Inés de la Cruz's *villancicos* were complex Baroque musical compositions that exploited the multilingual nature of culture in New Spain. The *retablos*, or altarpiece ensembles, in the churches of Mexico reflect an even more elaborate sense of the Baroque, characterized by gilded *estipite* columns. This style spread throughout the Viceroyalty of Mexico, as far north as San Xavier del Bac, near present-day Tucson, Arizona.

Glossary

absolutism A term applied to strong centralized monarchies that exert royal power over their dominions, usually on the grounds of divine right.

binary form Having a two-part structure.

brocateado The application of gold leaf to canvas.

Cavalier The term for the aristocratic royalist supporters of Charles I.

classical unities The notion, derived from Aristotle's *Poetics*, that requires a play to have only one action that occurs in one place and within one day.

comédie-ballet A drama that is part opera and part ballet.

divertissement An **intermezzo**.

estípite **column** A form of engaged column, narrow at the base and top, wider in the middle, that is constructed of segmented, upside-down and tapered pyramids and other sculpted forms.

French garden A style of formal garden that is characterized by a methodical, geometrical design.

French overture An overture distinguished by a slow homophonic melody (associated with the royal dignity) that built to a faster contrapuntal section.

intermezzo A short display of dance, song, or instrumental music.

masque A type of performance that combined speech, dance, and spectacle.

minuet An elegant triple-time dance of moderate tempo.

retablo A large altarpiece ensemble.

Roundheads Supporters of the Puritan Parliament who cropped their hair short and dressed plainly.

Scientific Revolution A time of major breakthroughs in mathematics, astronomy, geology, physics, chemistry, biology, and medical science, all the result of empirical reasoning.

suite An ordered series of instrumental dances.

tragédie en musique An operatic genre that generally consists of an overture, an allegorical prologue, five acts of sung drama, and many **intermezzos**.

 ## Critical Thinking Questions

1. What compositional features characterize the painting of Peter Paul Rubens, and how do they contrast with the painting of Nicolas Poussin?

2. There are many different gazes that ricochet throughout Velázquez's painting *Las Meninas* and act as focal points. Describe as many of them as you can find.

3. How are Cavalier and Roundhead politics reflected in seventeenth-century English art and poetry?

4. What are some of the ways in which the Baroque style was Indianized by artists in the Americas?

Excess and Restraint

An underlying characteristic of the Baroque age is its ultimate trust in the powers of reason. Major breakthroughs in mathematics, astronomy, geology, physics, chemistry, biology, and medical science dominate the history of the age. These products of empirical reasoning constituted a so-called **Scientific Revolution** that transformed the way the Western mind came to understand its place in the universe.

It may seem odd that painters like Caravaggio, Rubens, and Rembrandt, who appealed to the emotional and dramatic, the sensual and the spectacular, should be products of the same age as the Scientific Revolution. It would seem more reasonable to say that the scientific energies of the age found their painterly expression more in the likes of Poussin than Rubens, their literary expression more in Corneille than Molière. And yet Rembrandt's *Anatomy Lesson of Dr. Tulp* (see chapter 26 *Focus*, pages 852–853) clearly engages the scientific mind, and Rubens's swirling, flowing lines are the product of a mind confident that order and wholeness are the basic underpinnings of experience. In a very real sense, then, Rubens and Rembrandt, Molière and Wycherley, Calderón and Quevedo, can best be understood in terms of their ability to look beneath the surface of experience for the human truths that motivate us all. Their work—like the autobiographical writings of Montaigne in the sixteenth century—announces the dawn of modern psychology.

Still, the Baroque age does embody a certain tension between reason and emotion, decorum and excess, clearly defined in the contest between the *poussinistes* and the *rubenistes* for ascendancy in the arts. This tension is evident in an engraving that shows Louis XIV visiting the Académie des Sciences in 1671 (Fig. **27.22**). Following the lead of King Charles II of England, who had chartered the Royal Society in 1662, Louis created the French Academy of Sciences in 1666. He stands surrounded by astronomical and scientific instruments, charts and maps, skeletal and botanical specimens. Out the window, the ordered geometry of a classical French garden dominates the view. At the same time, Louis seems alien to his surroundings. Decked out in all his ruffles, lace, ribbons, and bows, he is the very image of ostentatious excess. The tension he embodies will become a defining characteristic of the following century. In the next two chapters we will examine the tension in the eighteenth century between the demands of reason, the value that defines the so-called Enlightenment, and the limits of excess, the aristocratic style that has come to be known as the Rococo. Both equally were the product of the Baroque age that precedes them. ∎

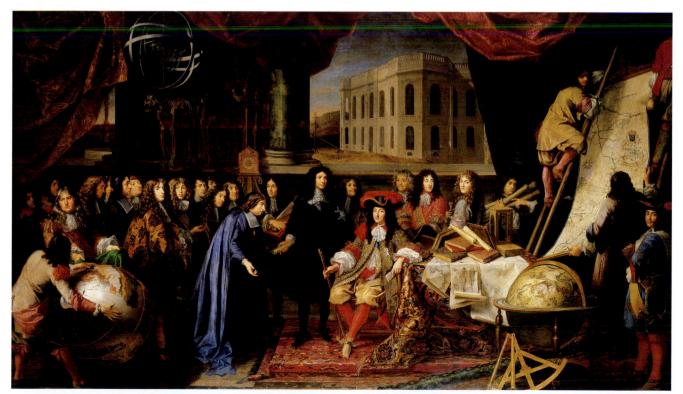

Fig. 27.22 Henri Testelin. *Jean-Baptiste Colbert Presenting the Members of the Royal Academy of Science to Louis XIV.* ca. **1667**. Oil on canvas. © Chateau de Versailles, France/Lauros/Giraudon/The Bridgeman Art Library.

28 The Rise of the Enlightenment in England

The Claims of Reason

The New London: Toward the Enlightenment

The English Enlightenment

Literacy and the New Print Culture

❝ *Know then thyself, presume not God to scan;*

The proper study of Mankind is Man. **❞**

Alexander Pope, *An Essay on Man*

← **Fig. 28.1 Canaletto. *London: The Thames and the City of London from Richmond House* (detail). 1747.** Oil on canvas, 44 ⁷/₈″ × 39³/₈″. Trustees of the Goodwood House, West Sussex, UK. From May 1746 until at least 1755, interrupted by only two visits to Venice in 1750–1751 and 1753–1754, the Venetian painter Canaletto occupied a studio in Beak Street, London. The geometric regularity and perspectival inventiveness of his paintings reflect the Enlightenment's taste for rationality. But his sense of grandeur and scale is, like Louis XIV's Versailles (see chapter 27), purely aristocratic.

LONDON, THE CITY OF ELEGANCE AND REFINEMENT PAINTED

in 1747 by Venetian master of cityscapes Canaletto (Giovanni Antonio Canal; 1697–1768), was rivaled only by Paris, across the Channel, as the center of European intellectual culture in the eighteenth century (Fig. **28.1**). Neither the map showing

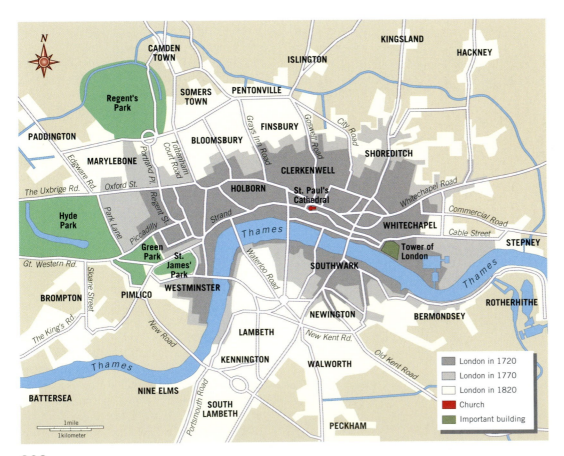

the growth of London from 1720 to 1820 (Map **28.1**) nor Canaletto's painting offers any hint that the city had been devastated by fire 80 years earlier. Before dawn on the morning of September 2, 1666, a baker's oven exploded on Pudding Lane in London. A strong east wind hastened the fire's spread until, by morning, some 300 houses were burning (Fig. **28.2**). In his private diaries, Samuel Pepys [peeps] (1633–1703) recorded what he saw on that fateful day:

> I rode down to the waterside, . . . and there saw a lamentable fire. . . . Everybody endeavoring to remove their goods, and flinging into the river or bringing them into lighters that lay off; poor people staying in their houses as long as till the very fire touched them, and then running into boats, or clambering from one pair of stairs by the waterside to another. . . .

[I hurried] to [Saint] Paul's; and there walked along Watling Street, as well as I could, every creature coming away laden with goods to save and, here and there, sick people carried away in beds. Extraordinary goods carried in carts and on backs. At last [I] met my Lord Mayor in Cannon Street, like a man spent, with a [handkerchief] about his neck. . . . "Lord, what can I do? [he cried] I am spent: people will not obey me. I have been pulling down houses, but the fire overtakes us faster than we can do it." . . . So . . . I . . . walked home; seeing people all distracted, and no manner of means used to quench the fire. The houses, too, so very thick thereabouts, and full of matter for burning, as pitch and tar, in Thames Street; and warehouses of oil and wines and brandy and other things.

From Samuel Pepys, *Diary* (September 2, 1666)

Map 28.1 The growth of London 1720–1820.

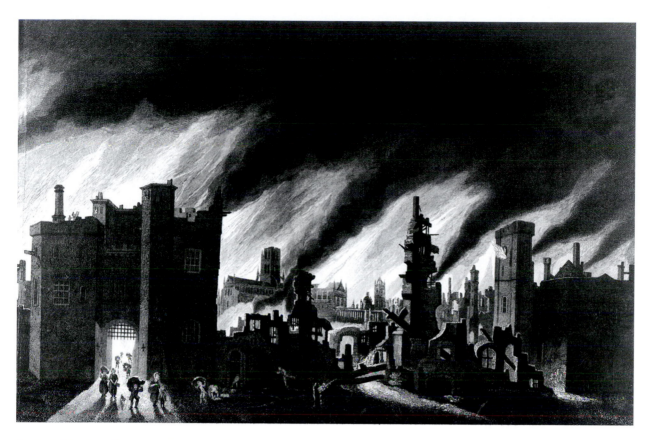

Fig. 28.2 *The Great Fire, 1666.* Engraving. The tower in the middle is Old Saint Paul's. It too would be destroyed. In the words of John Evelyn, "The stones of St. Paules flew like grenados, the Lead mealting down the streetes in a streame and the very pavements of them glowing with fiery rednesse, so as no horse, nor man, was able to tread on them."

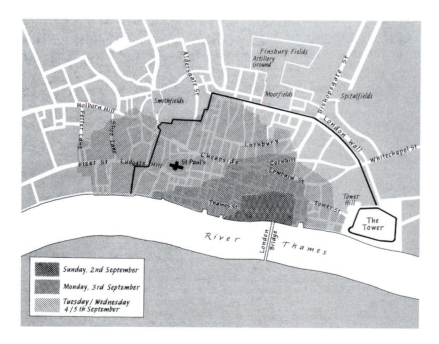

Map 28.2 The spread of the Great Fire from 2 to 5 September 1666. From Roy Porter, *London: A Social History* (New York: Penguin Books, 1996), p. 86. Reproduced by permission. Porter's highly represented history informs much of the discussion concerning England in these pages.

The fire in these warehouses so fueled the blaze that over the course of the next two days it engulfed virtually the entire medieval city and beyond (Map **28.2**). Almost nothing was spared. About 100,000 Londoners were left homeless. Eighty-seven churches had burned. Businesses, particularly along the busy wharves on the north side of the Thames, were bankrupted. Taken together with the Great Plague that had killed some 70,000 Londoners just the year before, John Evelyn, one of the other great chroniclers of the age, summed up the situation in what amounts to typical British understatement: "London was, but is no more."

Such devastation was both a curse and a blessing. While the task of rebuilding London was almost overwhelming, the fire gave the city the opportunity to modernize its center in a way that no other city in the world could even imagine. By 1670, almost all the private houses destroyed by the fire had been rebuilt, and businesses were once again thriving. Over the course of the next century, the city would

CULTURAL PARALLELS

Growth and Commerce in London and China

Even as London's population grew dramatically in the seventeenth century, leading to commercial opportunities as well as social problems, similar processes were unfolding in China, across the globe. Rapid demographic growth and increased foreign trade allowed entrepreneurs to take advantage of China's large and mobile labor force. They flocked to Nanjing, Hangzhou, and Beijing, bringing tremendous prosperity and a lively popular culture.

prosper as much or more than any other city in the world, so that by the middle of the eighteenth century it would come to look so beautiful that Canaletto had to muster every bit of his skill to capture its grandeur (see Fig. 28.1). "London," as one writer put it, "is the centre to which almost all the individuals who fill the upper and middle ranks of society are successively attracted. The country pays its tribute to the supreme city."

This chapter surveys developments in London, the literary center of what would come to be known as the Age of Enlightenment. Across Europe intellectuals began to advocate rational thinking as the means to achieving a comprehensive system of ethics, aesthetics, and knowledge. The rationalist approach owed much to scientist Isaac Newton (1642–1727), who in 1687 demonstrated to the satisfaction of just about everyone that the universe was an intelligible system, well ordered in its operations and guiding principles. The workings of human society—the production and consumption of manufactured goods, the social organization of families and towns, the functions of national governments, even the arts—were believed to be governed by analogous universal laws. The intellectuals of Enlightenment England thought of themselves as the guiding lights of a new era of progress that would leave behind, once and for all, the irrationality, superstition, and tyranny that had defined Western culture, particularly before the Renaissance. The turmoil that had led to Civil War in 1642 to 1648 was followed in 1688 by a bloodless "Glorious Revolution," the implementation of a Bill of Rights, and the establishment of a constitutional monarchy, all of which seemed proof that reason could triumph over political and religious intolerance. Still, recognizing that English society was deeply flawed, they also satirized it, attacking especially its aristocracy. At the same time, an expanding publishing industry and an increasingly literate public offered Enlightenment writers the opportunity to instruct their readers in moral behavior, even as they described English vice in prurient detail.

The New London: Toward the Enlightenment

After the Great Fire, architect Christopher Wren (1632–1723) proposed a grand redesign scheme that would have replaced the old city with wide boulevards and great squares. But the need to quickly rebuild the city's commercial infrastructure made his plan impractical, and each property owner was essentially left to his own devices.

Nevertheless, certain real improvements were made. Wood construction was largely banned; brick and stone were required. New sewage systems were introduced, and streets had to be at least 14 feet wide. Just a year after the fire, in a poem celebrating the devastation and reconstruction, "Annus Mirabilis" ("year of wonders"), the poet John Dryden (1631–1700) would equate London to the mythological Phoenix rising from its own ashes, reborn: "a wonder to all years and Ages . . . a *Phoenix* in her ashes." Moved by the speed of the city's rebuilding, Dryden is sublimely confident in London's future. Under the rule of Charles II, the city would become even greater than before (**Reading 28.1**):

READING 28.1 from John Dryden, "Annus Mirabilis," 1667

More great than human, now, and more august,[1]
New-deified she from her fires does rise:
Her widening streets on new foundations trust,
And, opening, into larger parts she flies. . . .

Now like the maiden queen, she will behold
From her high turrets, hourly suitors come:
The East with incense, and the West with gold,
Will stand like suppliants, to receive her doom.

[1] Augusta, the old name of London.

For Dryden, the Great Fire was not so much a disaster as a gift from God. And Charles II must have thought so as well, for as a way of thanking Dryden for the poem, the king named him poet laureate of the nation in 1668.

Although Christopher Wren's plans to redesign the entire London city center after the Great Fire proved impractical, he did receive the commission to rebuild 52 of the churches destroyed in the blaze. Rising above them all was Saint Paul's Cathedral (Fig. 28.3), a complex yet orderly synthesis of the major architectural styles of the previous 150 years (see *Focus*, pages 902–903). According to Wren's son, "a memorable omen" occurred on the occasion of his father's laying the first stone on the ruins of the old cathedral in 1675:

When the SURVEYOR in Person [Wren himself, in his role as King's Surveyor of Works] had set out, upon the Place, the Dimensions of the great Dome and fixed upon the centre; a common Labourer was ordered to bring a flat stone from the Heaps of Rubbish . . . to be laid for a Mark and Direction to the Masons; the Stone happened to be a piece of Grave-stone, with nothing remaining on the Inscription but the simple word in large capitals, RESURGAM [the Latin for "REBORN"].

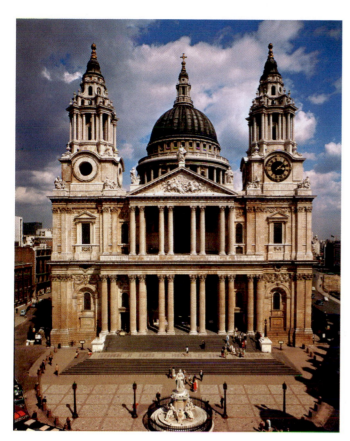

Fig. 28.3 **Christopher Wren. Saint Paul's Cathedral, London, western facade. 1675–1710.** A statue of Saint Paul stands on top of the central portico, flanked by statues of Saint John (*right*) and Saint Peter (*left*). The sculptural detail in the portico pediment depicts the conversion of Paul following his vision on the road to Damascus.

"RESURGAM" still decorates the south transept of the cathedral above a figure of a phoenix rising from the ashes.

Something of the power of Wren's conception can be felt in Canaletto's view of *The Thames and the City of London from Richmond House* (see Fig. 28.1). The cathedral does indeed rise above the rest of the city, not least because, in rebuilding, private houses had been limited to four stories. Only other church towers, almost all built by Wren as well, rise above the roof lines, as if approaching the giant central structure in homage.

Absolutism Versus Liberalism: Thomas Hobbes and John Locke

The new London was, in part, the result of the rational empirical thinking that dominated the Royal Society (see chapter 26). Following the Civil War and the Restoration, one of the most pressing issues of the day was how best to govern the nation, and one of the most important points of view had been published by Thomas Hobbes [hobz] (1588–1679) in 1651, in *Leviathan; or the Matter, Forme, and Power of a Commonwealth, Ecclesiasticall and Civil* (Fig. **28.4**). His classical

training had convinced Hobbes that the reasoning upon which Euclid's geometry was based could be extended to political and social systems. A visit to Galileo in Italy in 1636 reaffirmed that Galileo's description of the movement of the solar system—planets orbiting the central sun—could be extended to human relations—a people orbiting their ruler. Hobbes argued that people are driven by two things—the fear of death at someone else's hands and the desire for power—and that the government's role is to check both of these instincts, which if uncontrolled would lead to anarchy. Given the context in which *Leviathan* was written—the English Civil War had raged throughout the previous decade— Hobbes's position is hardly surprising. Most humans, Hobbes believed, recognize their own essential depravity and therefore willingly submit to governance. They accept the **social contract**, which means giving up sovereignty over themselves and bestowing it on a ruler. They carry out the ruler's demands, and the ruler, in return, agrees to keep the peace.

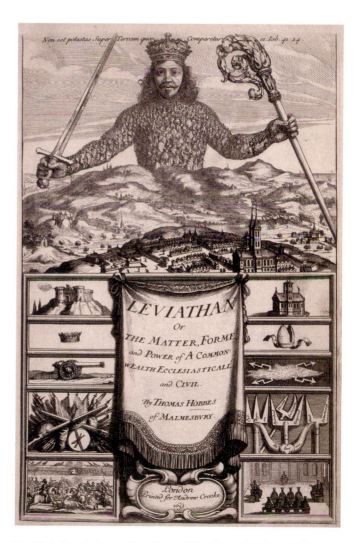

Fig. 28.4 **Frontispiece to *Leviathan*. 1651.** Bancroft Library, Berkeley, CA. At the top of the image, the body of the king is composed of hundreds of his subjects. Below his outstretched arms holding sword and scepter, the world is orderly and peaceful.

Focus

Christopher Wren's Saint Paul's Cathedral

Saint Paul's is the first cathedral ever built for the Anglican Church of England. It rises above the foundations of an earlier church destroyed in the Great Fire of London in 1666. In its design, architect Christopher Wren drew on classical, Gothic, Renaissance, and Baroque elements. Its imposing two-story facade is crowned by symmetrical twin clock towers and a massive dome. The floor plan—an elongated, cruciform (crosslike) design—is Gothic. The dome is Renaissance, purposefully echoing Bramante's Tempietto (see Fig. 18.6)

but maintaining the monumental presence of Michelangelo's dome for Saint Peter's (see Fig. 18.7). The facade, with its two tiers of paired Corinthian columns, recalls the French Baroque Louvre in Paris (see Fig. 25.22). And the two towers are inspired by a Baroque church in Rome. Wren manages to bring all these elements together into a coherent whole.

The church was laid out so that the congregation would directly face the sunrise on Easter morning, metaphorically revisiting the resurrection itself. Rather

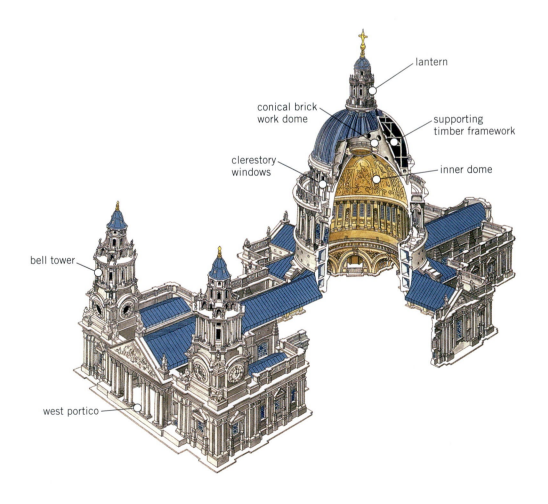

lantern

conical brick work dome

supporting timber framework

clerestory windows

inner dome

bell tower

west portico

than its ornamentation, the geometry of the building—especially the relationships established between geometric units—was at the heart of Wren's design. Notice the extraordinarily refined symmetry of the whole, particularly the relationships of the paired free-standing columns and the square embedded ones on the western facade (see Fig. 28.3). As Wren himself would write, "It seems very unaccountable that the generality of our late architects dwell so much on the ornamental, and so lightly pass over the geometrical, which is the most essential part of architecture." This reliance on geometric regularity is wholly consistent with Enlightenment thinking, reflecting Newton's description of the universe as an intelligible system, well ordered in its operations and guiding principles.

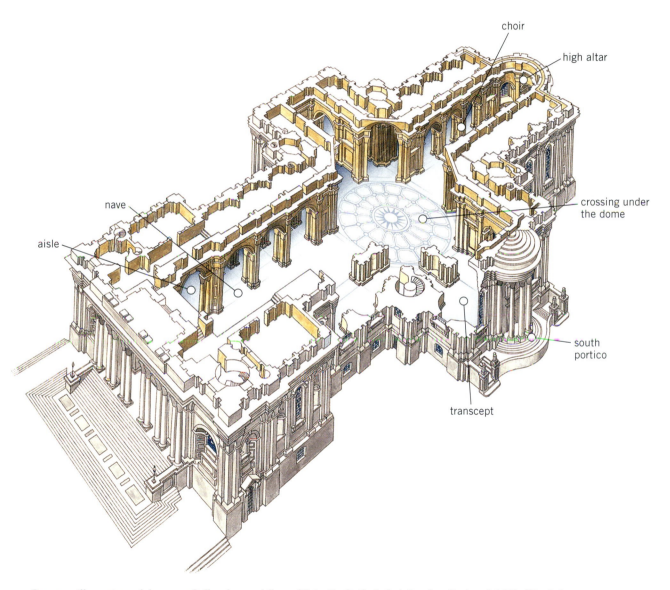

Cut-away illustrations of the outer shell and ground floor of Saint Paul's Cathedral, London. Designed 1675. Wren's dome transforms the relatively small scale of Bramante's Tempietto into monumental space. It is some 102 feet in diameter, spanning both nave and side aisles, and rises 366 feet to the top of the lantern cross (only Saint Peter's is higher, at 405 feet). The dome itself is a triple layer construction. The outer dome or shell is made of timber, covered with lead sheathing. A hidden central dome, conical in shape and made of brick, supports the outer shell and, with the help of iron bands, the lantern, ball, and cross at the top of the building as well. The inner dome—the dome viewed by the congregation—is made of light brick and is decorated with a *trompe l'oeil* representation of the heavens.

CULTURAL PARALLELS

Crisis in Holland

Within a few years of London's plague and fire of the mid-1660s, the city of Amsterdam underwent its own major crises, when France, England, and Spain attacked the Dutch as a result of a long series of diplomatic disagreements. The Dutch ultimately prevailed by opening their dikes and inundating the countryside around Amsterdam. The city and the Dutch Republic were saved, and Amsterdam, after a brief downturn economically and politically, resumed its place as the financial center of the European mainland.

Humankind's only hope, Hobbes argued (see **Reading 28.2**, pages 920–921), is to submit to a higher authority, the "Leviathan" [luh-VY-uh-thun], the biblical sea monster who is the absolutist "king over all the sons of pride" (Job 41:34).

John Locke (1632–1704) disagreed. In his 1690 *Essay on Human Understanding*, Locke repudiated Hobbes, arguing that people are perfectly capable of governing themselves. The human mind at birth, he claimed, is a *tabula rasa*, a "blank slate," and our environment—what we learn and how we learn it—fills this slate (**Reading 28.3**):

READING 28.3 from Locke's *Essay on Human Understanding* (1690)

1. Idea is the object of thinking. Every man being conscious to himself that he thinks; and that which his mind is applied about whilst thinking being the ideas that are there, it is past doubt that men have in their minds several ideas—such as are those expressed by the words whiteness, hardness, sweetness, thinking, motion, man, elephant, army, drunkenness, and others: it is in the first place then to be inquired, How he comes by them? . . .

2. All ideas come from sensation or reflection. Let us then suppose the mind to be, as we say, white paper, void of all characters, without any ideas—How comes it to be furnished? Whence comes it by that vast store which the busy and boundless fancy of man has painted on it with an almost endless variety? Whence has it all the materials of reason and knowledge? To this I answer, in one word, from EXPERIENCE. In that all our knowledge is founded; and from that it ultimately derives itself. Our observation employed either, about external sensible objects, or about the internal operations of our minds perceived and reflected on by ourselves, is that which supplies our understandings with all the materials of thinking. These two are the fountains of knowledge, from whence all the ideas we have, or can naturally have, do spring.

3. The objects of sensation one source of ideas. First, our Senses, conversant about particular sensible objects, do convey into the mind several distinct perceptions of things . . . [and] thus we come by those ideas we have of yellow, white, heat, cold, soft, hard, bitter, sweet, and all those which we call sensible qualities. . . .

4. The operations of our minds, the other source of them. Secondly, the other fountain from which experience furnisheth the understanding with ideas, is the perception of the operations of our own mind within us, as it is employed about the ideas it has got; which operations, when the soul comes to reflect on and consider, do furnish the understanding with another set of ideas, which could not be had from things without. And such are perception, thinking, doubting, believing, reasoning, knowing, willing, and all the different actings of our own minds. . . .

Given this sense that we understand the world through experience, if we live in a reasonable society, it should follow, according to Locke's notion of the *tabula rasa*, that we will grow into reasonable people. In his *Second Treatise of Government* (see **Reading 28.4**, pages 922–923), also published in 1690, Locke went further. He refuted the divine rights of kings and argued that humans are "by nature free, equal, and independent." They agree to government in order to protect themselves, but the social contract they admit to does not require them to surrender their own sovereignty to their ruler. The ruler has only limited authority that must be held in check by a governmental system balanced by a separation of powers. Finally, they expect the ruler to protect their rights, and if the ruler fails, they have the right to revolt in order to reclaim their natural freedom. This form of **liberalism**—literally, from the Latin, *liberare*, "to free"—sets the stage for the political revolutions that will dominate the world in the eighteenth and nineteenth centuries. (See chapters 31, 32, and 36.)

John Milton's *Paradise Lost*

The debate between absolutism and liberalism also informs what is arguably the greatest poem of the English seventeenth century, *Paradise Lost* by John Milton (1608–1674). Milton had served in Oliver Cromwell's government during the Commonwealth. (He had studied the great epics of classical literature, and he was determined to write his own, one which would, as he puts it in the opening verse of the poem, "justifie the wayes of God to men.") In 12 books, Milton composed a densely plotted poem with complex character development, rich theological reasoning, and long wavelike sentences of blank verse. The subject of the epic is the Judeo-Christian story of the loss of Paradise by Adam and Eve and their descendents. As described in the Bible, the couple, enticed by Satan, disobey God's injunction that they not eat the fruit of the Tree of Knowledge. Satan had revolted against God and then sought to destroy humanity.

While occasionally virulently anti-Catholic, the poem is, among other things, a fair-minded essay on the possibilities of liberty and justice. In many ways, God assumes the position of royal authority that Hobbes argues for in his *Leviathan*. In Book 5 of Milton's poem, God sends the angel Raphael to Adam to warn him of the nearness of Lucifer (Satan) and to explain how Lucifer became God's enemy. Raphael recounts how God had addressed the angels to announce that he now had a son, Christ, whom all should obey as if he were God, and he did so with the authority of hereditary kingship (**Reading 28.5a**):

READING 28.5a **from John Milton, *Paradise Lost*, Book 5 (1667)**

"Hear all ye angels, Progeny of Light,
Thrones, Dominations, Princedoms, Virtues, Powers,
Hear my Decree, which unrevoked shall stand.
This day I have begot whom I declare
My only Son, and on this holy hill
Him have anointed, whom ye now behold
At my right hand; your head I him appoint;
And by my Self have sworn to him shall bow
All knees in heav'n, and shall confess him Lord."

Lucifer, formerly God's principal angel, is not happy about the news of this new favorite. Motivated by his own desire for power, he gathers the angels loyal to him, and addresses them in terms more in the spirit of Locke than Hobbes. He begins his speech as God had begun his, invoking the imperial titles of those present; he reminds them, "which assert / Our being ordain'd to govern, not to serve" (**Reading 28.5b**):

READING 28.5b **from John Milton, *Paradise Lost*, Book 5 (1667)**

Thrones, Dominations, Princedoms, Virtues, Powers,
If these magnific titles yet remain
Not merely titular, since by decree
Another now hath to himself engrossed
All power, and us eclipsed under the name
Of King anointed. . . .

Will ye submit your necks, and choose to bend
The supple knee? ye will not, if I trust
To know ye right, or if ye know yourselves
Natives and sons of heav'n possessed before
By none, and if not equal all, yet free,
Equally free; for orders and degrees
Jar not with liberty. . . .

Who can in reason then or right assume
Monarchy over such as live by right
His equals, if in power and splendor less,
In freedom equal?

Lucifer's is a "reasonable" argument. Like Locke, he thinks of himself and the other angels as "by nature free, equal, and independent." The battle that ensues between God and Lucifer (see **Reading 28.5**, pages 923–925) is reminiscent of the English Civil War, with its complex protagonists, its councils, and its bids for leadership on both sides. It results in Lucifer's expulsion from Heaven to Hell, where he is henceforth known as Satan. While many readers understood God as a figure for the Stuart monarchy, and Satan as Cromwell, it is not necessary to do so in order to understand the basic tensions that inform the poem. The issues that separate God from Satan are clearly the issues dividing England in the seventeenth century: the tension between absolute rule and the civil liberty of the individual.

The English Enlightenment

Under the rule of William and Mary, the turmoil that had marked British political life for at least a century was replaced by a period of relative stability. The new king and queen moved quickly to reaffirm the Habeas Corpus Act, passed during the reign of Charles II in 1679. The act required a warrant for the arrest of anyone, detailing the reasons for the arrest, and the right to a speedy trial. It was a revolutionary abridgement of royal power. At least since the time of Henry VIII, English kings had imprisoned their enemies—or their suspected enemies—for as long as they liked without a trial. Parliament also passed a Bill of Rights, guaranteeing that no Catholic could ever rule England and no British king could ever marry a Catholic. Additionally, it required monarchs to obey the law like other British citizens, and banned them from raising taxes without the consent of Parliament. The Toleration Act provided Puritans with the freedom to worship as they chose, though neither Puritans nor Roman Catholics were allowed to hold positions in the government or attend universities. By the middle of the 1690s, the royal privilege of press censorship was permanently abandoned.

As royal power was being curtailed, Parliament also brought the succession of the monarchy under the rule of law. The Settlement Act of 1701 provided for the peaceful succession of the English crown. The act named Anne, Mary's younger sister, as heir to the throne upon William's death (Mary had died of smallpox in 1694), and, following Anne, should none of her children survive her (and in fact none did), the Protestant House of Hanover in Germany would succeed to the throne on England. Anne succeeded William in 1702, and upon her death, in 1714, George I, who spoke only German at the time, became King of England.

Even before George assumed the throne, Parliament's two factions, the Whigs and the Tories, had been at odds. The Whig faction tended to support constitutional monarchy as opposed to absolutism, and non-Anglican Protestants, such as the Presbyterians. The Tories tended to support the Anglican church and English gentry. Naturally, they preferred a strong monarchy, while the Whigs favored Parliament retaining final

sovereignty. Nevertheless, the Whigs gained favor with George, and so, when he assumed the throne, George was predisposed to the Whigs and to their leading the government. For the next 40 years, the Whigs had access to public office and enjoyed royal patronage, and the Tories were effectively eliminated from public life. The end result was that Whig leadership, chiefly that of Robert Walpole (1676–1745), who can be regarded as the first English prime minister and who dominated the English political scene from 1721 to 1742, was consistent and predictable. Nothing could have fostered the Enlightenment more. Above all else, England's transformation from a state in near chaos to one in comparative harmony demonstrated what is probably the fundamental principle of Enlightenment thought—that social change and political reform are not only desirable but possible.

Satire: Enlightenment Wit

Not every Englishman was convinced that the direction England was heading in the eighteenth century was for the better. London was a city teaming with activity; Canaletto's painting (see Fig. 28.1) was an idealized view of city life. Over the course of the eighteenth century, the rich and the middle class largely abandoned the city proper, moving west into present-day Mayfair and Marylebone, and even to outlying villages such as Islington and Paddington. At the start of the century these villages were surrounded by meadows and market gardens, but by century's end they had been absorbed into an ever-growing suburbia (see Map 28.1).

In the heart of London, a surging population of immigrants newly arrived from the countryside filled the houses abandoned by the middle class, which had been subdivided into tenements. The very poor lived in what came to be called the East End, a semicircle of districts surrounding the area that extended from Saint Paul's in the west to the Tower of London in the East (the area contained by the old London Wall). Here, in the neighborhoods of Saint Giles, Clerkenwall, Spitalfields, Whitechapel, Bethnal Green, and Wapping, the streets were narrow and badly paved, the houses old and constantly falling down, and drunkenness, prostitution, pickpocketing, assault, and robbery were the norm. On the outer edges, pig keepers and dairymen labored in a landscape of gravel pits, garbage dumps, heaps of ashes, and piles of horse manure.

Whatever the promise offered by the social order established by Robert Walpole and the Georgian government, thoughtful, truly enlightened persons could look beneath the surface of English society and detect a cauldron of social ferment and moral bankruptcy. By approaching what might be called the "dark side" of the Enlightenment and exposing it to all, dissenting writers and artists like William Hogarth (1697–1764), Jonathan Swift (1667–1745), and Alexander Pope (1688–1744) believed they might, by means of irony and often deadpan humor that marks their satire, return England to its proper path.

Hogarth and the Popular Print By 1743, thousands of Londoners were addicted to gin, their sole means of escape from the misery of poverty. In 1751, just four years after Canaletto painted his view of *The Thames and the City of London from Richmond House* (see Fig. 28.1), William Hogarth published *Gin Lane*, a print that illustrated life in the gin shops (Fig. **28.5**). In the foreground a man so emaciated by drink that he seems a virtual skeleton lies dying, half-naked, presumably having pawned the rest of his clothes. A woman takes snuff on the stairs as her child falls over the railing beside her. At the door to the thriving pawnshop behind her, a carpenter sells his tools, the means of his livelihood, as a woman waits to sell her kitchen utensils, the means of her nourishment. In the background, a young woman is laid out in a coffin, as her child weeps beside her. A building comes tumbling down, a man parades down the street with a bellows on his head and a child skewered on his staff—an allegorical if not realistic detail. In the top story of the building on the right, another man has hanged himself. At the lower left, above the door to the Gin Royal, one of the only buildings in good condition, are these words: "Drunk for a penny/ Dead drunk for two pence/ Clean Straw for Nothing."

In *Gin Lane*, Hogarth turned his attention, not to the promise of the English Enlightenment, but to the reality of London at its worst. He did so with the savage wit and broad humor that marks the best social satire. And he did so with the conviction that his images of what he called "modern moral subjects" might not only amuse a wide audience, but would influence that audience's behavior as well. Hogarth usually painted his subjects first, but recognizing the limited audience of a painting, he produced engraved versions of them for wider distribution. "As the Subjects of these Prints are calculated to reform some reigning Vices peculiar to the lower Class of People, in hopes to render them of the most extensive use," wrote Hogarth in his advertisement for them, "the Author has publish'd them in the cheapest Manner possible." In other words, Hogarth recognized that his work appealed to a large popular audience, and that by distributing engravings of his works he might make a comfortable living entertaining it.

A successful engraving had to sell enough impressions to pay for its production and earn a profit for its maker, who was not usually the artist. Before Hogarth's time British printmakers had kept most of the profits from an illustration. But Hogarth marketed his prints himself by means of illustrated subscription tickets, newspaper advertisements, and broadsides, and kept the profits. Especially popular were three series of prints, each telling a different tale devised by Hogarth. One of the series, *Marriage à la Mode* [ah-luh-moad], was produced as both one-of-a-kind paintings and a subscription series of engravings. In six images, the series tells the story of a marriage of convenience between the son of a bankrupt nobleman, the Earl of Squanderfield, and the daughter of a wealthy tradesman. The moral bankruptcy of British society—not just the poor—is Hogarth's subject.

His **caricature**—a portrait that exaggerates each person's peculiarities or defects—of each of his cast of characters is underscored by their names: Squanderfield, Silvertongue,

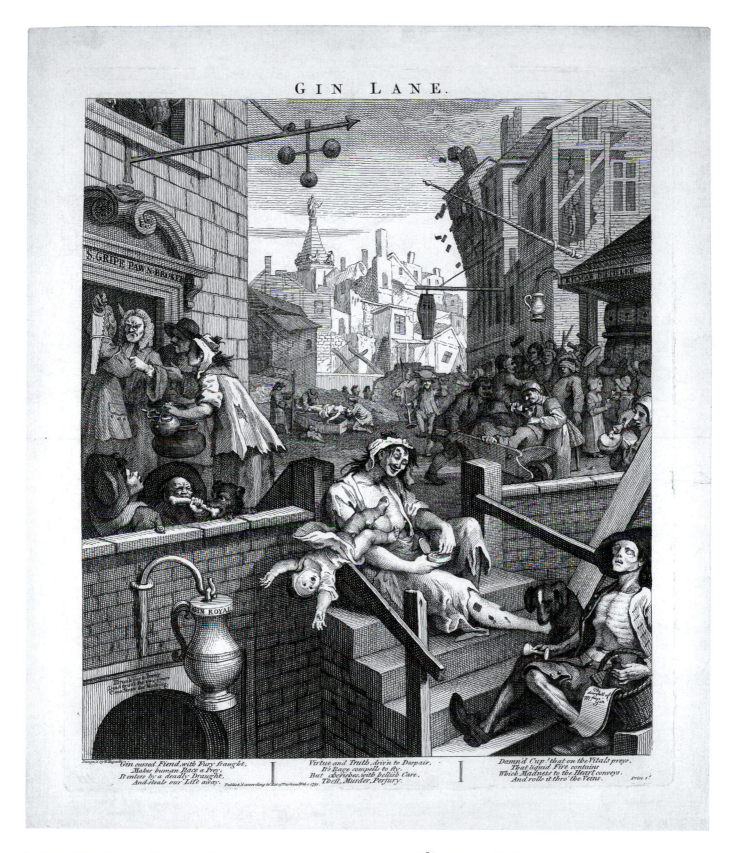

Fig. 28.5 William Hogarth. *Gin Lane.* **1751.** Engraving and etching, third state, 14″ × 11⅞″. Copyright The Trustees of the British Museum, London/Art Resource, NY. In his *Autobiographical Notes*, Hogarth wrote: "In gin lane every circumstance of its [gin's] horrid effects are brought to view; nothing but Idleness, Poverty, misery, and ruin are to be seen . . . not a house in tolerable condition but Pawnbrokers and the Gin shop."

and so on. The loveless couple is sacrificed to the desires of their parents, for money or social position, and the results of this union go from bad to worse. By the time we arrive at the fourth image, *The Countess's Levée* [luh-VAY], or *Morning Party* (Fig. **28.6**), which encapsulates the morning ritual of the young wife, the moral depravity of the couple's lifestyle is clear. An Italian *castrato* [kah-STRAH-toh]—a singer castrated in his youth so that he might retain his high voice—sings to the inattentive crowd, accompanied by his flautist. Next to them, a hanger-on with his hair in curlers sips his tea. The lady of the house listens attentively to her illicit lover Silvertongue, the family lawyer, whose portrait overlooks the room. Below them, a black child-servant points to a statue of Actaeon. (In classical mythology, Actaeon was a hunter who was transformed into a stag for having observed the goddess Diana bathing. His horns traditionally signify a cuckold, a man whose wife is unfaithful.)

The Satires of Jonathan Swift Perhaps the most biting satirist of the English Enlightenment was Jonathan Swift. In

a letter to fellow satirist and friend Alexander Pope, Swift confided that he hated the human race for having misused its capacity for reason simply to further its own corrupt self-interest. After a modestly successful career as a satirist in the first decade of the eighteenth century, Swift was named dean of Saint Patrick's Cathedral in Dublin in 1713, and it was there that he wrote his most famous works, *Gulliver's Travels*, published in 1726, and the brief, almost fanatically savage *A Modest Proposal* in 1729. There, reacting to the terrible poverty he saw in Ireland, Swift proposed that Irish families who could not afford to feed their children breed them to be butchered and served to the English. (Swift's text is **Reading 28.6**, pages 925–928.)

In *Gulliver's Travels*, Swift's satire is less direct. Europeans were familiar with the accounts of travelers' adventures in far-off lands at least since the time of Marco Polo, and after the exploration of the Americas, the form had become quite common. Swift played off the travel adventure narrative to describe the adventures of one Lemuel Gulliver as he moves among lands peopled by miniature people, giants, and other

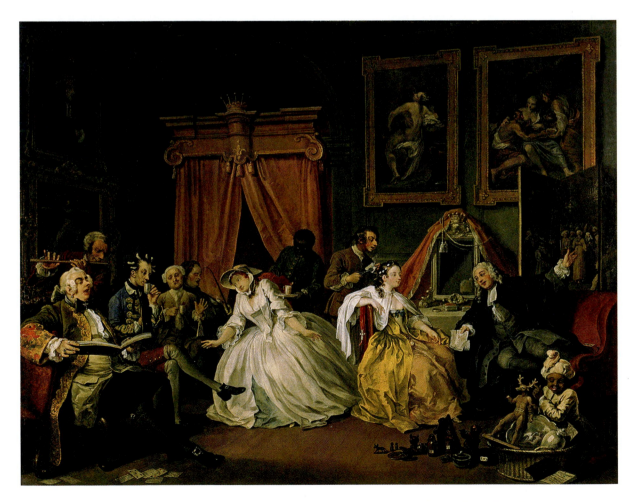

Fig. 28.6 William Hogarth. *The Countess's Levée,* or *Morning Party*, from *Marriage à la Mode*. 1743–1745. Oil on canvas, 27″ × 35″. The National Gallery, London. The reproductions on the wall tell us much about the sexual proclivities of the Countess and her court. Those directly above the Countess are Correggio's *Jupiter and Io* (see Figure 22.10) and a representation of Lot's seduction by his daughters. On the table between the Countess and Silvertongue is a French pornographic novel.

fabulous creatures. But Swift employs his imaginary peoples and creatures to comment on real human behavior. In Book I, the Lilliputians, a people that average 6 inches in height, are "little people" not just physically but ethically. In fact, their politics and religion are very much those of England, and they are engaged in a war with a neighboring island that very closely resembles France. Swift's strategy is to reduce the politics of his day to a level of triviality. In Book IV, Gulliver visits Houyhnhnms, a country of noble horses whose name sounds like a whinnying horse and is probably pronounced *hwinnum*. Gulliver explains that "the word *Houyhnhnm*, in their tongue, signifies a *horse*, and, in its etymology, *the perfection of nature*." Their ostensible nobility contrasts with the bestial and degenerate behavior of their human-looking slaves, the Yahoos. Of course, Gulliver resembles a Yahoo as well. At one point, Gulliver's Houyhnhnm host compliments him, saying "that he was sure I must have been born of some noble family, because I far exceeded in shape, colour, and cleanliness, all the yahoos of his nation." Gulliver's response is a model of Swift's satiric invective (**Reading 28.7**):

I made his Honour my most humble acknowledgments for the good opinion he was pleased to conceive of me, but assured him at the same time, "that my birth was of the lower sort, having been born of plain honest parents, who were just able to give me a tolerable education; that nobility, among us, was altogether a different thing from the idea he had of it; that our young noblemen are bred from their childhood in idleness and luxury; that, as soon as years will permit, they consume their vigor, and contract odious diseases among lewd females; and when their fortunes are almost ruined, they marry some woman of mean birth, disagreeable person, and unsound constitution (merely for the sake of money), whom they hate and despise. That the productions of such marriages are generally scrofulous, rickety, or deformed children; by which means the family seldom continues above three generations, unless the wife takes care to provide a healthy father, among her neighbours or domestics, in order to improve and continue the breed. That a weak diseased body, a meager countenance, and sallow complexion, are the true marks of noble blood; and a healthy robust appearance is so disgraceful in a man of quality, that the world concludes his real father to have been a groom or a coachman. The imperfections of his mind run parallel with those of his body, being a composition of spleen, dullness, ignorance, caprice, sensuality, and pride.

Gulliver's Travels was an immediate best-seller, selling out its first printing in less than a week. "It is universally read," said his friend, Alexander Pope, "from the cabinet council to the nursery." So enduring is Swift's wit that names of his characters and types have entered the language as descriptive terms—"yahoo" for a coarse or uncouth person, "Lilliputian" for anything small and delicate.

The Classical Wit of Alexander Pope The English poet Alexander Pope shared Swift's assessment of the English nobility. For 12 years, from 1715 until 1727, Pope spent the majority of his time translating Homer's *Iliad* and *Odyssey*, and producing a six-volume edition of Shakespeare, projects of such popularity that he became a wealthy man. But in 1727, his literary career changed directions and, as he wrote, he "stooped to truth, and moralized his song"—he turned, in short, to satire. His first effort was the mock epic *Dunciad* [DUN-see-ad], published in 1728 and dedicated to Jonathan Swift. The poem opens with a direct attack on the king, George II (r. 1727–1760), who had recently succeeded his father, George I, to the throne. For Pope, this suggested the goddess Dullness reigned over an England where "Dunce the second rules like Dunce the first." Pope's dunces are the very nobility that Swift attacks in the fourth book of Gulliver—men of "dullness, ignorance, caprice, sensuality, and pride"—and the writers of the day whom Pope perceived to be supporting the policies of Walpole and the king.

Against what he believed to be the debased English court, Pope argues for honesty, charity, selflessness, and the order, harmony, and balance of the classics, values set forth in *An Essay on Man*, published between 1732 and 1734. Pope intended the poem to be the cornerstone of a complete system of ethics that he never completed. His purpose is to show that despite the apparent imperfection, complexity, and rampant evil of the universe, it nevertheless functions in a rational way, according to natural laws. The world appears imperfect to us only because our perceptions are limited by our feeble moral and intellectual capacity. In reality, as he puts it at the end of the poem's first section (**Reading 28.8**):

All Nature is but Art, unknown to thee;
All Chance, Direction, which thou canst not see;
All Discord, Harmony not understood;
All partial Evil, universal good;
And, spite of Pride in erring Reason's spite,
One truth is clear: WHATEVER IS, IS RIGHT.

Pope does not mean to condone evil in this last line. Rather, he implies that God has chosen to grant humankind a certain imperfection, a freedom of choice that reflects its position in the universe. At the start of the second section

of the poem, immediately after this passage, Pope outlines humankind's place:

> Know then thyself, presume not God to scan;
> The proper study of Mankind is Man.
> Placed on this isthmus of a middle state,
> A Being darkly wise, and rudely great;
> With too much knowledge for the Sceptic side,
> With too much weakness for the Stoic's pride.
> He hangs between, in doubt to act, or rest;
> In doubt to deem himself a God, or Beast;
> In doubt his Mind or Body to prefer;
> Born but to die, and reas'ning but to err;
> Alike in ignorance, his reason such,
> Whether he thinks too little, or too much:
> Chaos of Thought and Passion, all confused;
> Still by himself abused, or disabused;
> Created half to rise, and half to fall;
> Great lord of all things, yet a prey to all;
> Sole judge of Truth, in endless Error hurled:
> The glory, jest, and riddle of the world!

In the end, for Pope, humankind must strive for good, even if in its frailty it is doomed to fail. But the possibility of success also looms large. Pope suggests this through the very form of his poem—**heroic couplets**, rhyming pairs of iambic pentameter lines (the meter of Shakespeare, consisting of five short-long syllabic units)—that reflect the balance and harmony of classical art and thought.

Isaac Newton: The Laws of Physics

In 1735, eight years after the death of the great English astronomer and mathematician Isaac Newton (1642–1727), Pope wrote an heroic couplet epitaph, "Intended for Sir Isaac Newton":

> Nature and Nature's laws lay hid in night;
> God said, *Let Newton be!* and all was light.

With the 1687 publication of his *Mathematical Principles of Natural Philosophy*, more familiarly known as the *Principia* [prin-CHIP-ee-uh], from the first word of its Latin title, Newton had demonstrated to the satisfaction of almost everyone that the universe was an intelligible system, well ordered in its operations and guiding principles. This fact appealed especially to the author of *An Essay on Man*, Pope. First and foremost, Newton computed the law of universal gravitation in a precise mathematical equation, demonstrating that each and every object exerts an attraction to a greater or lesser degree on all other objects. Thus, the sun exercises a hold on each of the planets, and the planets to a lesser degree influence each other and the sun. The earth exercises a hold on its moon, and Jupiter on its several moons. All form a harmonious system functioning as efficiently and precisely as a clock or machine. Newton's conception of the universe as an orderly system would remain unchallenged until the late nineteenth and early twentieth centuries, when the new physics of Albert Einstein and others would once again transform our understanding.

Newton's *Principia* marked the culmination of the forces that had led, earlier in the century, to the creation of the Royal Society in England and the Académie des Sciences in France. Throughout the eighteenth century, the scientific findings of Newton and his predecessors—Kepler and Galileo, in particular—were widely popularized and applied to the problems of everyday life. Experiments demonstrating the laws of physics became a popular form of entertainment. In his *Experiment on a Bird in the Air-Pump* (Fig. **28.7**), the English painter Joseph Wright (1734–1797) depicts a scientist conducting an experiment before the members of a middle-class household. He stands in his red robe behind an air pump, normally used to study the properties of different gases but here employed to deprive a white cockatoo of oxygen by creating a vacuum in the glass bulb above the pump. The children are clearly upset by the bird's imminent death, while their father points to the bird, perhaps to demonstrate that we all need oxygen to live.

Wright had almost certainly seen such an experiment conducted by the Scottish astronomer James Ferguson, who made scientific instruments in London and toured the country, giving lectures. However, Ferguson rarely used live animals. As he explains in the 1760 edition of his lecture notes:

> If a fowl, a cat, rat, mouse or bird be put under the receiver, and the air be exhausted, the animal is at first oppressed as with a great weight, then grows convulsed, and at last expires in all the agonies of a most bitter and cruel death. But as this experiment is too shocking to every spectator who has the least degree of humanity, we substitute a machine called the "lung-glass" in place of the animal; which, by a bladder within it, shows how the lungs of animals are contracted into a small compass when the air is taken out of them.

Wright illustrated the crueler demonstration, and the outcome is uncertain. Perhaps, if the bird's lungs have not yet collapsed, the scientist can bring it back from the brink of death.

Continuity & Change
p. 849

Supper at Emmaus

Whatever the experiment's conclusion, life or death, Wright not only painted the more horrific version of the experiment but drew on the devices of Baroque painting—dramatic, nocturnal lighting and chiaroscuro—to heighten the emotional impact of the scene (see Rembrandt, *Supper at Emmaus*, Fig. 26.18). The painting underscores the power of science to affect us all.

The Industrial Revolution

Among Wright's closest friends were members of a group known as the Lunar Society. The Society met in and around Birmingham each month on the night of the full moon (providing both light to travel home by and the name of the society). Its members included prominent manufacturers, inventors, and naturalists. Among them were Matthew Boulton (1728–1809), whose world-famous Soho Manufactury produced a variety of metal objects, from buttons and buckles to silverware; James Watt (1736–1819), inventor of the steam engine, who would

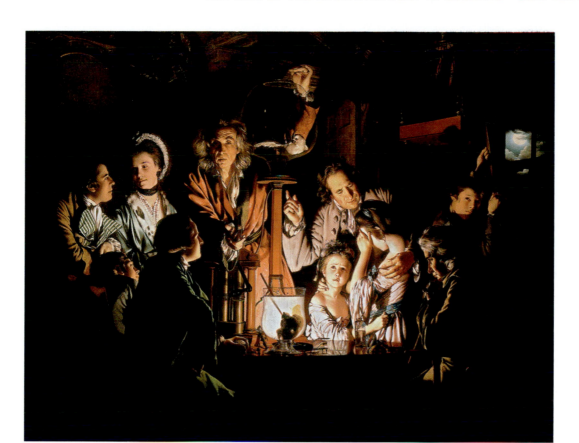

Fig. 28.7 Joseph Wright. *An Experiment on a Bird in the Air-Pump.* **1768.** Oil on canvas, 6′ × 8′. The National Gallery, London. The resurrection of apparently dead birds was a popular entertainment of the day, a trick usually performed by self-styled magicians. In this painting, however, Wright takes the idea seriously, demonstrating to his audience the power of science.

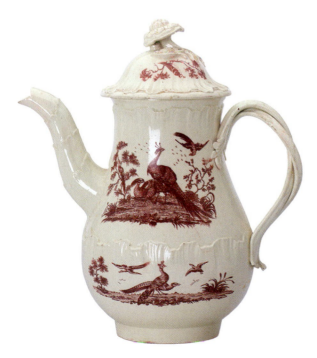

Fig. 28.8 Transfer-printed Queen's Ware. ca. 1770. The Wedgwood Museum, Barlaston, England. Elaborate decorations such as the one on this coffee pot were mechanically printed on ceramic tableware at Wedgwood's factory. Queen's Ware became so popular that pattern books, showing the available designs, were available across Europe by the turn of the century.

team with Boulton to produce it; Erasmus Darwin (1731–1802), whose writings on botany and evolution anticipate by nearly a century his grandson Charles Darwin's famous conclusions; William Murdock (1754–1839), inventor of gas lighting; Benjamin Franklin (1706–1790), who was a corresponding member; and Josiah Wedgwood (1730–1795), Charles Darwin's other grandfather and the inventor of mass manufacturing at his Wedgwood ceramics factories. From 1765 until 1815, the group discussed chemistry, medicine, electricity, gases, and any and every topic that might prove fruitful for industry. It is fair to say that the Lunar Society's members inaugurated what we think of today as the **Industrial Revolution**. The term itself was invented in the nineteenth century to describe the radical changes in production and consumption that had transformed the world.

Wedgwood opened his first factory in Belsem, Staffordshire, on May 1, 1759, where he began to produce a highly durable cream-colored earthenware (Fig. **28.8**). Queen Charlotte, wife of King George III, was so fond of these pieces that Wedgwood was appointed royal supplier of dinnerware. Wedgwood's production process was unique. Instead of shaping individual pieces by hand on the potter's wheel—the only way ceramic ware had been produced—he cast liquid clay in molds and then fired it. This greatly increased the speed of production, as did mechanically printing decorative patterns on the finished china rather than painting them. The catalog

described Queen's Ware, as it came to be known, as "a species of earthenware for the table, quite new in appearance . . . manufactured with ease and expedition, and consequently cheap." It was soon available to mass markets in both Europe and America, and Wedgwood's business flourished.

Wedgwood's Queen's Ware is an exemplary product of the Industrial Revolution. New machinery in new factories created a supply of consumer goods unprecedented in history, answering an ever-increasing demand for everyday items, from toys, furniture, kitchen utensils, and china, to silverware, watches, and candlesticks. Textiles were in particular demand, and in many ways, advances in textile manufacture could be called the driving force of the Industrial Revolution. At the beginning of the eighteenth century, textiles were made of wool from sheep raised in the English Midlands. A thriving cottage industry, in which weavers used handlooms and spinning wheels, textile manufacture changed dramatically in 1733 when John Kay in Lancashire invented the flying shuttle. Using this device, a weaver could propel the shuttle, which carries the yarn that forms the weft through the fibers of the warp, beyond the weaver's reach. Cloth could be made both wider and faster. Invention after invention followed, culminating in 1769 when Richard Arkwright

patented the water frame, a waterwheel used to power looms. With their increased power, looms could operate at much higher speeds. Arkwright had duped the actual inventors out of their design, and in 1771 installed the water frame in a cotton mill in Derbyshire, on the river Derwent. These first textile mills, needing water power to drive their machinery, were built on fast-moving streams like the Derwent. But after the 1780s, with the application of Watts's steam power, mills soon sprang up in urban centers. In the last 20 years of the eighteenth century, English cotton output increased 800 percent, accounting for 40 percent of the nation's exports.

Another important development was the discovery of techniques for producing iron of unprecedented quality in a cost-effective manner. Early in the century, Abraham Darby (1678–1717) discovered that it was possible to fire cast iron with coke—a carbon-based fuel made from coal. Darby's grandson, Abraham Darby III (1750–1791), inherited the patent rights to the process; to demonstrate the structural strength of the cast iron he was able to manufacture, he proposed to build a single-arch cast-iron bridge across the River Severn, high enough to accommodate barge traffic on the river. The bridge at Coalbrookdale (Fig. **28.9**) was designed by a local architect, while its 70-foot ribs were cast at Darby's ironworks. The

Fig. 28.9 Thomas Farnolls Pritchard. Iron Bridge, Coalbrookdale, England. 1779. Cast iron. Pritchard was keenly aware that the reflection of the bridge would form a visual circle, a form repeated in the ironwork at the corners of the bridge.

bridge's 100-foot span, arching 40 feet above the river, demonstrated once and for all the structural potential of iron. A century later, such bridges would carry railroad cars, as the need for transporting new mass-produced goods exploded.

Handel and the English Oratorio

The sense of prosperity and promise created by the Industrial Revolution in England found expression, particularly, in the music of German-born George Frederick Handel (1685–1759). Handel had studied opera in Italy for several years, and was serving as Master of the Chapel in the Hanover court when George I was named king of England. He followed the king to London in the autumn of 1712. He was appointed composer to the Chapel Royal in 1723, became a British citizen in 1727, and when George II was crowned in 1728, he composed four anthems for the ceremony. Over the course of his career Handel composed several orchestral suites (musical series of thematically related movements) that remain preeminent examples of the form. *Water Music* was written for a royal procession down the River Thames in 1717, and *Music for the Royal Fireworks* (1749) celebrated the end of a war with Austria. He wrote concertos for the oboe and the organ, performing the latter himself between acts of his operas and oratorios at London theaters. Opera was, in fact, his chief preoccupation—he composed 50 in his lifetime, 46 in Italian and 4 in German—but it was the oratorio, the same form that so attracted Johann Sebastian Bach (see chapter 26), that made his reputation.

An **oratorio** is a lengthy choral work, usually employing religious subject matter, performed by a narrator, soloists, choruses, and orchestra. It resembles opera in that it includes arias, recitatives, and choruses (see chapter 25), but unlike opera, it does not have action, scenery, or costumes. To compensate for the lack of action, a narrator often connected threads of the plot. Handel composed his oratorios in English rather than Italian, the preferred opera language at that time. It is not clear just why he wrote oratorios, but a displeased bishop of London may have had something to do with it. The bishop banned Handel's biblical opera, *Esther*, in 1732, asserting that a stage production of the Bible was inappropriate. By using the oratorio form, Handel could treat biblical themes decorously.

Handel's greatest achievement is the oratorio *Messiah*. Written in 24 days, the work premiered in Dublin, Ireland, in 1742, as a benefit for Irish charities. It is probably the best known of all oratorios, although it is thoroughly atypical of the genre: The *Messiah* has no narrator, no characters, and no plot. Instead, Handel collected loosely related verses from the Old and New Testaments. It was an immediate success. Many Englishmen thought of their country as enjoying God's favor as biblical Israel had in the Old Testament, and Handel tapped into this growing sense of national pride. It recounts, in three parts, the biblical prophecies of the coming of a Savior, the suffering and death of Jesus, and the resurrection and redemption of humankind. *Messiah* is sometimes remarkable

in its inventiveness. When, for instance, Handel scored the text "All we, like sheep, have gone astray," he made the last words scatter in separate melodies across the different voices, mimicking the scattering referred to in the text. This technique, known as *word painting*, had been used during the Renaissance—the mood of the musical elements imitated the meaning of the text (see chapter 19). Tradition has it that in 1743 when George II first heard the now famous "Hallelujah Chorus" (**CD-Track 28.1**), which concludes the second part of the composition, he rose from his seat—whether in awe or simply because he was tired of sitting, no one knows—a gesture that has since become standard practice for all English-speaking audiences. For the rest of Handel's life, he performed *Messiah* regularly, usually with a chorus of 16 voices and an orchestra of 40, both relatively large for the time.

Literacy and the New Print Culture

Since the seventeenth century, literacy had risen sharply in England, and by 1750 at least 60 percent of adult men and between 40 and 50 percent of adult women could read. Not surprisingly, literacy was connected to class. Merchant-class men and women were more likely to read than those in the working class. And among the latter, city dwellers had higher literacy rates than those in rural areas. But even the literate poor were often priced out of the literary marketplace. Few had enough disposable income to purchase even a cheap edition of Milton, which cost about 2 shillings at midcentury. (At Cambridge University, a student could purchase a week's meals for 5 shillings.) And even though, by the 1740s, circulating libraries existed in towns and cities across Britain, the poor generally could not afford the annual subscription fees. Nevertheless, libraries broadened considerably the periodicals and books—particularly, that new, increasingly popular form of fiction, the novel—available to the middle class. Priced out of most books and libraries, the literate poor depended on an informal network of trading books and newspapers. Sharing reading materials was so common, in fact, that the publisher of one popular daily periodical estimated "twenty readers to every paper." The publisher was Joseph Addison (1672–1719), who with Richard Steele (1672–1729) published the periodical *The Spectator* every day except Sunday from March 1711 to December 1712.

The Tatler and The Spectator

Since their schooldays in London, Addison and Steele, men of very different temperaments, had been friends. Addison was reserved and careful, Steele impulsive and flamboyant. Addison was prudent with his money, Steele frequently broke. In fact, it was Steele's need for money that got him into the newspaper business in April 1709 when he launched *The Tatler* under the assumed name of Isaac Bickerstaff. Published three times a week until January 1711, *The Tatler*, its

Voices

Rules for Behaviour in Company

The rapidly growing middle class and the influx of immigrants from the countryside fueled London's social and economic vitality in the eighteenth century. However, the city's stability, literacy, creativity, and elegance did not come about by accident. Britain's rulers understood that a continuing effort to educate its youngest inhabitants was an important ingredient in the formation of a well-behaved adult population. This "conduct book" from the early eighteenth century illustrates how children were instructed on how to behave, an important aspect of knowing one's place in society. How much of this prescriptive advice is still valid in contemporary society?

Enter not into the Company of Superiors without command of calling; nor without a bow.

Sit not down in presence of Superiors without bidding.

Put not thy hand in the presence of others to any part of thy body, not ordinarily discovered.

Sing not nor hum in thy mouth while thou art in company.

Play not wantonly like a Mimick with thy Fingers or Feet.

Stand not wriggling with thy body hither and thither, but steddy and upright.

In coughing or sneezing make as little noise as possible.

If thou cannot avoid yawning, shut thy Mouth with thine Hand or Handkerchief before it, turning thy Face aside.

When thou blowest thy Nose, let thy Handkerchief be used, and make not a noise in so doing.

Gnaw not thy Nails, pick them not, nor bite them with thy teeth.

> **"When thou blowest thy Nose, let thy Handkerchief be used, and make not a noise in so doing."**

Spit not in the Room, but in a corner, and rub it out with thy Foot, or rather go out and do it abroad.

. . .

Turn not thy back to any, but place thyself conveniently, that none be behind thee.

Read not Letters, Books, nor other Writings in Company, unless there be necessity, and thou ask leave.

Touch not nor look upon the Books or Writings of any one, unless the Owner invite or desire thee.

. . . .

Let thy Countenance be moderately chearful, neither laughing nor frowning.

Laugh not aloud, but silently Smile upon occasion.

. . .

Look not boldly or willfully in the Face of thy Superior.

To look upon one in company and immediately whisper to another is unmannerly.

Stand not before Superiors with thine hands in thy pockets, scratch not thy Head, wink not with thine Eyes, but thine Eyes modestly looking straight before thee, and thine Hands behind thee.

Be not among Equals forward and fretful, but gentle and affable.

Whisper not in company.

name purposefully evocative of gossip so that it might appeal to a female audience, mixed news and personal reflections and soon became popular in coffeehouses and at breakfast tables throughout London. Steele wrote the vast majority of *Tatlers*, although Addison and other friends occasionally contributed. *The Spectator* began its nearly 2-year run 2 months after the last *Tatler* appeared, with Addison assuming a much larger role.

Addison and Steele invented a new literary form, the **journalistic essay**, a form perfectly suited to an age dedicated to the observation of daily life, and drawing from life's experiences, in Locke's terms, an understanding of the world. Forced daily to describe—and reflect upon—English society, Addison and Steele's *Spectator* left almost no aspect of their culture unexamined. They instructed their readership in good manners, surveyed the opportunities that London offered the prudent shopper, and described the goings on at the Royal Exchange, the city's financial center, where, in Addison's words, one could witness "an assembly of countrymen and foreigners consulting together . . . and making this metropolis a kind of emporium for the whole earth." They reviewed the city's various entertainments, both high and low, offered brief, usually fictionalized biographies of both typical and atypical English citizens, and very often expounded upon more literary and philosophical issues, such as John Locke's reflections upon the nature of wit. In the tenth issue of *The Spectator*, Addison outlined the paper's aims (**Reading 28.9**):

READING 28.9 **from Joseph Addison,**
***The Spectator*, No. 10,**
Monday, March 12, 1711

I shall endeavor to enliven morality with wit, and to temper wit with morality. . . . I have resolved to refresh their memories from day to day, till I have recovered them out of that desperate state of vice and folly into which the age has fallen. . . .

I would . . . recommend these my speculations to all well-regulated families that set apart an hour in every morning for tea and bread and butter; and would earnestly advise them for their good to order this paper to be punctually served up, and to be looked upon as a part of the tea equipage. . . .

In the next place, I would recommend this paper to the daily perusal of those gentlemen whom I cannot but consider my good brothers and allies . . . in short, every-one that considers the world as a theater, and desires to form a right judgment of those who are the actors on it.

There is another set of men that I must likewise lay a claim to, whom I have lately called the blanks of society, as being altogether unfurnished with ideas till the business and conversation of the day has supplied them. . . . I would earnestly entreat them not to stir out of their chambers til they have read this paper. . . .

But there are none to whom this paper will be more useful than to the female world. I have often thought there has not been sufficient pain taken in finding out proper employments and diversions for the fair ones. Their amusements seem contrived . . . the right adjust-ing of their hair the principal employment of their lives. The sorting of a suit of ribbons is reckoned a very good morning's work; and if they make an excursion to a mercer's or toyshop,[1] so great a fatigue makes them unfit for anything else all the day after. Their more serious occupations are sewing and embroidery, and their greatest drudgery the preparation of jellies and sweetmeats. This, I say, is the state of ordinary women: though I know there are multitudes of those of a more elevated life and conversation, that move in an exalt-ed sphere of knowledge and virtue, that join all the beauties of the mind to the ornaments of dress, and inspire a kind of awe and respect, as well as love, into their male beholders. I hope to increase the number of these by publishing this daily paper.

[1] **mercer's** or **toyshop:** a textile merchant or a shop selling metal objects such as buttons and buckles.

Addison's strategy for increasing his paper's circulation is obvious: The "blanks of society" might think of themselves as among his "brothers and allies" should they read *The Spec-tator*, and all women who read it might count themselves

among those who inspire the "awe and respect" of their "male beholders."

One of Addison and Steele's greatest creations in *The Spectator* was the Tory eccentric Sir Roger de Coverley. Described by Steele in the second issue of the newspaper, Sir Roger was "a gentleman very singular in his behavior . . . [whose] humor creates him no enemies . . . and who is "now in his fifty-sixth year, cheerful, gay, and hearty; keeps a good house both in town and in country; a great lover of mankind . . . [with] such a mirthful cast in his behavior that he is rather beloved than esteemed." Sir Roger is the ancestor of many similar characters that inhabit English fiction. In fact, the cast of characters that inhabit Addison and Steele's *Spectator* anticipate, to an astonishing degree, those found in English fiction as a whole.

The Rise of the English Novel

The novel as we know it was not invented in eighteenth-century England—Cervantes's *Don Quixote*, written a centu-ry earlier, is often considered the first example of the form in Western literature (see chapter 22). But the century abound-ed in experiments in fiction writing that anticipate many of the forms that novelists have employed down to the present day. Works that today are called novels (from the French *nouvelle* and Italian *novella*, meaning "new") were rarely called "novels" in the eighteenth century itself. That term did not catch on until the very end of the century. Typically, they were referred to as "histories," "adventures," "expeditions," "tales," or—Hogarth's term—"progresses." They were read by people of every social class. What the novel claimed to be, and what appealed to its ever-growing audience, was a realis-tic portrayal of contemporary life. It concentrated almost always on the trials of a single individual, offering insight into the complexities of his or her personality. It also offered the promise, more often than not, of upward social mobility through participation in the expanding British economy and the prospect of prosperity that accompanied it. As London's population swelled with laborers, artisans, and especially young people seeking fame and fortune, and as the Industrial Revolution created the possibility of sudden financial success for the inventive and imaginative, the novel endorsed a set of ethics and a morality that were practical, not idealized. Above all, the novel was entertaining. Reading novels offered some respite from the drudgery of everyday life and, besides, was certainly a healthier addiction than drinking gin.

Daniel Defoe's Fictional Autobiographies One of the first great novels written in English is *Robinson Crusoe* by Daniel Defoe [dih-FOH] (1660–1731). Published in 1719, the full title of this sprawling work is *The Life and Strange Surprising Adventures of Robinson Crusoe of York, Mariner; Who lived Eight and Twenty Years, all alone in an un-inhabited Island on the coast of America, near the Mouth of the Great River of Oronoque; Having been cast on Shore by Shipwreck, wherein all*

the Men perished but himself. With An Account how he was at last as strangely deliver'd by Pirates. Written by Himself (Fig. **28.10**). The last three words are crucial, for they establish Defoe's claim that this novel is actually an autobiography.

Defoe's audience was used to reading accounts of real-life castaways that constituted a form of voyage literature. But far from falling into the primitive degradation and apathy of the average castaway, he rises above his situation, realizing, in his very ability to sustain himself, his God-given human potential. So many of Defoe's readers felt isolated and alone, like castaways, in the sea of London. For them, Crusoe represented hope and possibility.

This theme of the power of the average person to survive and flourish is what assured the novel's popularity and accounted for four editions by the end of the year. Defoe followed *Robinson Crusoe* with a series of other fictitious autobiographies of adventurers and rogues—*Captain Singleton* (1720), *Moll Flanders* (1722), *Colonel Jack* (1722), and *Rox-*

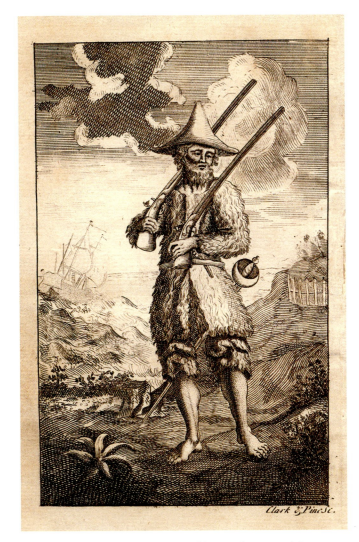

Fig. 28.10 Frontispiece to *The Life and Strange Surprising Adventures of Robinson Crusoe of York, Mariner. . . ,* by Daniel Defoe. London: W. Taylor, 1719. First edition. No other book in the history of Western literature has spawned more editions and translations, including Eskimo, Coptic, and Maltese.

anna (1724). In all of them, his characters are in one way or another "shipwrecked" by society and as determined as Crusoe to overcome their situations through whatever means—not always the most virtuous—at their disposal.

The Epistolary Novel: Samuel Richardson's *Pamela* One of the most innovative experiments in the new novelistic form was devised by Samuel Richardson (1689–1761). He fell into novel writing as the result of his work on a "how-to" project commissioned by two London booksellers. Aware that "Country Readers" could use some help with their writing, the booksellers hired Richardson to write a book of "sample letters" that could be copied whenever necessary. Richardson was both a printer and the author of a history based on the letters of a seventeenth-century British ambassador to Constantinople and India (see the section on India and Europe, chapter 30). He had never written fiction before, but two letters in his new project suggested the possibility of writing a novel—"A Father to a Daughter in Service, on hearing of her Master's attempting her Virtue," and "The Daughter's Answer." In just over 2 months, Richardson wrote *Pamela, or Virtue Rewarded*, the first example of what we have come to call the **epistolary novel**—that is, a novel made up of a series of "epistles," or letters. It was published in two volumes in 1740.

Pamela is a poor servant girl, of even poorer parents, in the service of a good lady who dies on page one of the novel. The good lady's son, Mr. B., promises to take care of her and all of his mother's servants: "For my Master said," Pamela reports in a letter home, "I will take care of you all, my Lasses; and for you, Pamela (and took me by the Hand; yes he took me by the Hand before them all) for my dear Mother's sake, I will be a Friend to you, and you shall take care of my Linen." From the outset, then, Richardson established Pamela's naiveté through the ambiguity implied in his "friendship" and, particularly, the word "linen," which includes, in the meaning of the day, his underwear. Indeed, Mr. B. abducts Pamela to his estate in Lincolnshire, where she is kept a prisoner and is continuously accosted to surrender her virginity. Thus virtue confronts desire, a confrontation that over the course of the novel is compounded by Pamela's own growing desire for Mr. B. (**Reading 28.10**):

READING 28.10 from Samuel Richardson's *Pamela* (1740)

My dear master is all love and tenderness. He sees my weakness, and generously pities and comforts me! I begged to be excused [from] supper; but he brought me down himself from my closet, and placed me by him. . . . I could not eat, and yet I tried, for fear he should be angry. . . . Well, said he, if you won't eat with me, drink at least with me: I drank two glasses by his over-persuasions, and said, I am really ashamed of myself. Why, indeed, said he, my dear girl, I am not a very dreadful enemy, I hope! I cannot bear any thing

that is the least concerning to you. Oh, sir! said I, all is owing to the sense I have of my own unworthiness!— To be sure, it cannot be any thing else.

He rung for the things to be taken away; and then reached a chair, and sat down by me, and put his kind arms about me, and said the most generous and affecting things that ever dropt from the honey-flowing mouth of love. All I have not time to repeat: some I will. And oh! indulge your foolish daughter, who troubles you with her weak nonsense; because what she has to say, is so affecting to her; and because, if she went to bed, instead of scribbling, she could not sleep.

Finally, after more than 1,000 pages of letters, Pamela's high moral character is rewarded by her marriage to her would-be seducer, Mr. B., and the novel's subtitle is justified. The success of Richardson's novel rested not only on the minute analysis of its heroine's emotions but also in the combination of its high moral tone and the sexual titillation of its story, which readers found irresistible.

The Comic Novels of Henry Fielding The morality of Richardson's *Pamela* was praised from church pulpits, recommended to parents skeptical of the novel as a form, and generally celebrated by the more Puritan elements of British society, who responded favorably to the heroine's virtue. Pamela herself asked a question that women readers found particularly important: "How came I to be his Property?" But the novel's smug morality (and the upward mobility exhibited by the novel's heroine) offended many, most notably Richardson's contemporary Henry Fielding (1707–1754), who responded, a year after the appearance of *Pamela*, with *Shamela*. Fielding's title tips the reader off that his work is a **parody**, a form of satire in which the style of an author or work is closely imitated for comic effect or ridicule. In Fielding's parody, his lower-class heroine's sexual appetite is every bit a match for her Squire Booby's—and from Fielding's point of view, much more realistic (**Reading 28.11**):

READING 28.11 **from Henry Fielding, *Shamela* (1741)**

I was sent for to wait on my Master. I took care to be often caught looking at him, and then I always turn'd away my Eyes, and pretended to be ashamed. As soon as the Cloth was removed, he put a Bumper of Champagne into my Hand, and bid me drink—O la I can't name the Health. . . . I then drank towards his Honour's good Pleasure. Ay, Hussy, says he, you can give me Pleasure if you will; Sir, says I, I shall be always glad to do what is in my power, and so I pretended not to know what he meant. Then he took me into his Lap.—O Mamma, I could tell you something if I would—and he kissed me—and I said I won't be slobber'd about so, so I won't; and he bid me

get out of the Room for a saucy Baggage, and said he had a good mind to spit in my Face.

Sure no Man ever took such a Method to gain a Woman's Heart.

Fielding presents Pamela's ardent defense of her chastity against her upper-class seducer as a sham; it is simply a calculated strategy, an ambitious hussy's plot to achieve financial security.

Fielding's greatest success came with the publication in 1749 of *The History of Tom Jones, a Foundling*. Fielding's model was Cervantes's *Don Quixote*, a loosely structured picaresque plot in which its outcast hero wanders through England and the streets of London. Fielding called it "a comic epic-poem in prose," which contrasts its generous, good-natured, and often naïve hero with cold-hearted and immoral British society. As Fielding himself explained, his purpose was to show "not men, but manners; not an individual, but a species." His characters are generally products, not of individual psychology, but of class. As opposed to Richardson, in Fielding's novels, plot takes precedence over character, the social fabric over individual consciousness. This is crucial to the comedy of his narrative. If readers were to identify too closely with Fielding's characters, they might not be able to laugh at them. It is, after all, the folly of human behavior that most intrigues Fielding himself.

The World of Provincial Gentry: Jane Austen's *Pride and Prejudice* Not all readers were charmed and entertained by Fielding's lavish portraits of vice. Many found his narratives deplorable. These readers found an antidote to Fielding in the writings of Jane Austen (1775–1817). Although Austen's best-known novels were published in the first quarter of the nineteenth century, she was more in tune with the sensibilities of the late eighteenth century, especially with Enlightenment values of sense, reason, and self-improvement.

None of Austen's heroines better embodies these values than the heroine of *Pride and Prejudice* (1813), Elizabeth Bennett, one of five daughters of a country gentlemen whose wife is intent on marrying the daughters off. The novel famously opens (**Reading 28.12a**):

READING 28.12a **from Jane Austen, *Pride and Prejudice*, Chapter 1 (1813)**

It is a truth universally acknowledged, that a single man in possession of a good fortune, must be in want of a wife.

However little known the feelings or views of such a man may be on his first entering a neighbourhood, this truth is so well fixed in the minds of the surrounding families, that he is considered the rightful property of some one or other of their daughters.

The level of Austen's irony in these opening sentences cannot be overstated, for while she describes the fate that awaits any single, well-heeled male entering a new neighborhood, these lines are a less direct, but devastating reflection upon the possibilities for women in English society. Their prospect in life is to be married. And if they are not themselves well-heeled and attractive—that is, marriageable— their prospects are less than that.

Austen first told this story in *First Impressions* (1796–1797), in the form of an exchange of letters between Elizabeth and Fitzwilliam Darcy, an English gentleman. When we first meet him in *Pride and Prejudice*, Austen describes him as follows: "He was looked at with great admiration for about half the evening, till his manners gave a disgust which turned the tide of his popularity; for he was discovered to be proud, to be above his company, and above being pleased; and not all his large estate in Derbyshire could then save him from having a most forbidding, disagreeable countenance. . . ." The novel's plot revolves around the two words of its title, "pride" and "prejudice." Where Elizabeth at first can only see Darcy's pride, she comes to realize that her view is tainted by her prejudice. Darcy's disdain for country people and manners is a prejudice that Elizabeth's evident pride helps him to overcome. Together, they come to understand not only their own shortcomings but their society's.

This reconciliation begins when Elizabeth tours Darcy's estate at Pemberley in the company of her aunt and uncle, the Gardiners. The scene Austen describes is quite literally the quintessential English garden, a new form of landscape design (see chapter 29), but it is also an extended metaphor for its owner (**Reading 28.12b**):

READING 28.12b from Jane Austen, *Pride and Prejudice*, Chapter 43 (1813)

Elizabeth, as they drove along, watched for the first appearance of Pemberley Woods with some perturbation; and when at length they turned in at the lodge, her spirits were in a high flutter.

The park was very large, and contained great variety of ground. They entered it in one of its lowest points, and drove for some time through a beautiful wood, stretching over a wide extent.

Elizabeth's mind was too full for conversation, but she saw and admired every remarkable spot and point of view. They gradually ascended for half a mile, and then found themselves at the top of a considerable eminence, where the wood ceased, and the eye was instantly caught by Pemberley House, situated on the opposite side of a valley, into which the road, with some abruptness, wound. It was a large, handsome, stone building, standing well on rising ground, and backed by a ridge of high woody hills;—and in front, a stream of some natural importance was swelled into greater, but without any artificial appearance. Its banks were neither formal nor falsely adorned. Elizabeth was delighted. She had never

seen a place for which nature had done more, or where natural beauty had been so little counteracted by an awkward taste. They were all of them warm in their admiration; and at that moment she felt that to be mistress of Pemberley might be something!

They descended the hill, crossed the bridge, and drove to the door; and, while examining the nearer aspect of the house, all her apprehensions of meeting its owner returned.

By subtly identifying Darcy with his estate, Austen affirms the commonly held belief that a man's estate and grounds were a reflection of the man himself. The description is certainly analogous to Elizabeth's aunt's assessment of Darcy toward the end of the chapter: "There is something a little stately in him to be sure . . . but it is confined to his air, and is not unbecoming. I can now say with the housekeeper, that though some people may call him proud, *I* have seen nothing of it." Austen's language here prepares us in fact for Darcy's own "large" and "handsome . . . eminence."

The subtle manipulation of descriptive language apparent in this passage is indicative of Austen's great talent. Her novels track, with uncanny precision, distinctions of class, rank, and social standing that mark her times. And she looks upon the English class system with a sense of both irony and compassion, and with a sensitivity to the pressures challenging it in her own day. But perhaps above all, she understands the weight that individual words can bear, how mere description—the use of the word "large," for instance—can influence and manipulate feeling.

Samuel Johnson: Stylist and Moralist The English novel, and the state of the society reflected in it, was of special concern to Samuel Johnson (1709–1784) (Fig. **28.11**). Johnson was editor of two coffeehouse magazines, *The Rambler* (1750–1752) and *The Idler* (1758–1760), author of the ground-breaking *Dictionary of the English Language*, published in 1755, the moral fable *Rasselas, Prince of Abyssinia* (1759), and the critical and biographical text *The Lives of the Most Eminent English Poets* (10 volumes, 1779–1781), as well as editor of a completely annotated edition of Shakespeare's plays (1765). He was also subject of what is arguably the first great biography of the modern era, *The Life of Samuel Johnson* by James Boswell (1740–1795), published in 1791, and unique in its inclusion of conversations among Johnson and his contemporaries that Boswell recorded in his journals at the time.

Born to a poor bookseller in Lichfield, Stratfordshire, he had been forced to leave Oxford for lack of funds and arrived in London penniless in 1737. For three decades he supported himself by his writing, until awarded a government pension in 1762. Three years later he received an honorary doctorate from Trinity College, Dublin, and another from Oxford ten years after that—which explains his commonly used title, Dr. Johnson.

Johnson's concerns about the novel are best articulated in an essay on fiction that appeared in *The Rambler*, an essay that demonstrates Johnson's considerable talents as a literary critic (**Reading 28.13**):

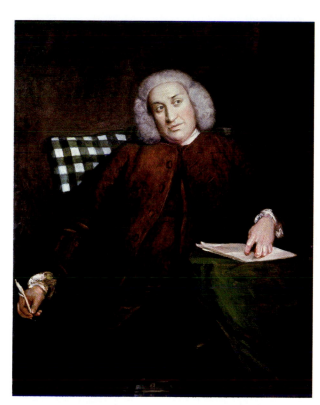

Fig. 28.11 Sir Joshua Reynolds. *Samuel Johnson.* **1756–1757.** Oil on canvas, 50 1/4″ × 40″. National Portrait Gallery, London. Given by an anonymous donor, 1911. NPG 1597. Reynolds was a close associate of Johnson's. The most prolific portrait painter of the era, he produced over 1,500 portraits of the English nobility, and was the first president of the English Royal Academy.

READING 28.13 **from Samuel Johnson,** ***The Rambler*** **No. 4, Saturday, March 31, 1750**

The works of fiction with which the present generation seems more particularly delighted are such as exhibit life in its true state, diversified only by accidents that daily happen in the world, and influenced by passions and qualities which are really to be found in conversing with mankind.

This kind of writing may be termed, not improperly, the comedy of romance. . . . Its province is to bring about natural events by easy means, and to keep up curiosity without the help of wonder: it is therefore precluded from the machine and expedients of the heroic romance, and can neither employ giants to snatch away a lady from the nuptial rites, nor knights to bring her back from captivity; it can neither bewilder its personages in deserts, nor lodge them in imaginary castles. . . .

The task of our present writers . . . requires, together with that learning which is to be gained from books, that experience which can never be attained by solitary diligence, but must arise from general converse and accurate observation of the living world. . . . These books are written chiefly to the young, the ignorant, and the idle, to whom they serve as lectures of conduct, and introductions into life. They are the entertainment of minds unfurnished with ideas, and therefore easily susceptible of impressions; not fixed by principles, and therefore easily following the current of fancy; not informed by experience, and therefore open to every false suggestion and partial account. . . .

I cannot discover why there should not be exhibited the most perfect idea of virtue; of virtue not angelical, nor above probability (for what we cannot credit, we shall never imitate), but the highest and purest humanity can reach, which, exercised in such trials as the various revolutions of things shall bring upon it, many, by conquering some calamities and enduring others, teach us what we may hope, and what we can perform. Vice (for vice is necessary to be shown), should always disgust. . . . Wherever it appears, it should raise hatred by the malignity of its practices, and contempt by the meanness of its stratagems. It is therefore to be steadily inculcated that virtue is the highest proof of understanding, and the only solid basis of greatness; and that vice is the natural consequence of narrow thoughts; that it begins in mistake, and ends in ignominy.

This last paragraph sums up what Johnson disliked in Fielding's novels, whose characters, he complained, were "of very low life."

Perhaps Johnson's most important contribution to English letters is his *Dictionary of the English Language,* published in 1755. A quintessential Enlightenment effort, it represents an attempt to standardize the English language, especially its wildly inconsistent spelling. Johnson's *Dictionary* consists of definitions for some 40,000 words, illustrated with about 114,000 quotations gathered from English literature. This dictionary has served as the basis for all English dictionaries since. Occasionally, Johnson's considerable wit surfaces in the text. His definition of "patron," for example, reads: "Patron: One who countenances, supports, or protects. Commonly a wretch who supports with insolence, and is repaid with flattery." "Angling" is treated even more amusingly: "A stick and a string, with a worm on one end and a fool on the other."

Johnson is notorious for the **aphorisms**—concise and clever observations—which are scattered throughout his essays. Here are a few examples:

Promise, large promise, is the soul of an advertisement. (from *The Idler*)

Language is the dress of thought. (from *The Lives of the English Poets*)

Marriage has many pains, but celibacy has no pleasures. (from *Rasselas*)

With his piercing wit, Johnson expressed his deep skepticism regarding the perfectibility of human nature. Humanity needed to be saved from itself, and doing that required a strict social and moral order. Most of the great thinkers of the Enlightenment shared his view.

READINGS

from Thomas Hobbes, *Leviathan* (1651)

Leviathan argues that the "natural condition of mankind" is a state of nature where life is "solitary, poor, nasty, brutish, and short." Born into this condition, human beings are motivated only by fear of violent death and accept the governance of a higher authority only to be protected from it and to guarantee their peace and security. When Leviathan was published, just 2 years after England's antiroyalist faction had beheaded Charles I, Hobbes's treatise shocked his contemporaries and caused others, such as John Locke, to construct very different theories in open opposition to it.

Part I Chapter 13: Of the Natural Condition of Mankind as Concerning their Felicity and Misery

Nature has made men so equal in the faculties of the body and mind as that, though there be found one man sometimes manifestly stronger in body or of quicker mind than another, yet, when all is reckoned together, the difference between man and man is not so considerable as that one man can thereupon claim to himself any benefit to which another may not pretend as well as he. For as to the strength of body, the weakest has strength to kill the strongest, either by secret machination or by confederacy with others that are in the same danger with himself. . . . 10

From this equality of ability arises equality of hope in the attaining of our ends. And therefore if any two men desire the same thing, which nevertheless they cannot both enjoy, they become enemies; and in the way to their end, which is principally their own conservation, and sometimes their delectation only, endeavor to destroy or subdue one another. And from hence it comes to pass that where an invader has no more to fear than another man's single power, if one plant, sow, build, or possess a convenient seat, others may probably be expected to come prepared with forces united to dispossess and deprive him, not only of the fruit of his labor, but also of his life or liberty. And the invader again is in the like danger of another. . . . 20

So that in the nature of man we find three principal causes of quarrel: first, competition; secondly, diffidence; thirdly, glory.

The first makes men invade for gain, the second for safety, and the third for reputation. The first use violence to make themselves masters of other men's persons, wives, children, and cattle; the second, to defend them; the third, for trifles, as a word, a smile, a different opinion, and any other sign of undervalue, either direct in their persons or by reflection in their kindred, their friends, their nation, their profession, or their name. 30

Hereby it is manifest that, during the time men live without a common power to keep them all in awe, they are in that condition which is called war, and such a war as is of every man against every man. For WAR consists not in battle only, or the act of fighting, but in a tract of time wherein the will to contend by battle is sufficiently known; and therefore the notion of *time* is to be considered in the nature of war as it is in the nature of weather. For as the nature of foul weather lies not in a shower or two of rain but in an inclination thereto of many days together, so the nature of war consists not in actual fighting but in the known disposition thereto, during all the time there is no assurance to the contrary. All other time is PEACE. 40 50

Whatsoever, therefore, is consequent to a time of war where every man is enemy to every man, the same is consequent to the time wherein men live without other security than what their own strength and their own invention shall furnish them withal. In such condition there is no place for industry, because the fruit thereof is uncertain; and consequently no culture of the earth; no navigation nor use of the commodities that may be imported by sea; no commodious building; no instruments of moving and removing such things as require much force; no knowledge of the face of the earth; no account of time; no arts; no letters; no society; and, which is worst of all, continual fear and danger of violent death; and the life of man solitary, poor, nasty, brutish, and short. . . . 60

Part II Chapter 17: Of the Causes, Generation, and Definition of a Commonwealth

The final cause, end, or design of men, who naturally love liberty and dominion over others, in the introduction of that restraint upon themselves in which we see them live in commonwealths, is the foresight of their own preservation, and of a more contented life thereby—that is to say, of getting themselves out from 70

that miserable condition of war which is necessarily consequent . . . to the natural passions of man when there is no visible power to keep them in awe and tie them by fear of punishment to the performance of their covenants and observations of [the] laws of nature. . . .

For the laws of nature—as *justice, equity, modesty, mercy,* and, in sum, *doing to others as we would be done to*—of themselves, without the terror of some power to cause them to be observed, are contrary to our natural passions, that carry us to partiality, pride, revenge, and the like. And covenants without the sword are but words, and of no strength to secure a man at all. Therefore, notwithstanding the laws of nature . . . if there be no power erected, or not great enough for our security, every man will—and may lawfully—rely on his own strength and art for caution against all other men. . . .

The only way to erect such a common power as may be able to defend them from the invasion of foreigners and the injuries of one another, and thereby to secure them in such sort as that by their own industry and by the fruits of the earth they may nourish themselves and live contentedly, is to confer all their power and strength upon one man, or upon one assembly of men that may reduce all their wills, by plurality of voices, unto one will; which is as much as to say, to appoint one man or assembly of men to bear their person, and everyone to own and acknowledge to himself to be author of whatsoever he that so bears their person shall act or cause to be acted in those things which concern the common peace and safety, and therein to submit their wills every one to his will, and their judgments to his judgment. This is more than consent or concord; it is a real unity of them all in one and the same person, made by covenant of every man with every man, in which manner as if every man should say to every man, *I authorize and give up my right of governing myself to this man, or to this assembly of men, on this condition, that you give up your right to him and authorize all his actions in like manner.* This done, the multitude so united in one person is called a COMMONWEALTH, in Latin CIVITAS. This is the generation of that great LEVIATHAN (or rather, to speak more reverently, of that *mortal god*) to which we owe, under the *immortal God,* our peace and defense. For by this authority, given him by every particular man in the commonwealth, he has the use of so much power and strength conferred on him that, by terror thereof, he is enabled to form the wills of them all to peace at home and mutual aid against their enemies abroad. And in him consists the essence of the commonwealth, which, to define it, is *one person, of whose acts a great multitude, by mutual*

covenants one with another, have made themselves every one the author, to the end he may use the strength and means of them all as he shall think expedient for their peace and common defense. And he that carries this person is called SOVEREIGN and said to have *sovereign power,* and everyone besides, his SUBJECT.

The attaining to this sovereign power is by two ways. One, by natural force. . . . The other is when men agree among themselves to submit to some man or assembly of men voluntarily, on confidence to be protected by him against all others. This latter may be called a political commonwealth, or commonwealth by *institution,* and the former a commonwealth by *acquisition.* . . .

Part II Chapter 30: Of the Office of the Sovereign Representative

The office of the sovereign, be it a monarch or an assembly, consists in the end for which he was trusted with the sovereign power, namely, the procuration of the *safety of the people,* to which he is obliged by the law of nature, and to render an account thereof to God, the author of that law, and to none but him. But by safety here is not meant a bare preservation but also all other contentments of life which every man by lawful industry, without danger or hurt to the commonwealth, shall acquire to himself.

And this is intended should be done, not by care applied to individuals further than their protection from injuries when they shall complain, but by a general providence contained in public instruction, both of doctrine and example, and in the making and executing of good laws, to which individual persons may apply their own cases.

And because, if the essential rights of sovereignty . . . be taken away, the commonwealth is thereby dissolved and every man returns into the condition and calamity of a war with every other man, which is the greatest evil that can happen in this life, it is the office of the sovereign to maintain those rights entire, and consequently against his duty, first, to transfer to another or to lay from himself any of them. For he that deserts the means deserts the ends. . . . ■

Reading Question

How does the figure of the Leviathan, the mythological marine monster described in the Bible, contribute to the power of Locke's thesis?

READING 28.4

from John Locke, *The Second Treatise of Government* (1690)

As opposed to Thomas Hobbes, John Locke argued that human beings can attain their maximum development only in a society free of the unnatural constraints placed upon them by absolute rulers. In his Two Treatises on Civil Government, *published the same year as his* Essay Concerning Human Understanding, *as something of a practical companion to the more philosophical* Essay, *and as a kind of applied theory, Locke argued that government must rest upon the consent of the governed. The work would deeply influence many thinkers in the eighteenth century, not least of all Thomas Jefferson, who drew heavily upon the work in drafting the American Declaration of Independence (see chapter 31).*

From Chapter II: Of the State of Nature

4. To UNDERSTAND political power right and derive it from its original, we must consider what state all men are naturally in, and that is a state of perfect freedom to order their actions and dispose of their possessions and persons as they think fit, within the bounds of the law of nature, without asking leave or depending upon the will of any other man.

A state also of equality, wherein all the power and jurisdiction is reciprocal, no one having more than another; there being nothing more evident than that creatures of the same species and rank, promiscuously born to all the same advantages of nature and the use of the same faculties, should also be equal one amongst another without subordination or subjection; unless the lord and master of them all should, by any manifest declaration of his will, set one above another, and confer on him by an evident and clear appointment an undoubted right to dominion and sovereignty.

From Chapter V: Of Property

26. God, who has given the world to men in common, has also given them reason to make use of it to the best advantage of life and convenience. The earth and all that therein is given to men for the support and comfort of their being. And though all the fruits it naturally produces and beasts it feeds belong to mankind in common, as they are produced by the spontaneous hand of nature; and nobody has originally a private dominion exclusive of the rest of mankind in any of them, as they are thus in their natural state; yet, being given for the use of men, there must of necessity be a means to appropriate them some way or other before they can be of any use or at all beneficial to any particular man. The fruit or venison which nourishes the wild Indian, who knows no enclosure and is still a tenant in common, must be his, and so his, i.e., a part of him, that another can no longer have any right to it before it can do him any good for the support of his life.

27. Though the earth and all inferior creatures be common to all men, yet every man has a property in his own person; this nobody has any right to but himself. The labor of his body and the work of his hands, we may say, are properly his.

Whatsoever then he removes out of the state that nature has provided and left it in, he has mixed his labor with, and joined to it something that is his own, and thereby makes it his property.

From Chapter VIII: Of the Beginning of Political Societies

95. MEN BEING, as has been said, *by nature all free, equal, and independent, no one can be put out of this estate and subjected to the political power of another without his own consent.* The only way whereby any one divests himself of his natural liberty and puts on the bonds of civil society is by agreeing with other men to join and unite into a community for their comfortable, safe, and peaceable living one amongst another, in a secure enjoyment of their properties and a greater security against any that are not of it. This any number of men may do, because it injures not the freedom of the rest; they are left as they were in the liberty of the state of nature. When any number of men have so consented to make one community or government, they are thereby presently incorporated and make one body politic wherein the majority have a right to act and conclude the rest.

96. For when any number of men have, by the consent of every individual, made a community, they have thereby made that community one body, with a power to act as one body, which is only by the will and determination of the majority . . . And therefore we see that in assemblies impowered to act by positive laws, where no number is set by that positive law which impowers them, the act of the majority passes for the act of the whole and, of course, determines, as having by the law of nature and reason the power of the whole.

97. And thus every man, by consenting with others to make one body politic under one government, puts himself under an obligation to every one of that society to submit to the determination of the majority and to be concluded by it; or else this original compact, whereby he with others incorporates into one society, would signify nothing, and be no compact, if he be left free and under no other ties than he was in before in the state of nature.

From Chapter IX: Of The Ends of Political Society and Government

123. IF MAN in the state of nature be so free, as has been said, if he be absolute lord of his own person and possessions, equal to the greatest, and subject to nobody, why will he part with his freedom, why will he give up his empire and subject himself to the dominion and control of any other power? To which it is obvious to answer that though in the state of nature he has such a right, yet the enjoyment of it is very uncertain and constantly exposed to the invasion of others; for all being kings as much as he, every man his equal, and the greater part no strict observers of equity and justice, the enjoyment of the property he has in this state is very unsafe, very unsecure. This makes him willing to quit a condition which, however free, is full of fears and continual dangers; and it is not without reason that he seeks out and is willing to join in society with others who are already united, or have a mind to unite, for the mutual preservation of their lives, liberties, and estates, which I call by the general name "property." 90

124. The great and chief end, therefore, of men's uniting into commonwealths and putting themselves under government is the preservation of their property.

From Chapter XVIII: Of Tyranny

199. AS USURPATION is the exercise of power which another has a right to, so tyranny is the exercise of power beyond right, which nobody can have a right to. And this is making use of the power any one has in his hands, not for the good of those who are under it, but for his own private separate advantage—when the governor, however entitled, makes not the law, but his will, the rule, and his commands 100 and actions are not directed to the preservation of the properties of his people, but the satisfaction of his own ambition, revenge, covetousness, or any other irregular passion . . .

202. Wherever law ends, tyranny begins if the law be transgressed to another's harm. And whosoever in authority exceeds the power given him by the law, and makes use of the force he has under his command . . . ceases in that to be a magistrate and, acting without authority, may be opposed as any other man who by force invades the right of another.

203. May the commands, then, of a prince be opposed? 110 May he be resisted as often as any one shall find himself aggrieved, and but imagine he has not right done him? This will unhinge and overturn all polities, and, instead of government and order, leave nothing but anarchy and confusion.

204. To this I answer that force is to be opposed to nothing but to unjust and unlawful force; whoever makes any opposition in any other case draws on himself a just condemnation both from God and man; and so no such danger or confusion will follow, as is often suggested. ■

Reading Question

Without looking forward to Jefferson's Declaration of Independence, what aspects of Locke's argument here do you recognize as fundamental to your own definition of American liberty?

READING 28.5

from John Milton, *Paradise Lost,* Book 6, (1667)

The following section opens Book 6 of Milton's epic poem. The passage opens with the angel Abdiel, referred to in the book's first line as the "dreadless" or fearless angel because in the previous book he had refused to join Satan's rebellion and had prophesied his downfall, flying about heaven as the other angels gather to confront Satan under the leadership of Gabriel and Michael. The passage takes us up to the moment that the two armies meet. The ensuing battle, in which Abdiel and Michael engage in hand-to-hand combat with Satan, is purposefully reminiscent of Homer's Iliad *(see chapter 5).*

All night the dreadless angel unpursued
Through heav'n's wide champaign held his way, till Morn,
Waked by the circling Hours, with rosy hand
Unbarred the gates of light. There is a cave
Within the mount of God, fast by his throne,
Where light and darkness in perpetual round
Lodge and dislodge by turns, which makes through heav'n
Grateful vicissitude, like day and night;

Light issues forth, and at the other door
Obsequious darkness enters, till her hour 10
To veil the heav'n, though darkness there might well
Seem twilight here; and now went forth the Morn
Such as in highest heav'n, arrayed in gold
Empyreal; from before her vanished night,
Shot through with orient beams: when all the plain
Covered with thick embattled squadrons bright,

[3] **Hours:** four beautiful daughters of love, goddesses of the seasons and guards of the gates of heaven.
[8] **vicissitude:** (L. *vicissim* in turn, *vicis* change, alternation) alternating succession of contrasting things.

[10] **Obsequious:** (L *ob* toward + *sequi* to follow) compliant.
[14] **Empyreal:** (CK *pyr* fire) heavenly.
[16] **embattled:** in battle array.

Chariots and flaming arms, and fiery steeds
Reflecting blaze on blaze, first met his view:
War he perceived, war in procinct, and found
Already known what he for news had thought 20
To have reported: gladly then he mixed
Among those friendly Powers who him received
With joy and acclamations loud, that one
That of so many myriads fall'n, yet one
Returned not lost: on to the sacred hill
They led him high applauded, and present
Before the seat supreme; from whence a voice
From midst a golden cloud thus mild was heard.
 "Servant of God, well done, well hast thou fought
The better fight, who single hast maintained 30
Against revolted multitudes the cause
Of truth, in word mightier than they in arms;
And for the testimony of truth hast borne
Universal reproach, far worse to bear
Than violence: for this was all thy care
To stand approved in sight of God, though worlds
Judged thee perverse: the easier conquest now
Remains thee, aided by this host of friends,
Back on thy foes more glorious to return
Than scorned thou didst depart, and to subdue 40
By force, who reason for their law refuse,
Right reason for their law, and for their King
Messiah, who by right of merit reigns.
Go Michael of celestial armies prince,
And thou in military prowess next
Gabriel, lead forth to battle these my sons
Invincible, lead forth my armed saints
By thousands and by millions ranged for fight;
Equal in number to that godless crew
Rebellious, them with fire and hostile arms 50
Fearless assault, and to the brow of heav'n
Pursuing drive them out from God and bliss,
Into their place of punishment, the gulf
Of Tartarus, which ready opens wide
His fiery chaos to receive their fall."
 So spake the Sovran Voice, and clouds began
To darken all the hill, and smoke to roll
In dusky wreaths reluctant flames, the sign
Of wrath awaked: nor with less dread the loud
Ethereal trumpet from on high gan blow: 60
At which command the powers militant,
That stood for heav'n, in mighty quadrate joined

Of union irresistible, moved on
In silence their bright legions, to the sound
Of instrumental harmony that breathed
Heroic ardor to advent'rous deeds
Under their godlike leaders, in the cause
Of God and his Messiah. On they move
Indissolubly firm; nor obvious hill,
Nor strait'ning vale, nor wood, nor stream divides 70
Their perfect ranks; for high above the ground
Their march was, and the passive air upbore
Their nimble tread; as when the total kind
Of birds in orderly array on wing
Came summoned over Eden to receive
Their names of thee; so over many a tract
Of heav'n they marched, and many a province wide
Tenfold the length of this terrene: at last
Far in th' horizon to the north appeared
From skirt to skirt a fiery region, stretched 80
In battailous aspect, and nearer view
Bristled with upright beams innumerable
Of rigid spears, and helmets thronged, and shields
Various, with boastful argument portrayed,
The banded powers of Satan hasting on
With furious expedition; for they weened
That selfsame day by fight, or by surprise
To win the mount of God, and on his throne
To set the envier of his state, the proud
Aspirer, but their thoughts proved fond and vain 90
In the mid-way: though strange to us it seemed
At first, that angel should with angel war,
And in fierce hosting meet, who wont to meet
So oft in festivals of joy and love
Unanimous, as sons of one great Sire
Hymning th' Eternal Father: but the shout
Of battle now began, and rushing sound
Of onset ended soon each milder thought.
High in the midst exalted as a god
Th' Apostate in his sun-bright chariot sat 100
Idol of majesty divine, enclosed
With flaming Cherubim, and golden shields;
Then lighted from his gorgeous throne, for now
'Twixt host and host but narrow space was left,
A dreadful interval, and front to front
Presented stood in terrible array
Of hideous length: before the cloudy van,
On the rough edge of battle ere it joined,

[19] **in procinct:** prepared.
[29] **Servant of God:** the literal meaning of the Hebrew word *abdiel*. Cf Matt. 25.21: "His lord said unto him. Well done, thou good and faithful servant." 2 Tim. 4.7: "I have fought a good fight, I have finished my course, I have kept the faith."
[33–34] Cf. Ps. 69.7: "Because for thy sake I have borne reproach."
[36] Cf. 2 Tim. 2.15: "Study to show thyself approved unto God."
[58] **reluctant:** L *re* back + *luctari* to struggle.
[62] **quadrate:** a square military formation in close order.

[69] **obvious:** standing in the way of.
[78] **terrene:** (an adjective used as a noun) terrain.
[81] **battailous:** warlike.
[83–84] On the shields were drawn heraldies emblems with their mottoes.
[86] **furious:** (L *furia* tage) rushing expedition: speed
[90] **fond** (ME. *fon* fool) foolish vain; L *vanus* empty.
[93] **hosting:** hostile encounter.
[100] **Apostate:** Gk *apo* out from, against + *stēnai* to stand.

Satan with vast and haughty strides advanced,
Came tow'ring, armed in adamant and gold;
Abdiel that sight endured not, where he stood
Among the mightiest, bent on highest deeds,
And thus his own undaunted heart explores. . . . ■

110

Reading Question

How do the opening 20 lines, with their description of darkness and light, reminiscent of the opening lines of the Book of Genesis in the Bible, contribute to both the emotional and moral thrust of the poem as the angels prepare for battle?

READING 28.6

from Jonathan Swift, *A Modest Proposal* (1729)

Swift's brief satire is an open parody of the economic theory that the wealth of a nation lies in its population. A Modest Proposal takes that proposition literally, by suggesting, outrageously, that poor Irish families breed their children to be eaten at the dinner tables of rich Englishmen. Such a solution to the problem of starving Irish families—they would, as it were, breed for profit—is meant to be understood as the symbolic equivalent of what was actually happening to Irish families and their children. In fact, many Irishmen worked farms owned by Englishmen who charged them such high rents that they were frequently unable to pay them, and consequently lived on the brink of starvation. As Dean of the Cathedral in Dublin, Swift was in a position to witness their plight on a daily basis. For all practical purposes, Swift believed, England was consuming the Irish young, if not literally then figuratively, sucking the lifeblood out of them by means of its oppressive economic policies.

A Modest Proposal

For Preventing the Children of Poor People in Ireland from Being a Burden to their Parents or the Country, and for Making them Beneficial to the Public, 1729.

It is a melancholy object to those who walk through this great town[1] or travel in the country, when they see the streets, the roads, and cabin doors, crowded with beggars of the female sex, followed by three, four, or six children, all in rags and importuning every passenger for an alms. These mothers, instead of being able to work for their honest livelihood, are forced to employ all their time in strolling to beg sustenance for their helpless infants: who as they grow up either turn thieves for want of work, or leave their dear native country to fight for the pretender in Spain,[2] or sell themselves to the Barbadoes.[3]

I think it is agreed by all parties that this prodigious number of children in the arms, or on the backs, or at the heels of their mothers, and frequently of their fathers, is in the present deplorable state of the kingdom a very great additional grievance; and, therefore, whoever could find out a fair, cheap, and easy method of making these children sound, useful members of the commonwealth, would deserve so well of the public as to have his statue set up for a preserver of the nation.

But my intention is very far from being confined to provide only for the children of professed beggars; it is of a much greater extent, and shall take in the whole number of infants at a certain age who are born of parents in effect as little able to support them as those who demand our charity in the streets.

As to my own part, having turned my thoughts for many years upon this important subject, and maturely weighed the several schemes of our projectors,[4] I have always found them grossly mistaken in their computation. It is true, a child just dropped from its dam may be supported by her milk for a solar year, with little other nourishment; at most not above the value of 2s., which the mother may certainly get, or the value in scraps, by her lawful occupation of begging; and it is exactly at one year old that I propose to provide for them in such a manner as instead of being a charge upon their parents or the parish, or wanting food and raiment for the rest of their lives, they shall on the contrary contribute to the feeding, and partly to the clothing, of many thousands.

There is likewise another great advantage in my scheme, that it will prevent those voluntary abortions, and the horrid practice of women murdering their bastard children, alas! too frequent among us! Sacrificing the poor innocent babes, I doubt, more to avoid the expense than the shame,

10

20

30

40

[1] Dublin.
[2] A reference to the fact that many Irish were recruited to fight in the Spanish and French armies against England. "The Pretender" is the son of James II who had been forced from the English throne in the Glorious Revolution of 1688.
[3] Many Irish emigrated to the Barbadoes to improve their lot.

[4] In the eighteenth century, the word "projector" meant more than simply "planner"; it also referred to someone who proposed foolish projects.

which would move tears and pity in the most savage and inhuman breast.

The number of souls in this kingdom being usually reckoned one million and a half, of these I calculate there may be about 200,000 couples whose wives are breeders; from which number I subtract 30,000 couples who are able to maintain their own children (although I apprehend there cannot be so many, under the present distresses of the kingdom); but this being granted, there will remain 170,000 breeders. I again subtract 50,000 for those women who miscarry, or whose children die by accident or disease within the year. There only remains 120,000 children of poor parents annually born. The question therefore is, how this number shall be reared and provided for? which, as I have already said, under the present situation of affairs, is utterly impossible by all the methods hitherto proposed. For we can neither employ them in handicraft or agriculture; we neither build houses (I mean in the country) nor cultivate land; they can very seldom pick up a livelihood by stealing, till they arrive at six years old, except where they are of towardly parts; although I confess they learn the rudiments much earlier; during which time, they can however be properly looked upon only as probationers; as I have been informed by a principal gentleman in the county of Cavan, who protested to me that he never knew above one or two instances under the age of six, even in a part of the kingdom so renowned for the quickest proficiency in that art.

I am assured by our merchants, that a boy or a girl before twelve years old is no saleable commodity; and even when they come to this age they will not yield above 3*l.* or 3*l.* 2*s.* 6*d.* at most on the exchange; which cannot turn to account either to the parents or kingdom, the charge of nutriment and rags having been at least four times that value.

I shall now therefore humbly propose my own thoughts, which I hope will not be liable to the least objection.

I have been assured by a very knowing American of my acquaintance in London, that a young healthy child well nursed is at a year old a most delicious, nourishing, and wholesome food, whether stewed, roasted, baked, or boiled; and I make no doubt that it will equally serve in a fricassee or a ragout.

I do therefore humbly offer it to public consideration that of the 120,000 children already computed, 20,000 may be reserved for breed, whereof only one-fourth part to be males; which is more than we allow to sheep, black cattle or swine; and my reason is, that these children are seldom the fruits of marriage, a circumstance not much regarded by our savages,[5] therefore one male will be sufficient to serve four females.

That the remaining 100,000 may, at a year old, be offered in sale to the persons of quality and fortune through the kingdom; always advising the mother to let them suck plentifully in the last month, so as to render them plump and fat for a good table. A child will make two dishes at an entertainment for friends; and when the family dines alone, the fore or hind quarter will make a reasonable dish, and seasoned with a little pepper or salt will be very good boiled on the fourth day, especially in winter.

I have reckoned upon a medium that a child just born will weight 12 pounds, and in a solar year, if tolerably nursed, will increase to 28 pounds.

I grant this food will be somewhat dear, and therefore very proper for landlords, who, as they have already devoured most of the parents, seem to have the best title to the children.

Infant's flesh will be in season throughout the year, but more plentifully in March, and a little before and after; for we are told by a grave author, an eminent French physician, that fish being a prolific diet, there are more children born in Roman Catholic countries about nine months after Lent than at any other season; therefore, reckoning a year after Lent, the markets will be more glutted than usual, because the number of popish infants is at least three to one in this kingdom: and therefore it will have one other collateral advantage, by lessening the number of papists among us.

I have already computed the charge of nursing a beggar's child (in which list I reckon all cottagers, labourers, and four-fifths of the farmers) to be about 2*s.* per annum, rags included; and I believe no gentleman would repine to give 10*s.* for the carcass of a good fat child, which, as I have said, will make four dishes of excellent nutritive meat, when he has only some particular friend or his own family to dine with him. Thus the squire will learn to be a good landlord, and grow popular among the tenants; the mother will have 8*s.* net profit, and be fit for work till she produces another child.

Those who are more thrifty (as I must confess the times require) may flay the carcass; the skin of which artificially dressed will make admirable gloves for ladies, and summer boots for fine gentlemen.

As to our city of Dublin, shambles[6] may be appointed for this purpose in the most convenient parts of it, and butchers we may be assured will not be wanting; although I rather recommend buying the children alive than dressing them hot from the knife as we do roasting pigs.

A very worthy person, a true lover of his country, and whose virtues I highly esteem, was lately pleased in discoursing on this matter to offer a refinement upon my scheme. He said that many gentlemen of this kingdom, having of late destroyed their deer, he conceived that the want of venison might be well supplied by the bodies of young lads and maidens, not exceeding fourteen years of age nor under twelve; so great a number of both sexes in every country being now ready to starve for want of work and service; and these to be disposed of by their parents, if alive, or otherwise by their nearest relations. But with due deference to so excellent a friend and so deserving a patriot, I cannot be altogether in his sentiments; for as to the males, my American acquaintance assured me, from frequent experience, that their flesh was generally tough and lean, like that of our school-boys by continual exercise, and their taste disagreeable; and to fatten

[5] i.e., the Irish.

[6] A slaughterhouse, a butcher shop.

them would not answer the charge. Then as to the females, it would, I think, with humble submission, be a loss to the public, because they soon would become breeders themselves: and besides, it is not improbable that some scrupulous people might be apt to censure such a practice (although indeed very unjustly), as a little bordering upon cruelty; which, I confess, has always been with me the strongest objection against any project, howsoever well intended.

But in order to justify my friend, he confessed that this expedient was put into his head by the famous Psalmanazar,[7] a native of the island Formosa, who came from thence to London above twenty years ago: and in conversation told my friend, that in his country when any young person happened to be put to death, the executioner sold the carcass to persons of quality as a prime dainty; and that in his time the body of a plump girl of fifteen, who was crucified for an attempt to poison the emperor, was sold to His Imperial Majesty's prime minister of state, and other great mandarins of the court, in joints from the gibbet, at 400 crowns. Neither indeed can I deny, that if the same use were made of several plump girls in this town, who without one single groat to their fortunes cannot stir abroad without a chair, and appear at playhouse and assemblies in foreign fineries which they never will pay for, the kingdom would not be the worse.

Some persons of a desponding spirit are in great concern about that vast number of poor people, who are aged, diseased, or maimed, and I have been desired to employ my thoughts what course may be taken to ease the nation of so grievous an encumbrance. But I am not in the least pain upon that matter, because it is very well known that they are every day dying and rotting by cold and famine, and filth and vermin, as fast as can be reasonably expected. And as to the young labourers, they are now in as hopeful a condition; they cannot get work, and consequently pine away for want of nourishment, to a degree that if at any time they are accidentally hired to common labour, they have not strength to perform it; and thus the country and themselves are happily delivered from the evils to come.

I have too long digressed, and therefore shall return to my subject. I think the advantages by the proposal which I have made are obvious and many, as well as of the highest importance.

For first, as I have already observed, it would greatly lessen the number of papists, with whom we are yearly overrun, being the principal breeders of the nation as well as our most dangerous enemies; and who stay at home on purpose to deliver the kingdom to the Pretender, hoping to take their advantage by the absence of so many good Protestants, who have chosen rather to leave their country than stay at home and pay tithes against their conscience to an Episcopal curate.

Secondly, The poor tenants will have something valuable of their own, which by law may be made liable to distress and help to pay their landlord's rent, their corn and cattle being already seized, and money a thing unknown.

Thirdly, Whereas the maintenance of 100,000 children, from two years old and upward, cannot be computed at less than 10s. a-piece per annum, the nation's stock will be thereby increased £50,000 per annum, beside the profit of a new dish introduced to the tables of all gentlemen of fortune in the kingdom who have any refinement in taste. And the money will circulate among ourselves, the goods being entirely of our own growth and manufacture.

Fourthly, The constant breeders, beside the gain of 8s. sterling per annum by the sale of their children, will be rid of the charge of maintaining them after the first year.

Fifthly, This food would likewise bring great custom to taverns; where the vintners will certainly be so prudent as to procure the best receipts for dressing it to perfection, and consequently have their houses frequented by all the fine gentlemen, who justly value themselves upon their knowledge in good eating; and a skilful cook, who understands how to oblige his guests, will contrive to make it as expensive as they please.

Sixthly, This would be a great inducement to marriage, which all wise nations have either encouraged by rewards or enforced by laws and penalties. It would increase the care and tenderness of mothers toward their children, when they were sure of a settlement for life to the poor babes, provided in some sort by the public, to their annual profit or expense. We should see an honest emulation among the married women, which of them could bring the fattest child to the market. Men would become as fond of their wives during the time of their pregnancy as they are now of their mares in foal, their cows in calf, their sows when they are ready to farrow; nor offer to beat or kick them (as is too frequent a practice) for fear of a miscarriage.

Many other advantages might be enumerated. For instance, the addition of some thousand carcasses in our exportation of barrelled beef, the propagation of swine's flesh, and improvement in the art of making good bacon, so much wanted among us by the great destruction of pigs, too frequent at our table; which are no way comparable in taste or magnificence to a well-grown, fat, yearling child, which roasted whole will make a considerable figure at a lord mayor's feast or any other public entertainment. But this and many others I omit, being studious of brevity.

Supposing that 1000 families in this city would be constant customers for infants' flesh, beside others who might have it at merry-meetings, particularly at weddings and christenings, I compute that Dublin would take off annually about 20,000 carcasses; and the rest of the kingdom (where probably they will be sold somewhat cheaper) the remaining 80,000.

I can think of no one objection that will possibly be raised against this proposal, unless it should be urged that the number of people will be thereby much lessened in the kingdom. This I freely own, and it was indeed one principal design in offering it to the world. I desire the reader will observe, that I calculate my remedy for this one individual kingdom of

[7] George Psalmanazar, a pseudonym for a French contemporary of Swift who became notorious for a series of impostures. In 1704, he published a "description" of Formosa where he claimed, falsely, that he had been born.

Ireland and for no other that ever was, is, or I think ever can be upon earth. Therefore let no man talk to me of other expedients:[8] *of taxing our absentees at 5s. a pound; of using neither clothes nor household furniture except what is of our own growth and manufacture; of utterly rejecting the materials and instruments that promote foreign luxury; of curing the expensiveness of pride, vanity, idleness, and gaming in our women; of introducing a vein of parsimony, prudence, and temperance; of learning to love our country, in the want of which we differ even from LAPLANDERS and the inhabitants of TOPINAMBOO; of quitting our animosities and factions, nor acting any longer like the Jews, who were murdering one another at the very moment their city was taken; of being a little cautious not to sell our country and conscience for nothing; of teaching landlords to have at least one degree of mercy toward their tenants; lastly, of putting a spirit of honesty, industry, and skill into our shopkeepers; who, if a resolution could now be taken to buy only our negative goods, would immediately unite to cheat and exact upon us in the price, the measure, and the goodness, nor could ever yet be brought to make one fair proposal of just dealing, though often and earnestly invited to it.*

Therefore I repeat, let no man talk to me of these and the like expedients, till he hath at least some glimpse of hope that there will be ever some hearty and sincere attempt to put them in practice.

But as to myself, having been wearied out for many years with offering vain, idle, visionary thoughts, and at length utterly despairing of success, I fortunately fell upon this proposal; which, as it is wholly new, so it has something solid and real, of no expense and little trouble, full in our own power, and whereby we can incur no danger in disobliging ENGLAND. For this kind of commodity will not bear exportation, the flesh being of too tender a consistence to admit a long continuance in salt, although perhaps I could name a country[9] which would be glad to eat up our whole nation without it.

After all, I am not so violently bent upon my own opinion as to reject any offer proposed by wise men, which shall be found equally innocent, cheap, easy, and effectual. But before something of that kind shall be advanced in contradiction to my scheme, and offering a better, I desire the author or authors will be pleased maturely to consider two points. First, as things now stand, how they will be able to find food and raiment for 100,000 useless mouths and backs. And secondly, there being a round million of creatures in human figure throughout this kingdom, whose whole subsistence put into a common stock would leave them in debt 2,000,000l. sterling, adding those who are beggars by profession to the bulk of farmers, cottagers, and labourers, with the wives and children who are beggars in effect; I desire those politicians who dislike my overture, and may perhaps be so bold as to attempt an answer, that they will first ask the parents of these mortals, whether they would not at this day think it a great happiness to have been sold for food at a year old in the manner I prescribe, and thereby have avoided such a perpetual scene of misfortunes as they have since gone through by the oppression of landlords, the impossibility of paying rent without money or trade, the want of common sustenance, with neither house nor clothes to cover them from the inclemencies of the weather, and the most inevitable prospect of entailing the like or greater miseries upon their breed for ever.

I profess, in the sincerity of my heart, that I have not the least personal interest in endeavouring to promote this necessary work, having no other motive than the *public good of my country, by advancing our trade, providing for infants, relieving the poor, and giving some pleasure to the rich.* I have no children by which I can propose to get a single penny; the youngest being nine years old, and my wife past child-bearing. ∎

Reading Question

A Modest Proposal **is a satire, deeply ironic in tone. When did you begin to suspect the irony of the proposal, and to realize the arguments are meant to be outrageous no matter how logical their tone?**

[8] These expedients were, in fact, measures that Swift had seriously proposed in earlier pieces he had written.

[9] England, obviously.

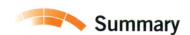

Summary

■ **The New London: Toward the Enlightenment** On September 2, 1666, the better part of London was destroyed by fire. The devastation was in many ways a blessing in disguise, giving the city the opportunity to modernize its center and rebuild in a way that no other European capital could imagine. Among the achievements of this rebuilding campaign is Christopher Wren's Saint Paul's Cathedral (and indeed the 51 other churches that he rebuilt). Simultaneously, English intellectuals began to advocate rational thinking as the means to achieve a comprehensive system of ethics, aesthetics, and knowledge. Political strife in England inevitably raised the question of who should govern and how. In *Leviathan*, Thomas Hobbes argued that ordinary people were incapable of governing themselves and should willingly submit to the sovereignty of a supreme ruler. John Locke argued in opposition that humans are "by nature free, equal, and independent." The ruler in this case should have only limited authority.

The debate between Hobbes's absolutism and Locke's liberalism underlies one of the greatest poems of the English seventeenth century, John Milton's epic *Paradise Lost*. Describing the contest for power between God, who ascribes to the absolutist position, and his angel Lucifer, who ascribes to the liberal position, it recapitulates in universal terms the politics of the English Civil War.

■ **The English Enlightenment** Deeply conscious of the fact that English society fell far short of its ideals, many writers and artists turned to satire. William Hogarth's prints, produced for a popular audience, satirized the lifestyles of all levels of English society. Jonathan Swift aimed the barbs of his wit at the same aristocracy and lambasted English political leaders for their policies toward Ireland in his *Modest Proposal*. Alexander Pope's *Dunciad* took on, not only the English nobility, but the literary establishment that supported it. In a more serious vein, his *Essay on Man* attempts to define a complete ethical system in classical terms of balance and harmony.

After the Glorious Revolution, in fact, English politics settled into a state of comparative harmony. Isaac Newton had demonstrated that the universe was an intelligible system, and it followed in the minds of many thinkers that the state's political problems could be solved through rational thinking and the careful observation of the world. Rational thinking as a solution to commercial problems also inspired the many inventions of the Lunar Society that launched what we think of today as the Industrial Revolution. Josiah Wedgwood's earthenware factory inaugurated mass production. The inventions of the Abraham Darbys I and III stimulated iron production. Richard Arkwright's water frame increased cotton production, and James Watt's steam engine revolutionized manufacturing.

In music, composer George Frederick Handel's oratorio the *Messiah* captured Britain's sense of identification with biblical Israel.

■ **Literacy and the New Print Culture** The growing literacy of the English population was matched by an explosion in publishing. Newspapers such as Joseph Addison and Richard Steele's *The Tatler* and *The Spectator* introduced a new genre, the journalistic essay, that described and reflected upon all aspects of English society. Fiction writers experimented with many forms of the novel, from Daniel Defoe's fictive autobiographies to Samuel Richardson's epistolary works, Fielding's "comic epic-poems in prose," and Jane Austen's novels extolling the virtues of good sense, reason, and self-improvement. Over the course of his literary career, Samuel Johnson worked in most every literary form available to him.

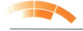

Glossary

aphorism A concise and clever observation.

caricature A portrait that exaggerates a person's peculiarities or defects.

epistolary novel A novel made up of a series of epistles, or letters.

heroic couplet A rhyming pair of iambic pentameter lines.

journalistic essay A reportorial set of observations of current events or other issues of interest to the author.

Industrial Revolution The term used to describe a change in practices of production and consumption that occurred in the nineteenth century.

liberalism A political theory that argues that people are by nature free, equal, and independent and that they consent to government for protection but not by surrendering sovereignty to a ruler.

oratorio A lengthy choral work, usually religious, performed by a narrator, soloists, choruses, and orchestra.

parody A form of satire in which a serious author or work is ridiculed or mocked in a humorous way through exaggerated imitation.

social contract An agreement by which a person gives up sovereignty over him- or herself and bestows it on a ruler.

 # Critical Thinking Questions

1. How would you compare and contrast the absolutism of Thomas Hobbes with the liberalism of John Locke? Provide two or three examples of how their positions play out in the politics of the era. Summarize how they play out in John Milton's *Paradise Lost*.

2. What characterizes the philosophical underpinnings of the Industrial Revolution? In other words, what ideals did the members of the Lunar Society share?

3. From what you know without necessarily having read the novels, in what particular ways does Samuel Johnson's assessment of the novel in his *Rambler* essay of 1850 apply to the works of Defoe, Richardson, and Fielding?

Signboard of a New World

Continuity & Change

The English Enlightenment's repudiation of the absolute authority of the monarchy was echoed across the Channel by French philosophers who likewise championed the right of the people to determine their own future. No image better sums up these feelings than *The Signboard of Gersaint* [zhair-SAHNT] (Fig. **28.12**), painted by Jean-Antoine Watteau [wah-TOH] in about 1721. (A detail is shown here. The full image appears in Fig. 29.4.) The painting is, quite literally, a signboard, a little over 5 feet high and 10 feet long and was commissioned to hang outside Gersaint's art gallery in Paris.

Gersaint called his gallery Au Grand Monarque ("At the Sign of the Great King"), and in this detail the artist alludes to the recently departed sun king by showing gallery workers putting a portrait of Louis XIV, probably painted by Hyacinthe Rigaud, into a box for storage. A woman in a pink satin gown steps over the threshold from the street, ignoring, for a moment, her companion's outstretched hand to gaze down at the portrait as it descends into its coffinlike confines.

It is as if she is taking one last look at the fading world of Louis XIV before turning her back on it once and for all. In fact, just one day after Louis's death, the aristocracy abandoned the palace and returned to Paris. Here they built elegant new homes (*hôtels*, in French), lavishly decorating them in a new style known as Rococo. The new king Louis XV was, at 5 years of age, in no position to demand their daily attentions. Even the young king's regent, the duke of Orléans, made his home in Paris, where he could attend the intellectual and social gatherings, the *salons*, that soon came to dominate Parisian social life.

Watteau's painting is really the signboard of a new world, dominated by the leisure, elegance, and refinement of the aristocratic Parisian elite. But he adds an ominous note. An ill-kempt passerby, stick in hand, stands just to the left of the crate. He too stares down at the Grand Monarque's picture as it is lowered into place, but with a certain disdain. He is the other France, the France that, so marginalized, will erupt in revolution in 1789.

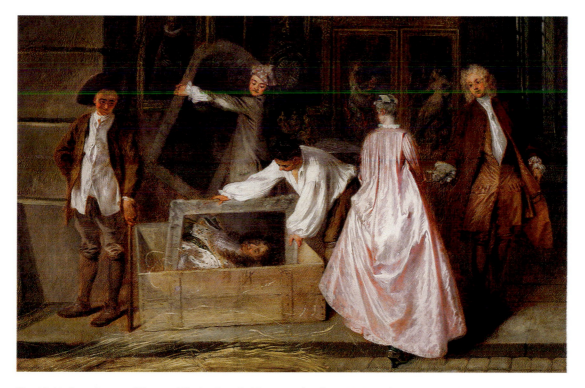

Fig. 28.12 Jean-Antoine Watteau. *The Signboard of Gersaint*, detail. ca. 1721. Oil on canvas, 5′4″ × 10′1″. Staatliche Museen zu Berlin, Preussischer Kulturbesitz, Verwaltung der Staatl, Schlösser und Gärden Kunstsammlungen.

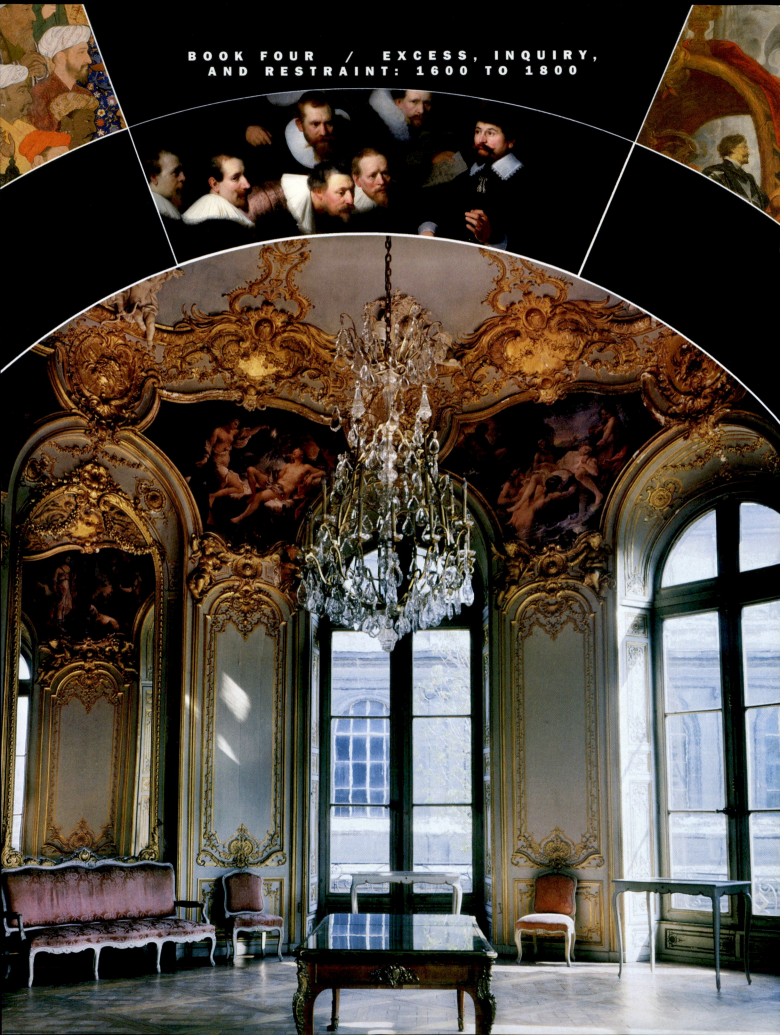

29 The Rococo and the Enlightenment on the Continent

Privilege and Reason

The Rococo

The *Philosophes*

Rococo and Classical Music

❝ *To renounce liberty is to renounce being a man, to surrender the rights of humanity and even its duties.* **❞**

Jean-Jacques Rousseau, *The Social Contract*

← **Fig. 29.1 Germain Boffrand.** *Salon de la Princesse de Soubise (Salon oval)*, **Hôtel de Soubise, Paris. ca. 1740.** Oval shape, 33′ × 26′. Photo: Bulloz. Reunion des Musees Nationaux/Art Resource, NY. In his 1745 *Livre d'architecture* (*Book on Architecture*), Boffrand compared architecture to theater, arguing that it had both a tragic and pastoral mode. In the lightness of its ornament and the eroticism of its paintings, the Salon de la Princesse is an example of the pastoral mode.

UNTIL HIS DEATH IN 1715, LOUIS XIV HAD OPENED HIS

private apartments in Versailles three days a week to his courtiers, where they entertained themselves by playing games. After his death such entertainments continued, only not at Versailles but in the *hôtels*—or Paris townhouses—

of the French nobility, where the same crowd who had visited the king's apartments now entertained on their own. The new king, Louis XV, was only 5 years old, and so there was no point in staying so far out of town in the rural palace where the Sun King had reigned supreme.

The *hôtels* all had a **salon**, a room designed especially for social gatherings. Very soon the term "salon" came to refer to the social gathering itself. A number of these rooms still survive, including the Salon de la Princesse, which was designed by Germain Boffrand to commemorate the 1737

marriage of the 80-year-old prince of Soubise to the 19-year-old Marie-Sophie de Courcillon (Fig. **29.1**). Decorated around the top of the room with eight large paintings by Charles-Joseph Natoire [nah-TWAHR] (1700–1777) depicting the story of Cupid and Psyche from Ovid's *Metamorphoses* (Fig. **29.2**), the room embodies the eroticism that dominated the art of the French aristocracy in the eighteenth century.

These salons became the center of French culture in the eighteenth century, and by 1850 they were emulated across

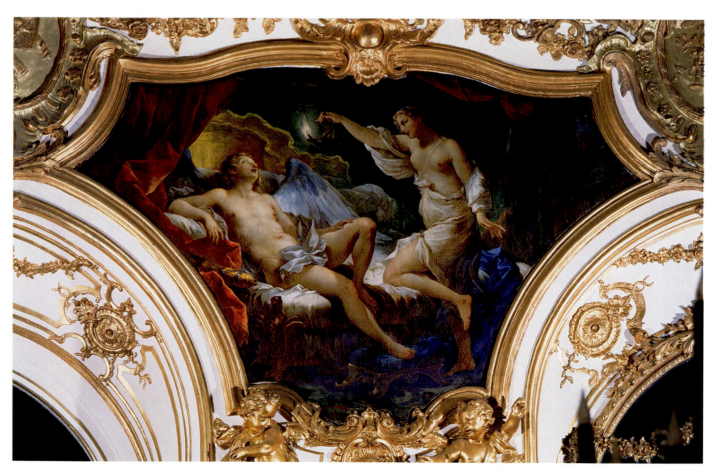

Fig. 29.2 Charles-Joseph Natoire. *Cupid and Psyche*, Salon de la Princesse, Hôtel de Soubise, Paris. 1738. Oil on canvas, 5′7 3/4″ × 8′6 3/8″. Peter Willi/The Bridgeman Art Library. Here Psyche has been brought to the palace of Love where Cupid, under cover of darkness, has consummated their union. Psyche had promised never to seek to know his identity. Here she breaks her oath by lighting her lamp to reveal Cupid's face.

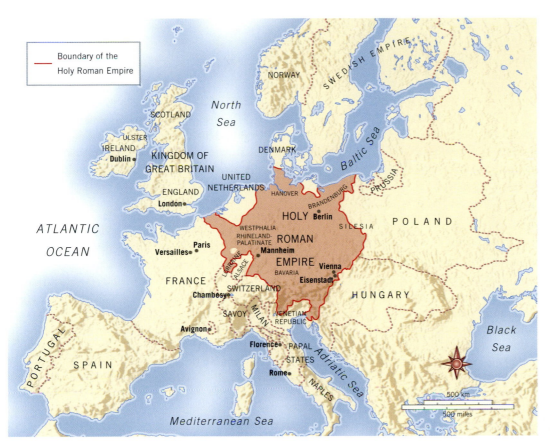

Map 29.1 Europe in 1750.

Europe (see Map **29.1**). The new princess de Soubise was perhaps too young to be herself an active *salonnière* [sah-lohn-YAIR], one of the hostesses who presided over the weekly gatherings that soon dominated Parisian social life. Among the most popular salons were those of Jeanne-Julie-Eleonore de Lespinasse [deh less-peen-AHSS] (1732–1776). In his memoirs, Friederich Melchior, baron von Grimm (1723–1807), a frequent guest, recalls the ambiance:

> Her circle met daily from five o'clock until nine in the evening. There we were sure to find choice men of all orders in the State, the Church, the Court—military men, foreigners, and the most distinguished men of letters. Every one agrees that though the name of M. d'Alembert [an intellectual who lived with Julie de Lespinasse, and who is discussed later in the chapter] may have drawn them thither, it was she alone who kept them there. Devoted wholly to the care of preserving that society, of which she was the soul and the charm, she subordinated to this purpose all her tastes and all her personal intimacies. She seldom went to the theatre or into the country, and when she did make an exception to this rule it was an event of which all Paris was notified in advance. . . . Politics, religion, philosophy, anecdotes, news, nothing was excluded from the conversation, and, thanks to her care, the most trivial little narrative gained, as naturally as possible, the place and notice it deserved. News of all kinds was gathered there in its first freshness.

The baron numbered among his friends many of the most influential Parisian thinkers of the day, the so-called *philosophes* [FILL-loh-sof], "philosophers," who frequented the salons and dominated the intellectual life of the French Enlightenment, a movement that emphasized reason and rationality and sought to develop a systematic understanding of divine and natural law. Not philosophers in the strict sense of the word because they did not concentrate on matters metaphysical, but turned their attention to secular and social concerns, the *philosophes* were almost uniformly alienated from the Church, despising its hierarchy and ritual. They were also committed to the abolition of the monarchy, which they saw as intolerant, unjust, and decadent.

The tension in the eighteenth century between the *philosophes*, who aspired to establish a new social order of superior moral and ethical quality, and the French courtiers, whose taste favored a decorative and erotic excess that the *philosophes* abhorred, is the subject of this chapter. The two often collided at the salons. Consider, for instance, the salons of Madame de Pompadour [mah-DAHM deh pohm-pah-DOOR] (1721–1764), born into a middle-class family involved in Parisian financial circles. She was a great defender of the *philosophes*, but she was also mistress to Louis XV after he assumed full power in 1743. She blocked efforts to have the works of the *philosophes* suppressed by censors and was successful in keeping works attacking the *philosophes* out of circulation. And yet, she was also the king's trusted advisor and the subject of many

erotic paintings done at court depicting her as Venus. The competing styles of Louis XIV's Baroque court survived into the eighteenth century, but now were no longer united or comfortable together. Whereas at Versailles essentially Classical architecture was embellished with Baroque ornamentation, the nobility now appreciated only an ever-more elaborate decoration and ornament, while the *philosophes* shunned ornamentation altogether, preferring the order, regularity, and balance of the Classical tradition. These tensions were apparent across Europe, particularly in Prussia, where an absolutist monarchy consciously emulated the courts of Louis XIV and XV. In painting, the absolutist courts preferred a sensual style of painting indebted to Rubens, while the *philosophes* admired paintings that were representational and conveyed emotional truth. In France, Germany, and England, a taste soon developed for gardens dominated by winding and circuitous paths, inspired by the curvilinear ornamentation of the Baroque as opposed to the geometric regularity of the French gardens at Versailles. And in music, the intricate and charming melodies of the court composers gave way to Classical form and structure, while *opera seria* gave way to *opera buffa* and to a hybrid form called *dramma giocoso*.

The Rococo

The decorative style fostered by the French court in the eighteenth century and quickly emulated by royal courts across Europe was known as the **Rococo** [ruh-KOH-koh]. The term is thought to derive from the French word *rocaille* [roh-KYE], a type of decorative rockwork made from round pebbles and curvilinear shells. But it also derives from *barocco*, the Italian word for "baroque." In fact, the Rococo style is probably best understood as the culmination of developments in art and architecture that began in the late work of Michelangelo and progressed through Mannerism and the Baroque into the eighteenth century. Along the way, the style became increasingly elaborate, with architectural interiors employing a vocabulary of S- and C-curves, shell, wing, scroll, and plant tendril forms, and rounded, convex, often asymmetrical surfaces surrounded by elaborate frames, called **cartouches** [car-TOOSH]. In its decorative excess, the Rococo is related to the ornate *retablos* of Mexican churches (see chapter 27). But, even if the style sometimes found its ways into religious architecture, it is more a secular decorative tradition, conceived for the residences and palaces of Europe's nobility and for the art and objects that filled them.

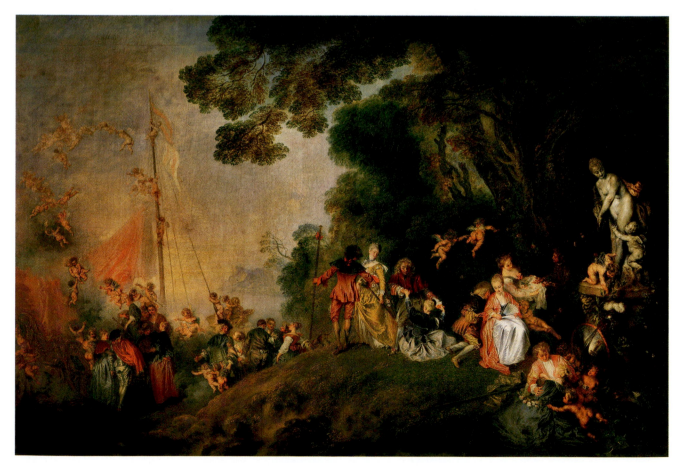

Fig. 29.3 Jean-Antoine Watteau. *The Embarkation from Cythera*. ca. 1718–1719. Oil on canvas, 50¾″ × 76⅜″. Staatliche Museen, Schloss Charlottenburg, Berlin. This painting, and the one in Fig. 29.4, were purchased by Frederick the Great of Prussia for his own collection. Frederick often staged *fêtes galantes* at Sanssouci.

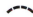

Rococo Painting in France: The *Fête Galante* and the Art of Love

Most eighteenth-century French painters still relied on the court for commissions. But once the courtiers had moved back from Versailles to the comfort of their Paris townhouses and country estates, they were less interested in commissioning paintings that glorified them than those that entertained. The new Rococo style as applied to French painting suited this domestic goal perfectly. Its subject matter is often frivolous, emphasizing the pursuit of pleasure, particularly love. Its compositions were generally asymmetrical, and its color range was light, emphasizing gold, silver, and pastels.

Jean-Antoine Watteau The Rococo found its most eloquent expression in France in the paintings of Jean-Antoine Watteau [wah-TOH] (1684–1721). This is ironic because he did not have aristocratic patrons and was little known during his lifetime beyond a small group of bourgeois buyers, such as bankers and dealers. Watteau was best known for his paintings of *fêtes galante* [fet gah-LAHNT]—gallant, and by extension amorous, celebrations or parties enjoyed by an elite group in a pastoral or garden setting.

The erotic overtones of these *fêtes galantes* are immediately apparent in *The Embarkation from Cythera* in the pedestal statue of Venus at the right side of the painting and the flock of winged cupids darting about among the revelers (Fig. 29.3). The scene is the island of Cythera, the mythical birthplace of the goddess. Below her statue, which the pilgrims have decked with garlands of roses, a woman leans across her companion's lap as three cupids try to push the two closer together. Behind them, a gentleman leans toward his lady to say words that will be overheard by another woman behind them, who gathers roses with her lover as she leans over them both. Further back in the scene a gentleman helps his lady to her feet while another couple turns to leave, the woman looking back in regret that they must depart the garden island.

Watteau was a great admirer of Rubens and copied his work often, including instances of cupids pushing couples together. He shared with Rubens a great love of painting flesh, as well as the ability to reflect in the sensuality of his brushwork and color the sensuality of his subject matter. In *The Signboard of Gersaint* [zhair-SAHNT], for instance, Watteau fills the room with *Rubeniste* canvases (Fig. **29.4**; see also Fig. 28.12). The kneeling gentleman and his companion seem to be examining a canvas depicting a drunken Silenus very much in the spirit of Rubens's many paintings of the same theme. The dog at the bottom right of the painting is an echo of Rubens's frequent use of a dog as an emblem of the sensual appetites.

François Boucher Madame de Pompadour's favorite painter was François Boucher [BOO-shay] (1703–1770), who began

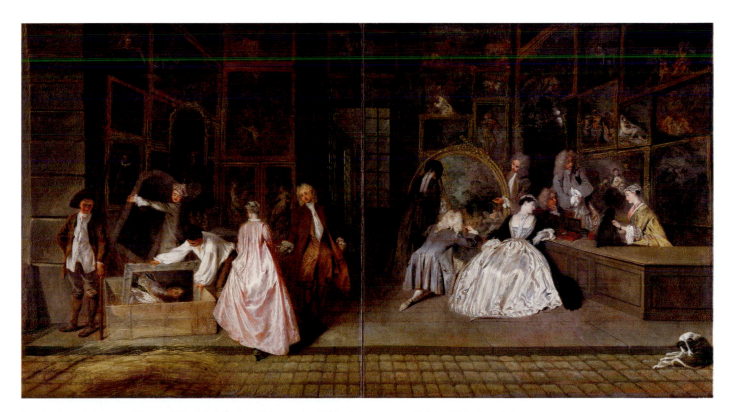

Fig. 29.4 Jean-Antoine Watteau. *The Signboard of Gersaint*. ca. 1721. Oil on canvas, 5′4″ × 10′1″. Staatliche Museen zu Berlin, Preussischer Kulturbesitz, Verwaltung der Staatl. Schlösser und Gärden Kunstsammlungen. After it was sold, the work was cut in two halves and displayed as two separate paintings. Its two halves were reunited in the twentieth century.

his career, in the mid-1720s, copying the paintings of Watteau owned by Jean de Jullienne, the principal collector of Watteau's works in France. Jullienne, a manufacturer of dyes and fine fabrics, had conceived the idea of engraving Watteau's work so that a wider public could enjoy it, and Boucher was easily the best of Jullienne's copyists. Boucher himself felt he needed more training, so he set off for Rome with his profits from Jullienne. Once there, he found the work of Raphael "trite" and that of Michelangelo "hunchbacked," perhaps a reference to the well-developed musculature of his figures. By the time Madame de Pompadour established herself as Louis XV's mistress, Boucher had returned from Rome and was firmly established as Watteau's heir, the new master of *fêtes galantes*.

In the 33 years since the death of Louis XIV, the court had enjoyed relatively free reign, and the younger king, Louis XV, essentially adapted himself to its carefree ways. He felt free to take a mistress. Madame de Pompadour was by no means the first, though by 1750 the king had apparently left her bed because, so the story went, her health was frail. But she remained his closest and probably most trusted advisor, and she happily arranged for other women to take her place in the king's bed. Given this context, it is hardly surprising that many of Boucher's portraits of Madame de Pompadour are like the portrait of 1756, which portrays her as an intellectual supporter of the French Enlightenment, reading a book, her writing table nearby with her quill inserted in the inkwell (Fig. **29.5**). What *is* somewhat surprising are his many paintings of nude goddesses in which the nude bears a striking resemblance to the king's mistress. (Boucher was notoriously famous for such nudes.) *The Toilet of Venus*, for instance, was commissioned by Madame de Pompadour for the bathing suites of the château of Bellevue, one of six residences just outside Paris that Louis built for her (Fig. **29.6**). She had played the title role in a production called *La Toilette de Vénus* staged at Versailles a year earlier, and evidently this is a scene—or more likely an idealized version—of one from that production. The importance of the work is that it openly acknowledges both Madame de Pompadour's sexual role in the court and the erotic underpinnings of the Rococo as a whole.

Jean-Honoré Fragonard Boucher's student Jean-Honoré Fragonard [frah-goh-NAHR] (1732–1806) carried his master's tradition into the next generation. Fragonard's most important commission was a series of four paintings for Marie-Jeanne Bécu, comtesse du Barry [kohn-TESS dew bah-REE], the last mistress of Louis XV. Entitled *The Progress of Love*, it was to portray the relationship between Madame du Barry and the king, but in the guise of young people whose romance occurs in the garden park of the countess's château at Louveciennes, itself a gift from Louis.

The most famous painting in the series, *The Swing*, suggests an erotic intrigue (Fig. **29.7**) between two lovers. It implies as well the aesthetic intrigue between the artist and

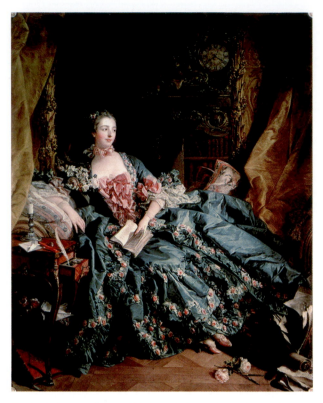

Fig. 29.5 François Boucher. *Madame de Pompadour*. 1756. Oil on canvas, 79$\frac{1}{8}$" × 61$\frac{7}{8}$". The Bridgeman Art Library. Bayerische Hypo und Vereinsbank, Alte Pinakothek, Bayerische Staatsgemäldesammlungen, Munich. Boucher's playful and fragile imagery, evident here in the elaborate frills decorating Madame's dress and in the decorative details on the column behind her, was miniatured within gold cartouches on the surfaces of the vases and urns of the Royal Porcelain Manufactory at Sevres, Madame de Pompadour's pet project.

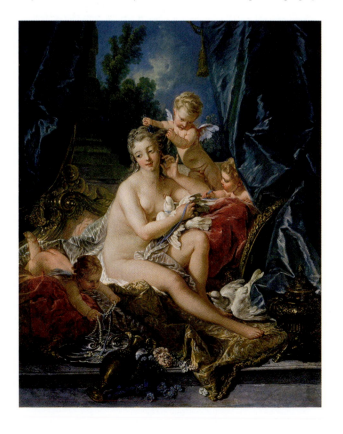

Fig. 29.6 François Boucher. *The Toilet of Venus*. 1751. Oil on canvas, 42$\frac{5}{8}$" × 33$\frac{1}{8}$". Signed and dated (lower right): f-Boucher-1751. Bequest of William K. Vanderbilt, 1920 (20.155.9). Photograph © 1. The Metropolitan Museum of Art, New York. Boucher's contemporaries likened his palette, which favored pinks, blues, and soft whites, to "rose petals floating in milk."

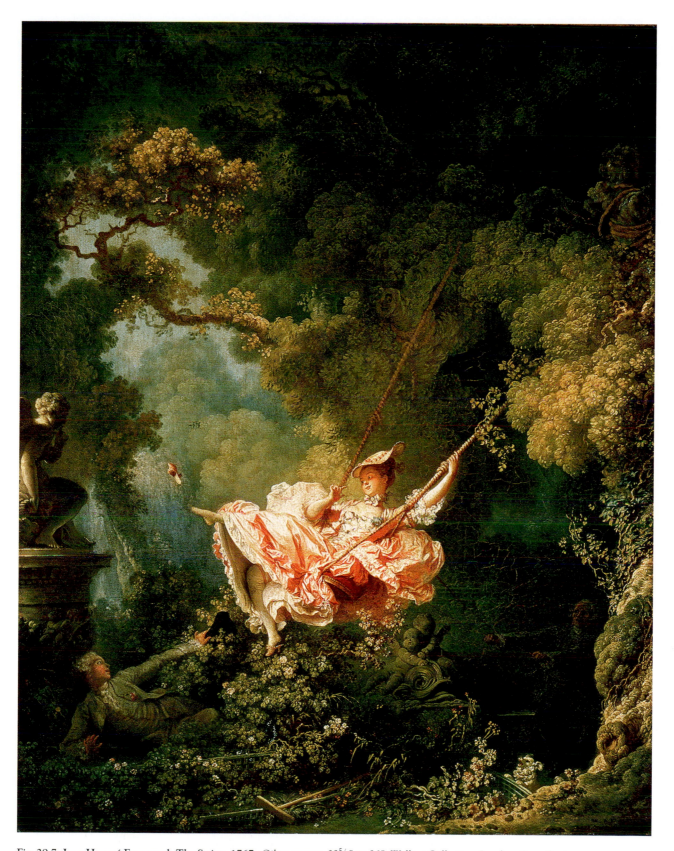

Fig. 29.7 Jean-Honoré Fragonard. *The Swing*. 1767. Oil on canvas, $32\frac{5}{8}"\times26"$. Wallace Collection, London. Contributing to the erotic overtones of the composition is the lush foliage of the overgrown garden into which the male lover has inserted himself.

the patron, a conspiracy emphasized by the sculpture of Cupid to the left, holding his finger to his mouth as if to affirm the secrecy of the affair. The painting's subject matter was in fact suggested by another artist, Gabriel-François Doyen, who was approached by the baron de Saint-Julien to paint his mistress "on a swing which a bishop is setting in motion. You will place me in a position in which I can see the legs of the lovely child and even more if you wish to enliven the picture." Doyen declined the commission but suggested it to Fragonard.

Much of the power of the composition lies in the fact that the viewer shares, to a degree, the voyeuristic pleasures of the reclining lover. The entire image is charged with an erotic symbolism that would have been commonly understood at the time. For instance, the lady on the swing lets fly her shoe—the lost shoe and naked foot being a well-known symbol of lost virginity. The young man reaches toward her, hat in hand—the hat that in eighteenth-century erotic imagery was often used to cover the genitals of a discovered lover. Even more subtly, and ironically, the composition echoes the central panel of Michelangelo's Sistine Ceiling, the *Creation of Adam* (see Fig. 18.11). The male lover assumes Adam's posture, and the female lover God's, although she reaches toward Adam—to bring him to life, as it were—with her foot, not her hand.

Rococo Architecture and Landscape Design in Central Europe and England

Continuity & Change
p. 813

Plan of San Carlo alle Quattro Fontane

Rococo architecture, as the Salon de la Princesse at the Hôtel de Soubise in Paris (see Fig. 29.1) demonstrates, is both a refined and exaggerated realization of the curvilinear Baroque architecture of such seventeenth-century masters as Borromini (see Fig. 25.11.) By the 1690s, architects in the Catholic regions of Central Europe began to explore the possibilities of this elaborate curvilinear style in a series of buildings designed to glorify the princes of the many small states that comprised the region, some of which, like Prussia, were extremely powerful. They turned their attention to the grounds as well, where a new type of garden design that had originated in England captured the Rococo imagination.

Balthasar Neumann and Giovanni Tiepolo in Bavaria One of the most magnificent statements of the Rococo in Central Europe is the Residenz (Episcopal Palace) for the prince-bishop of Würzburg in Bavaria. It is the work of Balthasar Neumann (1687–1753), a military engineer turned designer.

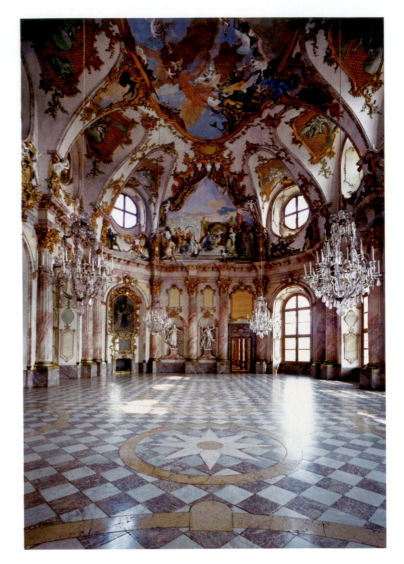

Fig. 29.8 Balthasar Neumann. Kaisersaal Residenz, Würzburg, Germany. 1719–1744. Frescoes by Giovanni Battista Tiepolo, 1751–1752. The chandeliers were specially designed to contribute to the overall effect.

To complete the work, the prince-bishop sent him to Paris and Vienna in 1723 to consult with the leading architects. Ribbonlike moldings that rise above columns and pilasters that serve no structural purpose dominate the decorative scheme for the oval-shaped Kaisersaal [kye-zur-ZAHL], or Imperial Hall (Fig. 29.8). The entire white surface of the interior is covered with irregular cartouches and garlands of floral motifs.

The paintings decorating the room seem to open the interior to the sky. They are the work of the Italian painter Giovanni Battista Tiepolo [tee-EH-po-lo] (1696–1770). The central panel is remarkable for its pastel colors and asymmetrical organization, in which a few figures seem to poke out from behind the clouds and even the frame of the cartouche itself (Fig. 29.9). Notice, for instance, how the two small openings at the top of the composition seem continuous with

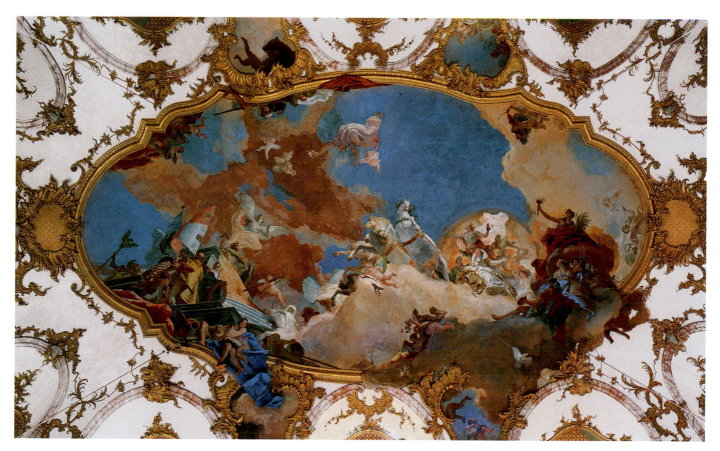

Fig. 29.9 Giovanni Battista Tiepolo. Ceiling fresco (detail). 1751. Kaisersaal, Residenz, Würzburg. Ninety percent of Würzburg was destroyed in an Allied bombing raid in March 1945. Tiepolo's paintings were saved by a U.S. army officer whose assignment was to protect and save threatened art objects. He temporarily replaced the vital section of the Residenz roof, which had burned to ashes, and so prevented rain water from pouring through into the vault beneath.

the space of the main painting, making the ceiling seem weightless and expansive. Yet the work feels remarkably different from ceiling paintings of the earlier Baroque, with their avalanches of figures propelled into space by dramatic bursts of light (see Fig. 25.18).

Prussia and the Rococo The Kingdom of Prussia, with its two royal capitals of Berlin and Potsdam (see Map **29.2**), exerted an almost uncanny power over Europe in the eighteenth century. As a state, Prussia demanded obedience to its rulers, the Hohenzollern [ho-un-TSOLL-urn] family. They had controlled the German territory of Brandenburg since 1417 and, over the next couple of centuries and through the good fortune of inheritance, had acquired additional scattered holdings in the west along the Rhine to New East Prussia in the east as far as present-day Lithuania, including most of northern Poland. By 1740, it was a military giant, its army numbering almost 80,000 men, the third largest in Europe. Its values were, at least to some degree, military: Discipline was valued above all else. The Prussian social elite was the officer

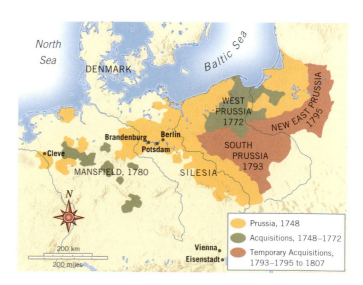

Map 29.2 Prussia in the late-eighteenth and early-nineteenth centuries.

corps, which was composed largely of Junkers, the sons of the German nobility.

The first Prussian ruler to assert himself in European affairs was Frederick William (r. 1640–1688), known as the Great Elector (an elector was one of the princes who elected the Holy Roman emperor). It was the Great Elector who first began to build a sizable Prussian army. His son, Frederick (r. 1701–1713), put this army at the disposal of the Habsburg Holy Roman Emperor in 1701, and in return was permitted to call himself "King Frederick I in Prussia"—that is, king in Prussia, but not beyond its bounds, and not to be confused with the emperor. He passed this title on to his son, King Frederick William I (r. 1713–1740).

Frederick I's personal taste leaned toward ostentation and extravagance. During his first year in power, he used more than half the state's annual revenue to support his Berlin court. But he balanced this tendency for pomp with an almost intolerant style of bureaucratic austerity and discipline. For instance, he disbanded the prestigious Berlin court orchestra, putting many musicians out of work. (This delighted Johann Sebastian Bach, who hired seven of the best ones to work with him in the small town of Coethen, where he was chapel master, and provide him with the musicianship required for what would later come to be known as the *Brandenburg* concertos.) Following in his father's footsteps, Frederick William I created a centralized bureaucracy, known as the General Directory. He imposed taxes on the nobility and enforced them by means of his army, which included his personal bodyguards. Known as the "Tall Fellows" for their extraordinary stature, the tallest among them was an Irishman who at nearly 7 feet was one of the tallest men of the age. In 1730, when the 18-year-old Crown Prince Frederick attempted to flee his father's tyrannical rule with a friend, Frederick William ordered the friend executed in front of the prince as a lesson in obedience.

This same crown prince would himself become Frederick II (r. 1740–1786), more commonly known as Frederick the Great. He assumed this mantle following a series of campaigns against the Habsburg province of Silesia (see Map 29.1), home of Maria Theresa (1717–1780), who had succeeded to the Habsburg throne in 1740. In defeating the House of Habsburg, which up to this time had been the leading power in Central Europe, and expanding his own holdings by over a third, Frederick II established Prussia as a force at least equal to the Habsburgs. But whereas his father had focused largely on matters of state, Frederick II turned his attention to the arts. For instance, the construction in Berlin that his father had overseen consisted of a series of meticulously laid-out streets with houses that one contemporary described as looking like "a line of soldiers, their bay windows resembling grenadiers' caps." By contrast, Frederick the Great, immediately upon assuming the throne, ordered construction of a new opera house, and he added an elaborate new wing to the Charlottenburg Palace, his principal residence in the city. Voltaire [vohl-TAIR], the French intellectual with whom Frederick had been corresponding since the 1730s (and who is discussed later in the chapter), described the change through a simple analogy with the two most important city-states of ancient Greece: "Things changed visibly: Sparta became Athens." In other words, Spartan and militaristic Prussia became a center of culture on a par with Athenian and artistic Paris.

The taste for elegance, luxury, and the arts that exemplified Frederick the Great's court in fact derived largely from Paris during the Rococo period. This is most evident at the palace of Sanssouci [sahn-soo-SEE], Frederick's summer residence in the countryside outside Potsdam. Georg Wenzeslaus von Knobelsdorff (1699–1753) designed it between 1745 and 1747 so that Frederick might escape the pomp and ceremony of the Berlin court. Frederick lavished his attention on the palace. The music room was decorated with mirrors opposite its windows—a trick learned, perhaps, from the Hall of Mirrors at Versailles (see Fig. 27.3) to increase the amount of light in an age still illuminated by candles (Fig. **29.10**). Here, musicians daily entertained Frederick, who often joined in on his own flute—"my best friend," he called it. Alternating with paintings depicting Ovid's *Metamorphoses*, the mirrors reflected the surrounding gardens, visually doubling the size of the room.

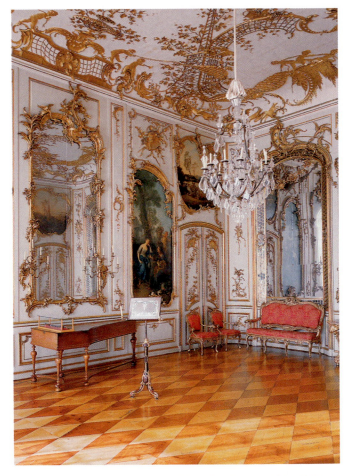

Fig. 29.10 Concert hall, Sanssouci Palace, Potsdam. ca. 1746–1747. The wall painting depicts a scene from Ovid's *Metamorphoses* by French painter Antoine Pesne, who had settled in Prussia by 1735.

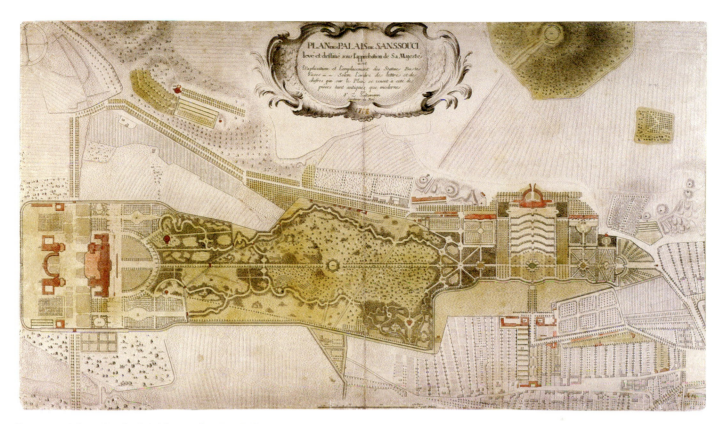

Fig. 29.11 Johann Friedrich Schleuen, after Friedrich Zacarias Saltzmann. **General Plan of Sanssouci Palace, Potsdam. 1772.** Etching, colored, $18\frac{1}{8}$" × $32\frac{3}{8}$". Stiftung Preussische Schlösser und Gärten, Berlin-Brandenburg, Plansammlung, Potsdam. The original palace, with its terraced vineyards, is at the right. The pleasure garden extends to the left, ending before the much larger New Palace, constructed between 1763 and 1769.

The most notable feature of the music room is its elaborate gilded stucco decorations. Executed under the direction of Johann August Nahl (1710–1781), whom Frederick appointed director of ornaments in 1741, they are among the finest examples of the Rococo style. The relationship between these interior details and the natural world is explicit in the General Plan of Sanssouci, with its cartouche title at top center (Fig. **29.11**). It shows the original palace and vineyard at the right and the larger New Palace at the left, joined by an extensive pleasure garden. In the pleasure garden there are none of the straight paths and manicured flowerbeds of the formal gardens of Versailles (see Figs. 27.4, 27.5). Instead, the left-to-right axis is framed by two winding and serpentine paths that contain a lightly forested deer park. The ensemble appeared entirely rural and natural but was actually "put into order by artistic means." These paths contrast dramatically with the architectural symmetry and geometry of the old and new palaces. They suggest a growing awareness of the need to acknowledge or balance the conflicting claims of order, reason, and intellect with those of the senses, pleasure, and the imagination—between what might be called the *useful*, or practical, and the *aesthetic*, or beautiful.

For Frederick the Great, the conflict amounted to the tension between what he called the "abominable work" of

state—at which he was, incidentally, very skilled—and the pleasure of decorating his palaces and grounds, every detail of which he oversaw. So the architectural regularity and symmetry of Frederick's palaces represented an emblem of his public life—a symbol of the state and its orderly workings—whereas the interior rooms and the grounds suggested his private life. And indeed this monarch had a powerful imagination, for in 1746 he composed his own *Symphony in D Major* (a form discussed later in the chapter), for two flutes (one part expressly for himself), two oboes, two horns, string orchestra, and bass continuo.

The English Garden The inspiration for Frederick's garden park at Sanssouci was a new kind of garden that became very popular in England beginning in about 1720 and that aspired to imitate rural nature. Instead of the straight, geometrical layout of the French garden, the walkways of the **English garden** are, in the words of one garden writer of the day, "serpentine meanders . . . with many twinings and windings." The English found precedent for this new garden in the pastoral poetry of Virgil and Horace (see chapter 8) and, especially, in Pliny's descriptions of the gardens of his Roman contemporaries, translated in 1728 by Robert Castell in *Villas of the Ancients Illustrated*. According to Castell, Pliny described three styles of

CULTURAL PARALLELS

Gardens in England and Japan

The English gardens that gained wide popularity during the eighteenth century throughout Europe paralleled the development of residential and temple gardens in Japan during the same period. The Japanese flat gardens, or *hira niwa,* were decorative, with areas of gravel adjacent to buildings bordered by trees, shrubs, rock arrangements, lanterns, and stepping stones.

Roman garden: the plain and unadorned; the "regular," laid out "by the Rule and Line"; and the *Imitatio Ruris,* or the imitation of rural landscapes. This last consisted of "wiggly" paths opening on "vast amphitheaters such as could only be the work of nature." But Castell understood that such landscapes were wholly artificial. For him, the *Imitatio Ruris* was

> . . . a close Imitation of Nature; where, tho' the Parts are disposed with the greatest Art, the Irregularity is still preserved; so that their Manner may not improperly be said to be an artful Confusion, where there is no Appearance of that Skill which is made use of, their Rocks, Cascades, and Trees, bearing their natural Forms.

The ideal estate was to be "thrown open" in its entirety to become a vast garden, its woods, gardens, lakes, and marshes all partaking of a carefully controlled "artificial rudeness" (in the sense of raw, primitive, and undeveloped).

The gardens at Stowe, in Buckinghamshire, are exemplary. Prior to about 1730, they were composed of straight pathways bordering geometrically shaped woods and by lakes with clearly defined linear forms, including, at the bottom of the hill below the house, an octagonal pool. These more regular gardens were adorned by artificial Greek temples designed by James Gibbs (1682–1754) and William Kent (1685–1748). Kent's Temple of Ancient Virtue, built in 1734, contained life-size statues of Homer, Lycurgus (a Spartan lawgiver), Socrates, and Epaminondas (a Theban general and statesman). Across the valley, on lower ground, was a Shrine of British Worthies, containing the busts of 16 famous Englishmen, including Shakespeare, Isaac Newton, and John Locke. After 1740, Lancelot "Capability" Brown (1716–1783) took over the gardens' design. Brown was nicknamed "Capability" because, he argued, any landscape is capable of improvement.

Brown was inspired by the gardens at Stourhead, built in the 1740s by wealthy banker Henry Hoare (Fig. **29.12**). Hoare had built dams on several streams to raise a lake, around which he created a serpentine path offering many views and vistas.

Continuity & Change
p. 260

The Pantheon

These included a miniature Pantheon that he probably modeled after similar buildings in the landscape paintings of the seventeenth-century French artist Claude Lorrain [klohd loh-REHN]. His Italian pastoral landscapes, with their winding streams and arched bridges framed by ruins and deftly placed trees, were widely popular in England (Fig. **29.13**).

Fig. 29.12 Henry Flitcroft and Henry Hoare. The Park at Stourhead, Wiltshire, England. 1744–1765. Each vista point along the Stourhead path looks over an artificial ruin that tells the story of Aeneas's visit to the underworld in Books 3–6 of Virgil's *Aeneid.*

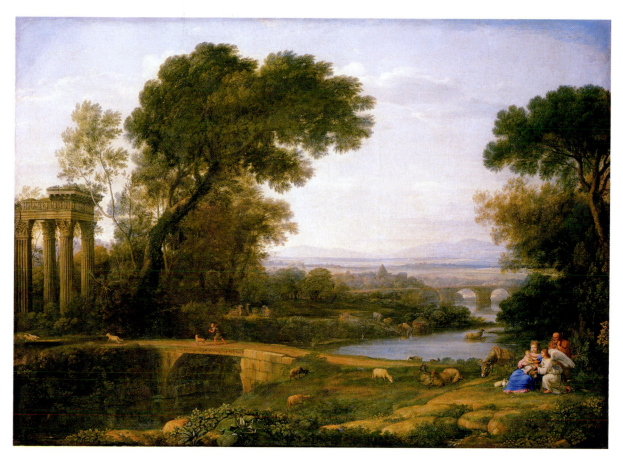

Fig. 29.13 Claude Lorrain. *The Rest on the Flight into Egypt (Noon).* 1661. Oil on canvas, 45 ⁵⁄₈″ × 62 ⁷⁄₈″. Hermitage Museum, Saint Petersburg, Russia. The Bridgeman Art Library. Collection of Empress Josephine, Malmaison, 1815. Note how the artist makes the viewer's eye move through the painting from the grouping at the lower right diagonally, across the bridge (following the shepherd boy and his dog) toward the ruin at the left, then in a zigzag down the road and over the arched bridge into the hazy light of the distant landscape. This serpentine organization directly inspired English garden design.

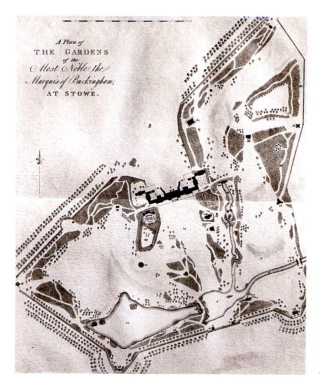

"Capability" Brown, too, was inspired by Claude. By the early 1750s the edges of the lakes at Stowe, once neatly regular, were completely naturalized, and the landscape had been reformed into an almost entirely pastoral setting, with wide vistas and broad views. Brown's site plan for the garden shows this more natural-looking arrangement (Fig. **29.14**).

Aristocratic visitors to Stowe would have arrived at the estate with their special "Claude" glasses, tinted yellow so that the landscape would glow with the same warmth as a Claude painting. On the one hand, they would have admired the Classical ruins and the Classical facade of the manor house itself. On the other, they would have discovered, in the grounds, a space in which they might escape emotionally, as Frederick the Great did at Sanssouci, from the very civilization that Classical architecture symbolized. The English garden, in other

Fig. 29.14 Charles Bridgeman and Lancelot "Capability" Browne. Plan of the Gardens of the Most Noble Marquis of Buckingham at Stowe, from the *Visitor's Guide Book.* 1797. Lithograph. English School, (18th century). Private Collection. The Bridgeman Art Library. This reflects the site plan of Stowe as it has appeared since the mid-eighteenth-century. Although the landscape looks completely natural, it is as thoroughly designed as a modern-day golf course.

words, embodied many of the same contradictions as the Parisian salon, where the demands of reason championed by the *philosophes* confronted the excesses of the French court.

The *Philosophes*

When in 1753 the French painter Jean-Baptiste-Siméon Chardin [shar-DEHN] (1699–1779) exhibited his *Philosopher Occupied with His Reading* in Paris, one French commentator described the painting (Fig. **29.15**) as follows:

> This character is rendered with much truth. A man wearing a robe and a fur-lined cap is seen leaning on a table and reading very attentively a large volume in bound parchment. The painter has given him an air of intelligence, reverie, and obliviousness that is infinitely pleasing. This is a truly philosophical reader who is not content merely to read, but who meditates and ponders, and who appears so deeply absorbed in his meditation that it seems one would have a hard time distracting him.

In short, this is the very image of the French *philosophe*.

Fig. 29.15 Jean-Baptiste-Siméon Chardin. *A Philosopher Occupied with His Reading*. 1734. Oil on canvas, 54 3/8″ × 41 3/8″. Photo: Hervè Lewandowski/ Musee du Louvre/RMN Reunion des Musees Nationaux, France. SCALA/Art Resource, NY. This is actually a portrait of Joseph Aved, a painter who was a friend of Chardin's.

Most *philosophes* were **Deists** [DEE-ists], who accepted the idea that God created the universe but did not believe he had much, if anything, to do with its day-to-day workings. Rather, the universe proceeded according to what they termed **natural law**, law derived from nature and binding upon human society. In Newtonian terms, God had created a great clock, and it ran like clockwork, except for the interference of inept humanity. So humans had to take control of their own destinies. Deists viewed the Bible as a work of mythology and superstition, not the revealed truth of God. They scoffed at the idea of the divine right of kings. The logic of their position led the *philosophes* to a simple proposition, stated plainly by the *philosophe* Denis Diderot (1713–1784): "Men will not be free until the last king is strangled with the entrails of the last priest."

Denis Diderot and the *Encyclopédie*

The crowning achievement of the *philosophes* was the *Encyclopédie* [on-see-kloh-pay-dee], begun in 1751 and completed in 1772. Its editors were the teacher and translator Denis Diderot and Jean le Rond d'Alembert [DAHL-ohm-behr] (1717–1783), a mathematician who was in charge of the articles on mathematics and science. Both were active participants in salon society, and d'Alembert in fact lived with the great hostess Julie de Lespinasse. The work was unpopular in the French court: Louis XV claimed that the *Encyclopédie* was doing "irreparable damage to morality and religion" and twice banned its printing. But despite the opposition, the court's salons proved useful to the Encyclopedists. In his memoirs, d'Alembert would recall a conversation with Madame Geoffrin [zhoh-fren] (1699–1777), the hostess who was Julie de Lespinasse's mentor:

> As she had always among the circle of her society persons of the highest rank and birth, as she appeared even to seek an acquaintance with them, it was supposed that this flattered her vanity. But here a very erroneous opinion was formed of her; she was in no respect the dupe of such prejudices, but she thought that by managing the humours of these people, she could render them useful to her friends. "You think," said she, to one of the latter, for whom she had a particular regard, "that it is for my own sake I frequent ministers and great people. Undeceive yourself,—it is for the sake of you, and those like you who may have occasion for them."

It is very likely that d'Alembert was the "friend" to whom she addressed these words.

Although the *Encyclopédie* was rather innocently subtitled a *Classified Dictionary of the Sciences, Arts, and Trades*, the stated intention of the massive 35-volume text, which employed more than 180 writers, was "to change the general way of thinking." Something of the danger that the *Encyclopédie* presented to the monarchy is evident in the entry on natural law written by French lawyer Antoine-Gaspart Boucher d'Argis [boo-SHAY dar-ZHEES] (1708–1791) (**Reading 29.1**):

from "Law of Nature or Natural Law," from the *Encyclopédie* (1751–1772)

Law OF NATURE, OR NATURAL LAW, in its most extended sense, refers to certain principles inspired only by nature that are common to men and to animals: on this *law* are based the union of male and female, the procreation of children and concern for their education, the love of liberty, the conservations of one's own person, and the effort each man makes to defend himself when attacked by others.

But it is an abuse of the term *natural* law to use it to refer to the impulses that govern the behavior of animals; for they have not the use of reason and are therefore incapable of perceiving any law or justice.

More frequently, we mean by *natural* law certain rules of justice and equity, which natural reason alone has established among men, or to put it better, which god has engraved in our hearts.

Such are the fundamental precepts of *law* and of all justice: to live honestly, to offend no one, and to render unto every man what belongs to him. From these general precepts are derived many other particular rules, which nature alone, that is to say reason and equity, suggests to men.

Such thinking was fundamental to the Enlightenment's emphasis on human liberty and would fuel revolutions in both America and France. Similar thinking could be found in the sections of the *Encyclopédie* on political science written by the baron de Montesquieu (1689–1755), a deep believer in the writings of John Locke and England's parliamentary democracy. In his 1748 treatise *The Spirit of the Laws*, he had argued for the separation of powers, dividing government into executive, legislative, and judicial branches—an argument that would provide one of the foundations for the American Constitution in the 1780s. Freedom of thought was, in fact, fundamental to the transmission of knowledge, and any state that suppressed it was considered an obstacle to progress. So when Louis XV's censors halted publication of the *Encyclopédie* in 1759, the *philosophes* affirmed the despotism of the French state, even if other government officials, prompted by the salon hostesses, secretly worked to ensure the work's continued viability.

Funded by its 4,000 subscribers, the *Encyclopédie* was read by perhaps 100 times that many people, as private circulating libraries rented it to customers throughout the country. In its comprehensiveness, it represents a fundamental principle of the Enlightenment, also evident in Samuel Johnson's *Dictionary of the English Language* (see chapter 28), to accumulate, codify, and preserve human knowledge. Like the *Histoire Naturelle* (*Natural History*) of Georges-Louis Leclerc [leh-kler], published in 36 volumes from 1749 to 1788, which claimed to include everything known about the natural world up to the moment of publication, the *Encyclopédie* claimed to be a collection of "all the knowledge scattered over the face of the earth." The principle guiding this encyclopedic impulse is **rational humanism**, the belief that through logical, careful thought, progress is inevitable. In other words, the more people knew, the more likely they would invent new ways of doing things. Thus, the *Encyclopédie* illustrated manufacturing processes in the most careful detail, imagining that astute readers might recognize better, more efficient methods of manufacturing even as the processes were demystified (Fig. **29.16**).

Fig. 29.16 A *Brazier's Workshop*, illustration from the *Encyclopédie*, edited by Denis Diderot. 1751–1772. The metalsmiths at work are making hunting horns. In the center, a worker pounds copper around a rod to make the horn's tube. Behind him, a worker standing above a fireplace pours molten lead into the tube to make it more malleable. At the left, the flared end of the horn is soldered to the tube. And at the right, a worker curves the horn into its final, snail-like form.

Jean-Jacques Rousseau and the Cost of the Social Contract

Another contributor to the *Encyclopédie* was Jean-Jacques Rousseau [roo-SOH] (1712–1778), an accomplished composer originally hired by Diderot to contribute sections on music. Rousseau had been born Protestant, in Geneva, was orphaned early in life, and converted to Catholicism while wandering in Italy. He eventually arrived in Paris. Published after his death, the *Confessions* is an astonishingly frank account of his troubles, from sexual inadequacy to a bizarre marriage, including his decision to place each of his five children in an orphanage soon after birth (see **Reading 29.2**, pages 961–962). More forthcoming and revealing than any autobiography previously written, it explains in large part the origins of Rousseau's tendency to outbursts of temper and erratic behavior, and makes it very clear why he eventually fell out with the other *philosophes*. Rousseau was not a social being, even though his writings on social issues were among the most influential of the age.

In the semifictional work *Émile* [ay-MEEL], published in 1762, Rousseau created a theory of education that would influence teaching to the present day. He believed that the education of a child begins at birth. *Émile*'s five books correspond to the five stages of its hero's social development. The first two books outline the youth's growth to age 12, what Rousseau calls the Age of Nature. The third and fourth books describe his adolescence, and the fifth, the Age of Wisdom, his growing maturity between age 20 to 25. The most important years, Rousseau believed, were early adolescence, from age 12 to 15. Entering the teenage years, the child, named Émile by Rousseau, begins formal education, turning his attention to only what he finds "useful" or "pleasing." As a result, the child finds education a pleasurable and exciting experience that naturally leads his imagination to the enjoyment and contemplation of beauty. In his early twenties, Émile is introduced to the corrupting forces of society. Not until he has absorbed these lessons is it safe for Émile to enter society without fear of submitting to its corrupting influence.

As advanced as Rousseau was in his ideas about education, he saw little reason to educate women in the same manner as men. In Book V, Émile encounters woman, in the form of Sophie, Émile's ideal mate: "Her education is in no way exceptional. She has taste without study, talents without art, judgment without knowledge. Her mind is still vacant but has been trained to learn; it is well-tilled land only waiting for the grain. What a pleasing ignorance! Happy is the man destined to instruct her." Within a very few years, women would reject such thinking and assert their equal right to liberty and education.

As *Émile* demonstrates, Rousseau believed in the natural goodness of humankind, a goodness corrupted by society and the growth of civilization. Virtues like unselfishness and kindness were inherent—a belief that gives rise to what he termed the "noble savage"—but he strongly believed that a new social order was required to foster

them. In *The Social Contract*, published in 1762, Rousseau describes an ideal state governed by a somewhat mystical "General Will" of the people that delegates authority to the organs of government as it deems necessary. In Chapter 4, "Slavery," Rousseau addresses the subjugation of a people by their monarch (**Reading 29.3**):

READING 29.3 **from Jean-Jacques Rousseau, *The Social Contract*, Book 1, Chapter 4 ("Slavery") (1762)**

No man has a natural authority over his fellow, and force creates no right. . . .

If an individual . . . can alienate his liberty and make himself the slave of a master, why could not a whole people do the same and make itself subject to a king? There are in this passage plenty of ambiguous words which would need explaining; but let us confine ourselves to the word *alienate*. To alienate is to give or to sell. Now, a man who becomes the slave of another does not give himself; he sells himself, at the least for his subsistence: but for what does a people sell itself? A king is so far from furnishing his subjects with their subsistence that he gets his own only from them; and, according to Rabelais, kings do not live on nothing. Do subjects then give their persons on condition that the king takes their goods also? I fail to see what they have left to preserve.

It will be said that the despot assures his subjects civil tranquility. Granted; but what do they gain, if the wars his ambition brings down upon them, his insatiable avidity, and the vexatious conduct of his ministers press harder on them than their own dissensions would have done? What do they gain, if the very tranquility they enjoy is one of their miseries? Tranquility is found also in dungeons; but is that enough to make them desirable places to live in? The Greeks imprisoned in the cave of the Cyclops lived there very tranquilly, while they were awaiting their turn to be devoured.

To say that a man gives himself gratuitously, is to say what is absurd and inconceivable; such an act is null and illegitimate, from the mere fact that he who does it is out of his mind. To say the same of a whole people is to suppose a people of madmen; and madness creates no right.

Even if each man could alienate himself, he could not alienate his children: they are born men and free; their liberty belongs to them, and no one but they has the right to dispose of it. Before they come to years of discretion, the father can, in their name, lay down conditions for their preservation and well-being, but he cannot give them irrevocably and without conditions: such a gift is contrary to the ends of nature, and

exceeds the rights of paternity. It would therefore be necessary, in order to legitimise an arbitrary government, that in every generation the people should be in a position to accept or reject it; but were this so, the government would be no longer arbitrary.

To renounce liberty is to renounce being a man, to surrender the rights of humanity and even its duties.

This passage explains the famous opening line of *The Social Contract*: "Man is born free, and everywhere he is in chains." What Rousseau means is that humans have enslaved themselves, and in so doing have renounced their humanity. He is arguing here, in many ways, against the precepts of the Enlightenment, for it is their very rationality that has enslaved humans.

Even though he was a contributor to it, Rousseau came to reject the aims of the *Encyclopédie*, especially its celebration of manufacturing and invention. In his 1755 *Discourse on the Origin of Inequality among Men*, he writes (**Reading 29.4**):

READING 29.4 **from Jean-Jacques Rousseau, *Discourse on the Origin of Inequality among Men* (1755)**

As long as men were content with their rustic huts, as long as they confined themselves to sewing their garments of skin with thorns or fishbones, and adorning themselves with feathers or shells, to painting their bodies with various colors, to improving or decorating their bows and arrows; and to using sharp stones to make a few fishing canoes or crude musical instruments; in a word, so long as they applied themselves only to work that one person could accomplish alone and to arts that did not require the collaboration of several hands, they lived as free, healthy, good and happy men. . . . but from the instant one man needed the help of another, and it was found to be useful for one man to have provisions enough for two, equality disappeared, property was introduced, work became necessary, and vast forests were transformed into pleasant fields which had to be watered with the sweat of men, and where slavery and misery were soon seen to germinate and flourish with the crops.

Given such thinking, it is hardly surprising that Rousseau ultimately withdrew from society altogether, suffering increasingly acute attacks of paranoia, and died insane.

Voltaire and French Satire

The third great figure among the Parisian *philosophes* was François-Marie Arouet, known by his pen name, Voltaire (1694–1778). So well-schooled, so witty, and so distinguished was Voltaire that to many minds he embodies all the facets of a very complex age. He wrote voluminously—plays, novels, poems, and history. More than any other *philosophe*, he saw the value of other, non-Western cultures and traditions and encouraged his fellow *philosophes* to follow his lead (Fig. **29.17**). He was a man of science and an advisor to both Louis XV and Frederick the Great of Prussia. He believed in an enlightened monarchy, but even as he served these rulers, he satirized them. This earned him a year in the Bastille prison in 1717–1718, and later, in 1726, another year in exile in London.

Voltaire's year in England convinced him that life under the British system of government was far preferable to life under what he saw as a tyrannical French monarchy. He published these feelings in his 1734 *Philosophical Letters*. Not surprisingly, the court was scandalized by his frankness, so in order to avoid another stint in prison, Voltaire removed himself to the country town of Cirey, home of his patroness the Marquise du Châtelet [dew SHAHT-lay], a woman of learning who exerted an important intellectual influence on him. In 1744 he returned once again to court, which proved tedious and artificial, but in 1750 he discovered in the court of Frederick the Great what he believed to be a more congenial atmosphere. While there he published his greatest historical work, *Le Siècle de Louis XIV* (*The Century of Louis XIV*) (1751). In four brief years he wore out his welcome in Prussia and had to remove himself to the countryside once again. From 1758 to 1778, he lived in the village of Freney in the French Alps. Here he was the center of what amounted to an intellectual court of artists and intellectuals who made regular pilgrimages to sit at his feet and talk.

Voltaire did not believe in the Bible as the inspired word of God. "The only book that needs to be read is the great book of nature," he wrote. He was, more or less, a Deist. What he championed most was freedom of thought, including the freedom to be absolutely pessimistic. This pessimism dominates his most famous work, *Candide* [kahn-DEED], or *Optimism* (1758). It is a prose satire, based in part on the philosophical optimism of Alexander Pope's *Essay on Man* (see chapter 28). Voltaire's work tells the tale of Candide, a simple and good-natured but star-crossed youth, as he travels the world struggling to be reunited with his love, Cunegonde.

Candide's journey leads from Germany to Portugal to the New World and back again, as he follows the belief that, in the words of German philosopher Gottfried Leibniz, "everything is for the best in the best of all possible worlds." This is a sentiment Candide learns from Dr. Pangloss, his tutor. Pangloss, whose name with its first syllable *pan* ("all" in Latin) suggests the ability to gloss over everything, lacks the clear vision needed to see life's darker sides. On his journey

Fig. 29.17 Anicet-Charles-Gabriel Lemonnier, after a drawing by François Boucher. *Reading of Voltaire's tragedy 'L'orphelin de la Chine' at the Salon of Madame Geoffrin in 1755*. **1812.** Oil on canvas. Photo: D. Arnaudet. Châteaux de Malmaison et Bois-Preau, Rueil-Malmaison, France. RMN Reunion des Musees Nationaux/Art Resource, NY. Here Jean le Rond d'Alembert reads Voltaire's new play *L'Orphélin de Chine* (*The Orphan of China*), a tragedy based on an actual fourteenth-century Chinese play brought to Paris by a Jesuit priest in 1735. Voltaire's bust looks on from the back of the room.

Candide finds himself beset by disasters of all kinds, including the 1755 Lisbon earthquake (see **Reading 29.5,** pages 962–964). He discovers a world filled with stupidity, plagued by evil, mired in ignorance, and completely boring. Although Candide survives his adventures—a testament to human resilience—and eventually finds his Cunegonde, the book concludes with the famous sentiment: "We must cultivate our garden." We must, in other words, give up our naïve belief that we live in "the best of all possible worlds," tend to the small things that we can do well—thus keeping total pessimism at bay—and leave the world at large to keep on its incompetent, evil, and even horrific way.

Art Criticism and Theory

One of the "gardens" most carefully cultivated by the French intellectuals (and those with intellectual pretensions) was art. By the last half of the eighteenth century, it was becoming increasingly fashionable for educated upper-class people to experience what the English called the "Grand Tour" and the French and Germans referred to as

the "Italian Journey." Art and architecture were the focal points of these travels, along with picturesque landscapes and gardens. A new word was coined to describe the travelers themselves—"tourist."

Tourists then, as they do today, wanted to understand what they were seeing. Among the objects of their travel were art exhibitions, particularly the Paris Salon—the official exhibition of the French Royal Academy of Painting and Sculpture. It took place in the Salon Carré [kah-ray] of the Louvre, which lent the exhibition its name. It ran from August 25 until the end of September almost every year from 1737 until 1751, and every other year from 1751 to 1791. But few visitors were well equipped to appreciate or understand what they were seeing, so a new brand of writing soon developed in response: art criticism.

Diderot's *Salons* Denis Diderot began reviewing the official exhibitions of the Paris Salon in 1759 for a private newsletter circulated to a number of royal houses outside France. Many consider these essays (there are nine of them) the first art criticism. Boucher and his fellow Rococo artists were the

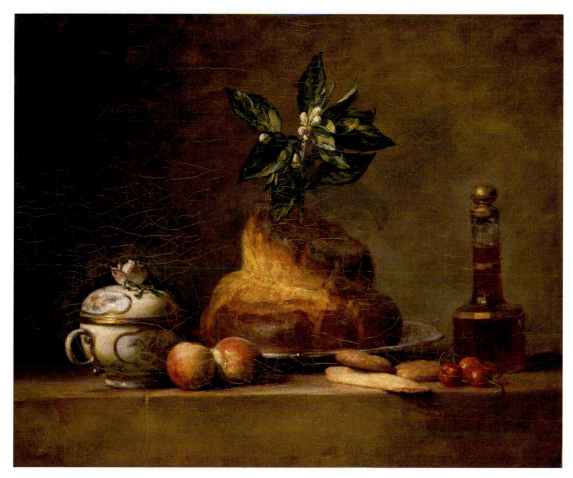

Fig. 29.18 Jean-Baptiste-Siméon Chardin. *The Brioche (The Dessert).* 1763. Oil on canvas, 18½″ × 22″.
Photo: Hervè Lewandowski. Musee du Louvre/RMN Reunion des Musees Nationaux, France. SCALA/Art Resource, NY.
Chardin painted from dark to light, the brightest parts of the canvas coming last.

object of his wrath. In 1763 Diderot asked, "Haven't painters used their brushes in the service of vice and debauchery long enough, too long indeed?" Painting, he argued, ought to be "moral." It should seek "to move, to educate, to improve us, and to induce us to virtue." And in his *Salon of 1765*, Diderot would complain about Boucher:

> I don't know what to say about this man. Degradation of taste, color, composition, character, expression, and drawing have kept pace with moral depravity. . . . And then there's such a confusion of objects piled one on top of the other, so poorly disposed, so motley, that we're dealing not so much with the pictures of a rational being as with the dreams of a madman.

An artist who did capture his imagination was the still-life and genre painter Jean-Baptiste-Siméon Chardin (see Fig. 29.15). Considering the small Chardin still life *The Brioche* (Fig. **29.18**), a painting of the famous French bread or cake eaten at the breakfast table, Diderot in the *Salon of 1767* wrote: "One stops in front of a Chardin as if by instinct, as a traveler tired of his journey sits down almost

without being aware of it in a spot that offers him a bit of greenery, silence, water, shade, and coolness." What impressed Diderot most was Chardin's use of paint: "Such magic leaves one amazed. There are thick layers of superimposed color and their effect rises from below to the surface. . . . Come closer, and everything becomes flat, confused, and indistinct; stand back again, and everything springs back into life and shape." What Diderot valued especially in Chardin's work was its detail, what amounts to an almost encyclopedic attention to the everyday facts of the world. As opposed to the Rococo artists of the court, whose *fêtes galantes*, he complained, conveyed only the affected and therefore false manners and conventions of polite society, Chardin was able to convey the truth of things. "I prefer rusticity to prettiness," Diderot proclaimed.

Despite Diderot's preference for subject matter of a "truthful" kind, he was fascinated with the individual work of art. He expressed this fascination in his description of its painterly surface beyond whatever "subject matter" it might possess. This fascination was part of a broader change in the way that the eighteenth century approached the arts in general.

Gotthold Ephraim Lessing's *Laocoön* At the beginning of the century, painting, sculpture, architecture, poetry, and music had begun to separate themselves from the traditional "liberal arts," to be recast as the "fine arts." In the process, these fine arts began to distinguish themselves from each other, most notably in the writings of Gotthold Ephraim Lessing [LESS-ing] (1729–1781), a native of Frederick the Great's Prussia. His major work, written while serving as secretary to a Prussian general, is *Laocoön: or, An Essay upon the Limits of Painting and Poetry*, published in 1766.

Since the Renaissance, painting and poetry had been considered "sister arts." The saying *"ut pictura poesis"* ("as is painting so is poetry") of the ancient Roman Horace in his *Ars Poetica* had prevailed. Lessing took a different approach. Basing his argument on his understanding of the famous

Continuity & Change
p. 240

Laocoön

Hellenistic statue *Laocoön* (see Fig. 8.10), he argued that the visual arts and poetry were essentially different. "Painting," and by extension a sculpture like *Laocoön*, "can use only one single moment of the action, and must therefore choose the most pregnant, from which what precedes and follows will be most easily apprehended." On the other hand, poetry consists of a *series* of actions in time. Images unfold in space, texts in time. While the distinction is a bit superficial since it takes time to look at a painting carefully, it was deeply influential. The German Romantic playwright, poet, and novelist Johann Wolfgang von Goethe was only 17 when the book was published, but he would later recall its impact. "It lifted us up from the region of miserably limited observation into the wide open spaces of thought," he wrote. "That long misunderstood dictum, *ut pictura poesis*, was instantly dispensed with; the difference between plastic and verbal arts was now clear."

Rococo and Classical Music

The growing distaste for the Rococo and the moral depravity associated with it was epitomized in the eighteenth century in the rise of what we have come to call **Classical music**. It would almost completely supplant Rococo music, which was characterized by pieces written for the harpsichord, a keyboard instrument the strings of which are plucked rather than struck with hammers as on a piano. Its sound, as a result, is delicate and light. The two most important Rococo composers were French: François Couperin [koop-uh-RAN] (1668–1733) and Jean-Philippe Rameau [rah-MOH] (1683–1764). Their harpsichord music was composed of graceful melodies, many of them dance pieces with charmingly simple harmonies displayed in intricate and complex rhythms that mirror the Rococo's taste for ornamentation.

Their work epitomized what came to be known as the *style galant* [steel gah-LAHN], the perfect accompaniment to the *fêtes galantes* of Rococo art. At least one of Couperin's pieces in the *style galant*, "The Chimes of Cythera," directly evokes Watteau. Rameau, in addition, composed dramatic operas that featured ballet sequences for a large corps of dancers, as Lully's had for the court of Louis XIV (see chapter 27). These operas exploit the sexual tensions inherent in their stories, just as so much Rococo art did.

The style of music we have come to call *Classical*, on the other hand, coalesced first in Vienna about 1760, and lasted into the nineteenth century. It is as an almost total rejection of the Rococo and Baroque. We call this style "Classical" because it shares with Greek and Roman art the essential features of symmetry, proportion, balance, formal unity, and, perhaps above all, clarity. This clarity was a direct result of the rise of a new musical audience, a burgeoning middle class that demanded from composers a more accessible and recognizable musical language than found in the ornate and complex structures of Baroque and Rococo music.

The Symphonic Orchestra

The most important development of the age, designed specifically to address the new middle-class audience, was the **symphonic orchestra**. This musical ensemble was much larger than the ensemble used by Baroque composers such as Vivaldi (see chapter 25). Its basic structure was established in the 1740s by Johann Stamitz [SHTAH-mits] (1717–1757), concertmaster and conductor of the orchestra in Mannheim, located in the Rhine Palatinate (now southwestern Germany). Although Renaissance and Baroque instruments were already organized into families of instruments, the relatively large size of Stamitz's ensemble set it apart (Fig. **29.19**).

Stamitz divided his orchestra into separate sections according to type of instrument: the *strings*, made up of

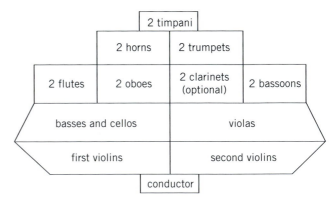

Fig. 29.19 The Classical symphonic orchestra in the time of Mozart and Haydn. From Jay Zorn, *Listening to Music*, 2nd edition. Used by permission of Prentice Hall, Inc.

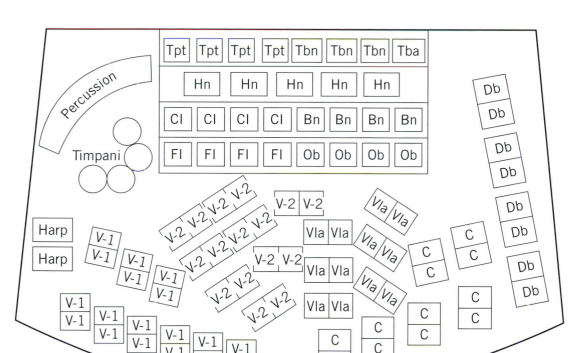

Fig. 29.20 **The Classical symphonic orchestra today.** From Jay Zorn, *Listening to Music*, 2nd edition. Used by permission of Prentice Hall, Inc. Over the years, the symphonic orchestra has added new instruments as composers increasingly experimented with them, and larger numbers of traditional instruments as they sought a fuller and richer sound. V-1: first violin; V-2: second violin; Via: viola; C: cello; Db: double bass; Ob: oboe; Fl: flute; Cl: clarinet; Bn: bassoon; Hn: French horn; Tpt: trumpet; Tbn: trombone; Tba: tuba.

violins, violas, cellos, and double basses; *woodwinds*, consisting of flutes, oboes, clarinets, and bassoons; a *brass* section of trumpets and French horns (by the end of the century, trombones were added); and a *percussion* section, featuring the kettledrums and other rhythm instruments. Gradually the piano, invented around 1720, was increasingly refined in design until it replaced the clavichord and harpsichord as the favored solo instrument at the heart of the orchestra. This improved piano was known as the **pianoforte** because it could play both soft (*piano*) and loud (*forte* [FOR-tay]), which the clavichord could not. The composer himself usually led the orchestra and often played part of the composition on the piano or clavier in the space now reserved for the conductor. The modern symphony orchestra (Fig. **29.20**) is a dramatically enlarged version of Stamitz's.

Stamitz's orchestra was the first to use an overall **score**, which indicated what music was to be played by each instrument. This let the composer view the composition as a whole. In addition, each instrument section was given its own individual part. The **time signature** (number of beats per measure), **key signature** (showing which notes should be played as a sharp or flat whenever they appear), **dynamics** (*forte*, for instance, for loud, *piano* for soft), **pace** (*allegro* [uh-LEG-roh], for fast; *lente* [LEN-tay], for slow), and interpretative directions (*affettuoso* [ah-fet-too-OH-soh] for "with feeling") were indicated both in the score as

a whole and the individual parts. These devices have remained part of the vocabulary of Western musical composition ever since (Fig. **29.21**).

Symphonic Form

The music most often played by the symphonic orchestra was the **symphony**. The term derives from the Italian *sinfonia*—the three-movement, fast–slow–fast, introduction or overture to

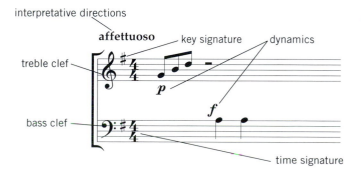

Fig. 29.21 **Devices of standard musical vocabulary.**

Italian operas. In Mannheim, however, Stamitz began to popularize a four-movement form, consisting of a first movement played in a fast tempo (*allegro*); a second movement that is slow (*adagio* [ah-DAHZ-oh] or *andante* [ahn-DAHN-tay]) and reflective; a third that picks up the pace again, often in the stately rhythms of the minuet; and a fourth movement which is generally *allegro* once again, spirited and lively. The predictability of the form is the source of its drama, since audiences anticipated the composer's inventiveness as the composition proceeded through the four movements. The first *allegro* movement (and occasionally the fourth) possessed its own distinct **sonata form**, a kind of small form within the larger symphonic form.

Each movement in the sonata form was divided into three parts: exposition, development, and recapitulation (Fig. **29.22**). In the *exposition*, the composer "exposes" the main theme in the composition's "home" key and then contrasts it with a second theme in a different key. In the *development*, the composer further develops the two themes in contrasting keys, and then, in the *recapitulation*, restates the two themes, but both now in the home key. Use of the home key in the restatement resolves the tension between the two themes. A short *coda* (or "tail") is often added to bring the piece to a definitive end.

There were several other important forms at the disposal of Classical composers in which they might write an individual movement of a composition. The most important of these are theme-and-variations form, aria form, minuet-and-trio form, and rondo form. One main musical theme dominates the theme-and-variations form. The theme repeats throughout the movement, each succeeding section presenting a variation or modification of it, but still in recognizable form so that its transformations are easy to follow. Aria form was a popular choice for slow movements, and it has already been discussed in connection with opera. However, in the symphony it is an instrumental not a vocal form. It consists of three parts, ABA. A slow, lyrical opening section (A), often in triple meter, is followed by a central section in a new key

(B), and, finally, by a repeat of the opening section (A), usually with variation of some kind.

The minuet-and-trio form was favored for the third movement of symphonies. It originates in the minuet dance form so popular in the Baroque courts. In the Classical symphony, minuet-and-trio movements are always in $\frac{3}{4}$ meter, played at a moderate tempo, and consist of three sections: a minuet (in two parts, each repeated, AABB); a trio, which follows the same pattern (CCDD), contrasting with the minuet in instrumentation, texture, dynamics, key, or some combination of these. Then the first minuet is played again, often without repeats (AABB, or simply AB):

MINUET	TRIO	MINUET
AABB	CCDD	AABB, or AB

The final form common to the Classical symphony is rondo form. It consists of a lively or catchy tune, played at a relatively fast pace, that keeps on returning or coming round again (hence the name "rondo"). Between occurrences of this main theme (A), contrasting episodes occur (ABACADA). Composers seeking a more balanced or symmetrical form often repeat the first episode just before the last occurrence of the main theme (ABACABA).

Although individual composers often modified and played with these main forms, the most common structure of a four-movement symphony would generally follow the scheme shown here.

Symphonic Movement	Form
I	Sonata
II	Aria, Sonata, or Theme and Variations
III	Minuet and Trio
IV	Rondo or Sonata

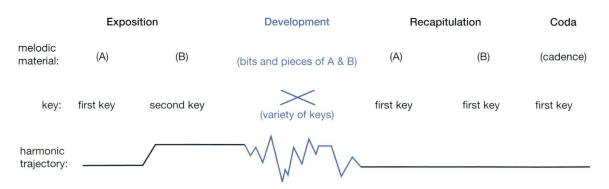

Fig. 29.22 Sonata form.

Some symphonies reverse the position of the middle two movements, putting the slower movement third instead of second. Sonata form was sometimes used twice, once for the first movement and then again, often in the fourth movement.

The String Quartets of Joseph Haydn

One of the most important contributors to the development of the symphonic form was the composer Joseph Haydn [HY-din] (1732–1809). In 1761, at the age of 29, he was appointed musical director to the court of the Hungarian nobleman Prince Paul Anton Esterházy. Haydn worked for Esterházy for nearly 30 years, isolated at Esterháza Palace in Eisenstadt, about 30 miles south of Vienna. The palace, modeled on Versailles, included two theaters (one for opera) and two concert halls. In these surroundings Haydn composed an extraordinary amount of music: operas, oratorios, concertos, sonatas, overtures, liturgical music, and above all, the two genres that he was instrumental in developing—the classical symphony and the string quartet. (He composed 106 of the former and 67 of the latter.) He also oversaw the repair of instruments, trained a chorus, and rehearsed and performed with a symphony of about 25 musicians.

The **string quartet**, the first of the new Classical genres that Haydn played such a large role in developing, features four string instruments: two violins, a viola, and a cello. Since all the instruments are from the same family, the music has a distinctly uniform sound. Its form closely followed that of the symphony. The string quartet was a product of the Classical age of music, performed almost exclusively in private settings, such as salons, for small audiences that understood the form to be a musical variation of their own conversations, an intimate exchange among friends.

Haydn was able to create new genres such as the string quartet precisely because Esterházy gave him the freedom to do so. "I could make experiments," Haydn told a biographer, "observe what elicited or weakened an impression, and thus correct, add, delete, take risks. I was cut off from the world . . . and so I had to become original." When Esterházy died in 1790, his son disbanded the orchestra and a London promoter, Johann Peter Salomon, invited Haydn to England. There he composed his last 12 symphonies for an orchestra of some 60 musicians. Among the greatest of the London symphonies is *Symphony No. 94*, the so-called *"Surprise" Symphony*. It was so named for a completely unanticipated *fortissimo* [for-TIS-uh-mo] ("very loud") percussive stroke that occurs on a weak beat in the second movement of the piece. This moment was calculated, so the story goes, to awaken Haydn's dozing audience, since concerts usually lasted well past midnight.

The third movement of *Symphony No. 94* (see **CD-Track 29.1**) is in minuet and trio form. It is among Haydn's greatest works. In the very first section of the move-

ment, the graceful cadences of the minuet last for only about 13 seconds, but in that short span Haydn changes dynamics four times. He then repeats this first section, so that in the first 30 seconds of the composition, a total of eight changes in dynamics occur. The violins alone play the quiet, or *piano*, passages, and the full orchestra the loud, or *fortissimo*, passages. This opening theme, with all its contrasting elements, is followed by the second theme of the opening minuet, after which the first theme briefly repeats, followed in turn by a repetition of the entire second theme. The trio manipulates the themes of the first minuet, lending them an entirely different texture, as first horns and violins alternate and then oboes and bassoons replace the horns, adding a sudden and surprising shift to a minor key. Finally, the entire minuet repeats exactly. The full effect is one of almost stunning emotional range.

Wolfgang Amadeus Mozart: Music to Chew On

The greatest musical genius of the Classical era was Haydn's younger contemporary and colleague, Wolfgang Amadeus Mozart [MOHT-sart] (1756–1791). Mozart wrote his first original composition at age six, in 1762, the year after Haydn assumed his post with Prince Esterházy. When he was just eight, the prodigy penned his first symphony. Over the course of his short, 35-year life, he would write 40 more, plus 70 string quartets, 20 operas, 60 sonatas, and 23 piano concertos. (All of Mozart's works were catalogued and numbered in the nineteenth century by Ludwig von Köchel, resulting in each of them being identified with the letter *K*.) Haydn told Mozart's father that the boy was simply "the greatest composer I know in person or by name," and in 1785 Mozart dedicated six string quartets to the older composer. On several occasions the two met at parties, where they performed string quartets together, Haydn on the violin, Mozart on the viola.

By the time Mozart was 6 years old, his father, Leopold, began taking him and his sister Anna, also a talented keyboard player, on concert tours throughout Europe (Fig. **29.23**). The tours exposed the young genius to virtually every musical development in eighteenth-century Europe, all of which he absorbed completely. As Mozart grew into adulthood, he suffered from depression and illness. He was unable to secure a position in the Habsburg court in Vienna until late in his life, when he was given the minor task of writing new dances for New Year's and other celebrations, so he was forced to teach composition to supplement his income. By the mid-1780s, he had also begun to perform his piano concertos in public concerts, from which he derived some real income.

Despite the stunning successes of his operas, Mozart's music was generally regarded as overly complicated, too demanding emotionally and intellectually for a popular audience to absorb. When the Habsburg Emperor Joseph II

commented that the opera *Don Giovanni* was beautiful "but no food for the teeth of my Viennese"—meaning too refined for their taste—Mozart reportedly replied, "Then give them time to chew it." Indeed, his work often took time to absorb. Mozart could pack more distinct melodies into a single movement than most composers could write for an entire symphony, and each line would arise and grow naturally from the beginning to the end of the piece. But the reaction of Joseph II to another of his operas is typical: "Too many notes!" Ironically, it is exactly this richness that we value today.

An example of Mozart's complexity is his *Symphony No. 40*, composed in the course of eight weeks in the summer of 1788. In the first movement, Mozart utilizes the sonata form in a way that is very easy for the listener to hear, and yet the movement is full of small—and sometimes larger—surprises (**CD-Track 29.2** and *Focus*, pages 958–959). The composition shifts dramatically between loud and soft passages, woodwinds and strings, rising and falling phrasings, and major and minor keys. Particularly dramatic is the way Mozart leads the listener to anticipate the beginning of the recapitulation, only to withhold it. As developed in the clear forms originated by Haydn and Mozart, the Classical symphony is nearly the antithesis of the delicately ornate *style galant* of the Rococo. As such, it announces the demise of the Rococo style.

The Popularization of Opera

The musical form that most clearly announces the death of the Rococo is opera. Its chief genre in the seventeenth and eighteenth centuries was **opera seria** ("serious opera"), a very formal kind of opera characterized by mythological or historical subjects and complex arias. *Opera seria* developed in Italy after Monteverdi's initial example (see chapter 25). Sung almost exclusively in Italian, its tragic mode had found favor throughout Europe.

By the middle of the eighteenth century the conventions of *opera seria* had come under attack. As early as 1728, in

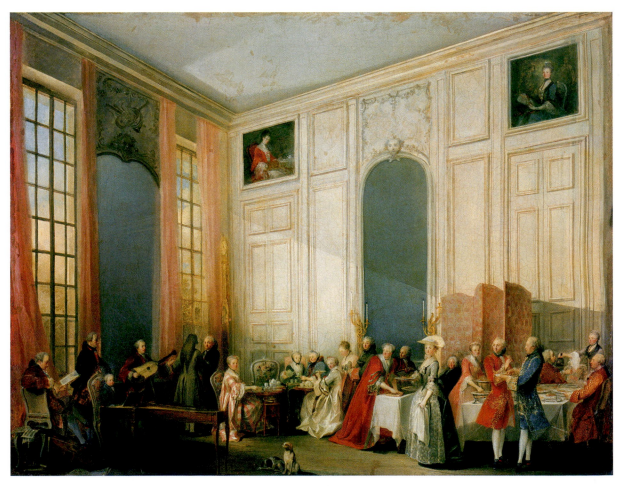

Fig. 29.23 Michel Barthélemy Ollivier. *Tea at Prince Louis-François de Conti's in the Temple, Paris.* **1766.** Oil on canvas. Musée du Louvre, Paris. The painting depicts an actual salon in the summer of 1766, during Mozart's second visit to Paris when he was about 10 years old. The prodigy is seated at the harpsichord, about to accompany the singer Pierre Jéylotte, seen tuning his guitar.

London, *The Beggar's Opera* by John Gay (1685–1732) openly lampooned them. Instead of mythological figures or historical heroes, it portrayed common criminals. Where in France, opera always opened with an overture honoring the king, Gay began his with a song attacking the prime minister. The setting (a prison as opposed to a grand hall) and score (69 songs, including 28 English ballads) stand in marked contrast to the elaborate scenery (including mechanical devices for grand spectacles) and arias and recitative of *opera seria*. In fact, Gay dispensed with recitative altogether, substituting spoken dialogue.

The Beggar's Opera was an instant success, so popular that it was soon performed in the American colonies. It is said to have been George Washington's favorite opera. For the remainder of the eighteenth century it was performed in one city or another throughout the English-speaking world at least once a year.

Opera Seria versus Opera Buffa Meanwhile, a new style of opera had developed in Italy—*opera buffa* ("comic opera")—which, like the novel or Gay's *Beggar's Opera*, took everyday people for its characters and their more or less everyday activities for its plot. Its melodies, like Gay's, were generally simple and straightforward, unlike the complex solo arias that mark *opera seria*.

But even those who were dedicated to *opera seria* sought to reform it. Leading the way was Christoph Willibald Gluck (1714–1787). A prolific composer of operas himself, he resolved "to free [Italian opera] from all the abuses which have crept in either through ill-advised vanity on the part of the singers or through excessive complaisance on the part of composers." The **da capo aria**, which comprised the vast majority of *opera seria* arias, particularly annoyed him. Meaning "from the head," or, as we would say today, "from the top," or the beginning, the da capo aria had an ABA form. Singers were expected to embellish the A section in its repetition, transforming long notes into runs, adding new higher notes, and generally showing off their singing skills. When an aria ended, the singer usually left the stage, thus allowing for curtain calls and even encores. A singer who performed the A section the second time around with little or no change would be booed off the stage or pelted with rotten vegetables. The way in which the audience interrupted the flow of the performance as it expressed its approval or disapproval frustrated Gluck. He therefore proposed replacing the da capo aria with a more syllabic setting of text to music. This would eliminate needless embellishment and make the words more intelligible. He also advocated simpler and more flowing melodies.

Opera buffa accepted Gluck's propositions and went even further, eliminating the chief practitioners of the da capo aria. These practitioners were **castrati**, men who subjected themselves to castration in their youth in order to preserve their high voices. The best of them enjoyed great financial success, comparable to a modern-day rock star. Their dispro-portionately long limbs and extremely high voices left them open to broad satire, which contributed to the growing image of *opera seria* as an "unnatural" or artificial art form. By eliminating castrati from its productions, *opera buffa* underscored the closeness of its comedies to real life.

Mozart's Stylistic Synthesis Mozart wrote five *opera seria*, but in his last four great operas—*The Marriage of Figaro*, *Don Giovanni*, *Così fan tutte*, and *The Magic Flute*—he united *opera seria* and *opera buffa*. Mozart referred to these four operas as **dramma giocoso**, "comic drama." The first three bring together nobles and commoners in stories that are at the same time comic and serious. What distinguishes them most, however—and the Italian librettist Lorenzo da Ponte (1749–1838) must be given some credit for this—is the depth of their characters. From the lowest to the highest class and rank, all are believable as they sort out their stormy relationships and love lives.

Based on the legend of Don Juan, a seducer of women who killed the father of one of his noble conquests and then got his comeuppance when the father's funerary statue accepted the Don's playful invitation to dinner and dragged the Don down to Hell, Mozart's *Don Giovanni* is a *tour de force*. The lead character is at once attractive and repulsive, a defier of all social convention and ethical norms. Opposite him are two noble female leads, Donna Anna and Donna Elvira, and a peasant girl, Zerlina, whom Don Giovanni is also intent on seducing.

As the curtain rises, Don Giovanni's servant Leporello guards the courtyard outside the bedroom where his master is trying to seduce Donna Anna. His opening aria is a complaint lamenting the wicked ways of his master yet asserting the desire to be a "gentleman" himself. Harmonically, rhythmically, and melodically simple, it sets a distinct *opera buffa* tone. But no sooner does Leporello finish than the noblewoman Donna Anna and Don Giovanni himself sing a duet of an entirely different tone. The Don has evidently failed to seduce Donna Anna and is trying to escape her cries of alarm, but she pursues him. Leporello, standing safely apart but observing the interchange, soon makes the duet a trio, commenting on the action and predicting his master's behavior will lead to his ultimate ruin. Donna Anna's father, the Commendatore, answers his daughter's cries and challenges Don Giovanni to a duel. The Don reluctantly agrees and quickly kills the Commendatore, who dies slowly as Leporello comments on his master's behavior again, this time even more despondently. When Donna Anna returns with her fiancé, Don Ottavio, to find her father dead, the two swear to avenge the murder.

So the opera's comic opening is transformed into a drama of high seriousness and consequence. Throughout this scene Mozart does not provide a single moment in which the audience can applaud. In the next scene, the *opera buffa* tone resumes as Leporello mockingly consoles Donna Elvira, whom Don Giovanni has already seduced and deserted. His

Focus

Mozart's *Symphony No. 40 in G Minor (K. 550),* First Movement: Molto Allegro

U nlike Joseph Haydn, who had a standing orchestra at his disposal, Wolfgang Amadeus Mozart had no compelling reason to compose symphonies on a regular basis. *Symphony No. 40* and the two others he wrote in 1788 were probably undertaken with an eye toward an upcoming trip to London, where he planned to showcase his talents. The symphony is marked by almost perfect balance and control, and although its sonata form is easy to hear and follow, it is also easy to hear the ways in which Mozart manipulates the form in order to play with his audience's expectations. The first movement is an excellent model of the complexity a listener can expect in the entire symphony. It is constructed of two main themes. The following guide to the first movement will help readers understand the structure of the entire work. Listeners can follow along using the cueing notes and elapsed time indications, consulting a wristwatch, as they hear the composition the first few times. The timings in parentheses are for the repeat.

Exposition

The first main theme inaugurates the exposition. It is very fast (*allegro molto*), played first by violins and then the full orchestra:

0.00 (2:01)

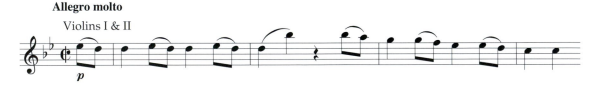

First theme of first movement of Mozart's Symphony No. 40

This is followed by a bridge passage, or transition theme, played loud by the full orchestra, with a rising set of notes that appears later in the movement:

0:32 (2.33)

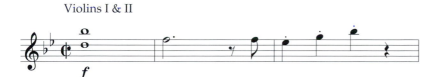

Bridge passage of first movement of Symphony No. 40

This bridge provides a clear stopping point before the introduction of the second theme, played by violin, then clarinet. (Incidentally, Mozart was one of the first composers to integrate the clarinet fully into the orchestra.):

0:51 (2:52)

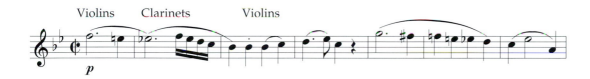

Second theme of first movement of Symphony No. 40

1:10 (3:14) Odd and surprising notes.

1:27 (3:27) Alternating soft and loud fragments of the first theme repeat (clarinet, bassoon, and strings).

1:41 (3:48) Ending passage, first theme loud with whole orchestra.

2:01 Exact repetition of entire exposition.

Development

4:00 The first theme is developed with lots of key changes.

4:47 The music gets quieter and quieter. The listener expects the recapitulation, but Mozart thwarts the expectation as . . .

5:03 the music suddenly gets very loud.

5:12 Another seeming preparation for the recapitulation as woodwinds quietly descend. (But the listener was thwarted last time—is this one for real?) The anticipation mounts.

Recapitulation

5:18 The first theme returns in the violins.

5:49 Mozart introduces new material, with the whole orchestra playing loudly. And here he reintroduces the rising set of notes first heard in the bridge between the first and second themes of the exposition.

6:31 The second theme recurs, with surprise notes and some new material.

7:12 The first theme recurs, opening out finally to. . . .

Coda

7:42 The first theme in violins, imitated by viola and woodwinds . . .

7:57 ending with three final chords in full orchestra.

aria, "Madamina," sometimes called the "Catalog Aria," enumerates Don Giovanni's numerous conquests throughout Europe and is a masterpiece of comic composition (**CD-Track 29.3** and Fig. **29.24**). As nobility confront peasantry, and then work together to bring Don Giovanni to justice, the concerns of *opera seria* and *opera buffa* coalesce into highly entertaining drama.

After debuting triumphantly in Prague, *Don Giovanni* was received with less enthusiasm in Vienna, at least at first. But Haydn loved it. "If every music-lover, especially among the nobility, could respond to Mozart's inimitable works with the depth of emotion and understanding which they arouse in me, the nations would compete to have such a jewel within their frontiers."

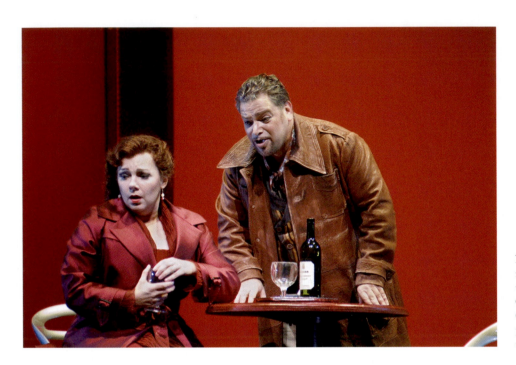

Fig. 29.24 Leporello (Edwardo Chame) recites a list of Don Giovanni's conquests to Donna Elvira (Marie Plette). Seattle Opera 2007 production of Mozart's *Don Giovanni.* As the modern costuming in this production suggests, Mozart's opera remains relevant to contemporary audiences.

READINGS

READING 29.2

from Jean-Jacques Rousseau, *Confessions*, Book 1 (completed 1770, published 1780)

The first two paragraphs of Confessions *set out the author's intention of total revelation, which he claims is totally new. In fact,* Confessions *does reveal more about the writer's private self than any other work before it. Only Montaigne's* Essais *come close. The* Confessions *are sometimes almost unbearably honest. In the longer excerpt below, Rousseau reveals his "spanking" fetish. Above all, the* Confessions *stands out as a supreme example of the autobiographical impulse in Enlightenment thought, the need to know oneself in as much detail as possible.*

[1712–1719]—I am commencing an undertaking, hitherto without precedent, and which will never find an imitator. I desire to set before my fellows the likeness of a man in all the truth of nature, and that man myself.

Myself alone! I know the feelings of my heart, and I know men. I am not made like any of those I have seen; I venture to believe that I am not made like any of those who are in existence. If I am not better, at least I am different. Whether Nature has acted rightly or wrongly in destroying the mold in which she cast me, can only be decided after I have been read. . . .

As Mademoiselle Lambercier had the affection of a mother for us, she also exercised the authority of one, and sometimes carried it so far as to inflict upon us the punishment of children when we had deserved it. For some time she was content with threats, and this threat of a punishment that was quite new to me appeared very terrible; but, after it had been carried out, I found the reality less terrible than the expectation; and what was still more strange, this chastisement made me still more devoted to her who had inflicted it. It needed all the strength of this devotion and all my natural docility to keep myself from doing something which would have deservedly brought upon me a repetition of it; for I had found in the pain, even in the disgrace, a mixture of sensuality which had left me less afraid than desirous of experiencing it again from the same hand. No doubt some precocious sexual instinct was mingled with this feeling, for the same chastisement inflicted by her brother would not have seemed to me at all pleasant. But, considering his disposition, there was little cause to fear the substitution; and if I kept myself from deserving punishment, it was solely for fear of displeasing Mademoiselle Lambercier; for, so great is the power exercised over me by kindness, even by that which is due to the senses, that it has always controlled the latter in my heart.

The repetition of the offense, which I avoided without being afraid of it, occurred without any fault of mine, that is to say, of my will, and I may say that I profited by it without any qualm of conscience. But this second time was also the last; for Mademoiselle Lambercier, who had no doubt noticed something which convinced her that the punishment did not have the desired effect, declared that it tired her too much, and that she would abandon it. Until then we had slept in her room, sometimes even in her bed during the winter. Two days afterwards we were put to sleep in another room, and from that time I had the honor, which I would gladly have dispensed with, of being treated by her as a big boy.

Who would believe that this childish punishment, inflicted upon me when only eight years old by a young woman of thirty,[1] disposed of my tastes, my desires, my passions, and my own self for the remainder of my life, and that in a manner exactly contrary to that which should have been the natural result? When my feelings were once inflamed, my desires so went astray that, limited to what I had already felt, they did not trouble themselves to look for anything else. In spite of my hot blood, which has been inflamed with sensuality almost from my birth, I kept myself free from every taint until the age when the coldest and most sluggish temperaments begin to develop. In torments for a long time, without knowing why, I devoured with burning glances all the pretty women I met; my imagination unceasingly recalled them to me, only to make use of them in my own fashion, and to make of them so many Mlles. Lambercier.

Even after I had reached years of maturity, this curious taste, always abiding with me and carried to depravity and even frenzy, preserved my morality, which it might naturally have been expected to destroy. If ever a bringing-up was chaste and modest, assuredly mine was. My three aunts were not only models of propriety, but reserved to a degree

[1]Actually, at the time described, Mlle. Lambercier was about 38 and Rousseau about 11.

which has long since been unknown amongst women. My father, a man of pleasure, but a gallant of the old school, never said a word, even in the presence of women whom he loved more than others, which would have brought a blush to a maiden's cheek; and the respect due to children has never been so much insisted upon as in my family and in my presence. In this respect I found M. Lambercier equally careful; and an excellent servant was dismissed for having used a somewhat too free expression in our presence. Until I was a young man, I not only had no distinct idea of the union of the sexes, but the confused notion which I had regarding it never presented itself to me except in a hateful and disgusting form. For common prostitutes I felt a loathing which has never been effaced: the sight of a profligate always filled me with contempt, even with affright. My horror of debauchery became thus pronounced ever since the day when, walking to Little Sacconex[2] by a hollow way, I saw on both sides holes in the ground, where I was told that these creatures carried on their intercourse. The thought of the one always brought back to my mind the copulation of dogs, and the bare recollection was sufficient to disgust me.

This tendency of my bringing-up, in itself adapted to delay the first outbreaks of an inflammable temperament, was assisted, as I have already said, by the direction which the first indications of sensuality took in my case. Only busying my imagination with what I had actually felt, in spite of most uncomfortable effervescence of blood, I only knew how to turn my desires in the direction of that kind of pleasure with which I was acquainted, without ever going as far as that which had been made hateful to me, and which, without my having the least suspicion of it, was so closely related to the other. In my foolish fancies, in my erotic frenzies, in the extravagant acts to which they sometimes led me, I had recourse in my imagination to the assistance of the other sex, without ever thinking that it was serviceable for any purpose than that for which I was burning to make use of it.

In this manner, then, in spite of an ardent, lascivious and precocious temperament, I passed the age of puberty without desiring, even without knowing of any other sensual pleasures than those of which Mademoiselle Lambercier had most innocently given me the idea; and when, in course of time, I became a man, that which should have destroyed me again preserved me. My old childish taste, instead of disappearing, became so associated with the other, that I could never banish it from the desires kindled by my senses; and this madness, joined to my natural shyness, has always made me very unenterprising with women, for want of courage to say all or power to do all. The kind of enjoyment, of which the other was only for me the final consummation, could neither be appropriated by him who longed for it, nor guessed by her who was able to bestow it. Thus I have spent my life in idle longing, without saying a word, in the presence of those whom I loved most. Too bashful to declare my taste, I at least satisfied it in situations which had reference to it and kept up the idea of it. To lie at the feet of an imperious mistress, to obey her commands, to ask her forgiveness—this was for me a sweet enjoyment; and, the more my lively imagination heated my blood, the more I presented the appearance of a bashful lover. It may be easily imagined that this manner of making love does not lead to very speedy results, and is not very dangerous to the virtue of those who are its object. For this reason I have rarely possessed, but have none the less enjoyed myself in my own way—that is to say, in imagination. Thus it has happened that my senses, in harmony with my timid disposition and my romantic spirit, have kept my sentiments pure and my morals blameless, owing to the very tastes which, combined with a little more impudence, might have plunged me into the most brutal sensuality. ■

Reading Question

One of the great questions Rousseau's *Confessions* raises concerns the quality of its purported honesty. Is such self-revelation evidence of Rousseau's sincerity and humility or the manifestation of a kind of perverse pride?

[2]A village on the outskirts of Geneva.

READING 29.5

from Voltaire, *Candide* (1758)

The following excerpt narrates a few of the many adventures of Candide and Dr. Pangloss. In Chapter 6, the Inquisition punishes Candide and Pangloss, blaming them for the earthquake that destroyed Lisbon on November 1, 1755. Pangloss is hanged, and Candide believes the philosopher to be dead. Not until Chapter 28 does he learn otherwise, when the two are reunited and Pangloss

tells him how he narrowly escaped death. These two passages convey Voltaire's conviction that religion is based in superstition and illusion even as they satirize the foolishness of Pangloss's philosophical optimism.

Chapter 6

How the Portuguese Made a Suberb Auto-da-fé to Prevent any Future Earthquakes, and How Candide Underwent Public Flagellation

After the earthquake which had destroyed three-quarters of the city of Lisbon[1] the sages of that country could think of no means more effectual to preserve the kingdom from utter ruin, than to entertain the people with an *auto-da-fé*,[2] it having been decided by the University of Coimbra that burning a few people alive by a slow fire, and with great ceremony, is an infallible secret to prevent earthquakes.

In consequence thereof they had seized on a Biscayan for marrying his godmother, and on two Portuguese for taking out the bacon of a larded pullet they were eating.[3] After dinner, they came and secured Dr. Pangloss, and his pupil Candide; the one for speaking his mind, and the other for seeming to approve what he had said. They were conducted to separate apartments, extremely cool, where they were never incommoded with the sun. Eight days afterwards they were each dressed in a *fanbenito*,[4] and their heads were adorned with paper mitres. The mitre and *fanbenito* worn by Candide were painted with flames reversed, and with devils that had neither tails nor claws; but Dr. Pangloss's devils had both tails and claws, and his flames were upright. In these habits they marched in procession, and heard a very pathetic sermon, which was followed by a chant, beautifully intoned. Candide was flogged in regular cadence, while the chant was being sung; the Biscayan, and the two men who would not eat bacon, were burnt, and Pangloss was hanged, although this is not a common custom at these solemnities. The same day there was another earthquake, which made most dreadful havoc.[5]

Candide, amazed, terrified, confounded, astonished, and trembling from head to foot, said to himself, 'If this is the best of all possible worlds, what are the others? If I had only been whipped, I could have put up with it, as I did among the Bulgarians; but, O my dear Pangloss! thou greatest of philosophers! that ever I should live to see thee hanged, without knowing for what!

[1] Lisbon was destroyed by an earthquake on November 1, 1755.
[2] An *auto-da-fé*, literally, an "act of faith." In the Inquisition, it was the announcement of judgment generally followed by execution.
[3] By marrying his godmother, the Biscayan is guilty of spiritual incest. By not eating bacon, the two Portuguese are assumed to be Jews.
[4] A long yellow garment worn by the criminals of the Inquisition.
[5] Lisbon suffered a second earthquake on December 21, 1755.

Chapter 28

What Befell Candide, Cunegunde, Pangloss, Martin, &c.

"But how happens it that I behold you again, my dear Pangloss?" said Candide.

"It is true," answered Pangloss, "you saw me hanged, though I ought properly to have been burnt; but you may remember that it rained extremely hard when they were going to roast me. The storm was so violent that they found it impossible to light the fire; so they hanged me because they could do no better. A surgeon purchased my body, carried it home, and prepared to dissect me. He began by making a crucial incision from my navel to the clavicle. It is impossible for any one to have been more lamely hanged than I had been. The executioner of the Holy Inquisition was a subdeacon, and knew how to burn people very well, but as for hanging, he was a novice at it, being quite out of the way of his practice; the cord being wet, and not slipping properly, the noose did not join. In short, I still continued to breathe; the crucial incision made me scream to such a degree that my surgeon fell flat upon his back; and imagining it was the devil he was dissecting, ran away, and in his fright tumbled downstairs. His wife hearing the noise flew from the next room, and, seeing me stretched upon the table with my crucial incision, was still more terrified than her husband. She took to her heels and fell over him. When they had a little recovered themselves, I heard her say to her husband, 'My dear, how could you think of dissecting an heretic? Don't you know that the devil is always in them? I'll run directly to a priest to come and drive the evil spirit out.' I trembled from head to foot at hearing her talk in this manner, and exerted what little strength I had left to cry out, 'Have mercy on me!' At length the Portuguese barber took courage, sewed up my wound, and his wife nursed me; and I was upon my legs in a fortnight's time. The barber got me a place as lackey to a Knight of Malta who was going to Venice; but finding my master had no money to pay me my wages, I entered into the service of a Venetian merchant, and went with him to Constantinople."

"One day I happened to enter a mosque, where I saw no one but an old imam and a very pretty young female devotee, who was saying her prayers; her neck was quite bare, and in her bosom she had a beautiful nosegay of tulips, roses, anemones, ranunculuses, hyacinths, and auriculas. She let fall her nosegay. I ran immediately to take it up, and presented it to her with a most respectful bow. I was so long in delivering it, that the imam began to be angry; and, perceiving I was a Christian, he cried out for help; they

carried me before the cadi, who ordered me to receive one hundred bastinadoes, and sent me to the galleys. I was chained in the very galley, and to the very same bench with my lord the Baron. On board this galley there were four young men belonging to Marseilles, five Neapolitan priests, and two monks of Corfu, who told us that the like adventures happened every day. The Baron pretended that he had been worse used than myself; and I insisted that there was far less harm in taking up a nosegay, and putting it into a woman's bosom, than to be found stark naked with a young Icoglan. We were continually in dispute, and received twenty lashes a-day with a thong, when the concatenation of sublunary events brought you on board our galley to ransom us from slavery." 90

"Well, my dear Pangloss," said Candide to him, "when you were hanged, dissected, whipped, and tugging at the oar, did you continue to think that every thing in this world happens for the best?"

"I have always abided by my first opinion," answered Pangloss; "for, after all, I am a philosopher . . . ■ 100

Reading Question

In what way does Pangloss's philosophical optimism directly contradict the philosophy of John Locke and by extension other Enlightenment thinkers?

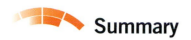

Summary

■ **The Rococo** The Rococo is a decorative style of art that originated in the *hôtels* and salons of Paris, characterized by S- and C-curves, shell, wing, scroll, and plant tendril forms, and cartouches. Parisian court life was conducted in the Rococo salons of the city's hostesses, where *philosophes*, artists, and intellectuals gathered, and where there was a continuing tension between the aims and values of the French monarchy and the Enlightenment views of the *philosophes*. On the one hand, artists, such as Jean-Antoine Watteau, captured the court's Rococo style in paintings of *fêtes galantes*, gatherings of noble men and women with amorous or erotic overtones. The paintings of François Boucher carried on the erotic Rococo style, which reached its apex in the paintings of his pupil, Jean-Honoré Fragonard, especially in his series entitled *The Progress of Love*.

Across the royal courts of Europe the Rococo style of the French court was widely emulated. In Germany at Würzburg, the architect Balthasar Neumann and the painter Giovanni Tiepolo created an elaborate Rococo interior for the prince-bishop's *Residenz*. In Prussia, Frederick the Great decorated his country palace of Sanssouci in a Rococo style. The palace's surrounding gardens forsook the straight and geometrical layout of the French garden, substituting the new English garden design, distinguished by serpentine and meandering paths, surprising vistas, and an artificial rusticity, inspired by the landscape paintings of Claude Lorrain.

■ **The *Philosophes*** In France, the *philosophes* carried the ideals of the Enlightenment forward, often in open opposition to the absolutist French court. They were mostly Deists, who accepted the idea that God created the universe but did not have much if anything to do with its day-to-day workings. They rejected the rule of a monarchy and championed what they believed to be humanity's inherent love of liberty. The guiding principle of Diderot's *Encyclopédie* was rational humanism, the belief that through logical, careful thought, progress is inevitable. Many of the *philosophes* contributed to it, as Diderot set out to accumulate, codify, and preserve all human knowledge. In contrast, Jean-Jacques Rousseau's profoundly personal autobiography, *Confessions*, was, in its self-centeredness, profoundly antagonistic to Enlightenment ideals. His social commentary *The Social Contract* validated virtues like unselfishness and kindness, which he believed

were inherent human virtues, and profoundly influenced Enlightenment thinking. Finally, the satirist Voltaire challenged all the forms of absolutism and fanaticism that he saw in the world, especially in his satirical narrative *Candide*.

The *philosophes* also contributed to the development of art criticism and theory. In his critical reviews called *Salons*, Diderot declared Boucher's work depraved but championed the anti-Rococo style of Jean-Baptiste-Siméon Chardin for its representational and emotional truthfulness. It was at this time that the fine arts began to distinguish themselves from the liberal arts, and that Gotthold Ephraim Lessing distinguished between the visual arts and poetry in his treatise *Laocoön*.

■ **Rococo and Classical Music** Rococo musical taste centered on light, airy tunes with intricate and complex rhythms generally played on the harpsichord in what came to be known as the *style galant*. François Couperin and Jean-Philippe Rameau were its chief proponents. Classical music is very different and developed in opposition to the Rococo style. It shares with Greek and Roman art the essential features of symmetry, proportion, balance, formal unity, and clarity. The symphony orchestra, the primary vehicle of Classical music, was first conceived by Johann Stamitz in the 1740s. The form of the symphony was strictly defined as having four movements: *allegro*; *adagio* or *andante*; a dance rhythm, often a minuet; and *allegro* once again. The first and fourth movements possessed their own distinctive sonata form. Two of the greatest composers of symphonies were Joseph Haydn and Wolfgang Amadeus Mozart. Haydn was also instrumental in developing the form of the string quartet. Mozart's music, in his own day, was considered by many to be too complex, but he was able to bring competing musical elements into a state of classical balance like no composer before him. Mozart also synthesized the two contrasting types of opera most popular at the time: *opera seria* and *opera buffa*. *Opera seria* is characterized by mythological or historic subjects, complex da capo arias performed by castrati, and spectacular scenery. *Opera buffa* has comic subject matter involving characters from everyday life. Mozart called the new form *opera giocoso* and used it in four operas, of which *Don Giovanni* is a good example. Opera is the musical form that most clearly reflects the decline of the Rococo.

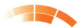

Glossary

cartouche An elaborate frame.

castrato A male singer who, in order to retain his high voice, was castrated before puberty.

Classical music A style of music that developed in Europe about 1760 and lasted into the nineteenth century as an alternative to and rejection of the Rococo and Baroque; it shares with

Greek and Roman art the essential features of symmetry, proportion, balance, formal unity, and, perhaps above all, clarity.

da capo aria A type of aria in the ABA form in which the singer was expected to embellish the music, especially in the return of the A.

Deist One who accepts the idea that God created the universe but does not believe that God is actively involved in its day-to-day workings.

dramma giocoso Literally "comic drama," Mozart's name for his last four operas, which combine both *opera seria* and *opera buffa* styles.

dynamics A notation in a musical score that indicates force (for example, *forte* for loud; *piano* for soft).

English garden A type of garden design of artificial naturalness that became popular in England beginning in the early 1700s with irregular features and winding walkways.

fête galante A gallant and, by extension, amorous celebration or party.

key signature The number of flats or sharps per section.

natural law Law derived from nature and binding upon human society.

opera buffa Comic opera, featuring everyday characters.

opera seria Literally "serious opera," emphasizing virtuoso singing, featuring themes from ancient history and mythology.

pace A notation in a musical score that indicates rate of movement (for example, *allegro*, for fast; *lente*, for slow).

philosophes The "philosophers" who dominated the intellectual life of the French Enlightenment and who frequented *salons*.

pianoforte A piano, so named because it can play both soft (*piano*) and loud (*forte*) sounds.

rational humanism The belief that through logical, careful thought, progress is inevitable.

Rococo The highly decorative and ornate style employed by the French court that was quickly emulated by royal courts across Europe, especially in Germany.

salon A room designed especially for social gatherings; later, also referred to the social gathering itself.

salonnière The hostess of a French salon.

score A musical composition that indicates what music is to be played by each instrument.

sonata form A kind of small form within the larger symphonic form.

string quartet A group of musicians playing four instruments from the same family—two violins, a viola, and a cello—thus lending the music a distinctly homogenous sound.

style galant A Rococo style of music characterized by graceful melodies, many of them dance pieces with charmingly simple harmonies.

symphony An orchestral composition with a strictly defined form consisting of a first movement played in a fast tempo (*allegro*); a second movement that is slow (*adagio* or *andante*) and reflective; a third that picks up the pace again; and a fourth that is generally *allegro* once again, spirited and lively.

symphonic orchestra A large ensemble that organized the orchestra into separate sections according to type of instrument: strings, woodwinds, brass, and percussion.

time signature The number of beats per measure.

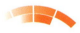

Critical Thinking Questions

1. How would you characterize the emotional content of Watteau's *fêtes galantes*?

2. What are the primary sources of the conflict between the *philosophes* and the French court?

3. What, according to Gotthold Ephraim Lessing, distinguishes the visual from the poetic arts?

4. What are the major structural divisions of the Classical symphony?

5. How does the Classical symphony differ in its emotional appeal from Rococo music?

A major talent of the Rococo era was the painter Marie-Louise-Elisabeth Vigée-Lebrun (1755–1842), whose career spanned two centuries. By 1775, when she was only 20 years old, her paintings were commanding the highest prices in Paris. Vigée-Lebrun painted virtually all the famous members of the French aristocracy, including on many occasions Marie-Antoinette, Louis XVI's queen, for whom she served as official portraitist.

Vigée-Lebrun was an ardent royalist, deeply committed to the monarchy. When she submitted *Marie-Antoinette en chemise* (Fig. 29.25) to the Salon of 1783, she was asked to withdraw it, because many on the committee thought the very expensive gown the queen wore in the painting was lingerie—*chemise*, in French usage, refers to undergarments. But the queen herself adored the painting, with its soft curves and petal-like textures. It presents her as the ideal Rococo female, the *fête galante*'s very object of desire.

Within six years the French nation was convulsed by revolution and Marie-Antoinette had fallen completely from grace. When Jacques-Louis David (1748–1825) sketched her from a second-story window as she was transported by cart to the guillotine on October 16, 1793, she was dressed in a much humbler chemise and cap (Fig. 29.26). Her chin is thrust forward in defiance and perhaps a touch of disdain, but her erect posture hints at the aristocratic grandeur she once enjoyed. David was one of the great painters of the period, and his career, like Vigée-Lebrun's, spanned two centuries. In fact, and as we shall soon see, his large-scale paintings with their classical structure and balance explicitly reject the Rococo values of the French monarchy. Instead, they embrace the moral authority of the French people who overthrew so corrupt a court.

Meanwhile, Marie-Antoinette's favorite painter, Vigée-Lebrun, escaped from Paris, traveling first to Italy, then Vienna, and finally Saint Petersburg. In all of these places she continued to paint for royal patrons and in the Rococo style she had used in France. Finally, in 1802, after 255 fellow artists petitioned the government, she was allowed to return to France, where, ever the ardent royalist, she lived in obscurity for the next 40 years. ■

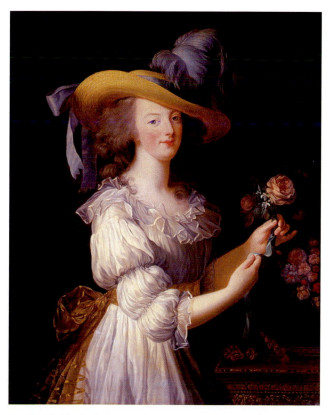

Fig. 29.25 Elisabeth-Louise Vigée-Le Brun. *Marie-Antoinette en chemise.* 1783. Oil on canvas, $35\frac{1}{2}'' \times 28\frac{1}{4}''$. Hessische Hausstiftung (Hessian House Foundation) Museum Schloss Fasanerie. Schloßmuseum, Darmstadt.

Fig. 29.26 Jacques-Louis David. *Marie-Antoinette conduite au supplice. (Queen Marie-Antoinette on the way to the guillotine)* 1793. Ink drawing. DR 3599 Coll. Rothschild. Musee du Louvre/RMN Reunion des Musees Nationaux, France. SCALA/Art Resource, NY.

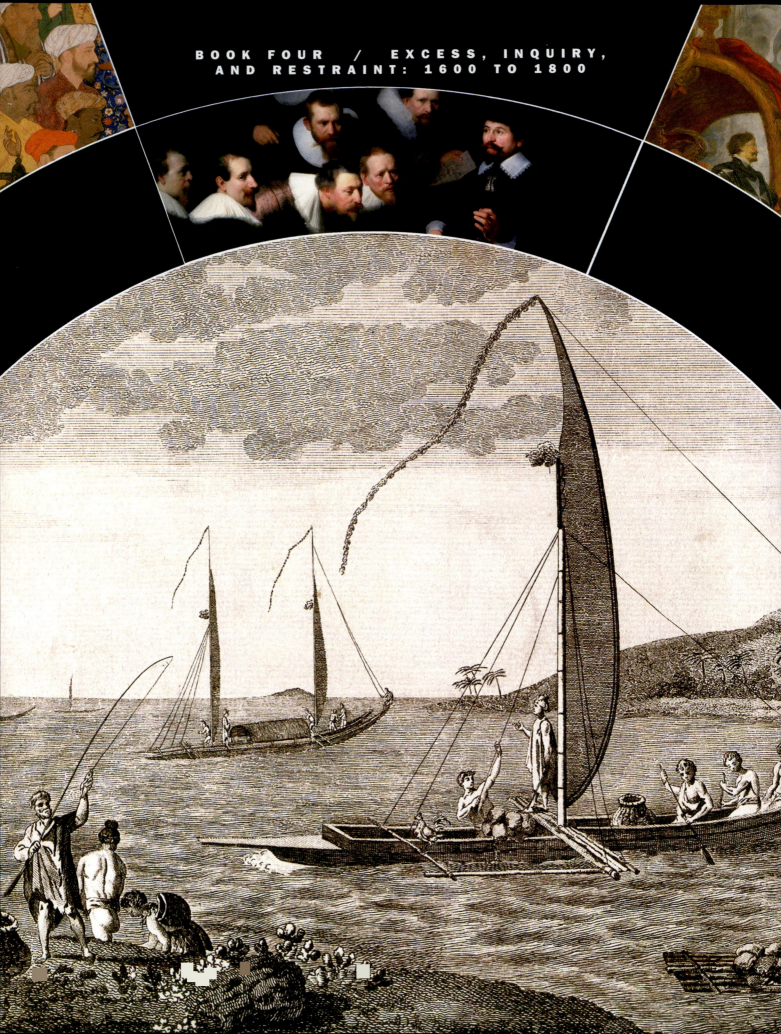

30 Cross-Cultural Encounter

Exploration and Trade in the Enlightenment

The South Pacific: The Cultures Captain Cook Encountered

China and Europe: Cross-Cultural Contact

India and Europe: Cross-Cultural Connections

Native American Traditions

❝ *Who is there to mourn for Logan?—Not one.* **❞**

Logan, Speech on the End of Lord Dunmore's War

← **Fig. 30.1 *Islanders in a Boat off Tahiti. From An Account of the Voyages . . . in the Southern Hemisphere . . . Undertaken by Captain Cook. 1773.*** The islanders of the Pacific were often idealized by Englightenment thinkers. Note the Classical Greek physiques of these fisherman, and, particularly, the Roman toga worn by the fisherman at the bottom left.

T O THIS DAY, THE ISLAND OF TAHITI EVOKES IMAGES OF AN exotic paradise. The idealized Tahiti is forever bathed in warmth and sunlight, far removed from the winters of the Northern Hemisphere and the sometimes even harsher burdens of life in Northern civilization. Such a utopian vision of life in Tahiti was

bestowed upon it by Western explorers from the outset. This was a place, they believed, from which the industrialized world might take some valuable lessons.

And so, when, on August 26, 1768, Captain James Cook (1728–1779) set sail on the *Endeavor* from Plymouth, England, for the uncharted waters of the South Pacific, both his sponsors, the Royal Society and the British Admiralty, and Cook himself believed the enterprise to be consistent with the aims of the Enlightenment. While Cook would claim new territories for the British crown, his primary mission was to extend human knowledge: to map the South Seas, record his observations, and otherwise classify a vast area of the world then unknown to European civilization. Although he was careful to document the lives of the people he encountered (Fig. **30.1**), his primary mission was to visit Tahiti in order to chart the transit of Venus, that moment in time when the planet Venus crosses directly between the sun and the earth. This phenomenon occurs twice, eight years apart, in a pattern that repeats every 243 years; in the eighteenth century that was in 1761 and 1769. (Astronomers around the world watched in fascination when it occurred in June 2004, and will study it again in June 2012.) The measurement of the transit of Venus was understood to be useful in calculating the size of the solar system.

The Royal Society knew of Tahiti because one of its members, the Frenchman Louis-Antoine de Bougainville [deh boo-gahn-VEEL] (1729–1811), had landed on its shores just months before, in April 1768. Bougainville's descriptions of Tahitian life, published in 1771 as *Voyage around the World*, captured the Enlightenment's imagination. Denis Diderot [dee-DROH] quickly penned a *Supplement* to Bougainville's text, arguing that the natives of Tahiti were truly Rousseau's "noble savages." They were free from the tyrannical clutches of social hierarchy and private property—in Diderot's words, "no king, no magistrate, no priest, no laws, no 'mine' and 'thine.'" All things were held for the common good, including the island's women, who enjoyed, in Diderot's eyes, the pleasures of free love. By following their natural instincts, these people had not fallen into a state of degradation and depravity, as Christian thinkers would have predicted, but rather formed themselves into a nation of gentleness, general well-being, and harmonious tranquility.

Cook, upon his return, took exception to Diderot's picture of Tahitian life. The careful observer would have noticed, he pointed out, a highly stratified social hierarchy of chiefs and local nobility, that virtually every tree on the island was the private property of one of the natives, and that the sexual lives of the Tahitians were in general as morally strict as those of the English (although women in port were as likely in Tahiti as in Plymouth to sell their sexual favors to visiting sailors). But if Cook's position seems at odds with that of the Enlightenment, it was, in its way, also consistent. The *philosophes* had argued that human nature and behavior were the same all over the world, and in his view the Tahitians proved that point. In addition, Enlightenment economists had argued that private property and social stratification were the basic features of a complex and flourishing society. Cook found both in Tahitian society, and this accounted for the general well-being of their society, he believed.

The impact of the Enlightenment's encounters with other cultures is the subject of this chapter. As the exploration of the South Sea islands suggested, Europeans had much to learn from the peoples of the world. Cook returned from the Pacific with sketches of peoples and societies as well as specimens of plants and beasts unknown in Europe. During the eighteenth century, China was still the largest empire in the world. In many respects, it was more advanced than any society in the West. Its people were better educated, with over a million graduates of its highly sophisticated educational system, and its industry and commerce more highly developed. It was also a more egalitarian society (at least for males) than any in the West, for, although a wealthy, landed nobility did exist, it was subject to a government of scholar-bureaucrats drawn from every level of society. As a result, China's was a society widely admired, especially by the *philosophes*, and its porcelains, lacquers, and textiles—even its garden design—deeply influenced European taste. And although the Chinese themselves continued to regard Westerners as barbarians, they began to create works of art, especially export wares, that incorporated Western pictorial traditions.

In India, where Muslim leaders ruled over a people that were largely Hindu, religious tolerance supported a society in

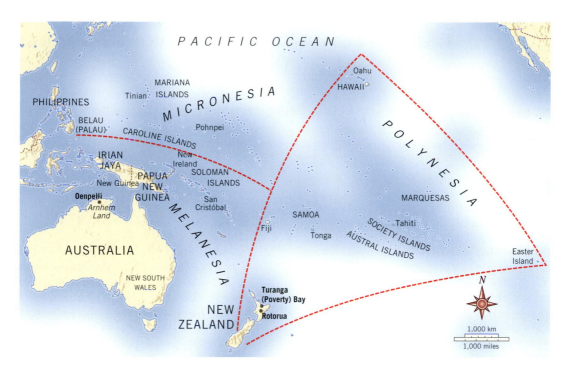

Map 30.1 The islands of the South Pacific.

which Christians, Jews, Hindus, Buddhists, and others were invited to debate with Muslim scholars. Influenced by the presence of the British East India Company, founded in 1599 to promote trade, Indian rulers developed a taste for Western art, although their architecture remained distinctly Muslim in inspiration. Finally, the Native American populations of North America—the "noble savages" that Rousseau so valued as examples of what he called "natural man"—were profoundly affected by contact with European culture in the eighteenth century. Native populations were decimated by disease, especially smallpox. Those who survived faced other challenges. After the Pueblo Revolt of 1680, Spanish authorities became more tolerant of existing native traditions. Many native communities isolated themselves, on mesa tops and in deep canyons, from European settlers. The tribes of the Northeast fared less well. There, French and English armies recruited tribes to help them in their fight with one another as they sought to control the region, and the introduction of firearms into Native American tribes did much to upset the balance of their cultures. By the end of the eighteenth century, the Native American presence in the Northeast had essentially evaporated.

The South Pacific: The Cultures Captain Cook Encountered

The islands of the South Pacific that Cook and others explored in the late eighteenth century consist of three primary groups and the continent of Australia (see Map **30.1**). Melanesia is a long crescent of relatively large islands stretching east from Indonesia and including New Guinea, the largest. Micronesia consists of many smaller islands to the north, most formed from coral reefs growing over submerged volcanoes. Polynesia, meaning "many islands," is a large, triangular area in the central Pacific Ocean defined by New Zealand in the southwest, Easter Island in the southeast, and the Hawaiian Islands in the north.

Polynesia

The people that Bougainville and Cook encountered in Tahiti had arrived in the islands around 200 CE from the vicinity of Tonga and Samoa to the west. Easter Island, the easternmost island in Polynesia, was first inhabited in about 300 CE, probably by Marquesas [mar-KAY-zuz] islanders. The peoples of Hawaii, the northernmost islands of Polynesia, arrived there about 100 years later, probably from the Marquesas also. A second wave of Tahitians populated the Hawaiian Islands between about 900 and 1200 CE. Finally, New Zealand, the western- and southernmost islands of Polynesia, was inhabited by the Maori [MAUR-ee] in about 900 CE. The Maori also may have come from Tahiti. In the course of his three voyages to the South Seas, beginning in 1768 and ending 11 years later, Cook visited all of these islands.

New Zealand: The Maori One of the most distinctive art forms that Cook and his crew encountered in Polynesia was tattooing, a word derived from *tatau* [ta-ta-OO], the Tahitian term for the practice. One of Cook's crew, Sydney Parkinson, a young draftsman on board to record botanical species, captured the tattooed face of a Maori warrior during the first

Voices

James Cook Interprets Tahitian Behavior

James Cook kept a detailed journal during his voyage to the Pacific in 1769 with the naturalist, Joseph Banks. This entry reveals Cook's Western view of native cultural practices (such as the self-mutilation described here) and the way his ideas were passed on to the reading public in Great Britain.

"It is not indeed strange that the sorrows of these artless people should be transient, any more than that their passions should be suddenly and strongly expressed. . . ."

Very early in the morning of the [April] 28th, even before it was day, a great number of them [native Tahitians] came down to the fort, and Terapo being observed among the women on the outside of the gate, Mr. Banks went out and brought her in; he saw that the tears then stood in her eyes, and as soon as she entered they began to flow in great abundance: he enquired earnestly the cause, but instead of answering she took from under her garment a shark's tooth, and struck it six or seven times into her head with great force; a profusion of blood followed, and she talked loud, but in a most melancholy tone, for some minutes, without at all regarding his enquiries, which he repeated with still more impatience and concern, while the other Indians, to his great surprize,[sic] talked and laughed, without taking the least notice of her distress.

But her own behaviour [sic] was still more extraordinary. As soon as the bleeding was over, she looked up with a smile, and began to collect some small pieces of cloth, which during her bleeding she had thrown down to catch the blood; as soon as she had picked them all up, she carried them out of the tent, and threw them into the sea, carefully dispersing

them abroad. . . . She then plunged into the river, and after having washed her whole body, returned to the tents with the same gaiety and cheerfulness as if nothing had happened.

It is not indeed strange that the sorrows of these artless people should be transient, any more than that their passions should be suddenly and strongly expressed: what they feel they have never been taught either to disguise or suppress, and having no habits of thinking which perpetually recal[l] the past, and anticipate the future, they are affected by all the changes of the passing hour, and reflect the colour of the time, however frequently it may vary: they have no project which is to be pursued from day to day, the subject of unremitted anxiety and solicitude, that first rushes into the mind when they awake in the morning, and is last dismissed when they sleep at night. Yet if we admit that they are upon the whole happier than we, we must admit that the child is happier than the man, and that we are losers by the perfection of our nature, the increase of our knowlege, [sic] and the enlargement of our views.

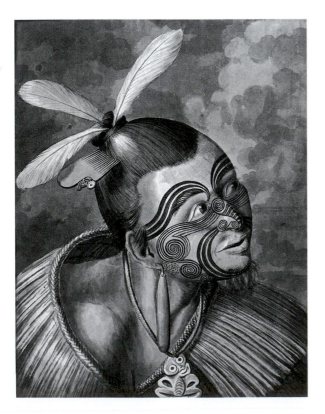

Fig. 30.2 Sydney Parkinson. *Portrait of a Maori.* 1769. Wash drawing, 15 1/2″ × 11 5/8″, later engraved and published as Plate XVI in Parkinson's *Journal*, 1773. The British Library, London. Add. 23920 f.55. Parkinson's drawings provide some of the earliest archeological records of Polynesian life.

voyage (Fig. **30.2**). The Maori had imported the practice from the Polynesian islands to the north.

Tattooing is an aspect of complex sacred and ritual traditions found throughout the Pacific Islands. The islanders believed that individuals, many places, and a great many objects are imbued with **mana** [MAH-nah], a spiritual substance that is the manifestation of the gods on earth. Chiefs, considered descendants of the gods, were supposedly born with considerable quantities of *mana*, nobility with less, and commoners with almost none. Anything or anyone possessing *mana* was protected by *tapu*, a strict state of restriction indicating that an object or person cannot be touched or a place entered. A chief's food might be protected by *tapu*. A person might increase his or her *mana* by skillful or courageous acts, or by wearing certain items of dress, including tattoos. Thus, the warrior depicted by Parkinson possesses considerable *mana*. This derives from the elegance of his tattoo, from his headdress and comb, his long earring, probably made of greenstone (a

form of jade), and his necklace. From it hangs a *hei-tiki*, a stylized carving of a human figure, a legendary hero or ancestor figure whose *mana* the warrior carries with him.

Among the Maori, the most sacred part of the body was the head, and so it was the most appropriate place for a tattoo. All high-ranking Maori were tattooed, including women (although less elaborately). The first tattoos were inscribed during the rituals marking the passage into adulthood.

Tattoos generally consisted of broad, curving parallel lines from nose to chin, spiral forms on the cheeks, and broad parallel lines between the bridge of the nose and the ears following the curve of the brow. Their design mirrors the human form and is meant to celebrate it. The design was almost always bilaterally symmetrical, but each one was so distinctive that, after coming in contact with Western practice, many Maori began signing documents with them. The tattoo artist possessed great skill and thus considerable *mana*, and was also *tapu*, in no small part because the process was extremely painful. Using a bone chisel, the tattoo artist cut deeply into the skin. Pigment made from burnt Kauri gum or burnt vegetable caterpillars was then pushed into the cuts by tapping, the sound of which, "ta-ta," gives the process its name.

More common objects, such as the canoe oars drawn by Parkinson in 1769 (Fig. **30.3**) are also imbued with *mana* by virtue of the elegance of their design. Complex designs usually symbolized cosmic forces, here probably the currents and winds of the sea itself.

Easter Island Cook arrived on Easter Island in 1794, where he discovered monumental heads with torsos known as **moai** [moe-eye], (Fig. **30.4**), the remains of an abandoned civilization. Like the *hei-tiki* figures in Maori culture, the *moai* may well represent ancestors' figures. Around 1000 CE, the Easter Islanders began erecting *moai* on stone platforms, called *ahu*, around the steep hillsides of the island facing the sea or turned away from the sea overlooking villages. They were probably

CULTURAL PARALLELS

The Voyages of Captain Cook on French Wallpaper

Within 20 years of Captain Cook's final voyage, a new and popular art form developed 7,000 miles away. A French businessman teamed up with a painter to design and market large-scale panoramic colored wallpaper depicting the peoples and landscapes of the South Pacific.

designed to protect the island's people, and they possessed great *mana*, but not until inlaid coral and stone eyes were set in place (today, these eyes exist only in a few restorations). The *ahu* average about 190 feet in length and 15 feet in height, and the *moai* range from 6 to about 70 feet in height. *Moai* of between 12 and 20 feet high are common. Carved out of compressed volcanic ash at Rano Raraku, a quarry where 394 *moai* are still visible today, the majority weigh between 18 and 20 tons, the largest as much as 80 or 90 tons.

The *moai* were carved out of large rock outcroppings that were still attached to the hillside as if lying on their backs, face up. Working from the front of the face and around the side to the back, the artists gradually carved out the entire

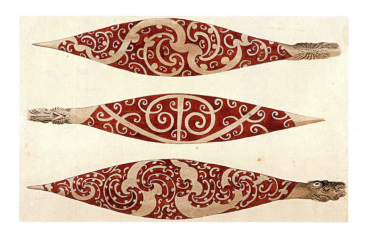

Fig. 30.3 Sydney Parkinson. Detail of *Three paddles from New Zealand.* 1769. From *A Collection of Drawings made in the Countries Visited by Captain Cook in his First Voyage, 1768–1771.* The British Library, London. Add. 23920, f. 71. "Their paddles," Parkinson wrote in his journal, "were curiously stained with a red colour, disposed into various strange figures; and the whole together was no contemptible workmanship."

Fig. 30.4 Thin *maoi* at Rano Raraku, Easter Island. ca. 1000–1600 CE. Rano Raraku is a volcanic crater with a crater lake in its center. Of the 394 *moai* at Rano Raraku, approximately 150 lie unfinished in the quarry.

form until only a narrow spine of stone connected the sculpture to the rock outcrop. Once cut free from the hill, the sculptures were transported around the island on sledges or rollers, and levered into place on the *ahu*.

The quarries in Rano Raraku appear to have been abandoned abruptly, with many incomplete statues still in place. Deforestation was at least partly responsible, since it became increasingly difficult to create the rollers and levers necessary to erect the statues. Some scholars believe that the religious or social system responsible for erecting the *moai* was overthrown by a cult that identified itself with bird imagery and that exercised rituals to ensure the fertility of the land. The deforestation associated with creation of the *maoi* might have been perceived by this new cult as a threat. Whatever the reason, by the nineteenth century, within a few years of Captain Cook's visit to the island in 1774, the standing *maoi* had all been toppled to lie on their faces and sides on the hillsides.

Hawaii On his last voyage in the Pacific, in January 1778, Cook visited the Hawaiian Islands for the first time. It was the middle of the rainy season and the Hawaiians at first treated him with reverence and awe, believing him to be an incarnation of the rain god Lono, father of waters and god of thunder and lightning, which they probably associated with his guns and cannon. From Hawaii, Cook traveled along the western coast of North America, all the way to the Bering Sea, and then returned to Hawaii. At first he was treated with the same respect and honor he had encountered previously, but his overreaction to the Hawaiians' theft of one of his small boats and the demands of his company upon the diminishing food supplies of the natives turned the islanders against him. On February 14, 1779, he was clubbed and stabbed to death in a skirmish on the beach at Kealakekua Bay on the Kona coast of the Island of Hawaii, the so-called Big Island.

Legend has it that among the warriors who attacked Cook was a young Kamehameha I (ca. 1758–1819), the Hawaiian king who first consolidated the islands under one rule. In Hawaiian society, each man worshiped a specific deity related to his work. The king worshiped the war god Kukailimoku ("Ku, Snatcher of Islands"), and Kamehameha was dedicated to him. A well-preserved wood statue of Kukailimoku captures the god's ferocity (Fig. **30.5**). The god's head is disproportionately large because it is the site of his *mana*. His nostrils flare menacingly, and his mouth, surrounded by what may be tattoos or scarification, is ferociously open, perhaps in a war cry, suggesting his *tapu*. Small, stylized pigs, possibly symbols of wealth, decorate his headdress. The statue is meant to convey the ferocity of Kamehameha I himself, the ferocity that was required in bringing all of the islands of Hawaii under his rule, "snatching" them, as Kukailimoku's name suggests.

Melanesia

The largest island in Melanesia, and the second largest island in the world after Australia, is New Guinea, which Cook first visited in 1778. Here he encountered an extremely hostile

Fig. 30.5 *Kukailimoku*, **Hawaii. Probably 1790–1810.** Wood, height 77″. The British Museum, London. Gift of W. Howard. Ethno 1839, 4-26.8. © The Trustees of the British Museum. The figure is probably a vehicle for the god to enter and make himself present in the temple.

and fearless native population. The eastern half of the island is Papua, known for its elaborate displays of ritual objects in ceremonial houses where young farmers are initiated into agricultural cults dedicated especially to growing yams as large as 7 feet long. The Asmat people of Irian Jaya, the western half of the island, were headhunters, and it is likely that it was the Asmat whom Cook first encountered in New Guinea. The Asmat created monumental sculptures in connection with the rituals surrounding the act of headhunting. They believed that in displaying the head of an enemy warrior, they could possess that warrior's strength.

Elaborate *bis* poles (Fig. 30.6), carved in connection with the Asmat funeral rituals, reflect each step in the headhunting process. First a tree is cut (symbolic of the decapitation of the enemy), its bark removed (skinning the victim), and its sap allowed to run like blood. Then artists

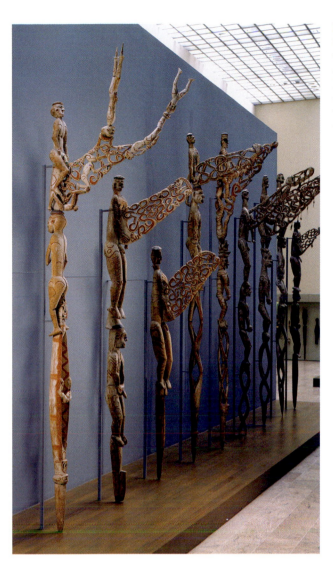

Fig. 30.6 *Bis Poles*. **Bis Pole. Mid-twentieth century. New Guinea, Irian Jaya, Faretsj River, Omadesep village, Asmat people.** Wood, paint, fiber, height 18'. The Michael C. Rockefeller Memorial Collection, Bequest of Nelson A. Rockefeller, 1979 (1979.206.1611). Image copyright © The Metropolitan Museum of Art/Art Resource, NY. After the *bis* ceremonies were concluded, the poles were moved to groves of sago palms, the primary food source of the Asmat. There, the poles were allowed to decay and nourish the palms.

carve various images into the poles. In addition to images of deceased ancestors, there are birds eating fruit, which symbolize the headhunter eating the brains of his victim. Hollows at the base of the poles were meant to hold the heads of enemies. Long, elaborately carved elements project from the groins of the topmost figures, whose bent knees are meant to suggest the praying mantis. (The female praying mantis eats the head of its mate—symbolic to the Asmat of headhunting.) The projections are called *tsjemen* (literally "enlarged penis") and symbolize the virility and strength of the warrior and his ancestors. The ceremonies involving these poles were meant to restore balance to the Asmat village after the death of one or more of their members created an imbalance.

Australia

Captain Cook first sailed along the eastern coast of Australia in 1770, claiming it for the British crown. He and his crew were the first Westerners to encounter the Australian Aboriginal culture. The British established their first permanent settlement there in 1788, in New South Wales, and the colony's first governor, Arthur Philip, reported seeing Aboriginal rock art (Fig. **30.7**), which represents the longest continuously practiced artistic tradition anywhere in the world. In Arnhem Land, in northern Australia, a

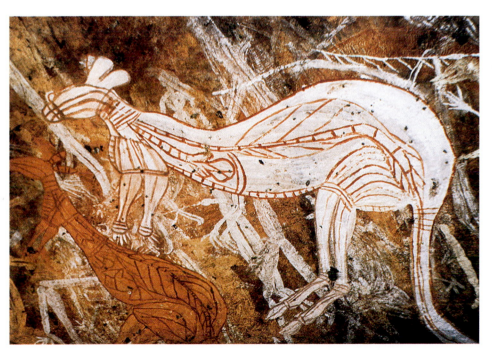

Fig. 30.7 *Mimis* and Kangaroo, rock art, Oenpelli, Arnhem Land, Australia. Older paintings before 7000 BCE; Kangaroo probably post-contact. Of all the pigments used in Aboriginal rock art, white is the most subject to chemical deterioration. This, along with the fact that many layers of art lie beneath it, suggests that the x-ray–style kangaroo was added relatively recently.

great many rock formations and caves are decorated with rock art dating from the earliest periods (40,000–6,000 BCE) to works created within living memory. The earliest works are sticklike figures that represent ancestral spirits, or *mimis*. Some of these are visible behind the kangaroo in Figure 30.7. According to Arnhem legend, *mimis* made the earliest rock paintings and taught the art to present-day Aborigines, who, in painting such figures, release the power of the *mimis*. Aboriginal artists do not believe that they create or invent their subjects; rather, the *mimis* give them their designs, which they then transmit for others to see. The act of painting creates a direct link between the present and the past.

The kangaroo in this prehistoric rock painting is rendered in what has come to be known as the **x-ray style**, where the skeletal structure, heart, and stomach of an animal are painted over its silhouetted form as if the viewer can see the life force of the animal through its skin. Painting of this kind was still prevalent when European settlers arrived in the nineteenth century, and even today bark painters from western Arnhem Land continue to work in the x-ray style. Although two centuries of contact with European culture significantly altered Aboriginal culture, many of their long-standing traditions and rituals survive.

China and Europe: Cross-Cultural Contact

Unlike the cultures of the South Pacific, which were unknown to Europeans until the expeditions of Cook and Bougainville, China and India were well known (see **Map 30.2**). The first Portuguese trading vessels had arrived in China in 1514 (see chapter 23), and by 1715 every major European trading nation had an office in Canton (see Map 32.2). Chinese goods—porcelains, wallpapers, carved ivory fans, boxes, lacquerware, and patterned silks—flooded the European markets, creating a widespread taste for what quickly became known as *chinoiserie* [sheen-WAHZ-ree] (meaning "all things Chinese"). The craze for *chinoiserie* even reached the English garden (see *Focus*, pages 978–979). Blue-on-white porcelain

ware—"china" as it came to be known in the West—was especially desirable (see Fig. 23.12) and before long ceramists at Meissen [MY-sen], near Dresden [DREZ-den], Germany, had learned how to make their own porcelain. This allowed for almost unbounded imitation and sale of Chinese designs on European-manufactured ceramic wares. Even the Rococo court painter François Boucher [boo-SHAY] imitated the blue-on-white Chinese style in oil paint (Fig. **30.8**). The scene is simply a *fête galante* [fet gah-LAHNT] (see chapter 29), in Chinese costume. A balding Chinese man bends to kiss the hand of his lady, who sits with her parasol beneath a statue, not of Venus (as might be appropriate in a European setting), but of Buddha [BOO-duh]. A blue-on-white Chinese vase of the kind Boucher is imitating rests on a small platform behind the lady, and the whole scene is set in a Rococo-like cartouche.

European thinkers were equally impressed by Chinese government. In his *Discourse on Political Economy*, 1755, Jean-Jacques Rousseau praised the Chinese fiscal system, noting that in China "taxes are great and yet better paid than in any other part of the world." That was because, as Rousseau explained, food was not taxed, and only those who could afford to pay for other commodities were taxed. It was, for Rousseau, a question of tax equity: "The necessaries of life, such as rice and corn, are absolutely exempt from taxation, the common people are not oppressed, and the duty falls only on those who are well-to-do." And he believed the Chinese emperor to be an exemplary ruler, resolving disputes between officials and the people according to the dictates of the "general will"—decidedly different from the practices of the French monarchy.

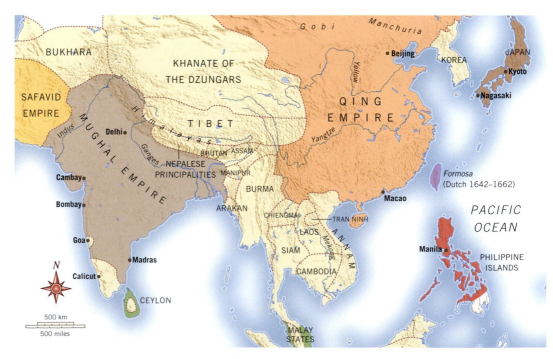

Map 30.2 The Far East. ca. 1600–1799.

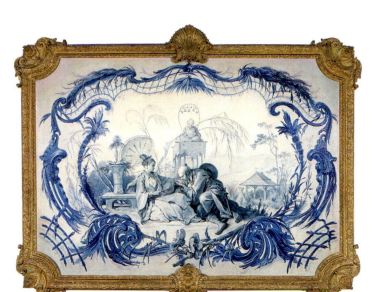

Fig. 30.8 François Boucher. *Le Chinois galant.* **1742.** Oil on canvas, 41″ × 57″. The David Collection, inv.B275. Photo: Pernille Klemp. Boucher also created a suite of tapestries on Chinese themes for the king. The style of both this painting and the tapestries is decidedly rococo, including, here, an elaborate rococo cartouche border.

Likewise, in his 1756 *Essay on the Morals and Customs of Nations,* Voltaire praised the Chinese emperors for using government to protect civilization, creating a social stability unmatched in Europe and built upon Confucian principles of respect and service. He somewhat naively believed that the Chinese ruling class, in cultivating virtue, refined manners, and an elevated lifestyle, set an example that the rest of its people not only followed but revered. In England, Samuel Johnson praised China's civil service examination system as one of the country's highest achievements, far more significant than their invention of the compass, gunpowder, or printing. He wished Western governments might adopt it.

The Arts in the Qing Dynasty (1644–1911)

The China that the West so idealized was ruled by Qing [ching] ("clear" or "pure") Manchus, or Manchurians, who had invaded China from the north, capturing Beijing in 1644. They made Beijing their capital and ruled China continuously until 1911, but they solidified their power especially during the very long reign of the Qianlong emperor (r. 1736–1795). By 1680, the Qing rulers had summoned many Chinese artists and literati to the Beijing court, and under the Qianlong, the imperial collections of art grew to enormous size, acquired as gifts or by confiscating large quantities of earlier art. (Today the col-

lection is divided between the National Palace Museum in Taipei and the Palace Museum in Beijing.) The collection was housed in the Forbidden City (see *Focus,* pages 742–743 in chapter 23), which the Qing emperors largely rebuilt.

While many court artists modeled their work on the earlier masterpieces collected by the emperor, others turned to the study of Western techniques introduced by the Jesuits. The most famous of these Jesuits was Giuseppe Castiglione [kahsteel-YOH-nay] (1688–1766), who had been trained as a painter of religious subjects before being sent to China in 1715. Once there, he virtually abandoned his religious training and worked in the court, where he was known as Lang Shi'ning. He painted imperial portraits, still lifes, horses, dogs, architectural scenes, and even designed French-style gardens on the model of Versailles. A series of prints made for the Qianlong emperor celebrated the suppression of rebellions in the Western provinces (present-day Xingjiang). The print illustrated here, *The Presentation of Uigar Captives,* from the series *Battle Scenes of the Quelling of Rebellions in the Western Regions, with Imperial Poems,* is a fine example of the representation of space through careful scientific perspective, a practice virtually unknown in Chinese painting before 1700 (Fig. **30.9**). It is the kind of work that made Castiglione extremely popular in the Qianlong court, for it combines an Eastern appreciation for the order of the political state with the Western use of perspective.

But it was not at court that Western conventions were most fully expressed. In the port cities such as Yangzhou and Guangzhou, throughout the eighteenth century, Chinese artists created images for export to both the West and Japan. At the same time, Westernized ceramics became very popular with the increasingly wealthy Chinese mercantile class. Local commercial artists decorated ceramic wares with images provided by

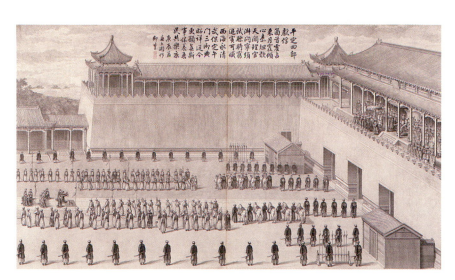

Fig. 30.9 Jean Denis Attiret, *The Presentation of Uigur Captives.* From *Battle Scenes of the Quelling of Rebellions in the Western Regions, with Imperial Poems.* **ca. 1765–1774; poem dated 1760.** Etching, mounted in album form, 16 leaves plus two additional leaves of inscriptions; 20″ x 34¼″. © The Cleveland Museum of Art, John L. Severanc Fund. 1998.103.14. In order to indicate his pride in the Qing military, the Qianlong emperor wrote a poem to accompany each etching.

Focus

Europe's *Chinoiserie* Craze

Although as early as the Renaissance, Chinese silks and blue-and-white porcelains were imitated in Italy and France, the term *chinoiserie* refers to objects in "the Chinese style" either imported from China or made in Europe in the late seventeenth and eighteenth centuries. *Chinoiserie* furniture was especially popular. European furniture makers lacked the ingredients for making true lacquer (see chapter 16), but methods of imitating Oriental lacquer (known as "Japanning") were widespread. European imitations, such as that by the German furniture maker David Roentgen were made of gum resin and shellac, dissolved in spirits. Although usually decorated in Western motifs, the best of Roentgen's work are remarkably like true Oriental lacquer.

An important source for the irregularity of the English garden (see chapter 29) was the Chinese garden. In the 1740s, the influential English landscape architect William Chambers (1723–1796) visited China, and by the 1760s he was including Chinese architectural features in English garden architecture. His most famous design is for the Chinese Pagoda in London's Kew Gardens. Kew, in fact, became the model for a whole new kind of garden architecture that swept France in the last half of the eighteenth century, the *jardin anglo-chinois*, the English-Chinese garden.

Not everyone was enamored of the "Chinese Style," however. In 1756, J. Shebbeare complained that "the simple and sublime have lost all influence almost everywhere, all is Chinese or Gothic. Every chair in an apartment, the frames of glasses and tables must be Chinese: the walls covered with Chinese paper fill'd with figures which resemble nothing in God's creation, and which a prudent nation would prohibit for the sake of pregnant women."

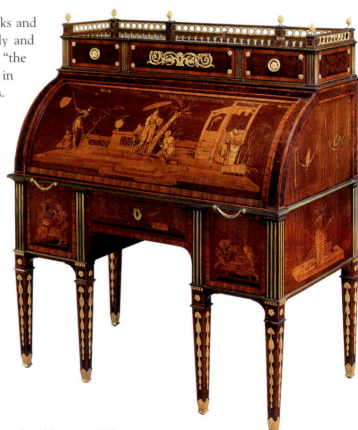

David Roentgen, Maker.
Cylinder-fall Desk with Cabinet Top. ca. 1776–1778.
Made in Neuwied, Germany. Various woods, brass, bronze-gilt, mother-of-pearl; height 53 $\frac{1}{2}$", width 43 $\frac{1}{2}$", depth 26 $\frac{1}{2}$". The Metropolitan Museum of Art, Rogers Fund, 1941 (41.82). Image copyright © The Metropolitan Museum of Art. Roentgen's desk, with its remarkably detailed inlay made of tiny pieces of various exotic woods, depicts, in its main panel, a man kneeling before his lady, but the costumes of Roentgen's characters are an odd amalgam of Chinese and Western fashions.

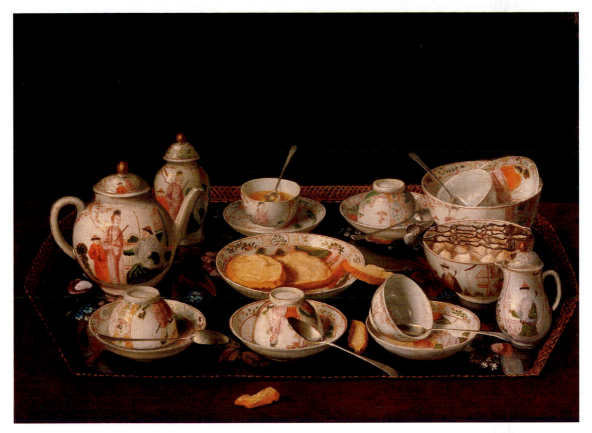

Jean-Étienne Liotard. *Still Life: Tea Set.* **ca. 1781–1783.** Oil on canvas mounted on board, 14$\frac{7}{8}$″ × 20$\frac{5}{16}$″. The J. Paul Getty Museum, Los Angeles, CA. Liotard represents three varieties of chinoiserie objects here. Perhaps the most important is tea, the trade in which was dominated by the Dutch. Across Europe, tea consumption rose from 40,000 pounds in 1699 to an annual average of 240,000 pounds by 1708. Liotard's still life also depicts a Chinese tea service made in China for export to Europe, and a lacquer tray, probably made in Europe in imitation of Chinese lacquerware.

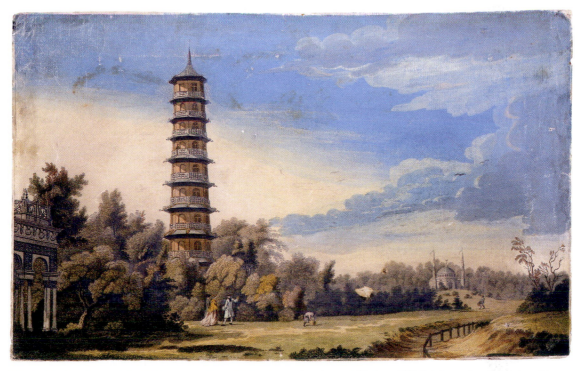

William Marlow. View of the *Wilderness at Kew.* **1763.** Watercolor; sheet: 11$\frac{1}{16}$″ × 17$\frac{17}{16}$″. Metropolitan Museum of Art, New York. The Chinese Pagoda was designed by Sir William Chambers (1726–1796). Chambers visited China in the 1740s, and his work on garden architecture, published in 1762 as *Dissertation on Oriental Gardening*, was widely influential.

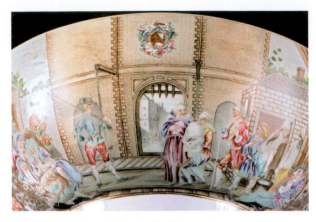

Fig. 30.10 Porcelain punch bowl, painted in overglaze enamels in Guangzhou (Canton) with a copy of William Hogarth's print, *The Gates of Calais*. ca. 1750–1755. Diameter 16″. Board of Trustees of the Victoria and Albert Museum, London (Basil Ionides Bequest), C. 23–1951.

European traders, such as the bowl illustrating Hogarth's print of *The Gates of Calais* [kah-LAY] (Fig. **30.10**). As Western trading companies placed large orders to meet the European demand for ceramics, Chinese artists mastered the art of perspective. Especially popular were aerial views of cities (Fig. **30.11**). Perspectival space appealed to the Chinese audience because it was both novel and exotic. The Western audience, used to perspective, found the views of urban China exotic in themselves.

As much as the Qianlong emperor enjoyed Western artistic conventions, he valued traditional Chinese art more. He commissioned large numbers of works painted in the manner of earlier masters, especially those of the Song [soong] dynasty (see chapter 16). A perfect example is *A Thousand Peaks and Myriad Ravines* (Fig. **30.12**), painted by Wang Hui [wahng hwee] (1632–1717). In typical literati fashion, the artist has added a poem at the top of the painting, by Li Cheng [lee-chung], a Tang [tahng] dynasty master:

> Moss and weeds cover the rocks and mist hovers over the
> water
> The sound of dripping water is heard in front of the temple
> gate.
> Through a thousand peaks and myriad ravines the spring
> flows,
> And brings the flying flowers into the sacred caves.

Below these lines Wang Hui states his artistic sources:

> In the fourth month of the year 1693, in an inn in the capital, I painted this based on a Tang dynasty poem in the manner of the [painters] Dong [Yuan] and Ju[ran].

Both poem and painting display the conventional elements of Chinese painting. Mountains rise over the valley as prominently as the emperor overseeing his people (see *Focus*, chapter 16, pages 504–505). A vast cosmic flow of river and stream, cascading waterfalls, jagged rock, and trees ready to flower dwarf all evidence of human life, including a temple on the right bank in the middle distance and the barely noticeable fishermen, wandering scholars, and priests who fill the scene.

Celebrating Tradition: The Great Jade Carving

The Qianlong emperor had already celebrated the conquest of the far western city of Khotan [koe-THAN] by commissioning a series of etchings from the artist Giuseppe Castiglione (see Fig. 30.9). Not long after, in the late 1770s, he would have reason to celebrate again. Digging not far from Khotan, workers unearthed the largest single boulder of jade ever discovered. It was 7 feet 4 inches high, over 3 feet in diameter, and it weighed nearly 6 tons. It took three years to bring the stone to Beijing, transported on a huge wagon drawn by 100 horses, and a retinue of 1,000 men to construct the necessary roads and bridges.

The Qianlong emperor immediately understood the stone's value—not just as an enormous piece of jade, but as a natural

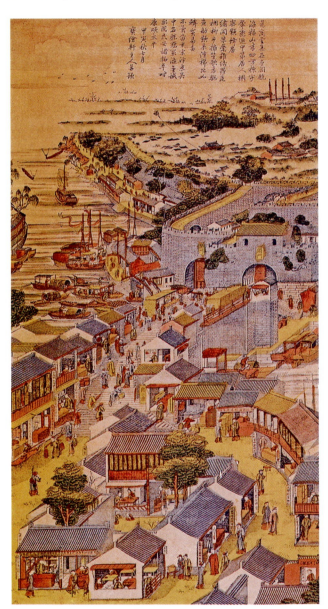

Fig. 30.11 Anonymous. *View of Suzhou Showing the Gate of Changmen*. 1734. Color print from woodblock, 42 3/4″ × 22″. Ohsha'joh Museum of Art, Hiroshima, Japan. Suzhou was a center of printmaking and luxury manufactured goods and was a popular tourist destination. Notice the three-masted Western ship in the harbor.

wonder of potentially limitless propagandistic value. He himself picked the subject to be carved on the stone: it would be based on an anonymous Song painting in his collection depicting the mythical emperor Yu [yoo] the Great (2205–2197 BCE) taming a flood. In this way, it would connect the Qianlong emperor to one of the oldest emperors in Chinese history and, implicitly, establish the continuity of the Qing dynasty with all that had preceded it.

The Qianlong court kept meticulous records of the jade's carving. Workers first made a full-size wax model of the stone. Then artists in the imperial household carved it to resemble what was to be the finished work. The emperor personally viewed and approved the carved model. Then, because he felt that Beijing jade-carvers were not as accomplished as those in

Yangzhou [yahng-joe], the center of luxury goods manufacturing, he decided to ship the model south. But fearing that the excessive heat of Yangzhou's southern climate would melt the wax model, he ordered another model to be made in wood. A team of Yangzhou craftsmen carved the stone in 7 years, 8 months—a total of 150,000 working days!

Meanwhile, the wooden model was shipped back to Beijing, where the emperor tried it out in various locations around the palace. When the actual jade returned in 1787, he placed it in the spot in the palace where it still stands today (Fig. **30.13**). On the base of the stone a carved inscription eulogized both Yu the Great and the great stone itself, and linked them to the magnificence of the Qianlong emperor himself.

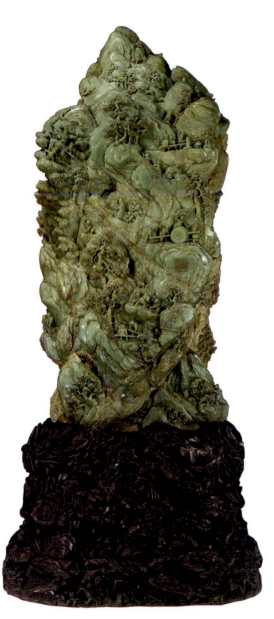

Fig. 30.12 Wang Hui. *A Thousand Peaks and Myriad Ravines*. Qing dynasty. 1693. Hanging scroll, ink on paper, 8′ 2$\frac{1}{2}$″ × 3′ 4$\frac{1}{2}$″. National Palace Museum, Taipei, Taiwan. Wang Hui was known, even in his own day, for his ability to synthesize the techniques of the old masters.

Fig. 30.13 *Yu the Great Taming the Waters*. Qing dynasty, completed 1787. Jade carving, 7′ 4$\frac{1}{4}$″ × 3′ 1$\frac{3}{4}$″. Collection of The Palace Museum, Beijing. The black area at the sculpture's base, full of swirling waves, represents the waters that Yu the Great is in the process of taming. The implication is that as the water recedes, the green plenty of the earth (represented by the green jade) will be restored.

The story of Yu the Great first appears in *The Book of History*, a collection edited by Confucius in the fourth century BCE (see chapter 4). When the farmlands of the Yellow River valley were inundated by a great flood, the emperor Shun ordered Yu to devise some means of controlling it. With the help of all the princes who ruled in the valley, Yu organized an army of people who, over the course of 13 years, cut channels in the land to drain the flood waters into the sea. *Yu the Great Taming the Waters* is not, in other words, the representation of a miracle, but a celebration of hard work, organizational skill, and dedicated service to one's ruler—traditional Confucian [kun-FYOO-shun] values. It is hard to say just which of the many humans carved onto the surface of the stone is Yu, because all are equally at work, digging, building, and pumping the waters of the Yellow River to the sea. Formally, in the way that a set of flowing curves seem to hold the strong diagonals of the jade and broad sweeps of stone balance its intimate detail, the sculpture also suggests the overall unity of purpose that characterizes the ideal Chinese state.

India and Europe: Cross-Cultural Connections

The synthesis of indigenous art traditions with Western conventions so evident in eighteenth-century Chinese art is also apparent in the art of India during the same period. In fact, in India, the synthesis is even more complex. The reason has much to do with the tolerance practiced by India's leaders in the seventeenth and eighteenth centuries.

Islamic India: The Taste for Western Art

India's leaders in the seventeenth and eighteenth centuries were Muslim. Islamic groups had moved into India through the northern passes of the Hindu Kush by 1000 and had established a foothold for themselves in Delhi by 1200 (see Map 30.2). In the early sixteenth century a group of Turko-Mongol Sunni Muslims known as Moguls (a variation on the word *Mongol*) established a strong empire in northern India, with capitals at Agra and Delhi, although the Hindus temporarily expelled them from India between 1540 and 1555.

Their exile, in Tabriz, Persia, proved critical. Shah Tamasp Safavi [SAH-fah-vee] (r. 1524–1576), a great patron of the arts who especially supported miniature painting, received them into his court. The Moguls reconquered India with the aid of the shah in 1556. The young new Mogul ruler, Akbar [AK-bar] (r. 1556–1605), was just 14 years of age when he took the throne, but he had been raised in Tabriz and he valued its arts. He soon established a school of painting in India, open to both Hindu and Islamic artists, taught by Persian masters brought from Tabriz. He also urged his artists to study the Western paintings and prints that Portuguese traders began to bring into the country in the 1570s. By the end of Akbar's reign, a state studio of more than 1,000 artists had created a library of over 24,000 illuminated manuscripts.

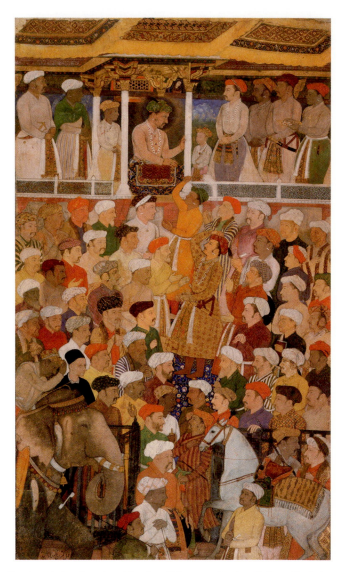

Fig. 30.14 Attributed to: Manohar, *Jahangir in Darbar,* **Indian. Mughal period. About 1620. Northern India.** Opaque watercolor and gold on paper, $13\frac{3}{4}'' \times 7\frac{7}{8}''$. Francis Bartlett Donation of 1912 and Picture Fund 14.654. Courtesy, Museum of Fine Arts. Nothing underscores the Mogul lack of interest in Western perspective more than the way in which the figure in the middle of the street seems to stand on the head of the figure below him.

Akbar ruled over a court of thousands of bureaucrats, courtiers, servants, wives, and concubines. Fully aware that the population was largely Hindu, Akbar practiced an official policy of religious toleration. He believed that a synthesis of the world's faiths would surpass the teachings of any one of them. Thus he invited Christians, Jews, Hindus, Buddhists, and others to his court to debate with Muslim scholars. Despite taxing the peasantry heavily to support the luxurious lifestyle that he enjoyed, he also instituted a number of reforms, particularly banning the practice of immolating surviving wives on the funeral pyres of their husbands.

ing left and right toward a central axis, makes a sharp contrast to the variety of faces with different racial and ethnic features that fills the scene.

The force behind this growing interest in portraiture was the British East India Company, founded by a group of enterprising and influential London businessmen in 1599. King James I awarded the Company exclusive trading rights in the East Indies. A few years later, James sent a representative to Jahangir to arrange a commercial treaty that would give the East India company exclusive rights to reside and build factories in India. In return, the company offered to provide the emperor with goods and rarities for his palace from the European market.

Jahangir's interest in all things English is visible in a miniature, *Jahangir Seated on an Allegorical Throne*, by an artist named Bichitr (Fig. **30.15**). The miniaturist depicts Jahangir on an hourglass throne, a reference to the brevity of life. The shah hands a book to a sufi teacher, evidently preferring the mystic's company to that of the two kings who stand below, an Ottoman [OT-tuh-mun] Turkish ruler who had been conquered by Jahangir's ancient ancestor Tamerlane and, interestingly, King James I of England. The English monarch's pose is a three-quarter view, typical of Western portraiture but in clear contrast to the preferred profile pose of the Mogul court, which Jahangir assumes. The figure holding a picture at the bottom left-hand corner of the composition may be the artist Bichitr himself. Two Western-style putti [POO-tee] (cherubs) fly across the top of the composition: The one at the left is a Cupid figure, about to shoot an arrow, suggesting the importance of worldly love. The one at the right apparently laments the impermanence of worldly power (as the inscription above reads). At the bottom of the hourglass, two Western-style angels inscribe the base of the throne with the prayer, "Oh Shah, may the span of your life be a thousand years." The throne itself is depicted in terms of scientific perspective, but the carpet it rests upon is not. Framing the entire image is a border of Western-style flowers, which stand in marked contrast to the Turkish design of the interior frame. All told, the image is a remarkable blend of stylistic and cultural traditions, bridging the gap between East and West in a single page.

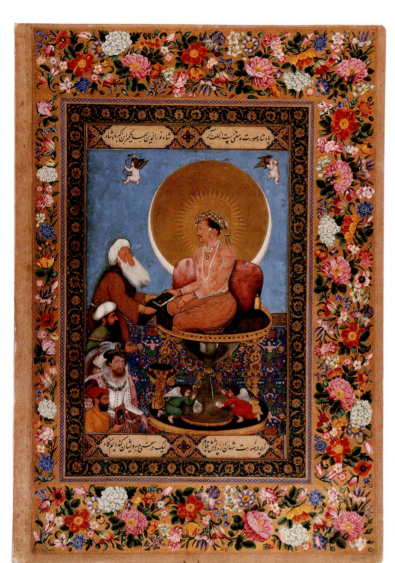

Fig. 30.15 Bichitr. *Jahangir Seated on an Allegorical Throne,* from the *Leningrad Album of Bichitr.* **ca. 1625.** Opaque watercolor, gold, and ink on paper, 10″ × 7⅛″. Freer Gallery of Art, Smithsonian Institution, Washington, DC (42.15V). Behind the shah is a giant halo or nimbus consisting of the sun and a crescent moon. It recalls those behind earlier images of Buddha.

Under the rule of Akbar's son, Jahangir [juh-HAHN-geer] (r. 1605–1627), the English taste for portraiture (see chapter 24) found favor in India. The painting *Jahangir in Darbar* is a good example (Fig. **30.14**). It shows Jahangir, whose name means "World Seizer," seated between the two pillars at the top of the painting, holding an audience, or *darbar,* at court. His son, the future emperor Shah Jahan [shah juh-HAHN], stands just behind him. The figures in the street are a medley of portraits, composed in all likelihood from albums of portraits kept by court artists. Among them is a Jesuit priest from Europe dressed in his black robes (although nothing in the painting shows a familiarity with Western scientific perspective). The stiff formality of the figures, depicted in profile fac-

Mogul Architecture: The Taj Mahal

Addicted to wine laced with opium, Shah Jahangir died in 1628, not long after the completion of the miniature wishing him a life of a thousand years. While his son Shah Jahan (r. 1628–1658) did not encourage painting to the degree his father and grandfather had, he was a great patron of architecture. His most important contribution to Indian architecture—and arguably one of the most beautiful buildings in the world—is the Taj Mahal [tazh muh-HAHL] ("Crown of the Palace"), constructed as a mausoleum for Jahan's favorite wife, Mumtaz-i-Mahal (the name means "Light of the Palace"), who died giving birth to the couple's fourteenth child (Fig. **30.16**).

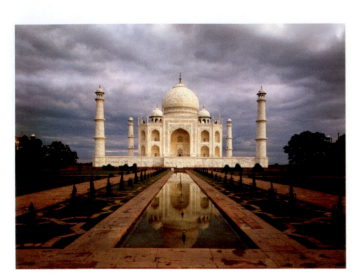

Fig. 30.16 Taj Mahal, Agra, India. Mogul period. ca. 1632–1648. Originally Shah Jahan planned to build his own tomb across the river, a matching structure in black marble, connected to the Taj Mahal by a bridge. The Shah's tomb was never built, and he is buried, with his beloved wife, in a crypt in the mausoleum's central chamber.

Sited on the banks of the Jumna [JUM-nuh] River at Agra in northern India, the Taj Mahal is surrounded by gardens meant to evoke a vision of paradise as imagined in the Koran (compare the mural in the Mosque of Damascus, chapter 11). Measuring 1,000 by 1,900 feet, the garden is interspersed with broad pathways, reflecting pools, and fountains that were originally lined by fruit trees and cypresses, symbols, respectively, of life and death. To the west of the building, in the corner of the property, is a red sandstone mosque, used for worship. Rising above the garden, and reflected in its pools, is the delicate yet monumental mausoleum of Taj Mahal itself.

The white marble tomb is set on a broad marble platform with minarets at each corner, their three main sections corresponding to the three levels of the mausoleum proper, thus uniting them with the main structure. At the top of these minarets are *chattri* [CHAT-tree], or small pavilions that are traditional embellishments of Indian palaces, from which muezzins can call the faithful to worship at the property's mosque. The main structure, the Taj Mahal proper, is basically square, although each corner is sliced off in order to create a subtle octagon. Each facade is identical: a central *iwan* (a traditional Islamic architectural feature consisting of a vaulted opening with an arched portal), flanked by two stories of smaller *iwans*. These voids in the facade contribute to the sense of weightlessness the building seems to possess. Four octagonal *chattris* positioned at each corner of the roof provide a transition to the central onion dome, which rises on its drum in a graceful swelling curve. The facades are inlaid with inscriptions and arabesques of semi-precious stones—carnelian, agate, coral, turquoise, garnet, lapis, and jasper—but so delicately and lacelike that they emphasize the whiteness of the whole rather than call attention to themselves.

Inside the Taj Mahal, the sequence of rooms is set out according to the favorite pattern of the Mogul period: an interpenetrating square and cross. There are eight small rooms on each of the two stories: one in each corner and one behind each *iwan*. The largest chamber is the octagonal central area, which rises two stories to a domed ceiling beneath the outer dome (Fig. **30.17**). An intricately carved openwork marble screen surrounds this central area.

With the Taj Mahal, Shah Jahan brought the Mogul style of architecture to its peak of beauty and splendor. Yet, in its placement among expanses of water and gardens, the Taj Mahal is similar to other buildings of the time, such as the Red Fort, the nickname for the palace which was constructed by Shah Jahan across the Jumna River from the Taj Mahal in Delhi. He fully intended it to be the most magnificent palace on the face of the earth. At its center, surrounded by gardens, pavilions, and baths, was the Peacock Throne Room (Fig. **30.18**). There, the Shah sat upon an enormous solid gold throne (subsequently destroyed and looted by Persian warriors in 1732), set upon a 6-by 4-foot platform. The platform throne itself supported 12 pillars covered with emeralds, over which was an enameled canopy inlaid with diamonds, emeralds, rubies, and garnets. It was flanked on each side by jeweled peacocks. The marble walls of the room were themselves inlaid with precious and semiprecious stones in a mosaic technique the Moguls had learned from the Italians, called *pietra dura* (Italian for "hard stone"), also employed at the Taj Mahal. Around the ceiling of the room, the Shah had these words inscribed: "If there is a paradise on the face of the earth, It is this, oh! it is this, oh! it is this." Such architectural splendor served one purpose—to glorify the worldly power of the ruler.

In 1658, Shah Jahan became very ill, and his four sons battled each other for power. The conservative, Aurangzeb (r. 1658–1707), eventually triumphed and confined his father to the Red Fort. Aurangzeb reinstituted traditional forms of Islamic law and worship, ending the pluralism that had defined the Mogul court under his father and grandfather even as he began to reinstate traditional Muslim prohibitions against figural art. But from his rooms in the Red Fort, the Shah could look out over the Jumna River to the Taj Mahal and recreate in poetry the paradise where he believed he would come to rest with his wife (**Reading 30.1**):

READING 30.1 **Shah Jahan, inscription on the Taj Mahal, ca. 1658**

Like a garden of heaven a brilliant spot,
Full of fragrance like paradise fraught with ambergris.
In the breadth of its court perfumes from the nose-gay of
 sweet-hearts rise.

Fig. 30.17 Plan of the Taj Mahal, Agra. ca. 1632–1648.

CULTURAL PARALLELS

Two Islamic Rulers

As Akbar began his rule in Mogul India in the mid-sixteenth century, almost 3,000 miles to the east, another great Muslim ruler was concluding his nearly five-decade reign. Suleiman the Magnificent led the Ottoman Empire to its high point, militarily, politically, and culturally. The Ottoman sultan personally led armies and annexed great swaths of territory in Europe and North Africa, while also running an efficient bureaucracy, lavishly supporting artists and scholars, and building spectacular mosques and government buildings.

Fig. 30.18 **The Peacock Throne Room, Red Fort (Shahjahanabad), Delhi. Mogul period, after 1638.** The design of the Peacock Throne itself has been attributed to one Austin de Bordeaux, whom the French physician François Bernier (1625–1688) described, in his *Travels in the Mogul Empire* (1670), as "a Frenchman by birth, who after defrauding several of the Princes of Europe, by means of false gems, which he fabricated with peculiar skill, sought refuge in the great Mogul's court, where he made his fortune."

Shah Jahan's tomb is, in fact, next to his wife's in the crypt below the central chamber of the Taj Mahal. Above both tombs are their marble cenotaphs, beautifully inlaid in *pietra dura* by the artisans of Northern India.

Native American Traditions

The Native American cultures north of Mexico that made significant contact with Europeans before the nineteenth century were affected by their encounter in a number of ways. From the idealized perspective of the *philosophes*, these Native American peoples were almost perfect examples of what Rousseau had labeled "noble savages," who although untutored in the social customs and intellectual traditions of the Europeans were, by nature, morally admirable (see chapter 29). The noble savage, it was believed, lived in harmony with nature, was selfless, generous, and courageous, and was incapable of fabrication. Because they were uncorrupted by civilization, they were innately good. In fact, it became evident to many that what was believed to be their inherent nobility was undermined and destroyed in direct proportion to their acquaintance with European colonists. From the point of view of the *philosophes*, this was almost inevitable. As Rousseau himself put it in *Emile*, "Everything is good in leaving the hands of the Creator of Things; everything degenerates in the hands of man."

The fate of the Native Americans seemed to prove the point. Especially in the English colonies along the Eastern seaboard, Native American populations were decimated by diseases—smallpox and measles being the two that most severely attacked native immune systems possessing no natural antibodies to the diseases. Entire cultures were wiped out in a matter of only a few years. The cultures of what is today the American Southwest, where Spanish missionaries had arrived in the early seventeenth century, were also devastated. Before the arrival of the Spanish, the Pueblo populations that lived in northern Arizona and along the Rio Grande River, in modern-day Texas and New Mexico, numbered over 75,000 people. By the beginning of the nineteenth century, warfare, smallpox epidemics, and drought had reduced their number to just over 10,000. As we saw in chapter 27, after the Pueblo Revolt of 1680, Spanish authorities became more tolerant of existing native traditions and many native communities settled on mesa tops and in deep canyons, isolating themselves from European settlers. Whereas many local craft traditions in the Northeast simply disappeared along with the peoples who had practiced them, in the Southwest, art and craft traditions survived and even thrived. Even today, local populations still practice their arts in the manner they did before contact.

The Pueblo Cultures of New Spain

For the Zuni [ZOO-nee], the Navajo [NAH-vuh-hoe], the Hopi [HOPE-ee], and other Pueblo peoples of the South-west, the village is not just the center of culture, but the very center of the world. And at the center of the village is the *kiva*, the semi-subterranean ceremonial enclosure that dates back to Anasazi times (see chapter 1), with its *sipapu* [see-paw-pool], a hole in the floor that symbolizes the emergence of the people from the underworld. Here Pueblo cultures conducted ceremonies celebrating female sexuality and fecundity, male military prowess and hunting, and the rains that made crops possible. Healing and curing rituals also occurred in the kiva.

The villages themselves are complexes of multi-room, multi-story apartment units, sometimes located in fortified positions atop mesas, as at Acoma [AHK-uh-muh] and the Hopi villages, but more usually on the valley floor, such as at Taos Pueblo (Fig. **30.19**). The main parts of the present buildings at Taos were most likely constructed between 1000 and 1450, and look today much as they did when Spanish explorers and missionaries first arrived. The Pueblo is divided into two house blocks, which rise on either side of a vast dance plaza bisected by a stream. The Pueblo's walls, which are several feet thick, are made of *adobe*, a mixture of earth, water, and straw formed into sun-dried bricks. The roofs are supported by large wooden beams called *vigas* which are topped by smaller pieces of wood, and the whole roof is then covered with packed dirt. Each of the five stories is set back from the one below, thus forming terraces which serve as viewing areas for ceremonial activities in the dance plaza below. Since colonial times, the people of Taos Pueblo have been practicing Catholics—missionaries built a church at the Pueblo as early as 1619 and sometimes forcibly insisted on their conversion. But they have also maintained the active practice of their ancient religious rites and ceremonies, which do not conflict, in their view, with their Catholicism, and they possess a detailed oral history. They have chosen to share neither their history nor their traditional religious practices with outsiders.

Weaving and Basketry

We can learn most about the traditions of the Pueblo peoples through their arts. Among the Navajo, weaving, basketry, and pottery are practiced today very much as they were in pre-colonial times. Anthropologists believe that the Navajo, or Dine'é [din-ER], meaning "the People," migrated south from North-eastern Canada and Alaska about 1000 CE. They are not Pueblos, but they learned to weave with domestic cotton and native grasses from their Pueblo neighbors. They took up weaving with wool sometime in the middle of the sixteenth century, after the introduction of sheep into the Americas by the Spanish, and by as early as 1706 they had their own flocks.

For the Navajo, weaving is a sacred activity that stretches back to creation itself when the universe was woven on an enormous loom by their mythic female ancestor, Spider Woman. In turn, Spider Woman taught Changing Woman,

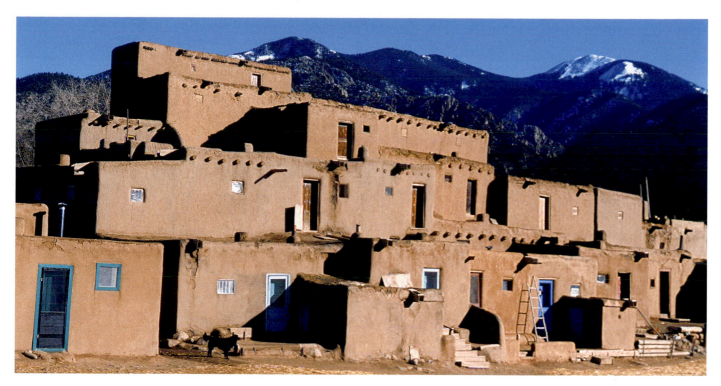

Fig. 30.19 Multi-story apartment block, Taos Pueblo, New Mexico. Originally built 1000–1450. Smithsonian American Art Museum, Washington, DC. Though other pueblos vie for the honor—most notably Acoma Pueblo in Arizona and the Hopi village of Oraibi—Taos Pueblo may well be the oldest continuously inhabited structure in the Western Hemisphere.

whose very name underscores the importance of transformation to Navajo culture, the art of weaving. When First Man and First Woman first discovered Changing Woman on the top of a sacred mountain, she was clothed in materials of the

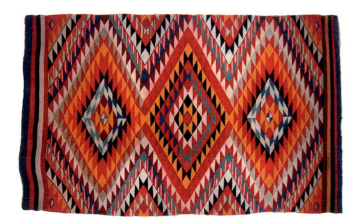

Fig. 30.20 *Germantown Eye–Dazzler Blanket*. Navajo. 1875–1890. Wool yarn, cotton string, 63″ × 40″. Lowe Art Museum, University of Miami, FL. Traders felt the "eye-dazzler" style was too garish to sell, but it was extremely popular among the Navajo themselves.

cosmos that Spider Woman had woven for her—clouds laced together with lightning, rainbows, and sunbeams. She is, thus, the embodiment of the natural world, renewing herself each spring in a garment of grasses and vegetation. When the Navajo weaver works, she imitates Changing Woman, transforming plants (wood used to construct the loom and vegetal dyes), animals (sheep wool), and human skill into the finished rug or *sarape* [suh-RAH-pay], or poncho.

When, after years of war, the Navajo people were defeated by the United States in 1863, they were force-marched on what became known as "the Long Walk" to Bosque Redondo on the Pecos River in eastern New Mexico. There they remained until 1868. Their herds of sheep were destroyed, and they were forced to buy factory-made wools, principally from commercial mills in Germantown, Pennsylvania, which were especially popular because of the brilliant colors. Germantown yarns were more uniform in diameter than the handspun Navajo yarns, and as a result weavers were able to create complex arrangements of small zigzag patterns. Known as "eye-dazzlers" (Fig. **30.20**) for the bright colors of their densely woven patterns, these blankets became the first widely collected Native American artifacts in the Southwest.

The Navajo and Pueblo facility with weaving probably originated in the grass-weaving techniques used for centuries by their forebears. The art of basketry is, of course, a fiber-weaving art, practiced throughout the Southwest but particularly honored among the Apache peoples of Arizona, where the native materials of the desert environment—willow, cottonroot, black devil's claw, and red yucca root—are used to create elaborate designs of mazes, animals, stars, and interlocking geometric forms.

Because natural grasses and fibers are so susceptible to decay, early examples are rare, but thousands of baskets from the nineteenth and early twentieth centuries survive (Fig. 30.21). During that time, basket collecting became a literal craze among white collectors, even spawning a quarterly journal in the early 1900s called *The Basket: The Journal of the Basket Fraternity or Lovers of Indian Baskets and Other Good Things*. In fact, as we will see in Book 6, the rebirth of pottery arts in the Southwest and the rejuvenation of Northwest Coast arts have both contributed to the survival of Indian arts (and, to a certain extent, the Indian traditions embodied in their art). The economic benefits resulting from commercial sales of artwork have stimulated the Native Americans' own desire to preserve the cultural integrity and traditions of their people.

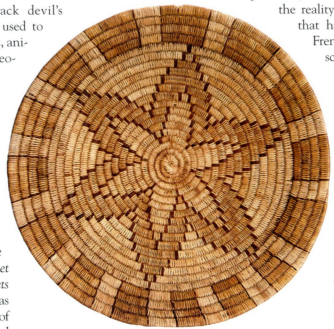

Fig. 30.21 Mescalero Apache Coiled Basket, early 20th century. Arizona State Museum, University of Arizona, Tucson. The image on the basket is a star suggesting that the basket was intended to hold the bounty of the cosmos—especially food.

The Northeast Woodlands Tribes

The indigenous peoples of the Northeast Woodlands did not fare as well as those in the Southwest in keeping their traditions alive. Painted nearly 100 years after the event, Benjamin West's depiction of William Penn's purchase of the Province of Pennsylvania from the Lenni Lenape [LEN-nee luh-NAHP-ee] or Delaware tribe, under an elm tree at Shackamaxon (Fig. 30.22) captures, unintentionally no doubt, the great gap between Native American and colonist sensibilities in the seventeenth and eighteenth centuries. In the first place, even as Penn buys the land from its Indian holders, the colony is already well established. Ships fill the harbor, large houses are being built in the background, and light shines upon the enterprise. To the right, the Lenni Lanape seem to emerge out of the dark canopy of the as yet uncolonized forest. West dresses them in a combination of clothing, some of it of Lenni Lenape origin, but much of it Iroquois, and all of it borrowed from the Philadelphia collections of the Penn family and others.

In fact, West had no actual Native Americans to serve as models, and his figures are idealized "noble savages," their bodies modeled after classical nudes, and their innocence established by the presence of children. West meant the painting to be an image of peace and its possibility, a celebration of Penn's pacifist Quaker convictions. The painting ignores the reality of warring colonists and Indians that had marked the previous decade's French and Indian War. And recent scholarship suggests that the painting may have been commissioned to reassert the Penn family's proprietorship of the colony of Pennsylvania. But it is clear that whatever West's intentions, by 1770, the Native Americans who once held the land were, at best, a distant memory, victims of the colonization that the painting embodies.

Penn believed wholeheartedly that peace with the Indians was preferable to hostility and that, though he had been granted a deed to the land by the English king, it was rightly owned by the Lenni Lenape. Thus, purchasing it from them was the morally right thing to do. But it is unclear whether, in 1682, the Lenni Lenape would have understood that Penn was buying their land from them by presenting them, as depicted here, with bolts of cloth and other material goods. Gift-giving was a deeply embedded custom in the culture of the Native American tribes in the Northeast, used primarily to resolve conflicts between individuals and whole tribes. Thus the Native Americans may have believed that Penn was making a peace treaty with them. Gift-giving was also a major obligation to the dead. Each year, at the Feast of the Dead, those who had recently died were disinterred, then reburied in a common grave with hundreds of gifts, including pipes, combs, carved images of animals, shells, beads, and pottery. Evidence suggests that early gifts from Europeans—mirrors, glass beads, and silver—were understood by Indians to share, or at least symbolically to represent, the same life-giving and healing properties that, since Mississippian and Hopewell times (see chapter 1), had been associated with the crystals, copper, mica, and shell traded widely throughout the eastern regions of North America. So, although Penn's motivations were material and, arguably, moral, the Indians' were probably more spiritual, as they acquired gifts that they might pass on to the dead. Indeed, this would explain the large quantities of European glass beads found at Native American grave sites.

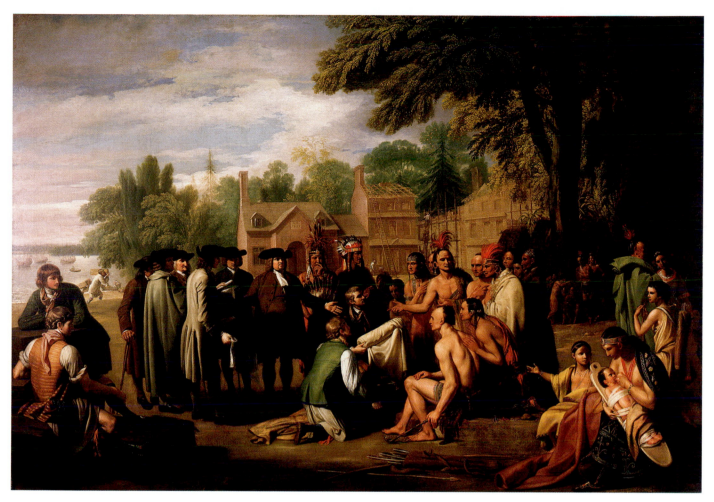

Fig. 30.22 Benjamin West. *Penn's Treaty with the Indians.* 1771–1772. Oil on canvas, 75½" × 107¾". Acc. No.: 1878.1.10. Courtesy of the Pennsylvania Academy of the Fine Arts. Gift of Mrs. Sarah Harrison (The Joseph Harrison Jr. Collection). The idealized Native Americans in this painting wear a combination of Lenni Lenape, Iroquois, and Algonquian clothes that West saw in private collections of the Penn family and Matthew Clarkson of Philadelphia.

The Iroquois Confederacy As it turned out, the Lenni Lenape were not empowered to sell their land to Penn. They could not do so without the permission of the Iroquois Confederacy, who by 1718, the year of Penn's death, had complete control of Lenni Lenape affairs.

The Iroquois Confederacy was a league of tribes who occupied the southern and eastern portions of what is now southeastern Ontario and northern New York State, but who exercised considerable influence over the entire Northeast, including Lenni Lenape lands, from the fifteenth to the end of the eighteenth centuries. The confederacy consisted of five tribes, or nations—the Seneca [SEN-uh-kuh], Cayuga [kay-YOO-guh], Onondaga [on-un-DA-guh], Oneida [oh-NYE-duh], and Mohawk [moe-HAWK]. The Iroquois thought of their confederacy as a giant longhouse, with the Seneca as "Keepers of the Western Door" and the Mohawks as "Keepers of the Eastern Door." The Onondaga, in the middle, were "Keepers of the Council Fire" (see Map **30.3**). The Cayuga were the "Keepers of the Pipe," and the Oneida, "Keepers of the Great Stone," a sacred granite boulder.

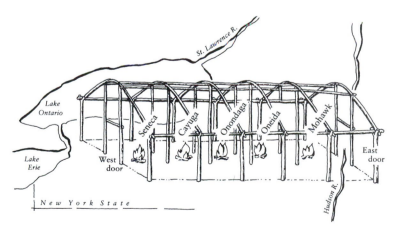

Map 30.3 Map of the Iroquois Confederacy as a longhouse. Diagram after P. Nabokov and R. Easton, *Native American Architecture* (Oxford, 1989), p. 85. A sixth tribe, the Tuscarora, moved north from the Carolinas in the early 1700s and joined the confederacy.

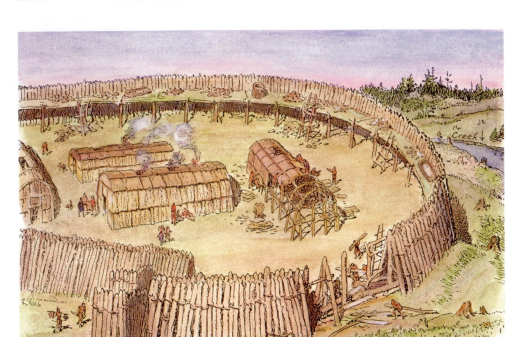

Fig. 30.23 Iroquois Village, ca. 1500.
The Granger Collection, New York. This is an artist's reconstruction of part of a Huron Iroquois palisaded village as it might have appeared around 1500.

All of the Iroquois traditionally lived in villages of long-houses made of poles sheathed in sheets of elm (Fig. **30.23**). Anywhere from 40 to 400 feet long and 20 to 30 feet wide, each longhouse was home to a number of families of the same lineage. Their culture was matriarchal. After marrying, a husband and wife lived in the longhouse of the wife and her family; their children were thus born into the mother's clan. Likewise, in their religion, the Iroquois dedicated themselves to "mother earth," and the entire confederacy was distinguished by a spirit of cooperation and mutual inter-dependence. But the Iroquois were also noted as fierce war-riors, and by the middle of the seventeenth century, the British had aligned themselves with them in opposition to the French, who in turn aligned themselves with the Huron, Erie, Tobacco, and Neutral confederacy to the west in Ontario. The firearms provided by the French and English to the men of the Native American tribes spurred animosity among the tribes and did much to upset the balance of Iroquois matriar-chal culture, since men with weapons now demanded a more central place in the culture, both contributing to the growing sense of cultural dissolution among the tribes.

The Vanishing Culture By the middle of the eighteenth century, these two confederacies had been drawn, first, into the war between Britain and France that resulted in the British victory over the French at Quebec in 1759, and then into the American Revolutionary War. Their sovereignty over their native lands was continually challenged. In 1773 and 1774, for instance, the British Royal Governor of Vir-ginia, Lord Dunmore, ordered troops into the Ohio River

Valley where settlers were increasingly coming under attack by Shawnee tribes, who, by treaty, had hunting rights in the region. The Shawnee were themselves fiercely anti-Iroquois, and deeply resented the fact the the Iroquois had deeded the land south of the Ohio River to the British in a treaty of 1768. But when troops attacked and killed the family of an Iroquois chief known as Logan, all the tribes in the region were drawn into the hostilities. When the Shawnee and Iro-quois were defeated by Dunmore's militia in the fall of 1774, Logan and the Iroquois refused to sign a treaty, and Logan's speech, delivered to Lord Dunmore, remains one of the most moving reminders of the demise of the Native American peoples (see **Reading 30.2,** page 992).

When hostilities between Europeans and Americans finally ended after the War of 1812, the strategic alliances with the tribes that had once seemed so necessary no longer seemed practicable or desirable. Neither did the recognition of the tribes' sovereignty that had come with those alliances. In 1793, construction began on a series of canals through the heart of the Iroquois Confederacy that would eventually lead to the construction of the Erie Canal in 1817–1825, opening not only New York State but the entire Great Lakes region to settlement and trade. When, a year after the Erie Canal opened, Thomas Cole included a lone Indian standing on the cliffs in his *Kaaterskill* [KAT-urz-kill] *Falls* (Fig. **30.24**), he was painting more fable than fact. Indeed, Kaaterskill Falls was already a tourist attraction, with a large hotel at the top of the falls, viewing towers, and railed platforms over-looking the site. Cole painted these out, even as he painted in the Indian, the "noble savage" long since vanished from the area. His painting is nothing short of an act of nostalgia.

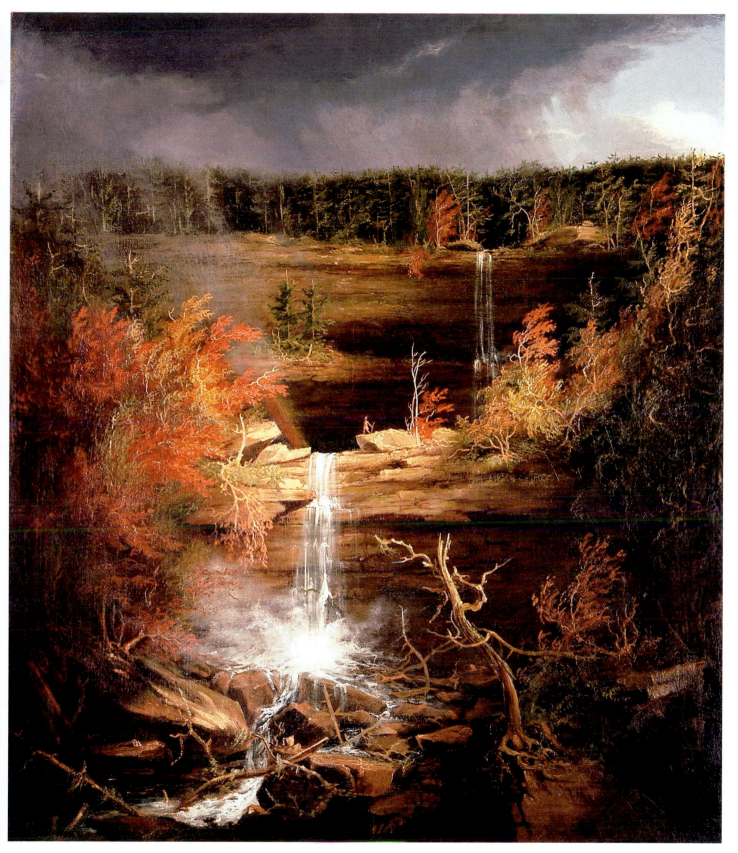

Fig. 30.24 Thomas Cole. *Kaaterskill Falls.* **1826.** Oil on canvas, 43″ × 26″. Property of the Westervelt Company and displayed in The Westervelt-Warner Museum of American Art in Tuscaloosa, AL. In 1823, a hotel on South Mountain at the top of Kaaterskill Falls was built by the Catskill Mountain Association, a group of Catskill merchants. Overlooking the entire Hudson valley, the hotel relied on the two lakes behind it for both water and recreational activities. Cole ignored the presence of the hotel and painted a lone Native American into the scene.

READINGS

Logan, Speech at the End of Lord Dunmore's War, from Thomas Jefferson, *Notes on the State of Virginia* (1784)

Thomas Jefferson's Notes on the State of Virginia, *begun in 1781, is a natural history of the future president's native Virginia. But it is also a far-reaching meditation on the social and political life of a country both anxious about its prospects and hopeful that, having just won its independence, it might thrive as no other. In the following passage, from a chapter entitled "Aborigines," Jefferson praises the eloquence of the Mingo (Iroquois) chief Tachnechdorus, known to the colonists as Logan. Jefferson quotes, in its entirety, the short speech, translated and delivered to Lord Dunmore, the British Royal Governor of Virginia, after Dunmore's army had defeated the chief's people in the Ohio River Valley in 1774. After its publication by Jefferson, the speech was widely reprinted, and throughout the nineteenth century, it was received by readers as painfully moving testimony to the fate of the Native American peoples.*

Of their [Native Americans'] eminence in oratory we have fewer examples, because it is displayed chiefly in their own councils. Some, however, we have of very superior lustre. I may challenge the whole orations of Demosthenes and Cicero, and of any more eminent orator, if Europe has furnished more eminent, to produce a single passage, superior to the speech of Logan, a Mingo chief, to Lord Dunmore, when governor of this state. And, as a testimony of their talents in this line, I beg leave to introduce it, first stating the incidents necessary for understanding it. In the spring of the year 1774, a robbery and murder were committed on an inhabitant of the frontiers of Virginia, by two Indians of the Shawanee tribe. The neighbouring whites, according to their custom, undertook to punish this outrage in a summary way. Col. Cresap, a man infamous for the many murders he had committed on those much-injured people, collected a party, and proceeded down the Kanhaway in quest of vengeance. Unfortunately a canoe of women and children, with one man only, was seen coming from the opposite shore, unarmed, and unsuspecting an hostile attack from the whites. Cresap and his party concealed themselves on the bank of the river, and the moment the canoe reached the shore, singled out their objects, and, at one fire, killed every person in it. This happened to be the family of Logan, who had long been distinguished as a friend of the whites. This unworthy return provoked his vengeance. He accordingly signalized himself in the war which ensued. In the autumn of the same year, a decisive battle was fought at the mouth of the Great Kanhaway, between the collected forces of the Shawanees, Mingoes, and Delawares, and a detachment of the Virginia militia. The Indians were defeated, and sued for peace. Logan however disdained to be seen among the suppliants. But, lest the sincerity of a treaty should be distrusted, from which so distinguished a chief absented himself, he sent by a messenger the following speech to be delivered to Lord Dunmore.

'I appeal to any white man to say, if ever he entered Logan's cabin hungry, and he gave him not meat; if ever he came cold and naked, and he clothed him not. During the course of the last long and bloody war, Logan remained idle in his cabin, an advocate for peace. Such was my love for the whites, that my countrymen pointed as they passed, and said, 'Logan is the friend of white men.' I had even thought to have lived with you, but for the injuries of one man. Col. Cresap, the last spring, in cold blood, and unprovoked, murdered all the relations of Logan, not sparing even my women and children. There runs not a drop of my blood in the veins of any living creature. This called on me for revenge. I have sought it: I have killed many: I have fully glutted my vengeance. For my country, I rejoice at the beams of peace. But do not harbour a thought that mine is the joy of fear. Logan never felt fear. He will not turn on his heel to save his life. Who is there to mourn for Logan? — Not one.'

Reading Question

How would you compare Logan's speech to Thomas Cole's painting *Kaaterskill Falls* (see Fig. 30.24)?

Summary

■ The South Pacific: The Cultures Captain Cook Encountered

The peoples of the South Seas were seen by Enlightenment thinkers such as Denis Diderot as examples of Rousseau's "noble savages." Unfettered by social hierarchy and private property, they were, Diderot argued, free to follow their natural instincts, which by definition were inherently good. But Captain Cook saw things otherwise. He saw in South Seas societies a well-developed social hierarchy and a well-established sense of private property. Enlightenment economists had argued that private property and social stratification were the hallmarks of complex and flourishing societies, which Cook took the South Seas cultures to be.

In New Zealand, Cook encountered the Maori, whose tattoo practices were connected to the *mana*, or invisible spiritual force, a manifestation of the gods on earth, with which, the culture believed, certain individuals, places, and objects were endowed. Tattoo designs mirrored the human form, with its bilateral symmetry, but each was distinctive and was symbolic of the individual's *mana*. On Easter Island, Cook discovered the remnants of a culture that had erected *moai*, monumental heads with torsos, since about 1000 CE. In Hawaii, Cook found himself in conflict with King Kamehameha I, the first Hawaiian king to consolidate the islands under one rule. In the western half of New Guinea, he encountered the Asmat, headhunters who believed that in displaying the head of an enemy warrior on *bis* poles, they could possess that warrior's strength. Finally, in Australia, Cook was the first to encounter Australian Aborigines, whose rock art represents the longest continuously practiced artistic tradition in the world.

■ China and Europe: Cross-Cultural Contact

Trade with China brought luxury goods from Asia to European markets in vast quantities, creating a widespread taste in Europe for "things Chinese"—*chinoiserie*. European thinkers such as Rousseau and Voltaire thought that China offered a model of exemplary government, and Samuel Johnson believed that the West should adopt the Chinese civil service examination system. During the Qing dynasty, the West influenced China as well. The Jesuit priest Giuseppe Castiglione introduced scientific perspective to the court of the Qianlong emperor, where he was known as Lang Shi'ning, and worked his entire career there. Traders also introduced Western conventions of representation as they gave Chinese artisans images for reproduction on ceramic ware and other luxury goods destined for Europe. But the Qianlong emperor valued traditional Chinese art above all else. His court painters copied the masters of the Song era, and the emperor modeled his giant jade carving of *Yu the Great Taming the Waters* on Song precedents.

■ India and Europe: Cross-Cultural Connections

Mogul rulers in India, Akbar and Jahangir in particular, not only introduced conventions of Islamic art to India, notably the tradition of Persian miniature painting, but opened the doors of the country to English traders from the British East India Company. A synthetic style of representation developed, incorporating elements of Eastern and Western art in a single image. But perhaps the greatest achievement of the Mogul emperors is the Taj Mahal of Shah Jahan, one of the architectural masterpieces of the world.

■ Native American Traditions

The *philosophes* also regarded the Native American populations of North America as examples of Rousseau's "noble savages," but it seemed that their inherent nobility was undermined and destroyed in direct proportion to their acquaintance with European colonists. In the Southwest, where after the Pueblo Revolt of 1680 native communities isolated themselves from Spanish settlers by relocating on mesa tops and in deep canyons, cultural traditions survived and even thrived. At the center of their communities was the *kiva*, the ceremonial center of the village, surrounded by multi-room, multi-story apartment units. Each story is set back from the one below, thus forming terraces which serve as viewing areas for ceremonial activities in the dance plaza below. We have learned much of what we know about the Hopi, Zuni, Navajo, and other Pueblo tribes through their arts, which are practiced today very much as they were in pre-colonial times. For the Navajo, weaving is a sacred activity that reflects the creation of the universe when their mythic female ancestor, Spider Woman, wove the cosmos together on an enormous loom. When the Navajo weaver works, she imitates Changing Woman, the embodiment of the natural world with its changing seasons, transforming plants (wood used to construct the loom and vegetal dyes), animals (sheep wool), and human skill into the finished rug or *sarape*, or poncho. The art of basketry was particularly honored among the Apache peoples of Arizona.

The tribes of the Northeast did not fare so well. The Lenni Lenape, or Delaware, tribe ceded large parts of Pennsylvania to William Penn and his heirs, much to the consternation of the Iroquois Confederacy. The latter was composed of the Seneca, Cayuga, Onondaga, Oneida, and Mohawk tribes. A matriarchal culture that was dedicated to "mother earth," they lived in villages of longhouses made of poles sheathed in sheets of elm. The distribution of firearms to the tribes during the French and Indian War did much to undermine the traditional balance of Iroquois society. By the end of the eighteenth century, Native Americans had essentially vanished from the Northeast.

Glossary

chattri Small pavilions that are traditional embellishments of Indian palaces.

chinoiserie A term meaning "all things Chinese."

iwan A traditional Islamic architectural feature consisting of a vaulted opening with an arched portal.

mana Among the Maori, an invisible, forceful, spiritual substance that is the manifestation of the gods on earth.

moai Monumental heads with torsos found on Easter Island, which probably represent ancestral figures.

pietra dura A mosaic technique using precious and semi-precious stones, which the Moguls learned from the Italians. The term means "hard stone."

x-ray style An Australian Aboriginal art style in which the skeletal structure, heart, and stomach of an animal are painted over its silhouetted form.

Critical Thinking Questions

1. How did the concept of *mana* influence the cultural production of the South Seas islanders?

2. What traditions of Western art became popular in China and in Mogul India?

3. In his writings, Jean-Jacques Rousseau argued for an idealized concept of uncivilized man who symbolizes the innate goodness of one not exposed to the corrupting influences of civilization, the so-called noble savage. If this seems to respect the Native American, Rousseau also argues, in *The Social Contract*, that if, in civil society, man "deprives himself of some advantages which he got from nature, he gains in return others so great, his faculties are so stimulated and developed, his ideas so extended, his feelings so ennobled, and his whole soul so uplifted, that, did not the abuses of this new condition often degrade him below that which he left, he would be bound to bless continually the happy moment which took him from it for ever, and, instead of a stupid and unimaginative animal, made him an intelligent being and a man." How are these contradictory sentiments reflected in the attitude of colonists and settlers toward Native Americans?

The most troubling instance of cross-cultural encounter during the Enlightenment revolved around slavery. Since the Portuguese introduced the slave trade in the sixteenth century (see chapter 23), hundreds of thousands of Africans had been forcibly transported to the Americas in conditions so appalling that many, even most, died in transit. Those who survived the voyage then experienced the brutality of slavery itself.

American slave owners sought to suppress their slaves' identification with their African heritage. Rarely were slaves from the same locales in Africa allowed to work on the same plantation. Even more radically, slave families were generally broken up—men, women, and children sold separately—in order to undermine their ability to carry on African traditions and practices.

Many leading Enlightenment thinkers in America defended the institution of slavery. Thomas Jefferson wrote in his *Notes on the State of Virginia*, "Comparing [blacks] by their faculties of memory, reason, and imagination, it appears to me that in memory they are equal to whites; in reason much inferior. . . . I advance it . . . as a suspicion only, that the blacks, whether originally a distinct race, or made distinct by time and circumstances, are inferior to the white in the endowments both of body and mind. . . . This unfortunate difference of color, and perhaps of faculty, is a powerful obsta-cle to the emancipation of these people." Nevertheless, Jefferson did attempt, unsuccessfully, to incorporate a paragraph condemning slavery in his Declaration of Independence, one of the great documents of Enlightenment thought—although he owned 187 slaves of his own.

In Britain, Jefferson was considered a hypocrite, and that hypocrisy would come to play a major role in the Revolutionary War. The British, as we will see in the next chapter, could not understand how the Declaration's call for "life, liberty, and the pursuit of happiness" was consistent with the defense of slavery as an institution. And, although the British were deeply involved in the slave trade, an increasingly large number of English Enlightenment thinkers had come to condemn it. John Zoffany's double portrait of Dido Elizabeth Belle Lindsay and Lady Elizabeth Murray (Fig. **30.25**) underscores the difference between British and American attitudes. Nothing like this portrait exists in eighteenth- or nineteenth-century American painting. Dido was the daughter of an English Captain and an enslaved African woman. Dido was raised by the Captain's uncle, Lord Chief Justice William Murray, First Earl of Mansfield, together with another of Mansfield's nieces, Elizabeth Murray. The girls were best friends and apparently equal in all things. When the colonial governor of Massachusetts, Thomas Hutchinson, saw them arm in arm at Mansfield's estate, Kenwood House on Hampstead Heath, he was shocked and outraged.

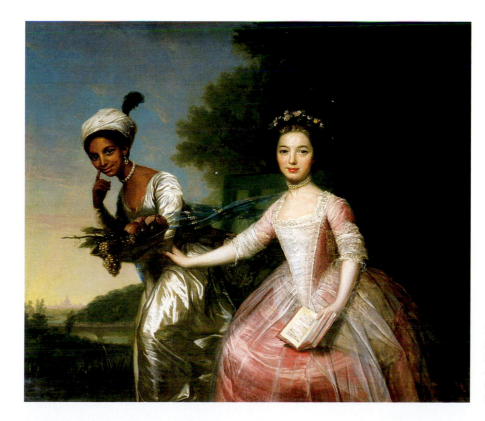

Fig. 30.25 John Zoffany. *Dido Elizabeth Belle Lindsay and Lady Elizabeth Murray.* 1779–1781. Oil on canvas, 35 1/2″ × 28 1/4″. From the Collection of the Earl of Mansfield, Scone Place, Scotland.

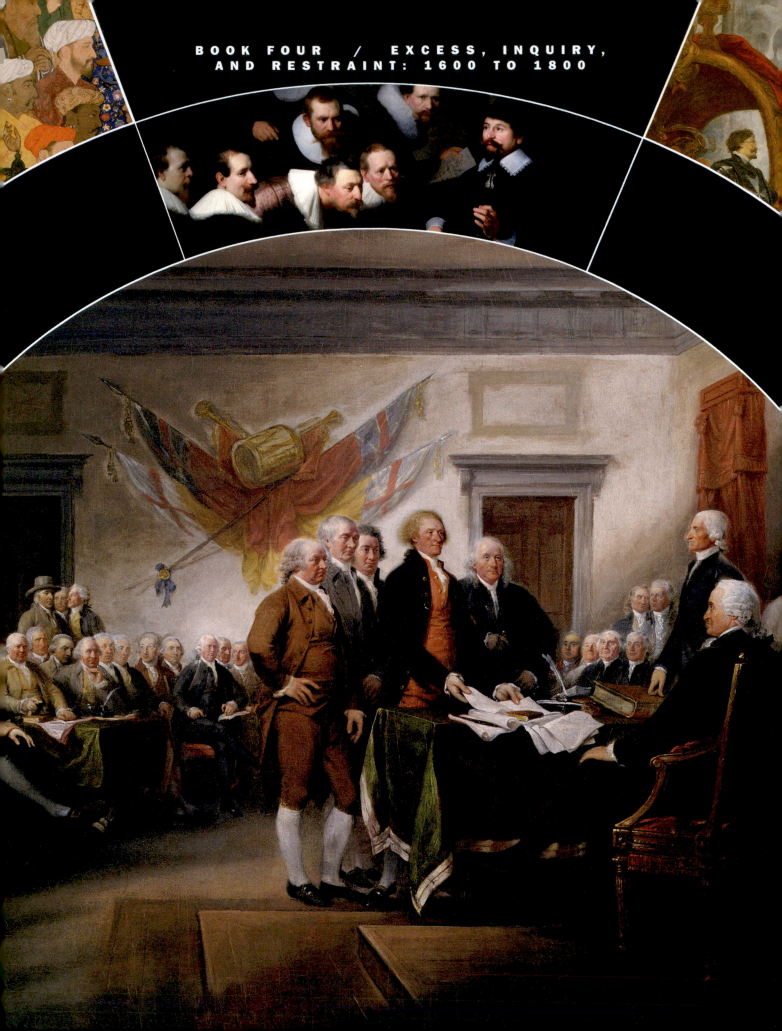

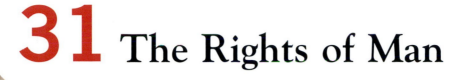

31 The Rights of Man

Revolution in America

The American Revolution

Neoclassicism in Britain and America

The Issue of Slavery

❝ *We hold these truths to be self-evident, that all men are created equal, that they are endowed by their Creator with certain unalienable Rights, that among these are Life, Liberty and the pursuit of Happiness.* ❞

The Declaration of Independence

◄ **Fig. 31.1 John Trumbull. *The Declaration of Independence, 4 July 1776.* 1786–1797.** Oil on canvas, 21⅛″ × 31⅛″. Trumbull Collection. 1832.3, Yale University Art Gallery, New Haven, CT/Art Resource NY. The canvas portrays 47 of the 56 delegates who signed the Declaration of Independence, and Trumbull painted 36 of them from life. Standing in front of John Hancock are, from left to right, John Adams, Roger Sherman, Robert R. Livingston, Thomas Jefferson, and Benjamin Franklin.

BY THE LAST DECADES OF THE EIGHTEENTH CENTURY, THE idea of freedom, if not literally a place, had become a rallying cry around which both European and American cultures organized themselves. The actual place around which the idea of freedom was centered was Philadelphia, in the American colony of Pennsylvania. There, the word "freedom" was on everybody's lips. Freedom, it was understood, would be the driving force of the new American culture, and the importance of the concept was understood throughout Europe.

In Germany, the philosopher Immanuel Kant (1724–1804) argued in his essay "What Is Enlightenment?" (1784) that the precondition of the Enlightenment was freedom:

> *Dare to know!* "Have the courage to use your own understanding"—that is the motto of Enlightenment. . . .
>
> [T]hat the public should enlighten itself is more possible; indeed, if only freedom is granted enlightenment is almost sure to follow. For there will always be some independent thinkers, even among the established guardians of the great masses, who, after throwing off the yoke of tutelage from their own shoulders, will disseminate the spirit of the rational appreciation of both their own worth and every man's vocation for thinking for himself. It is more nearly possible, however, for the public to enlighten itself; indeed, if it is only given freedom, enlightenment is almost inevitable. . . .
>
> For this enlightenment, however, nothing is required but freedom, and indeed the most harmless among all the things to which this term can properly be applied. It is the freedom to make public use of one's reason at every point.

Enlightenment historian Peter Gay sums up the driving forces of the era as "freedom from arbitrary power, freedom of speech, freedom of trade, freedom to realize one's talents, freedom of aesthetic response, freedom, in a word, of moral man to make his way in the world."

Nowhere was the drive for freedom stronger than in the English colonies of North America and in France—particularly in Philadelphia, where the Declaration of Independence was signed in 1776 (Fig. **31.1**), and in Paris. The American Revolution and the idea of freedom that inspired it are the subjects of this chapter. For nearly 200 years, the British colonies in the Americas had been ruled by the English king. After enduring unfair taxation and the king's tyrannical behavior, the colonies revolted and created the United States of America with a new political system. The American Revolution was essentially the revolt of an upper class that felt disenfranchised by its distant king. Inspired by the age's somewhat idealized view of the classical cultures of Rome and Athens, the American and French revolutions (chapter 32) were a major turning point in the history of Western democracy. The social changes they produced strongly influenced world history, and would spur the nineteenth-century revolutions in South America, in France, and across Europe in 1848.

In the arts, classical traditions were expressed in a style known as Neoclassicism, literally a "new classicism." The style was most eloquently expressed in Britain, in the architectural and interior designs of Robert Adam and in the decorative ceramics of Josiah Wedgwood. Both were widely imitated in the fledgling United States, where Thomas Jefferson was Neoclassicism's principal advocate. Jefferson designed his own home at Monticello, the Virginia capital, and even laid out the new national capital of Washington, DC using the trademarks of the Neoclassical style—balance and order. Yet the revolution in America occurred against the ominous backdrop of the slave trade in which the colonies participated. By 1700, the slave trade had helped make England the wealthiest nation in the world. No one could long ignore the hypocrisy of demanding human rights and freedom for some while subjugating others to abject misery and enslavement. And women, in both Europe and America, argued for their own equality in the same terms. Were they not, they argued, entitled to the same freedoms as their husbands and brothers?

The American Revolution

Since August 1774, representatives from the 13 British colonies in North America (see Map **31.1**) had periodically gathered in the city of Philadelphia to consider what action the colonies might take against the tyrannical behavior of the British king. Philadelphia was the largest city in the colonies, boasting 7 newspapers, 23 printing presses, 30 bookstores, and over 60 taverns and coffeehouses. It produced more goods than any other American city—from hardware to carriages to the Franklin stove. That stove's inventor, Benjamin Franklin, had founded the American Philosophical Society in the city in 1743. (The Society predated the English Lunar Society, which had many of the same aims as its

Map 31.1 legend:
- Thirteen Colonies
- Indian Reserve
- Spanish Louisiana

Map 31.1 North America in 1763, after the conclusion of the Seven Years' War.

American counterpart.) (See chapter 28.) The American Philosophical Society was dedicated, Franklin wrote, to the study of anything that might "let light into the nature of things . . . all new-discovered plants, herbs, roots, and methods of propagating them. . . . New methods of curing or preventing diseases. . . . New mechanical inventions for saving labor. . . . All new arts, trades, manufacturers, etc. that may be proposed or thought of." Therefore, when the 48 representatives of the 13 colonies gathered in Philadelphia's State House, now known as Independence Hall, on July 4, 1776, to sign the Declaration of Independence from Britain, the city was a true center of culture, a major site of the burgeoning nation's economic prosperity and a dominant force in shaping its ideas and policies (Fig. **31.2**). The revolt of the colonies followed nearly 200 years of British rule, but the most recent tensions began with the Seven Years' War (1756–1763) fought by Britain and France. The war spread to North America, where the two powers were competing for land and control.

The Road to Revolt: War and Taxation

Britain's defeat of the French in the Seven Years' War left it the most powerful colonial power in the Americas. The British felt that they had saved the colonists from the French. They had borne almost the entire cost of the war themselves, and they continued to provide protection from Indian uprisings on the Western frontier. Consequently, they felt entitled to tax the colonies as needed.

The colonists did not agree. They were particularly infuriated by the Stamp Act of 1765, which taxed all sorts of items, from legal documents to playing cards, calendars, liquor licenses, newspapers, and academic degrees. The colonists saw this as

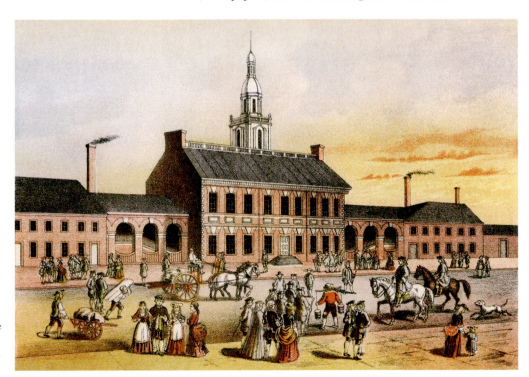

Fig. 31.2 Independence Hall as it looked to the delegates to the Continental Congress in 1776. North Wind Picture Archives. Ironically, the State House itself was a model of British culture. It reflects the variety of decorative features that characterize the Baroque style of Christopher Wren, considered by some the greatest English architect (see chapter 28).

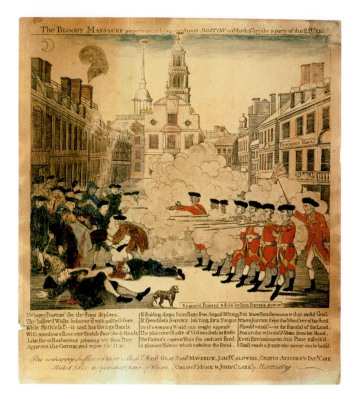

Fig. 31.3 Paul Revere, after Henry Pelham. *The Bloody Massacre.* **1770.** Hand-colored engraving, $8^{15}/_{16}'' \times 10^{3}/_{16}''$. The Metropolitan Museum of Art, NY. © Massachusetts Historical Society, Boston, MA, USA. The Bridgeman Art Library. Though it served to inflame the nation, Revere's print was largely fiction. John Adams defended the British troops in court, arguing that the soldiers had been attacked by a mob. "Facts are stubborn things," he concluded, "and whatever may be our wishes, our inclinations, or the dictums of our passions, they cannot alter the state of facts and evidence." The jury acquitted the British commander and six of the eight soldiers.

a clear case of taxation without representation. In the words of the Stamp Act Congress, convened in New York in 1765 to protest the tax, it was a "manifest" example of the British desire "to subvert the rights and liberties of the colonists."

For the next decade, tensions continued to rise. To protect its customs agents and tax collectors, the British sent troops to Boston in 1768, and on the evening of March 5, 1770, a mob attacked a small band of British troops stationed at the Custom House, yelling "Kill them! Kill them!" The troops fired on the mob, killing five, including Crispus Attucks, an African who had escaped slavery 20 years earlier. A print of the event by silversmith and engraver Paul Revere (1735–1818) called *The Bloody Massacre* was soon widely distributed, arousing the colonists to even greater resistance, though its depiction of the troops' brutal attack on a defenseless crowd misrepresented the facts (Fig. **31.3**).

In May 1773, another law, allowing direct importation of tea into the American colonies, without the usual colonial tax, was met with opposition because it represented one more instance of English interference in tax matters without the colonists' consent, and because it also removed colonial middlemen from participation in the tea trade. The following

December, Massachusetts Bay colonists gathered at the Boston waterfront and cheered as a group of men dressed as Native Americans, almost all of them with a financial stake in the tea market, emptied three ships of thousands of pounds of tea, dumping it into the harbor.

The so-called Boston Tea Party outraged the British, and they retaliated. In 1774, they deeded all the land west of the Alleghenies to Canada and passed what soon became known as the Intolerable Acts, closing the port of Boston to trade, suspending elections in Massachusetts colony, allowing British troops to be quartered in private homes, and providing for the trials of customs officials to take place in England. The colonists found these British measures unacceptable and responded by forming the first Continental Congress. Meeting in Philadelphia, the Congress declared the Intolerable Acts unconstitutional and called for the people to begin organizing for war. The first gunshots of the Revolutionary War were fired at Lexington and Concord, in Massachusetts, on April 19, 1775, when the British sent a regiment to confiscate arms and arrest revolutionaries. A Second Continental Congress in that year created the Continental Army under the leadership of George Washington and attempted to reconcile with the king, but failed.

In January 1776, in Philadelphia, an anonymous pamphlet written by an English immigrant named Thomas Paine argued for a new **republicanism**. The only solution to the colonists' problems with Britain, he wrote, was independence followed by a republican form of government. Such a government would have a chief of state who is not a monarch. Paine asked, "Why is it that we hesitate? . . . The birthday of a new world is at hand." The pamphlet was called *Common Sense*, and within a matter of months, 100,000 copies were in circulation. Colony-wide war was inevitable. Six months later, on July 4, 1776, the colonies ratified the U.S. Declaration of Independence.

The Declaration of Independence

The American Declaration of Independence is one of the Enlightenment's boldest assertions of freedom. The chairman of the committee that prepared the document and its chief drafter was Thomas Jefferson (1743–1826) of Virginia. Jefferson's argument came from his reading of English philosopher John Locke's vigorous denial of the divine rights of kings (see chapter 28). In *Two Treatises on Government* (1689), Locke asserted that humans are "by nature free, equal, and independent." Jefferson's denunciation of the monarchy was further stimulated by Rousseau's *Social Contract* (1763), and its principal point: "No man has a natural authority over his fellow," wrote Rousseau, "and force creates no right" (see chapter 29). Jefferson was influenced, too, by the writings of many of his colleagues in the Continental Congress, who were themselves familiar with the writings of Locke and Rousseau. George Mason had written: "All men are born equally free and independent and have certain inherent natural rights . . . among which are the enjoyment of life and liberty." An even

greater source of inspiration came from the writings of Jefferson's friend John Adams (1735–1826), whose Preamble to the Massachusetts State Constitution (1779) reflects their common way of thinking:

> The end of the institution, maintenance, and administration of government is to secure the existence of the body politic; to protect it; and to furnish the individuals who compose it with the power of enjoying, in safety and tranquility, their natural rights and the blessings of life; and whenever these great objects are not obtained, the people have a right to alter the government, and to take measures necessary for their safety, happiness, and prosperity.

But as powerful as the thinking of Mason and Adams might be, neither man could rise to the level of Jefferson's eloquence **(Reading 31.1)**:

READING 31.1 **from The Declaration of Independence (1776)**

When in the Course of human events, it becomes necessary for one people to dissolve the political bands which have connected them with another, and to assume among the powers of the earth, the separate and equal station to which the Laws of Nature and of Nature's God entitle them, a decent respect to the opinions of mankind requires that they should declare the causes which impel them to the separation.

We hold these truths to be self-evident, that all men are created equal, that they are endowed by their Creator with certain unalienable Rights, that among these are Life, Liberty and the pursuit of Happiness.— That to secure these rights, Governments are instituted among Men, deriving their just powers from the consent of the governed,—That whenever any Form of Government becomes destructive of these ends, it is the Right of the People to alter or to abolish it, and to institute new Government, laying its foundation on such principles and organizing its powers in such form, as to them shall seem most likely to effect their Safety and Happiness.

As indebted as it is to John Locke's *Two Treatises of Government*, Jefferson's Declaration extends and modifies Locke's arguments in important ways (see chapter 28). While Locke's writings supported a government *for* the people, he did not reject the idea of a monarchy per se. The people would tell the king what he should do, and the king was obligated to respect their rights and needs. But Jefferson rejected the idea of a monarchy altogether and argued that the people were themselves sovereign, that theirs was a government not *for* the people but *of* and *by* the people. Where Locke, in his *Two Treatises*, had argued for "life, liberty, and property," Jefferson argued for "Life, Liberty, and the pursuit of Happiness."

Locke's basic rights are designed to guarantee justice. Jefferson's are aimed at achieving human fulfillment, a fulfillment possible only if the people control their own destiny.

After reading Jefferson's document, John Adams wrote to his wife Abigail that he was "delighted with its high tone and [the] flights of oratory with which it abounded." When it was read in New York the day after its first presentation in Philadelphia, an enthusiastic mob pulled down a larger-than-life equestrian statue of England's King George III (r. 1760–1820). Later, in August, when the text finally made its way south to Savannah, Georgia, the largest crowd in the colony's history gathered for a mock burial of George III. The document had the power to galvanize the colonies to revolution.

A year after the colonists signed the Declaration of Independence, they adopted the Articles of Confederation, combining the 13 colonies into a loose confederation of sovereign states. The war itself continued into the 1780s and developed an international scope. France, Spain, and the Netherlands supported the revolutionaries with money and naval forces in order to dilute British power. This alliance was critical in helping the Americans defeat the British at Yorktown, Virginia, in 1781. This victory convinced the British that the war was lost and paved the way for the Treaty of Paris, signed on September 3, 1783. The war was over.

Neoclassicism in Britain and America

The founders of the newly created United States of America modeled their new republic on classical precedents. Theirs would be a Neoclassical society—a stable, balanced, and rational culture that might imitate their admittedly idealized view of Rome and Athens. After the Federal Convention presented the states with a new constitution to replace the six-year-old Articles of Confederation on October 27, 1787, a series of 85 articles appeared that came to be known as *The Federalist*, arguing for ratification. They were signed "Publius," a collaborative pseudonym in honor of Publius Valerius Publicola (d. 503 BCE), whose surname means "friend of the people" and who is generally considered one of the founding fathers of the Roman Republic. The authors were actually Alexander Hamilton (1757–1804), John Jay (1745–1829), and James Madison (1751–1836). More than any other delegate to the convention, Madison had been responsible for drafting the constitution itself, and his inspiration came from ancient Greece and Rome. (Among his papers was a list of books he thought were essential for understanding the American political system, among them Edward Gibbon's *On the Decline of the Roman Empire*, Basil Kennett's *Antiquities of Rome*, Plutarch's *Lives*, Plato's *Republic*, and Aristotle's *A Treatise on Government*.)

Federalist No. 10 (see **Reading 31.2**, pages 1016–1017), written by Madison, sums up the chief issue facing adoption of his new constitution—its argument for a centralized and strong federal government. To many, this appeared to be

nothing short of a sure path to despotism. The country had fought a war in order to shake off one strong government. Why should it put itself under the yoke of another? Madison's key contribution revolved around his analysis of "factions": "A zeal for different opinions concerning religion, concerning Government and many other points . . . an attachment to different leaders ambitiously contending for pre-eminence and power . . . have divided mankind into parties, inflamed them with mutual animosity, and rendered them much more disposed to vex and oppress each other, than to co-operate for their common good." But Madison understood that in a large republic these factions counteract each other. As a result, at the heart of the constitution was a system of checks and balances to guarantee that no faction or branch of government—each of which was vested with different, and sometimes opposing powers,—could wield undue power over any other.

The fledgling United States also embraced Neoclassicism as an architectural style, both as a reflection of its classically inspired political system and to give a sense of ancient stability to the new republic. Many of the founding fathers had traveled extensively in Europe, where they viewed the antiquities of Greece and Rome and many of the later works inspired by them. As a young man, Thomas Jefferson had dreamed of taking the Grand Tour, the capstone experience of any Briton's formal education. The Grand Tour could last anywhere from a few months to a few years. It included visits to Paris, Florence, Pisa, Bologna, and Venice, followed by a journey to Rome, Naples, and the ruins of Herculaneum and Pompeii. Travelers would then go on to German-speaking cities, Holland and Belgium. Although Jefferson never completed the Grand Tour, after his appointment as minister to the court of the French king, Louis XVI in 1784, he traveled extensively. With John Adams, he toured the gardens and estates of England, visiting Stowe (see chapter 29), Alexander Pope's garden at Twickenham, and other sites. Later, Jefferson visited Northern Italy and France, where he marveled at the Roman ruins (and also developed a deep enthusiasm for French wine). Jefferson also well knew that the next best thing to visiting the sights of Europe was to read about them.

Among the recently published books that described the antiquities of Rome and Athens, one of the most compelling was Johann Winckelmann's *History of Ancient Art* (1764)—the first book to include the words "history" and "art" in its title. While working as the Prefect of Papal Antiquities in Rome, Winckelmann (1717–1768) saw and described the vast collection of antique classical art at the Vatican as possessing "a noble simplicity and quiet grandeur." Capturing this same simplicity and grandeur became the primary aim of artists and architects whose works came to be known as Neoclassical. In fact, the taste for these values was enormous, and so was the market for classical objects.

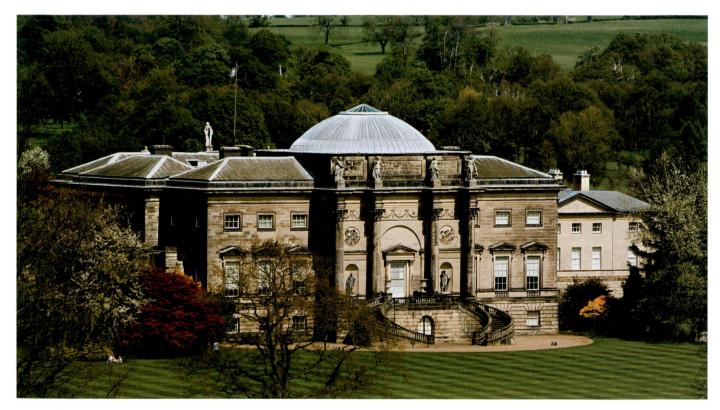

Fig. 31.4 Robert Adam. South front of Kedleston Hall, Derbyshire, England. ca. 1765–1770. Not only did the Adam architectural firm design every aspect of a house—at no small expense—it also owned interests in timber, brick, cast iron, stone, stucco, and sand businesses. In essence, the firm was a high-end developer, employing over 2,000 people.

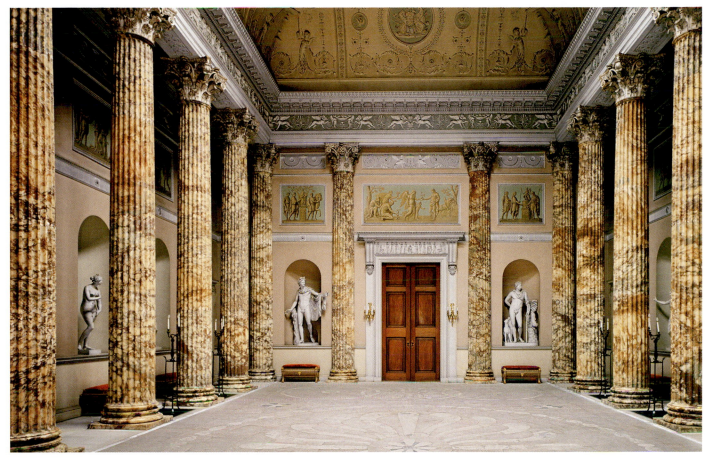

Fig. 31.5 Robert Adam. *Line Interior of the Marble Hall,* Kedleston Hall, Derbyshire, England. 1563–1577. 67′ × 42′. John Bethell. The Bridgeman Art Library. The *Apollo Belvedere,* which stands in the left niche at the end of the hall, was perhaps the most copied statue from Greek and Roman antiquity. Above the niches and door are panels with classical subjects.

The British Influence: Robert Adam and Josiah Wedgwood

The rise of Neoclassical architecture in the United States was directly inspired by the architectural practice of Robert Adam (1728–1792) in England. Adam and his brother James had taken the Grand Tour in 1754, including visits to Pompeii and Herculaneum. What they saw inspired an architectural style that interpreted and organized classical architectural forms and decorative motifs in innovative new ways. Adam's designs were so popular that he became the most sought-after architect of the day. He and his brother James employed a permanent staff that designed every detail of a house, both outside and in.

His work was so influential that his Neoclassical style became more commonly known in England as the **Adam style**.

Adam's motifs came from a variety of antique sources. His facade for the south front of Lord Scarsdale's country house, Kedleston [KED-ul-stun] Hall in Derbyshire [DAR-bee-shir] (Fig. **31.4**), for instance, is a direct copy of the Arch of Constantine in Rome (see Fig. 9.10) but

elevated on a platform with wings on each side and approached by a magnificent open-ended oval staircase. Adam filled the interior with opulent marbles, stucco decoration, Corinthian colonnades, and alcoves to contain sculpture copied from the ancients. He also decorated the walls with copies of ancient medallions, plaques, and other motifs that evoked what he labeled his "antique style." He placed a replica of the *Apollo Belvedere* at the far end of the Marble Hall (Fig. **31.5**), designed to suggest the open courtyard of a Roman villa. (See Figures 8.28 and 8.30.)

Very often Adam decorated his interiors with the ceramics of Josiah Wedgwood [WEDJ-wud], not the common earthenware that Wedgwood mass-produced known as Queen's Ware (see chapter 28), but his stoneware known as **jasperware**, ornamented in Neoclassical style with a white relief on a colored ground. His primary markets were his native England, Russia, France, and North America. The latter was especially lucrative, as Wedgwood explained in a letter to a friend: "For the islands of North America we cannot make anything too rich and costly."

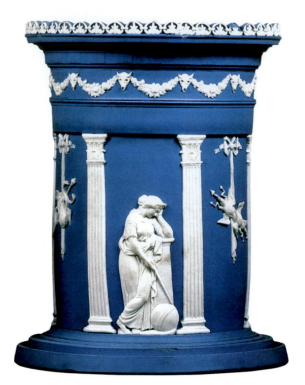

Fig. 31.6 John Flaxman. Wedgwood Vase. Late 18th century ca. 1780–1800. Made by Josiah Wedgwood and Sons, Etruria/Staffordshire, England. Jasperware: height 6½″; diameter 5⅛″. Metropolitan Museum of Art, NY, Rogers Fund, 1909 (09.194.79). Depicted here is Urania, muse of astronomy, contemplating a globe.

Most of the relief designs on the vases were by sculptor and draftsman John Flaxman (1755–1826). Flaxman's design for a vase depicting the Muses (Fig. **31.6**) was modeled on an ancient Roman household altar. The design is divided into six sections by columns. The three Muses Thalia, Urania, and Erato fill three of these sections, alternating with symbols representing Jupiter (thunderbolt), Mars (spear and helmet), and Mercury (caduceus, or winged staff). Flaxman's designs echo the flat vase painting of the original designs in their own extreme linearity and their extremely low relief, barely raised sculptural surfaces. This planarity and linearity became synonymous with Neoclassicism itself as the Wedgwood manufactury popularized the Neoclassical look.

American Neoclassical Architecture

The Neoclassical style of architecture dominated the architecture of the new American republic, where it became known as the **Federal style.** Its foremost champion was Thomas Jefferson. Like almost all leaders of the American colonies, Jefferson was well educated in the classics and knew works such as Stuart and Revett's *Antiquities of Athens* (1758) and Adam's *Works of Architecture* well. His taste for the classical would affect the design, the furniture, and even the gardens at his home outside Charlottesville, Virginia (Fig. **31.7**). For the convenience of getting goods to the marketplace, most American estates had been located near rivers. Jefferson located his on the top of a hill, the traditional site for a Greek or Roman temple. He called the place Monticello [mon-tih-CHEH-loh], or "little mountain."

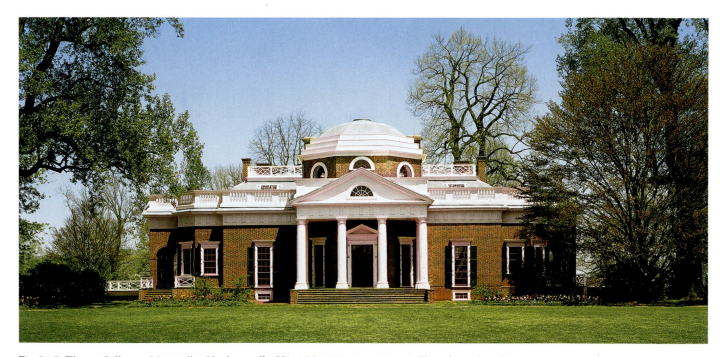

Fig. 31.7 Thomas Jefferson. Monticello, Charlottesville, VA. 1770–1784, 1796–1806. The colonnade at the entrance to Jefferson's Monticello, itself modeled on the work of Robert Adam, would inspire the architecture of countless antebellum Southern mansions.

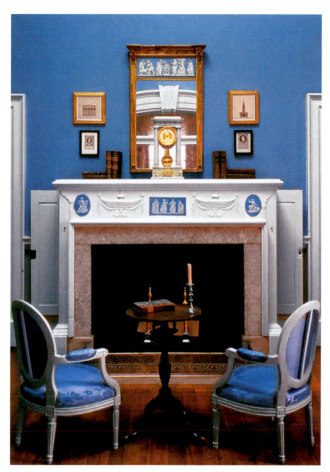

He designed the building himself after the villas of Andrea Palladio (see Fig. 19.16) but augmented with features he had seen in France when he served as American minister there, such as French doors and tall, narrow windows, and the use of a balustrade above the cornice to mask the second story. The facade, with its six Corinthian columns and classical pediment, is modeled on the work of Robert Adam. He also decorated the fireplace of the Monticello dining room with Wedgwood panels (Fig. **31.8**).

The house was surrounded by an English garden similar to the one he had seen at Stowe (see Fig. 29.14) when he traveled with his friend John Adams. Its meandering hilltop pathway opened to vistas of the surrounding Virginia countryside. An accomplished gardener, in characteristic Enlightenment fashion, Jefferson documented the plants and animals of the entire Virginia region, cataloguing his findings in a volume that remains useful to Virginia gardeners to this day.

Jefferson's Neoclassical tastes were not limited to his private life. He designed the Virginia State Capitol in Richmond, Virginia, which was, first of all, a "capitol," the very name derived from Rome's Capitoline Hill. The building (Fig. **31.9**) is a literal copy of the Maison Carrée [may-ZOHN kah-RAY] in Nîmes [neem], France, a Roman temple built in

Fig. 31.8 Thomas Jefferson. Dining room with Wedgwood reliefs. Monticello, Charlottesville, VA. 1770–1784, 1796–1806.
Jefferson kept books on this mantelpiece, and often read into the evening in front of this fireplace.

Fig. 31.9 Benjamin Henry Latrobe. *View of Richmond Showing Jefferson's Capitol from Washington Island.* **1796.** Watercolor on paper, ink and wash, 7″ × 10 3/8″. Maryland Historical Society, Baltimore. No view of an American capitol in the eighteenth century better captures the almost audacious aspirations of the new nation.

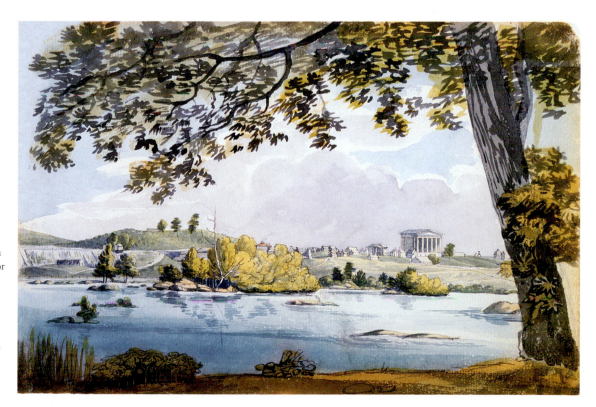

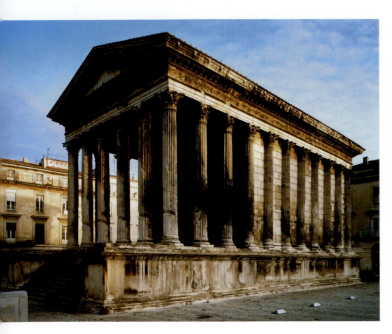

Fig. 31.10 Maison Carrée, Nîmes, France. Early 2nd century CE. The six Corinthian columns across the front of this ancient temple may also have inspired the entrance to Monticello.

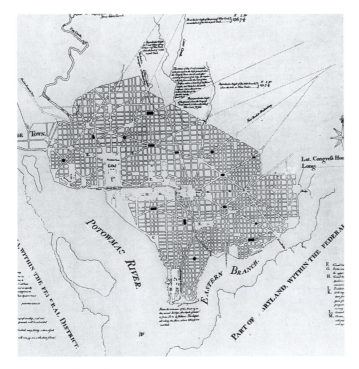

Fig. 31.11 Pierre Charles L'Enfant. Plan for Washington, DC (detail). 1791. Published in the *Gazette of the United States*, Philadelphia, January 4th 1792. The Bridgeman Art Library. Engraving after the original drawing, Library of Congress, Washington, DC. The architect, L'Enfant, had served as a volunteer in the Revolutionary War. He also designed Federal Hall in New York City, which hosted the first Continental

the first century BCE (Fig. 31.10). The view of Richmond by Jefferson's disciple, architect Benjamin Henry Latrobe [lah-TROHB] (1764–1820), gives some idea of the lack of harmony between the American landscape, in all its rustic and undeveloped expanse, and Jefferson's Neoclassical and highly cultivated vision. To prevent other such incongruities, Jefferson had proposed in 1785 that Congress pass a land ordinance requiring all new communities to be organized according to a grid. The measure—actually a call to order—resulted in a regular system of land survey across the American continent. It effectively installed a Neoclassical pattern on the American landscape.

The nation's new capitol in Washington, D.C., would, however, modify Jefferson's rectilinear scheme. President Washington believed that the swampy, humid site along the Potomac River required something more magnificent, so he hired Major Pierre Charles L'Enfant [lahn-FAHN] (1754–1825) to create a more ambitious design. The son of a court painter at Versailles, L'Enfant had emigrated to America from Paris in 1776 to serve in the Continental army. His plan (Fig. 31.11) is a conscious echo of the diagonal approaches and garden pathways at Versailles (see Fig. 27.4), superimposed upon Jefferson's grid. The result is an odd mixture of angles and straightaways that mirrored, though unintentionally, the complex workings of the new American state. Visiting in 1842, a half century later, English novelist Charles Dickens would be struck by the city's absurdity: "Spacious avenues . . . begin in nothing, and lead nowhere; streets, mile-long, that only want houses, roads, and inhabitants; public buildings that need but a public to be complete." It was, he wrote, a city of "Magnificent Intentions," as yet unrealized. Like the Latrobe painting of the capitol in Richmond, the city somewhat oddly combined Neoclassical cultivation with

Continuity & Change
p. 169

Corinthian capital

what might be called rural charm. Latrobe, in fact, was hired to rebuild the Capitol Building after the British burned it during the War of 1812. He invented a new design for the capitals of the Corinthian columns in the vestibule and rotunda of the Senate wing, substituting corncobs and tobacco for the Corinthian's acanthus leaves (Fig. 31.12).

Neoclassical Sculpture in America

During Jefferson's stay in France as minister to the court of Louis XVI, he became acquainted with the work of the two great Neoclassical sculptors of the day, the Italian Antonio Canova (1757–1822) and his French rival Jean-Antoine Houdon [oo-DOHN] (1741–1828). At Jefferson's recommendation, the Virginia Assembly commissioned Houdon in 1785 to create a full-length marble statue of George Washington for the Virginia State Capitol at Richmond. Convinced that a true likeness could only be achieved from life, Jefferson insisted that Houdon sail to America from France.

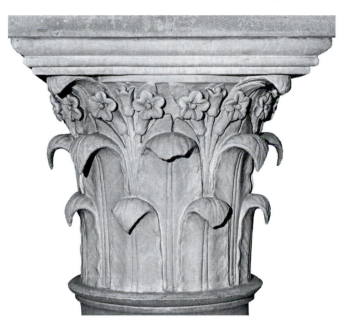

Fig. 31.12 **Benjamin Henry Latrobe. Tobacco Leaf Capital for the U.S. Capitol, Washington, DC. ca. 1815.** Despite this unique design, Latrobe used more traditional capitals elsewhere in the Capitol. For the Supreme Court area of the building, he designed Doric capitals in proportions similar to those at Paestum (see Fig. 6.1).

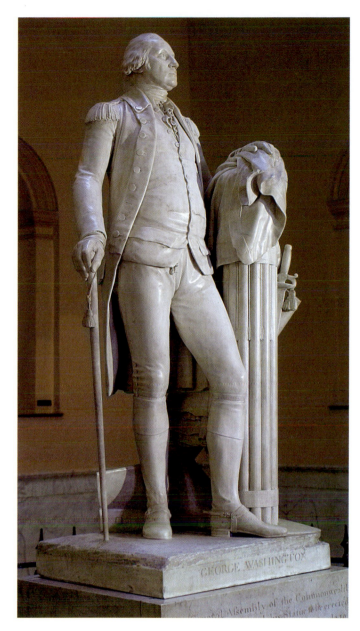

Fig. 31.13 **Jean-Antoine Houdon. *George Washington*. 1788.** Marble, life-size. Virginia State Capitol, Richmond. Houdon also sculpted busts of Benjamin Franklin and Thomas Jefferson.

Houdon traveled to Mount Vernon, Washington's Virginia estate, to make a cast of the general's bust in plaster; the rest of the body would be created from traditional plaster models. He finished the sculpture in Paris in 1788, the year before Washington's inauguration as the first president of the United States (Fig. **31.13**). Although Washington wears contemporary clothing, Houdon presents him as Cincinnatus [sin-sih-NAH-tus], the ancient Roman general who had returned to farming after a life of military service for his country, in the same way that the Roman poet Horace had done (see chapter 8). The medal of the Order of Cincinnatus, an organization created by retiring officers after the Revolutionary War, projects from under Washington's waistcoat. He leans against a column of 13 *fasces*, or rods, symbols of Roman political office as well as the 13 colonies of the new nation. Behind him is a plowshare, beaten from a sword, signifying his role as a warrior who has brought peace and prosperity to his people. Washington's relaxed contrapposto pose and serene but dignified facial expression derive from classical statues and suggest the high moral purpose, or *gravitas*, of a Roman senator; they successfully link the father of his country—*pater patriae*, "father of the fatherland"—with the ancient leaders who preceded him.

Continuity & Change
p. 242

Head of a Man

Years later, when the North Carolina legislature decided to place a sculpture of Washington in the rotunda of their state house, Jefferson recommended another sculptor, Canova. Jefferson insisted that the sculpture should depict Washington as a Roman senator, since, he wrote, "Our boots and regimentals have a very puny effect." Since the hall of the capitol in Raleigh was only 16 feet high, Washington was to be seated, attired in senatorial toga and sandals, signing the letter relinquishing command of the army, his sword at his feet. The sculpture stood in the capitol for 10 years, until a fire destroyed both. But early in the twentieth century, Canova's original model was discovered and the Italian government donated the plaster replica to North Carolina.

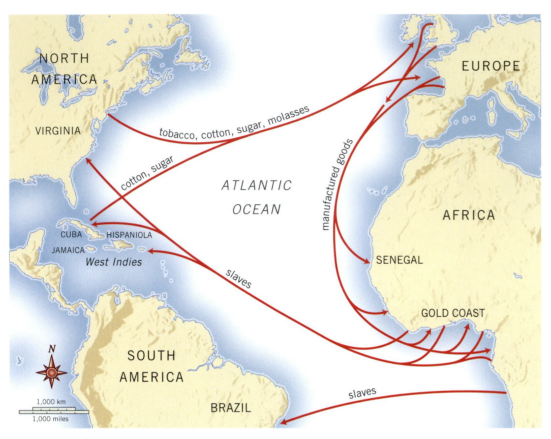

Map 31.2 The slave trade triangle.

And the American taste for Neoclassical art, epitomized by Wedgwood's assertion that for "North America we cannot make anything too rich and costly," was in very large part made possible by the slave trade.

No nation had profited more from the slave trade than England. It had been late to get into the business, leaving it largely to the Portuguese until 1672. By then, the English government needed labor for its sugar plantations in the Caribbean and its tobacco plantations in Virginia. England chartered the Royal African Company, granting it a monopoly in the slave trade. From 1680 to 1686, the company traded approximately 5,000 slaves a year. In 1698, Parliament yielded to the demands of English merchants eager to share in the Royal African Company's profits and opened the slave trade to all. The trafficking of African slaves on English ships increased four-fold to an average of more than 20,000 a year, and by the start of the eighteenth century, England's was the largest slave trade in the world.

Throughout the eighteenth century, slaves continued to be sold in Britain, especially in Bristol and Liverpool, which the trade had turned into boom towns. In fact, it became fashionable among aristocratic British women to have a black child servant. (See the black child at the lower right-hand corner of the *The Countess's Levée* in Hogarth's *Marriage à la Mode* series, Fig. 28.6.)

The Issue of Slavery

The high-minded idealism reflected in the American adoption of Neoclassicism in its art and architecture was clouded, from the outset, by the issue of slavery. In the debates leading up to the revolution, slavery had been lumped into the debate over free trade. Americans had protested not only the tax on everyday goods shipped to the colonies from Britain, including glass, paint, lead, paper, and tea, but the English monarchy's refusal to allow the colonies to trade freely with other parts of the world, and that included trade in enslaved Africans.

The Atlantic slave trade followed an essentially triangular pattern (see Map **31.2**). Europe exported goods to Africa, where they were traded for African slaves (see chapter 23), who were then taken to the West Indies and traded for sugar, cotton, and tobacco; these goods were then shipped either back to Europe or north to New England for sale. Since the slaves provided essentially free labor for the plantation owners, these goods, when sold, resulted in enormous profits. Although a port like Boston might seem relatively free of the slave trade, Boston's prosperity and the prosperity of virtually every other port on the Atlantic depended on slavery as an institution.

Autobiographical and Fictional Accounts of Slavery

The conditions on board slave ships have been described by Olaudah Equiano [ay-kee-AH-noh], a native of Benin [ben-EEN], in West Africa, who was kidnapped and enslaved in 1756 at age 11 (Fig. **31.14**). Freed in 1766, he traveled widely, educated himself, and mastered the English language. In his autobiography, published in England in 1789 (see **Reading 31.3**, pages 1017–1019, for a fuller account of this passage), he describes the transatlantic journey (**Reading 31.3a**):

Voices

Former Slaves Petition for Tax Relief

By the late eighteenth century, the United States had a substantial number of freed slaves living in northern states and cities. Many were skilled craftsmen or businessmen who yearned to have the broad-based freedoms heralded by the American Revolution. In 1780, Paul Cuffe, a free black seaman and active Quaker, wrote to the government of Massachusetts. His letter notes that, although he and the other petitioners cannot vote, they are heavily taxed.

To the Honorable Council and House of Representatives, in General Court assembled, for the State of the Massachusetts Bay, in New England:

The petition of several poor negroes and mulattoes, who are inhabitants of the town of Dartmouth, humbly showeth,—

That we being chiefly of the African extract, and by reason of long bondage and hard slavery, we have been deprived of enjoying the profits of our labor or the advantage of inheriting estates from our parents, as our neighbors the white people do, having some of us not long enjoyed our own freedom; yet of late, contrary to the invariable custom and practice of the country, we have been, and now are, taxed both in our polls and that small pittance of estate which, through much hard labor and industry, we have got together to sustain ourselves and families withall. We apprehend it, therefore, to be hard usage, and will doubtless (if continued) reduce us to a state of beggary, whereby we shall become a burthen to others, if not timely prevented by the interposition of your justice and your power.

> **"[W]hile we are not allowed the privilege of freemen . . . , having no vote or influence in the election of those that tax us, yet many of our colour . . . have cheerfully entered the field of battle in the defence of the common cause."**

Your petitioners further show, that we apprehend ourselves to be aggrieved, in that, while we are not allowed the privilege of freemen of the State, having no vote or influence in the election of those that tax us, yet many of our colour (as is well known) have cheerfully entered the field of battle in the defence of the common cause, and that (as we conceive) against a similar exertion of power (in regard to taxation), too well known to need a recital in this place.

We most humbly request, therefore, that you would take our unhappy case into your serious consideration, and, in your wisdom and power, grant us relief from taxation, while under our present depressed circumstances; and your poor petitioners, as in duty bound, shall ever pray, &c.

John Cuffe,
Adventur Child,
Paul Cuffe,
Samuel Gray, X his mark.
Pero Howland, X his mark.
Pero Russell, X his mark.
Pero Coggeshall.
Dated at Dartmouth, the 10th of February, 1780.

READING 31.3a **from Olaudah Equiano,** ***The Interesting Narrative of the Life of Olaudah Equiano, or Gustavus Vassa the African* (1789)**

The stench of the hold while we were on the coast [of Africa] was so intolerably loathsome that it was dangerous to remain there for any time, and some of us had been permitted to stay on the deck for the fresh air, but now that the whole ship's cargo were confined together it became absolutely pestilential. The closeness of the place and the heat of the climate, added to the number in the ship, which was so crowded that each had scarcely room to turn himself, almost suffocated us. This produced copious perspirations, so that the air soon became unfit for respiration from a variety of loathsome smells, and brought on a sickness among the slaves, of which many died, thus falling victims to the improvident avarice, as I may call it, of their purchasers. This wretched situation was again aggravated by the galling of the chains, now become insupportable; and the filth of the necessary tubs, into which the children often fell and were almost suffocated. The shrieks of the women and the groans of the dying soon rendered the whole a scene of horror almost inconceivable.

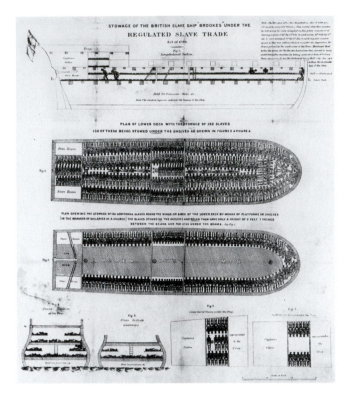

Fig. 31.14 *Stowage of the British Slave Ship "Brookes" Under the Regulated Slave Trade (Act of 1788). 1788.* Conditions on slave ships were appalling. Food was bad, space so cramped that movement was virtually impossible, and disease devastating.

Recent biographical discoveries cast doubt on Equiano's claim that he was born and raised in Africa and that he endured the Middle Passage (the name given to the slave ships' journey across the Atlantic Ocean) as he describes. Baptismal and naval records suggest, instead, that he was born around 1747 in South Carolina. Still, if Equiano did fabricate his early life, it appears that he did so based on the verbal accounts of his fellow slaves, for the story he tells, when compared to other sources, is highly accurate. Whatever the case, Equiano's book became a bestseller among the over 100 volumes on the subject of slavery published the same year, and it became essential reading for the ever-growing abolitionist movement in both England and the Americas.

The lot of the slaves, once they were delivered to their final destination, hardly improved. One of the most interesting accounts is *Narrative of a Five Years' Expedition against the Revolted Negroes of Surinam, in Guiana, on the Wild Coast of South America, from the Year 1772 to 1777*, written by John Gabriel Stedman (1747–1797) and illustrated by William Blake (1757–1827) (Figs. **31.15, 31.16**). Blake was already an established engraver and one of England's leading poets (see *Focus*, pages 1012–1013). Stedman had been hired by the Dutch to suppress rebel slaves in Guiana, but once there, he was shocked to see the conditions the slaves were forced to endure. Their housing was deplorable, but worse, they

were routinely whipped, beaten, and otherwise tortured for the nonperformance of impossible tasks, as a means of instilling a more general discipline. Female slaves endured sexual abuses that were coarse beyond belief. The planters maintained what amounted to harems on their estates and freely indulged their sexual appetites.

Even as Stedman moved on from Guiana to Surinam, Phyllis Wheatley (ca. 1753–1784) became the first black American to publish a book. Wheatley had been kidnapped as a child in Senegal and raised in Boston by John Wheatley along with his own children, where she was also a maid servant to Wheatley's wife. Wheatley had begun writing poems when she was 13 and was regarded as a prodigy in Boston. When she went to England with the Wheatleys in 1773 she achieved great popularity, perhaps most of all because she seemed to have so thoroughly accepted and adopted the attitudes of her new culture. It was in England that she published her *Poems on Various Subjects: Religious and Moral* in 1773.

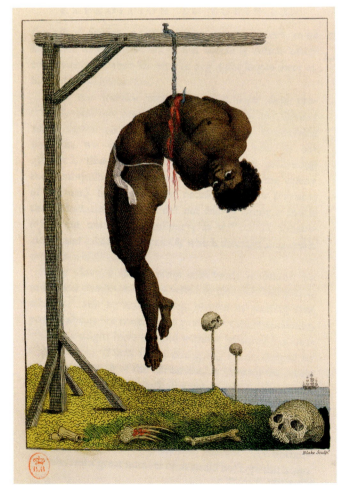

Fig. 31.15 William Blake. *Negro Hung Alive by the Ribs to a Gallows,* engraved illustration to John Gabriel Stedman's *Narrative of a Five Years' Expedition against the Revolted Slaves of Surinam. . . 1796.* Library of Congress, Catalog no. 1835. Private Collection, Archives Charmet/The Bridgeman Art Library. Blake executed the etchings for Stedman's volume after original drawings by Stedman himself. Stedman was impressed that the young man being tortured here stoically endured the punishment in total silence.

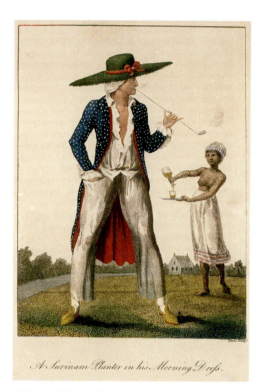

Fig. 31.16 William Blake. *A Surinam Planter in His Morning Dress*, engraved illustration to John Gabriel Stedman's *Narrative of a Five Years' Expedition against the Revolted Slaves of Surinam. . .* 1796. Library of Congress, Catalog no. 1835. Of the plantation owners, Stedman wrote: "Such absolute power . . . cannot help but be peculiarly delightful to a man who was, in all probability, in his own country, Europe, a nothing."

Most of Phyllis Wheatley's poems reflect her religious and classical New England upbringing and stress the theme of Christian salvation. She accepts her plight as divinely ordained, but in one of her poems she argues for equality with others and the ability of her race to attain the "refinement" of her European contemporaries. The poem, in fact, reflects what many in America and Britain, both pro-slavery and abolitionist, would hold up as the ideal aspiration of all African-Americans (**Reading 31.4**):

READING 31.4 **Phyllis Wheatley, "'Twas mercy brought me from my Pagan land" (1773)**

'TWAS mercy brought me from my Pagan land,
Taught my benighted soul to understand
That there's a God, and there's a Saviour too:
Once I redemption neither sought nor knew.
Some view our sable race with scornful eye,
"Their color is a diabolic die [dye]."
Remember, Christians, Negros, black as Cain,
May be refin'd, and join th' angelic train.

CULTURAL PARALLELS

The Dream of Freedom

During the late 1780s, as American revolutionaries labored to form a government and the French drew closer to open insurrection, a region of coastal West Africa reflected the turmoil surrounding the issue of slavery and the idea of freedom. Freed slaves from North America, England, Canada, and Jamaica founded a new colony, and eventually a new city called Freetown (present-day Sierra Leone), in an area formerly occupied by a slave market. They had help from British abolitionists and effectively created a new British colony, one that suffered attacks from the French and a revolt of indigenous inhabitants in the 1790s.

Soon after Phyllis Wheatley returned home from England, she was given her freedom. The beneficent treatment of Wheatley is, however, rare in the annals of American slavery, and more often than not, the Christianity of the kind she adopted and her acceptance of its values were seen by other slaves as hypocritical, even as a betrayal of her race. As Olaudah Equiano put it in his autobiography (see Reading 31.3): "O, ye nominal Christians! might not an African ask you—learned you this from your God, who says unto you, Do unto all men as you would men should do unto you?"

One of the earliest accounts of slavery is the short novel *Oroonoko* by Aphra Behn (1640–1689) published in 1688. As author of 20 plays for the stage, Behn was the first woman in the Western world to have made her living as a writer. *Oroonoko* tells the story of an African prince and the woman he loves, both of whom are sold separately into slavery and carried to Surinam, where Behn, a white woman, had lived for a time and where the British had begun importing slaves for the sugar cane plantations. In Surinam the two lovers are reunited, and Oroonoko, exerting his royal nature, organizes a slave revolt, for which he is punished by the deputy governor with public execution by dismemberment. Although Behn never criticizes slavery as an institution, she portrays her hero as a natural king and clearly superior to the whites around him (see **Reading 31.5**, page 1019).

Like Stedman, Behn is conflicted about her relationship to slavery. Although she was a lifelong militant royalist and opposed to democracy in favor of a strong king, she clearly identified as a woman with her hero's oppression by a sadistic deputy governor. But she was equally convinced of her own English culture's social superiority, even if some of her kind were capable of the Surinam deputy governor's act of atrocity.

Focus

Blake's "The Little Black Boy" and "The Chimney Sweeper"

William Blake's first important book of poems is *Songs of Innocence* (1789). Five years later, he combined it with *Songs of Experience*, subtitling the combined edition *Shewing the Two Contrary States of the Human Soul*. All of the poems are illustrated by Blake himself. The *Songs of Innocence* are decidedly upbeat, spiritually uplifting even, whereas the *Songs of Experience* are darker reflections of an age torn by revolution and social blight. For the most part, the poems are written in plain language in seemingly straightforward narrative style. Yet the complexity of each poem is revealed the more one studies it, especially in relation to the other poems in the volume.

The abolitionist poem "The Little Black Boy," from *Songs of Innocence*, is a case in point. The poem is the monologue of a black child slave taken from his mother in Africa, recalling the lessons she taught him there. The mother's lesson is filled with traditional Christian symbolism that Blake's audience would have quickly recognized.

Blake's intentions are underscored by the poem's relation to others in the volume, particularly "The Chimney Sweeper," a short, three-stanza Song of Experience. The chimney sweeper is one of many children working in London in Blake's time who crawled naked down chimneys to clean them. The poem's first stanza refers to a white boy covered with soot, standing naked in the snow.

> A little black thing among the snow:
> Crying weep, weep, in notes of woe!
> Where are they father & mother? say?
> they are both gone up to the church to pray.

The image resonates remarkably with the "little black boy" of the earlier poem. But the contrast of black and white, especially in the second stanza, becomes ominous:

> Because I was happy upon the heath,
> And smil'd among the winters snow;
> They clothed me in the clothes of death,
> And taught me to sing the notes of woe.

Finally, it is the poem's third and final stanza that most connects the sweeper to the little black boy of the Songs of Innocence.

> And because I am happy, & dance & sing,
> They think they have done me no injury:
> And are gone to praise God & his Priest & King
> Who make up a heaven of our misery.

The key word here is *our*—"our misery," the misery of all oppressed people. The British slave trade, Blake knew, was the basis of British wealth and power. The earthly "heaven" of the English clergy and nobility is built upon the misery and oppression of workers and slaves. The innocence depicted in "The Little Black Boy" is lost here to the realities of human experience.

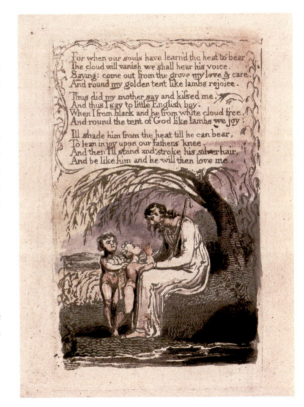

William Blake, *The Little Black Boy*, plate #6 of *Songs of Innocence* (1789). Courtesy of Dover Publications, Inc. Yale Center for British Art, Paul Mellon Collection, USA. The Bridgeman Art Library. Hand-colored relief etching This is the second page and last three stanzas of the poem as published by Blake, who illuminated each poem with one or two etchings created through a process of his own invention. First, he designed each poem with its illustrations, transferred his picture to a copper plate in an acid-resistant medium, and then etched away the remaining surface. He then made black ink impressions of the images on paper and hand-colored each page of each work. Blake understood poem and image to be intimately tied together. He believed that the human psyche was divided—a division that manifested itself not only in personal ways but in political and social divisiveness as well. By bringing the visual and verbal together, he believed he was unifying the conflicting impulses of human consciousness.

The Little Black Boy

My mother bore me in the southern wild,
 And I am black, but O, my soul is white!
White as an angel is the English child,
 But I am black, as if bereaved of light.

My mother taught me underneath a tree,
 And, sitting down before the heat of day,
She took me on her lap and kissed me,
 And, pointing to the East, began to say:

'Look at the rising sun: there God does live,
 And gives His light, and gives His heat away,
And flowers and trees and beasts and men receive
 Comfort in morning, joy in the noonday.

'And we are put on earth a little space,
 That we may learn to bear the beams of love;
And these black bodies and this sunburnt face
 Are but a cloud, and like a shady grove.

'For when our souls have learned the heat to bear,
 The cloud will vanish; we shall hear His voice,
Saying, 'Come out from the grove, my love and care,
 And round my golden tent like lambs rejoice.'

Thus did my mother say, and kissed me,
 And thus I say to little English boy.
When I from black and he from white cloud free,
 And round the tent of God like lambs we joy,

I'll shade him from the heat till he can bear
 To lean in joy upon our Father's knee;
And then I'll stand and stroke his silver hair,
 And be like him, and he will then love me.

Annotations:

Africa

The black child sees himself as "bereaved"—that is, deprived—"of light." "Light" here is symbolically, from a Christian point of view, the light of God, Christianity itself, but it may also be the Enlightenment's "light of reason."

The "rising sun" would be understood by a Christian to refer to "the rising son," Jesus Christ. The season here, from its "flowers and trees" to the "heat of day," evokes the Easter season.

That is, in Christian symbolism, toward Jerusalem.

And yet, for all the Christian imagery of the poem, Blake knew that African peoples had easily adapted the Christian message to their own beliefs. There is, in fact, nothing necessarily Christian about the mother's lesson. She may as well be speaking of a deity connected with the worship of the Sun.

In Christian understanding, mother and child identify themselves here with Christ, the "Lamb of God" (*Agnus Dei* in Latin).

Whatever his mother might have meant by "lambs" in her lesson to the boy, by now, in an English household, he understands "lambs" in a Christian sense.

This is the poem's darkest moment, revealing it to be a poem of longing. The boy longs for the love of his long-lost mother, he longs for the love of God, but he longs most of all for the love of his master. In all this, it is also a poem of indescribable loneliness.

1013

The Economic Argument for Slavery
and Revolution: Free Trade

In an odd conflict of interests and allegiances, slavery pitted abolitionist sentiments against freethinking economic theory. Free-trade economists, such as Adam Smith (1723–1790), would argue that people should be free to do whatever they might to enrich themselves. Thus Smith would claim that a *laissez-faire* [lay-say-FAIR], "let it happen as it will," economic policy was the best. "It is the maxim of every prudent master of a family," Smith wrote in *The Wealth of Nations*, published in 1776, "never to make at home what it will cost him more to make than to buy. . . . What is prudence in the conduct of every private family, can scarce be folly in that of a great kingdom. If a foreign country can supply us with a commodity cheaper than we ourselves can make it, better buy it of them." Labor, it could be argued, was just such a commodity and slavery its natural extension. At the same time, ironically, Smith was against the very tariffs and taxes that England had imposed on its colonies. He argued that free trade among nations, which the British had denied the colonies by asserting their own right to the accumulation of wealth over and above that of the colonists, should be the basis of economic policy.

Thus, in 1776, the arguments both for and against slavery as an institution seemed, to many people, to balance each other out. Economics and practicality favored the

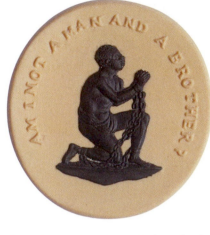

Fig. 31.17 William Hackwood, for Josiah Wedgwood. "*Am I Not a Man and a Brother?*" 1787. Black-and-white jasperware, $1\frac{3}{8}$" × $1\frac{3}{8}$". The Wedgwood Museum, Barlaston, Staffordshire, England. The image illustrated Erasmus Darwin's poem, "The Botanic Garden," which celebrates not only the natural world, but also the rise of British manufacturing at the dawn of the Industrial Revolution. The poem nevertheless severely criticized British involvement in the slave trade, which it deemed highly "unnatural."

practice of slavery, while human sentiment and, above all, the idea of freedom, denied it. Although at the time he wrote the Declaration of Independence, Jefferson himself owned about 200 slaves and knew that other Southern delegates supported slavery as necessary for the continued growth of their agricultural economy, in his first draft he had forcefully repudiated the practice. Abigail Adams (1744–1818), who, like her husband John, knew and respected Jefferson, but unlike him owned no slaves, was equally adamant on the subject: "I wish most sincerely," she wrote her husband in 1774, as he was attending the First Continental Congress in Philadelphia, "that there was not a slave in the province. It always seemed a most iniquitous scheme to me—fight for ourselves what we are daily robbing and plundering from those who have as good a right to freedom as we have."

The Abolitionist Movement in Britain and America

Many Britons, looking from across the Atlantic at the American Revolution, shared Abigail Adams's sentiments. As long as the colonies tolerated slavery, their demand for

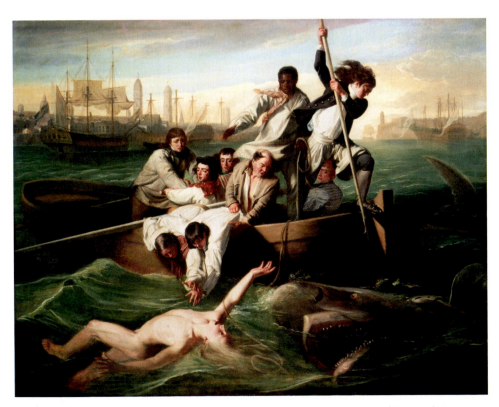

Fig. 31.18 John Singleton Copley. *Watson and the Shark*. 1778. Oil on canvas, $71\frac{3}{4}$" × $90\frac{1}{2}$". Museum of Fine Arts, Boston. Ferdinand Lammot Belin Fund. Photograph © 2006 Board of Trustees, National Gallery. The shark-infested waters are perhaps a metaphor for slavery itself, especially since it was well known that some slave traders threw slaves overboard into shark-infested waters in order to collect insurance.

their own liberty seemed hypocritical. The English poet Thomas Day (1748–1789) described the typical American as "signing resolutions of independence with one hand, and with the other brandishing a whip over his affrighted slaves."

Abolitionist opposition to slavery in both England and the American colonies began to gain strength in 1771 when Granville Sharp pled the case of an escaped American slave, James Somerset, before the Lord Chief Justice, Lord Mansfield. Somerset's American owner had recaptured him in England, but the Lord Chief Justice set Somerset free, ruling that the laws governing another country carried no weight in England. Leading the fight against slavery were the Quakers as well as the members of the Lunar Society (see chapter 28). In 1787, Josiah Wedgwood made hundreds of ceramic cameos of a slave in chains, on bent knee, pleading, "Am I Not a Man and a Brother?" (Fig. **31.17**). He distributed them widely, and the image quickly became the emblem for the abolitionist movement as a whole. In Philadelphia, Benjamin Franklin, president of the Philadelphia Abolitionist Society, received a set.

The sentiments of Wedgwood's cameo find expression even in paintings that seem to have no direct reference to slavery. *Watson and the Shark* by John Singleton Copley (1738–1815) is a case in point (Fig. **31.18**). The painting was commissioned by its subject, Brook Watson, a wealthy English merchant and Tory leader who was deeply opposed to slavery. As a young man, in 1749, Watson had lost his leg when a shark attacked him as he swam in Havana harbor. The ship he had been serving on had been involved with the triangular slave trade described earlier. It carried timber, dried fish, and other goods from Boston to Africa, where it had exchanged this merchandise for slaves, who were in turn traded in the West Indies for sugar and molasses, commodities then brought back to Boston. Even as Copley was at work on this painting, Watson was attacking the colonists in Parliament for the hypocrisy of their position. The black man who forms the focus of the composition serves an interesting purpose. Though the man's attitude seems ambiguous—as if not quite sure he should go so far as to save a white man—he holds the lifeline that has been thrown to Watson. Their relationship is thus affirmed, even as its complexities and tensions are openly acknowledged.

The African Diaspora

All told, about 14 million Africans survived the Atlantic crossing, the largest forced scattering of a peo-

ple in history and now known as the **African diaspora**. In some places, particularly in Brazil and the Caribbean, people from the same African homelands and speaking the same language were gathered together on plantations, where they were able to revive and continue cultural practices from their native lands. For instance, the Haitian religious practice known as Vodou combines recognizable elements from Yoruba, Kongo, and Dahomey. (The commonly used term, Voodoo, is considered offensive by practicing communities.) But in North America, slaveholders made a conscious effort to gather together only Africans of differing cultural and linguistic backgrounds, believing this would reduce the possibility of rebellion. Still, many forms of African culture survived. A late eighteenth-century painting of the Mulberry Plantation in South Carolina (Fig. **31.19**) depicts slave houses with steeply pitched roofs similar to the thatched roof houses of the same era found in West Africa. The roof comprises over half the height of the house, allowing warm air to rise in the interior and trapping cooler air beneath it—a distinct advantage in the hot climate of both Africa and the Carolinas.

Fig. 31.19 Thomas Coram. *View of Mulberry House and Street*. ca. 1800. Oil on paper. Carolina Art Association, 1968.1968.18.01. Gibbes Museum of Art, Charleston, SC. The steep-pitched roofs of the slave quarters allowed rain to wash rapidly off the roof, a fact that in Africa helped prevent the thatched roofs from leaking.

The cultural form that most thoroughly survived the African diaspora was music. Sub-Saharan African cultures, despite their enormous size and diversity, all shared certain fundamental characteristics. Almost all of these cultures played drums, in an array of rhythms and tones that may involve several rhythms produced simultaneously or two or more interwoven melodies (see chapter 23). In addition, almost all of these cultures played one form or another of **mbira** [em-BEER-ah], an instrument made of a small wooden box or gourd that acts as a resonator, attached to which is a row of thin metal strips that vibrate when plucked. Music performed on the drum or the mbira is largely improvisational, each performance involving a lengthy combination of repetition and gradual variation. Like drum music, mbira music displays the African fascination with complex rhythms and melodies (see **CD-Track 31.1**). In the mbira musical selection on the CD, two traditional songs of the Shona people of Zimbabwe, the widely popular *Chemutengure* and *Mudendero* (a children's song accompanying circle games), combine in a slow pattern of repetition and gradual variation. In this we can hear the patterns and movements that would, in the West, survive in American jazz.

READINGS

James Madison, *Federalist No. 10* (1787)

The Federalist is a series of 85 essays written by Alexander Hamilton, John Jay, and James Madison during the months following the adoption of the constitution by the Federal Convention on October 27, 1787. Thomas Jefferson would call the essays "the best commentary on the principles of government, which was ever written," and he would make them required reading at the University of Virginia. Subsequent generations have determined them to be equally important. As early as 1819, John Marshall, Chief Justice of the U.S. Supreme Court, cited them as an important source of judicial understanding of the Constitution's intent, and federal judges continue to refer to them to this day. In Federalist No. 10, Madison takes on the question of factions and how a government must address them.

Friday, November 23, 1787.
To the people of the State of New York:

Among the numerous advantages promised by a well-constructed Union, none deserved to be more accurately developed than its tendency to break and control the violence of faction. . . .

By a faction, I understand a number of citizens, whether amounting to a majority or a minority of the whole, who are united and actuated by some common impulse of passion, or of interest, adversed to the rights of other citizens, or to the permanent and aggregate interests of the community.

There are two methods of curing the mischiefs of faction: the one, by removing its causes; the other, by controlling its effects.

There are again two methods of removing the causes of faction: the one, by destroying the liberty which is essential to its existence; the other, by giving to every citizen the same opinions, the same passions, and the same interests.

It could never be more truly said than of the first remedy, that it was worse than the disease. Liberty is to faction what air is to fire, an aliment[1] without which it instantly expires. But it could not be less folly to abolish liberty, which is essential to political life, because it nourishes faction, than it would be to wish the annihilation of air, which is essential to animal life, because it imparts to fire its destructive agency.

The second expedient is as impracticable as the first would be unwise. As long as the reason of man continues fallible, and he is at liberty to exercise it, different opinions will be formed. As long as the connection subsists between his reason and his self-love, his opinions and his passions will have a reciprocal influence on each other; and the former will be objects to which the latter will attach themselves. The diversity in the faculties of men, from which the rights of property originate, is not less an insuperable obstacle to a uniformity of interests. The protection of these faculties is the first object of government. From the protection of different and unequal faculties of acquiring property, the possession of different degrees and kinds of property immediately results; and from the influence of these on the sentiments and views of the respective proprietors, ensues a division of the society into different interests and parties.

The latent causes of faction are thus sown in the nature of man; and we see them everywhere brought into different degrees of activity, according to the different circumstances of civil society. A zeal for different opinions concerning religion, concerning government, and many other points, as well of speculation as of practice; an attachment to different leaders ambitiously contending for pre-eminence and power; or to persons of other descriptions whose fortunes have been interesting to the human passions, have, in turn, divided mankind into parties, inflamed them with mutual animosity, and rendered them much more disposed to vex and oppress each other than to co-operate for their common good. So strong is this propensity of mankind to fall into mutual animosities, that where no substantial occasion presents itself, the most frivolous and fanciful distinctions have been sufficient to kindle their unfriendly passions and excite their most violent conflicts. But the most common and durable source of factions has been the various and unequal distribution of property. Those who hold and those who are without property have ever formed distinct interests in society. Those who are creditors, and those who are debtors, fall under a like discrimination. A landed interest, a manufacturing interest, a mercantile interest, a moneyed interest, with many lesser interests, grow up of necessity in civilized nations, and divide them into different classes, actuated by different sentiments and views. The regulation of these various and interfering interests forms the principal task of modern legislation, and involves the spirit of party and faction in the necessary and ordinary operations of the government. . . .

The inference to which we are brought is, that the CAUSES of faction cannot be removed, and that relief is only to be sought in the means of controlling its EFFECTS. . . .

A republic, by which I mean a government in which the scheme of representation takes place, opens a different prospect, and promises the cure for which we are seeking. Let us examine the points in which it varies from pure democracy, and we shall comprehend both the nature of the cure and the efficacy which it must derive from the Union.

The two great points of difference between a democracy and a republic are: first, the delegation of the government, in the latter, to a small number of citizens elected by the rest; secondly, the greater number of citizens, and greater sphere of country, over which the latter may be extended.

The effect of the first difference is, on the one hand, to refine and enlarge the public views, by passing them through

[1]Nutriment.

the medium of a chosen body of citizens, whose wisdom may best discern the true interest of their country, and whose patriotism and love of justice will be least likely to sacrifice it to temporary or partial considerations. . . .

It must be confessed that in this, as in most other cases, there is a mean, on both sides of which inconveniences will be found to lie. By enlarging too much the number of elec- 90 tors, you render the representatives too little acquainted with all their local circumstances and lesser interests; as by reducing it too much, you render him unduly attached to these, and too little fit to comprehend and pursue great and national objects. The federal Constitution forms a happy combination in this respect; the great and aggregate interests being referred to the national, the local and particular to the State legislatures.

The other point of difference is, the greater number of citizens and extent of territory which may be brought within the 100 compass of republican than of democratic government; and it is this circumstance principally which renders factious combinations less to be dreaded in the former than in the latter. The smaller the society, the fewer probably will be the distinct parties and interests composing it; the fewer the distinct parties

and interests, the more frequently will a majority be found of the same party; and the smaller the number of individuals composing a majority, and the smaller the compass within which they are placed, the more easily will they concert and execute their plans of oppression. Extend the sphere, and you take in a 110 greater variety of parties and interests; you make it less probable that a majority of the whole will have a common motive to invade the rights of other citizens; or if such a common motive exists, it will be more difficult for all who feel it to discover their own strength, and to act in unison with each other. Besides other impediments, it may be remarked that, where there is a consciousness of unjust or dishonorable purposes, communication is always checked by distrust in proportion to the number whose concurrence is necessary.

Hence, it clearly appears, that the same advantage which 120 a republic has over a democracy, in controlling the effects of faction, is enjoyed by a large over a small republic,—is enjoyed by the Union over the States composing it. . . . ■

Reading Question

How does the size of a given republic come to bear on Madison's argument?

READING 31.3

from *The Interesting Narrative of the Life of Olaudah Equiano* (1789)

The following passage concludes chapter 2 of Equiano's autobiography, entitled "Kidnapping and Enslavement," and it describes Equiano's passage to the Americas. Born in Benin, Equiano reports that he was first kidnapped (by fellow Africans) at the age of 11 and sold repeatedly to a succession of West African tribal families until finally sold to slavers bound for the Americas. Recent research has brought his account into question, but he undoubtedly captures experiences shared by many. The majority of his narrative concerns his life in the Americas, first on a Virginia plantation, then in the service of a British naval officer (who helped educate him), and then as the slave of a Philadelphia merchant, who finally helped him purchase his freedom. By the time he published his autobiography, he was a permanent resident in England, working for the abolition of slavery.

The first object that saluted my eyes when I arrived on the coast was the sea, and a slave ship, which was then riding at anchor, and waiting for its cargo. These filled me with astonishment, that was soon converted into terror, which I am yet at a loss to describe, and much more the then feelings of my mind when I was carried on board. I was immediately handled and tossed up to see if I was sound, by some of the crew; and I was now persuaded that I had got into a world of bad spirits, and that they were going to kill me. Their complexions too, differing so much from ours, their long hair, and 10 the language they spoke, which was very different from any I had ever heard, united to confirm me in this belief. Indeed such were the horrors of my views and fears at the moment, that if ten thousand worlds had been my own, I would have freely parted with them all to have exchanged my condition with the meanest slave in my own country. When I looked round the ship too, and saw a large furnace or copper boiling and a multitude of black people, of every description, chained together, every one of their countenances expressing dejection and sorrow, I no longer doubted of my fate; and, quite over- 20 powered with horror and anguish, I fell motionless on the

deck, and fainted. When I recovered a little, I found some black people about me, who I believed were some of those who brought me on board, and had been receiving their pay: they talked to me in order to cheer me, but all in vain. I asked them if we were not to be eaten by those white men with horrible looks, red faces, and long hair. They told me I was not: and one of the crew brought me a small portion of spirituous liquor in a wine glass; but, being afraid of him, I would not take it out of his hand. One of the blacks therefore took it from him and 30 gave it to me, and I took a little down my palate, which, instead of reviving me, as they thought it would, threw me into the greatest consternation at the strange feeling it produced, having never tasted any such liquor before.

Soon after this the blacks who brought me on board went off, and left me abandoned to despair. I now saw myself deprived of all chance of returning to my native country, or even the least glimpse of gaining the shore, which I now considered as friendly; and I even wished for my former slavery, in preference to my present situation, which was filled with hor- 40 rors of every kind, still heightened by my ignorance of what I was to undergo. I was not long suffered to indulge my grief. I was

soon put down under the decks, and there I received such a salutation in my nostrils as I had never experienced in my life: so that, with the loathsomeness of the stench, and with my crying together, I became so sick and low that I was not able to eat, nor had I the least desire to taste any thing. I now wished for the last friend, death, to relieve me; but soon, to my grief, two of the white men offered me eatables; and, on my refusing to eat, one of them held me fast by the hands, and laid me across, I think, the windlass, and tied my feet, while the other flogged me severely. I had never experienced any thing of this kind before, and although, not being used to the water, I naturally feared that element the first time I saw it, yet nevertheless, could I have got over the nettings, I would have jumped over the side, but I could not; and besides the crew used to watch us very closely, who were not chained down to decks, lest we should leap into the water. I have seen some of these poor African prisoners most severely cut for attempting to do so, and hourly whipped for not eating. This indeed was often the case with myself. In a little time after, amongst the poor chained men, I found some of my own nation, which in a small degree gave ease to my mind. I inquired of these what was to be done with us. They gave me to understand we were to be carried to these white people's country to work for them. I was then a little revived, and thought if it were no worse than working, my situation was not so desperate. But still I feared I should be put to death, the white people looked and acted, as I thought, in so savage a manner; for I had never seen among any people such instances of brutal cruelty: and this is not only shewn towards us blacks, but also to some of the whites themselves. One white man in particular I saw, when we were permitted to be on deck, flogged so unmercifully with a large rope near the foremast, that he died in consequence of it; and they tossed him over the side as they would have done a brute. This made me fear these people the more; and I expected nothing less than to be treated in the same manner. I could not help expressing my fearful apprehensions to some of my countrymen; I asked them if these people had no country, but lived in this hollow place, the ship. They told me they did not, but came from a distant one. 'Then,' said I, 'how comes it, that in all our country we never heard of them?' They told me, because they lived so very far off. I then asked, where their women were: had they any like themselves. I was told they had. And why, said I 'do we not see them?' They answered, because they were left behind. I asked how the vessel could go. They told me they could not tell; but that there was cloth put upon the masts by the help of the ropes I saw, and then the vessel went on; and the white men had some spell or magic they put in the water, when they liked, in order to stop the vessel. I was exceedingly amazed at this account, and really thought they were spirits. I therefore wished much to be from amongst them, for I expected they would sacrifice me; but my wishes were in vain, for we were so quartered that it was impossible for any of us to make our escape.

While we stayed on the coast I was mostly on deck; and one day, to my great astonishment, I saw one of these vessels coming in with the sails up. As soon as the whites saw it, they gave a great shout, at which we were amazed; and the more so as the vessel appeared larger by approaching nearer. At last she came to an anchor in my sight, and when the anchor was let go, I and my countrymen who saw it, were lost in astonishment to observe the vessel stop, and were now convinced it was done by magic. Soon after this the other ship got her boats out, and they came on board of us, and the people of both ships seemed very glad to see each other. Several of the strangers also shook hands with us black people, and made motions with their hands, signifying, I suppose, we were to go to their country; but we did not understand them. At last, when the ship, in which we were, had got in all her cargo, they made ready with many fearful noises, and we were all put under deck, so that we could not see how they managed the vessel.

But this disappointment was the least of my grief. The stench of the hold, while we were on the coast, was so intolerably loathsome, that it was dangerous to remain there for any time, and some of us had been permitted to stay on the deck for the fresh air; but now that the whole ship's cargo were confined together, it became absolutely pestilential. The closeness of the place, and the heat of the climate, added to the number in the ship, being so crowded that each had scarcely room to turn himself, almost suffocated us. This produced copious perspirations, so that the air soon became unfit for respiration, from a variety of loathsome smells, and brought on a sickness among the slaves, of which many died, thus falling victims to the improvident avarice, as I may call it, of their purchasers. This deplorable situation was again aggravated by the galling of the chains, now become insupportable; and the filth of necessary tubs, into which the children often fell, and were almost suffocated. The shrieks of the women, and the groans of the dying, rendered it a scene of horror almost inconceivable. Happily, perhaps, for myself, I was soon reduced so low here that it was thought necessary to keep me almost continually on deck; and from my extreme youth, I was not put in fetters. In this situation I expected every hour to share the fate of my companions, some of whom were almost daily brought upon deck at the point of death, and I began to hope that death would soon put an end to my miseries. Often did I think many of the inhabitants of the deep much more happy than myself; I envied them the freedom they enjoyed, and as often wished I could change my condition for theirs. Every circumstance I met with served only to render my state more painful, and heighten my apprehensions and my opinion of the cruelty of the whites. One day they had taken a number of fishes; and when they had killed and satisfied themselves with as many as they thought fit, to our astonishment who were on the deck, rather than give any of them to us to eat, as we expected, they tossed the remaining fish into the sea again, although we begged and prayed for some as well as we could, but in vain; and some of my countrymen, being pressed by hunger, took an opportunity, when they thought no one saw them, of trying to get a little privately; but were discovered, and the attempt procured for them some very severe floggings.

One day, when we had a smooth sea and moderate wind, two of my wearied countrymen, who were chained together

(I was near them at the time), preferring death to such a life of misery, somehow made through the nettings and jumped into the sea: immediately another quite dejected fellow, who on account of his illness was suffered to be out of irons also followed their example; and I believe many more would very soon have done the same, if they had not been prevented by the ship's crew, who were instantly alarmed. Those of us who were the most active were in a moment put down under the deck; and there was such a noise and confusion amongst the people of the ship as I never heard before, to stop her and get the boat out to go after the slaves. However, two of the wretches were drowned; but they got the other, and afterward flogged him unmercifully, for thus attempting to prefer death to slavery. In this manner we continued to undergo more hardships than I can now relate, hardships which are inseparable from this accursed trade. Many a time we were near suffocation from the want of fresh air, being deprived thereof for days together. This, and the stench of the necessary tubs, carried off many. ■

160

170

Reading Question

Several times in this passage Equiano refers to magic, yet he clearly understands that what he describes is not magical. What is he seeking to convey to the reader and why?

READING 31.5

from Aphra Behn, *Oroonoko, or The Royal Slave* (1688)

Behn's Oroonoko is a "history" written during the time when the novel was just beginning to be defined as a form, and when the word "history" could mean any story true or false. To a certain degree, Behn's history is probably true. She was in the new sugar colony of Surinam, where much of this narrative takes place, in 1664. Whether or not she witnessed a slave rebellion while there, let alone met anyone resembling the displaced African prince Oroonoko is a matter of pure conjecture. We can, though, be certain of her idealization of the "primitive." The following passage, from early in the narrative, describes Oroonoko's many virtues, virtues that more "civilized" Christians often fall short of matching.

I have often seen and convers'd with this great Man and been a Witness to many of his mighty Actions; and do assure my Reader, the most Illustrious Courts cou'd not have produc'd a braver Man, both for Greatness of Courage and Mind, a Judgment more solid, a Wit more quick, and a Conversation more sweet and diverting. He knew almost as much as if he had read much: He had heard of, and admir'd the *Romans*; he had heard of the late Civil Wars in *England*, and the deplorable Death of our great Monarch[1] and wou'd discourse of it with all the Sense, and Abhorrence of the Injustice imaginable. He had an extream good and graceful Mien, and all the Civility of a well-bred great Man. He had nothing of Barbarity in his Nature, but in all Points address'd himself, as if his Education had been in some *European* Court.

This great and just character of *Oroonoko* gave me an extream Curiosity to see him, especially when I knew he spoke *French* and *English*, and that I cou'd talk with him. But though I had heard so much of him, I was as greatly surpriz'd when I saw him, as if I had heard nothing of him; so beyond all Report I found him. He came into the Room, and addresse'd himself to me, and some other Women, with the best Grace in the World. He was pretty tall, but of a Shape the most exact that can be fancy'd: The most famous Statuary cou'd not form the Figure of a Man more admirably turn'd from Head to Foot. His Face was not of that brown, rusty Black which most of that Nation are, but a perfect Ebony, or polish'd Jett. His Eyes were the most awful that cou'd be seen, and very piercing; the White of 'em being like Snow as were his Teeth. His Nose was rising and *Roman*, instead of *African* and flat. His Mouth, the finest shap'd that cou'd be seen; far

10

20

30

from those great turn'd Lips, which are so natural to the rest of the *Negroes*. The whole Proportion and Air of his Face was so noble, and exactly form'd that bating[2] his Colour there cou'd be nothing in Nature more beautiful, agreeable and handsome. There was no one Grace wanting, that bears the Standard of true Beauty: His Hair came down to his Shoulders, by the Aids of Art; which was, by pulling it out with a Quill, and keeping it comb'd; of which he took particular Care. Nor did the Perfections of his Mind come short of those of his Person; for his Discourse was admirable upon almost any Subject; and who-ever had heard him speak, wou'd have been convinc'd of their Errors, that all fine Wit is confin'd to the *White* Men, especially to those of *Christendom*; and wou'd have confess'd that *Oroonoko* was as capable even of reigning well, and of governing as wisely, had as great a Soul, as politick Maxims, and was as sensible of Power as any Prince civiliz'd in the most refin'd Schools of Humanity and Learning, or the most Illustrious Courts.

This Prince, such as I have describ'd him, whose Soul and Body were so admirably adorn'd, was (while yet he was in the Court of his Grandfather) as I said, as capable of Love, as 'twas possible for a brave and gallant Man to be; and in saying that, I have nam'd the highest Degree of Love; for sure, great Souls are most capable of that Passion. ■

40

50

Reading Question

Behn presents Oroonoko as a royalist or at least as a man sympathetic to the English royalist cause. Why does she portray the African prince in this way?

[1]Charles I of England.

[2]Not withstanding.

Summary

■ **The American Revolution** The idea of human freedom was fundamental to the Enlightenment, finding one of its greatest expressions in the Declaration of Independence, authored by Thomas Jefferson and ratified by the 13 colonies on July 4, 1776. Jefferson's argument that the American colonies should be self-governing was preceded by British taxation of the colonies. But at the heart of the tension between England and the North American colonies was the issue of slavery, though obscured by the debate over free trade, of which it generally was considered a form.

■ **Neoclassicism in Britain and America** The founders of the newly created United States modeled their republic on classical precedents, as is evident in *The Federalist*, a series of articles designed to explain and defend the constitution adopted in 1787 by the Federal Convention. The fledgling country also embraced Neoclassicism as an architectural style. Thomas Jefferson, who served as minister to the court of Louis XVI from 1784 to 1789, was not able to take the Grand Tour of which he had always dreamed, but he was deeply affected by the Neoclassical art and architecture he saw in Europe, including the architectural innovations of Robert Adam and the Neoclassical ceramics of Josiah Wedgwood. Jefferson recommended the Italian sculptor Antonio Canova to carve a sculpture of George Washington for the North Carolina legislature, and also recommended Canova's

rival Jean-Antoine Houdon to sculpt another portrait of George Washington as the Roman general Cincinnatus for the Virginia State House. He designed his own home at Monticello as a Palladian villa surrounded by an English garden. His design for the new Virginia State Capitol was modeled on a Roman temple, the Maison Carrée in Nîmes, France. Washington hired Pierre Charles L'Enfant to design the new national capitol at Washington, DC, after the geometric French gardens at Versailles.

■ **The Issue of Slavery** Meanwhile, autobiographical and fictional accounts of slavery intensified abolitionist sentiments in both Europe and North America. Olaudah Equiano exposed the conditions on board slave ships in his *Travels*, and John Gabriel Stedman revealed the shocking treatment of slaves in Guiana. The black poet Phyllis Wheatley accepted her plight as divinely ordained, while novelist and playwright Aphra Behn, in *Oroonoko*, the first English novel to show blacks in a sympathetic light, identified with her hero's oppression despite her own sense of racial superiority. By 1700, England had become the largest trafficker of slaves in the world, and its own economy depended heavily on the trade. In the midst of this complex set of circumstances, African slaves adopted the cultures of their native lands to their American conditions. Their common musical heritage, especially, survived.

Glossary

Adam style The term for the Neoclassical style in England, where it became closely associated with the work of the architect Robert Adam.

African diaspora The forced scattering of millions of Africans as a result of the Atlantic crossing.

Federal style The term for the Neoclassical style as it appeared in the United States.

jasperware A type of stoneware produced by Josiah Wedgwood that was ornamented in Neoclassical style with a white relief on a colored ground.

laissez-faire Literally "let it happen as it will," this economic policy argues that people should be free to do whatever they might to enrich themselves.

mbira An instrument made of a small wooden box or gourd—to which is attached a row of thin metal strips that vibrate when plucked—that acts as a resonator.

republicanism Sympathy for a republican form of government, that is, a government having a chief of state who is not a monarch.

Critical Thinking Questions

1. In what ways does John Singleton Copley's painting *Watson and the Shark* reflect the issues raised by slavery?

2. How would you compare Phyllis Wheatley's response to slavery in her poem "'Twas mercy brought me from my Pagan land" to William Blake's in "The Little Black Boy"?

3. What specific aspects of Neoclassical art and architecture attracted American leaders like Thomas Jefferson?

The Rise of Neoclassicism in France

The taste of the eighteenth-century French court never strayed too far from the Rococo (see chapter 29). By the early 1780s, however, the populace began to resent the lavish lifestyles of its aristocracy. Even the court increasingly recognized that Rococo was decadent, or at least unwise politically. In its public works at least, France began to adopt a Neoclassical style that implied the restraint and refinement that the Rococo lacked. Interestingly, the rise of the Neoclassical in France, with its regularity, balance, and proportion, can be attributed to the same ideals that would lead to the overthrow of the aristocracy in the French Revolution. The civilizations of Greece and Rome were considered as close to a Golden Age as the Western world had ever come, and the aim of any revolution was to restore the intellectual and artistic values that those classical civilizations embodied. But France had more recent examples of order and balance as well, in the classical Baroque architecture of the Louvre's east facade (see Fig. 25.22) and in the formal symmetries of the gardens at Versailles (see Figs. 27.4, 27.5). The Neoclassical could also claim descent from Poussin (see chapter 27) and Palladio, not coincidentally Jefferson's favorite architect (see chapter 19).

The *philosophes*, with their aspirations to establish a new social order of superior moral and ethical quality, were influential as well (see chapter 29). Rousseau's *Social Contract*, published in 1762, laid the cornerstone for revolutionary thought: "To renounce liberty," he argued, "is to renounce being a man, to surrender the rights of humanity and even its duties." That essay's opening line— "Man is born free, and everywhere he is in chains"—would serve as the French Revolution's rallying cry. And Diderot would attack Rococo art in his *Salons*. Boucher's paintings, in particular, aroused his ire: "Degradation of taste, color, com-

Fig. 31.20 Antonio Canova. *Napoleon as Mars the Peacemaker.* 1802–1806. Marble, height 10′8″. The Wellington Collection, Apsley House, London.

position, character, expression, and drawing have kept pace with moral depravity." The great satirist Voltaire would mock the French court in his comedies, especially *Candide*.

But Enlightenment ideals were more easily expressed in art than practiced in reality. In America, the issue of slavery clouded the moral idealism embodied in the Neoclassical style. In France, the revolution itself quickly descended into fear, terror, and tyranny. Instead of order, the Neoclassical ideal, chaos reigned. It would be a young army officer, Napoleon Bonaparte (1769–1821), who would restore order to France.

Not surprisingly, Napoleon saw himself and his new government as embodying the Neoclassical ideal. In 1802, he commissioned Antonio Canova to sculpt a larger-than-life-size marble sculpture of his likeness. Napoleon expected a portrait of himself in full military dress, but the artist believed that he should be depicted in the nude as the modern embodiment of Mars, the Roman god of war (Fig. 31.20). As it turned out, by the time Canova's sculpture arrived in Paris in 1811, Napoleon was embroiled in the military campaigns that would end his career, and he rejected the statue, understanding that as a nude its propagandistic uses were limited. For Napoleon understood quite well the role of Neoclassical art in the service of the state: In its order and majesty it projected, like the sculpture of Caesar Augustus at the Primaporta (see Figure 8.13), his own dignity and power. To present himself to the public in the nude, however idealized, would be to subject himself to ridicule. Ironically, the sculpture would eventually be purchased by the British government as a gift—and sort of trophy—for the duke of Wellington, who defeated Napoleon at the Battle of Waterloo on June 18, 1815. Wellington would place it in the stairwell of his house in London. ■

AUX GRANDS HOMMES LA PATRIE RECONNAISSANTE

32 A Culture of Change in France

Neoclassicism and Revolution

Jacques-Louis David and the Neoclassical Style

The French Revolution

The Rights of Woman

Napoleon and Neoclassical Paris

“ *If virtue be the spring of popular government in times of peace, the spring of that government during a revolution is virtue combined with terror. . . . Terror is only justice prompt, severe and inflexible; it is then an emanation of virtue. . . .* ”

Robespierre

← **Fig. 32.1 The Panthéon, Paris.** 1764–1790. As the first Neoclassical building in Paris, the Panthéon (originally the church of Sainte-Geneviève) inaugurated a style in art and architecture that would dominate Western culture until at least 1860. Napoleon's new France and Jefferson's new United States regarded the geometric balance and proportion of antiquity as the primary principles upon which to build a new social order.

B

Y THE END OF THE EIGHTEENTH CENTURY, NEOCLASSICISM had in many ways become an international style, dominating taste across Europe to the newly formed United States. It was generally accepted, however, that the Neoclassical style reached its peak in Paris. The first Neoclassical building in that

city was the church that Louis XV commissioned to be built on the site of the medieval church of Sainte-Geneviève in 1764 (Fig. **32.1**). The new Sainte-Geneviève was the design of Jacques-Germain Soufflot [soo-FLOH] (1713–1780). The occasion for his commission was an oath, sworn 20 years earlier by the seriously ill king. At Metz, in northeast France, on the battlefront of the war of Austrian Succession, Louis XV was convinced that he was about to die. The terms of his oath were giving up his mistress, confessing his dissolute lifestyle, and promising to honor his God. The first two, he soon recognized, were promises of the immediate moment, hardly permanently binding, and he did not actually keep them. Honoring his God was another thing. Sainte-Geneviève would accomplish that.

Soufflot was mentor to the brother of Louis's mistress, Madame de Pompadour (see chapter 29). The architect had

Continuity & Change
p. 260

The Pantheon

groomed the young marquis to take over as the king's Superintendent of Royal Buildings, a relationship resulting in the commission itself. Soufflot's most direct inspiration for the new church was the Pantheon, which he had studied firsthand as a student at the French Academy in Rome in the 1730s. Then, on a second trip in 1749, he visited the excavations of Herculaneum, an ancient Roman city near Naples that had been destroyed by the eruption of Vesuvius in 79 CE; the dig had begun in 1738. (Excavations at nearby Pompeii, destroyed by the same eruption, had just begun in 1748.) But most significantly, on that same trip Soufflot himself rediscovered the temple ruins at the former Greek colony of Paestum (see chapter 6), which had lain forgotten for centuries in the swamps southeast of Naples.

When Sainte-Geneviève was actually completed, Soufflot's other inspiration became evident. The interior boasts the same immense spaces as the Gothic cathedral, thus marrying native French architecture with the classical Roman (Fig. **32.2**). Its huge Roman portico and freestanding interior colonnades surround a central-plan Greek cross (Fig. **32.3**), the largest dome of which probably took its inspiration from Christopher Wren's dome at Saint Paul's in London (see the *Focus* in chapter 28,

pages 902–903). Above all, the structure as a whole reveals a belief in the ancient classical values of order and balance. It possesses a clarity of form arising from its geometric symmetry and is designed to reflect the logic and morality of the Enlightenment as a whole. It embodies, in other words, the rational humanism of the *philosophes* (see chapter 29), the belief that through careful, logical thought, human beings can rise to an increasingly ideal state. These beliefs, in fact, are the values of Neoclassicism as a style.

Soufflot's Sainte-Geneviève was renamed the Panthéon (after the residence of the gods of classical antiquity) during the French Revolution, when it was rededicated to secular use to hold the remains of the great men of France's period of liberty. It marks the first installment in a long program of Neoclassical building in Paris. The program extends from the early eighteenth century and the tumult of the French Revolution through the imperial reign of Napoleon Bonaparte and eventually ends in the middle of the nineteenth century. It transferred to the political power of France some of the visual tokens of power of ancient Rome and reaffirmed Paris as a major center of culture even in the midst of internal upheaval.

That a taste for classical order and calm would grow to major proportions in the last half of the eighteenth century is hardly surprising. Europe needed a respite from the political and social chaos of the period. This chapter surveys the triumph of that taste in Paris as it supplanted the ornate, decorative—and, in some minds, dissolute—styles of Baroque and Rococo art. Neoclassicism found expression in painting and sculpture as well as architecture. Leading the way were Jacques-Louis David [dah-VEED], probably the most influential artist of the era, and Angelica Kauffmann, probably the most popular.

The idealism embodied in Neoclassicism, its call for order, balance, and proportion, was countermanded by the chaos and terror that the Revolution of 1789 and its aftermath imposed upon the nation. The revolution not only deposed the monarchy, executing both Louis XVI and his queen, Marie Antoinette, but it also de-Christianized the nation, turning churches, with Enlightenment flair, into Temples of Reason. Even the map of France changed (Map **32.1**). Threatened from without by Europe's other monarchies—especially those in Germany—and from within by royalists whose sympathies remained with the king and queen, the country soon fell into a state of mutual distrust and vindictive retribution. Hardly

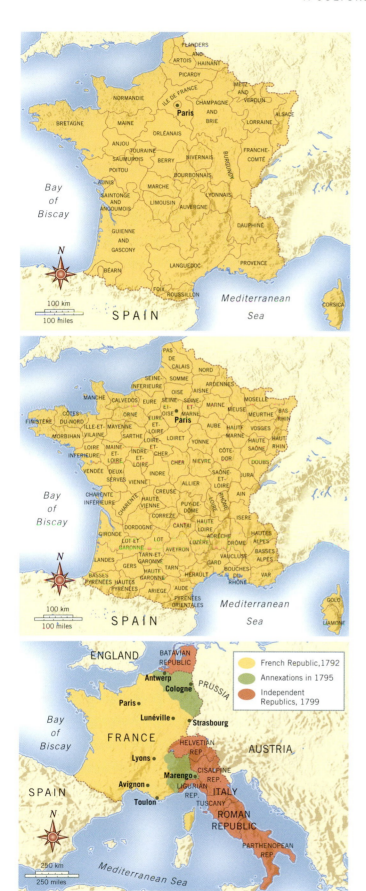

Map 32.1 France before and after the Constitution of 1791, including military expansion after 1795.

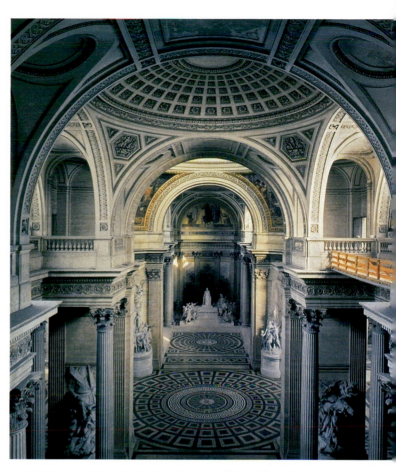

Fig. 32.2 Jacques-Germain Soufflot. Interior of Sainte-Geneviève, now known as the Panthéon, Paris. 1764–1790. After it became a civic building, the church became the burial site for France's greatest heroes, including Voltaire, Rousseau, novelist Emile Zola, the scientists Pierre and Marie Curie, and the writer and political figure André Malraux.

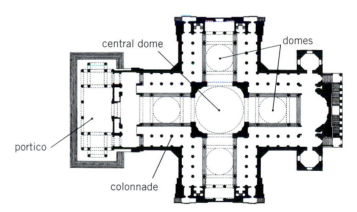

Fig. 32.3 Jacques-Germain Soufflot. Plan for Sainte-Geneviève, Paris.

anyone was exempt from the charge of betraying the revolution—and from the sentence of execution by guillotine. In the arts, French painters attempted to serve the post-revolutionary government in this atmosphere of uncertainty and almost continual change by turning from the depiction of historical events to the depiction of contemporary political events. Not until Napoleon Bonaparte, a young military leader who had

risen within the army's ranks, took control of the country was order restored and with it the values of Neoclassical art.

Jacques-Louis David and the Neoclassical Style

No artist more fully exemplifies the values of Neoclassicism in France than the painter Jacques-Louis David (1748–1825). His career stretches from pre-Revolutionary Paris, through the turmoil of the Revolution and its aftermath, and across the reign of Napoleon Bonaparte. He was, without doubt, the most influential artist of his day. "I do not feel an interest in any pencil but that of David," Thomas Jefferson wrote in a flush of enthusiasm from Paris during his service as minister to the court of Louis XVI from 1885 to 1889. And artists flocked to David's studio for the privilege of

studying with him. In fact, many of the major artists of the following century had been his students (see chapter 34), and those who had not been such defined themselves against him.

David abandoned the traditional complexities of composition that had defined French academic history painting since at least the time of Le Brun (see Fig. 27.6) and substituted a formal balance and simplicity that is fully Neoclassical. His works had a frozen quality to emphasize rationality, and the brushstrokes were invisible to create a clear focus and to highlight details. At the same time, his works had considerable emotional complexity. A case in point is his painting *The Oath of the Horatii* (Fig. **32.4**), commissioned by the royal government in 1784–1785. The story derives from a play by French playwright Corneille (see chapter 27), and is a sort of parable or example of loyal devotion to the state. It concerns the conflict between early Rome, ruled by Horatius [hor-AY-shus], and neighboring Alba, ruled by Curatius [kyoor-AY-shus]. In order to spare a war

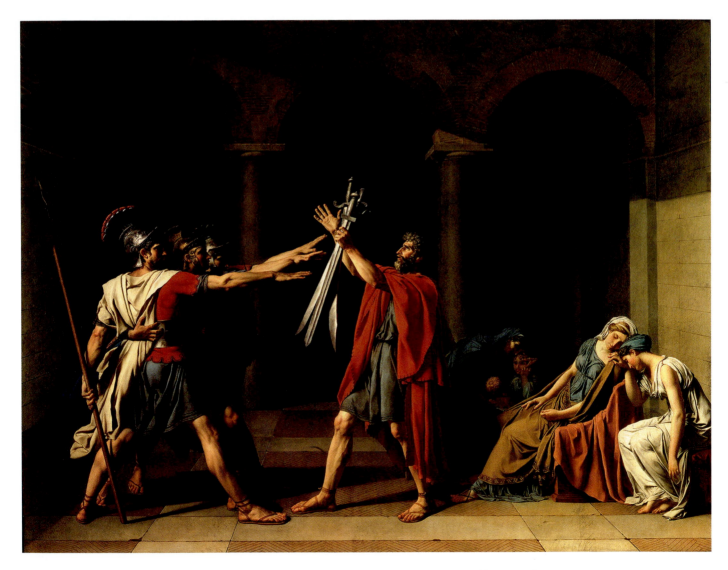

Fig. 32.4 Jacques-Louis David. *The Oath of the Horatii.* **1784–1785.** Oil on canvas, 10′10″ × 13′11½″. Musée du Louvre, Paris. RMN Reunion des Musees Nationaux, France/Art Resource, NY. Corneille's play *Horace*, inspired the painting (see chapter 27).

Fig. 32.5 Jacques-Louis David. *Old Horatius Defending his Sons*. ca. 1781. Black crayon and ink with Indian white wash on paper, $8\frac{4}{5}$" × $11\frac{3}{5}$". Cabinet des Dessins (RF 1917), Musée du Louvre, Paris. RMN Reunion des Musees Nationaux, France/Art Resource, NY. Photo: Michele Bellot. Only Horatius's extended hand survives in the final painting.

that would be more generally destructive, the two leaders agreed to send their three sons—the Horatii [hor-AY-shee-eye] and the Curatii [kyoor-AY-shee-eye]—to battle each other. An early sketch for this work (Fig. **32.5**) reveals that, initially, David was contemplating a more traditional composition. In the sketch, the battle is over. Horatius stands at the top of a set of stairs. Beside him is his youngest son, the sole survivor of the conflict, whose own wife is the sister of the dead Curatii. This son has just murdered his sister Camilla, whom he discovered mourning the loss of her husband, one of the Curatii. Camilla lies at the bottom of the stairs, a grieving sister beside her. A crowd of men is rushing up the stairs to arrest the brother. Horatius, arm extended, holds back the crowd, which in a moment, moved by the son's sacrifice of his sister for his country, will absolve him. The figures flow down the steps in a complex interweaving of gestures, poses, and flowing draperies that is virtually Baroque in its complex linear tangle.

There is no trace of this compositional complexity in the final painting. Here the classical Roman theme is defined by another, simpler phase in the story and supported by the readable clarity of a simpler organization of forms. Now David presents the moment *before* the battle when the three sons of Horatius swear an oath to their father, promising to fight to the death. The sons on the left, the father in the middle, and the sisters to the right are each clearly and simply contained within the frame of one of three arches behind them. Except for Horatius's robe, the colors are muted and spare, the textures plain, and the paint itself almost flat. The male figures stand rigidly in profile, their legs extending forward tensely,

as straight as the spear held by the foremost brother, which they parallel. Their orderly Neoclassical arrangement contrasts with that of the women, who are disposed in a more conventional, Baroque grouping. Seated, even collapsing, while the men stand erect, the women's soft curves and emotional despair contrast with the male realm of the painting. David's message here is that civic responsibility must eclipse the joys of domestic life, just as reason supplants emotion and classical order supplants Baroque complexity. Sacrifice is the price of citizenship (a message that Louis XVI would have been wise to heed).

David's next major canvas, *The Lictors Returning to Brutus the Bodies of his Sons*, was painted in 1789, the year of the Revolution but before it had begun. It is a more complex response to the issues of sacrifice for the state. The painting shares with the *Oath of the Horatii* the theme of a stoic father's sacrifice of his sons for the good of the state, as Brutus's lictors (the officers in his service as ruler) return the sons' bodies to him after their execution. Although received by the public in 1789 as another assertion of the priority of the republic over the demands of personal life, the painting is emotionally far more complex. That is, it seems to question the wisdom of such acts of heroism (see *Focus*, pages 1028–1029). Although David would serve the new French Republic with verve and loyalty as its chief painter after the Revolution, his paintings are rarely as straightforward as they at first appear. In David's work, it would seem, the austerity of the Neoclassical style is something of a mask for an emotional turbulence within, a turbulence that the style holds in check.

Focus

David's *The Lictors Returning to Brutus the Bodies of His Sons*

The French monarchy commissioned Jacques-Louis David to create *The Lictors Returning to Brutus the Bodies of His Sons,* and it was exhibited in 1789, just six weeks after the storming of the Bastille. As a result, the public closely identified it with the cause of the French republic. The hero of the historical tale that is the subject of this painting is the founder of the Roman republic, Lucius Junius Brutus (6th century BCE; not to be confused with the Brutus who would later assassinate Julius Caesar). He had become head of Rome and inaugurated the republic by eliminating the former monarch, Tarquinius, who himself had assumed the throne by conspiring with the wife of the former king. She murdered her husband, and he his own wife, and the two married. Brutus' sons had conspired to restore the monarchy—their mother was related to Tarquinius—and under Roman law Brutus was required, not only to sentence them to death, but to witness the execution.

In David's painting, Brutus sits in shadow at the left, his freshly beheaded sons passing behind him on stretchers carried by his lictors (officers who served rulers). Brutus points ignominiously at his own head, as if affirming his responsibility for the deed, the sacrifice of family to the patriotic demands of the state. In contrast to the darkened shadows in which Brutus sits, the boys' mother, nurse, and sisters await the bodies in a fully lighted stage space framed by a draperied colonnade. The mother reaches out in a gesture reminiscent of Horatius' in the *Oath of the Horatii.* The nurse turns and buries her head in the mother's robe. One of the sisters appears to faint in her mother's arms, while the other shields her eyes from the terrible sight. Their spotlit anguish emphasizes the high human cost of patriotic sacrifice, whereas the *Oath of the Horatii* more clearly celebrates the patriotic sacrifice itself.

This shift in David's emphasis can be at least partly explained by his own biography. Early in 1888, his favorite apprentice, Jean-Germain Drouais, died of smallpox at the age of 25 (see Fig. 32.6). David was devastated by this loss of one of the best young painters in France. (Drouais was a winner of the Prize of Rome, which sent him to study in that city for five years.) *The Lictors* probably reflects the strength of David's feelings for his young companion.

Jacques-Louis David. Details from *The Lictors Returning to Brutus the Bodies of His Sons*. 1789. Oil on canvas, 10'7$\frac{1}{4}$" × 13'10$\frac{1}{4}$". Musée du Louvre, Paris. RMN Reunion des Musees Nationaux, France. Gerard Blot/C. Jean/Art Resource, NY. Brutus' emotional exile from his proper place at the table as patriarch is emphasized by the subtle analogy that David draws between Brutus' own toes and the scrolling decoration at the base of the table where once he sat.

The **statue of Roma** represents the state and is darkened to suggest the turmoil that Rome is enduring.

The **Doric order** of the architecture underscores the severity of the scene and represents the reasonable and rational order of the Roman republic—the very model of the new French republic about to be born.

David reverses the structure of the *Horatii* by having Brutus's wife extend her hand as Horatius does in the earlier painting. Now the women stand, and the males sit (or lie dead). Female emotion stands triumphant over the demands of reason.

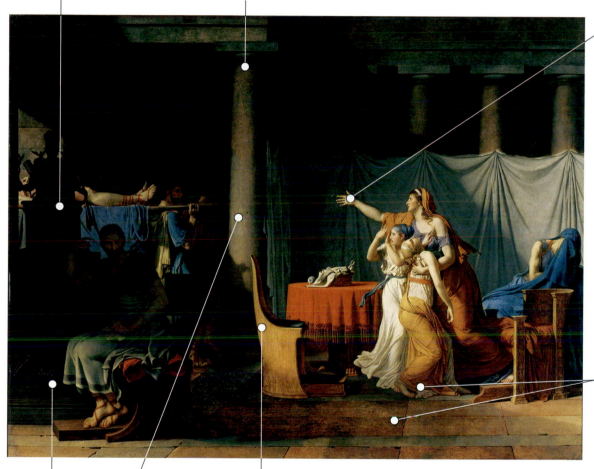

Much of the emotional tension of the painting derives from the contrast between the rigorous scientific perspective of the composition, most explicit in the floor tiles, and the soft, falling curves of the drapes and women's clothing.

This **central column** extends to the top of the painting, separating Brutus from his family and emphasizing the great gulf between them.

The graceful curve that defines the back of the empty chair in front of the central column suggests the powers of human feeling, compassion, and love. The chair is surely Brutus's own, from which he has been exiled.

The relief portraying the legend of the founders of Rome, **Romulus and Remus**, suckled by a wolf suggests how, at its origin, the Roman republic was integrally connected to the importance of family, especially after the rise of Augustus.

Jacques-Louis David. *The Lictors Returning to Brutus the Bodies of His Sons.* **1789.**
Oil on canvas, 10′ 7¼″ × 13′10¼″. Musée du Louvre, Paris. RMN Reunion des Musees Nationaux, France. Gerard Blot/C. Jean/Art Resource, NY.

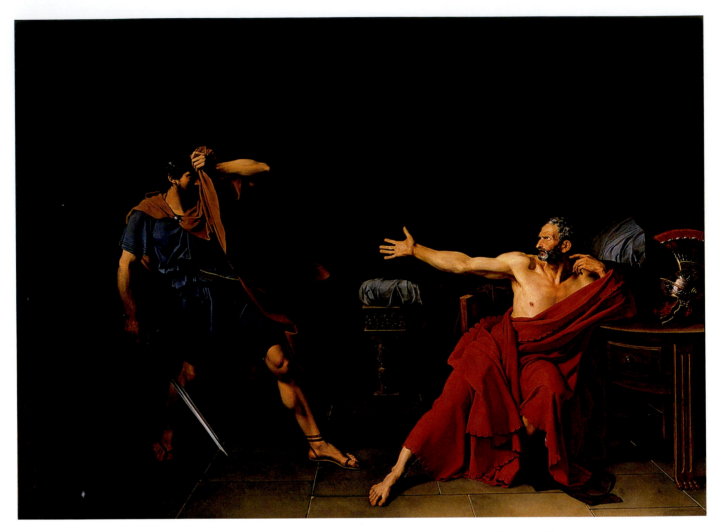

Fig. 32.6 Jean-Germain Drouais. *Marius at Minturnae (Plutarch, Life of Marius).* **1786.** Oil on canvas, 106³/₄″ × 143³/₄″. Inv. 4143. Photo: Renè-Gabriel Ojèda. Musée du Louvre, Paris/RMN Reunion des Musees Nationaux, France. David's favorite student, Drouais was awarded the French Academy's Rome Prize in 1783, intended to support the best young French painters for five years of study in Rome. He began work on this painting almost immediately after arriving in Rome in 1784. It took him two years to complete.

Three Paintings of 1787

Three paintings that were exhibited in Paris in 1787 suggest the growing importance of the Neoclassical over the Rococo style in France just before the Revolution. *Marius at Minturnae* by Jean-Germain Drouais [droo-AY] (1763–1788) caused the greatest stir (Fig. 32.6). The scene takes place at Minturnae [min-TOOR-nee] in the Roman countryside, where the Roman general Marius has been sentenced to death by the Roman Senate for corruption and tyranny. Defiantly, Marius extends his hand at the soldier who has come to execute him, asking, "Would you dare kill Marius?" The soldier steps back and covers his face. (According to legend, he then turned and ran, proclaiming, "I could never kill Marius!") Drouais had assisted David in painting *The Oath of the Horatii*, and that painting informs this one, particularly in the forcefulness of the gesturing hand at the painting's midpoint. As in the *Oath*, Drouais's figures are composed of straight, mostly diagonal lines. But this painting seems to possess more psychological

complexity and drama than David's. This was due largely to Drouais's use of severe lighting, reminiscent of Caravaggio's. Set off against the dark background, Marius's gesture and gaze draw the viewer's attention to that from which the soldier shields his eyes, the repository of tyranny and power. It is as if Drouais is forcing us to come to grips with our own complicity in tyranny's triumph. Whatever the case, the painting fascinated Paris. Among the many viewers was Thomas Jefferson. "It fixed me like a statue," he reported, "a quarter of an hour, or half an hour, I do not know which, for I lost all ideas of time, even the consciousness of my existence."

Also on display at the Salon of 1787 was a painting with an entirely different sensibility, a portrait of *The Marquise de Pezay and the Marquise de Rougé with Her Two Sons* by Elisabeth Louise Vigée-Lebrun [vee-ZHAY-leh-BRUHN] (1755–1842) (Fig. 32.7). Vigée-Lebrun was personal confidant and first painter to the queen, Marie Antoinette (see Fig. 29.25). In fact, in 1783, the queen had intervened to ensure Vigée-Lebrun's election to the Royal Academy of Painting and

Sculpture, an honor that, by rule, could only be bestowed upon four women at a time. The painting is typical of Vigée-Lebrun's works, most of which are idealized portraits of women and children that were understood at the time to extol the moral virtues of motherhood and family. The rich silks and taffetas of the ladies' gowns reflect the court's Rococo taste, but this sensibility is downplayed to emphasize familial piety and love. The composition, dominated by gentle curves and softly raking light, in keeping with its subject matter, is a far cry from the geometric clarity and rigor of the Drouais in the same exhibition (and of the David exhibited there as well, which also took an ancient classical narrative as its subject, the death of Socrates).

In fact, Vigée-Lebrun's painting was hung in the Salon of 1787 not so much as a work in its own right but as a gloss on a more politically sensitive painting that the royal family had commissioned from her: *Queen Marie Antoinette and Her Children* (Fig. 32.8). As the youngest of the Habsburg queen Maria Theresa's 16 children and the embodiment of France's ill-fated alliance with Austria in the Seven Years' War, Marie Antoinette was no favorite of the people. By 1785, she had become the object of public ridicule, maligned especially for her extravagance and scandalous behavior. The portrait, it was understood, would show the queen in the same light as the women in *The Marquise de Pezay and the Marquise de Rougé with Her Two Sons*, as the embodiment of motherhood and familial piety. Vigée-Lebrun posed the queen at Versailles, in the Salon of Peace just outside the Hall of Mirrors, visible at the left of the painting. She is hugged by her adoring daughter, her rambunctious youngest child plays on her lap, and her son, the dauphin, points at an empty cradle in a blatant attempt to elicit public sympathy since, as everyone knew, the queen had lost her youngest daughter just months before.

Even though Vigée-Lebrun succeeded in presenting the queen as the very embodiment of loving motherhood, the painting was withheld from the official opening of the Salon out of fear of public ridicule. When it was finally hung at the Salon several days later, the painting, with its Rococo sensibility, did little to rebuild the queen's reputation. Nor did it do much to further Vigée-Lebrun's. When in 1789 revolution seemed imminent, Vigée-Lebrun left France with her daughter for what would become a 12-year exile.

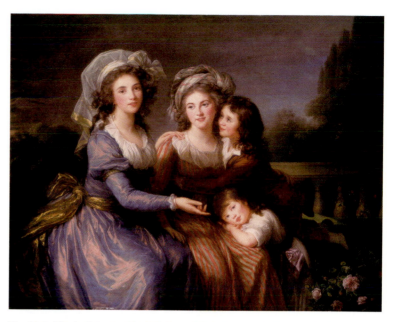

Fig. 32.7 Elisabeth Louise Vigée-Lebrun. *The Marquise de Pezay and the Marquise de Rougé with Her Two Sons.* **1787.** Oil on canvas: 48½″ × 61¼″. Image © 2007 Board of Trustees, National Gallery of Art, Washington, DC. Gift of the Bay Foundation in memory of Josephine Bay Paul and Ambassador Charles Ulrick Bay. 1964.11.1. A contemporary praised Lebrun's painting for showing "how beauty and talent are enhanced when they are allied to the tenderest and most delightful affections."

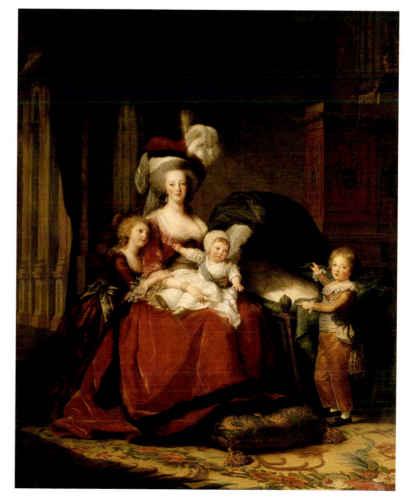

Fig. 32.8 Elisabeth Louise Vigée-Lebrun. *Queen Marie Antoinette and Her Children.* **1787.** Oil on canvas, 108¼″ × 84⅝″. Musée National du Château de Versailles. Inv.: MV 4520. Photo: Gerard Blot/Art Resource NY/RMN Reunion des Musees Nationaux. The queen's eldest daughter, Madame Royale, stands next to her, and the Dauphin, Louis-Joseph, stands beside the cradle. On her lap is the future King Louis XVII, born in 1785.

Angelica Kauffmann and Neoclassical Motherhood

It is useful to compare Vigée-Lebrun's paintings of mothers and their children with a fully Neoclassical treatment of the same theme. *Cornelia Pointing to Her Children as Her Treasures*, painted in 1785 by Swiss-born Angelica Kauffmann (1741–1807), depicts a popular subject among late-eighteenth-century Neoclassical painters (Fig. **32.9**). Cornelia was the daughter of the Roman hero Scipio Africanus, the Roman general who defeated Hannibal in 202 BCE, and she is remembered as the model of Roman motherhood. In this painting, Cornelia responds to a visiting lady who had been showing Cornelia her jewels. When the visitor asks to see Cornelia's jewels, Cornelia points to her two sons and says, "These are my most precious jewels." The two sons, as Kauffmann's audience knew, would one day be great reformers of the Roman republic, leading the effort to redistribute to the poor the public lands that had been taken over by the rich.

Cornelia is at the center of the composition, balancing the painting's two halves. This balance is emphasized by the fold down the front of her dress, the line of which extends directly up the side of the square column behind her. Cornelia recognizes that her children represent the future of the state and hence her care for them is her greatest civic responsibil-

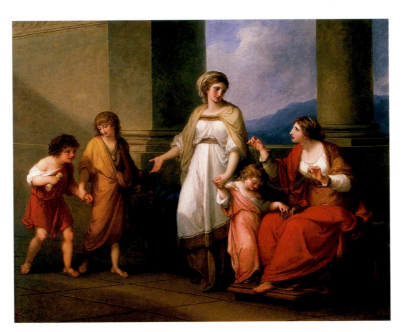

Fig. 32.9 Angelica Kauffmann. *Cornelia Pointing to Her Children as Her Treasures.* **1785.** Oil on canvas, 40″ × 50″. The Adolph D. and Wlkins C. Williams Fund. Photo: Katherine Wetzel. Virginia Museum of Fine Arts, Richmond. Kauffmann is unique in being the only female artist of the eighteenth century who became a successful history painter.

ity. What most distinguishes Kauffmann's painting from Vigée-Lebrun's, in sum, is that it carries the weight and force of historical narrative, the most esteemed genre for painting, whereas Vigée-Lebrun's works, however much they extol the virtues of motherhood, remain merely portraits.

Kauffmann was a great portraitist herself, in fact one of the most sought-after of the day. With Sir Joshua Reynolds, she was also one of the founding members of England's Royal Academy of the Arts. Kauffmann and her husband were employed by the architect Robert Adam (see chapter 31) to decorate the homes he designed for the English aristocracy with ceiling and wall paintings illustrating historical themes. It is her dedication to painting historical subjects that earned her the admiration of her contemporaries, a rare feat for women artists in the eighteenth century.

The French Revolution

When Vigée-Lebrun's portrait of *Marie Antoinette and Her Children* was withheld from the official opening of the Salon of 1787, the large empty space left on the wall to accommodate it later—it was over 9 by 7 feet in size—was quickly equated with the huge fiscal deficit of the country. France's alignment with the North American colonies in their revolution against England had drained a treasury already depleted by the Seven Years' War. By any measure, the country had been fiscally mismanaged for many years. Neither the nobility nor the clergy could be made to pay their fair share of taxes, the state bureaucracy barely functioned, and the nation, spurred on by the *philosophes*, had begun to demand change.

It was, in fact, the national debt that abruptly brought about the events leading to revolution, the overthrow of the royal government, and the country becoming a republic. In the 15 years after Louis XVI ascended to the throne in 1774, the debt tripled. In 1788, fully one-half of state revenues were dedicated to paying interest on debt already in place, despite the fact that two years earlier bankers had refused to make new loans to the government. The cost of maintaining Louis XVI's court was enormous, so the desperate king attempted to levy a uniform tax on all landed property. Riots, led by aristocrat and bourgeois alike, forced the king to bring the issue before an Estates General, an institution little used and indeed half-forgotten (it had not met since 1614).

The Estates General of 1789 and the National Assembly

The Estates General convened on May 5, 1789, at Versailles. It was composed of the three traditional French **estates**. The First Estate was the clergy, which comprised a mere 0.5 percent of the population (130,000 people) but controlled nearly 15 percent of French lands. The Second Estate was the nobility, consisting of only 2 percent of the population (about 500,000 people) but controlling about 30 percent of the land. The Third Estate was the rest of the population, composed of the bourgeoisie (around 2.3 million people), who controlled

about 20 percent of the land, and the peasants (nearly 21 million people), who controlled the rest of the land, although many owned no land at all.

Traditionally, each estate deliberated separately and each was entitled to a single vote. Any issue before the Estates General thus required a vote of at least 2:1—and the consent of the crown—for passage. The clergy and nobility usually voted together, thus silencing the opinion of the Third Estate. But from the outset, the Third Estate demanded more clout, and the king was in no position to deny it. The winter of 1788–1789 had been the most severe in memory. In December, the temperature had dropped to −19° Celsius (or −2° Fahrenheit), freezing the Seine over to a considerable depth. The ice blockaded barges that normally delivered grain and flour to a city already filled by unemployed peasants seeking work. With flour already in short supply after a violent hailstorm had virtually destroyed the crop the previous summer, the price of bread almost doubled. As the Estates General opened, Louis was forced to appease the Third Estate in any way he could. First he "doubled the third," giving the Third Estate as many deputies as the other two estates combined. Then he was pressured to bring the three estates together to debate and "vote by head," each deputy having a single vote. Louis vacillated on this demand, but on June 17, 1789, the Third Estate withdrew from the Estates General, declared itself a National Assembly, and invited the other two estates to join them.

A number of the First Estate, particularly parish priests who worked closely with the common people, accepted the Third Estate's offer, but the nobility refused. When the king banned the commoners from their usual meeting place, they gathered nearby at the Jeu de Paume [zhurd pohm], an indoor tennis court at Versailles that still stands, and there, on June 20, 1789, swore an oath never to disband until they had given France a constitution. Jacques-Louis David recreated the scene a year later in a detailed sketch for a painting that he would never finish, as events overtook its subjects (Fig. 32.10). David's plan was to combine exact observation (he drew the major protagonists from life) with monumentality on a canvas where everyone would be life-size (many of his subjects would soon fall out of favor with the revolution itself and be executed). The "winds of freedom" blow in through the windows as commoners look on. At the top left, these same winds turn an umbrella inside out, signaling the change to come. In the middle of the room, the man who would soon become mayor of Paris reads the proclamation aloud. Below him a trio of figures, representing each of the three estates, clasp hands as equals in a gesture of unity. At the actual event, all of the members of the National Assembly marched in alphabetical order and signed the Tennis Court Oath, except for one. He signed, but wrote after his name the word "opposed." David depicts him, an object of ridicule, seated at the far right, his arms folded despairingly across his chest. Faced with such unanimity, Louis gave in, and on June 27 ordered the noble and clerical deputies to join the National Assembly.

Nevertheless, rumors persisted, probably true, that Louis was bent on overthrowing the National Assembly, and so a volunteer bourgeois militia formed to protect the newly formed institution. (It soon named itself the National Guard.) On July 14, 1789, members of this militia, mostly merchants and artisans, especially woodworkers, broke into government buildings looking for arms and gunpowder. They found one arsenal in the military hospital, and then proceeded to the Bastille, a prison on the eastern edge of the city, where they hoped to find more. The prison governor panicked and ordered his guard to fire on the militia. In retaliation a mob gathered and stormed the Bastille, decapitating the prison governor and slaughtering six of the guards. The only practical effect of the battle was to free a few prisoners, but the next day Louis XVI asked if the incident had been a riot. "No, your majesty," was the reply, "it was a revolution."

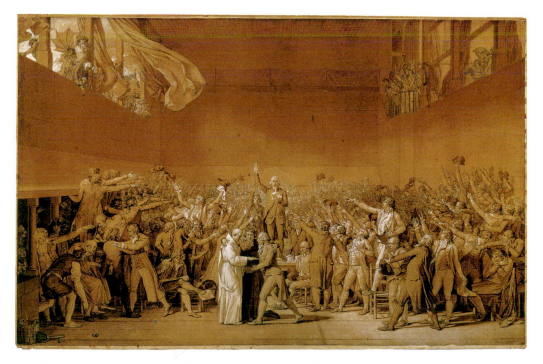

Fig. 32.10 **Jacques-Louis David.** *The Tennis Court Oath.* **1789–1791.** Pen and brown ink and brown wash on paper, 26″ × 42″. Musée National du Château, Versailles. MV 8409: INV Dessins. Photo: Gerard Blot. RMN Reunion des Musees Nationaux/Art Resource, NY. Note how the figures in this painting, all taking an oath, stretch out their hands in the manner of David's earlier painting, *The Oath of the Horatii* (Fig. 32.4).

The Great Fear and the October Days

In the French countryside, mayhem soon ruled. Rumors rapidly spread that mercenary troops hired by the aristocrats were about to enter the rural districts to control the peasantry by wiping out the new crop. What became known as the Great Fear took hold, as peasants grabbed hoes, rakes, and pitchforks to attack the local nobles. Some destroyed the chateaux and barns. The peasants paid particular attention to the archives that contained records of the manorial dues owed by the peasantry to the aristocrats. They seized foodstuffs and took back lands they believed were rightfully theirs. On the night of August 4, 1789, several liberal nobles and clerics rose in the National Assembly and renounced their feudal rights, dues, and tithes—surrendering what they had in fact already lost. But it was a scene of deep symbolic significance. That night, in an official decree, the National Assembly abolished "the feudal regime," declaring that henceforth "all citizens, without distinction of birth, are eligible to any office or dignity, whether ecclesiastical, civil or military." In effect, all French citizens were now subject to the same and equal laws.

But the troubles were hardly over. While the harvest was good, drought had severely curtailed the ability of watermills to grind flour from wheat. Just as citizens were lining up for what bread was available, a false rumor spread through the Paris press that the queen, Marie Antoinette, had flippantly remarked, on hearing that the people lacked bread, "Let them eat cake!" The antiroyalists so despised the queen that they were always willing to believe anything negative said about her. Peasant and working-class women, responsible for putting bread on the table, had traditionally engaged in political activism during times of famine or inflation, when bread became too expensive, and would march on the civic center to demand help from the local magistrates. But now, on October 5, 1789, about 7,000 Parisian women, many of them armed with pikes, guns, swords, and even cannon, marched on the palace at Versailles demanding bread (Fig. **32.11**). The next day, they marched back to the city with the king and queen in tow. The now essentially powerless royal couple lived as virtual prisoners of the people in their Paris palace at the Tuileries.

The Declaration of the Rights of Man and the Constitution of 1791

The National Assembly, which also relocated to Paris after the women's march on Versailles, had passed, on August 26, 1789, the Declaration of the Rights of Man and Citizen. It was a document deeply influenced by Jefferson's Declaration of Independence, as well as the writings of John Locke. It listed 17 "rights of man and citizen," among them these first three, which echo the opening of the American document (**Reading 32.1**):

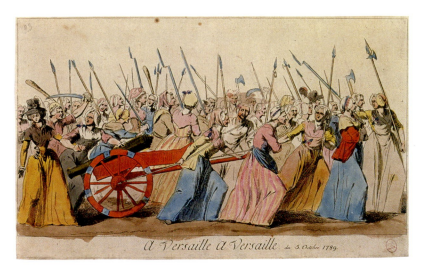

Fig. 32.11 To Versailles, To Versailles, October 5, 1789. Engraving. Musée de la Ville de Paris, Musée Carnavalet, Paris. The despair on the face of the aristocratic woman at the left contrasts sharply with the determined working-class women heading for Versailles.

> **READING 32.1** **from The Declaration of the Rights of Man and Citizen (1789)**
>
> 1. Men are born and remain free and equal in rights. . . .
> 2. The aim of every political association is the preservation of the natural and imprescriptible [inherent or inalienable] rights of man. These rights are liberty, property, security, and resistance to oppression.
> 3. The principle of all sovereignty resides essentially in the nation. No body nor individual may exercise authority which does not proceed from the nation.

Due process of law was guaranteed, freedom of religion was affirmed, and taxation based on the capacity to pay was announced.

For a time, the king managed to appear as if he were cooperating with the National Assembly, which was busy drafting a constitution declaring a constitutional monarchy on the model of England. The most important aspect of the document was its reorganization of the government. It converted the traditional 39 irregularly sized provinces of France into 83 new *départements* of approximately equal size (see Map 32.1). These were subdivided into *arrondissements*, or "districts," and further into communes, or municipalities. The government councils and officials in each of these new structures were given a considerable degree of self-governance. In addition, the new constitution promised a uniform code of law and free public education. It also declared marriage a civil, not religious, contract and abolished the old judiciary, replacing it with elected judges and prosecutors.

Then, in June 1791, just a couple of months before the new constitution was completed, Louis tried to flee France

with his family, an act that seemed treasonous to most Frenchmen. The royals were evidently planning to join a large number of French nobility who had removed themselves to Germany, where they were actively seeking the support of Austria and Russia in a counterrevolution. A radical minority of the National Assembly, the **Jacobins** [zhak-oh-behns], had been lobbying for the elimination of the monarchy and the institution of egalitarian democracy for months. Louis's actions strengthened their position.

In April 1792, fearing an attempt to reinstate the monarchy, the Legislative Assembly, newly elected under the new constitution, declared war on Austria, now ruled by Marie Antoinette's nephew. Austria quickly allied itself with Prussia, making the prospects of the French Revolution seem bleak. Nevertheless, the Jacobin orators, led by Georges-Jacques Danton (1759–1794), and the movement's press, especially Jean-Paul Marat's [mah-RAH] (1743–1793) *The Friend of the People*, rallied French sentiment. "Boldness," Danton urged, "more boldness, always boldness."

At the same time, the Jacobin radicals were consolidating their power. Over the summer of 1792, they gained total control of the Parisian *arrondisements*, and on August 9 took over the city hall of Paris. The next morning, they attacked the palace and massacred the king's Swiss guard even while the royal family took refuge in the Legislative Assembly. The assembly voted to suspend the king from office and imprison the royal family. They also called for a new Constitutional Convention to abolish the monarchy. In the weeks leading up to the convention, mobs moved from prison to prison, holding makeshift trials and sentencing more than 1,000 aristocrats and priests—but also common criminals and prostitutes—to death. This bloodbath became known as the September Massacres.

Robespierre and the Reign of Terror

When the Constitutional Convention convened, it immediately declared France a Republic, the only question being just what kind. Moderates favored executive and legislative branches independent of one another and laws that would be submitted to the people for approval. But Jacobin extremists, led by Maximilien Robespierre [rohbz-pee-YAIR] (1758–1794), argued for what he called a "Republic of Virtue," a dictatorship led by a 12-person Committee for Public Safety, of which he was one of the members. A second Committee for General Security sought out enemies of the republic and turned them over to the new Revolutionary Tribunal, which over the course of the next three years executed as many as 25,000 citizens of France. These included not only royalists and aristocrats, but also good republicans whose moderate positions were in opposition to Robespierre. Louis XVI himself was tried and convicted as "Citizen Louis Capet" (the last of the Capetian dynasty) on January 21, 1793, and his queen, Marie Antoinette, referred to as "the widow Capet," was executed ten months later (see Fig. 29.26). As Robespierre explained, defending his Reign of Terror:

If virtue be the spring of popular government in times of peace, the spring of that government during a revolution is virtue combined with terror.... Terror is only justice prompt, severe and inflexible; it is then an emanation of virtue....

It has been said that terror is the spring of despotic government. . . . The government in revolution is the despotism of liberty against tyranny.

The Constitutional Convention instituted many other reforms as well. Some bordered on the silly—expunging the king and queen from the deck of cards and eliminating use of the formal *vous* ("thou") in discourse, substituting the informal *tu* ("you") in its place. Others were of greater import. The delegates banned slavery in all the French colonies, inspired by the contributions of representatives such as Jean-Baptiste Bellay [beh-LAY] (Fig. **32.12**), a former slave and one of three black delegates from Santo Domingo (now Haiti), where slaves led by freed slave Toussaint-Louverture [too-SEHN loo-vair-tyoor] (ca. 1743–1803) had revolted in 1791.

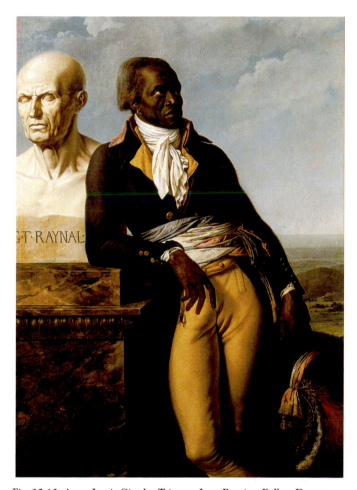

Fig. 32.12 Anne-Louis Girodet-Trioson. *Jean-Baptiste Bellay, Deputy from Santo Domingo.* **1797.** Oil on canvas, 63″ × 45″. Musée National du Château de Versailles, France. Art Resource/Reunion des Musees Nationaux. Bellay delivered a strong speech to the Constitutional Convention pledging the support of his people to the French Revolution and asking the Convention to abolish slavery. His efforts helped convince the Convention to declare the liberty of all black people.

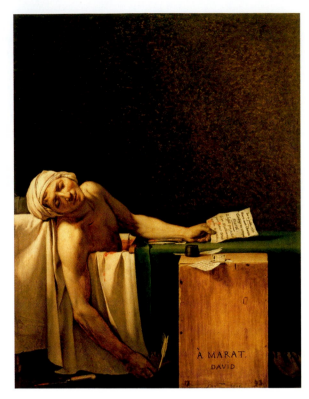

Fig. 32.13 Jacques-Louis David. *The Death of Marat.* 1793. Oil on canvas, 65″ × 50½″. Musée Royal des Beaux-Arts, Brussels. David inscribed the makeshift writing table in trompe-l'oeil fashion, as if carved into the wood, "À MARAT DAVID" —"To Marat David"—his own name in smaller capital letters than his hero's, suggesting his own humility and that the work is an homage to the greater man.

His portrait in the Neoclassical style by Anne-Louis Girodet [zhee-roh-DAY], a student of David's, shows Bellay dressed in the French fashion and leaning against a bust of the Abbé Reynal [reh-NAHL]. With the assistance of *philosophe* Denis Diderot, Reynal had written a six-volume *Philosophical and Political History of the Settlements and Trades of the Europeans* (1770), which openly asserted the right of oppressed peoples in the colonies to revolt. Reynal's thinking paved the way for the convention's ban on slavery in the colonies. The painting is important as a tribute to Reynal and Bellay's egalitarian principles rather than as a great portrait of Bellay himself.

Another reform was the de-Christianization of the country, which required that all churches become "Temples of Reason." The calendar was no longer to be based on the year of the birth of Christ, but on the first day of the Republic. Year one began, then, on September 21, 1792. New names, associated with the seasons and the climate, were given to the months. "Thermidor," for instance, was the month of Heat, roughly late July through early August. Finally, the idea of the Sunday sabbath was eliminated, and every tenth day was a holiday.

Tensions remained high. On July 13, 1793, the day before the celebration honoring the storming of the Bastille, the Jacobin hero and fiery editor of *The Friend of the People*, Jean Paul Marat, was assassinated in his bath, where he normally spent hours to treat a severe case of eczema. The assassin was

Charlotte Corday [KOR-day], a young royalist who believed she was the new Joan of Arc, destined to liberate France from Jacobin radicalism. The Jacobins of the National Assembly asked David to paint a *Death of Marat* (Fig. 32.13). This work is notable for its seemingly unflinching depiction of its hero at the moment of his brutal death and for David's ability to turn a lowly bathroom setting into a monumental image.

Marat had specifically designed a desk to fit over the bath to allow him to conduct business while attending to his terrible skin disease. The pose David chose for him is an instance of using a religious device for a secular image, for the revolutionary patriot confronts the viewer in a position reminiscent of the dead Christ at the Lamentation, traditionally depicted with his right arm dropping to his side. David also pushes Marat to the front of the picture plane so that the viewer seems to be in the same room with the body. Marat holds in one hand the letter from Corday that had gained her entry, and in the other his pen, with which he had been writing the note that hangs over the edge of the crate he used as a desk. The letter of introduction from Corday to Marat is partly legible. Translated from the French, it reads, "My unhappiness alone suffices to give a right to your good will." Her "unhappiness" was her distaste for Marat and the antiroyalist politics he represented, but Corday understood full well that Marat would misinterpret her meaning, supposing that she was complaining about the monarchy, not representing its interests.

When David presented the painting, on October 16, 1793, the day before Marie Antoinette was guillotined, he addressed the assembly in a remarkable speech:

> Hurry, all of you! Mothers, widows, orphans, oppressed soldiers, all whom he defended at the risk of his life, approach and contemplate your friend; he who was so vigilant is no more; his pen, the terror of traitors, his pen has slipped from his hand! Grieve! Our tireless friend is dead. He died giving you his last piece of bread; he died without even the means to pay for his funeral. Posterity, you will avenge him; you will tell our descendants how he could have possessed riches if he had not preferred virtue to fortune. . . .

In this image of self-enforced poverty David has purposefully contrasted Marat's pen, which he holds in his right hand, with Corday's knife, on the floor beside him. The pen, "the terror of traitors," David seems to say, is mightier than the sword.

Marat's self-imposed poverty is represented by the *assignat* [ah-seen-YAH], French paper money, that lies on the writing table beside him. The accompanying note, translated, says, "You will give this *assignat* for the defense . . ." of a widow with five children whose father had died for his country, indicating that Marat is voluntarily giving up money for a noble cause. The *assignat* is a sign of the same faith and conviction in the future of the Republic that led Marat unsuspectingly to admit Charlotte Corday to his rooms.

The Reign of Terror ended suddenly in the summer of 1794. Robespierre pushed through a law speeding up the work of the Tribunal, with the result that in six weeks some 1,300 people were sent to death. Finally, he was hounded out

of the Convention to shouts of "Down with the tyrant!" and chased to city hall. Here he tried to shoot himself but succeeded only in shattering his lower jaw. He was executed the next day with 21 others.

The last act of the convention was to pass a constitution on August 17, 1795. It established France's first bicameral (two-body) legislature, consisting of the Council of Five Hundred (modeled on the ancient Athenian Council of Five Hundred) and the Council of Elders. Only men who owned or rented property worth between 100 and 200 days' labor, could serve as electors to choose the Councils, effectively limiting the number of voters to 30,000 people. The Council of Five Hundred nominated a slate of candidates to serve on a five-person executive Directory, and the Council of Elders, a smaller body, chose the five. Over the next four years, the Directory improved the lot of French citizens, but its relative instability worried moderates. So, in 1799, the successful young commander of the army, Napoleon Bonaparte (1769–1821), conspired with two of the five directors in the *coup d'état* that ended the Directory's experiment with republican government. This put Napoleon in position to assume control of the country.

The Rights of Woman

It was obvious to most women in both revolutionary France and America that although the rights of "man" were forcefully declared, the rights of women were wholly ignored. Abigail Adams in a letter to her husband in the spring of 1776 reminded him that

> if particular care and attention is not paid to the ladies we are determined to foment a rebellion, and will not hold ourselves bound by any laws in which we have no voice or representation.
>
> That your sex are naturally tyrannical is a truth so thoroughly established as to admit of no dispute, but such of yours as wish to be happy willingly give up the harsh title of master for the more tender and endearing one of friend. Why then not put it out of the power of the vicious and the lawless to use us with cruelty and indignity with impunity. Men of sense in all ages abhor those customs which treat us only as vassals of your sex. Regard us then as being placed by providence under your protection and in imitation of the Supreme Being make use of that power only for our happiness.

Sentiments such as these represent the dawn of the modern movement for gender equality. Although Adams expressed her feelings privately to her husband, other women, such as Olympe de Gouges in France and Mary Wollstonecraft in England, took a more public stand.

Olympe de Gouges: The Call for Universal Rights

Olympe de Gouges [duh goozh] (1748–1793) was one of the victims of the Reign of Terror. Born in the south of France to a butcher and a washerwoman, she moved to Paris after the death of her husband and began to write essays, manifestos, and plays concerning social injustice. She greeted the start of the French Revolution with enthusiasm, but when it became clear that equal rights to vote and hold political office were not being extended to women, she became disenchanted. In 1791 she joined a group of advocates for women's rights. In particular, they called for more liberal divorce laws that would grant women equal rights to sue for divorce, and for a revision of inheritance laws that would grant women equal rights in inheriting family property. In this haven of Enlightenment thinking de Gouges declared, "A woman has the right to mount the scaffold. She must possess equally the right to mount the speaker's platform." In that same year she wrote a *Declaration of the Rights of Woman and the Female Citizen*, modeled on the Declaration of the Rights of Man and Citizen (Reading 32.1, page 1034). It begins as follows (**Reading 32.2**):

READING 32.2 from Olympe de Gouges, *Declaration of the Rights of Woman and the Female Citizen* (1791)

Article I. Woman is born free and lives equal to man in rights. . . .

Article II. The purpose of any political association is the conservation of the natural and imprescriptible [inherent or inalienable] rights of woman and man; these rights are liberty, property, security, and especially resistance to oppression.

Article III. The principle of all sovereignty rests essentially with the nation, which is nothing but the union of woman and man; no body and no individual can exercise any authority which does not come expressly from it [the nation].

Article IV. Liberty and justice consist of returning all that belongs to others; thus, the only limits on the exercise of the natural rights of woman are perpetual male tyranny wielded; these limits are to be reformed by the laws of nature and reason. . . .

De Gouges also published a *Social Contract*, an intentionally radical revision of Jean-Jacques Rousseau's work of the same name proposing marriage based on male and female equality. De Gouges tirelessly lobbied the Constitutional Convention for passage of her *Declaration*, and as her efforts appeared fruitless, she became more vehement in her writings about injustice. (Most revolutionary males followed the thinking of Rousseau in *Émile* [see chapter 29] and believed that the proper role for women remained in the home.) In 1793, the convention banned all women's clubs, ostensibly because of fights between women's club members and market women over proper revolutionary costume, but in reality because of widespread distaste for women's involvement in political activity. Four days later the government put de Gouges to death. She was guillotined as a

counterrevolutionary, for authoring a pamphlet arguing that the future government of the country should be determined by popular referendum, not by the National Convention.

Mary Wollstonecraft: An Englishwoman's Response to the French Revolution

Even as de Gouges was pleading her case before the Constitutional Convention, in England one of the great defenders of the French Revolution was Mary Wollstonecraft (1759–1797). She published *A Vindication of the Rights of Woman* in 1792, just a year before publishing her *History and Moral View of the Origin and Progress of the French Revolution*. The immediate incentive for the first of these two important publications was certain policies of the French Revolution unfavorable to women that were inspired by Rousseau. She accused Rousseau and others who supported traditional roles for women of trying to restrict women's experience and narrow their vision, thus keeping them as domestic slaves of men. Wollstonecraft, like Olympe de Gouges, broadened the agenda of the Enlightenment by demanding for women the same rights and liberties that male writers had been demanding for men. The tone of her attack is apparent in the following extract from the Introduction to *A Vindication* (**Reading 32.3a**). (For the Introduction in full, see **Reading 32.3**, page 1044.)

> Liberty is the mother of virtue, and if women be, by their very constitution, slaves, and not allowed to breathe the sharp, invigorating air of freedom, they must ever languish like exotics, and be reckoned beautiful flaws in nature. . . .

Wollstonecraft's own personal life was not nearly as clearly organized as her arguments in *A Vindication*. During a turbulent affair with an American timber merchant, she mothered an illegitimate child and attempted suicide on at least two occasions. She married the novelist William Godwin (1756–1836) when she became pregnant by him, giving birth to a daughter Mary (1797–1851), the future wife of poet Percy Bysshe Shelley (1792–1822) and author of the novel *Frankenstein* (see chapter 34). The placenta remained in Wollstonecraft's womb after the birth, and in 1797, at the age of 38, she died of blood poisoning resulting from her physician's attempt to remove it. But however troubled her personal life, the *Vindication of the Rights of Woman*, in contrast to the writings of her French contemporary Olympe de Gouges, was deeply influential. In many ways, Wollstonecraft fashioned the main points of what would later become the liberal feminist movement, arguing not for a radical restructuring of society, but for the right of women to access the same social and political institutions as men. She demanded, simply, equal opportunity.

Napoleon and Neoclassical Paris

Women's dissatisfaction with the outcome of the French Revolution was one of many problems facing the government. In fact, turbulence was the political reality of post-Revolutionary France. The Directory was not providing stability. On November 9 and 10, 1799, Napoleon Bonaparte staged a veritable *coup d'état* (violent overthrow of government) and forced three of the Directory's five directors to resign, barely managing to persuade the councils to accept himself and the two remaining directors. It was the threat of economic and international chaos—including a new coalition formed against France by England, Austria, Russia, and the Ottomans—that guaranteed his success. Order was the call of the day, and Napoleon was bent on restoring it. To this purpose he turned to models from classical antiquity.

The Consulate and the Napoleonic Empire: 1799–1814

Napoleon's *coup d'état* was intended to overthrow the existing constitution that the Directory had approved. The new constitution that he put in its place created a very strong executive called the Consulate, modeled on ancient Roman precedents. Composed of himself and the two directors, it established Napoleon as First Consul of the French Republic, relegating the other two to mere functionary status. The constitution also established something of a sham legislature composed of four bodies: a Council of State to propose laws; a Tribunate to debate

READING 32.3a **from Mary Wollstonecraft, Introduction to *A Vindication of the Rights of Woman* (1792)**

My own sex, I hope, will excuse me, if I treat them like rational creatures, instead of flattering their fascinating graces, and viewing them as if they were in a state of perpetual childhood, unable to stand alone. I earnestly wish to point out in what true dignity and human happiness consists—I wish to persuade women to endeavour to acquire strength, both of mind and body, and to convince them that the soft phrases, susceptibility of heart, delicacy of sentiment, and refinement of taste, are almost synonymous with epithets of weakness, and that those beings who are only the objects of pity and that kind of love, which has been termed its sister, will soon become objects of contempt.

Dismissing then those pretty feminine phrases, which the men condescendingly use to soften our slavish dependence, and despising that weak elegancy of mind, exquisite sensibility, and sweet docility of manners, supposed to be the sexual characteristics of the weaker vessel, I wish to show that elegance is inferior to virtue, that the first object of laudable ambition is to obtain a character as a human being, regardless of the distinction of sex. . . .

them (though not vote on them); a Legislative Corps to vote (though not debate); and a Senate, which possessed the right to veto any legislation. The First Consul appointed the Council of State, and thus it proposed laws as Napoleon decreed. It was understood that the duty of the other three bodies was to "rubber stamp" the First Consul's wishes. France's experiment with a republican form of government was over.

By 1802, Napoleon had convinced the legislators to declare him First Consul of the French Republic for life, with the power to amend the constitution as he saw fit. In 1804, he instigated the Senate to go a step further and declare that "the government of the republic is entrusted to an emperor." This created the somewhat paradoxical situation of a "free" people ruled by the will of a single individual. But Napoleon was careful to seek the consent of the electorate in all of these moves. When he submitted his constitution and other changes to the voters in a plebiscite, they ratified them by an overwhelming majority.

Napoleon justified voter confidence by moving to establish stability across Europe by force. To this end, in 1800 he crossed into Italy and took firm control of Piedmont and Lombardy. After establishing a position in Italy, he prepared to invade England, his chief enemy. Financed in no small part by the sale of the Louisiana Territory to the United States in 1803 for 80 million francs (roughly $16 million), Napoleon assembled over 100,000 troops and a thousand landing craft on the straits of Dover. His tactics were arguably flawless, but they were not executed as planned. In order to cross the Channel, he needed to lure away Vice-Admiral Horatio Nelson (1758–1805), commander of the British fleet. To this end, in the fall of 1805, he dispatched the French fleet to the West Indies under the command of Admiral Pierre de Villeneuve. The plan was for Villeneuve to give Nelson the slip and return to escort the French army across the Channel. But Nelson caught up to Villeneuve off Cape Trafalgar near the southwest corner of Spain in October and, at the cost of his own life, destroyed nearly half the French fleet without the loss of any of his own ships.

Although Napoleon never defeated the British navy—and thus never controlled the seas—from 1805 to 1807 he launched a succession of campaigns against Britain's allies, Austria and Prussia. He defeated both, and by 1807 the only European countries outside Napoleon's sphere of influence were Britain, Portugal, and Sweden. Through ten years of war and short periods of armed truce, Napoleon changed the map of Europe (see Map 32.2). Everywhere he was victorious, he brought the reforms that he had estab-

CULTURAL PARALLELS

Napoleon's Influence in Egypt

While Napoleon was transforming French society and government, 2,000 miles south of Paris, another society was also in the midst of revolutionary changes. Muhammad Ali, an Ottoman officer, took advantage of the short-lived French occupation of Egypt to seize power. After being named Viceroy by the Ottoman leaders, he modernized Egypt's government and created a modern army modeled on Napoleon's.

lished in France and overturned much of the old political and social order. Eventually the subdued lands became resentful. A series of military defeats, including the so-called Battle of the Nations at Leipzig in October 1813, led to his abdication and exile and then final defeat by the English under the duke of Wellington and the Prussians under Field Marshall von Blücher at Waterloo, Belgium, on June 18, 1815.

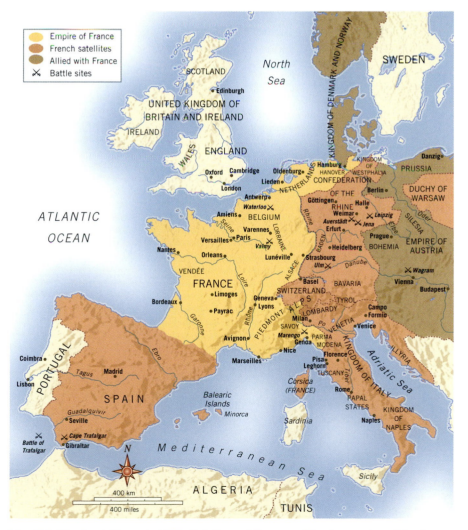

Map 32.2 Napoleonic Europe in 1807. Only Portugal, Britain, and Sweden were free of Napoleonic domination. Sicily and Sardinia, in the Mediterranean, were protected by the British fleet.

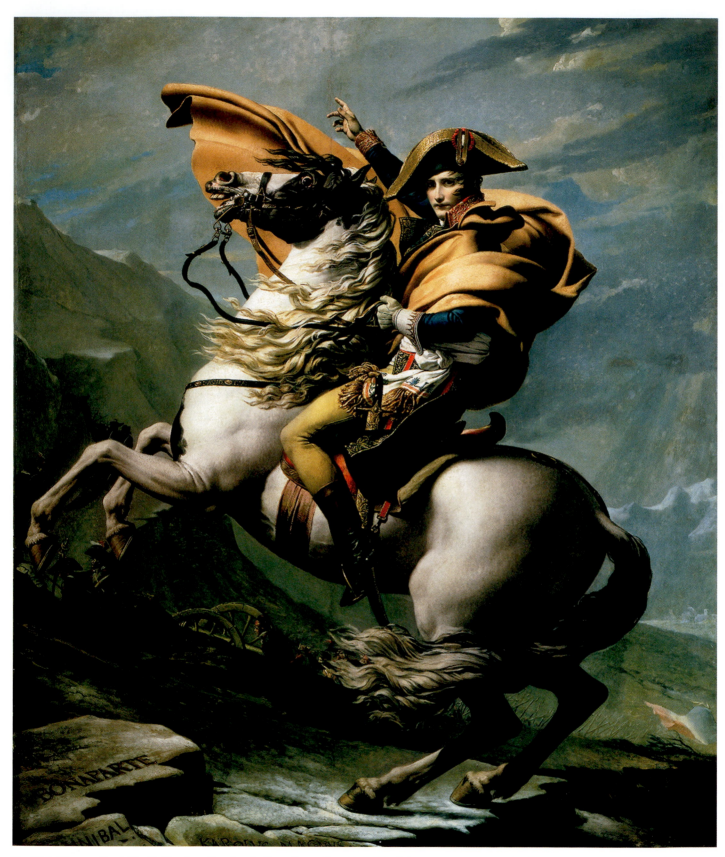

Fig. 32.14 Jacques-Louis David. *Napoleon Crossing the Saint-Bernard.* **1800–1801.** Oil on canvas, 8′11″ × 7′7″. Musée National du Château de la Malmaison, Rueil-Malmaison, France. RMN Reunion des Musees Nationaux/Art Resource, NY. David would claim to everyone, "Bonaparte is my hero!" This is one of five versions of the painting, which differ significantly in color, painted by David and his workshop. There are also many copies in French museums and elsewhere done by others.

Art as Propaganda: Painting, Architecture, Sculpture

Napoleon celebrated major events by commissioning paintings, sculpture, and architecture. The paintings and sculptures were prominently displayed in public settings and the architecture was situated at important junctions in Paris. All were meant to present the physically small but extremely ambitious man as hero and leader of France or to remind the public of his efforts on their behalf. The Neoclassical style was perfect for these purposes. It was already associated with the republicanism and liberty of the French Revolution, and it could easily be adapted to the needs of empire and authority. So Napoleon adopted it as First Consul and continued to do so after he crowned himself emperor in 1804. Contributing to these efforts were the painters Jacques-Louis David and Jean-Auguste-Dominique Ingres [eng], the architect Pierre-Alexandre Vignon [veen-YOHN], and the sculptor Antonio Canova [kuh-NOH-vah].

David as Chronicler of Napoleon's Career David, who had survived the revolutionary era and painted many of its events, went on to portray many of the major moments of Napoleon's career. He celebrated the Italian campaign in *Napoleon Crossing the Saint-Bernard* (Fig. **32.14**). Here he depicts Napoleon on horseback leading his troops across the pass at Saint-Bernard in the Alps. In its clearly drawn central image and its emphasis on right angles (consider Napoleon's leg, the angle of his pointing arm to his body, the relation of the horse's head and neck, and the angle of its rear legs), the painting is fully Neoclassical. In the background, as is typical of David, is a more turbulent scene as Napoleon's troops drag a cannon up the pass. In the foreground, inscribed on the rocks, are the names of the only generals who crossed the Alps into Italy: Hannibal, whose brilliance in defeating the Romans in the third century BCE Napoleon sought to emulate; Karolus Magnus (Charlemagne); and Napoleon.

Actually, Napoleon did not lead the crossing of the pass but crossed it with his rear guard, mounted on a mule led by a peasant. So the work is pure propaganda, designed to create a proper myth for the aspiring leader. Though still four years from crowning himself emperor, the First Consul's aspirations to unite Europe and rule it are made clear in his identification with the great Frankish emperor of the Holy Roman Empire, Charlemagne. Napoleon was boldly creating a myth that is probably nowhere better expressed than by the great German philosopher Georg Wilhelm Friedrich Hegel [HAY-gul] (1770–1831) in a letter of October 13, 1806: "I have seen the emperor, that world soul, pass through the streets of the town on horseback. It is a prodigious sensation to see an individual like him who, concentrated at one point, seated on a horse, spreads over the world and dominates it."

Ingres's Glorification of the Emperor No image captures Napoleon's sense of himself better than the 1806 portrait by Jean-Auguste-Dominique Ingres (1780–1867) of *Napoleon on His Imperial Throne* (Fig. **32.15**). Ingres was David's student, a winner of the Rome prize, and a frequent exhibitor at the annu-

al Salon of the French Academy of Fine Arts. He sought a pure form of classicism, characterized by clarity of line, a dedication to detail, and a formal emphasis on balance and symmetry.

In this commission from Napoleon, Ingres depicts him as a monarch who embodies the total power of his country. Ingres combines two well-known frontal images of the deities Jupiter, or Zeus, and God the Father with the imperial attributes of the historical emperors Charlemagne and Charles V of Spain. The Jupiter image was a lost sculpture known only in gemstone but attributed to Phidias, the master of the Greek Golden Age. The God the Father image was in Jan van Eyck's *Ghent Altarpiece* (see Figure 20.10), which Napoleon had taken from Ghent during his Prussian cam-

Continuity & Change
p. 649

Ghent Altarpiece

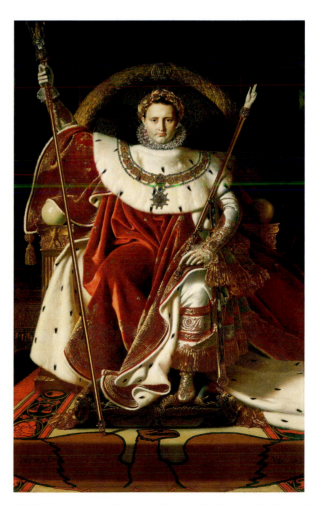

Fig. 32.15 Jean-Auguste-Dominique Ingres. *Napoleon on His Imperial Throne.* **1806.** Oil on canvas, 102″ × 64″. Musée de l'Armée, Paris. The carpet at Napoleon's feet is an imperial eagle flanked by signs of the zodiac, including Scorpio, Libra, and Virgo, at the left, and Pisces and Taurus at the right, as if the emperor's fame were written in the stars.

paign and installed in the Louvre. Ingres establishes the emperor's identification with Charlemagne by the sword beneath his left forearm and the ivory hand of justice, both of which were believed to have originally belonged to Charlemagne. And he evokes the Habsburg Holy Roman Emperor Charles V of Spain through the scepter in Napoleon's right hand, thus symbolically uniting France and Austria for the first time since Charlemagne's reign in the early Middle Ages. Like David's portrait *of Napoleon Crossing the Saint-Bernard*, Ingres's painting is a conscious act of propaganda, cementing in the public mind the image of the emperor as nearly godlike in his power and dominion. The David and Ingres portraits underscore the fact that Napoleon understood quite well the ability of art to move and control the popular imagination.

Vignon's La Madeleine Napoleon reasoned that if he was now the new emperor, Paris should be the new Rome. The city already tended to be dominated by Neoclassical architecture, from the east facade of the Louvre to Sainte-Geneviève (see Fig. 32.1) rising above the Left Bank. Napoleon sought to extend the sense of order and reason these buildings suggested. He soon commissioned the construction of Roman arches of triumph and other classically inspired monuments to commemorate his victories and convey the political message of the glory of his rule. One of the most impressive works was the redesign of a church that had been started under Louis XVI but that Napoleon wanted to see reinterpreted as a new Temple of the Glory of the Grand Army. This work, commissioned in 1806 from Pierre-Alexandre Vignon (1763–1828), was to have been identified by the following dedicatory inscription: "From the Emperor to the soldiers of the Great Army." It was another of the many Parisian churches, like Sainte-Geneviève, that were converted to secular temples during this epoch. Ironically, Napoleon reversed his decision to honor the army in 1813 after the unfortunate Battle of Leipzig and the loss of Spain. Although work continued on the building, its original name, the church of La Madeleine, was restored.

Not completed until after Napoleon's downfall, but nevertheless to Vignon's original design, La Madeleine is imperially Roman in scale and an extraordinary example of Neoclassical architecture (Fig. **32.16**). Eight 63-foot-high Corinthian columns dominate its portico, and 18 more rise to the same height on each side. Beneath the classical roofline of its exterior, Vignon created three shallow interior domes that admit light through

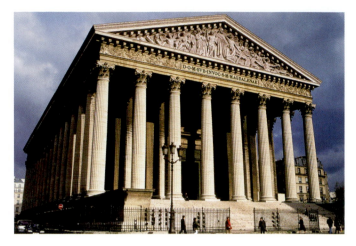

Fig. 32.16 Pierre-Alexandre Vignon. La Madeleine, Paris. 1806–1842. Length, 350′, width 147′, height of podium 23′, height of columns 63′. The church of La Madeleine was built to culminate a north–south axis that began on the left bank of the Seine at the Chamber of Deputies (newly refurbished with a facade of Corinthian columns), crossing a new bridge northward into the Place de la Concorde.

oculi at their tops that are hidden by the roofline. They light a long nave without aisles that culminates in a semicircular apse roofed by a semidome. This interior evokes traditional Christian architecture, even as the exterior announces its classicism through the Roman temple features. (For evidence that the beauty of such Neoclassical buildings in Paris was not the only reality, see *Voices*, page 1043.)

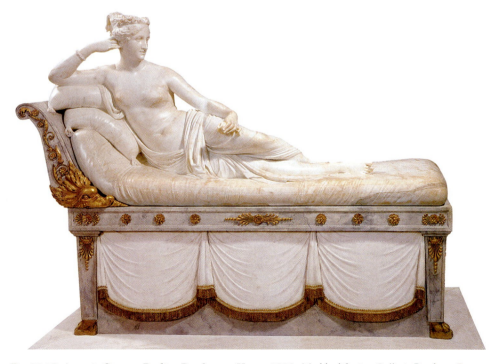

Fig. 32.17 Antonio Canova. *Paolina Borghese as Venus*. 1808. Marble, life-size. Galleria Borghese, Rome. Canova's sculpture was originally mounted on a pivot so that it might be turned toward the window for viewing in natural light or adjusted at night to be illuminated in torchlight from within.

Voices

The Perils of the Parisian Streets

The beauty of Paris's Neoclassical buildings and art sharply contrasted with the dense network of streets and alleys where most of its inhabitants lived. Although Napoleon intended to make great structural changes to Paris during his reign, relatively few were put into effect. Most of the city remained as it had for centuries, with narrow, dark, winding streets, open sewers, and foul-smelling stairs and public passageways within buildings. English writer Frances Trollope expressed her impressions of the city in a series of letters from 1835:

I n a city where everything intended to meet the eye is converted into graceful ornament, where the shops and coffee-houses have the air of fairy palaces and the markets show fountains wherein the daintiest naiads [water nymphs] might delight to bathe . . . where the women look too delicate to belong wholly to earth . . . in such a city as this you are shocked and disgusted at every step you take or at every gyration the wheels of your carriage can make by sights and smells that may not be described. Every day brings my astonishment on this subject to a higher pitch than the one which preceded it. . . .

"Nuisances and abominations of all sorts are without scruple committed to the street at any hour of the day or night . . . and happy it is indeed for the humble pedestrian if his eye and nose alone suffer from these ejectments"

Nuisances and abominations of all sorts are without scruple committed to the street at any hour of the day or night to await the morning visit of the scavenger to remove them: and happy it is indeed for the humble pedestrian if his eye and nose alone suffer from these ejectments [the contents of chamber pots, garbage] . . . happy indeed if he comes not in contact with them, as they make their unceremonious exit from the window or door.

On the subject of that monstrous barbarism, a gutter in the streets expressly formed for the reception of filth, which is still permitted to deform the greater part of this beautiful city, I can only say that the patient endurance of it is a mystery.

Canova and the Bonapartes Napoleon did not limit his propagandistic commissions to French artists and architects. In 1802 he had invited to Paris the highly reputed Italian sculptor Antonio Canova (1757–1822) to model a larger-than-life-size marble statue of him to celebrate his being named consul for life. Canova was famous for his ability to delicately render nude flesh in the Neoclassical style. Against Napoleon's wishes he had depicted the consul nude, as the god Mars, in a sculpture that eventually ended up as a war trophy for the duke of Wellington (see Fig. 31.20). Napoleon had argued with Canova about being portrayed in the nude and the sculptor had replied: "We, like the poets, have our own language. If a poet introduced into a tragedy, phrases and idioms used habitually by the lower classes in the public streets, he would be rightly reprimanded. . . . We sculptors cannot clothe our statues in modern costume without deserving a similar reproach."

In 1808, by which time the consul had had himself crowned as emperor, Canova had less trouble convincing Napoleon's sister, Paolina Bonaparte Borghese [bor-GAY-zeh] (1780–1825), to allow him to depict her in the nude as well. Perhaps this was because she understood that her sexuality was the means by which she had attained her position as the wife of one of the richest men in all of Europe, Prince Camillo Borghese.

Canova was bent on showing that his art was equal if not superior to that of the ancients. Following the recommendations of Winckelmann (see chapter 31), he searched for beauty in clear forms, harmonious lines, and all-around viewpoints. His portrait busts and sculptural groups ranged from delicately lyric to formal and symbolic. His sculpture of Paolina Borghese is life-size, and its pedestal is a different-colored marble, replicating a chaise (reclining chair) (Fig. **32.17**). She holds an apple, the traditional symbol of Venus, and thus, like her brother, appropriates mythical status, the personification of a goddess, untouchable by mortal hands. In its elegant contours and astonishingly smooth representation of flesh (unequaled by any of Canova's many imitators), the work aspires to the noble simplicity and calm grandeur that Winckelmann found in ancient classical sculpture (see Fig. 7.24).

Paolina Borghese never intended this sculpture to be viewed by a public any wider than her immediate social circle, and then only at night, under the dramatic lighting of torchlight. Thus, the sculpture is a sort of dramatic set piece, unlike the statue of her brother, which had a political intent. Her nudity was understood to suggest a goddess of antiquity and thus be aristocratic, not demeaning. It was a form of *personal* propaganda that belied her beginnings as the daughter of a poor family of lesser nobles.

READINGS

READING 32.3

from Mary Wollstonecraft, *A Vindication of the Rights of Woman* (1792)

Following is the author's Introduction to A Vindication of the Rights of Woman*, written a year after* A Vindication of the Rights of Man*, a defense of the French Revolution. She recognized that unlike the English and American revolutions, which were about a redistribution of power among the "already haves," the French Revolution was about the seizure of power by the "have nots." Women, she knew, were universally the "have nots." Wollstonecraft's essay was directly indebted to Rousseau. While accepting his essential thinking she extends his arguments to women.*

After considering the historic page, and viewing the living world with anxious solicitude, the most melancholy emotions of sorrowful indignation have depressed my spirits, and I have sighed when obliged to confess, that either nature has made a great difference between man and man, or that the civilization which has hitherto taken place in the world has been very partial. I have turned over various books written on the subject of education, and patiently observed the conduct of parents and the management of schools; but what has been the result?—a profound conviction that the neglect- 10 ed education of my fellow-creatures is the grand source of the misery I deplore; and that women, in particular, are rendered weak and wretched by a variety of concurring causes, originating from one hasty conclusion. The conduct and manners of women, in fact, evidently prove that their minds are not in a healthy state; for, like the flowers which are planted in too rich a soil, strength and usefulness are sacrificed to beauty; and the flaunting leaves, after having pleased a fastidious eye, fade, disregarded on the stalk, long before the season when they ought to have arrived at maturity.—One cause of this barren bloom- 20 ing I attribute to a false system of education, gathered from the books written on this subject by men who, considering females rather as women than human creatures, have been more anxious to make them alluring mistresses than wives; and the understanding of the sex has been so bubbled by this specious homage, that the civilized women of the present century, with a few exceptions, are only anxious to inspire love, when they ought to cherish a nobler ambition, and by their abilities and virtues exact respect.

In a treatise, therefore, on female rights and manners, the 30 works which have been particularly written for their improvement must not be overlooked; especially when it is asserted, in direct terms, that the minds of women are enfeebled by false refinement; that the books of instruction, written by men of genius, have had the same tendency as more frivolous productions; and that, in the true style of Mahometanism, they are only considered as females, and not as a part of the human species, when improvable reason is allowed to be the dignified distinction which raises men above the brute creation, and puts a natural sceptre in a feeble hand. 40

Yet, because I am a woman, I would not lead my readers to suppose that I mean violently to agitate the contested ques- tion respecting the equality or inferiority of the sex; but as the subject lies in my way, and I cannot pass it over without subjecting the main tendency of my reasoning to misconstruction, I shall stop a moment to deliver, in a few words, my opinion.—In the government of the physical world it is observable that the female is, in general, inferior to the male. The male pursues, the female yields—this is the law of nature; and it does not appear to be suspended or abrogated 50 in favour of woman. This physical superiority cannot be denied—and it is a noble prerogative! But not content with this natural pre-eminence, men endeavour to sink us still lower, merely to render us alluring objects for a moment; and women, intoxicated by the adoration which men, under the influence of their senses, pay them, do not seek to obtain a durable interest in their hearts, or to become the friends of the fellow creatures who find amusement in their society.

I am aware of an obvious inference:—from every quarter have I heard exclamations against masculine women; but 60 where are they to be found? If by this appellation men mean to inveigh against their ardour in hunting, shooting, and gaming, I shall most cordially join in the cry; but if it be against the imitation of manly virtues, or, more properly speaking, the attainment of those talents and virtues, the exercise of which ennobles the human character, and which raises females in the scale of animal being, when they are comprehensively termed mankind;—all those who view them with a philosophical eye must, I should think, wish with me, that they may every day grow more and more masculine. 70

This discussion naturally divides the subject. I shall first consider women in the grand light of human creatures, who, in common with men, are placed on this earth to unfold their faculties; and afterwards I shall more particularly point out their peculiar designation.

I wish also to steer clear of an error which many respectable writers have fallen into; for the instruction which has hither been addressed to women, has rather been applicable to ladies, I pay particular attention to those in the middle class, because they appear to be in the most natural state. Perhaps the seeds of 80 false refinement, immorality, and vanity, have ever been shed by the great. Weak, artificial beings, raised above the common wants and affections of their race, in a premature unnatural manner, undermine the very foundation of virtue, and spread

corruption through the whole mass of society! As a class of mankind they have the strongest claim to pity; the education of the rich tends to render them vain and helpless, and the unfolding mind is not strengthened by the practice of those duties which dignify the human character.—They only live to amuse themselves, and by the same law which in nature invariably produces certain effects, they soon only afford barren amusement.

But as I purpose taking a separate view of the different ranks of society, and of the moral character of women, in each, this hint is, for the present, sufficient; and I have only alluded to the subject, because it appears to me to be the very essence of an introduction to give a cursory account of the contents of the work it introduces.

My own sex, I hope, will excuse me, if I treat them like rational creatures, instead of flattering their fascinating graces, and viewing them as if they were in a state of perpetual childhood, unable to stand alone. I earnestly wish to point out in what true dignity and human happiness consists—I wish to persuade women to endeavour to acquire strength, both of mind and body, and to convince them that the soft phrases, susceptibility of heart, delicacy of sentiment, and refinement of taste, are almost synonymous with epithets of weakness, and that those beings who are only the objects of pity and that kind of love, which has been termed its sister, will soon become objects of contempt.

Dismissing then those pretty feminine phrases, which the men condescendingly use to soften our slavish dependence, and despising that weak elegancy of mind, exquisite sensibility, and sweet docility of manners, supposed to be the sexual characteristics of the weaker vessel, I wish to show that elegance is inferior to virtue, that the first object of laudable ambition is to obtain a character as a human being, regardless of the distinction of sex; and that secondary views should be brought to this simple touchstone.

This is a rough sketch of my plan; and should I express my conviction with the energetic emotions that I feel whenever I think of the subject, the dictates of experience and reflection will be felt by some of my readers. Animated by this important object, I shall disdain to cull my phrases or polish my style;—I aim at being useful, and sincerity will render me unaffected; for, wishing rather to persuade by the force of my arguments, than dazzle by the elegance of my language, I shall not waste my time in rounding periods, nor in fabricating the turgid bombast of artificial feelings, which, coming from the head, never reach the heart.—I shall be employed about things, not words!—and, anxious to render my sex more respectable members of society, I shall try to avoid that flowery diction which has slided from essays into novels, and from novels into familiar letters and conversation.

These pretty nothings—these caricatures of the real beauty of sensibility, dropping glibly from the tongue, vitiate the taste, and create a kind of sickly delicacy that turns away from simple unadorned truth; and a deluge of false sentiments and overstretched feelings, stifling the natural emotions of the heart, render the domestic pleasures insipid, that ought to

sweeten the exercise of those severe duties, which educate a rational and immortal being for a nobler field of action.

The education of women has, of late, been more attended to than formerly; yet they are still reckoned a frivolous sex, and ridiculed or pitied by the writers who endeavor by satire or instruction to improve them. It is acknowledged that they spend many of the first years of their lives in acquiring a smattering of accomplishments: meanwhile strength of body and mind are sacrificed to libertine notions of beauty, to the desire of establishing themselves,—the only way women can rise in the world,—by marriage. And this desire making mere animals of them, when they marry they act as such children may be expected to act:—they dress; they paint, and nickname God's creatures.—Surely these weak beings are only fit for a seraglio!—Can they govern a family, or take care of the poor babes whom they bring into the world?

If then it can be fairly deduced from the present conduct of the sex, from the prevalent fondness for pleasure which takes place of ambition and those nobler passions that open and enlarge the soul; that the instruction which women have received has only tended, with the constitution of civil society, to render them insignificant objects of desire—mere propagators of fools!—if it can be proved that in aiming to accomplish them, without cultivating their understandings, they are taken out of their sphere of duties, and made ridiculous and useless when the short-lived bloom of beauty is over, I presume that rational men will excuse me for endeavouring to persuade them to become more masculine and respectable.

Indeed the word masculine is only a bugbear: there is little reason to fear that women will acquire too much courage or fortitude; for their apparent inferiority with respect to bodily strength, must render them, in some degree, dependent on men in the various relations of life; but why should it be increased by prejudices that give a sex to virtue, and confound simple truths with sensual reveries?

Women are, in fact, so much degraded by mistaken notions of female excellence, that I do not mean to add a paradox when I assert, that this artificial weakness produces a propensity to tyrannize, and gives birth to cunning, the natural opponent of strength, which leads them to play off those contemptible infantile airs that undermine esteem even whilst they excite desire. Do not foster these prejudices, and they will naturally fall into their subordinate, yet respectable station, in life.

It seems scarcely necessary to say, that I now speak of the sex in general. Many individuals have more sense than their male relatives; and, as nothing preponderates where there is a constant struggle for an equilibrium, without it has naturally more gravity, some women govern their husbands without degrading themselves, because intellect will always govern. ■

Reading Question

Why is it important to Wollstonecraft that her argument not be merely "applicable to *ladies*" but that it extend as well to the "middle class"?

Summary

■ Jacques-Louis David and the Neoclassical Style

Beginning in the middle of the eighteenth century, when Louis XV commissioned Jacques-Germain Soufflot to build a new church on the site of Sainte-Geneviève, the Neoclassical style began to supplant the aristocratic taste for the Baroque and Rococo. Jacques-Louis David, the premier painter of the day, readily adopted the style in his painting *The Oath of the Horatii*, in which he champions heroism and personal sacrifice for the state. At the Salon of 1787 the painting of his student Jean-Germain Drouais caused the greatest stir. The theme of motherhood was the focus of portraits exhibited at that Salon by Elisabeth Vigée-Lebrun, but her Rococo approach, epitomized in *Queen Marie Antoinette and Her Children*, lacks the depth of Angelica Kauffmann's Neoclassical rendition of the same theme in *Cornelia Pointing to Her Children as Her Treasures*. All of these Neoclassical paintings, including David's 1789 painting, *The Lictors Returning to Brutus the Bodies of His Sons*, contain complex political messages reflecting the issues of the day.

■ The French Revolution

In France, the national debt, and taxes associated with paying it, produced events leading to revolution. In June 1789, the Estates General convened, but the Third Estate soon withdrew and reconvened in a tennis court near Versailles. There it swore an oath never to disband until it had given France a constitution, an act that David planned on celebrating in a monumental painting. Events soon overwhelmed his intention. On July 14, 1789, a National Guard formed to protect the new National Assembly stormed the Bastille, a prison on the edge of the city, looking for arms. The revolution had begun. Peasants in the countryside rose up against the local nobility, and in October 7,000 women marched on Versailles demanding bread.

Meanwhile, in August 1789, the National Assembly had passed the Declaration of the Rights of Man and Citizen, a document inspired by the American Declaration of Independence. A Constitutional Convention drafted a constitution by 1791, but conditions deteriorated until every faction suspected the other of treason and Maximilien Robespierre instituted his Reign of Terror. When the revolutionary newspaper editor Jean Paul Marat was assassinated in 1783, David was commissioned to paint his portrait. A second constitution establishing the first bicameral legislature in French history was approved in 1795. This phase of the French Republic ended in 1799 with the *coup d'état* of Napoleon Bonaparte.

■ The Rights of Woman

While the rights of "man" had been boldly asserted in both the American and French revolutions, the rights of women had been ignored. In France, Olympe de Gouges wrote a *Declaration of the Rights of Women*, for which she was sent to the guillotine. In England, Mary Wollstonecraft quickly followed with *A Vindication of the Rights of Woman*, equating women to slaves "not allowed to breathe the sharp, invigorating air of freedom."

■ Napoleon and Neoclassical Paris

As Napoleon took greater and greater control of French political life in the opening decade of the nineteenth century, he turned to antiquity, modeling his government particularly upon the military and political structures of the Roman Empire. He commissioned paintings of himself that served the propagandistic purpose of cementing his image as an invincible, nearly godlike leader rivaling the greatest emperors of antiquity, including Charlemagne. Convinced that Paris was the new Rome, he commissioned architectural monuments based on Roman precedents. And both he and his sister were sculpted in the nude, like Greek gods, by the Italian sculptor Antonio Canova.

Glossary

coup d'état A violent overthrow of government.

cult of feeling A term used to describe the Romantics' goal of diving into the depths of the emotional world to discover there whatever one might.

estate One of three traditional groups that comprised the Estates General in France. The First Estate was the clergy; the Second Estate was the nobility; and the Third Estate was the rest of the population, composed of the bourgeoisie and the peasants.

Jacobin A member of a radical minority of France's National Assembly who favored the elimination of the monarchy and the institution of egalitarian democracy.

Critical Thinking Questions

1. Discuss the "gender politics" of David's *Oath of the Horatii*? How do they compare to David's treatment of similar issues in *The Lictors Returning to Brutus the Bodies of His Sons*?

2. Discuss the symbolic content of David's *The Death of Marat*.

3. For Mary Wollstonecraft, how were women in eighteenth-century society equivalent to African slaves?

4. In what ways is David's *Napoleon Crossing the Saint-Bernard* a work of propaganda? How does Ingres's *Napoleon on His Imperial Throne* continue this propagandistic tradition?

As a style, Neoclassicism would hold sway in Europe well into the middle of the nineteenth century, championed particularly by David and his many students. Not the least of these students was Jean-Auguste-Dominique Ingres, who continued to be a force in French art in the 1860s. Most admired in Ingres's paintings were the clarity and precision of his line, the calmness and serenity of his figures, and the refined elegance of his style. These traits made him a favorite of an aristocratic public that valued, in particular, his portraiture.

But even in the last years of the eighteenth century, a new style was beginning to arise that seemed to many the very opposite of the Neoclassical. This style, which we have come to call Romanticism, is anticipated in the emotional turbulence that underlies otherwise Neoclassical works such as David's *The Lictors Returning to Brutus the Bodies of His Sons* (see *Focus*, pages 1028–1029). It values the personal and the individual—with all its psychological complexity—over the social and orderly. It praises the individual's relationship to the myriad forms of nature—from the beautiful to the most wild—over the individual's relation to the state. It distrusts the "checks and balances" that thinkers like American patriot James Madison believed would control government, and worries that its institutions would not so much free humankind as imprison it. Above all, where Neoclassicists considered human passion a threat to the stability and health of society, the Romantics developed what might best be described as a **cult of feeling**. To dive into the depths of the emotional world and discover whatever one might was the Romantics' goal. And much of what was found was beyond the bounds of reason, including passions like love, hatred, and the wellsprings of creativity itself.

If we compare David's *Napoleon Crossing the Saint-Bernard* (see Fig. 32.14) to the *Officer of the Imperial Guard on Horseback* (Fig. **32.18**), a canvas submitted to the Salon of 1812 by the young Romantic painter Théodore Géricault (1791–1824), we can immediately see the new brash and fiery personality that constituted one aspect of Romanticism. This, Géricault's first submission to the Salon, seemed to turn its back on Neoclassical values. It is an enormous painting, even larger than David's. But where the size of David's picture celebrates its subject as the embodiment of an heroic ideal, Géricault's work, painted at the time of Napoleon's devastating invasion of Russia, is, rather, a study in the immense horrors of war. Napoleon's horse rises on its hind legs in pride; the

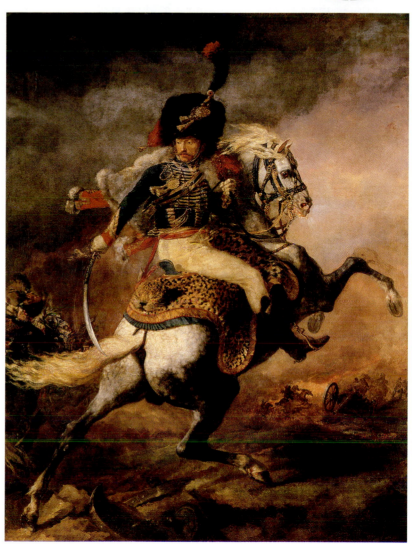

Fig. 32.18 Théodore Géricault. *Officer of the Imperial Guard on Horseback.* 1812. Oil on canvas, 11′5″ × 8′9″. Musée du Louvre, Paris. RMN Reunion des Musees Nationaux, France. Herve Lewandowski/Art Resource, NY.

chasseur's rears in terror. Napoleon turns to face the viewer in calm control; Géricault's cavalryman looks behind him as if fleeing from imminent attack. David's composition is full of right angles and his horse and horseman rise in profile, parallel to the picture plane; Géricault's horse and rider rise in a spiral, at a diagonal to the picture plane, as if exploding out of the bottom left corner of the composition up the horse's taut left leg. David's lines are clear and precise; Géricault's brushwork is vigorously expressive, applied in slabs of paint and thick splotches of color. Above all, where David's work is a form of establishment propaganda, Géricault's is an act of political protest. Géricault's Romanticism marks the dawn of a new era, which is the subject of Book 5. ■

The nineteenth century is dominated by two crucial social transformations—the emergence of industrial society, supplanting the predominantly agricultural way of life that had defined Western society for centuries, and the extension of European and American control over the native cultures of Africa, Asia, and the Americas. These two forces—industrialization and imperialism—gave rise, especially in the last half of the century, to many of the characteristics that still define Western culture today. More people began living in cities than in the country. Big business emerged, and trade unions organized to resist them. Liberals, recognizing that labor was consistently mistreated by industry, worked for reform, laying the foundations of the welfare state. Socialism, which decried the control of production by the wealthy few, became a central force in the political life of the West. Seeking work, literally millions of workers emigrated, especially from Eastern Europe to the United States, where, by 1890, fully three-quarters of the population was foreign-born. In Europe, the working class increasingly found itself pushed out of the city, as in Paris, or removed to one side, as in London. Where tenements had

Claude Monet, detail of *The Regatta at Argenteuil*, ca. 1872. Oil on canvas, 19″ × 29½″. Musée d'Orsay, Paris. (See Fig 37.6)
(right) Jacques-Louis David, *The General Bonaparte*. (See Figure 34.2).

Romanticism, Realism, and Empire: 1800 to 1900

once stood, the new bourgeois middle class gentrified the cityscape, creating parks, wide streets, and shopping districts. For the first time in history, a large percentage of the population had the time and money to indulge in leisure entertainment and activities, like sailing on the Seine, painting in the open air, or strolling on the island of La Grande Jatte outside Paris on a Sunday afternoon. Increasingly, the populations of the West began to assert their ethnic, linguistic, and cultural identities, and the nation-state as we know it began to take shape. Italy and Germany were unified. France, England, Germany, Russia, and even Belgium all competed to assert their national supremacy by gaining control of vast reaches of Africa and Asia. This was taking place even as, in the Americas, the United States moved to assert its supremacy over the American continent, driving the Native American population into reservations and its own Southern states, who tried to assert their own national identity by seceding from the Union, into subjugation. All this required great military expenditure, and the foundations of modern warfare were laid in place.

In the arts, such developments were not received uncritically. Reacting against the Neoclassical quest for order and control that was epitomized by the figure of Napoleon Bonaparte, the Romantic movement in art and literature sought to broaden its understanding of human experience, to recognize the tumultuous power of human emotion and imagination. Sentimentality, melancholy, and longing, as well as triumph and joy, all were symptomatic of the Romantic cast of mind. The darker side of the imagination also revealed itself—one tormented by the horrors of war, the destructive power of the human will, and the frightening prospects of nightmare and fantasy. In poetry, in painting, and in music, this new investigation into the subjective reaches of the self opened new realms of feeling and experience.

To some, such investigations were merely self-indulgent, especially given the sordid realities of working-class life that would lead, in 1848, to over a hundred revolutions across the European continent. Some writers chose to parody the Romantic frame of mind. Painters and writers celebrated the quiet heroism of the working class, even as they lambasted the ruling class and the blind eye it turned toward suffering. Idealism came to seem something of a sham, a retreat from the human condition— or what one author called the "human comedy." Forces larger than the self—biological and social—seemed to determine the course of existence. But art could also turn its eye to the bourgeoisie and celebrate its good life, as the Impressionist painters would come to paint not work but leisure.

Beginning in the 1880s, artists and thinkers begin to believe in the necessity of pushing aside previous norms and standards entirely, instead of merely revising past knowledge in light of current techniques, a process that suggests a nascent, burgeoning modernism. As one writer remarked, "It is essential to be thoroughly modern in one's tastes." The drive to be "modern" involved the self-conscious rejection of tradition, which very often asserted itself at major art exhibitions. In literature, the Symbolist movement would have a tremendous influence on the development of modernist poetry, and the first great modernist painters of the next century would develop directly out of a Symbolist tradition in painting. And philosophers and intellectuals in their abandonment of convention and tradition announced the liberation of modern consciousness.

Timeline Book Five: 1800 to 1900

	1770–1825	1825–1850
HISTORY AND CULTURE	**1796:** death of Catherine the Great of Russia **1799–1815:** Napoleon rules France **1807:** Napoleon invades Spain **1814–1815:** Congress of Vienna	**1830:** revolutions in France, Belgium **1833:** Britain bans employment of children under age 9 **1845–1849:** Irish Potato Famine **1848:** revolutions in France, Austria, Italy, Germany **1848:** French king Louis-Philippe deposed **1848–1860s:** Jews gain rights of citizenship in Western Europe **1849:** gold discovered in California
RELIGION AND PHILOSOPHY	**1790:** Immanuel Kant's *Critique of Judgment* **1806:** Georg Wilhelm Friedrich Hegel's *The Philosophy of History* **1820s:** Charles Fourier and Robert Owen plan utopian communities	**1848:** Karl Marx and Friedrich Engels write *The Communist Manifesto*
TECHNOLOGY AND SCIENCE		**1836:** London's first railway **1839:** first photographs; Charles Darwin's *The Voyage of the Beagle*
ART AND ARCHITECTURE	**1774–1840:** Caspar David Friedrich, German Romantic painter **1776–1837:** John Constable, English Romantic landscape painter **1793:** Kitagawa Utamaro's *Utamaro's Studio* **1796–1798:** Francisco Goya's *The Sleep of Reason Produces Monsters* **1814–1815:** Goya's *Third of May, 1808* **1818:** Théodore Géricault's *The Raft of the "Medusa"* Utamaro, *Utamaro's Studio*	**1826–1900:** U.S. Hudson River School painter Frederic Edwin Church **1829–1831:** Katshushika Hokusai's *Thirty-Six Views of Mount Fuji* **1830:** Eugene Delacroix's *Liberty Leading the People* **1836:** Thomas Cole's *The Oxbow (View from Mount Holyoke, Northampton, Massachusetts, After a Thunderstorm)* **1836–1837:** A.W.N. Pugin designs interiors for London's Houses of Parliament **1844:** J.M.W. Turner's *Rain, Steam, and Speed—The Great Western Railway* **1849:** Rosa Bonheur's *Plowing at the Nivernais* **1849–1850:** Gustave Courbet's *A Burial at Ornans* **1850:** Jean-François Millet's *The Sower*
LITERATURE AND MUSIC	**1774:** Johann Wolfgang von Goethe's novel *The Sorrows of Young Werther* **1798:** Samuel Taylor Coleridge's and William Wordsworth's *Lyrical Ballads* **1798:** Friedrich von Schlegel coins the term "Romanticism" **1804:** Ludwig van Beethoven's *Eroica* symphony **1815–1850s:** Franz Schubert and Robert and Clara Schumann set poetry to music in *lieder* form **1812:** Lord Byron's poem *Childe Harold's Pilgrimage* **1818:** Mary Shelley's novel *Frankenstein* **1819:** John Keats's *Ode to a Nightingale* and *Ode on a Grecian Urn*; Percy Bysshe Shelley's *Ode to the West Wind* **1824:** Beethoven's Ninth Symphony Stieler, *Beethoven*	**1826:** James Fenimore Cooper's novel *The Last of the Mohicans* **1827–1838:** John James Audubon's *Birds of America* **1830:** Hector Berlioz's *Symphonie Fantastique* **1832:** Goethe's play *Faust* **1833–1845:** Honoré de Balzac's 92-novel series *The Human Comedy* **1834:** Ralph Waldo Emerson (1803–1882) moves to Concord, Massachusetts, writes *Nature* (1836), helps found the "Transcendental Club" **1834:** F Chopin (1810–1849) composes *Fantasie impromptu* **1836:** Charles Dickens (1812–1870) writes *Sketches by Boz*, followed by *The Old Curiosity Shop* (1840) **1836:** Russian realist Nikolai Gogol (1809–1852) writes *The Inspector General*, followed by *Dead Souls* (1842) **1843:** Thomas Carlyle (1795–1881) writes *Past and Present* contrasting lives of workers with those of the prosperous **1845:** Frederick Douglass (1817–1895) writes *Narrative of the Life of Frederick Douglass: An American Slave* **1846:** French poet Charles Baudelaire (1821–1867) writes "To the Bourgeoisie," recognizing the power of the middle class **1849:** Henry David Thoreau (1817–1862) writes *Civil Disobedience*

1850–1875	1875–1900	
1850s: Florence Nightingale establishes nursing as honored profession **1852–1870:** Emperor Napoleon III rules France **1853:** Commodore Matthew Perry initiates contact with Japan **1861–1865:** U.S. Civil War **1868:** Meiji Restoration ends rule of shoguns, begins modernization of Japan **1870–1871:** Franco–Prussian War **1871:** Paris Commune	**1870s–1900:** Russian Westernizers battle Slavophiles **1880s–1890s:** European "Scramble for Africa" **1882:** United States prohibits Chinese immigration **1883:** U.S. Supreme Court nullifies Civil Rights Act, enabling Jim Crow laws in South **1890–1900:** fin de siècle era characterized by prosperity, opulence, decadence	HISTORY AND CULTURE
1872: Friedrich Nietzsche's *The Birth of Tragedy*	**1883–1886:** Nietzsche's *Beyond Good and Evil, Thus Spoke Zarathustra,* calling for society of *ubermenschen* ("higher men")	RELIGION AND PHILOSOPHY
1851: "Crystal Palace" exhibition in London **1853–1870:** Baron Haussmann redesigns Paris **1855:** municipal sewage system established in London **1859:** Darwin's *The Origins of Species* **1871:** Darwin's *The Descent of Man* **1872:** first long-distance railway in Japan	**1880s–1890s:** electricity introduced to commercial buildings, residences **1889:** Eiffel Tower erected for Paris Exposition **1893:** Chicago's Columbian Exhibition	TECHNOLOGY AND SCIENCE
1856–1870s: Frederick Law Olmsted and Calvert Vaux design Central Park, in New York City **1860–1875:** Paris Opera constructed, designed by Charles Garnier **1863:** Édouard Manet's *Le Déjeuner sur l'Herbe* **1867:** Manet's *The Execution of Maximilian* **1874:** first Impressionist exhibition in Paris **1874:** Edgar Degas's *Dance Class*; James McNeill Whistler's *Nocturne in Black and Gold: The Falling Rocket* Manet, Le *Déjeuner sur l'Herbe*	**1875:** Thomas Eakins's *The Gross Clinic* **1879:** Paul Cézanne's *Gulf of Marseilles, seen from l'Estaque* **1880s:** Art Nouveau movement **1881–1882:** Manet's *Bar at the Folies-Bergère* **1886:** Auguste Rodin's statue *The Kiss*; Georges Seurat's *Sunday Afternoon on the Island of La Grand Jatte* **1889:** Vincent van Gogh's *Starry Night* **1893:** Edvard Munch's *The Scream* **1894:** Paul Gauguin's *Mahna no Atua (Day of the Gods)* **1896–1897:** Louis Sullivan designs the Bayard Building in New York **1901–1902:** Gustav Klimt's *Judith, Portrait of Emilie Floge*	ART AND ARCHITECTURE
1851: Herman Melville's novel *Moby Dick*; Giuseppe Verdi's opera *Rigoletto* **1851–1853:** John Ruskin's *The Stones of Venice* **1852:** Harriet Beecher Stowe's novel *Uncle Tom's Cabin* **1854:** Henry David Thoreau's *Walden, or Life in the Woods* **1854:** Charles Dickens's novel *Hard Times* **1856:** Gustave Flaubert's novel *Madame Bovary* **1857:** Charles Baudelaire's poems *Les Fleurs du mal* **1866:** Jacques Offenbach's operetta *La Vie Parisienne*; Fyodor Dostoyevsky's novel *Crime and Punishment* **1869:** Leo Tolstoy's novel *War and Peace*; John Stuart Mill's essay *The Subjection of Women* argues for women's rights **1874:** Richard Wagner completes *Der Ring des Nibelungen* cycle of operas	**1877:** Tolstoy's novel *Anna Karenina* **1879:** Henrik Ibsen's play *A Doll's House* **1881:** Henry James's novel *Portrait of a Lady* **1885:** Mark Twain's novel *Huckleberry Finn* **1888–1889:** Gustav Mahler composes *Symphony No. 1* **1890s:** birth of jazz in New Orleans **1891:** first collection of poems by Emily Dickinson published **1892:** Walt Whitman's final edition of *Leaves of Grass* **1899:** Scott Joplin composes *Maple Leaf Rag*; Kate Chopin's novel *The Awakening* **1905:** Claude Debussy composes *La Mer*	LITERATURE AND MUSIC

33 The Self in Nature

The Rise of Romanticism

The Early Romantic Imagination

The Romantic Landscape

Transcendentalism and the American Romantics

> **"** *A motion and a spirit, that impels*
> *All thinking things, all objects of all thought,*
> *And rolls through all things. . . .* **"**
>
> Wordsworth, "Tintern Abbey"

◄ **Fig. 33.1 Tintern Abbey, Wye Valley, Gwent Monmouthshire.** Robert Harding Picture Library. The abbey was founded in the twelfth century, but gradually fell to ruin after Henry VIII dissolved the monasteries in 1536. Ruins such as the abbey and the surrounding woodlands fueled the Romantic imagination.

1053

TINTERN ABBEY IS A RUINED MEDIEVAL MONASTERY ON THE

banks of the Wye River north of Bristol in South Wales, England (Fig. **33.1**). Its

roofless buildings were open to the air and its skeletal Gothic arches overgrown

with weeds and saplings (Fig. **33.2**). In the late eighteenth century, it was common for

British travelers to tour the beautiful Wye River, and the final destination of the journey was the Abbey (Map **33.1**). In 1798, a British magazine writer assigned a degree of importance to the *Wye Tour* (as it was known) that might surprise the modern reader:

> The enchanting beauties of the River Wye are by this time pretty generally known among the lovers of the picturesque . . . [C]uriosity has been inflamed by poetry and by prose, by paintings, prints, and drawings. . . . An excursion on the Wye has become an essential part of the education . . . of all who aspire to the reputation of elegance, taste, and fashion.

That a "tour" of English scenery should be "essential" to one's education suggests that there is more to the picturesque than just the "view" it offers. The River Wye offered larger lessons.

This chapter surveys the growing taste for the natural world in the late eighteenth and first half of the nineteenth centuries in Europe, particularly England and Germany, and in America, where a loosely knit group known as the Transcendentalists sought to discover the "transcendent" order of nature. Unifying principles could be found in the natural world, which became a sacred space that pointed to the imminent presence of the divine. During this period, poets and painters, essayists and composers increasingly came to view nature itself as the greatest teacher, the defining center of culture, and the pivotal force that determined and guided human experience. London and New York might well have been the Western hubs of commerce, Washington, D.C. and Paris the focal points of political life, but it was to nature that artists turned for inspiration.

Romantic artists revolted against the classical values of order, control, balance, and proportionality championed by Neoclassical artists, many of whom—Jacques-Louis David, for instance (see chapter 32)—were their contemporaries. They approached the world instead with an outpouring of feeling and emotional intensity that came to be called *Romanticism* [roh-MAN-tih-siz-um]. Originally coined in 1798 by the German writer and poet Friedrich von Schlegel [SHLAY-gul] (1772–1829), "Romanticism" was an overt reaction against the Enlightenment and classical culture of the eighteenth century. For Schlegel, Romanticism refers mainly to his sense that the common cultural ground of

Europe—the Classical past from which it had descended, and the values of which it shared—was disintegrating, as Europeans formed new nation-states based on individual cultural identities.

Schlegel's own thinking was deeply influenced by the philosopher Immanuel Kant [kahnt] (1724–1804). In his *Critique of Judgment* (1790), Kant defined the pleasure we derive from art as "disinterested satisfaction." By this he meant that contemplating beauty, whether in nature or in a work of art, put the mind into a state of free play in which things that seemed to oppose each other—subject and object, reason and imagination—are united. Schlegel was equally influenced by Johann Winckelmann's perspective on Greek art (see chapter 31). What the Greeks offered were not works of art to be slavishly imitated, in the manner of Neoclassical artists. For Winckelmann, and for Schlegel, the Greeks provided a new way for the Romantic artist to approach nature: The Greeks studied nature in order to discover its essence. Nature only occasionally rises to moments of pure beauty. The lesson taught by the Greeks, Winckelmann argued, was that art might capture and hold those rare moments.

Dedicated to the discovery of beauty in nature, the Romantics rejected the truth of empirical observation, which John Locke and other Enlightenment thinkers had championed. The objective world mattered far less to them than their subjective experience of it. The poet Samuel Taylor Coleridge, one of the founders of the Romantic movement, offered a pithy summary in a letter to a friend: "My opinion is this—that deep Thinking is attainable only by a man of deep Feeling, and that all Truth is a species of Revelation." Knowing the exact distance between the earth and the moon mattered far less than how it *felt* to look at the moon in the dark sky. And it must be remembered that for Romantics, the night was incomparably more appealing, because it was more mysterious and unknowable, than the daylight world.

Nor did they believe that the human mind was necessarily a thinking thing, as Descartes had argued, when he wrote, "I think, therefore I am." For the Romantics, the mind was a feeling thing, not distinct from the body as Descartes had it, but intimately connected to it. Feelings, they believed, led to truth, and most of the major writers

and artists of the early nineteenth century used their emotions as a primary way of expressing their imagination and creativity. Indeed, since nature stimulated the emotions as it did the imagination, the natural world became the primary subject of Romantic poetry, and landscape the primary genre of Romantic painting. Because nurturing one's feelings restored human beings to their own true nature, examining the emotional life of the self in relation to the world characterized Romantic fiction. In nature the Romantics discovered not just the wellspring of their own creativity, but the very presence of God, the manifestation of the divine on earth.

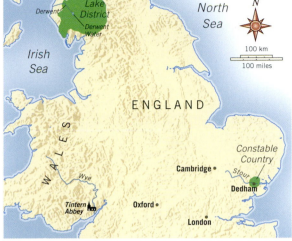

Map 33.1 Romantic England.

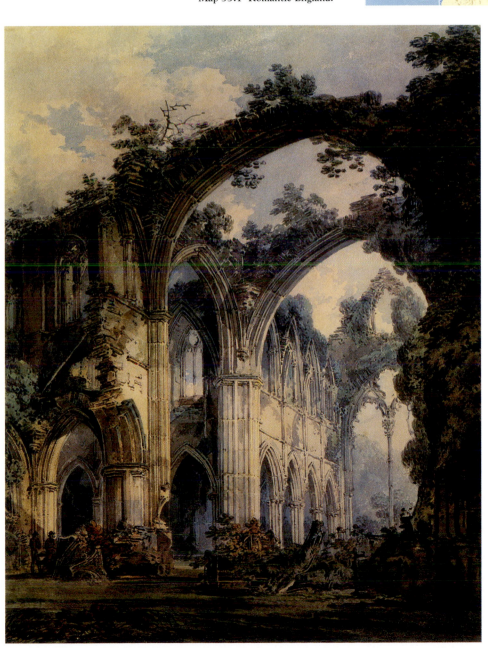

Fig. 33.2 J. M. W. Turner. *Interior of Tintern Abbey.* **1794.** Watercolor, $12\frac{5}{8}" \times 9\frac{7}{8}"$. The Trustees of the Victoria and Albert Museum, London, Art Resource, NY. Turner toured South Wales and the Wye Valley in 1792, when he was 19 years old. This watercolor is based on a sketch made on that trip.

The Early Romantic Imagination

In July 1798, the same year the British writer claimed that the Wye Tour was essential to everyone's education, the 28-year-old poet William Wordsworth (1770–1850) visited Wye Valley, accompanied by his sister Dorothy. There he composed a poem that for his entire generation would come to embody the very idea of the Romantic.

The Idea of the Romantic: William Wordsworth's "Tintern Abbey"

The Wordsworth poem that had such a major impact is generally known by the shortened title "Tintern Abbey." Its complete title is "Lines Composed a Few Miles above Tintern Abbey, on Revisiting the Banks of the Wye during a Tour, July 13, 1798" (see **Reading 33.1**, pages 1074–1075, for the complete poem). The poet had visited the valley five years before, and he begins his poem by thinking back to that earlier trip:

> Five years have passed; five summers, with the length
> Of five long winters! and again I hear
> These waters, rolling from their mountain-springs
> With a soft inland murmur. —Once again
> Do I behold these steep and lofty cliffs,
> That on a wild secluded scene impress
> Thoughts of more deep seclusion; and connect
> The landscape with the quiet of the sky.

The implication is that the scene evokes thoughts "more deep" than mere appearance, thoughts in which landscape and sky—and perhaps the poet himself—are all connected, united together as one.

After describing the scene before him at greater length, the poet then recalls the solace that his memories of the place had brought him in the five intervening years as he had lived "in lonely rooms, and 'mid the din / Of towns and cities." His memories of the place, he says, brought him "tranquil restoration," but even more important "another gift," in which "the weary weight / Of all this unintelligible world, / Is lightened" by allowing the poet to "see into the life of things."

Wordsworth does not completely comprehend the power of the human mind here. What the mind achieves at such moments remains to him something of a "mystery." But it seems to him as if his breath and blood, his very body—that "corporeal frame"—is suspended in a "power / Of harmony" that informs all things.

Wordsworth next describes how he reacted to the scene as a boy. The scene, he says, was merely "an appetite." But now, as an adult, he looks on the natural world differently. He finds in nature a connection between landscape, sky, and thought that is intimated in the opening lines of the poem. Humankind and Nature are united in total harmony:

> A motion and a spirit, that impels
> All thinking things, all objects of all thought,
> And rolls through all things.

In this perception of the unity of all things, Wordsworth is able to define nature as his "anchor" and "nurse," "The guide, the guardian of my heart, and soul / Of all my mortal being." Wordsworth's vision is informed not just by the scene itself, but by his memory of it, and by his imagination's understanding of its power. As the poem moves toward conclusion, Wordsworth turns to his sister beside him, praying that she too will know, as he does, that "Nature never did betray / The heart that loved her." Indeed, Wordsworth's prayer for his sister Dorothy is really intended as a prayer for us all. We should each of us become, as he is himself, "a worshiper of Nature."

"Tintern Abbey" can be taken as one of the fullest statements of the Romantic imagination. In the course of its 159 lines, it argues that in experiencing the beauty of nature, the imagination dissolves all opposition. Wordsworth suggests that the mind is an active participant in the process of human perception rather than a passive vessel. There is an ethical dimension to aesthetic experience, a way to stand above, or beyond, the "dreary intercourse of daily life," both literally and figuratively on higher ground. Perhaps most of all, the poem provides Wordsworth with the opportunity for communion, not merely with the natural world, but with his sister beside him, and by extension his readers as well. In individual experience, Wordsworth makes contact with the whole.

A Romantic Experiment: *Lyrical Ballads*

On his way to Tintern Abbey and the River Derwent [DUR-wunt] in 1798, Wordsworth had stopped in Bristol to drop off a book of poems at Joseph Cottle's publishing house. He had co-written the book, *Lyrical Ballads*, with his friend, Samuel Taylor Coleridge [KOLE-rij] (1772–1834). Coleridge had published with Cottle already, but *Lyrical Ballads* was published anonymously. As Coleridge put it, "Wordsworth's name is nothing—[and] to a large number of persons mine stinks." At the last moment, on his way back from South Wales, Wordsworth added "Tintern Abbey" to the volume.

For its next editions, in 1800 and 1802, the book was significantly revised and augmented, and Wordsworth included an important preface that discussed why poetry should attempt to reflect what he called "the language of conversation" (**Reading 33.2**):

READING 33.2 from William Wordsworth, "Preface" to *Lyrical Ballads* (1800)

The principal object ... proposed in these Poems was to choose incidents and situations from common life, and to relate or describe them, throughout, as far as was possible, in a selection of language really used by men. ... Humble and rustic life was generally chosen, because, in that condition, the essential passions of the heart find a better soil in which they can attain their maturity, are less under restraint, and speak a plainer and more emphatic language; because in that condition of life our elementary feelings co-exist in a state of greater simplicity, and, consequently, may be more accurately contemplated, and more forcibly communicated; because the manners of rural life germinate from those elementary feelings; and, from the necessary character of rural occupations, are more easily comprehended, and are more durable; and lastly, because in that condition the passions of men are incorporated with the beautiful and permanent forms of nature. The language, too, of these men is adopted ... because such men hourly communicate with the best objects from which the best part of language is originally derived; and because ... they convey their feelings and notions in simple and unelaborated expressions.

Although the Wordsworth of "Tintern Abbey" is no humble rustic, the aim of the poem is precisely that of the *Lyrical Ballads* as a whole, to discover that moment when "the passions of men are incorporated with the beautiful and permanent form of nature." Wordsworth further defines poetry as "the spontaneous overflow of powerful feelings" resulting from "emotion recollected in tranquility," emotions like those he recollected overlooking Tintern Abbey. The poet, Wordsworth writes, "considers man and nature as essentially adapted to each other, and the mind of man as naturally the mirror of the fairest and most interesting qualities of nature."

In 1799 Wordsworth and his sister moved to the northern Lake District, where they had grown up. Over the course of the next seven years, he wrote some of his greatest poems, such as "The Rainbow," published in 1807 as *Poems in Two Volumes* (see *Focus*, pages 1058–1059). Much of the remainder of his life was dedicated to completing two long poems, *The Recluse*, a meditation on the relationship between humanity, nature, and society that he never completed, and a book-length autobiographical poem, tracing, as he says, "the growth of a poet's mind," and published after his death in 1850 under the title of *The Prelude*.

Romanticism as a Voyage of Discovery: Samuel Taylor Coleridge

Wordsworth's statements in the Preface to *Lyrical Ballads* could not be further from the mind-sets of the characters created by his friend Coleridge. In fact, the Mariner in Coleridge's "Rime of the Ancient Mariner," a long narrative poem which opened *Lyrical Ballads*, is a man wholly at odds with nature. In Part I of the poem, the Mariner senselessly kills the albatross that had been his shipmates' companion at sea (see **Reading 33.3**, pages 1076–1077). He and his shipmates come to see this act as bringing them the worst luck a ship can have, to be floating in the middle of the ocean until they run out of food and water (**Reading 33.3a**):

READING 33.3a from Samuel Taylor Coleridge, "Rime of the Ancient Mariner," Part II (1797)

Day after day, day after day,
We stuck, nor breath nor motion;
As idle as a painted ship
Upon a painted ocean.

Water, water, everywhere,
And all the boards did shrink;
Water, water, everywhere,
Nor any drop to drink.

In fact, a death ship arrives in this unnatural sea, taking all the crew but leaving the Mariner alone in a kind of living death (**Reading 33.3b**):

READING 33.3b from Samuel Taylor Coleridge, "Rime of the Ancient Mariner," Part IV (1797)

Alone, alone, all, all alone,
Alone on a wide wide sea!
And never a saint took pity on
My soul in agony.

Focus

Wordsworth's "The Rainbow"

William Wordsworth wrote "The Rainbow" in 1802, while he was working on the first draft of *The Prelude*, his book-length autobiographical poem, in which he traced "the growth of a poet's mind." So, despite its shortness—only nine lines—"The Rainbow" has packed into it much of the thinking that went into *The Prelude*. Both poems express the idea that his poetic occupation had been foreordained in his childhood. In "The Rainbow," the poet is reaching back into his childhood in order to begin his quest for the unity of self.

The poem's first line brings together feeling ("my heart leaps up") and vision ("when I behold"), the subjective and objective are unified in a single moment.

Past, present, and future are united here in a parallel phrasing that is reminiscent of prayer.

Wordsworth's covenant is not between God and humanity, but between himself and nature. This is what he means by "natural piety," a reverence for nature of which he longs to be reminded each and every day.

The Rainbow

My heart leaps up when I behold
A rainbow in the sky:
So was it when my life began,
So is it now I am a man,
So be it when I shall grow old,
Or let me die!
The child is the father of the man;
And I could wish my days to be
Bound each to each by natural piety.

The rainbow is a traditional symbol of renewal, a renewal founded in Judeo-Christian tradition, where God says to Noah after the Flood: "I do set my bow in the cloud, and it shall be a covenant between me and the earth." It symbolizes the bridge between the secular world and the spiritual realm.

This line echoes lines from the 1799 first version of *The Prelude* asking of the River Derwent if it inspired his love of nature when, as a baby, his nurse first walked him along its banks:

For this didst thou,
O Derwent, traveling over the
 green plains
Near my "sweet birthplace," didst
 thou, beauteous stream. . .
[Give me] A knowledge, a dim
 earnest, of the calm
That nature breathes among her
 woodland haunts?

Rhyme Scheme and Meter

The rhyme scheme and meter are simple, but Wordsworth takes advantage of this simplicity to achieve surprising effects. The standard measure (or "foot") is iambic (short-long).

Rhyme	Meter	Rhyme	Meter
a	4 feet	b	2 feet
b	3 feet	c	4 feet
c	4 feet	d	4 feet
c	4 feet	d	5 feet
a	4 feet		

Only the first foot of line 7—"The child is"—is not iambic. It is, instead, a **dactyl** [DAK-tul], composed of one short and two long units. Thus Wordsworth emphasizes his theme, the presence of the child in the man, rhythmically, by drawing attention to the word "child." The five beats of the last line, and the final couplet rhyme, draw attention to the phrase "natural piety."

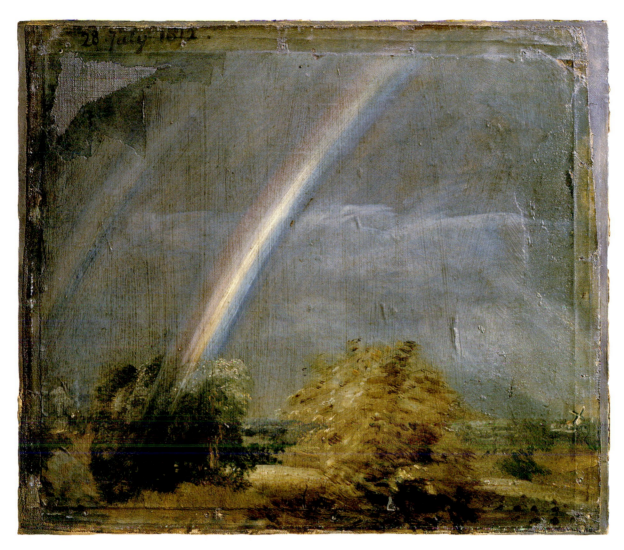

John Constable. *Landscape and Double Rainbow.* **1812.** Oil on paper mounted on canvas, 13 $\frac{1}{4}''$ × 15″. Victoria and Albert Museum, London/Art Resource, NY. 328-1888. Near the end of his life, Constable would copy Wordsworth's poem into his notebooks. Constable himself wrote: "Nature in all the varied aspects of her beauty exhibits no feature more lovely nor any that awakens a more soothing reflection than the rainbow."

His salvation comes only when he recognizes that even the water-snakes that surround him are "living things" (**Reading 33.3c**):

READING 33.3c **from Samuel Taylor Coleridge, "Rime of the Ancient Mariner," Part IV (1797)**

A spring of love gushed from my heart,
And I blessed them unaware:
Sure my kind saint took pity on me,
And I blessed them unaware. . . .

The self-same moment I could pray;
And from my neck so free
The Albatross fell off, and sank
Like lead into the sea.

Although the Mariner still faces many trials, this is the turning point of his life. His redemption seems possible.

The supernatural and mystical character of Coleridge's imagination—fueled not incidentally by his addiction to opium—helped to define Romantic art as a voyage of discovery.

Indeed, Coleridge's poem contains a clear moral lesson. The Mariner's killing of the albatross is an act of bad faith, an attack on the natural world that puts him at odds with it. Only after he blesses the water-snakes, creatures even more monstrous than the albatross, can he redeem himself, reuniting himself with nature as a whole.

Classical versus Romantic: The Odes of John Keats

The odes of John Keats (1795–1821) represent the essence of Romantic poetry. An **ode** is a poem of exaltation, exhibiting deep feeling. Keats's life was tragically short. Most of his greatest poems were written in one year (September 1818 to September 1819) when he was deeply in love with a young woman and was simultaneously diagnosed with tuberculosis, the disease that had killed his mother. All of his great odes were written during this period (Fig. **33.3**).

Keats's "Ode to a Nightingale" is typical of the Romantic's contemplation of nature. "My heart aches, and a drowsy numbness pains / My sense, as though of hemlock I had drunk," it begins, but the song of the Nightingale awakens his senses. Still, he says, "I have been half in love with easeful Death, / Call'd him soft names in many a mused rhyme." But he recognizes something eternal in the song of the nightingale (**Reading 33.4**):

READING 33.4 **from John Keats, "Ode to a Nightingale" (1819)**

Thou wast not born for death, immortal Bird!
No hungry generations tread thee down;
The voice I hear this passing night was heard
In ancient days by emperor and clown:
Perhaps the self-same song that found a path
Through the sad heart of Ruth, when, sick for home,
She stood in tears amid the alien corn;[1]
The same that oft-times hath
Charm'd magic casements,[2] opening on the foam
Of perilous seas, in faery lands forlorn. . . .

[1] In proclaiming the immortality of the nightingale, Keats alludes to the biblical Ruth. As a widow, she relocated to Bethlehem to care for her mother-in-law, Naomi, and ended up tending fields of grain in an alien land. She ultimately married the landowner, Boaz, and was great-grandmother to King David of Israel. Ruth attained immortality through her good deeds.

[2] Casements are windows.

Fig. 33.3 Joseph Severn. *John Keats*. 1821. Oil on canvas, 22¼" × 16½". National Portrait Gallery, London. Severn would later describe the scene recreated in this posthumous portrait: "This was the time he first fell ill & had written the Ode to the Nightingale on the morning of my visit to Hampstead. I found him sitting with the two chairs as I have painted him & was struck with the first real symptoms of sadness in Keats so finely expressed in that poem."

Keats comes to an awareness here of the eternal beauty and continuity of the nightingale's song. This is also the clear implication of Keats's "Ode on a Grecian Urn"—the beauty of art lives on. In the poem, Keats contemplates a Greek vase covered with figures whose joy in the fleeting pleasures of life is, paradoxically, permanently immortalized in the design of the vase (**Reading 33.5**):

READING 33.5 John Keats, "Ode on a Grecian Urn" (1819)

Thou still unravish'd bride of quietness,
Thou foster-child of silence and slow time,
Sylvan historian, who canst thou express
A flowery tale more sweetly than our rhyme:
What leaf-fring'd legend haunt about thy shape
Of deities or mortals, or of both,
In Tempe or the dales of Arcady?
What men or gods are these? What maidens loth?
What mad pursuit? What struggle to escape?
What pipes and timbrels? What wild ecstasy?

Heard melodies are sweet, but those unheard
Are sweeter: therefore, ye soft pipes, play on;
Not to the sensual ear, but, more endear'd,
Pipe to the spirit ditties of no tone:
Fair youth, beneath the trees, thou canst not leave
Thy song, nor ever can those trees be bare;
Bold lover, never, never canst thou kiss,
Though winning near the goal—yet, do not grieve;
She cannot fade, though thou hast not thy bliss,
For ever wilt thou love, and she be fair!

Ah, happy, happy boughs! that cannot shed
Your leaves, nor ever bid the spring adieu;
And, happy melodist, unwearied,
For ever piping songs for ever new;
More happy love! more happy, happy love!
For ever warm and still to be enjoy'd,
For ever panting, and for ever young;
All breathing human passion far above,
That leaves a heart high-sorrowful and cloy'd,
A burning forehead, and a parching tongue.

Who are these coming to the sacrifice?
To what green altar, O mysterious priest,
Lead'st thou that heifer lowing at the skies,
And all her silken flanks with garlands drest?
What little town by river or sea shore,
Or mountain-built with peaceful citadel,
Is emptied of this folk, this pious morn?
And, little town, thy streets for evermore
Will silent be; and not a soul to tell
Why thou art desolate, can e'er return.

O Attic shape! Fair attitude! with brede
Of marble men and maidens overwrought,
With forest branches and the trodden weed;
Thou, silent form, dost tease us out of thought
As doth eternity: Cold Pastoral!
When old age shall this generation waste,
Thou shalt remain, in midst of other woe
Than ours, a friend to man, to whom thou say'st,
"Beauty is truth, truth beauty,"—that is all
Ye know on earth, and all ye need to know.

Contemplating a Greek vase—probably a composite "ideal" vase made up of scenes derived from those in the collection of the British Museum—Keats admits ignorance about the symbolism of the decorative motifs and what "deities or mortals, or both" are painted on it. Yet the vase's scenes come alive in his imagination and are all the more poignant for being eternal, unchangeable, and silent. The melodies being played by the musicians illustrated on the vase, if anyone were to hear them, would, of course, be beautiful, "but those unheard / Are sweeter." The trees can never lose their leaves. And though the lover will never succeed in kissing his love, thus painted, he can take solace in the fact that she "cannot fade" and will be forever fair. He imagines that the people who populate the vase have been drawn out of some "little town," the streets of which are now forever silent. Then, to conclude, the poet addresses the vase directly: "O Attic shape," he says, when we are dead, you shall remain a "friend to man." The vase imparts an important message to humankind:

> "Beauty is truth, truth beauty,"—that is all
> Ye know on earth, and all ye need to know.

These last two lines are possibly the most discussed and debated in English poetry. They suggest that the vase, and by extension the poem itself, is a higher form of nature than mortal life. This is, of course, a traditional theme of poetry—think of Shakespeare's sonnets (see chapter 24)—but in the context of Keats's own tragic struggle with tuberculosis and his imminent death, it takes on a stunningly poignant and deeply Romantic tone. Rather than being terrified by the prospect of mortality, the individual contests death and exalts in the confrontation. Perhaps the poem's greatest achievement is that it dissolves the greatest opposition of them all, uniting life and death in the circularity of the "leaf-fring'd legend" that draws the viewers' eyes around the vase's shape. In February 1821, a few months after his twenty-fifth birthday, Keats died in Rome, survived only by his posthumously published poems.

The Romantic Landscape

The most notable landscape painting in Europe had developed in Italy and the Netherlands 200 years earlier. Even the term "landscape" derives from the Dutch word "landschap," meaning a patch of cultivated ground. Although influenced by Italian artists' use of light and color, the great seventeenth-century

Continuity & Change
p. 845

View of Haarlem

Dutch landscape painters, including Jacob van Ruisdael (see chapter 26), were also inspired by a dramatically changing physical geography sparked by the reclamation of hundreds of thousands of acres of land along the coasts. The Dutch landscape painters in turn influenced later English landscape painters. Two seventeenth-century French painters, Nicolas Poussin and Claude Lorrain, also influenced the British artists (see Figs. 27.8, 29.13). Lorrain's use of light and color, in particular, inspired the young John Constable, among the most popular of the English Romantic painters.

John Constable: Painter of the English Countryside

Tension between the timeless and the more fleeting aspects of nature deeply informs the paintings of John Constable (1776–1837). Constable focused most of his efforts on the area around the valley of the Stour River in his native East Bergholt, Suffolk. Like Wordsworth, he felt his talents depended on "faithful adherence to the truth of nature." In 1802, he complained that he had been too busy looking at the work of others: "I have been running after pictures, and seeking the truth at second hand." He acknowledged that "one's mind may be elevated, and kept up to what is excellent, by the works of the great masters," but believed that he needed to look to nature, for "Nature is the fountain's head, the source from which all originally must spring." To this end,

Constable sketched endlessly. His drawing of *Willy Lott's House, East Bergholt* is typical (Fig. **33.4**). Lott, a farmer, lived in this house his entire 80 years, spending only four nights of his life away from it. For Constable, the house symbolized a stability and permanence that contrasts dramatically with the impermanence of the weather, the constant flux of light and shadow, sun and cloud.

Like Wordsworth, Constable believed that his art could be traced back to his childhood on the Stour, to places that he had known his whole life. "I should paint my own places best," he wrote to a friend in 1821, "I associate my 'careless boyhood' to all that lies on the banks of the Stour. They made me a painter (& I am grateful)." A painting like *The Stour Valley and Dedham Village* could almost illustrate the opening lines of Wordsworth's "Tintern Abbey," with its "plots of cottage grounds," "orchard tufts," "hedge rows," and "pastoral farms" (Fig. **33.5**). Like Wordsworth, Constable also wished to depict incidents and situations from common life, including villages, churches, farmhouses, and cottages. But most of all, the painting captures Constable's sense that he was, like Wordsworth, "a worshipper of Nature," a religious sentiment underscored by the presence of the Dedham parish church in the distance. As Constable wrote in a letter of May 1819, "Every tree seems full of blossom of some kind & the surface of the ground seems quite living—every step I take & on whatever object I turn my Eye that sublime expression of the Scripture 'I am the resurrection and the life' &c, seems verified about me." In fact, the cathedral at the center of so many Constable landscapes symbolizes the permanence of God in nature.

From 1819 to 1825, Constable worked on a series of what he referred to as his "six-footers," all large canvases depicting scenes on the Stour painted in his London studio from sketches and drawings done earlier. *The Hay Wain* (Fig. **33.6**) is based on a number of studies, including the drawing of *Willy Lott's House* (see Fig. 33.4). Constable felt that a sketch reflected just one emotion. "A sketch," he wrote, "will not serve more than one state of mind & will not serve to drink at it again & again—in a sketch there is nothing but one state of mind—that which you were in at the time." This critique of the sketch goes a long way toward explaining the power of Constable's painting. It contains more than one state of mind—the passing storm, indicated by the darkened clouds on the left, contrasts with the brightly lit field below the billowing clouds at the right, the longevity of the tree behind the house with its massive trunk contrasts with the freshly cut hay at the right, the gentleman fisherman contrasts with the hardworking cart drivers.

Fig. 33.4 John Constable. *Willy Lott's House, East Bergholt*. ca. 1820. Graphite on paper (drawing made up of three sheets of paper), $9\frac{7}{8}$″ × $11\frac{1}{8}$″. Sir Robert Clermont Witt bequest; 1952. Copyright: © Courtauld Institute Gallery of Art, London. For Constable, this farmhouse symbolized a stability and permanence that contrasted dramatically with the unpredictability of weather, the constant flux of light and shadow, sun and cloud.

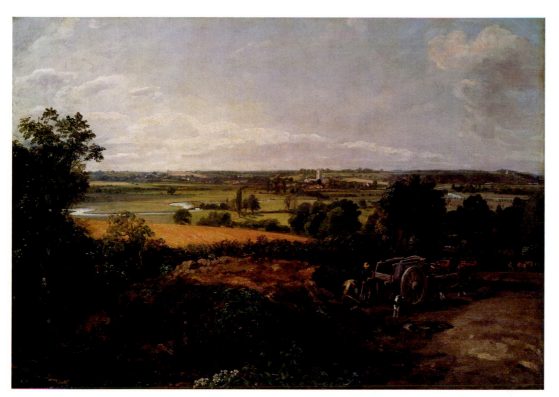

Fig. 33.5 John Constable. *The Stour Valley and Dedham Village.* **1814.** Oil on canvas, $21\frac{3}{4}'' \times 30\frac{3}{4}''$. Photograph © 2008 Museum of Fine Arts, Boston. William W. Warren Fund, 1948 (48.226). The workers in the foreground are loading manure onto a cart for spreading in the fields.

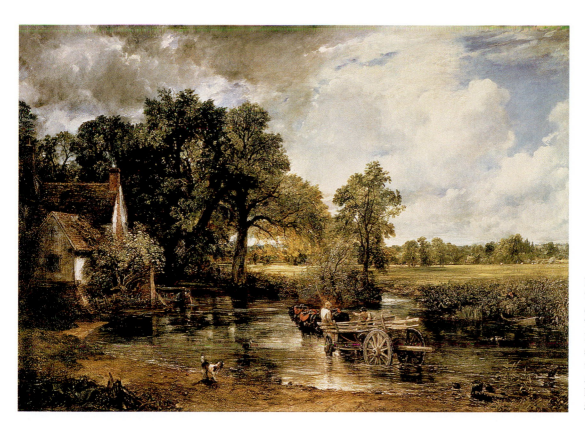

Fig. 33.6 John Constable. *The Hay Wain.* **1821.** Oil on canvas, $51\frac{3}{8}'' \times 73''$. The National Gallery, London. Constable failed to sell *The Hay Wain* when it was exhibited at the Royal Academy in 1821, though he turned down an offer of £70 for it.

When the painting was first exhibited at the Royal Academy in 1821, Londoners could not accept that this was a "finished" painting because it had been painted in economic, almost abstract terms. Constable used short, broken strokes of color in a variety of shades and tints to produce a given hue (the green of foliage, for example). Nor did they understand how such a common theme deserved such a monumental canvas. Constable subsequently complained to a friend, "Londoners with all their ingenuity as artists know nothing of the feeling of a country life (the essence of Landscape)—any more than a hackney coach horse knows of pasture."

Joseph Mallord William Turner: Colorist of the Imagination

The other great English landscape painter of the day, Joseph Mallord William Turner (1775–1851), was closer in temperament to Coleridge than to Wordsworth. He freely explored what he called "the colors of the imagination." Even his contemporaries recognized, in the words of the critic William Hazlitt (1778–1830), that Turner was interested less in "the objects of nature than . . . the medium through which they are seen." In Turner's paintings earth and vegetation seem to dissolve into light and water, into the very medium—gleaming oil or translucent watercolor—with which he paints them. In *The Upper Falls of the Reichenbach* [RY-khun-bahk], for instance,

Turner's depiction of the falls, among the highest in the Swiss Alps, seems to animate the rocky precipice (Fig. 33.7). Turner draws our attention, not to the rock, cliff, and mountain, but to the mist and light through which we see them.

Perhaps the best way to understand the difference between Constable and Turner is to consider the *scale* of their respective visions. Constable's work is "close," nearby and familiar, with an abundance of human associations. Turner's is exotic, remote, and even alienating. The human figure in Constable's paintings is an essential and elemental presence, uniting man and nature. The human figure in Turner's paintings is minuscule, almost irrelevant to the painting except insofar as its minuteness underscores nature's very indifference. Not only is *The Upper Falls of the Reichenbach* removed from the close-at-hand world of Constable's paintings, but the cowherd and his dog, barely visible at the lower left of the painting, are dwarfed by the immensity of the scene. Cattle graze on the rise at the bottom middle, and another herd is on the ridge across the gorge. The effect is similar to that described by Wordsworth in "Tintern Abbey":

> And I have felt
> A presence that disturbs me with the joy
> Of elevated thought; a sense sublime
> Of something far more deeply interfused,
> Whose dwelling is the light of setting suns,

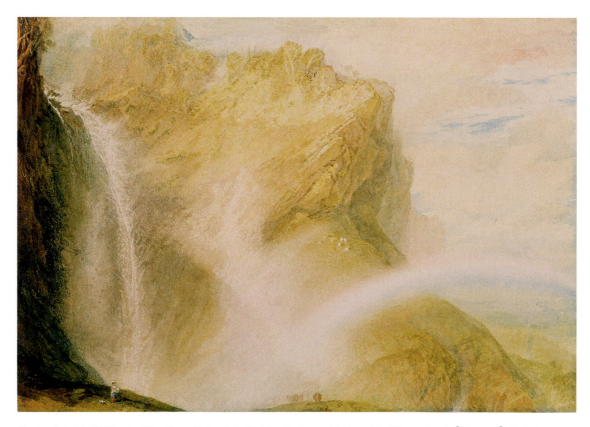

Fig. 33.7 **J. M. W. Turner.** *The Upper Falls of the Reichenbach.* ca. 1810–1815. Watercolor, 10⅞″ × 15⁷⁄₁₆″. Yale Center for British Art, Paul Mellon Collection. The Bridgeman Art Library. Turner achieved the transparent effect of the rainbow and the spray rising from the falls by scraping away the watercolor down to the white paper beneath.

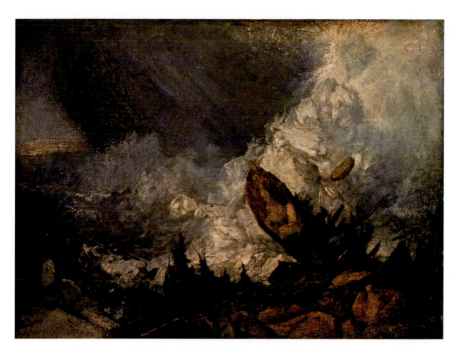

Fig. 33.8 J. M. W. Turner. *The Fall of an Avalanche in the Grisons.* **1810.** Oil on canvas, 35⅝″ × 47¼″. Clore Collection, Tate Gallery, London/Art Resource, NY. This and Fig. 33.7 were influenced by Turner's tour of the Alps in 1802.

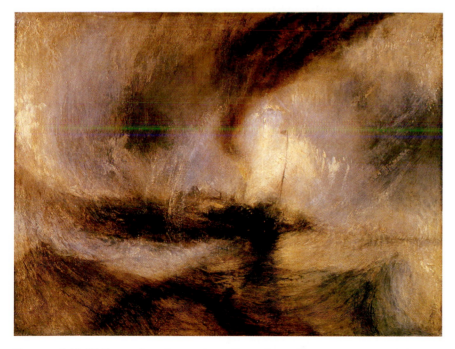

Fig. 33.9 J. M. W. Turner. *Snow Storm—Steam-Boat off a Harbour's Mouth.* **1842.** Oil on canvas, 36″ × 48″. Clore Collection, Tate Gallery, London/Art Resource, NY. Turner bequeathed 19,049 drawings and watercolors to the British nation. Many of these works anticipate the gestural freedom of this painting, with its sweeping linear rhythms.

We must keep in mind, though, the sublime is never altogether benign or kind. In *The Fall of an Avalanche in the Grisons* [gree-SOHNZ], for example, (Fig. **33.8**), there is no human figure, only a mountain hut about to be crushed beneath a giant thumb of rock and debris. The viewer has nowhere to stand, except in the path of this mammoth demonstration of nature's force. Turner himself wrote lines to accompany the painting in the exhibition catalogue:

> The downward sun a parting sadness
> gleams,
> Portentous lurid thro' the gathering
> storm'
> Thick drifting snow on snow,
> Till the vast weight bursts thro' the rocky
> barrier;
> Down at once, its pine clad forests,
> And towering glaciers fall, the work of
> ages
> Crashing through all! extinction
> follows,
> And the toil, the hope of man—
> o'erwhelms.

The painting suggests the "extinction" of the very "hope of man"—a sentiment far removed from Constable's pastoral landscapes or Wordsworth's "natural piety." Turner had never been to the Grisons, and this painting seems to have been inspired by an avalanche that occurred there in 1808, crushing a chalet beneath huge rocks propelled by a giant mass of snow. The painting is a pure act of imagination. It anticipates his great paintings of the 1840s, in which he focused on the immersion of the self (and the viewer) into the primal forces of nature.

One of the most daring of these later masterpieces was *Snow Storm—Steam-Boat off a Harbour's Mouth* (1842), originally subtitled *The author was in this storm on the night the Ariel left Harwich* (Fig. **33.9**). "I wished to show," Turner said, "what such a scene was like. I got the sailors to lash me to the mast to observe it . . . and I did not expect to escape: but I felt bound to record it if I did." We have no evidence confirming a ship named *Ariel.* Most likely, Turner imagined this scene of a maelstrom of steam and

And the round ocean and the living air
And the blue sky, and in the mind of man:
A motion and a spirit, that impels
All thinking things, all objects of all thought,
And rolls through all things.

storm that deposits us at its very heart. Turner's depiction of the raw experience of nature in its most elemental form clearly represents a Romantic view of the world. This view is the opposite of the Enlightenment ideal of the natural world characterized by clarity, order, and harmony.

The Romantic in Germany: Friedrich and Kant

Although Constable and Turner's approaches are very different, both believed that nature provoked their imaginations. In the German Romantic tradition, the imagination is also the fundamental starting point. The painter Caspar David Friedrich [FREED-rikh] (1774–1840) represents the imaginative capacities of the Romantic mind by placing figures, often solitary ones, before sublime landscapes. In *Monk by the Sea* (Fig. **33.10**), a figure stands alone, engulfed in the vast expanse of sand and storm, as if facing the void. His is a crisis of faith. How do I know God? he seems to ask. And how, in the face of this empty vastness, do I come to belief? Can I even believe?

These sentiments echo the philosopher Immanuel Kant's *Critique of Pure Reason* (1781), in which Kant had argued that the mind is not a passive recipient of information—not, that is, the "blank slate" that Locke had claimed. For Kant, the mind was an active agent in the creation of knowledge. He believed that the ways we understand concepts like space, time, quantity, the relations among things, and, especially, quality, are innate from birth. We come to understand the world through the operation of these innate mental abilities as they perceive the various aspects of experience. Each of our experiences is various as well, and so each mind creates its own body of knowledge, its own world. No longer was the nature of reality the most important question. Instead, the mind confronting reality was paramount. Kant shifted the basic question of philosophy, in other words, from What do we know? to How do we know?—even to How do we know that we know?

The theme of doubt is a constant in Friedrich's paintings, but more as a stimulant to the imagination than a source of anxiety and tension. In his *Wanderer above the Mists*, Friedrich pictures a lone man with windblown hair positioned directly in front of the viewer on a rocky promontory (Fig. **33.11**). Like the monk, we can view him as a projection of ourselves. His view is interrupted by the vast expanse of mist just as ours is cut off by the outcropping of rock. The full magnificence of the scene is only hinted at, a vague promise of eventual revelation. Friedrich, in fact, had this to say about the value of uncertainty:

> If your imagination is poor, and in fog you see nothing but gray, then an aversion to vagueness is understandable. All the same, a landscape enveloped in mist seems vaster, more sublime, and it animates the imagination while also heightening suspense—like a veiled woman. The eye and the imagination are generally more intrigued by vaporous distances than by a nearby object available to the eye.

The viewer's imagination is further stimulated by the contrast between near and far, between the rock in the foreground and the ethereal atmosphere stretching into the distance—that is, between the earthly and spiritual realms.

The American Romantic Landscape

In America, the Romantic landscape was literally shaped by the presence of vast tracts of wilderness. One of the foremost American landscape painters of the time was an Englishman, Thomas Cole (1801–1848). Cole immigrated to the United States when he was 18 years old, and he returned to London 10 years later, where he studied the paintings of Constable and Turner. Traveling on to Paris and Florence,

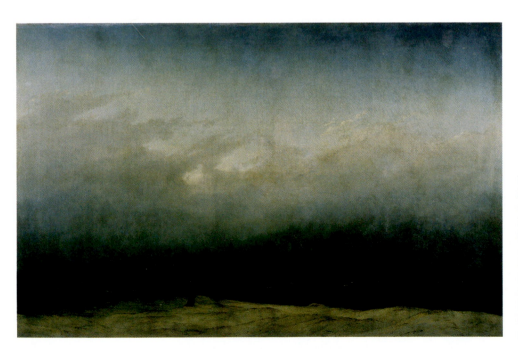

Fig. 33.10 Caspar David Friedrich. *Monk by the Sea.* 1809–1810. Oil on canvas, 47½″ × 67″. Inv.: NG 9/85. Nationalgalerie, Staatliche Museen zu Berlin, Berlin, Germany. Joerg P. Anders/Bildarchiv Preussischer Kulturbesitz/Art Resource, NY. Schloss Charlottenburg, Berlin. Bildarchiv reussischer Kulturbesitz. Some art historians believe that the monk is Friedrich himself, which makes this a self-portrait.

Fig. 33.11 Caspar David Friedrich. *The Wanderer above the Mists.* ca. 1817–1818. Oil on canvas, 37$\frac{1}{4}$″ × 29$\frac{1}{2}$″. Inv.: 5161. On permanent loan from the Foundation for the Promotion of the Hamburg Art Collections. Photo: Elke Walford. Hamburger Kunsthalle, Hamburg, Germany. Bildarchiv Preussischer Kulturbesitz/Art Resource, NY. The artist's identification with nature is underscored by the analogy Friedrich establishes between the figure's head and the distant rock at the right.

he came to recognize that "in civilized Europe the primitive features of scenery have long since been destroyed or modified." In America, on the other hand,

> . . . nature is still predominant, and there are those who regret that with the improvements of cultivation the sublimity of the wilderness should pass away; for those scenes of solitude from which the hand of nature has never been lifted, affect the mind with a more deep toned emotion than aught which the hand of man has touched. Amid them the consequent associations are of God the creator— they are his undefiled works, and the mind is cast into the contemplation of eternal things.

Cole's painting, *The Oxbow*, of a famous bend in the Connecticut River in Massachusetts, describes the boundary between those lands "which the hands of man has touched" and the "undefiled" wilderness (Fig. **33.12**). Cole paints himself into the scene—he is at his easel below the rocks to the left of his pack and umbrella—where he acts as mediator between the neatly defined fence rows and sunny fields of the valley below and the rugged wilderness behind him, symbolized by the blasted tree stump and the dark clouds of the thunderstorm in the distance.

Cole painted most often in the Catskill Mountains up the Hudson River halfway between Albany and New York. He was the most prominent artist in what became known as the Hudson River School. His pupil, Frederic Edwin Church (1826–1900), began construction of his own home, Olana, in 1860, overlooking the Hudson River and the Catskills from a ridge high over Hudson, New York.

By then Church had taken two trips to South America, which resulted in a number of enormous paintings of the Andes Mountains. After seeing these canvases, one British reviewer commented that "the mantle of our greatest painter [i.e., Turner] appears to us to have fallen" on Church. But for what many consider to be his masterpiece, Church turned to

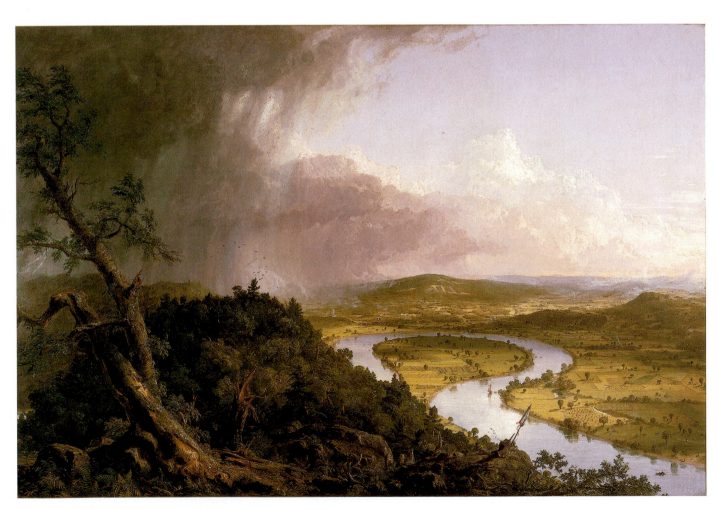

Fig. 33.12 Thomas Cole. *The Oxbow (View from Mount Holyoke, Northampton, Massachusetts, After a Thunderstorm).* 1836. Oil on canvas, 4′3 1/2″ × 6′4″. The Metropolitan Museum of Art, NY. Gift of Mrs. Russell Sage, 1908 (08.228). The painting suggests, as the storm departs to the left, that civilization will eventually overwhelm the wilderness, a prospect Cole anticipated with distress.

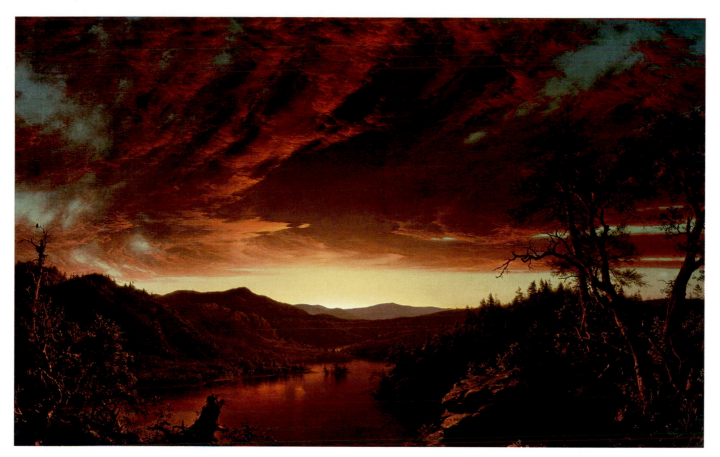

Fig. 33.13 Frederic Edwin Church. *Twilight in the Wilderness.* **1860.** Oil on canvas, 40″ × 60″. The Cleveland Museum of Art, Mr. and Mrs. William H. Marlatt Fund. The Bridgeman Art Library. As was true of almost all Church's major paintings of the era, this one was exhibited by itself as a paid-entrance event in New York City, where it became enormously popular.

his native land. *Twilight in the Wilderness* lacks any human presence (Fig. **33.13**). The painting suggests that its subject is not merely twilight *in* the wilderness, but twilight *of* the wilderness. This spot, above the glassy lake, might be among the last such places on the continent. Indeed, there was a growing interest in preserving such spaces. In 1864 President Lincoln signed an act which declared that Yosemite Valley in California "be held for public use, resort, and recreation . . . inalienable for all time." Eight years later, in 1872, Congress established Yellowstone as the nation's first national park.

Transcendentalism and the American Romantics

Just as the American landscape inspired the Romantic sensibilities of artists, it provoked in the minds of writers what Cole had described as "the contemplation of eternal things." American writers of a Romantic sensibility shared with the painters like Church a wonder at the natural world with which they felt an ecstatic communion. In many ways, they were shaped by the nation's emphasis on individualism and individual liberty. Free to think for themselves, their imaginations were equally free to discover the self in nature.

The Philosophy of Romantic Idealism: Emerson and Thoreau

In 1834, a 31-year-old minister, disenchanted with institutionalized religion and just back from England, where he had encountered Coleridge and heard Wordsworth recite his poetry, moved to the village of Concord, Massachusetts. Over the next several years, Ralph Waldo Emerson (1803–1882), a Unitarian minister, wrote his first book, *Nature*, published anonymously in 1836. The book became the intellectual beacon for a group of Concord locals, mostly ministers, that became known as the "Transcendental Club." It took its name from the *System of Transcendental Idealism*, written by Freidrich Schelling [SHELL-ing] (1775–1854), which argued that scientific observation and artistic intuition were complementary, not opposed, modes of thought. "Nature," Schelling wrote, "is visible Spirit; Spirit is invisible Nature."

This sense of the spirit's oneness with nature informs the most famous passage of *Nature*, when Emerson outlines the fundamental principle of transcendental thought: In the

direct experience of nature the individual is united with God, thus transcending knowledge based on empirical observation (**Reading 33.6**):

READING 33.6 **from Ralph Waldo Emerson, *Nature*, Chapter 1 (1836)**

Crossing a bare common, in snow puddles, at twilight, under a clouded sky, without having in my thoughts any occurrence of special good fortune, I have enjoyed a perfect exhilaration. Almost I fear to think how glad I am. In the woods too a man casts off his years, as the snake his slough, and at what period soever of life, is always a child. In the woods, is perpetual youth. Within these plantations of God, a decorum and sanctity reign, a perennial festival is dressed, and the guest sees not how he should tire of them in a thousand years. In the woods, we return to reason and faith. There I feel that nothing can befall me in life,— no disgrace, no calamity (leaving me my eyes,) which nature cannot repair. Standing on the bare ground,— my head bathed by the blithe air, and uplifted into infinite space,—all mean egotism vanishes. I become a transparent eye-ball. I am nothing. I see all. The currents of the Universal Being circulate through me; I am part or particle of God. The name of the nearest friend sounds then foreign and accidental. To be brothers, to be acquaintances,—master or servant, is then a trifle and a disturbance. I am the lover of uncontained and immortal beauty. In the wilderness, I find something more dear and connate [i.e., congenial] than in streets or villages. In the tranquil landscape, and especially in the distant line of the horizon, man beholds somewhat as beautiful as his own nature.

The sense of the self at the center of experience—the "eye/I" is also the sense of individualism and self-reliance fundamental to transcendental experience. In fact, in one of his most famous essays, "Self-Reliance," Emerson would declare, "Whoso would be a man must be a nonconformist. . . . Nothing is at last sacred but the integrity of your own mind." Of all Emerson's contemporaries, none fits this description better than Henry David Thoreau [thor-OH] (1817–1862). Educated at Harvard, Thoreau was fiercely independent. He resigned his first job as a schoolteacher in Concord because he refused to inflict corporal punishment on his students. He became one of the nation's most vocal abolitionists and was briefly jailed for refusing to pay a poll tax to a government that tolerated slavery. But most famously, for two years, from 1845 to 1847, he lived in a small cabin that he built himself, on Emerson's property at Walden Pond. This experience spawned *Walden, or Life in the Woods*, a small book published in 1854, dedicated to teaching the satisfactions and virtues of living simply and wisely in communion with

nature (Fig. **33.14**). Thoreau's woods are the same woods that Emerson extols in *Nature*. Thoreau writes (**Reading 33.7**):

READING 33.7 **from Henry David Thoreau, *Walden, or Life in the Woods*, Chapter 2 (1854)**

I went to the woods because I wished to live deliberately, to front only the essential facts of life, and see if I could not learn what it had to teach, and not, when I came to die, discover that I had not lived. . . . I wanted to live deep and suck out all the marrow of life, to live so sturdily and Spartan-like as to put to rout all that was not life. . . . Time is but the stream I go a-fishing in. I drink at it; but while I drink I see the sandy bottom and detect how shallow it is. Its thin current slides away, but eternity remains.

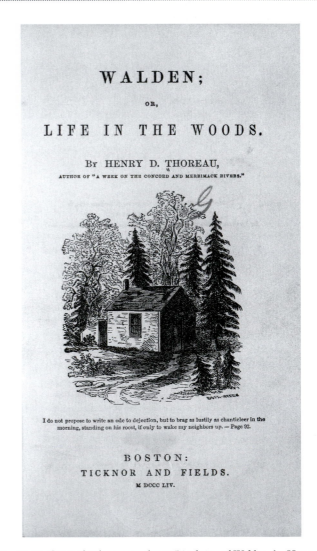

Fig. 33.14 Original title page to the 1854 edition of *Walden*, by Henry David Thoreau. This is as accurate a depiction of Thoreau's cabin at Walden Pond as we have.

The eccentricities of Thoreau's life are matched by the inventiveness of his prose, and in the end Thoreau's argument is for what he calls "the indescribable innocence and beneficence of Nature."

As powerful and as transformative as nature was, Thoreau viewed it as vulnerable to human encroachment, an insight that proved him far ahead of his time. He worried, for instance, that the railroad had destroyed the old scale of distances, a complaint shared by many of his contemporaries. His understanding of the environment's vulnerability and humanity's role in conserving or degrading it illustrates Thoreau's other enduring influence on American literature culture—as a powerful social conscience and spokesman for unpopular causes. Rebelling against unjust war in his essential essay "Civil Disobedience," against slavery as an active supporter of the Underground Railroad, and against conformism in his work as a writer and educator, Thoreau was both highly individualistic as well as a committed social activist. In his essay "Life without Principle," drawn from a series of lectures in 1854, Thoreau pondered "the way we spend our lives," and the negative effect it had on the natural world as well as our human nature (**Reading 33.8**):

READING 33.8 **from Henry David Thoreau, "Life without Principle" (1854)**

This world is a place of business. What an infinite bustle! I am awaked almost every night by the panting of the locomotive. It interrupts my dreams. . . . It would be glorious to see mankind at leisure for once. It is nothing but work, work, work. I cannot easily buy a blank-book to write thoughts in; they are commonly ruled for dollars and cents. . . . If a man was tossed out of a window when an infant, and so made a cripple for life, or scared out of his wits by the Indians, it is regretted chiefly because he was thus incapacitated for— business! I think that there is nothing, not even crime, more opposed to poetry, to philosophy, ay, to life itself, than this incessant business. . . . If a man walk in the woods for love of them half of each day, he is in danger of being regarded as a loafer; but if he spends his whole day as a speculator, shearing off those woods and making earth bald before her time, he is esteemed an industrious and enterprising citizen. As if a town had no interest in its forests but to cut them down!

Thoreau's sense of individualistic conscience is most evident in his 1849 essay "Civil Disobedience," written after his brief imprisonment for refusing to pay a poll tax (a tax levied on every male adult voter) as a protest against the Mexican-American war and slavery:

Must the citizen ever for a moment, or in the least degree, resign his conscience to the legislator? Why has every man a conscience, then? I think that we should be men first, and subjects afterward. It is not desirable to cultivate a respect for the law, so much as for the right. The only obligation which I have a right to assume is to do at any time what I think right. . . . Under a government which imprisons any unjustly, the true place for a just man is also a prison. The proper place to-day, the only place which Massachusetts has provided for her freer and less desponding spirits, is in her prisons. . . . It is there that the fugitive slave, and the Mexican prisoner on parole, and the Indian come to plead the wrongs of his race, should find them; on that separate, but more free and honorable ground, where the State places those who are not *with* her, but *against* her—the only house in a slave State in which a free man can abide with honor.

Herman Melville: The Uncertain World of *Moby Dick*

Nothing could be further from Thoreau's belief in the "innocence and beneficence of Nature" than the sensibility of Herman Melville [MELL-vill] (1819–1891). Melville had worked as a ship's cabin-boy, and later as a crew member on a whaler bound for the South Pacific. His experiences at sea led him to view the natural world (and the humans who inhabited it) as a severe challenge rather than a calm gateway to inspiration. After abandoning the whaling ship because of its intolerable conditions, Melville was taken prisoner by cannibals in the Marquesa islands. Once rescued, he survived by taking menial jobs in Tahiti and Hawaii in the 1840s.

Melville's hardscrabble years as a sailor would inform his great novel, *Moby Dick*. Published in 1851, the novel tells the story of Captain Ahab's [AY-hab] vengeful quest across the vast reaches of the Pacific Ocean for an elusive white whale to whom he had lost his leg.

Melville knew and appreciated Turner's work, collecting engravings of *Snow Storm—Steam-Boat off a Harbour's Mouth* (see Fig. 33.9). He was also aware that Turner had painted a number of whaling pictures, based on Thomas Beale's *Natural History of the Sperm Whale* (1839), which he himself used as a source for the novel. Among them is the 1845 *Whale Ship*, depicting a whale breaching in a fury of foam and spray, harpoonists approaching from its right (Fig. **33.15**). In fact, early in *Moby Dick*, its narrator, Ishmael [ISH-me-el], having decided to go to sea, arrives at the Spouter Inn in New Bedford, Massachusetts, where he encounters a picture hanging in the entry (**Reading 33.9**):

READING 33.9 **from Herman Melville, *Moby Dick*, Chapter 3, "The Spouter Inn" (1851)**

. . . a very large oil painting so thoroughly besmoked, and every way defaced, that in the unequal crosslights by which you viewed it, it was only by diligent study

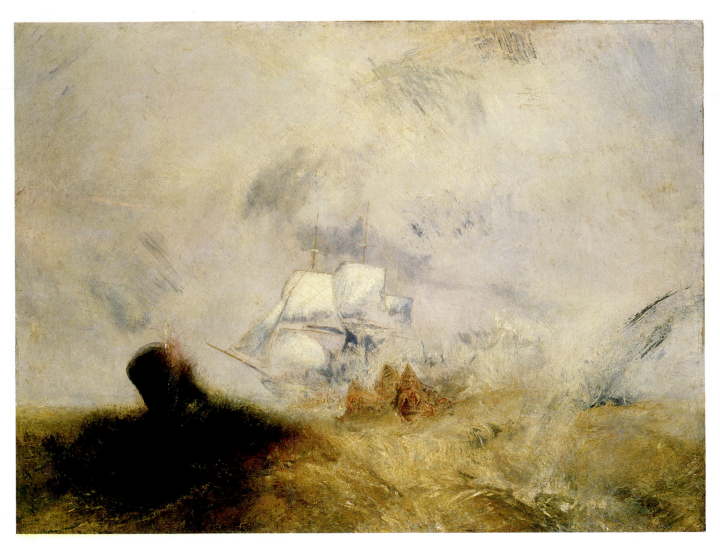

Fig. 33.15 J. M. W. Turner. *The Whale Ship.* **ca. 1845.** Oil on canvas, $36\frac{1}{8}''\times48\frac{1}{4}''$. The Metropolitan Museum of Art, NY. Catharine Lorillard Wolfe Collection, Wolfe Fund, 1896 (96.29). Image copyright © The Metropolitan Museum of Art. This painting was exhibited at the Royal Academy in 1845 with the caption "Vide Beale's Voyage p. 175." This refers to a passage in a book written by Thomas Beale, describing the harpooning of a large sperm whale off Japan in 1832.

and a series of systematic visits to it, and careful inquiry of the neighbors, that you could any way arrive at an understanding of its purpose.

. . .What most puzzled and confounded you was a long, limber, portentous, black mass of something hovering in the centre of the picture over three blue, dim, perpendicular lines floating in a nameless yeast. A boggy, soggy, squitchy picture truly, enough to drive a nervous man distracted. Yet was there a sort of indefinite, half-attained, unimaginable sublimity about it that fairly froze you to it. . . . Ever and anon a bright, but, alas, deceptive idea would dart you through.—It's the Black Sea in a midnight gale.—It's the unnatural combat of the four primal elements.—It's a blasted heath.—It's a Hyperborean [hy-pur-BOR-ee-un] winter scene.—It's the breaking-up of the icebound stream

of Time. But at last all these fancies yielded to that one portentous something in the picture's midst. . . . But stop; does it not bear a faint resemblance to a gigantic fish? even the great leviathan himself?

In fact, the artist's design seemed this. . . .The picture represents a Cape-Horner in a great hurricane; the half-foundered ship weltering there with its three dismantled masts alone visible; and an exasperated whale, purposing to spring clean over the craft, is in the enormous act of impaling himself upon the three mast-heads.

As long as the painting is mysterious, as long as its meaning escapes definition, then, like Friedrich's mist, "it animates the imagination." It is alive with sublime possibility. In this sense, the painting is analogous to Ahab's white whale, possessed of a whiteness that is at once "innocent"

and "pure" and like Coleridge's albatross, "pale dread . . . that white phantom [that] sails in all imaginations." (See **Reading 33.3**, pages 1078–1079) Readers have interpreted the white whale in countless ways since *Moby Dick* was published. It symbolizes both good and evil, as well as elements of the natural world that cannot be controlled by humans—that are truly wild.

As much as it reflects a Romantic sensibility, in many ways Melville's book is a challenge to American transcendentalism and the Romantic imagination. This is most evident in his chapter entitled, "The Mast-Head," in which Ishmael describes his first watch from the top of the ship's mast looking for whales. "There," he says, "you stand, lost in the infinite series of the sea, with nothing ruffled but the waves. The tranced ship indolently rolls; the drowsy trade winds blow; everything resolves you into languor." It is, he says, the perfect place for a young man with a Romantic sense of melancholy to find himself, even if it means that no whales will be spied on account of the watchman's reverie (**Reading 33.10**):

Here Melville indicates sensibly that the precarious sailor's perch on the mast of a ship is no place for deep thoughts of "romantic, melancholy, and absent-minded young men." They are lost "in the round ocean and the living air / And the blue sky" that Wordsworth describes in "Tintern Abbey," and risk falling to their death. In *Moby Dick*, Ishmael's Romantic vision is definitely limited. It cannot grasp the complexity of experience, just as Ahab cannot grasp the meaning of the whale that he longs to destroy. There is, as the next chapter suggests, a darker side to the Romantic imagination.

READING 33.10 from Herman Melville, *Moby Dick*, Chapter 35, "The Mast-Head" (1851)

And let me in this place movingly admonish you, ye ship-owners of Nantucket! Beware of enlisting in your vigilant fisheries any lad with lean brow and hollow eye; given to unseasonable meditativeness. . . . Beware of such an one, I say: your whales must be seen before they can be killed; and this sunken-eyed young Platonist will tow you ten wakes round the world, and never make you one pint of sperm the richer. Nor are these monitions at all unneeded. For nowadays, the whale-fishery furnishes an asylum for many romantic, melancholy, and absent-minded young men . . .

Very often do the captains of such ships take those absent-minded young philosophers to task, upbraiding them with not feeling sufficient "interest" in the voyage; half-hinting that they are so hopelessly lost to all honorable ambition, as that in their secret souls they would rather not see whales than otherwise" . . . Why, thou monkey," said a harpooneer to one of these lads, "we've been cruising now hard upon three years, and thou hast not raised a whale yet. Whales are scarce as hen's teeth whenever thou art up here." Perhaps they were; or perhaps there might have been shoals of them in the far horizon; but lulled into such an opium-like listlessness of vacant, unconscious reverie is this absent-minded youth by the blending cadence of waves with thoughts, that at last he loses his identity; takes the mystic ocean at his feet for the visible image of that deep, blue, bottomless soul, pervading mankind and nature . . .

READINGS

from William Wordsworth, "Lines Composed a Few Miles above Tintern Abbey, on Revisiting the Banks of the Wye during a Tour, July 13, 1798" (1798)

"Tintern Abbey" is the product of Wordsworth's visit to the medieval abbey's ruins on the banks of the Wye River in 1798. The 159-line poem is typical of Wordsworth's poetry in the way that it swings back and forth between his observation of an external scene and his contemplation of the feelings generated by that scene, between the past and the present, and between his personal experience ("I") and more universal and general experience ("we").

Five years have passed; five summers, with the length
Of five long winters! and again I hear
These waters, rolling from their mountain-springs
With a soft inland murmur.—Once again
Do I behold these steep and lofty cliffs,
That on a wild secluded scene impress
Thoughts of more deep seclusion; and connect
The landscape with the quiet of the sky.
The day is come when I again repose
Here, under this dark sycamore, and view 10
These plots of cottage-ground, these orchard-tufts,

Which at this season, with their unripe fruits,
Are clad in one green hue, and lose themselves
'Mid groves and copses. Once again I see
These hedge-rows, hardly hedge-rows, little lines
Of sportive wood run wild: these pastoral farms,
Green to the very door; and wreaths of smoke
Sent up, in silence, from among the trees!
With some uncertain notice, as might seem
Of vagrant dwellers in the houseless woods, 20
Or of some Hermit's cave, where by his fire
The Hermit sits alone.
 These beauteous forms,
Through a long absence, have not been to me
As is a landscape to a blind man's eye:
But oft, in lonely rooms, and 'mid the din
Of towns and cities, I have owed to them
In hours of weariness, sensations sweet,
Felt in the blood, and felt along the heart;
And passing even into my purer mind, 30
With tranquil restoration:—feelings too
Of unremembered pleasure: such, perhaps,
As have no slight or trivial influence
On that best portion of a good man's life,
His little, nameless, unremembered, acts
Of kindness and of love. Nor less, I trust,
To them I may have owed another gift,
Of aspect more sublime; that blessed mood,
In which the burthen of the mystery,
In which the heavy and the weary weight 40

Of all this unintelligible world,
Is lightened:—that serene and blessed mood,
In which the affections gently lead us on,—
Until, the breath of this corporeal frame
And even the motion of our human blood
Almost suspended, we are laid asleep
In body, and become a living soul:
While with an eye made quiet by the power
Of harmony, and the deep power of joy,
We see into the life of things. 50
 If this
Be but a vain belief, yet, oh! how oft—
In darkness and amid the many shapes
Of joyless daylight; when the fretful stir
Unprofitable, and the fever of the world,
Have hung upon the beatings of my heart—
How oft, in spirit, have I turned to thee,
O sylvan Wye! thou wanderer thro' the woods,
How often has my spirit turned to thee!
And now, with gleams of half-extinguished thought, 60
With many recognitions dim and faint,
And somewhat of a sad perplexity,
The picture of the mind revives again:
While here I stand, not only with the sense
Of present pleasure, but with pleasing thoughts
That in this moment there is life and food
For future years. And so I dare to hope,
Though changed, no doubt, from what I was when first
I came among these hills; when like a roe
I bounded o'er the mountains, by the sides 70
Of the deep rivers, and the lonely streams,
Wherever nature led: more like a man
Flying from something that he dreads, than one
Who sought the thing he loved. For nature then
(The coarser pleasures of my boyish days,
And their glad animal movements all gone by)
To me was all in all.—I cannot paint
What then I was. The sounding cataract
Haunted me like a passion: the tall rock,
The mountain, and the deep and gloomy wood, 80

Their colours and their forms, were then to me
An appetite; a feeling and a love,
That had no need of a remoter charm,
By thought supplied, nor any interest
Unborrowed from the eye.—That time is past,
And all its aching joys are now no more,
And all its dizzy raptures. Not for this
Faint I, nor mourn nor murmur, other gifts
Have followed; for such loss, I would believe,
Abundant recompence. For I have learned 90
To look on nature, not as in the hour
Of thoughtless youth; but hearing oftentimes
The still, sad music of humanity,
Nor harsh nor grating, though of ample power
To chasten and subdue. And I have felt
A presence that disturbs me with the joy
Of elevated thoughts; a sense sublime
Of something far more deeply interfused,
Whose dwelling is the light of setting suns,
And the round ocean and the living air, 100
And the blue sky, and in the mind of man;
A motion and a spirit, that impels
All thinking things, all objects of all thought,
And rolls through all things. Therefore am I still
A lover of the meadows and the woods,
And mountains; and of all that we behold
From this green earth; of all the mighty world
Of eye, and ear,—both what they half create,
And what perceive; well pleased to recognise
In nature and the language of the sense, 110
The anchor of my purest thoughts, the nurse,
The guide, the guardian of my heart, and soul
Of all my moral being.
 Nor perchance,
If I were not thus taught, should I the more
Suffer my genial spirits to decay:
For thou art with me here upon the banks
Of this fair river; thou my dearest Friend,
My dear, dear Friend; and in thy voice I catch
The language of my former heart, and read 120
My former pleasures in the shooting lights
Of thy wild eyes. Oh! yet a little while
May I behold in thee what I was once,
My dear, dear Sister! and this prayer I make,

Knowing that Nature never did betray
The heart that loved her; 'tis her privilege,
Through all the years of this our life, to lead
From joy to joy: for she can so inform
The mind that is within us, so impress
With quietness and beauty, and so feed 130
With lofty thoughts, that neither evil tongues,
Rash judgments, nor the sneers of selfish men,
Nor greetings where no kindness is, nor all
The dreary intercourse of daily life,
Shall e'er prevail against us, or disturb
Our cheerful faith, that all which we behold
Is full of blessings. Therefore let the moon
Shine on thee in thy solitary walk;
And let the misty mountain-winds be free
To blow against thee: and, in after years, 140
When these wild ecstasies shall be matured
Into a sober pleasure; when thy mind
Shall be a mansion for all lovely forms,
Thy memory be as a dwelling-place
For all sweet sounds and harmonies; oh! then,
If solitude, or fear, or pain, or grief,
Should be thy portion, with what healing thoughts
Of tender joy wilt thou remember me,
And these my exhortations! Nor, perchance—
If I should be where I no more can hear 150
Thy voice, nor catch from thy wild eyes these gleams
Of past existence—wilt thou then forget
That on the banks of this delightful stream
We stood together; and that I, so long
A worshipper of Nature, hither came
Unwearied in that service: rather say
With warmer love—oh! with far deeper zeal
Of holier love. Nor wilt thou then forget,
That after many wanderings, many years
Of absence, these steep woods and lofty cliffs, 160
And this green pastoral landscape, were to me
More dear, both for themselves and for thy sake! ■

Reading Question

At the heart of Wordsworth's poem is his sense that nature is not merely a scene but that it is infused with a moral value comparable to divinity itself. In what ways does he describe his growing realization that this is so?

READING 33.3

from Samuel Taylor Coleridge, "Rime of the Ancient Mariner," Part I (1798)

Coleridge's poem in seven parts is set on the foreboding ocean. It reveals truths about nature that seem, at first, the total opposite of Wordsworth's nurturing landscapes. In Coleridge's poem, nature is an indomitable force, a ruthless power. Yet, even in its most horrific aspects, it possesses an inherent value and beauty. In the first book of the poem, which sets up the tragic tale, the Mariner's destructive act in killing the albatross symbolizes humanity's destructive relation to the natural world as a whole. In the subsequent parts, the Mariner's regeneration and salvation come as he accepts responsibility for his actions.

Argument

How a Ship having passed the Line was driven by storms to the cold Country towards the South Pole; and how from thence she made her course to the tropical Latitude of the Great Pacific Ocean; and of the strange things that befell; and in what manner the Ancyent Marinere came back to his own Country.

Part I

An ancient Mariner meeteth three Gallants bidden to a wedding-feast, and detaineth one.

It is an ancient Mariner,
And he stoppeth one of three.
'By thy long beard and glittering eye,
Now wherefore stopp'st thou me?

The Bridegroom's doors are opened wide, 10
And I am next of kin;
The guests are met, the feast is set:
May'st hear the merry din.'

He holds him with his skinny hand,
'There was a ship,' quoth he.
'Hold off! unhand me, grey-beard loon!'
Eftsoons his hand dropt he.

The Wedding-Guest is spell-bound by the eye of the old seafaring man, and constrained to hear his tale.

He holds him with his glittering eye—
The Wedding-Guest stood still,
And listens like a three year's child: 20
The Mariner hath his will.

The Wedding-Guest sat on a stone:
He cannot choose but hear;
And thus spake on that ancient man,
The bright-eyed Mariner.

'The ship was cheered, the harbour cleared,
Merrily did we drop
Below the kirk, below the hill,
Below the lighthouse top.

The Mariner tells how the ship sailed southward with a good wind and fair weather, till it reached the Line.

The Sun came up upon the left, 30
Out of the sea came he!
And he shone bright, and on the right
Went down into the sea.

Higher and higher every day,
Till over the mast at noon—'
The Wedding-Guest here beat his breast,
For he heard the loud bassoon.

The Wedding-Guest heareth the bridal music; but the Mariner continueth his tale.

The bride hath paced into the hall,
Red as a rose is she;
Nodding their heads before her goes 40
The merry minstrelsy.

The Wedding-Guest he beat his breast,
Yet he cannot choose but hear;
And thus spake on that ancient man,
The bright-eyed Mariner.

The ship driven by a storm toward the south pole.

'And now the STORM-BLAST came, and he
Was tyrannous and strong:
He struck with his o'ertaking wings,
And chased us south along.

With sloping masts and dipping prow, 50
As who pursued with yell and blow
Still treads the shadow of his foe,
And forward bends his head,
The ship drove fast, loud roared the blast,
The southward aye we fled.

And now there came both mist and snow,
And it grew wondrous cold:
And ice, mast-high, came floating by,
As green as emerald.

The land of ice, and of fearful sounds where no living thing was to be seen.

And through the drifts the snowy cliffs 60
Did send a dismal sheen:
Nor shapes of men nor beasts we ken—
The ice was all between.

The ice was here, the ice was there,
The ice was all around:
It cracked and growled, and roared and howled,
Like noises in a swound!

Till a great sea-bird, called the Albatross, came through the snow-fog, and was received with great joy and hospitality.

At length did cross an Albatross,
Through the fog it came;
As if it had been a Christian soul,
We hailed it in God's name. 70

It ate the food it ne'er had eat,
And round and round it flew.
The ice did split with a thunder-fit;
The helmsman steered us through!

And lo! the Albatross proveth a bird of good omen, and followeth the ship as it returned northward through fog and floating ice.

And a good south wind sprung up behind;
The Albatross did follow,

And every day, for food or play,
Came to the mariner's hollo!

In mist or cloud, on mast or shroud, 80
It perched for vespers nine;
Whiles all the night, through fog-smoke white,
Glimmered the white Moon-shine.'

The ancient Mariner inhospitably killeth the pious bird of good omen.

'God save thee, ancient Mariner!
From the fiends, that plague thee thus!—
Why look'st thou so ?'—With my cross-bow
I shot the ALBATROSS. ■

Reading Question

The Mariner narrates his tale to a wedding guest, who in the fourth stanza "listens like a three years' child." Why do you suppose Coleridge wants the Mariner's audience to listen with child-like attentiveness?

 # Summary

■ **The Early Romantic Imagination** William Wordsworth's poem "Tintern Abbey" embodies the growing belief in the natural world as the source of inspiration and creativity that marks the early Romantic imagination. The Romantics were dedicated to the discovery of beauty in nature through their subjective experience of it. Wordsworth's poem was included in *Lyrical Ballads*, a book he coauthored with Samuel Taylor Coleridge in 1798 as a self-conscious experiment dedicated to presenting "incidents and situations from common life . . . in a selection of language really used by men." That said, Coleridge's "Rime of the Ancient Mariner" reflects the supernatural and mystical character of Coleridge's imagination, very different from Wordsworth's adherence to what he called "the truth of nature." Of all Romantic poetry, perhaps the odes of John Keats most fully embody the Romantic imagination's ability to transcend even death, which Keats faced when he realized at age 23 that he was dying of tuberculosis. In a nightingale's song or a Grecian urn, Keats discovers the essence of a beauty that represents a form of nature higher than mortal life itself.

■ **The Romantic Landscape** Landscape painters in the nineteenth century saw the natural world around them as the emotional focal point or center of their own artistic imaginations. John Constable, painting in the valley of the Stour River in his native Suffolk, considered himself "a worshipper of Nature," and in his paintings, especially his large canvases like *The Hay Wain*, he tried to capture nature in all its variety, thus reflecting the many states of mind in which he contemplated it. J. M. W. Turner specialized in capturing light, not the objects of nature so much as the medium through which they are seen. The scale of Turner's paintings is usually very large, dwarfing the human presence. And nature is never altogether benign or friendly—avalanches and storms constantly threaten the viewer. In Germany, the painter Caspar David Friedrich often places solitary figures before sublime landscapes that constantly raise the theme of doubt. Doubt—the inability to determine with certainty the meaning of the world before him—excites Friedrich's imagination. In America, the Romantic imagination found itself at home in the vast and sublime reaches of the untamed wilderness. The paintings of Thomas Cole and Frederic Edwin Church often confront the tension between the imaginative freedom offered by the wilderness and the impinging threat of civilization.

■ **Transcendentalism and the American Romantics** American writers of a Romantic sensibility were, like the painters, free to discover the self in nature. Ralph Waldo Emerson codified their thinking in his 1836 treatise *Nature*. His contemporary, Henry David Thoreau, sought to experience nature firsthand by retreating to a small cabin in the woods on Emerson's property, where he wrote *Walden, or Life in the Woods*, first published in 1854. Romantic thinking was more problematic for the novelist Herman Melville. While many of the characters in his *Moby Dick* reflect a deeply Romantic sensibility, Melville challenges their way of approaching the world as overly simplistic and even dangerously so.

 # Glossary

dactyl A metrical measure (or "foot") composed of one short and two long units.

ode A lyric poem of exaltation, exhibiting deep feeling.

 # Critical Thinking Questions

1. What is the "transcendence" that Wordsworth and Constable find in nature?

2. What is Turner's conception of the "sublime"?

3. How is the Romantic "self" different from other forms of individualism?

4. Compare Emerson's "transparent eyeball" and Thoreau's "stream of time" as metaphors for the Romantic experience in nature.

The Romantics and Napoleon

Continuity & Change

On February 8, 1807, during a fierce blizzard near the town of Eylau, Russia's General Bennigsen, with an army of 74,500 men engaged Napoleon Bonaparte and his much smaller army of less than 50,000 in battle. Napoleon struck first, knowing that he had reinforcements in the wings. But the blizzard hampered both sides. The Russians withdrew, and Bonaparte claimed victory. There were 23,000 Russian casualties who had died for their emperor, Alexander I, but the battlefield was also strewn with 22,000 dead and wounded French.

Five weeks after Napoleon's "victory" a competition was announced in France for a painting commemorating the great day. The director of French museums declared that it should depict "The moment . . . when, His Majesty visiting the battlefield at Eylau in order to distribute aid to the wounded, a young Lithuanian hussar, whose knee had been shot off, rose up and said to the Emperor, 'Caesar, you want me to live. . . . Well, let them cure me and I will serve you as faithfully as I did Alexander!'" Antoine Jean Gros [groh] (1771–1835) won the competition with the painting illustrated here (Fig. 33.16). The painting made an odd piece of official propaganda. The larger than life-size pile of bodies, frozen blue, at the bottom of the painting is so terrifying and so openly hostile to the idea of victory that it seems impossible Napoleon would have approved it. Yet he did, just as he would ignore the advice of his aides in the fall of 1812 not to push into Russia, where his army "took" the city of Moscow, even as the Russians burned it. Napoleon abandoned his troops to return to Paris. He had begun his march into Russia with over 1 million men. Only about 100,000 returned. Never before had the term "heroism" seemed more hollow.

The promise of Napoleon—his ability to impose classical values of order, control, and rationality upon a French society that had been wracked with revolution and turmoil—was thus undermined by a darker reality. The Romantics, whose fascination with the powers of individual intuition and creativity had led them to lionize Napoleon, would react to his failure and to the ensuing disorder that marked the first half of the nineteenth century. Artists, composers, and writers would express in their works a profound pessimism about the course of human events. The optimistic spirit we find in Wordsworth and Constable, Emerson and Thoreau, would be challenged, not merely by the sense of darkness and foreboding expressed by Coleridge and Melville, but by a pessimism that undermined the Romantics' faith in the powers of nature to heal and restore humanity's soul. ∎

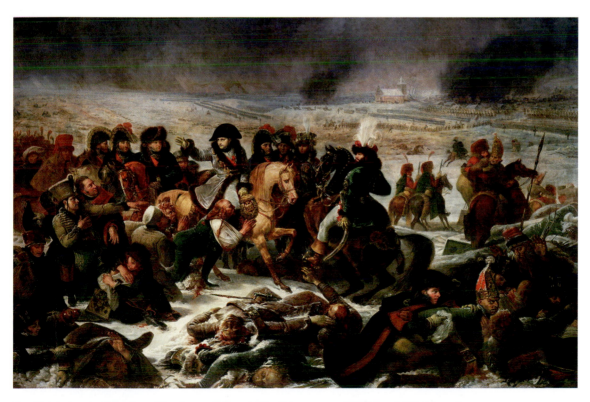

Fig. 33.16 Antoine Jean Gros. *Napoleon at Eylau*. 1808. Oil on canvas, 17′5½″ × 26′3″. Musée du Louvre, Paris. RMN Reunion des Musees Nationaux, France. Erich Lessing/Art Resource, NY

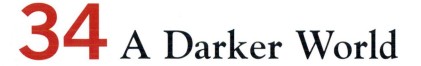

34 A Darker World

Napoleon and the Romantic Imagination

Napoleon and the Romantic Hero

Beethoven and the Rise of Romantic Music

Goya's Tragic Vision

French Painting after Napoleon: The Classic and Romantic

 Revisited

" *And this is all that I have found—*
The impossibility of knowledge! **"**

Goethe, *Faust*

◄ **Fig. 34.1 View of Vienna from the Josephstadt.** Colored engraving by Carl Schütz. 1785. Historisches Museum der Stadt Wien. Vienna was a city obsessed with leisure and entertainment, perhaps never more so than in 1815, when Europe's dignitaries gathered there for the Congress of Vienna, a peace conference that was, in essence, also a celebration of the defeat of Napoleon Bonaparte, at once the greatest hero of the day and the embodiment of Romanticism's darkest side.

VIENNA WAS A CITY OF CONTRADICTIONS IN THE EARLY YEARS

of the nineteenth century (Fig. **34.1**). In 1827 it still had not expanded beyond its medieval walls (Map **34.1**), but in the 1840s, its population would approach 400,000. Although smaller than both London (with nearly 1 million inhabitants in 1800)

and Paris (with about half that), it was one of the fastest-growing cities in the world. This growth coincided with Vienna's new position as the capital of the Austrian-Hungarian Empire.

Vienna's extraordinary growth and accompanying breakdown in infrastructure—its water system was probably the worst in Europe—contrasted sharply with the city's fondness for leisure and entertainment. As the century progressed, the city dismantled its elaborate system of defensive walls and constructed gardens, parks, and broad boulevards that allowed for urban expansion and a gradual transition to the surrounding suburbs. Yet even before the medieval walls came down, the streets of Vienna were lined with dance halls, theaters, coffeehouses, and wine bars. An English traveler, John Owen, reported in 1792, "good

cheer is, indeed, pursued here in every quarter, and mirth is worshiped in every form."

For 14 months, from September 1814 until November 1815, the city was especially lively and was in every way the center of European culture. All of Europe's heads of state gathered there for the Congress of Vienna, a conference called to guarantee peace in Europe both by treaty and other political tools after the defeat of Napoleon. This peace involved dividing Napoleon's empire and redrawing Europe's political map (Map **34.2**). The Habsburg emperor Franz I (1768–1835) appointed a festivals committee to entertain the visiting monarchs, their enormous entourages, and the continuing stream of dignitaries that flooded the city's streets. There were banquets and balls, tournaments and hunts, sleighing expeditions, torchlight parades, balloon ascents, theatricals, ballets, operas, and musical performances of every type.

Especially popular was a new orchestral work by Ludwig van Beethoven [BAY-toh-ven], Vienna's greatest composer, celebrating the June 1813 British victory over Napoleon at the Battle of Vittoria in Spain. Today the *Wellingtons Sieg* [seeg] (*Wellington's Victory*), a raucous noisemaker of a composition, is rarely performed. Beethoven himself later declared the work a "folly," but in a Vienna celebrating the defeat of the French, it was a sensation and was performed repeatedly. As minor as the composition is considered in retrospect, it illustrates how attractive the popular musical genre termed "battle music" was to Europeans of every social rank at this critical historical moment. Beethoven took full advantage of the unexpected acclaim, appearing in more public concerts in 1815 than in any other year of his

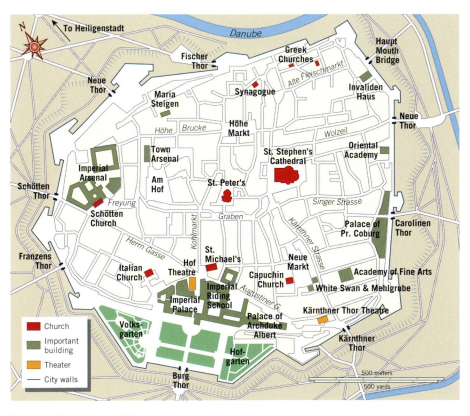

Map 34.1 Vienna ca. 1827.

lifetime. In fact, his late masterpieces were largely financed by *Wellingtons Sieg.*

While Vienna's great composer had sensed a commercial opportunity, the years immediately following Napoleon's final defeat also led to the rapid spread of a new nationalist political ideology despite the Congress of Vienna's attempt to restore a conservative political order in Europe. A blend of ethnic pride and cultural identity based on shared history and a sense of destiny, **nationalism** was the justification for the creation of many new nineteenth-century nation-states. Ironically, although it was Napoleon's defeat that triggered the spread of nationalism throughout his previously conquered territories, it was the French leader's political innovations that made nationalism so appealing.

Indeed, 11 years earlier, in 1803, before Napoleon had embarked on his monumentally destructive effort to conquer Europe, Beethoven had dedicated a symphony to the emperor whose defeat he now celebrated. And Beethoven had not been alone in his admiration for Napoleon. So stunningly successful were Napoleon's military campaigns, so fierce was his dedication to the principles of liberty, fraternity, and equality (abolishing serfdom throughout much of Europe), and so brilliant was his reorganization of the government, the educational system, and civil law, that in the first years of the nineteenth century, he seemed to many a savior. Ultimately,

Napoleon was the very personification of the Romantic hero as well as a French national icon, a man of common origin who had risen, through sheer wit and tenacity, to dominate the world stage.

But as everyone at the Congress of Vienna in 1814–1815 knew, there was a darker side to Napoleon. He was, for instance, a man of such ego that he led his armies on an endless series of military campaigns as if immune to defeat. He was a man with so great a desire for personal glory that he crowned himself emperor and established a royal dynasty to rule his various conquests. And in imposing his reforms, he brought war to many nations and suppressed their national identity. His reputation as a Romantic nationalist figure came to a crashing end in the midst of the Congress of Vienna in June 1815, when he was defeated once and for all at the battle of Waterloo—by Wellington once again—giving rise to a new flurry of *Wellingtons Sieg* performances. How the Romantics in various centers of culture throughout Europe reconciled their need for heroes of epic proportion with the inevitable human failings of heroic figures such as Napoleon is the subject of this chapter. The nature of the heroic is a constant theme in Romantic literature, music, and art. Many of the European artists who challenged the moral and aesthetic values of their time and championed their own and others' liberty self-consciously defined themselves as heroes.

Map 34.2 Post-Napoleonic Europe 1815. The Congress of Vienna created the territorial borders shown here.

Continuity & Change
p. 211

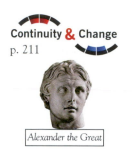

Alexander the Great

CULTURAL PARALLELS

Volcanic Eruption

At the same time that the Congress of Vienna convened during the spring and summer of 1815, 7,000 miles away in the Dutch East Indies (Indonesia), Mount Tambora erupted, ejecting enormous quantities of volcanic dust into the atmosphere. The next year, 1816, was dubbed "the year without a summer" or "the Poverty year" across the globe because of plunging temperatures and disruption in agricultural production worldwide.

Napoleon and the Romantic Hero

Napoleon's relative success at creating stability in France (see chapter 32) fueled his desire to establish stability across Europe, by force. To this end, in 1800 he crossed into Italy, establishing firm control of Piedmont and Lombardy. That same year, Jacques-Louis David celebrated the event in a painting (see Fig.

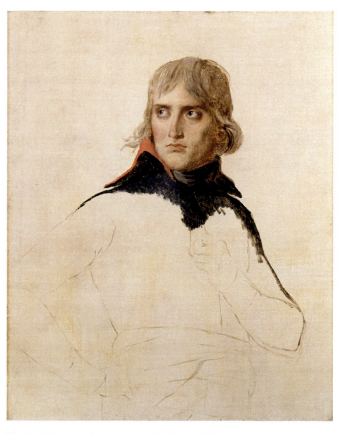

Fig. 34.2 Jacques-Louis David. *The General Bonaparte.* **ca. 1797–1798.** Unfinished oil on canvas, 31⅞″ × 25⅝″. Photo: R.G. Ojeda. Musée du Louvre/RMN Réunion des Musées Nationaux, France. SCALA/Art Resource, NY. David, who years earlier had created the epitome of the tribute to a French revolutionary with his painting of Marat, would claim to everyone, "Bonaparte is my hero!"

32.14) that is pure propaganda, designed to create a proper myth for the aspiring general. However, David's vision of Napoleon as a Romantic hero was evident years earlier in a sketch celebrating the emperor's peace treaty with Austria (Fig. **34.2**). Here Napoleon's penetrating eyes are meant to evoke the ancient Greek sculptor Lysippus's famous image of Alexander the Great (see Fig. 7.21) as the dashing young warrior about to dominate the world. One of the most influential early expressions of the Napoleonic myth came from German philosopher Georg Wilhelm Friedrich Hegel [HAY-gul] (1770–1831) in 1806: "I have seen the emperor, that world soul, pass through the streets of the town on horseback. It is a prodigious sensation to see an individual like him who, concentrated at one point, seated on a horse, spreads over the world and dominates it."

Extending his sights beyond the Continent, and financed in no small part by the sale of the Louisiana Territory to the United States in 1803 for 80 million francs (roughly $15 million), Napoleon prepared to invade England, his chief enemy. He assembled over 100,000 troops and 1,000 landing craft on the straits of Dover, but Vice Admiral Lord Nelson, commander of the British fleet, thwarted his tactics. Napoleon dispatched the French fleet to the West Indies in order to draw Nelson away from the English Channel, instructing the fleet to return secretly in order to escort the French troops across the channel. Instead, the British admiral caught up with the French ships off Cape Trafalgar [truh-FAL-gar] near the southwest corner of Spain and defeated them at the cost of his own life. Nelson destroyed nearly half the French fleet as well as Napoleon's dream of conquering England without the loss of any of his own ships.

Napoleon nevertheless remained undaunted and launched a succession of campaigns against Britain's continental allies, Austria and Prussia. By mid-October 1805, French forces occupied Vienna. Then on December 2, 1805, in one of Napoleon's greatest victories, his army of 73,000 defeated a combined Austrian and Russian force of 86,000, under the command of the tsar and the emperor of Austria, at Austerlitz [OH-ster-litz]. The resulting treaty left Napoleon in control of all of Italy north of Rome. By 1807, the only European countries outside Napoleon's sphere of influence were Britain, Sweden, and Portugal (see Map 32.2).

The Hegelian Dialectic and the "Great Man" Theory of History

For German philosopher Georg Wilhelm Friedrich Hegel, Napoleon was the force driving the world toward an absolute freedom embodied in the laws and institutions of a great European nation-state. From Hegel's point of view, the entire world is governed by a single divine nature, which he alternately called "absolute mind" or "world-spirit." Napoleon, whom Hegel termed "that world soul," personi-

fied this "absolute mind," which in seeking to know its own nature initiates a process known as the **dialectic**. At any given moment, the prevailing set of ideas, which Hegel termed the "thesis," finds itself opposed by a conflicting set of ideas, the "antithesis." For instance, chaotic revolutionary forces in France found themselves opposed by the call for order and rule of law embodied by Napoleon. This conflict resolves itself in a "synthesis," which inevitably establishes itself as the new thesis, generating its own new antithesis, with the process always moving forward, ever closer to the ultimate goal—spiritual freedom. Each period in history is necessary to the next, driven by conflict, which Hegel viewed as a positive and productive force rather than a damaging or destructive one.

Hegel, along with English philosopher-historian Thomas Carlyle, is also responsible for what is commonly called the **"Great Man" theory**, which asserts that human history is driven by the achievement of men (and men only) who lead humankind forward because they have sensed by intuition the "world-spirit" (**Reading 34.1**):

READING 34.1 **from Georg Wilhelm Friedrich Hegel, *Philosophy of History* (1805–1806)**

Such are all great historical men . . . they may be called Heroes, inasmuch as they have derived their purposes and their vocation, not from the calm, regular course of things, sanctioned by the existing order, but from a concealed fount—one which has not attained to phenomenal, present existence—from that inner Spirit, still hidden beneath the surface, which, impinging on the outer world as on a shell, bursts it in pieces. . . . Such individuals had no consciousness of the general Idea they were unfolding . . . but at the same time they were thinking men, who had an insight into the requirements of the time—what was ripe for development.

Hegel's primary emphasis here is the same as that of the Romantic writers and philosophers—history is driven by the spiritual rather than the material—but unlike the Romantics, he believed that world history revealed a rational process. "Reason is the Sovereign of the World," declared Hegel, and it was only through men such as Alexander, Charlemagne, or Napoleon that the world-spirit could manifest itself in an orderly process. The "Great Man" theory has many shortcomings, the most obvious being that women have no political or historical role. Neither do the common people and workers, a deficiency that one of Hegel's astute students, Karl Marx, would address several decades later when he revised Hegel's "dialectic" by contending that the struggle between social classes moves history forward (see chapter 36).

The Promethean Hero in England

The "Great Man" approach to history is part of the more general Romantic fascination with the powers of individual intuition and creativity. The literary manifestation of this fascination found its most compelling expression in the ancient Greek myth of Prometheus [pro-MEE-thee-us]. A member of the race of deities known as Titans [TY-tunz], Prometheus stole fire, the source of wisdom and creativity, from the sun and gave it to humankind, to whom Zeus [zoos], ruler of the Gods, had denied it. For this crime Zeus chained him to a rock, where an eagle fed daily on his liver, which was restored each night. The English Romantic poets embraced Prometheus. He was, for them, the all-suffering but ever noble champion of human freedom. The vulnerability and continued suffering of Prometheus, along with his bold and reckless ambition to achieve his goals by breaking the laws imposed by supreme authority, endeared him to generations of Romantically inclined artists.

The Promethean Idea in England: Lord Byron and the Shelleys For poet George Gordon, Lord Byron (1788–1824), Prometheus was the embodiment of his own emphatic spirit of individualism. Byron was a prodigious traveler to foreign countries, a sexual experimenter, and a champion of oppressed nations. In his 1816 ode "Prometheus," Byron rehearses the myth as described in Aeschylus' play *Prometheus Bound*, and then addresses his mythical hero (**Reading 34.2**):

READING 34.2 **from George Gordon, Lord Byron, "Prometheus" (1816)**

Thou art a symbol and a sign
To Mortals of their fate and force;
Like thee, Man is in part divine,
A troubled stream from a pure source;
And Man in portions can foresee

His own funereal destiny;
His wretchedness, and his resistance,
And his sad unallied existence:
To which his Spirit may oppose
Itself—an equal to all woes,

And a firm will, and a deep sense,
Which even in torture can descry
Its own concentred recompense,
Triumphant where it dares defy,
And making Death a Victory.

Byron balances the poem's sense of almost hopeless resignation by his defiant insistence on the power of the human spirit to overcome any and all troubles it encounters—even death.

Prometheus's daring to oppose the Olympian gods was, for Byron, the same daring that he saw in Napoleon. In

Childe Harold's Pilgrimage, the long narrative poem that established his reputation, Byron addressed Napoleon directly (**Reading 34.3a**):

READING 34.3a　　**from George Gordon, Lord Byron, *Childe Harold's Pilgrimage*, Canto III, stanzas 37, 42 (1812)**

Conqueror and captive of the earth art thou!
She trembles at thee still. . . .
　　　there is a fire
And motion of the soul which will not dwell
In its own narrow being, but aspire
Beyond the fitting medium of desire;
And, but once kindled, quenchless evermore,
Preys upon high adventure . . .

Childe Harold's Pilgrimage is written what in what is known as the *Spenserian stanza*, a nine-line stanza with the rhyme scheme *ababbcbcc* (see below). The meter of the stanza's first eight lines is iambic pentameter, and the ninth is iambic hexameter (known as an Alexandrine meter). This stanza was common to poetic travel literature at the time and is perfectly suited to a poem about a "Childe" (a medieval word for a young noble awaiting knighthood) setting out on a pilgrimage or journey of discovery. Harold is an outsider with a complex personality, loving Nature, hating crowds, never contented but forever seeking new experiences. He is the archetypal Romantic hero (**Reading 34.3b**):

READING 34.3b　　**from George Gordon, Lord Byron, *Childe Harold's Pilgrimage*, Canto II (1812)**

25　To sit on rocks, to muse o'er flood and fell,
　　To slowly trace the forest's shady scene,
　　Where things that own not man's dominion dwell,
　　And mortal foot hath ne'er, or rarely been;
　　To climb the trackless mountain all unseen,
　　With the wild flock that never needs a fold;
　　Alone o'er steeps and foaming falls to lean;
　　This is not solitude; 'tis but to hold
　　Converse with Nature's charms, and view her stores unroll'd.

26　But midst the crowd, the hum, the shock of men,
　　To hear, to see, to feel, and to possess,
　　And roam along, the world's tir'd denizen,
　　With none who bless us, none whom we can bless;
　　Minions of splendour shrinking from distress!
　　None that, with kindred consciousness endued,
　　If we were not, would seem to smile the less
　　Of all that flatter'd, follow'd, sought and sued;
　　This is to be alone; this, this is solitude!

Childe Harold's Pilgrimage essentially recounts Byron's own Grand Tour, his own restless travels through Spain, Portugal, Greece, Turkey, and Albania, where he purchased the costume in which he posed for Thomas Phillips (Fig. **34.3**). Barely distinguishable from his chief character, Byron in succeeding years would add new cantos to the poem, relating his travels through Belgium, Switzerland, the Alps, and Italy.

In Italy, Byron met up with the English poet Percy Bysshe Shelley (1792–1822) and his wife Mary Godwin Shelley (1797–1851), daughter of the philosopher and writer William Godwin and author Mary Wollstonecraft (see chapter 32). Shelley was also working on a Prometheus project, a four-act play entitled *Prometheus Unbound*. It concerns Prometheus's final release from captivity, and in it Shelley departs from tradition in choosing to have that release follow the overthrow of Zeus rather than precede a reconciliation between the hero and his tyrannical oppressor. A revolutionary text that champions free will, goodness, and idealism in the face of oppression, *Prometheus Unbound* is Shelley's answer to the mistakes of the French Revolution and its cycle of replacing one tyrant with another. Shelley declares his beliefs as a poet and revolutionary in the epilogue (**Reading 34.4**):

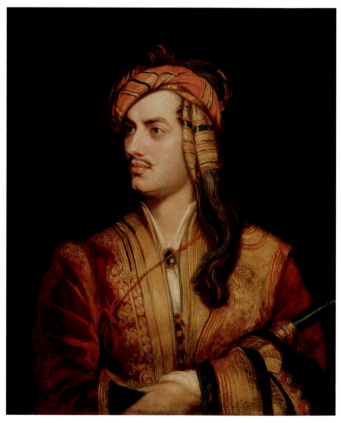

Fig. 34.3 Thomas Phillips. *Lord Byron Sixth Baron in Albanian Costume.* 1835. Oil on canvas, 29$\frac{1}{2}$" × 24$\frac{1}{2}$". National Portrait Gallery, London, UK. The Bridgeman Art Library. This is Phillips's own copy of the original 1813 painting, which hangs in the British Embassy in Athens. Bryon's dashing good looks and his exotic costume, the Albanian shawl wrapped round his head like a turban, underscore the poet's Romantic individualism.

READING 34.4 **from Percy Bysshe Shelley,**
***Prometheus Unbound* (1820)**

To suffer woes which Hope thinks infinite;
To forgive wrongs darker than death or night;
To defy Power, which seems omnipotent;
To love, and bear; to hope till Hope creates
From its own wreck the thing it contemplates;
Neither to change, nor falter, nor repent;
This, like thy glory, Titan, is to be
Good, great and joyous, beautiful and free;
This is alone Life, Joy, Empire, and Victory.

Shelley also shared with Byron a deep belief in the immortality of art. In his 1819 "Ode to the West Wind" a five-stanza lyric poem in which the Wind is the vehicle for spreading the word of reform and change, Shelley addressed the Wind as the enduring power of human expression (**Reading 34.5a**):

READING 34.5a **from Percy Bysshe Shelley,**
"Ode to the West Wind" (1819)

Be thou, spirit fierce,
My spirit! Be thou me, impetuous one!

Drive my dead thoughts over the universe
Like withered leaves to quicken a new birth!
And, by the incantation of this verse,

Scatter, as from an unextinguished hearth
Ashes and sparks, my words among mankind!

For Shelley, poets were, as he wrote in *A Defense of Poetry*, "the unacknowledged legislators of the world" who sought to change the world with their writing. In the lines above, he exhorts the Wind to give life to his message of reform and revolution by spreading his words over the world.

Mary Shelley was as galvanized by the Prometheus myth as her husband and Byron, but her attitude toward it was more ambivalent. When Byron arrived in Italy, she had already begun her novel *Frankenstein; or the Modern Prometheus*. The novel is narrated by an English explorer in the Arctic, whose ice-bound ship takes on a man in terrible condition named Victor Frankenstein, and reports the passenger's story. Dr. Frankenstein had learned the secret of endowing inanimate material with life.

Dr. Frankenstein subsequently created a monster of giant proportion and supernatural strength from assembled body parts taken from graveyards, slaughterhouses, and dissecting rooms. But as soon as the creature opened his eyes, the scientist realized that he had not so much created a miracle as a horror, a creature doomed to a miserable existence of exile from normal society. Dr. Frankenstein flees his laboratory

(Fig. **34.4**), leaving the creature to fend for himself (see **Reading 34.5**, page 1108 for this episode). What follows is the story of the monster's revenge—a series of murders that adversely affect Frankenstein and his family. So, like Prometheus, Dr. Frankenstein is punished for the acquisition of powerful knowledge. Promethean ambition and power, Mary Shelley tells us, can step beyond the bounds of reason and the human capacity to manage the consequences—as Napoleon had demonstrated.

In July 1823, Byron sailed to Greece to aid the Greeks in their War of Independence from the Ottoman Turks. Greece was for Byron a Promethean country, longing to be "unbound." Now he would come to its aid himself. But he never did face any action. Instead, he died in 1824 of fever and excessive bleeding, the result of his doctor's mistaken belief that bleeding would cure him. He was buried in his family vault in England, except for his heart and lungs, which were interred at Missolonghi, where he had perished. Keats had died of tuberculosis in 1821, Shelley had drowned in a boating accident in 1822. Of all the great English Romantic poets, only Wordsworth and Coleridge were still alive by the mid-1820s.

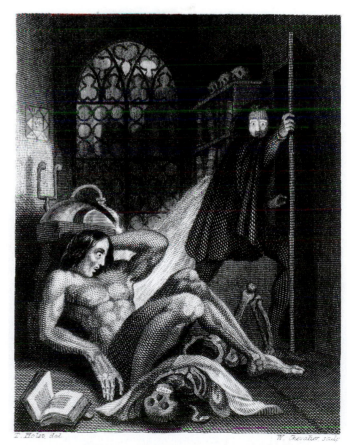

Fig. 34.4 Theodor M. von Holst. Illustration from *Frankenstein* by Mary Shelley. 1831. Engraving. Private Collection. The Bridgeman Art Library.

The Romantic Hero in Germany: Johann Wolfgang von Goethe's *Werther* and *Faust*

One of the great ironies in the development of Romanticism is that two of its greatest heroes, Werther [VER-tur] and Faust (rhymes with "oust"), were the creation of an imagination that defined itself as classical. The creator of these two heroes, Johann Wolfgang von Goethe [GUH-tuh] (1749–1832), had strong classical tastes and is often categorized as a "classical" author. He had moved to Weimar [VY-mar], one of the great cultural centers of Europe, in 1775, and later filled his house there with Greek and Roman statuary. His most famous portrait, painted by J. H. W. Tischbein [TISH-bine] in 1787, presents him in a pilgrim's garb before an array of Roman ruins (Fig. **34.5**), and, indeed, he found Romanticism abhorrent. In a famous letter of 1829, Goethe wrote a friend, "The classical I call healthy, the Romantic sick . . . [the Romantic] is weak, sickly, ill, and the [classical] is strong, fresh, cheerful . . ."

Goethe himself occasionally descended into what he called these "other darker places." As he admitted, the German poet Friedrich Schiller (1759–1805) had "demonstrated to me that I myself, against my will, was a Romantic." This ill-defined border between Goethe's "classical" and "Romantic" approaches to literature reminds us that labeling artistic and literary styles is helpful in gaining some basic understanding of their context, but does not produce ironclad, fixed categories.

Goethe's Romantic Novel: *The Sorrows of Young Werther* Early in his career, Goethe had written what was, for the age, the quintessential Romantic novel, *The Sorrows of Young*

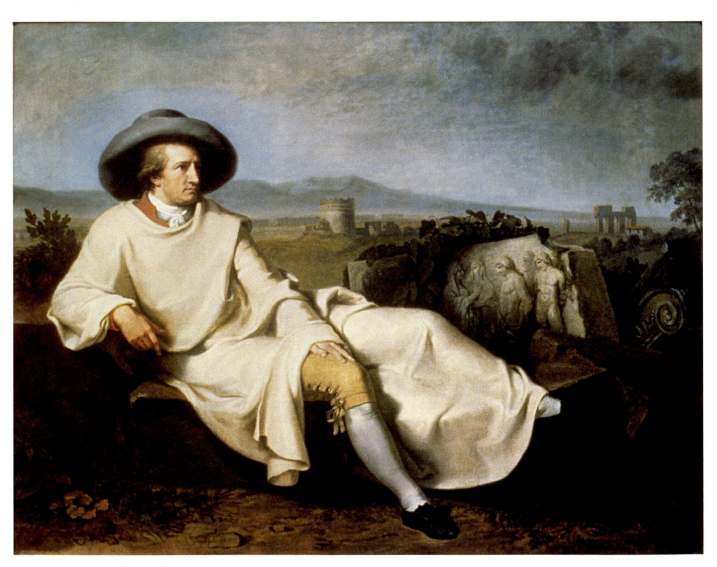

Fig. 34.5 J. H. W. Tischbein, *Johann Wolfgang von Goethe in the Roman Campana*. 1787. Oil on canvas, 64 1/2″ × 81″. Location: Staedelsches Kunstinstitut, Frankfurt am Main, Germany. Kavaler/Art Resource, NY. Tischbein painted this portrait during Goethe's first visit to Rome, which lasted from September 1786 until June 1788, during which time the two shared an apartment.

Werther. It told the story of a young man who feels increasingly disillusioned with life, even as he finds himself hopelessly in love with a happily married woman. This much was semiautobiographical—Goethe had fallen in love with his law partner's fiancée. But where Goethe's Werther ends his life by committing suicide, Goethe simply left town and turned his experiences into a best-selling novel, establishing a precedent for alienated, ambitious young artists for the next two centuries.

Werther is happiest when by himself, in nature: "I am so happy, my friend," he writes in one of the first letters in the book, ". . . when the lovely valley surrounds me in mist, and the sun at noon lingers on the surface of the impenetrable darkness of my woods, and only a few rays steal into the inner sanctum. . . . [then] the entire heavens come to rest in my soul, like the form of a beloved." But when he actually falls in love, he finds nothing but torment (**Reading 34.6**):

READING 34.6 **from Johann Wolfgang von Goethe, *The Sorrows of Young Werther* (1774)**

When I have spent several hours in her company, till I feel completely absorbed by her figure, her grace, the divine expression of her thoughts, my mind becomes gradually excited to the highest excess, my sight grows dim, my hearing confused, my breathing oppressed as if by the hand of a murderer, and my beating heart seeks to obtain relief for my aching senses.

Such sentiments were a revelation for readers at the time. Even Napoleon later admitted to Goethe that he had enthusiastically read *Young Werther* several times. Across Europe, young men began to wear the blue jacket and yellow trousers that Goethe describes as Werther's habitual dress, and some of these, disappointed like their hero, committed suicide, copies of the book in their pockets. It is, no doubt, these young men to whom Goethe refers when he says that the Romantic is "sick."

Goethe well understood that the Romantic aspirations of his fictional hero Werther represented the same feelings described by his friend, the poet Georg Friedrich Philipp von Hardenberg (1772–1801), who wrote under the pen-name Novalis [noh-VAH-lis]. Novalis defined the process of creating art from the Romantic perspective: "Insofar as I give the common an elevated meaning, the usual a secret perspective, the known the value of the unknown, the finite an infinite appearance—I thus romanticize." Goethe expanded on this theme, arguing that "Great works of art are comparable to the great works of nature; they have been created by men according to true and natural laws. Everything arbitrary,

imaginary collapses. Here is necessity, here is God." While great art is transcendent, Goethe suggests, it is ultimately, subject to God's grand design and the natural laws that govern the universe, a point of view similar to that of the Enlightenment *philosophes*.

Goethe's *Faust* and the Desire for Infinite Knowledge
Goethe conceived his greatest character and hero, Faust, in the 1770s, but did not start writing the work until 1800, and completed it just before his death in 1832. It is a 12,000-line verse play based on a sixteenth-century German legend about an actual traveling physician named Johann or Georg Faust, who was reputed to have sold his soul to the devil in return for infinite knowledge. To Goethe, he seemed an ideal figure for the Romantic hero—driven to master the world, with dire consequences.

Faust is a man of great learning and breadth of knowledge—like Goethe himself—but bored with his station in life and longing for some greater experience. He wants the kind of knowledge that does not always come from books (Reading 34.7a):

READING 34.7a **from Johann Wolfgang von Goethe, *Faust*, Part I (1808)**

FAUST Here stand I, ach, Philosophy
Behind me and Law and Medicine too
And, to my cost, Philosophy—
All these I have sweated through and through
And now you see me a poor fool
As wise as when I entered school!
They call me Master, they call me Doctor,
Ten years now I have dragged my college
Along by the nose through zig and zag
Through up and down and round and round
And this is all that I have found—
The impossibility of knowledge!
. . .
Besides, I have neither goods nor gold,
Neither reputation nor rank in the world;
No dog would choose to continue so! . . .
Oh! Am I still stuck in this jail?
This God-damned dreary hole in the wall
Where even the lovely light of heaven
Breaks wanly through the painted panes!

In essence, Faust is profoundly bored, suffering from one of the great afflictions of the Romantic hero, ***ennui*** [ahn-wee], a French term that denotes both listlessness and a profound melancholy. He longs for something that will challenge the limits of his enormous intellect. That challenge appears, not long after, in the form of Mephistopheles [mef-ih-STOFF-uh-leez]—the devil—who arrives in Faust's study dressed as a

Fig. 34.6 Eugène Delacroix. *Mephistopheles Appearing to Faust in His Study.* Illustration for Goethe's *Faust.* 1828. Lithograph, $10\frac{3}{4}'' \times 9''$. Private Collection. The Stapleton Collection. The Bridgeman Art Library. Delacroix's illustrations were Goethe's favorite representations of his work.

dandy, a (Fig. 34.6) nineteenth-century man of elegant taste and appearance:

READING 34.7b from Johann Wolfgang von Goethe, *Faust,* Part I (1808)

MEPHISTOPHELES . . .We two, I hope, we shall be good friends . . .
I am here like a fine young squire today,
In a suit of scarlet trimmed with gold
And a little cape of stiff brocade,
With a cock's feather in my hat
And at my side a long sharp blade,
And the most succinct advice I can give
Is that you dress up just like me,
So that uninhibited and free
You may find out what it means to live.

Mephistopheles makes a pact with Faust: He promises Faust "ravishing samples of my arts" which will satisfy his greatest yearnings, but in return, if Faust agrees that he is satisfied, Mephistopheles will win Faust's soul. As Faust leaves to prepare to accompany Mephistopheles, the fiend contemplates the doctor's future:

MEPHISTOPHELES . . . We just say go—and skip.
But please get ready for this pleasure trip.
[Exit Faust]
　　Only look down on knowledge and reason,
The highest gifts that men can prize,
Only allow the spirit of lies
To confirm you in magic and illusion,
And then I have you body and soul.
Fate has given this man a spirit
Which is always pressing onwards, beyond control,
And whose mad striving overleaps
All joys of the earth between pole and pole.
Him I shall drag through the wilds of life
And through the flats of meaninglessness,
I shall make him flounder and gape and stick
And to tease his insatiableness
Hang meat and drink in the air before his watering lips;
In vain he will pray to slake his inner thirst,
And even had he not sold himself to the devil
He would be equally accursed.

Mephistopheles recognizes Faust as the ultimate Promethean hero, a man "always pressing onwards, beyond control," whose insatiable ambition will inevitably lead him to "overleap" his limitations. After a tumultuous love affair with a young woman named Gretchen—"Feeling is all!" he proclaims—he abandons her, which causes her to lose her mind and murder their illegitimate child. For this she is condemned to death, but the purity of her love wins her salvation in the afterlife.

In Book Two, Faust follows Mephistopheles into the "other dark worlds" of the Romantic imagination, a nightmare world filled with witches, sirens, monsters, and heroes from the distant past, including Helen of Troy, with whom he has a love affair. But, in Goethe's ultimately redemptive story, Faust is unsatisfied with this unending variety of experiences. What begins to quench his thirst, ironically, is good works, namely putting knowledge to work in a vast land-reclamation project designed to provide good land for millions of people. (This reminds us of Prometheus's desire to benefit humanity through the gift of fire.) Before achieving his dream, Faust dies, but without ever having actually declared his satisfaction. So, despite Mephistopheles's attempt to grab Faust's soul as it leaves his body, a band of angels carry Faust to heaven with the divine Gretchen at their head. She is what Goethe calls the "Eternal Womanhead"—both nature itself and the redeeming power of love—and so the poem ends as follows (**Reading 34.7c**):

READING 34.7c from Johann Wolfgang von Goethe, *Faust,* Part II (1832)

All that is past of us
Was but reflected;
All that was lost in us
Here is corrected;
All indescribables

Here we descry;
Eternal Womanhead
Leads us on high.

In the end, Goethe's *Faust* is an extremely ambiguous figure, a man of enormous ambition and hence enormous possibility, and yet, like Frankenstein, his will to power is self-destructive. We see these ambiguities in the poem's high seriousness countered by ribald comedy, and in Faust's great goodness countered by deep moral depravity.

Beethoven and the Rise of Romantic Music

Fascination with the Promethean hero was not limited to literature. It was reflected in music, and especially that of Ludwig van Beethoven (1770–1827), the key figure in the transition from the Classical to the Romantic era. His Third Symphony, which came to be known as the *Eroica* [eh-ROH-ee-kah]—Italian for the "Heroic"—was originally dedicated to Napoleon because of the composer's admiration for the French leader as a champion of freedom. But when, on December 2, 1804, Napoleon had himself crowned as emperor, Beethoven changed his mind, saying to a friend: "Is he then, too, nothing more than an ordinary human being? Now he, too, will trample on all the rights of man and indulge only his ambition. He will exalt himself above all others, become a tyrant!" Thus, on the title page of the symphony he crossed out the words "*Intitulata* [in-tee-too-LAH-tah] *Bonaparte*," "Entitled Bonaparte."

Beethoven remained ambivalent about the emperor. Even as Napoleon occupied Vienna in 1809 in his second taking of the city (the first had been in 1805 without a battle when the citizens greeted him with interest), Beethoven had chosen to conduct the *Eroica* at a charity concert for the theatrical poor fund, probably in hopes of attracting the emperor to the performance. (Napoleon, it turns out, had left town the day before.) And as late as October 1810, he wrote a note to himself: "The Mass [in C, op. 86] could perhaps be dedicated to Napoleon." Bonaparte thus embodied the type of contradiction that always fueled Beethoven's imagination. The composer viewed the emperor as at once the enlightened leader and tyrannical despot, as did most of Europe.

Early Years in Vienna: From Classicism to Romanticism

Beethoven's music is a direct reflection of his life's journey, his joys and sorrows, and, in turn, an indication of the shift from the formal structural emphases of Classical music to the expression of more personal, emotional feelings in Romantic music. Other, earlier composers had expressed emotion in their works, but not in the personal, autobiographical way that Beethoven did. Arriving in Vienna from Bonn, Germany, in November 1792, just a month before his twenty-second birthday, Beethoven gained wide acclaim for his skills as a pianist.

The city of Mozart and Haydn was deeply aware of its musical preeminence. In fact, Haydn would serve as the young Beethoven's teacher during his first 14 months in the city. Although their relationship was stormy, Haydn's emphasis on formal inventiveness within the framework of Classical clarity guided Beethoven's development as an artist in his first decade in Vienna.

In Vienna, Beethoven began every day at his desk, working until midday. After his noontime dinner, he took a long walk around the city, often spending the entire afternoon in the streets until, in the early evening, he made his way to a favorite tavern like the White Swan Inn (Fig. **34.7**). Located across the

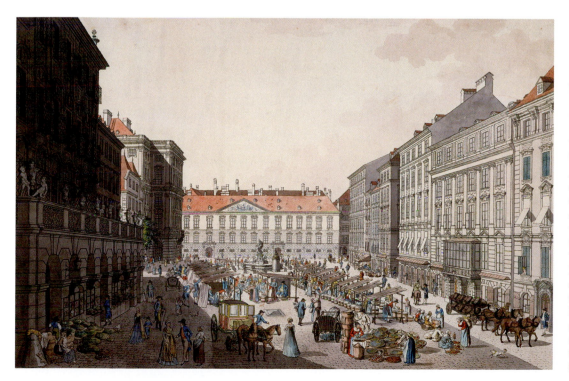

Fig. 34.7 Neuer Markt ("New Market"), Vienna. Colored engraving by Carl Schütz. ca. 1785. Location: Wien Museum Karlsplatz, Vienna, Austria. Erich Lessing, Art Resource, NY. The building at the far end is the Schwarzenberg Palace, where, among other works, Beethoven would premier his String Quintet in C, op. 29, in 1801. To the left of it is the Mehlgrube, literally "flour store," so-called because it had served that function in the Middle Ages. Here, Beethoven premiered his Symphony No. 1, on April 2, 1800. Beethoven's favorite tavern, the White Swan Inn, is at the right.

city square from the inn was Mehlgrube [MEHL-groo-beh] Hall, where, on April 2, 1800, Beethoven premiered his First Symphony. Mozart had performed a series of six concerts in the Mehlgrube in 1785. Yet in Beethoven's First and Second Symphonies, completed in 1802, there is a sense that he consciously intended to recapitulate and summarize the Classical tradition, preparing to move on to more exciting breakthroughs. A personal crisis, brought on by his increasing deafness, instigated an extraordinary period of creativity for Beethoven over the next decade, in which he produced six symphonies, four concertos, and five string quartets, leaving the Classical tradition behind.

The Heroic Decade: 1802–1812

In April 1802, Beethoven left Vienna for the small village of Heiligenstadt [HY-lig-en-shtaht], just north of the city. Though his hearing had been deteriorating for some time, what had started as humming and buzzing was becoming much worse. Moody and temperamental by nature, his deafness deeply depressed him. His frustrations reached a peak in early October as he contemplated ending his life. His feelings are revealed in a remarkable document found among his papers after his death, a letter to his brothers today known as the *Heiligenstadt Testament* (**Reading 34.8**):

READING 34.8 **from Ludwig van Beethoven, *Heiligenstadt Testament* (1802)**

From childhood on, my heart and soul have been full of the tender feeling of goodwill, and I was ever inclined to accomplish great things. But, think that for six years now I have been hopelessly afflicted, made worse by senseless physicians, from year to year deceived with hopes of improvement, finally compelled to face the prospect of a lasting malady . . . Though born with a fiery, active temperament, even susceptible to the diversions of society, I was soon compelled to withdraw myself, to live life alone . . . It was impossible for me to say to people, "Speak louder, shout, for I am deaf." Ah, how could I possibly admit an infirmity in the one sense which ought to be more perfect in me than in others. . . . I must live almost alone, like one who has been banished . . . If I approach near to people a hot terror seizes upon me, and I fear being exposed to the danger that my condition might be noticed. . . . What a humiliation for me when someone standing next to me heard a flute in the distance and I heard nothing, or someone heard a shepherd singing and again I heard nothing. Such incidents drove me almost to despair; a little more of that and I would have ended my life—it was only my art that held me back . . .

Beethoven soon reconciled himself to his situation, recognizing that his isolation was, perhaps, the necessary condition to his creativity. His sense of self-sufficiency, of an imagination turned inward, guided by an almost pure state of subjective feeling, lies at the very heart of Romanticism. Beethoven's post-Heiligenstadt works, often called "heroic" because they so thoroughly evoke feelings of struggle and triumph, mark the first expression of a genuinely Romantic musical style. When composer and author E. T. A. Hoffmann said, in 1810, that Beethoven's music evokes "the machinery of awe, of fear, of terror, of pain"—he meant that it evokes the *sublime* (see chapter 33). To this end, it is much more emotionally expressive than its Classical predecessors. In Beethoven's ground-breaking compositions, this expression of emotion manifests itself in three distinct ways: long, sustained *crescendos* that drive the music inexorably forward; sudden and surprising key changes that always make harmonic sense; and both loud and soft repetitions of the same theme that are equally, if differently, poignant.

The *Eroica* Beethoven's Third Symphony, the *Eroica*, is the first major expression of this new style in his work. Much longer than any previous symphony, the 691 measures of the first movement alone take approximately 19 minutes to play compared to 8 minutes for the first movement of Mozart's Symphony No. 40 in G minor (see **CD-Track 29.2**). In fact, the first movement is almost as long as an entire Mozart symphony! Dramatically introducing the main theme and recapitulating it after elongated melodies, this movement ends in a monumental climax, establishing the Romantic, Promethean mood of the piece. The second movement (see **CD-Track 34.1**), with its strong, repetitive beat of double basses imitating military drums, signals the start of the main theme, a solemn funeral march. At the end of the movement, the clockwork sound of the violins suggests the passing of time, while the return of the solemn theme in fragmented form suggests to many listeners the sighing of a dying man. This movement expresses despair with a few hints of consolation. For the third movement, Beethoven relaxed the tension and substituted a **scherzo** [SKER-tso]—an Italian term meaning "joke," denoting a type of musical composition, especially one that is fast and vibrant and presents a surprise—for the courtly measures of the traditional minuet, which had faded in popularity. The finale brings together the themes and variations of the first movement in a broad, triumphant conclusion featuring a majestic horn. Ultimately, this symphony dramatizes Beethoven's own descent into despair at Heiligenstadt (figured in the second movement), his inward struggle, and his ultimate triumph through art.

The Fifth Symphony Beethoven's Fifth Symphony, like the *Eroica*, brings musical form to the triumph of art over death, terror, fear, and pain. Premiering on December 22, 1808, the symphony's opening four-note motif, with its short-short-short-long rhythm, is in fact the basis for the entire symphony (for the first movement, see **CD-Track 34.2**):

Throughout the symphony's four movements, this rhythmic unit is used again and again, but never in a simple repetition. Rather, the rhythm seems to grow from its minimal opening phrasings into an expansive and monumental theme by the symphony's end.

A number of startling innovations emerge as a counterpoint to this theme: an interruption of the opening motif by a sudden oboe solo; the addition of piccolo and double bassoons to the woodwind sections and of trombones in the finale; the lack of a pause between the last two movements; the surprising repetition of the scherzo's theme in the finale; and the ending of the piece in a different key than it began—a majestic C major rather than the original C minor. In fact, the Fifth Symphony ends with one of the longest, most thrilling conclusions Beethoven ever wrote. Over and over again it seems as if the symphony is about to end, but instead it only gets faster and faster, until it finally comes to a rest on the single note C, played *fortissimo* [for-TISS-eh-moh] by the entire orchestra.

The Late Period: The Romantic in Music

Although initially Beethoven's musical innovations startled his public, by the end of the Heroic decade Beethoven was the most famous composer of instrumental music in Europe. His prominence in the Viennese musical scene always attracted an audience to see him perform or conduct (see *Voices*, page 1094). In 1815, during the Congress of Vienna when his *Wellingtons Sieg* was so popular and as he seemed to be rebounding from a hopeless romantic affair with a friend's wife, his brother Casper Carl died of tuberculosis, leaving a widow, Johanna [yoh-HAHN-uh], and a nine-year-old son, Karl, under Beethoven's protection. For five years, Johanna and Beethoven contested in court the guardianship of young Karl, which Beethoven finally won in 1820. During this time the composer was at first unproductive, but beginning in 1818, even as the court battle raged, he composed 23 of the Diabelli [dee-ah-BEH-lee] Variations for piano, brought the *Missa Solemnis* [MIS-sah soh-LEM-nis] a long way toward completion (Fig. **34.8**), and began sketching what would be his final great symphony, the Ninth. Once again, out of the chaos of his personal life, Beethoven gained new energy and artistic vision.

One of the most remarkable of Beethoven's last works is the Piano Sonata No. 30 in E Major, op. 109, which he completed in 1820 (see **CD-Track 34.3**). Beethoven's 32 piano sonatas are almost uniformly original, and many of them have acquired nicknames: the *Moonlight* Sonata, so named by a critic who was reminded of moonlight on a lake; *Les Adieux* ("The Farewell"), so named by Beethoven himself to commemorate the exile and return of his pupil and patron the Archduke Rudoph; and the *Appassionata*, which derives its name from the passionate tone of the first and last movements. The Piano Sonata No. 30 in E Major, one of three he composed in his late period, lacks a nickname but, like the other sonatas, is completely original and untraditional in

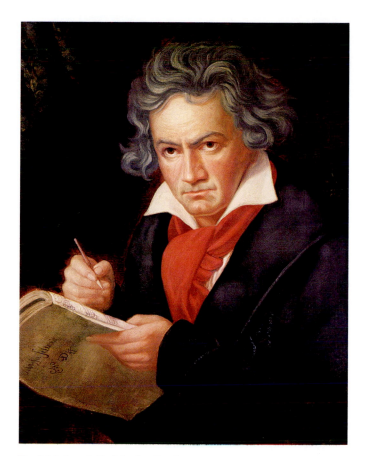

Fig. 34.8 Joseph Carl Stieler. *Beethoven*. 1820. Oil on canvas, 24 3/8″ × 19 3/8″. Beethoven Haus, Bonn, Germany. The Bridgeman Art Library. This portrait shows Beethoven writing the *Missa Solemnis* and was commissioned by Antonie Brentano, who kept a miniature copy of it on ivory.

form. In this sonata Beethoven alters the standard number and order of movements. In contrast to the traditional four-movement fast-slow-minuet-fast sonata form, he presents only three movements: *Vivace* ("Lively"), *Prestissimo* ("Very Fast"), and *Andante molto cantabile ed espressivo* ("Quite slow, lyrical, and expressive"). In addition to its Italian tempo marking, the last movement has a direction in German: *Gesangvoll mit innigster Empfindung* ("Songlike with the innermost feeling"). The animated but quiet first movement is interrupted by a slow passage that culminates in an explosive and passionate outburst. The short second movement creates a sense of powerful and dramatic tension. But the long third movement—at nearly 15 minutes nearly twice as long as the other two movements combined—is completely unanticipated. In the form of a theme and variations, it moves between extreme simplicity and profound, almost dreamlike feeling, culminating in a sense of peace and harmony.

The Ninth Symphony returns to the heroic style of the first decade of the nineteenth century. Simply put, it is a statement of faith in humanity, an utopian vision. The great innovation of the symphony is that in its finale it turns to song, introducing a vocal chorus into the symphonic form

Voices

An Englishman in Vienna Attends a Beethoven Premier

During a brief residence in Vienna early in the nineteenth century, the young English physician Henry Reeve had the good fortune of witnessing Beethoven conduct the second performance of Fidelio, *Beethoven's only opera. Circumstances were tense: Napoleon, in his war with Austria and Russia in late 1805, had just occupied the city, and French military officers claimed a substantial number of seats in the theater.* Fidelio, *with its themes of heroism and the quest for political liberty, was highly relevant to the situation. Reeve recorded his observations of that evening in his journal:*

> **"Beethoven presided at the pianoforte and directed the performance himself."**

Thursday, November 21—Went to the Wieden Theater to see the new opera "Fidelio" the music composed by Beethoven. The story and the plan of the piece are a miserable mixture of low manners and romantic situations; the airs, duets, and choruses equal to any praise. The several overtures, for there is an overture for each act, appeared to be too artificially composed to be generally pleasing, especially on being first heard. Intricacy is the characteristic of Beethoven's music and it requires a well-practised ear or a frequent repetition of the same piece to understand and distinguish its beauties. This was the first opera he ever composed and it was much applauded; a copy of the complimentary verses was showered down from the upper gallery at the end of the piece. Beethoven presided at the pianoforte and directed the performance himself. He is a small dark, young-looking man, wears spectacles and is like Mr. Koenig. Few people present, though the house would have been crowded in every part but for the present state of public affairs [the French military occupation].

(see **CD-Track 34.4**). For this reason the work is also known as the *Choral Symphony*. For the text, Beethoven used Friedrich Schiller's 1785 poem "An die Freude" [ahn dee FROY-duh] ("To Joy"), known to English-speaking audiences as the "Ode to Joy," a celebration of the joy of universal brotherhood:

Freude, schöner	Joy, beauteous spark
Götterfunken . . .	of divinity . . .
Alle Menschen werden Brüder	All men become brothers
Wo dein sanfter Flügel weilt.	Where your gentle
	wing abides.

Ninety voices performed the piece at its May 7, 1824, premiere. This, Beethoven's final expansive gesture, was designed to explore the full, expressive, and Romantic possibilities of the symphonic form.

Romantic Music after Beethoven

Beethoven's musical explorations of individual feelings were immensely influential on the Romantic composers who succeeded him. They strove to find new ways to express their own emotions. Some focused on the symphony as the vehicle for their most important statements. Others found a rich vehicle in piano music and song.

Hector Berlioz and Program Music French composer Hector Berlioz [BER-lee-ohz] (1803–1869) was the most star-tlingly original of Beethoven's successors, both musically and personally. His compositions were frankly autobiographical; Berlioz attracted attention with new approaches to symphonic music and instrumentation. He wrote three symphonies: the *Symphonie fantastique* [SAM-foh-nee FAHN-tahss-teek] (1830); *Harold en Italie* [AH-rold ahn EE-tah-lee] (1834), based on Byron's *Childe Harold*; and *Roméo et Juliette* [ROH-may-oh ay joo-lee-ET] (1839). All are notable for their inventiveness and novelty, and especially for the size of the orchestras Berlioz enlisted to play them. The enormity of the sound could be deafening. The symphonies are also instances of program music, which suggests a sequence of images or incidents and may be prefaced with a text identifying these themes (see chapter 25). As large as the orchestras were and as intricate as their narrative structure was, Berlioz was able to unify his symphonies by introducing recurring themes that provided continuity through the various movements.

The *Symphonie fantastique*, subtitled "Episode in the Life of an Artist," was inspired by the composer's passionate love affair with Irish Shakespearean actress Harriet Smithson. In the notes for the first movement, entitled "Reveries, Passions," Berlioz joyously describes the infatuation of young lovers (see **CD-Track 34.5**). Berlioz insisted on the importance of his written program notes. He believed it essential that the audience read the text in advance of the performance "in order," he wrote, "to provide an overview of the dramatic structure of this work." Here is his description of the first movement's dramatic structure:

The author imagines that a young musician . . . sees for the first time a woman who embodies all the charms of the ideal being of his dreams, and he falls hopelessly in love with her. By bizarre peculiarity, the image of the beloved always presents itself to the soul of the artist with a musical idea that incorporates a certain character he bestows to her, passionate but at the same time noble and shy.

This melodic image pursues the young musician ceaselessly as a double *idée fixe* [EE-day feex] ("fixed idea"), the term Berlioz gave to the leading theme or melody in his work. This is the reason for the persistent appearance, in every movement of the symphony, of the melody that begins the opening Allegro. The transition from this state of melancholic reverie (interrupted by a few spasms of unfounded joy) to one of delirious passion (with its animations of fury, jealousy, its return to tenderness, and tears) is the theme of the first movement.

As Berlioz's *idée fixe* changes appearance through the course of the symphony, it mirrors the progress of the composition. In the second movement, "A Ball," the composer sees his beloved dancing a concert waltz. The third movement, "Scene in the Country," mixes hope and fear, as the artist seeks the solace of nature. In the fourth movement, "March to the Scaffold," the artist hallucinates on opium, dreaming that he kills his beloved and is witness to his own execution. Finally, in the symphony's last movement, "Dream of a Witches' Sabbath," his beloved appears on her broomstick, accompanied by a virtual pandemonium of sound and a symphonic shriek of horror, echoing Faust's adventures with Mephistopheles (Fig. **34.9**). The emphasis on overwhelming emotion, passion, and otherworldly scenes

Fig. 34.9 Andrew Geiger. A Concert of Hector Berlioz in 1846. 1846.
Engraving. Musée de l'Opera, Paris, France. The Bridgeman Art Library. Berlioz was famous for his extraordinary hairstyle, which was as audacious as the loudness of his orchestras.

marks Berlioz as a key figure in the Romantic movement of the nineteenth century.

Felix Mendelssohn and the "Meaning" of Music Program music was an important part of the work of another Romantic composer after Beethoven. As a young man, Felix Mendelssohn [MEN-dul-zohn] (1809–1847) was befriended by Goethe, and their great friendship convinced the composer, who was recognized as a prodigy, to travel widely across Europe from 1829 to 1831. These travels inspired many of his orchestral compositions. These include the *Italian* Symphony (1833), which with its program has become his most popular work; the *Scottish* Symphony (1842), which is the only symphony he allowed to be published in his lifetime; and the *Hebrides* (1832), also known as *Fingal's Cave*. The last is a **concert overture**, a form that grew out of the eighteenth-century tradition of performing opera overtures in the concert hall. It consists of a single movement and is usually connected in some way with a narrative plot known to the audience, and in this sense is programmatic. The *Hebrides* overture, however, does not tell a story. Rather, it sets a scene—one of the first such compositions in Western music—the rocky landscape and swell of the sea that inspired Mendelssohn when he visited the giant cave carved into basalt columns on an island off the Scottish coast.

Mendelssohn himself played both piano and violin. For the piano he composed 48 "Songs without Words," published in eight separate books that proved enormously popular. The works challenge the listener to imagine the words that the compositions evoke. When asked by a friend to provide descriptive titles to the music, he replied:

> I believe that words are not at all up to it [the music], and if I should find that they were adequate I would stop making music altogether. . . . So if you ask me what I was thinking of, I will say: just the song as it stands there. And if I happen to have had a specific word or specific words in mind for one or another of these songs, I can never divulge them to anyone, because the same word means one thing to one person and something else to another, because only the song can say the same thing, can arouse the same feelings in one person as in another—a feeling that is not, however expressed by the same words.

The meaning of music, in other words, lies for Mendelssohn in the music itself. It cannot be expressed in language. The music creates a feeling that all listeners share, even if no two listeners would interpret it in the same terms.

One of Mendelssohn's most beautiful and popular works is the Concerto in E minor for Violin and Orchestra, composed in 1844 (see **CD-Track 34.6**). Its lyrical beauty is matched by the dazzling virtuosity Mendelssohn's score demands of the soloist. Throughout the composition, the violinist is required to finger and bow two strings simultaneously, a technique known as "double-stopping." This allows performers not only to demonstrate their skill but also to assert, in a manner consonant with Romantic individualism, their own expressive genius. The work is also innovative compositionally. Most notably, each movement follows the previous one without break, and in contrast to the Classical concerto, the violin states each melody first instead of the orchestra.

Song: Franz Schubert and the Schumanns Not all Romantic composers followed Beethoven in concentrating on the symphonic form to realize their most important innovations and to communicate most fully their personal emotions. Beginning in about 1815, German composers became intrigued with the idea of setting poetry to music, especially the works of Schiller and Goethe. Called **lieder** [LEE-der] (singular *lied* [leet]), these songs were generally written for solo voice and piano. Their popularity reflected the growing availability and affordability of the piano in middle-class households and the composers' willingness to write compositions that were within the technical grasp of amateur musicians. This early expansion of the market for music freed composers from total reliance on the patronage of the wealthy.

The *lieder* of Franz Schubert [SHOO-burt] (1797–1828) and Robert (1810–1856) and Clara Schumann [SHOO-mahn] (1819–1896) were especially popular. Schubert's life was a continual struggle against illness and poverty, and he worked feverishly. In his brief career, he composed nearly 1,000 works, 600 of which were *lieder*, as well as 9 symphonies and 22 piano sonatas. Schubert failed to win international recognition in his lifetime, for which his early death by typhoid was partially to blame. But his melodies, for which he had an uncanny talent, seemed to capture, in the minds of the many who discovered him after his death, the emotional feeling and depth of the Romantic spirit.

Before he married Clara in 1840, Robert Schumann had permanently damaged his hands by constant over-practice. He turned from performance to composition and journalism, founding and editing one of the most important journals of its kind, still published today, the *Neue Zeitschrift für Musik* [NOY-uh TSITE-shrift fure MOO-zeek] (*New Journal of Music*), even as he struggled to write music. His success was directly tied to his moods. In the decade before marrying Clara, he never wrote more than five pieces in a given year. In the year of his marriage, however, he composed 140 songs, including his wedding gift to Clara, the poem *Du bist wie eine Blume* [doo beest vee EYE-nuh BLOO-muh], "You are like a Flower," and another song performed at their wedding, *Widmung* [VEED-moong], "Dedication," which begins "You are my soul, / you are my heart," and ends with a brief musical quotation from Schubert (see **CD-Track 34.7**). So Clara was the inspiration for much of her husband's most moving music.

By the age of 20, Clara Schumann was so well known as a piano virtuoso that the Viennese court had given her the title Royal and Imperial Virtuosa. She was one of the most

famous and respected concert pianists and composers of her day, despite her difficult marriage to Robert Schumann. She specialized in performing piano works known as **character pieces**, works of relatively small dimension that explore the mood or "character" of a person, emotion, or situation, including her husband's 1835 *Carnaval*. After Robert's death she supported her family by performing lengthy concert tours and was among the first artists to do this on a regular basis.

Piano Music: Frédéric Chopin Performance of character pieces often occurred at **salon concerts**, in the homes of wealthy music enthusiasts. Among the most sought-after composer/performer pianists of the day was the Polish-born Frédéric Chopin [SHOH-pan] (1810–1849). He composed almost exclusively for the piano. Among his most impressive works are his *études* [ay-TOOD], or "studies," which address particular technical challenges on the piano; *polonaises* [poh-loh-NEZ], stylized versions of the Polish dance; **nocturnes** [NOK-turns], character pieces related to the tradition of the serenade performed outside a loved one's window; and larger-scale works, particularly the four **ballades** [bah-LAHD], dramatic narrative forms that are among his most famous works. Focusing on melodramatic romance, supernatural events, and stormy emotion, Chopin's ballades are rich and complex, synthesizing contemporary poetry and diverse moods.

The *Fantasie impromptu* [fahn-tah-ZEE em-prohm-TOO] showcases the expressive range Chopin was capable of even in a brief composition (see **CD-Track 34.8**). Like other pianists of the day, Chopin enhanced the emotional mood of the piece by using *tempo rubato* [TEM-poh roo-BAH-toh] (literally "robbed time"), in which the tempo of the piece accelerates or decelerates in a manner "akin to passionate speech" as described by one of his students. While the word *fantasie* connotes creativity, imagination, magic, and the supernatural, the word *impromptu* suggests spontaneous improvisation, though, of course, the piece was written down. Combining impulsive, spur-of-the-moment creativity and imaginary and fantastical effects, Chopin's work is the very definition of Romanticism.

Goya's Tragic Vision

The impact of Napoleon's Promethean ambition, and the human tragedy associated with it, extended not only to Beethoven's Austria but also into Spain. Like Beethoven, the Spanish painter Francisco Goya [GOY-ah] (1746–1828) was, at first, enthusiastic about Napoleon's accession to power in France. Yet he, too, came to see through the idealistic veil of the emperor's ostensible desire to establish a fair and efficient government in a still-feudal country that was debased, corrupt, and isolated from the rest of Europe. Indeed, Goya's feelings for Napoleon were far less ambivalent than Beethoven's. Goya came to simply hate the emperor, as most Spaniards did.

When Napoleon decided to send a French army across the Iberian Peninsula to force Portugal to abandon its alliance with Britain, he did not foresee a problem since Spain had been his ally since 1796 (see Map 32.2). At first, Napoleon's army was unopposed, but by the time the troops reached Saragossa, the Spanish population rose up against the invaders in nationalistic fervor. For the next five years, the Spanish conducted a new kind of warfare, engaging the French in innumerable *guerrillas* [gay-REEL-yah], or "little wars," from which derives the concept of guerrilla warfare.

In March 1808, Napoleon made a fatal error. Maneuvering the Spanish royal family out of the way through bribery, he named his brother, Joseph Bonaparte (r. 1808–1814), to the Spanish throne. This gesture infuriated the Spanish people. The crown was *their* crown, after all, not Napoleon's. Even as the royal family was negotiating with Napoleon, rumors had spread that Napoleon was planning to execute them. On May 2, 1808, the citizens of Madrid rose up against Napoleon's troops, resulting in hundreds of deaths in battle, with hundreds more executed the next day on a hill outside Madrid. Six years later, in 1814, after Napoleon had been deposed and Ferdinand reinstated as king, Goya commemorated the events of May 2 and 3 in two paintings, the first depicting the battle and the second the executions of the following day.

The Third of May, 1808: Napoleon's Spanish Legacy

The Third of May, 1808 is one of the greatest testaments to the horrors of war ever painted (Fig. **34.10**). The night after the events of May 2, Napoleon's troops set a firing squad and executed hundreds of Madrilenos—anyone caught bearing weapons of any kind. The only illumination comes from a square stable lantern that casts a bright light on a prisoner with his arms raised wide above his head in a gesture that seems at once a plea for mercy and an act of heroic defiance. Below him the outstretched arms of a bloody corpse mirror his gesture. To his left, in the very center of the painting, another soon-to-be casualty of the firing squad hides his eyes in terror, and behind him stretches a line of victims to follow. Above them, barely visible in the night sky, rises a solitary, darkened church steeple.

Much of the power of the painting lies in its almost Baroque contrast of light and dark and its evocation of Christ's agony on the cross, especially through the cruciform pose of the prisoner. The soldier-executioners represent the grim reality of loyalty to one's state, as opposed to loyalty to one's conscience. Goya documented the realities of war in other works, including *The Disasters of War*, a series of etchings begun in 1810 and completed about the same time as *The Third of May, 1808*. These prints testify to the brutality of Napoleon's army, which, by all accounts, saw the Spanish people as little better than animals. In one of these prints, satirically entitled *Great courage! Against corpses!* Goya shows

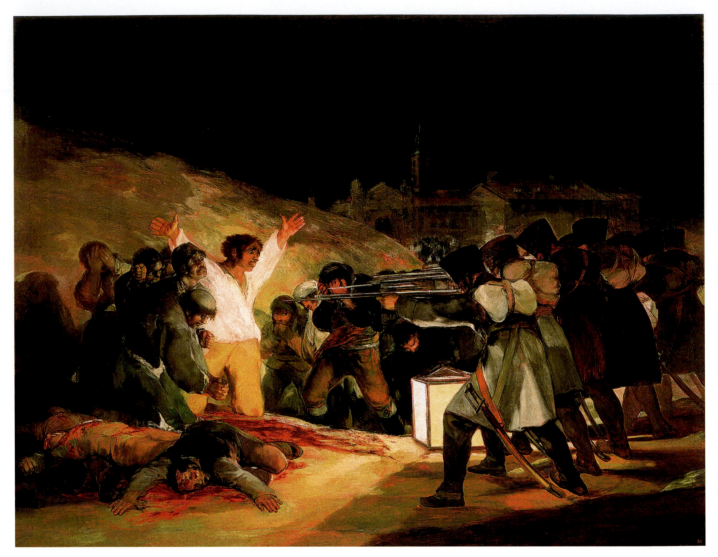

Fig. 34.10 Francisco Goya. *The Third of May, 1808.* **1814–1815.** Oil on canvas, 8′9 1/2″ × 13′4 1/2″. Museo del Prado, Madrid. Goya was later asked why he had painted the scene with such graphic reality. His reply was simple: "To warn men never to do it again."

that in the hands of the French troops, the human body is no longer human (Fig. **34.11**).

Goya before Napoleon: Social Satire

The Napoleonic invasion of Spain certainly galvanized Goya's imagination, but even such shocking and satiric images as *Great courage! Against corpses!* are anticipated in his earlier work. Both patriotic and antiwar, Goya embodies the two sides of Romanticism that are often contradictory since nationalism in the nineteenth century almost always led to the need for armed conflict. Under the rule of Charles III, from 1759 to 1788, Spain had instituted many liberal reforms, but the French Revolution frightened his successor, Charles IV. This monarch reinstated the Inquisition and went so far as to ban the importation of books from France.

Goya was angered at this abandonment of reform, and between 1796 and 1798 he executed a series of prints, called the *Caprichos* [kah-PREE-chohss], or *Caprices*, that expressed this sentiment. *The Sleep* [or Dream] *of Reason Produces Monsters* was originally designed as a title page to the series (Fig. **34.12**). According to biographers, it shows Goya himself asleep at his work table as winged creatures swarm in the darkness behind him. An owl, a symbol of wisdom, takes up Goya's pen as if urging him to depict the monsters of his dreams. Throughout the series, Goya shows the follies of Spanish society—social injustice, prostitution, vanity, greed, snobbery, and superstition (accounting for the many images depicting witches and monsters). Goya's criticism of Spanish society included the ruling class, but wisdom required him to take a more restrained yet still satirical approach in portraits of the royal family (see *Focus*, pages 1100–1101). In Goya's

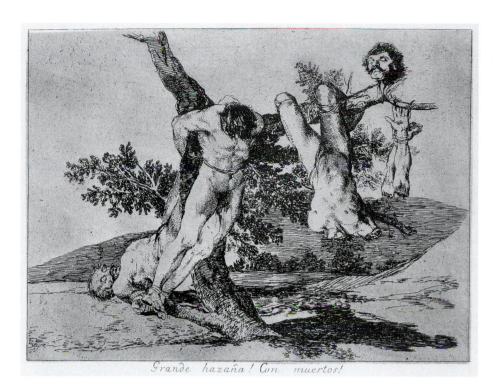

Fig. 34.11 Francisco Goya. *Grande hazara! Con muertos! (Great courage! Against corpses!),* from *The Disasters of War, No. 39.* **1810–1814.** Etching. Private Collection. The Bridgeman Art Library. The series was not published in Goya's lifetime—and not until 1863—probably because the government in Spain persecuted liberals after the return of Ferdinand VII in 1815.

view, Spanish society, although in no way Promethean in its ambition, similarly steps beyond the bounds of reason without any capacity to manage the consequences. For this reason, he presents it as a parody of the Promethean myth, in the same way that Miguel de Cervantes's delusional Don Quixote (see chapter 22) is a parody of the ideal knight.

The Black Paintings

Goya's sense that his world had abandoned reason dominated his final works. In 1819, when Goya was 72 years old, he moved into a small two-story house outside Madrid. The move was inspired at least in part by his relationship with his 30-year-old companion, Leocadia Weiss, which scandalized more conservative elements of Madrid society. It was also a more general expression of Goya's growing preference for isolation.

Goya spent the next four years executing a series of 14 oil paintings directly on the plaster walls of this house, Quinta del sordo. Today they are known as the "black paintings." There is no record that Goya ever explained them to any friend or relative, nor did he title them in any written form. Among these works are a painting of a woman who is evidently Leocadia, leaning on a tomb; two men dueling with cudgels; a pilgrimage

Fig. 34.12 Francisco Goya. *The Sleep of Reason Produces Monsters,* from the *Caprichos.* **1796–1798.** Etching and aquatint on paper, $8\frac{1}{2}'' \times 6''$. The Hispanic Society of America, NY. Goya offered 300 sets of the *Caprichos* series for sale in 1799, only to withdraw them two days later, presumably because the Church, which he portrayed in unflattering ways throughout, threatened to bring him before the Inquisition.

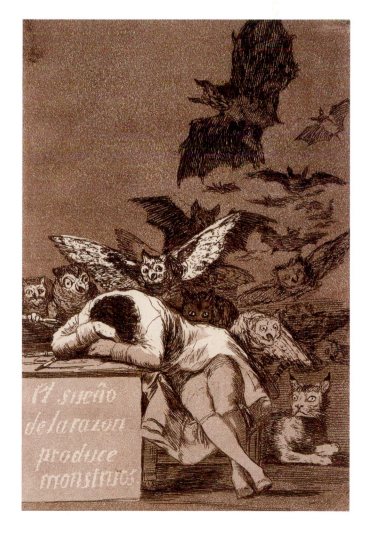

Focus

Goya's *The Family of Charles IV*

In 1789, Francisco Goya was appointed painter to Charles IV of Spain. As court painter he was responsible for producing portraits of the royal family and of courtiers. This may seem surprising given Goya's disapproval of Charles IV's Spain, but the position resulted mostly from Goya's great skill as a portraitist. In 1798, he was asked to produce a monumental portrait of the royal family. In its frank reference to Velázquez's *Las Meninas* (see Focus, chapter 27), which was in the royal collection, *The Family of Charles IV* is a sort of parody of greatness. Goya portrays himself standing at the back of the work at his easel, in the same position as Velázquez in *Las Meninas*. Queen Maria Luisa assumes the exact pose of the Infanta Margarita in the Velázquez work, but unlike the delicate infanta she is a giant presence, pudgy and grotesque. And Goya does nothing to hide the giant wart above the right eye of the king's sister, Maria Josepha. Nineteenth-century French writer Théophile Gautier (1811–1872) noted that Goya's royal couple resembles "the corner baker and his wife after they won the lottery."

How could the royal family accept such an unflattering work? The answer must lie in their own egotism, which Goya had anticipated in the *Caprichos*. In the image *Till Death*, an old woman tries on a new hat, primping herself before her mirror, as her maid barely suppresses a laugh. Two gentlemen share in her amusement, as one gazes up to the heavens as if in mock prayer. Vanity blinds the old woman, and so, presumably, does it blind the royal family, who, given Goya's position behind them, must be looking at their reflections in a mirror the painter had set up in front of them.

Caught up in their own self-admiration, the royal family evidently admired Goya's portrait of them immensely. In a letter to Manuel Godoy, the prime minister and her long-time lover, the queen pronounced it "the best of all paintings." Still, it turned out to be Goya's last royal commission. A recent cleaning of the painting has revealed on the wall behind the queen's head a lecherous scene, perhaps the biblical story of Lot and his daughters. It is possible that this story of incest upset the king and queen, who were, after all, first cousins, and caused them to request it be painted out.

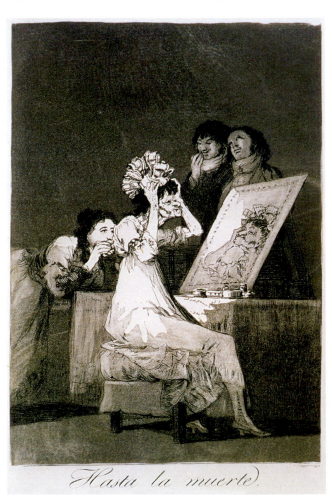

Francisco Goya. *Hasta la muerte (Till Death)*. 1797–1798. Etching, aquatint, and drypoint on paper, $8\frac{3}{4}'' \times 6''$. Private Collection. The Bridgeman Art Library. The title implies the marriage vow "Till Death Do Us Part," as if we are faithful to our own image—and perhaps blind to its faults—until we die.

Queen Maria Luisa at forty-eight years of age with two children: the Infanta Maria Isabelle, aged eleven, and the Infante Francisco de Paula, aged six. It was widely believed that both children had been fathered by Manuel Godoy, who rose to the position of prime minister at the queen's insistence.

Charles IV's eldest daughter, the **Infanta Carlota Joaquina**, 25 and already Queen of Portugal, was severely hunchbacked as a result of a hunting accident.

Charles IV's grotesquely deformed sister, **Maria Josepha**.

Goya at his easel presumably looking in a mirror to paint the group portrait.

The Prince of Asturias, the future king Ferdinand VII. Behind him is his brother Don Carlos, who after Ferdinand's death in 1833 would plunge Spain into civil war as he tried to assert his right to the throne as Charles V.

The identity of the woman turning away is not known, but lends an air of distraction to the work as a whole.

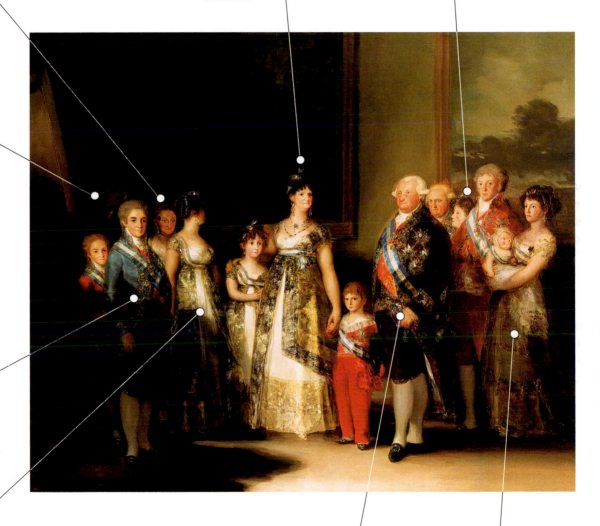

The king decked out in military regalia and a white wig. Behind him is his uncle, Don Antonio.

Another daughter, **Maria Luisa Jospeha**, holding her child beside her husband, Don Luis, prince of Parma.

Francisco Goya. *The Family of Charles IV.* **1800.** Oil on canvas, 9'2" × 11'. Museo del Prado, Madrid. Arixiu Mass, Barcelona/Derechos reservados © Museo Nacional Del Prado, Madrid. Goya subsequently painted Charles IV's successor, Joseph Bonaparte, Napoleon's brother, who ascended to the Spanish throne in 1808. When Ferdinand VII, son of Charles IV, returned to power in 1814, after Napoleon's defeat, he unleashed a wave of repression aimed at liberals and dissenters but spared Goya, allowing him to remain as court painter. He declared: "I ought to hang you, but you are a great artist, and I'll forgive everything."

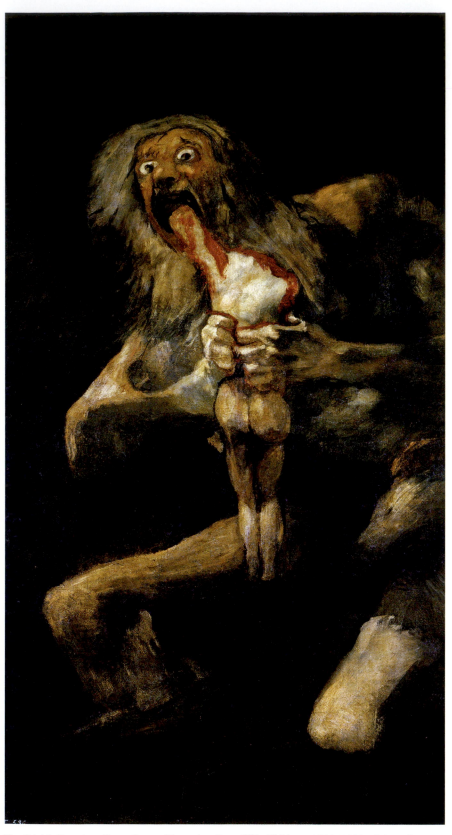

Fig. 34.13 Francisco Goya. *Saturn Devouring One of His Children*. 1820–1823. Oil on plaster transferred to canvas, $57\frac{7}{8}''$ × $32\frac{5}{8}''$. Derechos reservados © Museo Nacional Del Prado, Madrid. The painting reflects Goya's increasing disgust with Spanish politics. In 1824, he finally gave up on Ferdinand VII's Spain and, under the pretense of needing to visit the thermal baths, moved to Bordeaux, France, where he remained in self-exile until his death in 1828.

of terrifying and hideous figures through a nocturnal landscape; a convocation of these same figures in a witch's sabbath around a giant he-goat; two skeletal old people eating soup; and most terrifying of all, the painting today known as *Saturn Devouring One of His Children* (Fig. **34.13**). Derived from the story of Kronos [KROH-noss] eating his children, it is among the legends associated with the pre-Olympian Titans. *Saturn* is the Latin form of the Greek *Kronos*.

At the Quinta del sordo, the *Saturn* faced the main door, and it seems likely that Goya did not intend the Saturn myth as a "welcoming" image. His horrific giant with skinny legs, massive shoulders, wild hair, and crazed eyes is perhaps more an image of society as a whole, the social order, even Spain itself, devouring its own people. It is worth recalling that even as Goya was painting the *Saturn*, Beethoven was completing the Ninth Symphony. These works represent two sides of the Romantic imagination. Both share a profound sense of despair, isolation, and loneliness, but where Beethoven overcomes this condition and rises to a statement of hope and affirmation, Goya descends into a world of near madness and fear.

French Painting after Napoleon: The Classic and Romantic Revisited

After the fall of Napoleon in 1815, the battle between Classicism and Romanticism raged within France, fueled by political factionalism. Bourbon rule had been restored when Louis XVIII (r. 1814–1824), the deposed Louis XVI's brother, assumed the throne. Royalists, who favored this return of the monarchy, championed the more conservative Neoclassical style. Liberals identified with the new Romantic style, which from the beginning had allied itself with the French Revolution's radical spirit of freedom and independence.

The new king could not ignore the reforms implemented by both the revolution and Napoleon. His younger brother,

the count of Artois [AR-twah], dis- agreed, and almost immediately a so-called Ultraroyalist movement, composed of families who had suf- fered at the hands of the revolution, established itself. Advocating the return of their confiscated estates and the abolition of revolutionary and Napoleonic reforms, the Ultra- royalists imprisoned and executed hundreds of revolutionaries, Bona- parte's sympathizers, and Protestants in southern France. (David, who had supported Napoleon, was in exile during this period.) In order to solid- ify his control, Louis dissolved the largely Ultraroyalist Chamber of Deputies and called for new elec- tions, which resulted in a more mod- erate majority.

Relative calm prevailed in France for the next four years, but in Febru- ary 1820 the son of the count of Artois, who was the last of the Bour- bons and heir to the throne, was assassinated, initiating ten years of repression. The education system was placed under the control of Roman Catholic bishops, press censorship was inaugurated, and "dangerous" political activity banned. At the death of Louis XVIII, the count of Artois assumed the throne as Charles X (r. 1824–1830).

Fig. 34.14 Théodore Géricault. *The Wounded Cuirassier Leaving the Field.* 1814. Oil on canvas, 11′3/4″ × 115′3/4″. Musée du Louvre/RMN Réunion des Musées Nationaux, France. Bridgeman Art Library, NY. The emotional turbulence of the scene is underscored by the officer's apparent lack of balance.

Théodore Géricault: Rejecting Classicism

Against this political backdrop, the young painter Théodore Géricault [ZHAY-ree-koh] (1791–1824) inaugurated his career. Trained in Paris in a Neoclassical style, by the last years of Napoleon's reign he was painting largely military subjects that reflected a growing recognition of the emperor's limi- tations (see Fig. 32.18). In *The Wounded Cuirassier Leaving the Field*, the heroic ideal still finds expression in the rigid diagonals of the officer's and horse's legs and officer's sword—echoing the rigid poses of David's *Horatii* (see Fig. 32.4)—and in the painting's monumental size (Fig. **34.14**). But the cavalry officer's backward glance, the fear in the horse's eyes, and the fiery destruction in the background, all speak of the hollowness of heroism on the battlefield.

In fact, perhaps seeking some way to retrieve what was evidently lost, Géricault joined the Royal Musketeers soon after he completed this painting, assigned to protect the

future Louis XVIII from Napoleon. But events quickly over- came Géricault's brief royalist career. On July 2, 1816, a gov- ernment frigate named the *Medusa*, carrying soldiers and settlers to Senegal, was shipwrecked on a reef 50 miles off the coast of West Africa. The captain and crew saved themselves, leaving 150 people, including a woman, adrift on a makeshift raft. Only 15 survived the days that followed, days marked by insanity, mutilation, famine, thirst, and finally cannibalism. Géricault was outraged. An inexperienced captain, commis- sioned on the basis of his noble birth and connections to the monarchy, saved himself, providing a profound indictment of aristocratic privilege.

Géricault set himself the task of rendering the events. He interviewed survivors, and painted mutilated bodies in the Paris morgue. The enormous composition of *The Raft of the*

"*Medusa*" is organized as a double triangle (Fig. **34.15**). The mast and the two ropes supporting it form the apex of one triangle, and the torso of the figure waving in the direction of the barely visible *Argus*, the ship that would eventually rescue the castaways, the apex of the other. The opposing diagonals form a dramatic "X" centered on the kneeling figure whose arm reaches upward in the hope of salvation. Ultimately, however, the painting makes a mockery of the idea of deliverance, just as its rigid geometric structure parodies the ideal order of Neoclassicism. Like Byron, Géricault's Romanticism assumed a political dimension through his art. He had himself become a Promethean hero, challenging the authority of the establishment.

The Aesthetic Expression of Politics: Delacroix versus Ingres

When Géricault's *The Raft of the "Medusa"* was exhibited at the French Academy of Fine Arts Salon of 1819, it was titled simply *A Shipwreck Scene*, in no small part to avoid direct confrontation with the Bourbon government. Royalist critics dismissed it. The conservative press wrote that the painting was "not fit for moral society. The work could have been done for the pleasure of vultures." But its sense of immediacy, its insistence on depicting current events (but not how the castaways actually looked after 13 days adrift), made an enormous impression on another young painter, Eugène Delacroix (1798–1863), who actually had served as the model for the facedown nude in the bottom center of the *Raft*. Soon after Géricault's accidental death, Delacroix exhibited his *Scenes from the Massacres at Chios* at the Salon of 1824 (Fig. **34.16**).

The full title of the painting—*Scenes from the Massacres at Chios; Greek Families Awaiting Death or Slavery, etc.— See Various Accounts and Contemporary Newspapers*— reveals its close association with journalistic themes. It depicts events of April 1822, after the Greeks had initiated a War of Independence from Turkey, a cause championed by all of liberal Europe. In retaliation, the sultan sent

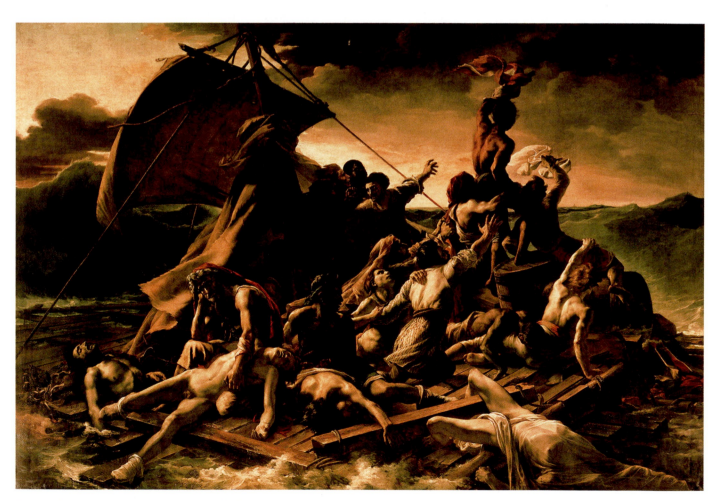

Fig. 34.15 Théodore Géricault. *The Raft of the "Medusa".* **1818.** First oil sketch. Oil on canvas, 16′1″ × 23′6″.
Musée du Louvre, Paris. Photo: Herve Lewandowski. Inv.: RF 2229. © Réunion des Musées Nationaux/Art Resource, NY.
The painting today is much darker than it was originally because Géricualt used bitumin, an organic carbon-based material, in his pigment.

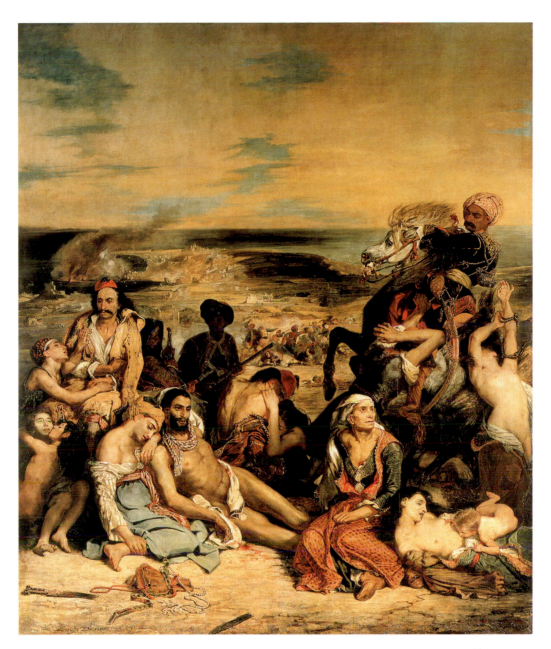

Fig. 34.16 Eugène Delacroix. *Scenes from the Massacres at Chios.* **1824.** Oil on canvas, 165″ × 139¼″.
Musée du Louvre, Paris. Photo: Le Mage. © Réunion des Musées Nationaux/Art Resource, NY. Delacroix relied
on the testimony of a French volunteer in the Greek cause for the authenticity of his depiction.

an army of 10,000 to the Greek island of Chios [KY-oss], just several miles off the west coast of Turkey. The troops killed 20,000 and took thousands of women and children into captivity, selling them into slavery across North Africa. In the left foreground, defeated Greek families await their fate. To the right a grandmother sits dejectedly by what is perhaps her dead daughter, even as her grandchild tries to suckle at its dead mother's breast. A prisoner vainly tries to defend a Greek woman tied to a triumphant Turk's horse. The vast space between the near foreground and the far distance is startling, almost as if the scene transpires before a painted tableau.

The stark contrast between Delacroix's *Scenes from the Massacres at Chios* and a traditional painting by Ingres entitled *The Vow of Louis XIII* (Fig. **34.17**) at the Salon of 1824 emphatically underscored Delacroix's Romanticism. Especially in the context of the times, Ingres's painting is a deeply royalist work. It depicts Louis XIII placing France under the protection of the Virgin in February 1638 in order to end a Protestant rebellion. The painting is divided into two distinct zones, the religious and the secular, or the worlds of church and state. The king kneels in the secular space of the foreground, painted in almost excruciating detail. Above him, the Virgin, bathed in a spiritual light, is

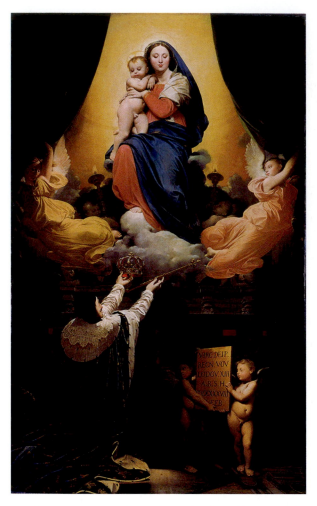

Fig. 34.17 Jean-Auguste-Dominique Ingres. *The Vow of Louis XIII*. 1824. Oil on canvas, 165 3/4″ × 103 1/8″. Montauban Cathedral, Montauban, France, Lauros. Giraudon/The Bridgeman Art Library, NY. The plaque in the hands of the putti reads "Louis XIII puts France under the protection of the Virgin, February 1638."

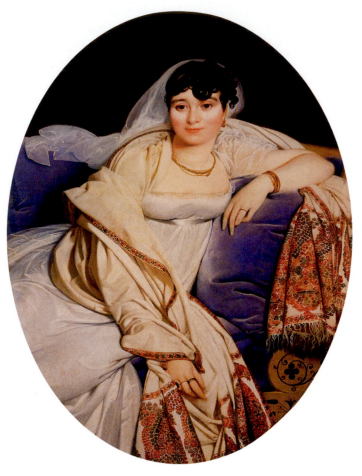

Fig. 34.18 Jean-Auguste-Dominique Ingres. *Madame Rivière,* (born Marie Françoise Jacquette Bibiane Blot de Beauregard). 1806. Oil on canvas, 46″ × 32 1/4″. Musée du Louvre/RMN Réunion des Musées Nationaux, France. SCALA/Art Resource, NY. Ingres exhibited this portrait as well as portraits of Philibert Rivière and the couple's 15-year-old daughter, Caroline, in the Salon of 1806.

a monument to Renaissance classicism, directly referencing the Madonnas of Raphael. In every way, the painting is a monument to tradition, to the traditions of the Bourbon throne, the Catholic Church, and classical art.

In his paintings, Ingres never hesitated to adjust the proportions of the body to the overall composition. A good example is his 1806 portrait of Madame Rivière [ree-vee-AIR] (Fig. **34.18**), wife of one of his earliest and most important patrons. The oval shape of her face almost perfectly mirrors the oval format of the frame, both echoed again in the long curve of Madame Rivière's right arm. But what a long curve it is! It is an arm of almost apelike proportion, disguised by flowing fabric. The rhythmic harmonies of the painting determine its length, not any anatomical precision.

In many ways, Delacroix's *Arab on Horseback Attacked by a Lion* (Fig. **34.19**) mirrors, in its circular flow of line, the composition of Ingres's *Madame Rivière*. But its emotional impact is radically different. In 1854, Delacroix wrote in his journal, "I pity those who work tranquilly and coldly. I am convinced

that everything they do can only be cold and tranquil." Delacroix preferred what he called "the fury of the brush," a fury especially evident in paintings such as this one. His brushwork, described by a contemporary as "plunged deep like sword thrusts," is indeed almost violent, rising like the spiral forms of the entangled horse and lion in a swift and energetic motion that culminates in the flowing red cape flying off the back of the horseman. Such gestural expression is a hallmark of Romantic painting.

So Delacroix and Ingres reenact the aesthetic debate that had marked French painting since the time of Louis XIII, the debate between the intellect and emotion, between the school of Poussin and the school of Rubens (see chapter 27). But now, Ingres's Neoclassicism and Delacroix's Romanticism entered into this debate not merely as expressions of aesthetic taste but as a political struggle, which by 1830 would happen again in a revolution that Delacroix would celebrate in his monumental painting *Liberty Leading the People* (see Fig. 35.12).

Fig. 34.19 Eugène Delacroix. *Arab on Horseback Attacked by a Lion.* **1849.** Oil on canvas, $17\frac{1}{4}'' \times 15''$. Potter Palmer Collection. 1922.403, The Art Institute of Chicago. Photograph © 2008, The Art Institute of Chicago. All Rights Reserved. Delacroix shared a fascination with the power of horses with his mentor Géricault, who died as a result of falling from one.

READINGS

from Mary Shelley, *Frankenstein*, chapter 5 (1818)

Mary Shelley's Frankenstein *was begun in 1816 at a villa in Switzerland after the English poet Lord Byron proposed to his companions that they compete in writing ghost stories.* Frankenstein *is an epistolary novel, a series of letters written by an English explorer in the Arctic whose ice-bound ship takes on a man in terrible condition, Victor Frankenstein, who narrates his own story to the explorer. Here, Frankenstein describes the horror he felt after creating a monster when he had dreamed of creating a creature of unparalleled beauty.*

It was on a dreary night of November that I beheld the accomplishment of my toils. With an anxiety that almost amounted to agony, I collected the instruments of life around me, that I might infuse a spark of being into the lifeless thing that lay at my feet. It was already one in the morning; the rain pattered dismally against the panes, and my candle was nearly burnt out, when, by the glimmer of the half-extinguished light, I saw the dull yellow eye of the creature open; it breathed hard, and a convulsive motion agitated its limbs.

How can I describe my emotions at this catastrophe, or how delineate the wretch whom with such infinite pains and care I had endeavoured to form? His limbs were in proportion, and I had selected his features as beautiful. Beautiful!—Great God! His yellow skin scarcely covered the work of muscles and arteries beneath; his hair was of a lustrous black, and flowing; his teeth of a pearly whiteness; but these luxuriances only formed a more horrid contrast with his watery eyes, that seemed almost of the same colour as the dun white sockets in which they were set, his shriveled complexion and straight black lips.

The different accidents of life are not so changeable as the feelings of human nature. I had worked hard for nearly two years, for the sole purpose of infusing life into an inanimate body. For this I had deprived myself of rest and health. I had desired it with an ardour that far exceeded moderation; but now that I had finished, the beauty of the dream vanished, and breathless horror and disgust filled my heart. Unable to endure the aspect of the being I had created, I rushed out of the room, and continued a long time traversing my bedchamber, unable to compose my mind to sleep. At length lassitude succeeded to the tumult I had before endured; and I threw myself on the bed in my clothes, endeavouring to seek a few moments of forgetfulness. But it was in vain: I slept, indeed, but I was disturbed by the wildest dreams. I thought I saw Elizabeth, in the bloom of health, walking in the streets of Ingolstadt. Delighted and surprised, I embraced her; but as I imprinted the first kiss on her lips, they became livid with the hue of death; her features appeared to change, and I thought that I held the corpse of my dead mother in my arms; a shroud enveloped her form, and I saw the grave-worms crawling in the folds of the flannel. I started from my sleep with horror; a cold dew covered my forehead, my teeth chattered, and every limb became convulsed: when, by the dim and yellow light of the moon, as it forced its way through the window shutters, I beheld the wretch—the miserable monster whom I had created. He held up the curtain of the bed; and his eyes, if eyes they may be called, were fixed on me. His jaws opened, and he muttered some inarticulate sounds, while a grin wrinkled his cheeks. He might have spoken, but I did not hear; one hand was stretched out, seemingly to detain me, but I escaped, and rushed down stairs. I took refuge in the courtyard belonging to the house which I inhabited; where I remained during the rest of the night, walking up and down in the greatest agitation, listening attentively, catching and fearing each sound as if it were to announce the approach of the demoniacal corpse to which I had so miserably given life.

Oh! no mortal could support the horror of that countenance. A mummy again endued with animation could not be so hideous as that wretch. I had gazed on him while unfinished; he was ugly then; but when those muscles and joints were rendered capable of motion, it became a thing such as even Dante could not have conceived.

I passed the night wretchedly. Sometimes my pulse beat so quickly and hardly that I felt the palpitation of every artery; at others, I nearly sank to the ground through languor and extreme weakness. Mingled with this horror, I felt the bitterness of disappointment; dreams that had been my food and pleasant rest for so long a space were now become a hell to me; and the change was so rapid, the overthrow so complete!

Morning, dismal and wet, at length dawned, and discovered to my sleepless and aching eyes the church of Ingolstadt, its white steeple and clock, which indicated the sixth hour. The porter opened the gates of the court, which had that night been my asylum, and I issued into the streets, pacing them with quick steps, as if I sought to avoid the wretch whom I feared every turning of the street would present to my view. I did not dare return to the apartment which I inhabited, but felt impelled to hurry on, although drenched by the rain which poured from a black and comfortless sky.

I continued walking in this manner for some time, endeavouring, by bodily exercise, to ease the load that weighed upon my mind. I traversed the streets, without any clear conception of where I was, or what I was doing. My heart palpitated in the sickness of fear; and I hurried on with irregular steps, not daring to look about me: . . . ■

Reading Questions

Why does Frankenstein reject his creation? Why does his dream turn to nightmare? Why did Mary Shelley leave so many questions unanswered?

Summary

■ **Napoleon and the Romantic Hero** When all of Europe's heads gathered for the Congress of Vienna in 1814–1815, called to guarantee peace in Europe after the defeat of Napoleon Bonaparte, the city was the focus of European culture. Almost everyone there recognized that even if Napoleon personified the Romantic hero, he also possessed a darker side. In many eyes, he was a modern Prometheus, what Hegel called a "Great Man," who sensed the "world-spirit" and in his singular action brought the dialectic of history closer to its utopian conclusion. Prometheus was the archetypal Romantic hero, celebrated by many cultural figures, including Lord Byron, Percy Bysshe Shelley, and Mary Shelley (whose Dr. Frankenstein was punished, like Prometheus, for acquiring knowledge beyond that of ordinary mortals). While the hero of Johann Wolfgang von Goethe's *The Sorrows of Young Werther* is self-absorbed and disillusioned with life, the hero of his later work, *Faust*, is a full-blown Promethean figure of almost insatiable drive for knowledge and experience.

■ **Beethoven and the Rise of Romantic Music** Like other Romantics of his era, Ludwig van Beethoven was fascinated by Napoleon, whose heroic deeds he celebrated in his Third Symphony, the *Eroica*, even as he began to recognize him as a tyrannical despot. Beethoven's musical career can be divided into three eras. In the early years he was deeply influenced by the classical music of Mozart and Haydn. In the so-called "Heroic Decade," after coming to the brink of suicide in 1802 due to his increasing deafness, he was guided by an almost pure state of subjective feeling. In great symphonies like the *Eroica* and the Fifth, he defined the Romantic style in music. After undergoing much personal anguish related to his family, Beethoven entered his late period, during which he completed three uniquely structured piano sonatas and his triumphal Ninth Symphony in 1824.

Beethoven's approach to the Romantic style in music required innovation and originality. Succeeding generations of composers followed his lead by expanding the musical vocabulary of orchestras and developing new symphonic forms. Hector Berlioz's autobiographical epic *Symphonie fantastique* describes a passionate love affair through inventive melodies and harmonies and an enormous orchestra. Felix Mendelssohn composed orchestral compositions inspired by his travels; nevertheless, he believed that the meaning of music lies in the music itself. It cannot be expressed in language. Other composers, such as Franz Schubert and Robert and Clara Schumann set the poems of Romantic poets such as Schiller and Goethe to music in compositions called *lieder*. Frédéric Chopin composed almost solely for the piano and was famous especially for his *études*, studies that address particular technical challenges.

■ **Goya's Tragic Vision** Like Beethoven, the Spanish painter Francisco Goya was at first enthusiastic about Napoleon, but quickly changed his mind after the emperor's invasion of Spain in 1808. Goya would commemorate the Spanish rebellion against Napoleon's army in his *Third of May, 1808*, and narrate the horrors of Napoleonic occupation in his series of prints *The Disasters of War*. Goya was no less critical of Spanish leadership. In the *Caprichos*, he depicts the follies of Spanish society, and in a monumental painting commissioned by the crown, he satirizes the pretensions of the royal family. Late in life his vision became even darker in a series of works on the plaster walls of his house known as the "black paintings," which include the so-called *Saturn Devouring One of His Children*.

■ **French Painting after Napoleon: The Classic and Romantic Revisited** After Napoleon's defeat, the monarchy was restored in France. Painters like Théodore Géricault became increasingly disenchanted with the monarchy and rejected their classical training. Géricault's *The Raft of the "Medusa,"* based on the wreck of a government frigate and the abandonment of its passengers, represents a new direction in Romantic painting by depicting with a sense of urgency and immediacy a disturbing contemporary event. Géricault's student Eugène Delacroix followed with another painting on a controversial contemporary subject, *Scenes from the Massacres at Chios*, illustrating the genocide of thousands of Greeks revolting against Ottoman rule.

Glossary

ballade A highly dramatic narrative form.

character piece A piano work of relatively small dimension that explores the mood or "character" of a person, emotion, or situation.

concert overture A programmatic form that grew out of the eighteenth-century tradition of performing opera overtures in the concert hall and that consists of a single movement usually connected in some way with a narrative plot known to the audience.

dialectic An evolutionary process in which the prevailing set of ideas, called the "thesis," finds itself opposed by a conflicting set of ideas, the "antithesis." This conflict resolves itself in a "synthesis," which inevitably establishes itself as the new thesis.

ennui A French term that denotes both listlessness and a profound melancholy.

étude In music, a study that addresses particular technical challenges.

"Great Man" theory A theory asserting that human history is driven by the achievement of men who lead humankind forward because they have sensed by intuition the "world-spirit."

idée fixe A French term meaning "fixed idea," or an idea that dominates one's mind for a prolonged period.

lieder Songs, generally written for solo voice and piano.

nationalism A blend of ethnic pride and cultural identity based on shared history and a sense of destiny.

nocturne In music, a character piece related to the tradition of the serenade performed outside a loved one's window.

polonaise A stylized version of the Polish dance.

salon concert A concert held in the homes of wealthy music enthusiasts.

scherzo An Italian term meaning "joke" denoting a type of musical composition, especially one that is fast and vibrant and presents a surprise.

 Critical Thinking Questions

1. Are the "darker" romantic qualities in Prometheus, Frankenstein's monster, and Faust attractive in any way? How so?

2. What is the "romantic style in music" that Beethoven defined, as opposed to Romantic musical themes or genres? Think of Mozart to contrast.

3. Describe the darker side of war and of the aristocracy as seen in the works of Goya, Géricault, and Delacroix.

The Romantic imagination as embodied in the works of Beethoven, Goethe, and Goya is profoundly subjective, the product of an interior world that was intent, like Faust, on developing itself to the fullest. Beethoven spoke regretfully on his deathbed of his failure to set Goethe's *Faust* to music not because he approved of Faust as a man, but because he recognized in the sweep of the character's ambition something of his own expansive spirit.

However, it was not to the subjective imagination alone that the nineteenth-century imagination turned. In paintings like Géricault's *Raft of the "Medusa"* or Delacroix's *Scenes from the Massacres at Chios*, we are witness to the reality of contemporary events. In such works, the painter accepts the role of a newspaper reporter and attempts to convey, if not the actuality, then the emotional reality of events. In the years just before his death in 1824, Géricault had, in fact, produced a series of paintings, none of which were discovered until a half century after his death, that are today known as his portraits of the insane (Fig. **34.20**). What motivated Géricault to paint these portraits remains a mystery, but they reveal an interest in the most intimate side of human emotion, depicting their subjects with something approaching deep reverence for their psychological fragility. These are not subjective paintings, but they are *about* subjectivity—or more precisely, about the subjective mind's inability to come to grips with its world. And they suggest, in the isolation of each figure within the confined dark space of traditional portraiture, that we are not witness to personalities—the traditional subject of portraiture—but to figures emptied of their personalities.

These paintings amount to an extended study of the impact of nineteenth-century society on the downtrodden, the forgotten, and the all-too-often-alienated masses. They are one of the first expressions of what would in the coming years be a redirection of artistic attention away from the personal turmoil and dramas of the Romantic self and toward the plight of those unable to manage for themselves in a quickly changing industrial world. Reacting to images like these—and there would soon be others—the arts would come to the service of those demanding social reform. And the reformists themselves, impatient for change, would foment revolution. A new realism would be born, one dedicated to righting social wrongs. ∎

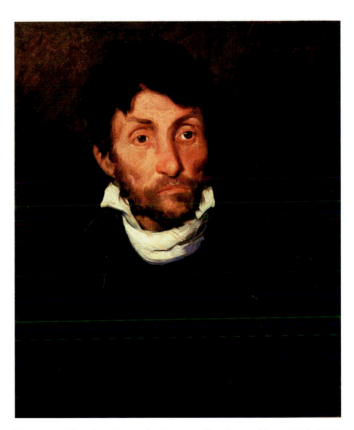

Fig. 34.20 **Théodore Géricault.** *Portrait of an Insane Man.* **1822–1823.** Oil on canvas, 24″ × 19³⁄₄″. Museum voor Schone Kunsten, Ghent, Belgium. The Bridgeman Art Library.

35 Industry and the Working Class

A New Realism

The Industrial City: Conditions in London

Reformists Respond: Utopian Socialism, Medievalism,
 and Christian Reform

Literary Realism

The New French Realism in Painting

Photography: Realism's Pencil of Light

Charles Darwin: The Science of Objective Observation

> **"** *The filthy and miserable appearance of this part of London can hardly be imagined . . . men and women, in every variety of scanty and dirty apparel, lounging, scolding, drinking, smoking, squabbling, fighting, and swearing.* **"**

Charles Dickens, *Sketches by Boz*

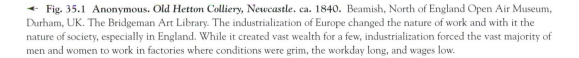

◄ **Fig. 35.1 Anonymous.** *Old Hetton Colliery, Newcastle.* **ca. 1840.** Beamish, North of England Open Air Museum, Durham, UK. The Bridgeman Art Library. The industrialization of Europe changed the nature of work and with it the nature of society, especially in England. While it created vast wealth for a few, industrialization forced the vast majority of men and women to work in factories where conditions were grim, the workday long, and wages low.

DURING THE LIFE OF THE GREAT ENGLISH NOVELIST CHARLES Dickens (1812–1870), London was both the capital of a nation of ever-increasing wealth and international preeminence and a city mired in poverty, crime, and urban blight. In part, Dickens saw London through the lens of a trained reporter. He had

covered endless, unproductive debates in Parliament about social reform that left him impressed only by that august body's inability to act in any meaningful way. But he also viewed the vast city from the perspective of his harsh childhood, details of which were so awful that he kept them secret his entire life. Two days after his twelfth birthday, he went to work in a boot-blacking factory, from 8:00 AM to 8:00 PM, for a wage of 6 shillings a week. (Twenty shillings equaled a British pound—worth approximately $5 at the time—so Dickens earned less than $2 per week.) Shortly afterward, his father was arrested and committed to debtors' prison. The family moved into the prison cell with him, as was common at the time. These events so indelibly marked young Charles that, later in life, he would become one of the English reform movement's most active speakers. As a novelist, he portrayed the lives of children whose suffering mirrored his own. These novels, published in serialized chapters in the London press beginning when Dickens was in his twenties, attracted hundreds of thousands of readers. In depicting the lives of the English lower classes with intense sympathy and great attention to detail, Dickens became a leading creator of a new type of prose fiction, **literary realism**.

Dickens's novels illuminated the enormous inequities of class that existed in nineteenth-century England, with his heroes and heroines, villains and scoundrels, often approaching the point of caricature. While his sentimentalism sometimes verged on the maudlin, Dickens also had an unparalleled ability to vividly describe England. Take, for instance, his description of industrial Birmingham in his 1840 novel *The Old Curiosity Shop*, a scene very much like the one depicted in the anonymous *Old Hetton Colliery, Newcastle* (Fig. **35.1**) painted at about the same time that Dickens wrote these words:

> A long suburb of red brick houses—some with patches of garden-ground, where coal-dust and factory smoke darkened the shrinking leaves, and coarse rank flowers, and where the struggling vegetation sickened and sank under the hot breath of kiln and furnace, making them by its presence seem yet more blighting and unwholesome than in the town itself—a long, flat, straggling suburb passed . . . where not a blade of grass was seen to grow, where not a bud put

forth its promise in the spring, where nothing green could live. . . . On every side, and far as the eye could see into the heavy distance, tall chimneys, crowding on each other, and presenting that endless repetition of the same dull, ugly form, which is the horror of oppressive dreams, poured out their plague of smoke, obscured the light, and made foul the melancholy air. On mounds of ashes by the wayside, sheltered only by a few rough boards, or rotten pent-house roofs, strange engines spun and writhed like tortured creatures; clanking their iron chains, shrieking in their rapid whirl from time to time. . . . Dismantled houses here and there appeared, tottering to the earth, propped up by fragments of others that had fallen down, unroofed, windowless, blackened, desolate, but yet inhabited.

Men, women, children, wan in their looks and ragged in attire, tended the engines, fed their tributary fire, begged upon the road, or scowled half-naked from the doorless houses. Then came more of the wrathful monsters, whose like they almost seemed to be in their wildness and their untamed air, screeching and turning round and round again; and still, before, behind, and to the right and left, was the same interminable perspective of brick towers, never ceasing in their black vomit, blasting all things living or inanimate, shutting out the face of day, and closing in on all these horrors with a dense dark cloud.

As the number of factories in and around cities such as London exploded over the course of the century (see Map **35.1**), not just the landscape, but the nature of work and with it the nature of human society, changed dramatically. Although industrialization created wealth for a few, it forced the vast majority of men and women into jobs as low-paid laborers. In the southern United States, where work was conducted by slaves, conditions in rural areas were equally horrifying. In England, France, Russia, and the United States, many artists and writers called for social reform. Some depicted the actual conditions of the working class in increasingly realistic works of art and literature; others demanded the reinvention of society itself. The new medium of photography allowed uniquely accurate representations of people, objects, and landscapes. The increasing emphasis on realism in the arts—depicting the world as it actually was rather than idealizing it—was mirrored by the growing popularity of the

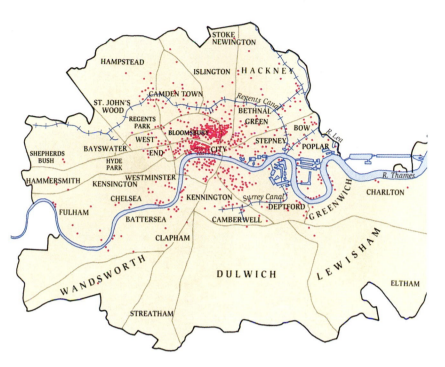

Map 35.1 London in 1898: Factories with over 100 workers.

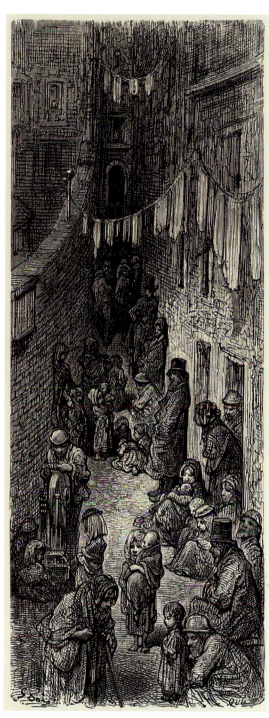

Fig. 35.2 Gustave Doré. *Orange Court—Drury Lane.* 1869. Illustration for Gustave Doré and Blanchard Jerrold. *London: A Pilgrimage,* 1872. Accompanied by policemen from Scotland Yard, Doré went around the city, including the East End and Whitechapel, making sketches on the spot. Though executed some 36 years after Dickens penned *Sketches by Boz,* Doré's drawings capture the poverty that Dickens describes, at the same time proving how enduring poverty was.

scientific methodology to rigorously investigate every facet of human experience and the natural world. In fact, Auguste Comte (1798–1857), an enormously influential French thinker, elevated science to a kind of religion, developing the philosophy of "positivism." According to Comte, society passes through three successive stages in its quest for knowledge of any subject—theological (religious), metaphysical (abstract, philosophical), and positive (scientific). It was only through the application of the scientific method that truth could be obtained about the natural world, technology, or human society. This chapter ends by summarizing the achievements of one of the century's most creative scientists, Charles Darwin. By challenging established theories, Darwin set the stage for viewing nature and the universe as part of a dynamic, ever-changing process.

The Industrial City: Conditions in London

In his earliest published book, writing under the pen name Boz, Dickens describes one of the worst slums in London, on Drury Lane (**Reading 35.1**). A century earlier, it had been a good address, but by the beginning of the 1800s it was dominated by prostitution and gin houses (Fig. **35.2**):

READING 35.1 from Dickens, *Sketches by Boz* (1836)

The filthy and miserable appearance of this part of London can hardly be imagined by those (and there are many such) who have not witnessed it. Wretched houses with broken windows patched with rags and paper; every room let out [rented] to a different family, and sometimes two or even three—fruit and "sweet stuff" manufacturing in the cellars, barners and red-herring vendors in the front parlours, cobblers in the back; a bird fancier in the first floor, three families on the second, starvation in the attics, Irishman in the passage, a "musician'" in the front kitchen, and a char-woman and five hungry children in the back one—filth everywhere—a gutter before the houses and a drain behind—clothes drying, and slops emptying from the windows, girls of fourteen or fifteen, with matted hair, walking about barefoot, and in white great-coats, almost their only covering; boys of all ages, in coats of all sizes and no coats at all; men and women, in every variety of scanty and dirty apparel, lounging, scolding, drinking, smoking, squabbling, fighting, and swearing.

The writing style is pure Dickens. Descriptions pile up in detail after detail, in one long sentence, so that the reader, almost breathless at its conclusion, feels overwhelmed, as the author tries to make the unimaginable real. His aim is not simply to entertain, but to advocate reform. Dickens was hardly alone in criticizing the fruits of "progress" of Western civilization. The plight of the poor, coupled with the indo-lence of the wealthy, was a matter of great concern for many writers and artists in mid-nineteenth-century England. Thomas Carlyle (1795–1881), the foremost essayist and social critic of the day, put it this way (**Reading 35.2**):

READING 35.2 from Thomas Carlyle, *Past and Present* (1843)

The condition of England . . . is justly regarded as one of the most ominous, and withal one of the strangest, ever seen in this world. England is full of wealth, of multifarious produce, supply for human want in every kind; yet England is dying of inanition [exhaus-tion, lack of social, moral vigor]. With unabated bounty the land of England blooms and grows; waving with yel-low harvests; thick-studded with worshops, industrial implements, with fifteen millions of workers, under-stood to be the strongest, the cunningest and the will-ingest our Earth ever had; these men are here; the work

they have done, the fruit they have realised is here, abundant, exuberant on every hand of us: and behold, some baleful fiat as of Enchantment has gone forth, say-ing, "Touch it not, ye workers, ye master-workers, ye master-idlers; none of you can touch it, no man of you shall be the better for it; this is enchanted fruit!". . . Of these successful skilful workers some two millions, it is now counted, sit in Workhouses, Poor-Law Prisons; or have "out-door relief" flung over the wall to them,—the workhouse Bastille [referring to the infamous Paris prison that triggered the French revolution in 1789] being filled to bursting, and the strong Poor-law broken asunder by a stronger. They sit there, these many months now; their hope of deliverance as yet small. In workhouses, pleasantly so-named, because work cannot be done in them. Twelve-hundred-thousand workers in England alone; their cunning right-hand lamed, shut in by narrow walls. They sit there, pent up, as in a kind of horrid enchantment; glad to be imprisoned and enchanted, that they may not perish starved. . . .

Carlyle argued that while the natural guardians of the poor, the English aristocracy, were out fox hunting and shoot-ing game, poverty was exploding around them. The upper classes and much of the government were blind to the hor-rors that were everywhere evident if they bothered to look. Those horrors penetrated all aspects of urban living: water, housing, labor, and family life.

Water and Housing

Carlyle and Dickens saw, every day, that the river Thames was little more than an open sewer. A petition of 1827 to the House of Commons advised against its use:

The water taken from the River Thames at Chelsea, for the use of the inhabitants of the western part of the metropolis, [is] being charged with the contents of the great common sewers, the drainings from dunghills, and laystalls [collections of human waste], the refuse of hospi-tals, slaughter houses, colour, lead and soap works, drug mills and manufactures, and with all sorts of decomposed animal and vegetable substances, rendering the said water offensive and destructive to health, ought no longer to be taken up by any of the water companies from so foul a source.

Among the lethal bacteria that thrived in this water was cholera, and its principal victims were the poor. Where they lived, one in three children died before the age of one. After several devastating cholera epidemics in the 1830s and 1840s, a municipal waterworks was finally established in London in 1855, charged with the construction of "a system of sewerage which should prevent . . . any part of the sewage

At the end of the 18th century.

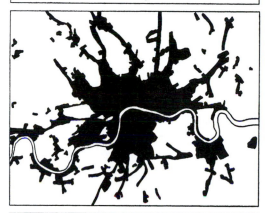

In the 1830s.

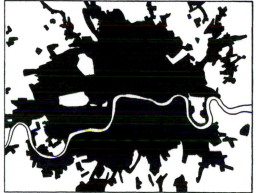

In the 1870s.

Map 35.2 The growth of London, 1800–1880. After Roy Porter, *London: A Social History* (New York: Penguin Books, 1994). London's population in 1800 was about 1 million. By 1881, the population had more than quadrupled, growing to 4.5 million, dwarfing the industrial cities to the north. Social services were unable to keep up with this rapid growth.

within the metropolis from passing into the Thames in or near the metropolis." Contributing to London's water pollution problem was the extraordinarily rapid growth of the population (Map **35.2**). As the city's boundaries expanded, high-density neighborhoods grew as well. Because laborers needed to walk to their jobs in urban factories, living in the countryside was no longer possible. As the poor crowded into buildings already stressed by age and disrepair, whole neighborhoods turned into slums. Map 35.1 shows factories employing more than 100 workers in London in 1898, with most of them concentrated in the inner city. Rent for an entire house cost about 7 shillings 6 pence a week, around $2.00, though most working families could afford only to rent a single room in a central London house. The 1841 census found 27 houses in Goodge Place, a poor neighborhood but no slum, occupied by 485 people, many practicing their trade in the same room where they lived!

Labor and Family Life

As a result of industrialization, the British workforce increasingly became **proletariat**—a class of workers who neither owned the means of production (tools and equipment) nor controlled their own work. Trades such as clothing and shoemaking that had flourished in the West End of London, close to the homes of wealthy customers in the eighteenth century, were replaced by factories, producing goods for the proletariat itself. The introduction of machine manufacture into the textile industry, especially, required fewer skilled workers, and more unskilled workers, mostly single young women and widows, who worked for lower wages than men (Fig. **35.3**).

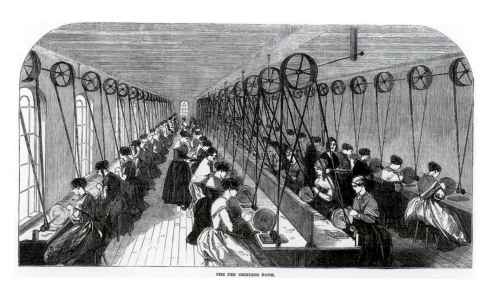

THE PEN GRINDING ROOM.

Fig. 35.3 A pen-grinding factory. ca. 1845. *The Illustrated London News* Picture Library. After 1840, mailing a letter anywhere in England cost just one penny. In just one year, the volume of mail rose from 76 million letters to 168 million. Letter-writers needed pens, and production in factories rose to meet the demand. The labor force in the pen industry was almost entirely female.

Voices

A Recipe for Domestic Harmony

French as well as English family life was profoundly altered during the first quarter of the nineteenth century as a result of transformations in working conditions, new industries, and a growing bourgeois class. Mme. Elizabeth Celnart's widely published manuals on domestic economy (many were translated into English) during the 1820s and 1830s offered detailed instructions to family members on how to behave in public and in private. In the passage below, she offers advice on the proper tone and manner of conversation between husbands and wives.

"If at any time the society of your husband or wife should cause you *ennui* [weariness or boredom], you ought neither to say so, nor give any suspicion of the cause by abruptly changing the conversation."

Care should be taken with the honors of the dinner table not only when you have guests but also for your husband's sake, in order to make life at home more civilized. I use the word "civilized" advisedly, for the mark of civilization is the ability to bestow pleasure and dignity on the satisfaction of all our needs. This must be done because the occupations of social life, especially for men, leave almost no time for family life except mealtimes, and because experience and what we know about prolonging life suggest that this time be devoted to gaiety so as to make digestion easy and unobtrusive. Here, then, is ample reason to enliven your meals with gentle conversation. . . .

The conversation of a husband and wife cannot be elegant and sustained in the same manner it is in society . . . but it should be free from all impoliteness and indelicacy. If at any time the society of your husband or wife should cause you *ennui* [weariness, boredom, lack of interest], you ought neither to say so, nor give any suspicion of the cause by abruptly changing the conversation. In all discussions you should watch yourself attentively lest domestic familiarity raise itself by degrees to the pitch of a quarrel. It is especially to females that this advice is addressed, since [according to] Scripture "woman was not created for wrath" and [we may add] "she was created for gentleness."

This in turn encouraged prostitution as a way to supplement a woman's meager wage income. In addition, the sexual exploitation of low-paid, uneducated women workers by their male supervisors was commonplace.

Children of poor families often worked as assistants in the factories. The English Factory Act of 1833 banned employment of children under the age of nine. Children 9 to 13 years of age could work a 9-hour day (down from 12 hours), and employers had to provide 2 hours of education to child-workers each day. Not surprisingly, these conditions radically altered family life. Before the nineteenth century, families had often worked together in textile production, usually at home. But as married women were displaced from the workforce and their husbands' wages allowed families to live on a single income, wives became solely responsible for domestic life—child-rearing, food preparation, and housekeeping. Gender-determined roles, which had previously been the rule only among the relatively small middle class and the aristocracy, now characterized the working-class family as well (see *Voices*, above).

Reformists Respond: Utopian Socialism, Medievalism, and Christian Reform

Faced with the reality of working-class life, reformist thinkers and writers across Europe reacted by writing polemical works that are meant to be understood as critiques of industrial society. Chief among its targets are the economic engine of the industrial state—its desire to reap a profit at whatever human cost—and the unbridled materialism that, in turn, seemed to drive industrialism's economic engine. This world seemed life-consuming and soul-destroying, a world in which the pulse of machinery was supplanting the pulse of the human heart.

For many humanist thinkers, London's social conditions were directly tied to economics. Ever since Adam Smith's *Wealth of Nations* (see chapter 31), economists had argued that a nation achieved economic growth by free enterprise and a marketplace unimpeded by governmental regulation. Competition would naturally result in the marketplace governing itself. By the 1820s, however, many began to question the free-market system, especially its low wages, unequal distribution of goods, and hollow materialism. Social critics deplored a system that permitted the factory owners, the "haves," to enjoy leisure and comfort at the expense of the impoverished working class who "had not." They argued that human society could be better organized as a cooperative venture, with each person working for the good of the whole.

Utopian Socialism

Among the critics of free enterprise were those who envisioned ideal communities, where production would be controlled by society as a whole rather than owned by individuals. In France, for instance, Charles Fourier [sharl foo-ree-AY] (1772–1837) argued for the establishment of phalanxes, communities that would liberate individuals to live freely rather than follow the drudgery of industrial life. Phalanxes would be located in the countryside, where no person performed the same kind of work for the entire day, where there was sexual freedom for the young (marriage was to be reserved for later life), and where all residents would be free to pursue pleasure. Scholars have come to call Fourier and those who sought to create such communities *utopian socialists.*

British industrialist Robert Owen (1771–1858), owner of one of the largest British cotton factories, developed a more practical scheme. At his factory at New Lanark, Scotland, he provided his workers with good quarters, recreational opportunities, education for their children, and classes for adults. In 1824, Owen left England for the United States, where he intended to found a series of communities in which factory and farm workers might live and work together. After purchasing the town of New Harmony, Indiana, for $135,000, Owen hired architect Stedman Whitwell to design a city plan, and invited people to apply for the 800 spaces that were available. Although New Harmony attracted hundreds of settlers, most found themselves unable to adapt to life in the community, and most lacked the skills to either farm or otherwise contribute meaningfully to the economy. By 1828, Owen's New Harmony experiment had failed.

A.W. N. Pugin, Architecture, and the Medieval Model

In 1836 (the same year that Dickens published his *Sketches by Boz*), the architect Augustus Welby Northmore Pugin

[PYOO-jin] (1812–1852) published a book called *Contrasts.* Pugin compared medieval and modern buildings, aiming to show the decay of taste over time. He contrasted a contemporary poor house to a medieval one, run with compassion by the Church (Fig. **35.4**). The rag-clad, miserable tenants of the nineteenth-century poorhouse were subjected to a whip-carrying master, a meager diet of bread and gruel, barren cells, and a sense of imminent death. In contrast, medieval tenants had had a beneficent master, a garden setting, and a bountiful supply of mutton, beef, bread, and ale. Such nostalgia for medieval life was rooted in the Romantic taste for Gothic ruins—Turner's view of the *Interior of Tintern Abbey* (Fig. 33.2), for instance, or Friedrich's *Abbey in the Oakwood.* Tales of adventure and love set in medieval times such as Sir Walter Scott's historical novel *Ivanhoe,* which described the late twelfth-century Crusades, also inspired the Romantics.

Yet Pugin found such Romantic medievalism shallow, even vacuous. He saw in medieval architecture not so much a style to be imitated as the expression of a way of life that would help reform nineteenth-century English society. "We do not want to revive a facsimile of the works of style of any particular individual or even period," he wrote—*but it is the devotion, majesty, and repose of Christian art, for which we are contending; it is not a style, but a principle.*" For the Catholic Pugin, the advantage of medieval society was that it was guided by Christian principles. These principles had long since been lost to English society. The problems inherent in industrialization, mechanization, and materialism, he believed, were created by society's lack of the ethical foundations provided by the Church. Pugin believed that architecture served not just a functional purpose, but also a moral one. The building itself embodied a spirit of ethical conduct.

Many found Pugin's ideas attractive, but his most celebrated commission came when architect Sir Charles Barry (1795–1860) asked him to design the interiors and ornamentation for London's new Houses of Parliament. (A fire had destroyed the old buildings in 1834.) To be consistent with Westminster Abbey, which it abutted, the new Parliament needed Gothic ornamentation (Fig. **35.5**). Barry's basic plan is classical—a symmetrical layout meant to suggest the balance of powers inherent in the British system of government. Pugin's ornamentation follows from what he called the "two great rules" of architecture: "first that there should be no features about a building which are not necessary for convenience, construction, or propriety; second, that all ornament should consist of enrichment of the essential structure of the building." Nevertheless, Pugin's scheme for decorative ornament was hardly restrained, as he also believed that legislators surrounded by "glorious" and elaborate ornament would deliberate with "the faith, the zeal, and, above all, the unity, of our ancestors."

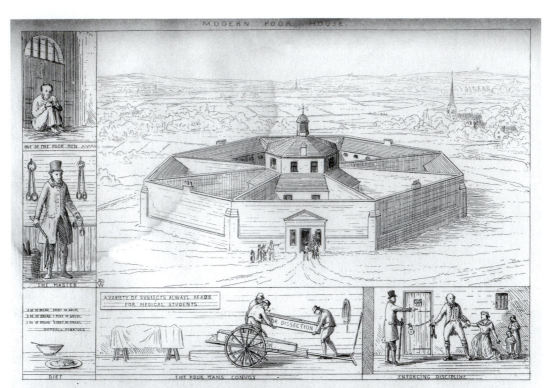

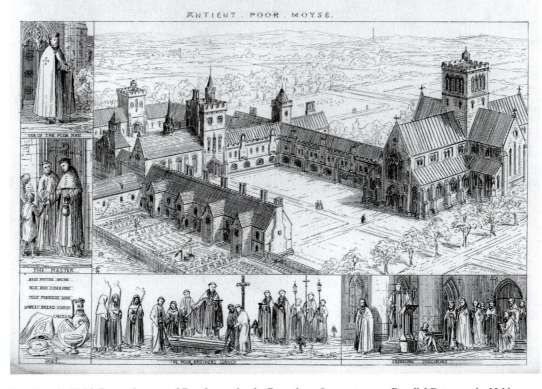

Fig. 35.4 A. W. N. Pugin. *Contrasted Residences for the Poor, from Contrasts: or, a Parallel Between the Noble Edifices of the Fourteenth and Fifteenth Centuries, and similar Buildings of the Present Day; showing the Present Decay of Taste: Accompanied by Appropriate Text.* **1836.** Pugin contrasts the harsh treatment of the Poor Law to the charitable good works of the medieval church.

Fig. 35.5 **Charles Barry and A. W. N. Pugin. Houses of Parliament, London. 1836–1860.** Length 940′. Barry was in charge of the structural floor plan while Pugin took care of the decorative plan. The tower of Westminster Abbey is at the far left.

Literary Realism

Faced with the reality of working-class life, reformist thinkers and writers across Europe reacted by writing polemical works that criticized industrial society. Chief among their targets were the economic engine of the industrial state—its desire to reap a profit at whatever human cost—and the unbridled materialism that seemed to drive industrialism's economic engine. Industrialized society seemed life-consuming and soul-destroying, a society in which the pulse of machinery was supplanting the pulse of the human heart. Even while essayists like Carlyle argued forcefully for social reforms in the new industrialized economic system, most reformists felt some ambivalence toward the Industrial Revolution. It seemed to promise both hope and despair. Probably nothing embodied this uncertainty more than the steam locomotive. London's first railway began operating in December 1836, with the London & Greenwich running 4 miles southeast from London Bridge. A virtual railroad mania followed as company after company vied to build new and competing lines. For Charles Dickens, writing in *Dombey and Son*, which appeared at the height of the mania between 1846 and 1848, the steam engine offered untold potential even as he imaged it as a kind of monster (**Reading 35.3**):

READING 35.3 **from Dickens, *Dombey and Son* (1846–1848)**

The miserable waste ground, where the refuse matter had been heaped of yore, was swallowed up and gone, and in its frowsy [ill-smelling] stead were tiers of warehouses, crammed with rich goods and costly merchandise. . . . The carcasses of houses, and beginnings of new thoroughfares, had started off upon the line at steam's own speed, and shot away into the country in a monster train. To and from the heart of this great change, all day and night, throbbing currents rushed and returned incessantly like its life's blood. Crowds of people and mountains of goods, departing and arriving scores upon scores of times in every four-and-twenty hours, produced a fermentation in the place that was always in action. The very houses seemed disposed to pack up and take trips. Wonderful Members of Parliament, who, little more than twenty years before, had made themselves merry with the wild railroad theories of engineers . . . [now] went . . . north with their watches in their hands, and sent on messages before by the electric telegraph, to say that they were coming. . . .

Night and day the conquering engines rumbled at their distant work, or, advancing smoothly to their journey's end, and gliding like tame dragons into the allotted corners grooved out to the inch for their reception, stood bubbling and trembling there, making the walls quake, as if they were dilating with the secret knowledge of great powers yet unsuspected in them, and strong purposes not yet achieved.

Even as the coming of the railroad transformed the "waste ground" of the inner city into "warehouses crammed with rich goods" and "costly merchandise," clearing out the "carcasses of houses" to make way for new rails, Dickens knew there was a

price to pay. Its "monstrous" effect was to displace thousands, perhaps as many as 100,000, of the poor from their homes.

"The poor are displaced," *The Times* of London warned in 1861, "but they are not removed. They are shovelled out of one side of the parish, only to render more overcrowded the stifling apartments in another part." In fact, construction of the London and Blackwall Railway caused almost 3,000 homes to be destroyed in 1836 alone, and the railway companies had no obligation to provide alternate housing for any of their residents.

The price of progress is the subject of J. M. W. Turner's 1844 painting *Rain, Steam, and Speed—The Great Western Railway* (Fig. **35.6**). We stare over the river Thames across the Maidenhead Bridge, the Great Western Railway barreling toward us. To the left, a boat floats gently on the river before an arched bridge on the far shore. To the right of the boat, strokes of white paint suggest a group of bathers. To the left lies the pre-industrial world, to the right post-industrial modernity. Rain and fog and machine-made vapor combine with a new factor, the blurring effects of speed, to leave the landscape largely undefined and indefinable. The rational architecture of the bridge and the railway—the very images of progress rendered in a strict two-point, linear perspective—are consumed in a Romantic light that renders the world at once beautiful and murky. "What price progress?" the painting ultimately asks.

Dickens's *Hard Times*

This question dominates the work of the writers whose novels probed the realities of life in the new industrial world. Nothing exasperated Dickens more than the promise of the Industrial Revolution to improve life and its ability to do just the opposite—to make life miserable for so many. None of his novels so openly address this issue as *Hard Times*, which appeared during the spring and summer of 1854 in weekly segments in *Household Words*, a periodical edited by Dickens himself.

Fig. 35.6 J. M. W. Turner. *Rain, Steam, and Speed—The Great Western Railway.* **1844.** Oil on canvas, 33³⁄₄″ × 48″. National Gallery, London, Great Britain. Erich Lessing/Art Resource, NY. Although not easily seen in reproduction, a hare races down the tracks in front of the train. A traditional symbol of natural speed, the hare is about to be overcome by the train speeding at 50 miles per hour.

Designed to satirize industrialists known as Utilitarians, who sought to create the greatest good for the greatest number of people, the novel portrayed them as aiming to create wealth for the upper and middle classes at the expense of the majority—the poor working class. Dickens describes Utilitarians as "those who see figures and averages, and nothing else." In *Hard Times*, they are represented by the "eminently practical" Mr. Thomas Gradgrind, who views literature as "destructive nonsense," emotion as "unmanageable thought," and "Fact"—statistics in particular—as the only truth. Dickens resolved to "strike the heaviest blow in my power" for those who worked in the inhuman conditions created by Utilitarian-endorsed industries.

Probably no passage in the novel better summarizes Dickens's beliefs about the social consequences of Utilitarianism than his description of the novel's fictional Coketown, an industrial wasteland that is an amalgam of his observations of all British industrial cities (**Reading 35.4**):

READING 35.4 **from Dickens, *Hard Times* (1854)**

It was a town of red brick, or of brick that would have been red if the smoke and ashes had allowed it; but as matters stood it was a town of unnatural red and black like the painted face of a savage. It was a town of machinery and tall chimneys, out of which interminable serpents of smoke trailed themselves for ever and ever, and never got uncoiled. It had a black canal in it, and a river that ran purple with ill-smelling dye, and vast piles of buildings full of windows where there was a rattling and a trembling all day long, and where the piston of the steam-engine worked monotonously up and down like the head of an elephant in a state of melancholy madness. It contained several large streets all very like one another, and many small streets still more like one another, inhabited by people equally like one another, who all went in and out at the same hours, with the same sound upon the same pavements, to do the same work, and to whom every day was the same as yesterday and tomorrow, and every year the counterpart of the last and the next.

In this setting, Gradgrind, a retired wholesale hardware dealer, runs a Utilitarian school. His closest friend is Josiah Bounderby, manufacturer, banker, and mill owner, "a man perfectly devoid of sentiment." As is often the case in Dickens's fiction, their lack of feeling is contrasted sharply with that of another character, Sissy, partially educated but also the irrepressible product of her life in the circus, a young woman full of imagination and hope.

Their story is told in three parts, "Sowing," "Reaping," and "Garnering," ironic references to agriculture rather than industry as well as to the biblical verse, "Whatever a man

sows, this he will also reap." Given what Gradgrind and Bounderby have sown in creating Coketown, Dickens must have delighted in manufacturing their demise: Gradgrind abandons his Utilitarian philosophy, which draws the wrath of his fellow members of Parliament whom he so admires, while Bounderby dies in a fit in the street one day, having squandered his fortune. Yet in the end, Dickens never really questions the ultimate wisdom of industrialization. Rather, the novel seems to argue that in the hands of more humane industrialists, who cared about the well-being of their workers, the industrialization of England might be good for everyone.

French Literary Realism

Literary realism was not restricted to England, although elsewhere in Europe writers rarely confronted the effects of the Industrial Revolution as forcefully as Dickens had. As in England, the work of French novels often appeared in serial form, designed to appeal to a growing middle-class audience. However, French authors aimed at creating fully rounded characters and were less inclined to caricature than Dickens was. French realists claimed to examine life scientifically, without bias, and to describe what they saw in a straightforward manner. The writings of Honoré de Balzac and Gustave Flaubert [floh-BAIR] are the foremost examples.

Balzac's *Human Comedy* "I am not deep," the novelist Honoré de Balzac (1799–1850) once said, "but very wide." In 1833, he decided to link together his old novels so that they would reflect the whole of French society. He would come to call this series of books *The Human Comedy*. Balzac's plan eventually resulted in 92 novels, which include more than 2,000 characters. Among the masterpieces are *Eugénie Grandet* [er-ZHEN GRAHN-deh] (1833), *Père Goriot* [pair GOH-ree-oh] (1834), *Father Goriot*, the trilogy *Lost Illusions* (1837–1843), and *Cousin Bette* [koo-ZEHN bet] (1846). The primary setting is

Paris, with its old aristocracy, new wealth, and the rising culture of the **bourgeoisie** (middle-class shopkeepers, merchants, and business people, as distinct from laborers and wage-earners). The novel is populated by characters from all levels of society—servants, workers, clerks, criminals, intellectuals, courtesans, and prostitutes. Certain individuals make appearances in novel after novel, for instance Eugène Rastignac [eh-ZHEN RAH-steen-yak], a central figure in *Father Goriot*, who comes from an impoverished provincial family to Paris to seek his fortune, and Henri de Marsay [ahn-REE deh mar-ZAY], a dandy who appears in 25 of the novels.

Balzac drew his characters from direct observation: "In listening to these people," he wrote of those he encountered in the Paris streets, "I could espouse their lives. I felt their rags on my back. I walked with my feet in their tattered shoes; their desires, their wants—everything passed into my soul." The story goes that he once interrupted one of his friends, who was telling about his sister's illness, by saying, "That's all very well, but let's get back to reality: to whom are we going to marry Eugénie Grandet?"

(*La Comédie humaine.* — Le père Goriot.)

Fig. 35.7 Honoré Daumier. *Father Goriot.* **1843.** From *Œuvres illustrées de Balzac. La comédie humaine*, Volume 3. Imp. Schneider/ Imp. Simon Raçon et Cie. Paris : MM. Marescq et Cie. et J. Bry aîné. 1851. Daumier captures Père Goriot's isolation and loneliness.

Father Goriot is an adaptation of Shakespeare's play *King Lear*. Rastignac falls in love with Delphine [DEL-feen], one of two daughters of old Goriot (Fig. **35.7**), a father who has sacrificed everything for his children. Both daughters have married into the French aristocracy, but they rely on their father's excessive paternal love to bail them out of the financial crises that constantly confront them through their husbands' profligacy. The novel contrasts the poverty of the boarding house, where both Goriot and Rastignac live, to their daughters' glittering social world, to which Rastignac aspires. Goriot dies penniless, and Rastignac is forced to pay for his funeral. (See **Reading 35.5**, page 1144, for the final scene.) When the funeral is over, Rastignac contemplates the possibilities that Paris offers:

> He went a few paces further, to the highest point of the cemetery, and looked out over Paris and the windings of the Seine; the lamps were beginning to shine on either side of the river. His eyes turned almost eagerly to the space between the column of the Place Vendome [plahss vahn-DOME] and the cupola of the Invalides [en-vah-LEED]; there lay the shining world that he had wished to reach. He glanced over that humming hive, seeming to draw a foretaste of its honey, and said magniloquently:
> "Henceforth there is war between us."

This comment ends the novel and is the very heart of serialization. It is the bone Balzac throws to his audience to create a sense of anticipation of more to come, another novel, and then another and another, in which Rastignac declares that he will take on French society. He will, as it turns out, have many lovers and a gambling problem of his own, before becoming a successful politician.

Flaubert's *Madame Bovary* The novel *Madame Bovary*, written by Gustave Flaubert [floh-BAIR] (1821–1880) at mid-century, is at its core a realist attack on Romantic sensibility. But Flaubert had a strong Romantic streak as well, for which his Parisian friends strongly condemned him. They suggested that he should write a "down-to-earth" novel of ordinary life, and further, that he base it on the true story of Delphine Delamare [del-MAR], the adulterous wife of a country doctor who had died of grief after deceiving and ruining him. Flaubert agreed, and *Madame Bovary*, first published in magazine installments in 1856, is the result.

The realism of the novel is born of Flaubert's struggle not to be Romantic. He would later say, "Madame Bovary—c'est moi!" [say- mwah] ("Madame Bovary—that's me!) in testament to his deep understanding of the bourgeois, Romantic sensibility that his novel condemns. Toward the middle of the novel, Emma imagines she is dying. She has been ill for two months, since her lover Rodolphe ended their affair. Now, she romanticizes what she thinks are her last moments, experiencing a rapturous ecstasy of the kind portrayed by Bernini in *The Ecstasy of St. Teresa* (**Reading 35.6**; also see Fig. 25.6):

READING 35.6 **from Flaubert, *Madame Bovary* (1856)**

One day, when at the height of her illness, she had thought herself dying, and had asked for the communion; and, while they were making the preparations in her room for the sacrament, while they were turning the night table covered with syrups into an altar, and while Felicite was strewing dahlia flowers on the floor, Emma felt some power passing over her that freed her from her pains, from all perception, from all feeling. Her body, relieved, no longer thought; another life was beginning; it seemed to her that her being, mounting toward God, would be annihilated in that love like a burning incense that melts into vapour. The bed-clothes were sprinkled with holy water, the priest drew from the holy pyx [small box containing the sacrament] the white wafer . . . The curtains of the alcove floated gently round her like clouds, and the rays of the two tapers burning on the night-table seemed to shine like dazzling halos. Then she let her head fall back, fancying she heard in space the music of seraphic harps, and perceived in an azure sky, on a golden throne in the midst of saints holding green palms, God the Father, resplendent with majesty.

In an 1852 letter describing a dinner conversation between Leon and Emma earlier in the book, Flaubert wrote: "I'm working on a conversation between a young man and a young lady on literature, the sea, the mountains, music—in short, every poetic subject there is. It could be taken seriously and I intend it to be totally absurd." The

same could be said of Emma's faint in which her paroxysm of religious experience is as staged as her illness itself. Words and phrases such as "an azure sky, on a golden throne" are examples of what Flaubert called *le mot juste* [leh moh joost], "the right word," exactly the precise usage to capture the essence of each situation, in this case a level of cliché that underscores the dramatic absurdity of Emma's experience. Flaubert felt he was proceeding like the modern scientist, investigating the lives of his characters through careful and systematic observation.

The Russian Realists under Nicholas I

In Russia, realism developed from a different social reality than it had in England and France. The serf system, with its entrenched rural poverty, had not changed since medieval times. After the death of Catherine the Great (1729–1796), Russia was ruled by first her son, Paul, and then by two of her grandsons, Alexander I (r. 1801–1825) and Nicholas I (r. 1825–1855). Alexander suppressed any vestiges of liberalism and reform remaining from the reign of his grandmother, when French *philosophes* were highly influential. Nicholas understood the need for reform, but was afraid of losing the support of the aristocracy. "There is no doubt," he told his State Council in 1842, "that serfdom, in its present form, is a flagrant evil which everyone realizes, yet to attempt to remedy it now would be, of course, an evil more disastrous."

Neoclassical Saint Petersburg By the time Nicholas came to the throne, the nation's capital, Saint Petersburg, was as grand as any city in Europe. Tsar Peter the Great, who ruled Russia from 1682 to 1725, literally pointed Russia toward the West by creating a new capital city at the mouth of the River Neva. The area was a swamp, frozen from November to March, but even a partially open harbor would support Russia's economic development and gave Russia permanent access to the Baltic Sea. Emulating the three-pronged design of the approaches to Versailles (see Fig. 27.4), its three broad avenues crossed a network of canals to meet at a giant parade-ground square in front of the Admiralty (Map **35.3**). Half Venice and half Classical Baroque, the city had grown to a population of 192,000 under the rule of Catherine the Great. Catherine, a German princess, had married the nephew of Tsar Peter the Great's daughter Elizabeth, murdered him when he became tsar, and then proclaimed herself empress. Dedicated to creating a city to rival both Rome and Paris, she declared Neoclassicism the official court style, sensing that it symbolized her own power. "Decency requires that affluence and magnificence should surround the throne," she said in 1769. She sought the advice of both Diderot and Voltaire to expand her art collection to some 3,000 works—installed in the Neoclassical Hermitage Palace in 1796—and was so influenced by the *philosophes* that she made French the official language of her court.

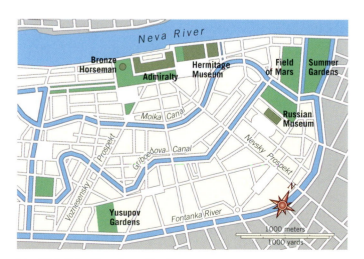

Map 35.3 Saint Petersburg, Russia.

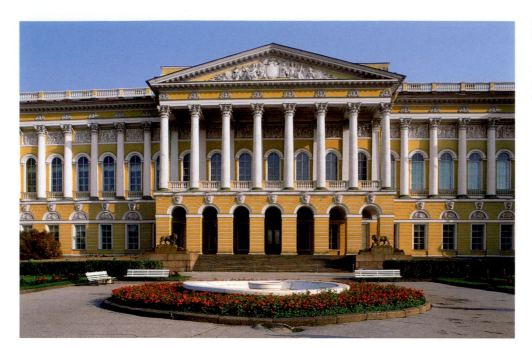

Fig. 35.8 Carlo Rossi. Mikhailovsky Palace, Saint Petersburg, Russia. 1819–1825. The yellow facade punctuated by white columns was designed to impart a sense of classical calmness to the whole.

Saint Petersburg's citizens seemed always to feel that it was an unnatural place. Darkness filled its winter months, but in the summer, for nearly three weeks in June, during the so-called White Nights, the city was bathed in round-the-clock daylight. The regularity, balance, and proportion of its Neoclassical architecture was consciously designed to counter the irregularity of its seasons and light. One of the great examples is the Mikhailovsky

Continuity & Change
p. 1042

La Madeleine

[mi-KILE-uv-skee] Palace (today the Russian Museum), designed by Carlo Rossi, an Italian-born architect who was brought to Russia by his ballerina mother as a young man (Fig. 35.8). The palace is perfectly symmetrical, its central facade of eight free-standing Corinthian columns bracketed on each side by eight engaged columns. Completed just as Nicholas I assumed the throne, it represents the culmination of the Neoclassical design in Saint Petersburg.

Aleksandr Pushkin Nicholas was particularly frightened of the intellectuals and writers living in his capital, the *intelligentsia*, as they were called. Chief among these was the poet Aleksandr Pushkin (1799–1837). Great-grandson of a black Ethiopian slave, whom Peter the Great had purchased in Constantinople and who rose to prominence in the tsar's court, Pushkin was a great champion of liberal causes. Among his most admired works is *The Bronze Horseman*, a poem written in 1833 commemorating both Peter the Great, whose bronze equestrian statue still stands in Saint Petersburg, and the devastating flood of the Neva that hit the city in November 1824. Pushkin opens the poem rhapsodizing on the beauty of the city (**Reading 35.7**):

READING 35.7 **from Pushkin, *The Bronze Horseman* (1833)**

I love you, Peter's creation, I love your stern
Harmonious look, the Neva's majestic flow,
Her granite banks, the iron tracery
Of your railings, the transparent twilight and
The moonless glitter of your pensive nights . . .
I love the motionless air and frost of your harsh winter,
The sledges coursing along the solid Neva,
Girls' faces brighter than roses, and the sparkle
And noise and sound of voices at the balls,
And, at the hour of the bachelor's feast, the hiss
Of foaming goblets. . . .

The poem goes on to describe the tragic fate of Yevgeni [yiv-GAYN-yee], a young man who goes insane imagining that the bronze horseman is chasing him through the streets of the city after his fiancée dies in the flood. He is the victim of both the great tsar's socially irresponsible and arrogant construction of the city on a floodplain, and the indifference of its nameless inhabitants to his plight. Because of its ambiguous attitude toward the tsar, the poem was banned from publication in Pushkin's lifetime. In its attention to the beauty of the city and its light, the poem is Romantic in tone, but its sense of social responsibility anticipates the new realism that will soon dominate Russian literature. The primary force for realism was Nikolai Gogol (1809–1852).

Nikolai Gogol In 1831, Nikolai Gogol, a young writer from the Ukraine, had the good fortune to meet Aleksandr Pushkin.

They became good friends, and Pushkin suggested ideas that would lead to Gogol's comic masterpiece of 1836, the play *The Inspector General*, and the novel *Dead Souls*, which inaugurated Russian realist fiction in 1842. In the former a young civil servant, Khlestakov, finds himself stranded in a small provincial town where the local officials assume he is a government inspector, visiting incognito. Khlestakov happily adapts to his new role and exploits the situation. The play is a not-so-subtle attack on the graft and corruption of the Russian bureaucracy, but its humor saved it. Even the tsar was said to have laughed at it. Gogol's novel *Dead Souls* is based on the fact that owners of serfs paid a tax on every "soul" registered to them. Chichikov, Gogol's hero-villain, travels through Russia to buy the "souls" of dead serfs, for whom their owners were required to pay taxes until a new census could eliminate them from the tax rolls. Chichikov thus acquires, very cheaply, a list of serfs that he, in turn, mortgages to a bank for a handsome profit. His plan is to buy an estate with his profits and populate it with real serfs. The novel was meant to be comic, but Pushkin found it all too real. On hearing it read aloud, he is said to have cried out at Gogol, "God! What a sad country Russia is!" He said later, "Gogol invents nothing; it is the simple truth, the terrible truth."

Literary Realism in the United States: The Issue of Slavery

It was, in fact, the "terrible truth" of slavery that most haunted American realist writers. They were inspired largely by the abolitionist movement. While the movement had been active in both Europe and America ever since the 1770s (see chapter 30), it didn't gain real momentum in the United States until the establishment of the American Anti-Slavery Society in 1833. The Society organized lecture tours by abolitionists, gathered petitions, and printed and distributed anti-slavery propaganda. By 1840, it had 250,000 members in 2,000 local chapters and was publishing more than 20 journals.

Frederick Douglass When William Lloyd Garrison (1805–1879), head of the Anti-Slavery Society, heard a speech delivered by a 24-year-old former slave in Nantucket in 1841, he was so impressed that he immediately enlisted him as a lecturer. The young man's name was Frederick Douglass (1817–1895) (Fig. **35.9**). He never knew his father, a white man, and was separated from his mother, a slave, while still very young. His account of life under slavery was so compelling that the society helped him publish his autobiography, *Narrative of the Life of Frederick Douglass: An American Slave*, in 1845.

The book moves from Douglass's first clear memory, the whipping of his Aunt Hester, which he describes as his "entrance into the hell of slavery" (see **Reading 35.8**, page 1146), to the book's turning point, when he resolves to stand up and fight his master. "From whence came the spirit I don't know," Douglass writes. "You have seen how a man was made a slave; you shall see how a slave was made a man, he says before summing up the fight's outcome (**Reading 35.8a**):

READING 35.8a **from *Narrative of the Life of Frederick Douglass* (1845)**

This battle with Mr. Covey was the turning point in my career as a slave. It rekindled the few expiring embers of freedom, and revived within me a sense of my own manhood. It . . . inspired me again with a determination to be free. The gratification afforded by the triumph was a full compensation for whatever else might follow, even death itself. . . . I felt as I never felt before. It was a glorious resurrection, from the tomb of slavery, to the heaven of freedom. My long-crushed spirit rose, cowardice departed, bold defiance took its place; and I now resolved that, however long I might remain a slave in form, the day had passed forever when I could be a slave in fact. I did not hesitate to let it be known of me, that the white man who expected to succeed in whipping, must also succeed in killing me.

Douglass guesses at the reason Covey spares him being beaten at the whipping post for raising his hand against a white man: "Mr. Covey enjoyed the most unbounded reputation for being a first-rate overseer and negro-breaker," he

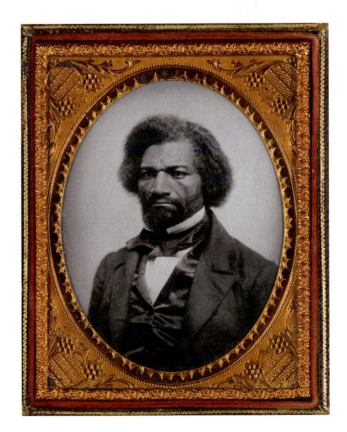

Fig. 35.9 Portrait of Frederick Douglass. 1847. Daguerreotype. National Portrait Gallery, Smithsonian Institution, Washington, D.C. Collection William Rubel. After publishing his *Narrative*, Douglass lectured in England and Ireland for 2 years, fearing recapture under the Fugitive Slave Act.

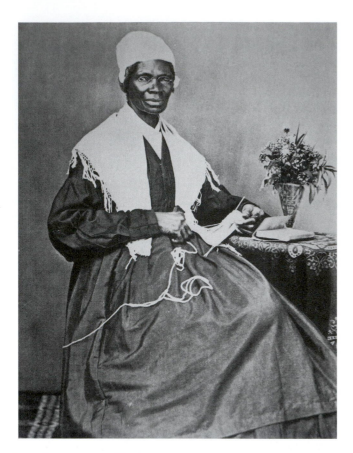

Fig. 35.10 Sojourner Truth Seated with Knitting. 1864. Sophia Smith Collection, Smith College Archives, Northampton, Massachusetts. In 1863, it occurred to Truth to earn money by selling photographs of herself. As she explained, "I'll sell the Shadow to support the Substance."

says, ". . . so, to save his reputation, he suffered me to go unpunished." The rest of the book recounts Douglass's escape to New York, and then to New Bedford, Massachusetts, up to the moment that he meets Garrison in Nantucket.

Douglass eventually broke with the Anti-Slavery Society because "its doctrine of 'no union with slaveholders,' carried out, dissolves the Union, and leaves the slaves and their masters to fight their own battles, in their own way. This I hold to be an abandonment of the great idea . . . to free the slave. It ends by leaving the slave to free himself." Douglass argued the issue with Abraham Lincoln in print during the early phases of the Civil War. Initially Lincoln was reluctant to emancipate the slaves, because he feared that emancipation would divide the Union. Lincoln finally agreed with Douglass, whom he welcomed to the White House several times, and issued the Emancipation Proclamation at the end of 1862.

Slave Narratives More than 100 book-length slave narratives were published in the 1850s and 1860s. Besides Douglass's, one of the other most important of these was the *Narrative of Sojourner Truth*, dictated by an illiterate former slave to her friend Olive Gilbert. Sojourner Truth (ca. 1797–1883) (Fig. 35.10) was born Isabella Baumfree to slave parents in Ulster County, New York, and was sold four times before she was 30 years old. In 1843, inspired by a spiritual revelation, she changed her name to Sojourner Truth and became a preacher advocating "God's truth and plan for salvation." She often tied her lessons to her own experiences as a slave, and she championed both abolition and the woman's suffrage movement.

Because Olive Gilbert tells Truth's story in the third person, occasionally quoting her subject's much more colloquial speech, it is hard to say just how much of the work is Gilbert's and how much Truth's. This question also surrounds Truth's most famous speech, "Ain't I a Woman?" delivered to a Women's Convention in Akron, Ohio in 1851. Unpublished until 1863, it still offers evidence of the rhetorical persuasiveness of Truth—and her undeniable wit (**Reading 35.9**):

READING 35.9 from Sojourner Truth, "Ain't I a Woman?" (1851)

Well, children, where there is so much racket there must be something out of kilter. I think that 'twixt the negroes of the South and the women at the North, all talking about rights, the white men will be in a fix pretty soon. But what's all this here talking about?

That man over there says that women need to be helped into carriages, and lifted over ditches, and to have the best place everywhere. Nobody ever helps me into carriages, or over mud-puddles, or gives me any best place! And ain't I a woman? Look at me! Look at my arm! I have ploughed and planted, and gathered into barns, and no man could head me! And ain't I a woman? I could work as much and eat as much as a man—when I could get it—and bear the lash as well! And ain't I a woman? I have borne thirteen children, and seen most all sold off to slavery, and when I cried out with my mother's grief, none but Jesus heard me! And ain't I a woman? . . .

Obliged to you for hearing me, and now old Sojourner ain't got nothing more to say.

Like so many others in the abolitionist movement, Truth saw the cause of women's rights as part of the effort to end slavery. The growing conviction that women—white and black—endured a brand of slavery of their own is one of the most important subtexts of the Civil War.

In fact, the Anti-Slavery Society was a leader in this effort. Sarah Grimke (1792–1873), daughter of a slaveholding judge from Charleston, South Carolina, publicly called for women "to rise from that degradation and bondage to which the faculties of our minds have been prevented from expanding." With help from some in the Society, she published the ground-breaking *Letters on the Equality of the Sexes* in 1838. Other members were not at all pleased by the society's advocacy of women's rights, and when three women

were elected to the executive committee, many withdrew, contending that "To put a woman on the committee with men is contrary to the usages of civilized society."

Harriet Beecher Stowe's *Uncle Tom's Cabin* The daughter of a minister and reformer who spoke out against slavery, Harriet Beecher Stowe (1811–1896) was raised with strong abolitionist convictions. She would write the best-selling anti-slavery novel of the day, *Uncle Tom's Cabin*, becoming the symbol of the abolitionist movement in America. Writing to a woman who admired the book, she connects its themes to the grief she endured after her young son died of cholera in 1849 (**Reading 35.10**):

READING 35.10 **letter from Harriet Beecher Stowe to Eliza Cabot Follen, December 16, 1852**

My Dear Madam,

So you want to know what sort of woman I am! . . . To begin, then, I am a little bit of a woman,—somewhat more than forty, about as thin and dry as a pinch of snuff—never very much to look at in my best days and looking like a used up article now.

I was married when I was twenty-five years old to a man rich in Greek and Hebrew and Latin and Arabic, and alas, rich in nothing else. . . . But then I was abundantly furnished with wealth of another sort. I had two little curly headed twin daughters to begin with and my stock in this line has gradually increased, till I have been the mother of seven children, the most beautiful and the most loved of whom lies buried near by our Cincinnati residence. It was at his dying bed and at his grave that I learned what a poor slave mother may feel when her child is torn away from her. In those depths of sorrow which seemed to me immeasurable, it was my only prayer to God that such anguish might not be suffered in vain. There were circumstances about his death of such peculiar bitterness, of what seemed almost cruel suffering that I felt that I could never be consoled for it unless this crushing of my own heart might enable me to work out some great good to others.

I allude to this here because I have often felt that much that is in that book had its root in the awful scenes and bitter sorrow of that summer. It has left now, I trust, no trace on my mind except a deep compassion for the sorrowful, especially for mothers who are separated from their children. . . .

I suffer exquisitely in writing these things. It may truly be said that I write with my heart's blood. Many times in writing "Uncle Tom's Cabin" I thought my health would fail utterly; but I prayed earnestly that God would help me till I got through, and still I am pressed beyond measure and above strength.

This horror, this nightmare abomination! Can it be in my country! It lies like lead on my heart, it shadows my life with sorrow; the more so that I feel, as for my own brothers, for the South, and am pained by every horror I am obliged to write, as one who is forced by some awful oath to disclose in court some family disgrace. Many times I have thought that I must die, and yet pray God that I may live to see something. . . .
Yours affectionately,
H. B. Stowe

Uncle Tom's Cabin is a narrative concerning the differing fates of three slaves—Tom, Eliza, and George—whose life in slavery begins together in Kentucky. Although Eliza and George are married, they are owned by different masters. In order to live together they escape to free territory with their little boy. Tom meets a different fate. Separated from his wife and children, he is sold by his first owner to a kind master, Augustine St. Clare, and then to the evil Simon Legree, who eventually kills him. Serialized in 1851 in the abolitionist newspaper *The National Era*, and published the year after, the book sold 300,000 copies in the first year after its publication. Stowe's depiction of the plight of slaves like Tom roused anti-slavery sentiment worldwide and it eventually became the best-selling novel of the nineteenth century. Only the Bible could compete, although it could be argued that Stowe's book was equally pious. The scene of Little Eva reading from the Bible to Tom (Fig. **35.11**) as Stowe sets it up in chapter 22 of the novel is deeply romanticized (**Reading 35.11**):

READING 35.11 **from Harriet Beecher Stowe, *Uncle Tom's Cabin* (1852)**

It is now one of those intensely golden sunsets which kindles the whole horizon into one blaze of glory, and makes the water another sky. The lake lay in rosy or golden streaks, save where white-winged vessels glided hither and thither, like so many spirits, and little golden stars twinkled through the glow, and looked down at themselves as they trembled in the water. . . .

At first, she read to please her humble friend; but soon her own earnest nature threw out its tendrils, and wound itself around the majestic book; and Eva loved it, because it woke in her strange yearnings, and strong, dim emotions, such as impassioned, imaginative children love to feel.

This passage points to a central mission of the abolitionist movement. Abolitionists felt the duty to enlighten the darkened souls of slaves by asserting Christian beliefs. Notice how light is used as a metaphor in the passage. But the condescension apparent to the modern reader—both Tom and Eva are

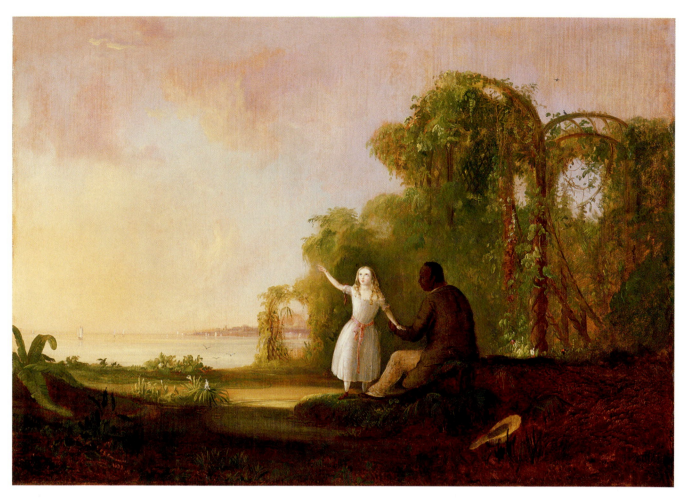

Fig. 35.11 Robert S. Duncanson. *Uncle Tom and Little Eva.* **1853.** Oil on canvas, $27\frac{1}{4}'' \times 38\frac{1}{4}''$. The Detroit Institute of Arts, USA. The Bridgeman Art Library. MI. Duncanson was the first African American artist to receive international fame.

depicted as children—together with Tom's sentimental attachment to both Eva and her pious Christianity—would eventually make the term "Uncle Tom" a derogatory label referring to anyone who is servile or deferential to white people.

Mark Twain's *Adventures of Huckleberry Finn* A patronizing tone dominates representations of African Americans by whites in the nineteenth and twentieth centuries, and it informs *Adventures of Huckleberry Finn*, arguably one of the greatest American novels. Published in 1885 by Samuel L. Clemens (1835–1910), whose pen name was Mark Twain, the novel tells the story of a young boy, Huck Finn, and Jim, an escaped slave, as they make their way by raft down the Mississippi River from Hannibal, Missouri. They intend to turn north at the juncture of the Ohio River so that Jim might reach freedom in Cincinnati. (Ohio was a slave-free state.) Set in the years just before the Civil War, the book is vigorously opposed to slavery, and portrays those who supported it in a uniformly unflattering light, designed precisely to expose them. When, for instance,

Huck and Jim are anticipating arriving at Cairo, where the Ohio meets the Mississippi, Huck is anguished by his role in helping Jim escape (**Reading 35.12**):

READING 35.12 from Mark Twain, *Huckleberry Finn* **(1885)**

Jim said it made him all over trembly and feverish to be so close to freedom. Well, I can tell you it made me all over trembly and feverish, too, to hear him, because I begun to get it through my head that he was most free—and who was to blame for it? Why, me. I couldn't get that out of my conscience, no how nor no way. It got to troubling me so I couldn't rest; I couldn't stay still in one place. It hadn't ever come home to me before, what this thing was that I was doing. But now it did; and it stayed with me, and

scorched me more and more. I tried to make out to myself that I warn't to blame, because I didn't run Jim off from his rightful owner; but it warn't no use, conscience up and says, every time, "But you knowed he was running for his freedom, and you could a paddled ashore and told somebody." That was so—I couldn't get around that noway. That was where it pinched. Conscience says to me, "What had poor Miss Watson done to you that you could see her nigger go off right under your eyes and never say one single word? What did that poor old woman do to you that you could treat her so mean? Why, she tried to learn you your book, she tried to learn you your manners, she tried to be good to you every way she knowed how. That's what she done." I got to feeling so mean and so miserable I most wished I was dead. I fidgeted up and down the raft, abusing myself to myself, and Jim was fidgeting up and down past me. We neither of us could keep still. Every time he danced around and says, "Dah's Cairo!" it went through me like a shot, and I thought if it was Cairo I reckoned I would die of miserableness.

storms, and we a-floating along, talking and singing and laughing. But somehow I couldn't seem to strike no places to harden me against him, but only the other kind. I'd see him standing my watch on top of his'n, 'stead of calling me, so I could go on sleeping; and see him how glad he was when I come back out of the fog. . . . and how good he always was; and at last I [remember] I saved him by telling the men we had small-pox aboard, and he was so grateful, and said I was the best friend old Jim ever had in the world, and the *only* one he's got now; and then I happened to look around and see that paper [the note informing his owner of his whereabouts].

It was a close place. I took it up, and held it in my hand. I was a-trembling, because I'd got to decide, forever, betwixt two things, and I knowed it. I studied a minute, sort of holding my breath, and then says to myself:

"All right, then, I'll *go* to hell"—and tore it up.

It was awful thoughts and awful words, but they was said. And I let them stay said; and never thought no more about reforming.

Huck is torn between the tenets of his upbringing, in which, of course, slaves were the legal property of their owner, and his affection for Jim as a human being. In helping Jim, he believes he is stealing from Miss Watson, one of the two sisters who have adopted him.

Twain put words into the mouths of his characters that are realistic for the time but offensive today. Thus, when Aunt Sally asks if anyone was hurt in a steamboat accident, Huck replies, "No'm. Killed a nigger." Twain fully intends the word to signify racist dehumanization of African Americans by whites, but Huck is speaking exactly as a young boy raised in the slaveholding South would. Part of Twain's great achievement is to allow his readers the chance to see the specter of racism rise up in otherwise basically good people, and along with Huck discover that presence in themselves. The triumph of *Huckleberry Finn*, then, lies in the fact that the reader joins Huck in coming to understand and appreciate Jim's humanity. Huck's realization occurs as he contemplates redeeming himself, becoming "washed clean of sin" by informing Miss Watson of his whereabouts, seeking the posted reward, and therefore returning "property" to its rightful owner (**Reading 35.13**):

READING 35.13 **from Mark Twain, *Huckleberry Finn* (1885)**

. . . And Got to thinking over our trip down the river; and I see Jim before me all the time: in the day and in the night-time, sometimes moonlight, sometimes

Thus Mark Twain, in a fictional setting, follows the path set by Thoreau in *Civil Disobedience* a quarter century earlier, forcefully rejecting the conventional morality of society that saw slaves as legal property. Rather than conforming to the law, Huck followed the dictates of his conscience, thinking "no more about reforming" and vowing to steal Jim out of slavery again if necessary because "as long as I was in, and in for good, I might as well go the whole hog."

The New French Realism in Painting

Perhaps the most down-to-earth, if not exactly realistic, description of nineteenth-century Paris came from Mark Twain, who was also America's master humorist. Ever the contrarian, Twain's satirical broadside in 1880 offers an unaffectionate remembrance of the "City of Light": ". . . anywhere is better than Paris. Paris the cold, Paris the drizzly, Paris the rainy, Paris the damnable. More than a hundred years ago somebody asked Quin, 'Did you ever see such a winter in all your life before?' 'Yes,' said he, 'Last summer.' I judge he spent his summer in Paris. Let us change the proverb; Let us say all bad Americans go to Paris when they die. No, let us not say it for this adds a new horror to Immortality" (from Clemens's letter to Lucius Fairchild, April 28, 1880, reprinted in *Mark Twain, The Letter Writer*).

However, events more dramatic than Paris's miserable weather inspired French Realist painting. We've seen such realist works as Géricault's *Raft of the "Medusa"* (see Fig. 34.15) and Delacroix's *Massacres at Chios* (see Fig. 34.16), but

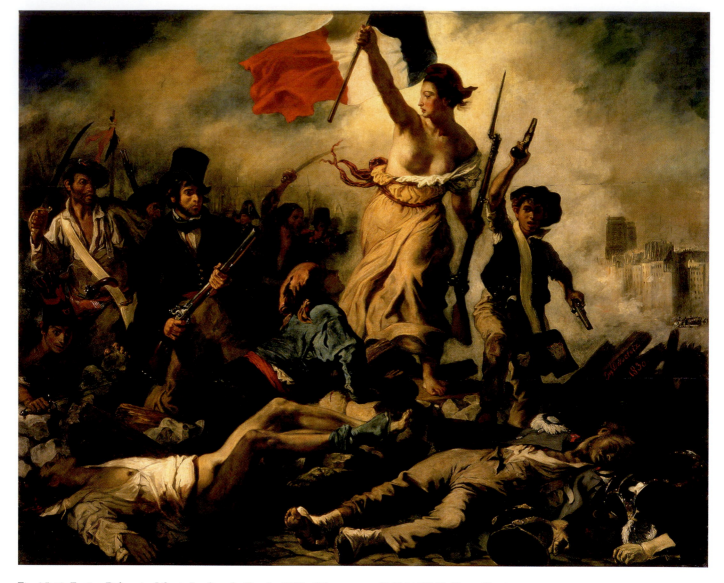

Fig. 35.12 Eugène Delacroix. *Liberty Leading the People.* **1830.** Oil on canvas, 8′ 6″ × 10′ 7″. Photo: Hervè Lewandowski. Musée du Louvre/RMN Réunion des Musées Nationaux, France. SCALA/Art Resource, NY. Note one of the towers of Notre Dame Cathedral in the right background of the painting, which contributes to the realism of the image.

realism in art gained new prominence after the summer of 1830. Three years earlier, after liberals won a majority in the Chamber of Deputies, King Charles X responded by relaxing censorship of the press and government control of education. But these concessions irked him, and in the spring of 1830 he called for new elections. The liberals won a large majority, but Charles was not to be thwarted. On July 25, he dissolved the new Chamber, reinstituted censorship of the press, and restricted the right to vote to the wealthiest French men. The next day, rioting erupted as workers took to the streets, erected barricades, and confronted royalist troops. In the following days, 1,800 people died. Soon after, Charles abdicated the throne and left France for England. In his place, the Chamber of Deputies named the duke of Orléans, Louis-Philippe [loo-

EE-fee-LEEP], king of their new constitutional monarchy. The two-century-old Bourbon dynasty had fallen.

In the end, the French workers may have overthrown the Bourbon dynasty, but their new king, Louis-Philippe, was hardly an improvement. He instructed the workers that if they displayed sufficient energy, they need not fear being poor, but he did nothing concrete to help them. As early as 1831, he ordered troops to suppress a worker's revolt in Lyons, and a year later he ordered the army to do the same in Paris, where they killed or wounded more than 800 workers. And in 1834, he crushed a silkworkers' strike, again in Lyons.

Eugène Delacroix's version of the events of July 1830, *Liberty Leading the People* (Fig. **35.12**) is an allegorical repre-

sentation with realistic details, an emotional call to political action. A bare-breasted Lady Liberty, symbolic of freedom's nurturing power, strides over a barricade, the tricolor flag of the revolution in hand, accompanied by a young street ruffian waving a pair of pistols. On the other side is a middle-class gentleman in his top hat and frock coat, a self-portrait of Delacroix, and beside him a man wielding a sabre. A worker, dressed in the colors of the revolution, rises from below the barricade. The whole triangular structure of the composition rises from the bodies of two French royalist guards, both stripped of their shoes and one of his clothing by the rioting workers. These figures purposefully recall the dead at the base of both Gros's *Napoleon at Eylau* (see Fig. 33.16) and Géricault's *Raft of the "Medusa"* (see Fig. 34.15).

To the middle-class liberals who had fomented the 1830 revolution, the painting was frighteningly realistic. The new king, Louis-Philippe, ordered that it be purchased by the state, and then promptly put it away so that its celebration of the commoners would not prove too inspiring. In fact, the painting was not seen in public again until 1848, when Louis-Philippe was himself deposed by yet another revolution, this one ending the monarchy in France forever.

Caricature and Illustration: Honoré Daumier

Despite strict censorship, the press quickly made king Louis-Philippe an object of ridicule. Honoré Daumier [DOH-mee-ay] (1808–1879), an artist known for his political satire, regularly submitted cartoon drawings to daily and weekly newspapers. The development of the new medium of **lithography** (see *Materials and Techniques*, page 1135), made Daumier's regular appearance in newspapers possible. He could literally create a drawing and publish it the same day. In a cartoon that appeared in the weekly paper, *La Caricature*, Daumier depicted the king—recognizable due to his pear-shaped head—as Gargantua (Fig. **35.13**), the sixteenth-century character created by the French writer Rabelais, who had a giant body and an equally gigantic appetite (see chapter 21). The drawing shows the king gorging himself with taxes that are carried up a ramp to his waiting mouth. The poor offer up their last coins to the corrupt king while an impoverished woman at the far right tries to breast-feed her baby. As the king digests the taxes, he evacuates a series of laws and regulations.

Louis-Philippe was not amused. Daumier, his publisher, and their printer were charged with inciting contempt and hatred of the French government and with insulting the king. Daumier was sentenced to six months in jail and fined 100 francs, but he continued to publish political cartoons. His *Rue Transnonain* [roo trahns-noh-NAN] is not a caricature but direct reportage of the killings committed by government troops during an insurrection by Parisian workers in April 1834 (Fig. **35.14**). After a sniper's bullet killed one of their officers, the police claimed it had come from 12 rue

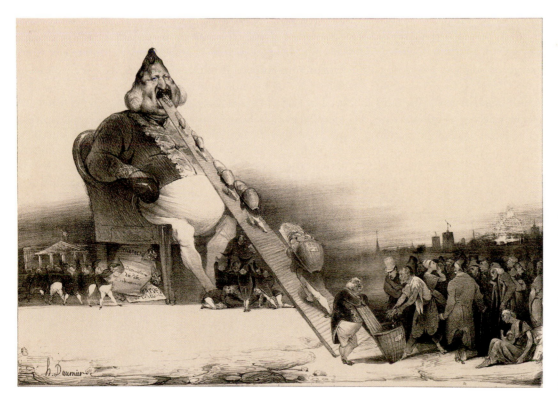

Fig. 35.13 Honoré Daumier. *Gargantua.* **1831.** Lithograph, 10⅜″ × 12″. Fine Arts Museums of San Francisco, Museum purchase, Herman Michels Collection, Vera Michels Bequest Fund, 1993.48.1. Daumier produced over 4,000 lithographs for Paris newspapers and journals over the course of his career, often publishing as many as three images a week.

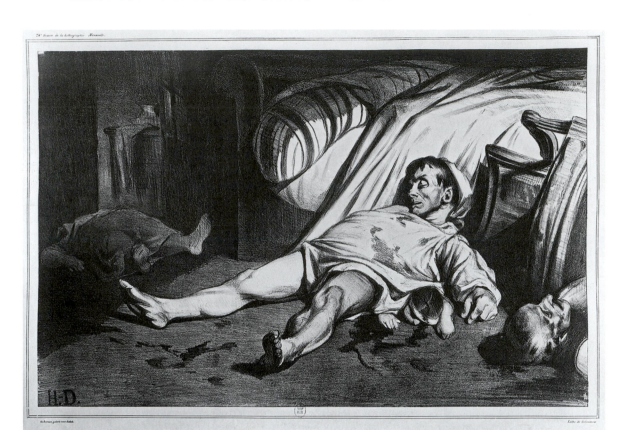

Fig. 35.14 Honoré Daumier. *Rue Transnonain, April 15, 1834.* **1834.** Lithograph, 11 1/2″ × 17 5/8″. Inv. A 1970-67. Kupferstichkabinett, Staatliche Kunstsammlungen, Dresden, Germany Erich Lessing / Art Resource, NY. A few days after the police killed the residents of 12 Rue Transnonain, Daumier exhibited this image in the window of a Paris store, drawing huge crowds.

Continuity & Change
p. 1104

The Raft of The "Medusa"

Transnonain and they killed everyone inside. Daumier's illustration shows the father of the family, who had been sleeping, lying dead by his bed, his child crushed beneath him, his dead wife to his right and an elder parent to his left. The strong diagonal of the scene draws us into its space, a working-class recasting of Géricault's *Raft of the "Medusa"* (see Fig. 34.15). The impact of such images on the French public was substantial, as the king clearly understood. Louis-Philippe eventually declared that freedom of the press extended to verbal but not pictorial representation.

Realist Painting: The Worker as Subject

In his focus on ordinary life, Daumier openly lampooned the idealism of both Neoclassical and Romantic art. No longer was the object of art to reveal some "higher" truth. What mattered instead was the truth of everyday experience. In his paintings, such as *The Third-Class Carriage* (Fig. **35.15**), Daumier clearly demonstrates his interest in the daily lives of working people. The painting conveys a sense of unity and continuity with the men gathered in the back-

ground apparently engaged in conversation, while a young mother breast-feeds her child, her own mother beside her, a basket (presumably of food) on her lap, and her young son asleep beside his grandmother.

The subject of Daumier's painting is typical of French realist painting as a whole. By focusing on laborers and common country folk rather than on the Parisian aristocracy and bourgeoisie, the painting is implicitly political. It reflects the social upheaval that in 1848 rocked almost all of Europe (see chapter 36).

One of the most successful painters of the working class was Rosa Bonheur [BUN-ur] (1822–1899). A student of zoology, she made detailed studies of animals in the Paris slaughterhouses and dressed in men's suits because women's clothing interfered with her work. After she won a medal at the 1848 Salon, the French government commissioned Bonheur to paint *Plowing in the Nivernais: The Dressing of the Vines* (Fig. **35.16**).

It was not only this new subject matter that was transforming the idea of what was beautiful in art. It was the new and rapid methods artists used as well—Daumier with his crayon in lithography, for instance, and Jean-François Millet [mee-YAY] (1814–1875) with his brush. In *The Sower*, Millet's broad brushstrokes of dark paint mirror the physical exhaustion of the peasant in the fields, working until

Materials & Techniques Lithography

Lithography, which literally means "stone writing," is a printing process that depends on the fact that oil and water do not mix. The process was discovered accidentally by a young German playwright named Alois Senefelder [AH-lo-us zay-nuh-FEL-dur]. Senefelder published his plays by writing them backward on a copper plate and then etching the text. But seeking a less expensive material, he chose a piece of Kelheim [KEL-hime] limestone, the material used to line the Munich streets and abundantly available. One day his laundry woman arrived to pick up his clothes and, with no paper or ink on the premises, he jotted down what she had taken in wax on the prepared limestone. It dawned on him to bathe the stone with nitric acid and water, and when he did so, he found that the acid had etched the stone and left his writing raised in relief above its surface. Here, at last, was an extraordinarily cheap—and quick—reproductive process.

Recognizing the commercial potential of his invention, by 1798 he had discovered that if he drew directly on the stone with a greasy crayon and then treated the entire stone with nitric acid, water, and gum arabic (a very tough substance obtained from the acacia tree that attracts and holds water), then ink, applied with a roller, would stick only to the greasy drawing. He also discovered that the acid and gum arabic solution did not actually *etch* the limestone. As a result, the same stone could be used again and again. So it would be possible to pull multiple prints from one stone.

In the lithographic process, the prepared stone is rolled with ink that sticks only to the crayon image. Then a layer of damp paper is placed over the stone and both are pressed together with a scraper, later replaced by a press. This transfers the image from the stone to the paper, thereby creating the lithograph. Lithography became an important commercial reproduction process and a popular artists' medium. The French artists Daumier, Géricault, and Delacroix dominated the early history of lithography.

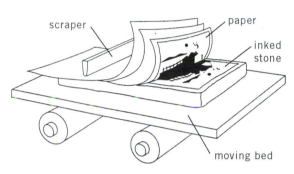

scraper · paper · inked stone · moving bed

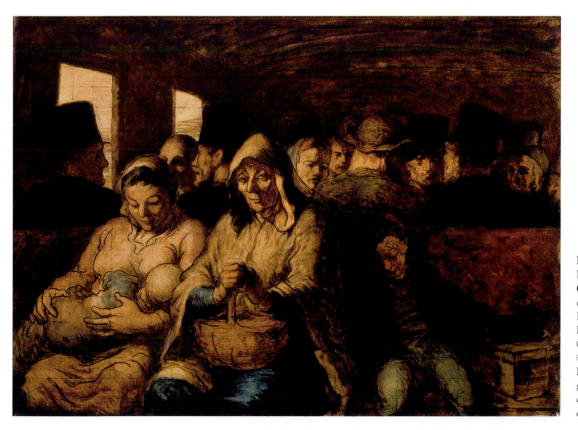

Fig. 35.15 Honoré Daumier. *The Third-Class Carriage*. ca. 1862. Oil on canvas, 25³⁄₄″ × 35¹⁄₂″. Bequest of Mrs. H. O. Havemeyer, 1929. The Ho. O. Havemeyer Collection. © 1922 The Metropolitan Museum of Art, NY. Without glass windows, third-class carriages were open to smoke, cinders, and the cold.

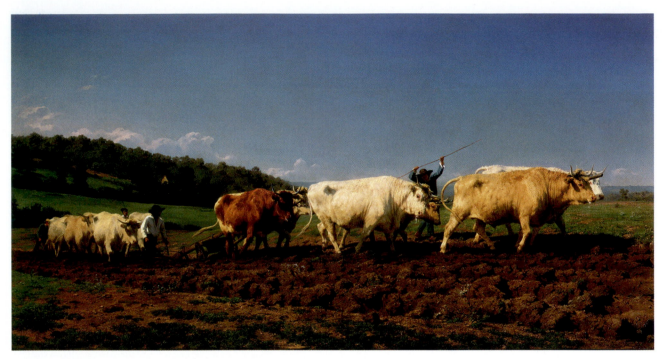

Fig. 35.16 Rosa Bonheur. *Plowing in the Nivernais: The Dressing of the Vines.* **1849.** Oil on canvas, 5′ 9″ × 8′ 8″. Musée d'Orsay, Paris, Gerard Blot/Reunion des Musées Nationaux. Art Resource, NY. Perhaps the most revolutionary feature of Bonheur's painting, given its humble subject, is its very large size.

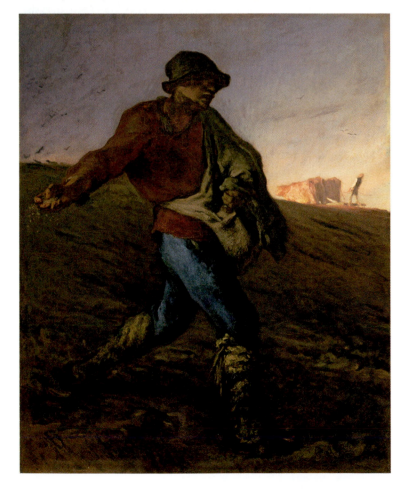

daylight is completely gone (Fig. **35.17**). On the horizon, a yoke of oxen till the field, bathed in the light of the setting sun. Following the tiller, the sower, cast in shadow, seems to emerge out of the very soil he sows, almost literally a "man of the earth." Birds flock behind the sower, eating his seed, allowing us a glimpse into the hard and futile work of the rural poor. When they were first exhibited, Millet's paintings were interpreted as political statements, in part because of the massive scale of his figures, which fill most of the picture frame. Objectionable to many aristocratic and bourgeois viewers was his apparent desire to romanticize his rural subjects. In *The Sower* and in Millet's most famous painting, *The Gleaners* (1857), he renders them in such heroic terms that they seem to rise to the level of poetry.

Fig. 35.17 Jean-François Millet. *The Sower.* **1850.** Oil on canvas, 40″ × 32 1/2″. Museum of Fine Arts, Boston. Gift of Quincy Adams Shaw through Quincy A. Shaw, Jr., and Mrs. Marian Shaw Haughton, 17.1485. Photograph © 2008 Museum of Fine Arts, Boston. Millet painted in the village of Barbizon, south of Paris. An artists' colony there was known for its nostalgic view of the simplicity and innocence of rural life. Millet was far less sentimental.

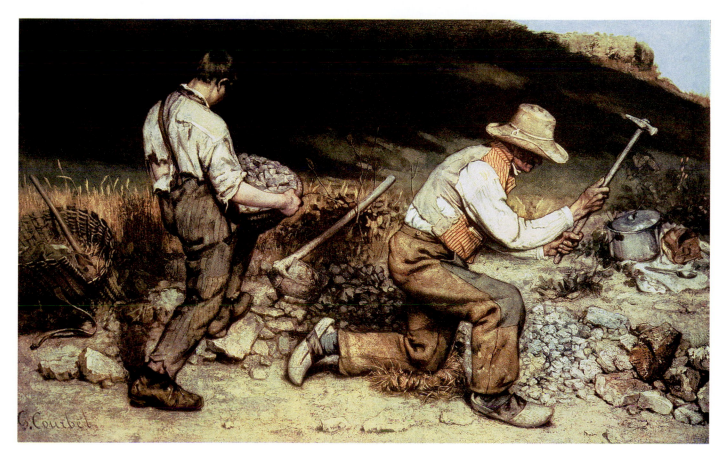

Fig. 35.18 Gustave Courbet. *The Stonebreakers*. 1849. (Salon of 1850–1851). Oil on canvas, 5′ 3″ × 8′ 6″.
(Destroyed in 1945), Galerie Neue Meister, Dresden, Germany, © Staatliche Kunstsammlungen Dresden. The Bridgeman
Art Library. The painting is believed to have been destroyed during the American fire-bombing of Dresden in World War II.

Gustave Courbet: Against Idealism

The leading realist painter of the era was undoubtedly Gustave Courbet (1819–1877). A farmer's son and self-taught artist, Courbet's goal was to paint the world just as he saw it, without any taint of Romanticism or idealism. "To know in order to be able to create," Courbet wrote in his Realist Manifesto of 1855, "that was my idea. To be in a position to translate the customs, the ideas, the appearance of my epoch, according to my own estimation; to be not only a painter, but a man as well; in short, to create living art—this is my goal." In fact, he rejected the traditional political and moral dimensions of realism in favor of a more subjective and apolitical approach to art. This new brand of realism would dominate the art of the following generations.

But when the public first saw his work at the Salon of 1850–1851, they were astonished by the monumental scale of his paintings. Such a grand size was usually reserved for paintings of historical events, but Courbet's subjects were the mundane and the everyday. Both *The Stonebreakers* (Fig. **35.18**) and *A Burial at Ornans* (see *Focus*, pages 1138–1139) are enormous paintings, all the figures in each life-size. In *The Stonebreakers*, Courbet depicts two workers outside his native Ornans, a town at the foot of the Jura Mountains near the Swiss border. They are pounding stones to make gravel for a road. Everything in the painting seems to be pulled down by the weight of physical labor—the strap pulling down across the boy's back, the basket of stones resting on his knee, the hammer in the older man's hand descending downward, the stiff, thick cloth of his trousers pressing against his thigh, even the shadows of the hillside behind them descending toward them. Only a small patch of sky peeks from behind the rocky ridge in the upper right-hand corner, the ridge itself following the same downward path as the hammer. Together, the older man and his younger assistant seem to suggest the unending nature of their work, as if their backbreaking work has afflicted generation after generation of Courbet's rural contemporaries—"a complete expression of human misery," as Courbet explained it.

Focus

Courbet's *A Burial at Ornans*

Perhaps Courbet's most daring effort to address ordinary life without expressing sentimentalism of any kind is a nearly 22-foot-wide painting of 1849–1850, *A Burial at Ornans*. Critics disliked Courbet's monumental treatment of a common country burial. The scene depicts the actual residents of Courbet's hometown in northeastern France, at the funeral of a local farmer, the painter's great uncle, Claude-Etienne Teste. Such a vast canvas was traditionally reserved for depicting historical events, considered the highest form of painting. By using a broad horizontal composition, with rows of 52 life-size mourners arranged without a hierarchy of importance, Courbet presents the scene in a matter-of-fact way. The crucifixion rises above the scene with no more authority than another spectator. No eye meets any other. In fact, like the dog who turns to look at something outside the frame, the entire work is a study in collective distraction. Even as the town gathers together in ritual mourning, each individual seems alone. Just as there is no single focal point in the painting, the community as a whole lacks focus. It is as if all unifying feelings, all shared beliefs, have been lost. As Courbet explained, his new realism was "the negation of the ideal . . . [and] *A Burial at Ornans* was in reality the burial of Romanticism."

A portrait of Courbet's beloved Grandfather Oudot, who had died in August 1848, just a month before the burial of his great-uncle, is represented here.

These are the same cliffs of Ornans which form the background for Courbet's *Stonebreakers*.

The funeral procession of pallbearers, choirboys, and priests on the left side of the painting is headed by two beadles (lay church officers one a vine-grower and the other a shoemaker. Dressed red, they add a comic air to the scene, and their flushed faces suggest that they have recently been sampling the vintner's wine.

Courbet's black-and-white color scheme was meant, at least in part, to evoke the realist medium of photography. The shroud over the coffin, with its black crossbones and tears, is an imaginative transformation of the usual coffin shroud design of black with gold or white crossbones and tears.

Gustave Courbet. *A Burial at Ornans,* **1849–1850 (Salon of 1850–** Oil on canvas, 10′ 3 ¹/₂″ × 21′ 9″. Hervè Lewandowski/Musée d'Orsay, France. RMN Réunion des Musées Nationaux/Art Resource, NY.

Courbet's three sisters contrast with the older women in white bonnets behind them. His sister Zoë, in the middle, covers her face with a handkerchief.

...bet's father stands at ...t the center of the ...ng in a tall, silk hat.

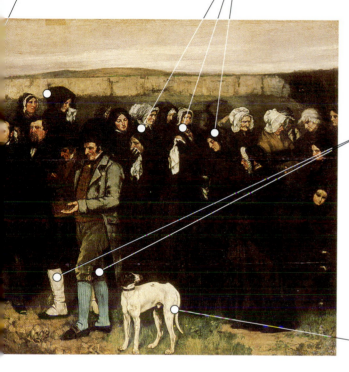

To the right of the open grave stand two older men. One wears white spatterdashes, typically used by soldiers, farmers, and others who were regularly exposed to rain and mud to prevent water from getting into walking boots. The old-fashioned culotte (knee-breeches), long coat, and blue gaiters (knee-socks) of the second figure identify him as a survivor of the French Revolutionary era.

The contrast here between the white dog and the black mourning dresses of the funeral attendees underscores the dominant contrast between black and white in the painting, as well as its other tensions—between the green gaiters of the veteran and the red robes of the beadles, between the sky at the top of the painting and the hard reality of the earth at its bottom, between the idea of transcendence implied by the crucifix rising above the horizon and the matter-of-factness of burial imaged in the open grave.

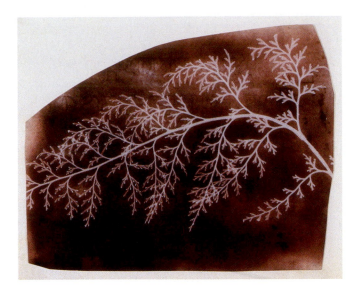

Fig. 35.19 William Henry Fox Talbot. *Wrack*. 1839. Photogenic drawing (salted paper print), 8 11/16″ × 8 7/8″. Harris Brisbane Dick Fund, 1936 (36.37.20). Image copyright © The Metropolitan Museum of Art / Art Resource, NY. Fox Talbot discovered that by placing an image, such as that of the wrack (or seaweed) shown here, on sensitized paper and exposing both to sunlight, a latent image was etched onto the paper and could be brought out by dipping the paper in gallic acid. This calotype process is the basis of modern photography.

Photography: Realism's Pencil of Light

It is no coincidence that the invention of photography coincides with the rise of realism in the arts. The scientific principles required for photography had been known in Europe since at least 1727 when Johann Heinrich Schulze (1684–1744), a German physician, showed that certain chemicals, especially silver halides, turn dark when exposed to light. And the optical principle employed in the camera is essentially the same as that used in the *camera obscura*, which Leonardo da Vinci described and Johannes Vermeer used in his paintings (see Fig. 26.7). While the *camera obscura* could capture an image, it could not preserve it. But in 1839, inventors in England and France discovered a means to fix the image. It was as if the world could now be drawn by a pencil made of light itself.

In England, William Henry Fox Talbot presented a process for fixing negative images on paper coated with light-sensitive chemicals, which he called **photogenic drawing** (Fig. **35.19**). In France, a different process, which yielded a positive image on a polished metal plate, was named the **daguerreotype** [duh-GAIR-oh-type], after one of its inventors, Louis-Jacques-Mandé Daguerre [dah-GAIR] (1789–1851). Wildly enthusiastic public reaction followed, and the French and English presses reported each advance in great detail.

When the French painter Paul Delaroche [deh-lah-ROSH] saw his first daguerreotype, he exclaimed, "From now on, painting is dead!" Delaroche overreacted, but he understood the potential of photography to seize painting's historical role of representing the world. Photographic portraiture quickly became a successful business, with daguerreotype images of individuals costing 15 francs in Paris. This new medium made personalized pictures available not only to the wealthy but to the middle and working classes. By 1849, a decade after the process was discovered, 100,000 daguerreotype portraits were sold in Paris each year.

At the time Daguerre first announced his discovery, imprinting an image on a metal plate took 8 to 10 minutes in bright summer light. His photo of *Le Boulevard du Temple* was exposed for so long that none of the people or traffic moving in the street left any impression, except for one solitary figure at the lower left who is having his shoes shined (Fig. **35.20**). By 1841, the discovery of so-called chemical "accelerators" had made it possible to expose the plate for only 1 minute, but a sitter, such as Daguerre himself (Fig. **35.21**), could not move for fear of blurring the image. The process remained cumbersome, requiring considerable time to prepare, expose, and develop the plate. Iodine was vaporized on a copper sheet to create light-sensitive silver iodide, and the picture developed by suspending it face down in heated mercury, The unexposed silver iodide was dissolved with salt and the plate was then carefully rinsed and dried.

The daguerrotype process resulted in a single, unreproducible image, but the invention of lithography had demonstrated that there was a market for mass-produced prints. Fox Talbot, whose photogenic drawings utilized paper instead of a metal plate, led the way to making multiple prints of an image. Talbot also discovered that sensitized paper, exposed for even a few seconds, held a latent image that could be brought out and developed by dipping the paper in gallic acid. This **calotype** [KAL-uh-type] process is the basis of modern photography. In 1843, Talbot's picture, which he called *The Open Door* (Fig. **35.22**), made it apparent that calotypes could become works of art in their own right. The power of the image rests in the contrast between light and dark, the visible and the unseen. Talbot published the image in *The Pencil of Nature* (1844–1845), the first book fully illustrated by photographs. It was accompanied by the following caption: "A painter's eye will often be arrested where ordinary people see nothing remarkable. A casual gleam of sunshine, or a shadow thrown across his path, a time-withered oak, or a moss-covered stone may awaken a train of thought and feelings. . . ." Thus, for Talbot, photography was a realist medium that might evoke Romantic sentiment. But the medium's ability to document current events quickly overshadowed its more artistic possibilities in the public mind.

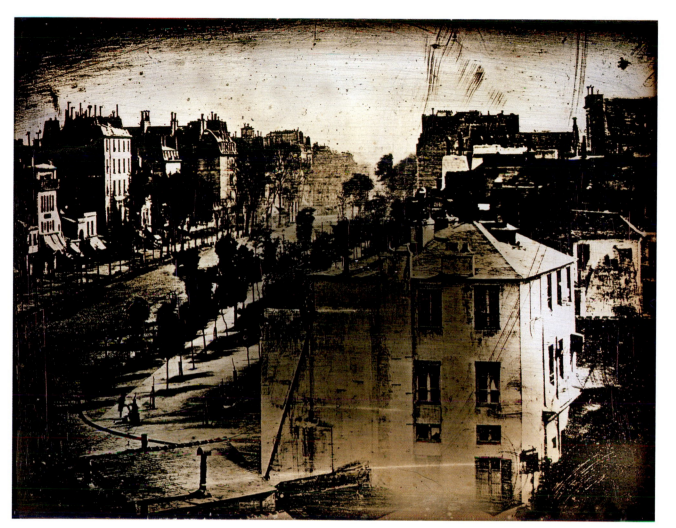

Fig. 35.20 Louis-Jacques-Mandé Daguerre. *Le Boulevard du Temple.*
1839. Daguerrotype. Bayerisches National Museum, Munich. Daguerre was
a painter who made his living producing panoramic dioramas, room-size
backlit paintings that appeared to change from daylight to dusk as the
illumination behind them decreased. Daguerre composed these large
painted scenes with a camera obscura, a tedious process requiring hours of
tracing. His interest in photography stemmed from his desire to speed up his
painting process. This daguerrotype was taken from the roof of the building
that housed his diorama attraction.

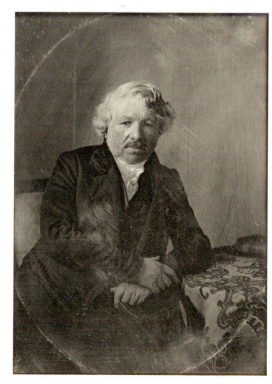

Fig. 35.21 Charles Richard Meade. Portrait *Louis-Jacques-*
***Mandé Daguerre*. 1848.** Daguerreotype, hand-colored half-
plate, $6\frac{3}{16}'' \times 4\frac{1}{2}''$. The J. Paul Getty Museum, Los
Angeles. 84.XT.953. Unaware that Daguerre very much
disliked having his own portrait made, Charles Richard
Meade traveled to France in 1848 to make a photograph
that would show American audiences what Daguerre
looked like. Meade visited Daguerre at his country home,
where he finally succeeded in making five portraits of the
inventor.

Fig. 35.22 William Henry Fox Talbot. *The Open Door.* **1843.** Salted paper print from a calotype negative $5\frac{5}{8}" \times 7\frac{5}{8}"$. Museum of Modern Art, NY. Gilman Paper Company Collection (L.1995.2.7). Talbot's experiments with photography were sparked by the fact that he drew poorly and yet he wanted to record his impressions of landscape.

Charles Darwin: The Science of Objective Observation

The emphasis on direct observation and the objective reporting of real conditions that is so evident in realist literature and painting is reflected as well in the science of the nineteenth century, especially in the work of Charles Darwin (1809–1882). In December 1831, the 22-year-old Darwin, grandson of Josiah Wedgwood and Erasmus Darwin, founding members of the Lunar Society (see chapter 28), set sail on the *HMS Beagle* (Fig. **35.23**), to serve as naturalist on the ship's survey of South America. On his 5-year journey he kept a daily diary, the basis for his *Journal of Researches into the Geology and Natural History of the Various Countries Visited by H. M. S. Beagle* (1839), commonly known as *The Voyage of the Beagle.* There he recorded his detailed observations of the geology, flora, and fauna of the region, from the rainforests of Brazil, "undefaced by the hand of man," to the barren landscape of Tierra del Fuego, and finally, the volcanic islands of Galapagos, just below the equator off the South American coast. Darwin was astonished at what he found there (**Reading 35.14**):

READING 35.14 from Darwin, *Voyage of the Beagle* (1839)

The natural history of these islands is eminently curious, and well deserves attention. Most of the organic productions are aboriginal creations, found nowhere else; there is even a difference between the inhabitants of the different islands; yet all show a marked relationship with those of America, though separated from that continent by an open space of ocean, between 500 and 600 miles. . . . The archipelago is a little world within itself, or rather a satellite attached to America, whence it has derived a few stray colonists. . . . Considering the small size of the islands, we feel the more astonished at the number of their aboriginal beings, and at their confined range. . . .

The circumstance, that several of the islands possess their own species of the tortoise, mocking-thrush, finches, and numerous plants, these species having the same general habits, occupying analogous situations, and obviously filling the same place in the natural

Fig. 35.23 Conrad Martens. *The Beagle Laid Ashore for Repairs,* from Charles Darwin, *Journal of Researches into the Geology and Natural History of the Various Countries Visited by H. M. S. Beagle,* Henry Colburn Publishers, London, 1839. The artist Conrad Martens sailed for South America from England in May 1833. When his ship docked at Rio de Janeiro, he heard that the *Beagle,* refitting at Montevideo, needed an artist. Martens was hired and served as the artist on board the *Beagle* until July 1834.

economy of this archipelago, that strikes me with wonder. . . . Reviewing the facts here given, one is astonished at the amount of creative force, if such an expression may be used, displayed on these small, barren, and rocky islands; and still more so, at its diverse yet analogous action on points so near each other. I have said that the Galapagos Archipelago might be called a satellite attached to America, but it should rather be called a group of satellites, physically similar, organically distinct, yet intimately related to each other, and all related in a marked, though much lesser degree, to the great American continent.

Twenty years later, Darwin would publish his analysis of the vast amount of data he had collected. In *The Origin of the Species by Means of Natural Selection, or the Preservation of the Favored Races in the Struggle for Life* (1859), he concluded that similar flora and fauna, in similar habitats, but isolated from each other, developed in a relatively brief period of time—geologically speaking—into distinct species. Darwin was on the way to understanding the "mystery of mysteries," the origin of life itself.

In the *Origin of Species*, Darwin argued that through the process of natural selection, certain organisms are able to increase rapidly over time by retaining traits conducive to their survival and eliminating those that are less favorable to survival. A given species' ability to *adapt to its environment,* then, is fundamental to its survival. A species' ability to repel predators—including environmental challenges such as drought or flood—enhances its chances for procreation and determines its "fitness" to survive. And, in the end, only the "fittest" survive, an idea that, misunderstood and misapplied, would have an enormous impact on social theory later in the century.

Darwin's theory met with instant resistance. In its picture of nature as a theater of competition and struggle, a process of local adaptation with no intrinsic drive toward a higher state or greater good, propelled not by some higher force but by sexual instinct, the theory was profoundly alienating, especially to Christians. Yet by 1862, when Darwin published a paper on the fertilization of orchids by insects and hummingbirds, he had convinced many that his theories were correct. Today, the science of molecular genetics—the study of the information stored in our DNA—provides biological confirmation of Darwin's theories, although no one has as yet fully explained the origins of life itself.

READINGS

READING 35.5

from Balzac, *Father Goriot* (1834)

Balzac published his first successful piece of fiction in 1829 at the age of 30, and for the next 20 years, he led an astonishingly active life. Writing and editing a number of journals, along with some 92 novels, he often worked for as many as 18 hours at a stretch, beginning at midnight and lasting until the late afternoon. Perhaps his greatest talent lies in his ability to link the material and psychological worlds of his characters so that readers feel, as he describes the furnishings of a room, or clothing, that they are delving into the soul of a real individual. But above all, it is his understanding of the passions and desires of every level of French society that makes The Human Comedy *such an extraordinary achievement. Excerpted below is part of the last chapter of* Father Goriot, *as Rastignac buries the penniless Goriot, the father of the woman whom he loves.*

They laid Father Goriot upon his wretched bed with reverent hands. Thenceforward there was no expression on his face, only the painful traces of the struggle between life and death that was going on in the machine; for that kind of cerebral consciousness that distinguishes between pleasure and pain in a human being was extinguished; it was only a question of time—and the mechanism itself would be destroyed.

"He will lie like this for several hours, and die so quietly at last, that we shall not know when he goes; there will be no rattle in the throat. The brain must be completely suffused." 10

As he spoke there was a footstep on the staircase, and a young woman hastened up, panting for breath.

"She has come too late," said Rastignac.

But it was not Delphine; it was Therese, her waiting-woman, who stood in the doorway.

"Monsieur Eugene," she said, "monsieur and madame have had a terrible scene about some money that Madame (poor thing!) wanted for her father. She fainted, and the doctor came, and she had to be bled, calling out all the 20 while, 'My father is dying; I want to see papa!' It was heart-breaking to hear her—"

"That will do, Therese. If she came now, it would be trouble throwaway. M. Goriot cannot recognize any one now."

"Poor, dear gentleman, is he as bad at that?" said Therese.

"You don't want me now, I must go and look after my dinner; it is half-past four," remarked Sylvie. The next instant she all but collided with Mme. de Restaud on the landing outside.

There was something awful and appalling in the sudden apparition of the Countess. She saw the bed of death by the 30 dim light of the single candle, and her tears flowed at the sight of her father's passive features, from which the life had almost ebbed. Bianchon with thoughtful tact left the room.

"I could not escape soon enough," she said to Rastignac.

The student bowed sadly in reply. Mme. de Restaud took her father's hand and kissed it.

"Forgive me, father! You used to say that my voice would call you back from the grave; ah! come back for one moment to bless your penitent daughter. Do you hear me? Oh! this is fearful! No one on earth will ever bless me henceforth; every 40 one hates me; no one loves me but you in the entire world. My own children will hate me. Take me with you, father; I will love you, I will take care of you. He does not hear me . . . I am mad . . ."

She fell on her knees, and gazed wildly at the human wreck before her.

"My cup of misery is full," she said, turning her eyes upon Eugene. "M. de Trailles has fled, leaving enormous debts behind him, and I have found out that he was deceiving me. My husband will never forgive me, and I have left my fortune 50 in his hands. I have lost all my illusions. Alas! I have forsaken the one heart that loved me (she pointed to her father as she spoke), and for whom? I have held his kindness cheap, and slighted his affection; many and many a time I have given him pain, ungrateful wretch that I am!"

"He knew it," said Rastignac.

Just then Goriot's eyelids unclosed; it was only a muscular contraction, but the Countess' sudden start of reviving hope was no less dreadful than the dying eyes.

"Is it possible that he can hear me?" cried the Countess. 60 "No," she answered herself, and sat down beside the bed. As Mme. de Restaud seemed to wish to sit by her father, Eugene went down to take a little food. The boarders were already assembled.

"Well," remarked the painter, as he joined them, "it seems that there is to be a death-orama upstairs."

"Charles, I think you might find something less painful to joke about," said Eugene.

"So we may not laugh here?" returned the painter. "What harm does it do? Bianchon said that the old man was quite 70 insensible."

"Well, then," said the employee from the Museum, "he will die as he has lived."

"My father is dead!" shrieked the Countess.

The terrible cry brought Sylvie, Rastignac, and Bianchon; Mme. de Restaud had fainted away. When she recovered they carried her downstairs, and put her into the cab that stood waiting at the door. Eugene sent Therese with her, and bade the maid take the Countess to Mme. de Nucingen.

Bianchon came down to them.

"Yes, he is dead," he said.

"Come, sit down to dinner, gentlemen," said Mme. Vauquer, "or the soup will be cold."

The two students sat down together.

"What is the next thing to be done?" Eugene asked of Bianchon.

"I have closed his eyes and composed his limbs," said Bianchon. "When the certificate has been officially registered at the Mayor's office, we will sew him in his winding sheet and bury him somewhere. What do you think we ought to do?"

"He will not smell at his bread like this any more," said the painter, mimicking the old man's little trick.

"Oh, hang it all!" cried the tutor, "let Father Goriot drop, and let us have something else for a change. He is a standing dish, and we have had him with every sauce this hour or more. It is one of the privileges of the good city of Paris that anybody may be born, or live, or die there without attracting any attention whatsoever. Let us profit by the advantages of civilization. There are fifty or sixty deaths every day; if you have a mind to do it, you can sit down at anytime and wail over whole hecatombs of dead in Paris. Father Goriot has gone off the hooks, has he? So much the better for him. If you venerate his memory, keep it to yourselves, and let the rest of us feed in peace."

"Oh, to be sure," said the widow, "it is all the better for him that he is dead. It looks as though he had had trouble enough, poor soul, while he was alive."

And this was all the funeral oration delivered over him who had been for Eugene the type and embodiment of Fatherhood.

The fifteen lodgers began to talk as usual. When Bianchon and Eugene had satisfied their hunger, the rattle of spoons and forks, the boisterous conversation, the expressions on the faces that bespoke various degrees of want of feeling, gluttony, or indifference, everything about them made them shiver with loathing. They went out to find a priest to watch that night with the dead. It was necessary to measure their last pious cares by the scanty sum of money that remained. Before nine o'clock that evening the body was laid out on the bare sacking of the bedstead in the desolate room; a lighted candle stood on either side, and the priest watched at the foot. Rastignac made inquiries of this latter as to the expenses of the funeral, and wrote to the Baron de Nucingen and the Comte de Restaud, entreating both gentlemen to authorize their man of business to defray the charges of laying their father-in-law in the grave. He sent Christophe with the letters; then he went to bed, tired out, and slept.

Next day Bianchon and Rastignac were obliged to take the certificate to the registrar themselves, and by twelve o'clock the formalities were completed. Two hours went by, no word came from the Count nor from the Baron; nobody appeared to act for them, and Rastignac had already been obliged to pay the priest. Sylvie asked ten francs for sewing the old man in his winding-sheet and making him ready for the grave, and Eugene and Bianchon calculated that they had scarcely sufficient to pay for the funeral, if nothing was forthcoming from the dead man's family. So it was the medical student who laid him in a pauper's coffin, despatched from Bianchon's hospital, whence he obtained it at a cheaper rate.

"Let us play those wretches a trick," said he. "Go to the cemetery, buy a grave for five years at Pere-Lachaise, and arrange with the Church and the undertaker to have a third-class funeral. If the daughters and their husbands decline to repay you, you can carve this on the headstone—'Here lies M. Goriot, father of the Comtesse de Restaud and the Baronne de Nucingen, interred at the expense of two students.'"

Eugene took part of his friend's advice, but only after he had gone in person first to M. and Mme. de Nucingen, and then to M. and Mme. de Restaud—a fruitless errand. He went no further than the doorstep in either house. The servants had received strict orders to admit no one.

"Monsieur and Madame can see no visitors. They have just lost their father, and are in deep grief over their loss."

Eugene's Parisian experience told him that it was idle to press the point. Something clutched strangely at his heart when he saw that it was impossible to reach Delphine.

"Sell some of your ornaments," he wrote hastily in the porter's room, "so that your father may be decently laid in his last resting-place."

He sealed the note, and begged the porter to give it to Therese for her mistress; but the man took it to the Baron de Nucingen, who flung the note into the fire. Eugene, having finished his errands, returned to the lodging-house about three o'clock. In spite of himself, tears came into his eyes. The coffin, in its scanty covering of blackcloth, was standing there on the pavement before the gate, on two chairs. A withered sprig of hyssop was soaking in the holy water bowl of silver-plated copper; there was not a soul in the street, no passer-by had stopped to sprinkle the coffin; there was not even an attempt at a black drapery over the wicket. It was a pauper who lay there; no one made a pretence of mourning for him; he had neither friends nor kindred—there was no one to follow him to the grave.

Bianchon's duties compelled him to be at the hospital, but he had left a few lines for Eugene, telling his friend about the arrangements he had made for the burial service. The house student's note told Rastignac that a mass was beyond their means, that the ordinary office for the dead was cheaper, and must suffice, and that he had sent word to the undertaker by Christophe. Eugene had scarcely finished reading Bianchon's scrawl, when he looked up and saw the little circular gold locket that contained the hair of Goriot's two daughters in Mme. Vauquer's hands.

"How dared you take it?" he asked.

"Good Lord! is that to be buried along with him?" retorted Sylvie. "It is gold."

"Of course it shall!" Eugene answered indignantly; "he shall at any rate take one thing that may represent his daughters into the grave with him."

When the hearse came, Eugene had the coffin carried into 190 the house again, unscrewed the lid, and reverently laid on the old man's breast the token that recalled the days when Delphine and Anastasie were innocent little maidens, before they began "to think for themselves," as he had moaned out in his agony.

Rastignac and Christophe and the two undertaker's men were the only followers of the funeral. The Church of Saint-Etienne du Mont was only a little distance from the Rue Nueve-Sainte-Geneviève. When the coffin had been deposited in a low, dark, little chapel, the law student looked 200 round in vain for Goriot's two daughters or their husbands. Christophe was his only fellow-mourner; Christophe, who appeared to think it was his duty to attend the funeral of the man who had put him in the way of such handsome tips. As they waited there in the chapel for the two priests, the chorister, and the beadle, Rastignac grasped Christophe's hand. He could not utter a word just then.

"Yes, Monsieur Eugene," said Christophe, "he was a good and worthy man, who never said one word louder than another; he never did any one any harm, and gave nobody 210 any trouble."

The two priests, the chorister, and the beadle came, and said and did as much as could be expected for seventy francs in an age when religion cannot afford to say prayers for nothing. The ecclesiastics chanted a psalm, the *Libera nos* and the *Deprofundis*. The whole service lasted about twenty minutes. There was but one mourning coach, which the priest and chorister agreed to share with Eugene and Christophe.

"There is no one else to follow us," remarked the priest, "so we may as well go quickly, and so save time; it is half-past five." 220

But just as the coffin was put in the hearse, two empty carriages, with the armorial bearings of the Comte de Restaud and the Baron de Nucingen, arrived and followed in the procession to Pere-Lachaise. At six o'clock Goriot's coffin was lowered into the grave, his daughters' servants standing round the while. The ecclesiastic recited the short prayer that the students could afford to pay for, and then both priest and lackeys disappeared at once. The two grave diggers flung in several spadefuls of earth, and then stopped and asked Rastignac for their fee. Eugene felt in vain in his pocket, and was 230 obliged to borrow five francs of Christophe. This thing, so trifling in itself, gave Rastignac a terrible pang of distress. It was growing dusk, the damp twilight fretted his nerves; he gazed down into the grave and the tears he shed were drawn from him by the sacred emotion, a single-hearted sorrow. When such tears fall on earth, their radiance reaches heaven. And with that tear that fell on Father Goriot's grave, Eugene Rastignac's youth ended. He folded his arms and gazed at the clouded sky; and Christophe, after a glance at him, turned and went—Rastignac was left alone. 240

He went a few paces further, to the highest point of the cemetery, and looked out over Paris and the windings of the Seine; the lamps were beginning to shine on either side of the river. His eyes turned almost eagerly to the space between the column of the Place Vendome and the cupola of the Invalides; there lay the shining world that he had wished to reach. He glanced over that humming hive, seeming to draw a foretaste of its honey, and said magniloquently:

"Henceforth there is war between us."

And by way of throwing down the glove to Society, Rasti- 250 gnac went to dine with Mme. de Nucingen. ■

Reading Question

The central concern of these last pages of the novel is not so much Father Goriot's death as it is money. What does Balzac mean us to understand?

READING 35.8

from the *Narrative of the Life of Frederick Douglass: An American Slave*, Chapter 1 (1845)

There are over 6,000 narratives recounting the pre–Civil War experience of slaves, many of them interviews and essays, and nearly 100 of them book-length works. Frederick Douglass's Narrative of the Life of Frederick Douglass, An American Slave, *is generally considered the greatest of these. In Chapter 1, Douglass recounts his witnessing, as a young boy, of the beating of his Aunt Hester by Mr. Plummer, the overseer of a small plantation in Maryland. The story inaugurates the first half of the book, what he refers to as his descent into "the hell of slavery."*

Chapter 1

was born in Tuckahoe, near Hillsborough, and about twelve miles from Easton, in Talbot county, Maryland. I have no accurate knowledge of my age, never having seen

any authentic record containing it. By far the larger part of the slaves know as little of their ages as horses know of theirs, and it is the wish of most masters within my knowledge to

keep their slaves thus ignorant. I do not remember to have ever met a slave who could tell of his birthday. They seldom come nearer to it than planting-time, harvest-time, cherry-time, spring-time, or fall-time. A want of information concerning my own was a source of unhappiness to me even during childhood. The white children could tell their ages. I could not tell why I ought to be deprived of the same privilege. I was not allowed to make any inquiries of my master concerning it. He deemed all such inquiries on the part of a slave improper and impertinent, and evidence of a restless spirit. The nearest estimate I can give makes me now between twenty-seven and twenty-eight years of age. I come to this, from hearing my master say, some time during 1835, I was about seventeen years old.

My mother was named Harriet Bailey. She was the daughter of Isaac and Betsey Bailey, both colored, and quite dark. My mother was of a darker complexion than either my grandmother or grandfather.

My father was a white man. He was admitted to be such by all I ever heard speak of my parentage. The opinion was also whispered that my master was my father; but of the correctness of this opinion, I know nothing; the means of knowing was withheld from me. My mother and I were separated when I was but an infant—before I knew her as my mother. It is a common custom, in the part of Maryland from which I ran away, to part children from their mothers at a very early age. Frequently, before the child has reached its twelfth month, its mother is taken from it, and hired out on some farm a considerable distance off, and the child is placed under the care of an old woman, too old for field labor. For what this separation is done, I do not know, unless it be to hinder the development of the child's affection toward its mother, and to blunt and destroy the natural affection of the mother for the child. This is the inevitable result.

I never saw my mother, to know her as such, more than four or five times in my life; and each of these times was very short in duration, and at night. She was hired by a Mr. Stewart, who lived about twelve miles from my home. She made her journeys to see me in the night, travelling the whole distance on foot, after the performance of her day's work. She was a field hand, and a whipping is the penalty of not being in the field at sunrise, unless a slave has special permission from his or her master to the contrary—a permission which they seldom get, and one that gives to him that gives it the proud name of being a kind master. I do not recollect of ever seeing my mother by the light of day. She was with me in the night. She would lie down with me, and get me to sleep, but long before I waked she was gone. Very little communication ever took place between us. Death soon ended what little we could have while she lived, and with it her hardships and suffering. She died when I was about seven years old, on one of my master's farms, near Lee's Mill. I was not allowed to be present during her illness, at her death, or burial. She was gone long before I knew any thing about it. Never having enjoyed, to any considerable extent, her soothing presence, her tender and watchful care, I received the tidings of her

death with much the same emotions I should have probably felt at the death of a stranger.

Called thus suddenly away, she left me without the slightest intimation of who my father was. The whisper that my master was my father, may or may not be true; and, true or false, it is of but little consequence to my purpose whilst the fact remains, in all its glaring odiousness, that slaveholders have ordained, and by law established, that the children of slave women shall in all cases follow the condition of their mothers; and this is done too obviously to administer to their own lusts, and make a gratification of their wicked desires profitable as well as pleasurable; for by this cunning arrangement, the slaveholder, in cases not a few, sustains to his slaves the double relation of master and father.

I know of such cases; and it is worthy of remark that such slaves invariably suffer greater hardships, and have more to contend with, than others. They are, in the first place, a constant offence to their mistress. She is ever disposed to find fault with them; they can seldom do any thing to please her; she is never better pleased than when she sees them under the lash, especially when she suspects her husband of showing to his mulatto children favors which he withholds from his black slaves. The master is frequently compelled to sell this class of his slaves, out of deference to the feelings of his white wife; and, cruel as the deed may strike any one to be, for a man to sell his own children to human flesh-mongers, it is often the dictate of humanity for him to do so; for, unless he does this, he must not only whip them himself, but must stand by and see one white son tie up his brother, of but few shades darker complexion than himself, and ply the gory lash to his naked back; and if he lisp one word of disapproval, it is set down to his parental partiality, and only makes a bad matter worse, both for himself and the slave whom he would protect and defend.

Every year brings with it multitudes of this class of slaves. It was doubtless in consequence of a knowledge of this fact, that one great statesman of the south predicted the downfall of slavery by the inevitable laws of population. Whether this prophecy is ever fulfilled or not, it is nevertheless plain that a very different-looking class of people are springing up at the south, and are now held in slavery, from those originally brought to this country from Africa; and if their increase do no other good, it will do away the force of the argument, that God cursed Ham, and therefore American slavery is right. If the lineal descendants of Ham are alone to be scripturally enslaved, it is certain that slavery at the south must soon become unscriptural; for thousands are ushered into the world, annually, who, like myself, owe their existence to white fathers, and those fathers most frequently their own masters.

I have had two masters. My first master's name was Anthony. I do not remember his first name. He was generally called Captain Anthony—a title which, I presume, he acquired by sailing a craft on the Chesapeake Bay. He was not considered a rich slaveholder. He owned two or three farms, and about thirty slaves. His farms and slaves were under the care of an overseer. The overseer's name was Plummer. Mr.

Plummer was a miserable drunkard, a profane swearer, and a savage monster. He always went armed with a cowskin and a heavy cudgel. I have known him to cut and slash the women's heads so horribly, that even master would be enraged at his cruelty, and would threaten to whip him if he did not mind himself. Master, however, was not a humane slaveholder. It required extraordinary barbarity on the part of an overseer to affect him. He was a cruel man, hardened by a long life of slave-holding. He would at times seem to take great pleasure in whipping a slave. I have often been awakened at the dawn of day by the most heart-rending shrieks of an own aunt of mine, whom he used to tie up to a joist, and whip upon her naked back till she was literally covered with blood. No words, no tears, no prayers, from his gory victim, seemed to move his iron heart from its bloody purpose. The louder she screamed, the harder he whipped; and where the blood ran fastest, there he whipped longest. He would whip her to make her scream, and whip her to make her hush; and not until overcome by fatigue, would he cease to swing the blood-clotted cowskin. I remember the first time I ever witnessed this horrible exhibition. I was quite a child, but I well remember it. I never shall forget it whilst I remember any thing. It was the first of a long series of such outrages, of which I was doomed to be a witness and a participant. It struck me with awful force. It was the blood-stained gate, the entrance to the hell of slavery, through which I was about to pass. It was a most terrible spectacle. I wish I could commit to paper the feelings with which I beheld it.

This occurrence took place very soon after I went to live with my old master, and under the following circumstances. Aunt Hester went out one night,—where or for what I do not know,—and happened to be absent when my master desired her presence. He had ordered her not to go out evenings, and warned her that she must never let him catch her in company with a young man, who was paying attention to her belonging to Colonel Lloyd. The young man's name was Ned Roberts, generally called Lloyd's Ned. Why master was so careful of her, may be safely left to conjecture. She was a woman of noble form, and of graceful proportions, having very few equals, and fewer superiors, in personal appearance, among the colored or white women of our neighborhood.

Aunt Hester had not only disobeyed his orders in going out, but had been found in company with Lloyd's Ned; which circumstance, I found, from what he said while whipping her, was the chief offence. Had he been a man of pure morals himself, he might have been thought interested in protecting the innocence of my aunt; but those who knew him will not suspect him of any such virtue. Before he commenced whipping Aunt Hester, he took her into the kitchen, and stripped her from neck to waist, leaving her neck, shoulders, and back, entirely naked. He then told her to cross her hands, calling her at the same time a d—d b—h. After crossing her hands, he tied them with a strong rope, and led her to a stool under a large hook in the joist, put in for the purpose. He made her get upon the stool, and tied her hands to the hook. She now stood fair for his infernal purpose. Her arms were stretched up at their full length, so that she stood upon the ends of her toes. He then said to her, "Now, you d—d b—h, I'll learn you how to disobey my orders!" and after rolling up his sleeves, he commenced to lay on the heavy cowskin, and soon the warm, red blood (amid heart-rending shrieks from her, and horrid oaths from him) came dripping to the floor. I was so terrified and horror-stricken at the sight, that I hid myself in a closet, and dared not venture out till long after the bloody transaction was over. I expected it would be my turn next. It was all new to me. I had never seen any thing like it before. I had always lived with my grandmother on the outskirts of the plantation, where she was put to raise the children of the younger women. I had therefore been, until now, out of the way of the bloody scenes that often occurred on the plantation. ■

Reading Question

Near the end of this chapter, Douglass makes the somewhat startling claim, "It was all new to me." How does this claim help the reader to identify with Douglass's plight?

Summary

■ **The Industrial City: Conditions in London** During much of the nineteenth century, industrialization created wealth for a few but left the vast majority of men and women living bleak and unhealthy lives. They worked long hours for low wages in an environment plagued by smoke and soot. In London, their drinking water was taken from the river Thames, which was little better than an open sewer. Cholera and other contagious diseases thrived in the rapidly growing urban areas of Britain, Europe, and the United States, causing millions of deaths. Housing was cramped at best, owing to the fact that workers needed to live near the factories in which they worked. As single women increasingly entered the workforce—their low wages often encouraging them to supplement their income by means of prostitution—married women were driven out, leaving men as the sole breadwinners for the family.

■ **Reformers Respond: Utopian Socialism, Medievalism, and Christian Reform** In France and England, the horrific conditions brought about by industrialization led socialist thinkers such as Charles Fourier and Robert Owen to argue for the creation of utopian communities where work and wealth would be shared by all. Other humanists called for a return to medieval values. Augustus Pugin was chief among those who argued that restoring Christian values to art and architecture would instill those principles into the social fabric of nations. Art and architecture served a moral as well as a functional purpose, exemplified in the ornamentation he designed for the new Houses of Parliament in London.

■ **Literary Realism** Humanist writers attacked the problems afflicting the working class by addressing their plight in realistic terms, describing in minute detail the material conditions and psychological impact wrought by unhealthy surroundings. Such Charles Dickens works as *Hard Times* reflected both the promise and the human cost of industrialization. Writers like Dickens argued that the workers' plight could be improved if industrialists treated the workforce more humanely.

In France, realist writers such as Honoré de Balzac depicted the full breadth of French society, from its poor to its most wealthy. In the 92 novels that make up Balzac's *Human Comedy*, some 2,000 characters come to life for the reader. In the novel *Madame Bovary*, Gustave Flaubert attacked the Romantic sensibilities to which he was himself strongly attracted. In Russia, writers reacted especially strongly to the social conditions brought about by the survival of a serf economy. Poet Aleksandr Pushkin was a great champion of social causes, condemning the indifference of the modern Neoclas-

sical city of Saint Petersburg to the plight of its citizens in *The Bronze Horseman*. His friend, novelist Nikolai Gogol, attacked the Russian bureaucracy in his masterful comedy *The Inspector General*, and took on the serf economy explicitly in his novel *Dead Souls*.

In the United States, slavery was the chief target of realist writers. Slaves themselves recounted the horrors of their lives in autobiographical narratives such as those by Frederick Douglass and Sojourner Truth. Truth saw the cause of women's rights to be intimately connected with the effort to end slavery. One of the most important attacks on the institution, the most widely read novel of the era, was Harriet Beecher Stowe's *Uncle Tom's Cabin*. Even so, Stowe's novel adopts a patronizing tone in its treatment of African Americans, an attitude that becomes one of the chief themes of Mark Twain's great novel *Huckleberry Finn*, although Huck comes to understand and appreciate the slave Jim's humanity.

■ **The New French Realism in Painting** French realist painting could be said to have begun in 1830 with Eugène Delacroix's *Liberty Leading the People*, which was received by the public as both a threat to the aristocracy and an attack on the middle class. In his cartoon work for daily and weekly newspapers, Honoré Daumier constantly held the French court of King Louis-Philippe up to ridicule, even as he depicted the plight of working people in a series of paintings not exhibited until near the end of his life. Working-class life became an increasingly popular subject, in the illustrations and prints of Gustave Doré, and the monumental agricultural paintings of Rosa Bonheur and Jean-François Millet.

■ **Photography: Realism's Pencil of Light** The new art of photography arose in the context of the rise of realism in the arts. In England, William Henry Fox Talbot developed a process for fixing a negative image on paper at the same time that in France Louis-Jacques Mandé Daguerre invented the daguerreotype, a process yielding a positive image on a metal plate. Daguerre's process, which produced single images that could not be reproduced, quickly revolutionized the art of portraiture, while Fox Talbot's calotype process offered a way of making multiple prints.

■ **Charles Darwin: The Science of Objective Observation** Realist artists tried to look at the world with objective eyes. This same objectivity defined the scientific method of Charles Darwin, whose voyage on the HMS *Beagle* led him, in the Galapagos Islands off the South American coast, to develop his theory of evolution, published in 1859 as *The Origin of the Species*.

Glossary

bourgeoisie Middle-class merchants, shopkeepers, and businessmen.

calotype An early photographic process in which sensitized paper, exposed for a few seconds, holds a latent image that is brought out and developed by dipping the paper in gallic acid.

daguerreotype A photographic process developed in the early 1800s that yielded a positive image on a polished metal plate; named after one of its two inventors, Louis-Jacques-Mandé Daguerre.

literary realism The depiction of contemporary life emphasizing fidelity to everyday experience and the facts and conditions of everyday life.

lithography Literally "stone writing," this printing process depends on the fact that oil and water do not mix.

photogenic drawing A process for fixing negative images on paper coated with light-sensitive chemicals, developed by William Henry Fox Talbot in the early 1800s.

proletariat A class of workers lacking ownership of the means of production (tools and equipment) and control over both the quality and price of their own work.

Critical Thinking Questions

1. What does Dickens seek to reform through the use of literary realism? How does he do it? Do French and Russian authors have similar goals?

2. The bare-breasted allegorical figure of Liberty, by Delacroix, and the caricatures or cartoons by Daumier, are both considered part of a "realist" style. Why?

3. How is photography a threat to painting's role of representing the world? Think of some examples among early photographs.

4. What do Darwin's nonfiction works have in common with the fiction of Dickens, Flaubert, and Twain?

In July 1864, the French painter Édouard Manet [mah-NAY] traveled from Paris to Boulogne-sur-Mer [boo-LOHN ser mair] on the English Channel expressly to paint the U.S.S. *Kearsarge* [KEER-sarj], a small warship ideal for coastal defense. *The Kearsarge* had sunk the Confederate sloop-of-war *Alabama* off Cherbourg [shair-BOOR], on the Norman coast, on June 19. The *Alabama* had been fitted with supplies and repaired at Cherbourg after nearly two years of roving the seas, from Brazil to Singapore. During that time it had sunk 65 Union merchant ships. The *Kearsarge* patiently waited for the *Alabama* to leave French waters, and then attacked, sinking it.

Manet relied on newspaper accounts to paint *The Battle of the "Kearsarge" and the "Alabama"* (Fig. **35.24**), exhibiting it only 26 days after the battle. Soon after, he traveled to Boulogne-sur-Mer to see the victorious ship in person.

Manet was, above all, the painter of a new, self-consciously modern bourgeois France. Under Napoleon III, the emperor who had come to power after the revolution of 1848, France, and England too, openly sympathized with the Confederacy. Both the French and English textile industries depended on Southern cotton, and the Union blockade of the Confederate ports had crippled them. Manet felt differently. He did not believe in placing economic self-interest above the cause of human equality and freedom. *The Battle of the "Kearsarge" and the "Alabama"* is, thus, a deeply political statement. Manet's painting challenges the complicity of the French government and the bourgeois culture supporting it with the Southern cause.

The painting, finally, epitomizes the dawning modern age, an age of revolution and civil war when tensions surrounding questions of freedom and equality, self-determination and national identity, erupted in violence. As revolution threatened, the bourgeoisie tightened its control of European society, and the attitudes and tastes of modern bourgeoisie culture are the constant targets of Manet's art. ∎

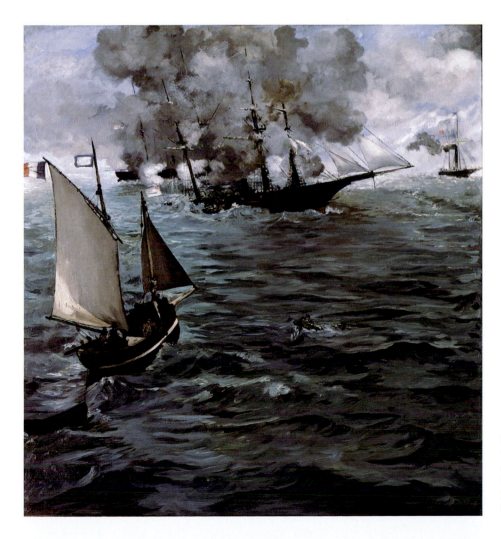

Fig. 35.24 Édouard Manet. *The Battle of the "Kearsarge" and the "Alabama."* **1864.** Oil on canvas, 54¼″ × 50¾″. John G. Johnson Collection, 1917. Philadelphia Museum of Art, Philadelphia, Pennsylvania, U.S.A. Art Resource, NY.

36 Revolution and Civil War

The Conditions of Modern Life

The Revolutions of 1848: From the Streets of Paris to Vienna

In Pursuit of Modernity: Paris in the 1850s and '60s

The American Civil War

There are, in my opinion, two elements in a work: the element of reality, which is nature, and the personal element, which is man. The element of reality, nature, is fixed, always the same; it is given equally to all men. . . . The personal element, man, is, on the other hand, infinitely variable; there are as many possible works as there are different minds. . . .

Émile Zola, *The Moment in Art*

◄ **Fig. 36.1 *The Barricade at the Church of la Madeleine*. February 1848.** This photograph, one of the first to be printed on paper, looks down rue de la Concorde (now rue Royale) toward Place de la Concorde and across the Seine to the National Assembly. The dome in the distance is Les Invalides, burial place of Napoleon I. The photo captures the reality of the revolutions that swept Europe in 1848 (see Map 36.1) when workers and middle-class liberals united to assert their right to democratic rule and civil liberty. It also prefigures the civil war that would soon consume the United States, itself fueled by the issue of slavery.

BETWEEN 1800 AND 1848, THE CITY OF PARIS DOUBLED IN size, to nearly 1 million people. Planning was nonexistent. The streets were a haphazard labyrinth of narrow, stifling passageways, so clogged with traffic that pedestrians were in constant danger. The gutters were so full of garbage and raw sewage

that cesspools developed overnight in low-lying areas. The odor they produced was often strong enough to induce vomiting. And they bred rats and fleas, and the diseases they carried, such as cholera, dysentery, typhus, and typhoid fever. One epidemic in Paris during 1848 and 1849 killed more than 19,000 people. Further complicating the situation, no accurate map of the streets existed prior to 1853, so to venture into them was to set out into unknown and dangerous territory.

By 1848, these conditions prevailed throughout urban areas in Europe, made worse by food shortages and chaos in the agricultural economy. The potato famine in Ireland that killed a million people was merely the worst of a widespread breakdown. The agricultural crisis in turn triggered bankruptcies and bank closings, particularly in places where industrial expansion had not been matched by the growth of new markets. In France, prices plummeted, businesses failed, and unemployment was rampant. The situation was ripe for revolution. Soon the streets of Paris were filled with barricades (Fig. **36.1**), occupied by workers demanding the right to earn a livelihood and determine their own destiny. In other European capitals, workers quickly followed the Parisians' lead (Map **36.1**).

This chapter explores the revolutions of 1848 in Europe and their aftermath. At the heart of these conflicts were two ideologies that were sometimes compatible and sometimes not: liberalism and nationalism. Liberal belief was founded in Enlightenment values—the universal necessity for equality and freedom at the most basic level. The nationalist agenda, however, focused on regional autonomy, cultural pride, and freedom from monarchical control, especially that of the Habsburgs, who controlled much of central, eastern, and southern Europe. Liberal politics were transnational; nationalism rested upon claims of distinct regional, even local, ethnic and linguistic identity.

While liberal and nationalist politics dominated all of Europe after 1848, Paris remained the center of revolutionary activity, a focus of world attention, as well as the center of European culture. The realist approach to art that developed in the 1830s and 1840s was integrated into an effort to define the term *modern*, which, after the revolutions of 1848, became a popular characterization of contemporary life. Writers and painters presented the conditions of life in France's new bourgeois (middle class) society in sometimes shockingly direct terms, interested not so much in revealing the physical realities, as their predecessors had done in describing the working class, but in examining the social condi-

tions and prejudices of their subjects. And in America, the Civil War—interpreted by Europeans primarily as a contest between liberal and nationalist politics—resulted in a new realism that demythologized the antebellum-era Romantic view of slavery in art and music while also depicting the horrors of war with brutal directness.

The Revolutions of 1848: From the Streets of Paris to Vienna

Although the working classes suffered most from the miserable living conditions in cities, they were not the initial cause of the revolutionary turmoil of 1848. It was the middle-class (bourgeois) political thinkers who most strongly argued for representative government and civil liberties. They considered themselves to be *liberal*, espousing legal equality, religious toleration, and freedom of the press. They generally believed, like Enlightenment writers John Locke and Thomas Jefferson, that government emanated from the people, who freely consented to its rule and had the power to

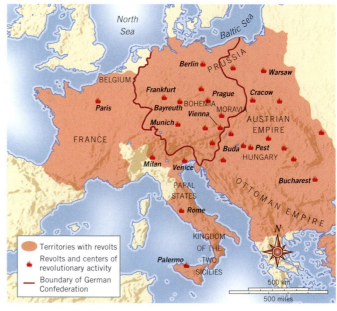

Map 36.1 Revolutionary activity in Europe in 1848.

oust unwanted leaders. The people expressed this consent through the election of representatives, and they protected their rights through written constitutions. Many liberals supported the ideas of Adam Smith, who argued (see chapter 31) that government should keep its nose out of economics and trade. Many were, in fact, self-serving capitalists, partisans of unregulated economic life, and opponents of tyranny of any government that threatened their self-interest. When they allied themselves with the working classes—generally more predisposed to violence—it was more a matter of convenience than conviction. Nineteenth-century liberalism thus expressed the French Revolution's principle, *"Liberté, Égalité, Fraternité,"* in less strident terms, but with the same concern for individual rights and common morality.

Marxism

There were, however, more radical thinkers whose convictions were untarnished by self-interest and who, furthermore, did not shy away from proposing violence to attain their goals. Karl Marx (1818–1883) and Friedrich Engels [EN-gulz] (1820–1895) were two young, middle-class Germans who believed that since the conditions in which one earns a living determined all other aspects of life—social, political, and cultural—capitalism must be eliminated because of its inherent unfairness. Reform was pointless—only a revolution of the working people would succeed in achieving meaningful change. In fact, Marx and Engels believed revolution was inevitable, following the logic of the philosopher Georg Wilhelm Friedrich Hegel's dialectic (see chapter 34). The struggle between the bourgeoisie—which Engels defined as "the class of modern capitalists, owners of the means of production and employers of wage labor"—and the proletariat (working class) amounted to the conflict between thesis and antithesis. (The term bourgeoisie generally referred to the capitalist or merchant class.) The resolution lay in the synthesis of a classless society, a utopian society at "the end of history," since the dialectic forces that drive history would be finally and permanently resolved.

The collaboration of Marx and Engels would ultimately help shape nineteenth- and twentieth-century history across the globe. Their epochal partnership began rather simply in a Parisian café in August 1844, where Marx first met Engels. Marx had been editing a German newspaper and Engels was the heir to his father's textile factory in Manchester, England. The following year Engels published his *Conditions of the Working Class in England*, a scathing indictment of industrial life, and in early 1848 the two had coauthored and published a manifesto for the newly formed Communist League in London. The term *communist* at the time suggested a more radical approach to communal politics than *socialist*. In the *Communist Manifesto* (see **Reading 36.1**, page 1179, for Part I, "Bourgeois and Proletarians"), Marx and Engels argued that class struggle characterized all past societies and that industrial society simplified these class antagonisms. "Society as a whole is splitting up more and more into two great hostile camps, into two great classes directly facing each other: Bourgeoisie and Proletariat."

In its most controversial phrases, the *Communist Manifesto* called for "the forcible overthrow of all existing social conditions," and concluded, "The proletarians have nothing to lose but their chains. They have a world to win. WORKING MEN OF ALL COUNTRIES, UNITE." This simplistic call-to-arms would gain support steadily through the ensuing decades, even though Marx and Engels failed to anticipate capitalism's ability to adapt to change and slowly improve the lot of "the proletariat." However, the *Manifesto*, as well as Marx's later *Das Kapital (Capital)*, offered an important testament of the living conditions of the proletariat and an incisive interpretation of the way capitalism operated. Ironically, this forceful critique of the effects of the free market became an influential factor in advancing reforms in working conditions, as well as providing higher wages and greater social equality.

The Streets of Paris

In February 1848, rioters overthrew Louis-Philippe, who had ruled since 1830. Tension between the bourgeoisie, the intellectual liberals, and the working people who fought beside them was evident from the first. In his *History of the Revolution of 1848*, writer and politician Alphonse de Lamartine [lah-mar-TEEN] (1790–1869) describes the scene just before the overthrow (**Reading 36.2**):

READING 36.2 **from Alphonse de Lamartine, *History of the Revolution of 1848* (1849)**

These two classes exhibited a characteristic difference of air and costume. The one was composed of young men belonging to the rich and refined mercantile classes, to the schools, to trade . . . to literature, and . . . to the periodical press. These harangued the people, inflamed popular indignation against the king, the minister, and the chambers; spoke of the humiliation of France before the foreigner, of the diplomatic treasons of the court, and the insolent corruption and servility of deputies, who had sold themselves to the sovereign will of Louis-Philippe. . . . The numerous promenaders and bystanders, whose curiosity was excited by whatever was new, crowded around these orators, and applauded their expressions. The other class was composed of the lower orders [workers], summoned within the last two days, from their shops, by the sound of firing; clad in their working dress, with their blue shirts open, and their hands still blackened with the smoke of the forge. These came down in silence, in little knots. . . . One or two workmen, better dressed than the rest, with long skirted cloth coats, walked before them, addressed them in a low tone, and seemed to be giving them the word of command. These were the heads of the sections of the Rights of Man and of Families [a reference to the French Revolution of the 1790s].

Within several days King Louis-Philippe fled to exile in England. A provisional government for the Second French Republic was installed by voice vote of a crowd that shouted its judgment for each name read by Alphonse de Lamartine.

The June Days in Paris: Worker Defeat and Rise of Louis-Napoleon

The mob that day had made one thing clear—it demanded the "right to work." The provisional government quickly acted to form *Ateliers Nationaux* [ah-tuh-lee-AY nah-see-oh-NOH], "National Workshops," to provide employment. Enrollment in these workshops quickly jumped from 10,000 in March to 120,000 in June. Unable to provide useful employment for such numbers, the government discovered it had inadvertently created a vast army eager to support almost every radical cause. On June 22, the National Workshops were officially terminated and disillusioned workers took up arms in response. The so-called June Days—three days of the bloodiest street fighting in nineteenth-century European history—followed, as workers built and occupied barricades in the streets (see Fig. 36.1). The army quickly overcame the workers at the cost of 10,000 dead and wounded. Eleven thousand more so-called leaders of the revolution were deported to France's new colony of Algiers [al-JEERZ], in North Africa. The brutal street fighting was so disturbing to Parisians that even such a traditional Salon painter as Ernst Meissonier (me-saw-NYEY) (1815–1891), who spent his entire career celebrating French military history, was moved, for once, to depict the truth of war (Fig. **36.2**).

Many members of the middle class were convinced that they had barely survived the complete collapse of social order. What came to be known as the Red Fear, an almost paranoid distrust of the working class, gripped France. Conservatives succeeded in passing legislation that curbed freedom of the press and limited political association. A new constitution provided for the election of a president who could deal with any future rebellions without interference.

In the December 1848 election for president, Charles-Louis-Napoleon Bonaparte (1808–1873) was the victor. Known as Louis-Napoleon [loo-EE-nah-poh-lay-OHN], this nephew of Napoleon I was awkward and spoke French with a German accent, but his name proved attractive to the electorate. When, in 1851, the assembly refused to amend the constitution to allow the president to run for a second term, Louis-Napoleon staged a *coup d'état* [koo day-TAH] (sudden, unlawful overthrow of a government). On December 2 of that year, the anniversary of his uncle's great victory at Austerlitz, he ordered his troops to disperse the assembly. Hundreds were killed resisting the coup, 26,000 people were arrested, and 10,000 deported to Algeria. A year later, Louis-Napoleon was proclaimed Emperor Napoleon III, again approved by an overwhelming popular plebiscite (a "yes or no" vote). The conservative bourgeoisie, or as Marx would term them, the capitalists, were firmly entrenched in power. An autocrat, Louis-Napoleon was popular with monarchists and the middle class as a force

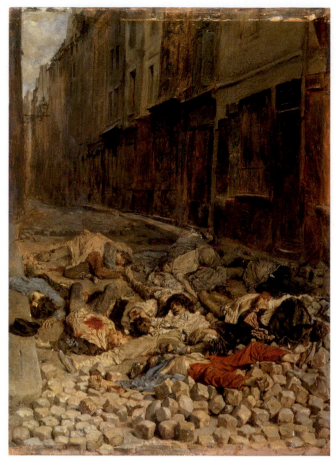

Fig. 36.2 Ernest Meissonier. *Memory of Civil War (The Barricades)*. 1849 (Salon of 1850–1851). Oil on canvas, 11½″ × 8¼″. Inv. RF1942-31. Location: Louvre, Paris, France. Musée du Louvre/RMN Réunion des Musées Nationaux, France. SCALA/Art Resource, NY. Meissonier served as a captain of the Republican Guard defending the Hôtel de Ville in the June Days and witnessed the bloodshed with his own eyes. The result is this painting, which a contemporary called an "omelette of men." It is Delacroix's *Liberty Leading the People* (see Fig. 35.12) stripped bare of all its glory.

for restoring order. To the working class, he promised economic progress for all, while the rural population revered him as Napoleon Bonaparte's nephew.

No image better illustrates the repressive role of the state in Paris after 1848 than *What Is Called Vagrancy* (Fig. **36.3**) by the Belgian painter Alfred Stevens (1823–1906) working in Paris. On a street in Vincennes [van-SEN], on the outskirts of Paris, troops of Napoleon III arrest for vagrancy a woman with a baby in her arms and a humiliated little boy at her skirt. A more elegantly dressed woman tries to intercede, but she is rebuffed by the threatening gesture of a soldier. An elderly disabled worker has already given up and turns away. Posters on the wall behind them emphasize the disparity between rich and poor—one announces a court auction of buildings (presumably for default) and the other a "*Bal*" [bahl] or dance. When Napoleon III saw this painting, he was outraged, believing such spectacles could stir up conflict. He ordered that vagrants should be transported to prison in closed coaches.

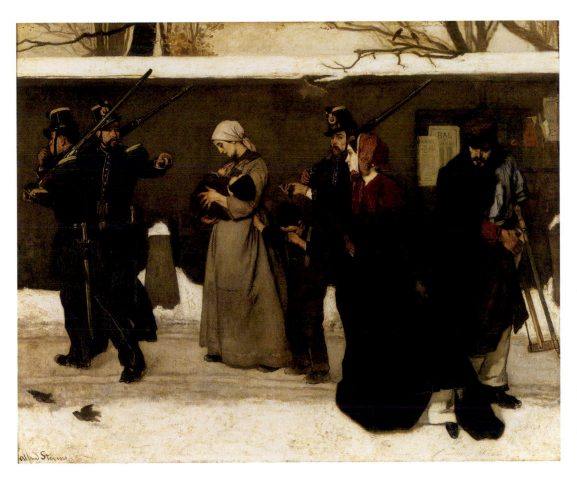

Fig. 36.3 Alfred Stevens. *What Is Called Vagrancy.* 1855 (1855 Exposition Universal). Oil on canvas, 52″ × 63¾″. Musee d'Orsay, Paris, France. Photo: Hervè Hewandowski/Réunion des Musées Nationaux. Art Resource, NY. The painting was also known in the mid-nineteenth century by the telling title *The Hunters of Vincennes.*

Revolution across Europe: The Rise of Nationalism

The Paris uprising of February 1848 triggered a string of successive revolts in Austria, many of the lesser German states, and throughout Italy, spreading northward from Sicily, Sardinia, and Naples to the Papal States, Tuscany, and the northern regions under Austrian rule (see Map 36.1). One of the most important factors contributing to revolution was nationalism, the exaltation of one's home territory. National groups across Eastern Europe sought to replace the rule of the Prussian and the Austrian Habsburgs with smaller independent states. First, in Vienna, Magyar [MAG-yar] nationalists called for the independence of Hungary, even as Czech [chek] nationalists demanded the right to create an autonomous Slavic [SLAH-vik] state in Bohemia [boh-HEE-mee-uh] and Moravia [mor-AY-vee-uh]. In early June, the first Pan-Slavic Congress, including Poles, Croats [KROH-ats], Slovenes [SLOH-veenz], and Serbs, met in Prague [prahg] and issued a manifesto that protested the repression of all Slavic peoples. By June 12, as the Congress closed, an anti-government riot broke out, and the Habsburgs' military smashed the radicals, thus temporarily ending the drive toward a Pan-Slavic state.

Meanwhile, in Italy, revolution against Habsburg domination began in Milan and moved southward. In Rome, radicals rose up against papal control, forcing the pope to appoint a new ministry. Republican nationalists from across Italy, including Giuseppe Mazzini [mah-TZEE-nee] (1805–1872) and Giuseppe Garibaldi [gah-ree-BAHL-dee] (1807–1882), converged on the city hoping to unite the rest of Italy behind the example of this new Republic of Rome. But by June 1849, 10,000 French troops, sent by Louis-Napoleon, laid siege in support of continued papal control, and by the end of the month, the Roman Republic was dissolved. (To get a sense of what it felt like to witness this revolution firsthand, see *Voices*, page 1158.)

In mid-March 1848, popular disturbances also erupted in Berlin, forcing the Prussian king, Frederick William IV (r. 1840–1861), to install a liberal government. But again the forces of reform were thwarted, and in April 1849, the Prussian monarch forced the liberal assembly to resign and proclaimed his own constitution. Elsewhere in Germany, the liberal Frankfurt Parliament offered the crown of a united Germany to Frederick William IV, who refused it. The Frankfurt Parliament, hopelessly caught between its fear of the working classes and its dependence on the troops of conservative monarchs, dissolved.

Given the nationalists' opposition to the monarchist (and papal) governments that controlled most of the rebelling regions, it is hardly surprising that they often found themselves allied with liberals. But important differences existed between the two camps. In fact, on many questions nationalism was distinctly at odds with liberal political values. Nationalist groups

Voices

Italian Nationalists Struggle for Liberty

The Italian battle for nationhood gained a number of foreign allies, including American writer Margaret Fuller (1810–1858), who assumed charge of a Roman hospital while her Italian husband fought the French invaders in 1849. While individual Americans and British sympathized with the Italian nationalists, their governments remained frustratingly neutral, thereby dooming the new democracy. Fuller detailed her experiences during the French siege in letters to friends in the United States:

May 6, 1849

I write you from barricaded Rome. The mother of nations is now at bay against them all. . . . The Americans here are not in a pleasant situation. Mr. Cass, the Charge of the United States, stays here without recognizing the government. . . . it gives us pain that our country, whose policy it justly is to avoid physical interference with the affairs of Europe, should not use a moral influence. Rome has—as we did—thrown off a government no longer tolerable; she had made use of the suffrage to form another; she stands on the same basis as ourselves [American democracy]. . . .

June 6, 1849

On Sunday . . . I witnessed a terrible, a real battle. It began at four in the morning: it lasted to the last

". . . [I]t gives us pain that our country, whose policy it justly is to avoid physical interference with the affairs of Europe, should not use a moral influence. Rome has—as we did—thrown off a government no longer tolerable; . . ."

gleam of light. The musket-fire was almost uninterrupted; the roll of the cannon, especially from St. Angelo, most majestic. I saw the smoke of every discharge, the flash of bayonets, with a glass [telescope] could see the men. The French could not use their heavy cannon, being always driven away by the legions of Garibaldi when trying to find positions for them. The loss on our side [the Italian nationalists] about three hundred killed and wounded; theirs must be much greater. In one casino [country house] have been found seventy dead bodies of theirs. . . . The French throw rockets into the town, one burst in the courtyard of the hospital just as I arrived there yesterday, agitating the poor sufferers very much; they said they did not want to die like mice in a trap.

often defined themselves in direct opposition to other ethnic groups whom they considered their cultural inferiors. The Hungarian Magyars, for instance, sought authoritarian control over all other ethnic groups living within the historical boundaries of Hungary, including Romanians, Croatians, and Serbs.

One group that appeared to benefit from the revolutions of 1848 was the Jews, who had historically been subject to great repression throughout Europe. In Scandinavia, Italy, Germany, Belgium, and Holland, Jews attained full rights of citizenship after 1848, and in 1867 Austria-Hungary extended them the same rights. By 1858, Jews were permitted to sit in Parliament in England. As a result, Jewish participation in European cultural life increased dramatically. For the first time, Jews were able to enter art and music schools, and subsequently they became leaders in science and education. From 1850 until about 1880, Jews lived their lives in relative freedom from persecution and discrimination.

Only in Russia and other parts of Eastern Europe did anti-Semitism continue unabated. In Russia, Jews were confined to designated ghettos, from which they could leave only with internal passports. They were banned from state service and

most forms of higher education, and publication of Jewish texts was severely restricted. The police regularly led *pogroms* [POH-grums] (organized and violent riots) against Jewish neighborhoods and villages. As a result, hundreds of thousands of Jews emigrated from the East to Western Europe as well as the United States.

Despite the anti-Semitic atmosphere in Russia, a new transnational Jewish literature began to surface, written in Yiddish, a German dialect using the Hebrew alphabet. Among its most notable authors is Sholem Yakov Rabinovitsh [SHOH-lem YAH-kov rah-bin-o-vits], widely known as Sholem Aleichem [ah-LAY-khum] (1859–1916). His stories about Tevye the Milkman would later inspire the Broadway musical and film *Fiddler on the Roof*.

In Pursuit of Modernity: Paris in the 1850s and '60s

Soon after the stunning events of 1848, Pierre-Joseph Proudhon [proo-DOHN] (1809–1865), the French journalist who

Fig. 36.4 Nadar (Gaspard-Félix Tournachon). *Portrait of Charles Baudelaire.* 1863. Silver print. Caisse Nationale des Monuments Historiques et des Sites, Paris. Baudelaire was deeply suspicious of photography, believing that it supported the naïve view that "Art is, and cannot be other than, the exact reproduction of Nature." He called Daguerre the "Messiah" of this point of view.

CULTURAL PARALLELS

The Rise of Bahá'í

As nationalist ideology grew throughout the West in the last half of the nineteenth century, the son of a Persian nobleman developed a religious philosophy aimed at transcending national, religious, and ethnic differences. Mírzá Husayn—who became known as "Bahá'u'lláh" or "Glory of God"—founded the Bahá'í faith in 1863. Bahá'í principles centered on transcending superstition and tradition through the independent search for truth, the fundamental oneness of humanity, the essential unity of all religions, and the condemnation of all forms of prejudice. Striving to harmonize religion and science, Bahá'í was a modernizing force in the Islamic world, while also being allied with progressive forces in the West.

READING 36.3 **from Charles Baudelaire, "To the Bourgeoisie," in** *Salon of 1846* **(1846)**

The government of the city is in your hands, and that is just, for you are the force. But you must also be capable of feeling beauty; for as not one of you today can do without power, so not one of you has the right to do without poetry. . . .

Very well, you need art.

Art is an infinitely precious good, a draught both refreshing and cheering which restores the stomach and the mind to the natural equilibrium of the idea.

You understand its function, you gentlemen of the bourgeoisie—whether lawgivers or businessmen—when the seventh or eighth hour strikes and you bend your tired head towards the embers of your hearth or the cushions of your arm-chair.

This is the time when a keener desire and a more active reverie would refresh you after your daily labors.

first called himself an "anarchist" and famously coined the phrase "property is theft," wrote: "We have been beaten and humiliated . . . scattered, imprisoned, disarmed, and gagged. The fate of European democracy has slipped from our hands." Political and moral idealism seemed vanquished. In their place remained only the banal prosperity of the triumphant bourgeoisie. In fact, the political, moral, and religious emptiness of the bourgeoisie became the targets of a new realism, which critiqued what Proudhon called the "fleshy, comfortable" bourgeois lifestyle.

Even before the revolution, the poet Charles Baudelaire [boh-deh-LAIR] (1821–1867) (Fig. **36.4**) recognized the triumph of bourgeois culture in the opening dedication to his *Salon of 1846*, a text that is both a social critique and an art review of the official government-sponsored exhibition of painting and sculpture by living artists held biannually at the Louvre (**Reading 36.3**):

Baudelaire recognized the bourgeoisie as his audience, but their hypocrisy was his constant target. His admonitions that they should love art masks his feelings that they are incapable of understanding true artistic innovation.

Charles Baudelaire and the Poetry of Modern Life

Baudelaire's own sense of the beautiful and marvelous is nowhere more apparent than in his poetry, which was passionately attacked for its unconventional themes and subject

matter, chosen to shock bourgeois minds. When Flaubert's *Madame Bovary* first appeared in magazine installments in 1856 (see chapter 35), its author had been brought to trial, charged with giving "offense to public and religious morality and to good morals." Eight months later, in August 1857, Baudelaire, Flaubert's good friend, faced the same charge for his book of 100 poems, *Les Fleurs du mal* [lay fler doo mahl], usually translated "Flowers of Evil." Unlike Flaubert, Baudelaire lost his case, was fined, and was forced to remove six poems concerning lesbianism and vampirism, all of which remained censored . . . for the next century!

The poems in *Les Fleurs du Mal* unflinchingly confront the realities of this "underworld" and of life itself. In the poem "Carrion," for example, Baudelaire recalls strolling with his love one day (**Reading 36.4**):

READING 36.4 Charles Baudelaire, "Carrion," in *Les Fleurs du mal* (1857) (translation by Richard Howard)

Remember, my soul, the thing we saw
that lovely summer day?
On a pile of stones where the path turned off,
the hideous carrion—

legs in the air, like a whore—displayed
indifferent to the last,
a belly slick with lethal sweat
and swollen with foul gas.

the sun lit up that rottenness
as though to roast it through,
restoring to Nature a hundredfold
what she had here made one.

And heaven watched the splendid corpse
like flower open wide—
you nearly fainted dead away
at the perfume it gave off.

The poem is an attack on the Romanticized view of death that marks, for instance, Emma Bovary's illusory ecstasy (see chapter 35). To look at such reality unflinchingly, with open eyes is, for Baudelaire, the central requirement of modern life.

The lover in "Carrion" is Jeanne Duval [zhun doo-VAHL], Baudelaire's Haitian-born mistress with whom he had a tumultuous on-again-off-again relationship for 20 years. His painter friend Édouard Manet (1832–1883) would paint her in 1862 sitting on a sofa, her enormous crinoline (hoop-skirt) dress spread around her (Fig. **36.5**). In his 1863 essay, "The Painter of Modern Life," Baudelaire writes: "What poet, in sitting down to paint the pleasure caused by the sight of a beautiful woman, would venture to separate her from her costume?" Such sentiments define the

attitude that would soon create the Paris fashion industry, the tradition of *haute couture* [oht koo-TOOR] that has come down to the present day.

Many critics and scholars have objected to Manet's rather unflattering depiction of his sitter. The work suggests that the woman and the dress embrace a larger unity, incorporating both attraction and repulsion. Nevertheless, both the painting and the many poems Baudelaire wrote about Jeanne openly address the attractions of her sexuality (**Reading 36.5**):

READING 36.5 Charles Baudelaire, "The Head of Hair," in *Les Fleurs du mal* (1857) (translation by Richard Howard)

Ecstatic fleece, that ripples to your nape
And reeks of negligence in every curl!
To people my dim cubicle tonight
with memories shrouded in that head of hair,
I'd have it flutter like a handkerchief!

For torpid Asia, torrid Africa,
—the wilderness I thought a world away—
survive at the heart of this dark continent.
As other souls set sail to music, mine
O my love! embarks upon your redolent hair.

Take me, tousled current, to where men
as mighty as the trees they live among
submit like them to the sun's long tyranny;
ebony sea, you bear a brilliant dream
of sails and pennants, mariners and masts.

A harbor where my soul can slake its thirst,
for color, sound and smell—where ships that glide
among the seas of golden silk throw wide
their yardarms to embrace a glorious sky
palpitating in eternal heat.

Drunk, and in love with drunkenness, I'll dive
into this ocean where the other lurks,
and solaced by these waves, my restlessness
will find a fruitful lethargy at last,
rocking forever at aromatic ease.

Poetry has rarely addressed sexual pleasure more openly, but Baudelaire also acts out what we can recognize today as imperialist imagery: Jeanne Duval's body becoming at once China and Africa, her harbors open to the colonizing fleet of his desire.

Édouard Manet: The Painter of Modern Life

In 1863, Baudelaire called for an artist "gifted with an active imagination" to actively pursue a new artistic goal: describing the modern city and its culture. Édouard Manet most clearly embodies this new vision of the artist as a recorder of every-

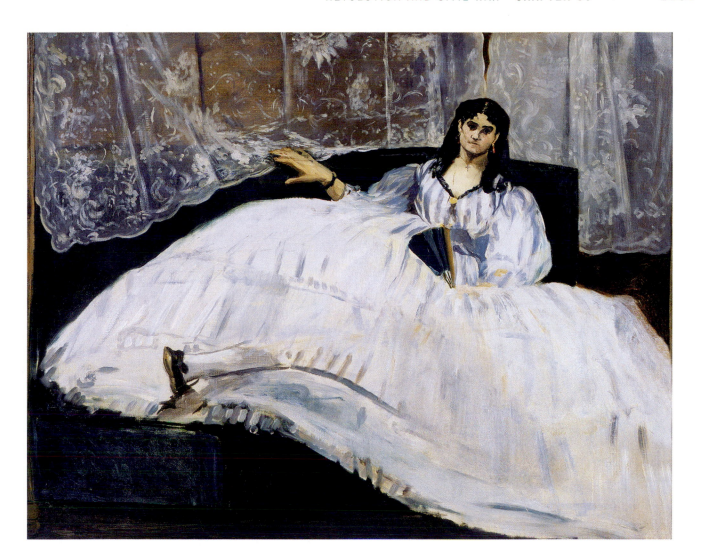

Fig. 36.5 Édouard Manet. *Baudelaire's Mistress Reclining (Study of Jeanne Duval).* **ca. 1862.** Oil on canvas, 35⅜" × 44½". Location: Museum of Fine Arts (Szépmuvészeti Muzeum), Budapest, Hungary. Giraudon/Art Resource, NY. Baudelaire referred to this dark-skinned actress, whom he first met in 1842, as his "Black Venus."

day city life, since he, like Baudelaire, was a *flâneur*. The *flâneur* was a man-about-town, with no apparent occupation, strolling the city, studying and experiencing it coolly, dispassionately. Moving among its crowds and cafés in fastidious and fashionable dress, the flâneur had an acute ability to understand the subtleties of modern life and the ability to create art, according to a definitive essay by Baudelaire (**Reading 36.6**):

READING 36.6 from Charles Baudelaire, "The Painter of Modern Life" (1863)

Be very sure that this man, such as I have depicted him—this solitary, gifted with an active imagination, ceaselessly journeying across the great human desert—[aims for] . . . something other than the fugi-

tive pleasure of circumstance. He is looking for that quality which you must allow me to call "modernity". . . By "modernity" I mean the ephemeral, the fugitive, the contingent. . . . This transitory, fugitive element, whose metamorphoses are so rapid, must on no account be despised or dispensed with. By neglecting it, you cannot fail to tumble into the abyss of an abstract and indeterminate beauty.

According to Baudelaire, the flâneur is distinguished by one other important trait: his attitude toward the bourgeoisie. He holds their vulgar, materialistic lifestyle in contempt, and his greatest devotion is to shocking them. "*Il faut épater le bourgeois*" [eel foh ay-pah-TAY leh boor-ZHWAH] ("One must shock the bourgeoisie"), he said. Thus, it came as no surprise to Manet when *Le Déjeuner sur l'herbe* [leh day-zhur-NAY sur lerb] (*Luncheon on the Grass*)

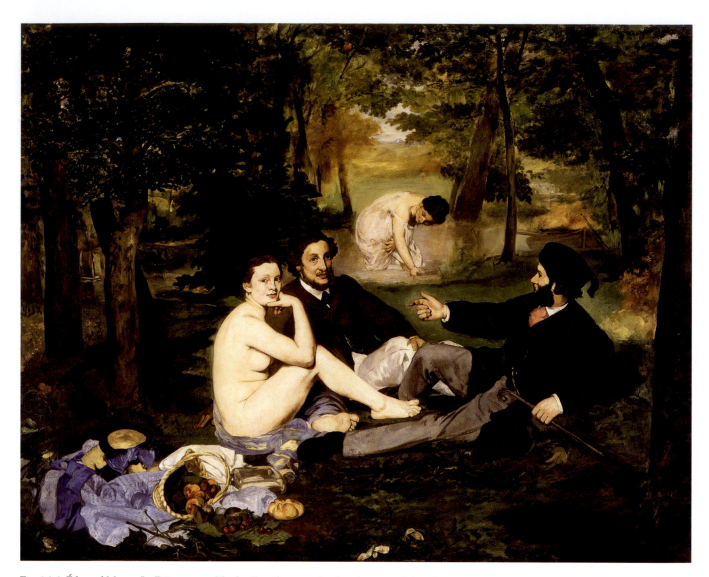

Fig. 36.6 Édouard Manet. *Le Déjeuner sur l'herbe (Luncheon on the Grass).* **1863.** Oil on Canvas, 7' x 8'10". Musee d'Orsay, Paris. RMN Réunion des Musées Nationaux/Art Resource, NY. © 2008 ARS Artists Rights Society, NY. The model for the reclining young man on the right, whose gesture seems to point simultaneously at both female figures, was Manet's future brother-in-law.

was rejected by the jury for the Salon of 1863 (Fig. **36.6**). It was not designed to please them. The Salon drew tens of thousands of visitors a day to the Louvre and was the world's most prominent art event. The public also reacted with outrage when Manet's painting appeared at the Salon des Refusés [sah-LOHN day reh-foo-ZAY], an exhibition hurriedly ordered by Louis-Napoleon after numerous complaints arose about the large number of rejected artworks. While many of the paintings included in the Salon des Refusés were of poor quality, others, including *Le Déjeuner sur l'herbe* by Manet and *The White Girl, Symphony in White, No. 1* by American artist James McNeill Whistler, were vilified because of their supposedly scandalous content or challenging style. The Paris newspapers lumped them all together: "There is something cruel about this

exhibition: people laugh as they do at a farce. As a matter of fact it is a continual parody, a parody of drawing, of color, of composition."

Manet's painting evokes the *fêtes galantes* of Watteau (see Fig. 29.3) and a particular engraving executed by Marcantonio Raimondi [ray-MOHN-dee] (Fig. **36.7**) after a lost painting designed by Raphael, *The Judgment of Paris* (1520). Manet's three central figures assume the same poses as the wood nymphs seated at the lower right of Raimondi's composition, and so Manet's painting can be understood as a "judgment of Paris" in its own right—Manet judging Paris the city in all its bourgeois decadence. It was, in fact, the discord between the seated female's frank nudity—and the fact that she appears to confront directly the gaze of the viewer—and her fully clothed male companions, who seem

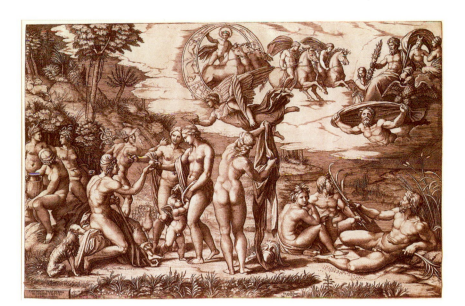

Fig. 36.7 Marcantonio Raimondi after Raphael. *The Judgment of Paris.* **ca. 1520.** Engraving. Inv. 4167LR. Rothschild Collection. Musée du Louvre/RMN Réunion des Musées Nationaux, France. SCALA/Art Resource, NY. Paris judges which of the goddesses—Aphrodite, Hera, or Athena—is the most beautiful. His choice has profound impact, leading as it does to the Trojan War.

engaged in a conversation wholly at odds with the sexualized circumstances, that most discomfited the painting's audience. Manet's assault on his fellow Parisians' sensibilities continued in 1863 with *Olympia* (see *Focus*, pages 1164–1165), though the painting was not exhibited until the Salon of 1865, where once again it was the object of public scandal and ridicule.

Émile Zola and the Naturalist Novel

Early in 1867, the novelist Émile Zola [ay-MEEL zoh-LAH] (1840–1902) came to the defense of his friend Manet and *Olympia* in particular in a short book entitled simply *Édouard Manet.* Manet, he said, painted "in a way which is contrary to the sacred rules taught in schools." He continues (**Reading 36.7**):

> **READING 36.7** from Émile Zola,
> *Édouard Manet* (1867)
>
> He has made us acquainted with Olympia, a contemporary girl, the sort of girl we meet every day on the pavements, with thin shoulders wrapped in a flimsy faded woolen shawl. The public as usual takes good care not to understand the painter's intentions. Some people tried to find philosophic meaning in the picture, others, more lighthearted, were not displeased to attach an obscene significance to it. . . . But I know that you have succeeded admirably in doing a painter's job, the job of a great painter; I mean to say you have forcefully reproduced in your own particular idiom the truths of light and shade and the reality of objects and creatures.

A year after Zola's defense, Manet painted his friend's portrait (Fig. **36.8**). On the wall behind him is a black-and-white reproduction of *Olympia*—perhaps a subtle tribute to Zola's claim that Manet was interested in portraying "the truths of light and shade." Zola himself was anything but disinterested in the gritty realities of modern life. He practiced a brand of literary realism called *naturalism*—that is, in his words, "nature seen through a temperament." It is distinct from realism because it does not pretend to objective reporting. Zola was, in other words, completely aware that the artist's own personality definitively influenced the work and his view of the world (**Reading 36.8**):

> **READING 36.8** from Émile Zola,
> "The Moment in Art" (1867)
>
> There are, in my opinion, two elements in a work: the element of reality, which is nature, and the personal element, which is man. The element of reality, nature, is fixed, always the same; it is given equally to all men. . . . The personal element, man, is, on the other hand, infinitely variable; there are as many possible works as there are different minds. . . . The word "realist" means nothing to me, since I am determined to subordinate the real to temperament. . . . For it is equally ridiculous to believe that in matters of artistic beauty, there is one absolute and eternal truth. The single and whole truth is no good for us, since we construct new truths each morning and have worn them out by the evening. . . . This means that the works of tomorrow cannot be the same as those of today. . . .

Focus

Critics particularly criticized Manet's treatment of this hand, its fingers smudged and unformed, seeming to lack joints. Its rendering appeared simply incompetent to them, but it announces that Manet's realism is something other than photographic. He is more interested in the social realities that inform the scene.

Manet's *Olympia*

Manet's Olympia is a courtesan, or, more properly, not quite a courtesan. For she possesses the slightly stocky body of the working class—a *petite fabourienne* [puh-TEET fah-boor-ee-EN], one critic of the day called her, a "little factory girl." Perhaps she is one of the many factory girls who, in 1863, found themselves out of work in Paris, a casualty of the American Civil War. Unable to get raw cotton from the South, the cotton mills of Paris had to shut down. Many girls turned to prostitution in order to survive. Viewers at the Salon of 1865 were disturbed by her class—a courtesan satisfied upper-class tastes, prostitutes did not—by the position of her left hand, and, above all, by her gaze. Not only is her gaze as direct as the nude in *Le Déjeuner* (Manet used the same model in both); it is confidently directed downward toward us, the viewers. It is as if we have just arrived on the scene, bringing flowers that we have handed to the black maid. We are suddenly Olympia's customers. And if her body is for sale, then we have entered as well into the economy in which human beings are bought and sold—the economy of slavery.

We know that Manet was acutely aware of the politics of slavery. At age 16, in 1848, he set sail for Brazil aboard a merchant marine ship. From Rio de Janeiro, he wrote his mother:

> In this country all the Negroes are slaves; they all look downtrodden; it's extraordinary what power whites have over them; I saw a slave market, a rather revolting spectacle for people like us. The Negresses are generally naked to the waist, some with a scarf tied at the neck.

Here, in all likelihood, is the original contact with slavery that 15 years later would be realized in *Olympia* itself.

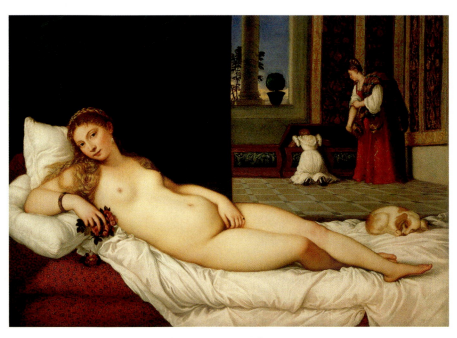

Titian. *Reclining Nude (Venus of Urbino).* **ca. 1538.** Oil on canvas, 47″ × 65″. Galleria degli Uffizi, Florence.

In the 1980s this very bracelet and medallion were found in France. In the medallion was a lock of hair and a note, apparently written by Manet's niece, Julie Manet. The note claimed that the hair was Édouard Manet's at the age of 15 months.

Manet's painting mirrors the structure of Titian's *Reclining Nude* (left), but where Titian portrays two ladies-in-waiting in the deep architectural space of the right side, Manet paints a single, barely lit window. This suggests that where Titian's painting takes place in daylight, Manet's takes place at night in a room lit by artificial light and may be a comment on the nature of love and beauty in Manet's Paris. In Titian's *Venus of Urbino* a dog, symbolizing fidelity, lies at the nude's feet. Here a black cat, symbolizing promiscuity, arches its back as if to hiss in protest at the viewer's arrival.

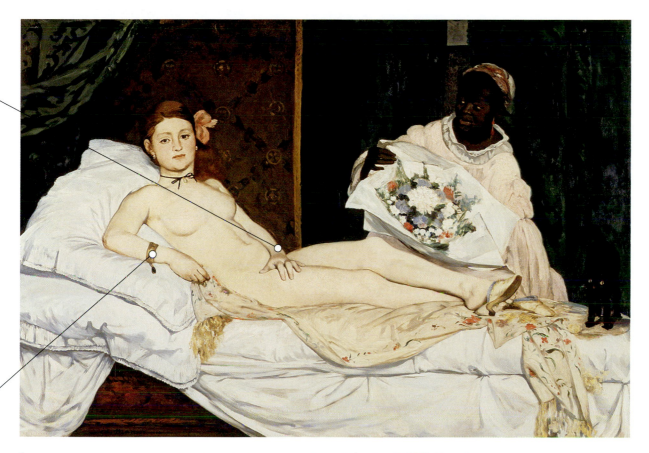

Édouard Manet. *Olympia.* 1863 (Salon of 1865). Oil on canvas, 51″ × 74 ³/₄″. Inv. RF 2772. Hervè Lewandowski/Musée d'Orsay, Paris, France. RMN Réunion des Musées Nationaux/Art Resource, NY. © 2008 Édouard Manet/Artists Rights Society (ARS), NY.

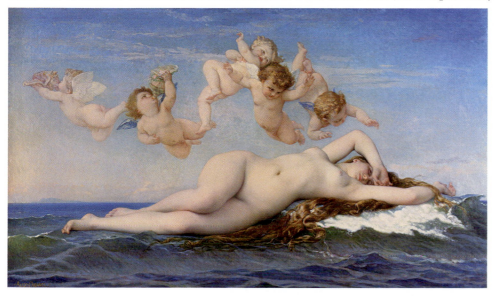

Alexandre Cabanel. *The Birth of Venus.* Salon of 1863. Oil on canvas, 52″ × 90″. P. Selert/Musée d'Orsay, Paris, France. Réunion des Musées Nationaux/Art Resource, NY. Just how radical Manet's painting must have seemed in 1865 can be understood by comparing it to this painting. The notoriously prurient Napoleon III, who had called Manet's *Le Déjeuner* "immodest," purchased it at the Salon of 1863. Cabanel's nude passively invites the gaze of the viewer, but does not meet it. The flock of cupids busy blowing conch shells above her head establishes the propriety of her nudity. She exists in mythological space, unlike Olympia, who rests firmly in the real.

Fig. 36.8 Édouard Manet. *Portrait of Émile Zola.* **1868.** Oil on canvas, 56 5/8″ × 44 7/8″ RF2205. Musée d'Orsay, Paris, France. Photo: Hervè Lewandowski. Reunion des Musées Nationaux/Art Resource, NY. The Japanese woodblock print in the painting, has been identified as a portrait of a sumo wrestler by Kuniaki II. Japanese culture was strongly represented at the Universal Exposition in Paris in 1867, and the growing interest of Western artists including Manet, become increasingly interested in Japanese art.

Zola also believed that all human beings (including authors and artists) are products of hereditary and environmental factors over which they have no control but which very much determine their lives. He applied this belief in such novels as *Thérèse Raquin* [tay-REZ rah-KEHN] (1867). The Thérèse of the title begins a love affair with a friend of her husband. The lovers drown the husband, only to find that their guilt makes life together intolerable, leading them to plot each other's murder. Zola described his strategy in the novel's preface (**Reading 36.9**):

READING 36.9 from Émile Zola, Preface to *Thérèse Raquin*, 2nd edition (1868)

I set out to study, not characters, but temperaments. Therein lies the whole essence of the book. I chose to portray individuals existing under the sovereign dominion of their nerves and their blood, devoid of free will and drawn into every act of their lives by the inescapable laws of their physical nature. Thérèse and Laurent are human animals, nothing more. I have endeavored to follow these animals through the devious working of their passions, the compulsion of their instincts, and the mental unbalance resulting from a nervous crisis. . . . I had only one desire: given a highly-sexed man and an unsatisfied woman, to uncover the animal side of them and see that alone, then throw them together in a violent drama and note down with scrupulous care the sensations and actions of these creatures. I simply applied to two living bodies the analytical method that surgeons apply to corpses.

Such realism reached its most powerful expression in Zola's 1885 novel *Germinal* [zher-mee-NAHL], about the lives of France's coal miners (see **Reading 36.10**, page 1181 for an extended passage). Permanently fatigued, anemic, emaciated by the coal dust they ceaselessly breathe, the miners live their lives in perpetual gloom (**Reading 36.10a**):

READING 36.10a from Émile Zola, *Germinal* (1885)

They all hammered away, and nothing could be heard but these irregular blows, muffled, seemingly far-off. The sounds took on a harsh quality in the dead, echoless air, and it seemed as if the shadows created a mysterious blackness, thickened by the flying coal dust and made heavier by the gas which weighed down their eyes. The wicks of their lamps displayed only glowing red tips through their metal screens. You couldn't make out anything clearly. The work space opened out into a large chimney, flat and sloping, on which the soot of ten winters had created a profound night. Ghostly forms moved about, random light beams allowing a glimpse of the curve of a thigh, a brawny arm, a savage face, blackened as if in preparation for a crime. . . .

Zola experienced these brutal realities firsthand when, in researching the novel, he descended into a mineshaft and took detailed notes. The scene could also be summed up as Zola's effort to capture "the truths of light and shade and the reality of objects and creatures," as he had written of Manet's *Olympia*. But it is the novel's intense documentary-like exposé of the living conditions his characters must endure that is most notable. The plight of the proletariat had never been so clearly depicted.

Nationalism and the Politics of Opera

Popular taste in Napoleon III's Second Empire was antithetical to the realism of a Courbet (see chapter 35) and the naturalism of artists like Manet and Zola. It preferred the Romanticism of an earlier generation, as illustrated by Emma Bovary's voracious consumption of romantic novels. The dynamics of this confrontation between bourgeois taste and what we have come to call the **avant-garde** [ah-vunt-GARD]—artists on the cutting edge—played itself out in the Second Empire most surprisingly at the opera. As a musical form favored by the aristocracy, and increasingly by the bourgeoisie, opera played an important social as well as musical role in Paris. Established by Louis XIV in 1669, the *Académie Nationale de Musique* (National Academy of Music) encompassed opera, music, and ballet. The opera was at once a state institution, a symbol of French culture and sovereignty, and a reminder of the country's royal heritage. In a period of rapid change during a century when the aristocracy lost its hold on power throughout Europe, the opera house seemed to be an oasis of conservative stability and aristocratic values. Or it should have been, thought its long-time aristocratic patrons and the *nouveau riche* (newly rich) bourgeois audience.

Yet change did arrive at the opera in the form of the most creative composers of the period, many of whom were associated with the revolutions of 1848 and the fervent nationalism sweeping the Continent. Since the aristocracy and the bourgeoisie shared a sense of hostility toward liberal nationalism and its notions of social equality and individual rights, a clash between opera's practitioners and audience was bound to happen.

Ever since Beethoven had briefly replaced his dynamic and tempo direction written in Italian, with German, nationalism had become a growing force in music. Frédéric Chopin (see chapter 34), a native of Poland, wrote many mazurkas and polonaises—traditional Polish folk dance forms—while living in Paris as part of a group of Poles forced into exile after the Russians had taken control of their country. The composer Robert Schumann immediately recognized Chopin's works as political compositions. If the Russian czar "knew what a dangerous enemy threatened him in Chopin's works," Schumann wrote, "in the simple tunes of his mazurkas, he would forbid this music. Chopin's works are cannons buried in flowers."

The confrontation between nationalism and the aristocracy played out, in Paris, at the new Paris Opéra [oh-pay-RAH], designed by Charles Garnier and constructed

Fig. 36.9 Charles Garnier. Facade of the Opéra, Paris. 1860–1875. Construction of the opera building started in 1862, but was slowed because of the high water table under the gigantic stage and fly tower. The water was drained, a massive concrete well was built to carry the stage and fly tower, and it was filled with water to counter the water pressure. This is the underground lake made famous in Paul Leroux's famous play *The Phantom of the Opera.*

between 1860 and 1875 (Fig. **36.9**). Its facade is a unique marriage of the Neoclassical and the Baroque, conceived to reflect a new imperial style. A Corinthian colonnade of paired columns tops a closed arcade of arches at the entrance, the whole embellished with exotic carved decorations. At the head of the new, broad Avenue de l'Opéra running at a diagonal from the rue de Rivoli and the Louvre, the Opéra literally commanded the center of Paris. Its Grand Staircase, rising to a height of 98 feet, is itself a theater within in the theater, designed to allow the aristocrats and the bourgeoisie to display themselves (Fig. **36.10**). So too were the loges, multi-seat boxes where women typically sat forward, in their finest evening wear, to show off their social position and wealth.

Giuseppe Verdi and the Grand Opera The Italian composer Giuseppe Verdi [VER-dee] (1813–1901) led the way in politicizing opera compositions. Verdi believed that opera should be, first of all, dramatically realistic. No longer were arias, duets, or quartets merely displays of the singers' technical virtuosity; rather, they dramatically expressed the characters' temperament or situation in magnificent sustained melodies. A case in point is Verdi's *Rigoletto* [ree-goh-LET-toh], a tragic opera in three acts, first performed in Venice in 1851, in which the womanizing duke of Mantua [MAHN-too-ah], disguised as a student, pays court to Gilda, who, unknown to him is the daughter of his hunchbacked court jester, Rigoletto. When Rigoletto learns that the duke has seduced her, he conspires to have him killed by a professional assassin, but the plan goes awry when the assassin's sister, Maddalena [mad-uh-LEH-nah], pleads for the duke's life. Because the assassin needs a victim in order to justify his payment, Gilda, who has overheard their conversation, sacrifices her own life to save the duke. For Act III, Verdi composed a quartet in which each of the characters conveys contrasting emotions (**CD-Track 36.1**). Two scenes are presented simultaneously. The duke tries to seduce Maddalena inside the inn while Rigoletto and Gilda watch from the outside. Rigoletto is demonstrating to the innocent Gilda the duke's moral depravity, and she reacts with shock and dismay. Here a wide range of human emotion occurs in a single scene.

As Italy struggled to achieve national unity, Verdi's operas came to symbolize Italian nationalism. Any time a female lead in his operas would yearn for freedom, the audience

Fig. 36.10 *Édouard Detaille, Inauguration of the Paris Opera House, January 5, 1875: Arrival of Lord Maire (with entourage) from London, Greeted by Charles Garnier.* Gouache on paper. Photo: Gerard Blot. Châteaux de Versailles et de Trianon, Versailles, France. Réunion des Musées Nationaux/Art Resource, NY. At the staircase's base, the two bronze *torchères*, large female figures brandishing bouquets of light, were illuminated by the new technological innovation of gaslight, as were the large sconces in front of the marble columns.

would understand her as a symbol of Italian unification, and it would erupt in a frenzy of applause. Even Verdi's name came to be identified with nationalist politics, as an acronym for the constitutional monarchy established in 1861 of Victor Emanuel—V[ictor], E[manuel], R[e] d'I[talia], "Victor Emanuel, King of [a unified] Italy."

To have his operas produced in Paris, Verdi was forced to make changes to satisfy the censors, who were sensitive to nationalist references. He had to accommodate French taste as well. Since all Paris operas traditionally included a second-act ballet, he inserted a gypsy dance around a campfire at an appropriate spot in *Il Trovatore* [eel troh-vah-TOR-eh] (*The Troubadour*). *Il Trovatore* (originally premiered in Rome in 1853) was set in Spain and centered on the Count di Luna's young brother, kidnapped and brought up by a gypsy woman, whose own mother had been burned as a witch by the count's father. The second-act ballet was a requirement of the Jockey Club, an organization of French aristocrats who came to the opera after dinner, long after the opera had begun, and expect-

ed a ballet when they arrived. As the French journalist Alfred Delvau [del-VOH] explained: "One is more deliciously stirred by the sight of the ballet corps than by the great arias of the tenor in vogue or the reigning prima donna." So Verdi, the most popular opera composer of the day, who also viewed himself as a pragmatist, went along with the idiosyncratic Paris tradition. Considering the large number of Verdi performances in Paris in the 1850s, his changes must have met with success. (In the 1856–1857 season, the Théâtre des Italiens in Paris offered 87 performances—54 of them Verdi operas.)

Wagner's Music Drama Meets the Jockey Club The Jockey Club's ability to dictate taste and fashion—which the bourgeoisie anxiously copied—extended, in a notorious example, to Richard Wagner's opera *Tannhäuser* [than-HOY-zur] in March 1861. Declaring that his was "the art of the future," Richard Wagner [VAHG-ner] (1813–1883) had arrived in Paris in 1859, where Wagner reported that the press found him "arrogant" and guilty of "repudiating all existing operatic music." Nonetheless, he managed to secure Louis-Napoleon's support for a production of *Tannhäuser*, an opera in three acts. Because of the Paris Opéra's rule that foreign works be presented in French, Wagner set about having the opera translated into French.

Tannhäuser's protagonist is a legendary knight minstrel (*Minnesinger*), the German equivalent of a medieval troubadour. When other minstrels gather for a tournament of song in the great hall of the Wartburg [vart-boorg] castle, near the Venusberg [VEH-noos-berg], a hill in which Tannhäuser has taken refuge for a year under the magic spell of Venus, goddess of love, he insists on returning to Earth in order to compete. Once again he meets his beloved, Elisabeth, who sings to him the famous aria *Dich, teure Halle* [dikh toy-ruh hah-leh] ("Thou, Beloved Hall") (**CD-Track 36.2**), welcoming him back to the great hall where he formerly sang. She is excited that this beautiful space will once again resonate with music.

Traditionally, the operatic voice carries the melody and the orchestra provides accompaniment. As a result, Wagner felt, the music overwhelmed the text. So, in order to make the text understandable, Wagner shifted the melodic element from the voice to the orchestra. Elisabeth thus sings in a declamatory manner that lies somewhere between aria and recitative, and the orchestra carries the melody, following Elisabeth's shift in mood from ecstatic welcome to sad remembrance of her year-long loss. So radical was this change, the orchestra more or less taking over from the vocalist the primary responsibility for developing the melodic character of the work, that French audiences found Wagner's music almost unrecognizable as opera.

For a French audience, the music was too new to appreciate fully, and the plot, derived directly from German folklore, was hopelessly foreign. The opera seemed aimed at inflaming French/German hostility. Wagner was informed, furthermore, of the necessity of writing a ballet for the opening of the second act. He refused, though he did agree to *begin* the opera with a ballet. Already unhappy that an expensive production of a German work was to be staged in *their* opera, the Jockey Club was doubly outraged that its composer refused to

insert the ballet in its traditional place. Wagner seemed nothing short of a liberal nationalist deliberately trying to provoke his conservative French audience.

As rehearsals progressed, the Jockey Club provided its members with silver whistles engraved with the words "*Pour Tannhaeuser.*" They used these whistles in defense of their aristocratic privileges on opening night, March 13, 1861. With Louis-Napoleon present in his box, the Jockey Club interrupted the music for as much as 15 minutes at a time as they hissed and whistled. "The Emperor and his consort stoically kept their seats throughout the uproar caused by their own courtiers," Wagner noted. The opera received the same reception at both its second and third performances. Paris was divided. The composer Berlioz found no virtue in the music, while Baudelaire admired it. After the third performance, which included several lengthy fights and continued whistling from the Jockey Club, Wagner demanded that the opera be withdrawn from performance. The French government accepted their financial losses and agreed.

Wagner's Music Drama The theme of *Tannhäuser*—the conflicting claims of sexual pleasure and spiritual love—is hopelessly Romantic, which might have appealed to bourgeois and aristocratic French taste, but its music and its approach to the opera as a form did not. Like Verdi, Wagner sought to convey realism, so that his recitatives, arias, and choruses made dramatic sense. And he considered his work a new genre—**music drama**—in which the actions acted out on stage are the visual and verbal manifestations of the drama created by the instruments in the orchestra, "deeds of music made visible," as he put it. This he accomplished by the **leitmotif** [LITE-moh-teef], literally a "leading motive." For Wagner this meant a brief musical idea connected to a character, event, or idea that recurs throughout the music drama each time the character, event, or idea recurs. However, as characters, events, and ideas change throughout the action, so do the leitmotifs, growing, developing, and transforming. Berlioz's *idée fixe* is a similar device in Romantic orchestral music (see chapter 34).

A clear example of the leitmotif is in the Prelude to Wagner's 1865 opera in three acts, *Tristan and Isolde* (**CD-Track 36.3**). The opera is based on the medieval legend of the ill-fated love of the Cornish knight Tristan and the Irish princess Isolde, whom Tristan's uncle, King Mark, wishes to marry against her will and for which purpose he has sent Tristan to Ireland to bring her back to Cornwall. Tristan's allegiance to King Mark is compromised by the fact that many years earlier Isolde, not knowing his identity as the man who had killed her fiancé and suffered wounds in the battle, had saved his life by nursing him back to health. When she did learn his identity, she could not bring herself to take vengeance. And so, as their ship sails for Cornwall, the two, unable to admit their mutual attraction but acknowledging the debt owed to Isolde, agree to drink poison before the ship lands. However, Isolde's maid substitutes a love potion for the poison, which frees the pair to admit their love. The leitmotif associated with drinking the love potion constitutes the first phrases of the Prelude:

At the first sounding of this leitmotif—known as both the "love potion" motif and the "yearning" motif—the audience does not understand its significance. The motif repeats throughout the Prelude in various forms and pitches. Not until it recurs, in Act I, as Tristan and Isolde are about to drink what they believe to be poison, does its full significance become clear (Fig. **36.11**). The longing that the leitmotif conveys is largely dependent on harmonic dissonance of the opening chord, which, as the very first harmony of the work, audiences found particularly disconcerting. The chord does not resolve itself, but rather changes into an equally dissonant harmony followed by a long silence. This refusal to resolve the leitmotif represents the lovers' unresolved longing.

Wagner's greatest realization of the leitmotif idea occurs in four music dramas dating from 1848 to 1874, titled collectively *Der Ring des Nibelungen* [der ring des nee-beh-LOONG-un] (*The Ring of the Nibelung*). The "*Ring*" forms an epic cycle based on Norse mythology involving the quest for a magical but accursed golden ring, the possessor of which can control the universe. Collectively, it represents Wagner's dream of composing a **Gesamtkunstwerk** [geh-SAHMT-koonst-verk], or total work of art, synthesizing music, drama, poetry, gesture, architecture, and painting (the latter two through stage design). The *Ring* features more than 20 leitmotifs that Wagner weaves into an intricate web, the four music dramas being performed over the course of four days. For instance, the hero Siegfried is associated with his famous horn call, and other leitmotifs represent objects like the Rhine gold and Valhalla (home of the gods), emotional states like love's awakening, and concepts like redemption. The cycle premiered in 1876 in Bayreuth, a small city in Bavaria. Here, with the help of his patron Ludwig II of Bavaria, Wagner oversaw the building of a *Festspielhaus* [FEST-shpeel-hows], or "festival drama house," that he hoped might help to unify Germany both culturally and politically (Fig. **36.12**). In his appeal for funds to underwrite construction, Wagner makes the political motives of his project plain:

> In Hellas [ancient Greece], the supreme flowering of the State went hand in hand with that of Art; so too the resurrection of the German Empire should be accompanied by a massive artistic monument to the German intellect. In the field of politics, the German mission in the history of the world has recently enjoyed its second triumph [the victory over France in the 1870 Franco-Prussian war]—now its spiritual victory is to be celebrated, through the German Festival in Bayreuth.

Fig. 36.11 **Bill Viola.** *The Fall into Paradise (Act I, Scene 5—Tristan and Isolde drink the potion).* **2004.** Still photo by Kira Perov from *The Tristan Project*, a collaborative semi-staging of Wagner's *Tristan und Isolde* by video artist Bill Viola, conductor Esa-Pakka Salonen, and director Peter Sellars. 2004. The video images echo rather than illustrate the inner story of the opera in much the same way as the music. Here in the new rapture of the confessed love, Tristan and Isolde caress each other as they float under water.

It was this spirit of German nationalism that would lead Adolf Hitler to lionize Wagner's music during the Third Reich [rykh] 60 years later.

Operetta: Jacques Offenbach and Musical Satire
As Wagner's experience suggests, serious opera was not particularly well received in Paris, the center of the art and music world during the 1860s. But the comic operas that played at the Opéra-Comique [oh-pay-RAH-koh-MEEK] were widely popular, enjoyed by Baudelaire and almost everyone else in Paris, aristocrats, the bourgeoisie, and the working class alike. Far and away the most admired of those writing comic operas was Jacques Offenbach [OFF-un-bahk] (1819–1880), a Jewish composer.

This fact must have appalled the virulently anti-Semitic Richard Wagner, who in 1850 had composed a polemic entitled "Jewry in Music," the chief target of which was composer Felix Mendelssohn.

Fig. 36.12 **Richard Wagner. Cross-section of the Bayreuth Festspielhaus. 1872–1876.**
From Frederic Spotts, *Bayreuth: A History of the Wagner Festival* (New Haven: Yale University Press, 1994). © 2003 Yale University Press/Spotts, BAYREUTH: A History of the Wagner Festival (1994), image p. 9. The design puts the orchestra beneath the stage, thus drawing the audience closer to the performance and projecting the orchestra's music directly toward it, all resulting in acoustics ideal for the integration of orchestral and vocal parts.

The tract makes clear that Wagner's feelings were driven largely by his nationalism. As a speaker of German he is offended by Yiddish, which he calls "intolerably jumbled blabber." From Wagner's point of view, Jewish speech necessarily rendered the Jews incapable of producing music. Of Offenbach's music in particular, Wagner would simply say that it "gives off the heat of the manure in which all the pigs of Europe have come to wallow."

Born in Germany, Offenbach did not care what Wagner thought of his music. After all, Wagner was a failure in Paris, while he, Offenbach, was a success. He dominated the fashionable music scene of the Second Empire, satirizing the politics of Louis-Napoleon's reign and capturing its cosmopolitan atmosphere and loose morals in light operas that he called **operettas**. This genre of musical theater usually mixed spoken dialogue with sung numbers that might include rowdy music from the dance halls of the day, including the "can-can." His hit of 1866, *La Vie Parisenne* [lah vee pah-ree-zee-EN] (*The Parisian Life*), has a baron and baroness bamboozled by two veterans of the boulevards as they enjoy the plays, cafés, and amorous entertainments the city has to offer. His hit of the following year, *The Grand Duchess of Gérolstein* [zhay-roll-SHTINE], was originally entitled simply *The Grand Duchess*, but censors objected on the grounds that Russia might take offense, thinking that Offenbach was satirizing Catherine II, which in fact he was. (Grand Duchess was her title upon marrying Grand Duke Peter.) At one point, the duchess lines up her troops for inspection: "Oh, how I love the military," she sings, "Their sexy uniforms, / Their mustaches and their plumes." Upon seeing a handsome young soldier named Fritz, she promotes him to sergeant, then lieutenant, captain, and ultimately commander-in-chief to replace General Boum [boom], a man who, instead of taking snuff, shoots off his pistol periodically and inhales the smoke from its barrel. In an amusing way, and under the guise of mindless entertainment, Offenbach effectively mocked the political and military authorities. Indeed, within three years the farcical war that Fritz wages—no one gets killed because he gets the enemy drunk—would suddenly become a reality in Paris, but no longer a farce, this time a tragedy led by the tyrant Louis-Napoleon, who precipitated the Franco-Prussian War (see chapter 37). In later life Offenbach tried to bridge the gulf between serious and light opera that he had helped to create in the five-act opera, *The Tales of Hoffmann*.

Verdi, Wagner, and Offenbach all played an important role in transforming opera from a staid bastion of aristocrats and conservative values to a popular art form. By the end of the century, Verdi and Wagner were firmly placed in the pantheon of national heroes of their countries alongside leaders and revolutionaries such as Garibaldi, Mazzini, and Bismarck. And by the end of the nineteenth century, aristocrats, bourgeoisie, and workers across Europe were enthralled by a nationalist ideology that would, little more than a decade

later, lead to an epochal conflict that would kill 10 million—World War I.

The American Civil War

There was a great cultural and geographical distance between Paris and the rural South of the United States, yet as the nineteenth-century world became increasingly interdependent, there were also important connections between the two areas. Cotton textiles were enormously important to Europeans, and much of their supply came from the American South. So there was great consternation in Britain, France, Germany, and other European states when, in 1860, the Civil War loomed. From the European point of view, the causes that led to that war (1861–1865) seemed all too familiar. On the one hand, it appeared that the Union (Northern) states were insisting on the abolition of slavery in the tradition of liberal ideology. On the other hand, the Confederate (Southern) states, a predominantly agricultural society based on slavery, desired, in typical nationalist ideological form, to become a sovereign state of its own.

Both the British and French textile industries, and indeed, the entire economies of both nations, depended heavily on the imports of Southern cotton. As a result, they sided with the South insofar as it fought, in the antebellum [an-tee-BELL-um] [prior to the Civil War] Congress, to uphold free-trade policies while the North pushed for protective tariffs. The South felt confident that out of economic necessity Britain, and possibly France, would side with it in any conflict. But abolitionist sentiment ran high in Europe. Harriet Beecher Stowe's *Uncle Tom's Cabin* (see chapter 35) was a bestseller across the Continent, and, besides, both the British and French governments were not disposed to support an uprising that appeared even vaguely nationalist. Both nations were busily acquiring colonial possessions in Asia and Africa, and were uncomfortable with nationalist sentiment. To the South's surprise, both maintained neutrality throughout the conflict, despite continued Confederate attempts to draw Europeans to their side.

Romanticizing Slavery in Antebellum American Art and Music

Many in Europe across the globe were surprised that war erupted in the United States, believing that some sort of compromise was likely. In no small part, this delusion resulted from a romanticized view of slavery embedded even in abolitionist literature such as *Uncle Tom's Cabin*. For every Simon Legree there is an Augustine Saint Clare and his daughter, Little Eva; for every abused slave, a grateful Christian convert.

Eastman Johnson: The Ambiguity of *Negro Life in the South* A prime example of blindness to the full implications of slavery in antebellum America is evident in the painting *Negro Life in the South* by Eastman Johnson (1824–1906)

Fig. 36.13 Eastman Johnson. *Negro Life in the South (Kentucky Home)*. 1859. Oil on canvas, 36″ × 45″.
© Collection of the New-York Historical Society, USA/The Bridgeman Art Library. Johnson studied in Europe from
1849 to 1855, culminating in Paris in the studio of Thomas Couture, where Édouard Manet was also a student.

(Fig. 36.13). The painting achieved instant success when exhibited in 1859 in New York. Much of its realism was contributed by the models Johnson employed—the household slaves owned by his father in Washington, DC.

Negro Life in the South was a curious painting in that it was highly ambiguous—it could be read as either for or against slavery. For some, Johnson's painting seemed to depict slaves as contented with their lot. A banjo-picker plays a song for a mother and child who are dancing together. A young man and woman flirt at the left, while another woman and child look out on the scene from the window above. The white mistress of the house steps through the gate at the left as if to join in the party. However, to an abolitionist, the contrast between the mistress's gown and the more ragged clothing of the slaves, between the dilapidated shed and the finer house behind, demonstrates the sorry plight of the slaves.

Stephen Foster and the Minstrel Song Of all representations of African Americans before the Civil War, perhaps the most popular was the **minstrel show**, a theatrical event that presented black American melodies, jokes, and impersonations, usually performed by white performers in blackface. It evolved out of two types of common entertainment in the early nineteenth century: theatrical or circus skits in which white actors impersonated black banjo-playing street musicians. In 1828, Thomas Dartmouth "Daddy" Rice, a white man, began performing as an old slave named Jim Crow, and his song-and-dance show soon had many imitators. By the 1840s, a group of white performers in New York were performing in blackface as the Virginia Minstrels. The instruments they used to accompany themselves—bone castanets, violin, banjo, and tambourine—quickly became standard. *The Virginia Minstrels'* success led to the formation of the Christy Minstrels, headed by white actor Edwin P.

Christy, whose show included songs, often referred to as "Ethiopian" melodies, usually set in the South and rendered in black dialect, as well as crude, racist jokes. The stereotypes perpetrated by the minstrel shows—African Americans as fun-loving, carefree people likely to break out in joyful song but also as ignorant, lazy, and superstitious buffoons—became a staple of American entertainment. And by the 1850s, songs about escaped slaves longing to return to their kindly masters were standard fare.

In 1848, the Christy Minstrels performed a song that quickly became a national hit: "Oh! Susanna," written by Stephen Foster (1826–1864), a young Pittsburgh bookkeeper. Foster realized that the minstrel stage was the key to securing an audience for his songs, but he also wanted to write a new kind of music for it. Rather than trivializing the hardships of slavery, he wanted to humanize the characters in his work and create songs that communicated to all people. Foster was also a music business pioneer, becoming a professional songwriter in an era when selling sheet music through a publisher was the only way to earn money from his wildly popular tunes.

In the next several decades, Foster wrote all kinds of songs, including "Camptown Races" (1850) (see **CD-Track 36.4**). The near-nonsense dialect of "Camptown Races" reinforces the portrayal of the black as a fool. Foster's so-called **plantation melodies** were also written in dialect but were quite different—depicting blacks as capable of a full range of human emotion. His 1849 song "Nelly Was a Lady," for instance, made popular by the Christy Minstrels, portrays a black man and woman as loving husband and wife. In "Nelly," Foster did something previously unheard of, allowing the husband to call his wife a "lady," a term heretofore reserved for well-born white women. Other famous Foster tunes included "Old Folks at Home" (Swanee River) (1851) and "My Old Kentucky Home" (1853). Finally, Foster wrote a number of parlor songs—so-called because they were to be performed in parlors—including "Jeanie with the Light Brown Hair" (1854) and "Beautiful Dreamer" (1862).

Eastman Johnson's *Negro Life in the South* was so closely associated with Foster's music that the painting quickly became known by another name—*Kentucky Home*. Together they sum up the complexities of antebellum attitudes about slavery. What they make apparent is how America before the Civil War was dominated by the mythologized, unrealistic, and romanticized view of slavery.

Representing the War

On October 16, 1859, relations between whites and slaves in America changed dramatically when John Brown (1800–1869), a white abolitionist, led 21 followers, five of them African American, on a raid to capture the federal arsenal at Harpers Ferry, West Virginia. Their intention was to set off a revolt of slaves throughout the South, but two days

later Lieutenant Colonel Robert E. Lee (1807–1879) recaptured the arsenal. Ten of Brown's men were killed in the battle, and he and the rest were hanged.

The prospect of a general slave insurgency, aided and abetted by abolitionists, convinced many in the South that the North was intent on ending slavery, a belief that the election of Abraham Lincoln (1809–1865) as president in November 1860 seemed to confirm. The images of contented slaves such as Eastman Johnson had painted in his *Negro Life* seemed to vanish instantly. After the war began in the spring of 1861, Johnson himself began to accompany Union troops to the front. His *A Ride for Liberty: The Fugitive Slaves*, which Easton painted in 1862–1863 from an incident he had witnessed, is entirely different in mood and handling from his earlier painting (Fig. **36.14**). The previous summer the Confederate army had soundly defeated the North at Bull Run, a stream near Manassas [man-ASS-uss], Virginia. Ever since that defeat the Northern and Confederate armies had stood their ground between Manassas and Washington, DC, with only minor skirmishes between the two forces. This delay gave Union commander George B. McClellan the opportunity to train a new Army of the Potomac. His intention in the spring of 1862 was to press on to Richmond, Virginia, and capture the Southern capital. In fact, in late June, before Johnson's painting was completed, now General Robert E. Lee would drive McClellan away from Richmond, back through Manassas, defeating him once more at Bull Run and moving forward to the outskirts of Washington.

In Johnson's painting, smoke fills the darkening sky. Under the muzzle of the horse, reflections flash off the barrels of the rifles of the advancing Union army. The myth of happy slave families living on Southern plantations is nowhere to be seen as the father urges his horse on, desperate to save his wife and children from the battle. Their drive for liberty, Johnson seems to say, made possible by McClellan's advance, is what the war is all about.

The American Civil War changed the nature of warfare and in response the nature of representing war. It was an intensely modern event, mechanized and impersonal in a way that no previous war had been—with hand-to-hand battles, face-to-face, bayonet-on-bayonet being the exception, not the rule. The traditional pageantry of war, "long lines advancing and maneuvering, led by generals in cocked hats and by bands of music," as one contemporary put it, were soon a thing of the past. When in the summer of 1861 the Union and Confederate armies clashed at Manassas, across the Potomac from Washington, DC, ladies and gentlemen from the capital drove out to the battleground to picnic and observe the conflict in their carriages. They quickly realized their mistake as the Union army retreated in panic, forcing its way through the wagons and buggies of the terror-stricken civilians. Still, a deep desire to know what was happening at the front consumed Americans. In response, a number of

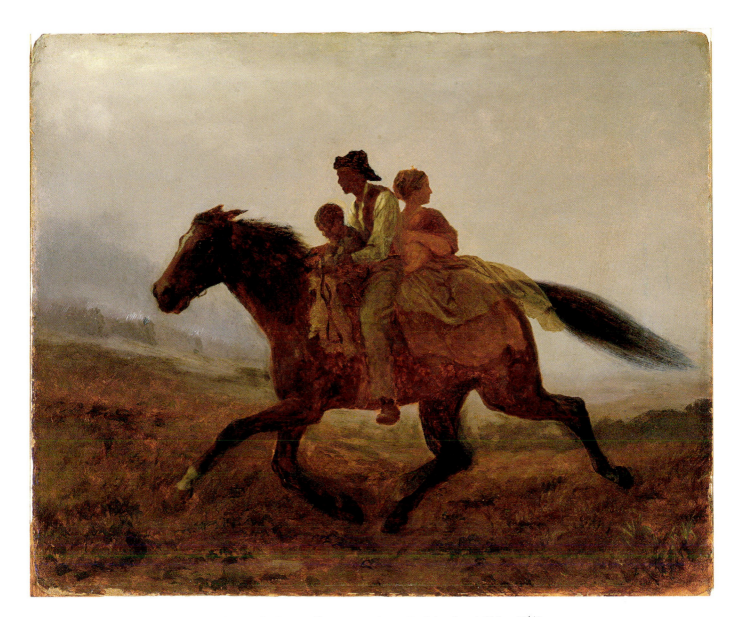

Fig. 36.14 Eastman Johnson. *A Ride for Liberty: The Fugitive Slaves.* **ca. 1862–1863.** Oil on board, 22″ × 26¼″.
© Brooklyn Museum of Art, New York, USA/The Bridgeman Art Library Nationality. Gift of Gwendolyn O. L. Conkling. The image of a family in flight inevitably evoked associations in viewers' minds with the flight of Mary, Joseph, and the baby Jesus into Egypt, though this is a family of four, not three. (Barely visible is a small child in the arms of its mother.) During the Civil War, over half a million slaves fled from the South, though 4 million remained.

newspapers and journals began to send "special artists" to the battlegrounds to picture events. One of these was a 25-year-old illustrator for *Harper's Weekly*, Winslow Homer (1836–1910).

Winslow Homer's Magazine Illustrations Homer immediately understood that this new war presented unique challenges. The battlefields were large—too large to represent—and death arrived not from near at hand but from the distance, from some cannon or rifle beyond the range of normal vision. The wood engraving *The Army of the Potomac—A Sharpshooter on Picket Duty* depicts this reality, with snipers hidden in the branches atop pine trees and using a telescopic sight capable of hitting a target more than a mile away (Fig. **36.15**). Death came without warning: "Our loss of officers," a Union officer said in 1862, ". . . has been awfully disproportioned, and indeed entirely unprecedented; and it may be attributed wholly to the presence of sharpshooters, who, by the brilliant uniforms which our generals wore, were enabled to pick them off like so many partridges." "Brilliant uniforms," like so many other traditional accoutrements of war, soon were relics of the past.

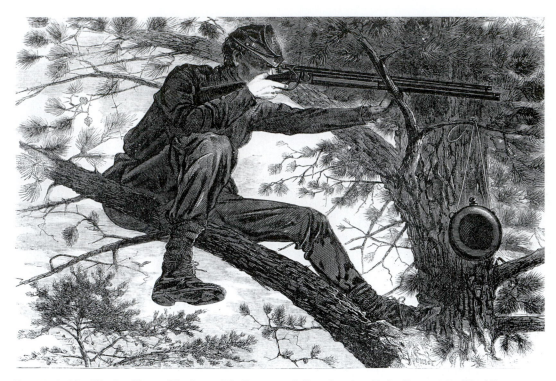

Fig. 36.15 After Winslow Homer. *The Army of the Potomac—A Sharpshooter on Picket Duty.* **1862.** Wood Engraving on paper, $9\frac{1}{8}'' \times 13\frac{13}{16}''$. Gift of International Machines Corp. Location: Smithsonian American Art Museum, Washington, DC. Art Resource, NY. This is the first of many wood engravings published in *Harper's Weekly* that were based on paintings that Homer would sometimes execute first, as is the case with Fig. 36.17 (on page 1178). More often the engravings were done before the painting was completed, as in this instance, serving as advertisements for the paintings to come.

Once, in April 1862, at Yorktown, Homer looked through the scope of a sharpshooter's rifle, and the image he saw, of an officer in the rifle's sights, "struck me as being as near murder as anything I could think of." This wood engraving, then, is for the artist an icon of murder and horror. It resonates with a particular irony through the near classical formality of Homer's setting: the sharpshooter in a visual square defined by the vertical trunk of the tree opposite his back and the horizontal line of his rifle and boot. The calm structure of the composition is a dramatic contrast with the terrible violence it describes.

Mathew Brady's Photographers It was the terror of war that increasingly impressed itself upon the American national consciousness. Given the mechanistic nature of modern warfare, this fear was, appropriately and accurately, captured by yet another machine—the camera. On September 19, 1862, Alexander Gardner, an employee of the photographer Mathew Brady (1823–1896), visited the battlefield at Antietam [an-TEET-um], Maryland. Twenty-six thousand Northern and Southern troops had just died in a battle that had no particular significance and decided nothing. Until that day, no American battlefield had ever been photographed before the dead were properly buried, but Gardner took many photographs of the scene. He even

rearranged the bodies of the dead for photographic effect—in part a necessity created by the technical limitations of photographing on a smoky battlefield. Gardner's manipulation of scenes for the camera was understood as an attempt to record a more accurate sense of the whole. Brady displayed Gardner's photographs in his New York gallery on Broadway in October—and took full credit for them, to Gardner's dismay. Within a month Brady was selling the pictures in both album-card size and stereoscopic views.

In July 1863, Gardner, now working on his own, went to the site of the Battle of Gettysburg with an assistant, Timothy O'Sullivan, who shot the most famous photograph to come out of the war, *A Harvest of Death, Gettysburg, Pennsylvania.* (Fig. **36.16**). It was published after the war in 1866 in *Gardner's Photographic Sketchbook of the War*, probably the first book-length photo essay. It is a condemnation of the horrors of war, with the Battle of Gettysburg at its center. O'Sullivan's matter-of-fact photograph is accompanied by the following caption:

> The rebels represented in the photograph are without shoes. These were always removed from the feet of the dead on account of the pressing need of the survivors. The pockets turned inside out also show that appropriation did not cease with the coverings of the feet. Around is scattered the litter of the battle-field, accoutrements, ammu-

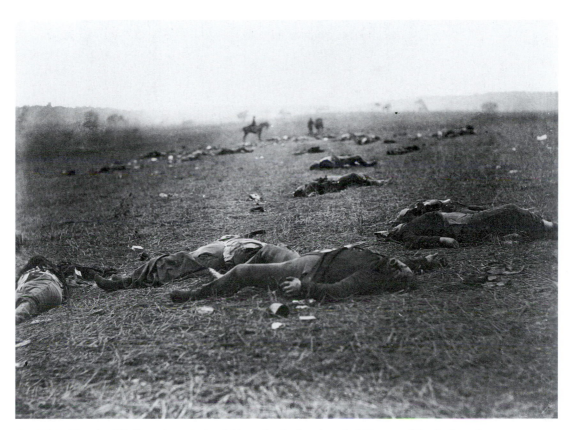

Fig. 36.16 Timothy O'Sullivan (negative) and Alexander Gardner (print). *A Harvest of Death, Gettysburg, Pennsylvania, July 1863*, from Alexander Gardner's *Gardner's Photographic Sketchbook of the War.* **1866.** Albumen silver print (also available as a stereocard), $6\frac{1}{4}'' \times 7\frac{13}{16}''$. Location: The New York Public Library, New York, NY/Art Resource, NY. The battle of Gettysburg was the decisive land battle of the American Civil War. O'Sullivan's photograph is meant to show something of the human cost of a battle that left 51,000 casualties—dead, wounded, captured, or missing—in three days of fighting.

nitions, rags, cups and canteens, crackers, haversacks, and letters that may tell the name of the owner, although the majority will surely be buried unknown by strangers, and in a strange land.

In O'Sullivan's photograph, both foreground and background are purposefully blurred to draw attention to the central corpses. Such focus was made possible by the introduction of albumen paper, which retained a high degree of sharpness on its glossy surface. "Such a picture," Gardner wrote, "conveys a useful moral: It shows the blank horror and reality of war, in opposition to the pageantry. Here are the dreadful details! Let them aid in preventing such another calamity falling upon the nation." These sentiments were echoed in Abraham Lincoln's famous Gettysburg Address, one of the most powerful, and short, speeches ever made (see **Reading 36.11**, page 1183).

Reconstruction Because most of the war was fought in the South, the region was devastated physically, economically, and socially. So the next decade became known as the era of Reconstruction. It also was home to nearly 4 million African Americans who suddenly found themselves free. The federal government established the Freedmen's Bureau to provide food, clothing, and medical care to refugees in the South, especially freed slaves. It also set up schools for African Americans, and teachers from the North and South worked to help young and old become literate. Additionally, Congress passed two amendments to the Constitution to give blacks equal rights with whites. The Fourteenth Amendment gave African Americans citizenship and struck down discriminatory state laws. Before they could be readmitted to the union, Southern states were ordered to ratify the amendment. The second amendment to the Constitution, the Fifteenth, gave African-American men the right to vote. Meanwhile, to maintain order, Union troops remained in the South.

African American emancipation, which advanced rapidly in the years immediately following the Civil War, would soon suffer setbacks, eliminating whatever gains had been made until the civil rights movement arose during the 1950s and 1960s. In 1877, Union troops withdrew from the South, and Southern whites who had never accepted African Americans as equals quickly restored their control of the region. Groups such as the Ku Klux Klan openly terrorized the African American community, and lynching became commonplace.

Fig. 36.17 Winslow Homer. *The Veteran in a New Field.* **1865.** Oil on canvas, 24 $\frac{1}{8}$" × 38 $\frac{1}{8}$". The Metropolitan Museum of Art, NY. Bequest of Adelaide Milton de Groot (1876–1967), 1967 (67.187.131). Image copyright © The Metropolitan Museum of Art. In the "New Field" of Homer's title, the veteran leaves behind the "field of battle." Homer was thinking of the biblical passage from Isaiah 2:4: "they shall beat their swords into plowshares, and their spears into pruning hooks," a theme also informing Jean-Antoine Houdon's famous statue of George Washington (see Fig. 31.13).

In 1883, the Supreme Court nullified the Civil Rights Act, and in 1896 the courts allowed segregation in the railroads, and thus, by extension, in all public services. These new laws that destroyed the legality of the postwar constitutional amendments for freed blacks were called Jim Crow laws. By 1900, African Americans were once again almost totally disenfranchised from American life.

The postwar North, where hundreds of thousands of Union soldiers returned home, was a region of almost unfettered optimism. As Mark Twain and Charles Dudley Warner described it in *The Gilded Age*, their bestseller of 1873, "the air [was] full of money, nothing but money, money floating through the air." One of the first painted images of the Reconstruction era—Winslow Homer's *The Veteran in a New Field* (1865)—also points to the possibilities of a prosperous future (Fig. **36.17**). It depicts a Union soldier at work in his agricultural field and so recently returned home that his canteen and army uniform jacket are visible at the lower right. The painting glows with golden light, the promise of a harvest of plenty. But the veteran is also the grim reaper with his scythe, and his harvest is the same harvest of death that O'Sullivan and Gardner recorded at Gettysburg. It is as if the veteran is slashing, not so much at grain as at his memories.

READINGS

READING 36.1

Karl Marx and Friedrich Engels, *The Communist Manifesto*, Part I, from "Bourgeois and Proletarians" (1848; English edition 1888; trans. Samuel Morse)

Marx and Engels began their collaboration in 1844 in Paris. In 1847, they were invited by a left-ist group in London to write their program for them, which they did during December 1847 and January 1848. The group changed its name to the Communist League and adopted Marx and Engels's 12,000-word program as their manifesto. The following is the first part, which describes the tensions between the proletariat (working class) and the modern bourgeoisie:

The history of all hitherto existing society is the history of class struggles.

Freeman and slave, patrician and plebeian, lord and serf, guild-master and journeyman, in a word, oppressor and oppressed, stood in constant opposition to one another, carried on uninterrupted, now hidden, now open fight, a fight that each time ended, either in a revolutionary reconstitution of society at large, or in the common ruin of the contending classes.

In the earlier epochs of history we find almost everywhere a complicated arrangement of society into various orders, a manifold gradation of social rank. In ancient Rome we have patricians, knights, plebeians, slaves; in the Middle Ages, feudal lords, vassals, guild-masters, journeymen, apprentices, serfs; in almost all of these classes, again, subordinate gradations.

The modern bourgeois society that has sprouted from the ruins of feudal society has not done away with class antagonisms. It has but established new classes, new conditions of oppression, new forms of struggle in place of the old ones.

Our epoch, the epoch of the bourgeoisie, possesses, however, this distinctive feature; it has simplified the class antagonisms. Society as a whole is more and more splitting up into two great hostile camps, into two great classes directly facing each other: Bourgeoisie and Proletariat.

From the serfs of the Middle Ages sprang the chartered burghers of the earliest towns. From these burgesses the first elements of the bourgeoisie were developed.

The discovery of America, the rounding of the Cape, opened up fresh ground for the rising bourgeoisie. The East Indian and Chinese markets, the colonization of America, trade with the colonies, the increase in the means of exchange and in commodities generally, gave to commerce, to navigation, to industry, an impulse never before known, and thereby, to the revolutionary element in the tottering feudal society, a rapid development.

The feudal system of industry, under which industrial production was monopolized by close guilds, now no longer sufficed for the growing wants of the new market. The manufacturing system took its place. The guild-masters were pushed on one side by the manufacturing middle class; division of labor between the different corporate guilds vanished in the face of division of labor in each single workshop.

Meantime the markets kept ever growing, the demand ever rising. Even manufacture no longer sufficed. Thereupon, steam and machinery revolutionized industrial production. The place of manufacture was taken by the giant Modern Industry, the place of the industrial middle-class, by industrial millionaires, the leaders of whole industrial armies, the modern bourgeois.

Modern industry has established the world-market, for which the discovery of America paved the way. This market has given an immense development to commerce, to navigation, to communication by land. This development has, in its turn, reacted on the extension of industry; and in proportion as industry, commerce, navigation, railways extended, in the same proportion the bourgeoisie developed, increased its capital, and pushed into the background every class handed down from the Middle Ages.

We see, therefore, how the modern bourgeoisie is itself the product of a long course of development, of a series of revolutions in the modes of production and of exchange.

Each step in the development of the bourgeoisie was accompanied by a corresponding political advance of that class. An oppressed class under the sway of the feudal nobility; an armed and self-governing association in the medieval commune, (here independent urban republic, as in Italy and Germany, there taxable "third estate" of the monarchy, as in France); afterwards, in the period of manufacture proper, serving either the semi-feudal or the absolute monarchy as a counterpoise against the nobility, and in fact cornerstone of the great monarchies in general—the bourgeoisie has at last, since the establishment of modern industry and of the world-market, conquered for itself, in the modern representative state, exclusive political sway. The executive of the modern state is but a committee for managing the common affairs of the whole bourgeoisie.

The bourgeoisie, historically, has played a most revolutionary part.

The bourgeoisie, wherever it has got the upper hand, has put an end to all feudal, patriarchal, idyllic relations. It has pitilessly torn asunder the motley feudal ties that bound man to his "natural superiors," and has left no other nexus between man and man than naked self-interest, than callous "cash payment." It has drowned the most heavenly ecstasies of religious fervor, of chivalrous enthusiasms, of philistine sentimentalism, in the icy water of egotistical calculation. It has resolved personal worth into exchange value, and in place of the numberless indefeasible chartered freedoms, has set up that single, unconscionable freedom—Free Trade. In one word, for exploitation, veiled by religious and political illusions, it has substituted naked, shameless, direct, brutal exploitation.

The bourgeoisie has stripped of its halo every occupation hitherto honored and looked up to with reverent awe. It has converted the physician, the lawyer, the priest, the poet, the man of science, into its paid wage laborers.

The bourgeoisie has torn away from the family its sentimental veil, and has reduced the family relation to a mere money relation. . . .

The need of a constantly expanding market for its products drives the bourgeoisie over the whole surface of the globe. It must elbow-in everywhere, settle everywhere, establish connections everywhere.

The bourgeoisie has through its exploitation of the world-market given a cosmopolitan character to production and consumption in every country. To the great chagrin of reactionists, it has drawn from under the feet of industry the national ground on which it stood. All old-established national industries have been destroyed or are daily being destroyed. They are dislodged by new industries, whose introduction becomes a life and death question for all civilized nations, by industries that no longer work up indigenous raw material, but raw material drawn from the remotest zones; industries whose products are consumed, not only at home, but in every quarter of the globe. In place of the old wants, satisfied by the productions of the country, we find new wants, requiring for their satisfaction the products of distant lands and climes. In place of the old local and national seclusion and self-sufficiency, we have intercourse in every direction, universal interdependence of nations. And as in material, so also in intellectual production. The intellectual creations of individual nations become common property. National onesidedness and narrowmindedness become more and more impossible, and from the numerous national and local literatures there arises a world-literature. . . .

In proportion as the bourgeoisie,—that is, as capital, is developed, in the same proportion is the proletariat, the modern working class, developed, a class of laborers who live only so long as they find work, and who find work only so long as their labor increases capital. These laborers, who must sell themselves piece-meal, are a commodity, like every other article of commerce, and are consequently exposed to all the vicissitudes of competition, to all the fluctuations of the market

The various interests and conditions of life within the ranks of the proletariat are more and more equalized, in proportion as machinery obliterates all distinctions of labor, and nearly everywhere reduces wages to the same low level. The growing competition among the bourgeois, and the resulting commercial crises, make the wages of the workers ever more fluctuating; the unceasing improvement of machinery, ever more rapidly developing, makes their livelihood more and more precarious; the collisions between individual workmen and individual bourgeois take more and more the character of collisions between two classes. Thereupon the workers begin to form combinations (trade unions) against the bourgeois; they club together in order to keep up the rate of wages; they found permanent associations in order to make provision beforehand for these occasional revolts. Here and there the contest breaks out into riots.

Now and then the workers are victorious, but only for a time. The real fruit of their battle lies not in the immediate result, but in the ever expanding union of workers. . . .

The first step in the revolution by the working class is to raise the proletariat to the position of ruling class, to win the battle of democracy.

The proletariat will use its political supremacy to wrest, by degrees, all capital from the bourgeoisie, to centralize all instruments of production in the hands of the state,—that is, of the proletariat organized as a ruling class; and to increase the total productive forces as rapidly as possible. . . .

When, in the course of development, class distinctions have disappeared, and all production has been concentrated in the hands of a vast association of the whole nation, the public power will lose its political character. Political power, properly so called, is merely the organization power of one class for oppressing another. If the proletariat during its contest with the bourgeoisie is compelled, by the force of circumstances, to organize itself as a class, if, by means of a revolution, it makes itself the ruling class, and, as such, sweeps away by force the old conditions of production, then it will, along with these conditions, have swept away the conditions for the existence of class antagonisms, and of classes generally, and will thereby have abolished its own supremacy as a class.

In place of the old bourgeois society, with its classes and class antagonisms, we shall have an association in which the free development of each is the condition for the free development of all. ■

Reading Question

What leads Marx and Engels to believe that the conflict between the bourgeoisie and the proletariat will have a different result from history's previous class conflicts?

READING 36.10

from Émile Zola, *Germinal* (1885)

Germinal is an unflinching depiction of life among the coalminers of northern France in the 1860s. It is generally considered Zola's masterpiece. In the following scene, the novel's central character, Étienne Lantier, is taken through the mine by the miner Maheu, who works with his teenage daughter, Catherine. Each of the mining disasters described here actually happens in the course of the novel, and almost every character dies in one or the other of them. Despite its uncompromising condemnation of life in the mines, Germinal is, in the end, a hopeful book. Its title, Germinal, was the name of the seventh month of the French Revolutionary calendar, which occurred in the spring, as new life began to germinate and with it the possibility of hope.

"Damn! It's not warm here," muttered Catherine, shivering.

Etienne simply nodded. He found himself before the shaft, in the center of a huge hall swept by drafts. Of course he thought of himself as brave, yet an unpleasant emotion caused his throat to contract among the thundering of the carts, the clanking of the signals, the muffled bellowing of the megaphone, facing the continuously flying cables, unrolling and rolling up again at top speed on the spools of the machine. The cages rose and fell, slithering like some noctur-[10]nal animal, continually swallowing men that the hole seemed to drink down. It was his turn now. He was very cold. He kept silent out of nervousness which made Zacharie and Levaque snicker, for both disapproved of the hiring of this stranger—Levaque especially, hurt because he had not been consulted. So Catherine was happy to hear her father explaining things to the young man.

"Look, up on top of the cage; there's a parachute and iron hooks that catch in the guides in case the cable breaks. It works . . . most of the time. . . . Yes, the shaft is divided into three ver-[20]tical compartments, sealed off by planks from top to bottom. In the center are the cages; on the left the ladder-well."

But he broke off to complain, without daring to speak very loudly, "What the hell are we doing waiting here, for God's sake? How can they let us freeze here like this?"

Richomme, the foreman, who was also going down, his open miner's lamp hanging from a nail in his leather cap, heard him complaining.

"Be careful; the walls have ears!" he muttered paternalis-[30]tically, as a former miner who still sided with the workers.

"They've got to make the adjustments . . . See? Here we are, get in with your team."

And in fact, the cage, banded with sheet iron and covered by a fine-meshed screen, was waiting for them, resting on its catches. Maheu, Zacharie, Levaque, and Catherine slid into a cart at the back; and since it was supposed to hold five people, Étienne got in as well; but all the good places were taken and he had to squeeze in beside the young girl, whose elbow poked into his belly. His lamp got in his way; he was advised to hang it from a buttonhole of his jacket. He didn't hear this advice [40]

and kept it awkwardly in his hand. The loading continued, above and below, a jumbled load of cattle. Couldn't they get going? What was happening? It seemed as if he'd been waiting for a long time. Finally a jolt shook him and everything fell away, the objects around him seemed to fly past while he felt a nervous dizziness that churned his guts. This lasted as long as he was in the daylight, passing the two landing levels, surrounded by the wheeling flight of the timbers.

Then, falling into the blackness of the pit, he remained stunned, no longer able to interpret his feelings. [50]

"We're off," said Maheu tranquilly.

They seemed relaxed. He, however, wondered at moments whether he was going down or up. There were moments at which they seemed immobile, when the cage was dropping straight down without touching the guides; then brusquely there were shudders, a sort of dancing between the planks, which made him fear a catastrophe was going to happen. In addition, he couldn't make out the walls of the shaft behind the grill to which his face was pressed. The lamps only dimly lit the heap of bodies at his feet. Alone, the open lamp of the [60] foreman shone from the next cart like a beacon.

"This one is fifteen feet wide," continued Maheu, instructing him. "The casing needs to be redone; water's leaking everywhere. . . . Listen, we're down at the water level. Can you hear it?"

Étienne had just been asking himself what this sound of a downpour could be. A few big drops had splashed first on the roof of the cage, like at the beginning of a storm; and now the rain grew, streamed, was transformed into a real deluge. The roof must have had a hole in it, for a trickle of water, flowing onto [70] his shoulder, was soaking him to the skin. The cold became glacial; they entered a damp blackness, then there was a blinding flash and a glimpse of a cave where men were moving about. But already they were plunging back into nothingness.

Maheu said:

"That's the first landing. We're a hundred feet down now . . . Look how fast we're going."

Lifting his lamp, he lit up a guide timber flying past like the rail beneath a train running full steam ahead; beyond that, nothing else could be seen. Three other platforms flew [80] out of the shadows.

"How deep it is!" murmured Étienne.

The fall seemed to have lasted for hours. He was suffering because of the awkward position he was in, not daring to move, above all tortured by Catherine's elbow. She didn't say a word; he only felt her pressed against him, warming him. When the cage finally halted at the bottom, at 12,828 feet, he was astonished to learn that the descent had lasted just one minute. But the sound of the catches taking hold and the feeling of something solid underneath him suddenly cheered him up. . . .

The cage was emptying; the workers crossed the landing dock, a room carved out of the rock vaulted over with bricks lit by three huge lamps with open flames. The loaders were violently shoving full carts across the cast-iron floor. A cellar-like odor seeped from the walls, a chilly smell of saltpeter traversed by warm gusts from the stable nearby. Four galleries gaped into the opening.

"This way," said Maheu to Étienne. You're not there yet. We have another good mile and a quarter to go. . . ."

The miners were separating, disappearing by groups into these black holes. Some fifteen of them had just entered the one on the left; and Étienne walked behind them following Maheu, who led Catherine, Zacharie and Levaque. It was a good tunnel for hauling the carts, cutting through a layer of rock so solid that only partial timbering had been necessary. They walked single file, walking always onward, without a word, led by the tiny flames in their lamps. The young man stumbled at every step, catching his feet in the rails. Suddenly a muffled sound worried him, the distant noise of a storm whose violence seemed to grow, coming from the bowels of the earth. Was it the thunder of a cave-in which would crush down onto their heads the enormous mass cutting them off from the light of day . . . ?

The further they went, the more narrow the gallery became, lower, with an uneven ceiling forcing them constantly to bend over.

Étienne bumped his head painfully. If he hadn't been wearing a leather cap, his skull would have been cracked. Yet he had been following closely the smallest movements of Maheu ahead of him, his somber silhouette created by the flow of the lamps. None of the workers bumped into anything; they must have known every hump in the ground, every knot in the timbers, every protrusion in the rock. The young man was also bothered by the slippery ground, which was getting more and more damp. Sometimes he passed through virtual seas which he discovered only as his feet plunged into the muddy mess. But what surprised him the most were the abrupt changes in temperature. At the bottom of the shaft it was very cold, and in the haulage tunnel, through which all the air in the mine flowed, a freezing wind was blowing, like a violent storm trapped between narrow walls. Further on, as they gradually traveled down other passageways which got less ventilation, the wind dropped and the warmth increased, creating a suffocating, leaden heat.

Maheu had not said another word. He turned right into a new gallery saying only to Étienne, without turning around, "The Guillaume vein."

This was the vein whose coal face they were to work. After a few steps Étienne bruised his head and elbows. The sloping roof descended so far that they had to walk doubled over for fifty or a hundred feet at a time. The water reached his ankles. They went on in this way for more than 600 feet when suddenly, Levaque, Zacharie and Catherine disappeared, seemingly swallowed by a tiny crack that opened in front of him.

"You have to climb up," said Maheu. "Hang your lamp from a buttonhole and hang on to the timbers."

He too disappeared. Étienne had to follow him. This chimney was left for the miners to allow them to reach all the secondary passageways, just the width of the coal vein, barely two feet. Fortunately the young man was thin: still clumsy, he drew himself up with a wasteful expense of strength, pulling in his shoulders and buttocks, hand over hand, clinging to the timbers. Fifty feet higher up they came to the first secondary passageway, but they had to go on; the work area of Maheu and his team was at the sixth level, "in Hell" as they said, and every fifty feet there was another passageway to be crossed. The climb seemed to go on forever, through this crack which scraped against his back and chest. Étienne gasped as if the weight of the rocks were crushing his limbs; his hands were skinned, his legs bruised. Worst of all, he was suffocating, feeling as if the blood was going to burst out through his skin. He could vaguely see down one of the passageways two animals crouched down, one small and one large, shoving carts ahead of them: Lydie and La Mouquette, already at work. And he still had to clamber up two more levels! Sweat blinded him, he despaired of catching up to the others whose agile legs he could hear constantly brushing against the rock.

"Come on; here we are!" said Catherine's voice. . . .

Little by little the veins had filled, the faces were being worked at each level, at the end of each passageway. The all-devouring mine had swallowed its daily ration of men, more than 700 workers laboring now in this giant ant heap, burrowing through the earth in every direction, riddling it like an old piece of wood infested by worms. And in the midst of this heavy silence, under the crushing weight of these deep layers of earth, could be heard—if you put your ear to the rock—the movement of these human insects at work, from the flight of the cable raising and lowering the extraction cage to the bite of the tools digging into the coal at the bottom of the mine. . . .

The four cutters had stretched out one above the other across the sloping coal face. . . . Maheu was the one who suffered most. High up where he was, the temperature was as high as 95°, the air did not circulate, and eventually you would suffocate. In order to see clearly he had had to hang his lamp on a nail near his head; but this lamp broiled his skull, making his blood seethe. His torture was worsened above all by the damp. Water kept flowing over the rock above him a few inches from his face; and huge drops kept rapidly, continuously, in a maddening rhythm, falling, always on the same spot. It was no use twisting his neck or bending his head, the drops fell on his face, beating at him, splattering endlessly.

After a quarter of an hour he was soaked, covered with his own sweat, steaming like a laundry tub. He didn't want to stop cutting and gave huge blows which jolted him violently between the two rocks, like a flea caught between the pages of a book, threatened by being completely crushed.

Not a word was spoken. They all hammered away, and nothing could be heard but these irregular blows, muffled, seemingly far-off. The sounds took on a harsh quality in the dead, echoless air, and it seemed as if the shadows created a mysterious blackness, thickened by the flying coal dust and made heavier by the gas which weighed down their eyes. The wicks of their lamps displayed only glowing red tips through their metal screens. You couldn't make out anything clearly. The work space opened out into a large chimney, flat and sloping, on which the soot of ten winters had created a profound night. Ghostly forms moved about, random light beams allowing a glimpse of the curve of a thigh, a brawny arm, a savage face, blackened as if in preparation for a crime. Sometimes blocks of coal stood out, suddenly lit up, their facets glinting like crystals. Then everything was plunged back into darkness, the picks beating out their heavy, dull blows; and there was nothing but the sound of heavy breathing, groans of pain and fatigue beneath the weight of the air and the showers from the underground streams. ■

Reading Question

In his research of the coalmining industry, Zola had taken careful notes about the elevator, or cage, in which workers were lowered into and raised out of the shaft. His description is thus meticulously realistic. But how does his writing exceed mere realistic description?

READING 36.11

from Abraham Lincoln, Address Delivered at the Dedication of the Cemetery at Gettysburg (1863)

Abraham Lincoln became president of the United States on March 4, 1861, just over a month before fighting between the Union and the Confederacy commenced, on April 12, 1861, when Confederate troops attacked the federal military installation at Fort Sumter, South Carolina. Lincoln exercised executive authority in a manner unprecedented in American history, an authority achieved, in no small part, by the persuasiveness of his rhetoric. At once lofty and colloquial, eloquent and down-to-earth, his speeches, which appeared within days of their delivery in almost every newspaper in the North, served to unite Northerners in their fight against the South. The Gettysburg Address was delivered on November 19, 1863, at the site of the decisive Battle of Gettysburg in which the Union's 90,000 men defeated 70,000 Southern troops in a three-day battle that ended in General Robert E. Lee's retreat to Virginia on July 3, 1863. The Union dead totaled 3,155, the Confederate dead 4,708. With combined wounded and missing soldiers standing at 46,000, Lincoln delivered his address at the Union Cemetery.

Four score and seven years ago our fathers brought forth on this continent, a new nation, conceived in Liberty, and dedicated to the proposition that all men are created equal.

Now we are engaged in a great civil war, testing whether that nation, or any nation so conceived and so dedicated, can long endure. We are met on a great battlefield of that war. We have come to dedicate a portion of that field, as a final resting place for those who here gave their lives that that nation might live. It is altogether fitting and proper that we should do this.

But, in a larger sense, we can not dedicate—we can not consecrate—we can not hallow—this ground. The brave men, living and dead, who struggled here, have consecrated it, far above our poor power to add or detract. The world will little note, nor long remember what we say here, but it can never forget what they did here. It is for us the living, rather, to be dedicated here to the unfinished work which they who fought here have thus far so nobly advanced. It is rather for us to be here dedicated to the great task remaining before us—that from these honored dead we take increased devotion to that cause for which they gave the last full measure of devotion—that we here highly resolve that these dead shall not have died in vain—that this nation, under God, shall have a new birth of freedom—and that government of the people, by the people, for the people, shall not perish from the earth. ■

Reading Question

Part of the power of this speech rests in its brevity. How does that serve to make it more forceful?

Summary

■ The Revolutions of 1848: From the Streets of Paris to Vienna

By the middle of the nineteenth century, living conditions in Paris and across Europe had deteriorated to an intolerable point. In 1848, in Paris, workers revolted with their battle cry "the right to work," and across Europe other revolutions quickly followed. Karl Marx and Friedrich Engels had anticipated these uprisings in the *Communist Manifesto*. In Paris, the bourgeois middle class was convinced that it had barely survived the complete collapse of the social order, and so it elected the nephew of Napoleon I, Charles-Louis-Napoleon Bonaparte, president and subsequently proclaimed him Emperor Napoleon III.

One of the most important factors contributing to revolutions elsewhere in Europe was nationalism, as ethnic groups tried to assert their independence from monarchist governments. Jews as the most transnational minority benefited from the revolutions of 1848 as liberal concerns for equality and freedom helped them attain the full rights of citizens almost everywhere in Europe except Russia.

■ In Pursuit of Modernity: Paris in the 1850s and '60s

Even before the revolution of 1848, French intellectuals had begun attacking the bourgeois lifestyle. While his *Salon of 1846* was a plea to the bourgeoisie to value art, the poet Charles Baudelaire was certain that they would ignore him. In his poems, he sought to shock them, using imagery that ranged from exotic sexuality to the grim reality of death in the modern city. Baudelaire styled himself a *flâneur*, and so did his friend, the painter Édouard Manet. Manet was Baudelaire's "Painter of Modern Life," a man who held the vulgar and materialistic lifestyle of the bourgeoisie in contempt. Manet's paintings of the 1860s, particularly *Le Déjeuner sur l'herbe* and *Olympia*, shocked his bourgeois audience, but the novelist Émile Zola championed them. He believed that all human beings are products of hereditary and environmental factors over which they

have no control but which determine their lives.

In music, the nationalist tendencies of the era played themselves out in the Paris opera. Giuseppe Verdi's *Rigoletto* and other works by him came to symbolize Italian nationalism, and the Parisian Jockey Club ostracized the German composer Richard Wagner on nationalist grounds when he tried to produce his opera *Tannhäuser*. Wagner shifted the melodic element from the voice to the orchestra and organized his opera dramas around the leitmotif, literally a "leading motive," changes so radical that French audiences found his music almost unrecognizable as opera. The Opéra Comique was, however, the most popular form of opera in Paris and the Jewish composer Jacques Offenbach its most popular artist.

■ The American Civil War

From Europe, the American Civil War appeared to be a contest between liberal Northern values and nationalist Southerners. Until the outbreak of hostilities, compromise seemed possible, especially in light of the mythologized and romanticized view of slavery of antebellum America. Especially popular were the songs of Stephen Foster, which gained a wide audience in the Northern states.

The outbreak of the Civil War in 1861 quickly extinguished all romanticized views of slavery or warfare. The war was an intensely modern event, mechanized and impersonal as no other war had been, and the nature of representation changed with it. Artists like Eastman Johnson and Winslow Homer followed troops into the field, as did photographers, who documented what Americans had never before witnessed—the battlefield before the dead had been properly buried. After the war, nearly 4 million African Americans in the South suddenly found themselves free as the federal government inaugurated a process of reconstruction, reforms that by 1900 were almost completely abandoned until the late1950s and 1960s.

Glossary

avant-garde Literally the "advanced guard," this military term is used to describe artists on the cutting edge.

flâneur A French version of the aristocratic English dandy. A man-about-town, with no apparent occupation, strolling the city, studying and experiencing it dispassionately.

Gesamtkunstwerk A total work of art, one that synthesizes music, drama, poetry, gesture, architecture, and painting.

leitmotif In opera, a brief musical idea connected to a character, event, or idea that recurs throughout the work.

minstrel show A theatrical event presenting a program of black American melodies, jokes, and impersonations, usually performed by white performers in blackface.

music drama A musical genre in which the actions on stage are the visual and verbal manifestations of the drama created by the instruments in the orchestra.

operetta Light musical drama usually incorporating spoken dialogue.

plantation melody A type of song written in dialect, the lyrics of which depicted blacks as capable of a full range of human emotion.

Critical Thinking Questions

1. What new European audience for culture emerged after the revolutions of 1848?

2. What makes Parisian opera in the mid-nineteenth century "political"?

3. How did American artists and composers deal both romantically and realistically with the Civil War and slavery?

Impressionist Paris

In the early 1870s, Édouard Manet befriended a number of young painters whom he would deeply influence and who would in turn come to be known as the Impressionists. Chief among his new, younger colleagues were Claude Monet, Pierre Renoir [ruh-NWAHR], Gustave Caillebotte [ky-BOTT], Edgar Degas, and Berthe Morisot [bert moh-ree-ZOH], who was married to Manet's brother. Starting in 1874, the Impressionists organized their own group exhibitions, in which Manet politely declined to participate, choosing instead to pursue recognition in the official Salons. Nevertheless, he came to be widely regarded as a pre-Impressionist if not the first Impressionist.

Manet never abandoned the complex social commentary that informs his earlier painting. In his *The Gare Saint-Lazare* [gahr san-luh-ZAHR] (Fig. **36.18**), his model is the same woman as in *Le Déjeuner sur l'herbe* and *Olympia*. The little girl is the daughter of Manet's friend Alphonse Hirsch, in whose garden the scene is set; she gazes through the fence at the tracks, obscured by the smoke of a passing train in the new train station of Saint-Lazare. The station was the work of the Baron Georges Eugène Haussmann [ohss-MAHN], who was appointed prefect of the Seine by Napoleon III on June 22, 1853, and charged with the task of "modernizing" the city by broadening its avenues, demolishing its worst neighborhoods, and building vast gardens and railway stations. By 1868, the station was receiving more than 13 million passengers a year, many of whom were workers, clerks, and laborers commuting in from the suburbs. The station and the bridge above the surrounding streets would become a favorite subject of the Impressionist painters. The front door to Manet's own studio from 1872 to 1878 can be seen through the railings behind the woman's head. In 1877, Claude Monet rented a studio nearby in order to paint a series of views of the station itself.

Manet's painting is a bouquet of contrasts. The little girl is dressed in white with blue trim, while the older woman, posed here as her mother, or perhaps her nanny, is in blue with white trim. The one sits, regarding us; the other stands, gazing through the fence railing. The nanny's hair is down, the little girl's up. The nanny's angular collar is countered by the soft curve of the little girl's neckline. The black choker around the one's neck finds its way to the other's hair. The older woman sits with her puppy on her lap, a symbol of her contentment. The little girl is eating grapes (beside her on the ledge), which have bacchanalian associations. The older escapes into her novel, perhaps a Romantic one, while the younger looks out at the trains leaving the station, possibly dreaming of adventure.

Manet's painting suggests that the little girl will grow up into the woman beside her. The painting implicitly portrays the limits of women's possibilities in French society. As the nineteenth century progressed, women like the Impressionist painters Mary Cassatt and Berthe Morisot would strive to eliminate those limitations as they increasingly demanded equality and respect, not only in their work, but also in their lives. ■

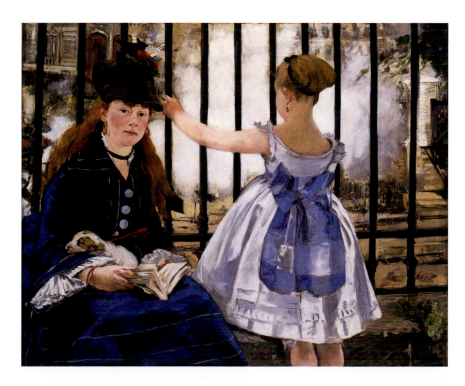

Fig. 36.18 Édouard Manet. *The Gare Saint-Lazare.* **1873.** Oil on canvas, 36 3/4″ × 45 1/8″. Gift of Horace Havemeyer in memory of his mother, Louisine W. Havemeyer. 1956.10.1. Image © 2007. Board of Trustees, National Gallery of Art, Washington, DC © 2008 ARS Artists Rights Society, NY.

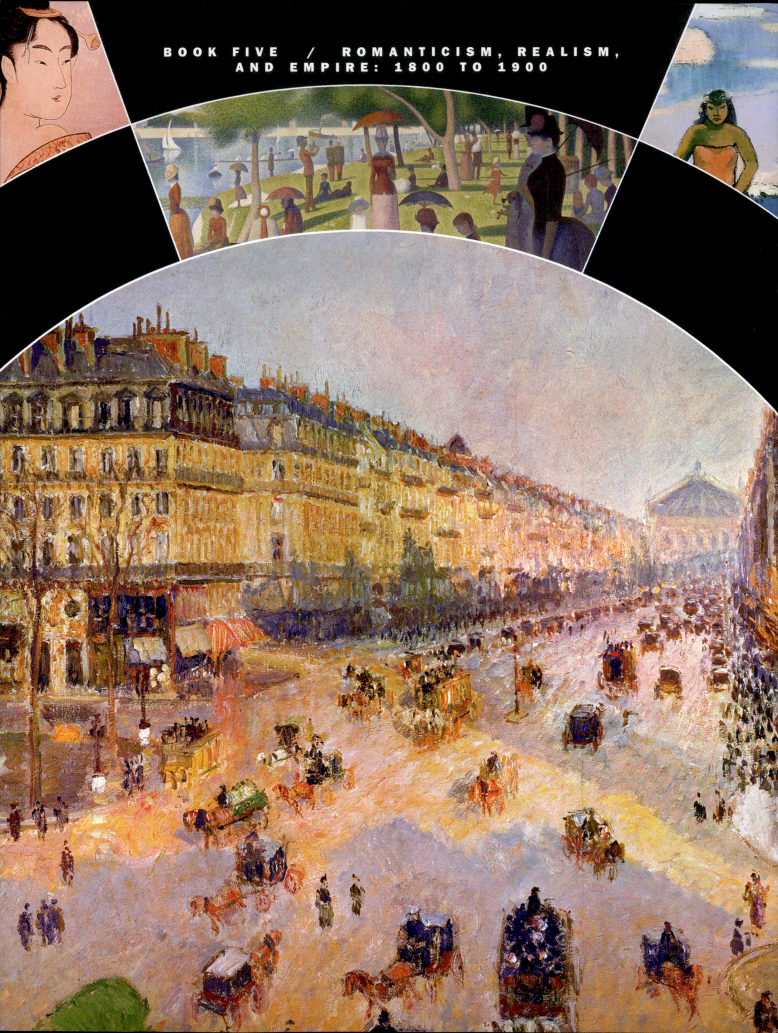

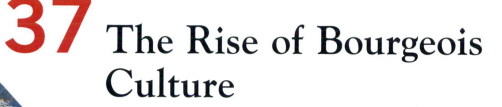

37 The Rise of Bourgeois Culture

Living the Good Life

The Haussmannization of Paris

The 1870s: From the Commune to Impressionism

Russian Realism and the Quest for the Russian Soul

Britain and the Design of Social Reform

❝ *The more I go on, the more I see that I must work a lot to succeed in rendering what I am looking for: 'instantaneity' . . . more than ever I'm disgusted by easy things that come without effort.* **❞**

Claude Monet

◄— **Fig. 37.1 Camille Pissarro.** *Avenue de l'Opera, Sunlight, Winter Morning.* **ca. 1880.** Oil on canvas, 28³⁄₄″ × 35⁷⁄₈″. Musée Saint-Remi, Reims, France. Noticeably absent in this view of the avenue, looking northwest from the Hôtel de Louvre toward Charles Garnier's Opéra at the other end of the street, are the trees that line the other Grand Boulevards of Paris. The Baron Georges-Eugène Haussmann forbade planting any in order to maintain what he called the "dignity" of the avenue, his monument to Louis-Napoleon's Second Empire.

N JULY 1853, FRENCH EMPEROR NAPOLEON III CHOSE BARON

Georges-Eugène Haussmann (1809–1891) to supervise a daunting task—planning the modernization of Europe's most celebrated city, Paris. They shared a dream: to rid Paris of its medieval character, transforming it into the most beautiful city in the world.

By 1870, their reforms were largely completed, resulting in improved housing, sanitation, and increased traffic flow, all of which encouraged growth in the city's shopping districts. The vast renovation also served to prevent the possibility of out-of-control street riots leading to revolutions—like those of 1830 and 1848—from ever happening again.

By widening the streets, Haussmann made it harder to build barricades. By extending long, straight boulevards across the capital, he made it easier to move troops and artillery rapidly within the city. And he integrated each project into a larger-scale city planning strategy. After demolish-

ing the labyrinth of ancient streets and dilapidated buildings that were home to the rebellious working class, for example, the government installed enormous new sewer lines before extending impressively wide boulevards atop them. Although many residents of the demolished areas were subsequently moved to new working-class suburbs, Haussmann's plan linked the new boulevards to enormous railway stations, providing easy access to transportation (Map **37.1**).

These gigantic projects ultimately reshaped Paris into a lively and expansive modern city with updated transportation networks and a worldwide reputation for innovative urban

Map 37.1 Paris. ca. 1870. The map shows (in red) the street work done by Haussmann between 1850 and 1870.

design. The renovations and their social and cultural effects on France comprise the initial focal point of this chapter. Like Paris, the rest of the world also underwent rapid and massive urbanization during the nineteenth century. Tens of millions of people moved into crowded cities in search of better prospects, all of which lacked adequate infrastructure. Now, in France, someone was doing something about it on a grand scale—and on an ambitiously quick timetable.

As powerful as they were, Emperor Napoleon III and Haussmann could not have succeeded without the large bourgeois population's ready acceptance of their plans. And the bourgeoisie remained central to the Parisian economy as it boomed in the decades after 1860. The art and literature that reflected the lifestyle of this growing affluent class comprise the first theme of this chapter. Other European capitals did not duplicate the economic and social progress evident in Paris. In Russia, the issue of serfdom clouded the nation's art and literature, even as its writers and artists sought to express the uniqueness of their cultural identity. The second part of the chapter therefore focuses on Slavic nationalism and the very different artistic styles that emerged in mid-nineteenth-century Russia, characterized by an emphasis on realism. The chapter concludes by examining the social reform movement in Britain, led by artists and designers who sought to reshape and revitalize English society by emphasizing beauty and utility as well as harmony and restraint.

The Haussmannization of Paris

When a group of young and rebellious painters, later dubbed the Impressionists, organized their first Paris exhibition in 1874, they installed it directly across the street from the Grand Hôtel, the luxurious building erected a dozen years earlier on the Place de l'Opéra. They may have been cultural rebels, but they too wanted to share in the prosperity established during Napoleon III's Second Empire. Haussmann's new parks, avenues, and boulevards, along with the cafés and racetracks where the bourgeoisie promenaded, were often their subjects (Fig. **37.1**). Not even war with Prussia in 1870–1871 and a German siege that brought the city to the edge of famine could halt the oncoming tide of art and commerce.

One of Haussmann's pet projects was construction of a broad Avenue de l'Opéra connecting the Louvre to Charles Garnier's new Paris Opéra (see Fig. 36.9). The project was not completed until 1877, but the vista Haussmann created was of stunning scale, inspiring many artists, such as Camille Pissarro [pee-SAH-roo], to paint it (see Fig. 37.1). The Opéra was itself carefully placed just above Paris's *grands boulevards* [grahn bool-uh-VAHR], the center of his modernization plans (Map **37.2**). The greatest wealth of the city was concentrated along these promenades, and so was the city's best shopping. In a memoir of his visit to the Paris Exposition of 1867, Edward King, an American, described how those seeking the trappings of bourgeois life were drawn to these new public venues:

> The boulevards are now par excellence the social centre of Paris. Here the aristocrat comes to lounge, and the stranger to gaze. Here trade intrudes only to gratify the luxurious. . . . On the grands boulevards you find porcelains, perfumery, bronzes, carpets, furs, mirrors, the furnishings of travel, the copy of Gérome's latest picture, the last daring caricature in the most popular journal, the most aristocratic beer, and the best flavored coffee.

Haussmann understood full well that the boulevards appealed to tourists, and so in 1860, as he was busy adding sidewalks, gas streetlights, and trees to the boulevard des Capucines, he facilitated the demolition of old buildings to

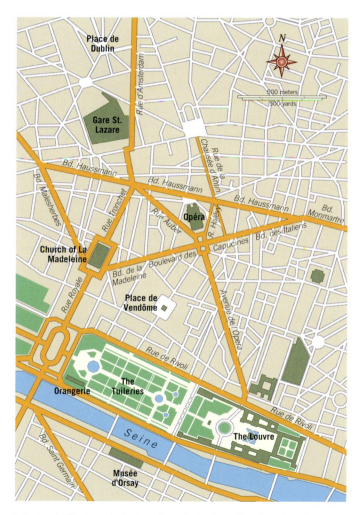

Map 37.2 The Grand Boulevards of Paris. The Grand Boulevards are composed of a continuous arc that changes its name every few blocks, running across the front of the Opéra. They begin in the west at the Church of La Madeleine with the boulevard de la Madeleine, then the boulevard des Capucines, then the Boulevard des Italiens, and finally bending eastward to become the Boulevard Montmartre.

Voices

Where Are the Roses?

Haussmann's transformation of Paris included the construction of large-scale plant nurseries and hothouses within the parks. As Anthony North Peat, the Paris correspondent of the London newspaper The Morning Star *writes in a letter, revolutionary workers and violent criminals were not the only threat to the city during the height of the Second Empire under Louis-Napoleon:*

"There are few roses cultivated here, for the simple reason that their flowers are invariably robbed during the night by lovers anxious to win a smile from their various lady-loves by the offering of a rose."

The nursery gardens of Paris are well worth the attention of the visitor. The most interesting, however, is that belonging to the city . . . in the Bois de Bologne. This vast horticultural laboratory contains about forty hothouses, some of which are of colossal proportions. . . . One hundred gardeners alone are occupied in the task of multiplying these plants whose number this year amounted to 3 million. . . . There are few roses cultivated here, for the simple reason that their flowers are invariably robbed during the night by lovers anxious to win a smile from their various lady-loves by the offering of a rose. It required at least three *sergents de ville* [policemen] in each square, and several more in such open gardens as the Champs-Élysées and the Parc Monceaux, to defend the roses. This being considered a somewhat superfluous duty by M. le Prefet de Police [chief of police], who required his men for different work, roses are but sparingly bestowed on the inhabitants of Paris.

make way for the 700-room Grand Hôtel [grahnd-oh-TEL]. Occupying a full block, it was a short walk to the city's most famous cafés, restaurants, and theaters.

Baron Haussmann's grand project became the model for cities around the world as they struggled to accommodate the demands of burgeoning populations and modern technology. In fact, his approach to urban redevelopment and its wide-scale destruction of existing structures is often simply called **Haussmannization**. Central to the plan was not only the widening of the city's arteries but also the development of a series of great public parks. Before 1848, there were perhaps 47 acres of parkland in Paris, most of it along the Champs-Élysées [shahnz-ay-lee-ZAY], but Emperor Louis-Napoleon soon opened to the public all the previously private gardens, including the Jardin des Plantes [zhar-DEHN deh plahnt], the Luxembourg [luks-om-BOOR] Gardens, and the royal gardens. Haussmann amplified this gesture by creating a series of new parks, squares, and gardens (see *Voices*, below). These included the massive redesign of the Bois de Boulogne [bwah deh boo-LOHN] on the city's western edge and the conversion of the old quarries in the working-class neighborhoods into a huge park with artificial mountains, streams, waterfalls, and a lake, all overlooked by new cafés and restaurants. By 1870, Haussmann had increased the total land dedicated to parks in the city by nearly 100 times, to 4,500 acres.

To create the new system of Parisian parks, the government demolished over 25,000 buildings between 1852 and 1859, and after 1860, another 92,000 (Fig. 37.2). The system of new streets that resulted is depicted in *Paris Street, Rainy Day* (Fig. 37.3), painted in 1877 by the youthful Gustave Caillebotte [cai-BOTT] (1848–1894), who was associated with the Impressionists, had grown up in Haussmann's Paris, and took its broad avenues and squares for granted. The casual elegance of the painting, the rhythms of the curved umbrellas and rounded shoulders of its pedestrians, play off the complex perspective of the scene. Here it seems as though Haussmann has bequeathed the good life—even on rainy days—to the city's inhabitants. Citizens and tourists alike enjoyed miles of new sidewalks with over 100,000 trees planted beside them. The eight new bridges that spanned the river Seine and pathways and roads along its banks further expanded the scenic vistas of the city's architectural treasures.

One of the jewels of Paris architecture, Notre Dame, and the island on which it was located was also part of Haussmann's grand design. Enlarging the open area in front of the great Gothic cathedral considerably, he replaced most of the housing on the Île de la Cité [eel deh la see-TAY] with public buildings symbolizing law, order, and civic well-being.

Fig. 37.2 Felix Thorigny. *Demolition of the rue de la Barillerie to allow for construction of the Boulevard Sebastopol, Paris, 1st arrondissement.* 1859. **Engraving.** Bibliothèque Nationale, Paris. Here thirteenth- and fourteenth-century streets and houses on the Right Bank are shown being cleared away.

CULTURAL PARALLELS

The Modernization of Tokyo

While Haussmann directed the renovation of Paris, Japan was also experiencing urbanization and a major shift in social and political policies. The Meiji Restoration in 1868 ended the rule of the *shoguns* (military dictators) and regional warlords (*daimyo*), replacing them with an oligarchy led by the emperor. The Restoration was a major catalyst for the rapid industrialization of Japan, the shift of the national capital to Tokyo, and a series of efforts at urban modernization.

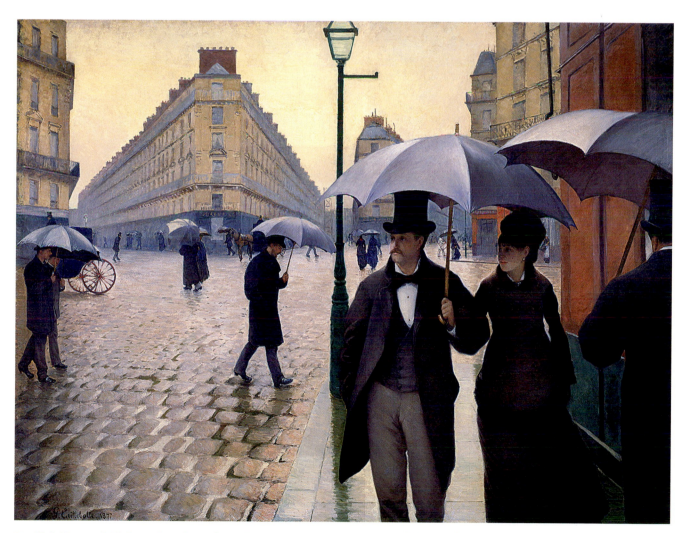

Fig. 37.3 Gustave Caillebotte. *Paris Street, Rainy Day.* 1876–1877. Oil on canvas, 83 1/2″ × 108 3/4″. Charles H. and Mary F. S. Worcester Collection, 1964.336. Photograph © 2006, The Art Institute of Chicago. All Rights Reserved. This view of the place de Dublin, near the Saint-Lazare railroad station, shows one of Haussmann's favorite devices, the so-called *places-carrefours*, or "crossroad-squares," where multiple boulevards converge.

Haussmann truthfully claimed that he built more new housing than he demolished. However, almost all of the less expensive housing for workers was erected on the outskirts of the city. As much as he wanted to open the city to air and light, he wanted to rid it of crowding, crime, and political disaffection. "Rue Transnonain," he bragged, referring to the site of Daumier's famous lithograph of 1834 (see Fig. 35.14), "has disappeared from the map of the city." The working-class exodus to the outskirts of Paris resulted in a city inhabited almost exclusively by the bourgeoisie and the upper classes. To further facilitate the exodus of the working class, Haussmann banned large-scale industry (as opposed to artisan workshops) from the city altogether. By the last quarter of the nineteenth century Paris became a city of leisure, of the good life, surrounded by a ring of industrial and working-class suburbs, as it remains to the present day.

The 1870s: From the Commune to Impressionism

A new era of French history and politics dawned in 1870. Haussmann was dismissed by Louis-Napoleon in January of that year, having become a political liability because of his questionable financing schemes for the massive reconstruction of Paris. While the complex accounting procedures and investment incentives proved unfathomable to most observers, no evidence has ever emerged that would prove extensive corruption. The pioneering urban planner was, in fact, a scapegoat of political opponents who despised Louis-Napoleon. Their displeasure mostly focused on the emperor's humiliating imperial adventure in Mexico, where he had sent 10,000 French troops in 1862 to depose the first indigenous president ever elected, Benito Juarez [hwar-EZ] (1806–1872). Louis-Napoleon seethed at Juarez's independent policies, then placed Maximilian (1832–1867), brother of the Austrian emperor, on the throne as a puppet ruler. Under severe criticism at home in 1867, Louis-Napoleon withdrew all French forces from Mexico, abandoning Maximilian, who was captured by Juarez's troops and summarily executed.

The painter Édouard Manet illustrated his displeasure with Louis-Napoleon's autocratic reign by depicting the scene in three full-scale paintings, an oil sketch, and a lithograph, none of which the government allowed to be exhibited at the time. The largest and most ambitious of these works is *The Execution of Maximilian* (Fig. **37.4**). The painting's most obvious influence is Francisco Goya's *The Third of May, 1808* (see Fig. 34.10), which Manet had probably seen in person in his August 1865 visit to Spain. Like the quasi-religious light shining on Goya's victims, the emperor's sombrero encir-

Continuity & Change
p. 1098

The Third of May, 1808

cles his head like a halo, an iconic symbol of martyrdom. The crowd leaning over the wall to observe the execution is reminiscent of many of Goya's bullfighting illustrations, lending the scene an aura of a bullfight's ritualistic death. But it is the point-blank range of the execution that most startles viewers, together with the evident coldness of the soldier in the red hat, who loads his rifle to deliver the final, mortal shot. (Manet read reports that the initial fusillade had failed to kill Maximilian, with two more shots required to finish him off.) Here Manet paints death as the matter-of-fact outcome of the emperor's own imperial ambitions.

Louis-Napoleon's ambitions would soon result in even greater disaster. In July 1870, Otto von Bismarck (1815–1898), prime minister of the kingdom of Prussia, goaded the increasingly vulnerable French emperor into declaring war. Two months later, at the Battle of Sedan, the Germans soundly defeated the French army. Louis-Napoleon was imprisoned and exiled to England, where he died three years later. Meanwhile Bismarck marched on Paris, setting siege to the city, forcing its government to surrender in January 1871 after four months of ever-increasing famine during which most of the animals in the Paris zoo were killed and consumed by the public.

The Commune

The new French National Assembly elected in February 1871 was dominated by monarchists. The treaty it negotiated with Bismarck concluding the Franco-Prussian war required France to pay its invader a large sum of money and give up the eastern provinces of Alsace and part of Lorraine. Most Parisians felt that the assembly had betrayed the true interests of France. In March, they elected a new city government, which they dubbed the Paris Commune [KOM-yoon], with the intention of governing Paris separately from the rest of the country. In a prelude to civil war, the National Assembly quickly struck back, ordering troops, led by General Lecomte [leh-KOHNT], to seize the armaments of the Commune. By the end of the day angry Paris crowds seized Lecomte and summarily shot him (Fig. **37.5**). By nightfall the National Assembly's troops, and the Assembly itself, had withdrawn to Versailles.

But the assembly was not about to let Paris go. Their troops surrounded the city and on May 8 bombarded it. Paris remained defiant, even festive. Edmond de Goncourt [ed-MOHN deh gohn-KOOR] (1822–1896), a chronicler of Parisian life, recalled: "I go into a café at the foot of the Champs-Élysées; and while the shells are killing up the avenue . . . men and women with the most tranquil, happy air in the world drink their beer and listen to an old woman play songs by Thérésa on a violin." Finally, on May 21, as hundreds of musicians entertained crowds in the Tuileries, 70,000 of the assembly's troops stormed the city. Caught unawares, the Communards began erecting barricades, only to discover that Haussmannization allowed the army to outflank them and clear the broad streets with artillery. By May 22, the city

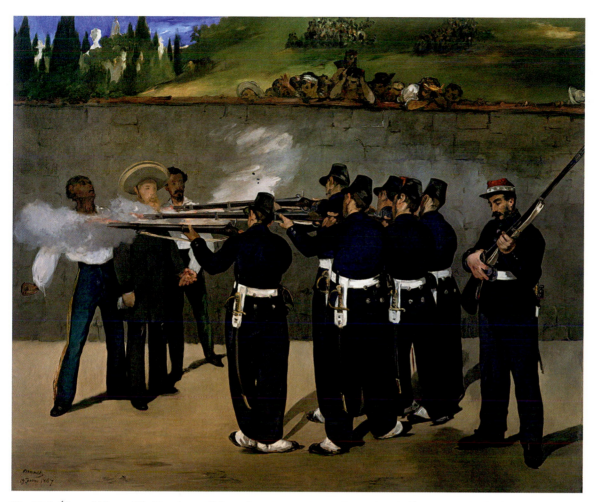

Fig. 37.4 Édouard Manet. *The Execution of Maximilian.* **1868–1869.** Oil on canvas, 99¼″ × 120″. Stadische Kunsthalle, Mannheim, Germany. This painting was never exhibited in France until 1905.

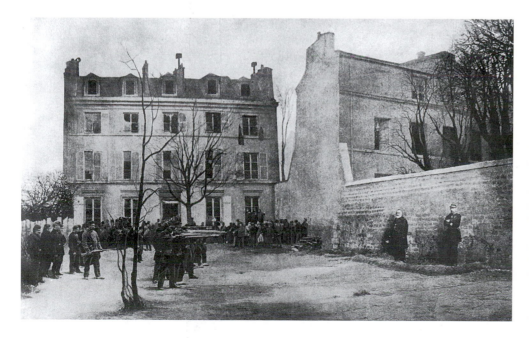

Fig. 37.5 The Execution of General Thomas and General Lecomte in the rue des Rosiers in Montmartre. **March 18, 1871.** Lecomte's troops easily seized the Communards' cannons, but they neglected to arrange for harnesses to haul them away. Over the course of the day, large crowds surrounded Lecomte's troops, and the Communard National Guard arrived. Three times Lecomte ordered his men to fire on their fellow Frenchmen. When they refused, Guards and Assembly troops cheered. Lecomte's execution quickly followed.

was ablaze, and a series of executions began as government troops arrested and killed anyone who seemed even vaguely sympathetic to the Commune. In what become known as "the bloody week," approximately 20,000 to 25,000 Parisians died. The Commune was crushed, and with it, the dreams of an independent Paris.

Impressionism

The painters of the Second Empire (Napoleon III's reign—1852–1870) struggled to respond to the rapidly changing circumstances. Courbet, who was president of the Commune's Art Commission, was arrested and jailed for six months. When he was released he moved to Switzerland. Manet fled the city for the Pyrenees after the siege, but he returned for at least the last days of the Commune and could not help but feel that his *Execution of Maximilian* had in some way foretold the execution of General Lecomte and subsequently the Paris Communards. He traveled to Bordeaux, the seat of the National Assembly, and attended a session with a friend who had been elected as a delegate. Manet was amazed: "I never imagined France could be represented by such doddering old fools, not excepting that little twit Thiers who I hope will drop dead one day in the middle of a speech and rid us of his wizened little person."

After the events of "the bloody week," Manet wrote despairingly: "What an encouragement all these bloodthirsty caperings are for the arts! But there is at least one consolation in our misfortunes: that we're not politicians and have no desire to be elected as deputies," a sentiment shared by many younger painters. Yet they also saw the entire apparatus of the French art world—the École des Beaux Arts [ay-KOHL deh bohz-AHR], the Salon, and the Salon des Refusés—as hopelessly mired in the politics that had led to the disaster of the Commune. Determined to begin anew, many writers called for the arts to lead the way in rebuilding French culture: "Today, called by our common duty to revive France's fortune," the editor of the *Gazette des Beaux-Arts* wrote, "we will devote more attention to . . . the role of art . . . in the nation's economy, politics, and education." Moved by such rhetoric, these young artists founded the *Société anonyme* [soh-see-ay-TAY ah-noh] for painters, sculptors, and other artists in December 1873. Membership was open to anyone who contributed 60 francs per year (about $12 when a dollar purchased the equivalent of 15 cents today). Among the founders were the painters Claude Monet (1840–1926) and Camille Pissarro (1830–1903); Pierre-Auguste Renoir [ruh-NWAHR] (1841–1919); Edgar Degas [deh-GAH] (1834–1917); and Berthe Morisot [moh-ree-SOH] (1841–1895), the lone woman in the group. Many of them had served in the military, and their close friend and fellow painter Frédéric Bazille [bah-ZEEL] (1841–1870) had been killed during the war with Prussia. On April 15, 1874, they held the first of eight exhibitions. The last was held in 1886, by which time the Société had forever changed the face of French painting. In fact, it had transformed Western painting altogether.

Monet's *Plein-Air* Vision From the outset, critics recognized that a distinguishing feature of this new group of painters was its preference for painting out-of-doors, in *plein air* [plen-air] ("open air"). The availability of paint in metallic tubes, introduced between 1841 and 1843, is in part responsible. Now paints could be easily transported out-of-doors without danger of drying. It was the natural effects of light that most interested these younger painters, which they depicted using new synthetic pigments consisting of bright, transparent colors. Before they were ever called "Impressionists," they were called the "École de Plein Air," although the term *Impressionist* was in wide use by 1876, when poet Stéphane Mallarmé [mahl-ar-MAY] (1842–1898) published his essay "Impressionism and Édouard Manet." (Manet, as noted in chapter 36, was generally considered the leader of the Impressionists, although he repeatedly denied invitations to exhibit with them.)

Plein-air painting implied, first of all, the artist's abandonment of the traditional environment of the studio. Of all the Impressionists, Claude Monet was the most insistent that only *en plein air* could he realize the full potential of his artistic energy. In rejecting the past, the painters of the Société cultivated the present moment, emphasizing improvisation and spontaneity. Each painting had to be quick, deliberately sketchy, in order to capture the ever-changing, fleeting effects of light in a natural setting. Although Monet habitually reworked his paintings in the studio, he would tell a young American artist: "When you go out to paint, try to forget what objects you have before you—a tree, a house, a field, or whatever. Merely think, here is a little square of blue, here an oblong of pink, here a streak of yellow, and paint it just as it looks to you, until it gives you your own näive impression of the scene before you." It is not surprising, then, that in Monet's *The Regatta at Argenteuil* [ar-zhan-TOY-eh] the reflection of the landscape in the water disintegrates into a sketchy series of broad dashes of paint (Fig. **37.6**). On the surface of the water, the mast of the green sailboat seems to support a red and green sail, but this "sail" is really the reflection of the red house and cypress tree on the hillside. Monet sees the relationship between his painting and the real scene as analogous to the relationship between the surface of the water and the shoreline above. Both of these surfaces—canvas and water—reflect the fleeting quality of sensory experience.

Two paintings by Monet in the first Impressionist exhibition offer different perspectives on this new approach to art. The first, *Impression: Sunrise*, went a long way toward giving Impressionism its name (Fig. **37.7**). The artist applied the paint in brushstrokes of pure, occasionally unmixed, color that evoke forms in their own right. He rendered waves in staccato bursts of horizontal dashes, the reflection of the rising sun on the water in swirls of orange brushstrokes highlighted with white. Violets and blues contrast with yellows and oranges as if to capture the prismatic effects of light. Most of all, one feels the very presence of the painter at work, his hand racing across the surface of the canvas before the morning light vanished. Although Monet would often work

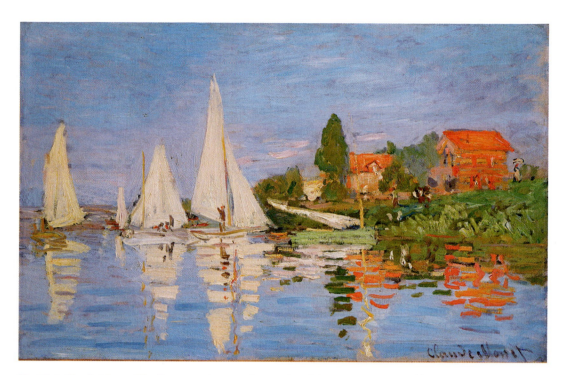

Fig. 37.6 Claude Monet. *The Regatta at Argenteuil.* ca. 1872. Oil on canvas, 19″ × 29½″. Musée d'Orsay, Paris, France. Erich Lessing/Art Resource, NY. Monet moved to Argenteuil, a suburb on the Seine just north of Paris, in December 1871, perhaps to leave memories of the Commune behind.

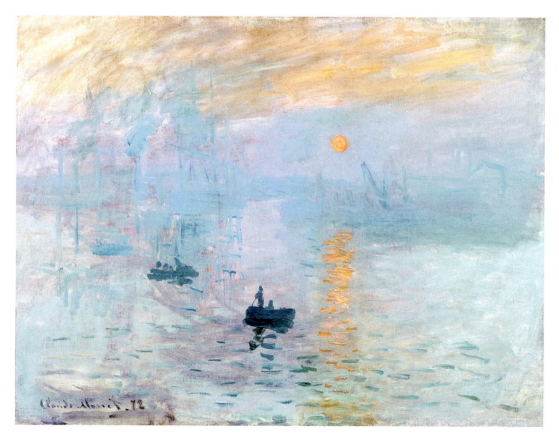

Fig. 37.7 Claude Monet. *Impression: Sunrise.* 1873. Oil on canvas, 19⅝″ × 25½″. Musée Marmottan-Claude Monet, Paris, France. Erich Lessing/Art Resource, NY. The painting is a view of the harbor in Le Havre, France, on the English Channel.

and rework his paintings, they seem "of the moment," as immediate as a photograph.

In the second painting, *Boulevard des Capucines*, we look out over the *grands boulevards* with the two top-hatted men who lean forward out the window at the right (Fig. **37.8**). The building at the left is the Grand Hôtel, and between it and the next building, the space compressed by Monet's perspective, is the Place de l'Opéra. We are, in fact, standing in the exhibition space of the first Impressionist show, and this is a work of art about its own marketplace. Monet's brushwork, capturing the play of light on the leaves on the trees and the crowds in the street, is even looser and freer than in *Impression: Sunrise*. Writing in *Paris-Journal* in May 1874, the critic Ernest Chesneau [shay-noh] recognized the painting's significance:

> The extraordinary animation of the public street, the crowd swarming on the sidewalks, the carriages on the pavement, and the boulevard's trees waving in the dust and light—never has movement's elusive, fugitive, instantaneous quality been captured and fixed in all its tremen-

dous fluidity as it has in this extraordinary, marvelous sketch. . . . At a distance, one hails a masterpiece in this stream of life, this trembling of great shadow and light, sparkling with even darker shadows and brighter lights. But come closer, and it all vanishes. There remains only an indecipherable chaos of palette scrapings. . . . It is necessary to go on and transform the sketch into a finished work. But what a bugle call for those who listen carefully, how it resounds far into the future!

Chesneau failed to understand that this "sketch" was already "finished." But he was right that it was a painting of the future. It would not take long for the public to understand that this "chaotic" brushwork was the very mark of a new sensibility, one dedicated to capturing what the French call *le temps* [tahn], a word that refers to the "time of day," "the weather," and "the age" all at once.

Monet's Escape to Giverny After the Commune, except for a brief stint in Paris in 1876–1877 when he painted a series of works on the *Gare Saint-Lazare* train station,

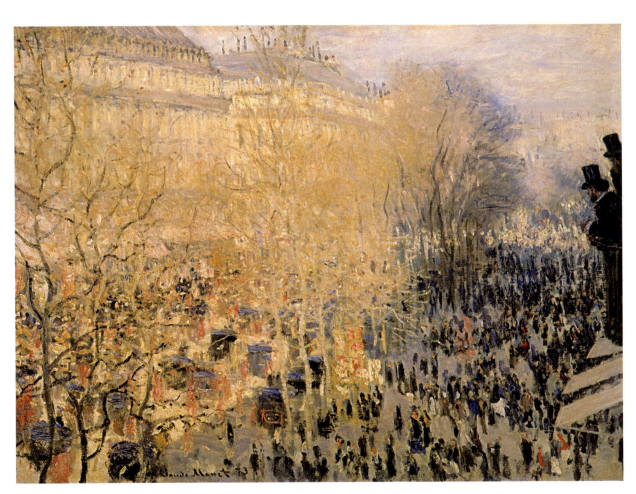

Fig. 37.8 Claude Monet. *Boulevard des Capucines.* 1873. Oil on canvas, 24″ × 31½″. Pushkin Museum of Fine Arts, Moscow, Russia. Scala/Art Resource, NY. There are two paintings by this name, both executed in 1873. The other is a winter scene. It is unclear which of these two was exhibited at the first Impressionist exhibition, but Chesneau's description points toward this one.

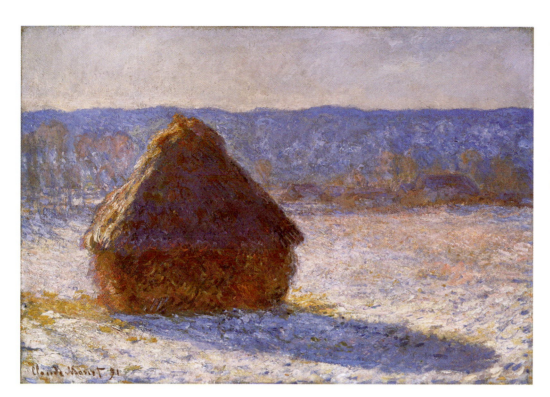

Fig. 37.9 Claude Monet. *Grainstack (Snow Effect).* 1891. Oil on canvas, 25 3/4″ × 36 3/8″. Museum of Fine Arts, Boston. Gift of Misses Aimee and Rosamond Lamb in memory of Mr. and Mrs. Horatio A. Lamb, 1970.253. Photograph © 2008 Museum of Fine Arts, Boston. This painting has a simple geometric structure—a triangle set on a rectangle, both set on a rectangular ground.

Monet had continually sought to escape the city for the pleasures of the countryside. In December 1871, he had moved to Argenteuil, an idyllic little village on the Seine downriver from Paris and where he lived for seven years. Then, faced with the suburb's increasing industrialization and urbanization, he moved farther downriver to Vétheuil [vay-TOY], another little town with a tiny population, no railroads, no industry, no pollution, and no weekend Parisian crowds. Finally, in April 1883, he moved farther downriver again, to Giverny [zhee-vair-NEE]. Monet's determined flight from the distraction of crowds is an announcement of the rapid growth of suburbs and outlying towns surrounding Paris (and every other growing metropolis) in the last quarter of the century.

Monet did not begin painting at Giverny immediately. Instead, he traveled—to the south of France, to the Côte d'Azur [koht dah-ZOOR], to Brittany and the Normandy coast, and to locations all across France. Monet's sojourn through the countryside points to the increased opportunities for leisurely travel afforded by the ever-expanding railroad networks in France. Indeed many of the towns and scenes he painted were tourist locales, frequented by the prosperous Parisian middle class that the Impressionists sought to cultivate. Many of his contemporaries attacked the master of Impressionism for the shallowness of his themes and his apparent instantaneous rendering of light effects. But the painting was anything but instantaneous. "The more I go on," Monet wrote in a letter to a friend, "the more I see that I must work a lot to succeed in rendering what I am looking

for: 'instantaneity' . . . more than ever I'm disgusted by easy things that come without effort."

In the autumn of 1888, Monet began using a different series format than before, painting the same subject at different times of day and in different atmospheric conditions. In addition to a series on a line of poplar trees and on Rouen Cathedral, he painted a series of grainstacks in the nearby farmer's field. In May 1891, he exhibited 15 grainstack paintings in Paris. They were a spectacular success (Fig. 37.9). In a preface to the catalog for the exhibition, art critic and Monet friend's Gustave Geffroy describes their effect on the viewer:

> These stacks in this deserted field are transient objects whose surfaces, like mirrors, catch the mood of the environment, the states of the atmosphere with the errant breeze, the sudden glow. Light and shade radiate from them, sun and shadow revolve around them in relentless pursuit; they reflect its dying heat, its last rays; they are shrouded in mist, soaked with rain, frozen with snow, in harmony with the distant horizon, the earth, the sky. . . .

Each painting in the series, then, becomes a fragment in the duration of the whole, and Geffroy's reading of the works transforms Monet into an artist who in rendering nature also depicts his own interior landscape. As he continued to work—almost daily until his death in 1926—he turned his attention to his gardens at Giverny, creating some of the most monumental paintings in the history of art (see *Focus*, pages 1198–1199).

Focus

Monet's *Water Lilies*

In 1893, Claude Monet bought the tract of land that included a pond across the railroad tracks from his property in Giverny, adjacent to the river. He proceeded to expand the pond, plant it with water lilies, and build a Japanese bridge after the model found in any number of Japanese prints, which he had collected for years. Then he began to paint the ensemble repeatedly. The garden at Giverny became a sort of dream world for him, its reflections a metaphor for his own thoughts, his own self-reflections.

Beginning the series in 1902, Monet often repainted the canvases, destroying some in frustration. But in 1909, he exhibited 48 *Water Lilies* paintings in Paris. And in 1914, encouraged by his friend and neighbor Georges Clemenceau (1841–1929), prime minister of France, he began a series of mural-sized versions of the paintings, which he agreed to donate to the state. He worked on them continuously until his death. In 1927 they were finally installed, encircling the viewer in two rooms of the Orangerie [or-ohn-zhuh-REE], a building at the top of the Tuileries gardens.

Standing in the midst of Monet's panoramic cycle, the viewer's eye is driven randomly through the space of the paintings. It is as if one were standing on an island in the middle of the pond itself. Without a single focal point, the viewer organizes the visual experience through personal acts of perception and movement.

Claude Monet. *Setting Sun.* **ca. 1921–1922.** Panel from the *Water Lilies* murals. Oil on canvas, 6′ 6¾″ × 19′ 8⅜″. Musée de l'Orangerie, Paris, France. Erich Lessing/Art Resource, NY.

Room 1 of the *Water Lilies*. Photo: Gèrard Blot/Hervè Lewandowski. Musée de l'Orangerie, Paris, France. Réunion des Musées Nationaux/Art Resource, NY. Monet's paintings verge on abstraction, as if the objective world is about to evaporate into a field of color and paint. In their enormous scale, they anticipate the abstract painting of Jackson Pollock. In their simultaneously transparent and opaque fields of color, they look forward to the color-field paintings of Mark Rothko. (Pollock and Rothko are discussed in chapter 45.)

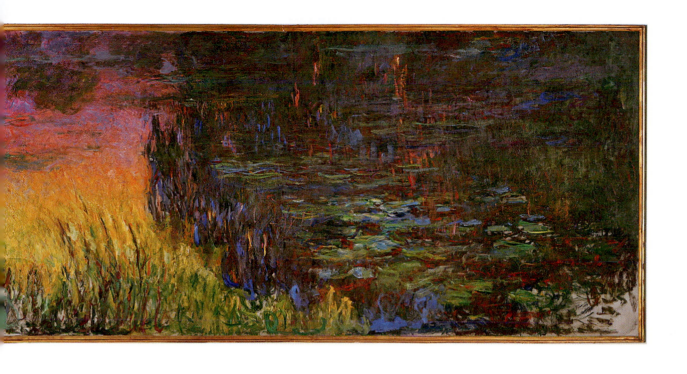

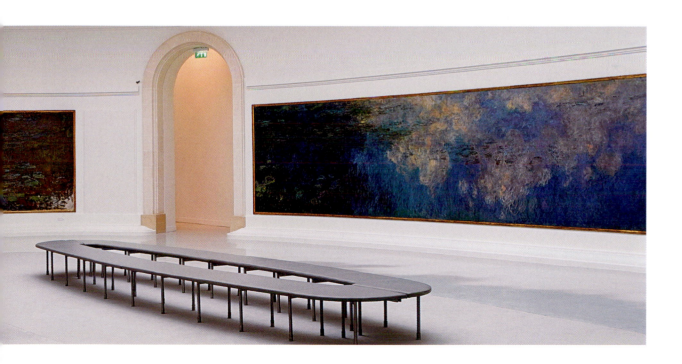

Fig. 37.10 Berthe Morisot. *Summer's Day.* **1879.** Oil on canvas, 18″ × 29 3/4″. National Gallery, London. Note the almost arbitrary brushwork that defines the bottoms of the dresses worn by both women, one a set of zigzags, the other a patchwork of straight strokes, emphasizing the distance and difference between the two.

Morisot and Pissarro: The Effects of Paint Monet's willingness to break his edges with feathery strokes of paint was even more radically developed in the work of Berthe Morisot. Born to a socially connected bourgeois family (she was the granddaughter of the Rococo painter Fragonard, noted for his rapid brushwork) (see Fig. 29.7), Morisot received an education that included lessons in drawing and painting from the noted landscape artist Camille Corot. She became a professional painter, and a highly regarded colleague to male artists of her generation. Morisot was the sister-in-law of Manet, and it was she who convinced him to adopt an Impressionist technique of his own. But no one could match her "vaporous and barely drawn lines," as one critic put it. "Here are some young women rocking in a boat," writes a critic of her painting *Summer's Day*, ". . . seen through fine gray tones, matte white, and light pink, with no shadows, set off with little multi-colored daubs . . ." (Fig. **37.10**). She drapes her bourgeois figures, out for a little recreation, in clothing that is often barely distinguishable from the background, like those worn by the woman in the middle of the boat. She shuns outline altogether—each of the ducks in the water is realized in several broad, quick strokes.

If Morisot's paintings seem to dissolve into a uniform white light, Camille Pissarro's landscapes give us the impression of a view never quite fully captured by the painter. In *Red Roofs*, a random patchwork of red and green, orange and blue appears through a veil of tree branches that interrupt the viewer's vision (Fig. **37.11**). Pissarro was deeply interested in the new science of color theory, and he paid close attention to the 1864 treatise of Michel-Eugène Chevreul [shev-RULL] (1786–1889), *On Colors and their Applications to the Industrial Arts.* Chevreul argued that complementary colors of pigment (that is, colors directly opposite each other on the traditional color wheel)—like red and green, yellow and violet, blue and orange—intensify each other's hue when set side by side. Pissarro adopted a later scheme by American physicist Ogden Rood, in which the primary colors of light, rather than pigment, were red, green, and blue-violet. In this he anticipated the color theories that would stimulate Neo-Impressionist painters of the next generation like Georges Seurat [suh-RAH] and Paul Signac [seen-YAK] (see chapter 40).

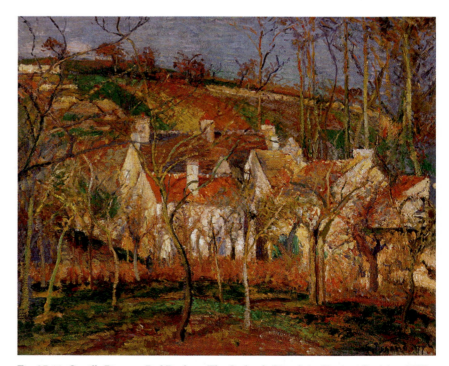

Fig. 37.11 Camille Pissarro. *Red Roofs, or The Orchard, Côtes Saint-Denis at Pontoise.* **1877.** Oil on canvas, 21 1/2″ × 25 7/8″. Musée d'Orsay, Paris, France. Erich Lessing/Art Resource, NY. When Bismarck advanced on Paris, Pissarro abandoned his home in Louveciennes, on the outskirts of the city, and Bismarck's forces moved in. On rainy days, they created a path across the courtyard with Pissarro's paintings to keep their feet from getting wet. As a result, few of his paintings before 1871 survive.

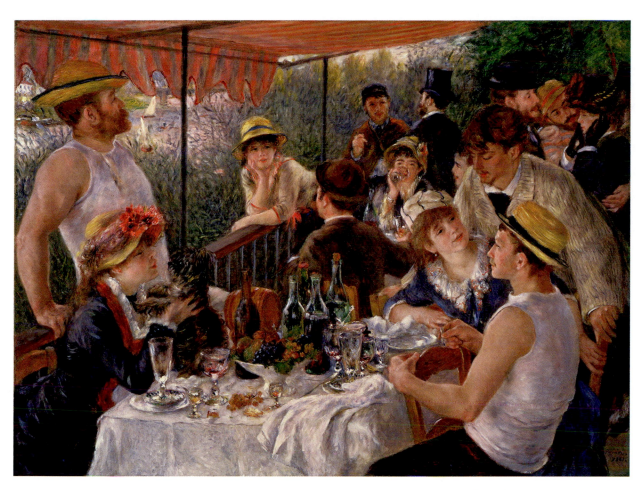

Fig. 37.12 **Auguste Renoir.** *Luncheon of the Boating Party.* **1881.** Oil on canvas, 51″ × 68″. Phillips Collection, Washington, DC. The woman leaning on the railing is Alphonsine Fournaise, the restaurant proprietor's daughter, and leaning against the rail at the left is Alphonse Fournaise, his son. Just below, about to kiss her little dog, is Aline Charigot, Renoir's future wife. The figure leaning over the table at the right—the only one without a hat—is Renoir's friend, the journalist Maggiolo. He addresses an actress by the name of Angèle and the painter Gustave Caillebotte, himself an avid sailor. The man in the top hat at the back of the painting is Charles Euphussi, editor of the *Gazette des Beaux-Arts.*

Renoir, Degas, and the Parisian Crowd While Monet and Pissarro concentrated on landscape painting, August Renoir and Edgar Degas preferred to paint the crowd in the cafés and restaurants, at entertainments of all kinds, and in the countryside, to which the middle class habitually escaped on weekends via the ever-expanding railroad lines. Renoir was especially attracted to Chatou [shah-TOO], a small village on the Seine frequented by rowers. No longer reserved for the upper class, Chatou and other riverside towns became retreats for a diverse crowd of Parisian artists, bourgeoisie, and even workers. Weekend escapes centered on cafés, dance halls, boating, and swimming. Renoir was particularly fond of the Maison and Restaurant Fournaise [foor-NEZ], a lodging house and restaurant on an island in the river, which served as the setting of *Luncheon of the Boating Party* (Fig. **37.12**). Through the foliage at the back of the painting we can make out two sailboats on the river and, just under the awning, a railroad bridge. We can identify many of the figures from his circle of friends and acquain-

tances at Chatou, including members of the Fournaise family. To represent such recognizable figures, Renoir had to abandon the gestural brushwork of Monet and Pissarro except in the background landscape. He composed his figures with firm outlines and modeled them in subtle gradations of light and dark, which clearly define their anatomical and facial features. And he carefully structured the group in a series of interlocking triangles, the largest of which is made up of Aline Charigot [shah-ree-GOH], Renoir's future wife, sitting at the table holding her dog. Scholars believe that the painting, begun in the summer of 1880, may represent Renoir's response to Émile Zola's critique in his review of the 1880 Salon charging the Impressionists with selling "sketches that are hardly dry" and challenging them to make more complex paintings that would be the result of "long and thoughtful preparation." For this reason, the theory goes, Renoir assimilates into this single work landscape, still life, and genre painting in a manner probably intentionally recalling seventeenth-century Dutch

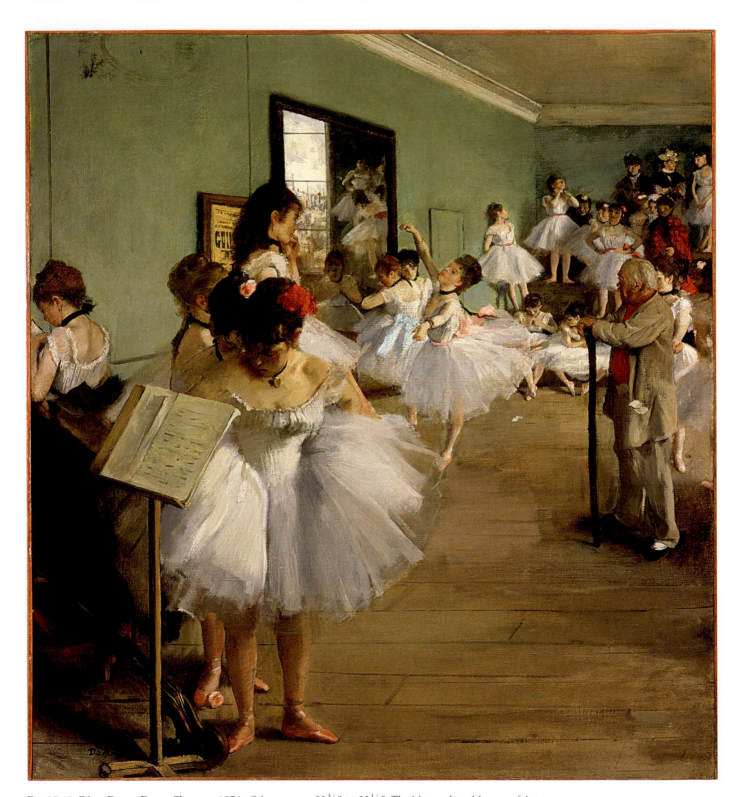

Fig. 37.13 Edgar Degas. *Dance Class*. ca. 1874. Oil on canvas, 32¾″ × 30¼″. The Metropolitan Museum of Art.
Bequest of Mr. and Mrs. Harry Payne Bingham, 1986 (1987.47.1). Image copyright © The Metropolitan Museum of Art.
The dance instructor is Jules Perrot, the most famous male dancer of the middle third of the century, whose likeness Degas
took from a photograph of 1861.

Continuity **&** Change
p. 870

The Kermis

and Flemish paintings like Rubens's *The Kermis* (see Fig. 27.7), which Renoir would have seen at the Louvre.

Edgar Degas was as dedicated as Renoir to the careful construction of his paintings. *Dance Class* depicts 21 dancers awaiting their turn to be evaluated by the ballet master, who stands leaning on a tall cane in the middle ground watching a young ballerina making her salute to an imaginary audience (Fig. **37.13**). The atmosphere is unpretentious, emphasizing the elaborate preparations and hard work necessary to produce a work of art that will appear effortless on stage. The dancers form an arc, connecting the foreground to the middle ground and drawing the eye quickly through the space of the painting. Degas draws the viewer's attention to the complex structure of his composition—that is, to the fact that he too has *worked* long and hard at it.

Work is, in fact, one of Degas's primary themes, and it is no accident that the ballet master leans on a cane—as a former dancer, he is understood to be physically impaired from a dance injury. Degas understood that the young women he depicted were, in fact, full-time child workers. Almost all were from lower-class families and normally entered the ballet corps at age seven or eight when their schooling ceased, leaving most of them illiterate. They had to pass examinations, such as the one Degas depicts here, in order to continue. By the time they were nine or ten, they might earn 300 francs a year (approximately 60 U.S. dollars in 1870, with a buying power of about 400 U.S. dollars today). If and when they rose to the level of performing brief solos in the ballet, they might earn as much as 1,500 francs—more than most of their fathers, who were shop clerks, cab drivers, and laborers. Should they ever achieve the status of *première danseuse* [pruh-mee-YAIR dahn-SUZ], in their late teens, they might earn as much as 20,000 francs, a status like today's richly compensated professional athlete that few reached but all dreamed of. Thus, Degas's *Dance Class* presents young women in a moment of great stress, struggling in a Darwinian world in which only the fittest survived.

Degas was the most radical of the Impressionists in experimenting with new media. He was especially stimulated by **pastels**—sticks of powdered pigment bound with resin or gum. The soft effects of pastel could simulate the gaslit atmosphere of Paris's café-concerts in the outdoor pavilions behind cafés such as the Café des Ambassadeurs , in the park at the base of the Champs-Élysées. Degas's *Aux Ambassadeurs*, displayed at the 1877 Impressionist exhibition, places the viewer in the audience close to the orchestra and behind three ladies and a gentleman (Fig. **37.14**). Onstage is the *chanteuse* ("singer"), her arm extended toward the audience as she sings. Behind her is the *corbeille* [kor-BAY], a term meaning "flowerbed" or "basket" but used figuratively to refer to the dress circle at the theater. In fact, the *corbeille* was composed of women of questionable repute hired to sit on the stage and look attractive and who communicated with admirers in the audience with a sign language, visible in Degas's pastel. Degas's taste for depicting such pleasure-seekers—on the stage and in the audience—is similar to Manet's earlier "judgments" of Paris.

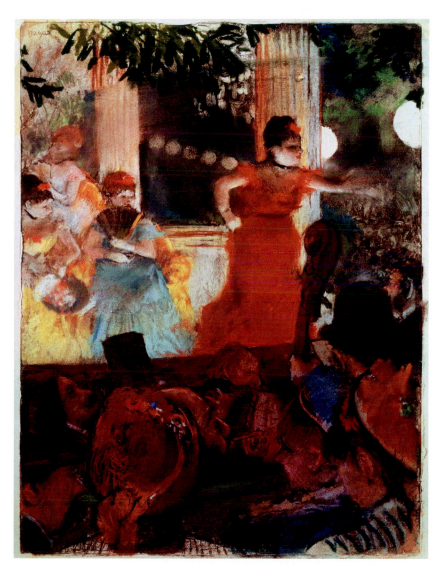

Fig. 37.14 Edgar Degas. *Aux Ambassadeurs*. 1877. Pastel over monotype, $14\frac{1}{2}" \times 10\frac{5}{8}"$. Musée des Beaux-Arts, Lyons, France. Erich Lessing/Art Resource, NY. The questionable quality of the performance is captured in the unkempt hair and unstylish hat of the orchestra members, positioned between the four figures in the foreground and the stage.

Japonisme An important influence on Impressionist imagery came from an unexpected location—Japan. After a period of more than 200 years of self-imposed isolation, Japan reached several agreements with the United States in the 1850s that heralded cultural and economic transformations in Asia and the West (see chapter 39). Two treaties signed in the 1850s opened diplomatic and trade relations between Japan and the West, and large quantities of Japanese goods began to arrive in Europe. Among the most distinctive items were **ukiyo-e**, or Japanese woodblock prints (literally, "pictures of the transient world of everyday life," commonly translated as "pictures of the floating world"), as well as fans, kimonos, bronzes, and silks. The Japanese Pavilion at the *Exposition Universelle* in Paris in 1867 highlighted the *ukiyo-e* along with other cultural artifacts, attracting much attention from the public and inaugurating the style known as **Japonisme**, the imitation of Japanese art.

The Impressionists were fascinated by the multilayered complexity of the *ukiyo-e*, which nevertheless remained commercial products rather than the artistic masterpieces that we consider them today. Claude Monet, it was said, spotted the engravings being used as wrapping material in a shop in

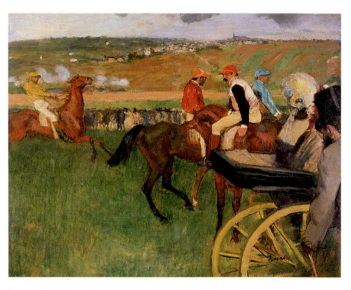

Fig. 37.16 Edgar Degas. *Racecourse, Amateur Jockeys.* ca. 1877–1880. Oil on canvas, 26″ × 31⅞″. Musée d'Orsay, Paris, France. The Bridgeman Art Library.

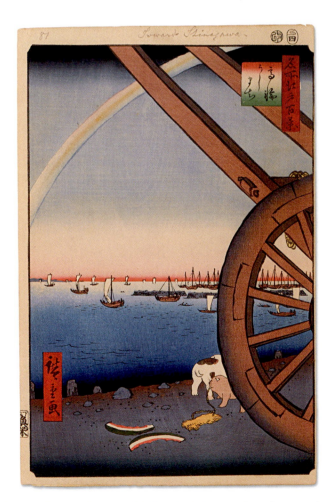

Fig. 37.15 Ando Hiroshige. *Ushimachi, Takanawa,* from the series *One Hundred Famous Views of Edo.* 1857. Woodblock print, 13¼″ × 8⅜″. Gift of Anna Ferris. Brooklyn Museum of Art.

Amsterdam in 1871 and walked out with the first of a collection that eventually numbered over 200. Édouard Manet's friend Zacahrie Astruc [ah-STROOK] summarized the sensation that Japanese woodblock printmaking caused in their circle: "Japanese art, which wrestles bodily with nature, which isn't at all like European art, prepared laboriously as a matter of absolute transmission (repetition) ... simply astonished us." When Camille Pissarro saw prints by Hiroshige, he wrote "the Japanese artist Hiroshige is a marvelous Impressionist." In Manet's *Portrait of Émile Zola* (see Fig. 36.8), we glimpse a Japanese woodcut by the nineteenth-century artist Kuniaki II.

What so impressed the Impressionists about Japanese prints? Most important, the Impressionists recognized in Japanese prints a common interest in everyday urban life, an urban world of courtesans, actors, and dancers. However, the prints fascinated them for more than just their thematic celebration of everyday life. These *ukiyo-e* images represented space in a novel way. Ever since the Japanese had been introduced to Western linear perspective in the late 1730s, woodblock print artists had copied the Western technique while transforming it. Because it was difficult to create consistent space from near to far, many *ukiyo-e* printmakers exploited the possibilities of rendering banal things that happened to be near at hand quite large and of making more important things in the distance much smaller. So in Hiroshige's view of *Ushimachi, Takanawa,* a wagon wheel, watermelon rinds, and a couple of pigs dominate the harbor (Fig. **37.15**). Degas similarly cropped the right foreground of his *Racecourse, Amateur Jockeys,* with its carriage wheels, advancing gentleman, and jockeys, into a similarly vast and empty landscape (Fig. **37.16**). Degas also exploits the Japanese sense of dramatic juxtapositions of color. Note how the jockeys' red hats and jackets are set against the green grasses of the landscape, echoing the red and green chop mark (seal) at the top right of Hiroshige's print.

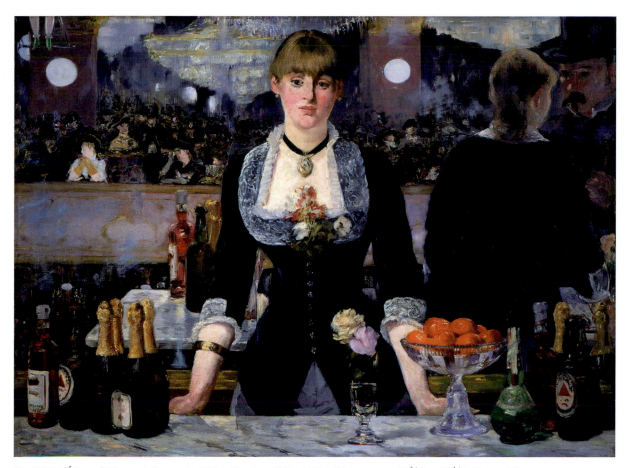

Fig. 37.17 Édouard Manet. *A Bar at the Folies-Bergère.* **1881–1882.** Oil on canvas, 37 3/4″ × 51 1/8″. Courtauld Institute Galleries, London. Manet's model was actually a waitress at the Folies-Bergère named Suzon.

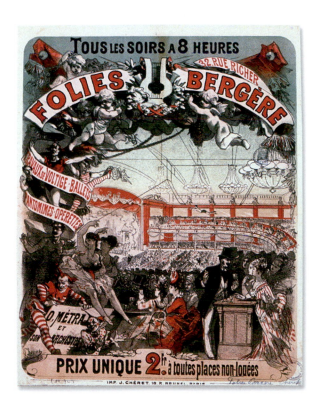

Fig. 37.18 Jules Chéret. *Aux Folies-Bergère.* **1875.** Poster. Mention obligatoire Les Arts Decoratifs, Paris (Inv. 7972); Musée de la Publicité (Inv. 10531); Photo: Laurent Sully Jaulmes. Tous droits reserves. The Folies-Bergère opened as a department store specializing in bedding in 1860, but a "salle des spectacles" at the back of the store became so successful that by 1869 the store gave up the bedding business to concentrate solely on entertainment.

Manet's Impressionism Throughout the 1870s the influence of Manet's sister-in-law, Berthe Morisot, caused Manet increasingly to adopt the Impressionist techniques of the younger generation, particularly the loose application of paint and the emphasis on capturing the effects of light. But whereas the Impressionists tended to celebrate the good life, Manet never gave up his penchant for critiquing it in terms much more direct than the subtle "judgments" offered by Degas. Manet's *A Bar at the Folies-Bergère* [foh-LEE-ber-ZHER], the last major painting he finished before his death in 1883, situates the viewer in a higher-class environment than Degas's café-concert (Fig. **37.17**). The viewer faces a barmaid standing behind her marble counter on a balcony in front of a mirror reflecting the Folies theater in front of her. She is more or less in the same position as the barmaid at the lower right of Jules Chéret's [shay-RAYS] 1875 poster for the Folies, which reveals the entertainment of the moment: a trapeze artist flying across the space (Fig. **37.18**). The same trapeze artist's feet are visible at the top left of Manet's painting.

What really captures viewer attention in this painting is the barmaid's eyes. Instead of gazing directly at the viewer, as in *Le Déjeuner sur l'herbe* (see fig. 36.6) or *Olympia* (see the Focus, chapter 36), the eyes look past us, perhaps even inward in thought. In the midst of the crowd, the barmaid seems totally alone. The oddity of this is compounded by the barmaid's reflection in the mirror, improbably shifted to the right. For, in fact, the barmaid is facing a gentleman, who stands before her in the place we occupy as viewers. She is the object of his gaze (and our own), and he affirms her status, in his own eyes at least, as a server of consolation. Manet's Impressionism, then, incorporates the viewer into its "atmosphere," which like the illusion of depth provided by the mirror is actually impenetrable.

Russian Realism and the Quest for the Russian Soul

Ever since Catherine the Great made French the official language of the Russian court in the eighteenth century, unabashed Francophiles [FRANK-oh-files]—lovers of all things French—dominated cultural life in Saint Petersburg. By the turn of the century, Moscow merchants Sergei Shchukin (1854–1936) and Ivan Morozov (1871–1921) had amassed important collections of Impressionist paintings. Shchukin purchased Camille Pissarro's *Avenue de l'Opéra* (see Fig. 37.1) as well as paintings from Claude Monet's *Grainstacks, Rouen Cathedral,* and *Water Lilies* series. Morozov purchased Monet's *Boulevard des Capucines* (see Fig. 37.8) and several important Renoirs. Such collecting was motivated, at least in part, by political beliefs. Those who turned to France and Germany for inspiration, known as Westernizers, believed that Russia was hopelessly backward, epitomized by the continuation of serfdom. They believed that only by adopting Western values could the nation be saved.

But many Russians disagreed, arguing that the country possessed a spirit uniquely its own. These so-called Slavophiles [SLAHV-oh-files]—Russian nationalists—rejected the West as a source of inspiration in favor of Old Russian traditions and the Orthodox Church. They prided themselves on their spirituality. These values were shared by Russian writers like Pushkin and Gogol (see chapter 35), as well as by Fyodor Dostoyevsky [dust-uh-YEF-skee] (1821–1881) and Leo Tolstoy (1828–1910). Russian nationalism found expression in art and music too. Underlying all Russian culture—Francophile and Slavophile alike—was the plight of the Russian serfs, 22 million souls who were essentially slaves who worked the fields of their landlords for their entire lives with little or no compensation.

The Writer and Artist under the Tsars

Under the rule of Nicholas I (1825–1855), literary culture in Russia was severely stifled. Constantly on guard against rebellion, the tsar exercised strict control over education, publishing, and all public entertainment. He might have laughed at Gogol's *Dead Souls* (see chapter 35), but he was by no means tolerant of liberal thinkers like Gogol and Pushkin, whom he kept under constant surveillance by government censors. Nicholas's successor, Alexander II (r. 1855–1881), was as autocratic as his father, but he instituted a series of reforms, including the emancipation of the serfs in 1861. This act would profoundly affect the cultural life of his country.

The Psychological Realism of Dostoyevsky Troubled by the European revolutions of 1848, Nicholas abolished the study of philosophy at the University of Saint Petersburg and arrested members of a radical discussion group called the Petrashevsky Circle. One of those detained was the 27-year-old novelist Fyodor Dostoyevsky. Found guilty of subversive activities, he, like his colleagues, was sentenced to death. On December 22, 1849, Dostoyevsky and the others were led before the firing squad, but at the last minute the tsar issued a reprieve. Dostoyevsky was sentenced to four years in a Siberian labor camp, followed by six years in the army in Mongolia. He would describe his experiences in prison in the short novel *The House of the Dead* (1862) as "A period of burial alive, I was put in a coffin. The torture was unutterable and unbearable."

However, Dostoyevsky slowly came to admire his fellow inmates—murderers, thieves, and social outcasts. And the question he began to contemplate, which would occupy him for the rest of his life, was this: Can we love the damned? Are we not obligated to face the horrors of life to which the damned are condemned? As one of his characters in *The Insulted and Injured* (1861) puts it: "It thrills the heart to realize that the most downtrodden man, the lowest of the low, is also a human being and is called your brother."

Dostoyevsky was not allowed to return to Saint Petersburg until 1859, four years after the death of Nicholas I. Two years later, in 1861, when the new tsar, Alexander II, ordered the emancipation of Russia's serfs, Dostoyevsky felt the impact personally. His domineering and alcoholic father, a retired military surgeon and doctor at a hospital for the poor in Moscow, may have been murdered by his own serfs in 1839. Dostoyevsky's greatest and last novel, *The Brothers Karamazov* (1880), would have as a central figure an abusive father who is killed by his sons.

The complexity of psychological guilt is the theme of his 1866 novel, *Crime and Punishment*, as is the basic question: "Can immoral means justify worthy ends?" Its hero, Rodion Petrovich Raskolnikov—Rodya, for short—is tormented by his senseless axe murder of a despised pawnbroker and her more likable sister. Prior to the murder, Raskolnikov, an intellectual, had written an article dividing the world into ordinary people and gifted heroes (like Napoleon) who are above the law (see **Reading 37.1**, page 1215). Like all of Dostoyevsky's heroes, Raskolnikov is driven by an idea, not by hereditary or environmental causes. Dostoyevsky called his style a "higher realism," because it is so infused with the anxieties, conflicts, and tensions that comprise modern consciousness. Raskolnikov believes himself to be the embodiment of his idea, as a gifted hero above the law. It was, in fact, a misguided attempt to assert individual freedom and to escape humanity's enslavement to scientific rationalism, capitalism, and industrialism. Dostoyevsky's hero, then, has damned himself—like Goethe's Faust

(see chapter 34). In a bold gambit the author asks you, the reader, to comprehend that Raskolnikov is also "your brother."

After the murder, Raskolnikov barely escapes detection at the pawnbroker's home, then makes his way through the streets of Saint Petersburg. A short excerpt captures the drama that characterizes Dostoyevsky's style (**Reading 37.1a**):

READING 37.1a **from Fyodor Dostoyevsky,** *Crime and Punishment,* **Part I, Chapter 7 (1866)**

No one was on the stairs, nor in the gateway. He passed quickly through the gateway and turned to the left in the street.

He knew, he knew perfectly well that at that moment they were at the flat, that they were greatly astonished at finding it unlocked, as the door had just been fastened, that by now they were looking at the bodies, that before another minute had passed they would guess and completely realise that the murderer had just been there, and had succeeded in hiding somewhere, slipping by them and escaping. They would guess most likely that he had been in the empty flat, while they were going upstairs. And meanwhile he dared not quicken his pace much, though the next turning was still nearly a hundred yards away. "Should he slip through some gateway and wait somewhere in an unknown street? No, hopeless! Should he fling away the axe? Should he take a cab? Hopeless, hopeless!"

At last he reached the turning. He turned down it more dead than alive. Here he was half way to safety, and he understood it; it was less risky because there was a great crowd of people, and he was lost in it like a grain of sand. But all he had suffered had so weakened him that he could scarcely move. Perspiration ran down him in drops, his neck was all wet. . . .

He was only dimly conscious of himself now, and the farther he went the worse it was. . . . He was not fully conscious when he passed through the gateway of his house! he was already on the staircase before he recollected the axe. And yet he had a very grave problem before him, to put it back and to escape observation as far as possible in doing so. He was of course incapable of reflecting that it might perhaps be far better not to restore the axe at all, but to drop it later on in somebody's yard. . . . Scraps and shreds of thoughts were simply swarming in his brain, but he could not catch at one, he could not rest on one, in spite of all his efforts. . . .

The drama continues to heighten as the detective, Porfiry Petrovich, persistently pecks away at Raskolnikov and as Sonya, a young woman driven to prostitution by her alcoholic father, tries to persuade him to confess. He does finally confess his guilt and is sentenced to imprisonment in Siberia, where Sonya faithfully accompanies him. By the novel's end, Raskolnikov realizes he is not a superhuman hero above the law, and he dreams that his nihilism was a deadly plague advancing on Russia and Europe. Rejecting his former beliefs, Raskolnikov undergoes a spiritual rebirth, accepting the necessity of religion as well as love:

> Life had stepped into the place of theory and something quite different would work itself out in his mind. . . . He did not know that the new life would not be given him for nothing, that he would have to pay dearly for it, that it would cost him great striving, great suffering. But that is the beginning of a new story—the story of the gradual renewal of a man, the story of his gradual regeneration, of his passing from one world into another, of his initiation into a new unknown life.

In this renewal, Raskolnikov discovers his connection with the common people and so the essence of his Russian soul.

The Historical Realism of Tolstoy If Dostoyevsky's realism turned inward to the psychology of his tormented Russian heroes, Leo Tolstoy's realism turned outward, to the epic stage of Russian history. Slightly younger than Dostoyevsky, Tolstoy was born to privilege and wealth, and he began publishing short stories in the mid-1850s, while serving in the army. These dealt with childhood memories and his military career and helped him establish a literary reputation. Yet no one anticipated the two great novels he would write after his return to the family estate, 100 miles south of Moscow: *War and Peace* (1869) and *Anna Karenina* [kuh-REN-ih-nuh] (1877). Although both novels focus on the lifestyle of the Russian aristocracy, they also critique it.

War and Peace surveys Russian life in the early nineteenth century, telling the story of five aristocratic families as they come to terms with Napoleon's 1812 invasion of their country. Two major male characters, the intellectual but pessimistic Prince Andre Bolkonsky and the spiritual, questing Pierre Bezukhov, represent conflicting moral positions: the Romantic desire to fully realize the self versus dedication to others. Against the backdrop of war, each falls in love with Natasha Rostov, the young daughter of a noble Moscow family whose fortunes are failing. Andre is prevented from marrying her by his father, while Pierre, after having been taken prisoner by the French, finally succeeds. Their story illustrates the triumph of the Russian soul over the logical Western mind of Napoleon, whose disastrous decision to invade Russia initiates his downfall.

There are scores of characters in *War and Peace*, but Natasha Rostov is one of the great characters in all of fiction. Along with his brilliant accounts of war, Tolstoy's depiction of her is the hallmark of his realist style. We first meet her in chapter 11 of the novel as a 13-year-old who, on her nameday (the day of the year associated with her name), bursts into the sitting room where her parents, the count and countess, have been receiving guests (**Reading 37.2**):

READING 37.2 from Leo Tolstoy, *War and Peace*, Part I, Chapter 11 (1869)

The countess looked at her callers, smiling affably, but not concealing the fact that she would not be distressed if they now rose and took their leave. The visitor's daughter was already smoothing down her dress with an inquiring look at her mother, when suddenly from the next room were heard the footsteps of boys and girls running to the door and the noise of a chair falling over, and a girl of thirteen, hiding something in the folds of her short muslin frock, darted in and stopped short in the middle of the room. It was evident that she had not intended her flight to bring her so far. . . .

The count jumped up and, swaying from side to side, spread his arms wide and threw them round the little girl who had run in. "Ah, here she is!" he exclaimed laughing. "My pet, whose name day it is. My dear pet!"

"Ma chere, there is a time for everything," said the countess with feigned severity. "You spoil her, Ilya," she added, turning to her husband.

"How do you do, my dear? I wish you many happy returns of your name day," said the visitor. "What a charming child," she added, addressing the mother.

This black-eyed, wide-mouthed girl, not pretty but full of life—with childish bare shoulders which after her run heaved and shook her bodice, with black curls tossed backward, thin bare arms, little legs in lace-frilled drawers, and feet in low slippers—was just at that charming age when a girl is no longer a child, though the child is not yet a young woman. Escaping from her father she ran to hide her flushed face in the lace of her mother's mantilla—not paying the least attention to her severe remark—and began to laugh.

The exuberance of the young girl, her ability to dominate any room into which she walks, is immediately established. From this moment, Natasha lives life boldly, determined to enjoy it to the fullest, and over the course of the novel she grows into a woman of real wisdom and understanding.

The scope of Tolstoy's next novel, *Anna Karenina* (1877), is narrower than in *War and Peace*, even as its representation of human feeling and emotions is more

fully realized. It tells the story of the adulterous love affair of Anna, who is married to a government official in Saint Petersburg, and Count Vronsky [VRON-skee], a dashing young cavalry officer. Anna's "double" in the book is Constantine Levin. He shares her intensity and passion, but unlike Anna does not easily fit into Saint Petersburg's social swirl and so chooses to live instead on his country estate, dedicating himself to farming and the lives of the peasants who work for him. Tortured by doubts about the meaning of his life throughout most of the book, he experiences a spiritual revelation at the novel's end that reveals his reason for being. By contrast, Anna's more carnal passion leads to her destruction, the inevitable victim of her society's double standards.

It is possible to see Tolstoy's own spiritual autobiography in Levin's struggle with God. Tolstoy experienced many religious crises in his life, struggling to find a way of living religiously without endorsing the hypocrisies and greed of the Russian Orthodox Church, from which he was eventually excommunicated. Most of his writing after *Anna Karenina* consisted of educational articles and pamphlets, the ideas of which are most clearly formulated in his 1886 *What Then Must We Do?* In the interest of leading an exemplary life, he gave up smoking and drinking alcohol, became a vegetarian, dressed in peasant clothes, engaged in hard labor (Fig. **37.19**), and renounced sexual relations with his wife, with whom he had fathered 13 children. Yet all of Tolstoy's spiritual striving and rationally constructed religious doctrine could not ensure a happy family life. Arguments continually flared between his wife and the leader of a group of his followers. Finally, in 1910, he determined to leave society altogether and lead a hermit's life. He died of pneumonia a few days after leaving his ancestral estate.

The Travelers: Realist Painters of Social Issues Dostoyevsky's and Tolstoy's rigorous examination of Russian society was sustained by 13 visual artists who organized a society known as the Travelers dedicated to presenting art exhibitions throughout the country in 1870. All were students at the Saint Petersburg Academy, which emphasized traditional European standards of beauty and the production of painting and sculpture depicting

Fig. 37.19 Ilya Repin. *Leo Tolstoy Ploughing.* **1887.** Oil on canvas. Photo: Roman Beniaminson. Tretyakov Gallery, Moscow, Russia. Bildarchiv Preussischer Kulturbesitz/Art Resource, NY. This portrait of Tolstoy by his friend and admirer Ilya Repin shows the writer and landowner engaged in the kind of manual labor that he believed it was his duty to perform so as not to take advantage of others.

mythological subjects in Neoclassical style. Several of the students were from peasant or working-class families and were more interested in addressing social issues than pursuing the Academy's more traditional, and less threatening, artistic agenda. Realism, they believed, was the only stylistic choice available to them. Like their literary predecessors, they addressed the inequities of Russian society in their paintings, often depicting peasants at work.

Ilya Repin (1844–1930), who painted the portrait of *Tolstoy ploughing* (see Fig. 37.19), visited Europe many times over the course of his career, and the fluid brushwork of the Impressionists is evident in his paintings. Ivan Kramskoy's [KRAM-skoys] portrait of another member of the group, landscape painter Ivan Shishkin [SHIS-kin], achieves a virtually photographic realism (Fig. **37.19**). In every detail, from the links in Shishkin's watch chain to the curls in his beard and hair, we feel as if we are looking at something more than a painting or a photograph—we are gazing into the eyes of an actual man.

The real force of the work of the Travelers group, however, lies in their means of exhibiting it. Previously, art exhibitions had been restricted to Saint Petersburg and Moscow, but as their name suggests, the Travelers "traveled," taking their paintings across the country for the peasantry to see and

Fig. 37.20 Ivan Nikolaevich Kramskoy. *Ivan I. Shishkin.* 1880. Oil on canvas, 46″ × 33½″. © 2009. State Russian Museum, St. Petersburg. As a young man, Kramskoy worked as a retoucher for a traveling photographer.

appreciate. Their desire to spread the message of social reform to the Russian countryside would be emulated by the Russian revolutionary movement in the twentieth century.

Russian Nationalist Music and Ballet

The quest to express the fundamental essence of Russia was reflected in the nation's music as well. Here too, a group of five musicians known as "the Mighty Handful" led the way, finding strength in unified action. The primary method by which they expressed their Slavic pride was through the incorporation of Russian folklore, folk songs, and native instruments like the balalaika into their compositions. The most ardent of these nationalists was Modest Mussorgsky [moos-ORG-skee] (1839–1881), whose 1869 opera *Boris Godunov*, about a sixteenth-century tsar of Russia who ascended the throne after murdering the rightful heir and who eventually died of guilt, was based on a play by Pushkin (see chapter 35).

Never included in their number—because they considered him too cosmopolitan—was Pyotr Ilyich Tchaikovsky [chy-KOF-skee] (1840–1893). However, influenced by the example of "the Mighty Handful," in 1880 he wrote *The 1812 Overture*, a work commemorating Napoleon's retreat from Moscow. It is one of the most nationalistic works ever composed, capturing in music the same drama as Tolstoy's *War and Peace* (see **CD-Track 37.1**). The work opens with a Russian hymn, "God Preserve Thy People." As horns and drums imitate Napoleon's march on Moscow, strains of the French national anthem, "The Marseillaise," are heard. After a day of battle, there is a traditional Russian lullaby and folk song, then, after a more furious battle, the "Tsar's Hymn," as bells chime to rifle and cannon fire. When the *Overture* was first performed in 1882 in front of Moscow's Cathedral of Christ the Redeemer, built by Tsar Alexander I to celebrate his victory over Napoleon, tsarist troops fired off actual rifles and cannons for the finale. (The church, later destroyed by the twentieth-century Communist leader Josef Stalin and replaced with an outdoor swimming pool, was rebuilt in 1997, an almost exact replica of the original.)

Tchaikovsky's real fame came from his ballet music, a very popular form in Europe, particularly in France. After dancing *en pointe* [on pwahnt] (on the tips of one's toes) was introduced early in the nineteenth century, costumes became skimpier, even skintight, showcasing the human form. Tchaikovsky's lyrical melodies and rich orchestrations in *Swan Lake* (1876), *Sleeping Beauty* (1889), and *The Nutcracker* (1892) raised ballet music to a new level, matching the groundbreaking choreography of Marius Pepita (1818–1910), ballet master of the Imperial Ballet in Saint Petersburg. (Pepita is often called the father of classical ballet.) In *The Nutcracker*, based on a story by Prussian writer E.T. A. Hoffmann, a young girl named Clara receives a magical nutcracker in the form of a soldier as a Christmas present. At night it comes to life and leads an army of toy soldiers into battle with an army of mice. When Clara saves the Nutcracker's life, he is transformed into a handsome youth. He takes her on a magical journey to the Land of the Sugar Plum Fairy, where she

encounters a variety of exotic dance images, including a French café, an Arabian dance, a Chinese tea party, and the Waltz of the Flowers, all culminating in her meeting the Sugar Plum Fairy herself. For this dance, Tchaikovsky contrasts the delicate sound of the celesta, a keyboard instrument similar to a glockenspiel, and the rich depth of a bass clarinet. So memorable is *The Nutcracker* that its music has found a permanent place in modern consciousness, with annual performances scheduled at Christmastime throughout the Western world.

Britain and the Design of Social Reform

In Great Britain, Haussmann's modernization of Paris did not go unnoticed. Nor did the revolution in painting that Impressionism represented escape the British. Yet the Impressionist interest in depicting light had been heralded by the work of J. M.W. Turner, and its looseness in depicting landscape by John Constable (see chapter 33). In fact, both had influenced the Impressionist approach to painting. As for Haussmann, experience had taught the British that public works had little power to effect social reform. London, after all, had rebuilt itself after the Great Fire of 1666 (see chapter 28), and that had done little to alleviate social suffering, perhaps even exaggerated it, until the early nineteenth century, when a program of reconstruction began. Aided by an ongoing series of sanitary improvements, along with accelerated clearing of slums and new building projects in the 1850s, London rivaled

Paris in setting the standard upon which European cities were judged. British thinkers like Thomas Carlyle and A.W. N. Pugin argued, however, that the problems inherent in industrialization, mechanization, and materialism could also be solved through increased attention to moral values connected with Christianity. And there were other more secular approaches to reform as well.

The answer appeared to many to lie in the question of design itself—so that as civil servant Henry Cole (1808–1882) argued, the "harmony of beauty and utility" would help the public understand the virtue of moderation and restraint. Cole argued for the creation of government-sponsored design schools—of which he became the director—and for the creation of the *Journal of Design*. Finally, in order to demonstrate the *lack* of standards in British design, he proposed an Exhibition of the Art and Industry of All Nations in London, which was held in 1851. To house the more than 14,000 exhibitors, half of whom were from outside Britain, a remarkable new type of building, designed by Joseph Paxton (1801–1865), was constructed in Hyde Park. Known as the Crystal Palace, it was made of glass and cast and wrought iron (Figs. **37.21, 37.22**). Distinctly modern, the Crystal Palace seemed to reflect the lack of standards that Cole ascribed to British design in general. Nevertheless, it revolutionized architectural design.

Resembling a horticultural greenhouse but of gigantic dimensions, the Crystal Palace called for 900,000 square feet of glass (about one-third of Britain's annual production). All its components were standardized, modular, and factory-made,

Fig. 37.21 Joseph Paxton's Crystal Palace. 1851. Iron, glass, and wood. Lithograph by Charles Burton with *Aeronautic View of the Palace of Industry for All Nations*, from *Kensington Gardens*, published by Ackerman (1851). Guildhall Library, City of London. The Bridgeman Art Library. Paxton described the roof as a "table and cloth"—the cast- and wrought-iron trusses providing a rigid "table" over which an external lightweight "cloth" of glass was draped. In summer the roof was covered by retractable canvas awnings which were sprayed with cool water.

Fig. 37.22 The interior of Joseph Paxton's Crystal Palace. 1851. Institut für Theorie der Architektur an der ETH, Zürich. The vault was high enough to allow for elm trees on the Hyde Park site to remain in place.

brought together on site and required a minimum of traditional building skills to assemble. The three-story structure, 1,848 feet long (the length of about six football fields) and 408 feet wide, was built over a period of months. Its vast expanses of glass solved the problem of lighting individual exhibits and aisles (an especially difficult issue in the era before electricity). It even incorporated the park's trees into its wide, open interiors. Above all, Paxton's design made clear that industrial mass production, prefabrication, and systematic site assembly had the potential to revolutionize architecture and construction.

Morris, the Guild Movement, and the Pre-Raphaelites

Although the Great Exhibition, as it became known, was a roaring success, not everyone appreciated its implications. If it bred confidence in the speed and utility of technological innovation, it also demonstrated, in the words of Owen Jones, an architect who was the director of the Fine Arts exhibits, "no principles, no unity . . . novelty without beauty, beauty without intelligence, and all work without faith."

A young student preparing for the clergy at Oxford University named William Morris (1834–1896) conceived of a different way to attack the problem of design. Morris was deeply affected by the writings of John Ruskin [RUSS-kin] (1819–1900), who argued in his essay "On the Nature of Gothic" that the benefits of mass production were illusory (**Reading 37.3**):

READING 37.3 **from John Ruskin, "On the Nature of Gothic," in *The Stones of Venice* (1851–1853)**

[I]n mass manufacture people were deprived of the satisfaction of making a thing from start to finish. "We have much studied and much perfected, of late, the great civilized invention of the division of labor . . . It is not, truly speaking, the labor that is divided; but the men: divided into mere segments of men—broken in small fragments and crumbs of life. . . . All the stamped metals, and artificial stones, and imitation woods and bronzes, over the invention of which we hear daily exaltation—all the short, and cheap, and easy ways of doing that whose difficulty is its honor—are just so many new obstacles in our already encumbered road. They will not make one of us happier or wiser—they will extend neither the pride of judgment nor the privilege of enjoyment. They will only make us shallower in our understandings, colder in our hearts, and feebler in our wits.

To rectify this situation, in 1855 Morris and a group of friends created a new design firm, the first task of which was to

Fig. 37.23 Morris and Company. The Woodpecker. 1885. Wool tapestry designed by Morris. William Morris Gallery, Walthamstow, England. The great contradiction in Morris and Company is that its beautifully crafted furnishings were beyond the means of the workers who made them.

produce the furnishings for Morris's new home in Kent, the Red House, designed by Philip Webb. "At this time," Morris wrote, "the revival of Gothic architecture was making great progress in England. . . . I threw myself into these movements with all my heart; got a friend [Webb] to build me a house very medieval in spirit . . . and set myself to decorating it." Morris longed to return to a handmade craft tradition, in which workers, as with the medieval craft guilds, would no longer be alienated from their labor. In effect, he was declaring war on the Industrial Revolution. The firm soon was turning out high-quality tapes-

tries, embroideries, chintzes, wallpapers, ceramic tiles and bowls, stained-glass windows, and furniture of all kinds.

In his designs, Morris constantly emphasized two principles: simplicity and utility. However, it is difficult to see "simplicity" in work such as *The Woodpecker*, a wool tapestry meant to decorate a wall and keep out drafts as they had in medieval palaces (Fig. **37.23**). For Morris, however, the natural and organic were by definition simple. Thus the pattern possesses, in Morris's words, a "logical sequence of form, this growth looks as if it could not have been otherwise." Anything, according to Morris, "is beautiful if it is in accord with nature." And just as Henry Cole believed that "harmony of beauty and utility" would transform public taste, Morris argued that "simplicity of taste" worked hand in hand with "simplicity of life"—all in accord with nature.

To assist him in creating the most beautiful designs possible, Morris hired many of his artist friends, among them Dante Gabriel Rossetti [roh-SET-tee] (1828–1882) and Edward Burne-Jones (1833–1898). Rossetti had been leader and spokesperson of a group at the Royal Academy named the Pre-Raphaelite Brotherhood, who denounced contemporary art as well as all painting done after the early work of Raphael—including the work of Leonardo da Vinci and Michelangelo, whose techniques they found appalling. (The Pre-Raphaelites knew Michelangelo primarily through the unrestored, grimy painted ceiling of the Sistine Chapel.) Instead, they admired the work of fifteenth-century Flemish artist Jan van Eyck, whose texture and clarity of detail they tried to emulate (see chapter 20), and the linear contours of fifteenth-century Italian painter Sandro Botticelli (see chapter 17), whose work had been almost entirely forgotten until they rediscovered him.

Continuity & Change
p. 561

Botticelli, *Primavera*

Although the Pre-Raphaelite Brotherhood officially dissolved by 1860, Rossetti continued to champion the spiritual values of medieval and early Renaissance culture, values that he imparted both to Morris and his friend Edward Burne-Jones. Modernity intruded, however, in the form of an undercurrent of erotic tension in Rossetti's work. The subject of his painting *Mariana*, for example, is a minor character in Shakespeare's play *Measure for Measure* who has been spurned by Angelo, her fiancé, because her dowry was lost in a shipwreck (Fig. **37.24**). Unbeknownst to Angelo, Mariana substitutes herself, in the darkness of Angelo's bedroom, for Isabella, whom Angelo has convinced to sleep with him. Rossetti's model in the painting is Jane Morris (1839–1914), William Morris's wife. Janey, as she was known, and her sister Bessie were the preeminent embroiderers at Morris's design company, producing many of the finest pieces themselves, as well as supervising the other workers. Rossetti portrays her here at work on a piece of embroidery of the kind that would be sold by the firm. Rossetti was obsessed with Jane, and there is good reason to believe that the two were romantically involved. In her role as Mariana, Jane's gaze directly addresses the painter. Behind her a boy, playing a lute, sings to her, a moment from the opening of Act 4 of Shakespeare's play:

Take, oh take those lips away,
that so sweetly were forsworne,

Rossetti inscribed these words on the frame of the painting, suggesting the undercurrent of sexual tension that informs the scene.

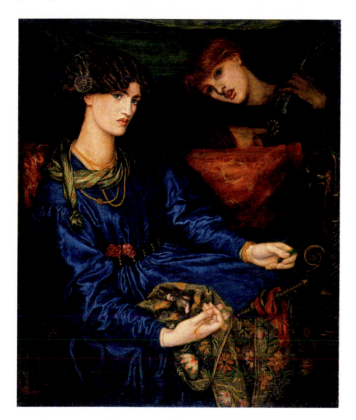

Fig. 37.24 Dante Gabriel Rossetti. *Mariana.* 1870. Oil on canvas, 43 1/4″ × 35 5/8″. Aberdeen Art Gallery and Museums, Aberdeen, Scotland. Acc. No. ABDAG002900. The richness of the fabrics in this painting are typical of Morris and Co.'s own production.

Burne-Jones, who regularly illustrated many of the books produced by Morris's press, including the famous *Kelmscott Chaucer*, was even more devoted to medieval culture than Rossetti. *Laus Veneris* (*In Praise of Venus*) depicts a scene from the legend of Tannhäuser, the hero of Wagner's opera (see chapter 36), who falls in love with Venus and lives with her, seduced by carnal pleasures, which he comes to understand as sinful (Fig. **37.25**). At this point, Tannhäuser has abandoned Venus, but the four maidens on the left, flute and clavichord in hand, are about to sing her praises, as she slumps in her chair on the right. The painting was inspired by a poem of the same name written four years earlier, in 1866, by the English poet Algernon Charles Swinburne (1837–1909). Swinburne describes Venus in terms that Burne-Jones captures in the painting (**Reading 37.4**):

READING 37.4 **from Algernon Charles Swinburne, "Laus Veneris" (1866)**

Her little chambers drip with flower-like red,
Her girdles, and the chaplets of her head,
Her armlets and her anklets; with her feet
She tramples all that wine-press of the dead.

Her gateways smoke with fume of flowers and fires,
With loves burnt out and unassuaged desires;
Between her lips the steam of them is sweet,
The languor in her ears of many lyres.

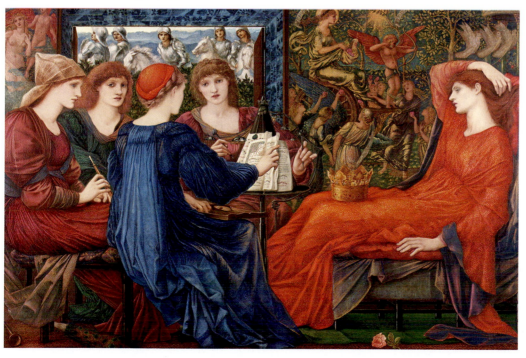

Fig. 37.25 Edward Burne-Jones. *Laus Veneris* (*In Praise of Venus*), 1873–1878. Oil on canvas, 48 3/4″ × 74 1/4″. Laing Art Gallery, Newcastle-upon-Tyne, England. The design of the tapestry on the right of the painting was created in 1861 by Burne-Jones as a design for tiles produced by Morris and Co. and in 1898 realized as an actual tapestry by the firm.

Venus's languorous sexuality has evidently captivated the knights outside the window, who gaze in longingly. The tapestry behind her shows her mounted on a chariot with Cupid, whose arrow is aimed at another victim. Like Rossetti's works, Burne-Jones's painting seethes with repressed sexuality and longing.

The influence of Morris's design company was enormous, fostering a guild movement throughout England intent on producing quality handcrafted goods. A socialist, Morris dreamed of a society "in which all men would be living in equality of condition." But despite the fact that female sexuality was something of an obsession of the company's designers—or perhaps precisely because they were so obsessed and thus unable to see women as anything more than sexual beings—this equality did not extend to women. Morris and Company employed women, but only to make embroidered wall hangings. As already noted, the embroidery workshop was at first managed by Morris's wife, Jane, and then, after 1885, by their daughter, May, then 23 years old. (Many of the designs attributed to her father after 1885 were actually her own. Apparently, she thought it important, at least from a commercial point of view, to give her father the credit.) May Morris would continue to practice her craft (Fig. **37.26**), helping to found the

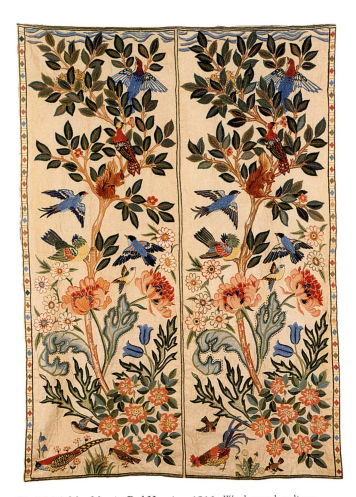

Fig. 37.26 May Morris. Bed Hanging. 1916. Wool crewel on linen, cotton lined, 76³/₄″ × 54″. Collection of Cranbrook Art Museum, Bloomfield Hills, Michigan. Gift of George Gough Booth and Ellen Scripps Booth. Photo: R. H. Hensleigh. (CAM 1955.402). The two halves of the embroidery are identical except for the birds at the lower left.

Women's Guild of Art in 1907, the purpose of which was to create a "centre and a bond for the women who were doing decorative work and all the various crafts." A successful businesswoman, author, and lecturer, she became an important role model for women in early twentieth-century England.

The Fight for Women's Rights: Mill's *Subjection of Women*

That socialists were not so liberal in their thinking about women was common. Many reformers felt that women were inherently conservative, unduly controlled by the clergy. So, too, upper-class women, sensitive to their own economic interests, often lacked the inclination to support feminist causes. But some liberals and reformers did provide intellectual support for women's causes. An essential text in this regard was *The Subjection of Women*, an 1860 essay by John Stuart Mill (1806–1873).

Mill was an advocate of **utilitarian** theory—believing that the goal of any action should be to achieve the greatest good for the greatest number. By that logic, it was evident that in assigning an inferior role to women, society was wasting an enormous resource. Thus, the essay opens with the following argument (**Reading 37.5**):

READING 37.5 **from John Stuart Mill, *The Subjection of Women* (1869)**

The principle which regulates the existing social relations between the two sexes—the legal subordination of one sex to the other—is wrong itself, and now one of the chief hindrances to human improvement; and . . . it ought to be replaced by a principle of perfect equality, admitting no power or privilege on the one side, nor disability on the other.

Mill further points out that for centuries women have been subordinate to men, excluded from the kinds of individual choices that naturally follow from the principle of liberty, which decrees "over himself, over his own body and mind, the individual is sovereign."

Mill wrote *The Subjection of Women* in collaboration with his wife, Harriet Taylor Mill, and after his wife's death in 1854, her daughter from an earlier marriage, Helen Taylor. Scholars are divided as to how much Mill relied on these women—some go so far as to suggest that the work was actually "ghost-written" by them. Although Mill never accepted his wife's contention that women should be able to work outside the home after marriage, there is no question that she and her daughter's ideas greatly influenced Mill's version of feminism. Whatever the case, the feminist sensibility defined by Mill reflects not only the spirit of reform that has been the focus of this chapter, but also the evolving lifestyle of the increasingly affluent class populating Europe's capitals. In an age demanding freedom, it is hardly surprising that women should take up the call.

READINGS

READING 37.1

from Fyodor Dostoyevsky, *Crime and Punishment*, Part 3, Chapter 5 (1866)

Dostoyevsky's novel describes the actions of a poor, young student, Raskolnikov, who is driven by the idea that extraordinary individuals, such as himself, have the right to commit immoral acts in the pursuit of greatness. As a result, he rationalizes the murder of an old woman and her younger sister. His crime goes unsolved, but a Saint Petersburg detective, Porfiry Petrovich, suspects him. The following scene demonstrates Dostoyevsky's fondness for developing character through dialogue. Note the way that Porfiry's "innocent" questions allow Raskolnikov to say more than he intends. Even more important, in explaining his "thesis" Raskolnikov exposes its very absurdity.

"All these questions about crime, environment, children, recall to my mind an article of yours which interested me at the time. 'On Crime' . . . or something of the sort, I forget the title, I read it with pleasure two months ago in the *Periodical Review*."

"My article? In the *Periodical Review*?" Raskolnikov asked in astonishment. "I certainly did write an article upon a book six months ago when I left the university, but I sent it to the *Weekly Review*."

"But it came out in the *Periodical*." . . .

Raskolnikov had not known.

"Why, you might get some money out of them for the article! What a strange person you are! You lead such a solitary life that you know nothing of matters that concern you directly. It's a fact, I assure you." . . .

"How did you find out that the article was mine? It's only signed with an initial."

"I only learnt it by chance, the other day. Through the editor; I know him. . . . I was very much interested."

"I analysed, if I remember, the psychology of a criminal before and after the crime."

"Yes, and you maintained that the perpetration of a crime is always accompanied by illness. Very, very original, but . . . it was not that part of your article that interested me so much, but an idea at the end of the article which I regret to say you merely suggested without working it out clearly. There is, if you recollect, a suggestion that there are certain persons who can . . . that is, not precisely are able to, but have a perfect right to commit breaches of morality and crimes, and that the law is not for them."

Raskolnikov smiled at the exaggerated and intentional distortion of his idea. . . .

"No, not exactly because of it," answered Porfiry. "In his article all men are divided into 'ordinary' and 'extraordinary.' Ordinary men have to live in submission, have no right to transgress the law, because, don't you see, they are ordinary. But extraordinary men have a right to commit any crime and to transgress the law in any way, just because they are extraordinary. That was your idea, if I am not mistaken?" . . .

Raskolnikov smiled again. He saw the point at once, and knew where they wanted to drive him. He decided to take up the challenge.

"That wasn't quite my contention," he began simply and modestly. "Yet I admit that you have stated it almost correctly; perhaps, if you like, perfectly so." (It almost gave him pleasure to admit this.) "The only difference is that I don't contend that extraordinary people are always bound to commit breaches of morals, as you call it. In fact, I doubt whether such an argument could be published. I simply hinted that an 'extraordinary' man has the right . . . that is not an official right, but an inner right to decide in his own conscience to overstep . . . certain obstacles, and only in case it is essential for the practical fulfilment of his idea (sometimes, perhaps, of benefit to the whole of humanity). . . ."

"Thank you. But tell me this: how do you distinguish those extraordinary people from the ordinary ones? Are there signs at their birth? I feel there ought to be more exactitude, more external definition. . . ."

"Oh, you needn't worry about that either," Raskolnikov went on in the same tone. "People with new ideas, people with the faintest capacity for saying something *new*, are extremely few in number, extraordinarily so in fact. . . . The man of genius is one of millions, and the great geniuses, the crown of humanity, appear on earth perhaps one in many thousand millions. . . ."

"Yes, yes." Porfiry couldn't sit still. "Your attitude to crime is pretty clear to me now. . . ." ■

Reading Question

Dostoyevsky sets up this exchange between Raskolnikov and Porfiry in the form of a Socratic dialogue (see chapter 7), with Raskolnikov taking the part of Socrates. What is the author's purpose in doing this?

 Summary

■ **The Haussmannization of Paris** From 1853 to 1870, under the direction of the Baron Haussmann, Paris was transformed, as working-class districts of the city were replaced with *grands boulevards* and promenades. Serving both practical and aesthetic purposes, the new parks, boulevards, and infrastructure drew worldwide acclaim. The French government increased the space dedicated to parks by 100 times, lined the streets with sidewalks and trees, and laid miles of sewer pipes, displacing the working class and the industry they supported to new suburbs.

■ **The 1870s: From the Commune to Impressionism** The renovation of the city came to a temporary halt in 1870 during the Franco-Prussian war. Embarrassed by the failure of his imperial adventuring in Mexico, where his hand-picked leader was executed by revolutionaries, Louis-Napoleon entered into war with Prussia. He was soundly defeated by Otto von Bismarck and exiled to England. After Bismarck laid siege to Paris, which surrendered in January 1871, the newly declared Third Republic was far too generous in granting concessions to its citizens. In March they created their own municipal government, the Commune. The National Assembly's army attacked, and after a bloody week the Commune was crushed.

Meanwhile, France's younger generation of painters believed that by rejecting the Second Empire's art institutions they could reestablish French cultural dominance. Many of these young artists, who came to be known as Impressionists, preferred painting out-of-doors to capture the natural effects of light. Monet, Pissarro, Renoir, Degas, and Morisot were the founders of the group. Although he never exhibited with them, Manet was considered by many to be their leader.

■ **Russian Realism and the Quest for the Russian Soul** In Russia, Francophiles followed developments in Paris carefully, but Slavophiles rejected the pro-Western bias and those Westernizers who believed that Russia was hopelessly mired in the medieval past. Slavophiles tended to be nationalists and saw Russian culture and its spirituality (or "soul") as essentially different from that of the West. Fyodor Dostoyevsky probed the psychological depths of the Russian personality in *Crime and Punishment*, and Leo Tolstoy delved into the epic scope of the country's history in his *War and Peace*. In painting, a group of young Russian painters called the Travelers created highly realistic works that celebrated peasant life. In music, the nationalist spirit manifested itself in the use of folklore and folk songs, particularly in the compositions of Modest Mussorgsky. Tchaikovsky's *1812 Overture* commemorated Napoleon's retreat from Moscow.

■ **Britain and the Design of Social Reform** The lack of standards of beauty in British industrial design was symptomatic of the country's social inequities, according to English civil servant and designer Henry Cole. In proposing a Universal Exposition for London's Hyde Park in 1850, Cole sought to set a new and progressive course for his country. The Exposition took place at Joseph Paxton's Crystal Palace, a prefabricated glass and iron structure that revolutionized architecture and construction.

William Morris took a different approach to the problem. With a group of friends he founded the design firm, Morris and Company in 1855. Modeled on the medieval guilds, the company made everything from tapestries and ceramic tiles to stained glass and furniture, all handcrafted. In his employ were the Pre-Raphaelite painters Daniel Gabriel Rossetti and Edward Burne-Jones, whose work was both medieval in spirit and highly charged with erotic tension. Morris's exclusion of women from higher-level production and design positions in his firm illuminates the importance of John Stuart Mill's 1869 essay *The Subjection of Women*, which argued against the continued subjugation of women in Western society.

 Glossary

Haussmannization The term used to describe Baron Haussmann's approach to urban redevelopment. He favored the destruction of existing structures to produce something for the betterment of society.

Japonisme The imitation of Japanese art.

pastel Sticks of powdered pigment bound with resin or gum.

plein air French for "open air" and referring to painting out of doors in front of the subject rather than in the studio.

ukiyo-e Japanese woodblock prints ("pictures of the floating world").

utilitarian A person who believes that the goal of any action should be to achieve the greatest good for the greatest number.

 Critical Thinking Questions

1. Which bourgeois values were the basis of Haussmannization?

2. How did Impressionism undercut conventional assumptions about the style and content of painting?

3. How do the Crystal Palace and Pre-Raphaelite artists express British values of social reform?

The Prospect of America

One of Edgar Degas's closest friends in Paris was the American expatriate painter Mary Cassatt (1824–1926), who began exhibiting with the Impressionists in 1867. Cassatt, like Monet and Degas, was fascinated with Japanese prints. She was especially impressed with its interest in the intimate world of women, the daily routines of domestic existence. Consciously imitating works like Utamaro's *Shaving a Boy's Head* (Fig. **37.27**), her *The Bath* exploits the same contrasts between printed textiles and bare skin (Fig. **37.28**). One of ten prints inspired by an April 1890 exhibition of Japanese woodblock prints at the École des Beaux-Arts in Paris, *The Bath* is a set of flatly silhouetted shapes against a bare ground, devoid of the traditional shading and tonal variations that create the illusion of depth in Western art.

American tastes were, in fact, deeply attracted to all things exotic, and France itself seemed attraction enough. Certainly, France appeared to offer Americans a kind of liberation from the cramped Puritan morality they found at home. And so creative people in particular were drawn to work and study there. The painter Theodore Robinson (1852–1896) went to France in 1884 to study with Monet at his home in Giverny. Other Americans came to sit at Monet's feet as well—Phillip Leslie Hale (1865–1931), who stayed at Giverny for four or five summers beginning in 1888, Lilla Cabot Perry, who spent nine summers there, and Theodore Earl Butler (1861–1936), who married Monet's stepdaughter.

These painters as well as more famous ones—including Cassatt, James Abbott McNeill Whistler (1834–1903), and John Singer Sargent (1856–1925)—as well as writers like Henry James (1843–1916) and Henry Adams (1838–1918), grandson of President John Quincy Adams—all came to Europe in the last half of the nineteenth century intent on immersing themselves in its cultural fervor. They admired what they saw in Europe. By comparison, when they turned their eyes back upon their own country, they saw only vulgarity and superficiality, moneymaking and materialism, boss-ridden politics, sanctimonious hypocrisy, and blind acceptance of social convention and conformity. It was Mark Twain who named this era in America the "Gilded Age", as opposed to a utopian Golden Age, and the name stuck.

The gilt covered, among other things, deep social unrest among the working poor, the continuing subjugation of women, the gradual elimination of all rights that African Americans had gained in the Civil War (see chapter 36), the removal of Native Americans to reservations, and, under the guise of enlightening the backward peoples of the world, the vast territorial theft of Africa and Asia by the imperial powers of Europe. But Europe offered many artists a way to ignore these realities, just as to those who stayed at home the thriving American economy offered a sense of well-being that enabled them to ignore the darker realities beneath the gilt. ■

Fig. 37.27 Kitagawa Utamaro. *Shaving a Boy's Head.* ca. 1795. Color woodblock print, 15 1/8″ × 10 1/4″. Signed Utamuro hitsu. Bequest of Richard P. Gale. The Minneapolis Institute of Arts. Utamaro was noted for his depictions of beautiful women, especially his 1793 *Ten Physiognomies of Women.*

Fig. 37.28 Mary Stevenson Cassatt. *The Bath.* 1890–1891. Drypoint and aquatint on laid paper, plate: 12 3/8″ × 9 3/4″; sheet: 17 13/16″ × 12″. Rosenwald Collection. Photograph © Board of Trustees, National Gallery of Art, Washington, D.C. Photo: Dean Beasom.

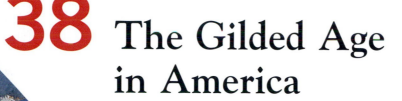

38 The Gilded Age in America

Expansion and Conflict

Walt Whitman's America

Ragtime and the Beginnings of Jazz

The American Abroad

Chicago and the Columbian Exposition of 1893

❝ *Thrive, cities—bring your freight, bring your shows, ample and sufficient rivers, Expand. . . .* **❞**

Walt Whitman, *"Crossing Brooklyn Ferry"*

◄ **Fig. 38.1 George Bellows.** ***Cliff Dwellers.*** **1913.** Oil on canvas, 40³⁄₁₆″ × 42¹⁄₁₆″. Los Angeles County Museum of Art. Los Angeles County Fund. Photograph © 2007 Museum Associates/LACMA. A preparatory drawing for this painting in *The Masses*, a socialist magazine published in New York from 1911 to 1917, was entitled "Why Don't They All Go to the Country for Vacation?" The painting's name comes from a remark reportedly made by a Fifth Avenue socialite observing the scene.

From 1870 to 1900, New York City was a boomtown of extraordinary diversity. The population of the old city—the boroughs of Manhattan and the Bronx—doubled. When, in 1898, it was proposed that the city annex Queens, Brooklyn, and Richmond (Staten Island), Brooklyn's social elite opposed it, fearing the immigrants who were sure

to cross the East River from the old city (Map 38.1). Nevertheless, the consolidation took place, the city's area increased more than ten-fold to 299 square miles, and its population doubled to 3.4 million. New York's port handled most of America's imports and roughly 50 percent of the country's exports. As the nation's financial center, the city teemed with lawyers, architects, engineers, and entrepreneurs of every nationality.

In 1892, 30 percent of all millionaires in the United States lived in Manhattan and Brooklyn, side by side with millions of the nation's working-class immigrants. By 1900, fully three-quarters of the city's population was foreign-born, having arrived via Ellis Island, which opened in 1892. Italians, Germans, Poles, and waves of Jews from Hungary, Rumania, Russia, and Eastern Europe sought the unlimited opportunities they believed were to be found in America. Many stayed in New York City. As the twentieth century dawned, these immigrants, and their descendents, would dramatically change American culture.

New York was the epicenter of a new kind of culture and economy in which poor immigrants, wealthy industrialists, ambitious merchants, and flagrantly corrupt politicians struggled to gain a share of the American Dream. This dream—usually expressed in dollars and the things those dollars could buy—was so often built on a framework of fraud and exploitation that Mark Twain gave this era the compelling name "The Gilded Age." The unprecedented expansion of New York was matched in the country as a whole as agricultural and industrial production, economic growth, and population soared.

As much as the Gilded Age signified prosperity and opportunity, it was also a byword for deceit, corruption, and financial manipulation at every level of government and business. This was especially true of large corporations and trusts (a holding company that controlled many other companies). During the era, an entire class of ultra-rich businessmen emerged, termed "robber barons" because of their use of unethical and anticompetitive methods to gain wealth and power. The rich were notable for their conspicuous consumption and self-indulgent excess, which became fodder for the gossip-hungry press and public. Wealth was on display at every turn. In 1904, Mrs. Stuyvesant Fish, a leader of New York society, threw a dinner party honoring her dog, who wore a $15,000 diamond collar for the occasion. At the time, more than 90 percent of America's families survived on less than $1,200 a year.

This chapter will survey America in the Gilded Age, the glittering facade of New York society as well as the very different and more representative experience of working-class Americans, both native-born and immigrants. These less-celebrated Americans can be glimpsed in artist George Bellows's [BELL-ohz] (1882–1925) painting *Cliff Dwellers* (Fig. 38.1). On a hot summer afternoon on the Lower East Side of Manhattan, teeming multitudes of working-class city dwellers crowd the cramped tenements and grimy streets.

In examining the nation's promise and comparing it to the often crushing reality, this chapter will illustrate how the working class, as well as disenfranchised women, began to assert themselves. African Americans, however, were increasingly oppressed, as their legal rights disappeared and they were systematically excluded from participating in civil affairs across the country. Only in New Orleans, where the new musical idiom of jazz developed, did African Americans participate significantly in the nation's cultural life. With all of these contradictions, America still saw fit to congratulate itself on the occasion of the four-hundredth anniversary of Columbus's expedition to the New World at the 1893 World Columbian Exposition in Chicago, probably the fastest-growing city in the country. The nation's mastery of the American continent, as well as its increasingly prominent place in the world economy, culture, and politics, were celebrated. Meanwhile, a new generation of expatriate American writers and artists in Europe looked back at their country with a mixture of admiration, frustration, and dismay.

Walt Whitman's America

There is no better human symbol for the restless, ambitious American spirit in the nineteenth century than the poet Walt Whitman (1819–1892), who revolutionized American literature as he linked the Romantic, Transcendental, and Realist movements. Born into a working-class Brooklyn household (his father was a carpenter), Whitman went to work full time as an office boy at age 11. Within a year he was a printer's devil (an apprentice who did odd jobs around print shops), soon contributing the occasional story.

After an unhappy five-year stint as a teacher beginning in his late teens, Whitman spent the next two decades working in

the newspaper trade as a printer and journalist, refining his writing skills. He also sharpened his powers of observation, as he gained a thorough knowledge of New York and its surrounding regions. Whitman became an ardent opponent of slavery in this period—even getting fired at one point by a conservative newspaper publisher who could not tolerate his views.

During a brief but memorable residence in New Orleans in 1846, where he helped set up a new newspaper, Whitman encountered a kaleidoscope of colorful characters and immersed himself in the city's exotic mixture of Indian, French, and African American culture. He liked the French market and the amazing variety of people and goods, and he enjoyed the strong coffee he purchased from a "Creole mulatto woman." Near his lodging house, Whitman also witnessed a less pleasant spectacle—slave auctions, which were a common occurrence in the American South. He would never forget the sight, and he kept an auction poster displayed in his room for years afterward to remind him of the degrading scene. More than a decade later, Whitman would make a slave auction the setting of one of his most famous poems, "I Sing the Body Electric."

As much as he appreciated the dynamism and unique appeal of New Orleans, Whitman was a confirmed New Yorker. He eventually gained fame with his portraits of the city's environment and people. He celebrated the sense of urgency and vigor conveyed by the urban atmosphere in "Crossing Brooklyn Ferry" (**Reading 38.1**):

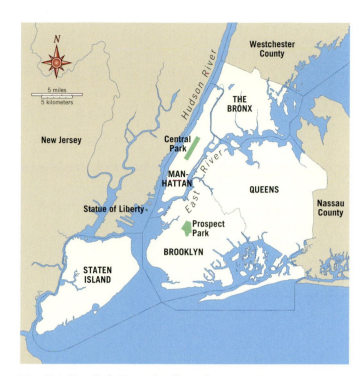

Map 38.1 New York City and its Boroughs, ca. 1900.

READING 38.1 **from Walt Whitman, "Crossing Brooklyn Ferry" (1856)**

Come on, ships from the lower bay! pass up or down, white-sail'd schooners, sloops, lighters!
Flaunt away, flags of all nations! be duly lower'd at sunset!
Burn high your fires, foundry chimneys! cast black shadows at nightfall! cast red and yellow light over the tops of the houses! . . .
Thrive, cities—bring your freight, bring your shows, ample and sufficient rivers,
Expand. . . .

New York City was the very embodiment of the vast American possibilities Whitman celebrated in *Leaves of Grass*, the long and complex volume of poems that he self-published in 1855 and continuously revised until 1892. It started out as a slim volume of 12 poems and grew to more than 400 as the author's life changed and as he grew into his self-defined role as "the American poet," speaking for the common man. In the first few years, *Leaves* was not received favorably and it did not sell many copies. But within a decade new editions would become a commercial success and the foundation of his growing reputation as the nation's most important poet. In "Song of Myself," the first and eventually longest of the poems, Whitman

spoke to his own and the country's diverse experiences (**Reading 38.2a**):

READING 38.2a **from Walt Whitman, "Song of Myself," in *Leaves of Grass* (1867)**

I am large, I contain multitudes. . . .
Of every hue and cast am I, of every rank and religion,
A farmer, mechanic, artist, gentleman, sailor, quaker,
Prisoner, fancy-man, rowdy, lawyer, physician, priest.

Whitman openly embraced all Americans in "Song of Myself," from immigrants to African Americans and Native Americans, from male to female, and heterosexual to homosexual. He celebrated all forms of sexuality, a fact that shocked many readers. One early reviewer called *Leaves* "a mass of stupid filth" and its author a pig rooting "among a rotten garbage of licentious thoughts." And in 1865, Whitman, who worked at the U.S. Interior Department as a clerk, was fired by his boss, the Secretary of Interior, for having violated in that work "the rules of decorum and propriety prescribed by a Christian Civilization."

"Song of Myself" consists of 52 numbered sections with the "I" of the narrator serving as a literary device for viewing the experiences of one man as representative of multitudes. *Leaves of Grass* is therefore a subjective epic. "Remember," Whitman would tell a friend late in his life, "the book arose out of my

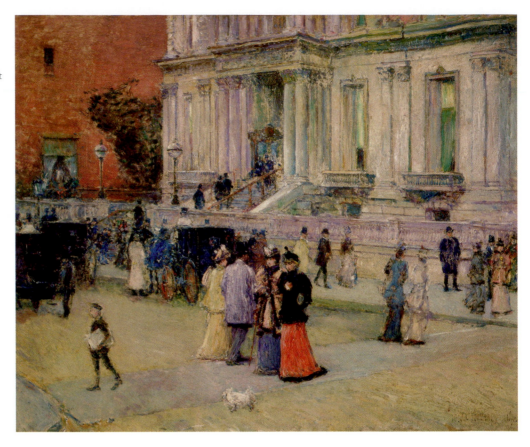

Fig. 38.2 Childe Hassam. *The Manhattan Club (The Stewart Mansion).* ca. 1891. Oil on canvas, 18¼″ × 22⅛″. Santa Barbara Museum of Art, California. Gift of Mrs. Sterling Morton to the Preston Morton Collection. 1960.62. At the northwest corner of 34th Street and Fifth Avenue, the Manhattan Club was originally the home of A. T. Stewart, owner of a department store on Broadway specializing in "feminine attire." It was the largest iron structure in the United States and contained 55 rooms, most with 19-foot ceilings.

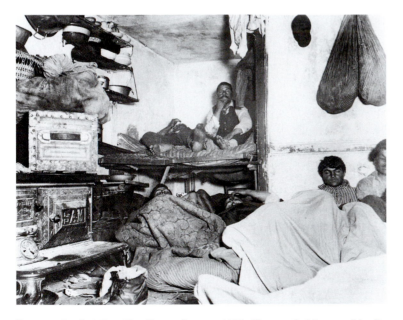

Fig. 38.3 Jacob A. Riis. *Five Cents a Spot.* ca. 1889. Photograph. Museum of the City of New York, NY. Jacob A. Riis Collection. Riis described this photo, taken on Bayard Street in Manhattan's Lower East Side, as follows: "In a room not thirteen feet either way slept twelve men and women, two or three in bunks set in a sort of alcove, the rest on the floor. A kerosene lamp burnt dimly in the fearful atmosphere, probably to guide other and later arrivals to their 'beds,' for it was only just past midnight."

life in Brooklyn and New York. . . . absorbing a million people for fifteen years, with an intimacy, an eagerness, an abandon, probably never equaled." (See **Reading 38.2**, page 1242, for a lengthy excerpt.)

Whitman loved equally the finery of New York's upper classes and the city's "newly-come immigrants." He appreciated the elegant lifestyle depicted by the American Impressionist painter Childe Hassam [child HASS-um] (1859–1935) in such works as *The Manhattan Club* (Fig. **38.2**) and how it contrasted with the impoverished lifestyle of the city's working class, accurately captured by photographer Jacob Riis [reess] in his book, *How the Other Half Lives* (1890) (Fig. **38.3**). "The pleasures of heaven are with me," Whitman writes in "Song of Myself," "and the pains of hell are with me, / the first I graft and increase upon myself, the latter I translate into a new tongue."

Whitman developed a **free-verse** style of writing poetry, based on irregular rhythmic patterns as opposed to conventional meter. Rhymes are rare in his work, but the "song" of the poems derives from his liberal use of alliteration, assonance (similar, repeated vowel sounds in successive words), and other forms of repetitive phrasing.

The style owes much to the opera arias that Whitman admired so much. As he wrote in "Song of Myself" (**Reading 38.2b**):

READING 38.2b **from Walt Whitman, "Song of Myself," in *Leaves of Grass* (1867)**

I hear the sound I love, the sound of the human voice,
I hear sounds running altogether, combined, fused or
 following,
Sounds of the city and sounds out of the city, sounds of the
 day and night . . .
I hear the chorus, it is a grand opera,
Ah this indeed is music—this suits me.

By the time Whitman issued his final ("deathbed") edition of *Leaves of Grass*, the work had grown from 96 printed pages in the 1855 edition to 438. He would come to anguish over the personal suffering of the soldiers who fought in the Civil War in "Drum Taps," and mourn the death of Abraham Lincoln in "When Lilacs Last in the Dooryard Bloom'd," both added to the 1867 edition. To celebrate the opening of the Suez Canal, he added to the 1876 edition the long "Passage to India." *Leaves of Grass*, in other words, was as expansive and as ever-changing as its author.

But it is finally in Whitman's feelings for New York City that we can best understand the complexity of his feelings for America. In a paragraph from a lengthy pamphlet in 1871 that argued for the necessity of reinvigorating American democracy, he tells of his feelings for the city (**Reading 38.3**):

READING 38.3 **from Walt Whitman, *Democratic Vistas* (1871)**

After an absence, I am now again (September, 1870) in New York City and Brooklyn, on a few weeks' vacation. The splendor, picturesqueness, and oceanic amplitude and rush of these great cities, the unsurpass'd situation, rivers and bay, sparkling sea-tides, costly and lofty new buildings, facades of marble and iron, of original grandeur and elegance of design, with the masses of gay color, the preponderance of white and blue, the flags flying, the endless ships, the tumultuous streets, Broadway, the heavy, low, musical roar, hardly ever intermitted, even at night; the jobbers' houses, the rich shops, the wharves, the great Central Park, and the Brooklyn Park of hills (as I wander among them this beautiful fall weather, musing, watching, absorbing)— the assemblages of the citizens in their groups, conversations, trades, evening amusements, or along the by-quarters—these, I say, and the like of these, completely satisfy my senses of power, fulness, motion, &c., and give me, through such senses and appetites, and through my esthetic conscience, a continued exaltation and absolute fulfilment. Always and more and more,

. . . I realize . . . that not Nature alone is great in her fields of freedom and the open air, in her storms, the shows of night and day, the mountains, forests, seas— but in the artificial, the work of man too is equally great—in this profusion of teeming humanity—in these ingenuities, streets, goods, houses, ships—these hurrying, feverish, electric crowds of men, their complicated business genius, . . . and all this mighty, many-threaded wealth and industry concentrated here.

In the Interest of Liberty: An Era of Contradictions

Whitman's essential optimism, his genuine belief in the egalitarian promise of democracy, was put to the test during Reconstruction. As he wrote in *Democratic Vistas*, the promise that he saw in New York's streets and harbors remained unfulfilled: "With such advantages at present fully, or almost fully, possess'd—the Union just issued, victorious, . . . and with unprecedented materialistic advancement—society, in these States, is canker'd, crude, superstitious, and rotten." As if to prove his point, the Supreme Court nullified the Civil Rights Act in 1883. Lynchings of African Americans became almost commonplace across the South as white-controlled state legislatures passed laws designed to rob blacks of their civil rights. Legally sanctioned segregation ("Jim Crow" laws) prevented blacks from using public facilities such as restrooms, hotels, and restaurants, and attending school with whites.

The Statue of Liberty and Tammany Hall Even as African Americans were losing their freedoms, the nation celebrated liberty when wealthy businessmen and politicians raised the necessary funds for a pedestal to support a French gift to the American people sculpted by Frédéric-Auguste Bartholdi [bar-tohl-DEE] (1834–1904), *Liberty Enlightening the World*. Known simply as the Statue of Liberty—a broken chain under Liberty's foot alludes to the emancipation of the slaves—it was positioned on an island in New York Harbor and dedicated in 1886. At the ceremony, President Grover Cleveland (held office 1885–1889) noted, with no irony intended, "Instead of grasping in her hand the thunderbolts of terror and death, she holds aloft the light that illumines the way to man's enfranchisement." Former slaves and their descendents along with all American women might have objected to the grand sentiments, since the prospect of gaining the vote or a voice in democracy was far in the future.

However it was perceived, democracy was a complicated and imperfect process of self-governance, and especially so in large urban areas with diverse populations. Organizations like the Tammany [TAM-uh-nee] Society, founded in the eighteenth century for social purposes, now used working-class and immigrant votes to gain and keep power indefinitely. By offering those at the bottom of society's ladder assistance in gaining citizenship, jobs, and housing, Tammany leaders such as William "Boss" Tweed (1823–1878) were able to create a

CULTURAL PARALLELS

Famine in India

As the Gilded Age began in America, India was experiencing a nationwide famine. The catastrophe, which claimed 25 million lives between 1875 and 1902, had several causes. Supporters of British imperialism liked to say that it modernized India by introducing railroads and the civil service system, but the introduction of low-cost British imports systematically undermined India's native industries. Also, British policies supported seizure of local farmlands and their conversion to foreign-owned plantations, and local trade was heavily taxed.

self-sustaining system of patronage, whereby favors would be traded in return for political loyalty.

By the 1860s the Tammany Society, which was closely aligned with the Democratic Party, completely controlled the city's political life. Under the leadership of Boss Tweed, City Hall became known as Tammany Hall. In his role as commissioner of public works, Tweed not only helped workers and immigrants, but also enriched himself and his cronies through swindling the city government. He purchased 300 benches for $5 each, which he turned around and resold to the city for $600 apiece. Tweed commissioned his friends to do work for the city. One carpenter received $360,747 for a month's labor, and a supplier of furniture and carpets was paid over $5 million.

Boss Tweed was not alone in helping to corrupt democratic government. President Ulysses S. Grant (held office 1868–1876) and his cabinet were implicated in a number of dubious schemes, leading to notorious scandals. It was just such corruption that led Mark Twain to remark in a *New York Tribune* newspaper column in 1871: "What is the chief end of man?—to get rich. In what way?—dishonestly if we can; honestly if we must."

Economic Depression, Strikes, and the Haymarket Riot
Widespread fraud and corruption contributed to the impoverishment of the working class, but so did the profit motive that drove the industrial sector of the economy. By 1890, 11 million of the nation's 12 million families had an average annual income of $380, well below the poverty line ($380 would buy about the same as $7,600 in today's dollars). Sudden, unexpected events also precipitated widespread economic hardship, as occurred in September 1873, when a Philadelphia banking firm failed, causing investors to panic, banks to shut down, and the New York Stock Market to close for ten days. The "Panic of 1873" triggered the "Long Depression," which lasted four years. In this period, over 20,000 American businesses failed and a quarter of the nation's 364 railroads went bankrupt. (The downturn also affected other countries, particularly Europe and Britain.)

Millions of American workers found themselves without jobs in the 1870s, while business owners began cutting wages—an oversupply of employees meant cheaper labor. Many lost their savings as well as their jobs when unregulated banks, insurance companies, and investment firms went out of business and federal and state governments stood by. As the unemployment rate in New York and other cities passed 25 percent, famine and starvation in the land of opportunity became a reality.

It should not be surprising that workers developed new forms of collective action in this harsh economic environment. Impromptu strikes, walkouts, and the beginnings of organized labor unions signaled the changing economic and social climate. When the Baltimore & Ohio Railroad cut wages in 1877, its workers staged spontaneous strikes, which spread rapidly to other railroads. In Baltimore, the state militia shot and killed 11 strikers and wounded 40 others. In Pittsburgh, the head of the Pennsylvania Railroad wryly suggested that strikers be given "a rifle diet for a few days and see how they like that kind of bread." Perhaps in response to his suggestion, troopers began firing at the unarmed crowd—leaving at least 20 dead. In Philadelphia, strikers burned down much of the downtown before federal troops stepped in. But despite the widespread strikes and development of labor organizations, workers were largely unsuccessful because of the power and wealth of those united against them.

Owners of railroads and other corporations together with the political leaders they supported made sure wage reductions remained in place. The federal government aided them when the U.S. War Department created the National Guard as a quick reaction force to put down future disturbances. It was an era of unparalleled political unrest, and *The Strike* by Robert Koehler [KOH-lur] (1850–1917) suggests something of the mood of the workers and their bosses, as well as the grim environment of industrial-age America (Fig. **38.4**). The painting depicts an angry crowd confronting an employer, demanding a living wage from the stern top-hatted man and a worried younger man standing behind him. An impoverished woman with her children looks on at the left, another woman, more obviously middle class, tries to talk with one of the workers, but behind him a striker bends down to pick up a stone to throw. Koehler's realism is evident in the diversity of his figures, each possessing an individual identity. But the background of the work, with its smoky, factory-filled landscape on the horizon, owes much to the Impressionist style.

The May 1, 1886, issue of *Harper's Weekly* included the painting as its central feature. On the same day a national strike called for changing the standard workday from 12 hours to 8. More than 340,000 workers stopped work at 12,000 companies across the country. In Chicago, a bomb exploded as police broke up a labor meeting in Haymarket Square. A police officer was killed by the blast and police retaliated, firing into the crowd of workers, killing one and wounding many more. Four labor organizers were charged with the policeman's death and subsequently hanged, demoralizing the national labor movement and energizing management to resist labor's demands.

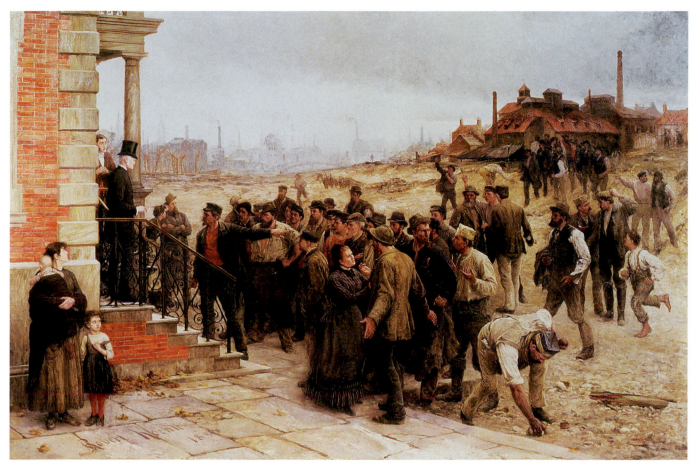

Fig. 38.4 Robert Koehler. *The Strike.* **1886.** Oil on canvas, 71 $\frac{5}{8}$″ × 9′ 5 $\frac{5}{8}$″. Deutsches Historisches Museum, Berlin, Germany/The Bridgeman Art Library, NY. Koehler's father was a machinist, and he identified with the plight of the working class. The painting was exhibited at the National Academy of Design in 1886, to general approval.

The American Woman

Women as well as working-class whites and blacks felt the contradictions and limitations of American democracy. In the post–Civil War years, women became the public face of social reform as they led the suffrage movement, aimed at gaining the right to vote, and the Temperance movement, which sought to moderate (or cease) the consumption of alcohol. Both movements met formidable opposition. At the dedication of the Statue of Liberty, officials barred the New York State Woman Suffrage Association from participating. The New York "suffragettes" sailed out to Bedloe's Island anyway and invited the public onboard their ship, where their president, Lillie Devereux Blake, spoke: "In erecting a Statue of Liberty embodied as a woman in a land where no woman has political liberty, men have shown a delightful inconsistency which excites the wonder and admiration of the opposite sex."

Yet women were making *some* gains. After the Civil War, they had assumed a growing role in education, as state-run schools trained women as teachers. And during the war, many had followed the lead of England's Florence Nightingale (1820–1910), who established nursing as an honored profession during the Crimean War in the 1850s. By the end of the century, nursing schools, usually associated with the nation's medical schools, had opened across the country, although physician training was still reserved for men. By 1900, fully 80 percent of the nation's colleges, universities, and professional schools were admitting women, though in small numbers. And the literacy rate of white women equaled that of white men.

If women were the symbols of social reform in Gilded Age America, they increasingly embodied education and literacy in art and literature as well. In *A Reading* by Thomas Dewing (1851–1938), created by a painter who worked with his wife, also an artist, in a professional partnership, we see women in the act of reading (Fig. **38.5**). It is even fair to say that women became the favorite subject of American painters in the last decades of the nineteenth century.

Formal portraits of society women were an important source of income for many painters, but artists also showed women in more relaxed settings. Thomas Dewing, for example, painted women almost exclusively, bathing them in a gauzy light, as in *A Reading*, a technique that he learned from the Impressionists during his training at the Académie Julian

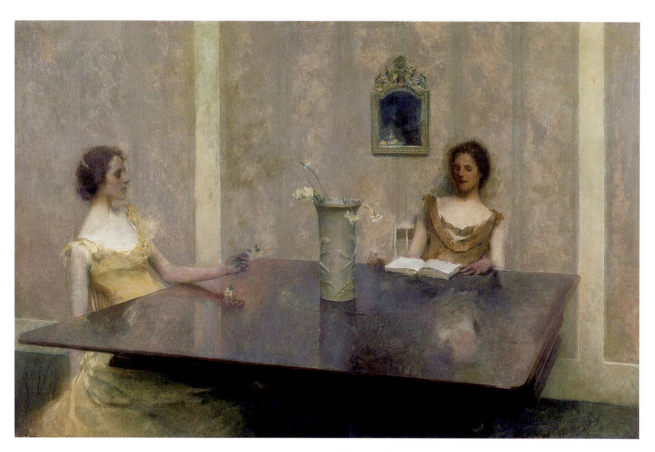

Fig. 38.5 Thomas Wilmer Dewing. *A Reading*. 1897. Oil on canvas, 20¼″ × 30¼″. Bequest of Henry Ward Ranger through the National Academy of Design. Smithsonian American Art Museum, Washington, DC/Art Resource, NY. For Dewing and many of his contemporaries, repose was therapeutic. His paintings were intended to evoke that state in the viewer.

[ah-kah-day-MEE zhoo-lee-AHN] in Paris in the 1870s. Such scenes are double-edged since on one hand, they celebrate the intellectual capacity of women, but on the other, they insulate these same women from the harsh world of labor and business by showing them sitting comfortably in their home, safely domestic. In short, nothing about such artworks challenged the status quo. Male painters of the Gilded Age depicted women as almost always passive—sitting, lounging, reading, writing a letter—and rarely physically active. Flowers are often present in these images, with the women sometimes contemplating a bloom, as in Dewing's painting. The ever-present cut rose might symbolize fallen virtue, while daffodils were associated with the innocence of spring. Or women might be depicted strolling in a garden, as in a view of Prospect Park by the American painter William Merritt Chase (1849–1916) (Fig. **38.6**). Chase's views of New York's parks were among the first fully Impressionist canvases to be painted in the United States. Monet's paintings of his wife Camille in their garden at Argenteuil influenced paintings like this, but the contrast between female passivity and male action was much more pronounced in American painting than in European art. Almost all of Chase's park views are populated exclusively with women. In his eyes, the park was their particular environment, a feminine space as nurturing

as the mother Chase depicts here, sitting with her baby in its pram, as opposed to the male world of business.

With the possible exception of Thomas Eakins's [AY-kinz] *Agnew Clinic* (see *Focus*, pages 1228–1229), no painting embodies the tension between genders more than Winslow Homer's *The Life Line* (Fig. **38.7**). Immediately recognized as a masterpiece when exhibited at the National Academy in 1884, it depicts a woman's rescue from a ship wrecked in a storm. A review in the *New York Times* summarizes the painting's attraction to its New York audience:

> The coast guard is a well-drawn muscular figure with face hidden. . . . The hiding of his features concentrates the attention very cleverly on his comrade, who has fainted or is numb with fright. She has nothing on but her shoes, stockings, and dress, while the skirt of the latter has been so torn that her legs are more or less shown above the knees. Then, the drenching she has received makes her dress cling to bust and thighs, outlining her whole form most admirable. She is a buxom lassie, by no means ill-favored in figure and face. Her disordered hair, torn skirt, drenched dress, and set face call for sympathy; a redness of the skin, above the stockings hints at a cruel blow, and puts the climax on one's pity; at the same time, one cannot forget her beauty.

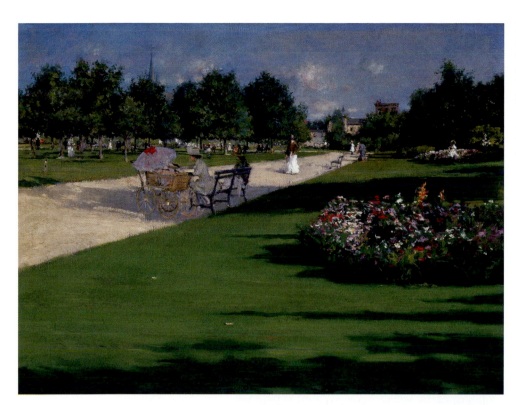

Fig. 38.6 **William Merritt Chase.**
***Prospect Park, Brooklyn.* ca. 1886.**
Oil on canvas, $17\frac{3}{8}'' \times 22\frac{3}{8}''$.
Colby College Museum of Art,
Waterville, ME. Gift of Miss Adeline
F. and Miss Caroline R. Wing.
1963.040. Benches were everywhere
in Olmsted and Vaux's parks. Ten
thousand of them were scattered
throughout Central Park.

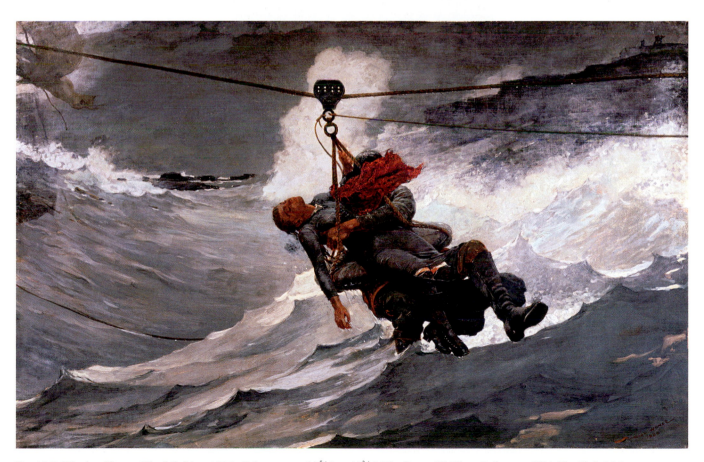

Fig. 38.7 **Winslow Homer.** ***The Life Line.* 1884.** Oil on canvas, $28\frac{5}{8}'' \times 44\frac{3}{4}''$. The George W. Elkins Collection, 1924. The Philadelphia
Museum of Art, Philadelphia/Art Resource, NY. In the first days that the painting was exhibited, the rescuer's face was visible. However, Homer
apparently felt that it detracted from the composition, so he painted in the windblown red shawl to cover him while the exhibition was in progress.

Focus

Eakins's *Gross Clinic* and *Agnew Clinic*

Thomas Eakins (1844–1916) was an American Realist who began teaching at the Pennsylvania Academy of Fine Art in Philadelphia in 1876 and became its director in 1882. Always controversial, he was dismissed from the Academy in 1886 for removing a loincloth from a nude male model in a studio where female students were present. Among his most notable—and controversial—works are two portraits of surgeons, *The Gross Clinic* and *The Agnew Clinic*, painted 14 years apart, in 1875 and 1889 respectively. Although anticipated in seventeenth-century European paintings such as Rembrandt's *Anatomy Lesson of Dr. Tulp* (see *Focus*, chapter 26), the subject was relatively unknown in American art and so not considered an appropriate subject for a painting. In addition, Eakins's graphic realization of both surgeries shocked the public.

The Gross Clinic is the product of the painter's own desire to paint Dr. Samuel D. Gross (1805–1884) in his surgical clinic, which he had attended when he studied anatomy a year before at the Jefferson Medical College in Philadelphia. It shows Dr. Gross standing in his surgical amphitheater, scalpel in hand, explaining a procedure to his students. Like Rembrandt's *Anatomy Lesson*, the composition is pyramidal in structure, with Dr. Gross at its apex. Light bathes the surgeon's head and hand and the surgery itself, emphasizing the intellectual capacity and physical dexterity of the surgeon. He and his colleagues are in the process of removing a piece of

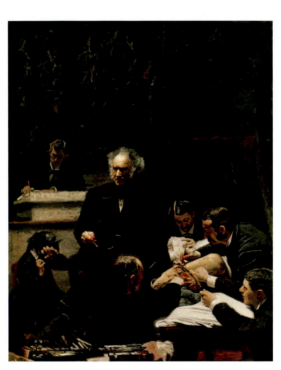

Thomas Eakins. *The Gross Clinic.* **1875.** Oil on canvas, 96″ × 78¹⁄₂″. Philadelpia Museum of Art on loan from the University of Pennsylvania School of Medicine. The brightest color in this painting is the red of oozing blood on the patient's wound and on the surgeon's hands and linens.

dead bone from the leg of a patient suffering from osteomyelitis, a bone disease that until the nineteenth century had been treated by amputation. Eakins evidently understood the shock the scene would cause his viewers because behind Dr. Gross he has depicted a woman, probably a relative of the patient, recoiling in horror from the scene. The era's prototypical weak woman, she is a far cry from the stoic nurse who watches Dr. Agnew's surgery in *The Agnew Clinic.*

The Agnew Clinic was a commission from the students of Dr. D. Hayes Agnew (1818–1892), who expected merely a portrait of their retiring mentor. Eakins, however, wanted to survey advances in medicine since his last effort and offered to paint all of Agnew's students and colleagues into a work echoing *The Gross Clinic.* The painting, the largest Eakins ever painted and depicting surgery on a young woman, was rejected by the Pennsylvania Academy—it had asked him to submit it to their annual exhibition—and then subsequently by the Society for American Artists. It was finally displayed at the Chicago World's Columbian Exhibition in 1893. Oblivious to the fact that Eakins was celebrating American medical advancement, one critic wrote: "It is impossible to escape from Mr. Eakins's ghastly symphonies in gore and bitumen. Delicate or sensitive women or children suddenly confronted by the portrayal of these clinical horrors might receive a shock from which they would never recover." Nevertheless, in *The Agnew Clinic* Eakins had replaced the fear and blood of *The Gross Clinic* with professionalism and detachment.

The doctors wear white coats, unlike the surgeons in *The Gross Clinic*. This indicated that in the 14 years separating the two paintings, principles of *antisepsis*—the destruction or minimization of germs and other microorganisms—had been introduced into the surgical arena. The figures are also much better lit by artificial lighting, whereas in *The Gross Clinic* the light enters the auditorium through skylights above.

The figure of Eakins himself stands in the doorway, listening as a colleague of Agnew's whispers to him, possibly explaining the procedure. Eakins's wife Susan added his likeness to the painting.

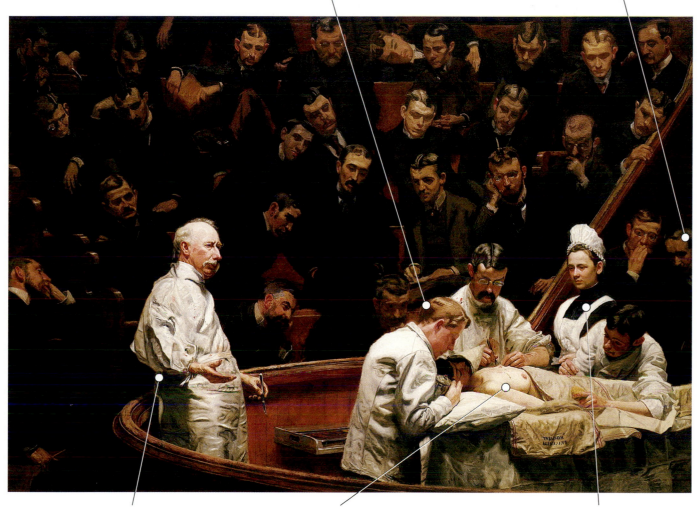

Dr. Agnew was professor of surgery at the University of Pennsylvania School of Medicine. His students described him, according to the Latin motto carved on the finished work's frame, as "the most experienced surgeon, the clearest writer and teacher, the most venerated and beloved man." At Dr. Agnew's request there is no blood shown on him or his patient.

The female patient is undergoing a mastectomy, or breast removal—still an experimental procedure—to combat her breast cancer. The doctor at her head administers chloroform as an anesthetic, another experimental technique. Poor men and women from almshouses were regularly recruited to undergo such experimental procedures in return for free medical care.

The nurse is Mary V. Clymer, at the top of her nursing class at the University of Pennsylvania. She serves a double function: overseeing the propriety of the male doctors' handling of the female patient and representing the new profession of nursing as a whole. While women were still not admitted to medical schools (an exclusion strongly supported by Dr. Agnew), the University of Pennsylvania was one of the first American universities to inaugurate a school of nursing. It was only three years old at the time of Eakins's painting.

Thomas Eakins. *The Agnew Clinic.* **1889.** Oil on canvas, $84\frac{3}{8}'' \times 118\frac{1}{8}''$. Jefferson College, Philadelphia, PA, USA/The Bridgeman Art Library. Today, this painting is reproduced on the diplomas of all graduates of the University of Pennsylvania School of Medicine.

This is the very image of the strong, active male in whose embrace the weak, passive female is rescued. And part of her attractiveness is her passivity and vulnerability. That the painting appealed to the prurient interests of its audience—in some other context the couple might be seen as lovers embracing—sealed its success. But above all, the painting positions woman in a condition of total dependency on a man, which is precisely where the American male, in the last quarter of the nineteenth century, thought she should be.

Emily Dickinson: The Poetry of Enigma As a result of the broadly condescending attitude toward women and the fierce resistance to the fledgling women's rights and suffrage movements, the achievements of women in the nineteenth century were often individual ones. A remarkable example is the work of Emily Dickinson (1830–1886), who lived in her father's Amherst, Massachusetts, home almost her entire life. Here she gardened, baked bread—her chief talent in her father's eyes—and read voluminously. Dickinson also wrote continuously, corresponding with a small circle of friends and composing some of the most remarkable poetry in the history of American literature. Her work is characterized by passion, simplicity, and an economy and concentration of style. She summarized her life in 1862, at age 31, when she wrote a letter to Thomas Higginson, at *Atlantic Monthly* magazine, responding to his published essay that offered advice to young authors:

> You ask of my Companions Hills—Sir—and the Sundown—and a Dog—large as myself, that my Father bought me—They are better than Beings—because they know—but do not tell—and the noise in the Pool, at Noon—excels my Piano. I have a Brother and Sister—My Mother does not care for thought—and Father, too busy with his Briefs—to notice what we do—He buys me many Books—but begs me not to read them—because he fears they joggle the Mind. They are religious—except me—and address an Eclipse every morning—whom they call their "Father." But I fear my story fatigues you—I would like to learn—Could you tell me how to grow—or is it unconveyed—like Melody—or Witchcraft?

Higginson could not, in fact, tell her how to grow as an author. He found her unconventional verse curious, and even powerful, but decidedly unorthodox. It was in this lack of orthodoxy, however, that Dickinson found her own form of freedom and her resemblance to Whitman. Even in the isolation of her Amherst home, her poetry awakened her senses, as she explained, in a poem: "I am alive—because / I am not in a Room— / The Parlor . . ." (In the New England parlor one met with one's visitors, and Dickinson studiously avoided visiting.) Dickinson so avoided the parlor (and the visitors in them) that she remained something of a mystery to her neighbors—and to us. In fact, there are only two known photographs of her (Fig. **38.8**).

Yet one day in 1882, in that dreaded parlor, Emily's mother read some of her daughter's poems to a young neighbor, Mabel Loomis Todd, who found them "full of power."

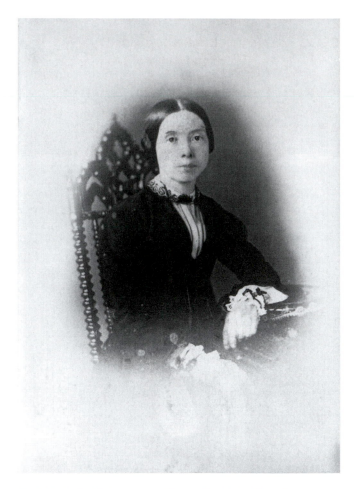

Fig. 38.8 Emily Dickinson. ca. 1848–1853. Mid-1860s. Albumen photograph copy of an original daguerreotype, $5\frac{1}{2}'' \times 3\frac{7}{8}''$. Until Professor Gura of the University of North Carolina purchased this photograph on eBay, only one other photograph of the reclusive Dickinson was known to exist. Asked at age 31 to supply a photograph of herself, she replied, "Could you believe me—without? I had no portrait, now, but am small, like the Wren, and my Hair is bold, like the Chestnut Bur—and my eyes, like the Sherry in the Glass, that the Guest leaves—Would this do just as well?"

Encouraged by Emily's sister, Todd undertook the task of transcribing them. By letter, Dickinson and Todd developed "a very pleasant friendship," even though they never actually met. In 1890, four years after Dickinson's death, Todd persuaded Thomas Higginson to publish a collection of Dickinson's poems, followed by a second series in 1891, and a third in 1896. They seemed to embody the pent-up imagination of the nineteenth-century American woman, and they became popular almost immediately.

The crisp, sharp imagery and economy of statement in poems like Dickinson's "Wild Nights" contrasts dramatically with its great emotional intensity. As is typical of Dickinson's work, her brevity seems to charge the poem, fuel its ambiguity, and contribute to the fierceness of her vision (**Reading 38.4**):

READING 38.4 **Emily Dickinson, "Wild Nights" (as published in 1953)**

Wild Nights—Wild Nights!
Were I with thee
Wild Nights should be
Our luxury!

Futile—the Winds—
To a Heart in port—
Done with the Compass—
Done with the Chart!

Rowing in Eden

Ah, the Sea!
Might I but moor—Tonight—
In Thee!

The poem contrasts the safety and repose of a port and the wildness of the open seas, which are metaphors for the poet's emotional state. It opens with the poet longing for the "wild nights" that would evidently be assured if she were with "thee." The second stanza seems to describe the circumstances of a heart safely harbored in port. It has no need of compass or chart and the winds do not stir it. She is "Rowing in Eden," in a paradise-like calm. But she rejects such calm, for it is "wildness" that the poet desires. The peace of Eden offers no risk, none of the passion represented by the wild seas.

The poem can also be read in terms of sexual encounter, adding to the ambiguity. We know that Dickinson used an 1844 dictionary that linked *luxury* with its Latin origins in wantonness, sexual desire, and riotous living. However, the poem remains enigmatic and suggestive rather than clear and detailed. The reader's imagination is as free to play as Dickinson's own. (See **Reading 38.5**, page 1243, for several other Dickinson poems.)

Kate Chopin and the New Feminist Novel Unlike the writings of Emily Dickinson, which were almost unknown in her lifetime, the works of writer Kate Chopin [shoh-PAN] (1851–1904), of St. Louis, Missouri, were well known. Having taken up writing in 1884 after the death of her husband, Chopin's first two books of stories, *Bayou Folk* (1894) and *A Night in Arcadie* (1897), were praised for their attention to local custom and dialect. *Vogue* magazine and other commercial publications featured her work. But when her short novel *The Awakening* (1899) appeared, she was harshly criticized for its frank treatment of female marital infidelity.

In its celebration of sensuality and its positive attitude toward the sexual desire of its central character, Edna Pontellier [pohn-tell-ee-AY], *The Awakening* owes much to Walt Whitman, whose work Chopin greatly admired. Set in New Orleans and Grand Isle, a summer resort on the Louisiana coast, *The Awakening* opens as Edna is falling in love with Robert Lebrun [luh-BRUHN], a young Creole [KREE-ohl]

whose family owns the resort. From the story's very first moments it becomes apparent that the author intends to challenge the viability of Edna's marriage. In the following passage, Mr. Pontellier watches her return from the beach with her new object of affection (**Reading 38.6a**):

READING 38.6a **from Kate Chopin, *The Awakening*, Chapter I (1899)**

Mr. Pontellier finally lit a cigar and began to smoke, letting the paper drag idly from his hand. He fixed his gaze upon a white sunshade that was advancing at snail's pace from the beach. He could see it plainly between the gaunt trunks of the water-oaks and across the stretch of yellow camomile. The gulf looked far away, melting hazily into the blue of the horizon. The sunshade continued to approach slowly. Beneath its shelter were his wife, Mrs. Pontellier, and young Robert Lebrun. . . .

"What folly! to bathe at such an hour in such heat!" exclaimed Mr. Pontellier. . . . "You are burnt beyond recognition," he added, looking at his wife as one looks at a valuable piece of personal property which has suffered some damage.

Edna is as seduced by the sea as she is by young Robert Lebrun. When he takes her to the beach a few chapters later, Edna begins to experience the "awakening" that will free her from her marriage (**Reading 38.6b**):

READING 38.6b **from Kate Chopin, *The Awakening*, Chapter VI (1899)**

A certain light was beginning to dawn dimly within her,—the light which, showing the way, forbids it. . . .

In short, Mrs. Pontellier was beginning to realize her position in the universe as a human being, and to recognize her relations as an individual to the world within and about her. . . .

But the beginning of things, of a world especially, is necessarily vague, tangled, chaotic, and exceedingly disturbing. How few of us ever emerge from such beginning. How many souls perish in its tumult!

The voice of the sea is seductive; never ceasing, whispering, clamoring, murmuring, inviting the soul to wander for a spell in abysses of solitude; to lose itself in mazes of inward contemplation.

The voice of the sea speaks to the soul. The touch of the sea is sensuous, enfolding the body in its soft, close embrace.

And so Edna learns to swim, both literally and figuratively, to fend for herself, free of her husband, in a newfound world of sensual, even carnal pleasure. No other writer of the era even tried to describe the feelings a woman experiences as she discovers her own sexual being and, more important, her own identity. The novel's commercial and critical failure, in fact, mirrored Edna's own inability, once she has in fact fully awakened to herself, to fit into her society. The author fared better than her character, and Chopin turned to writing more commercially acceptable short stories. Illustrating the changing social and literary environment, Kate Chopin was recognized in the first edition of Marquis *Who's Who* (1900), which includes concise biographies of "distinguished Americans."

Ragtime and the Beginnings of Jazz

Edna Pontellier was not the kind of woman that Americans were used to encountering personally. But Chopin had carefully chosen New Orleans as Edna's place of awakening. New Orleans was still a French city, but it was also African American, Spanish, Haitian, Creole, and Caucasian. At the end of the nineteenth century, it was probably the most cosmopolitan city in America. Out of this mixture a thriving musical culture developed, which included opera and chamber music, as well as a new form of music that evolved in the city's bars, dance halls, streets, and brothels. The bands that played at festivals, dances, and weddings, in the bars and in parades, at political rallies and funerals gained inspiration from African and Caribbean dance and drumming traditions.

Combining these traditions with the brass bands and syncopated musical tunes that gained popularity in the 1880s, New Orleans gave birth to a new musical tradition that has come to be known as **jazz**.

Jazz is characterized by a steady rhythm that plays off against a rhythmic **syncopation**—the accentuation of "off-beats." (Off-beats are not generally stressed in other forms of music.) **Ragtime** piano music is one of the earliest manifestations of this principle. A musician "rags" by playing a classical or popular melody in a syncopated style. The left hand maintains a steady marchlike tempo, while the right plays the melody in syncopated rhythm. The most famous ragtime pianist was Scott Joplin, whose *Maple Leaf Rag* (Fig. 38.9) sold hundreds of thousands of copies after 1899 (see **CD-Track 38.1**).

To many, more puritanical Americans, the loose rhythms of ragtime suggested loose morals, and ragtime was subjected to the same harsh criticisms as Chopin's novel, published in the same year that Joplin's tune was released. One American music critic, for instance, urged readers: "take a united stand against the Ragtime Evil.... In Christian homes, where purity of morals is stressed, ragtime should find no resting place.... Let us purge America and the Divine Art of Music from this polluting nuisance." Such sentiments, which would later also be aimed at jazz (in the 1920s and 1930s) and rock-and-roll (in the 1950s and 1960s), were often motivated by racism. However, more open-minded white audiences were attracted to the music's fresh spontaneity. Ragtime—and, later, jazz in general—represented a new, authentic form of American expression, a synthesis of diverse traditions that transcended the classical symphony, ballet, and opera musical forms that originated in Europe.

The American Abroad

As much as New Orleans offered Americans the prospect of a colorfully complex urban atmosphere, the rest of the world also beckoned, available as never before for exploration. Novelist Henry James remarked, "The world is shrinking to the size of an orange." He meant that it had become easy for Americans to travel to and live in London, Paris, and Rome. In fact, by the end of the nineteenth century there were 17 companies with over 173 steamships regularly sailing between New York and Europe. With the advent of steam turbine engines, screw propellers, and steel hulls, it took less than a week to cross the Atlantic. (Fifty years earlier it had taken two to three weeks, and in Benjamin Franklin's time it took from six weeks to three months.)

Another innovation that made international travel even more inviting was the development of ocean liners, ships that measured up to a thousand feet long with lavish accommodations for (some of) its passengers. Ocean liners had three classes of rooms for its customers, with the third or "steerage" class (originally referring to those housed in cargo holds of ships) comprising the greatest number, and the first and second class supplying the majority of profits. European immi-

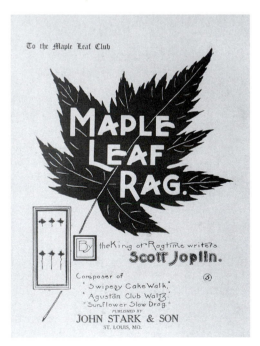

Fig. 38.9 Title page to an early edition of Scott Joplin's *Maple Leaf Rag*. ca. 1899. Joplin received $50 plus royalties for the work.

grants moving westward with dreams of a better life filled the steerage compartments, while newly rich Americans traveled eastward toward Britain and the Continent. In Europe, wealthy Americans, who would sometimes stay for months and years, took in the history and culture, spent their money freely, sometimes married (or dallied with) aristocrats, and generally indulged in behavior that would draw scorn from their more puritanical families and friends as well as from the scandal-seeking press in the United States.

Henry James and the International Novel

Perhaps the best-traveled and most cosmopolitan American writer in the nineteenth century was Henry James (1843–1916). His first years were spent in Paris—his first memory, he claimed, was of the Place Vendome [vahn-DOME] with its Napoleonic column—and he was educated there as well as in Geneva, Switzerland, and Bonn, Germany. American schooling was not up to his father's high standards. On his first European tour, undertaken when he was 26 years of age in 1869–1870, James met the intellectual elite of England: William Morris, Dante Gabriel Rossetti, Edward Burne-Jones, John Ruskin, and Charles Darwin. He then traveled on to Paris, to Switzerland, and from there he hiked into Italy, then on to Milan, Venice, and Rome. He took his aunt and sister on a second tour in 1872–1874, returned to Paris in 1875, meeting writers Gustave Flaubert and Émile Zola among others, and then settled in England in 1876. "My choice is the Old World," he wrote in his diary, "my choice, my need, my life."

James often depicted the drama of American innocence confronting European experience in his novels. In *Portrait of a Lady* (1881), for instance, Isabel Archer, a young woman freed by her inheritance to travel wherever she pleases, follows in James's footsteps to England and France, marrying a morally bankrupt American expatriate. Her relationship with him tests every fiber of her innocence and moral being. In *The Ambassadors*, Lambert Strether is sent to Europe to free Chad Newsome, his fiancée's son, from the perceived clutches of the older, more experienced Madame de Vionnet [vee-oh-NAY]. Yet he himself is transformed by his acquaintance, in London and Paris, with Maria Gostrey, an American émigré, and by Chad's new circle of friends. Over a period of weeks, Strether recognizes that Chad has in fact "improved," gaining new sophistication, and knows that something similar has occurred to himself.

James's prose style is distinctive and not easygoing for many contemporary readers. For example, he is often cited for his tendency to write paragraph-length sentences, which all college students are taught to avoid. The protagonists in his dialogues often circle around their subject rather than state it, as if its meaning is forever just out of their reach, and the same could be said of his elongated sentences. In chapter 11, Strether accidentally meets Chad and Madame de Vionnet at a country inn and finally discovers their relationship is a romantic one (**Reading 38.7**):

READING 38.7 **from Henry James, *The Ambassadors*, Chapter 11 (1903)**

What he saw was exactly the right thing—a boat advancing round the bend and containing a man who held the paddles and a lady, at the stern, with a pink parasol. It was suddenly as if these figures, or something like them, had been wanted in the picture, had been wanted more or less all day and had now drifted into sight, with the slow current on purpose to fill up the measure. . . . The air quite thickened, at their approach, with further intimations; the intimation that they were expert, familiar, frequent—that this wouldn't at all events be the first time. They knew how to do it, he vaguely felt, and it made them but the more idyllic, though at the very moment of the impression, their boat seemed to have begun to drift wide, the oarsman letting it go. It had by this time none the less come much nearer—near enough for Strether to dream the lady in the stern had for some reason taken account of his being there to watch them. . . . She had taken in something as a result of which their course had wavered, and it continued to waver while they just stood off. . . . He too within the minute had taken in something, taken in that he knew the lady whose parasol, shifting as to hide her face, made so fine a pink point in the shining scene. It was too prodigious, a chance in a million, but, if he knew the lady, the gentleman, who still presented his back and kept off, the gentleman, the coatless hero of the idyll, who had responded to her start, was, to match the marvel, none other than Chad.

The manner in which James teases out the last sentence, as if holding the identity of the boatman for as long as the reader can bear it, is characteristic of James. So is the impressionistic description—the way the lady is "a pink point in the shining scene"—so that the reader feels that for all its detail, the vision remains vague. We take an impression, rather than something sharply delineated. Like Emily Dickinson, whose brevity of statement contrasts with James's drawn-out sentences, James approached the world and its people as essentially enigmatic.

Painters Abroad: The Expatriate Vision

Henry James was as socially active as a hardworking writer could be. His network of friends and acquaintances included many British and European artists, as well as dozens of American expatriates. *The Ambassadors* began from a germ of an idea that the author captured in his notebook in October 1895 when he recorded how fellow American author William Dean Howells (1837–1920), standing in a Paris

Fig. 38.10 James Abbott McNeill Whistler. *Nocturne in Black and Gold: The Falling Rocket.* **ca. 1874.** Oil on oak panel, 23³/₄″ × 18³/₈″. The Detroit Institute of Arts. Gift of Dexter M. Ferry, Jr. 46.309. The Bridgeman Art Library. The painting depicts fireworks falling over Cremorne Gardens, the popular resort on the banks of the Thames.

verged on high comedy, as the jury was shown the offending picture upside down, and "experts" of all persuasions testified to the painting's worth. Whistler eventually won but was awarded only a farthing (the least valuable English coin), a far cry from the cost of the legal action, which eventually drove him into bankruptcy.

The painting at the center of the controversy is a kind of radical impressionistic illustration of a sea-side fireworks display, so deeply atmospheric that its subject matter is hard to fathom. Whistler was an admitted **aesthete**—someone who valued art for art's sake, for its beauty not for its content. In an 1890 collection of essays called *The Gentle Art of Making Enemies*, he explained the philosophy behind **aestheticism**:

[Art] should be independent of all clap-trap—should stand alone and appeal to the artistic sense of ear or eye, without confounding this with emotions entirely foreign to it, as devotion, pity, love, patriotism and the like. All these have no kind of concern with it, and that is why I insist on calling my works "arrangements" and "harmonies."

Whistler wanted the public to understand that the painter had a right to alter objective truth in order to conform to his or her own subjective standards of beauty. A work created in this way was not incompetent. It was, rather, of the highest order of art.

Another American painter who spent much of his life in Europe was John Singer Sargent (1856–1924). Born in Florence and trained in Italy and France, Sargent was Whistler's rival, though 22 years his junior. He took Whistler's old studio in London after Henry James convinced the young artist to leave Paris in 1886, and it was there that Sargent did most of his work. Sargent specialized in portraits of the aristocracy and the wealthy, and he was noted for his stylish, bravura brushwork. James and Sargent moved in similar social circles, becoming fast friends after James's review of the 26-year-old painter's work in *Harper's Weekly*.

In the *Harper's* article, James took special note of Sargent's *The Daughters of Edward Darley Boit*, exhibited in Paris at the Salon of 1883 (Fig. **38.11**). The painting depicts the four

garden, sermonized to a young man that he must live to the fullest while young. The Parisian home where the garden was located belonged to American expatriate painter James Abbott McNeill Whistler (1834–1903), who maintained a friendship with James for almost two decades.

The painter had notoriously sued English critic John Ruskin for libel after Ruskin published a scathing review of Whistler's *Nocturne in Black and Gold: The Falling Rocket* (Fig. **38.10**). In his review Ruskin berated the artist for asking "two hundred guineas for flinging a pot of paint in the public's face." The trial

Fig. 38.11 John Singer Sargent. *The Daughters of Edward Darley Boit.* **1882.** Oil on canvas, 87 3/8″ × 87 5/8″. Gift of Mary Louisa Boit, Julia Overing Boit, Jane Hubbard Boit, and Florence D. Boit in memory of their father, Edward Darley Boit, 19.124 Photograph © 2008 Museum of Fine Arts, Boston. The unusual, almost square canvas is probably something of a pun on the "Boit" name since *boîte,* in French, means "box."

daughters of an expatriate patrician couple from Boston, Edwin Darley Boit and Mary Louisa Cushing Boit, in the entry to their apartment in Paris. In the foreground, Julia, the youngest child, aged four, sits on the floor with her doll between her legs. To the left, facing the viewer forthrightly, but gazing just to the viewer's left, is Mary Louisa, aged eight. In the shadows of the doorway, Jane, aged 12, looks directly at us, while Florence, the eldest, aged 14, leans, as if unwilling to cooperate with the painter, against one of two enormous Chinese vases that lend the scene something of an "Alice in Wonderland" effect.

James first described this painting as "a rich, dim, rather generalized French interior (the perspective of a hall with a shining floor, where screens and tall Japanese vases shimmer

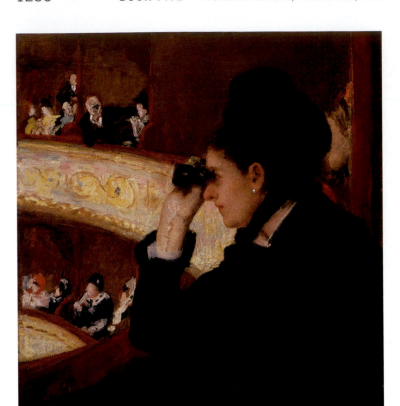

Fig. 38.12 Mary Stevenson Cassatt. *In the Loge*. 1879. Oil on canvas, 32″ × 26″. Museum of Fine Arts, Boston. The Hayden Collection - Charles Henry Hayden Fund, 10.35. Photograph © Museum of Fine Arts, Boston. This was the first of Cassatt's Impressionist paintings to be displayed in the United States. American critics thought the picture a promising sketch, but not, as the Impressionist Cassatt intended, a finished painting.

and loom), which encloses the life and seems to form the happy play-world of a family of charming children." But gradually he perceived in this work the same mysterious depth that he tried to convey in his own fiction—"the sense," he called it, "of assimilated secrets." At least at some level, the painting is a parable of the coming of age of young women in late nineteenth-century society, from the innocence of youth to the privacy and alienation of adolescence. As in James's fiction, there is always more than meets the eye, and this is the lesson that James continually impressed upon Americans who traveled or lived abroad.

One of the most successful of the American expatriate painters was Mary Cassatt, who moved to Paris in 1874 and was befriended by one of the founders of Impressionism, Edgar Degas. Participating in the Impressionist exhibitions in 1879, 1880, and 1881, Cassatt was a figure painter, concentrating almost exclusively on women in domestic and intimate settings. Among her most famous works are paintings of women at the Paris Opéra. *In the Loge* is a witty representation of

Opéra society (Fig. **38.12**). A woman respectfully dressed all in black peers through her binoculars in the direction of the stage. Across the way, a gentleman in the company of another woman leans forward to stare through his own binoculars in the direction of the woman in black. Cassatt's woman, in a bold statement, becomes as active a spectator as the male across the way. Cassatt continually explored new styles and methods of painting. She even created a series of colored lithograph prints in 1891 inspired by Japanese woodblock prints that had also influenced Degas, Renoir, van Gogh, Monet, and many other European artists (see Fig. 37.28).

Chicago and the Columbian Exposition of 1893

An influential artist in Europe and America, Mary Cassatt played an integral part in the 1893 Columbian Exposition (an early world's fair) in Chicago to which she contributed a large mural entitled *Modern Woman* for the Hall of Honor in the Woman's Building. The exposition marked the four-hundredth anniversary of the arrival of Christopher Columbus in the Americas, after Congress selected Chicago as the site for a massive exhibit that demonstrated the economic, technological, and cultural progress of the country. Chicago was a logical choice, since it had grown from a village of 250 people in 1833 to the nation's second-largest city in 60 years with a population of almost one million, most of them foreign-born. West Coast cities like San Francisco, though also growing swiftly in population, were still too rough, too much like frontier towns, to make the right impression (see *Voices*, page 1238).

Cassatt designed her mural as an allegorical triptych (three-paneled work of art). The left and right panels depicted *Young Girls Pursuing Fame* and *Arts, Music, Dancing*. She represented the allegorical figure of Fame as a flying female figure, her nudity emblematic of the necessity of abandoning conventional social constraints. Three girls chase Fame, and a gaggle of geese chase them in turn. The three self-confident and assured women at the other side of the central panel demonstrated that women are accomplished in their own right, not just the creative muses of men.

The central panel, entitled *Young Women Plucking the Fruits of Knowledge or Science*, drew the most attention. Here Cassatt offers a positive reinterpretation of the theme of Eve in the Garden of Eden, as women pass on knowledge, imaged as fruit, from one generation to the next. Although the mural does not survive, we know it from reproductions in contemporary periodicals (Fig. 38.13). In *Gathering Fruit*, a print from the same era as the mural, Cassatt combined the primary theme of the central panel with a baby, an element from the mural's border, which was decorated with several plump infants (Fig. **38.14**).

Fig. 38.13 **Mary Stevenson Cassatt.** *Modern Woman,* **central panel, in the Hall of Honor, Woman's Building, World's Columbian Exposition, Chicago, 1893 (destroyed).** Mural, 13′ × 58′. Reproduced in *Harper's New Monthly Magazine,* Vol. 86, Issue 516, May 1893, p. 837. At the opposite end of the Hall of Honor was a mural entitled *Primitive Woman,* painted by Mary Fairchild Macmonnies, an American artist who had moved to Paris in 1888 and spent each summer near Monet at Giverny.

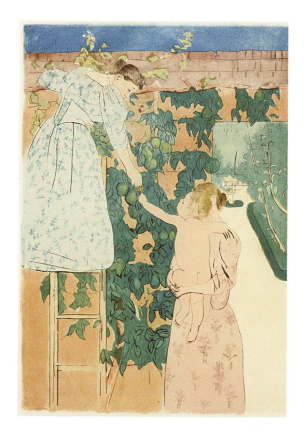

Fig. 38.14 **Mary Stevenson Cassatt.** *Gathering Fruit.* **ca. 1893.**
Drypoint, softground etching, and aquatint printed in color from three plates, 16⅞″ × 15⅜″. Gift of William Emerson and The Hayden Collection—Charles Henry Hayden Fund, 41.813. Photograph © 2008 Museum of Fine Arts, Boston. This is one of several prints by Cassatt related to the theme of the Hall of Honor mural.

Cassatt's murals coincided with the early development of the women's movement in America and Europe. The 1878 International Congress of Women's Rights, held in Paris, advocated for free and compulsory education for women through secondary school, a measure that the French in fact implemented in the 1880s. The meeting also focused on the important role women play in nurturing and educating their children—the theme, indeed, of Cassatt's central panel at the Chicago Exposition and one that she would paint continuously in her domestic scenes of mothers tending their children.

As plans for the Columbian Exposition were being made, the all-male World's Columbian Commission appointed a "Board of Lady Managers," headed by a Chicago socialite, to design a building where women could meet at the fair. When it became apparent that women would have difficulty exhibiting elsewhere, the project was transformed into the pavilion where Cassatt's painting and other women's artwork was displayed. Designed by the first female graduate of the Massachusetts Institute of Technology to earn a degree in architecture,

Voices

Saturday Night in San Francisco

In the 1860s and 1870s, California and its largest city, San Francisco, were growing, spurred by new discoveries of silver and gold, the building of the transcontinental railroad, and the expansion of such profitable and long-lasting businesses as Wells Fargo, Levi Strauss, and others. Albert S. Evans, a visitor from New Hampshire, provides an atmospheric tour of the Barbary Coast (nowadays covering parts of Chinatown, North Beach, and the Financial district) on an evening in 1871:

It is Saturday evening, in the middle of the rainy season, when no work is doing upon the ranches, and work in the placer mines is necessarily suspended, and the town fairly swarms with "honest miners" and unemployed farmhands, who have come down from the mountains and "the cow counties" to spend their money, and waste their time and health in "doing" or "seeing life" in San Francisco. The Barbary Coast is now alive with "jay-hawkers" [thieves], "short-card sharps," "rounders," pickpockets, prostitutes and their assistants and victims; we cannot find a better night on which to pay a visit to the locality. Half a dozen of us, more or less, make up the party, and we start out. The evening is pleasant, and Montgomery and Kearny streets are filled with the beauty, fashion, and wealth of San Francisco. A military company, in brilliant uniform, with a full and very superior band, returning from a target excursion, pass up the street, attracting the attention of the throng for a moment; and then come, in turn, a party of horsemen and horsewomen, gaily mounted, coming in from the Cliff House at Point Lobos, or just starting out for a night-ride, who dash down the street at a gallop, are glanced at, criticised, and forgotten.

> **"The Barbary Coast is now alive with 'jay-hawkers' [thieves] , 'short-card sharps,' 'rounders,' pickpockets, prostitutes and their assistants and victims. . ."**

Three men come up the street as we stand on the sidewalk looking and listening, and two of them eye our friend the policeman uneasily as they pass. These two are unmistakably of the Algerine pirate class, and the third evidently a middle-aged greenhorn from the mining country. The officer comprehends the situation at a glance, and stepping forward, says emphatically, "Look here, Jack; I told you once before to get out of the jayhawking [thieving] business, and not let me catch you on the Coast again. And you, Cockeye; when did you come back from over the Bay? I'll bag you both, as sure as I'm a living man, if I catch either of you on my beat again." The young fellows slink away without a word, like renegade curs caught in the act of killing sheep, and the officer addresses himself to their intended victim. "Look here, old fellow; those fellows picked you up at the wharf, or around the What Cheer, and pretended they used to know you at home. They are two State Prison thieves, and would have robbed you before daylight, sure. Now, you go back to your hotel, put your money in the safe, and go to bed, or I'll lock you up for a drunk; do you hear?" The countryman stares a moment with blank astonishment, and then, with many thanks, tells the officer just what the latter had already told him, and leaves the Barbary Coast in all haste.

Sophia Hayden (1868–1953), the two-story Women's Building was of Neoclassical design, with a central arcade flanked by pavilions at each end and a two-story pediment over the main entrance (Fig. **38.15**). Hayden, sadly, would never design another building. Constant interference by the all-male Board of Architects, a meager budget, and confused guidance led to a nervous breakdown and Hayden's withdrawal from her profession.

The fair was situated on 700 acres of swampland at the edge of Lake Michigan planned to resemble a Venetian park, complete with waterways and gondolas. Like all of the other buildings, the Woman's Building was steel-framed, with its plaster-of-Paris facade painted white, an effect that lent the fairgrounds their nickname—the White City. It was a white city in more ways than one. Although African Americans tried mightily to be represented at the fair, actively seeking membership on the planning committees and employment at its venues, they were systematically excluded from participation. They could attend the fair only on select days, even though on the mile-long Midway Plaisance [play-ZAHNSS] the fair's official Department of Ethnology created simulated African, Laplander, Turkish, Chinese, Pacific Island, and Japanese villages. Men from Dahomey [dah-HOH-may] populated the African village, brought to the fair by an eccentric French entrepreneur. Other indigenous peoples from America, Asia, and North Africa were also included in this "outdoor museum" of "primitive peoples." (Such ethnographic exhibits were already standard at European world fairs.) Frederick Douglass, appalled by the fair's segregationist admission policies, its indifference to African American job-seekers, and its representation of "the Negro as a repulsive savage," joined Ida B. Wells in writing a scathing review of the exposition, "The Reason Why the Colored American Is Not in the World's Columbian Exposition."

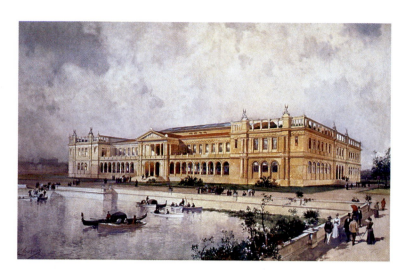

Fig. 38.15 Charles Graham. *Sophia Hayden's Woman's Building,* World's Columbian Exposition, Chicago. 1893. Watercolor, 17″ × 27½″. The Granger Collection, New York. Graham included a gondola in the lake to express the fair's Venetian theme.

Louis Sullivan and the Chicago School of Architecture

One of the main reasons Chicago was so attractive as a venue for the Columbian Exposition was the sheer volume and impressiveness of its original, contemporary architecture. Ironically, the origin of the city's vast expanse of modern buildings was due to a catastrophic accident. On Sunday evening, October 8, 1871, a fire began in the cow barn at the rear of the Patrick O'Leary cottage on Chicago's West Side. By midnight the city's business district was in flames. By Monday evening, as rains helped to douse the blaze, 300 residents of Chicago were dead, 90,000 homeless, and the property loss was estimated at $200 million. The entire central business district of Chicago was leveled.

While devastating, the fire also contributed substantially to Chicago's economic boom as the city raced to rebuild. This provided an extraordinary opportunity for architectural innovation. Four factors contributed to what became known as the Chicago School of architecture. First, there was an urgent need to rebuild with fireproof materials. Second, Chicago was a world leader in the manufacture and production of steel. Third, the hydraulic elevator was invented the same year as the fire. And fourth, there was a growing conviction that because land in the downtown district was so expensive, buildings should be built higher.

Until the 1880s, the height of buildings was restricted to 10 stories because of the structural limitations of masonry-bearing walls, even with cast iron built into them. The solution was metal-frame construction, first developed for building bridges in

Continuity & Change
p. 912

Iron Bridge

England (see Fig. 28.9). The frame supported the entire load of the building, with the **curtain wall** (a non-load-bearing wall applied to keep out the weather) carried on the structural skeleton. In Chicago, where the bearing capacity on soil at the edge of Lake Michigan was extremely poor and could not support the weight of a brick building over 10 stories high, the lightness of iron and then steel-frame construction became a driving force in rebuilding the downtown after the great fire of 1871.

Iron- and steel-frame construction also opened the curtain wall to ornamentation and large numbers of exterior windows. One of the leading proponents of this new method of design and construction was the Chicago architect Louis H. Sullivan (1856–1924). For Sullivan, the building's identity lay in its ornamentation. As he put it in his satirically titled 1901–1902 *Kindergarten Chats,* ornamentation was the "spirit" that enhanced the architectural idea. Inorganic, rigid, and geometric lines of the steel frame would flow through the ornamental detail that covered it into "graceful curves," and angularities would "disappear in a mystical blending of surface." So at the top of Sullivan's Bayard Building in New York, the vertical columns that rise between the windows blossom in an explosion of floral decoration (Fig. **38.16**).

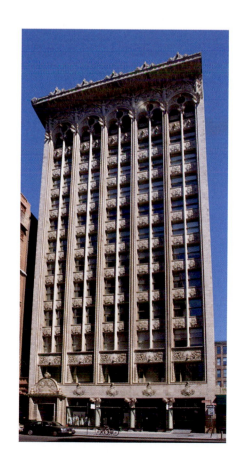

Fig. 38.16 Louis H. Sullivan. Bayard (Condict) Building, New York. 1897–1898. For Sullivan, the foremost problem that the modern architect had to address was how the building might transcend the "sinister" urban conditions out of which, of necessity, it had to rise.

Such ornamentation might seem to contradict the aphorism that Sullivan is most famous for: "Form follows function." If the function of the urban building is to provide a well-lighted and ventilated place in which to work, then the steel-frame structure and the abundance of windows on the building's facade make sense. But how does the ornamentation follow from the structure's function?

Down through the twentieth century, Sullivan's original meaning has largely been forgotten. He was not promoting a notion of design akin to the sense of practical utility found in the first mass-produced automobile, the Model T Ford. For Sullivan, "the function of all functions is the Infinite Creative Spirit," and it could be revealed in the rhythm of growth and decay that we find in nature. Thus the elaborate organic forms that cover his buildings were intended to evoke nature and the creative impulse. For Sullivan, the primary function of a building was to elevate the spirit of those who worked in it. No architect would have a greater influence on modern architecture in the twentieth century. He is at once the father of the skyscraper, and, perhaps most important, the teacher of one of the twentieth century's most influential architects, Frank Lloyd Wright.

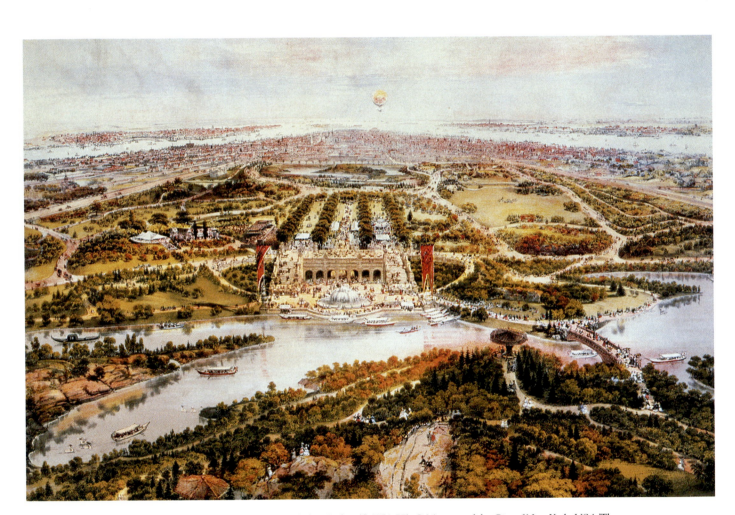

Fig. 38.17 John Bachman. *View of Central Park.* **ca. 1870.** Colour Litho. (fl.1850-77). © Museum of the City of New York, USA/The Bridgeman Art Library. Frederick Law Olmsted and Calvert Vaux designed the park, and construction began in 1857. For Olmsted, the park was an educational environment in which poor immigrants could mingle freely with the upper classes and learn how to properly "comport" themselves.

Frederick Law Olmsted and the Invention of Suburbia

Sullivan's buildings reflect the same motivation that inspired the parks movement inaugurated by Central Park in New York City and other parks throughout the country—the desire to bring the spirit of nature to the urban environment. In order to allow the rapidly growing population to escape the rush of urban life, New York City in 1856 acquired an 840-acre tract of land for a park in the still largely undeveloped regions north of 59th Street. It hired Frederick Law Olmsted [OLM-sted] (1822–1903) and Calvert Vaux [voh] (1824–1895) to effect the transformation (Fig. **38.17**). The two men modeled what is now known as Central Park on the English garden (see chapter 29) with, in Olmsted's words, "gracefully curved lines, generous spaces, and the absence of sharp corners, the idea being to suggest and imply leisure, contemplativeness, and happy tranquility." Here, immigrants from the hundreds of blocks of tenement housing in Manhattan could stroll side by side with the wealthy ladies and gentlemen whose homes lined Fifth Avenue facing the park. Sheep grazed in one area of the park, and in another, the Dairy, children could sip milk fresh from the cows that grazed nearby. In this artificial rural environment city dwellers could forget that they were even *in* the city.

So successful was Central Park that, in 1866, Olmsted and Vaux collaborated on the design of Prospect Park, across the East River, in Brooklyn (see Fig. 38.6). And after Vaux's dissolution of their partnership in 1872, Olmsted went on to design many other public commons, including South Park in Chicago, the parkway system of the City of Boston, Mont Royal in Montreal, and the grounds at Stanford University and the University of California at Berkeley. Moreover, Olmsted was able to foresee that the increasing population density of cities required the growth of suburbs, a residential community within commuting distance of the city. "When not engaged in business," Olmsted wrote, "[the worker] has no occasion to be near his working place, but demands arrangements of a wholly different character. Families require to settle in certain localities which minister to their social

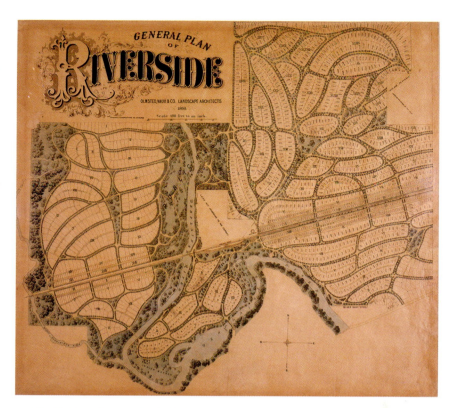

Fig. 38.18 Olmsted, Vaux, & Co., landscape architects. General plan of Riverside, Illinois. 1869. Francis Loeb Library, Graduate School of Design, Harvard University. In the Preliminary Report for Riverside, Olmsted remarks, "The city [of Chicago] as yet has no true suburb in which rural and urban advantages are agreeably combined."

and other wants, and yet are not willing to accept the conditions of town-life . . . but demand as much of the luxuries of free air, space and abundant vegetation as . . . they can be enabled to secure."

As early as 1869, Olmsted and Vaux laid out a general plan for the city of Riverside, Illinois, situated nine miles outside Chicago and one of the city's first suburbs (Fig. **38.18**). The plan incorporated the railroad as the principal form of transportation into the city, making it one of the very first commuter suburbs in America. The plan provided for the best-engineered streets of the time, with cobblestone gutters for proper drainage, sewers, water lines, gas lines, and gas street lamps. Olmsted strove to create a communal spirit by subdividing the site into small "village" areas linked by drives and walks, all intended to have "the character of informal village greens, commons and playgrounds." Together with Forest Hills in New York, Llewellyn Park in New Jersey, and Lake Forest, also outside Chicago, Olmsted's design for Riverside set the standard for suburban development along with a new pattern of living for Americans.

READINGS

from Walt Whitman, "Song of Myself," in *Leaves of Grass* (1867)

From the time of its first edition in 1855, Leaves of Grass constantly changed over the course of Whitman's lifetime. Its many revisions and additions reflect the changing course of American democracy, including the tragedy of the Civil War, the expansion of the nation into the West, and the industrialization of the eastern seaboard. At the center of the book is Whitman's "Song of Myself." It consists of 52 parts, reflecting the 52 weeks of the year. In the following passages, something of the range of Whitman's vision can be understood: his individualism in part 1, his sexuality in part 2, the development of his central metaphor, the grass, in part 6, and his all-encompassing inclusiveness in part 15.

1

I CELEBRATE myself, and sing myself,
And what I assume you shall assume,
For every atom belonging to me as good belongs to you.

I loafe and invite my soul,
I lean and loafe at my ease observing a spear of summer grass.

My tongue, every atom of my blood, form'd from this soil, this air,
Born here of parents born here from parents the same, and their parents the same,
I, now thirty-seven years old in perfect health begin, 10
Hoping to cease not till death.

Creeds and schools in abeyance,
Retiring back a while sufficed at what they are, but never forgotten,
I harbor for good or bad, I permit to speak at every hazard,
Nature without check with original energy.

2

Houses and rooms are full of perfumes, the shelves are crowded with perfumes,
I breathe the fragrance myself and know it and like it,
The distillation would intoxicate me also, but I shall not let it. 20

The atmosphere is not a perfume, it has no taste of the distillation, it is odorless,
It is for my mouth forever, I am in love with it,
I will go to the bank by the wood and become undisguised and naked,
I am mad for it to be in contact with me. . . .

6

A child said *What is the grass?* fetching it to me with full hands,
How could I answer the child? I do not know what it is any more than he. 30

I guess it must be the flag of my disposition, out of hopeful green stuff woven.

Or I guess it is the handkerchief of the Lord,
A scented gift and remembrancer designedly dropt,
Bearing the owner's name someway in the corners, that we may see and remark, and say *Whose?*

Or I guess the grass is itself a child, the produced babe of the vegetation.

Or I guess it is a uniform hieroglyphic,
And it means, Sprouting alike in broad zones and narrow zones, 40
Growing among black folks as among white,
Kanuck, Tuckahoe, Congressman, Cuff, I give them the same, I receive them the same.

And now it seems to me the beautiful uncut hair of graves. . . .
All goes onward and outward, nothing collapses,
And to die is different from what any one supposed, and luckier. . . .

15

The pure contralto sings in the organ loft,
The carpenter dresses his plank, the tongue of his foreplane 50
whistles its wild ascending lisp,
The married and unmarried children ride home to their Thanksgiving dinner,
The pilot seizes the king-pin, he heaves down with a strong arm,
The mate stands braced in the whale-boat, lance and harpoon are ready,
The duck-shooter walks by silent and cautious stretches,
The deacons are ordain'd with cross'd hands at the altar,
The spinning-girl retreats and advances to the hum of the 60
big wheel,
The farmer stops by the bars as he walks on a First-day loafe and looks at the oats and rye,

The lunatic is carried at last to the asylum a confirm'd case,
(He will never sleep any more as he did in the cot in his
 mother's bedroom;)
The jour printer with gray head and gaunt jaws works at his
 case,
He turns his quid of tobacco while his eyes blurr with the
 manuscript; 70
The malform'd limbs are tied to the surgeon's table,
What is removed drops horribly in a pail;
The quadroon girl is sold at the auction-stand, the drunkard
 nods by the bar-room stove,
The machinist rolls up his sleeves, the policeman travels his
 beat, the gate-keeper marks who pass,
The young fellow drives the express-wagon, (I love him,
 though I do not know him;)
The half-breed straps on his light boots to compete in the race,
The western turkey-shooting draws old and young, some 80
 lean on their rifles, some sit on logs,
Out from the crowd steps the marksman, takes his position,
 levels his piece;
The groups of newly-come immigrants cover the wharf or levee,
As the woolly-pates hoe in the sugar-field, the overseer
 views them from his saddle,

The bugle calls in the ball-room, the gentlemen run for their
 partners, the dancers bow to each other,
The youth lies awake in the cedar-roof'd garret and harks to
 the musical rain, 90
The Wolverine sets traps on the creek that helps fill the Huron,
The squaw wrapt in her yellow-hemm'd cloth is offering
 moccasins and bead-bags for sale,
The connoisseur peers along the exhibition-gallery with
 half-shut eyes bent sideways. . . .

The city sleeps and the country sleeps,
The living sleep for their time, the dead sleep for their time,
The old husband sleeps by his wife and the young husband
 sleeps by his wife;
And these tend inward to me, and I tend outward to them, 100
And such as it is to be of these more or less I am,
And of these one and all I weave the song of myself. ■

Reading Question

In the selection from part 6, Whitman refers to the grass as
"the flag of my disposition, out of hopeful green stuff woven."
How does part 15 develop that sentiment?

READING 38.5

from Emily Dickinson, *Poems* (as published in *The Complete Poems of Emily Dickinson*, ed. T. H. Johnson, 1953)

Dickinson wrote almost 2,000 poems in her lifetime. It was not until 1953 that all of her known poems were published—and for the first time as she wrote them, without editorial changes. The following three poems circulate around the theme of death, that greatest of all enigmas. Even in so small a selection they give a fair idea of the scope of her mind.

465

I heard a Fly buzz—when I died—
The Stillness in the Room
Was like the Stillness in the Air—
Between the Heaves of Storm—

The Eyes around—had wrung them dry—
And Breaths were gathering firm
For that last Onset—when the King
Be witnessed—in the Room—

I willed my Keepsakes—Signed away
What portion of me be 10
Assignable—and then it was
There interposed a Fly—

With Blue—uncertain stumbling Buzz—
Between the light—and me—

And then the Windows failed—and then
I could not see to see—

712

Because I could not stop for Death—
He kindly stopped for me—
The Carriage held but just Ourselves—
And Immortality. 20

We slowly drove—He knew no haste
And I had put away
My labor and my leisure too,
For His Civility—

We passed the School, where Children strove
At Recess—in the Ring—
We passed the Fields of Gazing Grain—
We passed the Setting Sun—

Or rather—He passed Us—
The Dews drew quivering and chill— 30
For only Gossamer, my Gown—
My Tippet—only Tulle—

We paused before a House that seemed
A Swelling of the Ground—
The Roof was scarcely visible—
The Cornice—in the Ground—

Since then—'tis Centuries—and yet
Feels shorter than the Day
I first surmised the Horses' Heads
Were toward Eternity – 40

754

My Life had stood—a Loaded Gun—
In Corners—till a Day
The Owner passed—identified—
And carried Me away—

And now We roam in Sovereign Woods—
And now We hunt the Doe—
And every time I speak for Him—
The Mountains straight reply—

And do I smile, such cordial light
Upon the Valley glow— 50
It is as a Vesuvian face
Had let its pleasure through—

And when at Night—Our good Day done—
I guard My Master's Head—
'Tis better than the Eider-Duck's
Deep Pillow—to have shared—

To foe of His—I'm deadly foe—
None stir the second time—
On whom I lay a Yellow Eye—
Or an emphatic Thumb— 60

Though I than He—may longer live
He longer must—than I—
For I have but the power to kill,
Without—the power to die— ■

Reading Question

One of Dickinson's preferred thematic forms was the riddle. How do these three poems reflect that preference?

Summary

■ **Walt Whitman's America** As New York City grew to over 3 million people in the last decades of the nineteenth century, poet Walt Whitman celebrated the city's as well as the nation's sense of energy, excitement, and unlimited possibility. As his often-updated volume *Leaves of Grass* grew in the decades between 1855 and 1892, Whitman continued to embrace all aspects of the Gilded Age in his country, both good and bad. The quintessential New Yorker, he fully recognized the corruption that characterized New York's Tammany Hall and the plight of the working class, which in 1877 erupted in a series of strikes across the country, precipitated by economic depression and wage cutbacks.

Women of the era continued to be disenfranchised, but they did make gains, as state-run schools trained women as teachers and nurses. In the last decades of the century, women became one of the favorite subjects of male American painters, who generally represented them as passive and removed from the real business of American culture. Women often made significant individual contributions to the culture, in the arts as well as in the fledgling women's rights movement. Emily Dickinson's poetry, although little known in her lifetime, was widely read and admired by century's end. But whenever women challenged their traditional place in American society, as Kate Chopin did in her novel exploring a woman's marital infidelity, *The Awakening*, they were harshly criticized.

■ **Ragtime and the Beginnings of Jazz** New Orleans by the end of the century was one of the nation's most cosmopolitan cities. In the city's bars and dance halls, at its political rallies, weddings, and funerals, a new kind of music developed that has come to be known as jazz. Characterized by a steady rhythm that plays off against a rhythmic syncopation, its first manifestation was in the ragtime piano music popularized by Scott Joplin. In the minds of many Americans, the loose rhythms of ragtime were equated with loose morals, but ragtime—and later jazz—represented a new, authentic form of American expression.

■ **The American Abroad** Many Americans, seeking to escape the perceived hypocrisy and limitations of the Gilded Age, traveled to Europe for lengthy sojourns. The novelist Henry James was the most famous of these, and his novels detail the experiences of Americans abroad. He was friendly with many expatriate painters, including James McNeill Whistler and John Singer Sargent. Whistler valued art for art's sake, for its beauty, not its content. Sargent specialized in portraiture, but he often found ways to lend his subjects a mysterious quality that hinted at similar uncertainties in the works of Henry James. Another important expatriate painter of the day was Mary Cassatt, who exhibited with the Impressionists in Paris. Specializing in domestic scenes and Parisian society, Cassatt grew as an artist throughout her long and productive career.

■ **Chicago and the Columbian Exposition of 1893** Cassatt advocated that women take an equal place in modern society alongside men. In 1892 she created a large mural entitled *Modern Woman* for the Woman's Building at the Columbian Exposition in Chicago. Its central panel depicted *Young Women Plucking the Fruit of Knowledge or Science*, and it spoke to Cassatt's dedication to women's education and advancement. Sophia Hayden, the first female graduate of the Massachusetts Institute of Technology to earn a degree in architecture, designed The Woman's Building.

Part of what attracted the fair's organizers to Chicago was its advanced architecture, represented particularly in the skyscrapers of Louis Sullivan. Sullivan used metal-frame construction to create structural skeletons that could be faced with light curtain walls, thus opening the facade of the building to ornamentation. Sullivan's love of ornamentation, in which he believed rested the true "spirit" of architecture, was reflected in the parks movement inaugurated by Frederick Law Olmsted and Calvert Vaux in New York's Central Park, begun in 1857. Olmsted and Vaux also designed Riverside, Illinois, one of the very first commuter suburbs in the nation, creating a parklike city with "informal village greens, commons and playgrounds."

Glossary

aesthete One who values art for art's sake, for its beauty rather than its content.

aestheticism A devotion to beauty in art.

curtain wall A non-load-bearing wall applied in front of a framed structure, often for decorative effect.

free-verse Poetry based on irregular rhythmic patterns as opposed to conventional meter.

jazz A uniquely American form of music characterized by a steady rhythm that plays itself off against a rhythmic accentuation of the "off-beats."

ragtime A type of music in which the musician takes a classical or popular melody and plays it in a syncopated way; see syncopation.

syncopation The accentuation of "off-beats."

 Critical Thinking Questions

1. What characteristics make jazz a uniquely American type of music?

2. How do the contrasting styles and content of Whitman's and Dickinson's verse define the American culture of their era?

3. Based on their life and works, why do you think Henry James, James McNeill Whistler, Mary Cassatt, and John Singer Sargent chose to be expatriates?

4. Summarize the ideal of America as exhibited at the Columbian Exposition. Do the buildings of Sullivan and the parks of Olmstead help to express this ideal?

The "Frontier Thesis" of Frederick Jackson Turner

Continuity & Change

Coinciding with the Columbian Exposition of 1893 was the American Historical Association's yearly convention, where Frederick Jackson Turner (1861–1932) presented one of the most influential essays on the American West ever written. Entitled "The Significance of the Frontier in American History," Turner argued that the frontier was "the meeting point between savagery and civilization." He further contended that "the existence of an area of free land, its continuous recession, and the advance of American settlement westward explain American development." Twenty years earlier, painter John Gast had essentially illustrated this argument in his widely popular painting *American Progress* (Fig. **38.19**). As trains, a covered wagon, a stagecoach, riders, miners, trappers, and farmers push westward driving bear, buffalo, and Indians before them, the frontiersmen are inspired by the allegorical figure of Progress. So when, in 1890, the U.S. Census Bureau proclaimed the frontier closed, Turner understood that a defining era in American history had passed. The frontier, according to Turner, had produced a "dominant individualism," men "of coarseness and strength . . . acuteness and inquisitiveness, [of a] practical and inventive turn of mind . . . [with] restless and nervous energy . . . [and the] buoyancy and exuberance which comes with freedom." From the beginning, he continued, this "frontier individualism . . . promoted democracy." Yet he also warned that

the democracy born of free land, strong in selfishness and individualism, intolerant of administrative experience

and education, and pressing individual liberty beyond its proper bounds, has its dangers as well as its benefits. Individualism in America has allowed a laxity in regard to governmental affairs which has rendered possible the spoils system and all the manifest evils that follow from the lack of highly developed civic spirit. In this connection may be noted also the influence of frontier conditions in permitting lax business honor, inflated paper currency and wildcat banking. . . . He would be a rash prophet who should assert that the expansive character of American life has now entirely ceased . . . [but] now, four centuries from the discovery of America, at the end of a hundred years of life under the Constitution, the frontier has gone, and with its going has closed the first period of American history.

Turner ignored the important role women played in settling the West, the role of slave labor in creating a productive economy, and perhaps most of all, the price Native Americans paid for the "free" land that Americans claimed as their own. Nevertheless, even as Buffalo Bill was performing his "Wild West Show" to tens of thousands of people just outside the Columbian Exposition's gates, Turner had articulated the seminal American myth. True or false, his "frontier thesis" affirmed the role that most people thought individualism would have to play if the nation were to continue to progress forward and meet the challenges of its increasing global presence. ■

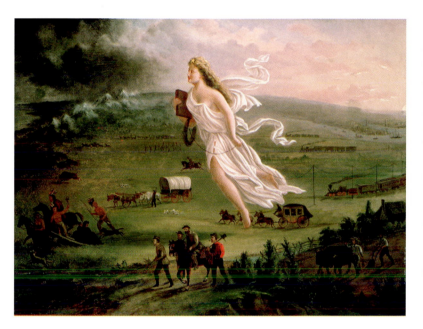

Fig. 38.19 John Gast. *American Progress*. 1872. Oil on canvas, 20¼″ × 30¼″. (fl.1872). Private Collection. Photo © Christie's Images/The Bridgeman Art Library. The allegorical figure of Progress unravels telegraph wire as Indians and buffalo flee before her. At the right is Manhattan Island, the twin towers of the Brooklyn Bridge just visible over the East River. Construction on the suspension bridge, designed by engineer John Augustus Roebling, had begun in 1869 but would not be completed until 1883.

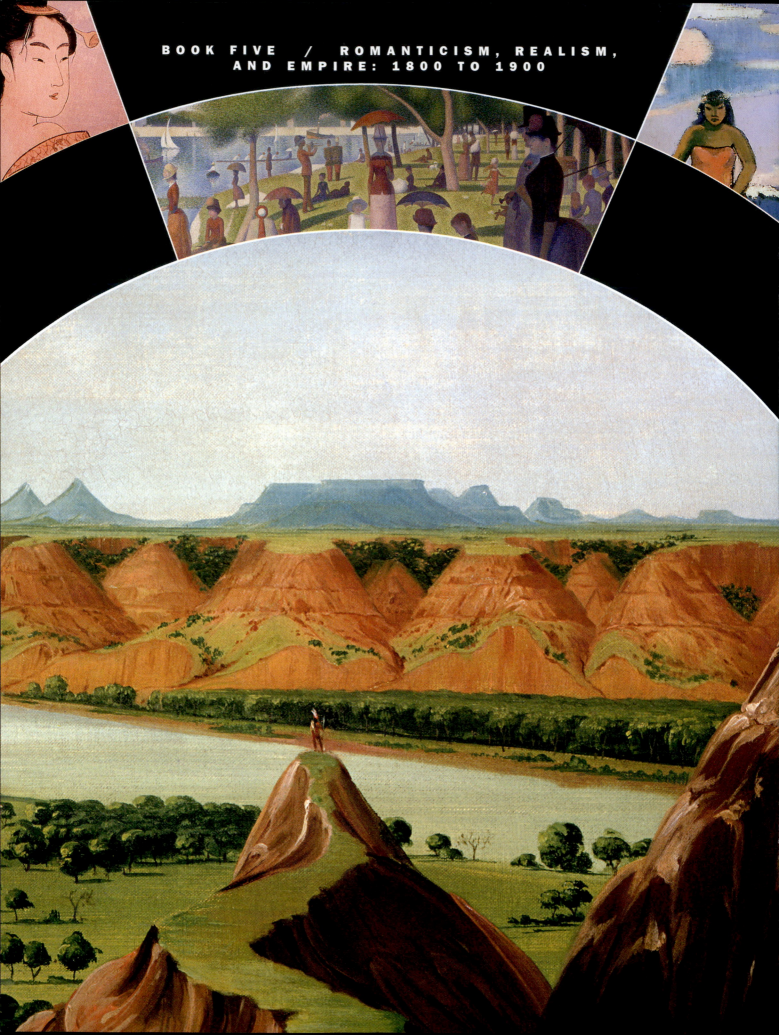

39 Global Confrontations

The Challenge to Cultural Identity

The Native American in Myth and Reality

The British in China and India

The Opening of Japan

Africa and Empire

❝ *. . . we will, imitating the clemency of Heaven, Who tolerates all sorts of fools on this globe, condescend to allow a limited amount of trading through the port of Canton.* **❞**

Chinese emperor Ch'ien-lung in a letter to
King George III of England

◄ **Fig. 39.1 George Catlin.** *Big Bend on the Missouri River, 1,900 Miles above St. Louis,* **detail. 1832.** Oil on canvas, 29″ × 24″. Smithsonian American Art Museum, Washington, DC / Art Resource, NY. 1985.66.390. The Big Bend is some 30 miles southeast of present-day Pierre, South Dakota. Catlin was one of the first artists to capture the vast expanses of the Louisiana Purchase and to document the peoples of the region, whose way of life, he very well understood, was doomed by the advance of a civilization he himself represented.

BEFORE THOMAS JEFFERSON PURCHASED THE LOUISIANA Territory from the French in 1803, it would not have occurred to the Native Americans who inhabited the region (see Map **39.1**) that it was either France's to sell or Jefferson's to buy. This massive expanse of land extending from Canada to the Gulf

of Mexico and from the Mississippi River to the Rocky Mountains cost Jefferson a mere $15 million, or about four cents an acre. The nation's third president had effectively doubled the size of the United States of America and greatly accelerated the opening of the Western frontier, which now extended to the Pacific coast. In setting the stage for the ensuing century of expansion, Jefferson was only dimly aware of the hundreds of Native American tribes that would be obliterated or forever changed as European-American settlers moved westward, staking their claim on the "empty" land (Fig. **39.1**).

The true extent of the devastation of Native American cultures was little understood at the time because invisible microbes that spread infectious diseases for which indigenous peoples had no immunity caused much of the damage. So too, the brutal nineteenth-century policy of "Indian Removal," the subsequent Indian Wars, and attempts to "civilize" Native Americans stemmed from the lack of awareness by Americans like Jefferson and his successors of the ancient

preliterate cultures of indigenous Americans. Yet much of America's nineteenth-century westward growth was driven by the desire for land and the determination to prevail over any obstructions posed by indigenous peoples, whether through legal means (agreements and treaties) or extralegal methods (ignoring those same treaties and agreements). And so the North American conflicts between Natives and Europeans echoed the global encounters between Western and non-Western cultures in the nineteenth century in which the West's aggressive military and economic policies combined with unintended consequences to produce momentous historical changes.

Revitalized by effective new military, communication, and naval technologies, Western nations sought to expand their influence and reap new economic and political power in far-distant lands during the nineteenth century. This chapter will explore the confrontation of Western civilization with the cultures of others whose values were often dramatically opposed to those of Western cultures. It suggests that by the dawn of the twentieth century the tradition and sense of centeredness that had defined indigenous cultures for hundreds, even thousands, of years was either threatened or in the process of being destroyed. Worldwide, non-Western cultures faced fundamental challenges to their cultural identities—not so much a *recentering* of culture but a *decentering* of culture.

In China, what had been the world's richest economy was increasingly dependent on manufacturing goods for export to Western countries, and a war instigated by England further damaged the economy. Soon large numbers of poor Chinese accepted the prospect of long periods of indentured servitude in both the United States and the Caribbean in order to survive. India's manufacturing economy had also been overwhelmed by British exploitation of its resources, coupled with an increased emphasis on low-cost exports that offered little profit. As with its Chinese neighbor, millions of people from the Indian subcontinent accepted indentured servitude in foreign lands. Japan, which had been closed to trade with the West and to almost all international contact since the 1630s, was forced to open its ports in 1854 when the U.S. Navy threatened military action. Japan subsequently underwent a rapid process of industrialization, even as it found ways to protect its cultural traditions. While the Japanese enthusiastically engaged in "Westernization," fasci-

Map 39.1 Major Native American tribes of the West.

nated by the technological progress and artistic accomplishments of Europe and America, Westerners were similarly captivated by Japan's ancient cultural traditions, from woodblock prints to silk fans.

In Africa, European countries vied with one another for control of the continent, motivated by both a sense of their own superiority to African peoples and competition for the region's vast natural resources. Large numbers of Africans worked in the diamond mines of South Africa as well as the copper mines and rubber plantations of Central Africa where European overseers exploited them. The slave trade, which had shipped around 20 million Africans to the Americas against their will, declined in the nineteenth century after more than 300 years of intensive activity. At the same time, Westerners began to penetrate into the African interior, developing trading posts and eventually colonies after the initial phases of exploration. By the beginning of the twentieth century, Westerners also began to remove large quantities of art and artifacts—Africa's cultural heritage—to museums and private collections around the world. It is not inaccurate to say that the African diaspora—the dispersion of its people and its culture across the globe—was an involuntary one prior to the twentieth century.

The Native American in Myth and Reality

The first consistent interactions between Native peoples and Europeans in North America occurred during the seventeenth century and were confined mostly to the eastern part of the continent. In the aftermath of the Revolutionary War and the Louisiana Purchase the movement westward accelerated, first into the Ohio Valley, then the Midwest and South Central regions (Indiana, Illinois, Kentucky), and last, the Great Plains, Rocky Mountain, and Pacific regions. Images such as *The Rocky Mountains, Lander's Peak* (Fig. **39.2**) by Albert Bierstadt [BEER-shtaht] (1830–1902) reinforced in the national consciousness the wisdom of Jefferson's purchase. First exhibited in New York in April 1864 at a public fair, the painting's display was accompanied by performances by Native Americans, who danced and demonstrated their sporting activities in front of it. However, the scenes depicted by the painting were almost entirely fictional. Although commonly believed at the time to be a representation of Lander's Peak in the Wind River Range, the mountain rising in the center of the painting does not bear even a vague resemblance to any Rocky Mountain, let alone

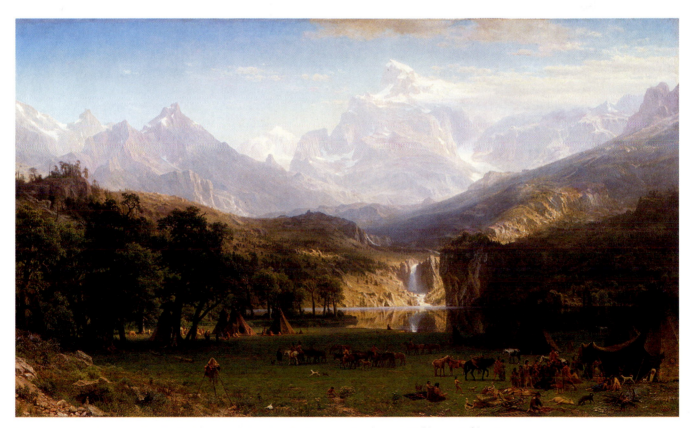

Fig. 39.2 Albert Bierstadt. *The Rocky Mountains, Lander's Peak.* 1863. Oil on panel, 73 1/2″ × 120 3/4″. The Metropolitan Museum of Art, Rogers Fund, 1907 (07.123). Image copyright © The Metropolitan Museum of Art. This painting established a visual rhetoric that Bierstadt applied in painting after painting—the bucolic foreground with a clear lake at the base of a waterfall that drops from the heights of the mountains beyond. It presented a myth of landscape and of the Native American presence within it. In China, India, Japan, and Africa, cultural confrontation with the West in the nineteenth century was not nearly so peaceful.

Voices

A Choctaw Festival

English merchant Adam Hodgson traveled throughout the United States and Canada from 1819 to 1821, providing a rich chronicle of people and landscapes. He offers an interesting perspective on the lives of indigenous Americans in the Eastern, Southern, and Midwestern states when they still maintained viable cultural traditions. He encountered the Choctaw tribe in northern Mississippi and visited for several days, describing an Indian festival.

About sunset we arrived at Smallwood's . . . in order to see a grand Indian dance and ball play, which was to take place in the neighbourhood. . . . On joining them [the Choctaw] . . . in an open space which they had partially cleared in the middle of the wood, we found them lying or sitting round fifteen or twenty fires, the ball poles erected at the distance of 200 yards from each other, serving, in some degree, as two common centres for the rival parties and their friends. There appeared to be altogether about 200.

The men were elegantly dressed in cotton dresses of white, or red, or blue, with belts, handsomely embroidered, and moccasins of brown deer skin. Several of them had circular plates of silver, or silver crescents, hanging from their necks, while others had the same round their arms, and others silver pendants attached to the cartilage of the nose. Some of them had cotton turbans, with white feathers in front, and others black plumes nodding behind. The women, too, were in their gala dress; and we had now, for the first time, the satisfaction of seeing them elevated to their proper rank, the companions, and not the abject slaves, of their husbands. . . . Gowns of printed calico formed the common dress, and some had, in addition, a loose red cloak, which they folded round them with an elegant negligence, which would have done no discredit to a duchess. Their long black hair, tied up behind, shone as brightly as if it had had the advantage of the highly vaunted Macassar Oil. They were, however, overloaded with necklaces and silver ornaments . . .

"the game . . . extremely resembles cricket. . . ."

Soon after our arrival, a tall Indian . . . went round to the different fires, making a singular noise, to induce the dancers to take their places; . . . At last, six women approached the ball poles, standing opposite each other three and three; and then about forty men of the same side gathered into a little crowd, at a short distance. A small drum, made of a deer skin, stretched upon a gourd, then beat, the women gradually mingling their voices with its sound, and dancing slowly in the same place, with eyes fixed upon the ground. In a minute or two, the men set up a hideous yell, brandished their ball sticks in the air, and ran with vehemence to a fire about forty paces distant, when they repeated their shrieks and vociferations, and then ran with impetuosity to their former places. This was repeated, with little intervals . . . till after midnight; the same thing going on in the other party, at the opposite ball poles. . . .

I forgot to say, that the men stripped, previous to the dance, retaining only their girdle, and a long white tail, like that of a wild colt, which gave them a most whimsical and savage appearance . . .

I was informed . . . that the dance, which always takes place on the eve of a celebrated ball play, is significant of the great feats they intend to perform the next day; and that the song of the women, which rather resembles a funeral dirge, is an encouragement to the men to dance, being literally, "Come to the dance—come follow the dance" . . . About eight o'clock [the next day], they all assembled in the ball-ground; the men again stripped. . . . The rival parties then met half-way between the ball-poles—their ball sticks laid on the division line; they then shook hands and joked with each other, while some went round to collect the stakes; . . . They then proceeded to the game, which I will not attempt to describe farther, than by saying it extremely resembles cricket. . . .

Lander's Peak. It is instead an illustration of a mountain from the Alps, a none-too-disguised version of the Matterhorn. Bierstadt presents the American West through a European lens, perhaps because he both understood that view was what his audience expected and saw the world through that lens himself. As Bierstadt wrote in 1859, describing a journey to the American Rockies:

The mountains are very fine; as seen from the plains, they resemble very much the Bernese Alps, one of the finest ranges of mountains in Europe, if not in the world. . . . The color of the mountains and of the plains, and, indeed of the entire country, reminds one of the color of Italy; in fact, we have here the Italy of America in primitive condition.

By "primitive," Bierstadt means pure, untainted, and unfallen, as if it were another biblical Garden of Eden before Eve ate of the apple of knowledge. The Native Americans in the foreground are similarly "primitive," the "noble savages" that Rousseau so admired (see chapter 30), at peace in a place as yet untouched by white settlement. But in the pamphlet accompanying the painting's exhibition as it toured the country, Bierstadt wrote that he hoped that, one day in the area occupied by the Native American encampment, "a city, populated by our descendants, may rise, and in its art-galleries this picture may eventually find a resting-place."

The onslaught of Western settlers is epitomized by Emanuel Leutze's [LOYT-zuh] (1816–1868) painting *Westward the Course of Empire Takes Its Way* (*Westward Ho!*) (Fig. **39.3**). Leutze, a German painter specializing in American subjects, conveys the expansion into the Louisiana Territory

as a matter of national pride. Commissioned by Congress, the mural for which the painting was a precursor decorates a stairwell of the Capitol building in Washington, giving it a kind of official seal of approval from the U.S. government. *Westward Ho!* depicts miners, trappers, scouts, and families in wagon trains converging on the golden promise of the sun setting in the West. (See Fig. 38.19 for a similar image.) At the base of the painting is a panorama depicting the end of the trail, Golden Gate Bay and San Francisco harbor, flanked by portraits of two original American pioneers, Daniel Boone and explorer William Clark, dressed in a buckskin jacket and animal-fur headdress.

The trickle of settlers moving west at the beginning of the nineteenth century soon became a torrent: From 1790 to 1860 the population density of nonnative-born Americans increased from 4 million to 31 million, with nearly half of them moving

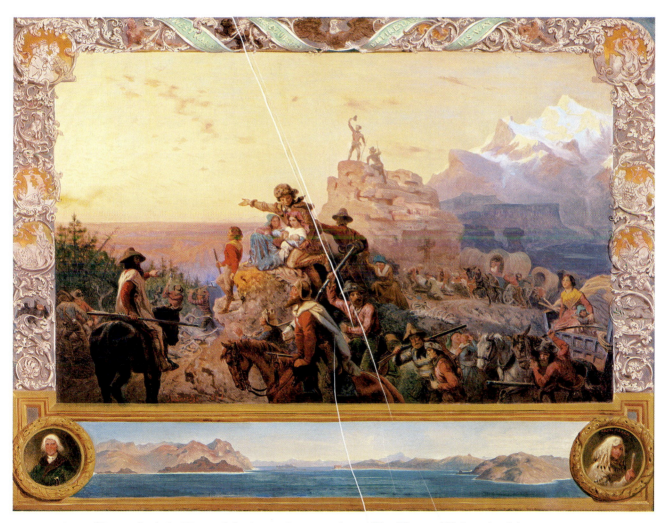

Fig. 39.3 Emanuel Leutze. Study for *Westward the Course of Empire Takes Its Way* (*Westward Ho!*). 1861. Oil on canvas, 33 1/4″ × 43 3/8″. Smithsonian American Art Museum, Washington, DC / Art Resource, NY. When Leutze transferred this image to the wall of the Capitol in 1862, he added, in the center foreground, a black man leading a white woman and child on a mule. Although Leutze's abolitionist sentiments were well known, he probably meant to suggest that blacks as well as whites might enjoy freedom in the West. It is notable, however, that the black man remains in a subservient position to the mother and child.

to territory west of the Atlantic coast states (see Map **39.2**). America's frontier shifted into regions where the possibilities (and natural resources) seemed limitless. It was as if America's future lay somewhere out past the pointing finger of Leutze's trapper. "Go West, young man, and grow up with the country," the Indiana journalist John Soule had advised in 1851. The influential New York journalist Horace Greeley (1811–1872) took up the first part of the refrain, and soon it became obvious that the American West would be central to America's self-identity. Unfortunately, the original inhabitants of the lands were only an afterthought to the artists, the political leaders in Washington, and most of all the settlers themselves. Native American culture and tribal identities were almost entirely ignored and disparaged in the process of "going West."

Conflict with Native Americans was therefore inevitable during the course of expansion. The most visible dimension of a multifaceted clash of cultures was the fight over land—who owned it and who had the right to live on it. The settlers thought of the land as something to organize, control, and own. (As early as 1784, Thomas Jefferson had proposed surveying public lands in the West in geographic units that were 10 miles

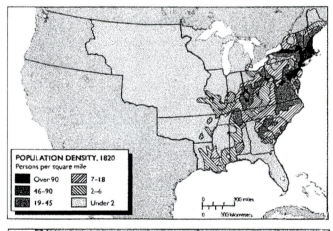

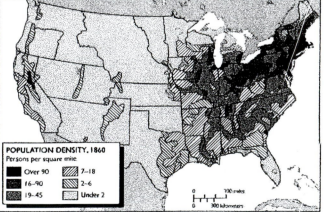

Map 39.2 Population density of nonnative peoples in the United States in 1820 (a) and 1860 (b). After G. B. Tindall and D. E. Shea, *America: A Narrative History.*

square, based on the decimal system. This was later replaced by townships of 6 miles square.) They saw the land as central to their own economic well-being and as a resource to exploit to their own benefit. Land was also fungible, like money—that is, it could be traded like any other commodity, and disposed of as well. The Native Americans, on the other hand, saw themselves as one element in the whole of nature, not privileged in relation to the natural world but part of its delicate balance. Their primary responsibility was to live in harmony with nature rather than transforming, trading, or altering it in a fundamental way.

The Indian Removal Act

In 1830, at the request of President Andrew Jackson (in office 1829–1837), Congress passed "An Act to provide for an exchange of lands with the Indians residing in any of the states or territories, and for their removal west of the river Mississippi." Jackson had provided Congress with the rationale in a speech the previous year:

> Their present condition, contrasted with what they once were, makes a most powerful appeal to our sympathies. Our ancestors found them the uncontrolled possessors of these vast regions. By persuasion and force they have been made to retire from river to river and from mountain to mountain, until some of the tribes have become extinct and others have left but remnants to preserve for awhile their once terrible names. Surrounded by the whites with their arts of civilization, which by destroying the resources of the savage doom him to weakness and decay, the fate of the Mohegan, the Narragansett, and the Delaware is fast overtaking the Choctaw, the Cherokee, and the Creek. That this fate surely awaits them if they remain within the limits of the states does not admit of a doubt. Humanity and national honor demand that every effort should be made to avert so great a calamity.

Jackson's apparent concern for the Native Americans' well-being was insincere, to put it mildly. As a military leader during the War of 1812, he had brutally suppressed the Creek tribal nation, which occupied much of the Southeast United States, then afterward negotiated a treaty that took more than half of Creek lands. He also spearheaded the movement to grant Native Americans individual ownership of land, inciting competition, and breaking down ancient traditions of communal landholding.

Jackson's presidential policies mirrored George Washington's idea of "civilizing" the Native Americans by teaching them to farm and build homes, educating their children, and helping them embrace Christianity. But many Americans viewed indigenous cultures more negatively, drawing from a wealth of lurid images that depicted them as morally depraved and violent. One of the most revealing of these portrayals was prompted by President Jefferson's envoy to France, Joel Barlow, who commissioned John Vanderlyn [VAN-der-lin] to paint *The Murder of Jane McCrea* (1803–1804), which occurred in 1777 (Fig. **39.4**). The painting depicts Jane McCrea, daughter of a Presbyterian minister in upstate New York, who followed her Loyalist fiancé to

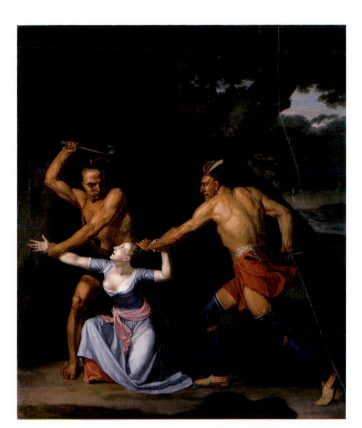

Fig. 39.4 John Vanderlyn. *The Murder of Jane McCrea.* **1803–1804.**
Oil on canvas, 32″ × 26½″. Courtesy Wadsworth Atheneum Museum of
Art, Hartford, Connecticut. Purchased by Supscription. Jane McCrea's
plight symbolized colonial vulnerability, but also warned about the fate of
women who disobeyed the wishes of their families.

Canada against the wishes of her pro-Revolutionary brother and
was captured, killed, and scalped by Native Americans fighting
for the British. Jane became an instant symbol of vulnerable
colonials preyed upon by diabolical and savage Native Ameri-
cans, and her story helped galvanize American colonists to resist
the British troops and Native American allies.

Such images, etched on the national consciousness, provoked
the likes of Henry Clay, who served as secretary of state
(1824–1828) under John Quincy Adams and who was nearly
elected president 20 years later, to contend that the Native Amer-
ican's "disappearance from the human family would be no great
loss to the world." Even a "civilized" tribe like the Cherokee in
Georgia was subject to Jackson's Removal Act. An 1825 census
revealed that the tribe, with a population of little over 13,000,
owned 2,486 spinning wheels, 2,923 plows, 69 blacksmith shops,
13 sawmills, and 33 grist mills, and 1,277 black slaves—signs of
Western acculturation—but the Cherokee made the fatal mistake
of insisting on their sovereignty. Jackson therefore assented to the
eviction of the Cherokee and the other "civilized" tribes of the
Southeast—the Choctaw, Chickasaw, Creek, and Seminole
[SEM-ih-nohl]—from their homes and farms. The Cherokee were
forced to march across the country to their newly assigned homes
in Oklahoma on a journey that would become known as the Trail
of Tears because of the 4,000 who died en route.

The Fate of the Native Americans: Cooper's *Leatherstocking Tales*

The disappearance of Native Americans and those who were
sympathetic to their plight was the subject of the first suc-
cessful American novelist, James Fenimore Cooper. In five
historical novels collectively known as *The Leatherstocking
Tales*, Cooper follows the career of Nathanial "Natty" Bump-
po, a white hunter and woodsman who lives his entire life
near the northeast Native American tribal lands. The order
of the publications was by no means chronological. In the
first book, *The Pioneers* (1823), Natty is in his seventies. In
the third, *The Prairie* (1827), he is in his eighties. In the second
and fourth books, *The Last of the Mohicans* (1826) and *The
Pathfinder* (1840), he is in his forties. And in *The Deerslayer*
(1841), the last of the series, he is in his mid-twenties.

In *The Pioneers*, Natty Bumppo witnesses the wholesale
slaughter of passenger pigeons by the residents of Otsego, in
central New York (see **Reading 39.1**, page 1273, for the com-
plete episode). What Cooper's villagers saw to inspire their
shooting spree was probably similar to the scene described by
the American naturalist and wildlife artist John James
Audubon [aw-duh-BON] (1785–1851), who authored *Birds of
America* (1851–1859). (Fig. **39.5** shows an illustration from
the book.) In 1813, in Kentucky, Audubon calculated that he
viewed more than a billion birds pass over him in about three
hours. "The air was literally filled with Pigeons," he wrote.
"The light of noon-day was obscured as by an eclipse." Natty
Bumppo looks on silently at the slaughter, as "the birds lay
scattered over the field in such profusion, as to cover the very
ground with the fluttering victims," until he is angered into
speech by the introduction of a cannon into the fray, designed
to bring thousands down at a time (**Reading 39.1a**):

READING 39.1a **from James Fenimore
Cooper,** *The Pioneers* **(1823)**

"This comes from settling a country" he said—"here I have
known the pigeons to fly for forty long years, and, till you
made your clearings, there was nobody to scare or to hurt them.
I loved to see them come into the woods, for they were compa-
ny to a body; hurting nothing; being, as it was, as harmless as a
garter-snake. But now it gives me sore thoughts when I hear the
frighty things whizzing through the air, for I know it's only a
motion to bring out all the brats in the village at them. Well! the
Lord won't see the waste of his creatures for nothing, and right
will be done to the pigeons, as well as others, by and by.

Natty clearly equates the fate of the pigeons with the fate of
the Native Americans. From Cooper's point of view, the native
peoples, so at home in the natural world, must inevitably suc-
cumb to the same destructive "civilizing" forces as nature itself.
Yet he is not happy about it.

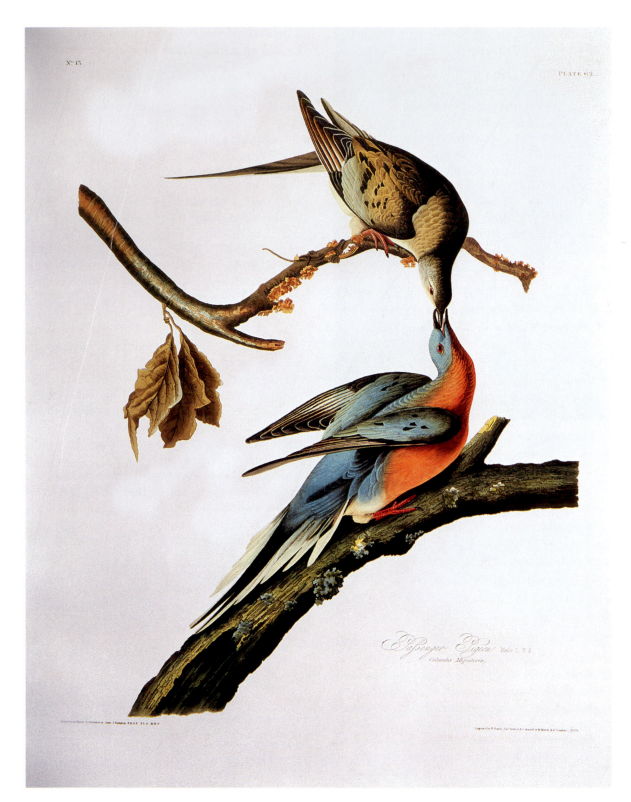

Fig. 39.5 John James Audubon. *Passenger Pigeon.* **ca. 1824.** Watercolor, pastel, and graphite on paper, 40″ × 30″
with mat. Collection of the New York Historical Society, Havell LXII. As a result of events such as Cooper describes in
The Pioneers, the passenger pigeon was extinct by 1914, when the last one died at the Cincinnati Zoological Gardens.

Recording and Mythologizing Native Americans: Catlin's Ethnographic Enterprise

In 1830, George Catlin (1796–1872), a successful portrait painter from the east coast, headed west to St. Louis from which he would make five trips in six years into the territory west of the Mississippi to record the costumes and practices of the Native Americans. On Catlin's historic but unheralded journeys, he encountered cultures of vast diversity and represented over 40 different tribes in 470 portraits and portrayals of daily life: Osage [OH-sage], Kickapoo, Iowa, Ojibwa [oh-JIB-wah], Pawnee [PAW-nee], and Mandan [MAN-dan], to name just a few. In 1832 Catlin discussed his reasons for painting the Native American peoples that he encountered:

> I have, for many years past, contemplated the noble races of red men who are now spread over these trackless forests and boundless prairies, melting away at the approach of civilization, their rights invaded, their morals corrupted, their lands wrested from them, their customs changed, and therefore lost to the world; and they at last sunk into the earth, and the ploughshare turning the sod over their graves, and I have flown to their rescue—not of their lives or of their race (for they are "doomed" and must perish), but to the rescue of their looks and their modes, at which the acquisitive world may hurl their poison . . . and trample them down and crush them to death; yet, phoenix-like, they may rise from the "stain on a painter's palette," and live again upon canvas, and stand forth for centuries yet to come, the living monuments of a noble race.

While Catlin assumes too much power for his art to resurrect the vanishing tribes, his contribution to Native American ethnography—the scientific description of individual cultures—is indisputable. His depiction of *The Last Race, Part of Okipa Ceremony* is one of several representing a four-day Mandan ceremony linking all of creation to the seasons (Fig. **39.6**). According to legend, the Mandan sprang from the earth like corn, the mainstay of their diet.

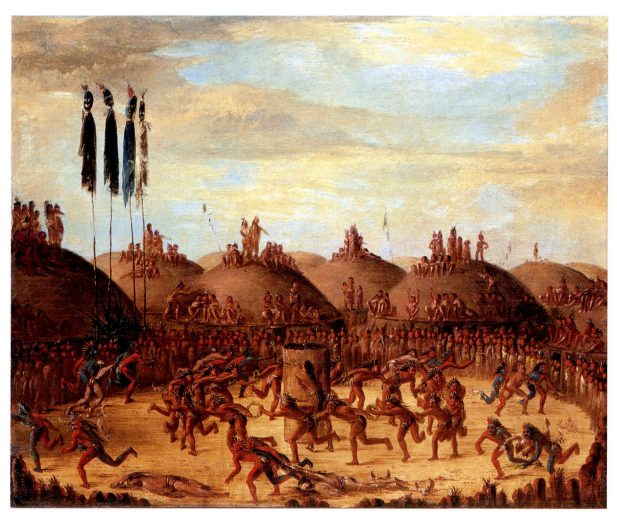

Fig. 39.6 George Catlin. *The Last Race, Part of Okipa Ceremony (Mandan)*. 1832. Oil on panel, 23 3/8″ × 28 1/8″. Smithsonian American Art Museum, Washington, DC/Art Resource, NY. Beginning in 1837, Catlin toured with his paintings, including a trip in 1839 to London and Paris. The Okipa Ceremony paintings were especially popular, but even as he began his tour, a plague of smallpox almost completely wiped out the Mandan themselves.

Their ceremonial life revolved around the "Old Woman Who Never Dies," keeper of the corn seed, who oversees the agricultural well-being and hunting success of the tribe. Performed each year, before and after the summer buffalo hunt, the Okipa Ceremony was designed to dramatize the tribe's myths and to provide an opportunity for young men to be initiated into manhood. The young men of the village fasted for a prolonged period, then suspended themselves from a central platform in the ceremonial lodge by thongs attached to the pierced skin of the back or chest. In the "last race" of the ceremony, they ran around outside the lodge pulling buffalo skulls similarly attached to the skin of their legs and arms, a ritual clearly depicted in the foreground of Catlin's painting.

Catlin's paintings of the Mandan are remarkable not only in their depiction of the ceremony but also for their careful depiction of the village itself with its hemispherical earthen lodges. This fidelity to detail was, he believed, the hallmark of his art. He took especially great pride in his portrait of *Mah-To-Toh-Pa*, or Four Bears, the Mandan Chief (Fig. **39.7**). Yet Catlin brings his own classical associations to bear on the portrait, as his description of the sitting in his 1841 *Letters and Notes*, makes clear. As the chief arrived for his portrait, Catlin writes, "No . . . gladiator ever entered the Roman Forum with

more grace and manly dignity. . . . He took his attitude before me . . . with the sternness of a Brutus and the stillness of a statue." If Catlin's intention was to record the chief's costume with ethnographic fidelity, we know from his *Letters and Notes* that he left several important details out—namely, a belt containing a tomahawk and scalping knife, a buffalo-hide robe, on which was painted the history of the chief's military exploits, and a bear-claw necklace. He claimed that these "interfered with the grace and simplicity of the figure."

Catlin has "pacified" the warrior, made him presentable to a white audience. Such gestures undermine the authority of his attempts to convey a realistic view of natives. Indeed, for the frontispiece of *Letters and Notes*, Catlin depicted himself painting this portrait, the chief standing among his people before a group of tepees [TEE-pees]. "The Author painting a Chief at the base of the Rocky Mountains," the caption reads. The Mandan villages on the Missouri River were far distant from the Rocky Mountains, and the Mandan did not live in teepees, the conical shelters of nomadic Plains tribes such as the Sioux. So Catlin helped create the myth of the Native American—highly inaccurate—while being intensely sympathetic to their plight.

Plains Narrative Painting: Picturing Personal History and Change

By choosing not to paint the buffalo-skin hide Mah-To-Toh-Pa wore to the sitting, Catlin ignored the most crucial part of the chief's character, his personal history. Unlike almost all other Native American tribes in North America, the Native Americans of the Great Plains developed a strong sense of history. They recorded their history as a narrative in relatively flat semiabstract images on buffalo-hide robes, the exterior hides of teepees, and shields, and in their highly detailed oral narratives (Fig. **39.8**). The wearer of a Plains robe owned all the designs on it, though he could sell or give them away. So each robe was doubly personal in being both autobiographical and aesthetically unique. In these designs, humans are generally stick figures, and events are described in selective detail. Both served as memory aids that would help the wearer in relating his history through the traditional art of storytelling.

Some tribes, particularly the Lakota and Kiowa, recorded family or band history in what are known as "winter counts."

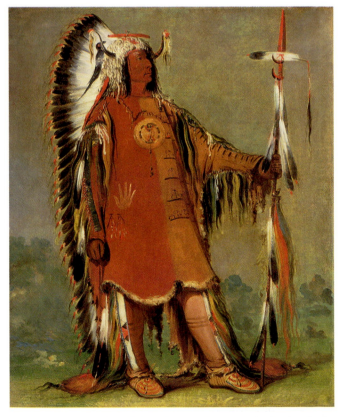

Fig. 39.7 George Catlin. *Mah-To-Toh-Pa (Four Bears)*, Mandan chief. 1832–1834. Oil on canvas, 29″ × 24″. Smithsonian American Art Museum, Washington, DC/Art Resource, NY. War bonnets were worn only by those warriors who could claim the special ability to match bravery with cunning. The wearer could never ask for mercy in battle.

Continuity & Change
p. 78

Palette of Narmer

Marking the passing of years in winters, tribal artists created pictographic images, such as those found on the Egyptian *Palette of Narmer*, one for each year, which would, in effect, stir the collective memory of what else happened in the year. They then arranged the pictographs in a pattern, often circular, reading from the center outward. By the mid-nineteenth century, encounters with artists such as George Catlin and the introduction of paper and pencils and inks by explorers and traders influenced the pictographic style of the Plains tribes. They began to use discarded recordkeeping ledgers from trading posts, and this genre of Plains tribal history painting became known as "ledgerbook art."

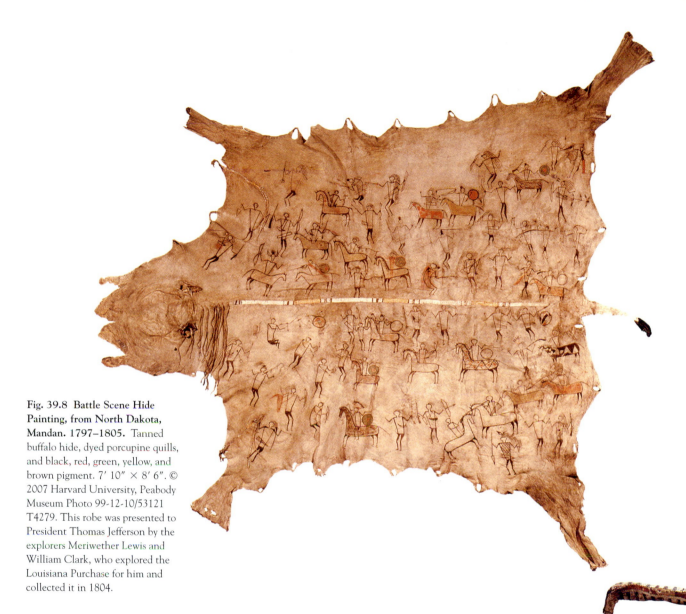

Fig. 39.8 Battle Scene Hide Painting, from North Dakota, Mandan. 1797–1805. Tanned buffalo hide, dyed porcupine quills, and black, red, green, yellow, and brown pigment. 7′ 10″ × 8′ 6″. © 2007 Harvard University, Peabody Museum Photo 99-12-10/53121 T4279. This robe was presented to President Thomas Jefferson by the explorers Meriwether Lewis and William Clark, who explored the Louisiana Purchase for him and collected it in 1804.

At first the artists used the typical pictographic conventions familiar from hide painting and depicted wars between their own and other tribes. But once they were imprisoned or forced to live on reservations, they began also to depict pre-reservation scenes of battles with Westerners as well as illustrating the cultural changes they were experiencing (see *Focus*, pages 1260–1261). In addition, as the buffalo disappeared in the last decades of the nineteenth century, Plains artists sought larger formats, turning to drawing on cloth.

Women's Arts on the Plains: Quillwork and Beadwork

The artwork of women was greatly respected in the Plains and Intermountain tribal cultures. Among the Cheyenne, women who worked on the construction, design, and decoration of teepees held some of the most prestigious positions in the tribe.

However, the two main art forms practiced by women were quillwork and beadwork. Quillwork, first practiced by Eastern Woodlands tribes, spread to the Plains, where it was considered a sacred art (Fig. 39.9). Using porcupine quills that range from $2\frac{1}{2}$ to 5 inches in length, quillworkers sorted them according to size, dyed them in batches, then softened and made them flexible for use by the artist, who repeatedly pulled the quills through her teeth as she stitched them into hides. Among the Lakota, a woman received an ornamented stick for each

Fig. 39.9 Baby Carrier, from the Upper Missouri River area, Eastern Sioux. 19th century. Board, buckskin, porcupine quill, length 31″. Smithsonian Institution Libraries, Washington, DC. Woven into the carrier are three bands of thunderbirds, symbols of protection capable of warding off supernatural harm as well as human adversaries.

Focus

Howling Wolf's *Treaty Signing at Medicine Lodge Creek*

In 1875, Howling Wolf, son of the Cheyenne chief Eagle Head, was taken, together with his father and 70 others considered ringleaders of an Indian uprising, to Fort Marion in Saint Augustine, Florida, and imprisoned for 3 years. At Fort Marion, Howling Wolf and others engaged in ledgerbook drawing, a practice Howling Wolf had already undertaken in order to record in the traditional manner his own narrative history, particularly his military exploits. Encouraged by the officer in charge of Fort Marion, the interred Native Americans sold their ledger art to buy things for themselves and to support their families back on the reservations.

Howling Wolf was one of the most innovative artists at Fort Marion. He abandoned most of the old pictographic style and composed colorful, decorative drawings with a strong sense of balance, symmetry, and rhythm. He carefully

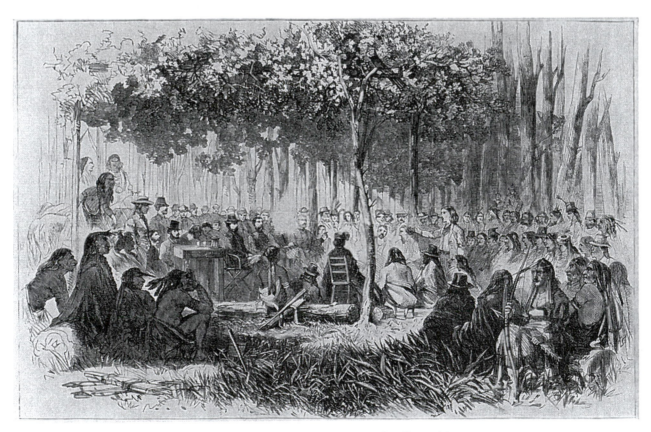

John Taylor. *Treaty Signing at Medicine Lodge Creek.* **1867.** Drawing for *Frank Leslie's Illustrated Gazette*, September–December 1867, as reproduced in Douglas C. Jones, *The Treaty of Medicine Lodge*, after page 144, Oklahoma University Press, 1966. Taylor's view of the treaty signing, produced at the time of the event, contains only one woman, Mrs. Margaret Adams, interpreter for the Arapaho. The daughter of a French-Canadian trapper and an Arapaho mother, she was the object of great fascination to the journalists present, especially when she arrived on the opening day in a red velvet dress and matching red bonnet.

outlined his figures in ink, then colored them with crayon, colored pencils, or watercolors. He also identified himself and others through signifying adornment and decoration. One of the most significant works he created at Fort Marion is *Treaty Signing at Medicine Lodge Creek*. It depicts the signing of a peace treaty in October 1867 between Cheyenne [SHY-an], Arapaho [uh-RAP-uh-ho], Kiowa [KY-uh-wah], and Comanche [kuh-MAN-chee] peoples and the U.S. govern- ment at the intersection of Elm Creek and Medicine Lodge Creek in Kansas. Medicine Lodge Creek was named for a shelter shared by the Plains tribes beside the creek that they believed to possess magical healing powers. But the terms of the treaty were anything but healing. In requiring their children to go to school and learn to speak English, and restricting the movements of the tribes, it signaled the end of their traditional way of life.

The women's braided hair is decorated with red paint in the part. Traditionally, when a Plains warrior committed himself to a woman, he ceremonially painted her hair in this manner to confirm his affection.

The grove of cottonwoods and elms where the treaty was negotiated with government agents in place.

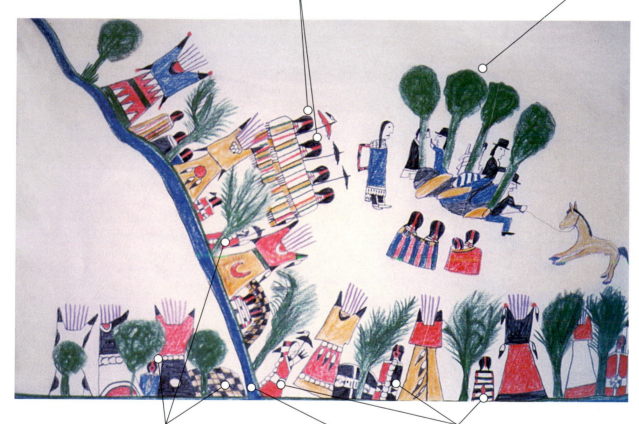

Compared to John Taylor's illustration of the treaty signing, Howling Wolf's representation seems naïve, but he has notably adopted some techniques of traditional Western representation, for instance depicting deep space by means of overlapping. He also abandoned the Plains pictographic style and created full-bodied, if not fully modeled, figures. The most startling difference is his depiction of the events as dominated by women, while Taylor completely ignores them.

The intersection of Elm Creek and Medicine Lodge Creek.

Each figure is identifiable by the decoration on garments and tepees. Most are women, who sit with their backs to the viewer, in formal attire, suggesting the importance of women in Plains society. In this drawing, it is they who establish identity.

Howling Wolf, *Treaty Signing at Medicine Lodge Creek*. 1875–1878. Pencil, crayon, and ink on ledger paper, 8″ × 11″. Courtesy, New York State Library, Albany, NY.

piece of work quilled, and the four women with the greatest number of sticks were honored by being seated in places of honor and being served food before all others. This reward system, in which valued accomplishments were often signified in elevated status rather than in material goods, was emblematic of many aspects of Native American social and economic life. It was a major difference from the value system of white settlers and colonists.

Quillwork design was quickly adapted to beadwork after the introduction of glass beads by explorers and traders. Before large numbers of whites came to the region, glass beads were so valuable that 100 of them were approximately equivalent to the value of a horse. Their bright, permanent colors were believed by many to be preferable to the softer tones attainable in quillwork. Nonetheless, artists imitated the quillwork stitch by creating what is known as a "lazy stitch," stringing about seven beads on each thread. Another seven beads are strung on the thread and laid parallel to the first seven, back and forth until a complete band is realized. In both quillwork and beadwork—and in the textile arts as well—Native tribes believed that artistic skill coexisted with divine and supernatural powers. This belief lent the artist a unique and immeasurable authority. Like the indigenous system of rewards, this power was largely invisible to Westerners.

The End of an Era

The ultimate fate of Plains tribes was inextricably linked to the fate of the buffalo. By the 1870s the military was pursuing an unofficial but effective policy of Native American extermination, and it encouraged the slaughter of the buffalo as a shortcut to this end. Echoing President Andrew Jackson 40 years earlier, General Philip Sheridan (1831–1888) urged that white settlers hasten the killing of buffalo herds, thereby undercutting the Native American supply of food. The effort to build a transcontinental railroad helped Sheridan's wish to be realized, as over 4 million buffalo were slaughtered by meat hunters for the construction gangs, by hide hunters, and by tourists. In the late summer of 1873, railroad builder Granville Dodge reported that "the vast plain, which only a short twelvemonth before teemed with animal life, was a dead, solitary, putrid desert." It was as if George Catlin had predicted the demise of the buffalo, and with it the demise of the Indian, when forty years earlier he had painted his lone Indian overlooking a Missouri River valley empty of game (Fig. **39.10**). The end of the buffalo signaled the end of Native American culture. A Crow warrior named Two Legs put it this way: "Nothing happened after that. We just lived. There were no more war parties, no capturing horses from the Piegan (tribe) and the Sioux [soo], no buffalo to hunt. There is nothing more to tell." History had come to an end.

The painter Albert Bierstadt was, by his own account, deeply affected by the buffalo's demise. But there is never, in any of his work, the slightest indication of his own, or white, complicity in the buffalo's fate. By 1889, about when Bierstadt painted *The Last of the Buffalo* (Fig. **39.11**) showing a Native American spearing a perfect specimen, he declared: "I have endeavored to show the buffalo in all his aspects and depict the cruel slaughter of a noble animal now almost extinct."

Such duplicity is also apparent in laws passed affecting Native Americans such as the Dawes Act (1887), which attempted to establish private ownership of Native American lands by initiating government partitions of reservations. Under the act, each Native American family head was to receive 160 acres, and all other Indians over the age of 18 were to receive 80 acres each. Officially, it was a gesture dedicated both to "civilizing" the tribes by giving them private property and to protecting their property from settlers during the Oklahoma Land Rush. However, to receive the allotment, Native Americans had to "anglicize" their names, so that Rolling Thunder, for instance, would henceforth be known as Ron Thomas. Many refused, but the requirement allowed government agents to register their own family and friends as "Indians"— and so grab more land. Who would be able to tell a white "Ron Thomas" from a Native American one back in Washington? In essence the Dawes Act was a land grab—Native American lands, which totaled 138 million acres at the

Fig. 39.10 George Catlin. *Big Bend on the Missouri River, 1,900 Miles above St. Louis.* 1832. Oil on canvas, 29″ × 24″. Smithsonian American Art Museum, Washington, DC/Art Resource, NY. Catlin's lone Indian contemplating the vastness of the landscape is symbolic of a vanishing people and a vanishing wilderness.

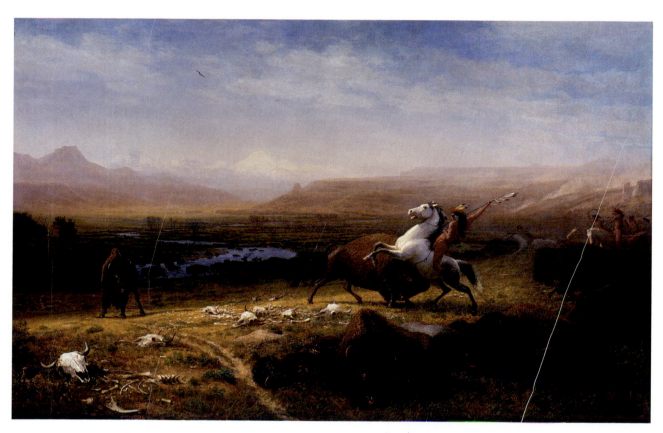

Fig. 39.11 Albert Bierstadt. *The Last of the Buffalo.* ca. 1888. Oil on canvas, 60¼″ × 96½″. Buffalo Bill Historical Center, Cody, WY. Gertrude Vanderbilt Whitney Trust Fund, 2.60. Bierstadt was a charter member of the Boone and Crockett Club, an organization of big-game hunters ostensibly dedicated to conservation.

time the Dawes Act was signed into law, were reduced to 47 million acres of land by 1934 when the act was repealed. Similarly, in the Western states and territories inhabited by the Nez Perce [nez pers], Yakima [YAK-uh-muh], Cayuse [ky-YOOS], and other tribes, Native Americans lost nearly 500 million acres of tribal land to settlement by white farmers.

The British in China and India

Westerners also posed dire threats to the two most populous and culturally influential Asian nations during the course of the eighteenth and nineteenth centuries. While not posing a threat to the actual existence of China and India, Western nations sought to dominate them through aggressive military and economic policies aimed at transferring wealth to their own countries and limiting their sovereignty. During the eighteenth century, both the English East India Company and the French Compagnie des Indes [kohm-pahn-YEE dayz-ahnd] (French East India Company) vied for control of trade with India and the rest of Asia even as they engaged in ruthless competition in Europe and North America. In fact, India's trade was seen as the stepping-stone to even larger markets in China, whose silks, porcelains, and teas were

highly valued throughout Europe and America. Rather than being mutually beneficial, however, trade with the West was a profound threat to local, regional, and national leaders in both China and India. Before the end of the nineteenth century, both countries would become outposts in new colonial empires developed by Europeans, resulting in the weakening of traditional cultural practices, political leadership, and social systems.

China and the Opium War

From the seventeenth century onward, the Chinese tolerated Western traders while also imposing strict controls on the people they called *fanqui* ("foreign devils"). By 1793, the tide was beginning to shift in favor of the West, with proud emperor Ch'ien-lung [chee-EN-loong] (r. 1735–1796) sending a defiant message to the English king George III (r. 1760–1820) concerning this trade:

> Our Empire produces all that we ourselves need. But since our tea, rhubarb and silk seem to be necessary to the very existence of the barbarous Western peoples, we will, imitating the clemency of Heaven, Who tolerates all sorts of fools on this globe, condescend to allow a limited amount of trading through the port of Canton.

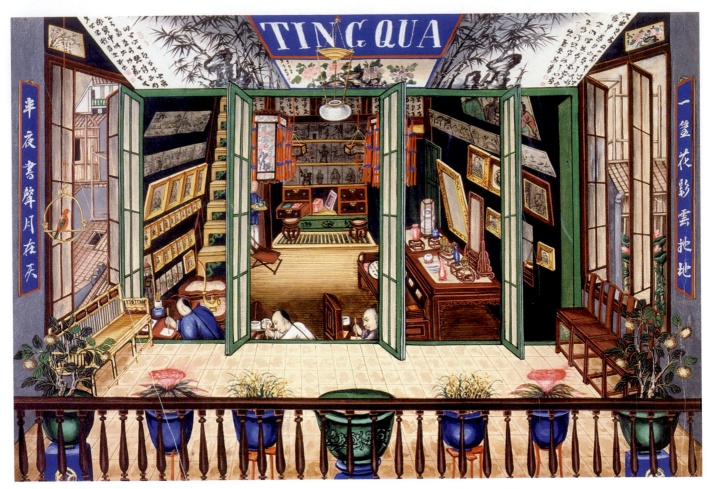

Fig. 39.12 Attributed to Tingqua. *Shop of Tingqua, the Painter.* ca. 1855. Watercolor on paper, $10^1/_2'' \times 13^3/_4''$. Photograph courtesy Peabody Essex Museum. Note that Tingqua depicted his shop in Western perspective.

The Chinese policy of admitting foreign ships to Canton [kant-ON] (modern Guangzhou [gwahng-JOE]) and confining traders to a narrow strip of land where they lived and did business in buildings or factories dated from the early eighteenth century. Chinese entrepreneurs quickly set up shops in the narrow lanes between the factories, selling silks, teas, porcelains, lacquerware, screens, chessboards, carvings, boxes, and pictures to satisfy the European taste for *chinoiserie* (see chapter 30). The shops of Lampqua and his younger brother Tingqua were famous for copying European engravings and for producing paintings of the daily life and ceremonies of the Chinese, along with scenes of Macao and Canton for export (Fig. **39.12**).

More important to the Westerners than these wares was the opium trade. In order to compensate for the gold and silver spent on the purchase of tea, porcelains, and silks, the British East India Company began selling to the Chinese large quantities of opium, which it grew in India. Produced at a very low cost, opium was a very profitable trade item for the British. Unfortunately for the Chinese, opium addiction rapidly became a severe social problem. In 1839, after the emperor's son died an opium-related death, the Chinese moved to ban the drug.

However, by this time, the British were increasingly impatient with the traditional trade restrictions in China as well as the new attempts to limit the opium trade. Since the English military and naval technologies were far superior to that of the Chinese, the nineteenth-century aphorism "Might makes right" can summarize the ensuing British course of action. The parallel with the antagonistic policies of the American government toward indigenous Americans during this period is clear.

A Chinese official, Commissioner Lin Zexu (1785–1850), even sought the help of Queen Victoria (r. 1837–1901) in a plea that invoked ethical and moral principles:

> Let us ask, where is your conscience? I have heard that the smoking of opium is very strictly forbidden by your country; that is because the harm caused by opium is clearly understood. Since it is not permitted to do harm in your own country, then even less should you let it be passed on to the harm of other countries—how much less to China! Of all that China exports to foreign countries, there is not a single thing which is not beneficial to people. . . . Suppose there were people from another country who carried opium for sale to England and seduced your people into

buying and smoking it; certainly you honorable ruler would deeply hate it and be bitterly aroused. . . . Now after this communication has been dispatched and you have clearly understood the strictness of the prohibitory laws of the Celestial Court, certainly you will not let your subjects dare again to violate the law.

Whether the Queen read the letter is unknown, but in fact, opium addiction was rampant in London during her reign. She certainly supported British merchants in their refusal to cooperate with the Chinese prohibition after Lin confiscated all the opium he could find and destroyed it in the spring and summer of 1839.

Curiously, the British acknowledged that Lin had the right to prohibit the Chinese from using opium, but they considered his ban on trading it an unlawful violation of the freedom of commerce. They declared war and subsequently crushed China, attacking most of its coastal and river towns. In the resulting Treaty of Nanjing [nan-JING], China ceded Hong Kong to Britain and paid an indemnity of 21 million silver dollars (roughly equivalent to $2 billion today). Chinese ports and markets were opened to Western merchants, and by 1880 the import of cheap machine-made products resulted in the collapse of the Chinese economy. It would not recover for over a century.

Indentured Labor and Mass Migration

While the coffers of British government and merchants were enriched, the declining Chinese economy produced a number of unforeseen consequences, typical of the interactions between Westerners and indigenous peoples during this period. First, ever-worsening economic conditions drove many Chinese to emigrate in order to earn a living. Tens of thousands were

attracted to California after gold was discovered there in 1849. Mostly single men, many worked for several years in the mines and then returned home. By 1852, 20,000 Chinese a year arrived in California, although that number declined in the ensuing decades. San Francisco, the port of entry to most Asian immigrants, soon boasted a growing "Chinatown," which offered further employment opportunities as immigrant entrepreneurs built new businesses. America's "melting pot" of cultures was continuing to grow.

The Chinese were also an important source of labor for the Central Pacific Railroad as it constructed railroad lines across the Western United States. By 1867, 90 percent of the workers on the railroad were Chinese. Hired for 30 percent less than the cost of hiring whites, they soon organized and struck for better wages. After the Burlingame Treaty of 1868, in which the United States and China established friendly relations, Chinese immigration to the United States increased to approximately 16,000 a year. By 1882, however, the threat to the American workforce posed by immigrant Chinese labor in a time of economic downturn led to the passing of the Chinese Exclusion Act, which outlawed further immigration and denied citizenship to those already in the country.

The Chinese did not emigrate only to the United States (see Map **39.3**), and they generally encountered much worse treatment elsewhere. They were technically indentured workers—laborers working under contract, generally for from 5 to 8 years, to pay off the price of their passage, usually for no pay, just food and accommodation. In 1873, the Chinese government conducted an investigation of Chinese emigration to Cuba. There it discovered horrific conditions as a Chinese plantation worker testified: "We labor 21 hours out of 24 and are beaten. . . . On one occasion I received 200 blows, and though my body was a mass of wounds I was still forced to continue labor. . . . A single day becomes a year. . . . And our families know not whether we are alive or dead."

East Indian indentured workers faced similarly harsh conditions. In the 1860s and 1870s, more than 50,000 Indians were shipped to French colonies in the Caribbean, where they were kept in "perpetual servitude." Just a century earlier, India had been one of the most productive economies in the world. In the 1760s, for instance,

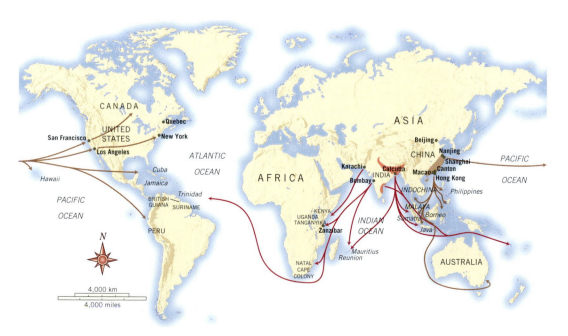

Map 39.3 The movement of indentured labor in the late nineteenth century.

Britain imported most of its best cast steel from India, where hundreds of thousands were employed in mills and mines. But by the end of the eighteenth century, India lost its European markets for finished goods after the British East India Company bought Indian raw materials at exploitatively low prices and then undercut Indian manufacturers by selling finished textiles in India at low prices. Backed by the force of the British Army and increasingly efficient mechanized factories in Britain, English merchants profited handsomely at the expense of traditional economic production in India. So, instead of manufacturing cast steel, India found itself producing only iron ore; instead of manufacturing finished textiles, it exported raw cotton. In this economy, from which manufacturing had been almost completely eliminated, work became a scarce commodity. As its population increased in the second half of the nineteenth century, India experienced an unprecedented series of intensive famines, as well as widespread unemployment and poverty. As a result, over the course of the late nineteenth and early twentieth centuries, nearly 1.5 million Indians sold themselves into indentured servitude. Having produced 25 percent of the world's industrial output in 1750, India by 1900 contributed only 2 percent.

Company School Painting in India

In the early seventeenth century, the Mogul court in India had already expressed an interest in Western art, especially the degree of realism that could be accomplished through modeling and perspective (see chapter 30). Yet most Indian artists considered European art an exotic oddity, and well into the nineteenth century traditional modes of picture making almost completely dominated Indian artistic production. Gradually, as the British Westernized India, they commissioned and purchased Indian art, and the subcontinent's

artists responded by incorporating Western techniques and pictorial traditions.

The British East India Company employed Indian artists as draftspersons, instructing them in European techniques, with others assigned to work as assistants to European artists. In art schools, Indians began to study and copy European prints. Thus encouraged and employed by the East India Company, they soon became known as the Company School.

The subjects favored by their European patrons tended to be images featuring Indian costumes and dress, and depictions of Indians at work—a weaver at his loom or a potter at his wheel. Europeans were also fascinated by the "curiosities" of Indian culture, particularly religious practices, which seemed exotically foreign. Indian artists also specialized in depicting the domestic lives of the British themselves. Among the greatest of the Company School painters was Sheikh Muhammad Amir of Karraya (a suburb of Calcutta [kal-CUT-tuh]). In depicting horses with their grooms, Sheikh Muhammad added newly adopted Western techniques—shading, texture, and accurately depicted anatomy—to the traditional subject matter (Fig. **39.13**). By the last decades of the century, the British were able to document their lives in India more effectively by means of photography, and so the Company School came to an end.

The Opening of Japan

As India was rapidly changing under the British colonial regime in the mid-nineteenth century, Japan sought to accommodate Western industrialization while maintaining the most important aspects of its cultural traditions. Until the American Commodore Matthew Perry sailed into Tokyo Bay on July 8, 1853, the archipelago had been closed to the West for 250 years (see Map 23.4). Seeking to gain the Japanese government's assistance in opening trade as well as providing safe havens for stranded sailors, Perry demanded and received concessions. His expedition ultimately led to the Treaty of Kanagawa (1854) and the Harris Treaty (1858) between the United States and Japan, which opened diplomatic and trade relations between the two countries and brought large quantities of Japanese goods to the West for the first time. The Japanese realized that they had to accommodate Perry, the immediate threat, as well as cope with the longer-term challenge from Western nations. Their goal was to modernize along Western lines but maintain sovereignty as well as their ancient cultural traditions. Visitors arriving in Japan in the late nineteenth and early twentieth centuries had to follow carefully laid out itineraries if they wished to venture beyond the "treaty ports" of Yokohama [yoh-koh-HAH-mah], just south of Tokyo; Kobe [KOH-bee], just outside Osaka; and Nagasaki

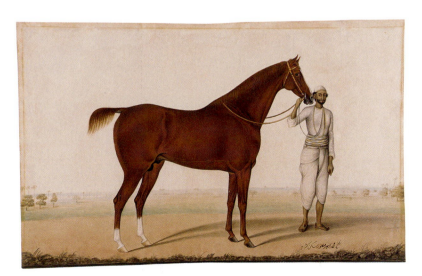

Fig. 39.13 Sheikh Muhammad Amir. *A Horse and Groom*. 1830–1850. Calcutta, India. Pencil and opaque watercolor with touches of white and gum arabic, 11″ × 17¹⁄₂″. Arthur M. Sackler Gallery. Smithsonian Institution, Washington, DC. Purchase, S1999.121. Note the carefully realized rocks and grasses in the foreground and the way the trees occupy perspectival space.

[nah-gah-SAH-kee]. The Japanese by this means tried to control the image of their country that visitors took home.

Industrialization: The Shifting Climate of Society

At first, Japan focused on closing the technology gap between its army and navy and Western military powers. Samuel Williams, the Perry expedition's interpreter, described the Japanese army as it appeared to him in July 1853: "Soldiers with muskets and drilling in close array," but also, "soldiers in petticoats, sandals, two swords, all in disorder." But pressure for change was growing, and by 1868 a historic shift occurred, as the Tokugawa Shogunate, which had held power since 1603, was replaced by a new coalition led by leaders of the Satsuma and Choshu provinces, who aimed to restore direct imperial rule. A new emperor, Meiji, had ascended the throne the year before, and the new government took his name, despite the fact that his role was largely symbolic. The new rulers, however, were determined to centralize power and decrease the influence of the previous shogun's clan, the daimyo (regional provincial leaders and warlords) and the samurai class, the military nobility that had little practical purpose in a modern society. In order to modernize their society, the new Meiji government had to industrialize, which they commenced without delay.

Exports of traditional Japanese products—raw silk (which accounted for more than a third of Japan's export trade), tea, cotton yarn, buttons (before 1853 unknown in Japan), and even woodblock prints—financed the industrialization process. The state took an active role, developing the railway lines within several years of the replacement of the Tokugawa Shogunate in order to, first, expand and speed up food distribution networks throughout the mountainous terrain of the country and, second, assist in centralizing political power. By 1872, the emperor presided over the opening of the first long-distance railway from Tokyo to Yokohama (Fig. **39.14**), and by 1900, the nation boasted 5,000 miles of track. Shipyards used to build warships in the 1850s and 1860s were converted to the production of iron and steel for other industries. Many of the large corporations that still dominate Japanese economic life, such as Mitsui and Mitsubishi, originated in this period as co-partners with the Japanese state.

Eiichi Shibusawa (1840–1931) was the father of Japanese capitalism. Founder of the National Bank of Japan and in charge of national industrialization until 1873, he admitted that he first believed that only the military and political classes could lead the nation. Traditionally, merchants had always been at the bottom of the Japanese social hierarchy, but Shibusawa changed his mind when he visited the 1867 World Exposition in Paris as a member of the Japanese delegation. "Then," Shibusawa wrote, "I realized that the real force of progress lay in business." Born to a poor farming family, Shibusawa rose to enormous political and economic power, and embodied the shifting climate of Japanese society.

Japanese Printmaking

By the late nineteenth century, the Japanese economy was booming, as was the art of woodblock printing, called *ukiyo-e*

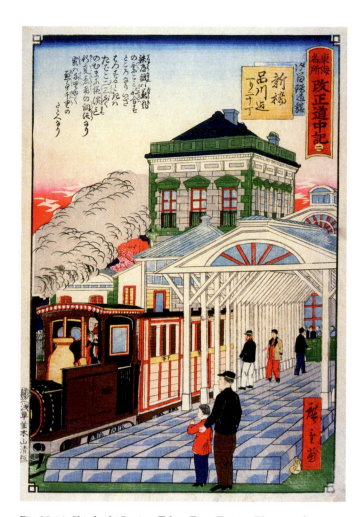

Fig. 39.14 *Shimbashi Station, Tokyo.* From *Famous Places on the Tokaido: A Record of the Process of Reform.* 1875. The Tokyo–Yokohama railway, the first long-distance railway in the country, was built in 1872 with the aid of foreign engineers.

[oo-kee-oh-ay] ("pictures of the floating world"), a tradition that had developed steadily since the beginning of the Tokugawa era (1603–1868). The export trade in prints was a vital part of the economy, and Western artists, particularly the Impressionists, were captivated by the effects Japanese printmakers were able to achieve (see chapter 37). Very popular among the urban classes in Edo (Tokyo) since the 1670s, *ukiyo-e* had gained new potential a century later when a Chinese painting manual, *The Mustard Seed Garden*, accelerated the shift to polychrome printing, which produced multicolored woodblock prints. Woodblock prints were mass produced and thus affordable to artisans, merchants, and other city dwellers. They depicted a wide range of Japanese social and cultural activity, including the daily rituals of life, the theatrical world of actors and geisha, sumo wrestlers, and artisans along with landscapes and nature scenes. Incorporating traditional themes from literature and history, the prints were also notable for introducing contemporary tastes, fads, and fashions, thus forming an invaluable source of knowledge on

the Japanese culture over the more than two centuries of its development.

One of the leading artists of the era, Kitagawa Utamaro [oo-tah-MAH-roh] (1753–1808), illustrated the process of developing color printing in a triptych entitled *Utamaro's Studio* (Fig. 39.15). Traditionally, the creation of a Japanese print was a team effort, and the publisher, the designer (such as Utamaro), the woodblock carver, and the printer were all considered equal in the process. The publisher conceived of the ideas for the prints, financing individual works or series of works that the public would, in his estimation, be likely to buy. In *Utamaro's Studio* the process begins, at the left, with the workers preparing paper. The paper itself was traditionally made from the inside of the bark of the mulberry tree mixed with bamboo fiber, and it was dampened for 6 hours before printing.

In the middle section of the print, the block is actually prepared. In the foreground, a worker sharpens her chisel on a stone. Behind her is a stack of blocks with brush drawings by Utamaro stuck face down on them with a solution of rice starch dissolved in water. The woman seated at the desk in the middle rubs the back of the drawing to remove several layers of fiber. She then saturates what remains with oil until it becomes transparent. At this point, the original drawing looks as if it were drawn on the block.

Next, in the middle section, workers carve the block, and we see large white areas being chiseled out of the block by the woman seated in the back. Black-and-white prints of this design are made and then returned to the artist, who indicates the colors for the prints, one color to a sheet. The cutter then carves each sheet on a separate block. The final print is, in essence, an accumulation of the individually colored blocks, each color requiring a separate printing.

Utamaro's depiction of *The Fickle Type*, from his series *Ten Physiognomies of Women*, embodies the sensuality of the urban world that *ukiyo-e* prints often reveal (Fig. 39.16). But probably the most famous series of Japanese prints is *Thirty-Six Views of Mount Fuji* by Katsushika Hokusai [HO-koo-sigh] (1760–1849). The print in that series known as *The Great Wave* has achieved almost iconic status in the art world (Fig. 39.17). It depicts two boats descending into a trough beneath a giant crashing wave that hangs over the scene like a menacing claw. In the distance, above the horizon, rises Mount Fuji [FOO-jee], symbol to the Japanese of immortality and of Japan itself, framed in a vortex of wave and foam. Though the wave is visually larger than the distant mountain, the viewer knows it will imminently collapse and that Fuji will remain, illustrating both the transience of human experience and the permanence of the natural world. The print also juxtaposes the perils of the

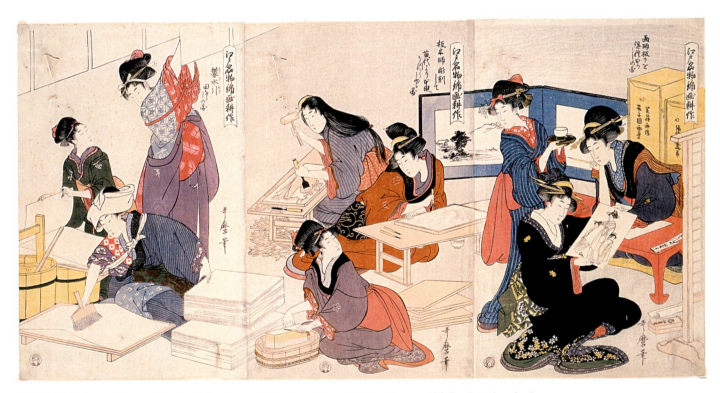

Fig. 39.15 Kitigawa Utamaro. *Utamaro's Studio*. ca. 1790. From the series *Edo meibutsu-e nishiki kosaku*. Ink and color on paper, Oban triptych, 24³⁄₄″ × 96³⁄₈″. Published by Tsuraya Kiemon. Clarence Buckingham Collection. 1939.2141. © The Art Institute of Chicago. All rights reserved. Each of the workers is pictured as a pretty girl—which gives the print its status as a *mitate*, or "fanciful picture"—workers in print shops were not normally pretty young women. To further the fancifulness of the image, Utamaro depicts himself at the right, holding a finished print and dressed in women's clothing. His publisher, also dressed as a woman, looks on from behind his desk.

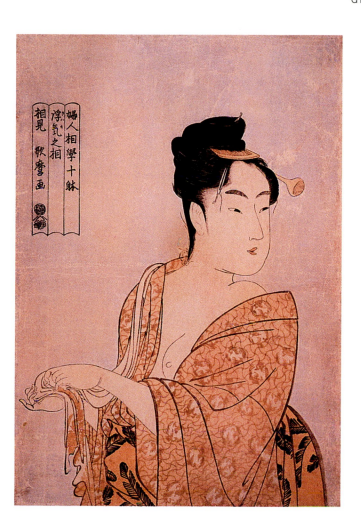

Fig. 39.16 Kitigawa Utamaro. *The Fickle Type,* from the series *Ten Physiognomies of Women.* ca. 1793. Color woodblock print with mica, 14 13/16″ × 9 3/4″. Miriam and Ira D. Wallach Division. The New York Public Library/Art Resource, NY. Utamaro captures the woman's fickleness by having her glance over her shoulder as she returns from the bath, evidently hoping to catch the interested eye of her suitor.

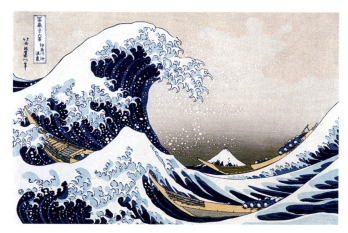

Fig. 39.17 Katsushika Hokusai. *The Great Wave,* from the series *Thirty-Six Views of Mount Fuji.* ca. 1823–1839. Color woodblock print, 10 1/8″ × 14 1/4″. © Historical Picture Archive/CORBIS. The boatsmen can be understood as working in harmony with the powers of nature, something like samurai of the sea.

CULTURAL PARALLELS

The Rise of the Zulu

While European countries projected their economic, military, and technological power worldwide, the southernmost region of Africa had its own strong ruling force, led by Zulu leader Shaka (1787–ca. 1827). Shaka established a large, highly disciplined fighting force aimed at destroying tribal enemies. After 1812, when he assumed full leadership, Shaka used brute force, diplomacy, and patronage to conquer or assimilate other tribes, gaining control of what is today South Africa. It took Europeans more than half a century after Shaka's death to defeat the Zulu nation. Today, the Zulu are South Africa's largest ethnic group.

moment, as represented by the dilemma of the boatmen, and the enduring values of the nation, represented by the solidity of the mountain. Those values can be understood to transcend the momentary troubles and fleeting pleasures of daily life.

Africa and Empire

During the second half of the nineteenth century, European nations competed with each other in acquiring territories in Asia, Africa, Latin America, and elsewhere around the world. In some cases, their management of these areas was direct, with a colonial political structure supervising the governance of the territory. In other cases, control was indirect, focusing on economic domination. In either case this effort to increase the power of nation-states was termed **imperialism**, and the world is still living with the consequences more than a century later. There is probably no more overt statement of the principle than when the British, in 1858, declared Queen Victoria to be the empress of India.

By the beginning of the twentieth century, Western powers had established cultural, political, and economic hegemony (control or domination) over much of the world. They were motivated by economic and strategic self-interest—that is, the control of natural resources and trade routes. Fierce nationalism, and a Europe-centered belief in the superiority of Western culture (as well as the white race), also fueled imperialism. Another important facet of the imperialist philosophy emphasized the humanitarian desire to "improve the lot" of indigenous peoples everywhere. By the last quarter of the century, the African continent was the focal point of imperialist competition.

European Imperialism

A quick glance at a map of Africa illustrates the spread of European domination of the continent after 1880 (Map **39.4**). The scramble for control of the continent began with

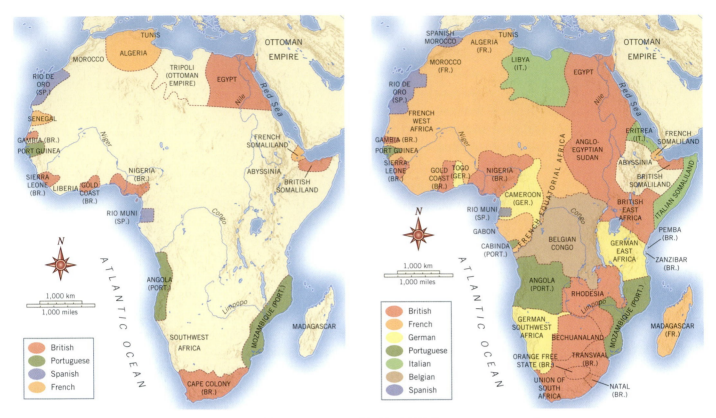

Map 39.4 Imperial expansion in Africa to 1880 (a) and from 1880 to 1914 (b). Until 1880, European occupation of Africa was limited to a few colonies that facilitated shipping along the coast. Between 1880 and 1914, European countries came to control almost the entire continent, with only Liberia and Abyssinia (present-day Ethiopia) remaining independent.

the opening of the Suez Canal in 1869, the shortest route to India, long England's most important and profitable colony. When internal squabbles threatened Egypt's stability in the 1880s, Britain stepped in to protect its interest in the canal, in which it had a major economic investment. Then, to further protect Egypt, it advanced into the Sudan. Beyond Africa's key strategic placement, its vast land area and untapped natural resources proved an irresistible lure for European nations.

France's direct control of Algeria in North Africa dated from 1834, when it formally annexed much of the region. Originally motivated by the desire to thwart piracy in the Mediterranean, France added Tunisia [too-NEE-zhuh], much of West Africa, and Madagascar [mad-uh-GASS-kar] (a large island nation off the east coast of Africa) to its colonies by the 1880s. Not to be left behind, and motivated by a desire to appear at least as powerful as Britain and France, Belgium, Portugal, Spain, and Italy all began to expand previous colonies or acquire new ones. To counter this expansion, and to protect trade routes around the Cape of Good Hope, Britain expanded into present-day Zimbabwe [zim-BAH-bway] and Zambia [ZAM-bee-uh].

Looking at the situation in Africa, Germany's Chancellor Bismarck decided to acquire Southwest Africa (Namibia [nam-IB-ee-uh]), Togoland [TOH-goh-land], the Cameroons [kam-uh-ROONZ], and East Africa (Tanzania [tan-zuh-NEE-

uh]). His motives were purely political, designed to improve his relations with Britain in his never-ending struggles with France and Russia. "My map of Africa lies in Europe," he said. "Here is Russia, and there is France, and here in the middle are we. That is my map of Africa." By and large, European imperial expansion in Africa and Southeast Asia was the nationalist expression of the desire of European countries to assert and expand their own political power.

Economic wealth was also at stake, for the exploitable resources of the African continent made Europe wealthy. France extracted phosphates from Morocco; Belgium acquired gems, ivory, and rubber from the Congo; and England obtained diamonds from South Africa. In this way, Europe's African colonies became (like India) primarily focused on producing large quantities of raw materials—a commodity-based export economy that left most Africans in dire poverty. The social dislocation created by the South African diamond mines is a case in point. In 1866, an African shepherd found a massive diamond of 83.5 carats, quickly dubbed the Star of Africa, on the Orange River. As news of the find spread, Europeans arrived in droves to Kimberley, South Africa, seeking their fortune. Mining was focused around the farm of Diederik Arnoldus de Beer, an Afrikaner [af-rih-KAHN-ur] (Dutch emigrant to South Africa). Gradually, these small, individual plots were bought up by Cecil Rhodes [roads] (1853–1902), and in 1880 he

founded the DeBeers Mining Company. By 1914, Rhodes's Kimberley mine was the largest artificial crater on earth, and he controlled as much as 80 percent of the world's diamonds.

The diamond mines required huge amounts of labor, and native Africans supplied it. Between 1871 and 1875 an estimated 50,000 Africans arrived every year at the diamond mines, replacing roughly the same number that left each year. In a newspaper article published in 1874, Reverend Tyamzashe, an African clergyman, described the scene:

> There are San, Khoikhoi, Griquas, Batlhaping, Damaras, Barolong, Barutse . . . Bapedi, Baganana, Basutu, Maswazi, Matonga, Matabele, Mabaca, Mampondo, Mamfengu, Batembu, Maxosa etc. many of these [people] can hardly understand each other. . . . Those coming from far up in the interior . . . come with the sole purpose of securing guns. Some of them therefore resolve to stay no longer here than is necessary to get some six or seven pounds for the gun. Hence you will see hundreds of them leaving the fields, and as many arriving from the North almost every day.

So the peoples of southern Africa were diffused and reunited around a diamond mine in the South African Central Plateau, before dispersing, presumably with enough money to buy Western weapons to deal with their enemies. Laborers lived in closed compounds designed to control theft but actually closer to prisons. Workers left the compound each morning and returned to it each evening after work, when they were searched for diamonds hidden on their person. These European-designed structures were also a sure way to control potentially unruly Africans. Christian missionaries such as Reverend Tyamzashe were encouraged to start congregations in the compounds to aid in the same policy of control. Their task, as Cecil Rhodes saw it, was to educate and prepare Africans for a future within British colonial society, however limited that might be. These compounds also effectively separated black Africans from the white residents of Kimberley, an enforced separation that in many respects marks the beginning of South African **apartheid** [uh-PAR-tite] (literally "seperateness" in Afrikaans [af-rih-KAHNZ], the dialect of Dutch spoken by Afrikaners).

Social Darwinism: The Theoretical Justification for Imperialism

In the extended title of the groundbreaking work *On the Origin of Species by Means of Natural Selection, or the Preservation of Favored Races in the Struggle for Life* (see chapter 35), Charles Darwin's use of the word "race" became a critical ingredient in the development of a new nineteenth-century ideology, **social Darwinism**. To those who desired to validate imperialism and the colonial regimes it fostered in Africa and Asia, social Darwinism explained the supposed social and cultural evolution that elevated Europe (and the white race) above all others nations and races. Europeans, it was argued, were the "fitter" race, and thus were destined not merely to survive but to dominate the world. While still a student at Oxford, Cecil Rhodes had written a "Confession of Faith" in which he clearly articulated the imperialists' faith in their ability to dominate the world:

> Why should we not form a secret society with but one object, the furtherance of the British Empire and the bringing of the whole civilized world under British rule for the recovery of the United States, for making the Anglo-Saxon race but one Empire? What a dream, but yet it is probable, it is possible.

Such grandiose thinking would later characterize the demented ambitions of Adolf Hitler in Germany. Social Darwinism seemed to overturn traditional Judeo-Christian and Enlightenment ethics, especially those pertaining to compassion and the sacredness of human life. It seemed at once to embrace moral relativism, the belief that ethical positions are determined not by universal truths but by social, political, or cultural conditions (such as the imperial imposition of its values upon another culture) and to support the superior evolutionary "fitness" and superiority of the Aryan [AR-ee-un] (or Anglo-Saxon) race.

Darwin himself meant nothing of the kind. Recognizing the ways in which his theories were being misapplied to social conditions, he published *The Descent of Man* in 1871. In it, he offered a theory of conscience that had a distinctly more ethical viewpoint. Darwin contended that our ancestors, living in small tribal communities, and competing with one another ruthlessly, came to recognize the advantages to successful propagation of the tribe. Over generations, the tribe whose members exhibited selfless behavior that benefited the whole group would tend to survive and prosper over tribes whose members pursued more selfish and individualistic goals. "There can be no doubt," he wrote, "that a tribe including many members who, from possessing in a high degree the spirit of patriotism, fidelity, obedience, courage, and sympathy, were always ready to give aid to each other and to sacrifice themselves for the common good, would be victorious over most other tribes, and this would be natural selection." This is not the ethical philosophy that motivated imperialism.

Darwin's ideas were not the last word on the issue, however, and social Darwinism continually evolved. English philosopher and political theorist Herbert Spencer (1820–1903) offered extensive interpretations of social evolution that were influenced by Darwin but that equated change with constructive progress. Francis Galton (1822–1911) advocated human intervention in evolution, through selective breeding. His theory of **eugenics** focused on eliminating undesirable and less fit members of society by encouraging the proliferation of intelligent and physically fit humans. Galton's theories emphasized eliminating "inferior" humans through increased breeding of the most fit members of society by means of such state intervention as tax and other incentives. Later his theories mutated into the dark ideologies that developed into Nazism in the twentieth century.

Imperialism and the Arts

European imperial involvement in Africa had a substantial impact on the arts over the last half of the nineteenth century

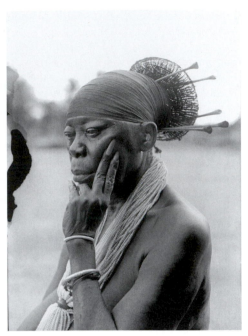

Fig. 39.18 Herbert Lang. Queen Nenzima in her husband Chief Okondo's village. 1910. Mangbetu, Kongo. Courtesy Department Library Services, American Museum of Natural History, NY. Note the length of the nails on the queen's left hand.

Fig. 39.19 Necklace presented to Herbert Lang by Queen Nenzima. 1910. Mangbetu, Kongo. Cord, beads, fingernails, length 12 3/8". American Museum of Natural History, NY. 90.1/4180. Each year the queen cut off the fingernails of her left hand, and sometimes her toenails as well, and gave them away as a very important gift.

One of the most fascinating types of sculpture that came into prominence after the invasion of colonial forces into the Kongo were magical figures known as *minkisi* ("sacred medicine"), which whites termed **fetishes**. *Minkisi* were made by the Kongo tribes for their own use, and they played a central role in symbolizing resistance to the imposition of foreign culture. Throughout Central Africa, all significant human powers are believed to result from communication with the dead. Certain individuals can communicate with the spirits in their role as healers, diviners, and defenders of the living. They are believed to harness the powers of the spirit world through *minkisi*. Among the most formidable of *minkisi* is the type known as *minkonde*, which are said to pursue witches, thieves, adulterers, and wrongdoers by night. The communicator activates a *minkonde* by driving nails, blades, and other pieces of iron into it so that it will deliver similar injuries to those worthy of punishment.

Minkonde figures usually stand upright (Fig. 39.20). One arm is raised and holds a knife or spear (often missing, as here), suggesting that it is ready to attack. A hole in the figure's stomach contained magical "medicines," often kaolin, a white clay believed to be closely linked to the world of the dead, and red ocher, linked symbolically to blood. Such figures—designed to evoke awe in the spectator—were seen by European missionaries as evidence of witchcraft, and the missionaries destroyed many of them. In fact, the *minkonde* represented a form of **animism**, a foundation to many religions, including that of Native Americans, and referring to the belief in the existence of souls and the conviction that nonhuman things can also be endowed with a soul. European military commanders saw them as evidence of an aggressive native opposition to colonial control. Despite their suppression during the colonial era, such figures are still made and used by the peoples of the Kongo.

as European and American collectors supplanted the royal courts of Africa as the major collectors of African art. In essence, foreigners replaced indigenous leaders as interpreters and authorities on the cultural heritage of the African continent. Also at this time the major European ethnographic museums were founded, furthering the ascent of European influence. In the United States, the American Museum of Natural History opened in New York in 1869, although its African collection was not significant until one of its scientists, Herbert Lang (1879–1957), organized a collecting trip in 1909. Over the course of 6 years, Lang and his assistant traveled throughout the Kongo River basin region of central Africa collecting over 54 tons of specimens and a large number of artifacts, requiring 38,000 porters and assistants. Among the most remarkable works brought back by Lang was a necklace made from the fingernails of Nenzima, the reigning queen of the Mangbetu (Figs. **39.18, 39.19**). Possession of a part of the queen's body conferred her power on the owner, and Lang was evidently given the necklace as a sign of trust. He returned the favor by leaving the queen his thumbnail.

Fig. 39.20 Magical figure, *nkisi nkonde*, Kongo (Muserongo), Zaire. Late nineteenth century. Wood, iron nails, glass, resin, height 20". The Stanley Collection. X1986.573. The University of Iowa Museum of Art, Iowa City, IA. The number of nails and blades driven into this figure indicates the number of clients who sought the aid of its magical powers.

READING

from James Fenimore Cooper, *The Pioneers*, Chapter XXII (1823)

The Pioneers was the first of a series of five novels that came to be known as The Leather-stocking Tales. The series derives its name from the nickname of Natty Bumppo, a character who is both frontiersman and Native American, and who thus embodies the tension between civilization and the untamed wilderness that is at the heart of Cooper's fiction. No moment in The Pioneers underscores this tension more than when Natty and villagers of Oswego confront the massive migration of passenger pigeons in chapter 22.

> "Men, boys, and girls.
> Desert th' unpeopled village; and wild crowds
> Spread o'er the plain, by the sweet frenzy driven."
> —Somerville

From this time to the close of April, the weather continued to be a succession of great and rapid changes. One day, the soft airs of spring would seem to be stealing along the valley, and, in unison with an invigorating sun, attempting, covertly, to rouse the dormant powers of the vegetable world; while on the next, the surly blasts from the north would sweep across the lake, and erase every impression left by their gentle adversaries. The snow, however, finally disappeared, and the green wheat fields were seen in every direction, spotted with the dark and charred stumps that had, the preceding season, supported some of the proudest trees of the forest. Ploughs were in motion, wherever those useful implements could be used, and the smokes of the sugar-camps were no longer seen issuing from the summits of the woods of maple. The lake had lost all the characteristic beauty of a field of ice, but still a dark and gloomy covering concealed its waters, for the absence of currents left them yet hid under a porous crust, which, saturated with the fluid, barely retained enough of its strength to preserve the contiguity of its parts. Large flocks of wild geese were seen passing over the country, which would hover, for a time, around the hidden sheet of water, apparently searching for an opening, where they might obtain a resting-place; and then, on finding themselves excluded by the chill covering, would soar away to the north, filling the air with their discordant screams, as if venting their complaints at the tardy operations of nature.

For a week, the dark covering of the Otsego was left to the undisturbed possession of two eagles, who alighted on the centre of its field, and sat proudly eyeing the extent of their undisputed territory. During the presence of these monarchs of the air, the flocks of migrating birds avoided crossing the plain of ice, by turning into the hills, and apparently seeking the protection of the forests, while the white and bald heads of the tenants of the lake were turned upward, with a look of majestic contempt, as if penetrating to the very heavens, with the acuteness of their vision. But the time had come, when even these kings of birds were to be dispossessed. An opening had been gradually increasing, at the lower extremity of the lake, and around the dark spot where the current of the river had prevented the formation of ice, during even the coldest weather; and the fresh southerly winds, that now breathed freely up the valley, obtained an impression on the waters. Mimic waves begun to curl over the margin of the frozen field, which exhibited an outline of crystallizations, that slowly receded towards the north. At each step the power of the winds and the waves increased, until, after a struggle of a few hours, the turbulent little billows succeeded in setting the whole field in an undulating motion, when it was driven beyond the reach of the eye, with a rapidity, that was as magical as the change produced in the scene by this expulsion of the lingering remnant of winter. Just as the last sheet of agitated ice was disappearing in the distance, the eagles rose over the border of crystals, and soared with a wide sweep far above the clouds, while the waves tossed their little caps of snow into the air, as if rioting in their release from a thralldom of five months duration.

The following morning Elizabeth was awakened by the exhilarating sounds of the martins, who were quarrelling and chattering around the little boxes which were suspended above her windows, and the cries of Richard, who was calling, in tones as animating as the signs of the season itself—

"Awake! Awake! My lady fair! the gulls are hovering over the lake already, and the heavens are alive with the pigeons. You may look an hour before you can find a hole, through which, to get a peep at the sun. Awake! awake! lazy ones! Benjamin is overhauling the ammunition, and we only wait for our breakfasts, and away for the mountains and pigeon-shooting."

There was no resisting this animated appeal, and in a few minutes Miss Temple and her friend descended to the parlour. The doors of the hall were thrown open, and the mild,

balmy air of a clear spring morning was ventilating the apartment, where the vigilance of the ex-steward had been so long maintaining an artificial heat, with such unremitted diligence. All of the gentlemen, we do not include Monsieur Le Quoi, were impatiently waiting their morning's repast, each being equipt in the garb of a sportsman. Mr. Jones made many visits to the southern door, and would cry—

"See, cousin Bess! see, 'duke! The pigeon-roosts of the south have broken up! They are growing more thick every instant. Here is a flock that the eye cannot see the end of. There is food enough in it to keep the army of Xerxes[1] for a month, and feathers enough to make beds for the whole county. Xerxes, Mr. Edwards, was a Grecian king, who—no, he was a Turk, or a Persian, who wanted to conquer Greece, just the same as these rascals will overrun our wheat-fields, when they come back in the fall.—Away! away! Bess; I long to pepper them from the mountain."

In this wish both Marmaduke and young Edwards seemed equally to participate, for really the sight was most exhilarating to a sportsman; and the ladies soon dismissed the party, after a hasty breakfast.

If the heavens were alive with pigeons, the whole village seemed equally in motion, with men, women, and children. Every species of fire-arms, from the French ducking-gun, with its barrel of near six feet in length, to the common horseman's pistol, was to be seen in the hands of the men and boys; while bows and arrows, some made of the simple stick of a walnut sapling, and others in a rude imitation of the ancient cross-bows, were carried by many of the latter.

The houses, and the signs of life apparent in the village, drove the alarmed birds from the direct line of their flight, towards the mountains, along the sides and near the bases of which they were glancing in dense masses, that were equally wonderful by the rapidity of their motion, as by their incredible numbers.

We have already said, that across the inclined plane which fell from the steep ascent of the mountain to the banks of the Susquehanna, ran the highway, on either side of which a clearing of many acres had been made, at a very early day. Over those clearings, and up the eastern mountain, and along the dangerous path that was cut into its side, the different individuals posted themselves, as suited their inclinations; and in a few moments the attack commenced.

Amongst the sportsmen was to be seen the tall, gaunt form of Leather-stocking, who was walking over the field, with his rifle hanging on his arm, his dogs following close at his heels, now scenting the dead or wounded birds, that were beginning to tumble from the flocks, and then crouching under the legs of their master, as if they participated in his feelings, at this wasteful and unsportsmanlike execution.

The reports of the fire-arms became rapid, whole volleys rising from the plain, as flocks of more than ordinary numbers darted over the opening, covering the field with darkness,

like an interposing cloud; and then the light smoke of a single piece would issue from among the leafless bushes on the mountain, as death was hurled on the retreat of the affrighted birds, who would rise from a volley, for many feet into the air, in a vain effort to escape the attacks of man. Arrows, and missiles of every kind, were seen in the midst of the flocks; and so numerous were the birds, and so low did they take their flight, that even long poles, in the hands of those on the sides of the mountain, were used to strike them to the earth.

During all this time, Mr. Jones, who disdained the humble and ordinary means of destruction used by his companions, was busily occupied, aided by Benjamin, in making arrangements for an assault of a more than ordinarily fatal character. Among the relics of the old military excursions, that occasionally are discovered throughout the different districts of the western part of New-York, there had been found in Templeton, at its settlement, a small swivel,[2] which would carry a ball of a pound weight. It was thought to have been deserted by a war-party of the whites, in one of their inroads into the Indian settlements, when, perhaps, their convenience or their necessities induced them to leave such an encumbrance to the rapidity of their march, behind them in the woods. This miniature cannon had been released from the rust, and mounted on little wheels, in a state for actual service. For several years, it was the sole organ for extraordinary rejoicings that was used in those mountains. On the mornings of the Fourth of July, it would be heard, with its echoes ringing among the hills, and telling forth its sounds, for thirteen times, with all the dignity of a two-and-thirty pounder; and even Captain Hollister, who was the highest authority in that part of the country on all such occasions, affirmed that, considering its dimensions, it was no despicable gun for a salute. It was somewhat the worse for the service it had performed, it is true, there being but a trifling difference in size between the touch-hole and the muzzle. Still, the grand conceptions of Richard had suggested the importance of such an instrument, in hurling death at his nimble enemies. The swivel was dragged by a horse into a part of the open space, that the sheriff thought most eligible for planting a battery of the kind, and Mr. Pump proceeded to load it. Several handfuls of duck-shot were placed on top of the powder, and the Major-domo soon announced that his piece was ready for service.

The sight of such an implement collected all the idle spectators to the spot, who, being mostly boys, filled the air with their cries of exultation and delight. The gun was pointed on high, and Richard, holding a coal of fire in a pair of tongs, patiently took his seat on a stump, awaiting the appearance of a flock that was worthy of his notice.

So prodigious was the number of the birds, that the scattering fire of the guns, with the hurling of missiles, and the cries of the boys, had no other effect than to break off small flocks from the immense masses that continued to dart along the valley, as if the whole creation of the feathered tribe were pouring through that one pass. None pretended to collect the

[1]Xerxes, King of Persia, led his vast army against the Greeks in 480 BCE, and was finally defeated in the naval battle at Salamis by Themistocles (see chapter 6).

[2]A small cannon that can be swung right or left.

game, which lay scattered over the fields in such profusion, as to cover the very ground with the fluttering victims. 180

Leather-stocking was a silent, but uneasy spectator of all these proceedings, but was able to keep his sentiments to himself until he saw the introduction of the swivel into the sports.

"This comes of settling a country" he said—"here have I known the pigeons to fly for forty long years, and, till you made your clearings, there was nobody to scare or to hurt them. I loved to see them come into the woods, for they were company to a body; hurting nothing; being, as it was, as harmless as a garter-snake. But now it gives me sore thoughts when I hear the frighty things whizzing through the air, for I 190 know it's only a motion to bring out all the brats in the village at them. Well! the Lord won't see the waste of his creaters for nothing, and right will be done to the pigeons, as well as others, by-and-by.—There's Mr. Oliver, as bad as the rest of them, firing into the flocks as if he was shooting down nothing but the Mingo[3] warriors."

Among the sportsmen was Billy Kirby, who, armed with an old musket, was loading, and, without even looking into the air, was firing, and shouting as his victims fell even on his own person. He heard the speech of Natty, and took upon 200 himself to reply—

"What's that, old Leather-stocking!" he cried; "grumbling at the loss of a few pigeons! If you had to sow your wheat twice, and three times, as I have done, you wouldn't be so massyfully[4] feeling'd to'ards the devils.—Hurrah, boys! scatter the feathers. This is better than shooting at a turkey's head and neck, old fellow."

"It's better for you, maybe, Billy Kirby," returned the indignant old hunter, "and all them as don't know how to put a ball down a rifle-barrel, or how to bring it up ag'in with a true 210 aim; but it's wicked to be shooting into flocks in this wastey manner; and none do it, who know how to knock over a single bird. If a body has a craving for pigeon's flesh, why! it's made the same as all other creaters, for man's eating, but not to kill twenty and eat one. When I want such a thing, I go into the woods till I find one to my liking, and then I shoot him off the branches without touching a feather of another, though there might be a hundred on the same tree. But you couldn't do such a thing, Billy Kirby—you couldn't do it if you tried." 220

"What's that you say, you old, dried cornstalk! you sapless stub!" cried the wood-chopper. "You've grown mighty boasting, sin[5] you killed the turkey; but if you're for a single shot, here goes at that bird which comes on by himself."

The fire from the distant part of the field had driven a single pigeon below the flock to which it had belonged, and, frightened with the constant reports of the muskets, it was approaching the spot where the disputants stood, darting first from one side, and then to the other, cutting the air with the swiftness of lightning, and making a noise with its wings, not 230

unlike the rushing of a bullet. Unfortunately for the wood-chopper, notwithstanding his vaunt, he did not see his bird until it was too late for him to fire as it approached, and he pulled his trigger at the unlucky moment when it was darting immediately over his head. The bird continued its course with incredible velocity.

Natty had dropped his piece from his arm, when the challenge was made, and, waiting a moment, until the terrified victim had got in a line with his eyes, and had dropped near the bank of the lake, he raised his rifle with uncommon 240 rapidity, and fired. It might have been chance, or it might have been skill, that produced the result; it was probably a union of both; but the pigeon whirled over in the air, and fell into the lake, with a broken wing. At the sound of his rifle, both his dogs started from his feet, and in a few minutes the "slut"[6] brought out the bird, still alive.

The wonderful exploit of Leather-stocking was noised through the field with great rapidity, and the sportsmen gathered in to learn the truth of the report.

"What," said young Edwards, "have you really killed a 250 pigeon on the wing, Natty, with a single ball?"

"Haven't I killed loons before now, lad, that dive at the flash?" returned the hunter. "It's much better to kill only such as you want, without wasting your powder and lead, than to be firing into God's creaters in such a wicked manner. But I come out for a bird, and you know the reason why I like small game, Mr. Oliver, and now I have got one I will go home, for I don't like to see these wasty ways that you are all practysing, as if the least thing was not made for use, and not to destroy."

"Thou sayest well, Leather-stocking," cried Marmaduke, 260 "and I begin to think it time to put an end to this work of destruction."

"Put an ind, Judge, to your clearings. An't the woods his work as well as the pigeons? Use, but don't waste. Wasn't the woods made for the beasts and birds to harbour in? and when man wanted their flesh, their skins, or their feathers, there's the place to seek them. But I'll go to the hut with my own game, for I wouldn't touch one of the harmless things that kiver the ground here, looking up with their eyes at me, as if they only wanted tongues to say their thoughts." 270

With this sentiment in his mouth, Leather-stocking threw his rifle over his arm, and, followed by his dogs, stepped across the clearing with great caution, taking care not to tread on one of the hundreds of the wounded birds that lay in his path. He soon entered the bushes on the margin of the lake, and was hid from view.

Whatever might be the impression the morality of Natty made on the Judge, it was utterly lost on Richard. He availed himself of the gathering of the sportsmen, to lay a plan for one "fell swoop"[7] of destruction. The musket-men were drawn up 280 in battle array, in a line extending on each side of his artillery, with orders to await the signal of firing from himself.

[3]In Cooper's novels the Mingo (Iroquois) are depicted as enemies of the white settlers.
[4]Mercifully.
[5]Since.

[6]A female dog, or "bitch."
[7]A quotation from Shakespeare's *Macbeth*, Act 4, Scene 3, as Macduff mourns the loss of his wife and children.

"Stand by, my lads," said Benjamin, who acted as an aid-de-camp on this momentous occasion, "stand by, my hearties, and when Squire Dickens heaves out the signal for to begin the firing, d'ye see, you may open upon them in a broadside. Take care and fire low, boys, and you'll be sure to hull the flock."

"Fire low!" shouted Kirby—"hear the old fool! If we fire low, we may hit the stumps, but not ruffle a pigeon." 290

"How should you know, you lubber?"[8] cried Benjamin, with a very unbecoming heat, for an officer on the eve of battle—"how should you know, you grampus? Havn't I sailed aboard of the Boadishy for five years? and wasn't it a standing order to fire low, and to hull your enemy? Keep silence at your guns, boys, and mind the order that is passed."

The loud laughs of the musketmen were silenced by the authoritative voice of Richard, who called to them for attention and obedience to his signals.

Some millions of pigeons were supposed to have already 300 passed, that morning, over the valley of Templeton; but nothing like the flock that was now approaching had been seen before. It extended from mountain to mountain in one solid blue mass, and the eye looked in vain over the southern hills to find its termination. The front of this living column was distinctly marked by a line, but very slightly indented, so regular and even was the flight. Even Marmaduke forgot the morality of Leather-stocking as it approached, and, in common with the rest, brought his musket to his shoulder.

"Fire!" cried the Sheriff, clapping his coal to the priming 310 of the cannon. As half of Benjamin's charge escaped through the touch-hole, the whole volley of the musketry preceded the report of the swivel. On receiving this united discharge of small-arms, the front of the flock darted upward, while, at the same instant, myriads of those in their rear rushed with amazing rapidity into their places, so that when the column of white smoke gushed from the mouth of the little cannon, an accumulated mass of objects was gliding over its point of direction. The roar of the gun echoed along the mountains, and died away to the north, like distant thunder, while the 320 whole flock of alarmed birds seemed, for a moment, thrown into one disorderly and agitated mass. The air was filled with their irregular flights, layer rising over layer, far above the tops of the highest pines, none daring to advance beyond the

dangerous pass; when, suddenly, some of the leaders of the feathered tribe shot across the valley, taking their flight directly over the village, and the hundreds of thousands in their rear followed their example, deserting the eastern side of the plain to their persecutors and the fallen.

"Victory!" shouted Richard, "victory! we have driven the 330 enemy from the field."

"Not so, Dickon," said Marmaduke; "the field is covered with them; and, like the Leather-stocking, I see nothing but eyes, in every direction, as the innocent sufferers turn their heads in terror, to examine my movements. Full one half of those that have fallen are yet alive: and I think it is time to end the sport; if sport it be."

"Sport!" cried the Sheriff; "it is princely sport. There are some thousands of the blue-coated boys on the ground, so that every old woman in the village may have a pot-pie for 340 the asking."

"Well, we have happily frightened the birds from this pass," said Marmaduke, "and our carnage must of necessity end, for the present.—Boys, I will give thee sixpence a hundred for the pigeons' heads only; so go to work, and bring them into the village, when I will pay thee."

This expedient produced the desired effect, for every urchin on the ground went industriously to work to wring the necks of the wounded birds. Judge Temple retired towards his dwelling with that kind of feeling, that many a 350 man has experienced before him, who discovers, after the excitement of the moment has passed, that he has purchased pleasure at the price of misery to others. Horses were loaded with the dead; and, after this first burst of sporting, the shooting of pigeons became a business, for the remainder of the season, more in proportion to the wants of the people. Richard, however, boasted for many a year, of his shot with the "cricket;"[9] and Benjamin gravely asserted, that he thought that they killed nearly as many pigeons on that day, as there were Frenchmen destroyed on the memorable occa- 360 sion of Rodney's victory.[10] ◼

Reading Question

The destructiveness of civilization is made abundantly clear in this narrative. How does Cooper's military metaphor underscore it?

[8]Landlubber, a landsman or untrained seaman.

[9]A little cannon.
[10]In April 1782, the British admiral George Bridges, Baron Rodney, defeated the French in a naval battle in the West Indies.

Summary

■ **The Native American in Myth and Reality** The confrontation between white settlers and indigenous Americans accelerated after the Louisiana Purchase in 1803, effectively doubling the size of the United States. With the population of nonnative Americans rising from 4 million in 1790 to 31 million in 1860, the pressure was relentless on Native American tribes seeking to maintain their traditional hunting and gathering lifestyles. While American presidents like Washington, Jefferson, and Jackson emphasized the importance of "civilizing" Native Americans by converting them to Christianity, teaching them to farm, and educating their children, settlers on the frontier often ran roughshod over native rights, breaking treaty agreements and ignoring Indian land rights.

American artists of the nineteenth century offered a range of mythic interpretations of the frontier experience. Albert Bierstadt emphasized the "primitive" landscape, untainted by human civilization, and Emanuel Leutze offered heroic depictions of white American pioneers moving westward to build a new destiny. Other popular artists, such as John Vanderlyn, represented Native Americans as depraved and violent or, in the unique case of George Catlin, as a noble, disappearing race of innocents. America's first successful novelist, James Fenimore Cooper, also took the disappearance of Native Americans and their lands as one of his main subjects in the five novels comprising *The Leatherstocking Tales*.

Native American artists offered unique testament to their cultures and the rapid changes that overtook them by the end of the century. Families, bands, and tribes illustrated their histories by painting semiabstract figures on buffalo-hide robes, tepees, and shields, which they then used as memory aids for oral narratives, often regarded as "storytelling." Indigenous women artists used quillwork and beadwork to decorate tepees, shields, and implements, offering evidence of history and tribal myths in their work.

■ **The British in China and India** The European-American conflict with indigenous Americans mirrored encounters between Westerners and non-Western peoples and cultures during the eighteenth and nineteenth centuries. With their scientific and technological advances providing a decided edge in military and economic competition, Western nations began a concerted effort to dominate Asian and African nations with abundant resources or productive economies in order to transfer the wealth to their own countries. Britain proved the most successful at this through the policy of imperialism, which included using aggressive military and economic policies to take control either directly or indirectly of non-Western nations. Colonists played a major role by establishing plantations, other economic enterprises, and colonial governments in order to effectively transfer sovereignty to Britain and other colonial powers, such as France, Germany, and Belgium.

China fell victim to Britain's aggressive imperialist tactics in the late 1830s. Resisting the British effort to import massive quantities of opium in their country, the Chinese struggled to impose trade restrictions on this addictive drug. British merchants, supported by their government and the British military, forced the Chinese to back down in the "Opium War" of 1840–1842.

India, having fallen under control of Britain in the late-eighteenth century, also was negatively affected by imperialism. Its economy was seriously damaged by the British policies that forced Indians to sell raw materials at exploitatively low prices, and then undercut Indian manufacturers by selling finished textiles at below-market prices.

■ **The Opening of Japan** Japan was one of the few major Asian nations not overwhelmed by the West's aggressive military and economic policies. After the forced "opening" of Japan by American Commodore Matthew Perry in 1853, Japan embarked on new trade and diplomatic relationships with Europe and the United States, while also beginning a rapid effort to modernize its economy and government. After 1868, Japanese industrialization quickened, and a flood of manufactured products reached the West for the first time.

Among the most distinctive of those products were woodblock prints, or *ukiyo-e*, which depicted the "floating world" of urban Japan—the rituals of everyday life, the theatrical world, artisans, as well as landscapes and nature scenes.

■ **Africa and Empire** Beginning with the opening of the Suez Canal in 1869, Africa proved an irresistible lure for European colonial and imperialist interests, particularly for Britain, France, Germany, and Belgium. At stake were the exploitable natural resources of the African continent, including phosphates, gems, ivory, and rubber. Europe's African colonies were mostly used to produce large quantities of raw materials at the lowest possible price, which left most Africans in dire poverty.

Europe's imperialists justified their policies through the philosophy of social Darwinism, which explained social and cultural evolution as a part of Charles Darwin's theory of biological evolution. "Survival of the fittest" was the explanation for the supposed superiority of Europeans over Africans (and all other races and ethnicities). By extension, Europeans theorized that their culture, government, and institutions were likewise superior.

Glossary

animism Belief in the existence of souls and that nonhuman things can also be endowed with a soul.

apartheid A policy that promotes or is founded on racial segregation, especially as occurred in South Africa.

eugenics A theory focused on eliminating undesirable and less fit members of society by encouraging the proliferation of intelligent and physically fit humans.

fetish A figure or object with magical properties.

imperialism The extension of one nation's authority over another by the exercise of its military, economic, and/or political power.

social Darwinism An extension of Darwin's theory of evolution positing that nations and societies advance according to the rule of "the survival of the fittest."

Critical Thinking Questions

1. What single event do you think was most responsible for the *decentering* of culture in each of the following: Native Americans, Japan, India, and Africa?

2. How would you describe the difference between Native American attitudes about the land and those of the white settlers of North America?

3. What factors motivated European imperialism? Were they the same for each nation or group of colonizers?

4. Compare and contrast *Japonisme* with Europeans' interest in African arts.

The African Mask

When Westerners first encountered African masks in the ethnographic museums of Europe in the late nineteenth and early twentieth centuries, they saw them in a context far removed from their original settings and purposes. Pablo Picasso first saw such masks sometime in 1907 at the Musée d'Ethnographie de Trocadéro (later the Museum of Man) in Paris as he was working on the painting that many think of as announcing the birth of modern art, *Les Demoiselles d'Avignon*, a painting of prostitutes in the red-light district of Barcelona (see chapter 41). He was strongly affected by the experience. The masks seemed to him imbued with power that allowed him, for the first time, to see art, he said, as "a form of magic designed to be a mediator between the strange, hostile world and us, a way of seizing power by giving form to our terrors as well as our desires." As a result, he quickly transformed the faces of three of the five prostitutes in his painting into African masks (Fig. **39.21**).

Picasso's appropriation of African masks neglects their ritual, often celebratory social function in African society. Even Africans, it would appear, recognize that in a Western context, their masks lose their ritual power. A mask from Zaire (Fig. **39.22**) is a case in point. This mask was used in initiation dances among the hunters and fishers of the Ngbandi peoples in northwest Zaire around 1920, before the arrival of an invading column of the Belgian *Force Publique* [forss poo-BLEEK]. Since the 1880s, the Belgian troops had conscripted millions of tribal members throughout the Kongo region into virtual slave labor in order to meet rubber quotas, sometimes burning whole villages. Women were often captured, flogged, and raped by the Belgian troops in order to force their husbands to collect rubber. This time, the Ngbandi defeated the colonial army, which fled, leaving behind pails of green and white camouflage paint. So the Ngbandi adorned this mask with camouflage and placed it on an altar to celebrate their victory. But the mask could never be danced in an initiation rite again because it was tainted by its European coloration. ■

Fig. 39.21 Pablo Picasso. *Les Demoiselles d'Avignon*, detail. 1907. Oil on canvas, 8′ × 7′ 8″. Acquired through the Lille P. Bliss Bequest. (333.1939). The Museum of Modern Art, New York, NY, U.S.A. Digital Image © The Museum of Modern Art/Licensed by SCALA/Art Resource, NY. © Estate of Pable Picasso/ARS Artists Rights Society, NY.

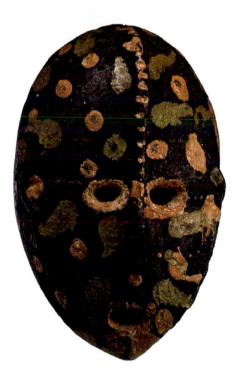

Fig. 39.22 Mask. ca. 1915–1920. Ngbandi, Zaire. Wood, European paint, height 11″. The Stanley Collection, The University of Iowa Museum of Art, Iowa City, IA. X1986.591.

40 From Realism to Symbolism

The Fin de Siècle

A Fair to Remember: The Paris Exposition of 1889

The Fin de Siècle: From Naturalism to Symbolism

Post-Impressionist Painting

Toward the Modern

❝ *One epoch of history is unmistakably in its decline, and another is announcing its approach. . . . Men look with longing for whatever new things are at hand . . .* **❞**

Max Nordau

◄ **Fig. 40.1 Les Fêtes de Nuit à la Exposition. 1900.** From *L'Exposition de Paris* (1900). Smithsonian Institution, Washington, DC. The 1889 and 1900 expositions in Paris drew visitors from around the world to celebrate the centennial of the French Revolution and the beginning of a new century. In 1900, Paris was lit for the first time by electric light, and the Eiffel Tower, erected for the Exposition of 1889, was the centerpiece of "les fêtes de nuit," the nighttime celebrations at the fair. It was as if darkness were evaporating, both literally and figuratively, and that a new light was about to dawn.

PARIS'S *EXPOSITION UNIVERSELLE* OF 1889 (MAP 40.1) WAS A fitting postscript to the nineteenth century as well as a precursor to the twentieth. It commemorated imperial supremacy, modern technology, and national pride one century after the beginning of the French Revolution. Further, the exposition

showcased France's cultural heritage and confirmed the status of Paris as one of the world's great centers of art. As he opened the fair, French President Sadi Carnot hailed the "new era in the history of mankind" that the revolutionary events of 1789 initiated, and the "century of labor and progress" that had unfolded since then.

But Carnot had little inkling of the darker side of technology and nationalism that would be unleashed over the next 50 years when two world wars killed over 60 million people with unparalleled efficiency. Ideologies also grew more strident and dangerous in the ensuing decades, becoming virulently transnational in scope and as dangerous as technology if unrestrained. France's president himself would become a victim of a new ideology 5 years later when an Italian anarchist assassinated him to avenge the execution of several

French anarchists who had participated in bombings. It seems that while nationalism held an increasing, often irrational sway over human behavior, political theories such as anarchism and, later, fascism and communism would also lead to violent and destructive actions by individuals and groups aiming to reshape society to their own standards.

This chapter surveys the era just before and after the 1889 Exposition, now labeled the *fin de siècle* [fen duh see-EKL], or "end of the century," but implying much more. The 1890s were characterized by an atmosphere of opulence, decadence, and anticipation as Europeans prepared to enter the twentieth century. Paris was widely acknowledged as the center of the fin de siècle spirit and one of the centers of artistic and literary innovation. The progression of Western cultural movements and styles

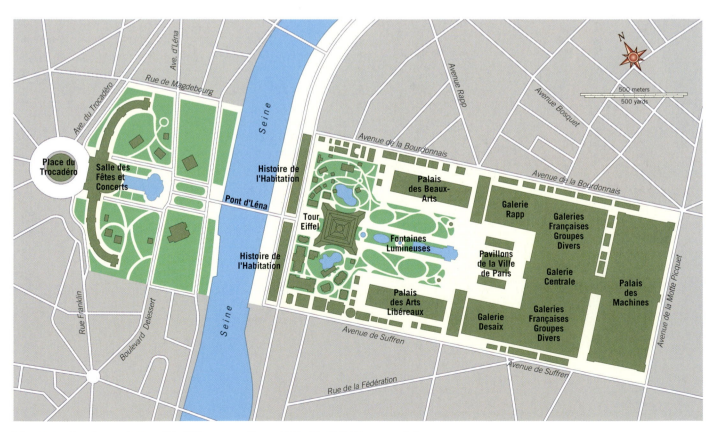

Map 40.1 **The Champs de Mars, World Exposition, Paris. 1889.** The Eiffel Tower is at left.

chronicled in this chapter—Art Nouveau, Symbolism, and Post-Impressionism—reveal a deeper mood of uncertainty about the world. Doubts about human rationality and about positivism—the belief that the scientific approach could explain and solve problems of the individual and society, were key elements of this uncertainty. In the realm of politics, revolution after revolution had promised a brighter future, but the rise of the bourgeois middle class proved unsettling, for its values seemed crassly materialistic, self-centered, and hypocritical. Even as scientific and technological innovation was everywhere apparent, artists found it difficult to reflect that spirit of innovation in their own work. A "new" modern art was struggling to be born, seemingly against the tide of popular culture and opinion.

A Fair to Remember: The Paris Exposition of 1889

The social and political problems of the next century were certainly not in the minds of the 28 million people who visited the Paris fair in 1889. They excitedly circulated among the artistic, commercial, and engineering marvels displayed by more than 6,000 exhibitors on over 235 acres and thought about a future embodied by that marvel of architecture and technology unveiled at the fair—the Eiffel Tower (Fig. **40.1**). The past was also represented at the fair in the form of a village of 400 native Africans and similar displays of numerous

other indigenous peoples from Asia and Africa in a "colonial" section. Together with reproductions of housing from around the world, the fair's "colonies" attested to the seemingly limitless ambition and power of imperial nations such as France to command the world's resources and peoples (Fig. **40.2**). A decade later, *Exposition Universelle* of 1900 (see Fig. 40.1) would reaffirm another decade of cultural progress, imperial power, and rapid technological advances.

The future was the chief attraction of the Paris Exposition, and *invention* was the key word of the day. In the Palace of Machines, Thomas Edison exhibited 493 new devices, including a huge carbon-filament electric lamp made from many smaller lamps. The magic of electricity made it possible to illuminate all 235 acres of the exposition. His phonograph was also a great attraction as thousands of visitors lined up each day to hear the machine. Other inventions fascinated the public—in the Telephone pavilion, one could listen to live performances of the Comédie Française through two earphones that created a convincing stereo effect.

The most popular "exhibit," however, was Gustav Eiffel's [EYE-ful] Tower (see Fig. 40.1), a 984-foot-high open-frame structure at the entrance of the fair that dominated the city. Almost twice the height of any other building in the world, the tower was meant "to raise to the glory of modern science and to the greater honor of French industry, an arch of triumph,"

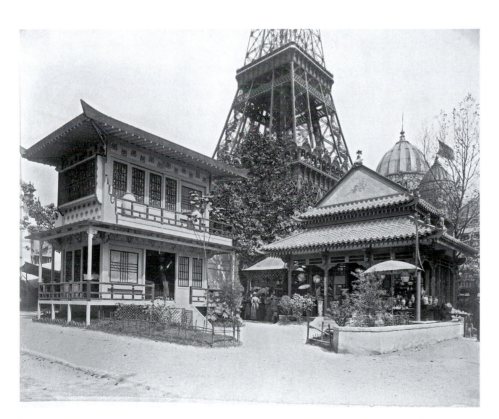

Fig. 40.2 Japanese house (left) and Chinese house (right) in the History of Habitation exhibit, *Exposition Universelle,* **Paris. 1889.** Library of Congress, Washington, DC. LC-US262-106562. The juxtaposition of East and West underscores the growing decentralization of culture discussed in chapter 39.

according to Eiffel. One of the main challenges he faced was how to protect the tower from the wind, which he solved by designing three levels of wrought-iron piers to provide efficient wind resistance. Once the tower was completed, spotlights positioned on the third level illuminated various Paris monuments. One of the world's first electric beacons on the top of the tower flashed a brilliant light, visible for more than a 100 miles, into the night sky. Electricity also allowed fair visitors to ascend almost a thousand feet to an observation platform at the top of the tower in a hydraulic elevator designed by the Otis Elevator Company.

Not everyone was pleased with the project. From the early 1880s, when the tower was under consideration, to 1887, when construction began, a fusillade of angry resistance issued forth from architects, artists, and people who lived in the vicinity of the project. Three hundred prominent artists and writers submitted the *Protestation des artistes* [pro-tes-tah-see-OHN dayz-ar-TEEST] to the Minister of Public Works, forcefully arguing that the erection of the tower was a violation of the city's beauty:

> Writers, painters, sculptors, architects, passionate lovers of the heretofore intact beauty of Paris, we come to protest with all our strength, with all our indignation, in the name of betrayed French taste, in the name of threatened French art and history, against the erection in the heart of our capital of the useless and monstrous Eiffel Tower.

Charles Garnier, the designer of the Paris Opera (chapter 36) and spokesperson for traditional architecture, was one of the key opponents because of the tower's bold new style and high profile as well as the fact that it eclipsed his own buildings at the fair. With his "History of Habitation" exhibit Garnier attempted to portray the progressive evolutionary history of humans through the buildings they lived in. The 33 buildings he carefully built to exacting historical standards illustrated how humans had improved their habitats over time through ingenious technology and architectural planning. However, Garnier's admiration for progress only went so far—and certainly did not include approval of the Eiffel Tower's mere "framework," as he ridiculed it.

If a writer like Guy de Maupassant [moh-pah-SOHN] lunched at the restaurant in the tower, it was not because he liked the food—he didn't—but because "It's the only place in Paris where I don't have to see it." Nevertheless, the tower quickly became one of the city's landmarks. Gradually, through the last decade of the century the Eiffel Tower came to symbolize not only Paris itself, but modernity. It was a very popular symbol of "the new."

The Fin de Siècle: From Naturalism to Symbolism

Although its meaning was never exact, *fin de siècle* came to refer to the last decade of the nineteenth century's climate of decadence, world-weariness, and dawn of a new kind of modernism in art. It was against the prevailing, popular spirit of progress and optimism as represented in the bourgeois values of the era. Max Nordau [NOR-dow], a Hungarian-born physician and Jewish leader, offered an eloquent and elaborate identification of the term in 1892:

> *Fin de siècle* is French, for it was in France that the mental state so entitled was first consciously realized . . . and Paris is the right place in which to observe its manifold expressions. . . . It means a practical emancipation from traditional discipline. . . . To the voluptuary, this means unbridled lewdness, the unchaining of the beast in man; . . . to the sensitive nature yearning for aesthetic thrills, it means the vanishing of ideals in art, and no more power in its accepted forms to arouse emotion. . . .
>
> One epoch of history is unmistakably in its decline, and another is announcing its approach. . . . Things as they are totter and plunge, and they are suffered to reel and fall, because man is weary, and there is no faith that it is worth an effort to uphold them. . . . Men look with longing for whatever new things are at hand . . .

While Nordau's popular essay bemoans the loss of "traditional views of custom and morality" and openly deplores the art of the era, it accurately captures European society's sense of being trapped between the end of one era and the start of another. The art of the era seems similarly caught in a state of "in between"—between a tradition whose values it rejects and a future that it cannot quite see but is struggling to define.

Art Nouveau

One of the most pervasive and influential new artistic styles beginning in the 1880s was Art Nouveau ("new art"), the name of which was derived from the Paris interior design shop of Siegfried Bing (1838–1905), named *Maison de l'art nouveau*. As with most artistic styles, Art Nouveau was associated with a number of contemporary trends, from the Arts and Crafts movement in England (chapter 37) to Symbolism, which endeavored to elevate feelings, imagination, and the power of dreams as creative inspiration. While Bing saw his galleries as displaying a wide range of art of the future, from fabrics by William Morris, to jewelry, glassware, and furniture, not everyone agreed. A Norwegian visitor put it this way:

> Rather than the rising sun of the coming century, this "new art" appears to symbolize the evening twilight of refinement, which has settled over French intellectual life and which, with a worn but still not worn out catch-word, calls itself "fin de siècle."

In fact, Art Nouveau was a transitional style, one caught between fin de siècle decadence and the innovations of modernity; between the nineteenth century's dedication to complex decorative designs and more abstract visions of the twentieth.

The fin de siècle era itself was transitional, and as an entrepreneur Bing, realized that he could take advantage of the mate-

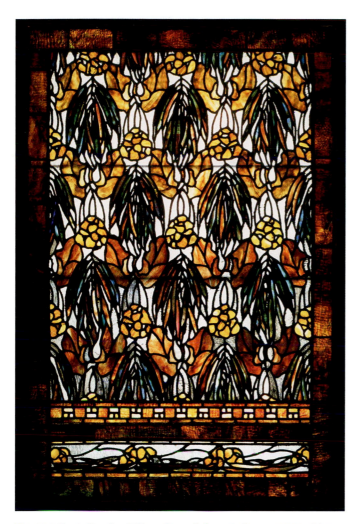

Fig. 40.3 **Louis Comfort Tiffany. Stained-glass window. ca. 1894.** Glass, 43″ × 27½″. Mention obligatoire Les Arts Decoratifs, Paris (Inv. 7972); Musee de la Publicite (Inv. 10531); Photo: Laurent Sully Jaulmes. Tous droits reserves. Tiffany's stained-glass and iridescent favrile glass vases, made by mixing different colors of glass together while hot (a process Tiffany patented in 1894), were widely popular in France. The Musée des Art Décoratifs purchased this window soon after it arrived at Bing's galleries in 1895.

with decorative items from Bing's workshop, where he supervised every aspect of the design and production.

As an international movement, Art Nouveau included architecture, glassware, textiles, furniture, and painting, and its practitioners could be found almost everywhere in Europe as well as in America's major cities. In one of the most important early innovations, Belgian architect Victor Horta [HOR-tuh] (1861–1947) incorporated the Art Nouveau style into architecture. Commissioned to design the Brussels home of scientist Emile Tassel, the traditionally trained Horta used floral patterns and designs resembling the tendrils and shoots of young plants to decorate the ironwork, walls, and floor tile of the house (Fig. 40.4). Such decorative effects spread rapidly across Europe, manifest in the long, flowing locks of female figures on posters, the peacock feathers on vases designed by Tiffany, budding flowerlike forms of glasswork, and the designs of furniture and metalwork.

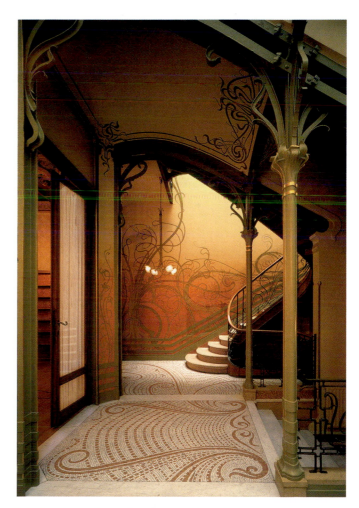

Fig. 40.4 **Victor Horta. Tassel House, Brussels. 1892–1893.** From a calyx like capital (calyxes are green and leaflike parts of a flower that enclose the petals), the iron columns sprout slender iron strips to support the floor above.

rialistic desires of the middle class by selling them a fashionable *art nouveau*. He was already the chief dealer of Japanese prints in Paris when he traveled to the United States in 1894 at the request of the French government to report on American art. While there, he visited the New York studios of Louis Comfort Tiffany (1848–1933), son of the founder of the famous New York jewelry house. Tiffany's decorative stained glass, Bing felt, might provide a model for French design (Fig. 40.3). Bing began to import Tiffany's designs and sell them, along with furniture by Émile Gallé and Eugène Gaillard [guy-YAHR], and ceramics by Georges de Feure [fehr], among others, in his new showrooms. So successful was his enterprise that he built his own pavilion at the 1900 *Exposition Universelle*, entitled *L'art nouveau Bing*. Consisting of six rooms—dining room, bedroom, sitting room, lady's boudoir, parlor, and foyer—this new, modern house was filled

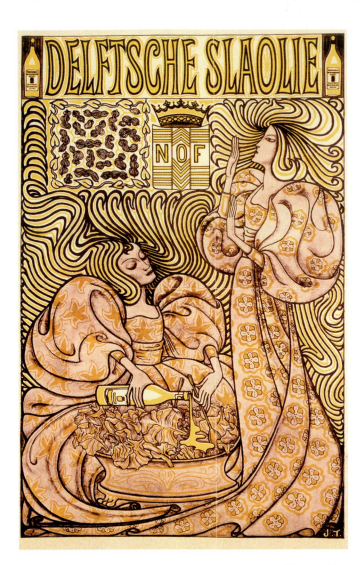

Fig. 40.5 Jan Toorop. *Delftsche Slaolie*. 1894. Lithograph, 37³/₄″ × 21¹/₄″. Dutch advertisement poster. Scala/Art Resource, NY. The undulating curvilinear rhythms of this poster advertising salad oil were widely emulated across Europe.

When viewing the poster design for Delftsche Slaolie salad oil (Fig. **40.5**) by Belgian painter Jan Toorop (1858–1928), one can easily understand how the whiplike tendrils, buds, and flowers of Art Nouveau could be interpreted not as a celebration of growth and rebirth but as decadent and suggestively sexual. The two women are preparing a salad, but in the undulating rhythms of their flowing robes and hair they elevate the mundane task "to the level of almost mystic rite," according to the Rijksmuseum in Amsterdam. As the best-known example of Dutch Art Nouveau, this commercial poster is now considered a masterpiece in the collection of one of Europe's greatest museums. Toorop's use of dynamic flowing lines, organic forms, color, and abstract designs to celebrate and enliven everyday life highlights an important aspect of the Art Nouveau movement. Rather than being confined to either the sphere of fine art or the practical applied designs of household objects and furniture, Art Nouveau encompassed a wide range of types of design.

Exposing Society's Secrets: The Plays of Henrik Ibsen

In the world of literature, the fin de siècle spirit was apparent in the later works of Norwegian playwright Henrik Ibsen (1828–1906), whose plays were performed across Europe in the last decades of the century. French author Émile Zola [zoh-LAH] introduced Ibsen's work to Paris and considered the playwright a naturalist (see chapter 36), who saw his world through an intensely acute and realistic lens. Ibsen's 1879 play *A Doll's House* was a sensation for its scathing depiction of Victorian marriage, with its oppression of women and cruelty of men. The heroine of the story, Nora, finally awakens to the truth of her existence, for although she lives a pampered, sheltered life, she is continually patronized and humiliated, treated like a child—or a doll—by her husband, Torvald (**Reading 40.1**):

READING 40.1 **from Henrik Ibsen, *A Doll's House*, Act III (1878)**

NORA: . . . While I was still at home I used to hear Father airing his opinions and they became my opinions; or if I didn't happen to agree, I kept it to myself— he would have been displeased otherwise. He used to call me his doll-baby, and played with me as I played with my dolls. Then I came to live in your house . . . from Father's hands I passed into yours. You arranged everything according to your tastes, and I acquired the same tastes, or I pretended to—I'm not sure which—a little of both, perhaps. Looking back on it all, it seems to me I've lived here like a beggar, from hand to mouth. I've lived by performing tricks for you, Torvald. But that's the way you wanted it. You and Father have done me a great wrong. You've prevented me from becoming a real person. . . . Our home has never been anything but a play-room. I've been your doll-wife, just as at home I was Papa's doll-child. And the children, in turn, have been my dolls. I thought it fun when you played games with me, just as they thought it fun when I played games with them. And that's been our marriage, Torvald.

In her weariness and her despair, Nora found a symbolic image—the doll's house—that offers expression to her previously inarticulate feelings. When, at the end of the play, she leaves home forever with a slam of the door, she has become the symbol of individual freedom, a whole person who declares as she leaves: "I cannot be satisfied any longer with what most people say, and with what is in books. I must think over things for myself, and try to get clear about them."

In Ibsen's play, Nora represents the future, Torvald the past, and the reaction of European audiences to the play reveals just how resistant nineteenth-century European society was to the

possibility of meaningful social change. Like the American audiences who reacted negatively to Kate Chopin's *The Awakening* (see chapter 38), Europeans were outraged. To admit that a woman might reject her familial duties to satisfy her own needs was unthinkable. In fact, the actress who played Nora in the first German production refused to play the final scene of the play, as Nora says to Torvald, "I'm sure I'll think of you often, and about the children and the house here." The German actress loudly protested, "*I would never leave my children*," abruptly ending the play with Nora unable to leave her children, sinking to the floor of their room in despair.

Ibsen was a realist, and he presented the hidden truths of European society as no one before had ever dared. In *Ghosts* (1881), which followed *A Doll's House*, he took on the problematic issues of children born out of wedlock, venereal disease, infidelity, and incest. Again the reaction was outrage for what was perceived as Ibsen's affront to public decency. In *Hedda Gabler* (1890) he explored the world of a neurotic woman at the edge of insanity, who successfully schemes to sabotage an academic rival to her husband. By destroying her husband's rival, however, Hedda also destroys herself, illuminating the powerful influence of irrational, sometimes unconscious motivations and values upon our lives. Ibsen, in short, revealed the lies behind the seemingly upright facade of contemporary European society, lies that many of his critics clearly wished he had kept secret. While Ibsen's work heralded new cultural trends that would come to fruition in the twentieth century, it also had many attributes of popular nineteenth-century literary styles, particularly realism. His emphasis on realistic dramas with complex moral questions would become central to the world of drama (and eventually film) in the new century.

The Symbolist Imagination in the Arts

With *The Master Builder* (1892), Ibsen began a series of four interrelated plays that explored the lives of powerful men who come to recognize their failures and shortcomings. Culminating with *When We Dead Awaken* (1899), they abandon the realism of his earlier work and explore the dreams and fantasy worlds of their protagonists. This focus on the subjective experience and the often irrational impulses that rule human behavior signaled a new emphasis on introspection and the realization that human behavior was difficult, if not impossible, to

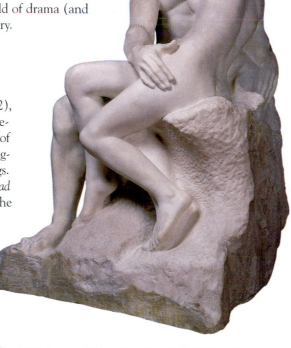

Fig. 40.6 Auguste Rodin. *The Kiss.* 1888–1889. Marble, 54½″ × 43½″ × 46½″. Musée Rodin, Paris. The sculpture was originally conceived as a depiction of Paolo and Francesca, the adulterous lovers whom Dante encounters in the Second Circle of Hell in *The Divine Comedy.*

quantify. Increasingly, Ibsen reflected the Symbolist aesthetic that in the last decade came to dominate the European imagination. The Symbolists aimed to "objectify the subjective . . . instead of subjectifying the objective," according to the poet Gustave Kahn (1859–1936). By describing transitory feelings of people through symbolic language and images, Symbolists hoped to convey the essential mystery of life.

Symbolism distinguished itself from naturalism as practiced by Émile Zola by downplaying the need to convey meaning through direct and accurate representation. Instead, it favored *suggesting* the presence of meaning in order to express the inexpressible. This movement away from the physical world and into the realm of impressionistic experience lays the groundwork for the modern in art because, detached as it is from tangible reality, it takes a first step toward abstraction.

The Sculpture of Rodin The transition from realism to Symbolism is notable in the expressive sculptures of Auguste Rodin [roh-DAN] (1840–1917), whose style matured in the years after 1877. In many ways, Rodin was an intense realist, identifiable in the fact that many people thought some of his pieces must have been the result of a mold being applied to a living model. Like the Impressionist painters who were his contemporaries, Rodin depended on the play of light upon surfaces for the energy of his works. And just as they worked *en plein air* [ahn plen air], Rodin based his sculpture on direct observation, which accounted for its smooth realization and considerable impact on critics and the public at large.

However, *The Kiss* (1888–1889), one of Rodin's most famous sculptures, is more than simply a sharply realistic portrayal of two bodies embracing (Fig. **40.6**). It is the very embodiment of ecstatic abandon in which the woman is clearly as active a participant as the man. The work was a purposeful homage to the opposite sex, according to Rodin. When it was exhibited at the Salon of 1886, viewers found it immodest and shocking. At the 1893 Columbian Exposition in Chicago (see chapter 38), a bronze version of *The Kiss* was considered too scandalous for public display.

Rodin's monumental homage to Balzac, a full-length representation of the writer in his dressing gown, also depicts a source

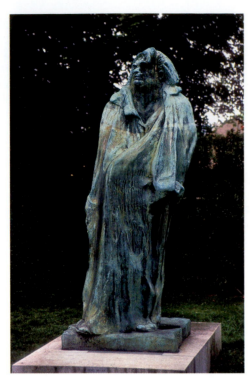

Fig. 40.7 Auguste Rodin. *Monument to Balzac.* **1898.** Bronze, 106¼″ × 47¼″ × 50⅜″. Garden of the Museum, Musée Rodin, Paris. When a model of the sculpture was first exhibited, it was dismissed as a "colossal fetus," a "colossal clown," and a "snowman." The Society of Men of Letters refused to accept it, and Rodin was forced to return payments for it that had already been made.

of creative power, in this case artistic (Fig. **40.7**). Rodin was grateful for the commission from the French literary organization of which Zola, an admirer of Rodin, was president. He immediately proceeded to study his subject in as much depth as Zola had studied the French mining industry for *Germinal* (see chapter 36). He traveled to Balzac's hometown of Tours in order to study the physical types of the city's inhabitants. He tracked down Balzac's tailor to find out his measurements so that he could model the artist's dressing gown to exact specifications. He viewed portraits, lithographs, and daguerreotypes of the writer. He modeled an imaginary Balzac nude so that he would know the body that he was to fit under the robe. But the finished nine-foot-high work is not realistic, although its "phallic, upward-thrusting form," as New York's Museum of Modern Art's catalog described it, is certainly memorable. It is recognizably Balzac, but a Balzac whose features have been exaggerated in the quest to illustrate the process of artistic creativity, enfolded in its robes. It is finally, as one contemporary critic has noted, as much Rodin's portrait as Balzac's, "the symbolic celebration, through Balzac, of the vigour and heroism of prolific genius."

Rodin, Lautrec, and the World of Montmartre In the early 1890s, a number of artists residing in Paris engaged in artistic experiments that combined music, dance, painting, and the new electrical lighting technology. Rodin was at the center of this community. He had always been attentive to the move-

ment of the human body, and he allowed his models—often dancers—to wander around the studio, striking poses at will (Fig. **40.8**). Gustav Kahn described Rodin's technique:

> She can sit, stand, lie down, stretch, and, according to her fancy or fatigue, propose a movement, an attitude, a letting go, and one of these images will be stopped by Rodin and captured in a drawing that seems to emerge almost instantaneously. Sometimes he does not even make her stop, but makes a cursive notation, for the rare movement he seeks is a transition between two movements.... The series of drawings furnishes him with an encyclopedia of human movements.... The huge sketchbook consulted by the artist takes on full meaning when he seeks the confirmation of a freshly-sprouted idea. The simplest movement, or observation of a physical attitude can give rise to an idea too.

Rodin's ideas inspired a close friend, the American dance sensation Loïe Fuller (1862–1928). She had arrived in Paris in 1892, bringing with her electricians skilled at devising dramatic lighting techniques. Within a short time, she was dazzling audiences at the Folies-Bergère [foll-EE-bair-ZHAIR] with a juxtaposition of colored lighting and dances marked by long, flowing, transparent fabrics swirling around her body. In 1893, French painter and printmaker Henri de Toulouse-Lautrec [too-LOOZ-loh-TREK] (1864–1901) executed a

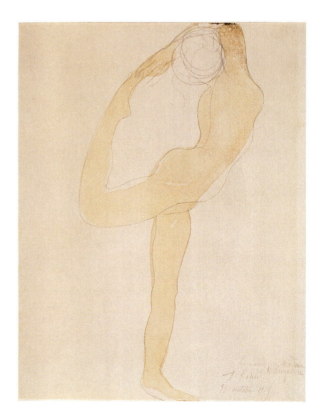

Fig. 40.8 Auguste Rodin. *Dancing Figure.* **1905.** Graphite with orange wash, 12⅞″ × 9⅞″. Gift of Mrs. John W. Simpson. 1942.5.36. Image © 2007 Board of Trustees, National Gallery of Art, Washington, DC. Rodin's drawings are characterized by their extreme simplicity, the outline of the body flowing continuously, without shadow or modeling. Broad bands of wash create a sense of volume.

Fig. 40.9 Henri de Toulouse-Lautrec. *Miss Loïe Fuller*. 1893. Color lithograph, sheet: $15\frac{1}{8}$″ × $11\frac{1}{16}$″. Rosenwald Collection. 1947.7.185 Image © 2007 Board of Trustees, National Gallery of Art, Washington, DC. Each of the approximately 60 impressions in the series is unique. Toulouse-Lautrec used five different lithographic stones in the process, inking them in a wide range of colors. He dusted some of the prints, including this one, with gold or silver powder, attempting to imitate the play of electric light on Fuller's dance.

series of 60 lithographs of Fuller dancing, each hand-colored in order to capture the full effect of her inventive show (Fig. **40.9**). An early champion of Rodin, Fuller helped organize the first exhibition of his work in New York in 1903.

Another popular dance of the era was the can-can, made infamous in 1890s Paris by La Goulue [goo-LEW] ("The Greedy One"), the stage name of Louise Weber (1866–1929). She was named La Goulue after her habit of dancing past café tables and quickly downing the drinks of the seated customers. When she danced the can-can, she lifted her skirts to reveal a heart embroidered on her panties. Then with a high kick she would flip a man's hat off with her toe. She performed regularly at the Moulin Rouge (Red Windmill), a cabaret in the Parisian red-light district in the Montmartre section of the city.

Such places and the people in them—gamblers, prostitutes, and circus performers—were Toulouse-Lautrec's favorite subjects. Severely deformed, the victim of a rare bone disease, Toulouse-Lautrec depicts himself walking with a tall cousin in the background of *At the Moulin Rouge* (Fig. **40.10**). Behind the two, La Goulue herself adjusts her red hair. At the table, a coterie of cabaret regulars, including the entertainer La Macarona, her face powdered in stark white makeup, and the dancer Jane Avril [ah-VREEL], noted for her long, red hair, share a drink. Toulouse-Lautrec's portrayals of the nightlife of Paris—in many ways a counterpart to Tokyo's "floating world" of courtesans, actors, and artists—helped define the fin de siècle era in lithographs and paintings. Although generally considered a Post-Impressionist (see page 1291), Toulouse-Lautrec is hard to categorize. He influenced the Art Nouveau movement

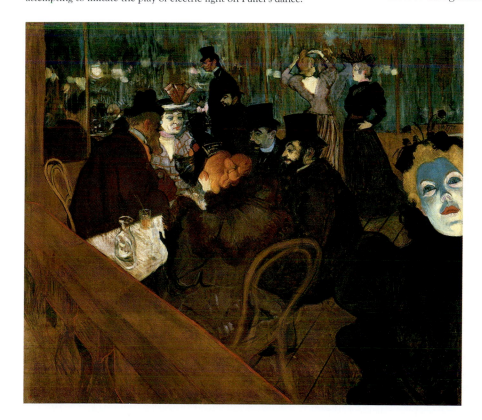

Fig. 40.10 Henri de Toulouse-Lautrec. *At the Moulin Rouge*. 1892–1895. Oil on canvas, $4'\frac{3}{8}$″ × $4'7\frac{1}{4}$″. Helen Birch Bartlett Memorial Collection, 1928.610. Photograph © 2006, The Art Institute of Chicago. All Rights Reserved. The faces of Toulouse-Lautrec's figures border on caricature, as if to mock traditional canons of beauty.

with his posters and lithographs, and also impacted the Symbolists. Perhaps the clearest assessment of Toulouse-Lautrec came from a German art historian who affirmed that "in his skilled hands, the denizens of Montmartre . . . are transformed into symbols of themselves. Toulouse-Lautrec's art is simultaneously realistic and symbolic. The figures are stripped of accidental detail and reduced to the essence of character. They are an essence distilled from reality by a great artist."

Mallarmé's Poetry Like Rodin and Toulouse-Lautrec, the Symbolist poet Stéphane Mallarmé [mah-lar-MAY] (1842–1898) was immediately enraptured by Loïe Fuller. She is "at once an artistic intoxication and an industrial achievement," he wrote, referring to her lighting effects, "fusing the swift changes of color that vary their limelit phantasmagoria of twilight and grotto with rapidly changing passions—delight, mourning, anger." If, for Mallarmé, to name a thing was to destroy it and to suggest it was to bring it to life, it was the dancer, not the lighting, that was the most important ingredient in Fuller's colorful show. "The dancer," he wrote,

> . . . does not dance, but suggests, by prodigies of bending and of leaping, by a corporeal writing, what would require paragraphs of prose, both dialogue and description, to express in words: a poem freed from all the machinery of the writer.

Because Mallarmé believed that a poem was somehow hindered by the writer's words and syntax—and that poetry might be freed of the necessity of words—it is not surprising that in his own works what is said is less important than how the poems evoke feelings. Their mysterious suggestions and overtones take precedence over the logic of grammar, replaced by a sensual web of free association. In one of his most famous poems, "L'Après-midi d'un faune" [lah-pray-mee-DEE duh fohn] ("The Afternoon of a Faun"), the faun—part-man, part-goat—wakes from a dream to remember his afternoon tryst with a group of nymphs (female goddesses, spirits of nature). The poem was inspired by the Ovidian myth of the god Pan's attempt to seduce the beautiful nymph Syrinx [SUR-inks], who is rescued from his clutches. Regretting his loss, Pan discovers the beauty of music by blowing air through the reeds into which Syrinx has been transformed. While Mallarmé takes many liberties with the myth, he maintains most of the core elements, and leaves the ending ambiguous (**Reading 40.2a**):

READING 40.2a **from Stéphane Mallarmé, "L'Après-midi d'un faune" ("Afternoon of a Faun") (1876)**

Ah well, towards happiness others will lead me
With their tresses knotted to the horns of my brow:
You know, my passion, that, purple and just ripe,

The pomegranates burst and murmur with bees;
And our blood, aflame for her who will take it,
Flows for all the eternal swarm of desire.
At the hour when this wood's dyed with gold and with ashes
A festival glows in the leafage extinguished:
Etna! 'tis amid you, visited by Venus
On your lava fields placing her candid feet,
When a sad stillness thunders wherein the flame dies.
I hold the queen!

It is clear that this passage is charged with sexual symbolism. The juxtaposition of "passion," "purple," and "just ripe" seems to suggest physical as well as imaginative readiness, and the pomegranate is a traditional symbol of fertility, bursting with seed. Above all, the poetry is suggestive, not definitive, creating a mood, an impression, an atmosphere, more than a clear image. (See **Reading 40.2**, page 1307, for the entire poem.)

The Music of Debussy The most notable missing element in any translation of Mallarmé's poetry is the sound of the French language—the music of his words. Something of their effect, however, was translated into instrumental music by the composer Claude Debussy [duh-boo-SEE] (1862–1918), who began attending Mallarmé's Tuesday salons in about 1892, when he was 30 years old. Mallarmé's friends and associates—the international cast of artists and intellectuals who met on Tuesdays (*mardi* in French) became known as *les Mardistes*. They included the Irish poet William Butler Yeats, the German poet Rainer Maria Rilke, and French poet Paul Verlaine. Two years later, Debussy composed one of his most famous and important pieces, *Prélude à l'après-midi d'un faune*, which many consider a defining moment in the history of music (see **CD-Track 40.1**).

Before its first performance on December 22, 1894, Debussy invited Mallarmé to attend: "I need not say how happy I would be if you were kind enough to honour with your presence the arabesque which, . . . I believe to have been dictated by the flute of your faun." Mallarmé was evidently delighted and responded with a short poem:

If you would know with what harmonious notes
Your flute resounds, O sylvan deity,
Then harken to the light that shall be breathed
There unto by Debussy's magic art.

Music's ability to bring to mind a torrent of images and thoughts without speech is almost perfectly realized in Debussy's composition, first by an opening flute solo that is shaped as a series of rising and falling arcs and then later by oboes, clarinets, and more flutes that develop the theme further. Debussy adds textures to this melody with harp, muted horns, the triangle, and lightly brushed cymbals, backed by orchestral accompaniment that provides atmospheric tone. The use of **chromatic scales**, which move in half-steps through all the black and white keys on a keyboard, lends *Prélude à l'après-midi d'un faune* a sense of aimless wandering.

As with other efforts by the fin de siècle artists, *Prélude* [pray-LOOD] was a controversial work. More than 20 years after the

premiere, another major French composer, Camille Saint-Saëns (1835–1921), declared: "The *Prelude to the Afternoon of a Faun* has a pleasing sonority, but one finds in it scarcely anything that could properly be called a musical idea. It is to a work of music what an artist's palette is to a finished painting." Indeed, because Debussy's music lacks clear-cut cadences and tonal centers, it has often—and somewhat erroneously—been labeled Impressionist, which he disagreed with at the time. His 1905 composition *La Mer* [mair] (*The Sea*) seems to be a clearly impressionistic evocation of water. It consists of three sections. They illustrate the play of light on the surface of the water in the first, the movement of waves in the second, and the sound of wind on the water in the third. Superficially, it seems similar to the observation of the shimmering effects of water in Monet's *Regatta at Argenteuil* (see Fig. 37.6).

Some have made the point that Debussy's music is more Symbolist than Impressionist in nature because of the subtle but important difference between the words *impression* and *suggestion*. *Impression* is a received image and *suggestion* is a created effect. If *La Mer* were Impressionist, it would recreate the way in which the composer literally viewed the sea. But it is Symbolist, suggesting the way that Debussy feels about the sea, expressing the profound mysteries of its unseen depths.

Post-Impressionist Painting

As we have seen, Toulouse-Lautrec has been labeled a Post-Impressionist, which refers to the generation of painters who followed the eight Impressionist Exhibitions in Paris, which ended in 1886. The other painters we think of as Post-Impressionists include Paul Cézanne, Paul Gauguin, and Georges Seurat, all of whom exhibited at various Impressionist shows. Rather than creating Impressionist works that captured the optical effects of light and atmosphere and the fleeting qualities of sensory experience, they sought to capture something transcendent in their act of vision, something that captured the essence of their subject. This is similar to the goal of Symbolist artists. The Post-Impressionists saw themselves as inventing the future of painting, of creating art that would reflect the kind of sharply etched innovation that, in their eyes, defined modernity.

Pointillism: Seurat and the Harmonies of Color

One of the most talented of the Post-Impressionist painters was Georges Seurat [suh-RAH] (1859–1891), who exhibited his masterpiece, *A Sunday on La Grand Jatte*, in 1886 when he was 27 years old (Fig. **40.11**). It depicts a Sunday crowd of Parisians

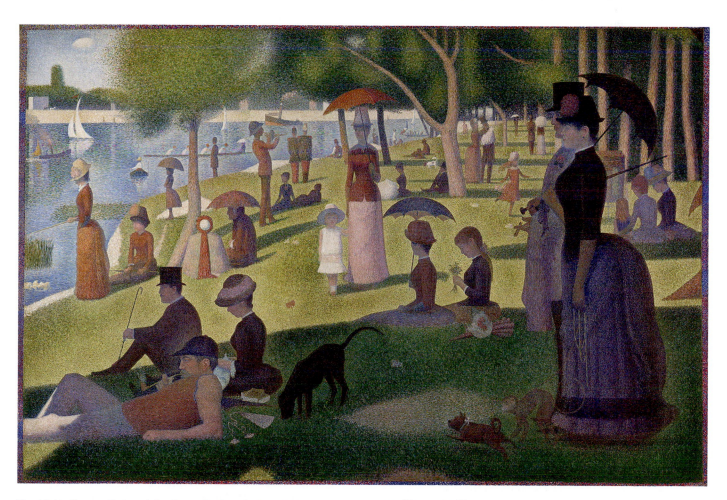

Fig. 40.11 Georges Seurat. A Sunday on La Grande Jatte. 1884. Oil on canvas, 5′ 11¾″ × 10′ 1¼″. Helen Birch Bartlett Memorial Collection, 1926.224. Combination of quadrant captures F1, F2, G1, G2. Photograph © 2006, The Art Institute of Chicago. All Rights Reserved. Capuchin monkeys like the one held on a leash by the woman on the right were a popular pet in 1880s Paris.

enjoying the weather on the island of La Grand Jatte in the Seine River just northeast of the city. The subject matter is typically Impressionist, but it lacks that style's sense of spontaneity and the immediacy of its brushwork. Instead, *La Grand Jatte* is a carefully controlled, scientific application of tiny dots of color—*pointilles* [pwahn-TEE], as Seurat called them—and his method of painting became known as pointillism [POIN-tih-lizm] to some, and neo-impressionism to others.

Seurat tried to incorporate systematically the theories of Michel Eugène Chevreul's *Principle of Harmony and Contrast of Colors* (1839) and Ogden N. Rood's *Modern Chromatics* (1879) into his paintings to better utilize combinations of colors. Chevreul, in particular, had established the value of employing red, yellow, and blue as primary colors, through which most other colors can be mixed, and orange, green, and violet as secondary colors, produced by the mixing of two primaries. Rood's ideas were more sophisticated than Chevreul's and more useful to the painter, because he recognized that there was a significant difference between colored light and colored pigments. Not only did light possess a different set of primary and secondary colors—red, blue, and green—but the laws governing the mixture of these colors were dissimilar as well. Mixing together the colors of pigment is a *subtractive* process—that is, mixing together all three primary pigments ultimately creates black, the absence of color. But mixing light is an *additive* process—when all the primary colors of light are mixed, they create white, which has all colors in it. This is illustrated when light refracting through the moisture in the air becomes a rainbow.

One of the most difficult tasks Seurat and other painters faced was imitating in the subtractive medium of pigments the additive effects of colored light observed in nature. In Rood's observation, placing "a quantity of small dots of two colors very near each other . . . allowing them to be blended by the eye placed at the proper distance. . . . [produces] true mixtures of colored light." The theory, it turns out, was not quite right, so while some found Seurat's painting to be luminous, others complained that "one could hardly imagine anything dustier or more dull." Ultimately, in pointillist paintings, dots of yellow-orange, meant to create a sensation of bright sunlight, will appear to be gray from a distance of even 15 feet.

Nevertheless, in setting his "points" of color side by side across the canvas, Seurat determined that color could be mixed, as he put it, in "gay, calm, or sad" combinations. Lines extending upward could also reflect these same feelings, he explained, imparting a cheerful tone, as do warm and luminous colors of red, orange, and yellow. Horizontal lines that balance dark and light, warmth and coolness, create a sense

of calm. Lines reaching in a downward direction and the dark, cool hues of green, blue, and violet evoke sadness.

With this symbolic theory of color in mind, we can see much more in Seurat's *La Grand Jatte* than simply a Sunday crowd enjoying a day at the park. There are 48 people of various ages depicted, including soldiers, families, couples, and singles, some in fashionable attire, others in casual dress. A range of social classes is present as well, illustrating the mixture of diverse people on the city's day of leisure. Although overall the painting balances its lights and darks and the horizontal dominates, thus creating a sense of calm, all three groups in the foreground shadows are bathed in the melancholy tones of blue, violet, and green. With few exceptions—a running child, and behind her a couple—almost everyone in the painting is looking either straight ahead or downward. Even the tails of the pets turn downward. This solemn feature is further heightened by the toy-soldier rigidity of the figures.

Like a Symbolist poem, Seurat's painting *suggests* more than it portrays—and his intentions are even more clearly revealed in *Les Poseuses* [pose-URZ] (*The Models*) (1888), a painting of his studio in which *La Grande Jatte* functions as a sort of painting-within-the-painting (Fig. **40.12**). A critic of the time had written of *La Grande Jatte*, "one understands then the rigidity of Parisian leisure, tired and stiff, where even recreation is a matter of striking poses." *Les Poseuses* affirms this view. Some of the clothes in the foreground—notably the hats, the red umbrella, and the blue gown—are recognizably costumes used in the *La*

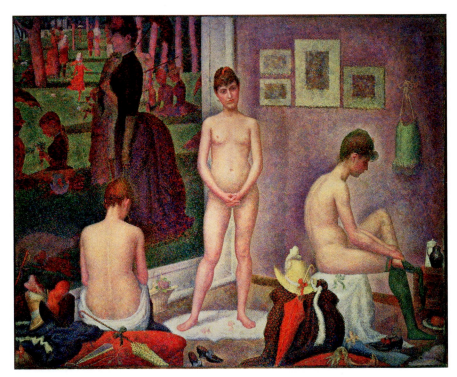

Fig. 40.12 Georges Seurat. *Les Poseuses* (The Models). 1886–1888. Oil on canvas, 6′ 6¾″ × 8′ 2⅜″. The Barnes Foundation, Merion, Pennsylvania. Seurat unites the elements of this painting through color. Note, for instance, how the green stockings and green bag hanging on the wall echo the greens of *La Grande Jatte*, the huge painting on the wall to the left of the models, while the red umbrella, lying against a polka-dot dress, echoes the little girl in red running in the painting.

Grande Jatte, and Seurat's models seem to be changing out of them into their street clothes. But the key element here is the title itself. As art historian Linda Nochlin has pointed out, *poseuse* is not the usual term employed by the French to describe an artist's model—*modèle* [moh-DELL] is. *Poseuse* rather means "one who seeks to attract attention by an artificial or affected manner." Seurat, then, in *Les Poseuses*, calls attention to the artificiality and affectation of the figures in *La Grande Jatte*.

Symbolic Color: Van Gogh

Seurat's influence on French painting was profound. Indeed many, including prominent critics of his era, considered him the founder of "neo-impressionism." Even Impressionist Camille Pissaro (see chapter 37) would take up the style for a time. Seurat's student Paul Signac would advance his theories by making his *pointilles* larger—passing on this innovation to twentieth-century painters such as Henri Matisse [mah-TEES] (see chapter 41). And perhaps the most famous of the nineteenth-century artists, Dutch painter Vincent van Gogh (1853–1890), also studied Seurat's paintings while living in Paris in 1886–1887. (He worked there for Siegfried Bing selling Japanese prints [see *Japonisme*—chapter 37].) Van Gogh experimented extensively with Seurat's color combinations and pointillist technique, which extended even to his drawings, as a means to create a rich textural surface.

Van Gogh was often overcome with intense and uncontrollable emotions, an attribute that played a key role in the development of his unique artistic style. Profoundly committed to discovering a universal harmony in which all aspects of life were united through art, van Gogh found Seurat's emphasis on contrasting colors appealing. It became another ingredient in his synthesis of techniques. He began to apply complementary colors in richly painted zones using dashes and strokes that were much larger than Seurat's *pointilles*. In a letter to his brother Theo in 1888, van Gogh described the way the complementary colors in *Night Café* (Fig. **40.13**) work to create visual tension and emotional imbalance:

> In my picture of the *Night Café* I have tried to express the idea that the café is a place where one can ruin oneself, run mad, or commit a crime. I have tried to express the terrible passions of humanity by means of red and green. . . . Everywhere there is a clash and contrast of the most alien reds and greens. . . . So I have tried to express, as it were, the powers of darkness in a low wine shop, and all this in an atmosphere like a devil's furnace of pale sulphur. . . . It is a color not locally true from the point of view of the stereoscopic realist, but color to suggest the emotion of an ardent temperament.

Color, in van Gogh's paintings, becomes symbolic, charged with feelings. Added to the garish conflict of colors is van Gogh's peculiar point of view, elevated above the room that sweeps away from the viewer in exaggerated and unsettling perspective. *Night Café* in this regard reflects not just a mundane view of the interior of a café lit by lamps, but van Gogh's "ardent" reaction to it.

For many viewers and critics, van Gogh's paintings are the most personally expressive in the history of art, offering unvarnished insights into the painter's unstable psychological state. As he was painting *Night Café*, van Gogh was living in the southern French town of Arles, where, over the course of 15 months, he produced an astounding quantity of work: 200 paintings, over 100 drawings and watercolors, and roughly 200 letters. Many of these letters, especially those addressed to his brother Theo, help us to interpret his paintings, which have become treasured masterpieces, each selling for tens of millions of dollars. Yet at the time he painted them, almost no one liked them, and he sold almost none of his art.

To viewers at the time, the dashes of thickly painted color, a technique known as *impasto*, seemed thrown onto the canvas as a haphazard and unrefined mess. And yet, the staccato rhythms of this brushwork seemed to van Gogh himself deeply autobiographic, capturing almost stroke by stroke the pulse of his own volatile personality.

Fig. 40.13 Vincent van Gogh. *Night Café*. 1888. Oil on canvas, 28½″ × 36¼″. Yale University Art Gallery, 1961.18.34. New Haven, Connecticut/Art Resource, NY. Van Gogh frequented this café on the place Lamartine in Arles. Gas lighting, only recently introduced, allowed it to stay open all night. Drifters and others with no place to stay would frequent it at night. Notice how many patrons seem to be asleep at the tables.

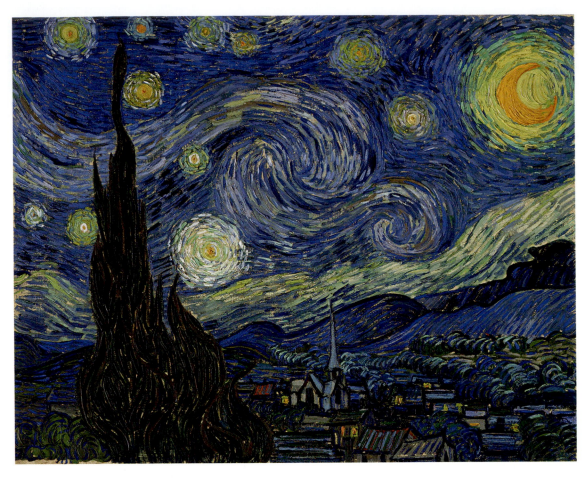

Fig. 40.14 Vincent van Gogh. *The Starry Night.* **1889.** Oil on canvas, 28$\frac{3}{4}$″ × 36$\frac{1}{4}$″. Acquired through the Lillie P. Bliss Bequest. (472.1941). Digital Image © The Museum of Modern Art/Licensed by Scala/Art Resource, NY. Saint-Rémy, where van Gogh painted this work, lies at the foot of a small range of mountains between Arles and Aix-en-Provence. This part of France is plagued in the winter months by the mistral, strong winds that blow day after day out of the Alps down the Rhone River valley. The furious swirls of van Gogh's sky and the blowing cypress trees suggest that he might be representing this wind known to drive people mad, in contrast to the harmonies of the painting's color scheme.

In December 1888, van Gogh's personal emotional turmoil reached a fever pitch when he sliced off a section of his earlobe and presented it to an Arles prostitute as a present. After a brief stay at an Arles hospital, he was released, but by the end of January the city received a petition signed by 30 townspeople demanding his committal. In early May, he entered a mental hospital in Saint-Rémy, not far from Arles, and there he painted *Starry Night*, perhaps his most famous composition (Fig. **40.14**). Unlike the violent contrasts that dominate the *Night Café*, here the swirling cypresses (in which red and green lie harmoniously side by side) and the rising church steeple unite earth and sky. Similarly, the orange and yellow stars and moon unite with the brightly lit windows of the town. Describing his thoughts about the painting in a letter to his brother, van Gogh wrote, "Is it not emotion, the sincerity of one's feeling for nature, that draws us?"

Another work of van Gogh's, the *Portrait of Patience Escalier* [ess-kah-lee-AY], is not just a portrait, but the embodiment of van Gogh's feeling for nature (Fig. **40.15**). The painting, the artist wrote, is "a sort of 'man with a

Continuity **&** Change
p. 1136

The Sower

hoe'"—that is, a peasant in the tradition of Millet (see Fig. 35.17). But if the painting recalls realist subject matter, its color is anything but. Escalier's blue coat, though traditional peasant garb, evokes the deep blue skies of the south of France, and the orange background reproduces what van Gogh described as "the furnace of the height of harvest time . . . orange colors flashing like lightning, vivid as red-hot iron." He further explained that ". . . although it does not pretend to be the image of a red sunset, [it] may nevertheless give a suggestion of one." Through color, van Gogh calls to mind not just the landscape of southern France, but also the enduring lifestyle and nobility of the peasants who live in it.

Van Gogh understood that in paintings like *Portrait of Patience Escalier*, he was actively abandoning Impressionism. In so doing, he established not only his signature style, but also a vigorous and modern aesthetic sense. As he wrote while working on the painting:

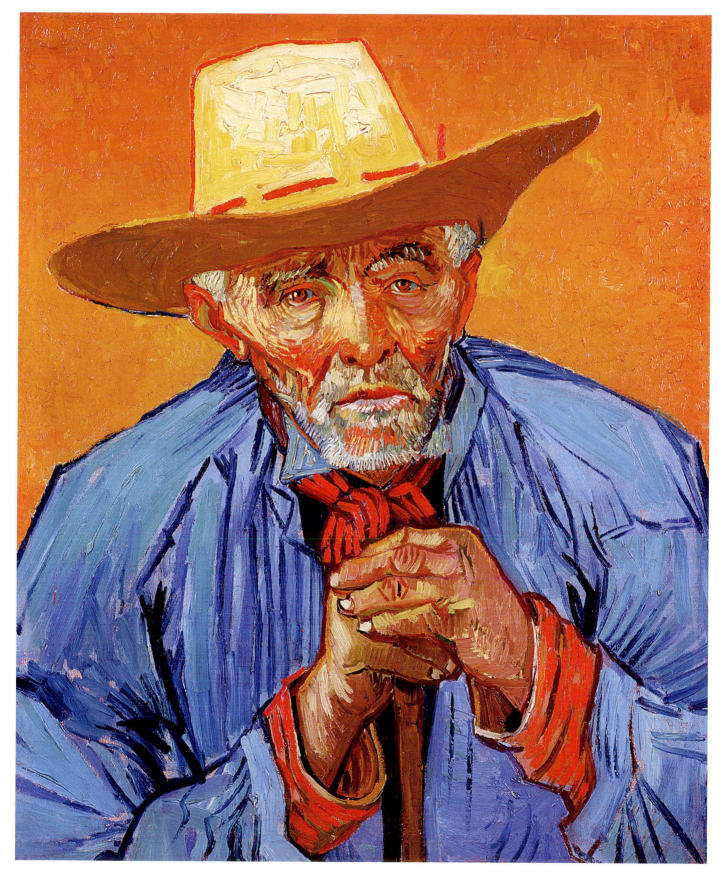

Fig. 40.15 Vincent van Gogh. *Portrait of Patience Escalier.* **August 1889.** Oil on canvas, 27 1/8″ × 22″. Private Collection/Photo © Lefevre Fine Art, Ltd., London/The Bridgeman Art Library. Van Gogh would comment on the

What I learned in Paris is leaving me and I am returning to the ideas I had . . . before I knew the impressionists. And I should not be surprised if the impressionists soon find fault with my way of working. . . . Because instead of trying to reproduce exactly what I have before my eyes, I use color more arbitrarily, in order to express myself forcibly.

Although his work grew ever bolder and more creative as the years passed, van Gogh continued to suffer from the emotional instability and depression that tormented him most of his adult life. In July 1890, after a number of stays in hospitals and asylums, he committed suicide in the fields outside Auvers-sur-Oise, where he was being treated by Dr. Paul Gachet, who was the subject of several of the great artist's last portraits.

The Structure of Color: Cézanne

The French painter Paul Cézanne [say-ZAHN] (1839–1906) might have written the same words as van Gogh with respect to Impressionism. He certainly had similar thoughts regarding the colors of the south of France. Writing in 1876 to another Impressionist painter, Camille Pissarro, he described the village of L'Estaque [less-TAHK] on the Gulf of Marseilles [mar-SAY]:

It's like a playing card. Red roofs against the blue sea. . . . The sun here is so tremendous that it seems to me that the objects are defined in silhouette, not only in black, but in blue, in red, in brown, in violet. I may be mistaken, but it seems to me to be the antithesis of modeling.

So it seems hardly accidental that Cézanne's *The Gulf of Marseilles, Seen from l'Estaque* (Fig. **40.16**) uses the same colors van Gogh used in *Patience Escalier*. Nevertheless, Cézanne did not much care for van Gogh's work. Indeed, there is little of the symbolism of van Gogh's colors in Cézanne's painting, since he was more interested in the way that color structures the space of the canvas.

Of all the Post-Impressionists, Cézanne was the only one who continued to paint *en plein-air*. In this regard, he remained an Impressionist, and he continued to paint what he called

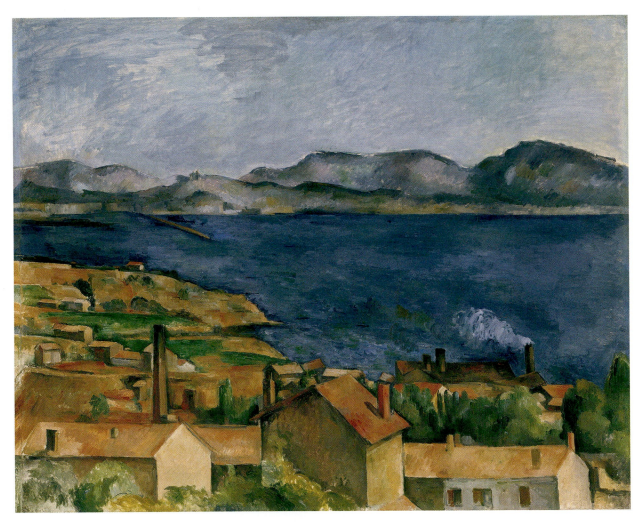

Fig. 40.16 Paul Cézanne. *The Gulf of Marseilles, seen from l'Estaque*. ca. 1885. Oil on canvas, 31 ½″ × 39 ¼″.
Mr. and Mrs. Martin A. Ryerson Collection. 1933.1116. Reproduction, The Art Institute of Chicago. All Rights Reserved.
Note the way in which the brightly lit side wall of the building at the lower right seems to parallel the picture plane rather than recede at an angle away from it.

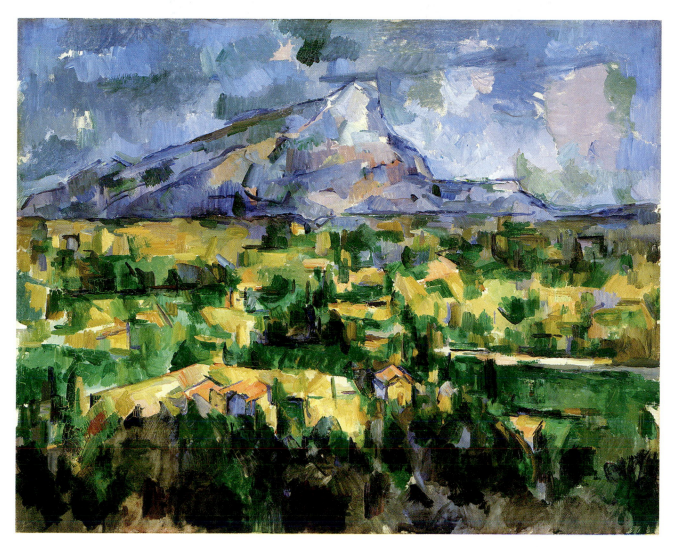

Fig. 40.17 Paul Cézanne. *Mont Sainte-Victoire*. 1902–1904. Oil on canvas, 28 ¾″ × 36 ³/₁₆″. Photo Graydon Wood.
Philadelphia Museum of Art: The George W. Elkins Collection, 1936. E1936-1-1. Cézanne painted this from the top of
the steep hill known as Les Lauves, just north of Aix-en-Provence but within walking distance of the city center. He built
his own studio on a plot of land halfway up the hill, overlooking the city.

"optics." The duty of the painter, he said, was "to give the image of what we see," but innocently "forgetting everything that has appeared before." The result of this vision is a representation of nature as a series of patches of color that tend to flatten the surface of his paintings. (For an examination of this topic in regard to Cézanne's still-life paintings, see *Focus*, pages 1298–1299.) In *The Gulf of Marseilles*, for instance, the roofs and walls of the houses seem to lose the sense of having been drawn in proper perspective as swathes of yellow, orange, red, and green lie against one another. The uniform saturation of the blue color of the sea contradicts the illusion of spatial recession into deep space, causing the sea to hang like a curtain over the village.

Similar to Monet at Giverny [zhee-ver-NEE], Cézanne returned to the same theme continually—Mont Sainte-Victoire, the mountain overlooking his native Aix-en-Provence [eks-ahn-proh-VAHNSS] in the south of France (Fig. **40.17**). In the last decade of his life, the mountain became something of an obsession, as he climbed the hill

behind his studio to paint it day after day. He especially liked to paint after storms when the air is clear and the colors of the landscape are at their most saturated and uniform intensity. Cézanne acknowledges the illusion of space of the mountain scene by means of three bands of color. Patches of gray and black define the foreground, green and yellow-orange the middle ground, and violets and blues the distant mountain and sky. Yet in each of these areas, the predominant colors of the other two are repeated—the green brushstrokes of the middle ground in the sky, for instance—all with a consistent intensity. The distant colors possess the same strength as those closest. Together with the uniform size of Cézanne's brushstrokes—his patches do not get smaller as they retreat into the distance—this use of color makes the viewer very aware of the surface qualities and structure of Cézanne's composition. It is this tension between spatial perspectives and surface flatness that would become one of the chief preoccupations of modern painting in the forthcoming century.

Focus

Cézanne's *Still Life with Plaster Cast*

In the late nineteenth century, few artists challenged the traditions of Western painting more dramatically than Paul Cézanne. In no painting is that challenge more explicit than *Still Life with Plaster Cast*, painted in about 1894. While the painting includes a plaster copy of a Cupid sculpted by Pierre Puget [poo-ZHAY] (1620–1694), it is also a commentary on the natural and artificial worlds. Since the Renaissance, Western art had been dedicated to representing the world as the eye sees it—that is, in terms of perspectival space. But Cézanne realized that we see the world in far more complex terms than just the retinal image before us. We see it through the multiple lenses of our lived experience. This multiplicity of viewpoints, or perspectives, is the dominant feature of Cézanne's paintings.

Cézanne consciously manipulates competing points of view in *Still Life with Plaster Cast*. Nothing in the composition is spatially stable. Instead we wander through the small space in the corner of Cézanne's studio just as the painter's eye would do. His viewpoint constantly moves, contemplating its object from this angle, then that one. In *Still Life with Plaster Cast* as well as other Cézanne still lifes, we experience the very uncertainty of vision. These still lifes consistently abandon Renaissance certainties about the position of objects in space in favor of a new, uncertain view, in which even a still life is animated. In French, the term for a "still life" is *nature morte* [nah-TOOR mort], literally "dead nature." Cézanne sought to reanimate vision, to bring "still life" back to life.

Paul Cézanne. *The Peppermint Bottle.* **1893–1895.** Oil on canvas, 26″ × 32⅜″. Image © 2007 Board of Trustees, National Gallery of Art, Washington. Chester Dale Collection. This is one of several paintings stacked against the wall of the painter's studio in *Still Life with Plaster Cast* that contribute to the visual complexity of that work. At the left side of *Still Life with Plaster Cast* a blue cloth, under the plate of apples, seems to rise up off the table to support what we can now see are actually two apples in the right side of *The Peppermint Bottle*, where they appear ready to fall forward into the lap of the viewer. They are in motion, like Cézanne's eye and mind, and perhaps our frenetic modern lives.

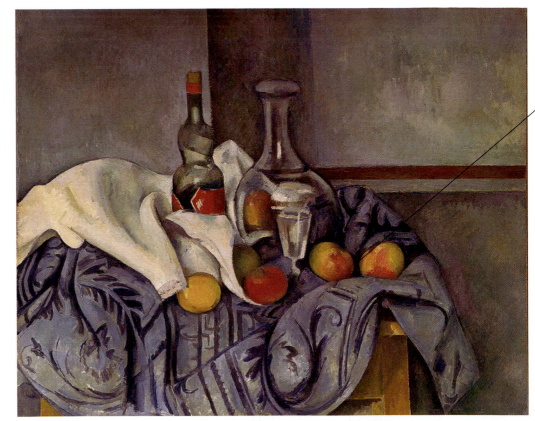

The edges of a canvas behind the statue visually reinforces the Cupid's posture, even as it seems to position him in the space of that canvas. This heightens the spatial confusion of the composition. What is in back seems to come forward. What is in front seems to fall back. Nothing is spatially stable.

If this is a green apple in the corner of the studio, it is far too large, larger than a grapefruit. Although we know that objects in the distance appear smaller than objects close at hand, Cézanne represents the apple not how it appears to us, but how we know it to be—the same size as the apple on the table directly below it.

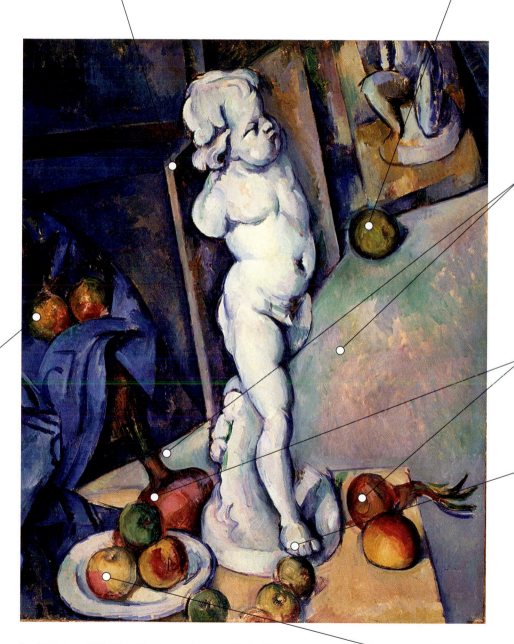

The studio floor seems oddly to angle away to the left and also to tilt up. In fact, to the left of the Cupid, Cézanne appears to be looking at the floor from across the table, whereas to the right of the Cupid, he seems to be looking down at the floor from above. Although the painting seems disjointed left to right, Cézanne seems to be suggesting that we never view the world from a single point of view. So he presents two different points of view here.

The two red onions are of radically different size, echoing the difference in size of the green apple on the floor at the corner of the room and the apples on the table. Yet, since both onions are on the same plane, it seems likely that this difference in size is real, which highlights Cézanne's manipulation of scale.

The Cupid is a highly ironic element. It has associations with traditional art and the Western ideal of love, which derives from Greco-Roman classical tradition. However, in the context of the apples that surround it, the Cupid also alludes to Christian tradition and Eve's eating of the fruit of knowledge.

Paul Cézanne. *Still Life with Plaster Cast.* **ca. 1894.** Oil on paper on board, 26½″ × 32½″. The Samuel Courtauld Trust, Courtauld Institute of Art Gallery, London.

The apple is modeled by radical shifts in color rather than gradations from light to dark (traditional chiaroscuro). The shaded areas are red, the lighted areas yellow. Furthermore, this apple and the other objects are outlined, which tends to flatten them, emphasizing their two-dimensional shape rather than their three-dimensional mass.

Escape to Far Tahiti: Gauguin

Cézanne's self-exile from Paris to the solitude of his native Aix-en-Provence is also characteristic of the Symbolists, who valued the comparative quiet of the countryside over the turmoil of cities. The belief that silence allowed for contemplation of the essence of things and that solitude further enhanced this introspection provided the Symbolists with a reason to escape, an urge to retreat from the hectic pace of modern life.

In 1891, the painter Paul Gauguin [goh-GAN] (1848–1903) left France for the island of Tahiti, part of French Polynesia, in the South Pacific. A frustrated businessman and father of five children, he had taken up art with a rare dedication a decade earlier, studying with Camille Pissarro and Paul Cézanne. Gauguin was also a friend of van Gogh, with whom he spent several months painting in Arles during the Dutch artist's most productive period. He had also been inspired by the 1889 *Exposition Universelle*, where indigenous peoples and housing from around the world were displayed. "I can buy a native house," he wrote his friend Émile Bernard, "like those you saw at the World's Fair. Made of wood and dirt with a thatched roof." To other friends he wrote, "I will go to Tahiti and I hope to finish out my life there . . . far from the European struggle for money . . . able to listen in the silence of beautiful tropical nights to the soft murmuring music of my heartbeats in loving harmony with the mysterious beings in my entourage."

Between the last Impressionist exhibition in 1886 and leaving for Tahiti, Gauguin divided his time between Paris and Brittany (in northwestern France), interrupted only by his visit to van Gogh in Arles in late 1888. "I like Brittany," he wrote, "it is savage and primitive." The landscape there was not heavily impacted by civilization, but more important, the people seemed "*primitif*" in their beliefs—a far cry from the *poseuses* of Seurat. In French, the word *primitif* suggests the primal, original, or irreducible. Gauguin believed that "primitive" ways of thinking offered an entry into the primal powers of the mind. (In some ways it resembles the eighteenth-century idea of the "noble savage.") Nonetheless, the *primitif* theme is an important ingredient in one of the most innovative paintings he executed in Brittany, *The Vision after the Sermon (Jacob Wrestling with the Angel)* (Fig. **40.18**). It depicts a group of Breton women and a priest envisioning a scene from the Bible—Jacob wrestling with a mysterious angel (Genesis 32), who is sometimes interpreted as God, Satan, or himself. In a letter to van Gogh, Gauguin offered his thoughts on the work:

> Breton women in a group, praying: very intense black clothes—yellow-white bonnets, very luminous. The two bonnets at the right are like monstrous helmets—an apple tree, which is dark violet, spreads across the canvas. . . . I think I have achieved great simplicity in the figures, very rustic, very superstitious—the overall effect is very severe—the cow under the tree is tiny in comparison with reality, and is rearing up— for me in this painting the landscape and the fight only exist in the imagination of the people praying after the sermon, which is why there is a contrast between the people, who are natural, and the struggle going on in a landscape which is non-natural and out of proportion.

Gauguin's *Vision*, then, is a testament to the primal power of faith, the ability of the primitive mind to envision the spiritual world as palpable. Originally intending to give the painting to the church of the Breton village where he painted it, Gauguin was rebuffed when the church refused it, possibly because of its radical and innovative space and color. Another interesting facet of the composition is its similarity to the café-concerts paintings of Degas (see Fig. 37.14), in which the audience and orchestra occupy the foreground and look up at the stage. However, Gauguin would probably say the *Vision* depicts the *real* theater of existence.

Gauguin's first trip to Tahiti was not everything he dreamed it would be, since by March 1892 he was penniless. When he arrived back in France, he had painted 66 pictures but had only four francs (about $12 today) to his name. He spent the next two years energetically promoting his work and writing an account of his journey to Tahiti, entitled *Noa Noa* (*noa* means "fragrant" or "perfumed"). It is a fictionalized version of his travels and bears little resemblance to the details of his journey that he honestly recorded in his letters. But *Noa Noa* was not meant to be true so much as sensational,

Fig. 40.18 Paul Gauguin. *The Vision after the Sermon (Jacob Wrestling with the Angel)*. 1888. Oil on canvas, 28³⁄₄″ × 36¹⁄₄″. The National Galleries of Scotland, Edinburgh, Scotland. When the painting was exhibited in Paris in 1889, it provoked a scandal, which did not surprise Gauguin. "I know quite well," he wrote in October 1888, "that I shall be *less and less* understood. . . . For most I shall be an enigma, but for a few I shall be a poet and sooner or later what is good wins recognition."

with its titillating story of the artist's liaison with a 13-year-old Tahitian girl, Tehamana, offered to him by her family. He presents himself as a *primitif* and his paintings as visionary glimpses into the primal forces of nature.

Gauguin arranged for two exhibitions at a Paris gallery in November 1893 and another in December 1894. He opened a studio of his own, painted olive green and a brilliant chrome yellow, and decorated it with paintings, tropical plants, and exotic furnishings. He initiated a regular Thursday salon where he lectured on his paintings and regaled guests with stories of his travels, as well as playing music on a range of instruments.

In this studio he painted *Mahana no atua* (*Day of the God*) of 1894 (Fig. **40.19**). Based on idealized recollections of his escape to Tahiti, the canvas consists of three zones. In the top zone or background, figures carry food to a carved idol, representing a native god, a musician plays as two women dance, and two lovers embrace beside the statue of the deity. Below, in the second zone, are three nude figures. The one to the right assumes a fetal position suggestive of birth and fertility. The one to the left appears to be day-dreaming or napping, possibly an image of

reverie. The middle figure appears to have just emerged from bathing in the water below that constitutes the third zone. She directs her gaze at the viewer and, so, suggests an uninhibited sexuality. The bottom, watery zone is an irregular patchwork of color, an abstract composition of sensuous line and fluid shapes. As in van Gogh's work, color is freed of its representational function to become an almost pure expression of the artist's feelings.

Gauguin returned to Tahiti in June 1895 and never came back to France, completing nearly 100 paintings and over 400 woodcuts in the eight remaining years of his life. He moved in 1901 to the remote island of Hivaoa [hee-vah-OH-uh], in the Marquesas [mar-KAY-suz], where in the small village of Atuona [aht-uh-WOH-nuh] he built and decorated what he called his House of Pleasure. Taking up with another young girl, who like Tehamana gave birth to his child, Gauguin alienated the small number of priests and colonial French officials on the islands but attracted the interest and friendship of many native Marquesans, who were fascinated by his nonstop work habits and his colorful paintings. Having suffered for years from heart disease and syphilis, he died quietly in Hivaoa in May 1903.

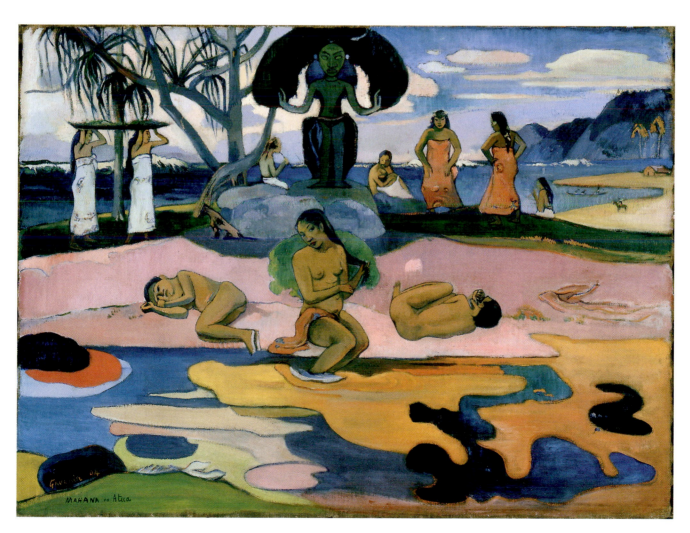

Fig. 40.19 Paul Gauguin. *Mahana no atua* (*Day of the God*). 1894. Oil (possibly mixed with wax) on canvas, 26⅝″ × 35⅝″.
The Art Institute of Chicago. Helen Birch Bartlett Memorial Collection (1926.198). Photograph © 2007, The Art Institute of Chicago.
All Rights Reserved. There is no record of Gauguin ever exhibiting this work. It was first exhibited at the Boston Art Club in 1925.

Toward the Modern

As a turn-of-the-century artistic movement, Symbolism was in many ways a revolt against reason, for to describe the world as it appears is to ignore the subjective experience of human beings—everything from belief and faith to intuition, the creative impulse, and the dream world. Symbolism represented a sort of return to spirituality, but without formalized religion, and especially its attendant moral rules. Symbolists practiced a kind of religion of the self, freed of social constraint. What further distinguishes that self from the Romantic self is that it does not merely seek the truth, even subjective truth—it attempts to *create* it.

Outside of Paris, artists and writers quickly adopted Symbolism as the style of the day. In Oslo, Norway, Henrik Ibsen's friend Edvard Munch [moongk] (1863–1944) adopted to his own explorations of the primordial forces of the human psyche the brushwork of Vincent van Gogh, whose paintings he had viewed in the early 1890s. In Vienna, Gustave Klimt (1862–1918) founded a movement dedicated to liberating art from the bonds of conventional morality. Perhaps the most influential thinker of the day was the German philosopher Friedrich Nietzsche [NEE-chuh] (1844–1900) (Fig. 40.20), whose new moral philosophy served to support the Symbolist movement.

The New Moral World of Nietzsche

Nietzsche's first important work was the *Birth of Tragedy from the Spirit of Music* (1872), which he dedicated to German composer Richard Wagner. Here he challenged Socrates' appeal for rationality in human affairs and outlined the turbulent conflict between what he called the "Apollonian" and "Dionysian" forces at work in Greek art and in the tragedies of Aeschylus and Sophocles (see chapter 7). The Apollonian leads to the art of sculpture, the beautiful illusion of the ideal form, while the Dionysian expresses itself in music and dance, with their ability to excite the senses (**Reading 40.3**):

READING 40.3 **from Friedrich Nietzsche, *The Birth of Tragedy*, section 1 (1872)**

In song and in dance man expresses himself as a member of a higher community; he has forgotten how to walk and speak and is on the way toward flying into the air, dancing. His very gestures express enchantment. Just as the animals now talk, and the earth yields milk and honey, supernatural sounds emanate from him too: he feels himself a god, he himself now walks about enchanted, in ecstasy, like the gods he saw walking in his dreams. He is no longer an artist, he has become a work of art.

Apollonian and Dionysian tendencies usually run parallel to each other, but when they join together they generate Athenian dramatic tragedies, with the Dionysian "spirit of music" in the

chorus supplemented by Apollonian dialogue. Socratic philosophy, particularly in the plays of Euripides, eliminated the Dionysian from the stage (by reducing the use of the chorus), destroying the delicate balance between Dionysus and Apollo that is fundamental to Athenian tragedy. *The Birth of Tragedy*, then, is a call to bring the Dionysian back into art and life, something Nietzsche sees occurring in the operas of Wagner, whose *gesamtkunstwerks* bring together song, music, dance, theater, and art (see chapter 36).

In his subsequent books, including *The Gay Science* (1882—the title refers to the medieval troubadour art of writing poetry), *Beyond Good and Evil* (1886), *The Genealogy of Morals* (1887), *Twilight of the Idols* (1888), and *Thus Spoke Zarathustra* (1882–1893), Nietzsche would reject organized religion for subjecting humanity to "slave morality." In *The Gay Science*, he announces the death of God, and in *Beyond Good and Evil* he defines the greatest men as those "who can be the loneliest, the most hidden, the most deviating," and the philosopher as one who seeks to live where everyone else is "least at home." (For excerpts from these two texts, see **Reading 40.4**, page 1308.) Democracy, according to Nietzsche, was a pretense, no more than a guarantee of mediocrity.

Following in the footsteps of Hegel's "Great Man" theory of history (see chapter 34), Nietzsche called for a society led by an *Übermensch* [oo-ber-MENCH], or "higher man," a hero of

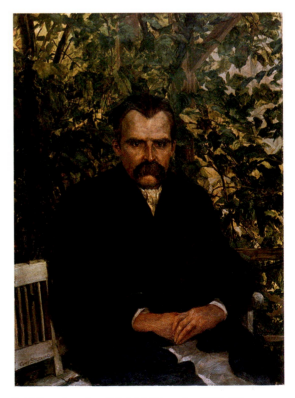

Fig. 40.20 Curt Stoeving. *Friedrich Nietzsche*. 1894. Oil on canvas. Stiftung Weimarer Klassik und Kunstsammlungen, Weimar, Germany. Bilderchiv Preussischer Kulturbesitz/Art Resource, NY. By the time this picture was painted, Nietzsche was virtually insane. In 1889, he had suffered a mental breakdown and never recovered. The critical moment occurred in Turin, Italy, where he collapsed embracing the neck of a horse that had just been cruelly whipped by a coachman.

singular vision and courage who could produce a new "master" morality. Nietzsche's ideas were bold, but in many ways they were also dangerous. For in empowering the individual in an industrial society, they left open the possibility of catastrophic evil being unleashed upon the world in a way that would be difficult to stop. In the twentieth century, Adolph Hitler would misconstrue Nietzsche's ideas to justify his notion of a master race of Germans, leading to mass genocide and a world war that killed more than 50 million people.

Nietzsche also argued that God was dead and that conventional morality was life-denying rather than life-affirming. In an argument directed particularly at social Darwinists that also echoes the sentiments of English reformers like A. W. N. Pugin (see chapter 35), he argued that progress was an illusion: "Mankind does not represent a development toward something better or stronger or higher in the sense accepted today. . . . The European of today is vastly inferior in value to the European of the Renaissance."

On the Cusp of Modern Music: Mahler and Brahms

Viennese composers and conductors Gustave Mahler [MAH-lur] (1860–1911) and Johannes Brahms (1833–1897) dominated the music scene of Vienna in the last years of the nineteenth century. Although temperamentally somewhat different, the two men recognized each other's genius, and enjoyed each other's company and friendship. Mahler was an avid student of Nietzsche's, and the influence of *The Birth of Tragedy* and the philosopher's other writings on Mahler's work was extensive. The first movement of his lengthy 95-minute Symphony No. 3 is a Dionysian procession, and the fourth movement is vocal, based on a song written by Nietzsche, the so-called "Drunken Song," from *Thus Spoke Zarathustra*. In fact, Mahler named the whole symphony *The Gay Science—A Summer Morning's Dream*, after Nietzsche's 1882 book. Though Mahler's symphonies are in many ways traditional nineteenth-century orchestral works, inspired by Beethoven, they are also evocations of Nietzsche's Dionysian spirit and so are clear assertions of modernity.

Mahler's Symphony No. 1 is a case in point. Originally called *Titan*, after Nietzsche's observation in *The Birth of Tragedy* that "the effects wrought by the Dionysian also seemed 'titanic,'" the symphony moves from struggle to triumph across its four movements. The third movement is a funeral march in the manner of the second movement of Beethoven's *Eroica* (see chapter 34), but it is a parody, based on the French children's song "Frère Jacques" (see **CD-Track 40.2**). As Mahler explained in his program notes:

> The composer found the external source of inspiration in the burlesque picture of the hunter's funeral procession in an old book of fairy tales known to all children in South Germany. The animals of the forest escort the dead forester's coffin to the grave. Hares carry flags; a band of gypsy musicians, accompanied by cats, frogs, crows, all making music, and deer, foxes, and other four-footed and feathered creatures of the woods, leads the procession in farcical postures.

Mahler introduces the movement with a solo double bass playing the march at a high range, one that challenges all double bass players to this day. The melody soon shifts to a minor mode in a variation of the "Frère Jacques" tune. This is followed in turn by so-called **klezmer music**, of Eastern European Jewish origin, characterized by its notable bass sound—"like a parody," Mahler indicates in the score—and the shrill sound of a clarinet. Soon the march metamorphoses into a lyrical song of great beauty, "The Two Blue Eyes of My Beloved," written by Mahler a few years earlier, and accompanied by a harp. Such contrasts were jarring to Mahler's audience, but the sense of conflict and tension he evoked by this means anticipated the modern and its rapid-fire juxtapositions of sensory images.

In both composing and conducting, Brahms at first seems more conservative than Mahler. For one thing, he was absolutely dedicated to building on the classical example of Beethoven and Mozart, and he reached even further back into Western musical tradition to the examples of Bach, Handel, and even Palestrina. So his works are rich in musical allusions. His lushly lyric Symphony No. 4 of 1885 is a case in point, with its many references to Beethoven's compositions. The fourth and final movement, marked *allegro energico e passionato* ("energetically fast and passionate"), reaches even further back to an old-fashioned Baroque form (see **CD-Track 40.3**). Its basic structure is a series of 30 variations in triple time, each eight measures long and of increasing intensity, based on a theme in the finale of Bach's Cantata No. 150 that is clearly stated by trombones in the first eight notes of the movement. The next variation makes only minor changes on the first, but as the movement progresses, each variation seems to grow increasingly complex, as they seem to explore the entire range of human emotion and feeling.

Despite its traditional sources—the triple-time variation form was very popular among Baroque composers in Bach's time—the Fourth Symphony is startlingly modern, full of a wide variety of harmonies and dissonances, competing rhythms and meter changes. For this reason many critics found Brahms's work as difficult to understand—and as modern—as Mahler's. But the final movement of the symphony is, above all, distinctly fin de siècle in tone, world-weary and pessimistic even as it seems to yearn for—and discover—the new.

The Painting of Isolation: Munch

By the time the Norwegian painter Edward Munch arrived in Paris in the early 1890s, he was deeply immersed in the writings of both Fyodor Dostoyevsky (see chapter 37) and Friedrich Nietzsche. (After Nietzsche's death in 1900, Munch was commissioned to paint a portrait of the philosopher.) Their writings captured the sense of extreme isolation that seemed the inevitable fate of people of genius in the materialist world of bourgeois European culture. Equally moved by the paintings of Gauguin and van Gogh, Munch expressed his debt to his artistic heroes in *The Scream*,

Voices

A Visitor in Vienna

Although it was not on the tourist circuit the way that Paris and London were, Mahler and Klimt's Vienna was one of the cultural capitals of nineteenth-century Europe. James Huneker's portrait of the Austrian city around 1909 is an affectionate tribute, filled with praise about the city's food, beverages ("But the Pilsner in Vienna! That would need a complete chapter."), tobacco, restaurants, cafés, and beer taverns, as well as its people.

> **"They eat and drink the best, and as a native said to me, if they were without a roof they would still go to the restaurants."**

The Viennese man is an optimist; he regards life not so steadily, or as a whole, but as a gay fragment. Clouds gather, the storm breaks, then the rain stops and the sun floats once more in the blue. Let tomorrow take care of itself, today we go to the Prater and watch the wheels go round. This irresponsibility is confined to no class. Whether all the folk you see in the restaurants, cafes, and gardens can afford to spend money as they indubitably do, I cannot pretend to know. They eat and drink the best, and as a native said to me, if they were without a roof they would still go to the restaurants. Well fed, with good flavoured food . . . the Viennese are seemingly contented; they look so, and they are always cheerful. . . . Coffee is the magnet late in the afternoon, and it is difficult to get a seat after five o'clock in any of the numerous places. I remember one café . . . called the Guckfenster from the windows of which you may stare at the passing show. Every afternoon I went there early so as to secure my favourite seat, and there I sipped and stared, and stared and sipped, and in the dolce far niente I marveled over the futility of life, especially the futility of American life, its hurry, bustle, money-making. . . . Oh, how mistaken I was! No one works harder than the Vienna business man and woman; their hours are at least a third longer than an American, yet they contrive so to space them that they appear to have limitless leisure. The climate is soft, which allows of open-air life . . . It gives Vienna its primal charm, it hums in the air. No wonder Johann Strauss composed his music, no wonder the otherwise ponderous Johannes Brahms preferred this spot to his birthplace, Hamburg; no wonder Beethoven here wrote the scherzi of his symphonies. Vienna inspired these composers as it inspired Mozart and Schubert.

. . . There is an earnest intellectual and artistic life. In one week last winter I attended conferences by Gerhart Hauptmann [German writer and Nobel Prize winner], Georg Brandes—the latter dealt with Goethe and Strindberg—and I heard Morz Rosenthal, Eugen D'Albert, Godowsky, and the Rose quartet, and attended a performance by the greatest of orchestras, the Vienna Philharmonic under Felix Weingartner . . . Then there is the opera, there are the theatres, and to jump to the other side of the scale, there are the medical schools and surgeons and physicians who have not their equal anywhere. And the University life.

painted in 1893 after moving to Berlin (Fig. **40.21**). From Gauguin he took the sensuous curvilinear patterning of color and form that distinguished the Brittany paintings (see Fig. 40.18). From van Gogh's work, he took the Dutch artist's intense brushwork and color, as well as his disorienting perspective. Compare, for instance, the uptilted walkway in *The Scream* to the floor of van Gogh's *Night Café* (see Fig. 40.13).

Munch's depiction of the horrifying anxiety of modern life is unmatched in the work of any previous painter. His grotesquely contorted figure in *The Scream* clasps its skull-like head as if to close its ears to its own anguished cry, which funnels out and sweeps across the landscape behind it. The blood-red sky elevates this cry to a fever pitch. Ironically, the two figures walking farther down the way and the single ship moored in the bay intensify rather than diminish the figure's isolation, as if distancing themselves from the scene.

There is good reason to believe that the color of the scene was prompted by the 1883 eruption of the Indonesian volcano Krakatoa, which could be heard for 1,500 miles and the ashes of which circled the globe, creating brilliant red sunsets

for many months afterward. On a gouache version of the painting, Munch wrote:

> I was out walking with two friends—the sun began to set—suddenly the sky turned blood red—I paused, feeling exhausted, and leaned on the fence—there was blood and tongues of fire above the blue-black fjord and the city—my friends walked on, and I stood there trembling with anxiety—and I sensed an endless scream passing through nature.

Munch would later include the painting in a series entitled *The Frieze of Life*, designed to occupy four walls of a Berlin exhibition in 1902. Each of the four walls, hung with four or five paintings, had its own title: *Love's Awakening, Love Blossoms and Dies, Fear of Life* (where he hung *The Scream*), and, finally, *Death*. He called *Frieze* "a poem of love, anxiety, and death." The trajectory of Munch's series is the opposite of a Mahler symphony. Where Mahler, like Beethoven, moves from struggle to triumph, Munch sees triumph as fleeting, and his work moves, always, toward despair. In fact, *Despair* was *The Scream*'s original title.

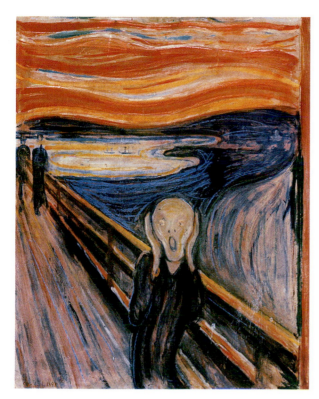

Fig. 40.21 Edvard Munch. *The Scream.* **1893.** Tempera and casein on cardboard, 36″ × 29″. Nasjonalgalleriet, Oslo. Photo: J. Lathion © 2008 Artists Rights Society (ARS), New York/ADAGP, Paris. The painting was stolen from the museum in August 2004, then recovered, severely damaged, in August 2006. It is now undergoing restoration.

The Vienna Secession: Klimt

The painters of Mahler's Vienna, another European capital city with a high concentration of artists and intellectuals (see *Voices*, page 1304), largely avoided the pessimism of Munch. They turned toward a frank investigation of human sexuality in their work. One of the most important Viennese painters, Gustav Klimt (1862–1918), was a master of the erotic. Even his society portraits, such as the exquisite *Portrait of Emilie Flöge*, seemed charged with sexual energy by virtue of a color palette that can only be described as sensual (Fig. 40.22). Like Nietzsche, Klimt sought to liberate art from the confines of conventional morality, believing that human life was driven by sexual desire. His paintings therefore seek to explore not only the sexual instincts of his sitters and models, but his own—and the viewer's.

By 1897, at age 35, Klimt, a traditionally trained academic painter, had led a group of mostly younger artists out of the established art academy in order to form an organization they called the Secession. They called themselves *die Jungen*, "the Youth," and the journal they founded called *Vers Sacrum* (*Sacred Spring*) was named after the Roman ritual of consecrating youth in times of national danger. In 1898 they had built themselves a new exhibition space, designed by Josef Olbrich

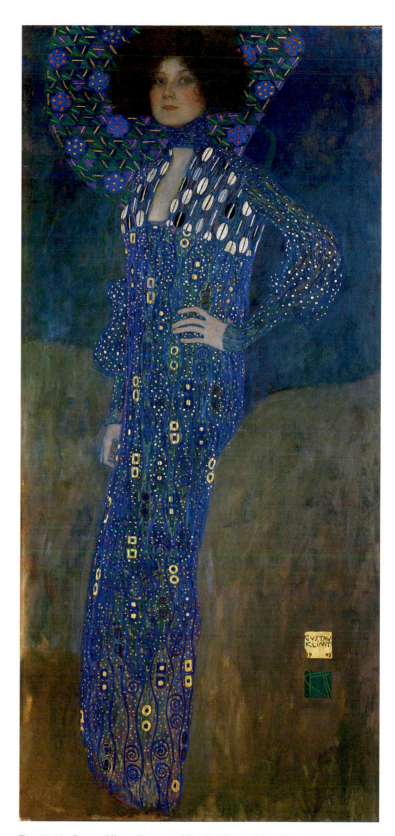

Fig. 40.22 Gustav Klimt. *Portrait of Emilie Flöge.* **1902.** Oil on canvas, 71¼″ × 33″. Österreichische Galerie, Vienna. Flöge and her sister owned a dress shop not far from the Secession building. Klimt frequently designed dresses for them, like the one Emilie wears here.

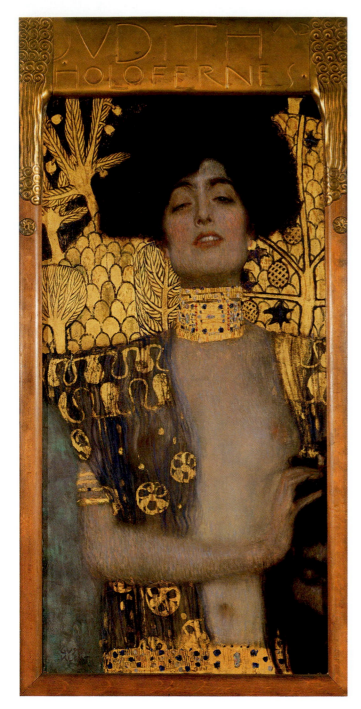

Fig. 40.23 Gustav Klimt. *Judith I*. 1901. Oil on canvas, 33″ × 16½″. Österreichische Galerie, Vienna. The frame identifies the subject of Klimt's painting as the biblical figures Judith and Holofernes.

[OHL-breekh] (1867–1908), called the House of the Secession. It was to serve as a retreat from daily life, a sanctuary that, in Olbrich's words, "would offer the art-lover a quiet place of refuge." Over the portal of the building these words were inscribed:

TO THE AGE ITS ART,
TO ART ITS FREEDOM.

The Secession would be dedicated, it proclaimed, to the proposition of showing "modern man his true face."

Continuity & Change
p. 819

Judith and Maidservant

Klimt's *Judith I*, based on the biblical story of the Jewish heroine Judith and the Assyrian general Holofernes [hoh-luh-FER-neez], is the very embodiment of the Secessionist revolt (Fig. **40.23**). Klimt's Judith, caressing with her right hand Holofernes's head, which she has just severed, is no biblical heroine. She is a contemporary wealthy Viennese woman, clothed— or half-clothed—in the same sort of costume as Emilie Flöge [FLER-guh], her neck adorned in a gold and jewel-studded version of Emilie's broad necklace. She is at once the malevolent femme fatale, a danger to any male who might desire her, as well as a symbol of the liberation of the newly emancipated woman of the twentieth century. Klimt's painting suggests that behind the facade of social decorum, and underneath the fine dresses worn by modern women, lies the earthy, elemental spirit of the heroic Judith. It also shows the continuing power of a theme that had been explored for many centuries.

Through his paintings, Klimt believed, he had begun to set society free of its inhibitions. This Secessionist spirit of liberation mirrored earlier artistic gestures of rebellion, such as Courbet's establishment of his own exhibit across the street from the 1855 *Exposition Universelle* (see Fig. 35.18), the Salons des Refusés established in the 1860s, and the Impressionist Exhibitions of the 1870s and 1880s. It would become a dominant theme of the arts in the century to come. This spirit of rebellion—and the artist's Nietzschean self-definition as one who lives where everyone else is "least at home," pushing the bounds of accepted taste and tradition—would come to dominate not just the dawning century's visual arts, but its music, literature, and philosophy as well.

READINGS

Stéphane Mallarmé, "L'Après-midi d'un faune" ("Afternoon of a Faun") (1876)

Mallarmé's poetry is experimental, combining words and images that are mysterious and ambiguous. "Afternoon of a Faun" was set to music by Claude Debussy and as a result is one of Mallaré's most famous poems. It is the monologue of a faun (a minor rural deity that possesses an animal's ears, horns, tail, and hind legs) who tries to seduce two nymphs. The poem begins with the faun waking up, and ends with him returning to the dream world, wine by his side.

These nymphs I would perpetuate.
So clear
Their light carnation, that it floats in the air
Heavy with tufted slumbers.
Was it a dream I loved?
My doubt, a heap of ancient night, is finishing
In many a subtle branch, which, left the true
Wood itself, proves, alas! that all alone I gave
Myself for triumph the ideal sin of roses.
Let me reflect 10
. . .if the girls of which you tell
Figure a wish of your fabulous senses!
Faun, the illusion escapes from the blue eyes
And cold, like a spring in tears, of the chaster one:
But, the other, all sighs, do you say she contrasts
Like a breeze of hot day in your fleece!
But no! through the still, weary faintness
Choking with heat the fresh morn if it strives,
No water murmurs but what my flute pours
On the chord sprinkled thicket; and the sole wind 20
Prompt to exhale from my two pipes, before
It scatters the sound in a waterless shower,
Is, on the horizon's unwrinkled space,
The visible serene artificial breath
Of inspiration, which regains the sky.
Oh you, Sicilian shores of a calm marsh
That more than the suns my vanity havocs,
Silent beneath the flowers of sparks, relate
That here I was cutting the hollow reeds tamed
By talent, when on the dull gold of the distant 30
Verdures dedicating their vines to the springs,
There waves an animal whiteness at rest:
And that to the prelude where the pipes first stir
This flight of swans, no! Naiads, flies
Or plunges . . .
Inert, all burns in the fierce hour
Nor marks by what art all at once bolted
Too much hymen desired by who seeks the la:
Then shall I awake to the primitive fervour,

Straight and alone, 'neath antique floods of light, 40
Lilies and one of you all through my ingenuousness.
As well as this sweet nothing their lips purr,
The kiss, which a hush assures of the perfid ones,
My breast, though proofless, still attests a bite
Mysterious, due to some august tooth;
But enough! for confidant such mystery chose
The great double reed which one plays 'neath the blue:
Which, the cheek's trouble turning to itself
Dreams, in a solo long, we might amuse
Surrounding beauties by confusions false 50
Between themselves and our credulous song;
And to make, just as high as love modulates,
Die out of the everyday dream of a back
Or a pure flank followed by my curtained eyes,
An empty, sonorous, monotonous line.
Try then, instrument of flights, oh malign
Syrinx, to reflower by the lakes where you wait for me!
I, proud of my rumour, for long I will talk
Of goddesses; and by picturings idolatrous,
From their shades unloose yet more of their girdles: 60
So when of grapes the clearness I've sucked,
To banish regret by my ruse disavowed,
Laughing, I lift the empty bunch to the sky,
Blowing into its luminous skins and athirst
To be drunk, till the evening I keep looking through.
Oh nymphs, we diverse memories refill.
My eye, piercing the reeds, shot at each immortal
Neck, which drowned its burning in the wave
With a cry of rage to the forest sky;
And the splendid bath of their hair disappears 70
In the shimmer and shuddering, oh diamonds!
I run, when, there at my feet, enlaced. Lie (hurt by the
 languor they taste to be two)
Girls sleeping amid their own casual arms; them I seize, and
 not disentangling them, fly
To this thicket, hated by the frivolous shade,
Of roses drying up their scent in the sun
Where our delight may be like the day sun-consumed.

I adore it, the anger of virgins, the wild
Delight of the sacred nude burden which slips 80
To escape from my hot lips drinking, as lightning
Flashes! the secret terror of the flesh:
From the feet of the cruel one to the heart of the timid
Who together lose an innocence, humid
With wild tears or less sorrowful vapours.
"My crime is that I, gay at conquering the treacherous
Fears, the dishevelled tangle divided
Of kisses, the gods kept so well commingled;
For before I could stifle my fiery laughter
In the happy recesses of one (while I kept 90
With a finger alone, that her feathery whiteness
Should be dyed by her sister's kindling desire,
The younger one, näive and without a blush)
When from my arms, undone by vague failing,
This pities the sob wherewith I was still drunk.

Ah well, towards happiness others will lead me
With their tresses knotted to the horns of my brow:
You know, my passion, that, purple and just ripe,
The pomegranates burst and murmur with bees;

And our blood, aflame for her who will take it, 100
Flows for all the eternal swarm of desire.
At the hour when this wood's dyed with gold and with ashes
A festival glows in the leafage extinguished:
Etna! 'tis amid you, visited by Venus
On your lava fields placing her candid feet,
When a sad stillness thunders wherein the flame dies.
I hold the queen!
O penalty sure . . .
No, but the soul
Void of word and my body weighed down 110
Succumb in the end to midday's proud silence:

No more, I must sleep, forgetting the outrage,
On the thirsty sand lying, and as I delight
Open my mouth to wine's potent star!
Adieu, both! I shall see the shade you became. ■

Reading Question

It is not entirely clear whether the faun is describing real events, memories, or dreams. Can you locate passages where this ambiguity is highlighted?

READING 40.4

from Friedrich Nietzsche, *The Gay Science*, "The Madman" (1882), and *Beyond Good and Evil*, section 212 (1888)

Nietzsche composed both of these works as a series of several hundred aphorisms the typical lengths of which range from a line or two to a page or two. The selection from The Gay Science *is a parable entitled "The Madman," in which Nietzsche announces the possibility that God is dead. Written in 1888,* Beyond Good and Evil *was designed to give the reader an overview of Nietzsche's philosophy as it had developed to this point. Subtitled* Prelude to a Philosophy of the Future, *it projects the terms of a new philosophy that has gotten rid of blind acceptance of Christian values and morality.*

The Madman

Have you not heard of that madman who lit a lantern in the bright morning hours, ran to the market place, and cried incessantly: "I seek God! I seek God!"— As many of those who did not believe in God were standing around just then, he provoked much laughter. Has he got lost? asked one. Did he lose his way like a child? asked another. Or is he hiding? Is he afraid of us? Has he gone on a voyage? emigrated?—Thus they yelled and laughed.

The madman jumped into their midst and pierced them with his eyes. "Whither is God?" he cried; "I will tell 10 you. *We have killed him*—you and I. All of us are his murderers. But how did we do this? How could we drink up the sea? Who gave us the sponge to wipe away the entire horizon? What were we doing when we unchained this earth from its sun? Whither is it moving now? Whither are we moving? Away from all suns? Are we not plunging continually? Backward, sideward, forward, in all directions? Is there still any up or down? Are we not straying, as through an infinite nothing? Do we not feel the breath of empty space? Has it not become colder? Is not night continually 20 closing in on us? Do we not need to light lanterns in the morning? Do we hear nothing as yet of the noise of the gravediggers who are burying God? Do we smell nothing as yet of the divine decomposition? Gods, too, decompose. God is dead. God remains dead. And we have killed him.

"How shall we comfort ourselves, the murderers of all murderers? What was holiest and mightiest of all that the world has yet owned has bled to death under

our knives: who will wipe this blood off us? What water is there for us to clean ourselves? What festivals of atonement, what sacred games shall we have to invent? Is not the greatness of this deed too great for us? Must we ourselves not become gods simply to appear worthy of it? There has never been a greater deed; and whoever is born after us—for the sake of this deed he will belong to a higher history than all history hitherto."

Here the madman fell silent and looked again at his listeners; and they, too, were silent and stared at him in astonishment. At last he threw his lantern on the ground, and it broke into pieces and went out. "I have come too early," he said then; "my time is not yet. This tremendous event is still on its way, still wandering; it has not yet reached the ears of men. Lightning and thunder require time; the light of the stars requires time; deeds, though done, still require time to be seen and heard. This deed is still more distant from them than most distant stars—*and yet they have done it themselves.*"

It has been related further that on the same day the madman forced his way into several churches and there struck up his *requiem aeternam deo*. Led out and called to account, he is said always to have replied nothing but: "What after all are these churches now if they are not the tombs and sepulchers of God?"

Beyond Good and Evil, Section 212

We Scholars

More and more it seems to me that the philosopher, being *of necessity* a man of tomorrow and the day after tomorrow, has always found himself, and *had* to find himself, in contradiction to his today: his enemy was ever the ideal of today. So far all these extraordinary furtherers of man whom one calls philosophers, though they themselves have rarely felt like friends of wisdom but rather like disagreeable fools and dangerous question marks, have found their task, their hard, unwanted, inescapable task, but eventually also the greatness of their task, in being the bad conscience of their time.

By applying the knife vivisectionally to the chest of the very *virtues of their time,* they betrayed what was their own secret: to know of a *new* greatness of man, of a new untrodden way to his enhancement. Every time they exposed how much hypocrisy, comfortableness, letting oneself go and letting oneself drop, how many lies lay hidden under the best honored type of their contemporary morality, how much virtue was *outlived.* Every time they said: "We must get there, that way, where *you* today are least at home."

Facing a world of "modern ideas" that would banish everybody into a corner and "specialty," a philosopher—if today there could be philosophers—would be com-

pelled to find the greatness of man, the concept of "greatness," precisely in his range and multiplicity, in his wholeness in manifoldness. He would even determine value and rank in accordance with how much and how many things one could bear and take upon himself, how *far* one could extend his responsibility.

Today the taste of the time and the virtue of the time weakens and thins down the will; nothing is as timely as weakness of the will. In the philosopher's ideal, therefore, precisely strength of the will, hardness, and the capacity for long-range decisions must belong to the concept of "greatness" —with as much justification as the opposite doctrine and the ideal of a dumb, renunciatory, humble, selfless humanity was suitable for an opposite age, one that suffered, like the sixteenth century, from its accumulated energy of will and from the most savage floods and tidal waves of selfishness.

In the age of Socrates, among men of fatigued instincts, among the conservatives of ancient Athens who let themselves go—"toward happiness," as they said; toward pleasure, as they acted—and who all the while still mouthed the ancient pompous words to which their lives no longer gave them any right, *irony* may have been required for greatness of soul, that Socratic sarcastic assurance of the old physician and plebeian who cut ruthlessly into his own flesh, as he did into the flesh and heart of the "noble," with a look that said clearly enough: "Don't dissemble in front of me! Here—we are equal."

Today, conversely, when only the herd animal receives and dispenses honors in Europe, when "equality of rights" could all too easily be changed into equality in violating rights—I mean, into a common war on all that is rare, strange, privileged, the higher man, the higher soul, the higher duty, the higher responsibility, and the abundance of creative power and masterfulness—today the concept of greatness entails being noble, wanting to be by oneself, being able to be different, standing alone and having to live independently. And the philosopher will betray something of his own ideal when he posits: "He shall be greatest who can be loneliest, the most concealed, the most deviant, the human being beyond good and evil, the master of his virtues, he that is overrich in will. Precisely this shall be called *greatness:* being capable of being as manifold as whole, as ample as full." And to ask it once more: today—is greatness *possible?* ■

Reading Question

It is important to recognize that the man who calls for the death of God is a "madman." But can you see a relation between this madman and Nietzsche's new philosopher as described in the section from *Beyond Good and Evil?*

Summary

■ A Fair to Remember: The Paris Exposition of 1889

When the *Exposition Universelle* opened in Paris in the spring of 1889, it heralded a new era of Western technological innovation and political and social superiority as displayed in the fair's thousands of exhibits. The most prominent exhibit was also the symbol of the exposition, and would soon become the embodiment of Paris itself—the Eiffel Tower. The fair's many exhibits displayed a wide range of technological innovations, including hundreds of inventions from Thomas Edison's laboratories, as well as an ambitious collection of houses from across the globe. France's imperial ambitions were represented by the inclusion of an exhibit of an entire African village and numerous other "exhibits" of indigenous peoples from Asia and the Pacific.

■ The Fin de Siècle: From Naturalism to Symbolism

The fin de siècle is the name given to the period just before and after the two great Paris expositions of 1889 and 1900 marked, from the point of view of those who looked at it with disfavor, by a degenerate abandonment in art and culture of the ideals of the past. It was also an era marked by a spirit of innovation. Art Nouveau embodied both points of view, its swirling tendrils and buds symbolizing rebirth and renewal, while its luxuriously curved female figures suggest decadent self-indulgence.

Henrik Ibsen's Realist drama presented the hidden realities of European social life as no one had ever before dared. *A Doll's House* showed a new kind of woman to European audiences, one capable of exercising her free will to leave behind an oppressive marriage. In his later work, Ibsen adopted a more dreamlike, experimental Symbolist approach to drama. Symbolism moves away from representations of the physical world into the realm of subjective experience, seeking to "objectify the subjective," to give the subjective form.

The transition from realism to Symbolism appears in the sculpture of Rodin, who came to value music and dance as the most Symbolist of art forms. The painter Toulouse-Lautrec loved dance's more earthy forms, such as the can-can. Dance also fascinated Mallarmé, whose elusive poems, such as "L'Après-midi d'un faune," suggest a mood by the presence of something that eludes meaning. The composer Claude Debussy put Mallarmé's poetry to music, creating a sense of mysterious ambiguity by means of chromatic scales.

■ Post-Impressionist Painting

The generation of painters that followed the Impressionist exhibitions was dedicated to advancing art in innovative directions. Seurat's Pointillist technique relied on colors blended in the viewer's eye. Van Gogh used color in much broader bands of paint to create deeply symbolic works. Cézanne assembled his canvases out of patches of color that tend to flatten the surface of the painting, thus exploiting the tension between the two-dimensional surface of the canvas and the representation of three-dimensional space. Finally, Gauguin reflected the *primitif*—the primal, irreducible base of existence—in paintings done first in Brittany and then in Tahiti.

■ Toward the Modern

The Symbolist spirit manifested itself outside of France as well. Leading the way was the German philosopher Friedrich Nietzsche. In *The Birth of Tragedy*, he argued for a return of the Dionysian spirit, long suppressed in Western civilization. In *The Gay Science* he announced—not in his own words, but in the words of a madman—the death of God. And in *Beyond Good and Evil* he argued that the true philosopher must live where everyone else is "least at home." Deeply influenced by Nietzsche, composer Gustave Mahler created music distinguished by its jarring contrasts of melody and mood. His contemporary, Johannes Brahms, composed lushly lyric works rich in allusions to classical and even earlier composers yet, at the same time, surprisingly modern. In Oslo, the painter Edvard Munch, influenced by van Gogh, Gauguin, and Nietzsche, captured the anguish of modern experience in works like *The Scream*, while in Vienna, Gustav Klimt revolted from tradition by painting deeply erotic works designed to set society free of its inhibitions.

Glossary

chromatic scales Scales that move in half-steps through all the black and white keys on a keyboard.

free association The practice developed by Sigmund Freud of directing patients to say whatever came to mind.

***klezmer* music** A type of music of Eastern European Jewish origin characterized by its oompah, oompah bass sound and the shrill sound of a clarinet.

pointilles Tiny dots of color and the building blocks of the pointillist style.

Critical Thinking Questions

1. What qualities of Art Nouveau make it a "transitional" style?

2. How does the modern self "create" subjective truth?

3. The Vienna Secession was dedicated to showing "modern man his true face." What is the significance of this?

In 1910, having lost his virility upon discovering that his young wife, Alma Schindler Mahler, was having an affair, Mahler sought out the Viennese psychoanalyst Sigmund Freud (1856–1939) (Fig. **40.24**). On August 26, the two spent four hours walking through the streets of Leiden, Holland, discussing Mahler's "condition." Mahler recalled for Freud an "especially painful scene" between his parents, which caused him to run out of the house where he encountered a barrel organ playing the popular song, *Ach, du lieber Augustin* [akh doo LEE-bur OW-goos-ten]. According to Freud, the tension between the tragic episode between his parents and the banality of the organ grinder's song was permanently imprinted on Mahler's mind for life—the very stuff of the third movement of his Symphony No. 1.

If, by 1910, Freud was not the most famous man in Vienna, then he was one of the most notorious. He had opened a medical practice there in 1886, specializing in psychic disorders. Just a year earlier he had gone to Paris to study with the famous neurologist Jean-Martin Charcot [shar-KOH], and in his new practice he began using Charcot's techniques—hypnosis, massage, and pressure on the head to get patients to call up thoughts related to their symptoms. In 1895, in collaboration with Josef Breuer [BROY-ur], another Viennese physician, he published *Studies in Hysteria*. But even then he was changing his techniques. He began to ask his patients to say whatever crossed their minds, a practice he called **free association**. With free association he was able to abandon hypnosis, as he discovered that patients tended to relate their particular neurotic symptoms to earlier, usually childhood experiences when freed to talk spontaneously about themselves.

For Freud, free association required interpretation, and he came more and more to focus on the obscure language of the unconscious. By 1897 he had formulated a theory of infantile sexuality based on the proposition that sexual drives and energy already exist in infants. Childhood could no longer be considered innocent. One of the keys to understanding the imprint of early sexual feeling upon adult neurotic behavior was the interpretation of dreams. Freud was convinced that their apparently irrational content could be explained rationally and scientifically. He concluded that dreams allow unconscious wishes, desires, and drives that are censored by the conscious mind to exercise themselves. "The dream," he wrote in his 1900 *The Interpretation of Dreams*, "is the (disguised) fulfillment of a (suppressed, repressed) wish."

Freud's work would become enormously influential, as we will see in Book 6, but as much as Freud was one of the innovative thinkers of the twentieth century, he is also a product of the nineteenth century's growing obsession with self-knowledge. He is also, in some measure, a Symbolist. Like Mallarmé, van Gogh, and Gauguin, for Freud the symbol is a vehicle for indirect expression. It is suggestive, elusive. In a manner of speaking, the entire dream life of an individual could be thought of as a Symbolist poem. ∎

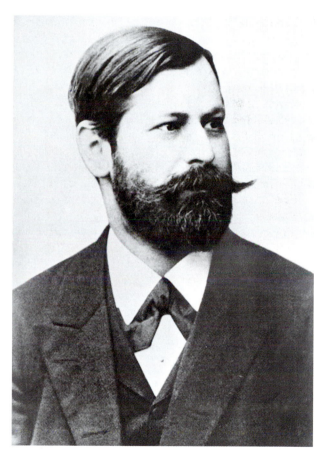

Fig. 40.24 *Sigmund Freud.* ca. 1895. Carte-de-visite. Prints & Photographs Division, Library of Congress, Washington, DC.

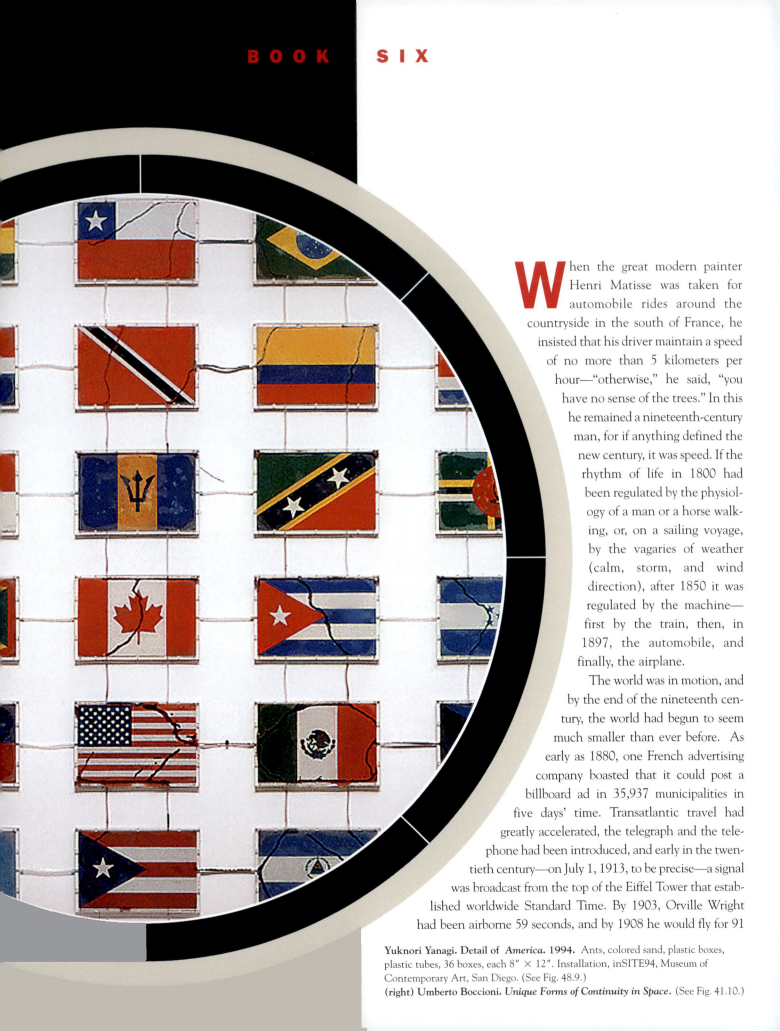

When the great modern painter Henri Matisse was taken for automobile rides around the countryside in the south of France, he insisted that his driver maintain a speed of no more than 5 kilometers per hour—"otherwise," he said, "you have no sense of the trees." In this he remained a nineteenth-century man, for if anything defined the new century, it was speed. If the rhythm of life in 1800 had been regulated by the physiology of a man or a horse walking, or, on a sailing voyage, by the vagaries of weather (calm, storm, and wind direction), after 1850 it was regulated by the machine—first by the train, then, in 1897, the automobile, and finally, the airplane.

The world was in motion, and by the end of the nineteenth century, the world had begun to seem much smaller than ever before. As early as 1880, one French advertising company boasted that it could post a billboard ad in 35,937 municipalities in five days' time. Transatlantic travel had greatly accelerated, the telegraph and the telephone had been introduced, and early in the twentieth century—on July 1, 1913, to be precise—a signal was broadcast from the top of the Eiffel Tower that established worldwide Standard Time. By 1903, Orville Wright had been airborne 59 seconds, and by 1908 he would fly for 91

Yuknori Yanagi. Detail of *America*. 1994. Ants, colored sand, plastic boxes, plastic tubes, 36 boxes, each 8″ × 12″. Installation, inSITE94, Museum of Contemporary Art, San Diego. (See Fig. 48.9.)
(right) Umberto Boccioni. *Unique Forms of Continuity in Space.* (See Fig. 41.10.)

Modernism and the Globalization of Cultures: 1900 to the Present

minutes. A year later, Blériot crossed the English Channel by plane (though it would be another 18 years until Charles Lindbergh would cross the Atlantic by air).

The still photograph suddenly found itself animated in the motion picture, first in 1895 by the Brothers Lumière, in Paris, and then after 1905, when the Nickelodeon, the first motion-picture theater in the world, opened its doors in Pittsburgh, Pennsylvania, in the United States. By 1925, Russian filmmaker Sergei Eisenstein would cram 155 separate shots into a four-minute sequence of his film *The Battleship Potemkin*—a shot every 1.6 seconds.

Amid all this speed and motion, the world also suddenly seemed a less stable and secure place. Discoveries in science and physics confirmed this. At the very end of the nineteenth century, in Cambridge, England, J. J. Thompson detected the existence of separate components in the previously indivisible atom. He called them "electrons," and by 1911, Ernest Rutherford had introduced a new model of the atom—a small, positively charged nucleus containing most of the atom's mass around which electrons continuously orbit. Suddenly matter itself was understood to be continually in motion. Meanwhile, in 1905, Albert Einstein had published his theory of relativity and by 1915 had produced the *General Principles of Relativity*, with its model of the non-Euclidean, four-dimensional space-time continuum. Between 1895 and 1915, the traditional physical universe had literally been transformed.

The traditions of science were by no means the only thing transformed. Rhymed verse gave way to "free verse," representational painting to abstraction. The faith in human progress that had shaped the nineteenth century was thrown into doubt first by World War I, in which civilized Europe committed a kind of self-genocide, and then by the rise of totalitarian states, themselves intent on committing genocide on their own. The fruits of "progress" seemed to be guns, tanks, poison gas, and, ultimately, the atomic bomb. Disillusion and doubt were the inevitable result. Sigmund Freud, who had begun his investigation of dreams at the end of the nineteenth century, posited a strong death wish in humankind's psychic makeup. The French existentialists, led by Jean-Paul Sartre, argued that the universe lacked both divine guidance and moral absolutes. Humans are thus "condemned to be free," he wrote, their condition one of perpetual anxiety, their only truth the inevitability of death.

But if humanity is condemned to freedom, many soon realized that freedom was theirs to gain. Anything seemed possible. Youth led the way, in the civil rights movement in the United States, the anti-war movement protesting U.S. involvement in Vietnam, in the drug and music cultures of the 1960s and 1970s, and the growing feminist movement. Between 1944 and 1960, nation after nation—Africa, Asia, and Southeast Asia—won their liberty from Britain, France, the Netherlands, Belgium, and Italy. The grip of the United States and Spain over the Western Hemisphere was loosened, most notably through the example of the Cuban Revolution, even as the United States and the Soviet Union vied for control of the developing world in the Cold War era.

By the beginning of the twenty-first century, many argued that, despite the continued existence of authoritarian rule in many parts of the world, a new form of power had substituted itself for the political control exercised in earlier times. In the new "global" culture, the control of information, the control of the media—from television to the Internet—was the most effective means of controlling people's minds. Thus, even as a global culture of extraordinary diversity and plurality had emerged by the dawn of the twenty-first century, many throughout the world struggled to find their unique cultural and personal identities—and to express their identities through their art—even as they sought to participate in the larger global culture.

Timeline Book Six: 1900 to the Present

	1890–1920	1920–1945
HISTORY AND CULTURE	**1900:** Sigmund Freud's *The Interpetation of Dreams* **1909:** Filippo Marinetti's *Founding and Manifesto of Futurism* **1910–1921:** Mexican Revolution **1914–1918:** World War I **1917:** Russian Revolution **1919–1933:** Weimar Republic in Germany	**1920–1935:** Harlem Renaissance **1922–1945:** Benito Mussolini rules Italy **1927–1953:** Josef Stalin rules U.S.S.R. **1929:** stock market crash leads to Great Depression **1933–1945:** Adolf Hitler and Nazi party rule Germany; Franklin D. Roosevelt's "New Deal" **1936–1939:** Spanish Civil War **1939–1945:** World War II **1941–1945:** Nazi Holocaust kills millions of Jews and others
RELIGION AND PHILOSOPHY	**1900–1920:** Ideas about the duration and flow of time in human consciousness proposed by William James and Henri Bergson gain popularity	**1924:** Andre Breton's *Surrealist Manifesto* **1920s–1930s:** Carl Jung develops theories of collective unconscious, archetypes **1930:** Sigmund Freud's *Civilization and its Discontents*
TECHNOLOGY AND SCIENCE	**1895:** first motion-picture camera **1897–1899:** J. J. Thompson detects existence of electrons **1903:** Orville and Wilbur Wright conduct successful test of airplane **1905:** Albert Einstein proposes theory of relativity **1908:** Henry Ford and Frederick Taylor design assembly-line production	**1926:** *The Black Pirate*, first Technicolor film **1928:** The Ford Motor Company's River Rouge Plant opens in Detroit **1931:** Empire State Building erected in New York **1934:** *Machine Art* exhibition at the Museum of Modern Art, New York
ART, ARCHITECTURE, AND FILM	**1907:** Alfred Stieglitz's *Steerage* **1907:** Pablo Picasso's *Les Demoiselles d'Avignon* **1908:** Georges Braque's *Houses at l'Estaque* **1911:** Wassily Kandinsky and Franz Marc found "Blue Rider" movement **1912:** Marcel Duchamp's *Nude Descending a Staircase* **1913:** New York Armory Show of modern art **1915:** D. W. Griffith directs *Birth of a Nation* **1915:** Ernst Ludwig Kirchner's *Self-Portrait as a Soldier* Picasso, *Les Demoiselles d'Avignon*	**1920s:** Lev Kuleshov develops theory of montage in cinema; rise of Bauhaus architecture **1922:** Piet Mondrian's *Composition with Blue, Red, Yellow, and Black* **1925:** Sergei Eisenstein directs *Battleship Potemkin*; Charlie Chaplin's film *The Gold Rush*; Le Corbusier, inaugurates International Style in architecture **1926:** Fritz Lang directs *Metropolis* **1927:** René Magritte's *The Meaning of Night*; *The Jazz Singer*, first feature film with sound **1929:** Salvador Dalì and Luis Buñuel direct *Un Chien Andalou (An Andalusian Dog)* **1930:** Josef von Sternberg directs *The Blue Angel*; Chrysler Building completed in New York **1934:** Diego Rivera's *Man, Controller of the Universe* **1935:** Leni Riefenstahl directs *Triumph of the Will* **1936:** Frank Lloyd Wright designs *Fallingwater* **1939:** *Wizard of Oz, Gone With the Wind, The Rules of the Game* **1941:** Orson Welles directs *Citizen Kane* Frank Lloyd Wright *Fallingwater*
LITERATURE AND MUSIC	**1903:** W.E.B. Du Bois's *The Souls of Black Folk* **1903–1914:** Charles Ives composes *Three Places in New England* **1904:** Puccini's opera *Madama Butterfly* **1910–1920:** development of "Dixieland jazz" in New Orleans **1913:** Sergei Diaghilev's Ballets Russes premiers *The Rite of Spring* with music by Igor Stravinsky **1916:** Dada movement **1918:** Wilfred Owen's "Dulce et Decorum Est" **1919:** William Butler Yeats's "The Second Coming"	**1921:** T. S. Eliot's *The Waste Land* **1922:** James Joyce's *Ulysses* **1922:** Marcel Proust's *À la recherche du temps perdu* **1924:** Arnold Schoenberg creates "twelve–tone system" of music; George Gershwin composes Rhapsody in Blue **1925:** Virginia Woolf's *Mrs. Dalloway*; F. Scott Fitzgerald's *The Great Gatsby*; Franz Kafka's *The Trial* **1926:** Puccini's opera *Turandot* **1928:** Erich Maria Remarque's *All Quiet on the Western Front*; Bertolt Brecht's *The Threepenny Opera* **1929:** Ernest Hemingway's *A Farewell to Arms* **1930:** William Faulkner's *As I Lay Dying* **1932:** Gertrude Stein's *The Autobiography of Alice B. Toklas* **1937:** Zora Neale Hurston's *Their Eyes Were Watching God* **1939:** John Steinbeck's *The Grapes of Wrath* **1942:** Albert Camus's *The Stranger*

1945–1975	1975–2007	
1949: Simone de Beauvoir's *The Second Sex* **1949:** Communists take power in China **1950–1953:** Korean War **1954–1962:** Algerian war of independence **1955:** U.S. civil rights movement begins **1963:** Betty Friedan's *The Feminine Mystique*; Martin Luther King's "Letter from Birmingham Jail" **1964–1973:** Vietnam War © Bettman/Corbis, Central High School, Little Rock, Ark., September 4, 1957	**1980s:** beginning of AIDS epidemic **1989:** Tiananmen Square massacre **1989–1990:** collapse of U.S.S.R. **1991:** Gulf War **2001:** terrorist attacks on U.S.; invasion of Afghanistan **2003:** U.S. and allies invade Iraq	**HISTORY AND CULTURE**
1940s: Reinhold Niebuhr and Paul Tillich articulate Christian existentialism **1940s–1970s:** Jean-Paul Sartre argues for atheistic existentialism	**1970s:** Idea of "postmodernism" gains increasing currency	**RELIGION AND PHILOSOPHY**
1950s: television transforms leisure time **1951:** first credit cards introduced **1960:** American television networks broadcasting to 60 million sets **1966–1967:** All three major television networks in U.S. broadcast all prime time shows in color **1967:** Introduction of SONY Portapak video camera	**1970–2000s:** technological revolution using microprocessors, computers	**TECHNOLOGY AND SCIENCE**
1945–1960s: Abstract Expressionism **1945:** Willem de Kooning's *Pink Angels* **1950:** Jackson Pollock's *Number 27* **1954:** first *Godzilla* film opens in Japan **1955:** Alain Renais directs *Night and Fog*, documentary about the Holocaust **1956:** Mark Rothko's *Green on Blue*; Richard Hamilton and others coin term "Pop Art" in England **1957–1959:** Frank Lloyd Wright's Guggenheim Museum **1962:** Andy Warhol, Roy Lichtenstein, and others develop Pop Art in U.S. **1960s–1970s:** Minimal Art **1970s–1990s:** Japanese *manga* comic books become popular Frank Lloyd Wright, Guggenheim Museum	**1970s–1990s:** Women artists increasingly included in art world as Feminist artists, led by the Guerrilla Girls, demand representation in galleries and museums. **1975:** Richard Estes's *Central Savings* **1980s–present:** Time-based media, such as video art, become inceasingly popular **1981:** Robert Mapplethorpe's *Ajitto* **1991:** Christo and Jeanne-Claude create *The Umbrellas* sculpture **1998:** Renzo Piano constructs Jean Marie Tjibaou Cultural Center in New Caldonia, example of the new "green architecture" **1996:** Richard Serra's *Tilted Ellipse I* **1997:** Frank Gehry's Guggenheim Museum, Bilbao, Spain **2001–2007:** Santiago Calatrava designs Tenerife Opera House, other extraordinary buildings **2007–2008:** Rem Koolhaas designs CCTV tower, China Serra, *Tilted Ellipse I*	**ART, ARCHITECTURE, AND FILM**
1952: Ralph Ellison's *The Invisible Man* **1953:** James Baldwin's *Go Tell It on the Mountain* **1953:** Karlheinz Stockhausen composes first synthesized music **1954:** Samuel Beckett's *Waiting for Godot* **1956:** Allen Ginsberg's "Howl" **1956–1970s:** development of Rock and Roll music, spearheaded by Elvis Presley **1958:** Chinua Achebe's *Things Fall Apart*; Leonard Bernstein composes *West Side Story* **1960:** Wole Soyinka's *A Dance in the Forests* **1967:** Gabriel Garcia Marquez's *One Hundred Years of Solitude* **1968:** Stanley Kubrick's film *2001: A space Odyssey* uses György Ligeti's composition "Lux Aeterna" in its score **1969:** Woodstock music festival **1972:** Robert Venturi, Denise Scott Brown, Steve Izenour write *Learning from Las Vegas* advocating architectural postmodernism	**1970s–present:** Argentinean *tango* undergoes revival of popularity led by composer Astor Piazzolla (1991–1992) **1976:** Philip Glass and Robert Wilson's *Einstein on the Beach* **1977:** John Ashbery writes "On the Towpath" **1978:** Luis Valdez writes *Zoot Suit* focusing on Chicano community **1980s–1990s:** development of World Music movement **1985:** Paul Auster writes *City of Glass*, postmodern fiction; Laurie Anderson composes *Home of the Brave* **1987–1988:** David Antin's "If We Get It" **1992:** Véronique Tadjo's *As the Crow Flies*	**LITERATURE AND MUSIC**

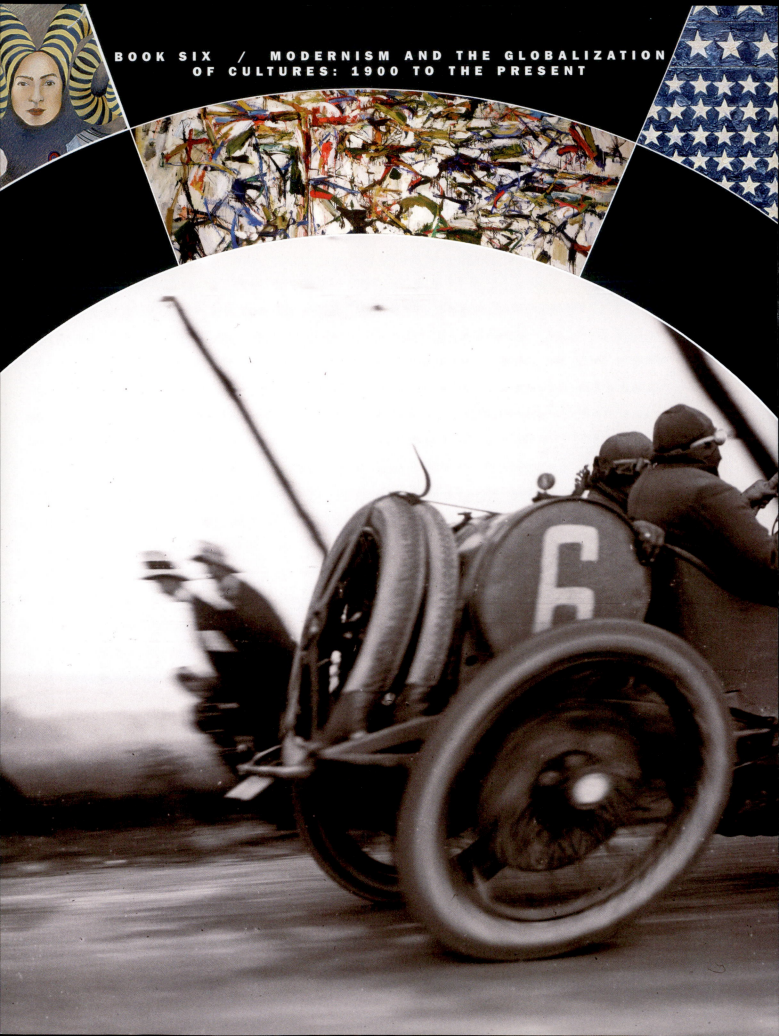

41 The Era of Invention

Paris and the Rise of Modernism

Pablo Picasso's Paris: At the Heart of the Modern

The Expressionist Movement: Modernism in Germany
 and Austria

Early Twentieth-Century Literature

Modernism Comes to America

The Origins of Cinema

" *Time and space died yesterday. We already live in the absolute, omnipresent speed.* **"**

Filippo Marinetti, *Manifesto of Futurism*

← **Fig. 41.1 Jacques-Henri Lartigue.** *Grand Prix of the Automobile Club of France.* **1912.** Gelatin silver print, 10″ × 13½″. Gift of the photographer. (28.1963). Digital Image © The Museum of Modern Art/Licensed by SCALA/ Art Resource, NY. © Copyright Grand Prix of the Automobile Club of France. Lartigue was the first great documenter of the automobile, photographing it in the streets of Paris, in parks, on family outings and adventures, and at auto races. His photographs seize the moment with a sense of speed that is the hallmark of the early twentieth century.

THE 1900 EXPOSITION UNIVERSELLE IN PARIS WAS
conceived as a demonstration of the promise of the new century. It was a celebra-
tion of innovation. A moving sidewalk, called the "Street of the Future," carried
visitors around the fair. The escalator and talking films debuted there. The first line of

Paris's famous subway system, the Métro, opened to carry visitors across the city. Rail-way stations and a spectacular bridge across the Seine that remain Parisian landmarks were built for the fair. For the first time, the entire grounds—and most of the city—were illuminated by electric light at night, transform-ing Paris into "the city of light," as it has since become known.

Among the more than 50 million people who visited the Exposition was Henry Adams (1838–1918), grandson of President John Quincy Adams and great-grandson of Presi-dent John Adams. In *The Education of Henry Adams* (1916), he records his struggles to come to terms with the modern world and describes how the Exposition affected him, always referring to himself in the third person.

> Until the Great Exposition closed its doors in Novem-ber, Adams haunted it, aching to absorb knowledge, and helpless to find it. . . . Langley [an aeronautical pioneer and physicist] came by, and showed it to him. . . . His chief interest was in new motors to make his airship feasible, and he taught Adams the astonish-ing complexities of the new Daimler motor, and of the automobile, which, since 1893, had become a night-mare at a hundred kilometres an hour. . . . Then he showed [Adams] the great hall of dynamos. . . . As he grew accustomed to the great gallery of machines, he began to feel the forty-foot dynamos as a moral force. . . . Thus it happened that . . . he found himself lying in the Gallery of Machines at the Great Exposi-tion of 1900, his historical neck broken by the sudden irruption of forces totally new.

Adams's world was in fact changing with incredible speed. In 1900, France had produced 3,000 automobiles; by 1907 it was producing 30,000 a year. Within two years of visiting the Exposition, Adams would write to one of his nieces: "My idea of paradise is a perfect automobile going thirty miles an hour on a smooth road to a twelfth-century cathedral." The auto-mobile symbolized the transition from the old to the new—or in Adams's terms, from the new to the old in the sense of using technological advances to gain better access to the glorious creations of the past.

The technological advances represented by the automobile were closely connected to the development of the internal com-bustion engine, pneumatic tires, and, above all, the rise of the assembly line. After all, building 30,000 automobiles a year required an efficiency and speed of pro-duction unlike any ever before conceived. Henry Ford (1863–1947), the American automobile maker, attacked the problem. Ford asked Frederick Taylor (1856–1915), the inventor of "scientific management," to determine the exact speed at which the assembly line should move and the exact motions workers should use to perform their duties; in 1908 assembly-line production as we know it was born.

Speed, whether of production, communications, or trav-el, was the call word of the day. In love with the automobile, the 18-year-old French photographer Jacques-Henri Lartigue [lar-TEEG] (1894–1986) blurred and cropped his shots to capture the speed of the times. The race car in *Grand Prix of the Automobile Club of France* is sliced in half by the right edge of the photograph, as if racing out of our view (Fig. **41.1**). It was not just speed that Lartigue recorded. It was change itself, a spirit of dynamic innovation. If speed was the word of the day, change was its offspring, and it appeared in all aspects of the intellectual and material culture of the Western world. In 1895, in Paris, the Lumière [loom-YAIR] brothers, Auguste (1862–1954) and Louis (1864–1948), had invented the cinematograph; the first motion-picture cam-era, which also served as a projector; and by 1905, the first motion-picture theater in the world, the Nickelodeon, opened in Pittsburgh, Pennsylvania. In 1903, the Wright brothers, Orville (1871–1948) and Wilbur (1867–1912), successfully tested their airplane: Orville flew for 59 seconds. In 1908, Orville was in the air for 91 minutes, and the fol-lowing year Louis Blériot [blay-ree-OH] (1872–1936) flew across the English Channel.

In 1897–1899, J. J. Thompson (1846–1940), in Cam-bridge, England, detected the existence of electrons, sepa-rate components in the structure of the previously indivisible atom. In 1900, German physicist Max Planck (1858–1947) proposed the theory of matter and energy known as quantum mechanics. By 1913, Danish physicist

Niels Bohr (1885–1962) had built on quantum physics to propose a new theory of complementarity: two statements, apparently contradictory, might at any moment be equally true. In 1905, Albert Einstein [INE-stine] (1879–1955) proposed a theory of relativity, and by 1915 he published the *General Principles of Relativity* with its revolutionary model of a four-dimensional space-time continuum. In other words, between 1895 and 1915, the way we understood the physical universe had radically changed. The modern world, in all its relativity, was born.

The spirit of change and innovation that permeated Western culture in the first years of the twentieth century ended abruptly with the eruption of World War I in August 1914. In the art world, at the center of this new spirit was the Spanish-born artist Pablo Picasso [pee-KAH-soh] (1881–1973). His studio in Paris was quickly recognized by artists and intellectuals as the center of artistic innovation in the new century. From around Europe and America, artists flocked to see his work, and they carried his spirit—and the spirit of French painting generally—back with them to Italy, Germany, and America, where it influenced the arts there. Picasso's work also encouraged radical approaches to poetry and to music, where the discordant, sometimes violent distortions of his paintings found their expression in sound.

Pablo Picasso's Paris: At the Heart of the Modern

Picasso's Paris was centered at 13 rue Ravignon [rah-veen-YOHN], at the Bateau-Lavoir [bah-TOH lah-VWAHR] ("Laundry Barge"), so named by the poet Max Jacob. It was Picasso's studio from the spring of 1904 until October 1909, and he continued to store his paintings there until September 1912. Anyone wanting to see his work would have to climb the hill topped by the great white cathedral of Sacre Coeur [sah-KRAY ker] in the Montmartre [mohn-MART] quarter, beginning from the Place Pigalle [plahss pee-GAHL], and finally climb the stairs to the great ramshackle space, where the walls were piled deep with canvases (see Map 41.1). Or they might see his work at the Saturday evening salons of expatriate American writer and art collector Gertrude Stein [stine] (1874–1946) at 27 rue de Fleurus [fler-OOS] behind the Jardin du Luxembourg [zhar-DEHN due louks-em-BOOR] on the Left Bank of the Seine. If you knew someone who knew someone, you would be welcome enough. Many Picassos hung on her walls, including his portrait of her, painted in 1906 (Fig. 41.2).

In her book *The Autobiography of Alice B. Toklas* (1932)—actually her own memoir disguised as that of her friend and

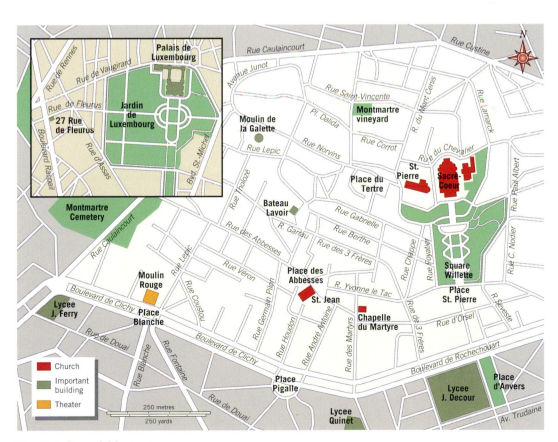

Map 41.1 Picasso's Montmartre.

CULTURAL PARALLELS

The Birth of Jazz in New Orleans

While Pablo Picasso's Paris was "at the heart of the modern" in the visual and literary arts in the first two decades of the twentieth century, 5,000 miles west, in New Orleans, Louisiana, a new musical form just being developed would also reshape contemporary culture. Jazz, and particularly the "Dixieland" style, grew out of the "Ragtime" musical form, incorporating more intricate rhythms and improvisations, and "call and response" patterns, characteristic of the traditional blues. New Orleans, as the meeting ground for Spanish, French, and Anglo-Saxon culture, gave birth to new musical fusions in which instrumentation and instrumental techniques were adapted from their original European context into entirely new forms. So too, the region's social traditions (many of them French in origin), including parades, festivals, and carnivals, created a constant demand for musical accompaniment, which jazz bands quickly filled.

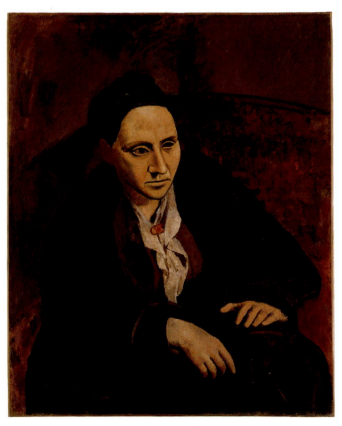

Fig. 41.2 Pablo Picasso. *Gertrude Stein*. Winter–Autumn 1906. Oil on canvas, 39 3/8″ × 32″. Bequest of Gertrude Stein, 1946 (47.106). The Metropolitan Museum of Art, NY. Image © The Metropolitan Museum of Art/Art Resource, NY. © ARS Art Rights Society, NY. According to Stein, in painting her portrait, "Picasso passed [on] . . . to the intensive struggle which was to end in Cubism."

lifelong companion—Stein described the making of this picture in the winter of 1906 (**Reading 41.1**):

READING 41.1 **from Gertrude Stein,
*The Autobiography of
Alice B. Toklas* (1932)**

Picasso had never had anybody pose for him since he was sixteen years old. He was then twenty-four and Gertrude had never thought of having her portrait painted, and they do not know either of them how it came about. Anyway, it did, and she posed for this portrait ninety times. There was a large broken armchair where Gertrude Stein posed. There was a couch where everybody sat and slept. There was a little kitchen chair where Picasso sat to paint. There was a large easel and there were many canvases. She took her pose, Picasso sat very tight in his chair and very close to his canvas and on a very small palette, which was of a brown gray color, mixed some more brown gray and the painting began. All of a sudden one day Picasso painted out the whole head. I can't see you anymore when I look, he said irritably, and so the picture was left like that.

Picasso actually finished the picture early the following fall, painting her face in large, masklike masses in a style very different from the rest of the picture. No longer relying on the visual presence of the sitter before his eyes, Picasso painted not his view of her, but his idea of her. When Alice B. Toklas later commented that some people thought the painting did not look like Stein, Picasso replied, "It will."

The Aggressive New Modern Art: *Les Demoiselles d'Avignon*

In a way, the story of Gertrude Stein's portrait is a parable for the birth of modern art. It narrates the shift in painting from an optical art—painting what one sees—to an imaginative construct—painting what one thinks about what one sees. The object of painting shifts, in other words, from the literal to the conceptual. The painting that most thoroughly embodied this shift was *Les Demoiselles d'Avignon* [lay dem-wah-ZELL dah-veen-YOHN], which Picasso began soon after finishing his portrait of Stein (Fig. **41.3**).

Completed in the summer of 1907, *Les Demoiselles d'Avignon* was not exhibited in public until 1916. So if you wanted to see it, you had to climb the hill to the Bateau-Lavoir. And many did because the painting was notorious, understood—correctly—as an assault on the idea of painting as it had always been understood. At the Bateau-Lavoir, a common insult hurled by Picasso and his friends at one another was "Still much too symbolist!" No one said this about *Les Demoiselles*. It seemed entirely new in every way.

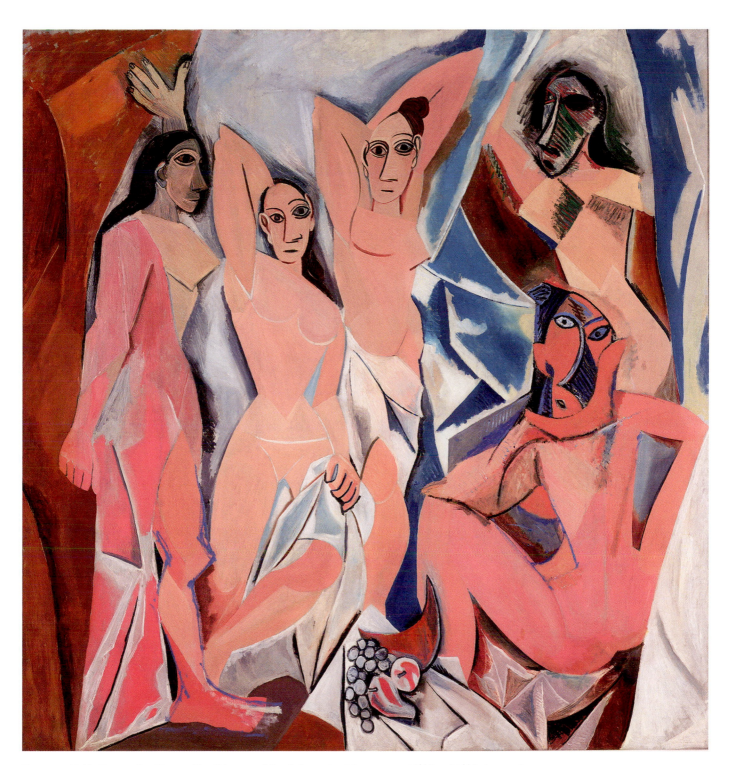

Fig. 41.3 Pablo Picasso. *Les Demoiselles d'Avignon.* **May–July 1907.** Oil on canvas, 95⅛″ × 91⅛″. Acquired through the Lillie P. Bliss Bequest. The Museum of Modern Art/Licensed by SCALA/Art Resource, NY. © 2008 ARS Artists Rights Society, NY. Central to Picasso's composition is the almond shape, first used for Gertrude Stein's eyes and repeated in the eyes of the figures here and in other forms—thighs and arms particularly. The shape is simultaneously

The painting represents five prostitutes in a brothel on the *carrer d'Avinyo* (Avignon Street) in Picasso's native Barcelona. As the figure on the left draws back a curtain as if to reveal them, the prostitutes address the viewer with the frankness of Manet's *Olympia* (see Focus, chapter 36), a painting Picasso greatly admired. Also extremely important to Picasso was the example of Cézanne, who, a year after his death in October 1906, was honored with a huge retrospective

Continuity & Change
p. 1299

Still Life with Plaster Cast

at the 1907 Salon d'Automne [doh-TUN]. Cézanne, Picasso would say, "is the father of us all." In the way Picasso shows one object or figure from two different points of view, the compressed and concentrated space of *Les Demoiselles* is much like Cézanne's (see *Still Life with Plaster Cast* in Focus, chapter 40). Consider the still-life grouping of melon, pear, apple, and grapes in the center foreground. The viewer is clearly looking down at the corner of a table, at an angle completely inconsistent with the frontal view of the nude who is parting the curtain. And note the feet of the nude second from the left. Could she possibly be standing? Or is she, in fact, reclining, so that we see her from the same vantage point as the still life?

Picasso's subject matter and ambiguous space were disturbing to viewers. Even more disturbing were the strange faces of the left-hand figure and the two to the right. X-ray analysis confirms that originally all five of the figures shared the same facial features as the two in the middle left, with their almond eyes and noses drawn in an almost childlike profile. But sometime in May or June 1907, after he visited the ethnographic museum at the Palais du Trocadéro [pah-LAY due troh-kah-DAY-roh], across the river from the Eiffel Tower, Picasso painted over the faces of the figure at the left and the two on the right, giving them instead what most scholars agree are the characteristics of African masks. But equally important to Picasso's creative process was a retrospective of Gauguin's painting and sculpture at the 1906 Salon d'Automne with their Polynesian imagery (see chapter 40). At any rate, Picasso's intentions were clear. He wanted to connect his prostitutes to the demonic—and emotionally energizing—forces that Gauguin had discovered in the "primitive." Many years later, he described the meaning of African and Oceanic masks to *Les Demoiselles*:

Continuity & Change
p. 1301

Mahana no atua

> The masks weren't just like any other pieces of sculpture. Not at all. They were magic things. . . . They were against everything—against unknown, threatening spirits. I always looked at fetishes. I understood; I too am against everything. I too believe that everything is unknown, that everything is an enemy! . . . All the fetishes were used for the same thing. They were weapons. To help people avoid

coming under the influence of spirits again, to help them become independent. They're tools. If we give spirits a form, we become independent. . . . I understood why I was a painter. All alone in that awful museum [the Trocadéro] with masks, with dolls made by the redskins, dusty manikins. *Les Demoiselles d'Avignon* must have come to me that very day, but not because of the forms; because it was my first exorcism painting—yes absolutely!

Les Demoiselles, then, was an act of liberation, an exorcism of past traditions, perhaps even of painting itself. It would allow Picasso to move forward into a kind of painting that was totally new.

Matisse and the Fauves: A New Color

When the painter Henri Matisse [mah-TEESS] saw *Les Demoiselles*, he is said to have considered it an "audacious hoax," an "outrage [ridiculing] the modern movement." It is little wonder as the two painters' aesthetic visions were diametrically opposed. Gertrude Stein had introduced the two men in April 1906, just after Matisse had exhibited his *The Joy of Life* at the Salon des Indépendants [en-day-pahn-DAHN] (Fig. 41.4). The painting is a sensual celebration of Symbolist sexuality, conceived under the sway of Baudelaire and Mallarmé. In fact, it verges on becoming an illustration for Mallarmé's *L'Après-midi d'un faune* (see chapter 40). And not long before he painted *The Joy of Life*, Matisse had titled one of his large canvases *Luxe, calme, et volupté* (*Luxury, Calm, and Pleasure*), taken from Baudelaire's poem "L'invitation au voyage":

Là, tout n'est qu'ordre et beauté,	There, all is only order and beauty,
Luxe, calme, et volupté.	Luxury, calm, and pleasure.

Twelve years older than Picasso, Matisse was the favorite of Gertrude Stein's brother Leo. He had established himself, at the Salon des Indépendants in 1904, as the leader of a radical new group of experimental painters known as the Fauves [fohvz]—or "Wild Beasts." **Fauvism** [FOHV-izm] was known for its radical application of arbitrary, or unnatural, color, anticipated in a few of van Gogh's paintings and in the pool of color in the foreground of Gauguin's *Mahana no atua* (see Fig. 40.19). The fractured angularity of Picasso's *Demoiselles*, its subdued coloration, its shallow space, and its childlike as opposed to sensuous use of line, are diametrically opposed to the circular, undulating, and frankly erotic space of Matisse's field of color in *The Joy of Life*. The tension that dominates Picasso's painting—the way it pulls the viewer into the scene even as it repels entry—is totally absent in the Matisse, where harmony rules. It is as if Picasso consciously rejected Matisse's modernism.

Picasso and Matisse saw each other regularly at the Steins' apartment, but their relationship was competitive. In fact, it is useful to think of Matisse's monumental *Dance II* (Fig. **41.5**) as something of a rebuttal to the upstart Picasso's *Demoiselles*.

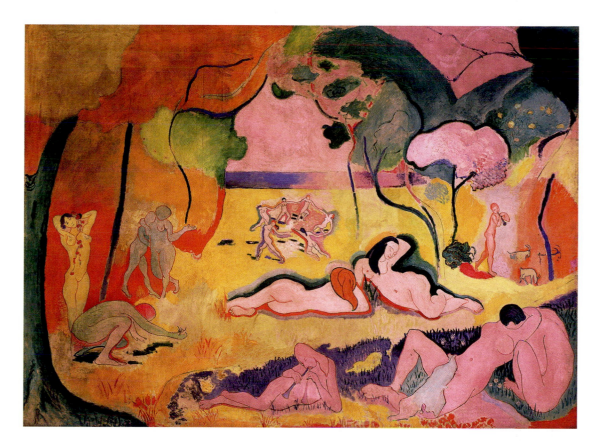

Fig. 41.4 Henri Matisse. *Bonheur de vivre (The Joy of Life)*. **1905–1906.** Oil on canvas, 69 1/8″ × 94 7/8″. © 1995 the Barnes Foundation. 2008 Succession H. Matisse, Paris/Artists Rights Society (ARS), NY. Note how Matisse balances the scene's eroticism with a relaxed, almost innocent sense of nudity.

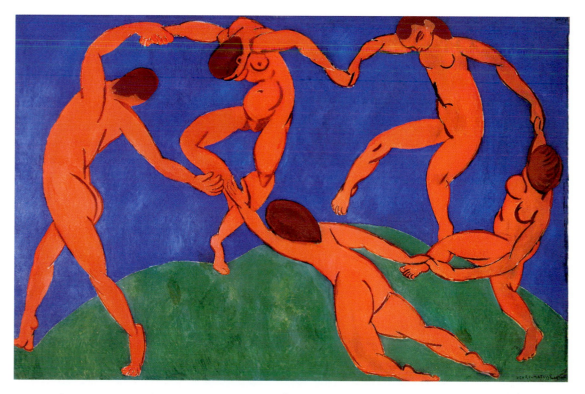

Fig. 41.5 Henri Matisse. *Dance II*. **1910.** Oil on canvas, 8′ 5 5/8″ × 12′ 9 1/2″. The State Hermitage Museum, St. Petersburg, Russia. © 2008 Succession H. Matisse, Paris/Artists Rights Society (ARS), NY. This work and another similarly colored painting of musicians called *Music* were commissioned by the Russian collector Sergei Shchukin to decorate the staircase of his home in Moscow.

For one thing, Matisse's circle dance consists of six figures that were in the distant yellow field of *Joy of Life*, but when Matisse repeats the motif in *Dance II*, the number is five, like Picasso's five prostitutes. Matisse also replaces Picasso's squared and angular composition with a circular and rounded one. Where Picasso's painting seems static, as if we are asked to hold our breath at the scene before us, Matisse's is active, moving as if to an unheard music. Most astonishing is Matisse's color—vermillion (red-orange), green, and blue-violet, the primary colors of light. In effect, Matisse's modernism takes place in the light of day, Picasso's in the dark of night; Matisse's with joy, Picasso's with fear and trepidation.

The Invention of Cubism: Braque's Partnership with Picasso

When the French painter Georges Braque [brahk] (1882–1963) first saw *Les Demoiselles*, in December 1907, he said that he felt burned, "as if someone were drinking gasoline and spitting fire." He was, at the time, a Fauve, painting in the manner of Matisse, but like Picasso, he was obsessed with Cézanne, so much so that he planned to paint the following summer in Cézanne's l'Estaque (see Fig. 40.16). When he returned to Paris in September, he brought with him a series of landscapes, among them *Houses at l'Estaque* (Fig. **41.6**). Picasso was fascinated with their spatial ambiguity and cube-like shapes. Note in particular the central house, where (illogically) the two walls that join at a right angle are shaded on both sides of the corner yet are similarly illuminated. And the angle of the roofline does not meet at the corner, thus flattening the roof. Details of windows, doors, and moldings have been eliminated, as have the lines between planes so that one plane seems to merge with the next in a manner reminiscent of Cézanne. The tree that rises on the left seems to merge at its topmost branch into the distant houses. The curve of the bush on the left echoes that of the tree, and its palmlike leaves are identical to the trees rising between the houses behind it. The structure of the foreground mirrors that of the houses. All this serves to flatten the composition even as the lack of a horizon causes the whole composition to appear to roll forward toward the viewer rather than recede in space.

Seeing Braque's landscapes at a gallery in November 1908, the critic Louis Vauxcelles [voh-SELL] wrote: "He [Braque] is contemptuous of form, reduces everything, sites and figures and houses to geometric schemas, to cubes." But the movement known as **Cubism** was born out of collaboration. "Almost every evening," Picasso later recalled, "either I went to Braque's studio or Braque came to mine. Each of us had to see what the other had done during the day." The two men were inventors, brothers—Picasso even took to calling Braque "Wilbur," after the aeronautical brothers Orville and Wilbur Wright. When Picasso returned to Paris from Spain in the fall of 1909, he brought with him landscapes that showed just how much he had learned from Braque (Fig. **41.7**).

Picasso and Braque pushed on, working so closely together that their work became indistinguishable to most viewers. They began to decompose their subjects into faceted planes, so that they seem to emerge down the middle of the canvas from some angular maze, as in *Violin and*

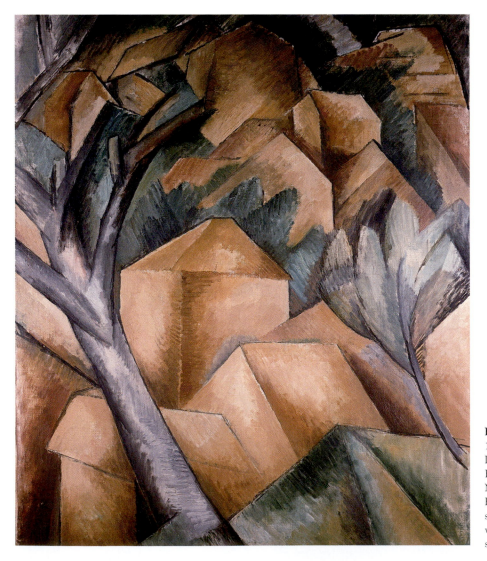

Fig. 41.6 Georges Braque's *Houses at l'Estaque*. 1908. Oil on canvas, $28\frac{3}{4}'' \times 23\frac{3}{4}''$. Peter Lauri/Kunstmuseum Bern. Estate of George Braque © 2008 Artists Rights Rights (ARS), NY/ADAGP, Paris. Hermann and Margit Rupf Foundation. Braque's trip to l'Estaque in the summer of 1908 was a form of homage to Cézanne, whose style he consciously radicalized in works such as this.

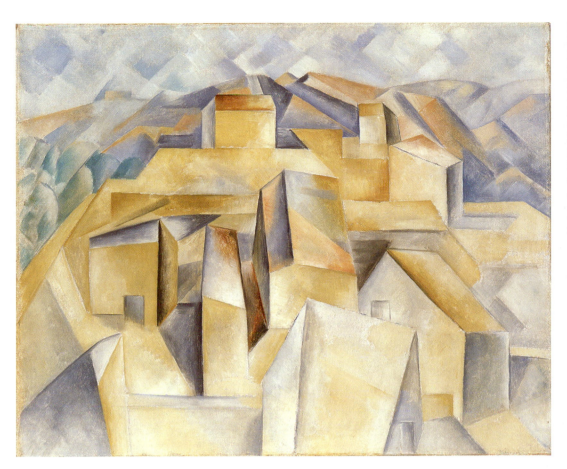

Fig. 41.7 Pablo Picasso. *Houses on the Hill, Horta de Ebro.* 1909. Oil on canvas, 25⅝″ × 31⅞″. Jens Ziehe/Nationalgalerie, Museum Berggruen, Staatliche Museen zu Berlin, Berlin, Germany. Bildarchiv Preussischer Kulturbesitz/Art Resource, NY. © ARS Artists Rights Society, NY. This is one of a series of some 15 paintings executed at Horta de Ebro (known today as Horta de Sant Joan) in the hills above Valencia during the summer of 1909.

Palette (Fig. **41.8**). Gradually they began to understand that they were questioning the very nature of reality, the nature of "truth" itself. This is the function of the *trompe-l'oeil* nail casting its shadow onto the canvas at the top of Braque's *Still Life with Violin and Pitcher.* It announces its own artifice, the practice of illusionistically representing things in three-dimensional space. But the nail is no more real than the violin, which is about to dissolve into a cluster of geometric forms. Both are painted illusions, equally real as art.

From 1910 to 1912, Picasso and Braque took an increasingly abstract approach to depicting reality through painting. They were so experimental, in fact, that the subject nearly disappeared. Only a few cues remained to help viewers understand what they were seeing—a moustache, the scroll of a violin, a treble clef.

Increasingly, they added a few words here and there. Picasso used words from a popular song "*Ma Jolie*" ("My pretty one") to identify portraits of his current lover, or "*Jou*," to identify the newspaper *Le Journal.* "Jou" was also a pun on the word *jeu* ("play"), and it symbolized the play between the reality of the painting as an object and the reality of the world outside the frame. This kind of ambiguity led Braque and Picasso to introduce actual two- and three-dimensional elements into the space of the canvas, in what Picasso and Braque came to call **collage** [kuh-LAHZH], from the French *coller* [koll-AY], "to paste or glue" (see *Focus,* pages 1326–1327). These elements—paper, fabric, rope, and other material—at least challenged, if they did not completely obliterate, the space between life and art.

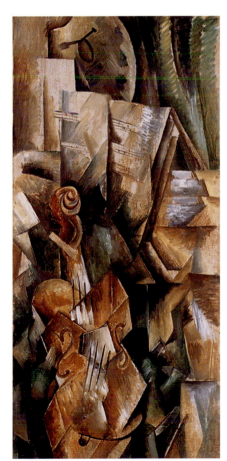

Fig. 41.8 Georges Braque. *Violin and Palette.* Autumn 1909. Oil on canvas, 36⅛″ × 16⅞″. Solomon Guggenheim Museum. 54.1412. George Braque © 2008 Artists Rights Rights (ARS), NY/ADAGP, Paris. Note how the pitcher (made of glass) seems opaque, the violin (made of wood) transparent. Such contradictions are typical of the Cubist enterprise.

Focus

Picasso's Collages

Late in the summer of 1912, wandering through Avignon, Braque came upon a decorator's shop selling wallpaper with a simulated wood-grain pattern. He bought it and pasted it onto a drawing called *Fruit Dish and Glass*, where it stood for both the wooden wall in the background and the drawer of a table. It was at once real wallpaper and fake wood. Now, the real and the recognizable had re-entered the Cubist vocabulary in the form of *papiers-collés*, meaning "pasted paper." It was as if modern life had erupted into the space of painting, interrupting what had been the increasing abstraction and subjectivity of the Cubist project. Picasso saw *Fruit Dish and Glass* when he returned to Paris from the south of France in September. "The bastard," Picasso later joked. "He waited until I'd turned my back." Soon Picasso was incorporating paper objects into his works, as in *Violin*.

The spiral scroll at the top of the violin is drawn from two points of view, in profile and three-quarter. The spiral has special significance. It occurs throughout Cubist painting and not only on violins. It can be found at the end of armrests on armchairs, as rope, and so on. It signifies the interplay between two and three dimensions, flat design versus the sculptural vortex or coil.

These two pieces of newspaper are cut from the same page. The one on top is the reverse side of the one on the bottom and, like a jigsaw puzzle piece, would fit into the left side of the bottom piece if it were turned over. So the two pieces reveal simultaneously the front and back of the same thing. The bottom piece also represents the body of the violin (note Picasso's drawing at its top left), while the upper piece, cupping the scrollwork, becomes the background or shadow.

Picasso depicts the *f*-holes of the violin in completely different ways. The one on the left is a small, simple line, while the one on the right is a much larger, fully open and fully realized form. It is as if we see the right one from the front, and the left one as if it were swiveled away to a three-quarter view and deeper in space.

Pablo Picasso. *Violin*. Late 1912. Charcoal and *papiers-collés* on canvas, 24$\frac{3}{8}$″ × 18$\frac{1}{2}$″. Musée National d'Art Moderne. Centre National d'Art et de Culture. Georges Pompidou Paris, France. CNAC/MNAM/Réunion des Musées Nationaux/Art Resource, NY. © 2008 ARS Artists Rights Society, NY.

Pablo Picasso. *Guitar, Sheet Music, and Wine Glass*. Autumn 1912.
Charcoal, gouache, and *papiers-collé*, $18\frac{7}{8}''\times14\frac{3}{8}''$. The McNay Art
Museum, San Antonio, Texas. Bequest of Marion Koogler McNay. © 2008
Estate of Pablo Picasso/Artists Rights Society (ARS), NY. The newspaper
fragment at the bottom of the painting derives from the front page of *Le
Journal*, November 18, 1912, reproduced below.

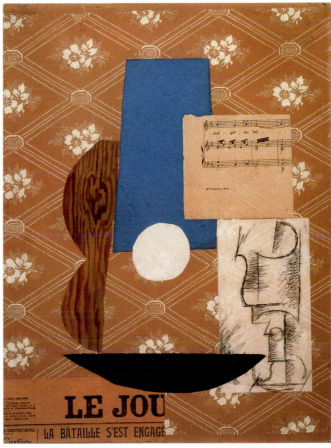

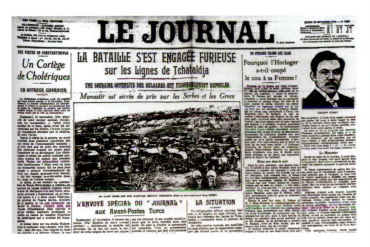

Picasso challenged the subjectivity of the creative act by including newspaper fragments in the painting. Newspaper insists on the inescapable reality of daily life. By admitting this element of pop culture into the space of art, Picasso and Braque defined painting as the setting in which the forces of the high and low, art and the real world, must engage one another.

Thus in Picasso's 1912 *Guitar, Sheet Music, and Wine Glass*, at the bottom of the page the headline of *Le Journal* reads, "*La bataille s'est engagé*," "The battle is joined." Literally, it refers to a battle in the Balkans, where Bulgaria attacked the Turks, November 17–19. But the "battle" is also metaphorical, the battle between art and reality (and perhaps between Braque and Picasso as they explored the possibilities of collage). Similarly, the background's trellis-and-rose wallpaper is no more or less real than the fragment of the actual musical score, the *faux-bois* ("false wood") guitar, and the Cubist drawing of a glass, cut out of some pre-existing source like the other *papiers-collé* elements in the work. Collage is the great equalizer in which all the elements are united on the same plane, both the literal plane of the canvas and the figurative plane of reality.

Futurism: The Cult of Speed

News of the experimental fervor of Picasso and Braque spread quickly through avant-garde circles across Europe, and other artists sought to match their endeavors in independent but related ways. On February 20, 1909, for instance, the front page of the Paris newspaper *Le Figaro* [fee-gah-ROH] published the *Founding and Manifesto of Futurism*, written by the Italian Filippo Marinetti [mah-ree-NET-tee] (1876–1944). It rejected the political and artistic traditions of the past and called for a new art. Marinetti quickly attracted a group of painters and sculptors to invent it. These included the Italian artists Giacomo Balla [BAHL-lah] (1871–1958), Umberto Boccioni [boch-ee-OH-nee] (1882–1916), Carlo Carrà [KAH-rah] (1881–1966), Luigi Russolo [roo-SOH-loh] (1885–1947), who was also a musician, and Gino Severini [sev-eh-REE-nee] (1883–1966). The new style was called Futurism. The Futurists repudiated static art and sought to render what they thought of as the defining characteristic of modern urban life—speed. But it was not until Marinetti took Boccioni, Carra, and Russolo to Paris for two weeks in the fall of 1911, arranging for visits to the studios of Picasso and Braque, that the fledgling Futurists discovered *how* they might represent it—in the fractured idiom of Cubism.

However, the work they created was philosophically remote from Cubism. It reflected Marinetti's *Manifesto* (see **Reading 41.2**, page 1344), which affirmed not only speed, but also technology and violence. In the manifesto, Futurism is born out of a high-speed automobile crash in the "maternal ditch" of modernity's industrial sludge, an intentionally ironic image of rebirth and regeneration. Where the Cubist rejection of tradition had largely been the invention of two men working in relative isolation, the Futurist rejection was public, bombastic, and political. As the Futurists traveled around Europe between 1910 and 1913 promoting their philosophy in public forums and entertainments, their typical evening featured insult slinging and scuffles with the audience, usually an arrest or two, and considerable attention in the press. In fact, it could be said that Marinetti understood, far in advance of its time, Canadian philosopher Marshall McLuhan's famous dictum of 1967, "The medium is the message" (see chapter 46).

Marinetti's artists turned to a variety of subjects for inspiration but particularly focused on the car, the plane, and the industrial town, all of which represented for the Futurists the triumph of humankind over nature. Balla painted a cycle of between 15 and 20 paintings representing speeding cars. Carrà was particularly sympathetic with Marinetti's poetic endeavors and Russolo's ideas about music, the former desiring to create "words-in-freedom . . . destroying the canals of

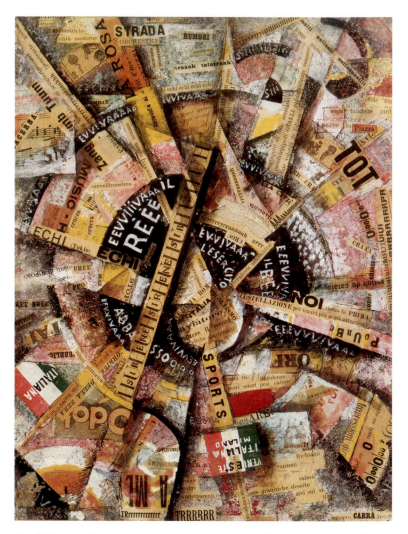

Fig. 41.9 Carlo Carrà. *Interventionist Demonstration*. 1914. Tempera and collage on cardboard, 15⅛″ × 11⅞″. Collezione Mattioli, Milan, Italy. Scala/Art Resource, NY. © 2008 ARS Artists Rights Society, NY. Carrà's inspiration for this image was a flurry of leaflets being dropped from an airplane flying over the Piazza del Duomo in Florence. The image is composed of sounds as much as words, suggesting a raucous political demonstration.

syntax," and the latter a music of "noise-sounds." His *Interventionist Demonstration*, he said, celebrates "a love for modern life in its essential dynamism—its sounds, noises and smells" (Fig. **41.9**). It takes the form, essentially, of a spinning phonograph, its "music" represented by collaged elements from the newspaper.

One of the great masterpieces of Futurist art is Boccioni's *Unique Forms of Continuity in Space* (Fig. **41.10**), a work oddly evocative of the very *Nike of Samothrace* (see Fig. 7.28) that Marinetti in his manifesto found less compelling than a speeding car. Boccioni probably intended to represent a nude, her musculature stretched and drawn out as she moves through space. "What we want to do," he explained, "is show the living object in its dynamic growth."

Continuity & Change
p. 218

Nike of Samothrace

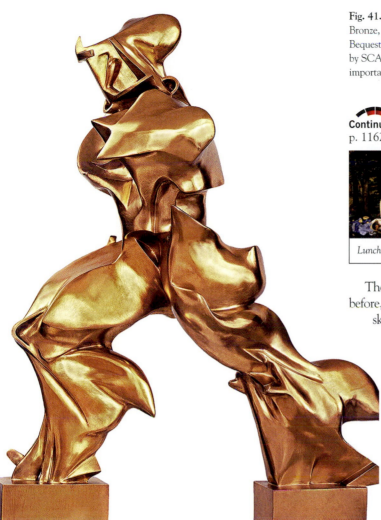

Continuity & Change
p. 1162

Fig. 41.10 Umberto Boccioni. *Unique Forms of Continuity in Space.* 1913. Bronze, 43⅞″ × 34⅞″ × 15¾″. Acquired through the Lillie P. Bliss Bequest. (231.1948). Digital Image © The Museum of Modern Art/Licensed by SCALA/Art Resource, NY. Between 1912 and 1914, Boccioni made twelve important sculptures. Five have survived, of which this is one.

Luncheon on the Grass

skee] (1890–1950), who had performed, a year earlier, as the faun in Debussy's *L'Après-midi d'un faune (Afternoon of a Faun)*. The performance was a scandal. Together with the Futurists' confrontational performances and, earlier, the public outrage at Manet's *Luncheon on the Grass*, and *Olympia* in the earlier 1860s, it helped to define modern art, as antagonistic to public opinion and an affront to its values (see chapter 36).

The events of that evening surprised everyone. The night before, a dress rehearsal performed before an audience, in Stravinsky's words, "of actors, painters, musicians, writers, and the most cultured representatives of society," had proved uneventful. But on the night of the public premiere the first chords of Stravinsky's score evoked derisive laughter. Hissing, booing, and catcalls followed, and at such a level that the dancers could not hear the music. Diaghilev ordered the lights to be turned on and off, hoping to quiet the crowd, but that just incensed the audience further. Finally the police had to be called, as Stravinsky himself crawled to safety out a backstage window.

What seemed most radically new to Stravinsky's audience was the music's angular, jarring, sometimes violent rhythmic inventiveness. The ballet's story—subtitled *Pictures from Pagan Russia*—centers on a pre-Christian ritual welcoming the beginning of spring that culminates in a human sacrifice. The music reflects the brutalism of the pagan rite with savage dissonance. Part I of the work, The Adoration of the Earth, culminates in a spirited dance of youths and maidens in praise of the earth's fertility. In Part II, The Sacrifice, one of the maidens is chosen to be sacrificed in order to guarantee the fertility celebrated in Part I. All dance in honor of the Chosen One, invoking the blessings of the village's ancestors, culminating in the frenzied Sacrificial Dance of the Chosen One herself (see **CD-Track 41.1**). Just before the dancer collapses and dies, Stravinsky shifts the meter eight times in twelve measures:

Modernist Music and Dance: Stravinsky and the Ballets Russes

The dynamism and invention evident in both Cubism and Futurism also appeared in music and dance. On May 29, 1913, the Ballets Russes, a company under the direction of impresario Sergei Diaghilev [dee-AH-ghee-lev] (1872–1929), premiered the ballet *Le Sacre de printemps* (*The Rite of Spring*) at the Théâtre des Champs-Élysées in Paris. The music was by the cosmopolitan Russian composer Igor Stravinsky [strah-VIN-skee] (1882–1971) and the choreography by his countryman Vaslav Nijinsky [nih-JIN-

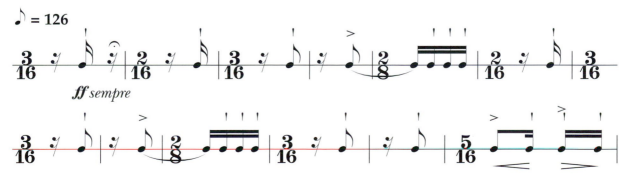

The men then carry the Chosen One's body to the foot of a sacred mound and offer her up to the gods.

Sometimes different elements of the orchestra play different meters simultaneously. Such **polyrhythms** contrast dramatically with other passages where the same rhythmic pulse repeats itself persistently—such as when at the end of the ballet's first part the orchestra plays the same eighth-note chords 32 times in succession. (This technique is known as **ostinato**—Italian for "obstinate.") In addition to its rhythmic variety, Stravinsky's ballet was also **polytonal**: Two or more keys are sounded by different instruments at the same time, and the traditional instruments of the orchestra are used in startlingly unconventional ways, so that they sound raw and strange. Low-pitched instruments, such as bassoons, play at the top of their range, for instance, and clarinets at the gravelly bottom of their capabilities. Integrated across these jarring juxtapositions are passages of recognizable Russian folk songs. Stravinsky's music was enormously influential on subsequent composers, who now thought about rhythmic structure in a totally different way.

If his first Paris audience found Stravinsky's music offensive—more than one critic thought he was a disciple of the Futurists' "noise-sound"—Nijinsky's choreography seemed a downright provocation to riot: "They repeat the same gesture a hundred times over," wrote one critic, "they paw the ground, they stamp, they stamp, they stamp, they stamp and they stamp. . . . Evidently all of this is defensible; it is prehistoric dance." It certainly wasn't recognizable as ballet. It moved away from the traditional graceful movements of ballerinas dancing *en pointe* (on their toes in boxed shoes) toward a new athleticism. Nijinsky's choreography called for the dancers to assume angular, contorted positions that at once imitated ancient bas-relief sculpture and Cubist painting, to hold these positions in frozen stillness, and then burst into wild leaps and whirling circle dances.

The Expressionist Movement: Modernism in Germany and Austria

Like Stravinsky, Nijinsky, and Diaghilev, by 1910 almost every European artist had turned to Paris for inspiration. German artists were no exception. We call the modernist style they created Expressionism, though no group of artists actually called itself Expressionist. We can think of German Expressionism as combining the Fauves' exploration of the emotional potential of color with Nijinsky's choreographic representation of raw primitivism and sexual energy. Like the Fauves, the Expressionists' interest in color can be traced to the art of van Gogh and Gauguin, while the sexual expressivity of their work has its roots in the art of the Vienna Secession (see chapter 40). Their subject matter was often drawn from their own psychological makeup. They laid bare in paint the torment of their lives. There were Expressionist groups throughout Europe that encompassed the visual arts and other media, but the most important in Germany were *Die Brücke*, originally based in Dresden but moving later to Berlin; *Der Blaue Reiter*, based in Munich; and the musicians of the Second Viennese School.

Die Brücke: The Art of Deliberate Crudeness

In 1905, four young artists from Dresden calling themselves *Die Brücke* [dee BROO-kuh] ("The Bridge") exhibited new work in an abandoned chandelier factory. They took the name from a passage in Nietzsche's *Thus Spoke Zarathustra* where Zarathustra calls for humanity to assert its potential to "bridge" the gulf between its current state and the condition of the *Übermensch*, the "higher man," who is the embodiment of the ideal future (see chapter 40).

The original four artists were Karl Schmidt-Rottluff [ROTT-luf] (1884–1976), Erich Heckel [HEK-ul] (1883–1970), Fritz Bleyl (1880–1966), and Ernst Ludwig Kirchner [KIRKH-nur] (1880–1938). In 1906, Emile Nolde [NOHL-duh] (1867–1956) and Max Pechstein [PEK-shtine] (1881–1955) joined them. They believed that through jarring contrasts of color, jagged linear compositions—they admired, especially, the gouging, splintered effects that could be achieved in woodblock printing, a deliberately crude but more "direct" and unmediated medium—they could free the imagination from the chains that enslaved it. Kirchner's *Self-Portrait with Model* (Fig. 41.11) embodies the raw, almost aggressive energy of Die

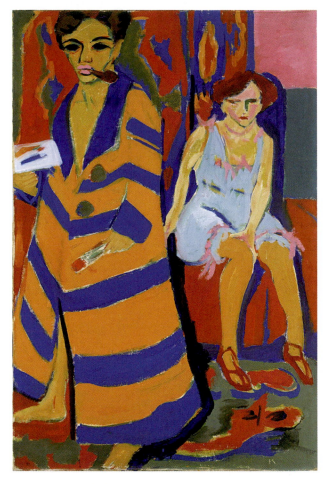

Fig. 41.11 Ernst Ludwig Kirchner. *Self-Portrait with Model.* **1910.** Oil on canvas, 58⅝″ × 39″. Photo: Elke Walford. Hamburger Kunsthalle, Hamburg, Germany. Bildarchiv Preussischer Kulturbesitz/Art Resource, NY. Die Brücke exhibited as a group in Berlin, Darmstadt, Dresden, Dusseldorf, Hamburg, and Leipzig, as well as in traveling exhibitions to smaller German communities.

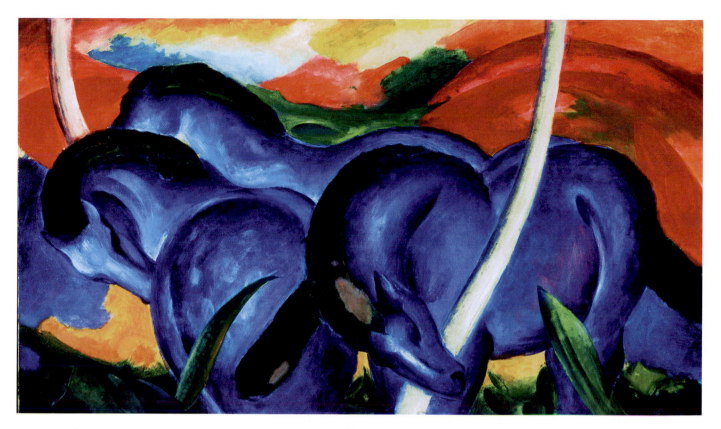

Fig. 41.12 Franz Marc. *The Large Blue Horses*. 1911. Oil on canvas, 41⅝" × 71⁵⁄₁₆". Collection Walker Art Center, Minneapolis. Gift of T. B. Walker Foundation, Gilbert M. Walker Fund, 1942. The painting is meant to contrast the beauty of the untainted natural world to the sordidness of modern existence, very much in the spirit of Gauguin.

Brücke's style. The artist stands in his striped robe, his mask-like face contemplating his painting (unseen but in the space occupied by the viewer). He grips his wide paintbrush (implicitly a symbol for his own sexuality) in a manner that could only result in slashing, almost uncontrolled bands of color, as in fact exist in the painting itself. Behind him, possibly seated on a bed, is his model, dressed in her underwear, present (as in almost all Die Brücke work) solely as the eroticized object of male sexual desire.

Der Blaue Reiter: The Spirituality of Color

Der Blaue Reiter [dair BLAU-uh RY-tuh] ("The Blue Rider") did not come into being until 1911. It was headed by the Russian emigré Wassily Kandinsky [kan-DIN-skee] (1866–1944) and by Franz Marc (1880–1916), an artist especially fond of painting animals, because he believed they possessed elemental energies. They were joined by a number of other artists, including Auguste Macke [MAH-kuh] (1887–1914) and Gabriele Münter [MUN-tur] (1877–1962), who met Kandinsky when she was his student in Munich in 1902.

These artists had no common style, but all were obsessed with color. "Color," Kandinsky wrote in *Concerning the Spiritual in Art*, first published in 1912 in the *Blaue Reiter Almanac*, "directly influences the soul. Color is the key-board, the eyes are the hammers, the soul is the piano with many strings. The artist is the hand that plays . . . to cause vibrations of the soul." The color blue, Kandinsky wrote, is "the typical heavenly color." Marc saw in blue what he thought of as the masculine principle of spirituality. So his *The Large Blue Horses*, with its seemingly arbitrary color and interlocking rhythm of fluid curves and contours, very much influenced by Matisse, is the very image of the spiritual harmony in the natural world (Fig. **41.12**).

Yellow, on the other hand, was the female principle, the earthly as opposed to the heavenly. Kandinsky's *Black Lines* contrasts earthly yellow with heavenly blue, and red with green (Fig. **41.13**). (Red, he wrote, "rings inwardly with a determined and powerful intensity," while green "represents the social middle class, self-satisfied, immovable, narrow.") The black lines, Kandinsky felt, were equivalent to dance, so the painting can be interpreted as a rendering of dance set to music. But it also suggests a landscape with three mountains rising in the distance. In fact, one of Kandinsky's chief themes was the biblical Apocalypse, the moment when, according to a long tradition in the Byzantine church, Moscow would become the New Jerusalem. "Der Reiter," in fact, was the popular name for Saint George, patron saint of Moscow, and the explosions of contrasting colors across *Black Lines* suggest that the fateful moment has arrived. With

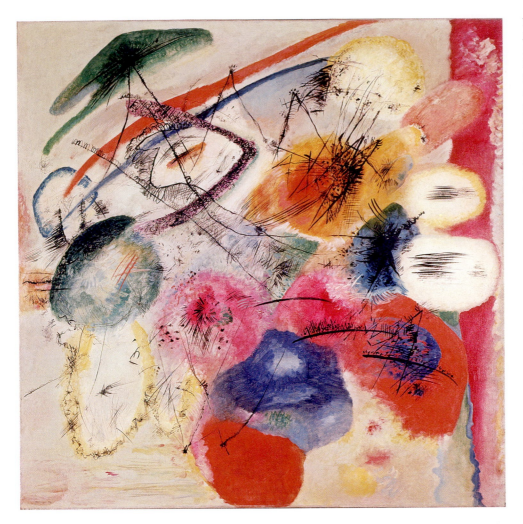

Fig. 41.13 Wassily Kandinsky. *Black Lines.* **December 1913.** Oil on canvas, 51″ × 51⅝″. Solomon R. Guggenheim Museum, NY. © DACS. Giraudon/The Bridgeman Art Library. © 2008 ARS Artists Rights Society, NY. Among practitioners of nonfigurative abstract art, Kandinsky was perhaps unique in not forcing his point of view on his colleagues. If his was what he called "the Greater Abstraction," theirs was "the Greater Realism," equally leading to "the spiritual in art."

paintings like *Black Lines*, Kandinsky made the jump from simply using color for its emotional message to abstraction. (Almost simultaneously, Picasso and Braque were at the very edge of creating totally nonfigurative paintings as well.)

One of the most original of the Blaue Reiter artists is Münter. At a time when, especially in Germany, it was widely believed that women were not capable of artistic creation, she created a body of totally original work, while involved in a relationship with Kandinsky that was emotionally painful for her. Eleven years her senior, he had seduced her as his student, promising to divorce his wife and marry her. Kandinsky never did marry her, though after he went to Russia in 1914, aspiring to help create a new revolutionary Russian art, he did divorce his wife and marry another woman. Münter remained deeply in love with Kandinsky and bought a summer house for them in the town of Murnau [MUR-now] in the foothills of the Bavarian Alps. At Murnau, she began to collect and emulate the Bavarian folk art of reverse-glass painting. The dark outlines of her forms in *The Blue Gable* function like leading in stained glass (Fig. **41.14**). A winter view of Murnau, it seems to suppress all the Blaue Reiter's coloristic tendencies, except for the deep blue gable itself. Given Kandinsky and Marc's color theory, the blue was probably a symbol of the

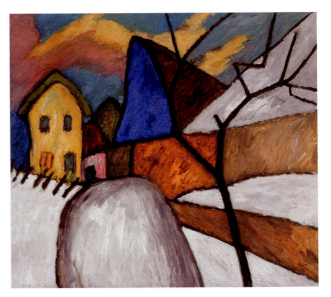

Fig. 41.14 Gabriele Münter. *The Blue Gable.* **1911.** Oil on canvas, 34¹⁵⁄₁₆″ × 39⅝″. Krannert Art Museum, University of Illinois, Champaign. Gift of Albert L. Arenberg 1956-13-1. Münter lived in Murnau until her death in 1962. During World War II, she preserved her collection of Blaue Reiter works in the cellar of her house, hiding them first from the Nazis, who thought her work "degenerate," then from the U.S. occupying troops.

masculine, even a symbol of Kandinsky himself. The yellow (feminine) house stands crookedly beside it, behind the tilted diagonals of a fence. In the foreground a giant snow-covered rock and a jagged leafless tree stand guard, suggesting the opposite of Marc's natural harmony. On a symbolic level, they seem to reflect Münter's troubled relationship with Kandinsky as images of her frustration and his denial.

A Diversity of Sound: Schoenberg's New Atonal Music versus Puccini's Lyricism

On January 2, 1911, Kandinsky and Marc heard the music of Arnold Schoenberg [SHERN-berkh] (1874–1951) at a concert in Munich. Schoenberg was from Vienna, where he led a group of composers, including Alban Berg and Anton Webern, who believed that the long reign of tonality, the harmonic basis of Western music, was over. Marc later wrote to a friend, "Can you imagine a music in which tonality is completely suspended? I was constantly reminded of Kandinsky.... Schoenberg seems, like [ourselves], to be convinced of the irresistible dissolution of the European laws of art and harmony."

Indeed, Kandinsky represented the concert hall stage in an abstract composition in which he visually expressed the movement of sound (Fig. **41.15**). He described the painting this way:

> The blank piano is the material source of sound, yellow, on the other hand, is the immaterial source. The yellow floods out to the side of the piano, flows downwards in a swinging movement, around the audience, and rises once again to the musicians in the orchestra, and from there finally settles as a round patch in front of the white, slanting columns.

Afterward, Kandinsky and Marc learned that Schoenberg was a self-trained painter, specializing in self-portraits (Fig. **41.16**). The two artists invited him to exhibit with them in the first Blaue Reiter exhibition in December 1911.

Schoenberg did in fact abandon **tonality**, the organization of the composition around a home key (the tonal center). In its place he created a music of complete **atonality**, a term he hated (since it implied the absence of musical tone altogether), preferring instead "pantonal." His 1912 setting for a cycle of 21 poems by Albert Giraud, *Pierrot lunaire* [pee-yair-OH lune-AIR], is probably the first atonal composition to be widely appreciated, though to many it represented, as one critic put it, "the last word in cacophony and musical anarchy" (see **CD Track-41.2**). Pierrot is a character from the Italian *commedia dell'arte* [kom-MAY-dee-ah dell-AR-tay], the improvisational traveling street theater that first developed in the fifteenth century. He is a

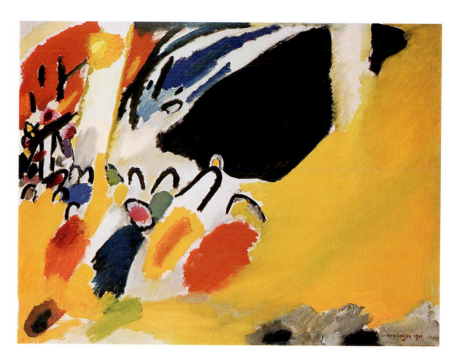

Fig. 41.15 Wassily Kandinsky. *Impression III (Concert).* **1911.** Oil on canvas, 12″ × 13⅛″. Städtische Galerie im Lenbachhaus, Munich, Germany. © DACS /Peter Willi. The Bridgeman Art Library. © 2008 ARS Artists Rights Society, NY. This painting, with its parenthetical title, is meant to suggest Kandinsky's emotional response to the expressivity of music.

Fig. 41.16 Arnold Schoenberg. *Green Self-Portrait.* **1910.** Oil on wood, 13″ × 9½″. Schoenberg Center, Vienna. Verwertungsgesellschaft Bildender Kunstler (VBK), Vienna. In *Concerning the Spiritual in Art*, Kandinsky wrote, "Schoenberg is endeavoring to make complete use of his freedom and has already discovered new mines of new beauty in his search for spiritual structure. His music leads us to where musical experience is a matter not of the ear, but of the soul—and from this point begins the music of the future."

moonstruck clown whose mask conceals his deep melancholy, brought on by living in a state of perpetually unrequited desire. (Picasso often portrayed himself as Pierrot, especially early in his career.) In *Pierrot lunaire*, five performers play eight instruments in various combinations in accompaniment to a voice that does not sing but instead employs a technique that Schoenberg calls **Sprechstimme** [SHPRAYK-shtim-muh] or "speech-song." "A singing voice," Schoenberg explained, "maintains the pitch without modification; speech-song does, certainly, announce it [the pitch], only to quit it again immediately, in either a downward or an upward direction." In the *Madonna* section of *Pierrot lunaire*, which addresses Mary at the moment of the *pietá*, when she mourns over the dead body of her son, the lyrics focus on the blood of Christ's wounds, which "seem like eyes, red and open." The atonality of Schoenberg's music reflects this anguish with explosive force.

Creating long works without the resources of tonality was a very real challenge to Schoenberg—hence the usefulness of 21 short works in the *Pierrot lunaire* series. By 1924, Schoenberg had created a system in which none of the 12 tones of the chromatic scale could be repeated in a composition until each of the other 11 had been played. This **twelve-tone system** reflected his belief that every tone was equal to every other. The twelve notes in their given order are called a **tone row**, and audiences soon grew accustomed to not hearing a tonal center in the progression and variation of the tone row as it developed in Schoenberg's increasingly **serial composition**. The principal tone row can be played upside down, backward, or upside down and backward. While the possibilities for writing an extended composition with a single tone row and its variations might at first seem limited, by adding rhythmic and dynamic variations, as well as contrapuntal arrangements, the development of large-scale works became feasible.

The radical nature of Schoenberg's composition can best be understood by comparing it to its opposite, the emotional lyricism of the Italian opera composer Giacomo Puccini (1858–1924). So romantic is Puccini's music, and so realist are his librettos, that in many ways he is closer to romantic and realist writers and painters of the nineteenth-century than to those of the twentieth. His first two great operas, *Manon Lescaut* and *La Bohème*, both love stories set in France, date from the last decade of the nineteenth century, 1893 and 1896 respectively, but the rest of his output dates from the twentieth century: *Tosca* (1900) is a passionate love story that ends in murder and suicide. *Madama Butterfly* (1904) describes the betrayal of a Japanese geisha by an American sailor, and her eventual suicide. *The Girl of the Golden West* (1910) is set in the American "Wild West" and features saloons, gunfights, and a manhunt. Puccini looked to Beijing, China, for the story of *Turandot*, an opera that is based on a Chinese folk tale. The opera was not quite finished when Puccini died in 1924, and the last two scenes were completed by a colleague. These operas and their continued popularity demonstrate the enduring power of tradition over both composers and listeners throughout the twentieth century and down to the present day.

Two arias, *Un bel dì* (One fine day) from *Madama Butterfly* and *Nessun dorma* (Let no one sleep) from *Turandot*, embody Puccini's extraordinary melodic gifts (**CD-Tracks 41.3** and **41.4**). *Madama Butterfly* tells the story of an American sailor, Lieutenant Benjamin Franklin Pinkerton, who has rented a house in Japan for 999 years. As part of the deal, he is also given a bride, Cio-Cio-San ("Butterfly"). Pinkerton does not take the marriage seriously and soon returns to America, promising to return. Cio-Cio-San gives birth to a son and fully expects the boy's father to return to them. Pinkerton has no such plan and marries an American woman. When he returns to Japan with his wife three years later, the devastated Cio-Cio-San kills herself. Cio-Cio-San sings *Un bel dì* (One fine day) near the beginning of Act II, after Pinkerton has left for America, as she tries to convince herself that her husband will one day return.

The aria *Nessun dorma* (Let no one sleep) occurs in the last act of *Turandot*. Turandot is a beautiful princess whose hatred of men has led her to declare that any suitor who does not correctly answer three riddles that she poses must die. Calàf, a prince from Tartary, is smitten by Turandot's beauty, and surprises her by answering each riddle correctly. Turandot is horrified, but Calàf offers her an out: If she can discover his name by dawn, he will forfeit his life. She immediately orders that no one shall sleep until Calàf's identity is discovered, and in *Nessun dorma*, Calàf's aria, he expresses his certainty that no one will discover his name.

The music of both Schoenberg and Puccini shares an emotionally charged expressivity, but there could be no greater contrast to Schoenberg's *Sprechstimme* than Puccini's lyricism. "Without melody," Puccini said, "there can be no music." If Schoenberg agreed, he differed in believing that melody could exist exclusive of harmony.

Early Twentieth-Century Literature

If one word could describe the literature of the early twentieth century, it would be innovation. Like visual artists and composers, writers too were drawn to uncharted ground and experimented with creating new forms in an effort to embrace the multiplicity of human experience. Like Picasso in his *Demoiselles d'Avignon*, they sought a way to capture the simultaneous and often contradictory onslaught of information and feelings that characterized the fabric of modern life. And writers understood that these multiple impulses from the real world struck the brain randomly, inharmoniously, in rhythms and sounds as discordant as the music of Stravinsky and Schoenberg.

Guillaume Apollinaire and Cubist Poetics

Picasso's good friend and a champion of his art, Guillaume Apollinaire [ah-pol-ee-NAIR] (1880–1918) was one of the leaders in the "revolution of the word," as this new approach to poetry and prose has been called. Modeling his work on the example of Picasso, Apollinaire quickly latched on to the principle of collage. In his poem "Lundi, rue Christine" [lun-DEE rue kree-STEEN] ("Monday in the rue Christine"), snatches of conversation over-

heard on a street in Paris, not far from the École des Beaux Arts [ay-KOHL day bohz-AR], follow one another without transition or thematic connection (**Reading 41.3**):

READING 41.3 **from Guillaume Apollinaire, "Lundi, rue Christine" (1913)**

Those pancakes were divine
 the water's running
Dress black as her nails
It's absolutely impossible
Here sir
The malachite ring
The ground is covered with sawdust

Then it's true
The red headed waitress eloped with a book seller.

A journalist whom I really hardly know
Look Jacques it's extremely important what I'm going
 to tell you
Shipping company combine

In this short, representative fragment from the poem, Apollinaire has transformed this collage of voices into poetry by the act of arranging each phrase into poetic lines.

He would feel free, as well, to reorganize poetic lines into visual images. In "Il Pleut" [eel pleh] ("It's Raining") (Fig. **41.17**), Apollinaire deployed the following lines in loose vertical columns down the page to represent windblown sheets of rain (**Reading 41.4**):

READING 41.4 **Guillaume Apollinaire, "Il Pleut" (1914)**

It is raining women's voices as if they were dead even in
 memory
you also are raining down marvelous encounters of my life
 o little drops
and these rearing clouds are beginning to whinny a whole
 world of auricular towns
listen to it rain while regret and disdain weep an old fash-
 ioned music
listen to the fall of all the perpendiculars of your existence

Apollinaire called such visual poems *calligrammes* [kah-lee-GRAHM], a word of his own invention related to *calligraphy* and meaning, literally, "something beautifully written." The poem purposefully combines sound and sight, imaging, for instance, clouds as rearing horses neighing, "auricular towns"— that is, towns addressed to the ear, the noise of the modern urban street. As we listen to "an old fashioned music"—

traditional verse/poetry, but also tradition as a whole—we also hear the "fall of all the perpendiculars" of our existence, everything generally considered "upright" both physically and morally. In Apollinaire's image of the poem, the voices of the old world literally rain down on us to give way to the new.

Il pleut

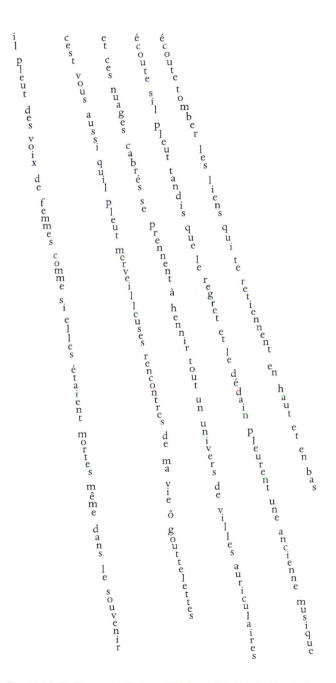

Fig. 41.17 Guillaume Apolliniare. "Il Pleut" (It's Raining). 1914. Translated in its original form by Oliver Bernard. From *Selected Poems of Apollinaire*, trans. Oliver Bernard. (Vancouver, British Columbia: Anvil Press, 2003). Apollinaire's book *Les peintres cubistes* (*The Cubist Painters*), published in 1913, helped to define the aims of Picasso and Braque for a broader, more general audience.

Words in Relation: The Language of Gertrude Stein

One of Picasso's other friends in Paris, Gertrude Stein, was also experimenting freely with the written word. In her short book *Picasso*, first published in 1938, Stein describes Picasso's habit of photographing still-life arrangements of various objects. She could just as well have been writing about her own literary style. She describes a time around 1910:

> I was very much struck at this period, when cubism was a little more developed, with the way Picasso could put objects together and make a photograph of them, I have kept one of them, and by the force of his vision it was not necessary that he paint the picture. To have brought the objects together already changed them to other things, not to another picture but to something else, to things as Picasso saw them.

This is very much Stein's literary strategy, to bring words together in a way that changes them into something else. Here are two examples from *Tender Buttons*, her 1914 collection of short prose pieces, really prose poems (**Reading 41.5**):

READING 41.5 **from Gertrude Stein,**
Tender Buttons (1914)

A Carafe, That is a Blind Glass

A kind in glass and a cousin, a spectacle and nothing strange a single hurt color and an arrangement in a system to pointing. All this and not ordinary, not unordered in not resembling. The difference is spreading.

A Petticoat

A light white, a disgrace, an ink spot, a rosy charm.

The first excerpt can best be understood as an essay on the nature of Cubism, the carafe not unlike, say, the pitcher in Braque's *Violin and Palette* (see Fig. 41.8). In a certain sense, these short sketches are riddles: how do "a light white, a disgrace, an ink spot, [and] a rosy charm" represent a petticoat? The similarities are opaque (like the "blind glass" that is a Cubist pitcher), much like someone describing what they see in a Rorschach [ROAR-shahk] test. They possess precisely that sense of psychological reality, and so are not easily interpreted. These lines demonstrate Stein's conviction that simple nouns and adjectives placed side by side—"hurt color," "petticoat/disgrace"—could evoke psychological depth that interested the many writers who came to admire her despite the opacity of her meaning. Stein's strategy, was, in fact, shared by many modern writers and artists.

Modernism Comes to America

While Americans in Paris generally gathered at Stein's salon at 27 rue de Fleurus to admire her collection of paintings and drawings, her literary experiments were soon admired across

the ocean by American writers of an experimental bent, even as they were ridiculed in the American popular press. The American short-story writer Sherwood Anderson would later call *Tender Buttons* "the most important pioneer work done in the field of letters in my time." The book, he would write, "gives words an oddly new intimate flavor and at the same time makes familiar words seem almost like strangers."

Ezra Pound and the Imagists

Stein's act of juxtaposing two unlike words, objects, or images and thereby transforming them into something else was, in fact, a fundamental strategy of modern art. It informs the poetry of the Imagists, a group of English and American poets who sought to create precise images in clear, sharp language. Imagism was the brainchild of American poet Ezra Pound (1885–1972), who in October 1912 submitted a group of poems under the title *Imagiste* to the new American journal *Poetry*. The poet and critic F. S. Flint would succinctly define the Imagist poem in the March 1913 issue of the magazine. Its simple rules were:

1. Direct treatment of the "thing," whether subjective or objective.
2. To use absolutely no word that does not contribute to the presentation.
3. As regarding rhythm: to compose in sequence of the musical phrase, not in sequence of the metronome.

Pound's "In a Station of the Metro" (**Reading 41.6**) which first appeared in *Poetry* in 1913, is in many ways the classic Imagist poem:

READING 41.6 **Ezra Pound,**
"In a Station of the Metro"
(1913)

The apparition of these faces in the crowd;
Petals on a wet, black bough.

Pound was an avid scholar of Chinese poetry, and the poem is influenced both thematically by the Chinese *waka* tradition, with its emphasis on the changing seasons, and formally, in its brevity at least, by the *haiku* tradition (see chapter 16). (Haiku normally consist of three lines in 17 syllables, while Pound's poem is made up of 19 syllables in two lines.) The poem's first line seems relatively straightforward—except for the single word "apparition." It introduces Pound's predisposition, his sense that Paris is inhabited by the "living dead." It contrasts dramatically with the poem's second and final line, which is an attractive picture of nature. The first line's six-beat iambic meter— da-duh, da-duh, etc.—is transformed into a five-beat line that ends in three long strophes—that is, single beats—"wet, black bough." The semicolon at the end of line one acts as a kind of hinge, transforming the bleak vision of the moment into a vision of possibility and hope, the implicitly "white"

apparition of the faces of the ghostlike crowd transformed into an image of spring itself, the petals on the wet, black bough. The poem moves from the literal subway underground, from burial, to life, reborn in the act of the poetic vision itself. It captures that moment, as Pound said, when a thing "outward and objective" is transformed into a thing "inward and subjective."

Pound was also self-consciously working in the shadow of Walt Whitman (see chapter 38), who, Pound believed, had opened poetry to the vast expanse and multiplicity of American culture. The poem, "A Pact," also published in 1913 in *Poetry,* addresses Whitman (**Reading 41.7**):

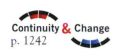

Continuity **& Change**
p. 1242

"Song of Myself"

READING 41.7 **Ezra Pound, "A Pact" (1913)**

I make truce with you, Walt Whitman—
I have detested you long enough.
I come to you as a grown child
Who has had a pig-headed father;
I am old enough now to make friends.
It was you that broke the new wood,
Now is a time for carving.
We have one sap and one root—
Let there be commerce between us.

Pound clearly recognizes in Whitman the poetic force that liberated poetry to address the world in all its multiplicity. But he feels he must whittle Whitman's voluminous work down to a more manageable size—to the single image, in fact. As it would turn out, over the course of his career, Pound would write a poem even longer than Whitman's *Leaves of Grass,* the massive *Cantos,* which would occupy him until his death (see chapter 44). In fact, the legacy Whitman left for twentieth-century American poetry was not only the freedom to invent, but the propensity to write the long poem.

Stieglitz, Gallery 291, and *Camera Work*

When modern painting made its first appearance in New York in 1908, the public hardly noticed. At a small New York gallery, named simply "291," after its address at 291 Fifth Avenue, its owner, photographer Alfred Stieglitz [STY-glitz] (1864–1946), hosted Matisse's first one-person show outside of France. He mounted two more shows of Matisse's work in 1910 and 1912. Stieglitz had also been the first in the United States to exhibit Picasso, showing more than 80 of his works on paper in 1911.

Stieglitz valued both artists for the attention they paid to formal composition over and above any slavish dependence on visual appearance. He valued, in other words, the conceptual qualities of their work as opposed to their imagery. This is perhaps surprising for a photographer, but describing the inspiration of his own 1906 photograph *The Steerage* (Fig. **41.18**), he would later recall:

Fig. 41.18 **Alfred Stieglitz.** *The Steerage.* 1907. Photogravure, $13\frac{3}{16}'' \times 10\frac{3}{8}''$. Courtesy George Eastman House. © 2008 ARS Artists Rights Society, NY. Stieglitz first published this photograph in *Camera Work* in 1911.

There were men, women and children on the lower level of the steerage [the lower class deck of a steamship]. . . .The scene fascinated me: A round straw hat; the funnel leaning left, the stairway leaning right; the white drawbridge, its railings made of chain; white suspenders crossed on the back of a man below; circular iron machinery; a mast that cut into the sky, completing a triangle. I stood spellbound for a while. I saw shapes related to one another—a picture of shapes, and underlying it, a new vision that held me. . . .

The photographers and painters Stieglitz championed—including Georgia O'Keeffe (1887–1986), whom he would later marry—were all dedicated to revealing these same geometries in the world. In *Camera Work,* the photography magazine he published from 1903 to 1916, Stieglitz reproduced modern paintings and similarly modern photographs like *Abstraction, Porch Shadows* by Paul Strand (1890–1976) (Fig. **41.19**). Strand's image is an unmanipulated photograph (that is, not altered during the development process) of the shadows of a railing cast across a porch and onto a white patio table turned on its side. Its debt to Picasso and Braque's Cubism was not lost on the magazine's audience.

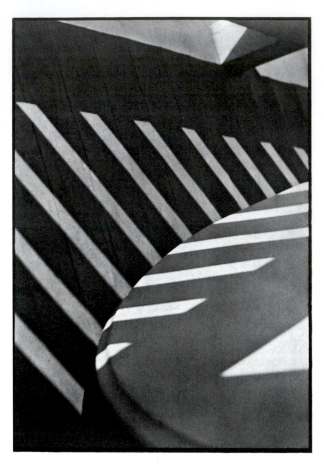

Fig. 41.19 Paul Strand. *Abstraction, Porch Shadows.* **1916.** Silver-platinum print, 12 $^{15}/_{16}$″ × 9 $^{5}/_{8}$″. Inv. Pho1981-35-10. Repro-Photo: Rene-Gabriel Ojeda. Musée d'Orsay, Paris, France. Réunion des Musées Nationaux/Art Resource, NY. When Stieglitz published this photograph in the last issue of *Camera Work*, June 1917, he called it "the direct expression of today."

The Armory Show and Marcel Duchamp

A few years after Stieglitz mounted his small shows at Gallery 291, modern art arrived in New York with a bang. The modern art epitomized by the work of Picasso and Braque drew crowds to the International Exhibition of Modern Art at the 69th Infantry Regiment Armory, on Lexington Avenue between 25th and 26th streets. Opening on February 17, 1913, the exhibit displayed nearly 1,300 pieces, including 17 Matisses, 7 Picassos, 15 Cézannes (plus a selection of lithographs), 13 Gauguins (plus, again, a number of lithographs and prints), 18 van Goghs, 4 Manets, 5 Monets, 5 Renoirs, 2 Seurats, a Delacroix, and a Courbet. Many other foreign and American artists were represented, most of the latter having spent considerable time in Europe over the previous decade.

By the time the Armory Show closed one month later, over 88,000 people had seen it, the most ever to attend an art exhibition in New York. In Chicago, where a somewhat smaller exhibition was installed at the Art Institute just one week later, another 190,000 visitors were drawn to the

show. Finally, in May, an exhibition consisting of only 300 works, all of them European, opened in Boston, drawing only 12,676 paid admissions (Boston was the only host to charge an admission fee—25 cents, an amount equivalent to $5 today).

Stieglitz was not involved in organizing the Armory Show but he was its inspiration. He had purchased the first Picasso sold in America—one of the drawings he had exhibited in 1911. At the Armory Show, he bought the only painting on exhibit by the Russian emigré German Expressionist Wassily Kandinsky. His example helped to convince the Metropolitan Museum of Modern Art to purchase the first Cézanne for an American museum, the painting *Poorhouse on the Hill* (1877). Lillie P. Bliss (1864–1931), whose collection would later be the first major bequest to the Museum of Modern Art in 1934, inaugurated her collecting habit at the Armory Show by purchasing 19 lithographs, including works by Cézanne, Gauguin, Odilon Redon [reh-DOHN], Renoir, and Edouard Vuillard [vwee-YAHR], all for an average of $18 apiece.

The most notorious purchase of all was by a San Francisco dealer in Japanese prints, Frank C. Torrey, who bought the French artist Marcel Duchamp's [doo-SHAHM] (1887–1968) *Nude Descending a Staircase* (Fig. **41.20**). The painting had been the object of much ridicule. One newspaper writer called it "an explosion in a shingle factory." The *American Art News* called it "a collection of saddlebags" and offered a $10 reward to anyone who could locate the nude lady it professed to portray. President Theodore Roosevelt compared it to the Navajo rug in his bathroom. Considering the European artists shown at the exhibition as a whole, he concluded that they represented the "lunatic fringe." One review of the exhibit was accompanied by a cartoon entitled "The Rude Descending a Staircase" (Fig. **41.21**). (See *Voices*, page 1340.)

If in 1913 Duchamp's nude seemed inexplicable to Americans, today, we can easily identify several influences that shaped the work. Duchamp was familiar with Picasso's Cubist reduction of the object into flat planes (see Fig. 41.7). He also knew of the Futurists' ideas about depicting motion, and, perhaps more important, he was aware of new developments in photography that could capture moving figures on film. Duchamp had read a book called *Movement*, published in Paris in 1894. It was a treatise on human and animal locomotion written by Étienne-Jules Marey [mah-RAY] (1830–1904), a French physiologist who had long been fascinated by the possibility of breaking down the flow of movement into isolated data that could be analyzed. Marey himself had seen the series of photographs of a horse trotting published by his exact contemporary, the American photographer Eadweard Muybridge [MY-brij] (1830–1904) in the French journal *La Nature* [nah-CHOOR] in 1878 (Fig. **41.22**). Muybridge had used a trip-wire device in an experiment commissioned by California governor Leland Stanford to settle a bet about whether there were moments in the stride of a trotting or galloping horse when all four feet are off the ground.

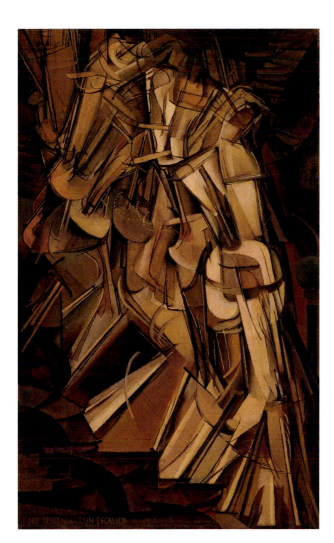

Fig. 41.20 Marcel Duchamp. *Nude Descending a Staircase, No. 2.* **1912.** Oil on canvas, 58″ × 35″. Philadelphia Museum of Art, Louise and Walter Arenberg Collection. Photo: Graydon Wood, 1994. © 2008 ARS Artists Rights Society, NY.

Fig. 41.21 The Rude Descending a Staircase. This article was provided by OldMagazineArticles.com which is from http://www.oldmagazinearticles.com/about_us.php. A derisive review of the Armory Show published by *The Literary Digest,* April 1913, included this cartoon, comparing Duchamp's *Nude* to a throng of New York City subway riders.

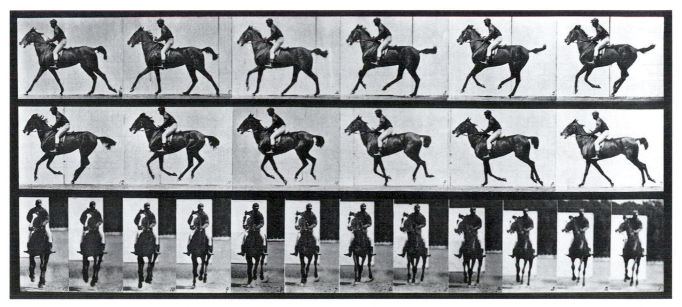

Fig. 41.22 Eadweard Muybridge. *Annie G, Cantering Saddled.* **December 1887.** Collotype print, sheet 19″ × 24″, image 7″ × 16″. Philadelphia Museum of Art: City of Philadelphia, Trade & Convention Center, Dept. of Commerce (Commercial Museum). From photographs such as this, especially others showing the human body in motion, the science of physiology was born.

Voices

Interviewing a Cubist

Negative reviews of the Armory Show, and Duchamp's Nude Descending a Staircase, *quickly spawned other, more general attacks on modern art, including the following account of an encounter with Pablo Picasso, which was illustrated in* The Literary Digest, *April 1913, (see Fig. 41.21).*

If you don't "feel" a cubist picture, give it up. But above all things don't ask anybody who is supposed to know, or who insinuates that he knows, to explain anything. It puts him in a bad humor. If you should ever chance to meet Picasso, the Spanish painter and arch-Cubist, you would be put upon your honor not to mention the subject to him, for it would spoil the whole evening for him, and he would become morose and wouldn't talk at all. Kate Carew, the clever correspondent for the New York *Tribune*, met him recently in Paris, but had to be put under bond to keep the peace before the door was opened to this vision. Her hostess who arranged the meeting confest that she understood all about these squares of canvas that emulate the paving-stones of the street, but she, too, refused to be drawn into any net of revelations. Only she did it "sweetly." "One can't explain these things. You must simply find them for yourself. . . . I always understand, of course." The correspondent tried to acquire the understanding mind before she encountered Picasso in person, and, under the benign smile of her hostess, exercised her ingenuity upon one or two pictures of Matisse, the first of the innovators:

"I was out in the cold. That was all there was to it, and me with such an eager, inquiring, young mind, too!

"I looked at the biggest Matisse.

"It showed gentlemen and ladies, old enough to know better, very lightly clad for the time of year or any time of year.

"They appeared to be eating fruit and thinking.

"Anything to do with the Garden of Eden?" I inquired, tentatively.

"It had.

"My first step in the right direction. I was getting on, and my head swelled a little.

"Thus encouraged, I progress still further. I went and squinted at some pink and blue and yellow chrysanthemum-like splotches.

"'Do you know,' I said dreamily, 'I seem to get a kind of Japanese feeling here,' and I put my head a trifle to the side and gazed.

"There you are! exclaimed my hostess triumphantly. That's just it. That's what I mean. One can't explain these things. One must feel. One must not look for details, one must get an impression, an emotion. That is a portrait of Matisse's wife in her Japanese kimono.

> **"How he can ever paint such ugly figures as he does . . I can't understand."**

"It seemed to have been an excellent guess. I was in luck.

"Now, between ourselves, I never did find Mme. Matisse in the picture, but I am practically sure that I traced the kimono; I found that among the chrysanthemum splashes.

"My stock jumped up with alacrity after that brilliant effort. I was treated as an equal."

This interchange was only by way of filling in time until the Cubist painter arrived:

"A short, stocky, boyish figure with one hand on the head of a huge snow-white dog.

"Amid a chorus of welcome he came further into the room, nodded amiably to every one and was presented to me, the only outsider.

"He looks very young. He is thirty-one, really, but he does not seem anywhere near that. He is built like an athlete, with his unusually broad shoulders and masculine frame, and his hands and feet are a contradiction, as they are very small and delicately formed. His hands look older than his face, for they are veined and knotted like the hands of the aged; yet they are artistic, with long, pointed fingers and sensitive, delicate finger tips.

. . ."His face is another contradiction.

"It is the face of a Spanish troubadour.

"You instinctively long to see him with a sombrero and a cloak and a red rose between his lips, twanging a guitar.

"He has a smooth, olive skin guiltless of hair on cheek or chin or mouth. His features are perfect. A Grecian nose, beautifully formed mouth, eyes set rather wide apart under well-arched brows, and thick, black hair cut short except for one lock which will come straggling down over his forehead.

"It isn't the face of a fanatic or a dreamer.

"It isn't the face of a practical business man who sees possible sales in sensationalism.

"It isn't the face of a humorist who would enjoy spoofing a guileless public.

"No; it is the very handsome face of a simple, sincere artist, without much sense of humor, perhaps, but with conviction and strength.

"How he can ever paint such ugly figures as he does, when he has only to look in a mirror, copy what he sees, and turn out something worth the trouble, I can't understand.

Intrigued by Muybridge's photographs, Marey began to use the camera himself, dressing models in black suits with white points and vertical stripes on the side that allowed him to study, in images created out of a rapid succession of photographs, the flow of their motion. He called them *chronophotographs*, literally "photographs of time." "In one of Marey's books," Duchamp later explained, "I saw an illustration of how he indicated [movement] . . . with a system of dots delimiting the different movements. . . . That's what gave me the idea for the execution of [the] *Nude*."

The Origins of Cinema

Not long after Muybridge and Marey published their work, Thomas Edison (1847–1931) and W. K. Laurie Dickson (1860–1935) invented the Kinetoscope [kih-NET-oh-skope], the first continuous-film motion-picture viewing machine. After visiting with Marey in 1889, Edison had become convinced that a motion picture was possible, especially if he utilized celluloid film, the new invention of George Eastman (1854–1932) that came on a roll. Eastman had introduced his film in 1888 for a new camera called the Kodak. Dickson devised a sprocket wheel that would advance the regularly perforated roll of film, and Edison decided on a 35mm width

(eventually the industry standard) for the film strip of their new motion-picture camera, the Kinetograph. But Edison's films were only viewable on the Kinetoscope through a peephole by one person at a time. Although viewing parlors first appeared in 1894, the commercial possibilities of film seemed limited since each of Edison's motion pictures lasted for about 20 seconds.

The Lumière Brothers' Celluloid Film Movie Projector

The first projected motion pictures available to a large audience had their public premiere on December 28, 1895, in Paris. That night, August and Louis Lumière (1862–1954, 1864–1948) showed 10 films that lasted for about 20 minutes through their *Cinématographe* [see-nay-may-toh-GRAHF], a hand-cranked camera that, when connected to the equipment used for "magic lantern" shows (early "slide" shows), served as a projector as well. The program began with *Workers Leaving the Lumière Factory*, a film that conveyed, if nothing else, the large size of the Lumière brothers' operation.

Two of their most famous films were not shown that night, *Arrival of a Train at La Ciotat* [see-oh-TAH] and *Waterer and Watered* (Fig. **41.23**). The first film depicts, in a single shot, a train arriving at a station—and the story goes that original

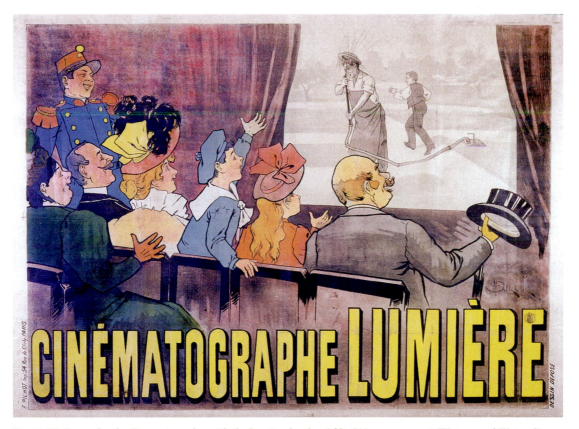

Fig. 41.23 Poster for the Cinématographe, with the Lumière brothers' film *L'Arroseur arrosé* (*Waterer and Watered*) on screen. 1895. British Film Institute. Notable in this poster is the audience. From the beginning, cinema defined itself as family entertainment.

audience members panicked as the train got closer to the camera because it seemed so real to them. The second film introduced comedy to the medium. A boy steps on a gardener's hose, stopping the flow of water; when the gardener looks at the nozzle, the boy steps off the hose, and the gardener douses himself. A brief chase ensues, with both boy and gardener leaving the frame of the stationary camera for a full two seconds.

The Nickelodeon: Movies for the Masses

By the turn of the century, the motion picture had established itself as little more than an interesting novelty. That would change when at first a few and then hundreds of entrepreneurs understood where the real audience for motion pictures was. By the turn of the century, thousands of immigrants to the United States, mostly from southern and central Europe, were living in overcrowded tenements in miserable city slums (see chapter 38). They could not afford to pay much for entertainment, but they could afford a nickel (approximately $1 in today's money)—and so by 1905 the nickelodeon theater was born. By 1910 there were more than 10,000 nickelodeons in the United States. With names like the World's Dream Theater, they catered to the aspirations of the working class, and most often to women and children (though even before Prohibition, the movies would pull so many men out of saloons that thousands of bars around the country closed down). The nickelodeons showed a wide variety of films. Vitagraph [VIGH-tah-graf], an early producer, released a military film, a drama, a Western, a comedy, and a

special feature each week. Civil war films were popular (though not as popular as Westerns, which European audiences also adored). There were also so-called quality films: adaptations of Shakespeare, biblical epics, and the like.

Although by 1909 motion picture companies were increasingly using **intertitles**—printed text that could announce a scene change, provide lines of dialogue, or even make editorial comment—to aid in the presentation of their narratives, by and large silent films were particularly accessible to working-class, immigrant audiences whose often rudimentary grasp of the English language was thus not a major obstacle to enjoying what remained primarily a visual medium.

D. W. Griffith and Cinematic Space

The need for a weekly supply of films to satisfy the nickelodeon audience dictated, at first, the length of films. Most were one-reelers—that is, a single film spool holding about 1,000 feet of film—and their running time was 10 to 15 minutes. But by 1914 more than 400 films of four reels or more had been produced in the United States (few survive), and audiences soon demanded longer narrative experiences.

This demand was met by D. W. Griffith (1875–1948), the foremost single-reel director of the day. In January 1915, his 13-reel epic *The Birth of a Nation* premiered, released with its own score, to be played by a 40-piece orchestra, and with an admission price of $2, the same as for legitimate theater (Fig. **41.24**). A film about the Civil War and Reconstruction, its unrepentant racism, culminating in a tightly edited sequence

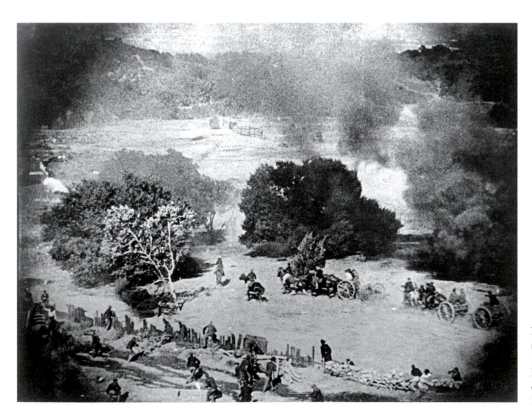

Fig. 41.24 D. W. Griffith. Battle scene from *The Birth of a Nation*. 1915. The Museum of Modern Art, Film Stills Archive. Griffith was the son of a Confederate colonel, which sheds light on his racism.

in which a white woman tries to fend off the sexual advances of a black man as the Ku Klux Klan rides to her rescue, led the newly formed NAACP (National Association for the Advancement of Colored People) to seek to have it banned. Riots broke out in Boston and Philadelphia, while Chicago, Denver, Pittsburgh, St. Louis, Minneapolis, and eight states denied its release. Nevertheless, its box-office receipts were among the largest in film history (partly due to its large admission fee), grossing nearly $18 million by the late twenties, when the advent of talking films made it more or less obsolete. If nothing else, *The Birth of a Nation* demonstrated the viability of what came to be called the feature film, a film of multiple reels that ran for at least 40 minutes; they were "featured" with prominent billing and shown after several shorts, including newsreels and animated cartoons.

An even more important aspect of *The Birth of a Nation* was the large repertoire of camera shots that Griffith used to create visual variety in a film of such length. A *shot* is a continuous strip of motion picture film that portrays a subject and runs for an uninterrupted period of time. As the contemporary American film critic Roger Ebert has put it, "Griffith assembled and perfected the early discoveries of film language, and his cinematic techniques have influenced the visual strategies of virtually every film made since; they have become so familiar we are not even aware of them." Griffith's film techniques created a new sense of space, what might be called "cinematic space," as he combined his shots in innovative ways. His repertoire included the *full shot*, showing the actor from head to toe; the *medium shot*, from the waist up; the *close-up* of the head and shoulders; and the *extreme close-up* of a portion of the face. The

image of the battle scene in Figure 41.24 is a *long shot*, a shot that takes in a wide expanse and many characters at once. It is also an example of an *iris shot*, which involves the frame slowly opening in a widening circle as a scene begins, or slowly blacking out in a shrinking circle to end a scene. Related to the long shot is the *pan*, a name given to the panoramic vista in which the camera moves across the scene from one side to the other. Griffith also invented the *traveling shot*, in which the camera moves back to front or front to back. He also made increasingly good use of intertitles.

Griffith arranged all of these shots by editing them in innovative ways as well. The *flashback*, in which the film cuts to narrative episodes that are supposed to have taken place before the start of the film, is now standard in film practice, but it was entirely original when Griffith first used it. And he was a master at *cross-cutting*, in which the film moves back and forth between two separate events in ever shorter sequences, the rhythm of the shots eventually becoming furiously paced. The alternating sequence at the end of *The Birth of a Nation*, of an endangered maiden and the KKK riding to her rescue, is a classic example. The technique would become a staple of cinematic chase scenes.

It is almost impossible to imagine what it must have been like for early audiences to see, for the first time, a film jump from, say, a full shot of a couple embracing to an extreme close-up of their lips kissing. But audiences rapidly learned Griffith's skillful cinematic language. Here, they must have recognized, was a medium for the new age—a dynamic, moving medium, embodying the change and speed of the times.

READINGS

from Filippo Marinetti, *Founding and Manifesto of Futurism* (1909)

Filippo Marinetti published the Founding and Manifesto of Futurism *on the front page of the Paris newspaper* Le Figaro *on February 20, 1909. The manifesto is a form of attack particularly suited to bombast and bravura, provocation and propaganda. Marinetti's first Futurist manifesto—many more would follow—is all of these. He thought of himself as "the caffeine of Europe," dedicated to keeping conservative culture awake all night with worry. He was also, as this excerpt from the document makes clear, something of an anarchist, desirous of overthrowing all traditions.*

We had stayed up all night, my friends and I, under hanging mosque lamps with domes of filigreed brass, domes starred like our spirits, shining like them with the prisoned radiance of electric hearts. For hours we had trampled our atavistic ennui into rich oriental rugs, arguing up to the last confines of logic and blackening many reams of paper with our frenzied scribbling. . . . Suddenly we jumped, hearing the mighty noise of the huge double-decker trams that rumbled by outside, ablaze with colored lights. . . . Under the windows we suddenly heard the famished roar of automobiles. "Let's go!" I said. "Friends, away! Mythology and the Mystic Ideal are defeated at last. . . . We went up to the three snorting beasts, to lay amorous hands on their torrid breasts. I stretched out on my car like a corpse on its bier, but revived at once under the steering wheel, a guillotine blade that threatened my stomach. The raging broom of madness swept us out of ourselves and drove us through streets as rough and deep as the beds of torrents. Here and there, sick lamplight through the window glass taught us to distrust the deceitful mathematics of our perishing eyes. . . . And on we raced. . . . Death, domesticated, met me at every turn, gracefully holding out a paw, or once in a while hunkering down, making velvety caressing eyes at me from every puddle. "Let's give ourselves utterly to the Unknown, not in desperation but only to replenish the deep wells of the Absurd!!" The words were scarcely out of my mouth when I spun my car around with the frenzy of a dog trying to bite its tail, and there, suddenly, were two cyclists coming toward me, shaking their fists. . . . I stopped short and to my disgust rolled over into a ditch with my wheels in the air. . . . Oh! Maternal ditch, almost full of muddy water! Fair factory drain! I gulped down your nourishing sludge. . . . When I came up—torn, filthy, and stinking—from under the capsized car, I felt the white-hot iron of joy deliciously pass through my heart. . . . And so, faces smeared with good factory muck—plastered with metallic waste, with senseless sweat, with celestial soot—we, bruised, our arms in slings, but unafraid, declared our high intentions to all the *living* of the earth:

Manifesto of Futurism

1. We intend to sing the love of danger, the habit of energy and fearlessness.

2. Courage, audacity, and revolt will be essential elements of our poetry. . . .

4. We say that the world's magnificence has been enriched by a new beauty; the beauty of speed. A racing car whose hood is adorned with great pipes, like serpents of explosive breath—a roaring car that seems to ride on grapeshot is more beautiful than the *Victory of Samothrace*.

. . .

8. Time and space died yesterday. We already live in the absolute, omnipresent speed.

9. We will glorify war—the world's only hygiene—militarism, patriotism, the destructive gesture of freedom-bringers, beautiful ideas worth dying for, and scorn for women.

10. We will destroy the museums, libraries, academies of every kind. . . .

11. We will sing of great crowds excited by work, by pleasure, and by riot; we will sing of the multicolored, polyphonic tides of revolution in the modern capitals; we will sing of the vibrant nightly fervor of arsenals and shipyards blazing with violent electric moons; greedy railway stations that devour smoke-plumed serpents; factories hung on clouds by the crooked lines of their smoke; bridges that stride rivers like giant gymnasts, flashing in the sun with a glitter of knives . . . and the sleek flight of planes whose propellers chatter in the wind like banners and seem to cheer like an enthusiastic crowd. ■

Reading Question

To many readers, one of the most appalling aspects of Marinetti's manifesto is its worship of war, "the world's only hygiene." Why might that be more a rhetorical strategy than an actual position?

Summary

■ **Pablo Picasso's Paris: At the Heart of the Modern** The new century was marked by technological innovation epitomized by the automobile (and its speed), the motion picture, the airplane, and, perhaps most of all, by new discoveries in physics, from quantum mechanics, the theory of complementarity, and the theory of relativity. The focal point of artistic innovation was Pablo Picasso's studio in Paris. There, in paintings like his portrait of *Gertrude Stein* and the large canvas *Les Demoiselles d'Avignon*, he transformed painting from an optical art to an imaginative construct. Picasso's project was quickly taken up by Georges Braque, and the two worked together to create the style that came to be known as Cubism in which they decomposed the subjects of their paintings into faceted planes of geometric forms that played upon the ambiguous relationship between two- and three-dimensional space—the space of painting and the space of the real world. This play would eventually lead to the invention of collage as a technique. Meanwhile, Henri Matisse and the Fauves would free color from its traditional representational role, representing the world in arbitrary blocks of brilliant hues; and the Futurists, led by Filippo Marinetti, would introduce the idea of speed and motion into painting. In music and dance, composer Igor Stravinsky and the Ballets Russes of impresario Sergei Diaghilev would shock Paris with the performance of *Le Sacre de printemps* in May 1913. Stravinsky's jarring polyrhythmic score and often bizarre instrumentation combined with Vaslav Nijinsky's frenzied and purposefully primitive choreography to create a work that seemed to turn tradition on its heels.

■ **The Expressionist Movement: Modernism in Germany and Austria** German Expressionism combined the Fauves' exploration of color with the primitivism of Nijinsky's choreography in an art that centered on the psychological makeup of its creators. The two chief groups in painting were *Die Brücke* and *Der Blaue Reiter*. The aggressive, sexually charged energy of the former found expression in woodblock printing—a deliberately crude and raw technique—and slashing bands of color found in the painting of Ernst Kirchner. Der Blaue Reiter was more obsessed with color, believing that it reflected, in its leader Wassily Kandinsky's words, the "vibrations of the soul." Kandinsky himself explored these vibrations in works that verge on total abstraction, while his colleagues, Franz Marc and Gabriele Münter, delved into the symbolic possibilities of color through more representational means. In music, the Viennese composer Arnold Schoenberg, who exhibited his own self-portrait paintings with the Der Blaue Reiter, dispensed with traditional tonality, the harmonic basis of Western music, and created new atonal works. Instead of song, his works employed *Sprechstimme*, and instead of organizing themselves around the traditional scale, he created a twelve-tone system in which none of the twelve tones of the chromatic scale could be repeated in a composition until each of the other eleven had been played. Nothing could be further from the

lyrical compositions of his near contemporary, Giacomo Puccini, whose operas—and a number of arias in particular—are nearly without parallel for the beauty of their melodies. Both Schoenberg and Puccini share, however, a dedication to the expressive potentiality of music.

■ **Early Twentieth-Century Literature** Like the visual arts and music, a spirit of innovation dominated the literary scene as well. The French poet Guillaume Apollinaire experimented with collage techniques adapted to poetry from the work of his friend Picasso. In his *calligrammes*, he also gave imitative visual form to his works. Gertrude Stein pushed writing to the edge of abstraction. And Ezra Pound and the Imagists sought to capture the moment, in the most economic terms, when the "outward and objective" turns "inward and subjective."

■ **Modernism Comes to America** When, in February 1913, the International Exhibition of Modern Art, the Armory Show, opened in New York, American audiences were introduced to the innovations of modern art for the first time in large numbers. Works by Matisse and Picasso had been exhibited in New York earlier at the gallery of photographer Alfred Stieglitz, named simply "291" after its address on Fifth Avenue. Stieglitz most valued the formal composition of the new European painting above and beyond any slavish dependence on visual appearance, and in his own work and those he championed he strove to realize the same formal character. The Armory Show, however, made modern art available for purchase and many great American collections were begun there, including that of Lillie P. Bliss, whose collection would later be the first major bequest to the Museum of Modern Art in 1934. Marcel Duchamp's *Nude Descending a Staircase*, based on studies conducted by Muybridge and Marey, also entered an American collection.

■ **The Origins of Cinema** The Kinetoscope, the first continuous-film motion-picture viewing machine, was invented by Thomas Edison and W. K. Laurie Dickson not long after Muybridge and Marey published their studies of motion. It utilized celluloid film on a role introduced by George Eastman in 1888 for the new Kodak camera. The first projected motion pictures available to a large audience had their public premiere on December 28, 1895, in Paris when August and Louis Lumière showed 10 films that lasted for about 20 minutes. When entrepreneurs realized the potential market of the thousands of immigrants who had arrived from southern and central Europe, the nickelodeon was born. Running time for most films was one reel—approximately 10 to 15 minutes, but in January 1915, D. W. Griffith introduced his 13-reel epic, *The Birth of a Nation*, demonstrating the viability of what came to be called the feature film. Even more important was Griffith's introduction of a visual vocabulary of camera shots that would define the medium for decades to come.

 ## Glossary

atonality The absence of musical tone.

calligrammes Literally, "something beautifully written," this term was invented by the poet Guillaume Apollinaire to describe his visual poems that purposefully conflate sound and vision.

collage The technique of pasting cut-out or found elements into the space of the canvas.

Cubism An art style developed by Pablo Picasso and Georges Braque noted for the geometry of its forms, its fragmentation of the object, and its increasing abstraction.

Fauvism A style in art known for its bold application of arbitrary color.

intertitles Text inserted between scenes in a film to announce a change of location, provide dialogue lines, or make editorial comment.

ostinato The continous variation of the same rhythmic pulse.

papiers-collés Literally "pasted paper," the technique that is the immediate predecessor of collage in Cubism.

polyrhythms A musical technique in which different elements of an ensemble might play different meters simultaneously.

polytonal Occurs when two or more keys are sounded by different instruments at the same time.

serial composition The principal or prime tone row can be played upside down, so that a rise of a major third in the prime row becomes the fall of a major third in the inverted row; it can be played backwards, or upside down and backwards.

Sprechstimme Literally "speaking tone," a technique between speech and song, in which a text is enunciated in approximated pitches.

tonality The organization of a composition around a home key (the tonal center).

tone row The twelve notes in their given order in a musical composition.

twelve-tone system In its most basic form, a system developed by the composer Arnold Schoenberg in which none of the twelve tones of the chromatic scale could be repeated in a composition until each of the other eleven had been played.

 ## Critical Thinking Questions

1. Which Modern values expressed in the 1900 Exposition Universelle appear in early twentieth-century literature?

2. Which basic qualities shared by Picasso, Matisse, and Stravinsky mark them as modernist innovators?

3. What made the New York Armory Show so significant for America?

4. What are the unique characteristics of the cinema genre? How do they embody the principles of modernism?

The Prospect of War

In his collages of 1912 and 1913, Picasso brought not only the "real" world into the space of the canvas, but also an edge of dread and foreboding. The subject of his still life, *Bottle of Suze* (Fig. **41.25**), is a tabletop at some Parisian café on which stand a bottle of aperitif, a glass, and newspaper. But what would appear to be a metaphor for a comfortable autumn morning, the good life in Paris, is not. The war in the Balkans, which everyone feared would erupt into a larger, pan-European conflict (as indeed it did), is the real theme of this collage. Suze is a Balkan aperitif. Injecting a serious note into the pleasantries of café culture, the upside-down newspaper reports a cholera epidemic at the front. It begins:

> Before long I saw the first corpse still grimacing with suffering and whose face was nearly black. Then I saw two, four, ten, twenty; then I saw a hundred corpses. They were stretched out there where they had fallen during the march of the left convoy, in the ditches or across the road, and the files of cars loaded with the almost dead everywhere stretched themselves out on the devastated route.

To the left of the bottle is another article, right side up, reporting on a mass socialist/pacifist/anarchist meeting attended by an estimated fifty thousand citizens. The third speaker to address the crowd is represented only by his opening words: "In the presence of the menace of a general [Euro]pean war . . ." Here Picasso's scissors have terminated the report.

The prospect of a general war was real enough. Raymond Poincaré (1860–1934), who became France's premier and foreign minister in 1912, quickly began to ready for a war with Germany, which, he predicted, would be "short but glorious." As is so often the case, the war, which would officially begin on August 4, 1914, was far worse than expected. Within a month, the first major fight, the battle of the Marne, was underway, resulting in a half million casualties on each side. By the time the war was over, in November 1918, it had cost Germany 3.5 million men. The Allies—England and America had joined forces with France—had lost over 5 million.

The day after the British entered the war, the novelist Henry James wrote a friend:

> The plunge of civilization into this abyss of blood and darkness . . . is a thing that gives away the whole long age during which we have supposed the world to be, with whatever abatement, gradually bettering, that to have to take it all now for what the treacherous years were all the while really making for and meaning is too tragic for words.

The myth of progress had ground to a halt. The technological advances that had driven the era of invention now seemed only preparation for wholesale human slaughter. The airplane, which had seemed so promising a machine, flying heavenward, was now an agent of death. The world had turned upside down. ∎

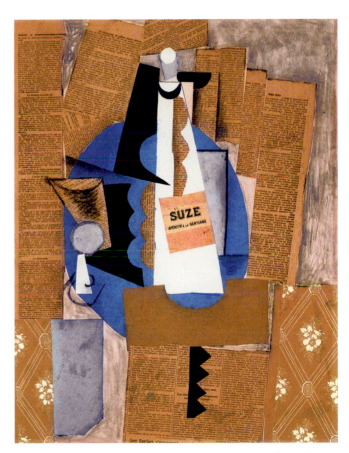

Fig. 41.25 Pablo Picasso. *Bottle of Suze.* **Autumn 1912.** Charcoal, gouache, and *papiers-collés*, 25³/₄″ × 19³/₄″. Mildred Lane Kemper Art Museum, Washington University in St. Louis. University purchase, Kende Sale Fund, 1946. © Succession Picasso/DACS 1998. © 2008 Estate of Pablo Picasso/Artists Rights Society (ARS), NY.

42 The Great War and Its Impact

A Lost Generation

Trench Warfare and the Literary Imagination

Escape from Despair: Dada in the Capitals

Russia: Art and Revolution

Freud, Jung, and the Art of the Unconscious

Experimentation and the Literary Life

> **❝** *Men have gained control over the forces of nature to such an extent that with their help they would have no difficulty in exterminating one another to the last man.* **❞**
>
> Sigmund Freud, *Civilization and its Discontents*

◄ **Fig. 42.1 John Singer Sargent.** *Gassed.* **1918.** Oil on canvas, 7.5′ × 20′. Private Collection. Imperial War Museum, Negative Number Q1460. In 1918, Sargent (see chapter 38) was commissioned to paint a large canvas commemorating British/American cooperation in the war. He went to France, where he saw this scene of troops blinded by mustard gas being evacuated from the field as others lay waiting to be led away.

ON JUNE 28, 1914, A YOUNG BOSNIAN NATIONALIST ASSASSINATED Archduke Francis Ferdinand, heir to the Austrian throne, in the Bosnian capital of Sarajevo. Europe was outraged, except for Serbia, which had been at war with Bosnia for years. Austria suspected that Serbian officials were involved (as in fact they were).

With Germany's support, Austria declared war on Serbia, Russia mobilized in Serbia's defense, and France mobilized to support its ally, Russia. Germany invaded Luxembourg and Belgium, and then pushed into France. Finally, on August 4, Britain declared war on Germany, and Europe was consumed in battle.

Though the Germans advanced perilously close to Paris in the first month of the war, the combined forces of the British and French stopped them. From then on, along the Western Front on the French/Belgian border, both sides dug in behind zigzagging rows of trenches protected by barbed wire that stretched from the English Channel to Switzerland (see Map **42.1**), some 25,000 miles of them. In the three years after its establishment, the Western Front moved only a few miles either east or west.

Stagnation accompanied the carnage. Assaults in which thousands of lives were lost would advance the lines only a couple of hundred yards. Poison mustard gas was introduced in the hope that it might resolve the stalemate, but it changed nothing, except to permanently maim and kill thousands upon thousands of soldiers (Fig. **42.1**). Mustard gas blinded those who encountered it, but it also slowly rotted the body from within and without, causing severe blis-

tering and damaging the bronchial tubes, so that its victims slowly choked to death. Most affected by the gas died within four to five weeks. British troops rotated trench duty. After a week behind the lines, a unit would move up, at night, to the front-line trench, then after a week there, back to a support trench, then after another week back to the reserve trench, and then, finally, back to a week of rest again. Attacks generally came at dawn, so it was at night, under the cover of darkness, that most of the work in the trenches was done—wiring, digging, moving ammunition. It rained often, so the trenches were often filled with water. The troops were plagued by lice, and huge rats, which fed on cadavers and dead horses, roamed through the encampments. The stench was almost as unbearable as the weather, and lingering pockets of gas might blow through at any time. As Germany tried to push both east and west (see Map **42.2**), the human cost was staggering.

By the war's end, casualties totaled around 10 million dead—it became impossible to count accurately—and somewhere around twice that many wounded. Among the dead and maimed were some of the artists and writers discussed in the last chapter: Auguste Macke, Franz Marc, and Umberto Boccioni died; Braque was severely wounded and Apollinaire suffered a serious head wound in 1916. Ernst Ludwig Kirchner served as a driver in the artillery, and the experience overwhelmed him. In 1915 he was declared unfit for service. While recuperating in eastern Germany, he painted himself in the uniform of the Mansfelder Field Artillery Regiment Nr. 75 (Fig. **42.2**), cigarette dangling from his mouth, his eyes flat and empty, his right hand a bloody stump. He was not literally wounded, but the painting is a metaphorical expression of his fears—his sense of both creative and sexual impotence in the aftermath of war. Three years later, John Singer Sargent painted *Gassed* (see Fig. 42.1) after witnessing soldiers maimed by a mustard gas attack. The nobility and heroism of the Hellenic *Dying Gaul* (see Fig. 7.27) has been replaced by the kind of brutal realism we saw earlier in the foreground of Antoine Jean Gros's celebration of Napoleon's victory in *Napolean at Eylau* (see Fig. 33.16).

Continuity & Change
p. 217

Dying Gaul

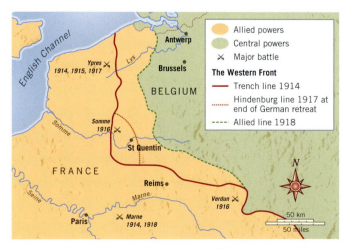

Map 42.1 The Western Front. 1914–1918. The crossed swords represent the sites of major battles.

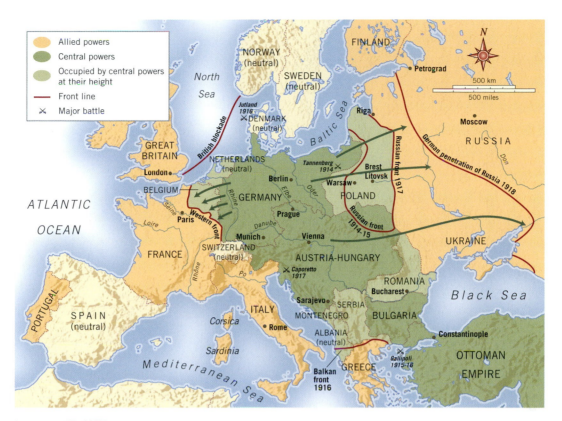

Map 42.2 World War I. 1914–1918.

This chapter explores the effect of the war on the Western imagination. After 1918, Western art and literature seemed fundamentally different from art before the war. For one thing, the spirit of optimism that marked the era of invention and innovation in the years before 1914 had evaporated. In its place, the art and literature of the period reflect an increasing sense of the absurdity of modern life, the fragmentation of experience, and the futility of even daring to hope. The war created such a sense of alienation that Gertrude Stein would say of those who had gone to war and survived, "You are all a lost generation"—aimless and virtually uncivilized. The term stuck.

Nevertheless, in Russia, the war years brought a sense of possibility, as revolution overturned centuries of imperial domination by the tsars and the Russian nobility. There, experimentation with new means of expression, including film, flourished. And in fact, the spirit of experimentation that marked the years before the war carried on afterward unabated, but tempered now with a sense of crisis, doubt, and despair. But perhaps it was the war's nightmare aspect that most profoundly affected the arts after 1918. Psychoanalysis and therapy, used to treat shell-shocked troops (what today we call post-traumatic stress syndrome), provided insights into the workings of the human mind, and artists and writers soon explored these insights in their work.

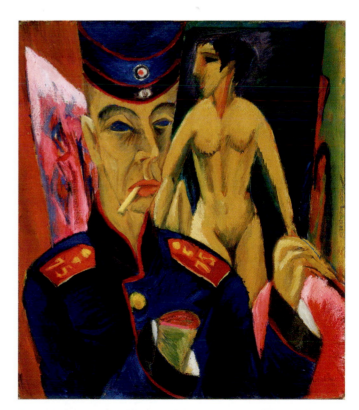

Fig. 42.2 Ernst Ludwig Kirchner. *Self-Portrait as a Soldier.* **1915.**
Oil on canvas, 27 1/4″ × 24″. The Allen Memorial Art Museum, Oberlin College, Oberlin, OH. Charles F. Olney Fund, 1950. 1950.29. This painting contrasts dramatically with his self-confident *Self-Portrait with Model* (Fig. 41.11), painted before the war.

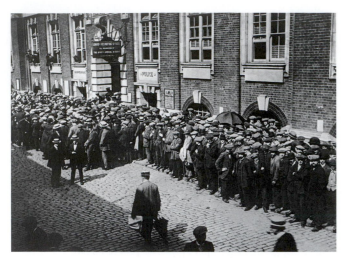

Fig. 42.3 Outside a London recruiting depot on the Declaration of War, August 1914. NMPFT Daily Herald Archive. Science and Society Picture Library, London. Literally hundreds of thousands of Englishmen rushed to enlist.

Trench Warfare and the Literary Imagination

At the outset of the war, writers responded to the conflict with buoyant enthusiasm, along with thousands of others, their patriotic duty calling them to arms (Fig. 42.3). Theirs was, after all, a generation raised on heroic poetry of the likes of Alfred, Lord Tennyson [TEN-ih-sen] (1809–1892), whose "Charge of the Light Brigade" celebrates the suicidal charge of the British cavalry at the Battle of Balaclava (Ukraine) in the Crimean [kry-ME-un] War, fought in the last century (**Reading 42.1**):

READING 42.1 **from Alfred, Lord Tennyson, "Charge of the Light Brigade" (1854)**

Cannon to right of them,
Cannon to left of them,
Cannon behind them
Volley'd and thunder'd;
Storm'd at with shot and shell,
While horse & hero fell,
They that had fought so well
Came thro' the jaws of Death,
Back from the mouth of Hell,
All that was left of them,
Left of six hundred.

When can their glory fade?
O the wild charge they made!
All the world wonder'd.
Honour the charge they made!
Honour the Light Brigade,
Noble six hundred!

Life in the trenches soon brought the meaninglessness of such rhetoric crashing down around this new generation of soldiers. Words like "glory" and "honor" suddenly rang hollow. The tradition of viewing warfare as a venue in which heroes exhibit what the Greeks called *areté*, or virtue (see chapter 5)—that is, an arena in which men might realize their full human potential—no longer seemed applicable to experience, and a new kind of writing about war, an anti-war literature far removed from the heroic battle scenes of poems like Homer's *Iliad*, soon appeared.

The American novelist Ernest Hemingway served as a Red Cross ambulance driver on the Italian Front, and on his first day on duty was required to pick up the remains, mostly those of female workers, who were blown to pieces when the ammunition factory at which they worked was blown up. He was himself later wounded by mortar fragments and machine-gun fire while delivering supplies to the troops. German soldiers like novelist Erich Maria Remarque shared similar stories. The titles alone of the poems that came out of the war speak volumes: "Suicide in Trenches" by Siegfried Sassoon; "Dead Man's Dump" by Isaac Rosenberg, who was killed on the Western Front in 1918; or "Disabled," a poem about a former athlete, with both legs and one arm gone, by Wilfred Owen.

Wilfred Owen: "The Pity of War"

In fact, the poetry of 25-year-old Wilfred Owen (1893–1918), killed in combat just a week before the armistice was signed in 1918, caused a sensation when it first appeared in 1920. "My subject is War, and the pity of War," he wrote in a manuscript intended to preface his poems, "and the Poetry is in the pity." The poems drew immediate attention for Owen's horrifying descriptions of the war's victims, as in "Dulce et Decorum Est," its title drawn from Ode 13 of the Roman poet Horace (see chapter 8), "It is sweet and fitting to die for one's country." But Owen's reference to Horace is bitterly ironic (**Reading 42.2**):

Continuity **&** Change
p. 267

Ode 13

READING 42.2 **Wilfred Owen, "Dulce et Decorum Est" (1918)**

Bent double, like old beggars under sacks,
Knock-kneed, coughing like hags, we cursed through sludge,
Till on the haunting flares we turned our backs
And towards our distant rest began to trudge.
Men marched asleep. Many had lost their boots
But limped on, blood-shod. All went lame; all blind;

Drunk with fatigue; deaf even to the hoots
Of disappointed shells that dropped behind.

GAS! Gas! Quick, boys!—An ecstasy of fumbling,
Fitting the clumsy helmets just in time;
But someone still was yelling out and stumbling
And floundering like a man in fire or lime.—
Dim, through the misty panes and thick green light
As under a green sea, I saw him drowning.

In all my dreams, before my helpless sight,
He plunges at me, guttering, choking, drowning.

If in some smothering dreams you too could pace
Behind the wagon that we flung him in,
And watch the white eyes writhing in his face,
His hanging face, like a devil's sick of sin;
If you could hear, at every jolt, the blood
Come gargling from the froth-corrupted lungs,
Obscene as cancer, bitter as the cud
Of vile, incurable sores on innocent tongues,—
My friend, you would not tell with such high zest
To children ardent for some desperate glory,
The old Lie: Dulce et decorum est
Pro patria mori.

The quotation from Horace in the last lines is, notably, labeled by Owen a "lie." And the fact is, Owen's intent is that the reader should share his horrific dreams. His rhetorical strategy is to describe the drowning of this nameless man in a sea of green gas in such vivid terms that we cannot forget it either.

In the Trenches: Remarque's *All Quiet on the Western Front*

The horror of trench warfare is probably nowhere more thoroughly detailed than in *All Quiet on the Western Front*, a novel by Erich Maria Remarque [ruh-MARK], a German soldier who had witnessed it firsthand. Remarque had fought and been wounded by grenade fragments on the front. In the preface to the novel, he writes that his story "is neither an accusation nor a confession, and least of all an adventure, for death is not an adventure to those who stand face to face with it. It will simply try to tell of a generation of men, who, even though they may have escaped its shells, were destroyed by the war." Remarque's narrator, Paul Baumer [BOW-mur], recounts a moment when, in the midst of battle, under bombardment in a cemetery, the British launch poisonous gas in their direction (**Reading 42.3**):

READING 42.3 **from Erich Maria Remarque,**
All Quiet on the Western Front
(1928)

I reach for my gas-mask.... The dull thud of gas-shells mingles with the crashes of the high explosives. A bell sounds between the explosions, gongs, and metal clappers warning everyone—Gas—Gas—Gaas.

Someone plumps down beside me, another. I wipe the goggles of my mask clear of the moist breath.... These first minutes with the mask decide between life and death: is it tightly woven? I remember the awful sights in the hospital: the gas patients who in day-long suffocation cough their burnt lungs up in clots.

Cautiously, the mouth applied to the valve, I breathe. The gas creeps over the ground and sinks into all the hollows. Like a big, soft jelly-fish it floats into our shell-hole and lolls there obscenely....

Inside the gas-mask my head booms and roars—it is nigh bursting. My lungs are tight. They breathe always the same hot, used-up air, the veins on my temples are swollen, I feel I am suffocating.

A grey light filters through to us. I climb out over the edge of the shell-hole. In the dirty twilight lies a leg torn clean off; the boot is quite whole, I take that all in at a glance. Now someone stands up a few yards distant. I polish the windows, in my excitement they are immediately dimmed again, I peer through them, the man there no longer wears his mask.

I wait some seconds—he has not collapsed—he looks around and makes a few paces—rattling in my throat I tear my mask off too and fall down, the air streams into me like cold water, my eyes are bursting, the wave sweeps over me and extinguishes me.

All Quiet on the Western Front sold more than a million copies in Germany the first year of its publication in 1928, and millions more read the book after it was translated into other languages and distributed outside Germany. In the United States, the film based on the novel won the Academy Award for Best Picture. The Nazi government considered the novel's antimilitarism disloyal and banned it in 1933; five years later, Remarque was stripped of his citizenship.

William Butler Yeats and the Specter of Collapse

The impact of the war unmoored the European poetic imagination from its earlier Symbolist reveries (see chapter 40). The Symbolists favored *suggesting* the presence of meaning in order to express the inexpressible, and turned away from the physical world to explore the realm of imaginative experience. In his youth, the Irish poet William Butler Yeats [yates] (1865–1939) had longed to escape to

an imaginary landscape that he dubbed the Lake Isle of Innisfree (**Reading 42.4**).

READING 42.4 **William Butler Yeats, "The Lake Isle of Innisfree" (1893)**

I will arise and go now, and go to Innisfree,
And a small cabin build there, of clay and wattles made:
Nine bean-rows will I have there, a hive for the honey-bee,
And live alone in the bee-loud glade.

And I shall have some peace there, for peace comes
 dropping slow,
Dropping from the veils of the morning to where the
 cricket sings;
There midnight's all a glimmer, and noon a purple glow,
And evening full of the linnet's wings.

And I will arise and go now, for always night and day
I hear the lake water lapping with low sounds by the shore;
While I stand on the roadway, or on the pavements gray,
I hear it in the deep heart's core.

Innisfree is the symbolic home of the poet's spirit, the source of his poetic inspiration, and although in the next to last line he acknowledges his physical presence in the everyday world, Innisfree remains for Yeats, as the memory of Tintern Abbey remains for Wordsworth a century earlier (see chapter 33, Reading 33.1), an imaginative reality in which he is literally attuned to the music and rhythms of nature.

But now, writing in 1919, Yeats imagines a much darker world. Apocalypse—if not the literal Second Coming of Christ predicted in the Bible's Book of Revelations, then its metaphorical equivalent—seemed at hand (**Reading 42.5**):

READING 42.5 **William Butler Yeats, "The Second Coming" (1919)**

Turning and turning in the widening gyre
The falcon cannot hear the falconer;
Things fall apart; the centre cannot hold;
Mere anarchy is loosed upon the world,
The blood-dimmed tide is loosed, and everywhere
The ceremony of innocence is drowned;
The best lack all conviction, while the worst
Are full of passionate intensity.

Surely some revelation is at hand;
Surely the Second Coming is at hand.
The Second Coming! Hardly are those words out
When a vast image out of Spiritus Mundi
Troubles my sight; somewhere in sands of the desert
A shape with lion body and the head of a man,
A gaze blank and pitiless as the sun,

Is moving its slow thighs, while all about it
Reel shadows of the indignant desert birds.
The darkness drops again; but now I know
That twenty centuries of stony sleep
Were vexed to nightmare by a rocking cradle,
And what rough beast, its hour come round at last,
Slouches towards Bethlehem to be born?

The poem's opening image, of the falcon circling higher and higher in wider and wider circles, is a metaphor for history itself spinning further and further from its origin until it is out of control. In another poem written at about the same time, "A Prayer for my Daughter," Yeats had asked, "How but in custom and ceremony / Are innocence and beauty born?" Now, he despairs, custom and ceremony, those things that connect us to our origins, have been abandoned and "mere anarchy is loosed upon the world." In their place, a beast resembling the Sphinx at Giza (see chapter 3, Fig. 3.7) rises in the desert, possibly an image of the anti-Christ, the embodiment of Satan who in some biblical traditions anticipates the second coming of Christ himself. This beast is the new Spiritus Mundi [SPIR-ih-toos MOON-dee], or collective spirit of mankind, the specter of life in the new postwar era, insentient, pitiless, and nightmarish.

T. S. Eliot: The Landscape of Desolation

The American poet T. S. (Thomas Sternes) Eliot (1888–1965) was studying at Oxford University in England when World War I broke out. Eliot had graduated from Harvard with a degree in philosophy and the classics, and his poetry reflects both the erudition of a scholar and the depression of a classicist who feels that the tradition he so values is in jeopardy of being lost. In Eliot's poem *The Waste Land*, the opening section, called "The Burial of the Dead," is a direct reference to the Anglican burial service, performed so often during and after the war. "April is the cruelest month," the poem famously begins (**Reading 42.6a**).

READING 42.6a **from T. S. Eliot, *The Waste Land* (1921)**

April is the cruelest month, breeding
Lilacs out of the dead land, mixing
Memory and desire, stirring
Dull roots with spring rain.
Winter kept us warm, covering
Earth in forgetful snow, feeding
A little life with dried tubers.

The world, in short, has been turned upside down. Spring is cruel, winter consoling. Eliot sees London as an "Unreal City" populated by the living-dead:

Unreal City,

Under the brown fog of a winter dawn,
A crowd flowed over London Bridge, so many,
I had not thought death had undone so many.
Sighs, short and infrequent, were exhaled,
And each man fixed his eyes before his feet.
Flowed up the hill and down King William Street,
To where Saint Mary Woolnoth kept the hours
With a dead sound on the final stroke of nine.

In the crucial middle section of the poem, Eliot describes modern love as reduced to mechanomorphic tedium (see **Reading 42.6**, page 1375). And in the poem's last section, "What the Thunder Said," the poet describes a landscape of complete emotional and physical aridity, a land where there is "no water but only rock," "sterile thunder without rain," and "red sullen faces sneer and snarl / From doors of mud-cracked houses." At first Eliot dreams of the possibility of rain:

If there were rock
And also water
And water
A spring
A pool among the rock
If there were the sound of water only
Not the cicada
And dry grass singing
But sound of water over a rock
Where the hermit-thrush sings in the pine trees
Drip drop drip drop drop drop drop
But there is no water.

Finally, as the poem nears conclusion, there is "a flash of lightning. Then a dry gust / Bringing rain." What this signifies is difficult to say—hope certainly, but hope built on what premise? The poem is richly allusive—the passages excerpted here are among its most accessible—and the answer seems to reside in the weight of poetic and mythic tradition to which it refers, from Shakespeare to the myth of the Holy Grail and Arthurian legend, what Eliot calls at the poem's end, the "fragments I have shored against my ruin." Eliot resolves, apparently, as the critic Edmund Wilson put it, "to claim his tradition and rehabilitate it."

Escape from Despair: Dada in the Capitals

Some writers and artists—Picasso, for instance—simply waited out the war. Many others openly opposed it and vigorously protested the social order that had brought about what seemed to them nothing short of mass genocide, and some of these soon formed the movement that named itself **Dada**. The Romanian poet Tristan Tzara [TSAH-rah] (1896–1963) claimed it was his invention. The German Richard Huelsenbeck [HULL-sen-bek] (1892–1974)

claimed that he and poet Hugo Ball (1886–1927) had discovered the name randomly by plunging a knife into a dictionary. Whatever the case, Tzara summed up its meaning best:

DADA DOES NOT MEAN ANYTHING . . . We read in the papers that the Negroes of the Kroo race call the tail of a sacred cow: dada. A cube, and a mother, in certain regions of Italy, are called: dada. The word for hobby-horse, a children's nurse, a double affirmative in Russian and Romanian, is also: DADA.

Dada was an international signifier of negation. It did not mean anything, just as, in the face of war, life itself had come to seem meaningless. But it would prove a potent force in modern art.

Dada came into being at the Cabaret Voltaire in Zurich, founded in February 1916 by a group of intellectuals and artists escaping the conflict in neutral Switzerland, including Tzara, Huelsenbeck, Ball, Jean Arp (1896–1966), and the poet, dancer, and singer, Emmy Hennings (1885–1948). At the end of May, Ball created a "concert bruitiste" [brwee-TEEST] or "noise concert," inspired by the Futurists, for a "Grand Evening of the Voltaire Art Association." Language, Ball believed, was irrevocably debased. After all, the vocabulary of nationalism—the uncritical celebration of one's own national or ethnic identity—had led to the brutality of the War. Ball replaced language with sounds, whose rhythm and volume might convey feelings that would be understood on at least an emotional level. Dressed in an elaborate costume, so stiff that he could not walk and had to be carried onto the stage, he read (**Reading 42.7**):

READING 42.7 from Hugo Ball, "Gadji beri bimba" (1916)

gadji beri bimba
glandridi lauli lonni cadori
gadjama bim beri glassala
glandridi blassala tuffm i zimbrabim
blass galassasatuffm i zimbrabim. . . .

Soon the entire Cabaret Voltaire group was composing such sound poems, which they viewed as a weapon against convention, especially the empty rhetoric of nationalism that had led to the War. Those who believed in the War—notably Apollinaire, in Paris—accused them in turn of nihilism, anarchism, and cowardice.

In March 1917, the group opened the Galerie Dada. Arp's collages were among the most daring works on display. They were constructed "according to the laws of

chance." His procedure was more or less the same as Tzara's recipe for writing poetry (**Reading 42.8**):

Arp, for his part, had been so frustrated with his painting, which seemed to him totally burdened by conventional technique, that he had torn it apart. When he looked at the random arrangement of fallen pieces (Fig. **42.4**), freed of the intervention of his aesthetic sensibility, they seemed to him more truthful than anything he had created before—and the work was funny, so outrageous that one could only laugh.

Such works, in their willful denial of the artist's aesthetic sensibilities, were considered by many used to thinking of art in more serious, high-minded terms as "anti-art." These more serious minds were especially offended by the so-called "ready-mades" of Marcel Duchamp. The term itself derived from the recent American invention, ready-made as opposed to tailor-made clothes, and Duchamp adopted it soon after arriving in New York in 1915 where he joined a group of other European exiles, including his close colleague Francis Picabia [peh-KAH-bee-ah] (1879–1953), in still-neutral America. The most audacious of his ready-mades was *Fountain* (Fig. **42.5**), an upside down urinal purchased by Duchamp in a New York plumbing shop, signed with the pseudonym "R. Mutt," and submitted to the Society of Independent Artists exhibition in April 1917. The exhibition committee, on which Duchamp served, had agreed that all work submitted would be shown, and was therefore unable to reject the piece. To Duchamp's considerable amusement, they decided instead to hide it behind a curtain. Over the course of the exhibition, Duchamp gradually let it be known that he was "R. Mutt," and in a publication called *The Blind Man* defended the piece:

Whether Mr Mutt with his own hands made the fountain or not has no importance. He CHOSE it. He took an ordinary article of life, placed it so that its useful significance disappeared under the new title and point of view—created a new thought for the object.

Fig. 42.4 Hans Arp. *Collage Made According to the Laws of Chance.* **1916.** Painted paper, 15⅞″ × 12⅝″. Purchase. (457.1937). Digital Image © The Museum of Modern Art/Licensed by SCALA/Art Resource, NY. © 2008 ARS Artists Rights Society, NY. Arp was from the sometimes German, sometimes French region of Alsace, and spoke both French and German, referring to himself sometimes as Jean (French), sometimes as Hans (German).

Fig. 42.5 Marcel Duchamp. *Fountain.* **1917; replica 1963.** Porcelain, height 14″. Purchased with assistance from the Friends of the Tate Gallery 1999. Tate Gallery, London, Great Britain. © 2008 ARS Artists Rights Society, NY. It is important to recognize that Duchamp has turned the urinal on its side, thus undermining its utility.

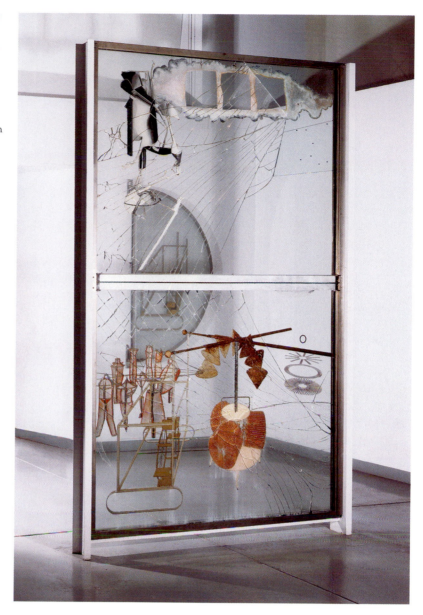

Fig. 42.6 Marcel Duchamp. *The Bride Stripped Bare by Her Bachelors, Even.* **1915–1923.** Oil and lead wire on glass, 109 1/4″ × 69 1/8″. Philadelphia, Pennsylvania, U.S.A. © 2008 ARS Artists Rights Society, NY. Duchamp brought *The Large Glass*, as it came to be called, to a "definitive state of incompletion" in February 1923. After an exhibition at the Brooklyn Museum in 1926, it was placed in storage until 1936, when it was discovered that it had splintered into fragments. Duchamp carefully restored it, patiently allowing the network of cracks to become part of the piece.

The photographer Stieglitz immediately recognized in Duchamp's position the same sensibility that informed photography—in works such as Paul Strand's *Abstraction, Porch Shadows* (see Fig. 41.19), the photographer looks at ordinary articles of life and frames them in such a way that he creates a new thought for the object—and Stieglitz's Gallery 291 soon became the center of Dada in America.

Duchamp meanwhile turned his attention to what turned out to be a decade-long undertaking, *The Bride Stripped Bare by Her Bachelors, Even*, also known as *The Large Glass* (Fig. 42.6). Though Duchamp did employ chance operations to create part of the piece—three times dropping a meter-long string from a height of a meter to create three unique curved meter "rulers"—unlike Arp's Dada work, it is a highly conceptualized, meticulously constructed composition. The bride, who occupies the top half of the piece, represents, Duchamp wrote in his preliminary notes, "an apotheosis [hence her cloud-like form] of virginity i.e. ignorant desire. blank desire. (with a touch of malice)." Below her are nine bachelors, forever futilely chasing after her atop a waterwheel driven by a chocolate grinder (which might best be described as their sexual engine). "Her timid-power," Duchamp wrote, "is a sort of automobiline, love gasoline that, distributed to the quite feeble cylinders [below], within reach of her constant love, is used for the blossoming of this virgin who has reached the goal of her desire." The bride and her bachelors, in other words, are not far removed from T. S. Eliot's typist and her carbuncular young man in *The Waste Land*. Love is reduced here to a mechanical operation perpetually unfulfilled, the very image of modern industrial culture and its sterile, mechanical "reproduction."

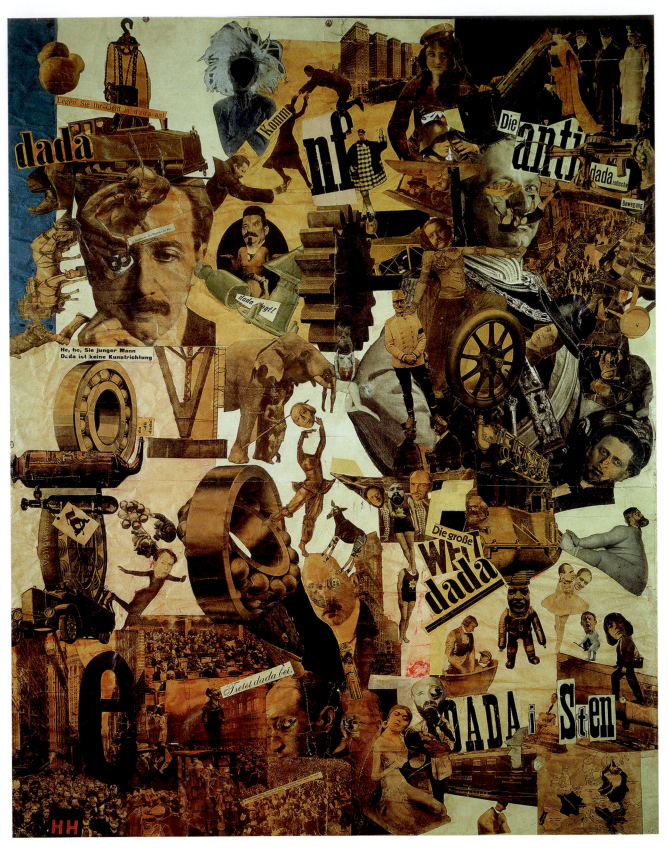

Fig. 42.7 Hannah Höch. *Cut with the Kitchen Knife*. 1919. Collage, $44\frac{7}{8}''\times35\frac{3}{8}''$. Staatliche Museum, Berlin. Erich Lessing/Art Resource, NY. © 2008 Artists Rights Society (ARS), NY. The largest face, at the top left, is Einstein's. Under the words "the anti-Dada movement" at the top right is the deposed emperor Wilhelm II, with two wrestlers forming his moustache. A tiny self-portrait sits atop the map at the bottom right corner, depicting the progress of women's enfranchisement in Europe.

Duchamp's anti-establishment sensibilities were reflected across the Dada scene. Even before the end of the war in November 1918, Huelsenbeck had attacked Expressionist painting, objecting to its subjective soul-searching. He called, instead, for "artists who every hour snatch the tatters of their bodies out of the frenzied cataract of life." Artists, he believed, could literally "snatch[ed] the tatters" of German life out of the everyday press, and they did, by snipping photographs from newspapers and recombining them as collages. His new *Club Dada* began publishing work that exploited the possibilities offered by this new technique, known as **photomontage**. Hannah Höch's [hokes] *Cut with the Kitchen Knife* (Fig. **42.7**) is a view of postwar Germany, running on cogs and ball bearings. Its full title, *Cut with the Kitchen Knife through the Last Weimar Beer Belly Cultural Epoch of Germany*, suggests that cutting photographs with the kitchen knife is a metaphor for slicing up the body politic as well. But the work, for all its rejection of the contemporary political world, is also humorous, reflecting the survival of a positive energy in the face of devastation and despair. Like all of Dada, it offers up an arena in which the creative impulse might not only survive, but thrive.

Russia: Art and Revolution

In 1914, Russia entered the war ill-prepared for the task before it; within the year, Tsar Nicholas II (1868–1918) oversaw the devastation of his army. One million men had been killed, and another million soldiers had deserted. Famine and fuel shortages gripped the nation. Strikes broke out in the cities, and in the countryside, peasants seized the land of the Russian aristocrats. The tsar was forced to abdicate in February 1917.

Vladimir Lenin and the Soviet State

Through a series of astute, and sometimes violent, political maneuvers, the Marxist revolutionary Vladimir Ilyich Lenin (1870–1924) assumed power the following November. Lenin headed the most radical of Russian post-revolutionary groups, the Bolsheviks. Like Marx, he dreamed of a "dictatorship of the proletariat," a dictatorship of the working class. Marx and Lenin believed that the oppression of the masses of working people resulted from capitalism's efforts to monopolize the raw materials and markets of the world for the benefit of the privileged few. He believed that all property should be held in common, that every member of society would work for the benefit of the whole and would receive, from the state, goods and products commensurate with their work. "He who does not work," he famously declared, "does not eat."

Lenin was a utopian idealist. He foresaw, as his socialist state developed, the gradual disappearance of the state: "The state," he wrote in *The State and Revolution* (1917), "will be able to wither away completely when society has realized the

Revolution in Russia and China

The Russian revolution of 1917 and the Chinese revolution of 1911 brought an end to centuries of feudal and monarchical rule, and set the stage for a period of struggle between contending political factions. In Russia, Vladimir Lenin and the Bolsheviks gained control within a year, but in China the conflict continued for years after the revolution. By 1916, China was again dominated by traditional warlords (regional military leaders) who divided up the country and weakened its ability to resist foreign threats, including those from Japan.

rule: 'From each according to his ability: to each according to his needs,' *i.e.*, when people have become accustomed to observe the fundamental rules of social life, and their labor is so productive that they voluntarily work *according to their ability*." But he realized, as well, that certain pragmatic changes had to occur as well. He emphasized the need to electrify the nation: "We must show the peasants," he wrote, "that the organization of industry on the basis of modern, advanced technology, on electrification . . . will make it possible to raise the level of culture in the countryside and to overcome, even in the most remote corners of land, backwardness, ignorance, poverty, disease, and barbarism." And he was, furthermore, a political pragmatist. When, in 1918, his Bolshevik party received less than a quarter of 1 percent of the vote in free elections, he dissolved the government, eliminated all other parties, and put the Communist party into the hands of five men, a committee called the Politburo, with himself at its head. He also systematically eliminated his opposition: Between 1918 and 1922 his secret police arrested and executed as many as 280,000 people in what has come to be known as the Red Terror.

The Arts of the Revolution

Before the Revolution in March 1917, avant-garde Russian artists, in direct communication with the art capitals of Europe, particularly Paris, Amsterdam, and Berlin, established their own brand of modern art. Most visited Paris, and saw Picasso and Braque's Cubism in person, but Kasimir Malevich [muh-LAY-vich] (1878–1935), perhaps the most inventive of them all, never did. By 1912, he had created "Cubo-Futurism," a style that applied modernist geometric forms to Russian folk themes. But Malevich was soon engaged, he wrote, in a "desperate attempt to free art from the ballast of objectivity." To this end, he says, "I took refuge in the square," creating a completely nonobjective painting, in 1913, consisting of nothing more than a black square on a white ground. He called his new art Suprematism [soo-PREM-uh-tizm], defining it as "the supremacy of . . . feeling in . . . art."

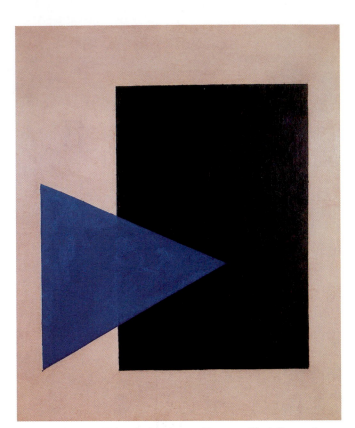

Fig. 42.8 Kasimir Malevich. *Suprematist Painting, Black Rectangle, Blue Triangle*. 1915. Oil on canvas, 26⅛″ × 22½″. Stedelijk Museum, Amsterdam. Erich Lessing/Art Resource, NY. In his 1916 *From Cubism and Futurism to Suprematism*, Malevich wrote, "Painters should abandon subject and objects if they wish to be pure painters."

From Suprematism to Constructivism The "feeling" of which Malevich speaks is not the kind of personal or private emotion that we associate with, say, German Expressionism. Rather, it lies in what he believed was the revelation of an absolute truth—a utopian ideal not far removed from Lenin's political idealism—discovered through the most minimal means. Thus, his *Suprematist Painting, Black Rectangle, Blue Triangle* (Fig. 42.8) is about the relation between the two forms (both of which, incidentally, can be read as "shorthand" for the earlier Cubo-Futurist paintings). Note that although the blue triangle is a uniform blue, it appears lighter where it is backed by the black rectangle, and darker where it is backed by the white ground. This phenomenon results from the fact that our perception of a color depends upon the context in which we see it. If the viewer stares for a moment at the line where the triangle crosses from white to black, a subtle visual vibration occurs, and the two parts of the triangle appear to be at different depths. Malevich reveals that in relation these apparently static forms are energized in a dynamic tension.

At the end of the Russian Revolution in 1917, Malevich and other artists in his circle were appointed by the Soviet government to important administrative and teaching positions in the country . Malevich went to the Vitebsk [vih-TEPSK] Popular Art School in 1919, soon becoming its director. In 1921, he wrote to one of his pupils that Suprematism

should adopt a more "Constructive" approach to reorganizing the world. By this he meant that art should turn to small-scale abstract works in three dimensions. He considered this "laboratory" work, explorations of the elements of form and color, space and construction, that would eventually serve some practical social purpose in the service of the revolution.

El Lissitzsky and the Constructivist Aesthetic A teacher of architecture and graphics at Vitebsk Popular Art School when Malevich arrived in 1919, Lazar Lissitzky [lih-SIT-skee] (1890–1941), known as El Lissitzky, quickly adopted Malevich's Suprematist designs to revolutionary ends. His poster *Beat the Whites with the Red Wedge* (Fig. 42.9) refers to the conflict between the Bolshevik "Reds" and the "White" Russians who opposed Lenin's party. As in Malevich's *Suprematist Painting*, a triangle crosses over into another form, this time a circle. The wedge is symbolically male, forceful and aggressive as opposed to the passive (and womblike) white circle, which it penetrates both literally and figuratively from the "left." Here design is in the service of social change.

Liubov' Sergeyevna Popova [poh-POH-vah] (1889–1924) was another member of Malevich's Suprematist group who by 1921 had given up painting entirely and turned instead to the practical Constructivist problems of industrial design. In 1923, just a year before she died of scarlet fever, Popova was appointed head of the Design Studio at the First State Textile Print Factory in Moscow. There she turned her attention to clothing and fabric design, and she also worked as a graphic designer producing posters, books, and photomontages. She was also extremely interested in stage and costume design, as evidenced in her drawing for the costume of Actor No. 7 in Crommelynk's play *The Magnanimous Cuckold* (Fig. 42.10). Here the transition of Russian avant-garde art from the Cubo-Futurism of Malevich's early paintings from around 1912 to the Constructivist style of the early twenties has come almost full circle, as the painting echoes the tubular forms of Malevich's peasants and his Suprematist squares, even as it applies these sources to Constructivist ends.

The New Russian Cinema One of the greatest of Russia's revolutionary innovators was the filmmaker Sergei Eisenstein [EYE-zen-shtine] (1898–1948). After the Revolution, he had worked on the Russian agit-trains, special propaganda trains that traveled the Russian countryside bringing "agitational" materials to the peasants. ("Agitational," in this sense, means to present a political point of view.) The agit-trains distributed magazines and pamphlets, presented political speakers and plays, and, given the fact that the Russian peasantry was largely illiterate, perhaps most important of all presented films, known as *agitkas*. These films were characterized by their fast-paced editing style, designed to keep the attention of an audience that, at least at first, had never before seen a motion picture.

Out of his experience making *agitkas*, Lev Kuleshov (1899–1970), one of the founders of the Film School in Moscow in the early twenties, developed a theory of **montage**. He used a close-up of a famous Russian actor and

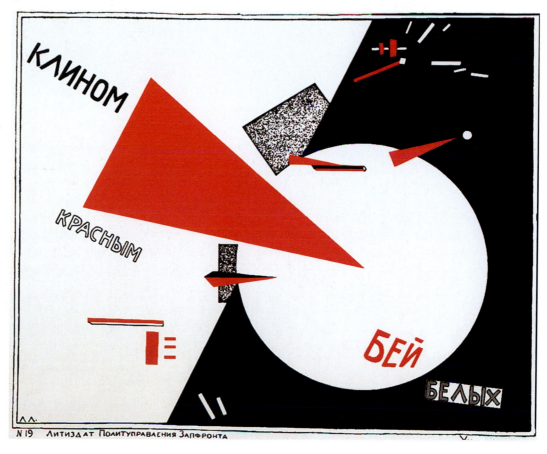

Fig. 42.9 El Lissitzky. *Beat the Whites with the Red Wedge.* **1919.** Lithograph. Collection: Stedelijk Van Abbemuseum, Eindhoven, Holland. © 2007 Artists Rights Society (ARS), New York/VG Bild-Kunst, Bonn. The diagonal design of the composition gives the red wedge a clear "upper hand" in the conflict.

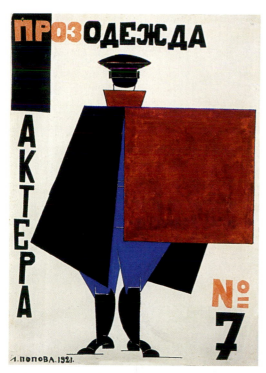

Fig. 42.10 Liubov' Popova. *Prozodezhda aktera No. 7 (The Magnanimous Cuckold: Actor no. 7).* **1921.** © Copyright 1999 Cooper-Hewitt, National Design Museum, Smithsonian Institution, NY. Merrill C. Berman Collection, NY. Costume design. Popova understood that the static geometry of her costumes would become animated and dynamic as actors moved in them.

combined it with three different images—a bowl of soup, a dead woman lying in a coffin, and a girl playing with a teddy bear. Although the image of the actor was the same in each instance, audiences believed that he was hungry with the soup, sorrowful with the woman, joyful toward the girl—a phenomenon that came to be known as the *Kuleshov effect.* Shots, Kuleshov reasoned, acquire meaning through their relation to other shots. Montage was the art of building a cinematic composition out of such shots.

Eisenstein learned much from Kuleshov, though he disagreed about the nature of montage. Rather than using montage to build a unified composition, Eisenstein believed that montage should be used to create tension, even a sense of shock, in the audience, which, he believed would lead to a heightened sense of perception and a greater understanding of the film's action. His aim, in a planned series of seven films depicting events leading up to the Bolshevik revolution, was to provoke his audience into psychological identification with the aims of the revolution.

None of his films accomplishes this better than *The Battleship Potemkin* [puh-TEM-kin], the story of a 1905 mutiny aboard a Russian naval vessel and the subsequent massacre of innocent men, women, and children on the steps above Odessa harbor by tsarist troops. The film, especially the famous "Odessa Steps Sequence," which is a virtual manifesto of montage, tore at the hearts of audiences and won respect for the Soviet regime around the world (see *Focus,* pages 1362–1363).

Focus

Eisenstein's *The Battleship Potemkin,* "Odessa Steps Sequence"

The most famous sequence in *The Battleship Potemkin* is the massacre on the Odessa Steps. Odessa's citizens have responded to the mutiny on the Potemkin by providing the sailors with food and good company. Without warning, tsarist soldiers carrying rifles appear at the top of the flight of marble steps leading to the harbor. They fire on the crowd, many of whom fall on the steps. Eisenstein's cuts become more and more frenetic in the chaos that ensues.

Eisenstein utilized 155 separate shots in 4 minutes and 20 seconds of film in the sequence, an astonishing rate of 1.6 seconds per shot. He contrasts long shots of the entire scene and close-ups of individual faces, switches back and forth between shots from below and from above (essentially the citizens' view up the steps and the soldiers' looking down), and he changes the pace from frenzied retreat at the start of the sequence to an almost frozen lack of action when the mother approaches the troops carrying her murdered son, to frantic movement again as the baby carriage rolls down the steps. Some shots last longer than others. He alternates between traveling shots and fixed shots.

Eisenstein also understood that sound and image could be treated independently in montage, or used together in support of one another. A phrase of music might heighten the emotional impact of a key shot. Or the rhythm of the music might heighten the tension of a sequence by juxtaposing itself to a different rhythm in his montage of shots, as when the soldiers' feet march to an altogether different rhythm in the editing. Eisenstein called this *rhythmic montage,* as he explains:

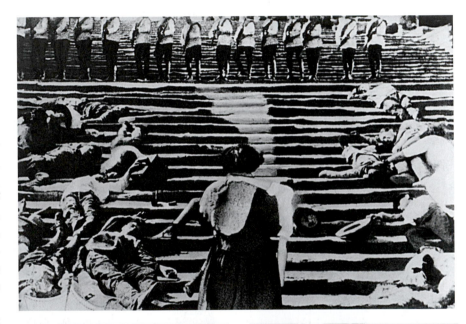

From the "Odessa Steps Sequence," of Sergei Eisenstein's *The Battleship Potemkin,* 1925.
Goskino. Courtesy of the Kobal Collection. A mother picks up her murdered child and confronts the troops marching down the steps. At the point where she stands, soldiers in front of her, she is framed by the diagonal lines of the steps and the bodies strewn on each side of her. The soldiers continue to advance.

In this the rhythmic drum of the soldiers' feet as they descend the steps violates all metrical demands. Unsynchronized with the beat of the cutting, this drumming comes in off-beat each time, and the shot itself is entirely different in its solution with each of these appearances. The final pull of tension is supplied by the transfer from the rhythm of the descending feet to another rhythm—a new kind of downward movement—the next intensity level of the same activity—the baby-carriage rolling down the steps.

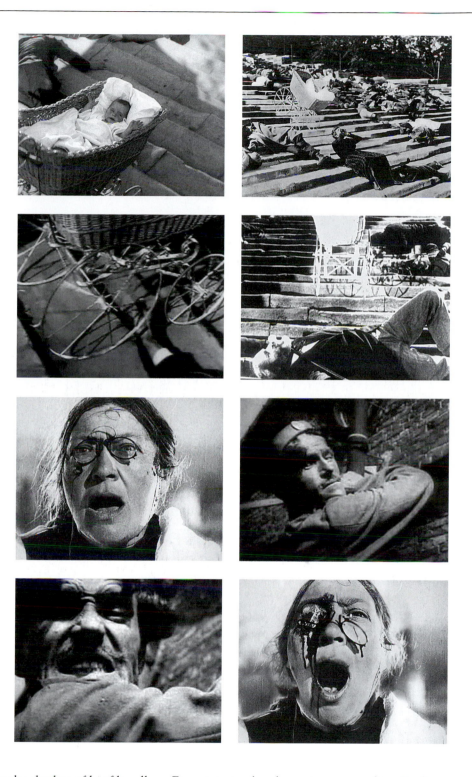

**From the "Odessa Steps Sequence,"
of Sergei Eisenstein's *The Battleship
Potemkin*, 1925.** Goskino. Courtesy of
the Kobal Collection. The falling body of
another mother, shot by the soldiers, falls
across her baby's carriage, causing it to
roll out of control down the steps. Note
the way the diagonals on the steps in the
last image at the right echo those of the
mother looking up the steps holding her
dead child in the earlier scene.

**From the "Odessa Steps Sequence,"
of Sergei Eisenstein's *The Battleship
Potemkin*, 1925.**
Goskino. Courtesy of the Kobal
Collection. At the end of the sequence
an old woman wearing pince-nez glasses
who has looked on horrified as the baby
stroller careens down the stairs, is
attacked and slashed by a saber-bearing
Cossack.

This attention to the rhythm of his film allows Eisenstein to abandon strict temporality. At the
start of the baby carriage scene, for instance, the rhythm of the music slows dramatically and the
pace of "real time" is elongated in a series of slow shots. The mother clutches herself. The carriage
teeters on the brink. The mother swoons. The carriage inches forward. The mother falls, in agony.
This is, as has often been said, "reel time," not "real time."

There was, in fact, no tsarist massacre on the Odessa Steps, though innocent civilians were
killed elsewhere in the city. Eisenstein's cinematic recreation is a metaphor for those murders, a
cinematic condensation of events that captures the spirit of events so convincingly that many
viewers took it to be actual newsreel footage.

1363

Freud, Jung, and the Art of the Unconscious

Eisenstein's emphasis on the viewer's psychological identification with his film was inspired in no small part by the theories of Viennese neurologist Sigmund Freud. By the start of World War I, Freud's theories about the nature of the human psyche and its subconscious functions (see *Continuity and Change*, chapter 40, page 1311) were gaining wide acceptance. As doctors and others began to deal with the sometimes severely traumatized survivors of the war, the efficacy of Freud's psychoanalytic techniques—especially dream analysis and "free association"—were increasingly accepted by the medical community.

Freud had opened a medical practice in Vienna in 1886, specializing in emotional disorders. Just a year earlier he had gone to Paris to study with neurologist Jean-Martin Charcot, and in his new practice, Freud began using Charcot's techniques— the use of hypnosis, massage, and cranial pressure to help patients recognize mental conditions related to their symptoms. This would later develop into a practice he called "free association," in which patients were asked to say whatever crossed their minds. In 1895, in collaboration with another Viennese physician, Josef Breuer, he published *Studies in Hysteria*. But even then he was changing his techniques. Free association allowed him to abandon hypnosis. Freud had observed that when patients spoke spontaneously about themselves, they tended to relate their particular neurotic symptoms to earlier, usually childhood, experiences.

But Freud understood that free association required interpretation, and increasingly, he began to focus on the obscure language of the unconscious. By 1897, he had formulated a theory of infantile sexuality based on the proposition that sexual drives and energy already exist in infants. Childhood was no longer "innocent." One of the keys to understanding the imprint of early sexual feeling upon adult neurotic behavior was the interpretation of dreams. Freud was convinced that their apparently irrational content could be explained rationally and scientifically. He concluded that dreams allow unconscious wishes, desires, and drives censored by the conscious mind to exercise themselves. "The dream," he wrote in his 1900 *The Interpretation of Dreams*, "is the (disguised) fulfillment of a (suppressed, repressed) wish." And the wish, by extension, is generally based in the sexual.

Freud theorized, as a result, that most neurotic behavior was the result of sexual trauma stemming from the subconscious attachment of the child to his or her parent of the opposite sex and the child's jealousy of the parent of the same sex. (Freud called this the Oedipus [ED-ih-pus] complex, after the Greek legend in which Oedipus, king of Thebes, unwittingly kills his father and marries his mother. In girls, the complex is called the Electra complex.) Since, as he argued, human behavior was governed by the libido, or sex drive, the guilt that resulted from the repression of the trauma associated with the child's sexual feelings and jealousy leads to powerful inner tensions that manifest themselves as psychic disorders.

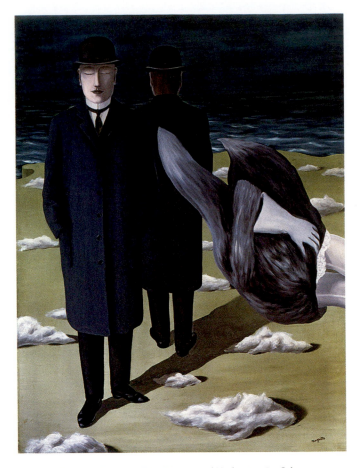

Fig. 42.11 **René Magritte.** *The Meaning of Night.* **1927.** Oil on canvas, 54½″ × 41½″. The Menil Collection, Houston. Freud's theories were widely influential, but surprisingly, *The Interpretation of Dreams* was not translated into French until 1923.

During the war itself, Freud continued work at the University of Vienna, speaking in 1916 on the psychological roots of sadism, homosexuality, fetishism, and voyeurism in a lecture called "The Sexual Life of Human Beings." These subjects were still largely taboo, as Freud acknowledged at the lecture's outset: "First and foremost," he began, "what is sexual is something improper, something one ought not to talk about." He then proceeded to shock his audience by talking in detail about sexual behaviors that he knew his audience found to be, in his words, "crazy, eccentric and horrible." Though his conclusions are disputable—predating later research linking homosexuality to biological rather than psychological causes, for example—Freud opened the subject of human sexuality to public discussion, altering attitudes toward sexuality permanently and irrevocably.

Paintings like René Magritte's [mah-GREETS] *The Meaning of Night* (Fig. **42.11**) explore the sexual life of human beings with a frankness that before Freud never would have been possible. Here, a middle-class gentleman stands by the sea, doubled as if to represent both the conscious and subconscious self, his hands in his coat pockets but in the dream-image reaching for the lower body of a female clothed in silk

stockings and lace underwear. One hand is fur-covered and bestial, the other more human, just as the dream-image female is half human and half fur-covered itself. This image of desire—and desire's complexities—is Freud's legacy.

Freud's *Civilization and Its Discontents*

But World War I provided Freud with evidence of another, perhaps even more troubling source of human psychological dysfunction—society itself. In 1920, in *Beyond the Pleasure Principle*, he speculated that human beings had death drives (*Thanatos*) that were in conflict with sex drives (*Eros*). Their opposition, he believed, helped to explain the fundamental forces that shape both individuals and societies; their conflict might also explain self-destructive and outwardly aggressive behavior. To this picture he added, in the 1923 work, *The Ego and the Id*, a model for the human mind that would have a lasting impact on all subsequent psychological writings, at least in their terminology. According to Freud, human personality is organized by the competing drives of the id, the ego, and the superego. The **id** is the seat of all instinctive, physical desire—from the need for nourishment to sexual gratification. Its goal is immediate gratification, and acts in accord with the pleasure principle. The **ego** manages the id. It mediates between the id's potentially destructive impulses and the requirements of social life, seeking to satisfy the needs of the id in socially acceptable ways. Freud used the word **sublimation** to describe the redirection of the id's primal impulses into constructive social behavior. So, for example, an artist or a writer might express unacceptable impulses in work or art rather than acting them out.

For Freud, civilization itself is the product of the ego's endless effort to control and modify the id. But Freud's recognition of yet a third element in the psyche—the **superego**—is crucial. The superego is the seat of what we commonly call "conscience," the psyche's moral base. The conscience comes from the psyche's consideration of criticism or disapproval leveled at it by the family, where "family" can be understood broadly as parents, clan, and culture. The superego is always close to the id and can act as its representative to the ego. But, since it does not distinguish between thinking a deed and doing it, it can also instill in the id enormous subconscious guilt. Though he was barely familiar with Freud's work, the painter Giorgio de Chirico [day KEE-ree-koh] (1888–1978) was understood to share Freud's vision. When *The Child's Brain* (Fig. **42.12**) was exhibited in Paris in the early twenties, the art world understood it as the very embodiment of the ego (the father figure) and the superego (the book) exercising their authority over the child's id.

Freud's thinking culminated in 1930 in *Civilization and Its Discontents* (see **Reading 42.9**, page 1375). In that book, Freud wrote that the greatest impediment to human happiness was aggression, what he called the "original, self-subsisting instinctual disposition in man." Aggression was the basic instinctual drive that civilization was organized to control, and yet, on every count, civilization had failed miserably at

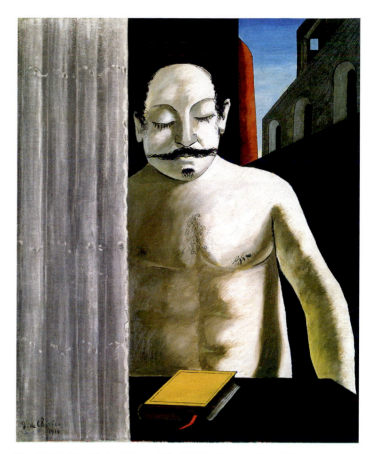

Fig. 42.12 Giorgio de Chirico. *The Child's Brain*. 1914. Oil on canvas, 31 1/8″ × 25 5/8″. Moderna Museet, SKM, Stockholm. The Italian de Chirico would become a force in modern thought after an exhibition of his work arranged in Paris in March 1922 by Paul Guillaume.

its job. "The fateful question for the human species," Freud argued, in terms that would ring truer and truer as the twentieth century wore on,

seems to me to be whether and to what extent their cultural development will succeed in mastering the disturbance in their communal life by the human instinct of aggression and self-destruction. It may be that in this respect precisely the present time deserves a special interest. Men have gained control over the forces of nature to such an extent that with their help they would have no difficulty in exterminating one another to the last man.

The Jungian Archetype

Almost as influential as Freud was his colleague, the Swiss physician Carl Jung [yung] (1875–1961). Jung believed that the unconscious life of the individual was founded on a deeper, more universal layer of the psyche, which he called the **collective unconscious**, the innate, inherited contents of the human mind. It manifests itself in the form of **archetypes** [AR-kuh-types], those patterns of thought that recur throughout history and across cultures, in the form of dreams,

myths, and fairy tales. The "mother archetype," for instance, recurs throughout ancient myth in symbols associated with fertility, such as the garden, the lotus, the fountain, the cave, and so on. It manifests itself positively in Christianity as the Virgin Mary, and negatively as the witch in fairy tales and legends. Other archetypes include the father figure, the hero (who is essentially the ego), the child (often the child-hero), the maiden, the wise old man, the trickster, and so on. Such archetypal figures are prominent in popular culture—consider Darth Vader, Luke Skywalker, Princess Leia, and Obi-Wan Kenobi in George Lucas's *Star Wars*.

The Dreamwork of Surrealism

In his 1924 *Surrealist Manifesto*, the French writer, poet, and theorist André Breton [bruh-TOHN] (1896–1966) credited Freud with encouraging his own creative endeavors: "It would appear that it is by sheer chance that an aspect of intellectual life—and by far the most important in my opinion—about which no one was supposed to be concerned any longer has, recently, been brought back to light. Credit for this must go to Freud. On the evidence of his discoveries a current of opinion is at last developing which will enable the explorer of the human mind to extend his investigations, since he will be empowered to deal with more than merely summary realities." Breton continued (**Reading 42.10**):

READING 42.10 **from André Breton, *Surrealist Manifesto* (1924)**

It was only fitting that Freud should appear with his critique on the dream. In fact, it is incredible that this important part of psychic activity has still attracted so little attention. . . . I have always been astounded by the extreme disproportion in the importance and seriousness assigned to events of the waking moments and to those of sleep by the ordinary observer. Man, when he ceases to sleep, is above all at the mercy of his memory, and the memory normally delights in feebly retracing the circumstance of the dream for him, depriving it of all actual consequence and obliterating the only determinant from the point at which he thinks he abandoned this constant hope, this anxiety, a few hours earlier. He has the illusion of continuing something worthwhile. The dream finds itself relegated to a parenthesis, like the night. And in general it gives no more counsel than the night.

In order to restore the dream to its proper authority, Breton adopted the term "surrealism," previously used by the poet Guillaume Apollinaire, and defined it as follows:

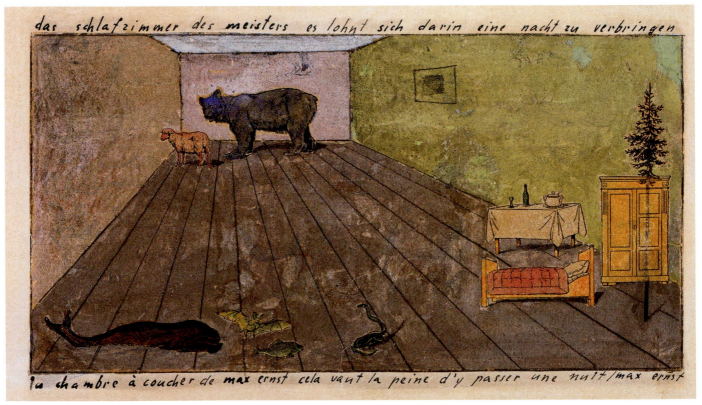

Fig. 42.13 Max Ernst. *The Master's Bedroom, It's Worth Spending a Night There*. 1920. Collage, gouache and pencil on paper, $6\frac{3}{8}'' \times 8\frac{5}{8}''$. Yale Collection of American Literature, Beinecke Rare Book and Manuscript Library. Translation form German by John W. Gabriel. From "Max Ernst, Life and Work" by Werner Spies, published by Thames & Hudson, Page 67. © 2008 Artists Rights Society (ARS), NY. Prior to World War I, Ernst studied philosophy and abnormal psychology at the University of Bonn. He was well acquainted with the writings of Freud.

SURREALISM, noun, masc., Pure psychic automatism by which it is intended to express, either verbally or in writing, the true function of thought. Thought dictated in the absence of all control exerted by reason, and outside all aesthetic or moral preoccupations.

ENCYCL. Philos. Surrealism is based on the belief in the superior reality of certain forms of association heretofore neglected, in the omnipotence of the dream, and in the disinterested play of thought. It leads to the permanent destruction of all other psychic mechanisms and to its substitution for them in the solution of the principal problems of life.

Breton had trained as a doctor and had used Freud's technique of free association when treating shell-shock victims in World War I. As his definition indicates, he had initially conceived of Surrealism as a literary movement, with Breton himself at its center. All of the Surrealists had been active Dadaists, but as opposed to Dada's "anti-art" spirit, their new "surrealist" movement believed in the possibility of a "new art." Nevertheless, Surrealism retained much of Dada's spirit of revolt. They were committed to verbal automatism, a kind of writing in which the author relinquishes conscious control of the production of the text. In addition, the authors wrote dream accounts, and Breton's colleague Louis Aragon [ah-rah-GOHN] (1897–1982), especially, emphasized the importance of chance operations: "There are relations other than reality that the mind may grasp and that come first, such as chance, illusion, the fantastic, the dream," Aragon wrote. "These various species are reunited and reconciled in a genus, which is surreality."

They found precedent for their point of view not only in Freud, but in the painting of Giorgio de Chirico and the Dadaist Max Ernst (1891–1976). When Breton saw *The Child's Brain* (see Fig. 42.12) in the window of Paul Guillaume's [ghee-YOHMZ] gallery in March 1922, he jumped off a bus in order to look at it. He bought the canvas and immediately published a reproduction in his magazine *Littérature*. Breton would later look back at Ernst's 1921 exhibition of small collage-paintings like the aptly titled *The Master's Bedroom* (Fig. **42.13**) as the first Surrealist work in the visual arts. This painting consists of two pages from a small pamphlet of clip art, on the left depicting assorted animals and on the right various pieces of furniture. Ernst painted over most of the spread to create his perspectival view, leaving unpainted the whale, fish, and snake at the bottom left, the bear and sheep at the top, and the bed, table, and bureau at the right. This juxtaposition of diverse elements, which would normally never occupy the same space—except perhaps in the dream work—is one of the fundamental stylistic devices of Surrealist art.

Picasso and Miró Breton argued that Picasso led the way to Surrealist art in his *Les Demoiselles d'Avignon* (see Fig. 41.3), which jettisoned art's dependence on external reality. The

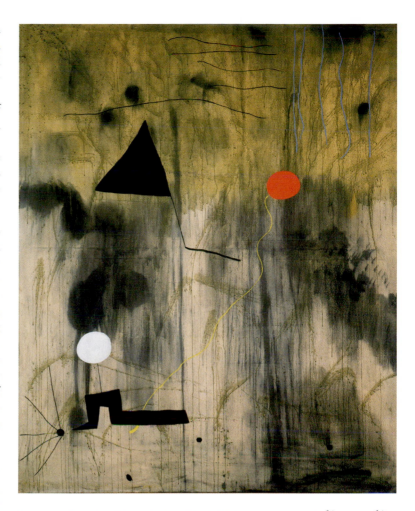

Fig. 42.14 Joan Miró. *The Birth of the World.* **1925.** Oil on canvas, 8′ 2¾″ × 6′ 6¾″. Museum of Modern Art, NY. Acquired through an Anonymous Fund, the Mr. and Mrs. Joseph Slifka and Armand G. Erpf Funds, and by gift of the Artist. (262.1972). Digital Image © The Museum of Modern Art/Licensed by SCALA/ Art Resource, NY. © ARS Artists Rights Society, NY. André Breton would come to call this painting "the *Demoiselles d'Avignon* of the '*informel*'"—in other words, the founding painting of the European free gesture painting in the fifties, *l'art informel.*

great founder of Cubism, Breton said, possessed "the facility to give materiality to what had hitherto remained in the domain of pure fantasy." Picasso was attracted to the Surrealist point of view because it offered him new directions and possibilities, particularly in the example of his fellow Spanish artist, Joan Miró [mee-ROH] (1893–1983), whose work Breton was avidly collecting. Miró's first Paris exhibition was mounted expressly as a Surrealist show, highlighted by a private midnight opening for all the Surrealist crowd. It was followed quickly by an astonishing array of paintings, including *The Birth of the World* (Fig. **42.14**). "Rather than setting out to paint something," Miró explained, "I begin painting and as I paint, the picture begins to assert itself. . . . The first stage is free, unconscious." But, he added, "The second stage is carefully calculated." He equated the first stage with Breton's "psychic automatism." Like the universe itself, the painting began with the "void"—the blank canvas. This was followed by "chaos," randomly distributed stains and dots. Then, Miró

explained, "One large portion of black in the upper left seemed to need to become bigger. I enlarged it and went over it with opaque black paint. It became a triangle to which I added a tail. It might be a bird." He later identified the red circle with the yellow tail as a shooting star, and, at the bottom left, a "personage," with a white head whose foot almost touches a spider-like black star.

Picasso's Surrealism would assert itself most fully in the late twenties and early thirties, especially in a series of monstrous bone-like figures that alternated with sensuous portraits of his mistress Marie-Thérèse Walter (1909–1977), whom he had met when she was only 17 in January 1927. For eight years, until 1935, he led a double life, married to Olga Khokhlova [koh-KLOH-vah] (1891–1955) while conducting a secret affair with Marie-Thérèse. Since Marie-Thérèse is so readily identifiable in her portraits, it is tempting to see the more monstrous figures as portraits of Olga.

Picasso was indeed obsessed in these years with the duality of experience, the same opposition between Thanatos (the death drive) and Eros (the sex drive) that Freud had outlined in *Beyond the Pleasure Principle*. His 1932 double portrait of Marie-Thérèse, *Girl before a Mirror* (Fig. **42.15**), expresses this—she is the moon, or night, at the right, and the sun, or light, on the left, where her own face appears in both profile and three-quarter view. Her protruding belly on the left suggests her fertility (indeed, she gave birth to their child, Maya, in 1935, soon after Picasso finally separated from Olga), though in the mirror, in typical Picasso fashion, we see not her stomach but her buttocks, her raw sexuality. She is the conscious self on the left, her subconscious self revealing itself in the mirror. Picasso's work addresses Surrealism's most basic theme—the self in all its complexity. And he adds one important theme—the self in relation to the Other, for Picasso is present himself in the picture, not just as its painter, but in his symbol, the harlequin design of the wallpaper. But the painting also suggests that the self, in the

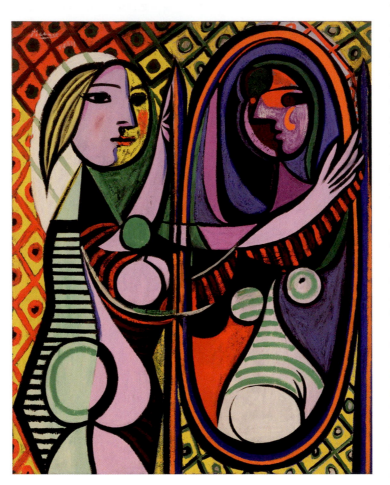

Fig. 42.15 Pablo Picasso. *Girl Before a Mirror.* **1932.** Oil on canvas, 64″ × 51¼″. Gift of Mrs. Simon Guggenheim. (2.1938). Digital Image © The Museum of Modern Art/Licensed by SCALA/Art Resource, NY. © ARS Artists Rights Society, NY. The long oval mirror into which Marie-Thérèse gazes, supported on both sides by posts, is known as a *psyche*. Hence Picasso paints her psyche both literally and figuratively.

dynamic interplay between the conscious and unconscious selves, might actually be the Other to itself.

Salvador Dalí's *Lugubrious Game* This sense of self-alienation is central to the work of Spanish artist Salvador Dalí [dah-LEE] (1904–1989), who in 1928, at age 24, was introduced to the Surrealists by Joan Miró. Already eccentric and flamboyant, Dalí had been expelled from the San Fernando Academy of Fine Arts two years earlier for refusing to take his final examination, claiming that he knew more than the professor who was to examine him. He brought this same daring self-confidence to the Surrealist movement. Among the first paintings executed under the influence of the Surrealists is *The Lugubrious Game* (Fig. **42.16**). At the lower right, a man wears a suit jacket but no pants, only his soiled underwear. He holds up one hand that clutches a blood-stained cloth, signifying his castration. He stares at the vision in front of him: a cluster of men's hats at the top (probably signifying the father), metamorphosing into egg-like forms. Below it is Dalí's own profile, his eye closed in sleep or dream, with a grasshopper perched on his mouth. Below his mouth stretches a bowel-like form culminating at the bottom of the stairs in a woman's buttocks seen from the rear. The statue of the male figure on the left reaches out an enlarged hand toward Dalí even as it covers its eyes in disgust.

Dalí, in other words, did not hesitate to confront the "lugubrious"—or mournful and gloomy side—of sexuality. He followed, he said, a "paranoiac critical method," a brand of self-hypnosis that he claimed allowed him to hallucinate freely. "I believe the moment is at hand," he wrote in a description of his method, "when, by a paranoiac and active advance of the mind, it will be possible (simultaneously with automatism . . .) to systematize confusion and thus to help to discredit the world of reality." He called his images "new and menacing," and works such as the famous 1931 *Persistence of Memory* (Fig. **42.17**) are precisely that. Again, this is a self-portrait of the sleeping Dalí, who lies slug-like in the middle of the painting, draped beneath

Fig. 42.16 Salvador Dalí. *The Lugubrious Game.* **1929.**
Oil and collage on card, 17½″ × 12″. Private Collection, Paris, France, ©
DACS. The Bridgeman Art Library. © 2008 ARS Artists Rights Society, NY.
Grasshoppers terrified Dalí—hence its nightmarish presence beneath his nose.

Fig. 42.17 Salvador Dalí. *The Persistence of Memory.* **1931.** Oil on
canvas, 9½″ × 13″. The Museum of Modern Art/Licensed by Scala-Art
Resource, NY. © 1999 Demart Pro Arte (R), Geneva/Artists Rights Society
(ARS), NY. Given anonymously. Dalí called such paintings "hand-painted
dream photographs."

the coverlet of time. Ants, which are a symbol of death, crawl
over a watchcase on the left. A fly alights on the watch drip-
ping over the ledge, and another limp watch hangs from a
dead tree that gestures toward the sleeping Dalí in a manner
reminiscent of the statue in *The Lugubrious Game*.

By the mid-1930s, Breton and the Surrealists parted ways
with Dalí over his early admiration for Adolf Hitler and his
reluctance to support the Republic in the Spanish Civil War.
To this could be added Dalí's love of money, for which he
earned the name Avida Dollars (Greedy Dollars), an anagram
of his name created by Breton. In 1938, he was formally
expelled from the Surrealist movement.

Surrealist Sculpture The work that caused the Surrealists to
take serious interest in the possibilities of a Surrealist sculptur-
al project was *Suspended Ball* (Fig. **42.18**), a sculpture made by
the Swiss sculptor Alberto Giacometti [jah-koh-MET-tee]
(1901–1966) in 1930–1931. The work is composed of a cres-
cent-shaped wedge above which hangs a ball with a slotted
groove in its underside, the pair contained in an open three-
dimensional frame. It invites touch, for the ball is meant to
swing in a pendulum fashion across the crescent wedge. Bre-
ton and Dalí were both ecstatic with the object. Many years

Fig. 42.18 Alberto Giacometti. *Suspended Ball.* **1930–1931.**
Wood and metal, 24″ × 14½″ × 14″. Inv. AM 1996-205. Photo: Georges
Meguerditchian. Musée National d'Art Moderne. Centre National d'Art et
de Culture. Georges Pompidou. CNAC/MNAM/Dist. Réunion des Musées
Nationaux/Art Resource, NY. © 2008 ARS Artists Rights Society, NY. A
plaster version of this sculpture, from which this version was cast, exists in
the Kunstmuseum, Basel, Switzerland.

Fig. 42.19 Meret Oppenheim. *Object (Le Déjeuner en fourrure).* **1931.** Fur-covered cup, saucer, and spoon; cup 4 $\frac{3}{4}$" diameter; saucer 9 $\frac{3}{8}$" diameter; spoon 8" long; overall height 2 $\frac{3}{8}$". Purchase. The Museum of Modern Art/Licensed by Scala-Art Resource, NY. © 2008 ARS Artists Rights Society, NY. This work was given its title by Breton in 1938, when it was included in the new Museum of Modern Art's exhibition "Fantastic Art, Dada, Surrealism."

later, in his *History of Surrealism*, Maurice Nadeau recalled the sculpture's impact: "Everyone who saw it experienced a strong but indefinable sexual emotion relating to unconscious desires. The emotion was ... one of disturbance, like that imparted by the irritating awareness of failure."

For the most part, women were allowed to participate in the movement only as the object of their male companion's dreams and fantasies, but the German-born Meret Oppenheim [OH-pen-hime] (1913–1985) made a significant contribution in her own right, by creating strikingly original objects that captivated the Surrealists' imagination. Oppenheim's sense of humor, which consists largely in the unexpected transformations that she works upon her objects, is at its most obvious in her *Object (Le Déjeuner en fourrure)* [leh day-zhun-AY ahn foo-RURE] (Fig. **42.19**), literally her "luncheon in fur." One day, while Oppenheim and Picasso were at a café, Picasso noticed a bracelet she was wearing of her own design lined with ocelot [OSS-uh-lot] fur. He remarked that one could cover anything in fur, and Oppenheim agreed. Then, her tea having gotten cold, she asked the waiter for "a little more fur." The Freudian slip suggested the work. Its title is a reference to Manet's *Le Déjeuner sur l'herbe* (see Fig. 36.6), in which a naked model blithely sits between two dressed gentlemen in the Bois de Bologne. The sexual frankness of Manet's painting is transformed here into a suggestion of oral eroticism, the potential user of this tea set becoming a kind of animal licking its own fur or cleaning the fur of its children. But what sets Oppenheim's work apart is the good-natured humor that she brings to Surrealism's "lugubrious" game.

Experimentation and the Literary Life

Surrealist art's investigation of the human unconscious was reflected as well in the experimentation of the writers working after the war. American writers—many of them influ-

enced by the example of Gertrude Stein—sought a style of writing that seemed to them authentic, a true expression of their emotions. In Europe, writers were deeply affected by Freud's theories of personality and the workings of the unconscious.

Hemingway in Paris: "One True Sentence"

In his memoir of his years in Paris after the war, *A Moveable Feast*, the American novelist Ernest Hemingway (1899–1961) described the kind of prose he was trying to write by stating that he might write "one true sentence" that would accurately reflect what he "had seen or had heard someone say." Like Flaubert searching out *le mot juste* (see chapter 35), Hemingway was striving for something as immediately real as the sputter of blue flame created by the orange peel, something to hold onto in the inauthentic world that had led to a Great War that still seemed unresolved.

When the United States entered the war in 1917, Hemingway tried to enlist but was judged unfit for service because of his poor eyesight. "I can't let a show like this go on without getting into it," he wrote to his family, and so he volunteered to serve as an ambulance driver for the American Red Cross. He was stationed on the Italian Front where he was almost immediately wounded in the legs from mortar fire. Recuperating in Milan, he fell in love with Agnes von Kurowsky, who nursed him back to health and won immortality as the inspiration for Catherine in Hemingway's 1929 novel, *A Farewell to Arms.* "Abstract words, such as glory, honor, courage, or hallow," Hemingway wrote in that novel, in what amounts to a manifesto of his rhetorical style, "were obscene beside the concrete names of villages, the numbers of roads, the names of rivers, the numbers of regiments and dates." For Hemingway the use of a stripped-down, concrete language became a means of survival. In the concrete he could not be betrayed, either by his own emotions or by his belief in the sincerity of someone else's.

Thus, in his story "Big Two-Hearted River," published in the collection *In Our Time* in 1925 (see **Reading 42.11**, page 1377), Hemingway's hero, Nick Adams, back from the war, goes fishing by himself in northern Minnesota: "He felt he had left everything behind, the need for thinking, the need to write, other needs. It was all back of him." The story is only ostensibly about fishing. It is more about healing, about doing concrete things—making camp, cooking, smoking, feeding out a line into a stream—that in their very simplicity convince us that we are alive.

The meticulous, careful observations of Nick Adams in "Big Two-Hearted River" evoke an emotional depth and complexity mirrored by "the swamp" that Nick does not yet feel he is ready to conquer. As Hemingway put it, "I was trying to write then, and I found the greatest difficulty ... was to put down what really happened in action; what the actual things were which produced the emotion that you experi-

Voices

Parisian Nightlife

Parisian nightlife in the 1920s was a curious mixture of high culture and audacious behavior. In 1925, the year before he published his first novel, the American writer William Faulkner (1897–1962) visited Paris for the first time. In a letter to his mother he described the scene at the Moulin Rouge, the Paris cabaret in the red light district of Pigalle, near Montmartre, that Toulouse-Lautrec had celebrated in his fin de siècle paintings of Parisian nightlife. He misspells the name of the Russian composer, Rimsky-Korsakov (1844–1908), most famous for his composition "The Flight of the Bumblebee." The other composer Faulkner mentions is Jean Sibelius (1865–1957), one of the more conservative symphonic classical composers of the twentieth century.

". . . a music hall, a vaudeville, where ladies come out clothed principally in lip stick."

Anyone in America will tell you it is the last word in sin and iniquity. It is a music hall, a vaudeville, where ladies come out clothed principally in lip stick. Lots of bare beef, but that is only secondary. Their songs and dances are set to real music—there was one with not a rag on except a coat of gold paint who danced a ballet of Rimsky-Korsakoff [sic], a Persian thing; and two others, a man stained brown like a faun and a lady who had on at least 20 beads, I'll bet money, performed a short tone poem of the Scandinavian composer Sibelius. It was beautiful.

enced." The cafés of Paris were, for Hemingway, the energizing force in his search. The intersection of the boulevard du Montparnasse and the boulevard Raspail was a crossroads dominated, then as now, by four large cafés—the Coupole, the Rotonde, the Dôme, and the Sélect. If Stein's apartment was the intellectual center of what might be called "American Paris," these four cafés, and the quieter Closerie des Lilas, farther down the boulevard du Montparnasse, were its social center. In these cafés, the expatriate Americans, who lived in small, cold flats, gathered to get warm, meet, and talk. (They also found entertainment in some less reputable Parisian clubs. See *Voices*, above.) Immediately after arriving in Paris, on December 23, 1921, Hemingway wrote home to the writer Sherwood Anderson, who had provided him with letters of introduction to Gertrude Stein and Ezra Pound:

> Well here we are. And we sit outside the Dôme Café, opposite the Rotunde that's being redecorated, warmed up against one of those charcoal brazziers and it's so damned cold outside and the brazzier makes it so warm and we drink rum punch, hot, and the rum enters into us like the Holy Spirit. . . . What a town.

Hemingway worked best at the quiet Closerie. It was there that Ezra Pound edited Eliot's *Waste Land* and began writing his own *Cantos*. It was here as well that, sitting on the terrace, Hemingway wrote most of *The Sun Also Rises* in about six weeks' time.

The novel takes for its epigraph Gertrude Stein's famous phrase, "You are all a lost generation," and its cast of hard-drinking, fast-living, essentially aimless American expatriates seemed to capture the spirit of the age. It was an immediate success. As the American critic Malcolm Cowley put it in his 1934 memoir, *Exile's Return*: "Young men tried to get as

imperturbably drunk as the hero, young women of fairly good family cultivated the heroine's nymphomania, and the name 'the lost generation' was fixed. It was a boast at first, like telling what a hangover one had after a party to which someone else wasn't invited." The hero, Jake Barnes, an American journalist, has suffered an injury in World War I, which makes it impossible for him to consummate his relationship with the novel's heroine, Lady Brett Ashley. About halfway through the novel, a character named Jeff Gorton mockingly describes to Jake just who he has become: "You're an expatriate. You've lost touch with the soil. You get precious. Fake European standards have ruined you. You drink yourself to death. You become obsessed by sex. You spend all your time talking, not working. You are an expatriate, see? You hang around cafés." It is safe to say that the only thing separating Hemingway from his character—aside from his own sexual self-esteem—was that Hemingway worked, and worked hard, on his writing.

The Stream-of-Consciousness Novel

Where Hemingway sought to pare down his writing style to the most basic and direct description, perhaps the most important literary innovation of the era was the stream-of-consciousness novel. The idea had arisen in the late nineteenth century, in the writings of both William James (1842–1910), the novelist Henry James's older brother; and the French philosopher Henri Bergson (1859–1941). For Bergson, human consciousness is composed of two somewhat contradictory powers: intellect, which sorts and categorizes experience in logical, even mathematical terms; and intuition, which understands experience as a perpetual stream of sensations, a duration or flow of perpetual becoming. Chapter XI of James's 1892 *Psychology* is actually entitled "The Stream of Consciousness."

"Now we are seeing," James writes, "now hearing; now reasoning, now willing; now recollecting, now expecting; now loving, now hating; and in a hundred other ways we know our minds to be alternately engaged. . . . Consciousness . . . is nothing jointed; it flows. A 'river' or a 'stream' are the metaphors by which it is most naturally described. *In talking of it hereafter, let us call it the stream of thought, of consciousness, or of subjective life.*"

The rise of the stream-of-consciousness novel in the twentieth century can be attributed to two related factors. On the one hand, it provided authors a means of portraying directly the psychological makeup of their protagonists, as their minds leap from one thing to the next, from memory to self-reflection to observation to fantasy. In this it resembles the "free association" method of Freudian psychoanalysis. But equally important, it enabled writers to emphasize the subjectivity of their characters' points of view. What a character claims might not necessarily be true. Characters might have motives for lying, even to themselves. And certainly no character in a "fiction" need be a reliable narrator of events. Nothing need prevent them from creating their own fiction within the author's larger fictional work. Thus, in the stream-of-consciousness novel, the reader is forced to become an active participant in the fiction, sorting out "fact" from "fantasy," distinguishing between the actual events of a story and the characters' "memory" of them.

Joyce, *Ulysses*, and Sylvia Beach No writer was more influential in introducing the stream-of-consciousness narrative than James Joyce (1882–1941), the Irish writer who left Ireland in 1905 to live, chiefly, in Paris, and no novel better demonstrates its powers than his *Ulysses*.

Early chapters of *Ulysses* had originally been serialized in the American *Little Review*, but postal authorities in both Britain and the United States had banned it for obscenity. Joyce's cause was taken up by Sylvia Beach, owner of an English-language-only bookstore and lending library on the rue l'Odéon [loh-day-OHN] frequented by almost every American writer in Paris. After meeting Joyce at the bookstore, she agreed to publish *Ulysses* in an edition of 1,000, the first two copies of which were delivered on the eve of Joyce's fortieth birthday, February 2, 1922 (Fig. **42.20**).

The novel takes place on one day, June 16, 1904, in 18 episodes spread about an hour apart and ending in the early hours of June 17. It loosely follows the episodes of Ulysses from the *Odyssey* of Homer, with Stephen Dedalus figuring as the new Telemachus, Leopold Bloom as Ulysses, and Molly Bloom as Penelope. Like Penelope in the *Odyssey*, Molly has a suitor, the debonair Blazes Boylan. To win back her affection, Bloom must endure 12 trials—his Odyssey—in the streets, brothels, pubs, and offices of Dublin. Each character is presented through his or her own **stream-of-consciousness** narration—we read only what is experienced in the character's mind from moment to moment, following their thought process through their interior monologue.

Continuity & Change
p. 149

Odyssey

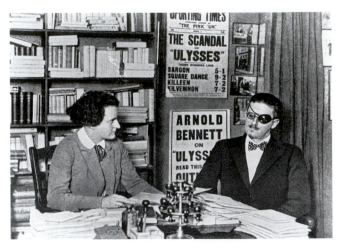

Fig. 42.20 Sylvia Beach and James Joyce reading reviews of *Ulysses*, 1922. Princeton University Library, Princeton, NJ. Sylvia Beach Collection. Joyce suffered from glaucoma, and endured a number of operations. In order to support Joyce, Beach went into debt herself to advance him money, printing 11 small editions of the novel over the next decade.

Molly Bloom's final soliloquy, the last episode of the book, underscores the experimental vitality of Joyce's prose. It opens with Molly contemplating her husband's request to be served breakfast in bed in the morning. A full-blown stream-of-consciousness monologue in which the half-asleep Molly mulls over her entire sexual life, it concludes with her rapturous remembrance of giving herself to Bloom on Howth Head, the northern enclosure of Dublin Bay, sixteen years earlier.

In its near-total lack of punctuation—there are eight sentences in the entire episode, the first of which is 2,500 words long—as well as its uncensored exploration of a woman's sexuality, Joyce's final episode remains revolutionary, as does the novel as a whole.

Virginia Woolf: In the Mind of Mrs. Dalloway As soon as episodes from *Ulysses* began to appear in the *Little Review*, Joyce's experiments caught the attention of other writers. Although the English novelist Virginia Woolf (1882–1941) disapproved of Joyce's book—it ultimately seemed to her the product of a "working man," and, she added, "we all know how distressing they are, how egotistic, insistent, raw, striking, & ultimately nauseating"—she was fascinated by Joyce's style. In August 1922, just as she was beginning her novel *Mrs. Dalloway*, a work published in 1925 about a higher social class of people than those of Joyce's *Ulysses*, she wrote that after reading the first 200 pages of Joyce's novel she was "amused, stimulated, charmed[,] interested." So she determined to examine for herself "an ordinary day" of a decidedly different character. As she explained:

The mind receives a myriad of impressions—trivial, fantastic, evanescent, or engraved with the sharpness of steel. . . . Life is not . . . symmetrically arranged; but a luminous halo, a semi-transparent envelope surrounding us from the beginning of consciousness to the end. Is it not the task of

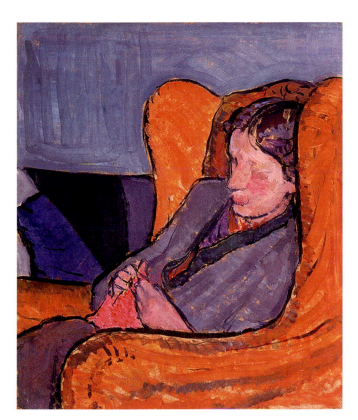

Fig. 42.21 Vanessa Bell. *Virginia Woolf.* **1912.** Oil on board, 15 3/4″ × 13 3/8″. National Portrait Gallery, London. NPG 5933. This portrait of Woolf crocheting was painted before her marriage to Leonard Woolf in 1915. The painting evokes Woolf's own withdrawal into her interior life.

the novelist to convey this varying, this unknown and uncircumscribed spirit, whatever aberration or complexity it may display, with as little mixture of the alien and external as possible?

Woolf was at the center of a circle of London intellectuals known as the "Bloomsbury Group," named for the London neighborhood in which they lived. Among the group was her sister, the artist Vanessa Bell (1879–1961), who in 1912 painted her sister's portrait in a block like geometric style deeply influenced by modernist painting in Paris and Germany (Fig. **42.21**). By the mid-twenties, Woolf had largely eliminated external action from her prose, concentrating instead on trying to capture the ebb and flow of her characters'—particularly her women characters'—consciousness. It was their psychological makeup, and by extension her own, that most interested her.

Mrs. Dalloway takes place on a single day in post–World War I London as Clarissa Dalloway prepares for a party, and Woolf follows her heorine's stream of consiousness, her memories and feelings, as well as the streams of consciousness of other characters who encounter her as they go through the day. Chief among these other characters is Septimus Warren Smith, a shell-shocked war veteran whose depression in many ways mirrors Woolf's own. These are the novel's opening paragraphs (**Reading 42.12**):

READING 42.12 from Virginia Woolf, *Mrs. Dalloway* (1925)

Mrs. Dalloway said she would buy the flowers herself.

For Lucy had her work cut out for her. The doors would be taken off their hinges; Rumpelmayer's men were coming. And then, thought Clarissa Dalloway, what a morning—fresh as if issued to children on a beach.

What a lark! What a plunge! For so it had always seemed to her, when, with a little squeak of the hinges, which she could hear now, she had burst open the French windows and plunged at Bourton into the open air. How fresh, how calm, stiller than this of course, the air was in the early morning; like the flap of a wave; the kiss of a wave; chill and sharp and yet (for a girl of eighteen as she then was) solemn, feeling as she did, standing there at the open window, that something awful was about to happen; looking at the flowers, at the trees with the smoke winding off them and the rooks rising, falling; standing and looking until Peter Walsh said, "Musing among the vegetables?"—was that it?—"I prefer men to cauliflowers"—was that it? He must have said it at breakfast one morning when she had gone out on to the terrace—Peter Walsh. He would be back from India one of these days, June or July, she forgot which, for his letters were awfully dull; it was his sayings one remembered; his eyes, his pocket-knife, his smile, his grumpiness and, when millions of things had utterly vanished—how strange it was!—a few sayings like this about cabbages.

She stiffened a little on the kerb, waiting for Durtnall's van to pass. A charming woman, Scrope Purvis thought her (knowing her as one does know people who live next door to one in Westminster); a touch of the bird about her, of the jay, blue green, light, vivacious, though she was over fifty, and grown very white since her illness. There she perched, never seeing him, waiting to cross, very upright.

For having lived in Westminster—how many years now? over twenty,—one feels even in the midst of the traffic, or waking at night, Clarissa was positive, a particular hush, or solemnity; an indescribable pause; a suspense (but that might be her heart, affected, they said, by influenza) before Big Ben strikes. There! Out it boomed.

As the 52-year-old Clarissa leaves her house to buy flowers for her party, she recalls standing at the open window of her father's estate when she was 18, chatting with Peter Walsh, and feeling "something awful was about to happen." Clarissa's neighbor, Scrope Purvis, notices her from his window, and we are briefly in his mind. Then we return to Clarissa. As past and present mingle, and points of view shift from character to character, we enter into the private worlds of them all, all ironically frustrated in their attempts to communicate with one another.

Woolf's next novel, the 1927 *To the Lighthouse*, opens with a long stream-of-consciousness account of a day in the life of Mr. and Mrs. Ramsay and their guests vacationing on the Isle of Skye, followed by a shorter poetic description of the passing of 10 years' time, and concluding with another stream-of-consciousness narrative in which the actions of 10 years earlier are finally resolved. The contrast in the passing of time—two days' events narrated at length, 10 years' in a matter of pages—underscores Woolf's sense of the malleability of time. But at the heart of the narrative is the realization that it is the consciousness of Mrs. Ramsay that determines the events of the final day, even though in the intervening years she has died.

Marcel Proust and the Novel of Memory If Joyce was the first to use stream of consciousness as a narrative device, it was Marcel Proust [proost] who first imagined the novel as a mental space. Proust was born in 1871 and grew up in Paris near the Champs-Elysées, spending holidays with relatives in the country towns of Auteuil [oh-TOY] and Illiers [eel-ee-AY]. These two villages inspired Proust's fictional village, Combray [kohm-BRAY], site of the narrator's childhood memories in his monumental seven-volume novel *À la recherche du temps perdu* (literally *In Search of Lost Time*, but known in the English-speaking world for decades as *Remembrance of Things Past*, a title invented by the novel's translator from Shakespeare's Sonnet XXX: "When to the sessions of sweet silent thought/ I summon up remembrance of things past"). After a bout of depression that followed the deaths of his father in 1903 and his mother in 1905, Proust gave up his social life almost entirely, retreating to his quiet, cork-lined apartment on the boulevard Haussmann and devoting almost all his waking hours to the composition of his novel.

Calling the novel "psychology in space and time," his plan was to explore the deepest recesses of the unconscious and bring them to conscious life. Thus the famous moment that concludes the "Overture" to *Swann's Way*, the first volume of *À la recherche*, published in 1913, when the narrator, Marcel, tastes a madeleine, "one of those short, plump little cakes ... which look as though they have been moulded in the fluted scallop of a pilgrim's shell" (**Reading 42.13**):

READING 42.13 from Marcel Proust, *Swann's Way* (1913)

I raised to my lips a spoonful of the tea in which I had soaked a morsel of the cake. No sooner had the warm liquid, and the crumbs with it, touched my palate than a shudder

ran through my whole body, and I stopped, intent upon the extraordinary changes that were taking place. An exquisite pleasure had invaded my senses, but individual, detached, with no suggestion of its origin. And at once the vicissitudes of life had become indifferent to me, its disasters innocuous, its brevity illusory—this new sensation having had on me the effect which love has of filling me with a precious essence; or rather this essence was not in me, it was myself. I had ceased now to feel mediocre, accidental, mortal. Whence could it have come to me, this all-powerful joy? I was conscious that it was connected with the taste of tea and cake, but that it infinitely transcended those savours, could not, indeed, be of the same nature as theirs. Whence did it come? What did it signify? How could I seize upon and define it?

What Marcel comes to understand is that, in a process of free association, the taste of the madeleine had evoked his experience of tasting the same little cake, given him by his aunt Léonine [lay-oh-NEEN] on Sunday mornings at Combray, and thus the entire landscape of Combray itself. The past, in other words, comes alive in the present, freeing Marcel from the constraints of time and opening to him the recesses of his subconscious.

The philosopher Henri Bergson, whom Proust considered "the first great metaphysician" of the modern era, had argued that past, present, and future were part of an organic whole, in which the past is a "continuous progress . . . which gnaws into the future and which swells it as it advances." The role of art, he argued, was to capture "certain rhythms of life and breath" which invite us to "join in a dance. Thus," he wrote, "they compel us to set in motion, in the depth of our own being, some secret chord which was only waiting to thrill." Just as the madeleine struck this same secret chord in Marcel, Proust hoped his fiction would strike it in his reader. In the last volume of *À la recherche*, *Time Regained*, not published until 1927, he wrote:

> I thought more modestly of my book and it would be inaccurate even to say that I thought of those who would read it as "my" readers. For, it seemed to me that they would not be "my" readers but the readers of their own selves, my book being merely a sort of magnifying glass like those which the optician at Combray used to offer his customers—it would be my book but with its help I would furnish them with the means of reading what lay inside themselves.

It is the book and the acts of memory that it restores to the present—and hence the future—that time, in all its flux, is finally "regained."

READINGS

from T. S. Eliot, *The Waste Land*, Part III, "The Fire Sermon" (1921)

The following selection from Eliot's long poem occurs at the very center of the poem. Eliot describes the sexual encounter between a typist and her "young man carbuncular"—that is, covered with boils—as overseen by the figure of Tiresias. In a note, Eliot describes Tiresias as "the most important personage in the poem," despite the fact that he is a "mere spectator." In his Metamorphoses *(see chapter 8), Ovid describes how Tiresias spent seven years as a woman. Later, he was asked to settle a quarrel between Zeus and Hera over who enjoyed sex more, men or women. When Tiresias agreed with Zeus that women enjoyed it more, Hera blinded him, but Zeus compensated him by giving him the gift of prophesy. Tiresias, here, blind yet able to see with complete clarity, embodies the modern condition, a doomed individual who can neither hope nor act, but only sit and watch.*

At the violet hour, when the eyes and back
Turn upward from the desk, when the human engine waits
Like a taxi throbbing waiting,
I Tiresias, though blind, throbbing between two lives,
Old man with wrinkled female breasts, can see
At the violet hour, the evening hour that strives
Homeward, and brings the sailor home from sea,
The typist home at teatime, clears her breakfast, lights
Her stove, and lays out food in tins.
Out of the window perilously spread 10
Her drying combinations[1] touched by the sun's last rays,
On the divan are piled (at her night bed)
Stockings, slippers, camisoles, and stays.
I Tiresias, old man with wrinkled dugs
Perceived the scene, and foretold the rest—
I too awaited the expected guest.
He, the young man carbuncular, arrives,
A small house agent's clerk, with one bold stare,
One of the low on whom assurance sits
As a silk hat on a Bradford millionaire.[2] 20
The time is now propitious, as he guesses,
The meal is ended, she is bored and tired,
Endeavours to engage her in caresses
Which are still unreproved, if undesired.

Flushed and decided, he assaults at once;
Exploring hands encounter no defense;
His vanity requires no response,
And makes a welcome of indifference.
(And I Tiresias have foresuffered all
Enacted on this same divan or bed; 30
I who have sat by Thebes below the wall
And walked among the lowest of the dead.)[3]
Bestows one final patronising kiss,
And gropes his way, finding the stairs unlit . . .

She turns and looks a moment in the glass,
Hardly aware of her departed lover;
Her brain allows one half-formed thought to pass:
"Well now that's done: and I'm glad it's over."
When lovely woman stoops to folly and
Paces about her room again, alone, 40
She smoothes her hair with automatic hand,
And puts a record on the gramophone.

Reading Question

In his notes to *The Waste Land*, Eliot writes: "What Tiresias sees, in fact, is the substance of the poem." How would you summarize that "substance"?

from Sigmund Freud, *Civilization and Its Discontents* (1930)

Civilization and Its Discontents is among Freud's most philosophical works. In it he traces the effects of archaic instinctual impulses, once necessary for survival, on modern society. In the following passage, he surveys the role that aggression plays in impeding man's ability to live in peace and harmony. Later in this same argument, he will argue that civilization often forces us to turn our aggression inward, to the Self, causing the psychological phenomenon of depression and despair.

[1]*combinations* one-piece underwear.
[2]*Bradford millionaire* The industrial town of Bradford thrived on war contracts during World War I, and thus the gentleman described is, for Eliot, the image of a war profiteer.

[3]*Thebes . . . lowest of the dead* Tiresias was originally from the Greek city of Thebes, but prophesied from Hades.

Men are not gentle creatures, who want to be loved, who at the most can defend themselves if they are attacked; they are, on the contrary, creatures among whose instinctual endowments is to be reckoned a powerful share of aggressiveness. As a result, their neighbor is for them not only a potential helper or sexual object, but also someone who tempts them to satisfy their aggressiveness on him, to exploit his capacity for work without compensation, to use him sexually without his consent, to seize his possessions, to humiliate him, to cause him pain, to torture and to kill him. *Homo homini lupus* [man is wolf to man]. Who in the face of all his experience of life and of history, will have the courage to dispute this assertion? As a rule this cruel aggressiveness waits for some provocation or puts itself at the service of some other purpose, whose goal might also have been reached by milder measures. In circumstances that are favorable to it, when the mental counter-forces which ordinarily inhibit it are out of action, it also manifests itself spontaneously and reveals man as a savage beast to whom consideration towards his own kind is something alien. Anyone who calls to mind the atrocities committed during the racial migrations or the invasions of the Huns, or by the people known as Mongols under Jenghiz Khan and Tamerlane, or at the capture of Jerusalem by the pious Crusaders, or even, indeed, the horrors of the recent World War—anyone who calls these things to mind will have to bow humbly before the truth of this view.

The existence of this inclination to aggression, which we can detect in ourselves and justly assume to be present in others, is the factor which disturbs our relations with our neighbor and which forces civilization into such a high expenditure [of energy]. In consequence of this primary mutual hostility of human beings, civilized society is perpetually threatened with disintegration. The interest of work in common would not hold it together; instinctual passions are stronger than reasonable interests. Civilization has to use its utmost efforts in order to set limits to man's aggressive instincts and to hold the manifestations of them in check by psychical reaction-formations. . . .

The communists believe they have found the path to deliverance from our evils. According to them, man is wholly good and as well-disposed to his neighbor; but the institution of private property has corrupted his nature. The ownership of private wealth gives the individual power, and waited the temptation to ill-treat his neighbor; while the man who is excluded from possession is bound to rebel in hostility against his oppressor. If private property were abolished, all wealth held in common, and everyone allowed to share in the enjoyment of it, ill-will and hostility would disappear among men. Since everyone's needs would be satisfied, no one would have any reason to regard another as his enemy; all would willingly undertake the work that was necessary. I have no concern with any economic criticisms of the communist system; I cannot inquire into whether the abolition of private property is expedient or advantageous. But I am able to recognize that the psychological premises on which the systems based are an untenable illusion. In abolishing private property we deprive the human love of aggression of one of its instruments, certainly a strong one, though certainly not the strongest; but we have in no way altered the differences in power and influence which are misused by aggressiveness, nor have we altered anything in its nature. Aggressiveness was not created by property. It reigned almost before property had given up its primal, anal form; it forms the basis of every relation of affection and love among people (with the single exception, perhaps, of the mother's relation to her male child). If we do away with personal rights over material wealth, there still remains prerogative in the field of sexual relationships, which is bound to become the source of the strongest dislike in the most violent hostility among men who in other respects are on an equal footing. If we were to remove this factor, too, by allowing complete freedom of sexual life and thus abolishing the family, the germ-cell of civilization, we cannot, it is true, easily foresee what new paths the development of civilization could take; but one thing we can expect, and that is that this indestructible feature of human nature will follow it there.

It is clearly not easy for man to give up the satisfaction of this inclination to aggression. They do not feel comfortable without it. The advantage which a comparatively small cultural group offers of allowing this instinct an outlet in the form of hostility against intruders is not to be despised. It is always possible to bind together a considerable number of people in love, so long as there are other people left over to receive the manifestations of their aggressiveness. . . . In this respect the Jewish people, scattered everywhere, have rendered most useful services to the civilizations of the countries that have been their hosts; but unfortunately all the massacres of the Jews in the Middle Ages did not suffice to make that period more peaceful and secure for their Christian fellows. When once the Apostle Paul had posited universal love between men as the foundation of his Christian community, extreme intolerance, part of Christendom towards those who remained outside it became the inevitable consequence. To the Romans, who had not founded their communal life as a State upon love, religious intolerance was something foreign, although with them religion was a concern of the State and the State was permeated by religion. Neither was it an unaccountable chance that the dream of a Germanic world-dominion called for anti-Semitism as its complement; and it is intelligible that the attempts to establish a new, communist civilization in Russia should find its psychological support in the persecution of the bourgeois. One only wonders, with concern, what the Soviets will do after they have wiped out their bourgeois. ■

Reading Question

How and why does Freud disagree with Lenin's basic premise as stated in _The State and Revolution_?

READING 42.11

from Ernest Hemingway, "Big Two-Hearted River" (1925)

Hemingway's "Big Two-Hearted River" was published in 1925 in a book of his stories entitled In Our Time. Although World War I is never mentioned in the text itself, it narrates the healing process of the shell-shocked Nick Adams, who hopes that by returning to the activities of his boyhood he can retrieve, if not his lost innocence, then a certain peace of mind. Hemingway has divided the story into two parts. In Part I, Nick arrives by train at the town of Seney, Michigan, destroyed by a forest fire sometime between the present and Nick's last visit. The burnt countryside is, in some sense, a metaphor for the post-war world itself. Nick walks up the Big Two-Hearted River, full of trout, until he leaves the burnt countryside behind and carefully sets up camp near a meadow overlooking the river. Part II, which is included here, takes place the next morning when Nick goes fishing. Note that Hemingway's prose is as spare and carefully controlled as Nick's actions.

Part II

In the morning the sun was up and the tent was starting to get hot. Nick crawled out under the mosquito netting stretched across the mouth of the tent, to look at the morning. The grass was wet on his hands as he came out. The sun was just up over the hill. There was the meadow, the river and the swamp. There were birch trees in the green of the swamp on the other side of the river.

The river was clear and smoothly fast in the early morning. Down about two hundred yards were three logs all the way across the stream. They made the water smooth and deep above them. As Nick watched, a mink crossed the river on the logs and went into the swamp. Nick was excited. He was excited by the early morning and the river. He was really too hurried to eat breakfast, but he knew he must. He built a little fire and put on the coffee pot. [10]

While the water was heating in the pot he took an empty bottle and went down over the edge of the high ground to the meadow. The meadow was wet with dew and Nick wanted to catch grasshoppers for bait before the sun dried the grass. He found plenty of good grasshoppers. They were at the base of the grass stems. Sometimes they clung to a grass stem. They were cold and wet with the dew, and could not jump until the sun warmed them. Nick picked them up, taking only the medium-sized brown ones, and put them into the bottle. He turned over a log and just under the shelter of the edge were several hundred hoppers. It was a grasshopper lodging house. Nick put about fifty of the medium browns into the bottle. While he was picking up the hoppers the others warmed in the sun and commenced to hop away. They flew when they hopped. At first they made one flight and stayed stiff when they landed, as though they were dead. [20] [30]

Nick knew that by the time he was through with breakfast they would be as lively as ever. Without dew in the grass it would take him all day to catch a bottle full of good grasshoppers and he would have to crush many of them, slamming at them with his hat. He washed his hands at the stream. He was excited to be near it. Then he walked up to the tent. The hoppers were already jumping stiffly in the grass. In the bottle, warmed by the sun, they were jumping in a mass. Nick put in a pine stick as a cork. It plugged the mouth of the bottle enough, so the hoppers could not get out and left plenty of air passage. [40]

He had rolled the log back and knew he could get grasshoppers there every morning.

Nick laid the bottle full of jumping grasshoppers against a pine trunk. Rapidly he mixed some buckwheat flour with water and stirred it smooth, one cup of flour, one cup of water. He put a handful of coffee in the pot and dipped a lump of grease out of a can and slid it sputtering across the hot skillet. On the smoking skillet he poured smoothly the buckwheat batter. It spread like lava, the grease spitting sharply. Around the edges the buckwheat cake began to firm, then brown, then crisp. The surface was bubbling slowly to porousness. Nick pushed under the browned under surface with a fresh pine chip. He shook the skillet sideways and the cake was loose on the surface. I won't try and flop it, he thought. He slid the chip of clean wood all the way under the cake, and flopped it over onto its face. It sputtered in the pan. [50]

When it was cooked Nick regreased the skillet. He used all the batter. It made another big flapjack and one smaller one. [60]

Nick ate a big flapjack and a smaller one, covered with apple butter. He put apple butter on the third cake, folded it over twice, wrapped it in oiled paper and put it in his shirt pocket. He put the apple butter jar back in the pack and cut bread for two sandwiches.

In the pack he found a big onion. He sliced it in two and peeled the silky outer skin. Then he cut one half into slices and made onion sandwiches. He wrapped them in oiled paper and buttoned them in the other pocket of his khaki shirt. He turned the skillet upside down on the grill, drank the coffee, sweetened and yellow brown with the condensed milk in it, and tidied up the camp. It was a good camp. [70]

Nick took his fly rod out of the leather rod-case, jointed it, and shoved the rod-case back into the tent. He put on the reel and threaded the line through the guides. He had to hold it from hand to hand, as he threaded it, or it would slip back through its own weight. It was a heavy, double tapered fly line. Nick had paid eight dollars for it a long time ago. It was made heavy to lift back in the air and come forward flat and

heavy and straight to make it possible to cast a fly which has no weight. Nick opened the aluminum leader box. The leaders were coiled between the damp flannel pads. Nick had wet the pads at the water cooler on the train up to St. Ignace. In the damp pads the gut leaders had softened and Nick unrolled one and tied it by a loop at the end to the heavy fly line. He fastened a hook on the end of the leader. It was a small hook; very thin and springy. 80

Nick took it from his hook book, sitting with the rod across his lap. He tested the knot and the spring of the rod by pulling the line taut. It was a good feeling. He was careful not to let the hook bite into his finger. 90

He started down to the stream, holding his rod, the bottle of grasshoppers hung from his neck by a thong tied in half hitches around the neck of the bottle. His landing net hung by a hook from his belt. Over his shoulder was a long flour sack tied at each corner into an ear. The cord went over his shoulder. The sack slapped against his legs.

Nick felt awkward and professionally happy with all his equipment hanging from him. The grasshopper bottle swung against his chest. In his shirt the breast pockets bulged against him with the lunch and the fly book. 100

He stepped into the stream. It was a shock. His trousers clung tight to his legs. His shoes felt the gravel. The water was a rising cold shock.

Rushing, the current sucked against his legs. Where he stepped in, the water was over his knees. He waded with the current. The gravel slid under his shoes. He looked down at the swirl of water below each leg and tipped up the bottle to get a grasshopper. The first grasshopper gave a jump in the neck of the bottle and went out into the water. He was sucked under in the whirl by Nick's right leg and came to the surface a little way down stream. He floated rapidly, kicking. In a quick circle, breaking the smooth surface of the water, he disappeared. A trout had taken him. 110

Another hopper poked his face out of the bottle. His antennas wavered. He was getting his front legs out of the bottle to jump. Nick took him by the head and held him while he threaded the slim hook under his chin, down through his thorax and into the last segments of his abdomen. The grasshopper took hold of the hook with his front feet, spitting tobacco juice on it. Nick dropped him into the water. 120

Holding the rod in his right hand he let out line against the pull of the grasshopper in the current. He stripped off line from the reel with his left hand and let it run free. He could see the hopper in the little waves of the current. It went out of sight.

There was a tug on the line. Nick pulled against the taut line. It was his first strike. Holding the now living rod across the current, he hauled in the line with his left hand. The rod bent in jerks, the trout pulling against the current. Nick knew it was a small one. He lifted the rod straight up in the air. It bowed with the pull. 130

He saw the trout in the water jerking with his head and body against the shifting tangent of the line in the stream.

Nick took the line in his left hand and pulled the trout, thumping tiredly against the current, to the surface. His back was mottled the clear, water-over-gravel color, his side flashing in the sun. The rod under his right arm, Nick stooped, dipping his right hand into the current. He held the trout, never still, with his moist right hand, while he unhooked the barb from his mouth, then dropped him back into the stream. 140

He hung unsteadily in the current, then settled to the bottom beside a stone. Nick reached down his hand to touch him, his arm to the elbow under water. The trout was steady in the moving stream resting on the gravel, beside a stone. As Nick's fingers touched him, touched his smooth, cool, underwater feeling, he was gone, gone in a shadow across the bottom of the stream.

He's all right, Nick thought. He was only tired.

He had wet his hand before he touched the trout, so he would not disturb the delicate mucus that covered him. If a trout was touched with a dry hand, a white fungus attacked the unprotected spot. Years before when he had fished crowded streams, with fly fishermen ahead of him and behind him, Nick had again and again come on dead trout furry with white fungus, drifted against a rock, or floating belly up in some pool. Nick did not like to fish with other men on the river. Unless they were of your party, they spoiled it. 150

He wallowed down the steam, above his knees in the current, through the fifty yards of shallow water above the pile of logs that crossed the stream. He did not rebait his hook and held it in his hand as he waded. He was certain he could catch small trout in the shallows, but he did not want them. There would be no big trout in the shallows this time of day. 160

Now the water deepened up his thighs sharply and coldly. Ahead was the smooth dammed-back flood of water above the logs. The water was smooth and dark; on the left, the lower edge of the meadow; on the right the swamp. Nick leaned back against the current and took a hopper from the bottle. He threaded the hopper on the hook and spat on him for good luck. Then he pulled several yards of line from the reel and tossed the hopper out ahead onto the fast, dark water. It floated down towards the logs, then the weight of the line pulled the bait under the surface. Nick held the rod in his right hand, letting the line run out through his fingers. 170

There was a long tug. Nick struck and the rod came alive and dangerous, bent double, the line tightening, coming out of water, tightening, all in a heavy, dangerous, steady pull. Nick felt the moment when the leader would break if the strain increased and let the line go. 180

The reel ratcheted into a mechanical shriek as the line went out in a rush. Too fast. Nick could not check it, the line rushing out, the reel note rising as the line ran out. With the core of the reel showing, his heart feeling stopped with the excitement, leaning back against the current that mounted icily his thighs, Nick thumbed the reel hard with his left hand. It was awkward getting his thumb inside the fly reel frame.

As he put on pressure the line tightened into sudden hardness and beyond the logs a huge trout went high out of water.

As he jumped, Nick lowered the tip of the rod. But he felt, as 190 he dropped the tip to ease the strain, the moment when the strain was too great; the hardness too tight. Of course, the leader had broken. There was no mistaking the feeling when all spring left the line and it became dry and hard. Then it went slack.

His mouth dry, his heart down, Nick reeled in. He had never seen so big a trout. There was a heaviness, a power not to be held, and then the bulk of him, as he jumped. He looked as broad as a salmon.

Nick's hand was shaky. He reeled in slowly. The thrill had 200 been too much. He felt, vaguely, a little sick, as though it would be better to sit down.

The leader had broken where the hook was tied to it. Nick took it in his hand. He thought of the trout somewhere on the bottom, holding himself steady over the gravel, far down below the light, under the logs, with the hook in his jaw. Nick knew the trout's teeth would cut through the snell of the hook. The hook would imbed itself in his jaw. He'd bet the trout was angry. Anything that size would be angry. That was a trout. He had been solidly hooked. Solid as a rock. He 210 felt like a rock, too, before he started off. By God, he was a big one. By God, he was the biggest one I ever heard of.

Nick climbed out onto the meadow and stood, water running down his trousers and out of his shoes, his shoes squichy. He went over and sat on the logs. He did not want to rush his sensations any.

He wriggled his toes in the water, in his shoes, and got out a cigarette from his breast pocket. He lit it and tossed the match into the fast water below the logs. A tiny trout rose at the match, as it swung around in the fast current. Nick 220 laughed. He would finish the cigarette.

He sat on the logs, smoking, drying in the sun, the sun warm on his back, the river shallow ahead entering the woods, curving into the woods, shallows, light glittering, big water-smooth rocks, cedars along the bank and white birches, the logs warm in the sun, smooth to sit on, without bark, gray to the touch; slowly the feeling of disappointment left him. It went away slowly, the feeling of disappointment that came sharply after the thrill that made his shoulders ache. It was all right now. His rod lying out on the logs, Nick tied a 230 new hook on the leader, pulling the gut tight until it crimped into itself in a hard knot.

He baited up, then picked up the rod and walked to the far end of the logs to get into the water, where it was not too deep. Under and beyond the logs was a deep pool. Nick walked around the shallow shelf near the swamp shore until he came out on the shallow bed of the stream.

On the left, where the meadow ended and the woods began, a great elm tree was uprooted. Gone over in a storm, it lay back into the woods, its roots clotted with dirt, grass 240 growing in them, rising a solid bank beside the stream. The river cut to the edge of the uprooted tree. From where Nick stood he could see deep channels like ruts, cut in the shallow bed of the stream by the flow of the current. Pebbly where he

stood and pebbly and full of boulders beyond; where it curved near the tree roots, the bed of the stream was marly and between the ruts of deep water green weed fronds swung in the current.

Nick swung the rod back over his shoulder and forward, and the line, curving forward, laid the grasshopper down on 250 one of the deep channels in the weeds. A trout struck and Nick hooked him.

Holding the rod far out toward the uprooted tree and sloshing backward in the current, Nick worked the trout, plunging, the rod bending alive, out of the danger of the weeds into the open river. Holding the rod, pumping alive against the current, Nick brought the trout in. He rushed, but always came, the spring of the rod yielding to the rushes, sometimes jerking under water, but always bringing him in. Nick eased downstream with the rushes. The rod above his 260 head he led the trout over the net, then lifted.

The trout hung heavy in the net, mottled trout back and silver sides in the meshes. Nick unhooked him; heavy sides, good to hold, big undershot jaw and slipped him, heaving and big sliding, into the long sack that hung from his shoulders in the water.

Nick spread the mouth of the sack against the current and it filled, heavy with water. He held it up, the bottom in the stream, and the water poured out through the sides. Inside at the bottom was the big trout, alive in the water. 270

Nick moved downstream. The sack out ahead of him sunk heavy in the water, pulling from his shoulders.

It was getting hot, the sun hot on the back of his neck.

Nick had one good trout. He did not care about getting many trout. Now the stream was shallow and wide. There were trees along both banks. The trees of the left bank made short shadows on the current in the forenoon sun. Nick knew there were trout in each shadow. In the afternoon, after the sun had crossed toward the hills the trout would be in the cool shadows on the other side of the stream. 280

The very biggest ones would lie up close to the bank. You could always pick them up there on the Black. When the sun was down they all moved out into the current. Just when the sun made the water blinding in the glare before it went down, you were liable to strike a big trout anywhere in the current. It was almost impossible to fish then, the surface of the water was blinding as a mirror in the sun. Of course, you could fish upstream, but in a stream like the Black, or this, you had to wallow against the current and in a deep place, the water piled up on you. It was no fun to fish upstream with this much current. 290

Nick moved along through the shallow stretch watching the banks for deep holes. A beech tree grew close beside the river, so that the branches hung down into the water. The stream went back in under the leaves. There were always trout in a place like that.

Nick did not care about fishing that hole. He was sure he would get hooked in the branches.

It looked deep though. He dropped the grasshopper so the current took it under water, back in under the overhanging

branch. The line pulled hard and Nick struck. The trout 300 threshed heavily, half out of water in the leaves and branches. The line was caught. Nick pulled hard and the trout was off. He reeled in and holding the hook in his hand walked down the stream.

Ahead, close to the left bank, was a big log. Nick saw it was hollow; pointing up river the current entered it smoothly, only a little ripple spread each side of the log. The water was deepening. The top of the hollow log was gray and dry. It was partly in the shadow.

Nick took the cork out of the grasshopper bottle and a 310 hopper clung to it. He picked him off, hooked him and tossed him out. He held the rod far out so that the hopper on the water moved into the current flowing into the hollow log. Nick lowered the rod and the hopper floated in. There was a heavy strike. Nick swung the rod against the pull. It felt as though he were hooked into the log itself, except for the live feeling. He tried to force the fish out into the current. It came, heavily.

The line went slack and Nick thought the trout was gone. Then he saw him, very near, in the current, shaking his head, 320 trying to get the hook out. His mouth was clamped shut. He was fighting the hook in the clear flowing current. Looping in the line with his left hand, Nick swung the rod to make the line taut and tried to lead the trout toward the net, but he was gone, out of sight, the line pumping. Nick fought him against the current, letting him thump in the water against the spring of the rod. He shifted the rod to his left hand, worked the trout upstream, holding his weight, fighting on the rod, and then let him down into the net. He lifted him clear of the water, a heavy half circle in the net, the net drip- 330 ping, unhooked him and slid him into the sack.

He spread the mouth of the sack and looked down in at the two big trout alive in the water.

Through the deepening water, Nick waded over to the hollow log. He took the sack off, over his head, the trout flopping as it came out of water, and hung it so the trout were deep in the water. Then he pulled himself up on the log and sat, the water from his trouser and boots running down into the stream. He laid his rod down moved along to the shady end of the log and took the sandwiches out of his pocket. He 340 dipped the sandwiches in the cold water. The current carried away the crumbs. He ate the sandwiches and dipped his hat full of water to drink, the water running out through his hat just ahead of his drinking.

It was cool in the shade, sitting on the log. He took a cigarette out and struck a match to light it. The match sunk into the gray wood, making a tiny furrow. Nick leaned over the side of the log, found a hard place and lit the match. He sat smoking and watching the river.

Ahead the river narrowed and went into a swamp. The 350 river became smooth and deep and the swamp looked solid with cedar trees, their trunks close together, their branches solid. It would not be possible to walk through a swamp like that. The branches grew so low. You would have to keep almost level with the ground to move at all. You could not crash through the branches. That must be why the animals that lived in swamps were built the way they were, Nick thought.

He wished he had brought something to read. He felt like reading. He did not feel like going on into the swamp. He looked down the river. A big cedar slanted all the way across 360 the stream. Beyond that the river went into the swamp.

Nick did not want to go in there now. He felt a reaction against deep wading with the water deepening up under his armpits, to hook big trout in places impossible to land them. In the swamp the banks were bare, the big cedars came together overhead, the sun did not come through, except in patches; in the fast deep water, in the half light, the fishing would be tragic. In the swamp fishing was a tragic adventure. Nick did not want it. He didn't want to go up the stream any further today. 370

He took out his knife, opened it and stuck it in the log. Then he pulled up the sack, reached into it and brought out one of the trout. Holding him near the tail, hard to hold, alive, in his hand, he whacked him against the log. The trout quivered, rigid. Nick laid him on the log in the shade and broke the neck of the other fish the same way. He laid them side by side on the log. They were fine trout.

Nick cleaned them, slitting them from the vent to the tip of the jaw. All the insides and the gills and tongue came out in one piece. They were both males; long gray-white strips of 380 milt, smooth and clean. All the insides clean and compact, coming out all together. Nick took the offal ashore for the minks to find.

He washed the trout in the stream. When he held them back up in the water, they looked like live fish. Their color was not gone yet. He washed his hands and dried them on the log. Then he laid the trout on the sack spread out on the log, rolled them up in it, tied the bundle and put it in the landing net. His knife was still standing, blade stuck in the log. He cleaned it on the wood and put it in his pocket. 390

Nick stood up on the log, holding his rod, the landing net hanging heavy, then stepped into the water and splashed ashore. He climbed the bank and cut up into the woods, toward the high ground. He was going back to camp. He looked back. The river just showed through the trees. There were plenty of days coming when he could fish the swamp. ∎

Reading Question

What does the "swamp" symbolize to Nick?

Summary

■ Trench Warfare and the Literary Imagination

The realities of trench warfare along the Western Front in northeast France and northwest Germany had an immense impact on the Western imagination. The almost unbounded optimism that preceded the war was replaced by a sense of the absurdity of modern life, the fragmentation of experience, and the futility of even daring to hope. The heroic poetry of the prewar generation with its sense of war as an adventure was replaced by startling depictions of war's horror and futility, the possibility of discovering a peaceful life of spiritual fulfillment scotched by the recognition that, in poet William Butler Yeats's words, "the center will not hold" and "mere anarchy is loosed upon the world." Among the most powerful realizations of this condition is T. S. Eliot's poem *The Waste Land*, with, at its center, a depiction of modern love as an empty, mechanical, and meaningless enterprise.

■ Escape from Despair: Dada in the Capitals

Many found the war incomprehensible, and they reacted by creating an art movement based on negation and meaninglessness: Dada. Believing language to be irrevocably debased, they created sound poetry, intelligible only on an emotional level. They constructed works of art based not on thoughtful composition but on the laws of chance. One of their most influential spokesmen, Marcel Duchamp, turned found objects into works of art, including the urinal *Fountain*, which he called "ready-mades." He portrayed modern love in his *Bride Stripped Bare by Her Bachelors, Even* in the same mechanical terms that T. S. Eliot had in *The Waste Land*. Dada, finally, was an art of provocation, but in its very energy, it posited that the forces of creativity might survive.

■ Russia: Art and Revolution

In Russia, political upheaval offered the promise of a new and better life. Led by Vladimir Lenin, the Bolshevik party envisioned an ideal utopian state in which society does away with government and life is lived upon the principle "From each according to his ability: to each according to his needs." In order to bring Russian society into the twentieth century and raise the level of culture in the countryside, Lenin advocated the electrification of the nation. In the arts, Kasimir Malevich pursued an art of emotion driven by his search for the absolute truth he discovered in primary geometric forms, a form of art that he called Suprematism. Soon Malevich sought to apply these principles in more practical ways that might serve a social

purpose—Constructivism, he called it—a geometry-based art that quickly found application in poster and textile design. In film, Sergei Eisenstein's new montage techniques were created to attract a largely illiterate audience through fast-paced editing and composition.

■ Freud, Jung, and the Art of the Unconscious

The era after the war was especially influenced by the work of Sigmund Freud, whose psychoanalytic techniques, especially that of free association, were employed to treat victims of shell shock. Free association required interpretation, and Freud had developed a theory of infantile sexuality and desire that expressed itself in dreams. But after the war, in *Beyond the Pleasure Principle*, he added to his theory of the sex drive, the idea that humans might be equally driven by a death drive that begins to explain self-destructive and aggressive human behaviors, including war, a position further articulated in his 1930 book *Civilization and Its Discontents*. Almost as influential as Freud was his colleague Carl Jung, who believed that the unconscious life of the individual was founded on a deeper, more universal layer of the psyche, which he called the collective unconscious, and which he believed manifested itself in the form of archetypes.

In the arts, the discoveries of Freud and Jung manifested themselves in the Surrealist project of André Breton and his colleagues. Breton championed the art of Giorgio de Chirico and Max Ernst, reproducing their work in the journals that he published. He recruited Picasso to the movement, as well as Picasso's Spanish colleague Joan Miró. Miró in turn introduced Salvador Dalí to the movement. All of these artists, including sculptors like Alberto Giacometti and Meret Oppenheim, openly pursued the undercurrent of Freudian sexual desire that they believed lay at the root of their creative activity.

■ Experimentation and the Literary Life

After the war, writers, many of them working in Paris, struggled to find a way to express themselves authentically in a language that the war had seemed to have left impoverished. Ernest Hemingway attempted to write what he called "one true sentence" in an economical prose style that avoided abstract nouns and created emotion through description. The life of the unconscious was the subject of the stream-of-consciousness novel that rose to prominence in the same era, including James Joyce's *Ulysses*, Virginia Woolf's *Mrs. Dalloway*, and Marcel Proust's *À la recherche du temps perdu*.

 Glossary

archetypes In Jung's view, a pattern of thought that recurs throughout history, and across cultures, in the form of dreams, myths, and fairy tales.

collective unconscious The innate, inherited contents of the human mind.

Dada A movement that developed among European artists and writers as a result of disillusionment with World War I; its founders claimed that it meant nothing, just as, in the face of war, life itself had come to seem meaningless.

ego In Freudian psychology, the part of the human mind that manages the id, mediating between the id's potentially destructive impulses and the requirements of social life.

id In Freudian psychology, the part of the human mind that is the seat of all instinctive, physical desire; the principal mechanism of the subconscious.

montage An image (whether photographic or cinematographic) made by combining several different images.

photomontage A collage work containing photographic clippings.

stream of consciousness A type of narration in which the reader reads only what is experienced in the character's mind from moment to moment, following their thought process through their interior monologue.

sublimation The act of modifying and redirecting the id's primal impulses into constructive social behavior.

superego In Freudian psychology, the seat of what is commonly called "conscience," the psyche's moral base.

 Critical Thinking Questions

1. What characteristic images and themes from the World War I influence the verse of the period?

2. How do Dada and Surrealism reflect the concerns of Freud and Jung?

3. How much do the arts of Russia after 1917 have in common with the arts of the same era in Europe?

4. How do you explain the great motivation of so many American artists and writers to visit and live in Europe after the World War I?

Harlem and the Great Migration

Continuity & Change

In February 1924, a young African American student named Langston Hughes (1902–1967), restless, determined to see the world, and equally determined to become a poet, arrived in Paris. He had graduated from Central High School in Cleveland, Ohio, in 1920. After dropping out of Columbia University in 1922, he made three transatlantic voyages working as a seaman on a freighter that took him to Senegal, Nigeria, the Cameroons, the Belgian Congo, Angola, and Guinea in Africa, and later to Italy and France, Russia, and Spain. Paris did not much impress him. In the second week of March, he wrote his friend, Countee Cullen (1903–1946):

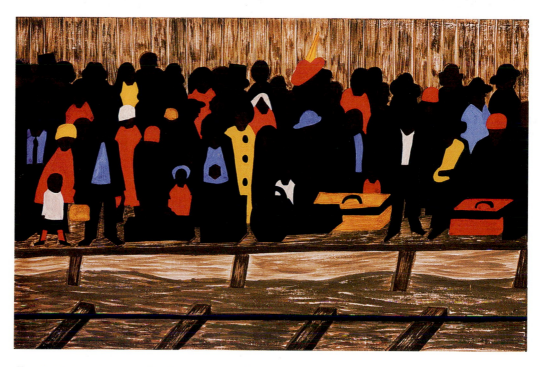

Fig. 42.22 Jacob Lawrence, *The Migration of the Negro*, Panel no. 60: *And the migrants kept coming*, 1940–1941. Casein tempera on hardboard panel, 18″ × 12″. Gift of Ms. David M. Levy. (28.1942.30). Digital Image © The Museum of Modern Art/Licensed by SCALA/Art Resource, NY. © ARS Artists Rights Society, NY.

But about France! Kid, stay in Harlem! The French are the most franc-loving, sou-clutching, hard-faced, hard-worked, cold and half-starved set of people I've ever seen in my life. Heat unknown. Hot water, what is it? You even pay for a smile here. Nothing, absolutely nothing is given away. You even pay for water in a restaurant or the use of the toilette. And do they like Americans of any color? They do not!! Paris, old and ugly and dirty. Style? Class? You see more well-dressed people in a New York subway station in five seconds than I've seen all my three weeks in Paris. Little old New York for me! But the colored people here are fine, there are lots of us.

Over the course of the First World War, Hughes's Harlem—and New York City itself—had changed dramatically. In 1914, nearly 90 percent of all African Americans lived in the South, three-quarters of them in the rural South. But as millions of men in the North went to fight in Europe, a huge demand for labor followed. Lured by plentiful jobs, Southern blacks began to move north—between 200,000 and 350,000 in the years 1915–1918 alone. This Great Migration, as it was called, was later celebrated in a series of 60 paintings by the African-American artist Jacob Lawrence (1917–2000) (Fig. **42.22**),

who moved to Harlem in 1924 at the age of seven, into a cultural community so robust, and so new, that the era has come to be known as the Harlem Renaissance. Lawrence was trained as a painter at the Harlem Art Workshop, and in his teens he was introduced to Hughes. "Without the black community in Harlem, I wouldn't have become an artist," he later said. Lawrence painted his *Migration* series when he was just 23 years old. It won him immediate fame. In 1942, the Museum of Modern Art in New York and the Phillips Collection in Washington, DC, each bought 30 panels. That same year Lawrence became the first black artist represented by a prestigious New York gallery—the Downtown Gallery. In 1949, he would team up with Hughes to illustrate Hughes's own book of poems about the Great Migration, *One Way Ticket*. "I pick up my life," the title poem begins:

And take it with me,
And I put it down in
Chicago, Detroit,
Buffalo, Scranton,
Any place that is
North and East,
And not Dixie. ∎

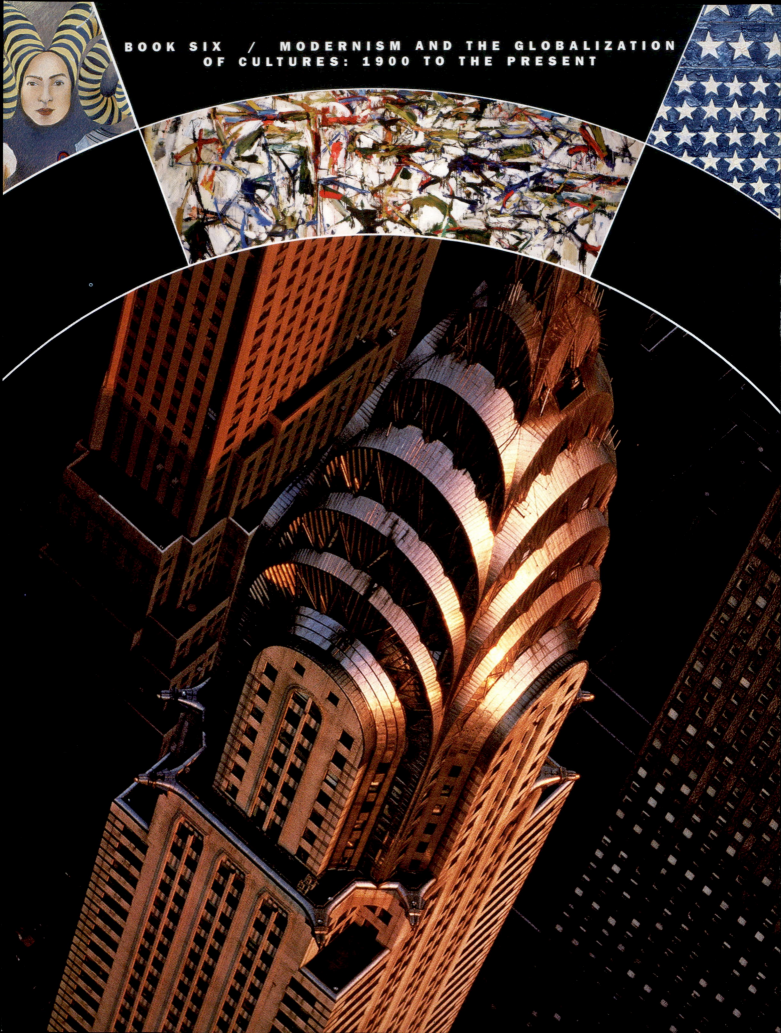

43 New York and Skyscraper Culture

Making it New

Skyscraper and Machine: Architecture in New York

The Harlem Renaissance

Making It New: The Art of Place

The Golden Age of Silent Film: Hollywood in the 1920s

" *As the sun makes it new*

Day by day make it new

Yet again make it new **"**

Ezra Pound's translation from the Confucian *Ta Hsio*

◄ **Fig. 43.1 William van Alen. Chrysler Building, New York. 1928–1930.** The Chrysler Building was designed as almost pure commercial propaganda for Walter P. Chrysler's automotive company, founded in 1925. When completed, it was the tallest building in the world, although it was shortly overtaken by the Empire State Building. Its steel crown, shown in this detail, was understood to be an emblem of the new technological ascendancy of not just the Chrysler Corporation, but America itself.

AFTER THE FIRST WORLD WAR, NEW YORK EXPERIENCED A building boom outstripped only by the growth of its population. The skyscraper, a distinctly American invention, first developed in Chicago, where Louis Sullivan took the lead (see chapter 38), but it found its ultimate expression in New York. There,

skyscrapers were usually commissioned by corporations as their national and international headquarters (see Map **43.1**). The skyscraper was above all a grand advertisement, a symbol of corporate power and prestige that changed the skyline of New York and became a symbol for the city around the world. The Singer Building of 1902 was followed by the Metropolitan Life Tower (1909), the Woolworth Building (1913), the Shelton Towers (1924), the Chrysler Building (1930) (Fig. **43.1**), the Empire State Building (1931), and the RCA Building (1933). Each strove to be the world's highest, and briefly was, until succeeded, often within a matter of months, by the next. From Wall Street to midtown, construction boomed, and the rapid pace of building mirrored the frenetic pace of New York City itself. Like the pre–World War I years, movement and speed defined the era. Until the stock market crash of 1929, New York was the center of world commerce. Uptown, in Harlem, nightlife thrived—in the clubs and cabarets life seemed to continue 24 hours a day. Despite Prohibition, which had outlawed the production, transportation, and sale of alcoholic beverages in 1920, liquor was plentiful, and white socialites from downtown filled the jazz clubs, dancing the night away to the bands that catered to their sense of freedom—and the "outlaw" status that their willful disregard for Prohibition underscored.

It was, as one prominent writer of the era recognized, a Jazz Age—a world moving to its own beat, improvising as it went along, discovering new and unheard-of chords with which life might resonate. The stock market boomed, money flowed, and American industry thrived. And everywhere one looked, new buildings, new products, new creations, and new works of art competed for the public's attention. Across the country in Hollywood, the film industry advanced the new, machine-created art that seemed to capture the spirit of the day. "Make it new" was the catchphrase of the era.

Skyscraper and Machine: Architecture in New York

The era's spirit of innovation spawned a new appreciation for the aesthetic properties of their machine design, an appreciation that was probably first inspired by Marcel Duchamp's sculpture, *Fountain*, the "ready-made" urinal (see Fig. 42.5). This machine aesthetic was most fully articulated by Alfred H.

Barr, Jr. (1902–1981), director of the new Museum of Modern Art in New York, and his young curator of architecture, Philip Johnson (1906–2005), in an exhibition entitled *Machine Art* (Fig. **43.2**). The subject of enormous press coverage when it opened in 1934, the exhibit featured springs, propellers, ball bearings, kitchen appli-

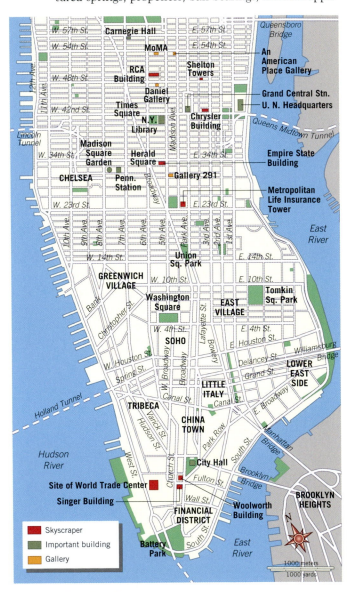

Map 43.1 **New York City skyscrapers.**

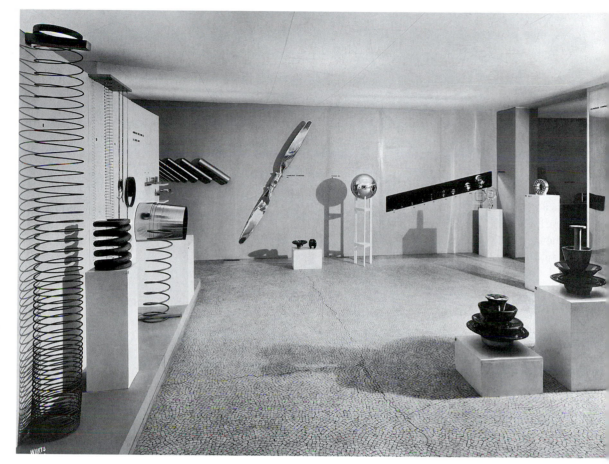

Fig. 43.2 Installation view, *Machine Art* Exhibition, The Museum of Modern Art, NY. 1934. Photograph by Wurts Brothers, Digital Image The Museum of Modern Art/Licensed by SCALA / Art Resource, NY. If the machine was transforming culture, it might also reflect, the curators of the Museum of Modern Art argued in 1934, an aesthetic of the "new," a purity of form that seemed to them to increasingly embody the modern idea of beauty.

ances, laboratory glass and porcelain (including boiling flasks made from Pyrex, a new durable material that would transform modern kitchenware), and machine parts displayed on pedestals. Crowds thronged to the museum to see the 402 items Barr and Johnson had chosen. All of these objects were defined by their simple geometric forms, symmetry, balance, and proportion—in short a new, machine-inspired classicism.

Earlier in the century, Alfred Stieglitz had proposed that modern art—and his own photography in particular—should concern itself with revealing the underlying geometries of the world (see chapter 41). In 1925, Stieglitz moved into an apartment on the 30th floor of the 36-story Shelton Towers (see Map 43.1), and from his window he began to photograph the city rising around him—the grids of buildings under construction, the rhythmic repetition of window and curtain wall, the blocks of form delineated by the intense contrast of black and white in the photographic print (Fig. **43.3**). In the

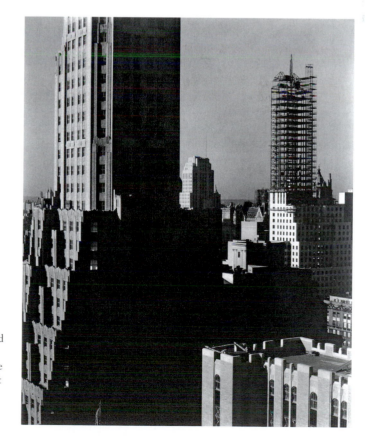

Fig. 43.3 Alfred Stieglitz *Looking Northwest from the Shelton, New York.* 1932. Gelatin silver print, $9\frac{1}{2}'' \times 7\frac{9}{16}''$. The Metropolitan Museum of Art, NY, U.S.A. Ford Motor Company Collection, Gift of Ford Motor Company and John C. Waddell, 1987 (1987.1100.11). Image copyright © The Metropolitan Museum of Art/Art Resource, NY. © 2008 ARS Artists Rights Society, NY. The Shelton Towers, on Lexington Avenue between 48th and 49th streets, was built in 1924. At 36 stories it was the tallest building in the world, a record soon surpassed as this photograph, taken from Stieglitz's suite on the 30th floor, suggests.

skyscraper, he believed he had discovered the underlying geometry of modernity itself.

Stieglitz lived in the Shelton Towers for 12 years, and from his window he witnessed a building boom like none other in the history of architecture. In the second half of the 1920s, the city's available office space increased by 92 percent. By the early

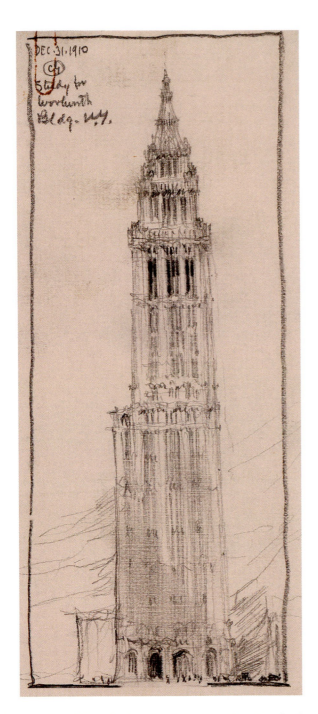

Fig. 43.4 Cass Gilbert. *Woolworth Building, New York City, sketch elevation.* December 31, 1910. Graphite on paper. Library of Congress, Prints and Photographs Division. Gilbert's sketch captures the building's Gothic spirituality even better than actual photographs of the finished building, which was completed in 1913.

1930s, after buildings begun before 1929 were completed, the available space increased another 56 percent. The building frenzy took place in an atmosphere of intense debate among architects themselves. On one side were those who advocated an austere, clean modernism that revealed its plain geometries, what Alfred H. Barr and Philip Johnson would come to call the International Style. On the other side of the debate were the traditionalists whose decorative style was epitomized by the Woolworth Building (Fig. **43.4**). Writing about its neo-Gothic facade, architect Cass Gilbert (1859–1934) described it as follows: "A skyscraper, by its height . . . a monument whose masses must become more and more inspired the higher it rises. . . . The Gothic style gave us the possibility of expressing the greatest degree of aspiration . . . the ultimate note of the mass gradually gaining in spirituality the higher it mounts." From the modernist point of view, Gilbert's building represented the height of absurdity, and "Woolworth Gothic" became synonymous with bad taste, but building after building continued to emulate the Woolworth's emphasis on decorative styling (see *Focus*, pages 1390–1391). But whatever its style, the skyscraper pointed to the sky, climbing into the heavens as the architectural embodiment of promise and hope for the future.

The Harlem Renaissance

While skyscrapers rose downtown—almost literally symbols of American ascendancy—uptown in Harlem, a new cultural center began to define itself. By the mid-1920s, both white and black Americans understood that Harlem was the focal point of a new, vibrant sense of cultural possibility. This sense of possibility had been inaugurated by the mass migration of blacks out of the South into the North after the outbreak of World War I (see Fig. 42.22). In 1914, nearly 90 percent of all African Americans lived in the South, three-quarters of them in the rural South. But lured by a huge demand for labor in the North once the War began, and impoverished after a boll weevil infestation ruined the cotton crop, blacks flooded into the North. In the course of a mere 90 days early in the 1920s, 12,000 African Americans left Mississippi alone. An average of 200 left Memphis every night. Many met with great hardship, but there was wealth to be had as well, and anything seemed better than life under Jim Crow in the South.

The Origins of the Harlem Renaissance

If the social roots of the Harlem Renaissance can be traced back to the Great Migration during the First World War, the philosophical roots reach back to the turn of the century and the work of black historian and sociologist W.E.B. DuBois (1868–1963), whose *The Philadelphia Negro* (1899) was the first sociological text on a black community published in the United States. In 1903, in his book *The Souls of Black Folk*, DuBois had proposed that the identity of African Americans was fraught with ambiguity (**Reading 43.1**):

READING 43.1 from W. E. B. DuBois, *The Souls of Black Folk* (1903)

[America] yields him no true self-consciousness. . . . It is a peculiar sensation, this double-consciousness, this sense of always looking at one's self through the eyes of others, of measuring one's soul by the tape of a world that looks on in an amused contempt and pity. One ever feels his two-ness,—an American, a Negro; two souls, two thoughts, two unreconciled strivings; two warring ideals in one dark body, whose dogged strength alone keeps it from being torn asunder.

The history of the American Negro is the history of this strife,—this longing to attain self-conscious manhood, to merge his double self into a better and truer self. In this merging he wishes neither of the older selves to be lost. He would not Africanize America, for America has too much to teach the world and Africa. He would not bleach his Negro soul in a flood of white Americanism, for he knows that Negro blood has a message for the world. He simply wishes to make it possible for a man to be both a Negro and an American, without being cursed and spit upon by his fellows, without having the doors of Opportunity closed roughly in his face.

READING 43.2 Claude McKay, "If We Must Die" (1919)

If we must die—let it not be like hogs
Hunted and penned in an inglorious spot,
While round us bark the mad and hungry dogs,
Making their mock at our accursed lot.

If we must die—oh, let us nobly die,
So that our precious blood may not be shed
In vain; then even the monsters we defy
Shall be constrained to honor us though dead!

Oh, Kinsmen! We must meet the common foe;
Though far outnumbered, let us show us brave,
And for their thousand blows deal one deathblow!
What though before us lies the open grave?

Like men we'll face the murderous, cowardly pack,
Pressed to the wall, dying, but fighting back!

When in 1909 the National Association for the Advancement of Colored People (NAACP) was founded to advance the rights of blacks, DuBois became editor of its magazine, *The Crisis*. His sense of the double-consciousness informing African-American experience (a double-consciousness that informs the very term "African American") was often expressed in the magazine's pages.

This double-consciousness is especially apparent in the work of Claude McKay (1889–1948), a poet who generally published in white avant-garde magazines and only occasionally in magazines like *The Crisis*. His poem "If We Must Die" was inspired by the race riots that exploded in the summer and fall of 1919 in a number of cities in both the North and South. The three most violent episodes of what came to be known as the "Red Summer" occurred in Chicago, Washington, DC, and Elaine, Arkansas, all started by whites, who were stunned when blacks fought back. A "Southern black woman," as she identified herself, wrote a letter to *The Crisis*, praising blacks for fighting back: "The Washington riot gave me a thrill that comes once in a life time . . . at last our men had stood up like men. . . . I stood up alone in my room . . . and exclaimed aloud, 'Oh I thank God, thank God.' The pent up horror, grief and humiliation of a life time—half a century—was being stripped from me." McKay's poem expresses the same militant anger (**Reading 43.2**):

Ironically, years later, during World War II, British Prime Minister Winston Churchill would use the poem, without acknowledging its source—probably without even knowing it—to rally British and American troops fighting in Europe. That Churchill could so transform the poem's meaning is indicative of its very doubleness. Written in sonnet form, it harks back to the genteel heroism of Alfred, Lord Tennyson's "Charge of the Light Brigade" (see chapter 42, page 1352), and yet it was, in its original context, a call to arms.

McKay's book of poems, *Harlem Shadows*, is one of the first works by a black writer to be published by a mainstream, national publisher (Harcourt, Brace and Company). Together with the novel *Cane* (1923), by Jean Toomer, an experimental work that combined poetry and prose in documenting the life of American blacks in the rural South and urban North, it helped to launch the burst of creative energy that came to be known as the Harlem Renaissance.

"The New Negro"

Perhaps the first self-conscious expression of the Harlem Renaissance took place at a dinner party, on March 21, 1924, hosted by Charles S. Johnson (1893–1956) of the National Urban League. The League was dedicated to promoting civil rights and helping black Americans address the economic and social problems they encountered as they resettled in the urban North. At Johnson's dinner, young writers from Harlem were introduced to New York's white literary establishment. A year later, the *Survey Graphic*, a national magazine dedicated to sociology, social work, and social analysis, produced an issue dedicated exclusively to Harlem. The issue,

Focus

William van Alen's Chrysler Building

Before the Great Depression brought the American economy to a crashing halt, the stock market boom generated expansive building projects across the country, especially in New York, where entrepreneurs saw the opportunity to construct tall skyscrapers that would serve both as symbols of their own prestige and wealth and as massive advertisements for their businesses.

John D. Rockefeller II hired Raymond Hood to design his signature Rockefeller Center, beginning in 1929, with the RCA building as its focal point. But automobile tycoon Walter Chrysler's Chrysler Building was pure advertisement, and it consciously ignored the call for simplicity and lack of ornamentation that modernists, championing the International Style, preferred. The site was opposite Grand Central Station on 42nd Street and Lexington Avenue, at the very heart of Manhattan. Chrysler informed William van Alen, his architect, that he expected the building to be the tallest building in the world, "higher than the Eiffel Tower."

Van Alen's former partner, H. Craig Severance, had already broken ground for the Bank of Manhattan Trust Building at 40 Wall Street (today the Trump Building), and the two entered into a fierce competition. When Sever-

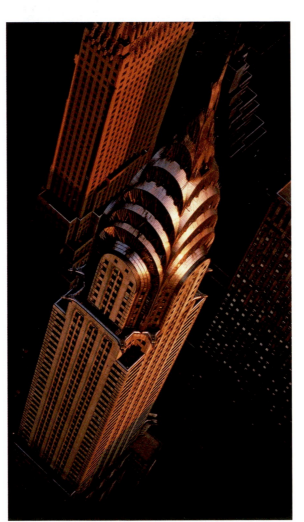

William van Alen. Chrysler Building, New York. 1928–1930.

ance's building was completed, just months before van Alen's, it was, at 71 stories and 927 feet tall, the tallest structure in the world. Then van Alen surprised everyone. He had secretly constructed a 185-foot spire inside his building, and he hoisted it up through the roof and bolted it in place. The Chrysler Building was now a staggering 77 stories and 1,046 feet tall.

The first six floors of the spire were reserved for Walter Chrysler's private use. They included an observation deck, and a lounge displaying his personal tool box, consisting of forged and tempered steel tools that Chrysler made by hand when he was 17 years of age and that he referred to as the "tools that money couldn't buy." The exterior of the spire was crowned with a stainless steel crest, punctuated by triangular windows in radiating semicircles (designed to evoke Chrysler hubcaps). At night, the windows were lit, adding a new graceful, arcing form to the increasingly rectilinear horizon of the New York cityscape.

Within a year, the Empire State Building became the world's tallest building, at 102 stories and 1,250 feet high. But aside from its sheer size, the Chrysler Building's decoration was what set it apart. It was self-consciously Art Deco, a term coined in the 1960s after the 1925 "Arts Décoratifs" exhibition in Paris to describe a style that was known at the time as *Art Moderne*, noted for its highly stylized forms and exotic materials.

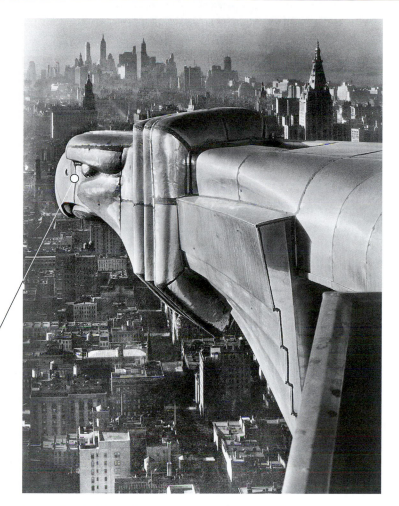

The Chrysler Building was the first to use stainless steel over a large exterior surface, specifically over the tower with it arcs and sunbursts meant to express optimism for the future. Around the thirty-first floor, Chrysler hubcaps were placed in brickwork shaped like tires. At the corners of the thirty-first floor were replicas of late 1920s Chrysler radiator caps, and from the sixty-first floor, giant stainless steel eagles, replicas of Chrysler's hood ornaments, pointed their beaks outward like gargoyles.

Margaret Bourke-White. *Chrysler Building: Gargoyle outside Margaret Bourke-White's Studio.* **1930.** Gelatin silver print, $12\frac{15}{16}'' \times 9\frac{1}{4}''$. Courtesy George Eastman House, Rochester, NY.

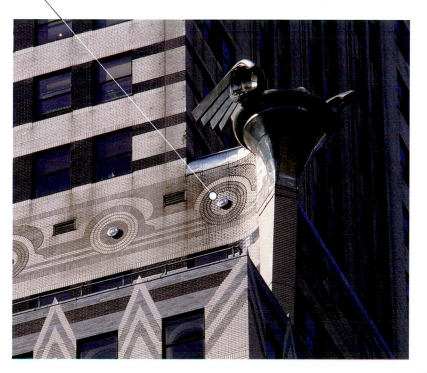

The Chrysler radiator cap, used on late 1920s Chryslers and Imperials, was positioned at the corners of the 31st floor of the building (right). Note that the brickwork represents a series of automobile front hoods and front tires.

subtitled *Harlem: Mecca of the New Negro*, was edited by Alain Leroy Locke (1886–1954), an African-American professor of philosophy at Howard University in Washington, DC. He was convinced that a new era was dawning for black Americans, and wrote a powerful introduction to a new anthology. In his essay, sometimes referred to as the manifesto of the New Negro Movement, Locke argued that Harlem was the center of this new arena of creative expression (**Reading 43.3**):

READING 43.3 **Alain Locke,
The New Negro (1925)**

[T]here arises a] consciousness of acting as the advance-guard of the African peoples in their contact with Twentieth Century civilization . . . [and] the sense of a mission of rehabilitating the race in world esteem from that loss of prestige for which the fate and conditions of slavery have so largely been responsible. Harlem, as we shall see, is the center of both these movements. . . . The pulse of the Negro world has begun to beat in Harlem. . . . The New Negro . . . now becomes a conscious contributor and lays aside the status of beneficiary and ward for that of a collaborator and participant in American civilization. The great social gain in this is the releasing of our talented group from the arid fields of controversy and debate to the productive fields of creative expression. . . . And certainly, if in our lifetime the Negro should not be able to celebrate his full initiation into American democracy, he can at least, on the warrant of these things, celebrate the attainment of a significant and satisfying new phase of group development, and with it a spiritual Coming of Age.

In Locke's view, each ethnic group in America had its own identity, which it was entitled to protect and promote, and this claim to cultural identity need not conflict with the claim to American citizenship. Locke further emphasized that the spirit of the young writers who were a part of this anthology would drive this new Harlem-based movement by focusing on the African roots of black art and music, but they would, in turn, contribute mightily to a new, more inclusive American culture.

Among the many poems and stories published in the *Survey Graphic* and *The New Negro* is "Heritage" by Countee Cullen (1903–1946) (Fig. 43.5). Cullen was the adopted son of Frederick Cullen, pastor of the Salem Methodist Episcopal church in Harlem and his wife, Carolyn, both of whom had strong ties to the NAACP and the National Urban League. Cullen later described his life in their household as a constant attempt at "reconciling a Christian upbringing with a pagan inclination." "Heritage" investigates that tension (see **Reading 43.4**, page 1412, for the complete poem):

Lamb of God, although I speak
With my mouth thus, in my heart
Do I play a double part.
Ever at Thy glowing altar
Must my heart grow sick and falter,
Wishing He I served were black . . .

Although the poem has been criticized for its romantic depiction of Africa, it remains a powerful statement of DuBois's sense of African-American double-consciousness. As cultural historian Houston Baker, Jr., has described it in *Afro-American Poetics: Revisions of Harlem and the Black Aesthetic*, "The entire poem is placed in a confessional framework as the narrator tries to define his relationship to some white, . . . being and finds that a black impulse ceaselessly draws him back."

Fig. 43.5 Carl Van Vechten. *Portrait of Countee Cullen in Central Park.* **1941.** Gelatin silver photographic print. Library of Congress Prints and Photographs Division, Washington, DC. The photographer, Carl Van Vechten (1880–1964), was a white novelist whose photographs of Harlem Renaissance figures comprise one of the most important documentary records of the era. His popular 1926 novel *Nigger Heaven*, named after the top tier of seats reserved for blacks in a segregated theater, was white America's introduction to Harlem culture, although the black intelligentsia almost unanimously condemned it for its depiction of Harlem as an amoral playground.

Voices

The Jazz Capital of the World

The Harlem Renaissance was a multifaceted social and cultural phenomenon that drew the attention of daily newspapers such as the New York Times. In the article below, some antiquated language and attitudes combine with interesting details of the economic prosperity that provided the foundation for the burst of cultural creativity in 1920s Harlem.

> **"Downtown specialists who have wearied of the tricks of Broadway come northward to this new centre of pleasure."**

Black fingers whipping furiously over the white keys, beating out cascades of jazz; black bodies swaying rhythmically as their owners blow or beat or pluck the grotesque instruments of the band; on the dancing floor throngs, black and white, sliding, halting, swinging back madly in time to the music—this is Harlem of the cabarets, jazz capital of the world. Downtown specialists who have wearied of the tricks of Broadway come northward to this new centre of pleasure. In some of the fifteen cabarets black and white eat together, dance together in the rich abandon of the race which evolved that first jazz classic, the Memphis Blues; which refined the cakewalk into the fantastic fling of the "Charleston." But this is only one Harlem. Jazz is only the foam on the surface. Beneath it lie depths of which New York, rumbling under it on the subway, or past it on the elevated or bus, little dreams.

Fifteen years ago, Harlem looked much as it does today on the surface—a prosperous district north of Central Park, with brownstone houses bordering the broad streets with costly churches, magnificent avenues.... About 1904 a few Negroes began to trickle in east of Lenox Avenue. The district had been overbuilt, and a Negro real estate operator, Phillip A. Payton offered to fill the vacant houses with self-respecting Negro tenants.... With the [First World] War a black tide of laborers rolled in from the south and the West Indies to [New York] where work was waiting at wages beyond their rosiest dreams. The white resistance in Harlem broke. And then a strange thing happened. According to all popular legends, those Negroes who were earning big money for the first time in their lives should have spent it all on silk shirts and white buckskin shoes. But they did no such thing. They bought real estate.

This theme of "doubleness" was underscored when the poem appeared in *Survey Graphic*. There it was illustrated by photographs of African statues and masks, reproduced from the collection of the Barnes Foundation in Philadelphia. Albert C. Barnes, who had made his fortune from the development of an antiseptic drug, was particularly noted not only for his collection of modern art, including Matisse's *Bonheur de vivre* (see Fig. 41.4), but also for his early and vigorous collecting of African art. In an article for the *Survey Graphic*, entitled "Negro Art and America," Barnes wrote:

> The renascence [sic] of Negro art is one of the events of our age which no seeker for beauty can afford to overlook. It is as characteristically Negro as are the primitive African sculptures. As art forms, each bears comparison with the great art expressions of any race or civilization. In both ancient and modern Negro art we find a faithful expression of a people and of an epoch in the world's evolution.

This kind of support from the white establishment was central to the cultural resurgence of Harlem. Many of New York's whites also supported the uptown neighborhood's thriving nightlife scene. Prohibition, and the speakeasies it spawned, had created in Harlem a culture of alcohol, nightlife, and dancing, and with them, the loose morality of the party life, indulged in particularly by the white clientele that the clubs catered to.

Langston Hughes and the Poetry of Jazz

As the young poet Langston Hughes (1902–1967) later put it, "Negro was in vogue." Hughes was among the new young poets that Locke published in *The New Negro*, and the establishment publishing house, Knopf, would publish his book of poems, *Weary Blues*, in 1926. Twenty-two years of age in 1924, Hughes had gone to Paris seeking a freedom he could not find at home (see *Continuity and Change*, chapter 42). He was soon writing poems inspired by the jazz rhythms he was hearing played by the African-American bands in the clubs where he worked as a busboy and dishwasher. The music's syncopated rhythms can be heard in poems such as "Jazz Band in a Parisian Cabaret" (**Reading 43.5a**):

> **READING 43.5a** **from Langston Hughes, "Jazz Band in a Parisian Cabaret" (1925)**
>
> *Play that thing,*
> Jazz band!
> Play it for the lords and ladies,
> For the dukes and counts,
> For the whores and gigolos,

For the American millionaires,
And the school teachers
Out for a spree.
.
You know that tune
That laughs and cries at the same time
.
May I?
Mais oui,
Mein Gott!
Parece una rumba.
Play it, jazz band!

African Americans like Hughes had been drawn to Paris by reports of black soldiers who had served in World War I, in the so-called Negro divisions, the 92nd and 93rd infantries. Jazz itself was introduced to the French by Lieutenant Jimmy Europe, whose 815th Pioneer Infantry band played in city after city across the country. They had experienced something they never had in the United States—total acceptance by people with white skin. Paris presented itself after the war as the new land of freedom—and opportunity. But Harlem, largely because of the efforts of DuBois, Johnson, and Locke, soon replaced Paris in the African-American imagination.

In Harlem, Hughes quickly became one of the most powerful voices. His poems (see **Reading 43.5**, page 1413, for a selection) narrate the lives of his people, capturing the inflections and cadences of their speech. In fact, the poems celebrate, most of all, the inventiveness of African-American culture, especially the openness and ingenuity of its music and language. Hughes had come to understand that his cultural identity rested not in the grammar and philosophy of white culture, but in the vernacular expression of the American black, which he could hear in its music (the blues and jazz especially) and its speech.

Zora Neale Hurston and the Voices of Folklore

The writer and folklorist Zora Neale Hurston (1891–1960) felt the same way. Slightly younger than many of her other Harlem Renaissance colleagues, while still an undergraduate at Howard University she attracted the attention of Hughes when she published a short story, "Spunk," in the black journal *Opportunity*. She transferred to Columbia, where she finished her degree under the great anthropologist Franz Boas, undertaking field research from 1927 to 1932 to collect folklore in the South. Her novel, *Their Eyes Were Watching God* (1937), takes place in a town very much like her native Eatonville, Florida, where she was raised. Its narrator, Janie Crawford, has returned home after being away for a very long time. The townsfolk, particularly the women, are petty, unwelcoming, and gossipy.

From the outset, Hurston's writing concerned itself primarily with the question of African-American identity—

an identity she located in the vernacular speech of her native rural South and in the stories of the people who lived there. Her own complex sense of identity as an African American is the subject of her short essay, "How It Feels to Be Colored Me," in which she finds herself most conscious of her race in relation to a white companion who cannot identify with the jazz they hear in a Harlem club (see **Reading 43.6**, page 1414).

Hurston's mastery of the dialect and the nuances of African-American speech is unsurpassed, as this excerpt from her short story, "The Gilded Six-Bits," reveals. Missie May and her husband Joe are discussing the arrival in town of Otis D. Slemmons:

READING 43.7 from Zora Neale Hurston, "The Gilded Six-Bits" (1933)

"Ah went down to de sto' tuh git a box of lye and Ah seen 'im standin' on de corner talkin' to some of de mens, and Ah come on back and went to scrubbin' de floor, and he passed and tipped his hat whilst Ah was scourin' de steps. Ah thought Ah never seen him befo'."

Joe smiled pleasantly. "Yeah, he's up to date. He got de finest clothes Ah ever seen on a colored man's back."

"Ah he don't look no better in his clothes than you do in yourn. He got a puzzle gut on 'im and he so chuckle-headed, he got a pone behind his neck."

Joe looked down at his own abdomen and said wistfully, "Wisht Ah had a build on me lak he got. He ain't puzzle-gutted, honey. He jes' got a corporation. Dat make 'im look lak a rich white man. All rich mens is got some belly on 'em."

"Ah seen de pitchers of Henry Ford and he's a spare-built man and Rockefeller look lak he ain't got but one gut. But Ford and Rockefeller and dis Slemmons and all de rest kin be as many-gutted as dey please, Ah'm satisfied wid you jes' lak you is, baby. God took pattern after a pine tree and built you noble. Youse a pritty man, and if Ah knowed any way to make yo mo' pretty still Ah'd take and do it."

At the end of *Their Eyes Were Watching God*, Phoeby says to Janie, "Ah done growed ten feet higher from jus' listenin' tuh you." In fact, for Hurston such storytelling is empowering in its own right.

All That Jazz

By the time of the Great Migration, jazz had established itself as the music of African Americans. So much did the music seem to define all things American that the novelist F. Scott Fitzgerald (1896–1940) entitled a collection of short stories published in 1922 *Tales of the Jazz Age*, and the name stuck.

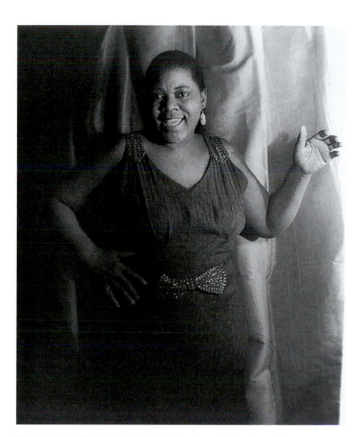

Fig. 43.6 Carl Van Vechten. Bessie Smith. n.d. Black-and-white negative, 4″ × 5″. Yale Collection of American Literature, Beinecke Rare Book and Manuscript Library. Van Vechten was a white journalist, author, and photographer who actively promoted black artists and writers in the 1920s. His collection of photographs and other documents pertaining to the Harlem Renaissance remains one of the era's most important documentary records.

By the end of the 1920s, jazz was *the* American music, and it was almost as popular in Paris and Berlin as it was in New York, Chicago, and New Orleans. As we saw in chapter 38, it originated in New Orleans in the 1890s, probably the most racially diverse city in America, particularly in the ragtime piano music of Scott Joplin and others. But it had deep roots as well in the blues.

The Blues and Their "Empress," Bessie Smith If syncopated rhythm is one of the primary characteristics of jazz, another is the **blue note**. Blue notes are slightly lower or flatter than conventional pitches. In jazz, blues instrumentalists or singers commonly "bend" or "scoop" a blue note—usually the third, fifth, or seventh notes of a given scale—to achieve heightened emotional effects. Such effects were first established in the blues proper, a form of song that originated among enslaved black Americans and their descendants.

The **blues** are by definition laments bemoaning loss of love, poverty, or social injustice, and they contributed importantly to the development of jazz. The standard blues form consists of three sections of four bars each. Each of these sections corresponds to the single line of a three-line stanza, the first two lines of which are the same. In his 1925 poem "Weary Blues,"

Langston Hughes describes listening to a blues singer in a Harlem club (see **Reading 43.5**, page 1413 for the entire poem):

> Droning a drowsy syncopated tune,
> Rocking back and forth to a mellow croon,
> I heard a Negro play.
> Down on Lenox Avenue the other night
> By the pale dull pallor of an old gas light
> He did a lazy sway . . .
> He did a lazy sway . . .
>
> Thump, thump, thump, went his foot on the floor.
> He played a few chords then he sang some more—
> "I got the Weary Blues
> And I can't be satisfied.
> I got the Weary Blues
> And I can't be satisfied.
> I ain't happy no mo'
> And I wish that I had died."

The last lines are the standard blues form (expanded by Hughes to six instead of three lines for the sake of his own poetic meter).

Early blues artists whose performances are preserved on record include Ma Rainey (1886–1939) and Blind Willie Johnson (1902–1947). But perhaps the greatest of the 1920s blues singers was Bessie Smith (1892–1937), who grew up in Tennessee singing on street corners to support her family (Fig. **43.6**). In 1923, when she was 29 years old, she made her first recording, and audiences were stunned by the feeling that she brought to her performances. She was noted particularly for the way she added a chromatic note before the last note of a line, so that, in her *Florida-Bound Blues* (see **CD-Track 43.1**), for instance,

becomes

The additional note might be delivered quickly, or it might be stretched out, adding an extended sense of dissonance and anguished tension to the blues form. When, by the early 1930s, audiences began to prefer a less rough approach to the blues, Smith's popularity waned. Nor did she fit the more acceptable image of the light-skinned, white-featured black entertainer. Traveling from one-night stand to one-night stand in honky-tonks across the Deep South, she died in an automobile accident in 1937.

CULTURAL PARALLELS

Shanghai and New York

While New York was a global center of culture and entertainment in the 1920s and 1930s, Shanghai, China, offered spirited competition. Home to over 3 million Chinese and close to 100,000 foreigners, Shanghai was the country's banking and commercial center, drawing businessmen from across Asia and Europe as well as refugees from Hitler's Germany and Stalin's Russia. Drugs were readily available, and alongside the Western-style department stores, skyscrapers, and genteel British men's clubs, the broad avenues were filled with rickshaws and American cars. The heady atmosphere of jazz, spy rings, writers, artists, and celebrities created a place where, a British writer said, "the extraordinary had become ordinary: the freakish commonplace."

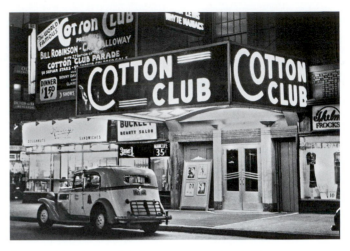

Fig. 43.7 The Cotton Club, Lenox Avenue and 143rd Street. Early 1930s. Corbis-Bettmann Photo Archive. In 1927, Duke Ellington's orchestra was hired to play at the club, and soon Cab Calloway's band alternated with Ellington. It was also at the Cotton Club that Lena Horne began her career in 1933, at age 16.

Dixieland and Louis Armstrong in Chicago The bands that played around 1910–1920 in the red-light district of New Orleans, the legendary Storeyville, quickly established a standard practice. A "front line," consisting of trumpet (or cornet), clarinet, and trombone, was accompanied by banjo (later guitar), piano, bass, and drums. In **Dixieland jazz**, as it came to be known, the trumpet carried the main melody, the clarinet played off against it with a higher countermelody, while the trombone played a simpler, lower tune. The most popular forms of Dixieland were the standard 12-bar blues and a 32-bar AABA form. The latter consists of four eight-measure sections. Generally speaking, the trumpet plays the basic tune for the first 32 measures of the piece, then the band plays variations on the tune in a series of solo or collective improvisations keeping to the 32-bar format. Each 32-bar section is called a "chorus."

When Storeyville was shut down in 1917 (on orders from the U.S. Navy, whose sailors' discipline they believed was threatened by its presence), many of the bands that had played in the district joined the Great Migration and headed north. Among them was trumpeter Louis Armstrong (1900–1971), who arrived in Chicago in 1922 to play for Joe Oliver's Creole Jazz Band. The pianist and composer Lil Hardin (1898–1971) was the pianist and arranger for Oliver's band, and the two were married in 1924. Soon, Armstrong left Oliver's band to play on his own. He formed two studio bands composed of former New Orleans colleagues, the Hot Five and the Hot Seven, with whom he made a series of ground-breaking recordings. One, *Hotter Than That* (see **CD-Track 43.2**), written by Hardin and recorded in 1927, is based on a 32-bar form over which the performers improvise. In the third chorus, Armstrong sings in nonsense syllables, a method known as **scat**. This is followed by another standard form of jazz band performance, a **call-and-response** chorus between Armstrong and guitarist Lonnie Johnson, the two imitating one another as closely as possible on their two different instruments.

Swing: Duke Ellington at the Cotton Club The same year that Armstrong recorded *Hotter Than That*, Duke Ellington, born Edward Kennedy Ellington in Washington, DC (1899–1974), began a five-year engagement at Harlem's Cotton Club (Fig. **43.7**). The Cotton Club itself was owned by a gangster who used it as an outlet for his "Madden's #1 Beer," which, like all alcoholic beverages, was banned after National Prohibition was introduced in 1920. The Club's name was meant to evoke leisurely plantation life for its "white only" audience who came to listen to its predominantly black entertainers.

Ellington had formed his first band in New York in 1923. His 1932 *It Don't Mean a Thing (If It Ain't Got That Swing)* (see **CD-Track 43.3**) introduced the term **swing** to jazz culture. (A particularly clear example of a "blue note" can be heard, incidentally, on the first "ain't" of the first chorus of *It Don't Mean a Thing*.) Swing is characterized by big bands—as many as 15 to 20 musicians, including up to five saxophones (two altos, two tenors, and a baritone)—resulting in a much bigger sound. Its rhythm depends on subtle avoidance of downbeats with the solo instrument attacking the beat either just before or just after it.

By the time Ellington began his engagement at the Cotton Club, commercial radio was seven years old, and many thousands of American homes had a radio. Live radio broadcasts from the Cotton Club brought Ellington national fame, and he was widely imitated throughout the 1930s by bands who toured the country. These included bands led by clarinetist Benny Goodman, soon known as "the King of Swing"; trumpeter Harry James; trombonist Glenn Miller; trombonist Tommy Dorsey; pianist Count Basie; and clarinetist Artie Shaw. These bands also featured vocalists, and they introduced the country to Frank Sinatra, Bing Crosby, Perry Como, Sarah Vaughan, Billy Holiday, Peggy Lee, Doris Day, Rosemary Clooney, and Ella Fitzgerald.

Jazz influenced almost every form of music after 1920. Debussy imitated rag in his 1908 *Golliwog's Cakewalk*. Stravinsky composed a *Ragtime for Eleven Instruments* in 1917. The American composer George Gershwin incorporated jazz rhythms into his 1924 piano and orchestra composition, *Rhapsody in Blue*, and his 1935 opera *Porgy and Bess* incorporated jazz, blues, and spiritual in a way that revived musical theater and paved the way for the great musicals of the 1940s and 1950s. In fact, *Porgy and Bess* has been staged and recorded both by jazz greats—Louis Armstrong and Ella Fitzgerald—and by professional opera companies, bridging the gap between popular art and high culture as few works before it ever had.

The Visual Arts in Harlem

The leading visual artist in Harlem in the 1920s was Aaron Douglas (1898–1979), a native of Topeka, Kansas, who arrived in Harlem in 1925. His first major work was as illustrator of a book of verse sermons by the Harlem Renaissance poet and executive secretary of the NAACP James Weldon Johnson (1871–1938), *God's Trombones: Seven Sermons in Verse*. Like his friend and colleague Zora Neale Hurston, Johnson was interested in preserving the voices of folklore, specifically folk sermons. "I remember," Johnson writes in the preface to *God's Trombones*, "hearing in my boyhood sermons that . . . passed with only slight modifications from preacher to preacher and from locality to locality." One of these was the story of "The Prodigal Son," updated to reflect life in the streets of 1920s Harlem (**Reading 43.8**):

READING 43.8 **from James Weldon Johnson, "The Prodigal Son" (1927)**

And the city was bright in the night-time like day,
The streets all crowded with people,
Brass bands and string bands a-playing,
And ev'rywhere the young man turned
There was singing and laughing and dancing.
And he stopped a passer-by and he said:
Tell me what city is this?
And the passer-by laughed and said: Don't you know?
This is Babylon, Babylon,
That great city of Babylon.
Come on, my friend, and go along with me.
And the young man joined the crowd. . . .

And the young man went with his new-found friend,
And bought himself some brand new clothes,
And he spent his days in the drinking dens,
Swallowing the fires of hell.
And he spent his nights in the gambling dens,
Throwing dice with the devil for his soul.
And he met up with the women of Babylon.
Oh, the women of Babylon!

Dressed in yellow and purple and scarlet,
Loaded with rings and earrings and bracelets,
Their lips like a honeycomb dripping with honey,
Perfumed and sweet-smelling like a jasmine flower;
And the jasmine smell of the Babylon women
Got in his nostrils and went to his head,
And he wasted his substance in riotous living,
In the evening, in the black and dark of night,
With the sweet-sinning women of Babylon.
And they stripped him of his money,
And they stripped him of his clothes,
And they left him broke and ragged
In the streets of Babylon. . . .

Douglas's illustration (Fig. 43.8) makes the timeliness of Johnson's poem abundantly clear. His two-dimensional silhouetted figures would become the signature style of Harlem Renaissance art, in which a sense of rhythmic movement and sound is created by abrupt shifts in the direction of line and mass.

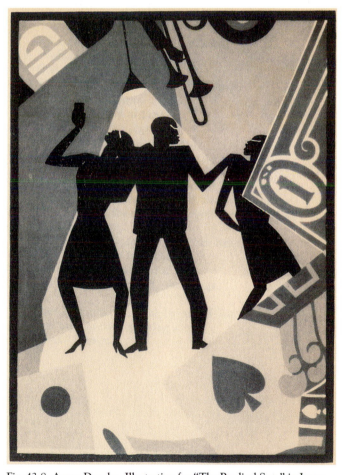

Fig. 43.8 Aaron Douglas. Illustration for "The Prodigal Son," in James Weldon Johnson, *God's Trombones: Seven Sermons in Verse*. 1927. University of North Carolina Library. Douglas's inclusion of the fragment of a dollar, the tax stamp from a package of cigarettes (at the bottom right), a playing card, and the fragment of the word "Gin" all reflect his awareness of French Cubism.

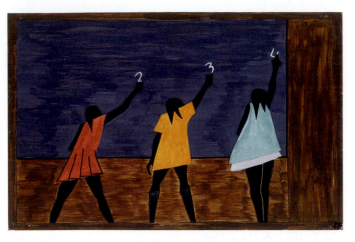

Fig. 43.9 Jacob Lawrence. *In the North the Negro had better educational facilities,* panel 58 from *The Migration of the Negro.* 1940–1941. Casein tempera on hardboard, 12″ × 18″. Gift of Mrs. David M. Levy. The Museum of Modern Art/Licensed by Scala-Art Resource, NY. © 2007 ARS Artists Rights Society, NY. Note that Lawrence dresses the girls in the primary colors of red, yellow, and blue, thus emphasizing the fundamental nature of primary education.

His influence is evident in the later work of Jacob Lawrence (see Fig. 42.22), who met Douglas soon after arriving in Harlem in the mid-1930s. The angularity and rhythmic repetition of forms that Douglas introduced is evident in many of Lawrence's paintings for the *Great Migration* series of 1939–1941, particularly in his illustration of three girls writing on a chalkboard at school (Fig. **43.9**). Here the intellectual growth of the girls, as each reaches higher on the board, is presented as a musical crescendo in a syncopated, 4-beat, rhythmic form where the first beat, as it were, is silent and unplayed. But above all, what the art of both Douglas and Lawrence makes clear is the connectedness of literature, music, and visual image in African-American experience. Such connections would continue to inform African-American culture for the rest of the century.

Making It New: The Art of Place

Indeed, the influence of the Harlem Renaissance on American art and literature was enormous. Its music, especially, was widely understood as one of the first truly "authentic" expressions of American experience, unfettered by European influence or tradition. The blues, jazz, and swing constituted a "new" distinctly American music, to which the writer, F. Scott Fitzgerald, had responded by coining the phrase "Jazz Age." But if the music of the era seemed to grow out of the American experience with the ring of certain truth, the Jazz Age itself, as Fitzgerald portrayed it, seemed to rise out of its opposite, the crassly and tragically materialistic culture of the day—the same world of easy money, fast women, and alcohol that swirls around Douglas's illustration of Johnson's "Prodigal Son."

Fitzgerald and *The Great Gatsby*

"That's the whole burden of this novel," Fitzgerald wrote of his novel *The Great Gatsby* in 1924, the year before it was published, "the loss of those illusions that give such color to the world that you don't care whether things are true or false as long as they partake of the magical glory." Set in New York City and on Long Island in the 1920s, the novel tells the story of Jay Gatsby, born Jimmy Gatz, who, as a boy of 17, "his heart . . . in a constant turbulent riot," had imagined for himself "a universe of ineffable gaudiness," and by the time he was 32, realized it. His neighbor, Nick Carraway, the novel's narrator, relates the weekend scene at Gatsby's West Egg home (**Reading 43.9a**):

READING 43.9a from F. Scott Fitzgerald, *The Great Gatsby* (1925)

In his blue gardens men and girls came and went like moths among the whisperings and the champagne and the stars. At high tide in the afternoon I watched his guests diving from the tower of his raft, or taking the sun on the hot sand of his beach while his two motorboats slit the waters of the Sound, drawing aquaplanes over the cataracts of foam. . . . And on Mondays eight servants, including an extra gardener, toiled all day with mops and scrubbing-brushes and hammers and garden-shears, repairing the ravages of the night before.

Every Friday, five crates of lemons and oranges arrived from a fruiterer in New York—every Monday these same lemons and oranges left his backdoor in a pyramid of pulpless halves. There was a machine in the kitchen that could extract the juice of two hundred oranges in half an hour if a little button was pressed two hundred times by a butler's thumb.

At least once a fortnight a crop of caterers came down with several hundred feet of canvas and enough colored lights to make a Christmas tree of Gatsby's enormous garden. On buffet tables, garnished with glistening hors-d'oeuvre, spiced baked hams crowded against salads of harlequin designs and pastry pigs and turkeys bewitched to a dark gold. In the main hall, a bar with a real brass rail was set up, and stocked with gins and liquors and with cordials. . . .

By seven o'clock the orchestra has arrived, no thin five-piece affair, but a whole pitful of oboes and trombones and saxophones and viols and cornets and piccolos and high and low drums. . . . The bar is in full swing, and floating rounds of cocktails permeate the garden outside, until the air is alive with chatter and laughter, and casual innuendo and introductions forgotten on the spot, and enthusiastic meetings between women who never knew each other's names.

It is all a great show, a charade conceived by Gatsby to win the heart of Daisy Buchanan, who lives with her husband Tom across the bay in more fashionable East Egg, the green light on her dock forever in his view. Gatsby is "an unbroken series of successful gestures," a fabric of deceit built on an empty morality of wealth as an end itself that inevitably collapses. Nick Carraway goes so far as to say that listening to Gatsby talk "was like skimming hastily through a dozen magazines," the American dream in all its shallowness.

And yet, Nick recognizes, there is something about Gatsby that is indeed "great." At the novel's end, Gatsby dead, Nick stretches out on Gatsby's beach and recalls the spirit of discovery and wonder that the original settlers of America must have felt (**Reading 43.9b**):

READING 43.9b **from F. Scott Fitzgerald, *The Great Gatsby* (1925)**

I gradually became aware of the old island here that flowered once for Dutch sailors' eyes—a fresh, green breast of the new world. Its vanished trees, the trees that had made way for Gatsby's house, had once pandered in whispers to the last and greatest of all human dreams; for a transitory enchanted moment man must have held his breath in the presence of this continent, compelled into an aesthetic contemplation he neither understood nor desired, face to face for the last time in history with something commensurate to his capacity for wonder.

And as I sat there brooding on the old, unknown world, I thought of Gatsby's wonder when he first picked out the green light at the end of Daisy's dock. He had come a long way to his blue lawn, and his dream must have seemed so close that he could hardly fail to grasp it. He did not know that it was already behind him, somewhere back in the vast obscurity beyond the city, where the dark fields of the republic rolled on under the night.

Gatsby believed in the green light, the orgiastic future that year by year recedes before us. It eluded us then, but that's no matter—tomorrow we will run faster, stretch out our arms farther. . . . and one fine morning—

So we beat on, boats against the current, borne back ceaselessly into the past.

As corrupted by the crass materialism of the day as Gatsby's dream is, it remains the quintessential American dream, the dream of a new world in which the imagination is free to create itself anew as well. From Fitzgerald's point of view, Gatsby had simply been born too late for his dream to have been realized—that is both his tragedy and his greatness.

The New American Poetry and the Machine Aesthetic

If Fitzgerald's novel concludes with a certain sense of hopelessness, it also, in its last line, asserts at least Nick's determination to "beat on," to rediscover "something commensurate to [our] capacity to wonder." It was, in the view of many, art itself that offered this possibility. But if art could "make it new," as Ezra Pound would soon assert, then it could do so only by renewing tradition, the very tradition that Nick Carraway imagines in his vision of Dutch sailors seeing "the green breast of the new world" for the first time.

In 1928, Ezra Pound (see chapter 41) had invoked the necessity of newness when he translated from the Chinese the *Ta Hsio*, or *Great Digest*, a Confucian text dating from the fifth to second century BCE:

As the sun makes it new
Day by day make it new
Yet again make it new

The saying "make it new," Pound well knew, had originated in the eighteenth century BCE, when the Emperor Tang, founder of the Shang dynasty (see chapter 4), had written the phrase on his bathtub. Pound is obviously not invoking the phrase in the interest of leaving tradition behind. In fact, he invokes tradition—centuries of Chinese tradition—in order to underscore the necessity of continual cultural renewal. Like the poets and artists of the Harlem Renaissance, his short poem is driven by the rhythmic repetition not only of the phrase ("make it new") but "day by day," the diurnal cycle. Even more to the point, it underscores the labor of making the repetitive, often tedious rhythm of writing and rewriting, each successive line a revision of what has come before. And it is, perhaps above all, a "translation," an act of renewal as Pound transforms the original Chinese into English. The lesson is, for Pound, a simple one: In each new context, each new place, tradition is itself renewed.

Pound would publish a collection of essays in 1934 titled *Make It New*, and his "make it new" mantra soon became something of a rallying cry for the new American poetry. It especially influenced his friends, the poets William Carlos Williams (1883–1963), E. E. Cummings (1894–1962), and Hart Crane (1899–1932). Williams met Pound when they were both students at the University of Pennsylvania in 1902. Cummings had been a volunteer ambulance driver for the Red Cross in France, and in 1921 returned to Paris, where he met Pound. They were also attracted to the Imagist principle of verbal simplicity: "Use absolutely no word that does not contribute to the presentation," as F. S. Flint put it in the March 1913 issue of *Poetry* magazine. Their language should reflect, in Williams's words, "the American idiom," just as the Harlem Renaissance writers sought to capture black American vernacular in their work.

Continuity & Change p. 110

Shang Dynasty

William Carlos Williams and the Poetry of the Everyday
Williams was a physician in Rutherford, New Jersey, across the Hudson River from New York City. He was immediately attracted to Imagism when Pound defined it in the pages of *Poetry* magazine (see chapter 41). He praised it for "ridding the field of verbiage." His own work has been labeled "Radical Imagism," for concentrating on the stark presentation of commonplace objects to the exclusion of inner realities. His famous poem, "The Red Wheelbarrow," is an example (**Reading 43.10**):

READING 43.10 **William Carlos Williams, "The Red Wheelbarrow," from *Spring and All* (1923)**

so much depends
upon

a red wheel
barrow

glazed with rain
water

beside the white
chickens

The first line of each stanza of Williams's poem raises expectations which the second line debunks in two syllables. Thus a mere preposition, "upon," follows the urgency of "so much depends." A "red wheel" conjures images of Futurist speed, only to fall flat with the static "barrow." "Rain/water" approaches redundancy. Our expectations still whetted by the poem's first line, the word "white" suggests purity, only to modify the wholly uninspiring image, "chickens." Williams's aesthetic depends upon elevating the commonplace and the everyday into the realm of poetry, thus transforming them, making them new.

Williams often wrote poems on the spur of the moment—on prescription pads, for instance—and as a result his work has a certain sense of immediacy, even urgency. Take, for instance, "The Great Figure" (**Reading 43.11**):

READING 43.11 **William Carlos Williams, "The Great Figure," from *Sour Grapes* (1921)**

Among the rain
and lights
I saw the figure 5
in gold
on a red
fire truck
moving
tense
unheeded
to gong clangs
siren howls
and wheels rumbling
through the dark city

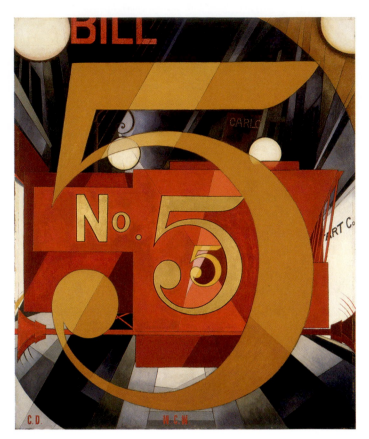

Fig. 43.10 Charles Demuth. *The Figure 5 in Gold*. 1928. Oil on cardboard, 35 1/2″ × 30″. Metropolitan Museum of Art, NY. Alfred Stieglitz Collection, 1949 (49.59.1). Image © The Metropolitan Museum of Art / Art Resource, NY. Demuth's painting was called by his friend William Carlos Williams "the most distinguished American painting that I have seen in years."

In his *Autobiography*, Williams recalls writing the poem one day after leaving his post-graduate clinic in Manhattan on his way to visit the painter Marsden Hartley (1877–1943) for a drink: "As I approached his number I heard a great clatter of bells and the roar of a fire engine passing the end of the street down Ninth Avenue. I turned just in time to see a golden figure 5 on a red background flash by. The impression was so sudden and forceful that I took a piece of paper out of my pocket and wrote a short poem about it."

Their friend, the painter Charles Demuth (1883–1935), later celebrated the poem in paint (Fig. **43.10**). The focus of the poem, and later the painting, is "the figure 5." It serves to organize the chaotic urban landscape that confronts the artist's vision just as the poem itself organizes the passing engine's cacophony of sirens, clangs, and howls into a formal poetic arrangement. The poem's central image embodies tension, speed, and change, a fact that Williams underscores by placing the lines "moving / tense" at the poem's heart. The figure 5 contradicts this tension. The poet sees the number with a clarity that is very different from the blurry refracted light of the night's rain. As Demuth's painting makes clear, the figure 5 is a kind of

ordering design, its curvilinear form echoed in the street lights and light posts, its strong horizontal top echoed in the red engine and its horizontal axle all racing down the street into the geometric one-point perspective of the sky-scraper canyon.

E. E. Cummings and the Pleasures of Typography In 1920, when Williams wrote this poem, the motorized fire engine was not even a decade old. Williams's poem celebrates the same machine culture, a culture of the "new," that Alfred Barr, Jr., and Philip Johnson would later pay homage to in their *Machine Art* exhibition (see Fig. 43.2). In fact, his "Great Figure" is something of a mechanical God, delivering salvation in the streets of New York.

In his poem "she being Brand," the newness of this same machine aesthetic is celebrated by E. E. Cummings. (His name is commonly spelled entirely in lowercase letters, a practice initiated by his publishers to which Cummings objected) (**Reading 43.12**):

READING 43.12 E. E. Cummings, "she being Brand" (1926)

she being Brand

-new;and you
know consequently a
little stiff i was
careful of her and(having
thoroughly oiled the universal
joint tested my gas felt of
her radiator made sure her springs were O.

K.)i went right to it flooded-the-carburetor cranked her

up,slipped the
clutch(and then somehow got into reverse she
kicked what
the hell)next
minute i was back in neutral tried and

again slo-wly;bare,ly nudg. ing(my

lev-er Right-
oh and her gears being in
A 1 shape passed
from low through
second-in-to-high like
greasedlightning)just as we turned the corner of Divinity

avenue i touched the accelerator and give
her the juice,good

 (it

was the first ride and believe i we was

happy to see how nice she acted right up to
the last minute coming back down by the Public
Gardens i slammed on

the
internalexpanding
&
externalcontracting
brakes Bothatonce and

brought allofher tremB
-ling
to a:dead.

stand-
;Still)

Cummings's poem is laden with sexual innuendo, describing his first ride in his new car as if he were making love to the machine, and linking, in a fashion already long exploited by the automobile industry in the 1920s, his own sexual prowess with freedom and mastery of the road. But one of the most notable aspects of this poem is its dependence on the visual characteristics of capitalization, punctuation, and line endings to surprise the reader—effects evident in the first two lines: "Brand /-new." The poem, like Williams's work, is addressed both to the eye and the ear.

Hart Crane and *The Bridge* Although a poet of very different temperament than either Williams or Cummings, both of whom he knew well, Hart Crane (1899–1932) believed like both of them that the modern poet must, in his words, "absorb the machine." For Crane, the symbol of the machine aesthetic was the Brooklyn Bridge, and from 1926 until 1930 he worked on a long, epic poem that attempted to encapsulate, for modernity, the America that Walt Whitman had celebrated in the last half of the nineteenth century. The first great suspension bridge in the United States, the bridge was built in 1883 and was anything but new, yet it was precisely Crane's intention to "make it new" in the poem, to reinvent it as the gateway to modernity itself (**Reading 43.13**):

READING 43.13 from Hart Crane, "To Brooklyn Bridge," *The Bridge* (1930)

How many dawns, chill from his rippling rest
The seagull's wings shall dip and pivot him,
Shedding white rings of tumult, building high
Over the chained bay waters Liberty—

Then, with inviolate curve, forsake our eyes
As apparitional as sails that cross

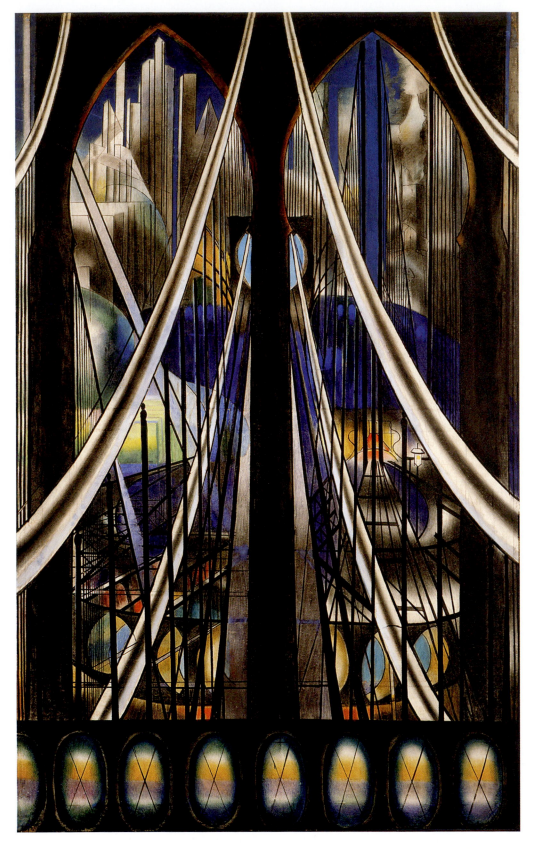

Fig. 43.11 Joseph Stella. *The Voice of the City of New York Interpreted: The Brooklyn Bridge (The Bridge).*
1920–1922. Oil and tempera on canvas, 88$\frac{1}{2}$″ × 54″. Collection of the Newark Museum, NJ. This is one of five panels, each over seven feet high, celebrating New York. The others are *The Battery (The Port)*, *The Great White Way Leaving the Subway (White Way I)*, *The Prow (The Skyscrapers)*, and *Broadway (White Way II)*.

Some page of figures to be filed away;
—Till elevators drop us from our day . . .

I think of cinemas, panoramic sleights
With multitudes bent toward some flashing scene
Never disclosed, but hastened to again,
Foretold to other eyes on the same screen;

And Thee, across the harbor, silver-paced
As though the sun took step of thee, yet left
Some motion ever unspent in thy stride—
Implicitly thy freedom staying thee! . . .

O harp and altar, of the fury fused,
(How could mere toil align thy choiring strings!)
Terrific threshold of the prophet's pledge,
Prayer of pariah, and the lover's cry,—

Again the traffic lights that skim thy swift
Unfractioned idiom, immaculate sigh of stars,
Beading thy path—condense eternity:
And we have seen night lifted in thine arms. . . .

O Sleepless as the river under thee,
Vaulting the sea, the prairies' dreaming sod,
Unto us lowliest sometime sweep, descend
And of the curveship lend a myth to God.

As Crane was preparing *The Bridge* for publication, a friend showed Crane a short essay by painter Joseph Stella (1877–1946), who had painted the Brooklyn Bridge as part of a large five-panel painting, *The Voice of the City of New York Interpreted* in 1920–1922 (Fig. **43.11**). Stella's essay, "The Brooklyn Bridge (A Page of My Life)," which appeared in the little magazine *Transition* in 1929, captured Crane's attention:

Many nights I stood on the bridge – and in the middle alone – lost – a defenseless prey to the surrounding swarming darkness – crushed by the mountainous black impenetrability of the skyscrapers – here and there lights resembling suspended falls of astral bodies or fantastic splendors of remote rites – shaken by the underground tumult of the trains in perpetual motion, like the blood in the arteries – at times, ringing as alarm in a tempest, the shrill sulphurous voice of the trolley wires – now and then strange moanings of appeal from tug boats, guessed more than seen, through the infernal recesses below – I felt deeply moved, as if on the threshold of a new religion or in the presence of a new DIVINITY.

Stella's painting is, in fact, a kind of altarpiece to the machine age, and for a while Stella considered using the painting as the frontispiece to his poem. But he finally settled for three photographs of the bridge by his neighbor, the photographer Walker Evans, whose work is discussed in chapter 44.

The New American Painting: "That, Madam . . . is paint."

Both Stella's view of the Brooklyn Bridge and Demuth's celebration of Williams's "figure 5" indicated the new direction of American painting. Even its focal point changed. During the early 1900s, Alfred Stieglitz's Gallery 291 had been the place to exhibit. In the late 1920s, his new space in midtown Manhattan, An American Place on Madison Avenue at 53rd Street and the Daniel Gallery, a few blocks away, at 2 West 47th Street (see Map 43.1), were the places artists and writers gathered routinely to discuss new directions in American art and literature. In his *Autobiography*, Williams recalls a story that, he said, "marks the exact point in the transition that took place, in the world at that time," to the conception of the modern in American art. Alanson Hartpence was employed at the Daniel Gallery (**Reading 43.14**):

> **READING 43.14** **from William Carlos Williams, *The Autobiography of William Carlos Williams* (1948)**
>
> One day, the proprietor being out, Hartpence was in charge. In walked one of their most important customers, a woman in her fifties who was much interested in some picture whose identity I may at one time have known. She liked it, and seemed about to make the purchase, walked away from it, approached it and said, finally, "But Mr. Hartpence, what is all that down in this left hand lower corner?"
>
> Hartpence came up close and carefully inspected the area mentioned. Then, after further consideration, "That, Madam," said he, "is paint."

The object lesson was plain and simple. Painting was not about copying reality, not about "merely reflecting something already there, inertly," in Williams's words, but to make it new, in the new twentieth-century American landscape. It did so, he explained, by recognizing that a picture was "a matter of pigments upon a piece of cloth stretched on a frame . . . It is in the taking of that step over from feeling to the imaginative object, on the cloth, on the page, that defined the term, the modern term—a work of art."

Charles Demuth, Charles Sheeler, and the Industrial Scene Charles Demuth and Williams met as students at the University of Pennsylvania, and they remained close friends. It was Demuth's wit that most attracted Williams to the painter, and his clear-eyed view of what constituted the new American landscape. He would, for instance, paint a picture of two grain elevators and call it *My Egypt*, ironically suggesting their equivalence to the pyramids on the Nile. Or he would paint a chimney rising in the sky beside a silo and name it *Aucassin and Nicolette*, after the medieval fable of the love affair between a French nobleman and a Saracen slave

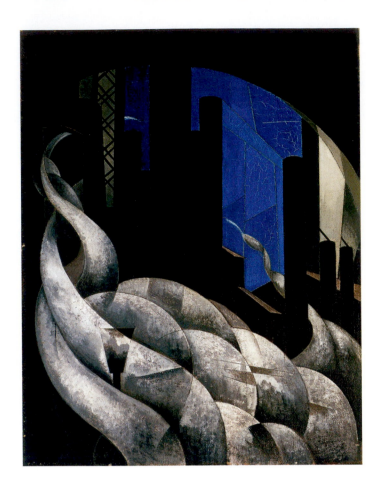

girl. Without its title, *Incense of a New Church* (Fig. **43.12**) is as depressing an image as any painted in America in the 1920s, its factory chimneys belching forth an almost suffocating flume of soot and smoke. But with the title, the painting becomes a deeply ironic—and funny—commentary on the American worship of machine and manufacture.

Charles Sheeler (1883–1965) was equally gifted as a painter and a photographer, and his painting clearly evidences the impact of photography. In 1927, he was commissioned to photograph the Ford Motor Company's new River Rouge Plant near Detroit, the world's largest industrial complex employing more than 75,000 workers to produce the new Model A, successor to the Model T. The subject, he said, was "incomparably the most thrilling I have had to work with," and he soon translated it into paint. *Classic Landscape* (Fig. **43.13**) depicts an area of the plant where cement was made from byproducts of the manufacturing process. The silos in the middle distance stored the cement until it could be shipped for sale. For Sheeler they evoke the classic architecture of ancient Greece and Rome—which inspired the painting's title, *Classic Landscape*.

Fig. 43.12 Charles Demuth. *Incense of a New Church.* **1921.** Oil on canvas, 26¼″ × 20″. The Columbus Gallery of Fine Arts, Columbus, OH. Gift of Ferdinand Howald 1931.135; Courtesy Demuth Museum, Lancaster PA. William Carlos Williams owned a painting similar to this—of factories billowing smoke—entitled *End of the Parade—Coatsville, Pa.* He purchased it at the Daniel Gallery in 1920.

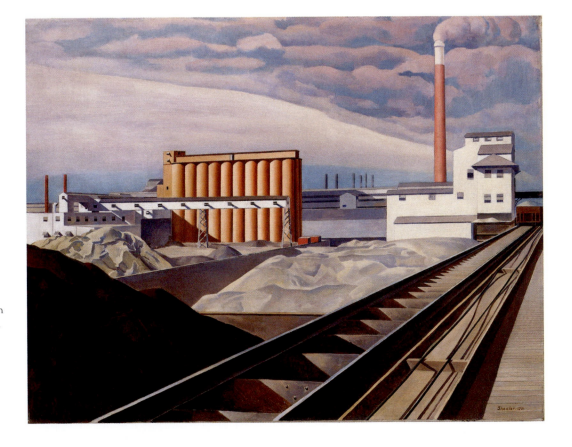

Fig. 43.13 Charles Sheeler. *Classic Landscape.* **1931.** Oil on canvas, 25″ × 32¼″. Collection of Barney A. Ebsworth. Image © 2009 Board of Trustees, National Gallery of Art, Washington, DC. The strong perspectival lines created by the railroad tracks underscore the geometric classicism of the scene.

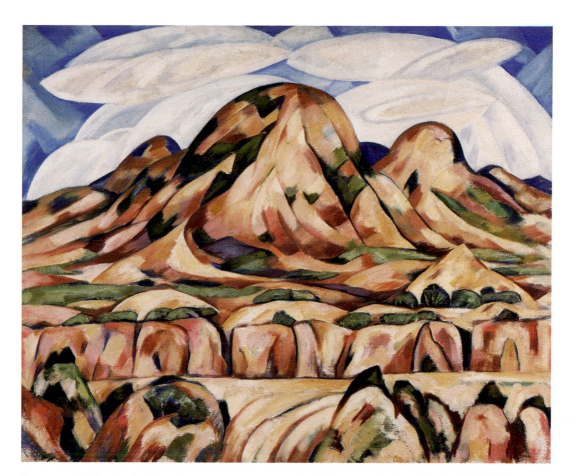

Fig. 43.14 Marsden Hartley. *New Mexico Landscape.* 1920–1922. Oil on canvas, 30″ × 36″. The Alfred Stieglitz Collection, 1949. Philadelphia Museum of Art, Philadelphia, Pennsylvania, U.S.A. Art Resource, NY. Hartley would visit Aix-en-Provence in 1928, where he undertook a series of landscapes with Mont Sainte-Victoire as their theme.

Continuity & Change
p. 1297

Mont Sainte-Victoire

Marsden Hartley and the Influence of Cézanne Of all the American modernists, Marsden Hartley was most influenced by the example of Paul Cézanne, especially Cézanne's paintings of Mont Sainte-Victoire (see Fig. 40.17). Stieglitz had exhibited watercolors by Cézanne at 291 in 1913, and by the 1920s a number of significant Cézannes had entered American collections.

Hartley was particularly drawn to the American Southwest, visiting Santa Fe and Taos in both 1918 and 1919. Like Mont Sainte-Victoire for Cézanne, the mountains there became a motif for Hartley that he returned to again and again. In a June 1918 letter to Stieglitz, he describes them as "Chocolate mountains . . . those great isolated, altar-like forms that stand alone in a great mesa with the immensities of blue around and above them and that strange Indian red earth making such almost unearthly foregrounds."

Although Hartley's painterly and curvilinear forms seem far removed from the machine age art of Demuth and Sheeler, Hartley's work was as formally balanced and orderly as any classical composition. For example, compare the formal symmetry of Hartley's *New Mexico Landscape* (Fig. **43.14**) to

Joseph Stella's *The Bridge* (see Fig. 43.11). Hartley's is a completely natural landscape, rising to a central mountain balanced by two smaller mountains on each side. Stella's is a man-made architectural environment, and yet both are reminiscent of church altarpieces, each placing the viewer before his chosen subject— landscape and bridge—in a composition not far removed from Masaccio's 1425 *Trinity* at Santa Maria Novella in Florence.

Continuity & Change
p. 554

Trinity

Georgia O'Keeffe and the Question of Gender Of all the American artists who came into their own in the 1920s and 1930s, Georgia O'Keeffe (1887–1986) would become the most famous. But, from her first exhibit on, her work was burdened by its identification with her gender. Alfred Stieglitz showed a group of her abstract charcoal drawings at his Gallery 291 in 1916, calling them an example of "feminine intuition," and for the rest of her career, O'Keeffe's work was described solely in terms of its "female" imagery.

Marsden Hartley wrote an article in 1920 describing her work in Freudian terms as examples of "feminine perceptions and feminine powers of expression." By then she had

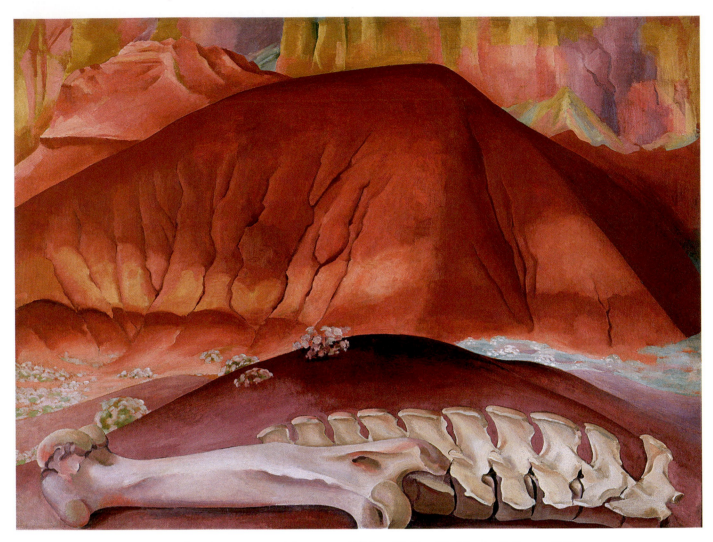

Fig. 43.15 Georgia O'Keeffe. *Red Hills and Bones*. 1941. Oil on canvas, 29³/₄″ × 40″. The Alfred Stieglitz Collection, 1949.
Philadelphia Museum of Art, Philadelphia, Pennsylvania, U.S.A. © 2008 ARS Artists Rights Society, NY. In 1940, O'Keeffe bought a house,
Rancho de los Burros, a few miles from Ghost Ranch, an isolated dude ranch near the small town of Abiquiu.

married Stieglitz, who viewed O'Keeffe's art in the same way, so Hartley's review carried some authority. O'Keeffe's flower paintings—large-scale close-ups of petals, stamens, and pistols—were especially susceptible to Freudian interpretation. Many viewers found them erotically charged; between 1918 and 1932 she made over 200 of them. O'Keeffe complained that no one read flower paintings by male artists in this way—Demuth and Hartley both did many floral still lifes—and she addressed one critic directly: "Well—I made you take time to look at what I saw and when you took time to really notice my flower you hung all your own associations with flowers on my flower and you write about my flower as if I think and see what you think and see of the flower—and I don't."

O'Keeffe's struggle for recognition of her painting on its own terms was intensified by her closeness to Stieglitz. "His power to destroy," she later acknowledged, "was as destructive as his power to build—the extremes went together. I have experienced both and survived, but I think I only

crossed him when I had to—to survive." After 1929, one of her major modes of survival was to retreat to New Mexico, to which she returned for part of every year until 1949, three years after Stieglitz's death, when she moved there permanently. *Red Hills and Bones* (Fig. **43.15**) is an example of the many paintings of the New Mexican landscape that so moved her. Its surprising juxtaposition of hills and bones animates the hills, lending them a sort of body, like skin stretched over a hidden skeletal structure. Though, in her words, "the red hill is a piece of the badlands where even the grass is gone," it is anything but dead. In the same breath she would call it "our waste land . . . our most beautiful country," reminding the viewer that the red hill was made "of apparently the same sort of earth that you mix with oil to make paint." And explaining her attraction to bones, she wrote: "When I found the beautiful white bones on the desert I picked them up and took them home too. . . . I have used these things to say what is to me the wideness and wonder of the world as I live in it."

O'Keeffe's career would span almost the entire twentieth century. She would, in 1946, become the first woman to have a one-person retrospective of her work at the Museum of Modern Art. In 1970, at the age of 83, the Whitney Museum of American Art staged the largest retrospective of her work to date, introducing it to a new generation of admirers just at the moment that the feminist movement in the United States was taking hold. Finally, in July 1997, 11 years after her death, the Georgia O'Keeffe Museum opened its doors in Santa Fe, New Mexico, with a permanent collection of over 130 O'Keeffe paintings, drawings, and sculptures.

The American Stage: Eugene O'Neill

If many American artists sought to portray the everyday reality of American life, just as poets of the era sought to reflect everyday speech in their poems, it was on the stage that both the visual texture of American life and the language of modern America were best experienced. Eugene O'Neill (1888–1953) took up the challenge. The son of an Irish actor and raised in a Broadway hotel room in New York's theater district, O'Neill was sensitive both to the subtleties of the American scene and to the rhythms and vocabulary of American speech.

Toward the end of 1912, while hospitalized for tuberculosis in a Connecticut sanitarium, O'Neill read Ibsen (see chapter 40) and the Greek tragedies. Their effect was so powerful that he decided to become a playwright. By 1920, he had won the Pulitzer Prize, the first of four, for his first full-length play, *Beyond the Horizon*, and he had begun to experiment freely with theatrical conventions in another play, *The Emperor Jones*.

The subject of the play was unheard of. It narrates the life of one Brutus Jones, an African American who kills a man and goes to prison before escaping to a Caribbean island where he declares himself emperor. His story is told, against an incessant beat of drums, almost entirely in monologue, as a series of flashbacks as he flees through a forest chased by his rebellious former subjects. *The Emperor Jones* was soon followed by *The Hairy Ape* (1922), the story of a powerful, hulking engine stoker on an ocean liner, who is called a "filthy beast" by a socialite onboard ship. Unable to understand what she means, he leaves the ship and wanders through Manhattan, seeking someplace to fit in. Finally, dehumanized by his experiences, he enters the gorilla cage at the New York's City Zoo and dies, himself a "hairy ape," in the animal's embrace.

Both of these plays—and O'Neill's many great later plays, including *Desire Under the Elms* (1924), *Strange Interlude* (1928), *The Iceman Cometh* (1946), and the posthumously produced *Long Day's Journey into Night* (1953)—stress the isolation and alienation of modern life. Even in dialogue, his characters seem to talk past one another, not to one another, as this stage direction, from *Strange Interlude*, suggests: "They stare straight ahead and remain motionless. They speak, ostensibly one to the other, but showing by their tone it is a thinking aloud to oneself, and neither appears to hear what the other has said."

The Golden Age of Silent Film: Hollywood in the 1920s

It is a bit of an exaggeration to claim that New York invented Hollywood, but in many ways it did. In 1903, Hollywood (Fig. 43.16) was a scattered community in the foothills of the Santa Monica mountains boasting about 700 residents. Twenty years later it was the center of a "colony" of movie people, almost none of them native Californians, and a large majority of them second-generation American Jews newly arrived from points east. Many had gravitated to the movie business—first as exhibitors, then distributors, and then producers—from the garment industry in New York City, where they had learned to appraise popular taste and react to it with swift inventiveness. And, indeed, they were so successful in understanding their audience's desires that by 1939, arguably the greatest year in the history of the medium, between 52 and 55 million Americans went to the movies they made each week. There were 15,115 movie theaters, and box office receipts were $673 million.

The Americanization of a Medium

Why Hollywood came to be the center of the movie industry—and not New York, or Chicago, or, for that matter, just about anyplace else—is a complex question. Weather played a role—350 days a year of temperate sunshine, perfect for the slow film speeds of the day. So did the city's remoteness from the East, where the so-called "Trust"—the Motion Picture Patents Company, run by Thomas Edison, which controlled the rights to virtually all the relevant technology—sought to monopolize the industry. There was lots of relatively cheap available property on which to build giant

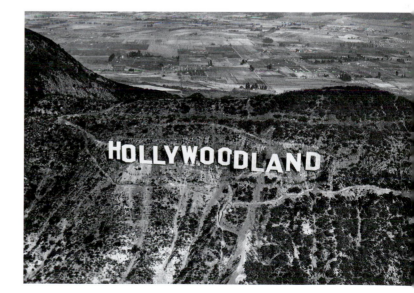

Fig. 43.16 The "Hollywoodland" sign. 1923. The famous sign, rebuilt in 1978 after years of abuse and wear and shortened then to just "Hollywood," was originally constructed to advertise a real estate development in the foothills above Hollywood.

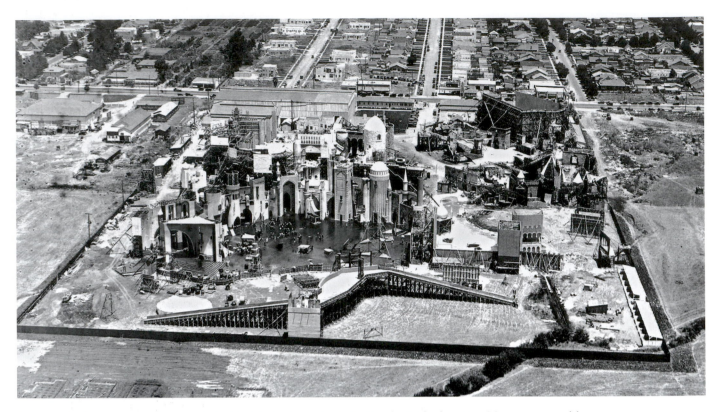

Fig. 43.17 William Cameron Menzies. Sets for *The Thief of Bagdad*, starring Douglas Fairbanks. 1924. Menzies was one of the greatest set designers and art directors of the day. In 1939, he would design the sets for David O. Selznick's *Gone with the Wind* (see Fig. 44.30), working for roughly two years on the epic motion picture.

"lots" and construct elaborate sets (Fig. **43.17**). It is also true that after the first companies arrived in the early 1900s—producers Jesse Lasky and Sam Goldfish (later Goldwyn) hired Cecil B. DeMille to make the first feature-length American movie, *The Squaw Man*, in a rented barn at Vine and Selma in Hollywood in 1914, and William Fox (born Wilhelm Fuchs in Hungary) set up his studios at the corner of Sunset and Western in 1916—other Jewish immigrant independent filmmakers followed, sensing the creation of a real community.

But for whatever reason the movie industry was drawn to Hollywood, it is certain that once there, it made Hollywood the center of cinema as a medium. Filmmaking went on all over the city of Los Angeles, not just in Hollywood—in Culver City, in the west, toward the ocean, and Universal City, an incorporated town over the Santa Monica mountains in the San Fernando Valley owned by Universal Pictures. But they were all "Hollywood." Despite the fact that not a single technological innovation in the medium was made anywhere near the city, despite the fact that it depended almost entirely upon New York City institutions for financing, it became the place where dreams came true, where fame and wealth were there for the taking, and where anything seemed possible.

It was the studio system that set Hollywood filmmaking apart from filmmaking anywhere else in the world, an orga-nizational structure of production, distribution, and exhibition within the same company. In this system, studio magnates owned and controlled a "stable" of actors, writers, and directors who contracted to work exclusively for the studio. These companies produced predictable product—westerns, horror pictures, romances, etc.—featuring stars whom the public adored. By the end of the 1920s, there were five major American studios—Fox, MGM, Paramount, RKO, and Warner—and three smaller ones—Universal, Columbia, and United Artists. These companies all had agents in Europe. Metro-Goldwyn-Mayer and Paramount, for instance, loaned money to help the German film production company UFA establish itself after the war, and in return UFA distributed their films in Germany. UFA executives soon recognized that it was more profitable to import American movies than to produce their own. The pattern was repeated across Europe, so that during the 1920s and 1930s, somewhere between 75 percent and 90 percent of the films screened in most countries were made in Hollywood. Europeans, who had long imposed their cultures on the world, now found American culture imposing itself on them.

The Studios and the Star System

As early as 1920, Hollywood was making 750 feature films a year and focusing its promotional efforts on the appeal of its stars. Among the most important of the early stars was Mary

Pickford. She had risen to fame starring in D. W. Griffith's early one-reelers, specializing in the role of the adolescent girl. By 1917, when "America's Sweetheart," as Pickford soon became known, starred in feature films such as *The Poor Little Rich Girl* and *Rebecca of Sunnybrook Farm*, she was making $10,000 a week, working for Adolph Zukor's Famous Players-Lasky Corporation. Paramount, the Famous Players distributor, soon began block-booking its entire yearly output of 50 to 100 feature films, so that if theaters wanted to show the enormously popular Pickford films, they were forced to show films featuring less-well-known stars as well. When theaters resisted this arrangement, Zukor borrowed $10 million from the Wall Street investment banking firm of Kuhn Loeb and bought them, thus gaining control of the entire process of movie-making, from production to distribution to exhibition. Other studios followed suit—Metro-Goldwyn-Mayer, Fox, and Universal all soon mirrored Zukor's operations.

It didn't take the stars long to recognize that the studios' successes depended on them. Some negotiated better contracts, but in 1919, three of the biggest stars—Pickford, Douglas Fairbanks, and Charlie Chaplin—and its most famous director, D. W. Griffith, bucked the studio system and formed their own finance and distribution company, United Artists. Each of the United Artists' principles had their own production studios. Griffith's was on an estate in Mamaroneck, New York, but the cost of converting the property into a functioning movie studio drove him deeper and deeper in debt and before long he was forced to return to Paramount as a studio director.

Chaplin was film's leading comedian, his trademark Little Tramp known worldwide. At his studio in Hollywood, in 1925, he made what many consider his greatest film, *The Gold Rush*. To open the film, Chaplin brought in thousands of extras, many of them hoboes, to the location in northern California near Truckee for a shot of prospectors making their way up the snow-covered Chilkoot Pass in the Alaskan gold rush of 1897 (Fig. **43.18**). Thematically, the gold rush is a vehicle that allows Chaplin to play the pathos of poverty off against the dream of wealth. In one of its most memorable scenes, at once funny and poignant, the starving tramp eats his own boot with the relish of a New York sophisticate, twisting his shoelaces around his fork like spaghetti and sucking on its nails as if they were the most succulent of morsels.

Fairbanks and Pickford married and formed their own studio. Pickford, now over 30, continued to cast herself as an adolescent girl, but Fairbanks began making a series of humorous adventure films, often drawing on stories written for boys. Increasingly elaborate sets were created for these films on the Santa Monica Boulevard lot, culminating with *The Thief of Bagdad*'s (see Fig. **43.17**), one of the largest sets ever built in Hollywood. Special effects included flying carpets, winged horses, fearsome beasts, and an invisibility cloak, but neither the sets nor the effects could match the audience's attraction to Fairbanks's winning smile (Fig. **43.19**).

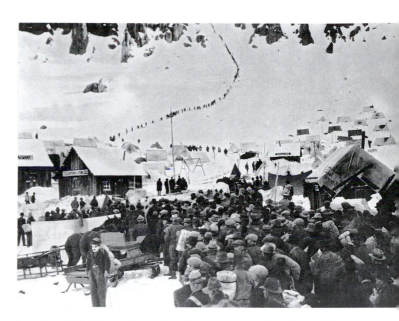

Fig. 43.18 Charlie Chaplin, in *The Gold Rush*. 1925. Chaplin modeled this opening scene on photographs he had seen of prospectors headed for the Klondike gold fields in 1897.

Fig. 43.19 Douglas Fairbanks, in *The Thief of Bagdad*. 1924. Museum of Modern Art, Film Stills Archive. Almost 40 years old, Fairbanks appeared bare-chested throughout most of the movie, to the delight of his female fans.

Audience and Expectation: Hollywood's Genres

In addition to the appeal of its stars, Hollywood also depended on its audience's attraction to certain **genres** of film. A genre is a standard type, a sort of conceptual template or form readily recognizable by its audience. By the early 1920s, most of the genres that characterized Hollywood production through the 1950s had come into existence—comedy; fantasy; adventure; the crime or gangster film; the coming-of-age film (a Pickford specialty); the so-called woman's film, combining romance and family life; romantic drama; the horror film; war films; and the Western chief among them—all, that is, except the musical, which awaited the advent of sound.

From the earliest days of cinema, producers had been well aware that their stars' sex appeal was fundamental to their popularity, and romantic drama was the main genre in which a star's sex appeal could be exploited. Female audience members worshiped Rudolph Valentino, whose soft sensuality infuriated many American males, even as he seduced on-screen actress after actress through the 1920s. The Swedish actress Greta Garbo, who arrived in the United States in 1925 to work at MGM, was appealing on a different level. From the moment of her first American film, the 1926 *Flesh and the Devil*, she exuded a combination of mature, adult sexuality and melancholy sadness. A sex siren like none before her, she was perfectly cast as the adulteress, playing Tolstoy's Anna Karenina in her next picture, *Love* (1927), and *A Woman of Affairs* (1928) in her next. Nearly all of Garbo's Hollywood films were shot in a rich, romantic lighting style that became synonymous in film with romance itself.

Male fans, who of course adored Garbo, also gravitated to Lon Chaney, whose most famous roles were *The Hunchback of Notre Dame* and *The Phantom of the Opera*, 1923 and 1924 respectively. Traditionally, the monster in horror films stands for that which society rejects or is uncomfortable with. Chaney specialized in characters who were disfigured, mutilated, or otherwise physically grotesque, and he single-handedly defined the horror genre in the 1920s. What appealed to his largely male audience was apparently the very horror of his appearance, the romantic agony of his characters' inability to fit comfortably into society, his audience's sense of their own alienation.

The Western was introduced with Edwin S. Porter's 1903 film *The Great Train Robbery*, with its famous final shot of a sheriff shooting his six-gun straight at the camera (and the audience). William S. Hart was the first big Western star, generally playing the part of an outlaw reformed by the love of a good woman. The most popular of the Western stars in the 1920s was Tom Mix (Fig. **43.20**), who had been a working cowboy. Decked out in his huge white hat, Mix performed his own stunts in movies filled with galloping horses, fistfights, and chases. Many of his films were shot on location in spectacular Western landscapes like the Grand Canyon, adding to their appeal.

Fig. 43.20 Tom Mix in *The Great K & A Train Robbery*. 1926. Poster, 11″ × 17″. The film is laden with Mix stunts, opening with Mix sliding down a long cable to the bottom of a gorge. He also, as shown here, jumps off his horse onto a train so that he might fight the villains. This would become a staple of the Western genre—riding on the roof of the moving train.

Cinema in Europe

At the same time Hollywood dominated the American film industry, a distinctly European cinema thrived. Many of Europe's greatest filmmakers and stars were hired by American companies and brought to the United States to work. (Remember that before the talkies, language was not a barrier in the film industry.) Moreover, it seems clear that many of the more experimental and avant-garde contributions to the cinema originated in Europe. (See the *Focus* on Sergei Eisenstein in chapter 42.) Europeans tended to regard cinema, at least potentially, as a high art, not necessarily as the crassly commercial product aimed at a low-brow popular audience that characterized most American movies.

German Expressionism Influenced directly by the Expressionist painting of Ernst Kirchner, Wassily Kandinsky, and Franz Marc (see Figs. 41.11–41.13), soon after the war, some German filmmakers began to search for ways to express themselves similarly in film. Their films were deeply affected by the violence of the war and the madness they perceived the war to embody.

Chief among these was Robert Wiene, whose *Cabinet of Dr. Caligari* appeared soon after the war. An inmate at an insane asylum narrates the action, the story of a mysterious doctor, Caligari, who makes a living exhibiting a sleepwalker named Cesare at sideshows. At night Cesare obligingly murders the doctor's enemies. All the action takes place in a deliberately exotic and weirdly distorted landscape of tilting

houses, misshapen furniture, and shadowy atmospherics. As it turns out, the doctor is the head of the mental ward, is the sleepwalker, another patient, and the entire story perhaps a figment of the storyteller's insane imagination.

The word *Stimmung*—an emphasis on mood or feeling, particularly melancholy— is often used to describe German cinema throughout the silent era. A film's entire *mise-en-scène*—a French phrase for the totality of a film's visual style, from decor to lighting, camera movement, and costume—was often constructed to convey this sense of melancholy and resignation. Fritz Lang and his wife Thea von Harbou created one of the most oppressive and disquieting *mise-en-scènes* of all for their 1926 vision of a world in which humanity is at the edge of extinction, *Metropolis* (Fig. **43.21**). In a city in which workers are virtually cogs in a giant machine, barely human, a scientist by the name of Rotwang has succeeded in constructing a robot, which proves, he says, that "now we have no further use for living workers." But the Master of Metropolis orders Rotwang to recreate the robot in the likeness of Maria, an idealistic young woman who has been preaching to the workers in order to help them free themselves from oppression. Instead, the robot preaches violence and leads them to self-destruction. In retrospect, the film seems ominously prescient, as if Lang and von Harbou have at least subconsciously exposed what influential film historian Siegfried Krakauer has called "the deep layers of collective mentality" that would soon manifest themselves in the rise of the fascist state.

Surrealist Film Throughout the early 1900s and 1920s, while moviemakers were striving to make their narratives coherent and understandable to a wide audience, the Surrealists had an entirely different agenda. They saw film's potential to fragment rather than create sense. Through skillful editing of startling images and effects, film became a new tool for exploring the unconscious. The two Spanish Surrealists, Salvador Dalí and Luis Buñuel, collaborated in 1929 on the 17-minute film *Un Chien andalou* (*An Andalusian Dog*) (Fig. **43.22**). Buñuel was a huge fan of Eisenstein and montage, and he used the technique to create a dream logic of fades—from a hairy armpit to a sea urchin, for instance. The film's famous opening sequence, a close-up of a girl's eye being sliced open by a razor (a cow's eye from the local butcher shop was actually used), is probably best understood as a metaphor for giving up dependence on reality and acceptance of Surrealism's inner vision. A year later, this time on his own, Buñuel made *L'Age d'or* (*The Golden Age*), one of the first French sound films. One scene, in which a religious reliquary was placed on the ground in front of an elegant lady getting out of her car, resulted in a riot that led Parisian authorities to destroy all prints of the film (in fact a few copies survived).

But despite the spirit of innovation in Europe, films made in "Hollywood"—which soon simply meant in the general vicinity of Los Angeles—dominated the world market and defined the medium, initiating the exportation of American culture that, for better or worse, would result in the gradual "Americanization" of global culture as a whole.

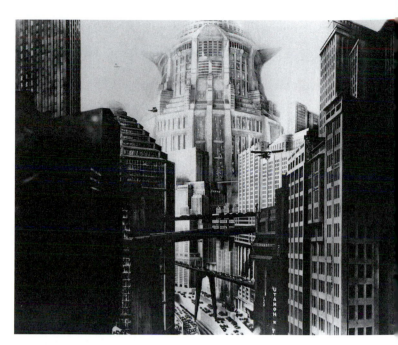

Fig. 43.21 The City, in Fritz Lang and Thea von Harbou's *Metropolis*. 1926. The cinematographer for *Metropolis*, responsible for creating the film's towering and sweeping visual effects, was Karl Freund, who later became director of photography for Desilu, supervising over 400 episodes of *I Love Lucy*, where he revolutionized television lighting and production.

Fig. 43.22 Scene from Salvador Dalí and Luis Buñuel's *Un Chien andalou* (*An Andalusian Dog*). 1929. Museum of Modern Art, Film Stills Archive. Though it is never easy to say with any conviction just what a Surrealist image might "mean," it seems likely that the two pianos with dead donkeys laid across them, being dragged across the room, suggest the weight of tradition.

READINGS

Countee Cullen, "Heritage" (1925)

The poem Heritage is both typical and something of an anomaly in Countee Cullen's work. Cullen longed to write poetry that succeeded not by force of his race but by virtue of its place in the tradition of English verse. In its form, the poem is completely traditional: rhymed couplets and iambic tetrameter (the first foot in each line is truncated—that is, the short syllable of the iambic foot has been dropped, leaving only the long syllable). But in its subject matter—Cullen's sense of his own uncivilized Africanness—its concerns are entirely racial.

What is Africa to me:
Copper sun or scarlet sea,
Jungle star or jungle track,
Strong bronzed men, or regal black
Women from whose loins I sprang
When the birds of Eden sang?
One three centuries removed
From the scenes his fathers loved,
Spicy grove, cinnamon tree,
What is Africa to me?　　　　　　　　10

So I lie, who all day long
Want no sound except the song
Sung by wild barbaric birds
Goading massive jungle herds,
Juggernauts of flesh that pass
Trampling tall defiant grass
Where young forest lovers lie,
Plighting troth beneath the sky.
So I lie, who always hear,
Though I cram against my ear　　　　　20
Both my thumbs, and keep them there,
Great drums throbbing through the air.
So I lie, whose fount of pride,
Dear distress, and joy allied,
Is my somber flesh and skin,
With the dark blood dammed within
Like great pulsing tides of wine
That, I fear, must burst the fine
Channels of the chafing net
Where they surge and foam and fret.　　　30

Africa? A book one thumbs
Listlessly, till slumber comes.
Unremembered are her bats
Circling through the night, her cats
Crouching in the river reeds,
Stalking gentle flesh that feeds
By the river brink; no more
Does the bugle-throated roar
Cry that monarch claws have leapt
From the scabbards where they slept.　　　40
Silver snakes that once a year
Doff the lovely coats you wear,

Seek no covert in your fear
Lest a mortal eye should see;
What's your nakedness to me?
Here no leprous flowers rear
Fierce corollas in the air;
Here no bodies sleek and wet,
Dripping mingled rain and sweat,
Tread the savage measures of　　　　　50
Jungle boys and girls in love.
What is last year's snow to me,
Last year's anything? The tree
Budding yearly must forget
How its past arose or set—
Bough and blossom, flower, fruit,
Even what shy bird with mute
Wonder at her travail there,
Meekly labored in its hair.
One three centuries removed　　　　　60
From the scenes his fathers loved,
Spicy grove, cinnamon tree,
What is Africa to me?

So I lie, who find no peace
Night or day, no slight release
From the unremittent beat
Made by cruel padded feet
Walking through my body's street.
Up and down they go, and back,
Treading out a jungle track.　　　　　70
So I lie, who never quite
Safely sleep from rain at night—
I can never rest at all
When the rain begins to fall;
Like a soul gone mad with pain
I must match its weird refrain;
Ever must I twist and squirm,
Writhing like a baited worm,
While its primal measures drip
Through my body, crying, "Strip!　　　80
Doff this new exuberance.
Come and dance the Lover's Dance!"
In an old remembered way
Rain works on me night and day.

Quaint, outlandish heathen gods
Black men fashion out of rods,
Clay, and brittle bits of stone,
In a likeness like their own,
My conversion came high-priced;
I belong to Jesus Christ, 90
Preacher of humility;
Heathen gods are naught to me.

Father, Son, and Holy Ghost,
So I make an idle boast;
Jesus of the twice-turned cheek,
Lamb of God, although I speak
With my mouth thus, in my heart
Do I play a double part.
Ever at Thy glowing altar
Must my heart grow sick and falter, 100
Wishing He I served were black,
Thinking then it would not lack
Precedent of pain to guide it,
Let who would or might deride it;
Surely then this flesh would know
Yours had borne a kindred woe.
Lord, I fashion dark gods, too,
Daring even to give You

Dark despairing features where,
Crowned with dark rebellious hair, 110
Patience wavers just so much as
Mortal grief compels, while touches
Quick and hot, of anger, rise
To smitten cheek and weary eyes.
Lord, forgive me if my need
Sometimes shapes a human creed.
All day long and all night through,
One thing only must I do:
Quench my pride and cool my blood,
Lest I perish in the flood. 120
Lest a hidden ember set
Timber that I thought was wet
Burning like the dryest flax,
Melting like the merest wax,
Lest the grave restore its dead.
Not yet has my heart or head
In the least way realized
They and I are civilized. ■

Reading Question

How are the sentiments Cullen expresses in the last three lines of the poem reflected in the rest of the poem?

READING 43.5

Langston Hughes, Selected Poems

Hughes began writing poems almost directly out of high school, and by the mid-1920s his was considered the strongest voice in the Harlem Renaissance. The Weary Blues, below, reflects Hughes's lifelong interest in the spoken or sung qualities of African-American vernacular language and its roots in musical idiom. The other two poems, from later in Hughes's career, reflect the challenges faced by African-American society, their simultaneous hope and despair in relation to American culture as a whole.

The Weary Blues (1923)

Droning a drowsy syncopated tune,
Rocking back and forth to a mellow croon,
 I heard a Negro play.
Down on Lenox Avenue the other night
By the pale dull pallor of an old gas light
 He did a lazy sway . . .
 He did a lazy sway . . .
To the tune o' those Weary Blues.
With his ebony hands on each ivory key
He made that poor piano moan with melody. 10
 O Blues!
Swaying to and fro on his rickety stool
He played that sad raggy tune like a musical fool.
 Sweet Blues!
Coming from a black man's soul.

O Blues!
In a deep song voice with a melancholy tone
I heard that Negro sing, that old piano moan—
"Ain't got nobody in all this world,
Ain't got nobody but ma self. 20
I's gwine to quit ma frownin'
And put ma troubles on the shelf."

Thump, thump, thump, went his foot on the floor.
He played a few chords then he sang some more—
 "I got the Weary Blues
 And I can't be satisfied.
 Got the Weary Blues
 And can't be satisfied—
 I ain't happy no mo'
 And I wish that I had died." 30
And far into the night he crooned that tune.

The stars went out and so did the moon.
The singer stopped playing and went to bed
While the Weary Blues echoed through his head.
He slept like a rock or a man that's dead.

Harlem (1951)

What happens to a dream deferred?
Does it dry up
Like a raisin in the sun?
Or fester like a sore—
And then run? 40
Does it stink like rotten meat?
Or crust and sugar over—
like a syrupy sweet?
Maybe it just sags
like a heavy load.

Or does it explode?

Theme for English B (1951)

The instructor said,

Go home and write
a page tonight.
And let that page come out of you— 50
Then, it will be true.

I wonder if it's that simple?
I am twenty-two, colored, born in Winston-Salem.
I went to school there, then Durham, then here
to this college on the hill above Harlem.
I am the only colored student in my class.
The steps from the hill lead down into Harlem,
through a park, then I cross St. Nicholas,
Eighth Avenue, Seventh, and I come to the Y,
the Harlem Branch Y, where I take the elevator 60

up to my room, sit down, and write this page:

It's not easy to know what is true for you or me
at twenty-two, my age. But I guess I'm what
I feel and see and hear, Harlem, I hear you:
hear you, hear me—we two—you, me, talk on this page.
(I hear New York, too.) Me—who?
Well, I like to eat, sleep, drink, and be in love.
I like to work, read, learn, and understand life.
I like a pipe for a Christmas present,
or records—Bessie, bop, or Bach. 70
I guess being colored doesn't make me *not* like
the same things other folks like who are other races.
So will my page be colored that I write?
Being me, it will not be white.
But it will be
a part of you, instructor.
You are white—
yet a part of me, as I am a part of you.
That's American.
Sometimes perhaps you don't want to be a part of me. 80
Nor do I often want to be a part of you.
But we are, that's true!
As I learn from you,
I guess you learn from me—
although you're older—and white—
and somewhat more free.

This is my page for English B. ■

Reading Question

Although Hughes's voice is distinctly African American, his poetry also reflects his clear understanding of modernist principles. What does it share with the writing of poets like Ezra Pound or William Carlos Williams?

READING 43.6

Zora Neale Hurston, "How It Feels to Be Colored Me" (1928)

Hurston's autobiographical essay describes her own ambiguous relationship to her color. It opens with memories of growing up in her native Eatonville, Florida, and ends in Harlem, detailing her growing identity as a person of color across the years, largely in terms of how others define her, not as she defines herself.

I am colored but I offer nothing in the way of extenuating circumstances except the fact that I am the only Negro in the United States whose grandfather on the mother's side was not an Indian chief.

I remember the very day that I became colored. Up to my thirteenth year I lived in the little Negro town of Eatonville, Florida. It is exclusively a colored town. The only white people I knew passed through the town going to or coming from Orlando. The native whites rode dusty horses, the Northern tourists chugged down 10 the sandy village road in automobiles. The town knew the Southerners and never stopped cane chewing when they passed. But the Northerners were something else again. They were peered at cautiously from behind curtains by the timid. The more venturesome would come out on the porch to watch them go past and got just as much pleasure out of the tourists as the tourists got out of the village.

The front porch might seem a daring place for the rest of the town, but it was a gallery seat to me. My favorite place was atop the gate-post. Proscenium box for a born first-nighter. Not only did I enjoy the show, but I didn't mind the actors knowing that I liked it. I usually spoke to them in passing. I'd wave at them and when they returned my salute, I would say something like this: "Howdy-do-well-I-thank-you-where-you-goin'?" Usually the automobile or the horse paused at this, and after a queer exchange of compliments, I would probably "go a piece of the way" with them, as we say in farthest Florida. If one of my family happened to come to the front in time to see me, of course negotiations would be rudely broken off. But even so, it is clear that I was the first "welcome-to-our-state" Floridian, and I hope the Miami Chamber of Commerce will please take notice.

During this period, white people differed from colored to me only in that they rode through town and never lived there. They liked to hear me "speak pieces" and sing and wanted to see me dance the parse-me-la, and gave me generously of their small silver for doing these things, which seemed strange to me for I wanted to do them so much that I needed bribing to stop. Only they didn't know it. The colored people gave no dimes. They deplored any joyful tendencies in me, but I was their Zora nevertheless. I belonged to them, to the nearby hotels, to the county—everybody's Zora.

But changes came in the family when I was thirteen, and I was sent to school in Jacksonville. I left Eatonville, the town of the oleanders, as Zora. When I disembarked from the river-boat at Jacksonville, she was no more. It seemed that I had suffered a sea change. I was not Zora of Orange County any more, I was now a little colored girl. I found it out in certain ways. In my heart as well as in the mirror, I became a fast brown—warranted not to rub nor run.

But I am not tragically colored. There is no great sorrow dammed up in my soul, nor lurking behind my eyes. I do not mind at all. I do not belong to the sobbing school of Negrohood who hold that nature somehow has given them a lowdown dirty deal and whose feelings are all hurt about it. Even in the helter-skelter skirmish that is my life, I have seen that the world is to the strong regardless of a little pigmentation more or less. No, I do not weep at the world—I am too busy sharpening my oyster knife.

Someone is always at my elbow reminding me that I am the granddaughter of slaves. It fails to register depression with me. Slavery is sixty years in the past. The operation was successful and the patient is doing well, thank you. The terrible struggle that made me an American out of a potential slave said "On the line!" The Reconstruction said "Get set!"; and the generation before said "Go!" I am off to a flying start and I must not halt in the stretch to look behind and weep. Slavery is the price I paid for civilization, and the choice was not with me. It is a bully adventure and worth all that I have paid through my ancestors for it. No one on earth ever had a greater chance for glory. The world to be won and nothing to be lost. It is thrilling to think—to know that for any act of mine, I shall get twice as much praise or twice as much blame. It is quite exciting to hold the center of the national stage, with the spectators not knowing whether to laugh or to weep.

The position of my white neighbor is much more difficult. No brown specter pulls up a chair beside me when I sit down to eat. No dark ghost thrusts its leg against mine in bed. The game of keeping what one has is never so exciting as the game of getting.

I do not always feel colored. Even now I often achieve the unconscious Zora of Eatonville before the Hegira. I feel most colored when I am thrown against a sharp white background.

For instance at Barnard. "Beside the waters of the Hudson" I feel my race. Among the thousand white persons, I am a dark rock surged upon, overswept by a creamy sea. I am surged upon and overswept, but through it all, I remain myself. When covered by the waters, I am; and the ebb but reveals me again.

Sometimes it is the other way around. A white person is set down in our midst, but the contrast is just as sharp for me. For instance, when I sit in the drafty basement that is The New World Cabaret with a white person, my color comes. We enter chatting about any little nothing that we have in common and are seated by the jazz waiters. In the abrupt way that jazz orchestras have, this one plunges into a number. It loses no time in circumlocutions, but gets right down to business. It constricts the thorax and splits the heart with its tempo and narcotic harmonies. This orchestra grows rambunctious, rears on its hind legs and attacks the tonal veil with primitive fury, rending it, clawing it until it breaks through the jungle beyond. I follow those heathen—follow them exultingly. I dance wildly inside myself; I yell within, I whoop; I shake my assegai above my head, I hurl it true to the mark yeeeooww! I am in the jungle and living in the jungle way. My face is painted red and yellow and my body is painted blue. My pulse is throbbing like a war drum. I want to slaughter something—give pain, give death to what, I do not know. But the piece ends. The men of the orchestra wipe their lips and rest their fingers. I creep back slowly to the veneer we call civilization with the last tone and find the white friend sitting motionless in his seat, smoking calmly.

"Good music they have here," he remarks, drumming the table with his fingertips.

Music! The great blobs of purple and red emotion have not touched him. He has only heard what I felt. He is far away and I see him but dimly across the ocean and the continent that have fallen between us. He is so pale with his whiteness then and I am so colored.

At certain times I have no race, I am me. When I set my hat at a certain angle and saunter down Seventh Avenue, Harlem City, feeling as snooty as the lions in front of the Forty-Second Street Library, for instance. So far as my feelings are concerned, Peggy Hopkins Joyce on the Boule Mich with her gorgeous raiment, stately carriage, knees knocking together in a most aristocratic manner, has nothing on me. The cosmic Zora emerges. I belong to no race nor time. I am the eternal feminine with its string of beads. 140

I have no separate feeling about being an American citizen and colored. It merely astonishes me. How can any deny themselves the pleasure of my company! It's beyond me.

But in the main, I feel like a brown bag of miscellany propped against a wall. Against a wall in company with other bags, white, red and yellow. Pour out the contents, and there is discovered a jumble of small things priceless and worthless. A first-water diamond, an empty spool,

bits of broken glass, lengths of string, a key to a door 150
long since crumbled away, a rusty knifeblade, old shoes saved for a road that never was and never will be, a nail bent under the weight of things too heavy for any nail, a dried flower or two, still a little fragrant. In your hand is the brown bag. On the ground before you is the jumble it held—so much like the jumble in the bags, could they be emptied, that all might be dumped in a single heap and the bags refilled without altering the content of any greatly. A bit of colored glass more or less would not matter. Perhaps that is how the Great Stuffer of Bags 160
filled them in the first place—who knows? ■

Reading Questions

How would you explain the metaphor with which Hurston's essay concludes? What, exactly, is this "brown bag of miscellany propped against a wall"?

Summary

■ **Skyscraper and Machine: Architecture in New York** The 1920s represent a period of unprecedented growth in New York City, as downtown skyscraper after skyscraper rose to ever greater heights, and the promise of the machine became a driving force in culture. Artists and photographers saw in both the skyscraper and the machine the revelation of a geometry and form underlying all existence. The New York building boom of the 1920s, dominated by the highly ornamented and decorative architecture epitomized by Cass Gilbert's neo-Gothic Woolworth Building and William van Alen's Art Deco Chrysler Building, was countered by the modernist purity of a newly International Style that emphasized this geometric simplicity and directness.

■ **The Harlem Renaissance** Originating in the writings of W.E.B. DuBois, the Harlem Renaissance explored the double-consciousness defining African-American identity. Inspired by DuBois, poet Claude McKay and Charles S. Johnson of the National Urban League, philosopher Alain Locke saw Harlem as the center of the new African-American avant-garde destined to rehabilitate his people from a position of spiritual and financial impoverishment for which, in his words, "the fate and conditions of slavery have so largely been responsible." To this end, first in the Harlem issue of the sociology journal the *Survey Graphic*, and then in his anthology *The New Negro*, both published in 1925, Locke emphasized the spirit of the young writers, artists, and musicians of Harlem, including the poets Langston Hughes and James Weldon Johnson, fiction writer Zora Neale Hurston, and the artist Aaron Douglas, whose work would influence the later painting of Jacob Lawrence. All were interested in capturing the essence of African-American experience, and they paid special attention to the rhythms of black speech and music. Harlem was, after all, the center of the blues and jazz. The greatest of the blues singers in the 1920s was Bessie Smith. In jazz, Louis Armstrong's Dixieland jazz, which originated out of New Orleans and made its way north to Chicago, gained wide popularity, as did the swing rhythms of Duke Ellington, who in 1927 began a five-year engagement at Harlem's Cotton Club.

■ **Making It New: The Art of Place** The "new" sound of jazz embodied the modernist imperative, first expressed by Ezra Pound, to "make it new." In poetry, this imperative was realized in the work of William Carlos Williams, E. E. Cummings, and Hart Crane. The work of all three celebrates the new machine culture of the era even as it attempts to capture the vernacular voice of everyday Americans. These interests are reflected as well in the painting of Joseph Stella, Charles Demuth, Marsden Hartley, and Georgia O'Keeffe, all of whom were supported by photographer Alfred Stieglitz first at his Gallery 291 and later at An American Place. Like the poets of the era, the experimental plays of Eugene O'Neill captured, as perhaps never before in the theater, the vernacular voices of the American character even as they stressed the isolation and alienation of modern experience.

■ **The Golden Age of Silent Film: Hollywood in the 1920s** During the early 1900s, large numbers of immigrants, particularly second-generation American Jews, migrated out of New York, where many had worked in the garment industry, to California, where they founded the motion picture industry in and around Hollywood. The studio system they developed—controlling all aspects of the industry from production to distribution and exhibition—dominated filmmaking worldwide. By the end of the 1920s, there were five major American studios—Fox, MGM, Paramount, RKO, and Warner—and three smaller ones—Universal, Columbia, and United Artists. They focused their promotional efforts on the appeal of their stars, including Mary Pickford, Charlie Chaplin, and Douglas Fairbanks. They also depended on their audience's attraction to certain genres—comedy; fantasy; adventure; the crime or gangster film; the coming-of-age film; the so-called woman's film, combining romance and family life; romantic drama; the horror film; war films; and the Western chief among them. Experimental film flourished in Europe—in German Expressionist cinema and Surrealist film—but the American studios dominated the industry, producing between 75 percent and 90 percent of all films in the 1920s.

Glossary

blue note A musical note that is slightly lower or flatter than a conventional pitch.

blues A musical genre consisting of laments bemoaning loss of love, poverty, or social injustice; the standard blues form consists of three sections of four bars each.

call-and-response A technique in which two musicians imitate each other as closely as possible on their different instruments.

Dixieland jazz A musical genre in which the trumpet carries the main melody, the clarinet plays off it with a higher counter-melody, and the trombone plays a simpler, lower tune.

genre A standard type that is usually readily recognizable by its audience.

scat A technique in which the performer sings in nonsense syllables.

swing A musical genre characterized by big bands that produced a powerful sound and whose rhythm depends on subtle avoidance of downbeats.

Critical Thinking Questions

1. Explain how the prose, verse, and visual arts of the Harlem Renaissance constitute an "art of place." Characterize that place.

2. How is the idea of a new "machine-inspired classicism" expressed in American verse and painting of the 1920s?

3. What makes the silent film culture of the 1920s a "Golden Age"?

The Rise of Fascism

Continuity & Change

The experimental fervor of the avant-garde did not go forward without meeting resistance. In the Soviet Union, abstract art was banned as the product of "bourgeois decadence," and artists were called upon to create "a true, historically concrete portrayal of reality in its revolutionary development." In other words, artists were expected to create propaganda in support of the Soviet state. In Germany, a similar edict was issued by Hitler, this time motivated by racism. He began a 1934 speech by declaring, "All the artistic and cultural blather of Cubists, Futurists, Dadaists, and the like is neither sound in racial terms nor tolerable in national terms. It . . . freely admits that the dissolution of all existing ideas, all nations and races, their mixing and adulteration, is the loftiest goal."

A year earlier, Nazi Minister for Popular Enlightenment and Propaganda Joseph Goebbels had inaugurated a program to "synchronize culture"— that is, align German culture with Nazi ideals. To that end, he enlisted German university students to lead the way, and on April 6, 1933, the German Student Association proclaimed a nationwide "Action against the Un-German Spirit." They demanded, in 12 "theses" (a direct reference to Martin Luther's revolutionary theses), the establishment of a "pure" national culture as opposed to the spread of what they called "Jewish intellectualism."

Then, on the night of May 10, in most university towns, the students staged a national march "Against the Un-German Spirit," culminating in the burning of more than of

25,000 volumes of "un-German" books, including works by Thomas Mann, Erich Maria Remarque, Albert Einstein, Jack London, Upton Sinclair, H. G. Wells, Sigmund Freud, Ernest Hemingway, and Helen Keller. The events were broadcast live on radio to the nation. Addressing the crowd in front of the Opera House in Berlin's Opernplatz (Fig. **43.23**), Goebbels proclaimed:

> German students: We have directed our dealings against the un-German spirit; consign everything un-German to the fire, against class conflict and materialism, for people, community, and idealistic living standards. . . .
>
> Against decadence and moral decay! For discipline and propriety in family and state! I hand over to the fire the writings of Heinrich Mann. . . .
>
> Against literary betrayal of the soldiers of the world war, for education of the people in the spirit of truthfulness! I hand over the writings of Erich Maria Remarque to the fire.

Authors whose works were spared felt insulted. Bertolt Brecht, author of The Three-penny Opera and Mother Courage, wrote an angry poem, Die Bücherverbrennung (The Book Burning), demanding that the regime burn him, since it had not burned his writings. Soon art criticism was required to be purely descriptive, German Expressionist painting was described as "Nature as seen by sick minds," and the market in modern art was explained as a conspiracy of Jewish dealers to dupe the German public. Conflict extending far beyond the art world soon seemed inevitable. ■

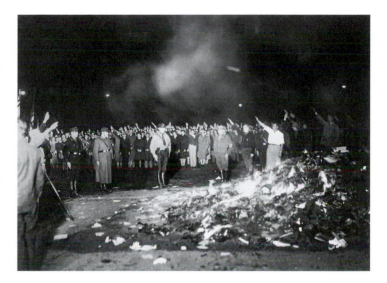

Fig. 43.23 Burning books on the Opernplatz, Berlin, May 10, 1933.

44 Between the Wars

The Age of Anxiety

The Glitter and Angst of Berlin

The Rise of Fascism

Revolution in Mexico

The Great Depression in America

Cinema: The Talkies and Color

In the souls of the people, the grapes of wrath are filling and growing heavy, growing heavy for the vintage.

John Steinbeck, *The Grapes of Wrath*

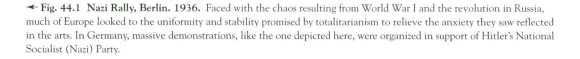

◄ **Fig. 44.1 Nazi Rally, Berlin. 1936.** Faced with the chaos resulting from World War I and the revolution in Russia, much of Europe looked to the uniformity and stability promised by totalitarianism to relieve the anxiety they saw reflected in the arts. In Germany, massive demonstrations, like the one depicted here, were organized in support of Hitler's National Socialist (Nazi) Party.

N THE 1920s, BERLIN, THE CAPITAL OF GERMANY, RIVALED AND

may even have surpassed New York and Paris as a center of the arts. Its Philharmonic

Orchestra was without equal in the world, its political theater and cabaret were daring

and innovative, its architecture was the most advanced and modern in Europe, and its art

was challenging, nonconformist, and politically committed. It is no wonder that Dada thrived in Berlin (see chapter 42).

Not everyone was mesmerized by Berlin's cultural glitter. The Austrian writer Stefan Zweig [tsvike (long "i," as in "eye")] (1881–1942), who arrived in the city in the early 1920s, described the place in disapproving terms:

> I have a pretty thorough knowledge of history, but never, to my recollection, has it produced such madness in such gigantic proportions. All values were changed, and not only material ones, the laws of the State were flouted, no tradition, no moral code, was respected, Berlin was transformed into the Babylon of the world. Bars, amusement parks, honky-tonks sprang up like mushrooms. . . . Along the entire Kurfürstendamm [ker-fer-shten-dahm] powdered and rouged young men sauntered . . . and in the dimly lit bars one might see government officials and men of the world courting drunken sailors without shame. . . . In the collapse of all values a kind of madness gained hold.

This is the libertine world of homosexuals and prostitutes that the National Socialist (Nazi) party of Adolf Hitler (1889–1945) would condemn in its massive public demonstrations (Fig. **44.1**). Hitler blamed intellectuals for his country's moral demise—specifically Jewish intellectuals. And he assumed without question that they were, in one way or another, associated with communism, which he saw as a threat to the economic health of Germany due to the association of communists with labor unions. Hitler's success at controlling German public opinion brought the Nazi party to power in 1933 and led to the imposition of a fascistic (totalitarian and nationalistic) regime known as the Third Reich on that formerly republican state. Similar regimes arose across Europe as well.

This chapter surveys the rise of fascism and its consequences for art and culture in the two decades after World War I in Germany, Italy, Spain, and the Soviet Union. It also surveys the struggle for freedom in Mexico and the work of the artists who supported the Mexican Revolution. Finally, it focuses on the effects of the Great Depression in the United States—from the Works Progress Administration

(the WPA) to the rise of regional fiction in the New South and the heyday of the motion-picture industry. Over all of these developments the specter of fascism hung like a dark cloud as, throughout the 1930s, another world war seemed increasingly inevitable.

The Glitter and Angst of Berlin

At the end of World War I the Weimar Republic became successor to the German Empire, with Berlin remaining as its capital (Map **44.1**). Two years later, in 1920, the Greater Berlin Act united numerous suburbs, villages, and estates around Berlin into a greatly expanded city with Berlin as its administrative center. The population of the expanded city was around 4 million. As a result, Berlin was Germany's largest city. It was the center not only of German cultural and intellectual life but also that of Eastern Europe, a city to which artists and writers were drawn by the very liberalism and collapse of traditional values that Stefan Zweig bemoaned. The poet and playwright Carl Zuckmayer [TSOOK-my-er] (1896–1977) described the

Map 44.1 Weimar Germany, 1919–1933.

decadent glitter of the city's brothels and nightclubs in sexually frank terms:

> People discussed Berlin . . . as if Berlin were a highly desirable woman, whose coldness and capriciousness were widely known; the less chance anyone had to win her, the more they decried her. We called her proud, snobbish, nouveau riche, uncultured, crude. But secretly everyone looked upon her as the goal of their desires. Some saw her as hefty, full-breasted, in lace underwear, others as a mere wisp of a thing, with boyish legs in black silk stockings. The daring saw both aspects, and her very capacity for cruelty made them the more aggressive. All wanted to have her, she enticed all.

Here was a city of pleasures that one could not resist, yet its attractions were informed by a deeply political conscience. German communists shuttled back and forth between Moscow and Berlin, bringing with them Lenin's views on culture (see chapter 42). They scoffed at the politics of the Weimar Republic, which seemed farcical to them. (In the 15 years of its life, there were 17 different governments as the economy plunged into chaos.) Political street fights were common. In Berlin, artists and intellectuals, workers and businessmen wandered through a maze of competing political possibilities—all of them more or less strident.

The painter Georg Grosz [grohs] (1893–1959) would parody this world in his 1926 *The Pillars of Society* (Fig. **44.2**). The title refers to three major divisions of society: the military, the clergy, and above all, the middle class. All varieties of German politics are Grosz's target. Standing at the bar, sword in one hand, beer in the other, is a middle-class National Socialist (identifiable by the swastika on his tie), a warhorse rising out of his open skull. Behind him, the German flag in his hand, is a Social Democrat, his skull likewise open, displaying his party's slogan—"Socialism is work"—as he stands idly at the bar. Beside him is a journalist, chamberpot on his head, quill and pencil in hand, apparently ready to demonstrate to the National Socialist that the pen is mightier than the sword. A clergyman, his eyes closed, turns as if in praise of the fiery streets visible out the door even as soldiers commit violence behind his back. Grosz's vision is of a society at the edge of chaos and doom, led by brainless politicians, incompetent journalists, an angry middle class, a blind clergy, and a vindictive military. Such a vision, shared by many, created a certain feeling of *angst* in Berlin and elsewhere in Germany, a feeling of nervous anxiety and dread that would manifest itself in fiction, the theater, and the arts.

Kafka's Nightmare Worlds

One of the many Eastern Europeans drawn to Berlin—perhaps for its angst as well as its glitter—was the Jewish Czech-born author Franz Kafka [KAHF-kuh] (1883–1924), who wrote in German. He came to Berlin in 1923 only to leave a year later, just before dying from complications of tuberculosis. His fellow

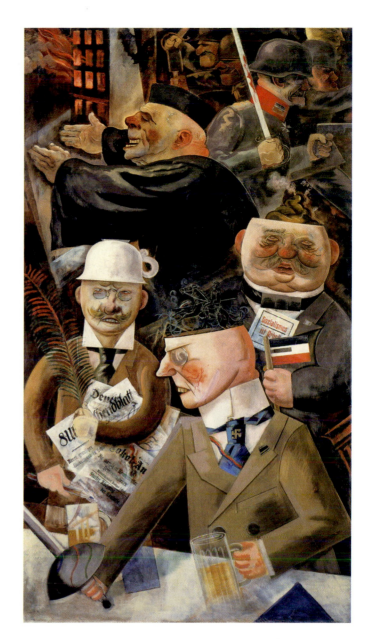

Fig. 44.2 Georg Grosz. *The Pillars of Society.* **1926.** Oil on canvas, 78³/₄″ × 42¹/₂″. Photo: Joerg P. Anders. Nationalgalerie, Staatliche Museen zu Berlin, Berlin, Germany. Art © Estate George Grosz/Licensed by VAGA, NY. Grosz's biting wit was not tolerated by Hitler's fascist regime, and in the 1930s he fled Germany to the United States.

Prague native and friend Max Brod (1884–1968) made sure that Kafka's unpublished works found their way to press in Germany.

Kafka was something of a tortured soul, and the characters in his works of fiction typically find themselves caught in inexplicable circumstances that bear all the markings of their own neuroses. Berliners identified with these characters immediately. His novel *The Trial*, left unfinished but published in Berlin in 1925, opens with this sentence: "Someone must have been telling lies about Josef K., he

knew he had done nothing wrong but, one morning, he was arrested." The story is at once an indictment of modern bureaucracy and a classic study in paranoia. Never informed of what he has been accused, Josef K. can only address the empty court with a virtually paranoid sense of his own impotence (**Reading 44.1**):

READING 44.1 **from Franz Kafka, *The Trial* (1925)**

There can be no doubt that behind all the actions of this court of justice, that is to say in my case, behind my arrest and today's interrogation, there is a great organization at work. An organization which not only employs corrupt warders, oafish Inspectors, and Examining Magistrates of whom the best that can be said is that they recognize their own limitations, but also has at its disposal a judicial hierarchy of high, indeed of the highest rank, with an indispensable and numerous retinue of servants, clerks, police, and other assistants, perhaps even hangmen, I do not shrink from that word. And the significance of this great organization, gentlemen? It consists in this, that innocent persons are accused of guilt, and senseless proceedings are put in motion against them.

Embodied in this excerpt and in the entire novel is the clash between state politics and individual liberty that fueled Berlin life.

In Kafka's novella *The Metamorphosis*, first published in 1915, Gregor Samsa [SAHM-sah] similarly awakes to a stunning predicament: Overnight he has been transformed into a gigantic insect. (See **Reading 44.2**, page 1453, for the story's opening paragraphs.) Gregor's predicament is not unlike that of a person suffering from a severe disability, but it also suggests the deep-seated sense of alienation of the modern consciousness. For Gregor's metamorphosis is inexplicable and unexplained. It is simply his condition: dreadful, doomed, and oddly funny—a condition with which many in Berlin identified.

Brecht and the Berlin Stage

In 1924, Bertolt Brecht [brehkt](1898–1954), a young playwright from Munich, arrived in Berlin. He had already achieved a certain level of fame among intellectuals of his own generation for his deeply cynical and nihilistic play *Drums in the Night* (1918). It is the story of a young woman, Anna Balicke, who believes her love, Andreas, has died in the war and who is about to marry a wealthy war materials manufacturer when Andreas returns. It encapsulates the

feelings of a generation of soldiers who felt that they had fought for nothing while a greedy older generation profited from their sacrifice.

Drums in the Night is set against the backdrop of the communist-inspired Spartakistbund (Spartacus League) uprising of January 1919 in Germany. (The *bund* took its name from Spartacus, leader of the largest slave rebellion in the Roman Republic.) It was the last act of a postwar revolution that had begun the previous November when sailors in the German navy refused to sacrifice themselves in a pointless final battle with the British Royal Navy. Quickly supported by workers across Germany, the league protested in the streets under the slogan, *Frieden und Brot* [FREE-den oond brot] ("Peace and Bread"). So massive was the protest that it forced Kaiser Wilhelm II to abdicate in favor of the Social Democratic Party (SPD) under the leadership of Friedrich Ebert [AY-bert] (1871–1925). But when 500,000 people surged into the streets of Berlin on January 7, 1919, occupying buildings, Ebert ordered the anti-Republican paramilitary organization known as the *Freikorps* [FRY-kor], which had kept its weapons and equipment after the war, to attack the workers. The *Freikorps* quickly retook the city, killing many workers and innocent civilians even as they tried to surrender.

These events inspired Brecht to turn to Marxism, which he began to study intensely. The first major hit to result from this study was *The Threepenny Opera*, an updating of John Gay's eighteenth-century play *The Beggar's Opera* (see chapter 29), set to music by Kurt Weill [vile](1900–1950). When it premiered at Berlin's Shiffbauerdamm [SHIF-bau-er-dahm] Theater in 1928, *The Threepenny Opera* was a huge success. It is not, in fact, an opera but a work of musical theater focusing on the working class of Victorian London, who are as organized and well-connected in their shady businesses as any bourgeois banker or corporation president. Its hero, Macheath, or Mackie Messer (Mack the Knife), is a criminal sentenced to hang at the instigation of his lover Polly's father, Mr. Peachum, an entrepreneur of the crassest kind. Mr. Peachum is boss of London's beggars, whom he equips and trains in return for a cut of whatever they can beg. At the last moment Macheath is unexpectedly saved by a royal pardon and is granted a castle and a pension as an unjust reward for his life of crime.

The play is Brecht's socialist critique of capitalism, but aside from its political message it embodies a revolutionary approach to theater based on alienation. It rejects the traditional relationship between play and audience, in which the viewer is invited to identify with the plight of the main character and imaginatively enter the world of the play's illusion. Brecht wanted his audience to maintain a detached relationship with the characters in the play and to view them critically. He believed they should always be aware that they were watching a play, not real life. Brecht called his new approach to the stage **Epic theater**, which he later explained as follows (**Reading 44.3**):

READING 44.3 from Bertolt Brecht, "Theater for Pleasure or Theater for Imagination" (ca. 1935)

The spectator was no longer in any way allowed to submit to an experience uncritically (and without practical consequences) by means of simple empathy with the characters in a play. The production took the subject matter and the incidents shown and put them through a process of alienation: the alienation that is necessary to all understanding. When something seems "the most obvious thing in the world" it means that any attempt to understand the world has been given up.

What is "natural" must have the force of what is startling. This is the only way to expose the laws of cause and effect. People's activity must simultaneously be so and be capable of being different.

It was all a great change.

The dramatic theater's spectator says: Yes, I have felt like that too—Just like me—It's only natural—It'll never change—The sufferings of this man appall me, because they are inescapable—That's great art; it all seems the most obvious thing in the world—I weep when they weep, I laugh when they laugh.

The epic theater's spectator says: I'd never have thought it—That's not the way—That's extraordinary, hardly believable—It's got to stop—The sufferings of this man appall me, because they are unnecessary—That's great art; nothing obvious in it—I laugh when they weep, I weep when they laugh.

Brecht realizes this alienation effect, as he called it, in many ways. First, the scenes do not flow continuously one to the next; rather, the narrative jumps around. Second, actors make it clear that they are, indeed, acting. Third, there is no curtain; stage sets are visible from the point the audience enters the theater, and stage machinery is entirely visible. Fourth, the musical numbers, such as the play's opening song, "Mack the Knife" (see **CD-Track 44.1**), were purposefully designed to interrupt, not further, the action.

This song, like the rest of the score, is strongly influenced by jazz. In fact, the original production specified a 15-piece jazz combo. The play opens, then, with a raucous cabaret number that celebrates the dark underworld of murder and mayhem that lies beneath the surface of London life, jarring its audience out of complacency.

Kollwitz and the Expressionist Print

One of the most powerful voices of protest in Berlin during the 1920s was artist Käthe Kollwitz [KOLL-vits] (1867–1945). She trained at art schools in Berlin and Munich but married a doctor whose practice concentrated on tending the poor of the city. As a result, she was in constant contact with workers and their plight. As she explained:

> The motifs I was able to select from this milieu (the workers' lives) offered me, in a simple and forthright way, what I discovered to be beautiful. . . . People from the bourgeois sphere were altogether without appeal or interest. All middle-class life seemed pedantic to me. On the other hand, I felt the proletariat had guts. . . . [W]hen I got to know the women who would come to my husband for help, and incidentally also to me . . . I was powerfully moved by the fate of the proletariat and everything connected with its way of life.

Kollwitz's work before World War I consisted of highly naturalist portrayals of the German poor, including a series of prints depicting the Peasants' War during the Reformation in 1525 (see chapter 21). They are profoundly moving images of grief, suffering, and doom. The loss of her son Peter in October 1914, just months into World War I, permanently changed Kollwitz's art, politicizing it, as she became increasingly attracted to communism. The death also radicalized her work stylistically. Before the war, she had concentrated on etching—the rich, densely linear medium of her German forebear Albrecht Dürer (see chapter 21). But now she turned to the more dramatic, Expressionist media of woodblock and lithograph favored by members of *Die Brücke* and *Der Blaue Reiter* (see chapter 41). On the block, she could gouge out the areas of white with the violent ferocity evident in her 1925 woodblock *Hunger* (Fig. **44.3**). Here Death with his waving scythe lords it over the starving mothers and children. In lithographs, which she used particularly to make broadly distributed political posters with messages such as *Never Again War!* (1924), she was able to achieve a gestural freedom as powerful and strident as her woodblocks.

The Rise of Fascism

In response to the exciting but disturbing freedom so evident in Berlin's urban art world and nightlife, European conservatives longed to return to a premodern, essentially rural past. In Germany, bourgeois youth thronged to the *Wandervogel* [VAHN-der-foh-gul] (literally, "freebirds" or "hikers") movement, joining together around campfires in the mountains to play the guitar and sing in an effort to reinvent a lost German romantic ideal. They longed for the sense of order and cultural preeminence that had been destroyed by Germany's defeat in World War I. They longed to be "whole" again, a longing that to many was geographical as well as psychological because the country had been stripped of the territories of Alsace-Lorraine [AHL-sahss-lor-REN] to the west and Silesia [sy-LEE-zhuh] to the east.

Fig. 44.3 Käthe Kollwitz. _Hunger_. 1925. Woodcut on heavy japan paper, 22 $\frac{7}{8}$″ × 16 $\frac{7}{8}$″. Los Angeles County Museum of Art, the Robert Gore Rifkind Center for German Expressionist Studies. Photograph © 2009 Museum Associates/ LACMA M82.288.185. © 2009 Artists Rights Society (ARS), NY/VG Bild-Kunst, Bonn. Kollwitz shunned the painting medium, choosing to work in prints, which could be circulated to a wide audience that included the working class.

Modernity itself, which after all had brought them the war, was their enemy. It was in the city of Weimar [VY-mar], where the nineteenth-century Romantics Goethe and Schiller had lived, that the National Assembly convened to draft a new constitution at the end of World War I, lending the new republic its name even as Berlin remained the German capital (see Map 44.1). But the politics of the Weimar Republic were anything but comfortable. As historian Peter Gay has put it, "The hunger for wholeness was awash with hate: the political, and sometimes the private, world of its chief spokesmen was a paranoid world, filled with enemies: the dehumanizing machine, capitalist materialism, godless rationalism, rootless society, cosmopolitan Jews, and that great all-devouring monster, the city." Out of this hate, the authoritarian political ideology known as fascism was born. Fascism arose across Europe after World War I. It was the manifestation of mass movements that subordinated individual interests to the needs of the state as they sought to forge a sense of national unity based on ethnic, cultural, and, usually, racial identity. The German fascists led the way.

Hitler in Germany

Late in 1923, Adolf Hitler, the son of an Austrian customs official, staged an unsuccessful *putsch* [pooch], or revolt, at a Munich beer hall. In his youth Hitler had wanted to be an artist and had served in the German army in World War I, where he was awarded the Iron Cross for bravery but rose only to the rank of private. He was strongly affected by the German defeat to join the National Socialist (Nazi) party. He was accompanied in his revolt by fellow "storm troopers," the private soldiers of the Nazi party noted for their brown shirts and vigilante tactics. Local authorities killed 16 Nazis and arrested Hitler. He used his trial to attract national attention, condemning the Versailles Treaty, Jews, and the national economy, which was suffering from astronomical inflation as paper money became essentially worthless. Convicted and sentenced to five years in jail, he spent the few months that he actually served writing the racist tract *Mein Kampf* [mine kahmpf] (*My Struggle*), published in 1925. In it he argued that the German race (wrongly described as Aryan) was superior to all others (**Reading 44.4**):

READING 44.4 **from Adolf Hitler, *Mein Kampf* (1925)**

Every manifestation of human culture, every product of art, science and technical skill, which we see before our eyes today, is almost exclusively the product of Aryan creative power.... On this planet of ours human culture and civilization are indissolubly bound up with the presence of the Aryan. If he should be exterminated or subjugated, then the dark shroud of a new barbarian era would enfold the earth.

Anti-Semitism Hitler felt that the forces of modernity, specifically under the leadership of Jewish intellectuals, were determined to exterminate the Aryan race. Fear-mongering was the rhetorical bread and butter he used to drive others to his view:

> Jewish youth lies in wait for hours on end satanically glaring at and spying on the unconscious girl whom he plans to seduce, adulterating her blood with the ultimate idea of bastardizing the white race which they hate and thus lowering its cultural and political level so that the Jew might dominate.

The collapse of world economies in the Great Depression, a direct result of the crash of the New York stock market on October 29, 1929, fueled middle-class fear to even greater heights. As far as Hitler was concerned, Jewish economic interests were responsible for the crash. By 1932, more than 6 million Germans were unemployed, and thousands of them joined the Nazi storm troopers. Their ranks rose from 100,000 in 1930 to over 1 million in 1933.

Artists and intellectuals responded to this anti-Semitic challenge. Some of the most extraordinary examples are the posters of John Heartfield (1891–1968). Heartfield had anglicized his name from Helmut Herzfeld to antagonize Germans who, as a result of World War I, almost reveled in Anglophobia. He had satirized the Weimar Republic from the outset, but he savagely attacked Hitler in political photomontages—collages composed of multiple photographs—many published in the *Arbeiter-Illustrierte Zeitung* [AR-by-tuh-ill-oos-TREER-tuh TSY-toong], a widely distributed workers' newspaper that had 500,000 readers in 1931. Heartfield clearly understood the ability of photomontage to bring together images of a vastly different scale in a single work with an immense impact. In *Der Sinn des Hitlergrusses: Kleiner Mann bittet um grosse Gaben. Motto: Millonen Stehen Hinter Mir!* (The Meaning of the Hitler Salute: Little Man Asks for Big Gifts. Motto: Millions Stand Behind Me!) Heartfield exposes Hitler's reliance on fat, wealthy German industrialists—whom the readers of *Arbeiter-Illustrierte Zeitung* despised—suggesting that the famous Nazi salute is, in reality, a plea for money (Fig. **44.4**).

Many workers were sympathetic to communism. But if they were initially leery of Hitler, enough of them had been won over by the end of January 1933 to elect him chancellor (prime minister) of Germany. This election ended the Weimar Republic and inaugurated the Third Reich [ryek] (1933–1945), Hitler's name for the totalitarian and nationalistic dictatorship he led. When, on February 27, 1933, a mentally ill Dutch communist set fire to the Reichstag, seat of the German government in Berlin, Hitler invoked an act that had been written into the original Weimar Constitution allowing the president to rule by decree in an emergency. (He convinced the president to sign the decree.) By the next day he had arrested 4,000 members of the Communist Party. Communism was, after all, the creation of yet another German Jew, Karl Marx. So, from Hitler's paranoid point of view, the destruction of the German state was part and parcel of communism's international conspiracy.

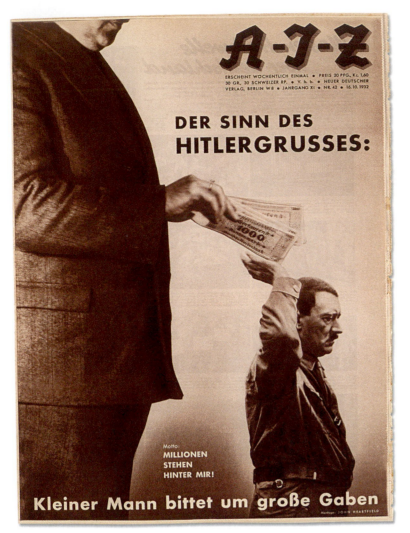

Fig. 44.4 John Heartfield. *Der Sinn des Hitlergrusses: Kleiner Mann bittet um grosse Gaben. Motto: Millonen Stehen Hinter Mir!* (The Meaning of the Hitler Salute: Little Man Asks for Big Gifts. Motto: Millions Stand Behind Me!). 1932. Photo-mechanical reproduction. The Metropolitan Museum of Art, NY (1987.1125.8). Image © The Metropolitan Museum of Art/Art Resource, NY. After the National Socialists took power in 1933, Heartfield fled to Czechoslovakia, where he continued to create photomontages for *Arbeiter-Illustrierte Zeitung*. He did not return to Germany until after World War II.

The Nazis urged German citizens to boycott Jewish business-es, and they expelled Jews from the civil service. Finally, in Sep-tember 1935, with the passage of the so-called Nuremberg Laws, anti-Semitism became official German policy. A Jew was defined as anyone with at least one Jewish grandparent, and his or her German citizenship was revoked. Intermarriage and extramarital relationships between Jews and non-Jews were for-bidden. Jews were prohibited from writing, publishing, making art, giving concerts, acting on stage or screen, teaching, work-ing in a bank or hospital, and selling books. In this atmosphere of hatred, it is little wonder that, in November 1938, Herschel Grynszpan, a Jewish boy of 17, would take it upon himself to kill the secretary of the German embassy in Paris, driven mad by the persecution of his parents in Germany. And it is even less wonder that mobs throughout Germany and parts of Austria,

egged on by the Nazis, responded, on what has become known as the *Kristallnacht* [kri-SHTAHL-nahkt] (Night of Broken Glass), by burning and looting Jew-ish shops and synagogues, invading Jews' homes, beat-ing them, and stealing their possessions.

The Bauhaus and the Rise of the International Style
The impact on the arts of Hitler's rise to power is nowhere more clearly demonstrated than in the history of the Bauhaus (from the German verb *bauen* [BOW-en (as in "now")], "to build"), the art school created by architect Walter Gropius [GROH-pee-us] (1883–1969) in Weimar in 1919. Its aim, Gropius wrote in the Bauhaus manifesto, was to

> conceive and create the new building of the future, which will combine everything—archi-tecture and sculpture and painting—in a single form which will one day rise towards the heavens from the hand of a million workers as the crys-talline symbol of a new and coming faith.

To this end, Gropius recruited the most outstanding faculty he could find. Among them were the Expres-sionist painters Wassily Kandinsky (see chapter 41) and Paul Klee [klay] (1879–1940), the designer and architect Marcel Breuer [BROY-ur] (1902–1981), the painter and color theorist Josef Albers [AL-berz] (1888–1976), the graphic designer Herbert Bayer [BY-ur] (1900–1985), and later the architect Ludwig Mies van der Rohe [meez van-der ROH] (1886–1969).

The Bauhaus aesthetic drew on developments from across Europe—the Cubism of Picasso and Braque (see chapter 41), the geometric simplicity of Kasimir Male-vich and the Russian Constructivists (see chapter 42), and especially the Dutch Modernist movement known as De Stijl, literally "the style." The De Stijl movement was led by the painter Piet Mondrian (1872–1944) and the architect, painter, and theorist Theo van Doesburg (1883–1931), who sought to cre-ate a new, "purely plastic work of art" of total abstrac-tion. It completely rejected literal reality as experienced by the senses. Instead it reduced creative terms to the bare minimum: the straight line, the right angle, the three primary colors (red, yellow, and blue), and the three basic non-colors (black, gray, and white). Mondrian believed that the grid, a network of regularly spaced lines that cross one another at right angles, represented a cosmic interaction between the masculine and spiritual (vertical) and the feminine and mate-rial (horizontal). By the early 1920s, he had extended this belief to include a color/noncolor interaction. More important, he eliminated the traditional figure/ground relation of repre-sentational painting, where the blank white canvas is consid-ered the painting's "ground." In his *Composition with Blue, Red, Yellow, and Black* of 1922, the white square set off-center in the middle of the painting appears to be on exactly the same plane as the colored planes that surround it (Fig. **44.5**).

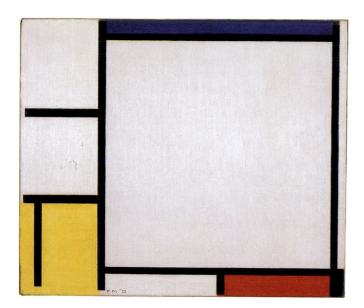

Fig. 44.5
Piet Mondrian (1872-1944), *Composition with Blue, Yellow, Red and Black,* 1922. Oil on canvas, 16$\frac{1}{2}$″ × 19$\frac{1}{4}$″ (41.9 × 48.9 cm). Minneapolis Institute of Arts. © 2008 Mondrian/Holtzman Trust c/o HCR International, Warrenton, VA, USA. For Mondrian, "each thing represents the whole on a smaller scale; the structure of the microcosm resembles that of the macrocosm." This painting suggests the structure of what Mondrian called the "Great Whole."

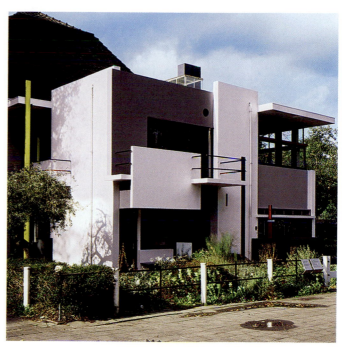

Fig. 44.6 Gerrit Rietveld. Schroeder House, Utrecht, The Netherlands. 1924. Artists Rights Society (ARS), New York/Beeldrecht, Amsterdam.

Like the Bauhaus theorists and despite his own interest in painting, Mondrian claimed that the culmination of art rested in architecture. The principles of De Stijl, he wrote, govern "the interior as well as the exterior of the building." Gerrit Rietveld's Schroeder House, built in Utrecht, Holland, in 1924–1925, has been called "a cardboard Mondrian" (Fig. 44.6). To a certain extent this is true, but in other ways it is the exact opposite of his dogmatically flat canvases, as if Mondrian's surface has been stretched out into three-dimensional space. The house is a cubelike form interrupted by the planar projections of its interior walls. All of the walls of the upper floor could be removed, sliding back into recesses and transforming a series of small rooms into a single space (Fig. 44.7). In other words, the space is fluid and open, waiting to be composed by its inhabitants. Built-in and movable furniture of Rietveld's design is geometric and abstract in concept. The predominant colors are white and gray, highlighted by selective use of primary colors and black lines. According to van Doesburg, it demonstrated that "the work of art is a metaphor of the universe obtained with artistic means."

Equally influential was the architecture of Frenchman Charles-Édouard Jeanneret (1887–1965), known as Le Corbusier [kor-booz-YAY], who founded the magazine and movement known as *L'Esprit Nouveau* (The New Spirit) after World War I. Le Corbusier's importance rested on his belief in the possibility of creating low-cost, easily replicable, but essentially superior housing for everyone. In order to cope with the massive destruction of property in the war, Le Corbusier proposed what he called the "domino" system of architecture, a

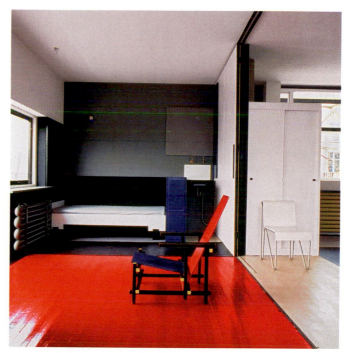

Fig. 44.7 Gerrit Rietveld. Schroeder House, Utrecht, The Netherlands. 1924. Photo: Jannes Linders Photography. © 2008 ARS Artists Rights Society, NY. Rietveld explained the openness of the top floor: "It was of course extremely difficult to achieve all this in spite of the building regulations and that's why the interior of the downstairs part of the house is somewhat traditional, I mean with fixed walls. But upstairs we simply called it an 'attic' and that's where we actually made the house we wanted." Note the famous *Red-Blue Chair,* designed by Rietveld in 1918, when he was still working as a cabinetmaker.

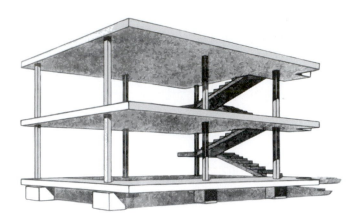

Fig. 44.8 Le Corbusier. Domino House. 1914. The plan's name derives from the six pillars positioned on the floor like the six dots on a domino.

basic building prototype for mass production (Fig. **44.8**). The structural frame of this building was of reinforced concrete supported by steel pillars. The lack of supporting walls turned the interior into an open, free-flowing, and highly adaptable space that could serve as a dwelling for a single family or be replicated again and again to form apartment units or industrial and office space. In a 1923 article called "Five Points of a New Architecture," Le Corbusier insisted that (1) the house should be raised on columns to provide for privacy, with only an entrance on the ground level; (2) it should have a flat roof, to be used as a roof garden; (3) it should have an open floor plan; (4) the exterior curtain walls should be freely composed; and (5) the windows should be horizontal ribbons of glass.

Calling his homes "machines for living in," Le Corbusier employed those five principles to design the Villa Savoye in Poissy-sur-Seine, France, west of Paris (Fig. **44.9**). The entry is set back, beneath the main living space on the second floor, which is supported by steel columns. Rounded windbreaks shelter a roof garden. The combination of rectangle, square, and circle creates a sense of geometric simplicity. As Le Corbusier had put it in his 1925 *Towards a New Architecture*: "Primary forms are beautiful forms because they can be clearly appreciated."

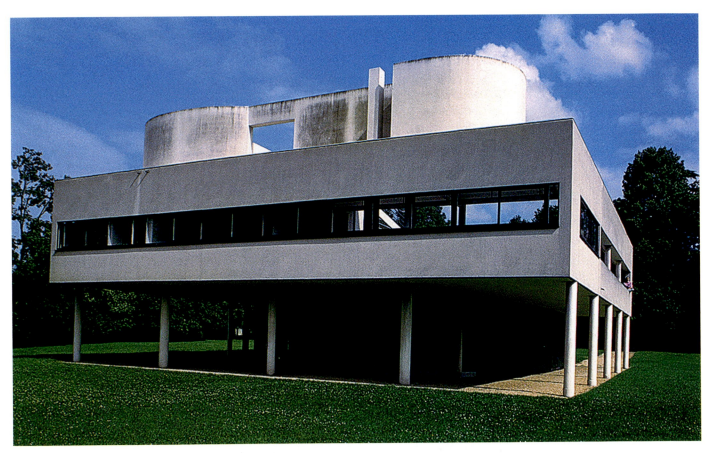

Fig. 44.9 Le Corbusier. Villa Savoye, Poissy-sur-Seine, France. 1928–1930. Anthony Scibilia/Art Resource, NY.
© 2008 Artists Rights Society (ARS), New York/ADAGP, Paris/FLC. Le Corbusier wrote: "The columns set back from the facades, inside the house. The floor continues cantilevered. The facades are no longer anything but light skins of insulating walls or windows. The facade is free."

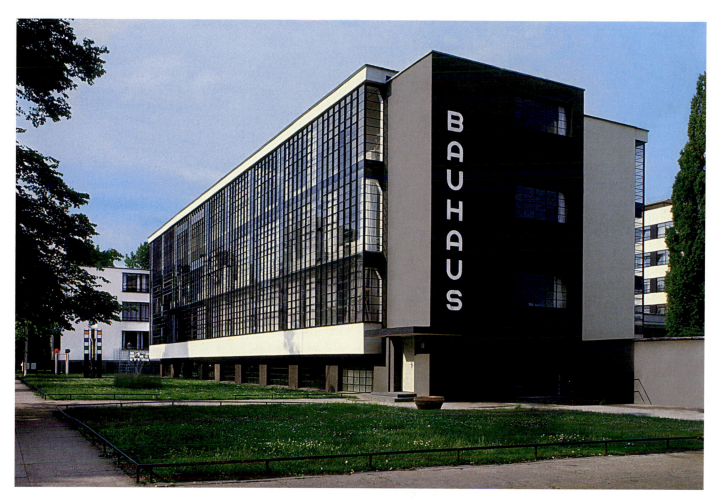

Fig. 44.10 Walter Gropius. Bauhaus Building, Dessau, Germany. 1925–1926. Photograph courtesy Bauhaus Dessau Foundation, Dessau, Germany. Gropius described his building as a "clear, organic [form] whose inner logic [is] radiant, naked, unencumbered by lying facades and trickeries."

This new architecture would come to be known as the International Style, after Alfred H. Barr, Jr., and Philip Johnson, who had curated the *Machine Art* exhibition at the Museum of Modern Art in New York (see chapter 43), put on another show, in 1932, called the *International Exhibition of Modern Architecture* with an accompanying catalogue titled *The International Style: Architecture since 1922*. From the curators' point of view, a new "controlling" architectural style had emerged in Europe after the war without regard to national tastes or individual concerns. The principles of this new International Style were related to the machines they also admired: pure forms ("architecture as volume rather than mass") without "arbitrary applied ornament" (a slap at Louis Sullivan's Chicago School of architecture—see chapter 38), and with severe, flat surfaces in its place. The show featured the work of Le Corbusier and two Bauhaus architects, Gropius and Mies van der Rohe.

Nazi pressure had forced the Bauhaus out of Weimar in 1925, when the community withdrew its financial support due to the school's perceived leftist bent. The school moved to Dessau, closer to Berlin, where Gropius designed a new building (Fig. **44.10**). Although its look is familiar enough today—an indication of just how influential it would become—the building was revolutionary at the time. It was essentially a skeleton of reinforced concrete with a skin of transparent glass. As Gropius himself explained:

> One of the outstanding achievements of the new constructional technique has been the abolition of the separating function of the wall. Instead of making the walls the element of support, as in a brick-built house, our new space-saving construction transfers the whole load of the structure to a steel or concrete framework. Thus the role of the walls becomes restricted to that of mere screens stretched between the upright columns of this framework to keep out rain, cold, and noise. . . . This, in turn, naturally leads to a progressively bolder (i.e. wider) opening up of the wall surfaces, which allows rooms to be much better lit. It is, therefore, only logical that the old type of window—a hole that had to be hollowed out of the full thickness of a supporting wall—should be giving place more and more to the continuous horizontal casement, subdivided by thin steel mullions, characteristic of the New Architecture.

Matching this "new architecture" was a new furniture, inexpensive, mass-produced tubular steel chairs inspired by the bicycle and designed by Breuer (Fig. **44.11**).

Gropius stepped down as director in 1928. He was replaced by Hannes Meyer [MY-er], a communist architect who saw nothing wrong with teaching Marxist doctrine in the classroom and who deemphasized fine art in favor of functional goods to benefit the working class. Meyer's communist politics made the Bauhaus an easy target for the Nazis. Even after Mies van der Rohe replaced Meyer in 1930, the Nazis proposed demolishing Gropius's "decadently modern" building. Although the plan was rejected, the school in Dessau was closed in October 1932 and then reopened by Mies in Berlin as a private institution. Finally, on April 11, 1933, Gestapo (secret state police) trucks appeared at the door. They padlocked the school, and it never reopened.

The Degenerate Art Exhibition To the Nazis the Bauhaus represented everything that was wrong with modernism—its inspiration by foreigners (especially Russians like Kandinsky), its rejection of traditional values, and its willingness to "taint" art with (leftist) politics. Between the Bauhaus's closing and 1937, virtually all avant-garde artists in Germany were removed from teaching positions and their works confiscated by the state. On July 19, 1937, many of these same works were among the over 600 displayed in the exhibition of Degenerate Art in Munich, organized at Hitler's insistence to demonstrate the mental and moral degeneracy of modernist art. Over 2 million people—nearly 20,000 a day—visited the show before it closed in November.

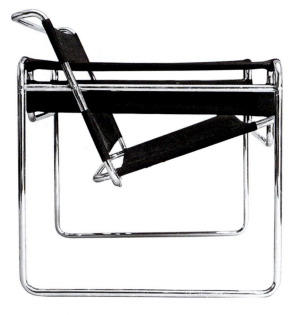

Fig. 44.11 Marcel Breuer. *Breuer Chair*. 1925. Chrome-plated tubular steel with canvas slings, height, 28$\frac{1}{8}$" × 30$\frac{1}{4}$" × 27$\frac{3}{4}$". The Museum of Modern Art/Licensed by Scala-Art Resource, NY. Gift of Herbert Bayer. Digital Image © The Museum of Modern Art/Licensed by Scala-Art Resource, NY. Like the architecture it was designed for, the chair is not so much mass as volume, two cubic spaces, the seat set at an angle to the legs.

In the first room, religious art was chosen that, according to the catalogue, illustrated the "insolent mockery of the Divine" that had been championed by the Weimar Republic. It featured a nine-painting cycle by Emile Nolde (see chapter 41), who was, ironically, a member of the Nazi party and so believed himself to be immune from persecution. In the second gallery, Jewish art was pilloried. In the third gallery Dada and abstract painting were attacked, and Expressionist nudes were labeled "An insult to German womanhood." In another gallery, Expressionist still lifes were introduced as "Nature as seen by sick minds." After the exhibition, the Commission for the Disposal of Products of Degenerate Art arranged for those pieces with the highest value in the international art market to be sold at auction in Lucerne [loo-SERN], Switzerland. However, most of the confiscated works—1,004 oil paintings and 3,825 works on paper—were burned in the yard of the Berlin Fire Brigade on March 20, 1939.

The Art of Propaganda The Degenerate Art show was carefully calculated to create public outrage. It coincided with the first of eight Great German Art exhibitions, which opened the day before, on July 18, 1937. Hitler spoke for an hour and a half on the nature and function of art. A pageant with more than 6,000 participants depicting 2,000 years of German culture followed the speech. It was all part of a concentrated effort by the Nazis to control culture by controlling what people saw and heard.

Radio played an enormous role. The Nazis understood that radio was replacing the newspaper as the primary means of mass communication. Since they controlled all German radio stations, they could make effective use of it. Addressing a group of German broadcasters, Joseph Goebbels [GOHB-uls] (1897–1945), Hitler's Minister for Public Enlightenment and Propaganda, emphasized the medium's importance:

> I consider radio to be the most modern and the most crucial instrument that exists for influencing the masses. I also believe—one should not say that out loud—that radio will in the end replace the press.... First principle: At all costs avoid being boring. I put that before everything.... The correct attitudes must be conveyed but that does not mean they must be boring.... By means of this instrument you are the creators of public opinion. If you carry this out well we shall win over the people and if you do it badly in the end the people will once more desert us.

Hitler's extraordinary oratorical skills were perfectly suited to the radio. Loudspeakers were set up throughout the nation so that everyone might hear his broadcasts. "Without the loudspeaker," Hitler wrote in 1938, "we would never have conquered Germany."

Film was likewise understood to be an important propaganda tool. In 1933, Hitler invited the talented director Leni Riefenstahl [REEF-en-shtahl] (1902–2003) to make a film of the 1934 Nazi rally in Nuremberg, providing her with a staff of more than 100 people, 30 cameras, special elevators, ramps, and tracks (Fig. **44.12**). The result was *Triumph of the Will*, a

film that does not so much politicize art as aestheticize politics. Riefenstahl portrays Hitler as at once hero and father figure, lending him and his Nazi party a sense of grandeur and magnificence. March music dominates the score. The regularity of its beat mirrors the regularity and order of Hitler's storm troopers and suggests military strength and the order and stability that the Nazi regime promised to bring to the German people. Hitler also appointed Riefenstahl to film the 1936 Olympic Games in Berlin. Her two-part film, *Olympia*, was less political and emphasized the beauty of the human body. The film was designed to demonstrate that Germans were fair and friendly competitors capable of cheering even the black American runner, Jesse Owens. However, Hitler and Riefenstahl also hoped that German athletes would be shown winning many prizes, thus demonstrating Aryan superiority.

Stalin in Russia

Nazism was not the only totalitarian ideology to achieve political power in the aftermath of World War I. The consolidation of the Bolshevik revolution in Russia after World War I produced the longest-lasting totalitarian government.

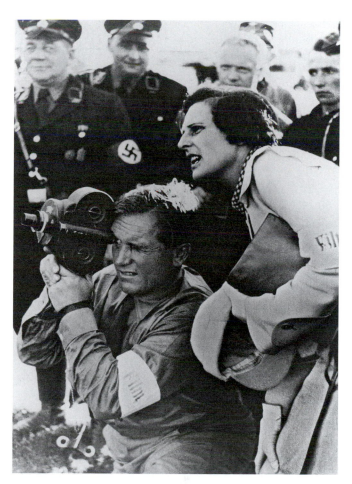

Fig. 44.12 Leni Riefenstahl filming Hitler. 1934. The Museum of Modern Art, NY. Film Stills Archive.

In the power vacuum that followed Lenin's death in 1924, two factions emerged in the Communist Party. Leon Trotsky [TROT-skee] (1879–1940) led one of them and Joseph Stalin [STAH-lin] (1878–1953) headed the other. Their rivalry took the form of a debate over the speed of industrialization of the Russian economy. Trotsky's faction favored rapid industrialization through the collectivization of agriculture; Stalin's faction pressed for relatively slow industrialization and the continuation of Lenin's tolerance of a modest degree of free enterprise in which peasant farmers were allowed to sell their produce for profit. Stalin was a master at manipulating the party bureaucracy, and by 1927 he had succeeded in expelling Trotsky from the party and sending him into exile, first to Siberia and then later to Mexico. He was murdered in Mexico in 1940, probably by one of Stalin's agents.

The Collectivization of Agriculture Once Stalin took power, he behaved very much the way Trotsky had advocated. In 1928, he decided to collectivize agriculture, consolidating individual land holdings into cooperative farms under the control of the government. This alleviated food shortages in the cities, produced enough for export, and freed the peasant labor force for work in the factories. At the same time, he inaugurated a series of five-year plans for the rapid industrialization of the economy. Finally, he accepted Trotsky's position that terror was a necessity of revolution. Stalin blamed the few prosperous peasant farmers, or **kulaks** [KOO-lahks], for the economic ills of the country.

The kulaks represented less than 5 percent of the rural population, but they did not want to collectivize and were unhappy that there were so few goods to purchase with their cash. In protest they withheld grain from the market. "Now," Stalin proclaimed, "we are able to carry on a determined offensive against the kulaks, to break their resistance, to eliminate them as a class." Before long, anyone who opposed Stalin was considered a kulak, and between 1929 and 1933 his regime killed as many as 10 million peasants and sent millions of others to forced labor on collective farms and **gulags** [GOO-lahgs], labor camps. The peasants retaliated by killing over 100 million horses and cattle, causing a severe meat shortage. But Stalin persevered, not least of all because his plan for rapid industrialization was working. Soviet industrial production rose 400 percent between 1928 and 1940, by far the fastest-growing economy in the world at the time.

The Rise of Social Realism in Art and Music Stalin's five-year economic plans were supported by a series of propaganda posters that appeared across the country, such as *The Development of Transportation, The Five-Year Plan* by Gustav Klucis [kloo-cis] (1895–1944) (Fig. **44.13**). Klucis's poster is an example of social realism, the style of Russian art that followed constructivism in the early 1920s (see chapter 42). Klucis was himself a Constructivist, but like his fellow Constructivists he was drawn to the necessity of communicating clearly with the largely illiterate peasant class. So he, like they, turned to graphic design and photomontage, a technique that seemed

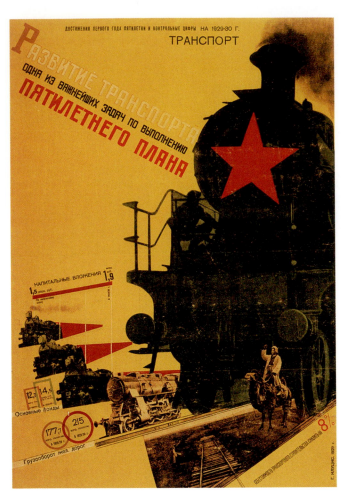

Fig. 44.13 Gustav Klucis. *The Development of Transportation, The Five-Year Plan.* **1929.** Gravure, $28\frac{7}{8}'' \times 19\frac{7}{8}''$. Purchase fund, Jan Tschichold Collection. (146.1968). Digital Image © The Museum of Modern Art/Licensed by SCALA/Art Resource, NY. While incorporating realist imagery through photomontage, Klucis retains the dynamic interplay of geometric forms that mark earlier, more abstract Russian Constructivist design (see chapter 42).

at once modern and Realist in the tradition of the great Russian realists of the nineteenth century, especially the revered Travelers (see chapter 37). In doing so, he sacrificed abstraction in favor of an unwavering political commitment.

As early as 1921, the Soviet government had urged Russian artists to give up their avant-garde experiments on the grounds that abstraction was unintelligible to the masses. Other groups argued that it was necessary to concentrate on themes such as the daily life of the workers and the peasants. By 1934, the First All-Union Congress of Soviet Writers officially proclaimed all expressions of "modernism" decadent and called upon Soviet artists to create "a true, historically concrete portrayal of reality in its revolutionary development." Social realism was from that time on the official state style, and in literature, music, and the visual arts all other styles were banned.

The Soviet authorities brought all musical activities under their control by a decree in 1932 and attacked Russian avant-garde composers in the same way they had attacked artists.

They accused Sergei Prokofiev [pro-KOF-ee-ev] (1891–1953) and Dimitri Shostakovich [shoh-stuh-KOV-ich] (1906–1975) of writing music that was "too formalistic" and "too technically complicated"—and thus "alien to the Soviet people." The party Central Committee pressured both men to apologize publicly for the error of their ways. Prokofiev's very accessible symphonic fairy tale of 1936, *Peter and the Wolf,* is most likely an attempt to appease the Soviet authorities. Two years earlier, in 1934, the Soviet press had hailed Shostakovich's four-act opera *Lady Macbeth of the Mtsensk District* as a model of social realism. The opera was meant to be the first part of a trilogy dealing with Russian womanhood. It featured not only modernist dissonance but also themes of adultery, murder, and suicide. Two years later, in 1936, after Stalin had seen it himself and decided that the themes did not live up to the standards of official Soviet art, the newspaper *Pravda* [PRAHV-dah] condemned it as "Chaos, Not Music," and the opera was dropped from the repertory. Shostakovich repented by composing his 1937 Symphony No. 5, subtitled "A Soviet Artist's Response to Just Criticism."

In its relative lack of dissonance Symphony No. 5 appeared to conform more closely to the ideals of social realism, but the piece is actually a monument to musical irony. Everything about it is a repudiation of Stalin and the Soviet authorities. The first movement opens with a cry of despair that, after a fairly long development, gives way to a march that is meant to evoke Stalinist authority. The party Central Committee was able to hear this passage as a sign of Shostakovich's capitulation, but Shostakovich hoped that his audience would understand the goose-stepping march as hopelessly shallow. The third movement is a profound work of mourning. If the Central Committee took it as an apology, Shostakovich meant it as a memorial to those lost in the gulags. The final, fourth movement, overtly a celebration of Soviet triumph, is instead a parody of celebration (**CD-Track 44.2**). In his memoirs, smuggled out of Russia after his death, Shostakovich explained what he had in mind:

> What exultation could there be? I think it is clear to everyone what happens in the Fifth. The rejoicing is forced, created under threat. . . . It's as if someone were beating you with a stick and saying "Your business is rejoicing, your business is rejoicing," and you rise, shaky, and go marching off, muttering, "Our business is rejoicing, our business is rejoicing." What kind of apotheosis is that? You have to be a complete oaf not to hear that.

The fourth movement is brassy and bombastic, but its chords continually rise into an almost shrill hysteria. About seven minutes into the movement, the percussion beats out the rhythms of a militaristic march, asserting a kind of totalitarian control over the symphony. At the end, the percussion seems almost threatening as it insists on its controlling authority.

Mussolini in Italy

One of the most important differences between Stalin's totalitarian state and the totalitarian regimes in the rest of Europe is that the latter all arose out of a vigorously anti-Marxist

point of view and fear of the Soviet state. By 1920, the Communist Party in Russia had made it clear that it intended to spread its doctrines across Europe. "The Communist International has declared," it announced, "a decisive war against the entire bourgeois world." Such pronouncements nourished a climate of fear among middle-class small-business owners, property owners, and small farmers, which opportunistic leaders could easily exploit.

Italy's Benito Mussolini [moo-soh-LEE-nee] (1883–1945) was one of these. After World War I, Italy was in disarray. Peasants seized uncultivated land, workers went on strike and occupied factories, and many felt that a Communist revolution was imminent. In the face of inaction by the government of King Victor Emmanuel III, Mussolini and his followers formed local terrorist squads, called Black Shirts because they always dressed in shirts of that color. These squads beat up and even murdered Socialist and Communist leaders, attacked strikers and farm workers, and systematically intimidated the political left.

By 1921, Mussolini's Fascist Party had hundreds of thousands of supporters, and when in October 1922 they marched on Rome, Victor Emmanuel III appointed Mussolini prime minister in order to appease them. In November, the king and Parliament granted Mussolini dictatorial powers for one year in order to produce order in the country. By 1926, Mussolini had managed to outlaw all opposition political parties, deny all labor unions the right to strike, and organize major industries into 22 corporations that encompassed the entire economy. Although the king remained nominal ruler, Mussolini had established a single-party totalitarian state, declaring himself *Il Duce* [DOO-cheh], "the leader."

Ezra Pound: *The Cantos* and Fascism The American poet Ezra Pound had moved to Italy in 1924 and became one of Mussolini's staunchest supporters. He liked the way Mussolini's government respected both the cultural heritage of the past and the aspirations of workers and peasants for economic justice. And he agreed with Mussolini that the aspiration to create a just and orderly society had been systematically thwarted by "obstructers," whom Pound identified with communists and then increasingly with Jews. His anti-Semitism became vehement, finding its way into *The Cantos*, the book-length series of 120 poems (called cantos) that he began in the early 1920s and that occupied him until his death in 1972, when it was left unfinished.

The Cantos lack a plot or definite ending but they are concerned with such themes as culture, economics, and governing. They include some stunningly beautiful passages, including the magnificent Canto 49, known as "The Seven Lakes Canto," which derives from his work translating Chinese poetry (see **Reading 44.5**, page 1454). The poem is a testament to Pound's ability to capture the beauty of natural tranquility. But vicious anti-Semitism can be found in the poems as well, culminating in Canto 52, where he seethes against "jews, real jews, chazims, and neschek / also superneschek or the international racket." (*Chazim* [khah-zeem] is Yiddish for "pig," *nescheck* [neh-shek] Hebrew for "usury.")

Such sentiments would lead Pound to broadcast to American troops Fascist propaganda on Mussolini's "American Hour," an act for which he was indicted back in the United States, and charged with treason. American troops arrested him in Rome in May 1945 and imprisoned him near Pisa. There, confined to a small cage, he wrote Cantos 74–84, the so-called *Pisan [PEE-zahn] Cantos*. They possess a distinct tone of repentance. At the end of Canto 81, in one of the epic's most famous passages, Pound admonishes himself for his vanity and salvages a sense of his own self-worth as a poet by dedicating himself to carrying on "a live tradition." In 1946, Pound was acquitted but declared mentally ill and so was committed to Saint Elizabeth's Hospital in Washington, DC, where he remained for 10 years. In his last years, back in Italy, he wrote a note for a projected last Canto, number 120 (**Reading 44.5a**):

READING 44.5a **from Ezra Pound, Canto 120**

I have tried to write Paradise.

Do not move.
 Let the wind speak.
 That is paradise.
Let the Gods forgive what I have made
May those I have loved try to forgive
 what I have made.

In an interview for *The Paris Review* in the early 1960s, he explained: "It is difficult to write a paradise when all the superficial indications are that you ought to write an apocalypse."

Franco in Spain

The Fascist ideologies that dominated Germany and Italy spread to Spain by the mid-1930s. Spain was in political turmoil. A free election in 1931 had resulted in a victory for republican democrats and the declaration of the Second Republic of Spain. Support for the monarchy collapsed, and King Alfonso XIII, who had called for the elections hoping to establish a constitutional monarchy, left the country without abdicating. This gave conservatives the hope that the monarchy might one day be restored. A strong anarchist movement soon developed, however, resulting in major uprisings, strikes, and full jails. In February 1936, the Spanish Popular Front, a coalition of republicans, communists, and anarchists that promised amnesty to all those previously imprisoned, was elected to office. This dismayed the *Falange* [fah-LAHN-hay] ("Phalanx"), a right-wing fascist organization with a private army much like Hitler's and that had the sympathy of the Spanish army stationed in Morocco. In July, the *Falange* retaliated, the army in Morocco rebelled, and General Francisco Franco [FRAHN-koh] (1892–1975) led it into Spain from Morocco in a coup d'etat against the Popular Front government.

CULTURAL PARALLELS

The Rape of Nanjing

The bombing of Guernica was not the only atrocity of 1937, and by no means the worst. Shortly before Christmas, invading Japanese soldiers captured the Chinese city of Nanjing and began executing the city's citizens. For the next six to eight weeks, the Japanese raped, and then mutilated and killed, as many as a thousand Chinese women a night. They skewered their babies on bayonets, and slaughtered their husbands before their eyes. Decapitation was standard practice, and the heads of Chinese victims were piled in the streets. All told somewhere around 250,000 people were killed. A group of Westerners living in the city were witness to the events, and films and photographs of the atrocities found their way to the West by early spring.

In the civil war that ensued, Germany and Italy supported Franco's right-wing Nationals, while the Soviet Union and Mexico sent equipment and advisors to the leftist Republicans. The United States remained neutral, but liberals from across Europe and America, including Ernest Hemingway, joined the republican side, fighting side by side with the Spanish.

Hitler conceived of the conflict as a dress rehearsal for the larger European conflict he was already preparing. He was especially interested in testing the Luftwaffe [LOOFT-vah-fuh], his air force. Planes were soon sent on forays across the country in what the German military called "total war," a war not just between armies but between whole peoples. This allowed for the bombing of civilians, as in the famous incident of Guernica, in the Basque region of Spain, which inspired Spanish-born artist Pablo Picasso to produce a painterly act of searing rage from his base in Paris (see *Focus*, pages 1438–1439).

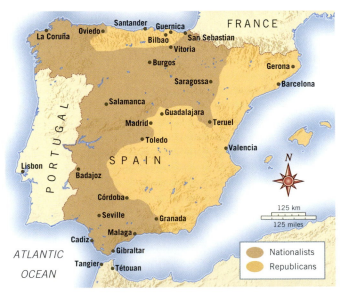

Map 44.2 The Spanish Civil War on March 30, 1937.

The Spanish Civil War extended from 1936 to 1939 and tore the country apart (see Map **44.2**). With the help of the Falangists, Franco was able to overcome the Republicans, first capturing Madrid in March 1939 and then, a few weeks later, Barcelona. He ruled Spain in a totalitarian manner until 1975.

Revolution in Mexico

Armed conflict had begun in Mexico in 1910, when Franciso I. Madero [mah-DHAY-roh] (1873–1913), a respectable upper-class politician, led the overthrow of Mexican dictator Porfirio Díaz [DEE-ahs] (1830–1915). In trying to modernize Mexico, Díaz had turned over large landholdings to foreign investors for the United States and Britain to the dismay of many, including Madero. But Madero quickly lost control of events, and Díaz's supporters soon deposed and executed him. This inaugurated a period of intense bloodshed during which some 900,000 Mexicans (of a population of about 15 million) lost their lives.

Guerrilla groups led in southern Mexico by Emiliano Zapata [zah-PAH-tah] (1879–1919) and in northern Mexico by Doroteo Arango Arámbula [ah-RAHM-boo-lah] (1878–1923), better known as Pancho Villa [VEE-yah], demanded "land, liberty, and justice" for Mexico's peasant population. Their primary purpose was to give back to the people land that the Díaz government had deeded to foreign investors. Technically, the Mexican Revolution ended in 1921 with the formation of the reformist government of Álvaro Obregón [oh-rbay-GOHN] (1880–1928), but bloodshed continued through the 1920s. Zapata and Villa were assassinated, as was Obregón himself. Peace was not finally restored until the administration of Lázaro Cárdenas [KAR-day-nahs] (1895–1970) in 1934, when the reforms of the 1917 Constitution of Mexico were finally implemented.

The Mexican Mural Movement

The Mexican Revolution fueled a wave of intense nationalism to which artists responded by creating art that, from their point of view, was true to the aspirations of the people of Mexico. When the government initiated a massive building campaign, a new school of muralists arose to decorate these buildings. It was led by Diego Rivera [ree-VAIR-ah] (1886–1957), David Siqueiros [see-KAIR-ohs] (1896–1974), and José Clemente Orozco [oh-ROH-skoh] (1883–1949).

Rivera had lived in Europe from 1907 to 1921, mostly in Paris, where he had developed a Picasso-inspired Cubist technique. But responding to the revolution—and the need to address the Mexican people in clear and concise terms—he transformed his style by using a much more realist and accessible imagery focused on Mexican political and social life. He shared the style with the other muralists as well. The large fresco *Sugar Cane* depicts the plight of the Mexican worker before the revolution (Fig. **44.14**). Armed overseers hired by foreign landowners, including one lounging on a hammock in the shade with his dogs, force the peasants to work. But in the foreground, Rivera celebrates the dignity of the Mexican peasants, as they collect coconuts from a palm. Their rounded forms echo one another to create a feeling of balance and harmony.

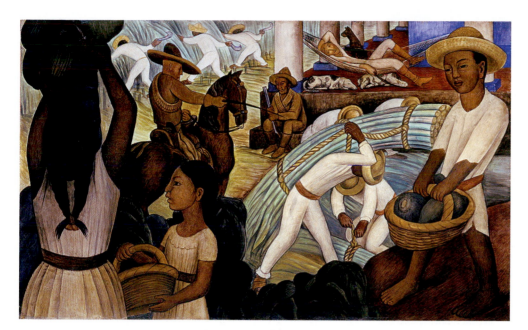

Fig. 44.14 Diego Rivera. *Sugar Cane*. 1931. Fresco, 57 1/8″ × 94 1/8″. Philadelphia Museum of Art. Gift of Mr. and Mrs. Herbert Cameron Morris. 1943-46-2. © Banco de Mexico Diego Rivera & Frida Kahlo Museums Trust. Av. Cinco de Mayo No. 2, Col. Centro, Del. Cuauhtemoc 06059, Mexico, D.F. Reproduction authorized by the Instituto Nacional de Bellas Artes y Literatura. This is one of eight portable murals that Rivera created for a special exhibition at the Museum of Modern Art in New York in 1931. It replicates a stationary mural at the Palace of Cortez in Cuernavaca, Mexico, painted in 1929.

From 1930 to 1934, Rivera received a series of commissions in the United States. They included one from Edsel B. Ford and the Detroit Institute of Arts to create a series of frescoes for the museum's Garden Court on the subject of *Detroit Industry*, and another from the Rockefellers to create a lobby fresco entitled *Man at the Crossroads Looking with Hope and High Vision to a New and Better Future* for the RCA Building in Rockefeller Center in New York. When Rivera included a portrait of Communist leader Lenin in the lobby painting, Nelson A. Rockefeller insisted that he remove it. Rivera refused, and Rockefeller, after paying Rivera his commission, had the painting destroyed.

Rivera reproduced the fresco soon after in Mexico City and called it *Man, Controller of the Universe* (Fig. **44.15**). At the center, Man stands below a telescope with a microscope in his hand. Two ellipses of light emanate from him, one depicting the cosmos, the other the microscopic world. Beneath him is the earth, with plants growing in abundance, the products of scientific advancements in agriculture. To the right, between healthy microbes and a starry cosmos, is Lenin, holding the hands of workers of different cultures. On the left, between microscopic renderings of syphilis and other diseases and a warring cosmos, is New York society, including Nelson Rockefeller enjoying a cocktail. At the top left, armed figures wearing gas masks and marching in military formation evoke World War I, while at the upper right, workers wearing Communist red scarves raise their voices in solidarity. Man must steer his course between the evils of capitalism and the virtues of communism, Rivera appears to be saying.

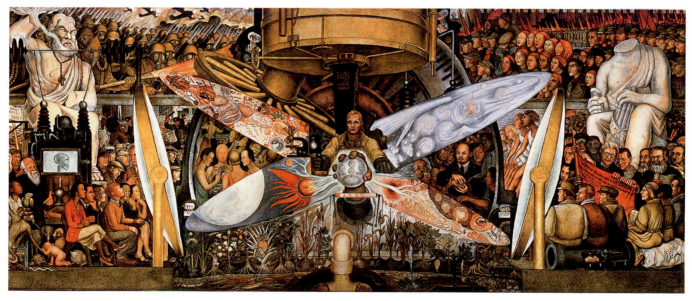

Fig. 44.15 Diego Rivera. *Man, Controller of the Universe*. 1934. Fresco, main panel 15′11″ × 37′6″. Palacio de Bellas Artes, Mexico City, D.F. Mexico. © 2003 Banco de Mexico Diego Rivera & Frida Kahlo Museums Trust. Av. Cinco de Mayo No. 2, Col. Centro, Del. Cuauhtemoc 06059, Mexico, D.F. Reproduction authorized by the Instituto Nacional de Bellas Artes y Literatura. Photo Credit: Schalkwijk/Art Resource, NY. Rivera's mural is a plea for social and economic reform through industrial progress.

Focus

Picasso's *Guernica*

On April 26, 1937, a German air-force squadron led by Wolfram von Richthofen, cousin of the famous Red Baron of World War I, bombed the Basque town of Guernica, in Spain, during the Spanish Civil War. The attack was a *blitzkrieg*, the sudden coordinated air assault that the Germans would later use to great effect against England in World War II. It lasted for three and a quarter hours. The stated target was a bridge used by retreating Republican forces at the northern edge of the town, but the entire central part of Guernica—about 15 square blocks—was leveled, and 721 dwellings (nearly three-quarters of the town's homes) were completely destroyed and a large number of people killed. In Paris, Picasso heard the news a day later. Complete stories did not appear in the press until Thursday, April 29, and photographs of the scene appeared on Friday and Saturday, April 30 and May 1. That Saturday, Picasso began a series of sketches for a mural that he had already been commissioned to contribute to the Spanish Pavilion at the 1937 Exposition Universelle in Paris. Only 24 days remained until the Fair was scheduled to open.

In the final painting, Picasso links the tragedy of Guernica to the ritualized bullfight, born in Spain, in which the preordained death of the bull symbolizes the ever-present nature of death. The work portrays a scene of violence, helpless suffering, and death. Picasso's choice of black-and-white instead of color evokes the urgency and excitement of a newspaper photograph. When the exposition closed, the painting was sent on tour and was used to raise funds for the Republican cause. *Guernica* would become the international symbol of the horrors of war and the fight against totalitarianism. Below is a history of the painting's life.

A *Guernica* Chronology

January 8, 1937 – Picasso accepts commission from Republican Spain for a painting for the Spanish Pavilion at the 1937 Exposition Universelle in Paris.

April 26 – Guernica bombed.

April 28 – Guernica occupied by Franco's troops; French Press coverage begins.

May 1 – Picasso draws six initial studies for *Guernica*.

May 11 – First photograph of the *Guernica* canvas.

May 28 – Picasso is paid 150,000 francs for *Guernica*, which he completes on June 4.

July 12 – Inauguration of the Spanish Pavilion at the Paris Exposition.

November 25 – Exposition closes, having received 33 million visitors.

Spring 1938 – *Guernica* exhibited in Stockholm and Copenhagen.

October 1938 to January 1939 – *Guernica* exhibited in London.

May 1, 1939 – *Guernica* arrives in New York, where it begins a fundraising tour to Los Angeles, San Francisco, and Chicago, concluding at the Museum of Modern Art, New York, November 15–January 7, 1940, as part of the exhibition *Picasso: Forty Years of His Art*. After the outbreak of war in Europe, Picasso asks the Museum of Modern Art to accept *Guernica* for safekeeping.

1940–1941 – The Picasso retrospective tours America with *Guernica*, traveling to Chicago, Saint Louis, Boston, San Francisco, Cincinnati, Cleveland, New Orleans, Minneapolis, and Pittsburgh.

1942 – *Guernica* exhibited at Fogg Art Museum, Cambridge, Massachusetts; thereafter, on continuing display at the Museum of Modern Art.

1950s – *Guernica* travels worldwide, until given to the Museum of Modern Art "on extended loan" in 1958. Picasso expresses the wish that the museum return the painting to Spain when and if civil liberties are restored in his native land.

November 20, 1975 – Franco dies in Madrid; two days later Juan Carlos is crowned constitutional monarch.

June 15 – First general elections in Spain since the Civil War.

February 1981 – Picasso's lawyer approves returning *Guernica* to Spain.

October 24, 1981 – *Guernica* exhibited in Madrid and put on permanent display at Museo Nacional Centro de Arte Reina Sofia.

The bull is a symbol of the Spanish character and a reference to the legendary Minotaur of classical myth. For the Surrealists the bull represented the irrational forces of the human psyche.

A spear penetrates the flank of the horse, whose scream echoes that of the mother at the left holding her dead child in her arms.

A woman screams to the sky, her house in flames.

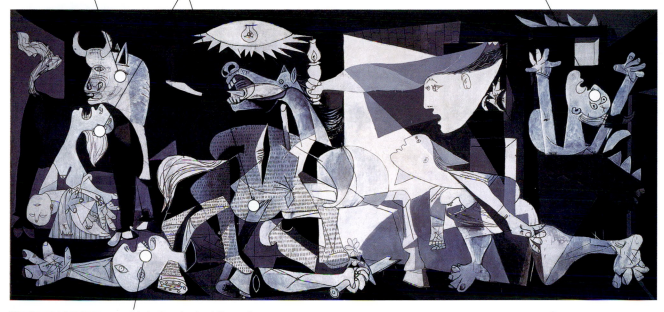

The figure lying face upward is both a dead soldier and a slain picador (the chief antagonist of the bull and the one who torments him on horseback with a lance).

Pablo Picasso, *Guernica*, 1937. Oil on canvas, 11′ 5$\frac{1}{2}$″ × 25′ 5$\frac{1}{4}$″. Museo Nacional Centro de Arts Reina Sofia, Madrid, Spain. John Bigelow Taylor/Art Resource, NY. © 2007 Estate of Pablo Picasso/Artists Rights Society (ARS), NY.

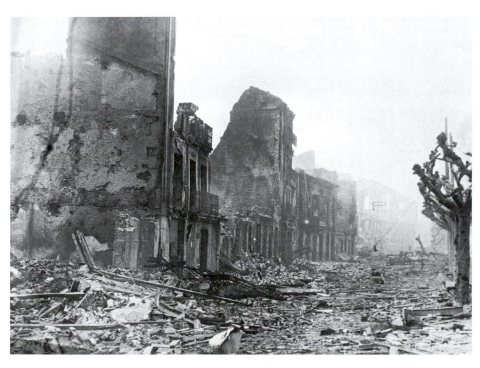

Ruins of Guernica, Spain. April 1937.

The Private World of Frida Kahlo

Rivera's wife, Frida Kahlo [KAH-loh] (1907–1954), was also an artist. Although she was as political as her husband, her paintings document her personal tragedy. Already crippled by a bout of polio in childhood, she was injured severely in 1925 at the age of 18 when a tram hit the bus in which she was riding home from school. A metal handrail pierced her body through, her spine and pelvis were broken, and so were her right leg and foot. Her long recuperation was not completely successful, requiring some 30 operations and eventually the amputation of her right leg. In the hospital, she began painting, using a small lap easel, and somewhat miraculously regained the ability to walk.

A close friend introduced Kahlo to Diego Rivera, and in 1929 they were married. In addition to leftist political views, they shared a love for Mexican culture—Frida [FREE-dah] often dressed in traditional Mexican costume—and a passion for art. But they were also a study in contrasts, Kahlo small and slender, barely five feet tall, Rivera much taller, of considerable girth, and 20 years her senior. Frida's father remarked, "It was like the marriage between an elephant and a dove." Their stormy relationship survived infidelities, the pressures of Rivera's career—she was clearly second fiddle to his murals—a divorce and remarriage, and Kahlo's poor health.

Kahlo's paintings—mostly self-portraits—bear witness to the trials of her health and marriage. "I have suffered two grave accidents in my life," she once said, "one in which a street car ran me over; the other accident is Diego." Many of the self-portraits are violent, showing, for instance, her body pierced with nails and ripped open from neck to navel to expose her spine as a broken stone column. Even in more serene images, such as *Self-Portrait with Monkey*, the bones that form her necklace suggest such violence (Fig. **44.16**). Her work not only evokes her intense personal struggle, but also sets that struggle in an almost mythic or heroic universal struggle for survival.

Kahlo and Rivera traveled to the United States and France, where Kahlo met luminaries from the worlds of art and politics. Surrealist André Breton [bruh-TOHN] was especially attracted to her work. Although grateful for Breton's attention, she was quick to emphasize that she was by no means a Surrealist herself. "I never painted my dreams," she said. "I painted my own reality."

The Great Depression in America

After World War I, American money had flowed into Europe, mostly in the form of short-term loans, but by 1928 most of it was withdrawn and placed in the booming New York stock market, jeopardizing European economies. Investors borrowed freely from banks and overinvested in stocks. When the market crashed on October 29, 1929, investors lost huge amounts of money and could not repay their loans. Across the country, one bank after another closed its doors, savings were lost, businesses failed, and unemployment grew. Nearly 16 million men were out of work by the early 1930s, about one-third of the national workforce. Franklin Roosevelt's election as president

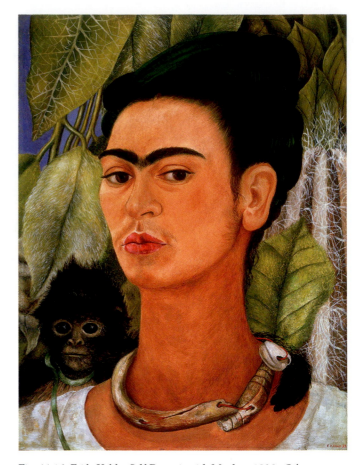

Fig. 44.16 Frida Kahlo. *Self-Portrait with Monkey.* **1938.** Oil on masonite, 16″ × 12″. Albright-Knox Art Gallery, Buffalo, New York. Bequest of A. Conger Goodyear, 1996. Museo Nacional de Arte Moderno, © 2008 Banco de Mexico Diego Rivera & Frida Kahlo Museums Trust. Av. Cinco de Mayo No. 2, Col. Centro, Del. Cuauhtemoc 06059, Mexico, D.F. Reproduction authorized by the Instituto Nacional de Bellas Artes y Literatura. Left barren by an accident that crippled her for life, Kahlo often included her pet spider monkey in her paintings, where it served as something of a surrogate child.

in 1932 was understood as a mandate for the federal government to bring its resources to bear against what became known as the Great Depression.

The Road to Recovery: The New Deal

Roosevelt quickly implemented a host of measures that came to be known as the **New Deal**. To safeguard bank deposits, he created the Federal Deposit Insurance Corporation. The National Recovery Act regulated industrial competition and ensured the right of workers to organize and bargain. The 1935 Social Security Act provided for unemployment insurance and old-age pensions. New-home construction was encouraged by the Home Owners' Loan Corporation. The 1933 Civil Works Administration created 4 million make-work jobs on public projects for persons on relief in an effort to help them contribute to economic recovery by increasing their purchasing power. The program continued when it was replaced by the Work Projects Administration (WPA) two years later.

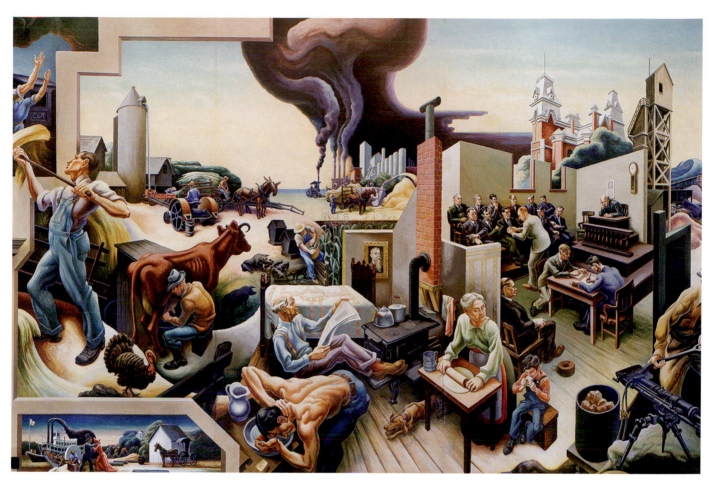

Fig. 44.17 Thomas Hart Benton. *A Social History of the State of Missouri* (detail). 1936. Oil on canvas. Missouri State Capitol, Jefferson City, Missouri. © T. H. Benton and R/P. Benton testamentary Trusts/UMB Bank Trustee. Art © Licensed by VAGA, NY. Reading from left to right, the traditional ways of Missouri agriculture are threatened by the specter of industry and litigation.

The WPA peaked at about 3.5 million people employed, but over its lifespan it helped about 8.5 million people get back to work. The WPA's work force constructed 116,000 buildings, 78,000 bridges, and 651,000 miles of road, and improved 800 airports. But its most important contributions to American culture were the Federal Art Project, the Federal Writers' Project, the Federal Theatre Project, and the Federal Music Project. Through the WPA, artists produced nearly 10,000 drawings, paintings, and sculptures and decorated many public buildings (especially post offices) with murals. Theater performances under the project averaged 4,000 a month. Writers were employed to create a series of state and regional guidebooks, and musicians found work in newly created orchestras.

The Mural Movement The WPA mural project was led in large part by the example of Thomas Hart Benton (1889–1975), who between 1930 and 1936 created four enormous murals that required about 7,000 square feet of canvas and included more than 1,000 figures. They are *America Today* (for the New School of Social Research in New York, 1930), *The Arts of Life in America* (for the Whit-

ney Studio Club in New York, 1932), *A Social History of Indiana* (for the Indiana pavilion at the 1933 Chicago World's Fair), and *A Social History of the State of Missouri* (for the House Lounge in the Missouri State Capitol Building, Jefferson City, 1935/36). For the last of these he was paid $16,000 over two years—a handsome sum at the time—and offered a position at the Kansas City Art Institute. The north wall of the Capitol lounge depicts Missouri's "Pioneer Days" and is highlighted by a depiction of Huckleberry Finn and Jim over the doorway. The east wall, the right half of which is illustrated here, is dedicated to "Politics, Farming, and Law in Missouri" (Fig. **44.17**). The south wall celebrates the state's two great cities, "St. Louis and Kansas City," including the lover's quarrel of the 1880s immortalized in the popular song "Frankie and Johnny." Benton worked in egg tempera, a medium seldom used in such a large scale since the Renaissance. He liked the medium's bright, clear colors and the fact that the paint dried quickly.

The WPA created special programs focused on three centuries of African-American cultural accomplishments. In 1935 it hired Aaron Douglas (see chapter 43) to paint a four-panel series, called *Aspects of Negro Life*, for the 135th Street

Fig. 44.18 Aaron Douglas. *Study for Aspects of Negro Life: The Negro in an African Setting.* 1934. Gouache on Whatman artist's board, $37\frac{1}{8}"\times40\frac{5}{8}"$. Arts and Artifacts Collection. Schomburg Center for Research in Black Culture, The New York Public Library, NY, U.S.A. Art Resource, NY. The statue in the back center is meant to suggest the central place of spirituality in African life.

branch of the New York Public Library in Harlem (today the Schomburg [SHOM-berg] Center for Research in Black Culture). It traces African-American history from freedom in Africa to enslavement in the United States and from liberation after the Civil War to life in the modern city. In a study for the first panel, drummers beat out a rhythm for two dancers as the village looks on (Fig. **44.18**). The style is characteristic of Douglas—silhouetted figures, overlaid with colored bands of concentric circles.

The Music Project: Aaron Copland's American Music
The Depression had an enormous impact on the music industry. Thousands of musicians lost their jobs as orchestras and opera companies closed their doors, hotels and restaurants eliminated orchestras, and music education disappeared from school and university budgets. By 1933, two-thirds of the national membership of the American Federation of Musicians was unemployed. The WPA's Federal Music Project addressed this situation, organizing orchestras around the country.

When the project first began there were only 11 recognized symphony orchestras in the United States. At the peak of the WPA, 34 more new orchestras had been created, and thousands of Americans were attending concerts. From October 1935 to May 1, 1937, almost 60 million people listened to 81,000 separate performances of WPA musical events. And through the Composers' Forum Laboratory new music was created and performed.

One of the beneficiaries of this support was composer Aaron Copland [KOPE-lund] (1900–1990). Copland had

begun his career deeply influenced by European modernism, particularly the work of Arnold Schoenberg (see chapter 41), but he became increasingly interested in folk music. This interest began in the fall of 1926, when he met Mexican composer Carlos Chávez [SHAH-vays] (1899–1978), who was rooming with Mexican artist Rufino Tamayo [tah-MAH-yoh] (1899–1991) in a tenement on Fourteenth Street in New York and who introduced him as well to Diego Rivera. Writing about Chávez in 1928, Copland declared that the composer's "use of folk material in its relation to nationalism" constituted a major strain of modern music, one that he himself would soon begin to pursue.

In the early 1930s Copland composed *El Salón México* [el sah-LOHN MAY-hee-koh], based on Mexican folk music he had heard when visiting Chávez in Mexico. Soon after this he began to use purely American themes and material, including New England hymns, folk songs, and jazz, particularly in his work for the ballet: *Billy the Kid* (1938), *Rodeo* (1942), and *Appalachian Spring* (1944).

Copland composed *Appalachian Spring* for dancer and choreographer Martha Graham (1894–1991). Copland simply called it "Ballet for Martha," but Graham renamed it when she decided to set the ballet in the Pennsylvania hill country early in the nineteenth century. In Graham's dance, a young woman and her fiancé both express their excitement and joy at the prospect of their upcoming marriage and their sober apprehension of the responsibilities that their new life demands. While an older neighbor conveys a mood of confidence and satisfaction, a religious revivalist reminds the new bride and groom of their tenuous place in God's cosmos. At the end, the couple have evidently grown into their new life as they come to live in their new house. Copland's score for this concluding section is built around a single Shaker hymn, "Simple Gifts," which serves as the basis for a stirring set of final variations (see **CD-Track 44.3**). The orchestral version of *Appalachian Spring* was extremely popular and demonstrated that Copland had found a truly American style.

The Dust Bowl in Film and Literature Copland was not the only American composer moved by the Depression to pursue distinctly American themes. Virgil Thomson (1896–1989), who like Copland had studied in Paris, was hired in 1936 by the Resettlement Administration to score two documentary films directed by Pare Lorentz (1905–1992) in order to raise awareness about the New Deal. *The Plow That Broke the Plains* is about the devastation of the almost-ten-year drought that struck the American Midwest, particularly the southern Great Plains, and turned the region into a virtual dust bowl. *The River* celebrates the accomplishments of the Tennessee Valley Authority to harness water for electrical energy.

Thomson's score for *The Plow That Broke the Plains* consists of six movements that follow the transition from fertile plain to Dust Bowl: *Prelude, Pastorale* (Grass) (see **CD-Track 44.4**), *Cattle, Blues* (Speculation), *Drought,* and *Devastation.* Thomson spent considerable time researching the rural

Fig. 44.19 Still from *The Plow That Broke the Plains.* 35mm black-and-white film, mono sound, 25 minutes. Directed and written by Pare Lorentz. Original music by Virgil Thomson. Cinematography by Leo Hurwitz, Paul Ivano, Ralph Steiner, and Paul Strand. The film traces the history of farming on the Great Plains, pointing out the environmental abuses that led to the Dust Bowl.

music of the Great Plains. He also incorporated military marches, gunfire, and the sound of rolling tanks into the score to accompany a film sequence of farmers plowing the land. In doing so he addressed musically a theme ignored in the narration, the contribution of agriculture to the war effort.

Lorentz shot *The Plow That Broke the Plains* in Montana, Wyoming, Colorado, Kansas, and Texas, and was able to capture extraordinary dust-storm sequences and the pathos of those caught in their wake (Fig. **44.19**). The film's public premier was at the Mayflower Hotel in New York on May 10, 1936, at an evening sponsored by the Museum of Modern Art. The event also featured several foreign documentaries, including portions of Leni Riefenstahl's *Triumph of the Will.* Although *Plow* was critically acclaimed, none of the Hollywood studios would agree to distribute it commercially because, they claimed, it was strictly government propaganda. But the movie was shown at independent theaters with great success, and its popularity soon changed the distributors' minds. When *The River* was released in 1937, Paramount jumped to distribute it. The script was nominated for the Pulitzer Prize in Poetry in 1938.

The great novel of the Dust Bowl years was *The Grapes of Wrath* by John Steinbeck [STINE-bek] (1902–1968). Published in 1939, its interplay between panoramic interludes and close-up accounts of a family's cross-country journey was inspired by Lorentz's films. Steinbeck even worked briefly with Lorentz on the documentary *The Fight for Life*, about a maternity ward in Chicago, the year after *The Grapes of Wrath* was published. The title of Steinbeck's novel comes from "The Battle Hymn of the Republic":

Mine eyes have seen the glory of the coming of the Lord
He is trampling out the vintage where the grapes of wrath are stored,
He has loosed the fateful lightning of His terrible swift sword
His truth is marching on.

This mention of "grapes of wrath," as Steinbeck knew, was a reference back to the Bible: "And the angel thrust his sickle into the earth, and gathered the vine of the earth, and cast it into the great winepress of the wrath of God" (Rev. 14:19).

In a style so realistically detailed that it might be called cinematic, Steinbeck tells the story of the Oklahoma Joads, who lose their tenant farm and join thousands of others traveling to California on Route 66, the main migrant road. Their motivation is summarized in a handbill that they find on the road: "PEA PICKERS WANTED IN CALIFORNIA. GOOD WAGES ALL SEASON. 800 PICKERS WANTED." Things in California do not turn out as planned—thousands of workers turn up for the few available jobs, and food is scarce: "In the souls of the people," Steinbeck writes, "the grapes of wrath are filling and growing heavy, growing heavy for the vintage." Steinbeck's Joads are stoically heroic (especially Ma Joad) but also deeply perceptive about the social injustices that pervade the America they encounter in their journey. The novel is an outcry against the injustice encountered by all migrant workers in the Great Depression.

Photography and the American Scene One of the important cultural contributions of the New Deal was the photographic documentation of the plight of poor farmers and migrant workers during the Dust Bowl and Great Depression under the auspices of the Farm Security Administration (FSA). The head of the FSA's photographic project, Roy Stryker, found in the work his team of 15 photographers created, the same stoic heroism that Steinbeck had portrayed in the Joad family: "You could look at the people and see fear and sadness and desperation," Stryker wrote. "But you saw something else, too. A determination that not even the Depression could kill. The photographers saw it—documented it."

This is certainly the quality that Dorothea Lange (1895–1965) captures in *Migrant Mother*, a portrait of Native American Florence Owens Thompson and three of her children in a pea-pickers' camp (Fig. **44.20**). Stryker said of this image: "When Dorothea took that picture, that was the ultimate. She never surpassed it. To me it was the picture of Farm Security. She has all the suffering of mankind in her, but all

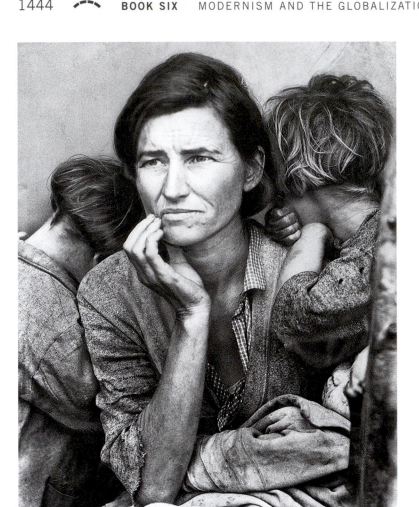

Fig. 44.20 Dorothea Lange. *Migrant Mother, Nipomo, California.* **1936.** Gelatin silver print, 37 1/8″ × 40 5/8″. Library of Congress, Washington, DC. The original caption for this photograph, taken for the Farm Security Administration, was: "Destitute pea pickers in California. Mother of seven children."

the perseverance too. A restraint and a strange courage." In the 1940s, Lange's documentary work included photo essays of the Japanese internment camps as well as a series focusing on World War II factory workers. She later was the first woman awarded a Guggenheim fellowship and spent nearly ten years making photo essays for *Life* and other magazines.

Of all the FSA photographs, the most well-known today are those of Walker Evans (1903–1975) first published in *Let Us Now Praise Famous Men*, a book produced in 1941 with writer James Agee [AY-jee] (1909–1955). The book's title is ironic, for Agee's subject is the least famous, the poorest of the poor: sharecroppers, the men, women, and children of Depression-ridden central Alabama in the summer of 1936 when he and Evans lived among them. But again, it is the simple life and inherent nobility of these poor people that form Evans's and Agee's theme. This theme is captured in the rich textures and clean lines of Evans's photograph of a share-

cropper's humble dwelling (Fig. **44.21**). The photo is a revelation of the stark beauty in the middle of sheer poverty.

Not all of the important photographers with a social conscience worked for the FSA. Margaret Bourke-White (1904–1971) was one of the first four photographers hired by publisher Henry Luce for the new picture magazine *Life*, founded in 1936. That same year, she traveled the American South with writer Erskine Caldwell, documenting the living conditions of poor tenant farmers, a project that resulted in the 1937 book *You Have Seen Their Faces*. That same year, *Life* published one of her most famous photographs, *At the Time of the Louisville Flood* (Fig. **44.22**). Over 900 people had died when the Ohio River inundated Louisville, Kentucky, in January 1937. Bourke-White's photo stunningly indicts the American dream by juxtaposing desperately poor folk who have lost their homes (reality) with a government billboard touting well-being (propaganda).

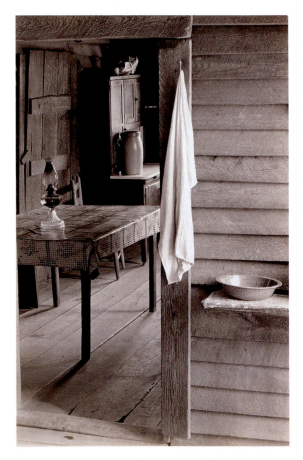

Fig. 44.21 Walker Evans. *Washroom and Dining Area of Floyd Burroughs's Home, Hale County, Alabama.* **1936.** 35mm photograph, Library of Congress, Washington, DC. During its eight-year existence, the Farm Security Administration created over 77,000 black-and-white documentary photographs.

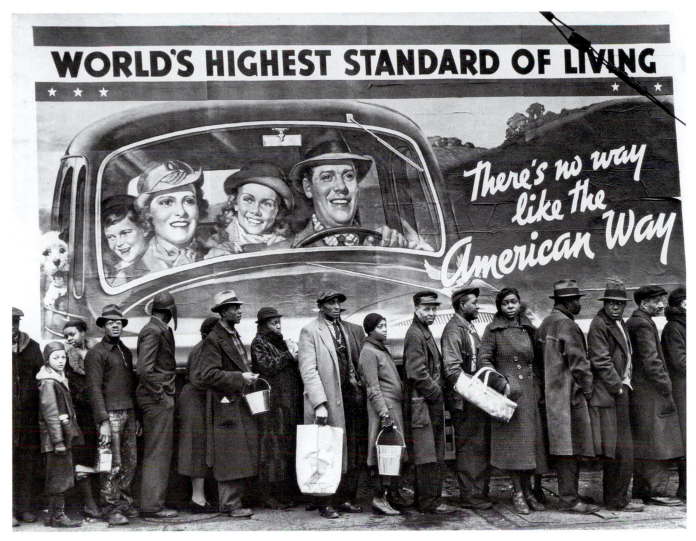

Fig. 44.22 Margaret Bourke-White. *At the Time of the Louisville Flood.* 1937. Gelatin silver print, 9¾″ × 13½″. The Hallmark Photographic Collection, Hallmark Cards, Inc., Kansas City, Missouri. Bourke-White later covered World War II and the Korean War for *Life*. She was the first woman photographer attached to the U.S. armed forces, and the only American photographer to cover the siege of Moscow in 1941.

Woody Guthrie and the American Protest Song One of the great musicians of the Dust Bowl years was Woodrow Wilson, "Woody" Guthrie [GUTH-ree] (1912–1967). In 1937, Guthrie left his wife and two children at home in the Texas Panhandle in order to head west on Route 66. The poverty and hardships he witnessed and personally experienced left an indelible mark on him. When he finally arrived in Los Angeles—having hitchhiked, walked, and worked his way across the country—KFVD radio hired him and his cousin Jack as performers, and they soon attracted a large appreciative audience in the migrant camps. Political and social protest soon found expression in his lyrics to such songs as "Talking Dust Bowl Blues," "Tom Joad," and "Hard Travelin'." His most famous song, "This Land Is Your Land" (see **CD-Track 44.5**), was written in 1940 and is also a protest song. It begins this way (**Reading 44.6a**):

READING 44.6a from Woody Guthrie, "This Land Is Your Land" (1940)

This land is your land, this land is my land
From California to the New York island
From the redwood forest to the Gulf Stream waters
This land was made for you and me.

The song was a response to "God Bless America," composed by Irving Berlin (1888–1989) in 1918 and revised in 1938 as a rallying cry against the rise of Hitler. Guthrie felt Berlin's song was jingoistic (very nationalistic and marked by a call for war) and elitist. While Guthrie's song celebrates the greatness

of the land itself, two of its stanzas (today often not published or performed) are a stinging reproach to a nation that too easily ignores the plight of its citizens (**Reading 44.6b**):

READING 44.6b **from Woody Guthrie, "This Land Is Your Land" (1940)**

As I went walking, I saw a sign there,
And on the sign it said, "No Trespassing."
But on the other side it didn't say nothing.
That side was made for you and me.

In the shadow of the steeple, I saw my people,
By the relief office, I seen my people;
As they stood there hungry, I stood there asking,
Is this land made for you and me?

The Rise of Regional Art

The various arts projects on the WPA underscored the presence, across the country, of a vast number of regional and local styles, each with its own particular and unique characteristics. Artists, photographers, composers, and writers explored these regional styles with increasing interest, and architecture soon followed suit.

William Faulkner and the Southern Novel The Southern rural life captured in the photography of Lange, Evans, and Bourke-White was also the subject of the novels of William Faulkner (1897–1962), a native of Mississippi. "I discovered," Faulkner wrote, "that my own little postage stamp of native soil was worth writing about and that I would never live long enough to exhaust it. . . . I opened up a gold mine of other people, so I created a cosmos of my own." This cosmos is the imaginary Mississippi county of Yoknapatawpha, with Jefferson its county seat. *As I Lay Dying* (1930), which Faulkner wrote while working the night shift in the University of Mississippi boiler room, tells the story of the Bundren family's efforts to fulfill their deceased mother's wishes to bury her in Jefferson. Deeply experimental, the story unfolds through the alternating interior monologues of 15 different characters, whose motives and perspectives are sometimes wildly at odds. Also experimental is its use of the stream-of-consciousness technique (see chapter 42) pioneered by Irish writer James Joyce and English writer Virginia Woolf, and its use of chapters of widely varying length.

Even more experimental is the 1929 novel *The Sound and the Fury*, which tells the story of the Compson family from four perspectives: those of the three Compson brothers, Benjy, Quentin, and Jason, and their maid, Dilsey. In this novel is probably the most daring use of stream of consciousness in modern fiction: Faulkner's representation of the mental workings of the intellectually and developmentally disabled Benjy Compson. It is Benjy's interior monologue that opens the novel (**Reading 44.7**):

READING 44.7 **from William Faulkner, *The Sound and the Fury* (1929)**

Through the fence, between the curling flower spaces, I could see them hitting. They were coming toward where the flag was and I went along the fence. Luster was hunting in the grass by the flower tree. They took the flag out, and they were hitting. Then they put the flag back and they went to the table, and he hit and the other hit. Then they went on, and I went along the fence. Luster came away from the flower tree and we went along the fence and they stopped and we stopped and I looked through the fence while Luster was hunting in the grass.

"Here, caddie." He hit. They went away across the pasture. I held to the fence and watched them going away.

"Listen at you, now." Luster said. "Aint you something, thirty-three years old, going on that way. After I done went all the way to town to buy you that cake. Hush up that moaning. Aint you going to help me find that quarter so I can go to the show tonight."

This scene takes place in the present, on April 7, 1928, as Benjy accompanies the black servant Luster, who is assigned to take care of him, as he hunts for a quarter beside the golf course. Benjy confuses the golfer's call for his "caddie" with the name of his sister Caddy, who has treated him with more respect than any other member of the family. It is when he thinks of her that he begins to moan and holler.

Benjy's mind moves fluidly by free association across time. In the opening pages of the novel, we are carried back to Christmas Day 1900, when he and Caddy deliver a letter to Mrs. Patterson, then back to the present ("What you moanin' about," Luster says), then back to December 23, 1900, back to the present once more ("Can't you shut up that moaning"), then to a trip to the cemetery shortly after Mr. Compson's funeral in 1912, then back to the present ("Cry baby"), then to Christmas Day 1900 when Benjy delivers the letter ("Mrs. Patterson was chopping flowers"), and finally into the present again ("There ain't nothing over yonder but houses"). Faulkner asks his readers to abandon the traditional literary categories of space, time, and causality, but in compensation he teaches them the humility required of compassion and empathy. In all his novels, Faulkner celebrates the many strengths of his fellow Southerners, while exposing with almost pitiless precision the price their history of racism, denial, and guilt has extracted from them. His work would inspire the next generation of Southern fiction writers—Eudora Welty, Flannery O'Connor, William Styron, and Walker Percy.

Frank Lloyd Wright and American Architecture Although the curators of the International Style exhibition at the Museum of Modern Art in 1932 had argued that the new architecture should ignore regional and nationalist styles, the chief American architect they included in the exhibition was Frank Lloyd Wright

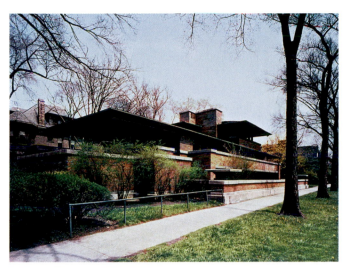

Fig. 44.23 **Frank Lloyd Wright. Robie House, South Woodlawn, Chicago, Illinois. 1909.** Wright derived from Louis Sullivan the belief that good architecture must be rooted in its relation to the natural world.

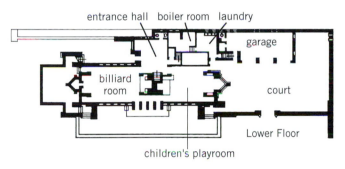

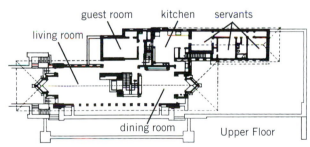

Fig. 44.24 **Plan of the Robie House.**

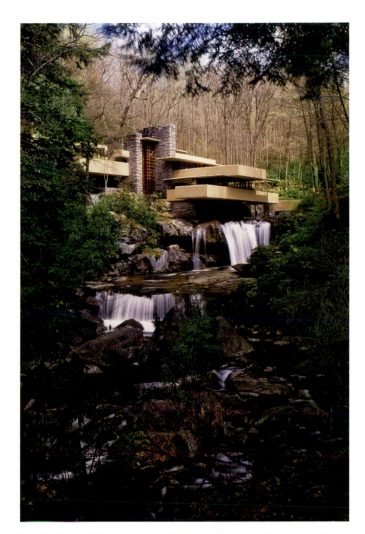

Fig. 44.25 **Frank Lloyd Wright. Fallingwater (Kaufmann House), Bear Run, Pennsylvania. 1935–1936.** The first drawings for Fallingwater were done in a matter of hours after Wright had thought about the project for months.

(1867–1959), who was as dedicated to reflecting regional character in his work as Southern writers in their prose. It had been Alfred H. Barr, Jr., who insisted that Wright be included in the exhibition. His colleague Philip Johnson regarded Wright as old-fashioned, of no serious worth, and stylistically inconsistent with the International style. Wright, in turn, despised both the International style and Johnson. But he was included because he was a former student of Louis Sullivan and because Europeans considered him the leader of modern architecture. In fact, it was after De Stijl members discovered the work of Wright, which was published in Europe in 1911, that they began to conceive of ways to apply De Stijl design to architecture. What Wright had done,

they understood, was open up the interior of the building, to destroy the boxlike features that traditionally defined a room.

In his early architecture, like the Robie House, Wright had employed many of the same principles that guided architects of the International style—open interior spaces, steel-frame construction, concrete cantilevers that extended over porches to connect exterior and interior space, a raised first floor to provide for privacy, and walls consisting entirely of windows (Figs. **44.23, 44.24**). But his inspiration was nature, not the machine. He called houses such as the Robie House "Prairie Houses," because in their openness and horizontality they reflected the Great Plains. The materials he employed were local—brick from local clays, oak woodwork, and so on.

Furthermore, Wright believed that each house should reflect not just its region but also its owner's individuality. He abhorred the uniformity that the International Style promoted. This is especially evident at Fallingwater, the house at Bear Run in Pennsylvania that he designed in 1935 for Pittsburgh entrepreneur Edgar Kaufmann, owner of the largest men's clothing store in the country (Fig. **44.25**). (Kaufmann's

own personal wealth was an indication of America's recovery from the Depression.) Wright thought of Fallingwater as consistent with his earlier Prairie Houses because it was wedded to its site. But this site was distinguished by the cascades of Bear Run, falling down over a series of cliffs. Wright opened a quarry on the site to extract local stone and built a three-level house literally over the stream, its enormous cantilevered decks echoing the surrounding cliffs.

Fallingwater, finally, for Wright had to be in harmony with its site, not some white industrial construction plopped into the landscape. "I came to see a building," Wright wrote in 1936, "primarily . . . as a broad shelter in the open, related to vista; vista without and vista within. You may see in these various feelings, all taking the same direction, that I was born an American, child of the ground and of space." Wright's stunning and original design suggests a distinctly American sensitivity to place.

Cinema: The Talkies and Color

Throughout the Great Depression, going to the movies was America's favorite leisure activity. The movies took people's minds off the harsh realities of the era, and although ticket prices were relatively expensive, ranging between 25 cents and 55 cents (between $4 and $9 in terms of today's buying power), people still found the means to flock to the movies. By the late 1930s, some 50 million viewers were drawn into American theaters each week.

Prior to the depression, two forces were transforming motion pictures simultaneously—the introduction of sound and the advent of color film. Technicolor, the brainchild of Herbert Kalmus (1881–1963), was the first widely successful color-film process in which two film strips were dyed and pasted together to create a single positive print containing all the colors that the audience would see. Douglas Fairbanks's 1926 film *The Black Pirate* was the first feature film in full color. By the mid-1930s a three-color Technicolor process had been perfected, and motion-picture companies gradually began to work it into their productions.

What slowed the introduction of color in the industry was sound, the development of which consumed the attention of the industry. Before the advent of motion-picture sound, movies were by no means "silent." Every theater had a piano or organ to provide musical accompaniment to the films it projected. This made cinema a multimedia event, a live musician or orchestra reacting to and participating in the presentation of the film, mediating between audience and image. In this sense, films, before sound, were literally local events. But the introduction of sound radically changed the motion-picture industry. For one thing, theaters everywhere had to be wired, a process that took several years to accomplish. For another, incorporating sound into the film itself changed the culture of film viewing. In the 1920s, the cinema was the world's largest employer of musicians. Then, just as the Great Depression hit, thousands of cinema musicians found themselves out of work.

Sound and Language

Sound also changed the nature of acting in the cinema. Before sound, communication with the audience depended on facial expression and physical gesture, often exaggerated. Now actors had to rely on speech to communicate, and many silent-era stars simply lacked a compelling voice. Foreign actors were especially affected—Greta Garbo, with her deeply sonorous and melancholy voice ("I vhant to be alone") was one of the few foreign stars to make the transition successfully except for English actors. Dialogue writing had never been important before, but now playwrights became an instrumental force in movie production. Most important, sound brought foreign languages into the theaters—English into European theaters, various European languages into each other's and American theaters. At first, some producers tried to produce their films in several languages, but this proved too expensive.

In Europe, English-language films were commonly **dubbed** (short-hand for "vocal doubling"), with native speakers synchronizing new dialogue to the lip movements of the actor. In the United States, where a large part of the audience for foreign films were immigrants who spoke the foreign language, English-language text was more commonly scrolled across the bottom of the screen as subtitles. Interestingly, subtitles tend to announce the "foreignness" of the film, while dubbing suppresses it, so dubbing played a major role in the "Americanization" of world cultures.

***The Jazz Singer*: The First Feature-Length Talkie** Sound came to the feature-length motion picture on October 6, 1927, when Warner Bros. Studio premiered *The Jazz Singer*, starring Al Jolson [JOL-sun] (1886–1950) (Fig. **44.26**). The first words of synchronous [SING-kruh-nus] speech were Jol-

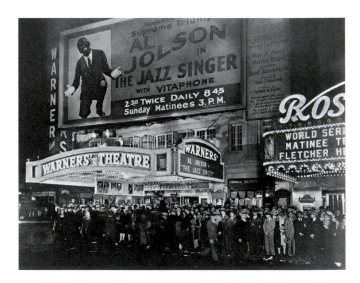

Fig. 44.26 **Opening night crowd gathering to see Al Jolson in *The Jazz Singer*, Warner's Theatre, Times Square, NY, October 6, 1927.** The film convinced producers and audiences that sound could be more than a novelty.

son's prophetic statement, "Wait a minute. Wait a minute. You ain't heard nothing yet." *The Jazz Singer* is the story of a cantor's son, Jakie Rabinowitz [ruh-BIN-oh-vits], who longs to play jazz (calling himself Jack Robin) rather than follow his family's footsteps into the synagogue. Jakie/Jack falls in love with a woman outside his own faith, performs in minstrel-style blackface makeup, and otherwise challenges every notion of ethnic identity. The film contained only two dialogue scenes (in other respects it was a silent-era feature), but its success lay as much in this story line as in its introduction of sound. Audiences everywhere recognized it as an "American"—as opposed to an ethnic—tale.

The Blue Angel One of the most interesting early experiments with sound was the two-language production *Der blaue engel [der BLAU-uh EN-gul]/The Blue Angel*, directed by Josef von Sternberg [SHTERN-berg] (1894–1969). Sternberg had emigrated from Germany to the United States at the turn of the century, and through the 1920s he had gradually worked his way up the directorial ladder in Hollywood. In 1930, Paramount hired him to go to Germany to direct a co-production in both German and English with UFA (Universum Film Aktiengesellschaft), one of the largest studios in Europe. Marlene Dietrich (1901–1992) starred in the film as the nightclub performer Lola Lola opposite Emil Jannings as Professor Rath, a sexually repressed instructor at a boys' school whom Lola Lola seduces by exploiting his self-loathing (Fig. **44.27**). Dietrich's portrayal of a temptress secured her fame. Sternberg would bring her back to Hollywood, where he would feature her in the role of the vamp who sexually humiliates her masochistic male counterpart in six more films over the next five years. The films demonstrate how thoroughly Freudian psychology had taken hold of the popular imagination.

The Hollywood Musical The earliest talkies faced huge technological obstacles—stationary microphones that hampered the actors' ability to move and immobile cameras that had to be enclosed in large sound-tight boxes so that microphones would not pick up the hum of the noisy camera motors, and so on. But the problems were quickly overcome. Microphones were hung on booms, long arms that extended high above the performers out of camera range, and placed on dollies that freed the actors to move. Cameras were covered with sound-insulating material, and though bulky, they came out of the stationary box. These innovations gave producers new latitude in their use of music. Now they were free to more fully exploit the audience taste for music that Jolson's *Jazz Singer* had demonstrated.

Fig. 44.27 Marlene Dietrich in *Der blaue engel/The Blue Angel*. 1930. UFA (Germany). Not unjustifiably, Sternberg was accused of putting Dietrich on display to exploit her sexuality.

In 1933, Warner's started to produce musicals in which opulent song-and-dance spectacles, directed by choreographer Busby Berkeley (1895–1976), were interwoven with a love story, generally between a chorus girl and a handsome young man. At the same time, RKO, a studio that had been created when RCA entered the film industry in order to promote its own sound system, introduced the dancing couple Fred Astaire [uh-STAIR] and Ginger Rogers. Like the Warner's films, the RKO films were largely vehicles to celebrate their leading couple's romance in song and dance. Nevertheless, both studios freed the musical from stage convention by using overhead shots of dancers, tracking shots as the dancers passed over the floor, and so on.

Disney's Color Animation

Between 1928 and 1937, Disney studios, headed by Walt Disney (1901–1966), created over 100 animated cartoons, most starring Mickey Mouse but depending, for variety and development, on Mickey's entourage of sidekicks, particularly Pluto, Goofy, and Donald Duck. At least as important technically, however, were Disney's so-called Silly Symphonies, with scores that are masterpieces of parody, subjecting classical music—from opera to the piano concerto—to the good-natured fun of the cartoon medium. In essence, Disney's animation gave rise to the art of **postsynchronization**, in which sound is added as a separate step after the creation of the visual film. Actors became increasingly adept at speaking lines mouthed by cartoon characters, and musical scores could be adapted to fit the action.

Fig. 44.28 Judy Garland, as Dorothy, sees the Yellow Brick Road in *The Wizard of Oz*. 1939. © 1939 The Kobal Collection/ MGM. Warner Brothers Motion Picture Titles. Until this film, audiences associated color almost exclusively with cartoons.

Disney studios began work on its first feature-length Technicolor animation, *Snow White and the Seven Dwarfs*, in 1934. Over 300 animators, designers, and background artists worked on the film, with Disney hiring animators away from other studios and training many other artists who had never worked at animation before. The film took three years to finish and premiered in December 1937. It was an instant success, and Disney immediately set his team to work on three more features, *Bambi*, *Pinocchio*, and *Fantasia* [fan-TAY-zhuh]. The last of these animated classical music in order to introduce young people to the various classical forms. The didactic nature of *Fantasia* is unique in the annals of cartoon animation.

1939: The Great Year

As the nation recovered from its economic downturn, and audiences were able to afford to go the movies more often, Hollywood responded by making more and better films. In 1939, Hollywood created more film classics than at any time before or since. Among these are *Stagecoach*, *Mr. Smith Goes to Washington*, *Drums Along the Mohawk*, *Wuthering Heights*, *Of Mice and Men*, *Gone with the Wind*, and *The Wizard of Oz*, to name just a few.

The Wizard of Oz *The Wizard of Oz* was the most expensive film MGM made in 1939. It was in fact MGM's most expensive film of the decade—costing $2.77 million to produce (Fig. **44.28**). It starred Judy Garland (1922–1969), by then well known to movie audiences for her work with Mickey Rooney (1920–) in his string of box-office hits in the role of "Andy Hardy." The film begins in the black-and-white "reality" of Kansas. It switches to color when Dorothy and her dog Toto arrive in Oz after being transported there by a tornado. The sudden intrusion of color announced to the audience that Oz was the stuff of fantasy. Despite grossing over $3 million, *The Wizard of Oz* lost nearly $1 million, owing to higher-than-usual marketing costs.

Although the film launched Garland into stardom, virtually guaranteeing future income from her performances, it

also taught the studio an important corporate lesson. Having paired Garland with Rooney once again in a series of remakes of Broadway musicals, beginning with *Babes in Arms*, the studio reaped similar or larger grosses with much less expenditure. The formula for studio success was clear: the economical production of star-driven vehicles with recyclable narrative traits. In this rested both Hollywood's financial success and its artistic limitations.

Gone with the Wind The most ambitious project of 1939 was *Gone with the Wind*, produced by David O. Selznick [SELZ-nik] (1902–1965) and based on the Civil War novel by Margaret Mitchell (1900–1949). Arguably the first true "blockbuster," its running time was 3 hours 42 minutes, plus an intermission, keeping audiences in theaters for over 4 hours. They came to see English actress Vivien Leigh in the role of Southern belle Scarlett O'Hara, for Selznick had made sure everyone knew that America's biggest stars had all auditioned for the part, including Katharine Hepburn, Susan Hayward, Barbara Stanwyck, Joan Crawford, Lana Turner, Mae West, Tallulah Bankhead, and Lucille Ball. Errol Flynn, Ronald Colman, and Gary Cooper were also considered for Clark Gable's role as the Southern gunrunner Rhett Butler. Selznick spent an unheard-of $4 million to produce the film, but he was rewarded when it became the highest-grossing film ever—$400 million in lifetime box-office gross receipts. Finally, audiences were stunned by its sweeping Technicolor, a technology that producer Selznick was more fully committed to than any other Hollywood producer.

The film was not easy to make. Selznick went through three directors during production, with Victor Fleming, who was responsible for about half the film and had just finished directing *The Wizard of Oz*, finally getting credit. As usual in Hollywood, a number of writers had a hand in the script. There were over 50 speaking roles and 2,400 extras. The subject matter was controversial—the fate of *Birth of a Nation*

Fig. 44.29 The burning of Atlanta from *Gone with the Wind*. 1939. Selznick and Menzies shot the burning-of-Atlanta sequence first so that the studio lot could be cleared for other sets.

Fig. 44.30 William Cameron Menzies. **Storyboard for the burning-of-Atlanta scene from** *Gone with the Wind.* **1939.** Photofest. Such storyboards reflect the detailed level of planning necessary before filming could begin.

weighed on Selznick's mind—and the film was carefully scripted to avoid racial caricature. Indeed, Hattie McDaniel, who played the house servant Mammy in the film, would become the first African American to win an Academy Award (as Best Supporting Actress).

Much of the film's success can be attributed to art director William Cameron Menzies [MEN-zeez], whose reputation had been established years before when he designed the sets for *The Thief of Bagdad* (see Fig. 43.17). Menzies worked on visualizing the film for two years before production began, creating storyboards to indicate camera locations for the sets. This allowed the determination of camera angles, locations, lighting, and even the editing sequence well in advance of actual shooting. His panoramic overviews, for which the camera had to pull back above a huge railway platform full of wounded Confederate soldiers, required the building of a crane, and they became famous as a technical accomplishment. For the film's burning-of-Atlanta scene, Menzies's storyboard shows seven shots, beginning and ending with a panoramic overview, with cuts to close-ups of both Rhett Butler and Scarlett O'Hara fully indicated (Figs. **44.29, 44.30**).

The Rules of the Game Not made in Hollywood but France, perhaps the greatest film of 1939 was *La Règle du jeu* (*The Rules of the Game*), directed by Jean Renoir (son of Impressionist painter Auguste Renoir). With *The Battleship Potemkin*, it is the only film always on the list of the top ten films ever made in the poll conducted every decade since 1952 by the European magazine *Sight and Sound*. At the most basic level, the film is a love farce with a double upstairs/downstairs plot that takes place one weekend at the country chateau of the Marquis de la Chesnaye. Upstairs are the rich: the Marquis, Robert; his wife, Christine; his mistress, Genevieve; and a famous aviation hero named André Jurieux, who is desperately in love with Christine. Downstairs among the hired help are Lisette, private maid to Christine; Schumacher, her groundskeeper husband; and the newly hired valet, Marceau, whom the Marquis is intent on assisting in his efforts to seduce Christine. But Renoir's film is much more than a tale of his lovers' intrigues. It is a scathing indictment of French society at the brink of World War II, of a society intent on maintaining the status quo as each person pursues their own individual desires at the expense of social responsibility and engagement.

As a result, the movie was greeted by hisses and boos when first screened in 1939 and banned as demoralizing by the French government after the outbreak of war. Renoir himself called it a "war film" with "no reference to the war." War, in fact, seems imminent in the film as, in the forest surrounding the chateau, the random gunfire of "hunters" periodically startles the weekend party. Yet—and this is the point—it is a sound they choose to ignore.

Orson Welles and *Citizen Kane*

One of the most cinematographically inventive films of the postwar era was the 1940 *Citizen Kane*, directed by Orson Welles (1915–1985). The story is presented in a series of flashbacks as told to a journalist who is seeking to unravel the mystery of why media baron Charles Foster Kane (generally understood as a character based on actual newspaper mogul William Randolph Hearst) spoke the single word

"Rosebud" on his deathbed. So the story is nonlinear, fragmented into different voices and different points of view, and its various perspectives carry over into the film's unorthodox construction.

Welles had made history—and a large reputation—in 1938 when his Halloween radio dramatization of H. G. Wells's novel *The War of the Worlds* convinced many listeners that Martians had actually invaded New Jersey. RKO gave him unprecedented freedom to make *Citizen Kane* in any manner he chose. Working as writer, director, producer, and actor simultaneously—and collaborating with cinematographer Gregg Toland on almost every shot—Welles produced a film unprecedented in its fresh look. In fact, he insisted that Toland experiment with almost every shot. Toland employed a special deep-focus lens that maintains focus from foreground to background in the deep space of the sets, in order to highlight multiple planes of action in the same shot (Fig. **44.31**). These shots were often lit with **chiaroscuro lighting**, a term borrowed from Renaissance painting to describe pools of light illuminating parts of an otherwise dark set. Toland also had the sets constructed in such a way that he could shoot from well above or well below the action.

Citizen Kane marked the end of the great era of the American motion picture. By 1945, with World War II in full swing, Hollywood production had fallen by more than 40 percent. Great films would continue to be made—the 1943 war film *Casablanca*, starring Humphrey Bogart [BOH-gart] and Swedish star Ingrid Bergman was everyone's favorite wartime movie. After the war, the population began to shift to the suburbs, increasingly engaging in outdoor leisure activities, and television began to replace film as the primary delivery system of the moving image. As a result, motion-picture attendance began a slow decline.

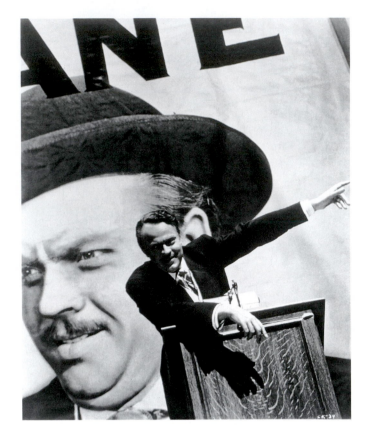

Fig. 44.31 Orson Welles as Kane campaigning for governor in *Citizen Kane*. 1941. CITIZEN KANE © 1941 The Kobal Collection/RKO. Warner Brothers Motion Picture Titles. This shot is a subtle reference to film editing, simultaneously both a medium shot of Kane and a close-up in the poster behind him.

READINGS

READING 44.2

from Franz Kafka, *The Metamorphosis* (1915)

Franz Kafka's novella The Metamorphosis *is one of the few works he published during his lifetime. Dreamlike in its central premise—it begins with its main character, Gregor Samsa, waking from "uneasy dreams" transformed into a "gigantic insect"—it is narrated in a direct, matter-of-fact style that seems at odds with its fantastic plot. While Kafka never questions the fact of Samsa's transformation, which leads inevitably to his death, we as readers understand that the story is something of a parable for the modern individual's alienation from his or her own humanity as well as from society.*

As Gregor Samsa awoke one morning from uneasy dreams he found himself transformed in his bed into a gigantic insect. He was lying on his hard, as it were armor-plated, back and when he lifted his head a little he could see his domelike brown belly divided into stiff arched segments on top of which the bed quilt could hardly stay in place and was about to slide off completely. His numerous legs, which were pitifully thin compared to the rest of his bulk, waved helplessly before his eyes.

What has happened to me? he thought. It was no dream. ¹⁰ His room, a regular human bedroom, only rather too small, lay quiet within its four familiar walls. Above the table on which a collection of cloth samples was unpacked and spread out—Samsa was a traveling salesman—hung the picture which he had recently cut out of an illustrated magazine and put into a pretty gilt frame. It showed a lady, with a fur hat on and a fur stole, sitting upright and holding out to the spectator a huge fur muff into which the whole of her forearm had vanished!

Gregor's eyes turned next to the window, and the overcast ²⁰ sky—one could hear raindrops beating on the window gutter—made him quite melancholy. What about sleeping a little longer and forgetting all this nonsense, he thought, but it could not be done, for he was accustomed to sleep on his right side and in his present condition he could not turn himself over. However violently he forced himself toward his right side he always rolled onto his back again. He tried it at least a hundred times, shutting his eyes to keep from seeing his struggling legs, and only desisted when he began to feel in his side a faint dull ache he had never felt before. ³⁰

Oh God, he thought, what an exhausting job I've picked out for myself! On the road day in, day out. It's much more irritating work than doing the actual business in the home office, and on top of that there's the trouble of constant traveling, of worrying about train connections, the bad food and irregular meals, casual acquaintances that are always new and never become intimate friends. The devil take it all! He felt a slight itching up on his belly, slowly pushed himself on his back nearer to the top of the bed so that he could lift his head more easily, identified the itching place which was surround- ⁴⁰ ed by many small white spots the nature of which he could not understand and was about to touch it with a leg, but drew the leg back immediately, for the contact made a cold shiver run through him.

He slid down again into his former position. This getting up early, he thought, can make an idiot out of anyone. A man needs his sleep. Other salesmen live like harem women. For instance, when I come back to the hotel in the morning to write up my orders these others are only sitting down to breakfast. Let me just try that with my boss; I'd be fired on the ⁵⁰ spot. Anyhow, that might be quite a good thing for me, who can tell? If I didn't have to hold back because of my parents I'd have given notice long ago, I'd have gone to the boss and told him exactly what I think of him. That would knock him right off his desk! It's a peculiar habit of his, too, sitting on top of the desk like that and talking down to employees, especially when they have to come quite near because the boss is hard of hearing. Well, there's still hope; once I've saved enough money to pay back my parents' debts to him—that should take another five or six years—I'll do it without fail. ⁶⁰ I'll cut my ties completely then. For the moment, though, I'd better get up, since my train leaves at five.

He looked at the alarm clock ticking on the chest of drawers. Heavenly Father! he thought. It was half-past six and the hands were quietly moving on, it was even past the half-hour, it was getting on toward a quarter to seven. Had the alarm clock not gone off? From the bed one could see that it had been properly set for four o'clock; of course it must have gone off. Yes, but was it possible to sleep quietly through that ear-splitting noise? Well, he had not slept quietly, yet apparently ⁷⁰ all the more soundly for that. But what was he to do now? The next train went at seven o'clock; to catch that he would need to hurry like mad and his samples weren't even packed, and he himself wasn't feeling particularly fresh and energetic. And even if he did catch the train he couldn't avoid a tirade from the boss, since the messenger boy must have been

waiting for the five o'clock train and must have long since reported his failure to turn up. This messenger was a creature of the boss's, spineless and stupid. Well, supposing he were to say he was sick? But that would be very awkward and would look suspicious, since during his five years' employment he had not been ill once. The boss himself would be sure to come with the health insurance doctor, would reproach his parents for their son's laziness, and would cut all excuses short by handing the matter over to the insurance doctor, who of course regarded all mankind as perfectly healthy malingerers. And would he be so far wrong in this case? Gregor really felt quite well, apart from a drowsiness that was quite inexcusable after such a long sleep, and he was even unusually hungry.

As all this was running through his mind at top speed without his being able to decide to leave his bed—the alarm clock had just struck a quarter to seven—there was a cautious tap at the door near the head of his bed. "Gregor," said a voice—it was his mother's—"it's a quarter to seven. Didn't you have a train to catch?" That gentle voice! Gregor had a shock as he heard his own voice answering hers, unmistakably his own voice, it was true, but with a persistent horrible twittering squeak behind it like an undertone, which left the words in their clear shape only for the first moment and then rose up reverberating around them to destroy their sense, so that one could not be sure one had heard them rightly. Gregor wanted to answer at length and explain everything, but in the circumstances he confined himself to saying: "Yes, yes,

thank you, Mother, I'm getting up now." The wooden door between them must have kept the change in his voice from being noticeable outside, for his mother contented herself with this statement and shuffled away. Yet this brief exchange of words had made the other members of the family aware that Gregor was, strangely, still at home, and at one of the side doors his father was already knocking, gently, yet with his fist. "Gregor, Gregor," he called, "What's the matter with you?" And after a little while he called again in a deeper voice: "Gregor! Gregor!" At the other side door his sister was saying in a low, plaintive tone: "Gregor? Aren't you well? Do you need anything?" He answered them both at once: "I'm just about ready," and did his best to make his voice sound as normal as possible by enunciating the words very clearly and leaving long pauses between them. So his father went back to his breakfast, but his sister whispered: "Gregor, open the door, I beg you." However, he was not thinking of opening the door, and felt thankful for the prudent habit he had acquired on the road of locking all doors during the night, even at home. ■

Reading Question

Not long after Kafka's death, the term *Kafkaesque* began to be widely employed to describe the vision of modern life that his writing embodies. How would you define the Kafkaesque?

READING 44.5

Ezra Pound, Canto 49 ("The Seven Lakes Canto") (1937) from *The Cantos* (1922–1972)

One of the ironies of modern literature is that a poet capable of writing some of the most beautiful American verses should have been filled with such vitriolic hatred for Jews that he would see the Fascist dictatorships of Europe as the only hope for the future. The following poem from Ezra Pound's lifelong work of 120 poems known as The Cantos is among the most beautiful of his works. It was composed just before the outbreak of World War II and gives evidence of Pound's great love of Japanese and Chinese verse. In fact, the first 32 lines are a translation of a seventeenth-century manuscript given to him by his father consisting of eight poems in Japanese and Chinese describing the lakes and hills around the river Hsiao-hsiang in Central China. The poem's aim is to describe the ideal state in Confucian terms. At the end of World War II Pound was imprisoned by American forces in Pisa, Italy. There he was first put in a steel-reinforced cage where he was exposed to the weather, but he became so weak and thin that he was transferred to a medical facility. Eventually he was taken to America to stand trial for treason, and later committed to a mental institution for most of his remaining years.

For the seven lakes, and by no man these verses:
Rain; empty river; a voyage,
Fire from frozen cloud, heavy rain in the twilight
Under the cabin roof was one lantern.
The reeds are heavy; bent;
and the bamboos speak as if weeping.

Autumn moon; hills rise about lakes
against sunset
Evening is like a curtain of cloud,
a blur above ripples; and through it 10
sharp long spikes of the cinnamon,
a cold tune amid reeds.

Behind hill the monk's bell
borne on the wind.
Sail passed here in April; may return in October
Boat fades in silver; slowly;
Sun blaze alone on the river.

Where wine flag catches the sunset
Sparse chimneys smoke in the cross light

Comes then snow scur on the river 20
And a world is covered with jade
Small boat floats like a lanthorn,
The flowing water clots as with cold. And at San Yin
they are a people of leisure.

Wild geese swoop to the sand-bar,
Clouds gather about the hole of the window
Broad water; geese line out with the autumn
Rooks clatter over the fishermen's lanthorns,

A light moves on the north sky line;
where the young boys prod stones for shrimp. 30
In seventeen hundred came Tsing to these hill lakes.
A light moves on the South sky line.

State by creating riches shd. thereby get into debt?
This is infamy; this is Geryon.[1]

This canal goes still to TenShi[2]
Though the old king built it for pleasure

KEIMENRANKEI
KIUMANMANKEI
JITSU GETSU KO KWA
TAN FUKU TANKAI[3] 40

Sun up; work
sundown; to rest
dig well and drink of the water
dig field; eat of the grain
Imperial power is? and to us what is it?

The fourth; the dimension of stillness.
And the power over wild beasts. ∎

Reading Question

If Pound means to describe the ideal political state in this poem, how would you characterize that state?

[1] **Geryon:** a three-headed, three-bodied monster killed by Hercules; also guardian of the eighth circle of Dante's Inferno, a symbol of usury and violence against nature and art.
[2] **TenShi:** Japanese son of God.

[3] **Poem:** By Fu Shen (Chinese transliterated into Japanese):
How bright and colorful the auspicious clouds
Hang gracefully
Let sun and moon be thus resplendent
Morn after morn.

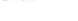 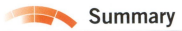

Summary

■ **The Glitter and Angst of Berlin** In the 1920s, Berlin was a thriving center of the arts, rivaling New York and Paris in its innovation. It was notable especially for the libertine atmosphere of its cafés and cabarets, the deep political commitment of its artists, and its cultural paranoia and alienation, epitomized in the writing of Franz Kafka, the theater of Bertolt Brecht, and the Expressionist prints of Käthe Kollwitz.

■ **The Rise of Fascism** European conservatives were horrified at the Berlin lifestyle and yearned for a return to a lost past that they idealized as orderly and harmonious. In Germany, Adolf Hitler harnessed this interest, blaming Communists and intellectuals, but especially the Jews, for the country's economic and social problems. Hitler's Nazi party forced the Bauhaus, the leading exponent of modernist art and architecture in Germany inspired by the Dutch De Stijl movement, to close down. The Bauhaus's own architects, Walter Gropius and Mies van der Rohe, together with French architect Le Corbusier, helped to define the new International Style in architecture. In 1937, Hitler's conservative sensibility resulted in the Exhibition of Degenerate Art, an attack on what he believed to be modernist.

In Russia, Stalin likewise attacked modernist art, which he proposed to replace with social realism, an art designed to be totally intelligible to the masses. And in Italy, Benito Mussolini's fascist government was supported by the violently anti-Semitic American poet Ezra Pound. Finally, in Spain, with Hitler's aid, Francisco Franco instigated a civil war. The *blitzkrieg* attack of the German air force on the Basque city of Guernica would be memorialized by Pablo Picasso in his painting *Guernica*.

■ **Revolution in Mexico** In 1910, guerrilla groups in Mexico had initiated a civil war to overthrow the government and restore to the peasants land that had been confiscated and turned over to foreign companies. The war inspired the nationalist feelings of many artists, including a number of painters, chief among them Diego Rivera, who sought to celebrate the Mexican people in murals. Rivera's wife, Frida Kahlo, long crippled by a debilitating childhood accident, developed an intensely personal and autobiographic painting style.

■ **The Great Depression in America** The collapse of the stock market in 1929 led to severe economic depression in the United States that President Franklin D. Roosevelt sought to remedy, in part, by the Work Projects Administration. The WPA funded painting projects (especially murals in public buildings, a project inspired by the example of muralist Thomas Hart Benton) and performances by musicians and theater companies, and employed writers to create a series of state and regional guidebooks. Meanwhile, Frank Lloyd Wright strove to create a thoroughly American architecture, quite independent of the International Style developing in Europe.

■ **Cinema: The Talkies and Color** In the 1930s the motion picture changed dramatically and became the most popular American art medium. Al Jolson's 1927 *The Jazz Singer* introduced sound into a feature film. Producers were forced to perfect sound technology on the set and in theaters. Walt Disney introduced color film but in 1939, perhaps the greatest year in the history of cinema, color became a real force. *The Wizard of Oz* led the way, soon followed by *Gone with the Wind*. The most technically innovative film of the era was Orson Welles's *Citizen Kane* of 1940.

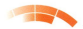

Glossary

chiaroscuro lighting In cinema, a term borrowed from Renaissance painting to describe pools of light illuminating parts of an otherwise dark set.

dubbing In cinema, short-hand for "vocal doubling," in which native speakers synchronize new dialogue to the lip movements of the actor.

Epic theater A brand of theater created by Bertolt Brecht in which the audience is purposefully alienated so that it might approach the performance with a critical eye.

gulags Labor camps in Stalinist Russia.

kulaks Properous peasant farmers in Russia blamed by Stalin for the country's economic ills.

New Deal President Franklin D. Roosevelt's economic recovery program.

postsynchronization The term that refers to the addition of sound as a separate step after the creation of a visual film.

Critical Thinking Questions

1. While many of the economic conditions that fueled the rise of Fascism in Europe existed in the United States, Americans did not turn to totalitarian solutions. How do you explain this?

2. In what ways can the creative works produced under the WPA and other New Deal agencies be viewed as propaganda? How does it differ from Hitler's propaganda?

3. What were the effects of the introduction of sound on the film industry? Which do you consider the most important of these and why?

4. Is "De Stijl" the same as "International Style"? What essential characteristics are suggested by such artists as Mondrian and Mies van der Rohe?

After the Bauhaus closed in April 1933, many of its teachers left Germany for the United States. By the early 1950s, they dominated American architecture and arts education. Walter Gropius and Marcel Breuer moved to Cambridge, Massachusetts, to teach at the Harvard Graduate School of Design. Gropius would go on to design the Harvard Graduate Center (1949–1950) and Breuer the Whitney Museum of American Art (1966) in New York. Joseph Albers would become head of the design department at Yale University in New Haven, Connecticut. Ludwig Mies van der Rohe was appointed head of the architecture school at Chicago's Armour Institute of Technology (later the Illinois Institute of Technology), where he was commissioned to design the new buildings for the campus.

These Bauhaus artists came into their own in America after World War II, when the nation's economy was once again on the rebound. Their influence was nowhere more dramatically felt than in Mies van der Rohe's Seagram Building in New York, completed in 1958 on Park Avenue between 52nd and 53rd streets (Fig. 44.32). Just ten blocks from the Chrysler Building, it set a new standard for skyscraper architecture. Mies had begun to experiment with designs for glass towers in the early 1920s, and by the time he joined with Philip Johnson on the Seagram Building he had cultivated an aesthetic of refined austerity summed up by the phrase "less is more."

The siting of the building, separated from the street by a 90-foot-wide plaza and bordered on either side by reflecting pools and ledges, used open space in a manner unprecedented in urban architecture, where every vertical foot above ground spells additional rent revenue. A curtain wall of dark amber-tinted glass wraps the building and is interrupted by bronze-coated I-beams and by spandrels and mullions (the horizontal and vertical bands between the glass). Depending on the light, the reflective qualities of the glass make the skin appear bronze from one angle and almost pitch black from another. At night, the building is entirely lit, creating a golden grid framed in black.

The Seagram Building gives the impression of a giant monolith set on a granite plinth—a sort of sacred homage to the modernist spirit. As one critic raptured, "The commercial office building in this instance has been endowed with a monumentality without equal in the civic and religious architecture of our time." ∎

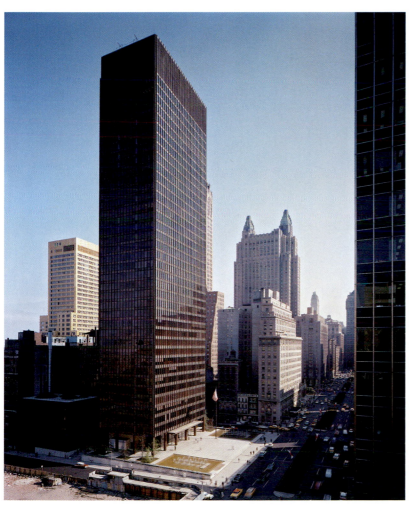

Fig. 44.32 Ludwig Mies van der Rohe and Philip Johnson. **Seagram Building, New York City. 1954–1958.** The entry is set back beneath the columns on the first floor, just as it is at the Villa Savoye (see Fig. 44.9).

45 World War II and Its Aftermath

Devastation and Recovery

World War II

Europe after the War: The Existential Quest

America after the War: Triumph and Doubt

> " *I saw the best minds of my generation destroyed by madness, starving hysterical naked . . .* "
>
> Allen Ginsberg, "Howl"

← Fig. 45.1 **Philippe Giraud.** *Entrance, Auschwitz-Birkenau Death Camp.* **Photographed 2003.** Known as "Hell's Gate," this is the main entrance to Birkenau viewed from the unloading ramp where prisoners arrived by railroad. Nearly one-third of the 6 million Jews killed by the Nazis in World War II died here.

AUSCHWITZ-BIRKENAU [AUSH-VITS-BER-KEN-OW] WAS NAZI Germany's largest concentration and extermination camp facility, located near the provincial Polish town of Oshwiecim [osh-VYEN-tseem], from which it took its Germanized name. The first camp on that site, known as Auschwitz I, was reserved

for political prisoners, mainly Poles and Germans, but in October 1941 Birkenau (so named because birch trees surrounded the site) supplemented it. Here a subdivision of Adolf Hitler's protection units known as the SS developed a gigantic extermination complex. It included "Bathing Arrangements," lethal gas jets disguised as showerheads. Upon their arrival in cattle cars at the Hell's Gate (Fig. **45.1**), Jewish prisoners underwent a "Selection." Those deemed able-bodied were selected to work in the forced-labor camp, while the others—the old and the weak, as well as young children and their mothers—were exterminated in the Bathing Arrangements. Every newcomer, except those selected for extermination, was given a number, which was tattooed on the arm. Altogether 444,000 numbers were officially issued, but the total number of Jews killed at Auschwitz-Birkenau can never be known with certainty because so many arrivals were exterminated and never registered. Estimates range from 1 to 2.5 million.

Auschwitz-Birkenau was one of six extermination camps. The others—Belzec [BEL-zek], Chelmno [KELM-no], Majdanek [my-DAH-nek], Sobibor [SO-bih-bore], and Treblinka [treb-LING-kah]—were also in Poland, off German soil and in a country that Hitler had invaded. All were equally dedicated to making Europe *Judenrein* [yoo-den-RINE], "free of Jews." There were many other concentration camps scattered across Germany and German-occupied territories (see Map **45.1**). One of the largest on German soil was Buchenwald [BOO-ken-vahld], situated on the northern slope of Ettersberg [ETT-urz-berg], a mountain five miles north of Weimar. In February 1945, just before the American troops reached the camp, it housed over 85,000 prisoners. Of these, more than 25,500 people, severely weakened by their experience, died as the Germans tried to evacuate the camp in order to hide their crimes before the Americans arrived.

The Buchenwald dead (Fig. **45.2**) were photographed by Lee Miller (1907–1977), an American photographer and former model who had worked with the Surrealists in Paris. The only woman combat photojournalist to cover the war in Europe, she had arrived on the Continent a mere 20 days after American forces assaulted the beaches of Normandy on D-Day. She witnessed the liberation of Paris and then followed American soldiers into Germany. The horror of her photograph is not just its depiction of the dead, but also its

evidence of their starvation and suffering before dying. Somewhere around 6 million Jews met this fate along with 5 million others whom the Nazis considered racially inferior or otherwise culturally problematic—particularly Gypsies, Slavs, the handicapped, and homosexuals—in what has come to be called the **Holocaust**.

The concentration camps exposed an unprecedented capacity for hatred and genocide at the center of Western culture. That revelation and its impact on global culture are the subjects of this chapter. The horrors of World War II provoked a profound philosophical uneasiness in Europe, best articulated in the existentialist philosophy of Frenchman Jean-Paul Sartre (1905–1980). In America, the realities of the Cold War and what many perceived as the country's crass materialism muted the rapid economic expansion and the sense of well-being that accompanied it. Artists and writers responded by creating a rebellious, individualistic art to represent the absolute truth of authentic experience.

World War II

Ever since the nineteenth century, when Japan, China, India, and Africa experienced social dislocation and upheaval as a result of confrontation with the West (see chapter 39), and as the West colonized large parts of the globe, the impact of political events and social issues had become increasingly global in impact. World War I had taken place along a fairly compact front in northeastern France and northwestern Germany. By contrast, World War II was a truly worldwide conflict. No other event of the first half of the twentieth century so greatly increased the growing decenteredness of culture.

The War in Europe

The immediate causes of World War II can be traced to the meeting in Munich, on September 29–30, 1938, of Adolf Hitler and Benito Mussolini with the leaders of Britain and France. In an effort to appease the German dictator, the English and French granted him control of the Sudetenland [soo-DEN-ten-lahnd], an area of Czechoslovakia near the German border and home to 3.5 million Germans. In return, Hitler promised to spare the rest of Czechoslovakia and make

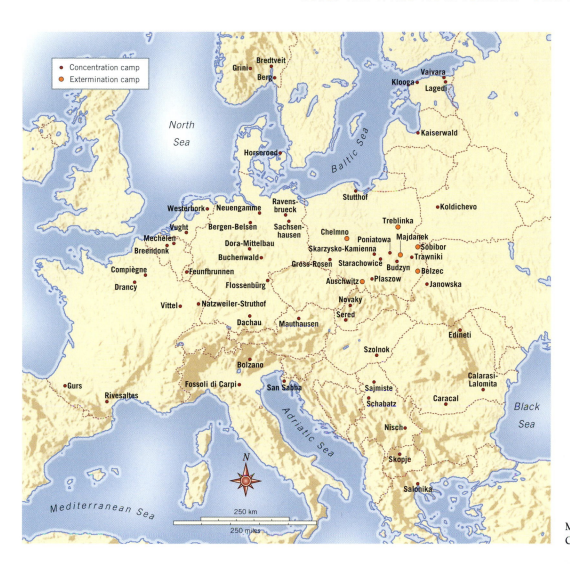

Map 45.1 German Concentration Camps in Europe, 1942–1945.

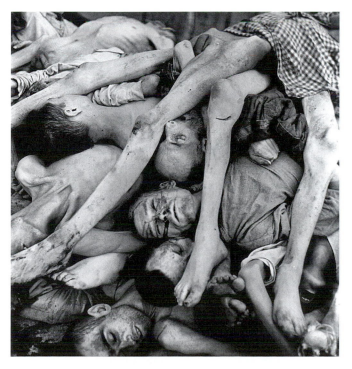

no further territorial demands in Europe. Neville Chamberlain (1869–1940), the British prime minister, returned from Munich announcing he had secured "peace in our time." Statesman Winston Churchill (1874–1965) predicted a different outcome in Parliament: "All is over," he said. "Silent, mournful, abandoned, broken, Czechoslovakia recedes into the darkness." Six months later, his prediction proved true. On March 15, 1939, Hitler occupied Prague, and Czechoslovakia was no more. Poland would be next. On September 1, 1939, Hitler invaded that country, employing the *Blitzkrieg* [BLITZ-kreeg] tactics he had practiced in Spain. Two days later, Britain and France declared war on Germany. As the United States attempted to maintain its neutrality, the following spring Hitler invaded Norway and Denmark, then Belgium, the Netherlands, and Luxembourg.

Fig. 45.2 Lee Miller. *Buchenwald, Germany.* **April 30, 1945.** © Lee Miller Archives, England 208. All Rights Reserved. Miller's pictures of Buchenwald and Dachau (liberated a few days earlier) appeared in British *Vogue* magazine in June under the headline "Believe It."

The fighting lasted only two days in the Netherlands, two weeks in Belgium. Hitler quickly marched on Paris. By mid-June 1940, France fell, and the Nazis installed the Vichy [VEE-shee] government of Marshall Pétain [pay-TEHN], with which they pursued a policy of collaboration.

From this point, the struggle continued on many fronts (see Map **45.2**). The *Luftwaffe* [LOOFT-wah-fuh], the German air force, attacked Britain. At first it targeted Britain's air bases, but then it bombed London itself nearly every night throughout September and October. The raids only steeled British resolve to resist. To the east, Hitler turned his sights on Russia and the Ukraine, which he planned to invade in May 1941, a *Blitzkrieg* assault that he hoped would be complete by the onset of winter. But meanwhile Mussolini attacked the British in Egypt and invaded Greece, meeting with little success. This caused Hitler to send General Erwin Rommel into North Africa and considerable forces into the Balkans. As a result, the Russian campaign was delayed six weeks, which together with several tactical errors on Hitler's part resulted in the loss of the entirety of his eastern forces at the Battle of Stalingrad in the summer of 1942.

The War in the Pacific

Meanwhile, in the Pacific, Japan was emboldened by the war in Europe to step up its imperial policy of controlling Asia. It had initiated this policy as early as 1931 with an invasion of Manchuria [man-CHOOR-ee-uh], followed by the conquest of Shanghai [SHANG-high] in 1932 and the invasion of the rest of China in 1937. By 1941, Japan had occupied Indochina, and when the United States in response froze Japanese assets in the United States and cut off oil supplies, Japan responded by attacking Pearl Harbor, Hawaii, the chief American naval base in the Pacific, on December 7, 1941. The surprise attack destroyed 188 aircraft, five battleships, one minelayer, and three destroyers, and left 2,333 dead and 1,139 wounded. The next day, the United States declared war on Japan, and Germany and Italy, with whom Japan had joined in an alliance known as the Axis, declared war on the United States. During the war, the American government interred thousands of Japanese and Japanese Americans (many of whom were U.S. citizens) living in California, Oregon, and Washington on the theory that they might be dangerous. (In 1988, President Ronald Reagan signed legislation that officially apologized for this act of racism.) Racism and consciousness of ethnic identity flourished in the American armed forces as well (see *Voices*, page 1464).

Six months later, the U.S. Navy began to recover from the Pearl Harbor air strike and moved on the Japanese, who had meanwhile captured Guam [gwahm], Wake Island, and the Philippines [fill-ih-PEENZ] (see Map **45.3**). A decisive naval battle in the Coral Sea, in which the Americans sank many

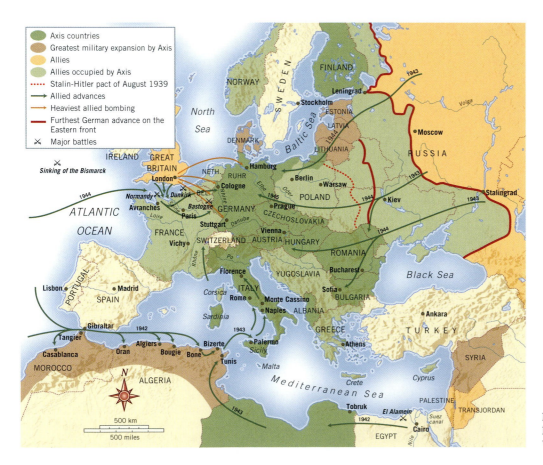

Map 45.2 European and Mediterranean Theaters in World War II, 1939–1945.

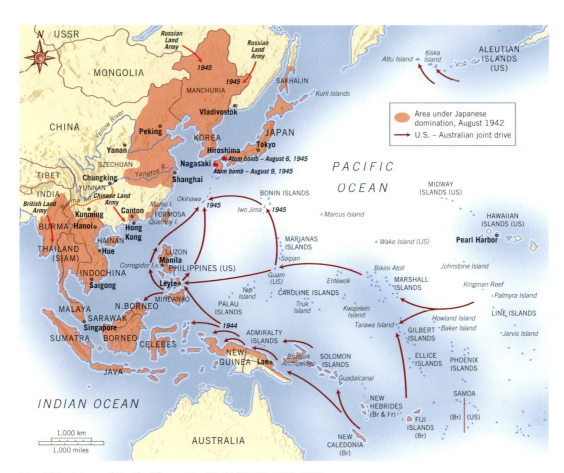

Map 45.3 Asian and Pacific Theaters in World War II, 1941–1945.

Japanese ships, was followed by a victory at Midway Island and the landing of American Marines at Guadalcanal [gwah-dul-kuh-NAL] and the Solomon Islands. This turned the tide and enabled the United States to concentrate more fully on Europe.

The Allied Victory

Even as Russian forces were pushing westward, driving the Germans back through the Ukraine, Hungary, and Poland, Allied forces—largely troops from the United States and Great Britain—attacked the Germans on the Normandy coast on June 6, 1944, known as D-Day. Two months later, the Allies landed in southern France and advanced northward with little resistance. By the beginning of September they had pushed back the Germans to their own border and had liberated France.

In December 1944, an increasingly desperate Hitler, his oil refineries decimated by Allied air strikes, launched a counterattack on Antwerp, the Allies' port of supply, through the Ardennes Forest of Belgium. Surprise and weather almost won him the day, as the Germans pushed forward into the Allied lines—hence the name, the Battle of the Bulge—but he was turned back. By March the Allies had crossed the Rhine, and the Russians, the eastern arm of the Allied offensive, had approached the outskirts of Berlin. On April 30, 1945, Hitler and his intimates, recognizing that the war was

lost, committed suicide in an underground bunker in Berlin. On May 8, the war in Europe came to an official end.

Meanwhile, in the Pacific, American troops had advanced as far north as Iwo Jima [ee-woh JEE-muh] and the southern Japanese island of Okinawa [oh-kih-NAH-wah], but the Japanese steadfastly refused to surrender. Faced with the possibility that an invasion of Japan itself might cost 1 million American lives, the Americans made the decision to drop the newly developed atomic bomb on the city of Hiroshima on August 6, 1945. Two days later, the Soviet Union declared war on Japan and invaded Manchuria. The next day, the United States dropped an atomic bomb on Nagasaki. The power of the atomic bomb, which devastated Hiroshima and Nagasaki, convinced Japan to surrender on August 14, 1945.

Decolonization and Liberation

The war was felt far beyond the Pacific and European theaters, in the many nations subject to colonial rule. The war had drawn the military forces of the colonial powers back to Europe, and in their absence indigenous nationalist movements arose in Africa, Asia, and the Middle East. The American president Franklin D. Roosevelt felt especially strongly that it was hypocritical to fight tyranny in Europe and then tolerate colonial dominance in the rest of the world. His

 V o i c e s

Racial and Ethnic Identity in the U.S. Military

Consciousness of racial differences and outright racism was not confined to the Axis powers (Germany, Japan, and their allies during World War II). The U.S. military was still thoroughly segregated, and Allied powers like Britain and France were still imperial rulers of vast territories (and nonwhite populations) in Asia and Africa. U.S. Army infantryman John Garcia's upbringing in multicultural Hawaii gave him a unique perspective on the issues of racial and ethnic identity in the military as it engaged the Japanese army in ferocious combat across the Pacific after 1944. Studs Terkel interviewed Garcia and many others in the early 1980s:

When I went into the military, they asked "What race are you?" I had no idea what they were talking about because in Hawaii we don't question a man's race. They said "Where are your parents from?" I said they were born in Hawaii. "Your Grandparents?" They were born in Hawaii. "How about your great-grandparents?" I said they're from Europe, some from Spain, some from Wales. They said "You're Caucasian." I said "What's that?" They said, "You're white." I looked at my skin. I was pretty dark, tanned by the sun. I said "You're kidding." (Laughs.) They put me down as Caucasian and separated me from the rest of the Hawaiians.

Some of my new buddies [in the army] asked me not to talk to three of the men. I asked why. They said, "They're Jews." I said, "What's a Jew?" They said, "Don't you know? They killed Jesus Christ." I says, "You mean them guys? They don't look old enough." They said, "You're tryin' to get smart?" I said, "No, It's my understanding he was killed about nineteen hundred years ago."

I joined the Seventh Infantry Division in time for the run to Kwajalein in the Marshal Islands. It took six days to take it. We went back to Hawaii [for more combat training]. . . . Several nights later [after completion of jungle training], a broadcast came from Tokyo Rose: "Good evening, men of the Seventh Infantry. I know you're on your way to the Philippines." She was right. (Laughs.) We were there from October of '44 until March of '45. Total combat. I fought very carefully. I fought low.

. . . . The next stop was Okinawa. We landed there on April 1, '45. . . . We were there eighty-two days.

"I still feel I committed murder."

I did what I had to do. When I saw a Japanese, I shot at him and ducked. Shot and ducked, that's all I did. I was always scared. . . .

We buried General Ushijima and his men inside a cave. This was the worst part of the war. . . . They were hiding in caves, all the time, women, children, soldiers. We'd get up on the cliff and lower down barrels of gasoline and then shoot at it. It would explode and just burn them to death. . . . They would show us movies [propaganda]. Japanese women didn't cry. They would accept the ashes stoically. I knew different. They went home and cried.

I personally shot one Japanese woman because she was coming across a field at night. We kept dropping leaflets [warning] not to cross the field at night because we couldn't tell if they were soldiers. We set up a perimeter. Anything in front, we'd shoot at. This one night I shot and when it came daylight, it was a woman there and a baby tied to her back. The bullet had gone through her and out the baby's back. That still bothers me, that hounds me. I still feel I committed murder.

I was drinking about a fifth and a half of whiskey every day. Sometimes homemade, sometimes what I could buy. It was the only way I could kill. I had friends who were Japanese [in Hawaii] and I kept thinking every time I pulled a trigger or pushed a flamethrower down into hole: What is this person's family gonna say when he doesn't come back? He's got a wife, he's got children, somebody. . . .

I drank my last drink on the night of August 14, 1945, I think it was. When we heard from the radio that the Japanese wanted to contact the Americans to order to end the war, we just went wild. . . .

I haven't touched a drop since. I wasn't a drinking man before. I started in the Philippines when I saw the bodies of men, women, and children, especially babies, that were hit by bombs. . . . I still lose nights of sleep because of that woman I shot. . . . I still dream about her. I dreamed about it perhaps two weeks ago. (He lets out a deep breath; it's something more turbulent than a sigh.)

moral position was strengthened by the realization that American economic interests were far more likely to thrive in a decolonized world. Furthermore, the founding of the United Nations in 1945 guaranteed that the argument against colonization would find a public forum.

Mohandas Gandhi [moh-HAHN-dus GAHN-dee] (1869–1948) led the anticolonial movement in India. While studying law in England, he had learned the concept of **passive resistance** from reading American writer Henry David Thoreau (see chapter 33). Gandhi had worked for 20 years as an advocate for Indian immigrants in South Africa, and after returning to India in 1915, he began a long campaign against the British government. He was repeatedly arrested, and during his imprisonments he engaged in long hunger strikes, bringing himself to the brink of death on more than one occasion. Gandhi's campaign of nonviolence finally convinced the British to leave India, which they did in 1947, partitioning the country into two parts, India and Pakistan. This partition acknowledged the desire of the Muslim population within India to form their own distinctly Muslim state.

Almost simultaneously, Burma and Sri Lanka became independent, the Dutch were forced out of Indonesia, and the British packed up and left Palestine, which they had occupied since the end of the Ottoman Empire in 1918. The British left behind a murderous conflict between Arab nationalists and Jews whom they had helped to install in the new country of Israel. In the following decade, the British withdrew from Ghana, Nigeria, Cyprus, Kenya, and Aden (now part of Yemen), sometimes at their own choosing, sometimes under pressure from militant nationalists. The British never resisted decolonization militarily, but this was not the case with France.

In Southeast Asia, the French had occupied Indochina (Laos [laus (rhymes with "mouse")], Cambodia, and Vietnam) since the late nineteenth century. But as early as 1930, Ho Chi Minh [ho chee min] (1890–1969) had transformed a nationalist movement resisting French rule into the Indochina Communist Party. During World War II, Ho Chi Minh led the military campaign against the invading Japanese and the pro-Vichy colonial French government allied with the Japanese. He established himself as the major anticolonial player in the region. When, in 1945, he declared Vietnam an independent state, civil war erupted. It ended with the artificial division of Vietnam at the seventeenth parallel of northern latitude with Ho Chi Minh in control north of that line and centered in Hanoi, and the French in charge south of that line and centered in Saigon (see Map 45.3).

Meanwhile, France had to deal with growing unrest in North Africa. It had maintained a strong base in Algeria since the early nineteenth century, and during World War II, the anti-fascist government of Free France had headquartered there (see Map 45.2). But at the end of the war violence broke out between French and European settlers, comprising

about 1 million people, and a much larger population of Algerian Muslim nationalists who quickly demanded independence. The postwar French Republic, however, declared Algeria an integral part of France. Guerrilla resistance to the French began in 1954, led by the National Liberation Front (FLN), and lasted until 1962, during which time hundreds of thousands of Muslim and European Algerians were killed. Finally, in 1962, French president Charles de Gaulle [deh gohl] (1890–1970) called for a referendum in Algeria on independence. It passed overwhelmingly. Algeria became independent on July 3, 1962.

Bearing Witness: Reactions to the War

The human cost of World War II was enormous. Somewhere in the vicinity of 17 million soldiers had died, and at least that many civilians had been caught up in the fighting. Hitler had exterminated 6 million Jews, and millions of other people had died of disease, hunger, and other causes. The final toll approached 40 million dead.

It was what Hitler had done to the Jews that most troubled the Western imagination, and a large body of literature and film grew out of the events as survivors began to tell their stories to the world. Italian chemist Primo Levi's memoir, *If This Is a Man* (also known as *Survival at Auschwitz*), is the wrenching story of a man attempting to fathom why he survived the death camp. Levi would go on to write stories and novels for the rest of his life that he himself described as "accounts of atrocities." American cartoonist Art Spiegelman's graphic novel *Maus: A Survivor's Tale*, in which Jews are depicted as mice, Germans as cats, and Americans as dogs, recounts his parents' experiences as Jews in Poland before and at Auschwitz during the war. Paris-based documentary filmmaker Claude Lanzmann's $9^1/_2$-hour *Shoah* (a Hebrew word meaning "catastrophe") is a series of deeply moving testimonies about the Holocaust drawn from survivors, those who stood by without doing anything, and the perpetrators themselves.

Wiesel's *Night* One of the most important memoirs to come out of the Holocaust is *Night* by Elie Wiesel [vee-ZELL] (1928–). "Auschwitz," wrote Wiesel, "represents the negation and failure of human progress: it negates the human design and casts doubts on its validity."

Wiesel was 16 years old in 1944, when he and his family were taken to Auschwitz, where he and his father were separated from his mother and younger sister. He never saw them again and learned later that they had died in the gas chambers. During the following year, Wiesel was moved to the concentration camps at Buna, Gleiwitz [GLY-vits], and finally Buchenwald, where his father died from dysentery, starvation, exposure, and exhaustion, like the many whom Lee Miller had photographed when the camp was liberated in April 1945 (see Fig. 45.2). The author of 36 works dealing with Judaism, the Holocaust, and the moral responsibility of all people to

fight hatred, racism, and genocide, Wiesel's powerful prose and commitment won him the Nobel Peace Prize in 1986. He recounts his first day at Auschwitz (**Reading 45.1**):

READING 45.1 **from Elie Wiesel, *Night* (1958)**

Never shall I forget that night, the first night in camp, which has turned my life into one long night, seven times cursed and seven times sealed. Never shall I forget that smoke. Never shall I forget the little faces of the children, whose bodies I saw turned into wreaths of smoke beneath a silent blue sky.

Never shall I forget those flames which consumed my faith forever.

Never shall I forget that nocturnal silence which deprived me, for all eternity, of the desire to live. Never shall I forget those moments which murdered my God and my soul and turned my dreams to dust. Never shall I forget these things, even if I am condemned to live as long as God Himself. Never.

Wiesel subsequently led the way to the creation of the United States Holocaust Memorial Museum in Washington, DC.

Resnais's *Night and Fog* In 1955, the young French filmmaker Alain Resnais [ray-NAY] (1922–) startled the world with a 32-minute documentary about the Holocaust called *Night and Fog*. Combining contemporary footage of the eerily abandoned Auschwitz landscape with archival documentary footage recorded during the liberation, Resnais posed the question that desperately needed to be addressed: Who was responsible? The question stands for many more specific ones. Why did so many ordinary Germans passively stand by as Jews were hauled off to the camps? Why did the Soviets as they moved into Poland not halt it? Why had the Allies—and the United States in particular—not responded to the situation more quickly? And why had the Jews themselves not organized more active resistance in the camps? Resnais's narrator, Michel Bouquet [boo-KAY], himself a camp survivor, concludes with a dire warning. As the events of the Holocaust retreat into the past, it seems possible, he says, to hope again. It seems possible to believe that what happened in the camps was a one-time occurrence that will never be repeated. But, he insists, the Holocaust is symptomatic of humanity's very indifference to suffering and pain. Its truth always surrounds us.

The Japanese Response Japan was haunted for generations by the bombing of Hiroshima and Nagasaki. Both cities were civilian sites that contributed almost nothing to the Japanese military effort, and President Truman's motives for bombing them were unclear—to many Americans as well as the Japanese. Some argued that the bombings spared both the United States and the Japanese from a painful and devastating invasion and saved the lives of thousands of American soldiers if the war had

continued. Others argued that the bombings were a means of forcing the question of the emperor's fate, a major sticking point in peace negotiations before the bombs were dropped. Still others felt that the bombings were a just retribution for devastation at Pearl Harbor. Truman's archives suggest that the president wanted to demonstrate U.S. military might to the Soviets, whom he recognized would be a threat to world stability after the war. There is probably some truth in all of these points, but none justified the bombings in the eyes of the Japanese.

One of the most powerful responses to the events is a series of photographs entitled *11:02—Nagasaki* by Shomei Tomatsu [toh-mah-tsoo] (1930–). The series is dedicated to the enduring human tragedy wrought by the atomic bomb, not merely to depicting keloidal burns and physical deformities that radiation from the explosion wreaked upon its survivors (Fig. **45.3**). The images are metaphors for the process of Americanization that Japan underwent at the war's conclusion. "If I were to

Fig. 45.3 Shomei Tomatsu. *Man with Keloidal Scars.* 1962. From the series *11:02—Nagasaki.* 1966. Gelatin silver print, 16 1/8″ × 10 7/8″. Gift of the photographer. (700.1978). Digital Image © The Museum of Modern Art/Licensed by SCALA/Art Resource, NY. As horrified as they were by images such as this, the Japanese, who were near starvation by war's end, were equally attracted to the obvious wealth and plenty of the occupying American forces.

Fig. 45.4 Godzilla destroys Tokyo, in Ishiro Honda's *Gojira* (*Godzilla*). **1954.** The Japanese have made at least 27 other Godzilla films.

characterize postwar Japan in one word," Tomatsu would write in an essay entitled "Japan Under Occupation," "I would answer without hesitation: 'Americanization.'" His photographs of survivors propose that to become "Americanized" is not necessarily a good thing. It is to become scarred, mutilated, deformed.

One of the more interesting ways in which the Japanese came to deal with the atomic bomb and its aftermath is the creation, in 1954, of the movie monster known in this country as *Godzilla*, but in Japan as *Gojira* [go-jee-rah], a hybrid name which joins the Western word *gorilla*—in honor of the 1933 film *King Kong*—with the Japanese *kujira* [koo-jee-rah], meaning "whale." The radiation-breathing monster, born from the sea after an American test of an atomic bomb in the Pacific, was a creation of Toho Studios in Tokyo. This, the first of many Godzilla films, was directed by Ishiro Honda (1911–1993). It was inspired by the success of the 1953 U.S. film *The Beast from 20,000 Fathoms*, in which Rhedosaurus, a giant dinosaur, is awakened from eons of dormancy after an atomic bomb test in the northern polar ice cap. The dinosaur wreaks havoc on New York City, culminating in a showdown with military marksmen at Coney Island amusement park.

Godzilla became for the Japanese a vehicle through which they could confront the otherwise unspeakable significance of the atomic bomb. At the same time they could also shift blame for World War II from themselves to the Americans. Scenes of Tokyo devastated by the radiation-breathing monster leave little doubt as to the symbolic intent of the film (Fig. **45.4**). In its original form, it remains a powerful indictment of the bomb, but that was not the version available in the United States

until 2004. *Gojira* was acquired by U.S. distributors in 1956. They renamed it *Godzilla: King of the Monsters* and completely reedited it. Leaving only its monster scenes, they excised most of the human story, replacing it with scenes featuring a U.S. reporter (played by Raymond Burr, television's Perry Mason) who has come to Tokyo to chronicle the devastation caused by "a force which up until a few days ago was entirely beyond the scope of man's imagination." But, of course, the film represents not the unknown but a force completely within the scope of human imagination—the bomb—a fact that today American audiences can finally appreciate.

Europe after the War: The Existential Quest

The Holocaust and the devastation at Hiroshima and Nagasaki dramatically increased the profound pessimism that had gripped intellectual Europeans ever since the turn of the century. How could anyone pretend that the human race was governed by reason, that advances in technology and science were for the greater good, when human beings were not only capable of genocide, but also possessed the ability to annihilate themselves?

Christian Existentialism: Kierkegaard, Niebuhr, and Tillich

Christianity found itself in crisis as well. In the face of World War II's horrors, Christians had to question God's benevolence, if not his very existence. Their faith was put to a test that had been first articulated by the nineteenth-century Danish philosopher Søren Kierkegaard [keer-keh-GAHRD] (1813–1855). Kierkegaard had argued that Christians must live in a state of anguish caused by their own freedom of choice. They must first confront the fundamental Christian paradox, the assertion that the eternal, infinite, transcendent God became incarnated as a temporal, finite, human being (Jesus). To believe in this requires a "leap of faith" because its very absurdity means that all reason be suspended. So Christians must choose to live with objective uncertainty and doubt, a situation that leaves them in a state of "fear and trembling." But if the individual Christian can never really "know" God, he or she can and must choose to act responsibly and morally. What humans can define, in other words, are the conditions of their own existence. This is their existential obligation.

After World War II, Protestant theologians Reinhold Niebuhr [KNEE-bor] (1892–1971) and Paul Tillich [TILL-ick] (1886–1965) further articulated this position of **Christian existentialism** in America. When Tillich was forced to leave Germany in 1933 following Hitler's rise to power, Niebuhr arranged for Tillich to join him on the faculty of the Union Theological Seminary in New York City. There Tillich lectured on modern alienation and the role that religion could play as a "unifying center" for existence.

Religion, he believed, provides the self with the courage *to be*. Niebuhr shared Tillich's dedication to reconciling religion and modern experience. "Without the ultrarational hopes and passions of religion," he wrote, "no society will ever have the courage to conquer despair."

The Philosophy of Sartre: Atheistic Existentialism

During and after World War II, the French philosopher Jean-Paul Sartre (1905–1980) rejected the religious existentialism of Kierkegaard, Niebuhr, and Tillich and argued for what he termed **atheistic existentialism**. "Existentialism isn't so atheistic," Sartre would write, "that it wears itself out showing that God doesn't exist. Rather, it declares that even if God did exist, that would change nothing. . . . His existence is not the issue." Living in a universe without God, and thus without revealed morality, individuals unable to make Kierkegaard's "leap of faith" must nevertheless choose to act ethically. "Existence precedes essence," was Sartre's basic premise; that is, humans must define their own essence (who they are) through their existential being (what they do, their acts). "In a word," Sartre explained, "man must create his own essence; it is in throwing himself into the world, in suffering it, in struggling with it, that—little by little—he defines himself." Life is defined neither by subconscious drives, as Freud had held, nor by socioeconomic circumstances, as Marx had argued: "Man is nothing else but what he makes of himself. Such is the first principle of existentialism."

For Sartre there is no meaning to existence, no eternal truth for us to discover. The only certainty is death. Sartre's major philosophical work, the 1943 *Being and Nothingness*, outlines the nature of this condition, but his argument is more accessible in his play *Huis Clos* [hwee kloh] (*No Exit*). As the play opens, a Valet greets Monsieur Garcin [gahr-SEN] as he enters the room that will be his eternal hell (**Reading 45.2**):

READING 45.2 from Jean-Paul Sartre, *No Exit* (1944)

GARCIN (enters, accompanied by the VALET, and glances around him):
So here we are?
VALET Yes, Mr. Garcin.
GARCIN And this is what it looks like?
VALET Yes.
GARCIN Second Empire furniture, I observe . . . Well, well, I dare say one gets used to it in time.
VALET Some do, some don't.
GARCIN Are all the rooms like this one?
VALET How could they be? We cater for all sorts: Chinamen and Indians, for instance. What use would they have for a Second Empire chair?
GARCIN And what use do you suppose I have for one? Do

you know who I was? . . . Oh, well, it's no great matter. And, to tell the truth, I had quite a habit of living among furniture that I didn't relish, and in false positions. I'd even come to like it. A false position in a Louis-Philippe dining room—you know the style?—well, that had its points, you know. Bogus in bogus, so to speak.
VALET And you'll find that living in a Second Empire drawing-room has its points.
GARCIN Really? . . . Yes, yes, I dare say . . . Still I certainly didn't expect—this! You know what they tell us down there?
VALET: What about?
GARCIN About . . . this—er—residence.
VALET Really, sir, how could you believe such cock-and-bull stories? Told by people who'd never set foot here. For, of course, if they had—
GARCIN Quite so. But I say, where are the instruments of torture?
VALET The what?
GARCIN The racks and red-hot pincers and all the other paraphernalia?
VALET Ah, you must have your little joke, sir.
GARCIN My little joke? Oh, I see. No, I wasn't joking. No mirrors, I notice. No windows. Only to be expected. And nothing breakable. But damn it all, they might have left me my toothbrush!
VALET That's good! So you haven't yet got over your—what-do-you-call-it?—sense of human dignity? Excuse my smiling.

The play was first performed in May 1944, just before the liberation of Paris. If existence in existential terms is the power to create one's future, Garcin and the two women who will soon occupy the room with him are in hell precisely because they are powerless to do so. Garcin's "bad faith" consists in his insistence that his self is the creation of others. His sense of himself derives from how others perceive him. Thus, in the most famous line of the play, he says, "*l'enfer, c'est les autres*" [lehn-fair, say layz-ohtr]—"Hell is other people." In the drawing room, there need be no torturer because each character tortures the other two.

De Beauvoir and Existential Feminism

Sartre's existential call to self-creation resonated powerfully with Simone de Beauvoir [deh boh-VWAHR] (1908–1986), who argued that women had passively allowed men to define them rather than creating themselves. Sartre and de Beauvoir lived independent lives, but they maintained an intimate relationship that intentionally challenged bourgeois notions of decency. The open and free nature of their liaison, described and defended by de Beauvoir in four volumes of memoirs, became part of the mystique of French existentialism.

In her classic feminist text *The Second Sex*, which first appeared in 1949, de Beauvoir debunked what she called "the myth of femininity." She was well aware, as she said, that

woman "is very often very well pleased with her role as *Other*"—that is, her secondary status beside men, what de Beauvoir describes as "the inessential which never becomes the essential." The reason for this, she writes, is their unwillingness to give up the advantages men confer upon them (**Reading 45.3**):

READING 45.3 **from Simone de Beauvoir,
The Second Sex (1949)**

Now, woman has always been man's dependent, if not his slave; the two sexes have never shared the world in equality. . . . To decline to be the Other, to refuse to be a party to the deal—this would be for women to renounce all the advantages conferred upon them by their alliance with the superior caste. Man-the-sovereign will provide woman-the-liege with material protection and will undertake the moral justification of her existence; thus she can evade at once both economic risk and the metaphysical risk of a liberty in which ends and aims must be contrived without assistance. Indeed, along with the ethical urge of each individual to affirm his subjective existence, there is also the temptation to forgo liberty and become a thing. This is an inauspicious road. . . . But it is an easy road; on it one avoids the strain involved in undertaking an authentic existence.

The need to create an authentic existence motivates de Beauvoir's feminism. How much she personally succeeded in realizing her own existence, given her lifelong dedication to Sartre, remains a matter of some debate. What is indisputable, however, is the centrality of *The Second Sex* in defining the boundaries of the ever-growing feminist movement.

The Literature of Existentialism

Apart from Simone de Beauvoir, Sartre's closest companions were the novelists Albert Camus [kah-MOO] (1913–1960), Jean Genet [zhuh-NAY] (1910–1986), Boris Vian [vee-YAHN] (1920–1959), and fellow philosopher Maurice Merleau-Ponty [mare-loh-pon-TEE] (1908–1961), editor-in-chief of *Les Temps Modernes* [lay tahm moh-DAIRN], the journal founded by Sartre in 1945 to give "an account of the present, as complete and faithful as possible." Merleau-Ponty was a particular champion of Camus, whose novels he believed embodied the existential condition. The main protagonist of Camus's 1942 novel *The Stranger* is a young Algerian, Meursault [mer-SOH], who is more an antihero than a hero, since he lacks the personal characteristics that we normally associate with heroes. Meursault becomes tangled up with a local pimp whom he somewhat inexplicably kills. He is imprisoned and brought to trial. His prosecutors' case is

absurdly beside the point—they demonstrate, for instance, that he was both unmoved by his mother's death and, worse, attended a comic movie on the eve of her funeral. Despite the irrelevance of the prosecutors' evidence, the jury convicts Meursault. Camus explained why in a preface written for a 1955 reissue of the novel (**Reading 45.4**):

READING 45.4 **from Albert Camus,
Preface to *The Stranger* (1955)**

I summarized *The Stranger* a long time ago, with a remark I admit was highly paradoxical: "In our society any man who does not weep at his mother's funeral runs the risk of being sentenced to death." I only meant that the hero of my book is condemned because he does not play the game. In this respect, he is foreign to the society in which he lives; he wanders, on the fringe, in the suburbs of private, solitary, sensual life. And this is why some readers have been tempted to look upon him as a piece of social wreckage. A much more accurate idea of the character, or, at least one much closer to the author's intentions, will emerge if one asks just how Meursault doesn't play the game. The reply is a simple one; he refuses to lie. To lie is not only to say what isn't true. It is also and above all, to say more than is true, and, as far as the human heart is concerned, to express more than one feels. This is what we all do, every day, to simplify life. He says what he is, he refuses to hide his feelings, and immediately society feels threatened. He is asked, for example, to say that he regrets his crime, in the approved manner. He replies that what he feels is annoyance rather than real regret. And this shade of meaning condemns him. For me, therefore, Meursault is not a piece of social wreckage, but a poor and naked man enamored of a sun that leaves no shadows. Far from being bereft of all feeling, he is animated by a passion that is deep because it is stubborn, a passion for the absolute and for truth.

The absurdity of Mersault's position found its fullest expression in what critic Martin Esslin in the 1960s termed the **Theater of the Absurd**, a theater in which the meaninglessness of existence is the central thematic concern. Sartre's own *No Exit* was the first example, but many other plays of a similar character followed, authored by Samuel Beckett (1906–1989), an Irishman who lived in Paris throughout the 1950s, the Romanian Eugène Ionesco [ee-oh-ness-KOH] (1909–1994), the Frenchman Jean Genet, the British Harold Pinter (1930–), the American Edward Albee (1928–), and the Czech-born Englishman Tom Stoppard (1937–). All of these playwrights share a common existential sense of the absurd plus, ironically, a sense that language is a barrier to

communication, that speech is almost futile, and that we are condemned to isolation and alienation.

The most popular of the absurdist plays is Samuel Beckett's *Waiting for Godot* [goh-DOH], first written and performed in French in 1954 and subtitled *A Tragicomedy in Two Acts*. The play introduced audiences to a new set of stage conventions, from its essentially barren set (only a leafless tree decorates the stage), to its two clownlike characters, Vladimir and Estragon, whose language is incapable of affecting or even coming to grips with their situation. The play demands that its audience, like its central characters, try to make sense of an incomprehensible world in which nothing occurs. In fact, the play's first line announces as Estragon tries without success to remove his boot, "Nothing to be done." In Act I, Vladimir and Estragon await the arrival of a person referred to as Godot (**Reading 45.5a**):

Fig. 45.5 Alberto Giacometti. *City Square (La Place)*. 1948. Bronze, 8½″ × 25⅜″ × 17¼″. Digital Image © The Museum of Modern Art/Licensed by SCALA/Art Resource, NY. © ARS Artists Rights Society, NY. Purchase. In 1958, Giacometti proposed transforming this small piece into a monumental composition for the plaza in front of the Chase Manhattan Bank in New York, with these figures towering over pedestrians. The project was never realized.

READING 45.5a from Samuel Beckett,
Waiting for Godot, Act I (1954)

VLADIMIR What do we do now?
ESTRAGON Wait.

That is exactly what the audience must do as well—wait. Yet nothing happens. Godot does not arrive. In despair, Vladimir and Estragon contemplate hanging themselves but are unable to. Then they decide to leave but do not move. Act II takes place the next day, but nothing changes—Vladimir and Estragon again wait for Godot, who does not arrive, and again contemplate suicide. There is no development, no change of circumstance, no crisis, no resolution. The play's conclusion, which repeats the futile decision to move on that ended Act I, demonstrates this (**Reading 45.5b**):

READING 45.5b from Samuel Beckett,
Waiting for Godot,
Act II (1954)

VLADIMIR Well? Shall we go?
ESTRAGON Yes, let's go.
(They do not move.)
(Curtain.)

The promise of action and the realization of none: That is the Theater of the Absurd.

The Art of Existentialism

Faced with the lack of life's meaning that Sartre's existentialism proposed, painters and sculptors sought to explore the truth of this condition in their own terms. The Swiss-born Paris resident Alberto Giacometti took up sculpture while exiled from

France in Switzerland during World War II, abandoning his earlier Surrealist mode (see Fig. 42.18). The existential position of his new figurative sculpture was clear to Jean-Paul Sartre, whose essay "The Search for the Absolute" appeared in the catalogue for the 1948 exhibition of Giacometti's sculpture at the Pierre Matisse Gallery in Paris. It was Giacometti's first exhibition in ten years, and Sartre tells the story of the artist beginning with life-size plaster sculptures and working at them obsessively until, in Sartre's words, "these moving outlines, always half-way between nothingness and being, always modified, bettered, destroyed and begun once more" were reduced to the size of matchsticks.

What impressed Sartre most was Giacometti's commitment to a search for the absolute, admittedly doomed to failure, but important for that very reason. The figures on the giant metal field in *City Square* are all uniformly striding men, each heading in a different direction to seek fulfillment (Fig. **45.5**). These figures, which do not interact, do not merely embody the alienation of the human condition. In their very frailty, they also embody the will to survive, which Giacometti guaranteed by finally casting his plaster sculptures in bronze.

One of the most important ideas contributing to postwar artists' understanding of what an existential art might be was the notion writer Georges Bataille [bah-TIGH] (1897–1962) first articulated in 1929 that beneath all matter lies a condition of formlessness that requires the artist to "un-form" all categories of making. This notion led the French artist Jean Dubuffet [doo-boo-FAY] (1901–1985) to collect examples of what he called **art brut**, "raw art," from psychotics, children, and folk artists—anyone unaffected by or untrained in cultural convention. His own work ranged from scribbling gesture and cut-up canvases reconstructed as collages to paintings employing sand and paste. In a series of nudes created during 1950 and 1951, he expanded the human body to fill the whole canvas (Fig. **45.6**). He described the result in the following terms:

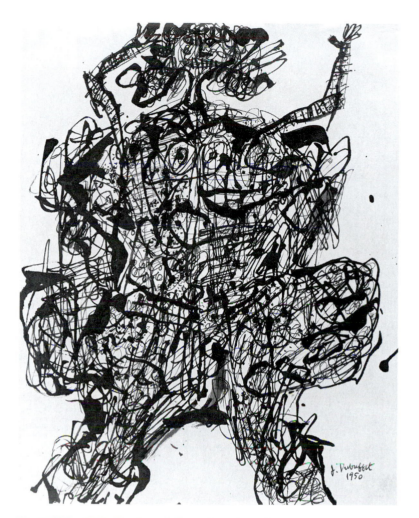

Fig. 45.6 Jean Dubuffet. *Corps de Dame*. **June–December, 1950.** Pen, reed pen, and ink, 10⅝″ × 8⅜″. The Museum of Modern Art/Licensed by Scala-Art Resource, NY. The Joan and Lester Avnet Collection. Photograph © 2000 The Museum of Modern Art/Licensed by Scala-Art Resource, NY. © 2005 Artists Rights Society (ARS), NY/ADAGP, Paris. Although one might interpret this work as having been done by someone who hates women, it is certainly an attack on tradition by targeting academic figure painting.

disorder of images, of beginnings of images, of fading images, where they cross and mingle, in a turmoil, tatters borrowed from memories of the outside world, and facts purely cerebral and internal—visceral perhaps.

The existential basis of Dubuffet's art resides both in its acceptance of the formlessness of experience and its quest for what he called an "authentic" expression, divorced from convention and tradition.

America after the War: Triumph and Doubt

The 1950s was an era of unprecedented prosperity in the United States. In July 1955, Walt Disney opened Disneyland in Anaheim, California, the first large-scale theme park in America. That same year, two of the first fast-food chains

opened their doors—Colonel Sanders's Kentucky Fried Chicken (KFC) and McDonald's. In 1953, the first issue of *Playboy* magazine appeared, featuring Marilyn Monroe as its first nude centerfold, and by 1956 its circulation had reached 600,000. Sales of household appliances exploded, and women, still largely relegated to the domestic scene, suddenly found themselves with leisure time. Diner's Club and American Express introduced the charge card in 1951 and 1958 respectively. Both cards required payment in full each month, but they paved the way for the Bank Americard, introduced in 1959 (eventually evolving into the Visa card), which allowed for individual borrowing—and purchasing—at an unprecedented level.

New products proliferated—CorningWare, Sugar Pops, and Kraft Minute Rice (1950), sugarless chewing gum and the first 33-rpm long-playing records, introduced by Deutsche Grammophon (1951), Kellogg's Sugar Frosted Flakes, the Sony pocket-sized transistor radio, fiberglass and nylon (1952), Sugar Smacks cereal and Schweppes bottled tonic water (1953), Crest toothpaste and roll-on deodorant (1955), Pampers disposable baby diapers, Comet cleanser, Raid insecticide, Imperial margarine, and Midas mufflers (1956), the Wham-O toy company's Frisbee (1957) and Hula Hoop (1958), Sweet'n Low, Green Giant canned beans, and Teflon frying pans (1958). Finally, in 1958 as well, Pizza Hut opened its doors for the first time.

Television played a key role in marketing these products since advertisers underwrote entertainment and news programming by buying time slots for commercials. In television commercials people could see products firsthand. Although television programming had been broadcast before World War II, it was suspended during the war and did not resume until 1948. By 1950, four networks were broadcasting to 3.1 million television sets. By the end of the decade, that number had swelled to 67 million. Even the food industry responded to the medium. Swanson, which had introduced frozen potpies in 1951, began selling complete frozen "TV dinners" in 1953. The first, in its sealed aluminum tray, featured turkey, cornbread dressing and gravy, buttered peas, and sweet potatoes. It cost 98 cents, and Swanson sold 10 million units that year. Consumer culture was at full throttle, and Americans quickly took the proliferation of new products and services for granted. Only in Europe, where economic recovery lagged far behind the United States because its industries had been devastated by the war, could the magnitude of American consumption seem obvious. It was in Europe, specifically London, that the first artistic critiques of consumer culture were produced by a group of artists known as the Independents (see *Focus*, pages 1472–1473).

Focus

Hamilton's *Just What Is It That Makes Today's Homes So Different, So Appealing?*

In the mid-1950s in London, a group of artists seeking to express contemporary culture in art formed the Independents. Headed by Richard Hamilton (1922–) and critic Lawrence Alloway (1926–1990), they were fascinated with the goods and products advertised in the American magazines that poured into an England still recovering from World War II. The third leader of the group, Edouardo Paolozzi [pow-LOH-tzee] (1924–2005), avidly collected these ads. The group soon began to describe their work as "Pop Art." It was meant to evoke the tension between popular culture and highbrow art.

In August and September 1956, the group staged an exhibition at the Whitechapel Gallery in London called "This Is Tomorrow." The show consisted of individual pavilions, each designed by a team of artists working in three different media. Hamilton and his two collaborators built a sort of funhouse just inside the gallery's front door. It included a working jukebox, a live microphone so that visitors might participate in the work, films, and a 14-foot-high cutout of the poster for the 1956 film *The Forbidden Planet* showing Robby the Robot carrying off a pinup model. Beneath her knees, they stenciled in the famous photograph of Marilyn Monroe standing over an air vent in the 1955 film *The Seven Year Itch*, her skirt blowing up to reveal her legs.

Hamilton's collage *Just What Is It That Makes Today's Homes So Different, So Appealing?* was used as a catalog illustration to the exhibition and reproduced as a poster for the show. Its title came from a magazine, as did its imagery. In a later commentary Hamilton listed the following as the subject of the work: "Journalism, Cinema, Advertising, Television, Styling, Sex symbolism, Randomization, Audience participation, Photographic image, Multiple image, Mechanical conversion of the imagery, Diagram, Coding, Technical drawing." In 1957, he created a second list, this one defining the Independents' art in general: "Popular (designed for a mass audience); Transient (short-term solution); Expendable (easily forgotten); Low Cost; Mass Produced; Young (aimed at Youth); Witty; Sexy; Gimmicky; Glamorous; and Big Business." Hamilton and his fellow British artists recognized the power of advertising to manipulate human desire for commercial ends, but at the same time, they celebrated that power.

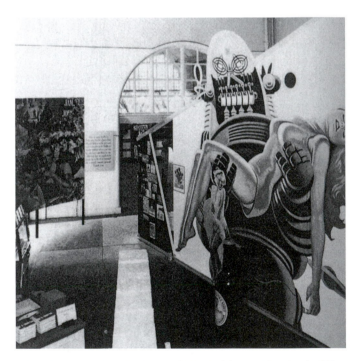

Richard Hamilton, John McHale, and John Voelcker. Pavilion for the "This Is Tomorrow" exhibition at the Whitechapel Gallery, London. 1956.

Out the false window the movie marquee advertises the first "talkie," Al Jolson's *The Jazz Singer* (see Fig. 44.26).

This advertisement for a Hoover vacuum cleaner reads "Ordinary cleaners reach only this far."

The *Romance* magazine cover on the back wall is at once an ironic comment on the relationship between the body builder and the stripper on the couch and a reference to such traditional depictions of relationships as Jan van Eyck's *Giovanni Arnolfini and His Wife Giovanna Cenami* (see Fig. 20.11).

A telescopic rendering of the surface of the moon serves as the room's ceiling, a reference to the theme of space and *The Forbidden Planet* in the "This Is Tomorrow" exhibition.

The Ford Motor Company logo decorates a lampshade that casts a strangely geometric white light on the wall behind it.

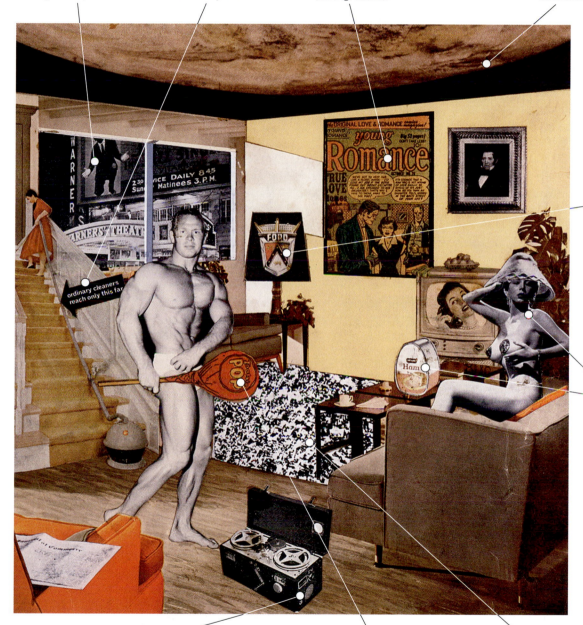

The canned ham on the table and the nearly nude stripper sitting on the sofa are "meat," consumable flesh, as is the body builder in the center of the room.

The reel-to-reel tape recorder, introduced in the early 1950s, symbolizes, like the television set and the newspaper on the chair in the foreground, the impact of the media on modern life.

The Tootsie Roll Pop, reproduced in giant scale, is a direct reference to *pop*ular culture.

The carpet is a blowup of the photograph of a beach by Weegee, the pseudonym of Arthur Felig (1899–1968), who became famous in 1945 with the publication of his first book of black-and-white photographs, *The Naked City*. That title resonates with Hamilton's composition.

Richard Hamilton, *Just What Is It That Makes Today's Homes So Different, So Appealing?* **1956.** Collage on paper, 10¼" × 9¾". Kunsthalle Tübingen. Sammlung Zundel, Germany. © 2007 Artists Rights Society (ARS) New York/DACS, London.

The Literature of Irony: Heller's *Catch-22*

Against this backdrop of prosperity and plenty, more troubling events were occurring. After the war, the territories controlled by the Nazis had been partitioned, and the Soviets had gained control of Eastern Europe, which they continued to occupy. Berlin, fully enclosed by Soviet-controlled East Germany, was a divided city, and it quickly became a focal point of tension when the Soviets blockaded land and river access to the city in 1948. President Truman responded by airlifting vital supplies to the 2 million citizens of West Berlin, but the crisis would continue, culminating in the construction of the Berlin Wall in 1961.

Events in Asia were equally troubling. In China, the communists, led by Mao Tse-tung [mauw (rhymes with "cow") dzu-doong] (1893–1976), drove the pro-Western nationalists, led by Chiang Kai-shek [kigh-shek] (1887–1975), off the mainland to the island of Taiwan and established the pro-Soviet People's Republic of China on October 1, 1949. Korea was likewise partitioned into a U.S.-backed southern sector and a Soviet-backed northern sector, culminating in the 1950 invasion of the south by the north and the Korean War (1950–1953) which involved American and Chinese soldiers, the latter supported by Russian advisors and pilots, in another military conflict. As the tension between the Soviet bloc and the West escalated throughout the 1950s, nuclear confrontation seemed inevitable.

The novel *Catch-22* by Joseph Heller (1923–1999), which appeared in 1961 (a chapter was published as a novel-in-progress as early as 1955), is a deeply sarcastic response to both the commercialism of the era and the horrible realities of war. Its **black humor**, the treatment of serious topics in a humorous or satirical manner, lies in the fact that the horrors it portrays are so absurd that they evoke laughter instead of pain. The novel follows a fictional World War II U.S. Army Air Corps bombardier, Captain Yossarian [yo-SAH-ree-un], and a number of other American airmen based on the island of Pianosa [pee-uh-NO-suh] off the coast of Tuscany. Yossarian longs to quit flying missions, but he is trapped, like his roommate, Orr, by "Catch-22," which the battalion doctor explains to Yossarian (**Reading 45.6a**):

READING 45.6a **from Joseph Heller, *Catch-22*, Chapter 5 (1961)**

There was only one catch and that was Catch-22, which specified that a concern for one's safety in the face of dangers that were real and immediate was the process of a rational mind. Orr was crazy and could be grounded. All he had to do was ask; and as soon as he did, he would no longer be crazy and would have to fly more missions. Orr would be crazy to fly more missions and sane if he didn't, but if he was sane he had to fly them. If he flew them he was crazy and didn't have to; but if he didn't want to he was sane and had to. Yossarian was moved very deeply by the absolute simplicity of this clause of Catch-22 and let out a respectful whistle.

"That's some catch, that Catch-22," he observed.

"It's the best there is," Doc Daneeka agreed.

In Sartre's phrase, such logic allows for "no exit." The same mind-numbing logic drives Lieutenant Milo Minderbinder, who represents the spirit of capitalism with all its confidence games, shady dealings, and immoral decision making. If the market demands it, Milo reasons, it is okay to take carbon dioxide out of his comrades' life preservers or morphine from their first-aid kits. In a hilarious and classic passage parodying the American market system, Milo explains to Yossarian how he makes a profit buying eggs for seven cents apiece and selling them for five cents each: "I am the people I buy them from" (see **Reading 45.6**, page 1488). Milo's interest in profit goes so far that he contracts with both sides to conduct the war (**Reading 45.6b**):

READING 45.6b **from Joseph Heller, *Catch-22*, Chapter 24 (1961)**

Milo's planes were a familiar sight. They had freedom of passage everywhere, and one day, Milo contracted with the American military authorities to bomb the German-held highway bridge at Orvieto and with the German military authorities to defend the highway bridge at Orvieto with antiaircraft fire against his own attack. His fee for attacking the bridge for America was the total cost of the operation plus six percent, and his fee from Germany for defending the bridge was the same cost-plus-six agreement augmented by a merit bonus of a thousand dollars for every American plane he shot down.

When Yossarian angrily accuses Milo of killing their friend Snowden when he was shot down on the mission, Milo replies, "I didn't kill him! I wasn't even there that day, I tell you."

The Triumph of American Art: Abstract Expressionism

The moral apathy of Milo Minderbinder and the frustrating "no exit" situation of Yossarian disgusted American artists working during and after the war in the style known as **abstract expressionism**, even as they identified with and very well understood the existential underpinnings of both characters. These artists included immigrants like Arshile Gorky

[GOR-kee] (1904–1948), Hans Hoffmann (1880–1966), Milton Resnick (1917–2004), and Willem de Kooning [KOO-ning] (1904–1997), as well as slightly younger American-born artists like Franz Kline (1910–1962) and Jackson Pollock (1912–1956). All freely acknowledged their debts to Cubism's assault on traditional representation, German expressionism's turn inward from the world, Kandinsky's near-total abstraction, and Surrealism's emphasis on chance operations and psychic automatism. Together the Abstract Expressionists saw themselves as standing at the edge of the unknown, ready to define themselves through a Sartrian struggle with the blank canvas, through the physical act of applying paint and the energy that each painted gesture reveals.

After the War, the State Department toured mammoth exhibitions of their painting and sculpture across Europe—and in Paris, especially—in order to demonstrate the spirit of freedom and innovation in American art (and, by extension, American culture as a whole). The individualistic spirit of these artists was seen as the very antithesis of communism, and their work was meant to convey the message that America had not only triumphed in the war, but in art and culture as well. New York, not Paris, was now the center of the art world.

Action Painting: Pollock and de Kooning In 1956, Willem de Kooning commented that "every so often, a painter has to destroy painting. Cézanne did it. Picasso did it with Cubism. Then Pollock did it. He busted our idea of a picture all to hell. Then there could be new paintings again." Around 1940, Pollock underwent psychoanalysis in order to explore Surrealist psychic automatism and to reveal, on canvas, the deepest areas of the unconscious. His 1943 *Guardians of the Secret* is an expression of that effort (Fig. **45.7**). Locked in the central chest are indecipherable "secrets," watched over by a dog (perhaps the Id) and two figures at each side (perhaps the Ego and the Super-Ego). Rising from the trunk are a mask, a rooster, and perhaps even a fetus.

This depiction of a mental landscape would soon develop into large-scale **"action paintings,"** as described by the critic Harold Rosenberg in 1942 (Fig. **45.8**). The canvas had become, he said, "an arena in which to act." It was no longer "a picture but an event." Pollock would drip, pour, and splash oil paint, house and boat paint, and enamel over the surface of the canvas, determining the top and bottom of the piece only after the process was complete. The result was a galactic sense of space, what Rosenberg called "all-over" space, in which the viewer can almost trace Pollock's rhythmic gestural dance around the painting's perimeter.

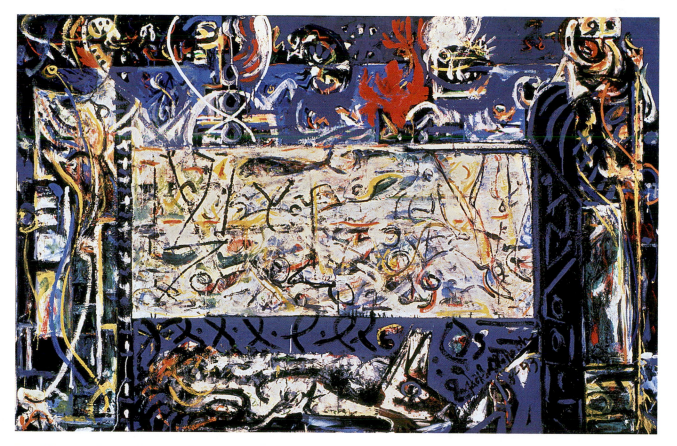

Fig. 45.7 Jackson Pollock. *Guardians of the Secret.* **1943.** Oil on canvas, 4′3⅜″ × 6′3⅜″. San Francisco Museum of Modern Art. Albert M. Bender Collection. Albert M. Bender Bequest Fund Purchase. © Pollock-Krasner Foundation/ARS Artists Rights Society, NY. SFMOMA Internal Number: 45.1308. The rooster (top center) had deep psychological and autobiographical meaning to Pollock because, as a boy, a friend had accidentally chopped off the top of his right middle finger with an ax, and a rooster ran up and stole it.

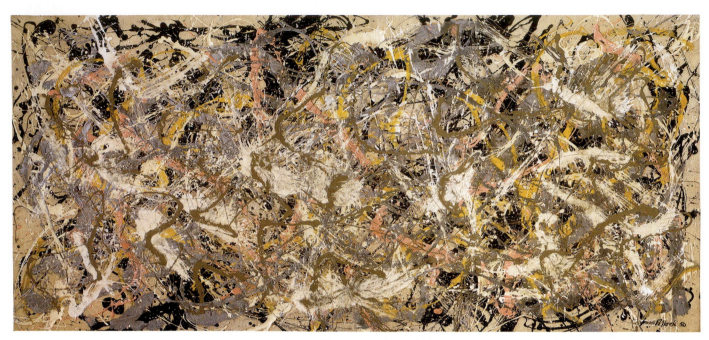

Fig. 45.8 Jackson Pollock. *Number 27.* **1950.** Oil on canvas, 4′1″ × 8′10″. Collection, Whitney Museum of American Art, NY. Purchase. The year *Number 27* was painted, *Life* magazine ran a long, profusely illustrated story on Pollock asking, "Is he the greatest living painter in the United States?" It stimulated an astonishing 532 letters to the editor, most of them answering the question with a definitive "No!"

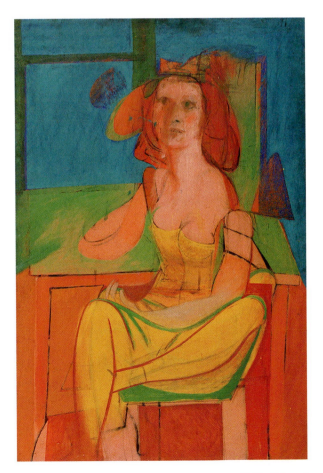

Fig. 45.9 Willem de Kooning. *Seated Woman.* **ca. 1940.** Oil on charcoal on masonite, 54¼″ × 36″. The Albert M. Greenfield and Elizabeth M. Greenfield Collection, 1974. Philadelphia Museum of Art, Philadelphia, Pennsylvania. U.S.A. Art Resource, NY. © ARS Artists Rights Society, NY. The remarkable color contrasts reveal de Kooning's stunning sense of color.

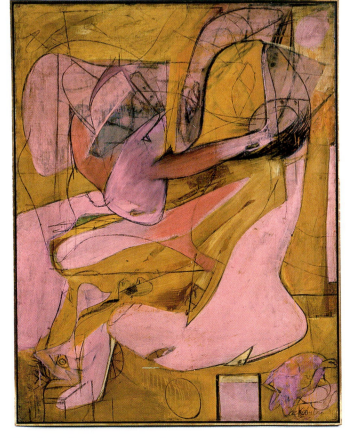

Fig. 45.10 Willem de Kooning. *Pink Angels.* **1945.** Oil on canvas, 52″ × 40″. Frederick Weisman Company, Los Angeles. The female anatomy here seems to have been disassembled, stretched, pushed, and pulled, and then rearranged in a sort of collage.

De Kooning was 12 years Pollock's senior and had begun in the late 1930s and early 1940s in a more figurative vein. His 1940 *Seated Woman* shows the influence of Picasso's Cubist portraits of the 1930s (see *Girl Before a Mirror* Fig. 42.15), even as it allows various anatomical parts to float free of the body or almost dissolve into fluid form (Fig. **45.9**). By the mid-1940s, in works like *Pink Angels*, the free-floating forms seem to refer to human anatomy even as they remain free from it (Fig. **45.10**). An eye here, a seated figure there, an extended arm, a breast, all set free of any logical skeletal relationships, begin to create the same allover space that distinguishes Pollock's work. The difference is that de Kooning's space is composed of shapes and forms rather than the woven linear skein of Pollock's compositions.

Continuity & Change
p. 1368

Girl Before a Mirror

By 1950, the surface of de Kooning's paintings seemed densely packed with free-floating, vaguely anatomical parts set in a landscape of crumpled refuse, earthmoving equipment, concrete blocks, and I-beams. None of these elements is definitively visible, just merely suggested. *Excavation* is a complex organization of open and closed cream-colored forms that lead from one to the other, their black outlines overlapping, merging, disappearing across the surface (Fig. **45.11**). Small areas of brightly colored brushwork interrupt the surface.

When, in 1951, *Excavation* was featured in an exhibition of abstract painting and sculpture at the Museum of Modern Art in New York, de Kooning lectured on the subject "What Abstract Art Means to Me." His description of his relationship to his environment is a fair explanation of what we see in the painting: "Everything that passes me I can see only a little of, but I'm always looking. And I see an awful lot sometimes."

De Kooning's abstraction differs from Pollock's largely in this. As opposed to plumbing the depths of the psyche, he represents the psyche's encounter with the world. Even in such early figurative works such as *Seated Woman*, where the curvilinear features of his sitter contrast with the geometric features of the room, de Kooning's primary concern is the relation of the individual to his or her environment. The tension between the two is the focus of his works.

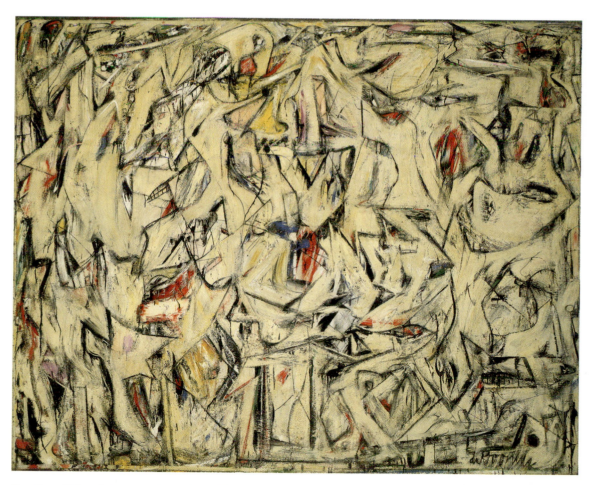

Fig. 45.11 Willem de Kooning. *Excavation.* **1950.** Oil on canvas, 6′8″ × 8′4⅛″. Unframed. Mr. and Mrs. Frank G. Logan Purchase Prize Fund; restricted gifts of Edgar J. Kaufmann, Jr., and Mr. and Mrs. Noah Goldowsky, Jr., 1952.1 Reproduction, The Art Institute of Chicago. All Rights Reserved. © 2009 ARS Artists Rights Society, NY. This is one of de Kooning's largest paintings. "My paintings are too complicated," he explained. "I don't use the large-size canvas because it's too difficult for me to get out of it."

Women Abstract Expressionists In many ways, women Abstract Expressionist artists held a position in the movement as a whole that is comparable to the women associated with the Surrealists in Europe. From the point of view of the men—and the critics who wrote about the men—they were spouses or lovers and, when noticed at all as artists, part of a "second generation" following on the heels of the great male innovators of the first generation. In 1948, for instance, the male Abstract Expressionists organized a group known as "The Club," a social gathering that met regularly in a rented loft on 8th Street in New York City. According to Pat Passlof, herself a painter and married to fellow Abstract Expressionist Milton Resnick, the Club's charter explicitly excluded communists, homosexuals, and women because, she was told, "those are the three groups that take over." In fact, women did attend meetings, though they were excluded from board meetings or policy discussions.

Although excluded from the inner circle, a number of the women associated with abstract expressionism were painters of exceptional ability. Elaine de Kooning (1918–1989), who married Willem in 1943, was known for her highly sexualized portraits of men. Lee Krasner [KRAZ-ner] (1908–1984), who married Jackson Pollock in 1945, developed her own distinctive allover style of thickly applied paint consisting of calligraphic lines. Though these lines sometimes enclose symbol-like forms, in *White Squares* their architecture possesses some of the energy of automatic writing—a kind of visual equivalent to "noise poetry" (Fig. **45.12**). Krasner later defined her relationship to the Abstract Expressionists and Pollock in particular:

I was put together with the wives. They worked, they supported their husbands, they taught school and kept their mouths absolutely closed tight. I don't know if they were instructed never to speak publicly, I don't know if they had a thought. Jackson always treated me as an artist but his ego was so colossal, I didn't threaten him in any way. So he was aware of what I was doing, I was working, and that was that. That was our relationship.

One of the major tensions in abstract expressionism is the dynamic relationship between figuration and abstraction. As de Kooning once said, "Even abstract shapes must have a likeness." In *River Bathers* by Grace Hartigan [HAR-tih-gan] (1922–), the broad, gestural abstract washes of color have a powerful emotional and visual presence (Fig. **45.13**). She would later say, "My art was always about something," which in this case is five or six figures standing at a river's edge. For Hartigan the painting is not realistic, but it captures real feelings experienced in a specific place and time.

Inspired by de Kooning, Joan Mitchell (1926–1992) began painting in New York in the early 1950s, but after 1955 she divided her time between Paris and New York, moving to Paris on a more permanent basis in 1959. Ten years later, she moved down the Seine to Vétheuil [vay-TOY], living in the house that Monet had occupied from 1878 to 1881. Although she denied the influence of Monet, her paintings possess something of the scale of Monet's water lily paintings, and her brushwork realizes in large what Monet rendered in detail. Like Monet, she was obsessed with water, specifically Lake Michigan, which as a child she had constantly viewed from her family's Chicago apartment. "I paint from remembered landscapes that I carry with me—and remembered feelings of them, which of course become transformed." As in most of her works, the unpainted white ground of *Piano mécanique* takes on the character of atmosphere or water, an almost touchable and semitransparent space that reflects the incidents of weather, time, and light (Fig. **45.14**).

Continuity & Change
p. 1199

Water Lilies

Fig. 45.12 Lee Krasner. *White Squares*. ca. 1948. Oil on canvas, 24″ × 30″. Gift of Mr. and Mrs. B. H. Friedman. 75.1. Collection of the Whitney Museum of American Art, NY. The painting creates a tension between the geometric regularity of the grid and the gestural freedom of Krasner's line.

Fig. 45.13 Grace Hartigan. *River Bathers*. 1953. Oil on canvas, 5′9³/₈″ × 7′4³/₄″. Given anonymously. (11.1954). Digital Image. The Museum of Modern Art/Licensed by SCALA/Art Resource, NY. The most obvious bather is at the top right. Another seems to be splashing in the water in the middle section of the painting. Two others are behind her and another appears to be standing at the left.

The Color-Field Painting of Rothko and Frankenthaler A second variety of abstract expressionism offered viewers a more meditative and quiet painting based on large expanses of relatively undifferentiated color. Mark Rothko (1903–1970) began painting in the early 1940s by placing archetypal figures in front of large monochromatic bands of hazy, semi-transparent color. By the early 1950s, he had eliminated the figures, leaving only the background color field.

The scale of these paintings is intentionally large. *Green on Blue*, for instance, is over seven feet tall (Fig. **45.15**). "The reason I paint [large pictures]," he stated in 1951,

> is precisely because I want to be very intimate and human. To paint a small picture is to place yourself outside your experience, to look upon an experience as a stereopticon view or reducing glass. However you paint the larger picture, you are in it. It isn't something you command.

Viewers find themselves enveloped in Rothko's sometimes extremely somber color fields. These expanses of color become, in this sense, stage sets for the

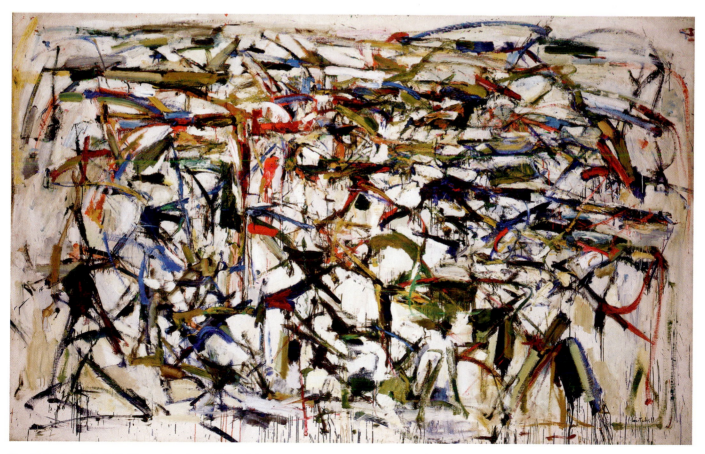

Fig. 45.14 Joan Mitchell. *Piano mécanique*. 1958. Oil on canvas, 78″ × 128″. Gift of Addie and Sidney Yates. Image © 2009 Board of Trustees, National Gallery of Art, Washington, DC. Alberto Giacometti and Samuel Beckett were among Mitchell's closest friends after she moved to Paris in 1959.

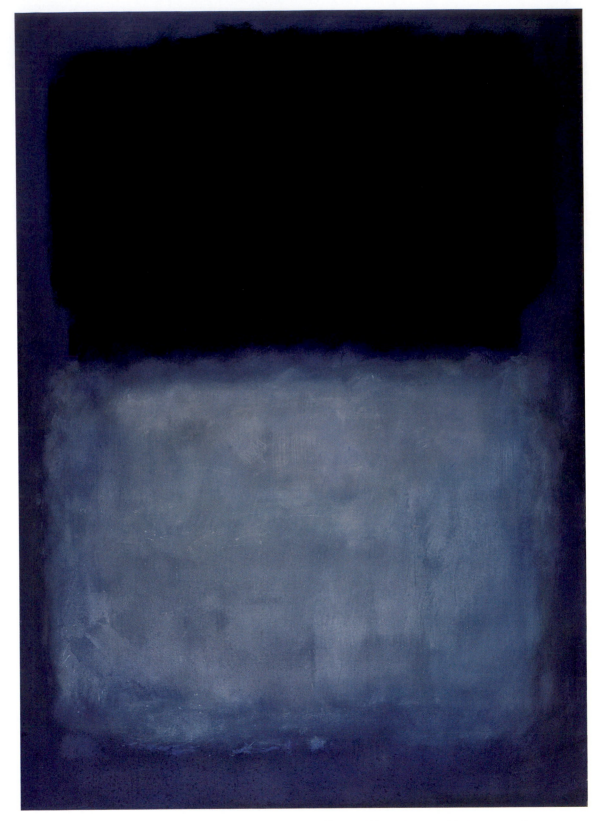

Fig. 45.15 Mark Rothko. *Green on Blue.* **1956.** Oil on canvas, 7′5³⁄₄″ × 5′3¹⁄₄″. Collection of the University of Arizona Museum of Art, Tucson, Gift of E. Gallagher, Jr. Acc. 64.1.1. The religious sensibility of Rothko's painting brought him, in 1964, a commission for a set of murals for a Catholic chapel in Houston, Texas.

human drama that transpires before them. As Rothko further explains:

> I am interested only in expressing the basic human emotions—tragedy, ecstasy, doom, and so on—and the fact that lots of people break down and cry when confronted with my pictures shows that I communicate with those basic human emotions. The people who weep before my pictures are having the same religious experience I had when I painted them.

The emotional toll of such painting finally cost Rothko his life. His vision became darker and darker throughout the 1960s, and in 1970 he hanged himself in his studio.

In 1952, directly inspired by Pollock's drip paintings, 24-year-old Helen Frankenthaler (1928–) diluted paint almost to the consistency of watercolor and began pouring it onto unprimed cotton canvas to achieve giant stains of color that suggest landscape (Fig. **45.16**). The risk she assumed in controlling her flooding hues, and the monumentality of her compositions, immediately inspired a large number of other artists.

The Dynamic Sculpture of Calder and Smith Sculpture, too, could partake of the same gestural freedom and psychological abstraction as Abstract Expressionist painting. It could become a field of action, like Pollock's and de Kooning's paintings, in which the sculptor confronts the most elemental forms of being.

When the American sculptor Alexander Calder (1898–1976) had arrived in Paris in 1926, his studio was a favorite haunt of the Surrealists, who came to witness performances of his *Circus*, a miniature arena in which he manipulated marionette figures built of wire and wood, including bareback riders, acrobats, sword

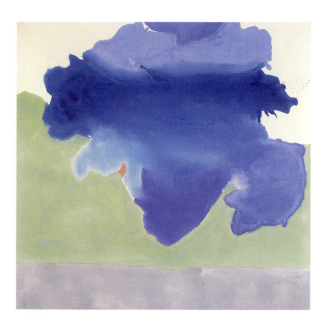

Fig. 45.16 Helen Frankenthaler. *The Bay.* 1963. Acrylic on canvas, 6'8¾" × 6'9½". The Detroit Institute of Arts, USA, Founders Society Purchase, Dr. & Mrs. Hilbert H. DeLawter Fund/The Bridgeman Art Library. This is one of the first paintings in which Frankenthaler used acrylic rather than oil paint, resulting in a much more stable surface.

swallowers, and the like. So time and chance—the happenstance of live performance—were built into his work. By the early 1930s he began to make what Marcel Duchamp labeled *mobiles*, which in French refer not only to things that move but "motives" as well, the causes or incentives for action (Fig. **45.17**). The

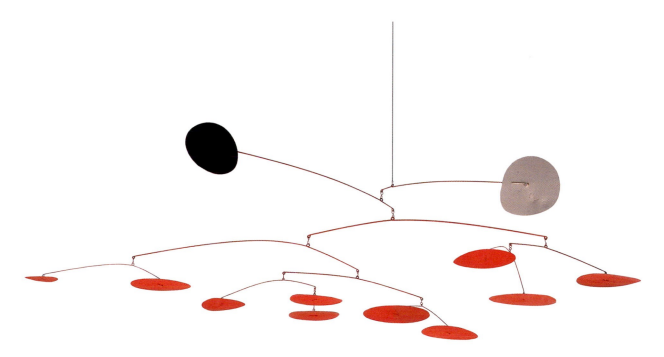

Fig. 45.17 Alexander Calder. *Black, White, and Ten Red.* 1957. Painted sheet metal and wire, 33" × 144". Image © 2009 Board of Trustees, National Gallery of Art, Washington, DC © 2009 Artists Rights Society (ARS), NY. Because space exploration was occurring in the 1950s, Calder's mobiles were widely understood in astronomical terms, as if they were planets circling about a fixed point in space.

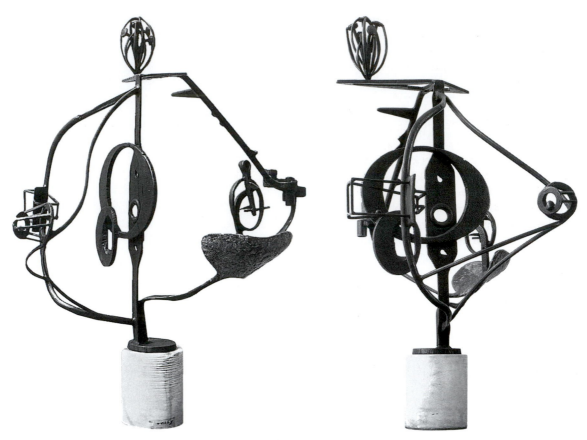

Fig. 45.18 David Smith. *Blackburn: Song of an Irish Blacksmith*, frontal and profile views. 1949–1950. Steel and bronze, $46\frac{1}{4}"\times 49\frac{3}{4}"\times 24"$. Wilhelm Lehmbruck Museum, Duisburg, Germany. Art © Estate of David Smith/Licensed by VAGA, NY. Smith was the descendant of a pioneer blacksmith in Indiana. The piece resonates with that autobiographical reference.

movement of Calder's mobile comes from accidental and often unpredictable currents of air that hit the suspended sculpture—a breeze, a sudden gust from the air-conditioning system, a wave of air from a passing bus. The mobile's appearance changes as continuously and as arbitrarily as a cumulus cloud on a summer's day, suggesting familiar shapes—fish, lily pads, birds—in exactly the manner of a cloud. As the mobile turns in space, it defines a virtual volume like that defined by the linear tracery of a handheld light swung in an arc and photographed with a long exposure time. In other words, its path is like a dancer's over the space of a stage, a choreography of graceful forms. In a 1946 catalog for an exhibition of Calder mobiles, Sartre summed up the mobile's appeal as stemming from "the beauty of its pure and changing forms, at once so free and so disciplined."

The sculpture of David Smith (1906–1965) offers the same sense of change but in a more stable form. Here it is not the sculpture that moves, but the viewer who must. For instance, when one views *Blackburn: Song of an Irish Blacksmith* from the front, the sculpture seems totally open and airy, consisting of negative spaces defined by linear elements, whereas from the side it becomes a complex network of densely packed forms (Fig. **45.18**). There is really no way for the viewer to intuit all of the sculpture's aspects without walking around it. From any single view it remains unpredictable. And the surprises that the sculpture presents extend to its materials. It is constructed out of found objects from the industrial world—bent steel rods, cotter pins, and what appears to be the metal seat of a farm tractor—all transformed, in a consciously Surrealist manner, into something new, unique, and marvelous.

What most distinguishes Smith's work is the requirement of active participation from the viewer to experience it fully. So the responsibility for the creation of meaning in art begins to shift from artist to audience, as it does in abstract expressionism generally if less clearly. This shift will profoundly alter the direction of art in the last half of the twentieth century, when a work of art will increasingly have as many meanings as the viewers it attracts.

The Beat Generation

The participation of the audience and the multiple perspectives that the work of both Calder and Smith embodies became the central focus of the group of American poets, writers, and artists that we have come to call "beats" or "hipsters." *Beat* was originally a slang term meaning "down and out," or "poor and exhausted," but it came to designate the

purposefully disenfranchised artists of the American 1950s who turned their back on what they saw as the duplicity of their country's values. The **Beat generation** sought a heightened and, they believed, more authentic style of life, defined by alienation, nonconformity, sexual liberation, drugs, and alcohol.

Robert Frank and Jack Kerouac The Beats' material lay all around them, in the world, as they sought to expose the tensions that lay under the presumed well-being of their society. One of their contemporary heroes was the Swiss photographer Robert Frank (1924–), who with the aid of a Guggenheim fellowship had traveled across America for two years, publishing 83 of the resulting 2,800 photographs as *The Americans* in 1958. The book outraged a public used to photographic compilations like the 1955 exhibition *The Family of Man*, which drew 3,000 visitors daily to the Museum of Modern Art in celebration of its message of universal hope and unity. Frank's photographs offered something different. They capture everyday, mundane things that might otherwise go by unseen, with a sense of spontaneity and directness that was admired, especially, by writer Jack Kerouac (1922–1969), who had chronicled his own odysseys across America in the 1957 *On the Road*.

On the Road describes Kerouac's real life adventures with his friend Neal Cassady (1926–1968), who appears in what Kerouac called his "true-story novel" as Dean Moriarty. Cassady advocated a brand of writing that amounted to, as he put it in a letter to Kerouac, "a continuous chain of undisciplined thought." In fact, Kerouac wrote the novel in about three weeks on a single, long scroll of paper, improvising, he felt, like a jazz musician, only with words and narrative. But like a jazz musician, Kerouac was a skilled craftsman, and if the novel seems a spontaneous outburst, it reflects the same sensibility as Robert Frank's *The Americans*. Frank, after all, had taken over 2,800 photographs, but he had published only 83 of them. One senses, in reading Kerouac's rambling adventure, something of the same editorial control.

Ginsberg and "Howl" The work that best characterizes the Beat generation is "Howl," a poem by Allen Ginsberg (1926–1997). This lengthy poem in three parts and a footnote has a memorable opening (**Reading 45.7**):

READING 45.7 **from Allen Ginsberg, "Howl" (1956)**

I saw the best minds of my generation destroyed by madness, starving hysterical naked,
dragging themselves through the negro streets at dawn looking for an angry fix,
angelheaded hipsters burning for the ancient heavenly connection to the starry dynamo in the machinery of night,
who poverty and tatters and hollow-eyed and high sat up

smoking in the supernatural darkness of cold-water flats floating across the tops of cities contemplating jazz
who bared their brains to Heaven under the El and saw Mohammedan angels staggering on tenement roofs illuminated,
who passed through universities with radiant cool eyes hallucinating Arkansas and Blake-light tragedy among the scholars of war,
who were expelled from the academies for crazy & publishing obscene odes on the windows of the skull,
who cowered in unshaven rooms in underwear, burning their money in wastebaskets and listening to the Terror through the wall . . .

Ginsberg's spirit of inclusiveness admitted into art not only drugs and alcohol but also graphic sexual language, to say nothing of his frank homosexuality. Soon after "Howl" was published in 1956 by Lawrence Ferlinghetti's City Lights bookstore in San Francisco, federal authorities charged Ferlinghetti with obscenity. He was eventually acquitted. Whatever the public thought of it, the poem's power was hardly lost on the other Beats. The poet Michael McClure (1932–) was present the night Ginsberg first read it at San Francisco's Six Gallery in 1955:

Allen began in a small and intensely lucid voice. At some point Jack Kerouac began shouting "GO" in cadence as Allen read it. In all of our memories no one had been so outspoken in poetry before—we had gone beyond a point of no return—and we were ready for it, for a point of no return. None of us wanted to go back to the gray, chill, militaristic silence, to the intellective void—to the land without poetry—to the spiritual drabness. We wanted to make it new and we wanted to invent it and the process of it as we went into it. We wanted voice and we wanted vision. . . .

Ginsberg read on to the end of the poem, which left us standing in wonder, or cheering and wondering, but knowing at the deepest level that a barrier had been broken, that a human voice and body had been hurled against the harsh wall of America and its supporting armies and navies and academies and institutions and ownership systems and power-support bases.

Here, in fact, in the mid-1950s were the first expressions of the forces of rebellion that would sweep the United States and the world in the following decade.

Cage and the Aesthetics of Chance

Ginsberg showed that anything and everything could be admitted into the domain of art. This notion also informs the music of composer John Cage (1912–1992), who by the mid-1950s was proposing that it was time to "give up the desire to control sound . . . and set about discovering means to let sounds be themselves." Cage's notorious *4'33"* (4 *minutes 33 seconds*) is a case in point. First performed in Woodstock,

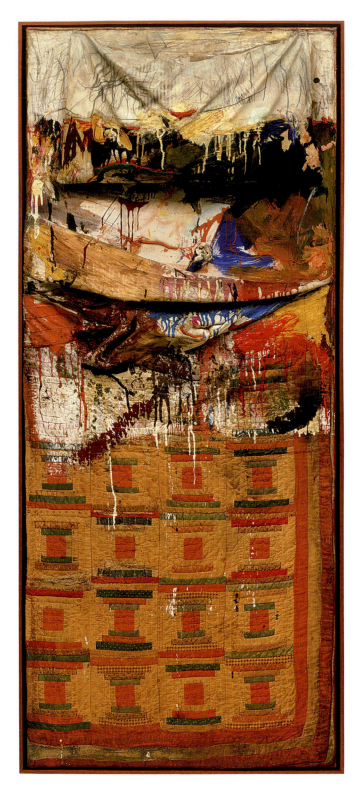

Fig. 45.19 Robert Rauschenberg. _Bed._ 1955. Combine painting: oil and pencil on pillow, quilt, and sheet on wood supports, 75 $\frac{1}{4}$″ × 31 $\frac{1}{2}$″ × 8″. Gift of Leo Castelli in honor of Alfred H. Barr, Jr. (79.1989). Digital Image © The Museum of Modern Art/Licensed by SCALA / Art Resource, NY. © Art Robert Rauschenberg Foundation/VAGA, NY. The mattress, pillow, quilt, and sheets are believed to be Rauschenberg's own and so may be thought of as embodying his famous dictum: "Painting relates to both art and life. . . . (I try to act in that gap between the two.)"

New York, by pianist David Tudor on August 29, 1952, it consists of three silent movements, each of a different length, but when added together totaling four minutes and thirty-three seconds. The composition was anything but silent, however, admitting into the space framed by its duration all manner of ambient sound—whispers, coughs, passing cars, the wind. Whatever sounds happened during its performance were purely a matter of chance, never predictable. Like Frank's, Cage's is an art of inclusiveness.

That summer Cage organized a multimedia event at Black Mountain College in North Carolina, where he occasionally taught. One of the participants was 27-year-old artist Robert Rauschenberg [RAUW-shen-berg] (1925–). By the mid-1950s, Rauschenberg had begun to make what he called **combine paintings**, works in which all manner of materials—postcards, advertisements, tin cans, pinups—are combined to create the work. If Rauschenberg's work does not literally depend upon matters of chance in its construction, it does incorporate such a diverse range of material that it creates the aura of representing Rauschenberg's chance encounters with the world around him. And it does, above all, reflect Cage's sense of all-inclusiveness. _Bed_ literally consists of a sheet, pillow, and quilt raised to the vertical and then dripped not only with paint but also with toothpaste and fingernail polish in what amounts to a parody of Abstract Expressionist introspection (Fig. **45.19**). Even as it juxtaposes highbrow artmaking with the vernacular quilt, abstraction with realism, _Bed_ is a wryly perceptive transformation of what Max Ernst in the early days of Surrealism had called "The Master's Bedroom" (see Fig. 42.13).

The Art of Collaboration Rauschenberg had known Cage since the summer of 1952 when, not long before the premiere of _4′33″_ in New York State, Cage had organized an "event," later known as _Theater Piece #1,_ in the dining hall of Black Mountain College near Asheville, North Carolina. Although almost everyone who participated remembers the event somewhat differently, it seems certain that the poets M. C. Richards (1916–1999) and Charles Olson (1910–1970) read poetry from ladders, Robert Rauschenberg played Edith Piaf [pee-AHF] records on an old windup phonograph with his almost totally "White Paintings" hanging around the room, Merce Cunningham (1919–) danced through the audience, a dog at his heels, while Cage himself sat on a stepladder, sometimes reading a lecture on Zen Buddhism, sometimes just listening. "Music," Cage declared at some point in the event, "is not listening to Mozart but sounds such as a street car or a screaming baby."

The event inaugurated a collaboration between Cunningham (dance), Cage (music), and Rauschenberg (decor and costume) that would span many years. Their collaboration is unique in the arts because of its insistence on the _independence_, not interdependence, of each part of the dance's presentation. Cunningham explains:

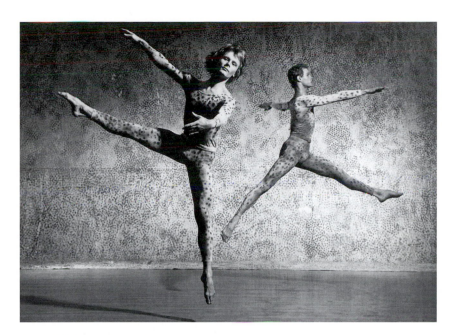

Fig. 45.20 Merce Cunningham. *Summerspace*. 1958. Set and costumes by Robert Rauschenberg. Photo by Jack Mitchell. Courtesy of Cunningham Dance Foundation, Inc. © Estate of Robert Rauschenberg/VAGA, NY. *Summerspace*, Cunningham said, was "about space. I was trying to think about ways to work in space. . . . When I spoke to Bob Rauschenberg—for the decor—I said, 'One thing I can tell you about this dance is it has no center. . . .' So he made a pointillist backdrop and costumes."

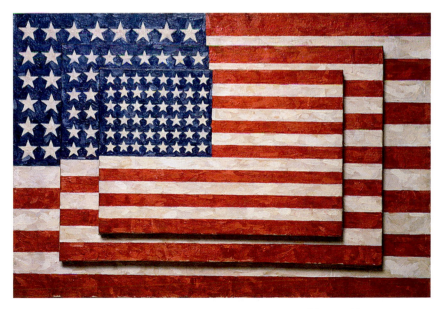

Fig. 45.21 Jasper Johns. *Three Flags*. 1955. Encaustic on canvas, 35 7/8″ × 45 1/2″ × 5″. 50th Anniversary Gift of the Gilman Foundation, Inc., The Lauder Foundation, A. Alfred Taubman, an anonymous donor, and purchase. 80.32. Collection of Whitney Museum of American Art, NY. Photo by Geoffrey Clements. Art © Jasper Johns/Licensed by VAGA, NY. Each of the three flags diminishes in scale by about 25 percent from the one behind. Because the flags project outward, getting smaller each time, they reject pictorial perspective's illusion of depth and draw attention to the surface of the painting itself.

In most conventional dances there is a central idea to which everything adheres. The dance has been made to the piece of music, the music supports the dance, and the decor frames it. The central idea is emphasized by each of the several arts. What we have done in our work is to bring together three separate elements in time and space, the music, the dance and the decor, allowing each one to remain independent.

So Cunningham created his choreography independently of Cage's scores, and Rauschenberg based his decors on only minimal information offered him by Cunningham and Cage (Fig. 45.20). The resulting dance was, by definition, a matter of music, choreography, and decor coming together (or not) as a chance operation.

The music Cage composed for Cunningham was also often dependent on chance operations. The year 1952 also saw the creation of *Water Music*, a composition for piano using, among other objects, an assortment of whistles (including a siren and a duck call), water, and the radio (**CD-Track 45.1**). Although the real-world sounds are smoothly collaged into the score, no two performances are alike because there is always something different on the radio. For a later collaboration, *Variations V*, Cage's score consists of sounds randomly triggered by sensors reacting to the movements of Cunningham's dancers. This results in what Gordon Mumma, a member of Cunningham's troupe, called "a superbly poly: -chromatic, -genic, -phonic, -morphic, -pagic, -technic, -valent, multi-ringed circus."

Johns and the Obvious Image Whereas the main point for Cunningham, Cage, and Rauschenberg was the idea of composition without a central focus, Rauschenberg's close friend and fellow painter Jasper Johns (1930–) took the opposite tack. Throughout the 1950s, he focused on the most common, seemingly obvious subject matter—numbers, targets, maps, and flags—in a manner that in no way suggests the multiplicity of meaning in his colleagues' work. Johns's painting *Three Flags* is nevertheless capable of evoking in its viewers emotions ranging from patriotic respect to equally patriotic outrage, from anger to laughter (Fig. 45.21). But Johns means the imagery to be so obvious that viewers turn their attention to the wax-based paint itself, to its almost sinuous application to the canvas surface. In this sense, the work—despite being totally recognizable—is as abstract as any Abstract Expressionist painting, but without abstract expressionism's assertion of the primacy of subjective experience.

Allan Kaprow and the Happening Cage's aesthetic of diversity and inclusiveness also informs the inventive multimedia pieces of Alan Kaprow (1927–2006). In an essay called "The Legacy of Jackson Pollock," written just two years after Pollock's death in an automobile accident in 1956, Kaprow described Pollock's art, with its willingness to bury nails, sand, wire, screen mesh, even coins in its whirls of paint, as pointing toward new possibilities for the subsequent generation of artists (**Reading 45.8**):

READING 45.8 **from Allan Kaprow, "The Legacy of Jackson Pollock" (1958)**

Pollock, as I see him, left us at the point where we must become preoccupied with and even dazzled by the space and objects of our everyday life, either our bodies, clothes, rooms, or, if need be, the vastness of Forty-second Street. Not satisfied with the suggestion through paint of our other senses, we shall utilize the specific substances of sight, sound, movements, people, odors, touch. Objects of every sort are materials for the new art: paint, chairs, food, electric and neon lights, smoke, water, old socks, a dog, movies, a thousand other things that will be discovered by the present generation of artists. Not only will these bold new creators show us, as if for the first time, the world we have always had about us but ignored, but they will disclose entirely unheard-of happenings and events, found in garbage cans, police files, hotel lobbies; seen in store windows and on the streets; and sensed in dreams and horrible accidents. An odor of crushed strawberries, a letter from a friend, or a billboard selling Drano; three taps on the front door, a scratch, a sigh, or a voice lecturing endlessly, a blinding staccato flash, a bowler hat—all will become materials for this new concrete art.

Young artists of today need no longer say, "I am a painter" or "a poet" or "a dancer." They are simply "artists." All of life will be open to them.

It is hardly surprising that it was Kaprow who founded the **Happening**, a new multimedia event in which artists and audience participated as equal partners. Kaprow's *18 Happenings in 6 Parts* took place over the course of six evenings in October 1959 at the Reuben Gallery in New York. It was inspired by *Theater Piece #1* . In order to add sound to his environment, Kaprow enrolled in Cage's music composition course at the New School for Social Research in New York. Included in the environment were record players, tape recorders, bells, a toy ukelele, a flute, a kazoo, and a violin. Kaprow scored the directions for playing them in precisely timed outbursts that approximated the cacophony of the urban environment. He divided the gallery into three rooms, created by plastic sheets and movable walls, between which audience members were invited to move in unison. Performers played instruments and records, painted, squeezed orange juice, spoke in sentence fragments—all determined by chance operations. The audience, although directed to move according to Kaprow's instructions, was also invited to participate in the work, and Kaprow would increasingly include the audience as a participant in his later Happenings.

Architecture in the 1950s

If the Beat generation was anti-establishment in its sensibilities, the architecture of the 1950s embodied the very opposite. The International Style aesthetic that Mies van der Rohe brought to his 1954–1956 Seagram Building (see Fig. 44.32) could also be applied to the private residence, as he made clear with the 1950 Farnsworth House (**Fig. 45.22**). A more direct homage to Le Corbusier's Villa Savoye (see Fig. 44.9), though more severe in its insistence on the vertical and the horizontal, it is virtually transparent, opening out to

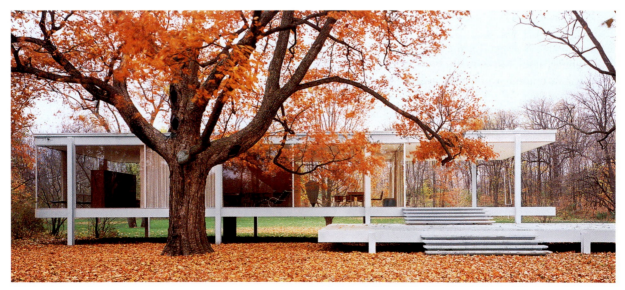

Fig. 45.22 Ludwig Mies van der Rohe. Farnsworth House, Fox River, Plano, Illinois. 1950. © 2008 Artists Rights Society (ARS), New York/VG Bild-Kunst, Bonn. The house was commissioned as a weekend retreat. Its bathroom and storage areas are behind non-load-bearing partitions that divide the interior space.

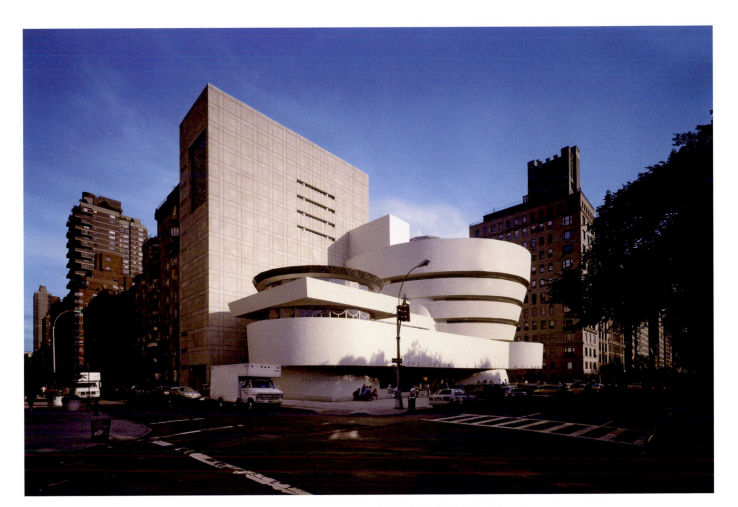

Fig. 45.23 Frank Lloyd Wright. The Solomon R. Guggenheim Museum, New York, 1957–1959. Photo: David Heald/Courtesy of the Solomon R. Guggenheim Museum. FL W#7. © 2008 Artists Rights Society (ARS), NY. The tower behind Wright's original building was designed much later by Gwathmey Siegel and Associates. It contains 51,000 square feet of new and renovated gallery space, 15,000 square feet of new office space, a restored theater, new restaurant, and retrofitted support and storage spaces. Wright had originally proposed such an annex to house artists' studios and offices, but the plan was dropped for financial reasons.

the surrounding countryside, with views of the Fox River, and also inviting the countryside in.

Frank Lloyd Wright's design for the Solomon R. Guggenheim [GOO-ghen-hime] Museum in New York is a conscious counterstatement to Mies's severe rationalist geometry, which, in fact, Wright despised (Fig. **45.23**). Situated on Fifth Avenue directly across from Central Park, the museum's organic forms echo the natural world. The plan is an inverted spiral ziggurat, or stepped tower, that dispenses with the right-angle geometries of standard urban architecture and the conventional approach to museum design, which led visitors through a series of interconnected rooms. Instead, Wright whisked museumgoers to the top of the building via elevator, allowing them to proceed downward on a continuous spiral ramp from which, across the open rotunda in the middle, they can review what they have already seen and anticipate what is to come. The ramp is cantilevered to such an extent that several contractors were frightened off by Wright's plans. The plans were complete in 1943, but construction did not begin until 1956 because of a prohibition of new building during World War II and permit delays stemming from the radical nature of the design. It was still not complete at the time of Wright's death in 1959. In many ways Wright's Guggenheim Museum represents the spirit of architectural innovation that still pervades the practice of architecture to this day.

READINGS

from Joseph Heller, *Catch-22*, Chapter 22, "Milo the Mayor" (1961)

Catch-22 satirizes the horrors of war and the technological society and consumer culture that Heller felt was responsible for it. The connection between consumerism and militarism is made through the character of Milo Minderbinder, the officer in charge of the mess hall. Heller actually flew as a bombardier with the 12th Air Force in the Mediterranean in World War II, and in the passage excerpted here, his hero Yossarian, himself a bombardier who is desperately trying to get himself grounded, seeks to understand Milo's elaborate and ultimately hilarious traffic in eggs and tomatoes.

"I don't understand why you buy eggs for seven cents apiece in Malta and sell them for five cents," [says Yossarian].

"I do it to make a profit," [replies Milo].

"But how can you make a profit? You lose two cents an egg."

"But I make a profit of three and a quarter cents an egg by selling them for four and a quarter cents an egg to the people in Malta I buy them from for seven cents an egg. Of course, *I* don't make the profit. The syndicate makes the profit. And everybody has a share." 10

Yossarian felt he was beginning to understand. "And the people you sell the eggs to at four and a quarter cents apiece make a profit of two and three quarter cents apiece when they sell them back to you at seven cents apiece. Is that right? Why don't you sell the eggs directly to you and eliminate the people you buy them from?"

"Because I'm the people I buy them from," Milo explained. "I make a profit of three and a quarter cents apiece when I sell them to me and a profit of two and three quarter cents apiece when I buy them back from me. That's a total 20 profit of six cents an egg. I lose only two cents an egg when I sell them to the mess halls at five cents apiece, and that's how I can make a profit buying eggs for seven cents apiece and selling them for five cents apiece. I pay only one cent apiece at the hen when I buy them in Sicily."

"In Malta," Yossarian corrected. "You buy your eggs in Malta, not Sicily."

Milo chortled proudly. "I don't buy eggs from Malta," he confessed . . . "I buy them in Sicily for one cent apiece and transfer them to Malta secretly for four and a half cents 30 apiece in order to get the price of eggs up to seven cents apiece when people come to Malta looking for them."

"Why do people come to Malta for eggs when they're so expensive there?"

"Because they've always done it that way."

"Why don't they look for eggs in Sicily?"

"Because they've never done it that way."

"Now I really don't understand. Why don't you sell your mess halls the eggs for seven cents apiece instead of for five cents apiece?" 40

"Because my mess halls would have no need for me then. Anyone can buy seven-cents-apiece eggs for seven cents apiece."

"Why don't they bypass you and buy the eggs directly from you in Malta at four and a quarter cents apiece?"

"Because I wouldn't sell it to them."

"Why wouldn't you sell it to them?"

"Because then there wouldn't be as much room for a profit. At least this way I can make a bit for myself as a middleman."

"Then you do make a profit for yourself," Yossarian declared. 50

"Of course I do. But it all goes to the syndicate. And everybody has a share. Don't you understand? It's exactly what happens with those plum tomatoes I sell to Colonel Cathcart."

"*Buy*," Yossarian corrected him. "You don't *sell* plum tomatoes to Colonel Cathcart and Colonel Korn. You *buy* plum tomatoes from them."

"No, *sell*," Milo corrected Yossarian. "I distribute my plum tomatoes in markets all over Pianosa under an assumed name so that Colonel Cathcart and Colonel Korn can buy them up from me under their assumed names at four cents apiece and sell them 60 back to me the next day for the syndicate at five cents apiece. They make a profit of one cent apiece, I make a profit of three and a half cents apiece, and everybody comes out ahead." ■

Reading Question

Heller's ploy in this passage is to make nonsense sound sensible. How can the passage be understood as an indictment of war itself?

Summary

■ **World War II** No event underscores the growing decenteredness of twentieth-century culture more than World War II. The fighting occurred across the Pacific region, in Southeast Asia, in North Africa and the Middle East, and in Europe, from France to Russia. As colonial powers withdrew their troops from occupied territories to fight in the war, nationalist movements arose in India, Palestine, Algeria, Indonesia, and across Africa, making the war's impact truly global. The human destruction was staggering—some 40 million dead—but even more devastating was the human capacity for genocide and murder revealed by the Holocaust in Germany and the American bombing of Hiroshima and Nagasaki in Japan. Elie Wiesel's *Night* recounts his own experiences in the German concentration camps. Alain Resnais's documentary film *Night and Fog* addressed the question of responsibility for the Holocaust. Shomei Tomatsu recorded the physical deformities of Japanese survivors of the American atomic bomb, equating their monstrous features with the postwar Americanization of Japan. The monstrosity of the bomb was also the subject of the *Godzilla* films of director Ishiro Honda.

■ **Europe after the War: The Existential Quest** After the war, Europe was gripped by a profound pessimism. The existential philosophy of Jean-Paul Sartre was a direct response. Sartre argued that "Existence precedes essence . . . In a word, man must create his own essence; it is in throwing himself into the world, in suffering it, in struggling with it, that—little by little—he defines himself." He agreed that the human condition is defined by alienation, anxiety, lack of authenticity, and a sense of nothingness, but that this did not abrogate the responsibility to act and create meaning. Sartre's lifelong companion, Simone de Beauvoir, argued, in *The Second Sex*, that the only way women could undertake an authentic existence was to create themselves rather than allowing men to define them. Others in Sartre's circle contributed to the existential movement. Albert Camus' anti-hero Meursault, in *The Stranger*, possesses one great existential virtue—the refusal to lie. The absurdity of Meursault's position mirrored Sartre's own play *No Exit* and Samuel Beckett's *Waiting for Godot*, both of which are examples of the Theater of the Absurd. In art, Alberto Giacometti's emaciated figures seemed to capture the human condition as trapped halfway between being and nothingness. Jean Dubuffet's *art brut*, "raw art," projected a condition of formlessness that reflected the disorder and chaos of the age.

■ **America after the War: Triumph and Doubt** The unprecedented prosperity of the United States after the war included the introduction of new products and services and the mass adoption of television as the primary form of entertainment. This created a culture of consumerism that Joseph Heller parodied in his novel *Catch-22*. A note of sincerity was struck by the Abstract Expressionist painters, who applied Sartre's existentialist philosophy to art by defining themselves through a personal struggle with paint and canvas and the gestural energy that struggle revealed. Jackson Pollock and Willem de Kooning inspired a generation of artists, including their own wives, to abandon representation in favor of directly expressing their emotions on the canvas in totally abstract terms. Color-field painters Mark Rothko and Helen Frankenthaler created more meditative spaces based on large expanses of undifferentiated color. The sculptors Alexander Calder and David Smith created dynamic works that, in the first instance, literally moved, and in the second, required the viewer to move around them.

At the same time, the Beat generation, a younger, more rebellious generation of writers and artists, began to critique American culture. Swiss photographer Robert Frank's *The Americans* revealed a side of American life that outraged a public used to seeing the country through the lens of a happy optimism. Allen Ginsberg lashed out in his poem "Howl" with a forthright and uncensored frankness that seemed to many an affront to decency. Composer John Cage, dancer Merce Cunningham, and artist Robert Rauschenberg collaborated on works in which each part—music, dance, and stage and costume design—was created independently of the other. Chance determined how the production would turn out. Rauschenberg brought elements from everyday life into his combine paintings—works that were half sculpture, half painting—while Cage's music relied on randomly generated or found sounds. Allan Kaprow invented works of art called Happenings in which artist and audience participated on equal terms.

In architecture, Mies van der Rohe, transplanted from the Bauhaus to Chicago, brought the International Style to America. Frank Lloyd Wright's Solomon R. Guggenheim Museum, however, is a conscious counterstatement to Mies's rationalist geometry, its organic forms echoing the natural world.

Glossary

abstract expressionism A style of painting practiced by American artists working during and after World War II.

action painting A term coined by critic Harold Rosenberg to reflect his understanding that the Abstract Expressionist canvas was "no longer a picture, but an event."

art brut Literally "raw art," any work unaffected by cultural convention.

atheistic existentialism A philosophy that argues that individuals must define the conditions of their own existence and choose to act ethically even in a world without God.

Beat generation The American poets, writers, and artists of the 1950s who sought a heightened and, they believed, more authentic style of life, defined by alienation, nonconformity, sexual liberation, drugs, and alcohol.

black humor A type of humor characterized by dark sarcasm and irony.

Christian existentialism A philosophy that argues that individuals must define the conditions of their own existence and that religion can provide a "unifying center" for that existence.

combine paintings Works created by Robert Rauschenberg beginning in the mid-1950s that combine all manner of materials.

Happening A type of multimedia event in which artists and audience participate as equal partners.

Holocaust The systematic extermination of 6 million Jews and 5 million others—particularly Gypsies, Slavs, the handicapped, and homosexuals—by the Nazis during World War II.

mobiles Alexander Calder's suspended sculptures, the movement of which are subject to the unpredictable currents of air.

passive resistance The method of protest used by Gandhi in his nonviolent campaign against the British in India resulting in his repeated arrest.

Theater of the Absurd A theater in which the meaninglessness of existence is the central thematic concern.

Critical Thinking Questions

1. In what ways do the American Beats reflect the existentialism of Jean-Paul Sartre?

2. To the Beats, the architecture of the International Style represented all that was wrong with America. How would you explain their thinking?

3. The Holocaust and the bombing of Hiroshima and Nagasaki demonstrated, as Freud had put it in his 1930 *Civilization and Its Discontents* (see chapter 42), that "Men have gained control over the forces of nature to such an extent that with their help they would have no difficulty in exterminating one another to the last man." How do you account for Freud's ability to so accurately foretell the future?

O n February 27, 1933, the Reichstag [RIKE-shtahg] in Berlin, the seat of Germany's parliamentary government, was set ablaze and almost completely destroyed by fire. Only its walls remained standing. Adolf Hitler, then chancellor of Germany, was able to convince President Hindenburg that a communist revolution was underway and that the urgency of the moment required an emergency decree suspending the basic rights of the country's citizens. In this way Hitler initiated his final rise to power, though he never ruled from the Reichstag itself.

After World War II, with Germany divided, the West German Parliament was relocated to Bonn. The Reichstag was the only structure in Germany under the jurisdiction of all the allies—the Americans, the Soviets, the English, the French—and the two Germanys, East and West. But it remained empty, a ghostly symbol of a possible unified Germany, a dream that seemed remote after the Berlin Wall was erected in 1961 just to its east.

To the Bulgaria-born artist Christo [KRISS-toh] (Javacheff), however, the Reichstag seemed to offer the greatest of possibilities. He was just a child when Hitler subsumed Bulgaria at the outset of World War II, and still a teenager during the country's bitter postwar Stalinization. Christo had escaped through Czechoslovakia to Vienna in 1957 at the age of 22, arriving in Paris the following year. There he explored the formal and philosophical possibilities of packaging. There he also met his wife and partner, Jeanne-Claude [zhun-klohd], and together this creative team began producing art by wrapping objects that ranged from furniture to automobiles, though often the contents of the packages remained a mystery. By the late 1960s they had begun wrapping entire buildings.

Wrapping, for Christo and Jeanne-Claude, is a form of renewal, of giving back to people what has been forgotten, lost, or repressed. The prospect of wrapping the Reichstag was one that Christo and Jeanne-Claude found particularly appealing. As Christo told an interviewer:

> East–West relations shaped the culture and life of the 20th century. That is why I am here in the West, because there was the Cold War. . . . The Cold War was part of my arriving in the West and I was very eager to do a project involving East-West relations. The only place in the world where East and West were meeting, with tremendous drama and space in an extraordinary situation was Berlin.

East–West relations being what they were when Christo and Jeanne-Claude began the project in 1971, negotiations among all the interested parties were protracted. But after the reunification of Germany in 1990 and the collapse of the Soviet Union a year later, Christo and Jeanne-Claude's dream finally became a reality. After 54 trips to Germany, Christo and Jeanne-Claude completed wrapping the Reichstag on June 14, 1995 (Fig. **45.24**). It remained wrapped for 14 days. The German parliament was transferred to the Reichstag in April 1999. ■

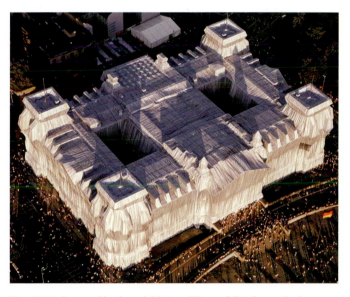

Fig. 45.24 Jeanne-Claude and Christo. *Wrapped Reichstag, Berlin.* **1971–1995.** Silver polypropylene cloth and blue cord, triptych, aerial view. © Christo 1995. Wrapping the building required 119,603 square yards of fabric and 48,836 miles of yarn for weaving. (See chapter 48 for further discussion of Christo and Jeanne-Claude.)

46 The Turbulent 1960s

Decade of Change

The Ongoing Fight for Civil Rights

Mass Media and the Culture of Consumption

Minimalism in Art and Music

The Vietnam War: Rebellion and the Arts

High and Low: The Example of Music

The Birth of the Feminist Era

> **"** *There are just laws and there are unjust laws. One has not only a legal but a moral responsibility to obey just laws. Conversely, one has a moral responsibility to disobey unjust laws. . . . We can never forget that everything Hitler did in Germany was 'legal' and everything the Hungarian freedom fighters did in Hungary was 'illegal.'* **"**
>
> Martin Luther King, "Letter from Birmingham Jail"

◄ **Fig. 46.1 One of the "Little Rock Nine," Elizabeth Eckford, braves a jeering crowd, September 4, 1957.** Alone, as school opened in 1957, Elizabeth Eckford faced the taunts of the crowd defying the Supreme Court order to integrate Central High School in Little Rock, Arkansas. The image captures perfectly the hatred—and the determination—that the civil rights movement inspired.

N 1954, THE U.S. SUPREME COURT RULED THAT RACIALLY SEGREGATED
schools violated the Constitution. In *Brown v. Board of Education,* the Court found that
it was not good enough for states to provide "separate but equal" schools. "Separate
educational facilities are inherently unequal," the Court declared, and were in

violation of the Fourteenth Amendment to the Constitution's guarantee of equal protection. The Justices called on states with segregated schools to desegregate "with all deliberate speed."

Within a week, the state of Arkansas announced that it would seek to comply with the court's ruling. The state had already desegregated its state university and its law school. Now it was time to desegregate elementary and secondary schools. The plan was for Little Rock Central High School to open its doors to African American students in the fall of 1957. But on September 2, the night before school was to start, Governor Orval Faubus ordered the state's National Guard to surround the high school and prevent any black students from entering. Faubus claimed he was trying to prevent violence. The nine black students who were planning to attend classes that day decided to arrive together on September 4. Unaware of the plan, Elizabeth Eckford arrived alone (Fig. **46.1**). The others followed, but were all turned away by the Guard. Nearly three weeks later, after a federal injunction ordered Faubus to remove the Guard, the nine finally entered Central High School. Little Rock citizens then launched a campaign of verbal abuse and intimidation to prevent the black students from remaining in school. Finally, President Eisenhower ordered 1,000 paratroopers and 10,000 National Guardsmen to Little Rock, and on September 25, Central High School was officially desegregated. Nevertheless, chaperoned throughout the year by the National Guard, the nine black students were spit at and reviled every day, and none of them returned to school the following year.

By April 1963, the focal point of racial tension and strife in the United States had shifted to Birmingham, Alabama (see Map **46.1**). In protest over desegregation orders, the city had closed its parks and public golf courses. In retaliation, the black community called for a boycott of Birmingham stores. The city responded by halting the distribution of food normally given to the city's needy families. In this progressively more heated atmosphere, the Southern Christian Leadership Conference (SCLC), led by the Reverend Martin Luther King, Jr. (1929–1968), decided Birmingham would be their battlefield. In the spring of 1963, groups of protesters, gathering first at local churches, descended on the city's downtown both to picket businesses that continued to maintain "sepa-

rate but equal" practices, such as different fitting rooms for blacks and whites in clothing stores, and to take seats at "whites only" lunch counters. The city's police chief, Bull Connor, responded by threatening to arrest anyone marching on the downtown area. On April 6, 50 marchers were arrested. The next day, 600 marchers gathered, and police confronted them with clubs, attack dogs, and the fire department's new water hoses, which, they bragged, could rip the bark off a tree. But day after day, the marchers kept coming, their ranks swelling. A local judge issued an injunction banning the marches, but on April 12, the Reverend Martin Luther King led a march of 50 people in defiance of the injunction. Crowds gathered in anticipation of King's arrest, and, in fact, he was quickly taken into custody and placed in solitary confinement in the Birmingham jail.

The civil rights movement that was ignited in Birmingham was just one manifestation of a growing dissatisfaction in America—and abroad—with the status quo, especially among a younger generation that had not experienced the hardships of the Great Depression and the horrors of the Second World War. African-American artist Faith Ringgold (1934–) captures something of the dynamics of this dissatisfaction in her 1964 painting *God Bless America* (Fig. **46.2**). The blue-eyed white woman portrayed in the painting, hand over her heart as she hears the same Irving Berlin song that a generation earlier Woody Guthrie had found jingoistic and elitist (see chapter 44), embodies the status quo of blind patriotism. But this same woman, the image implies, is also a racist, as on the right side of the painting, the stripes of the flag are transformed into the black bars of a jail cell and the star of the flag, by implication, into a sheriff's badge. This is an image painted by a 30-year-old woman challenging the worldview of an older generation—and not without a sense of righteous indignation.

That challenge is the subject of this chapter. It manifested itself not only in the civil rights movement, but in the anti-Vietnam War movement, in the burgeoning feminist movement, in student unrest both in the United States and abroad, and it finds particularly powerful expression in popular music, epitomized by Bob Dylan's 1964 anthem "The Times They Are A-Changin'." It manifested itself in ways that, in retrospect, seem slightly ridiculous—in the way, for instance, that long hair, on young males especially, signified

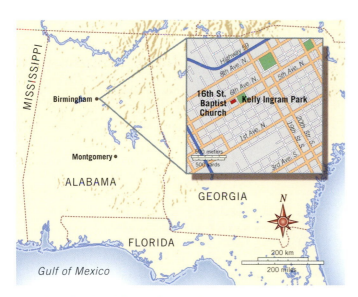

Map 46.1 The City of Birmingham, Alabama.

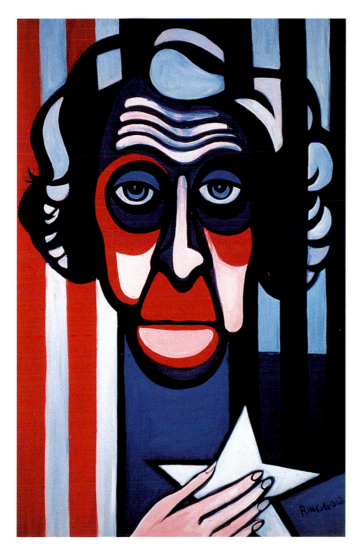

Fig. 46.2 Faith Ringgold. *God Bless America.* **1964.** Oil on canvas, 31″ × 19″. © Faith Ringgold, 1964. This is one of a series of 20 paintings done between 1963 and 1967 called *The American People*, focusing on racial conflict and discrimination.

to their elders a rejection of traditional values. But it manifested itself in other ways that have had a profound impact on American culture ever since—in, for instance, the 1973 Supreme Court decision *Roe v. Wade* that legalized abortion. This challenge to traditional values found a sympathetic audience in the arts, which, after all, had been challenging the authority of tradition since at least Picasso. But as never before, except perhaps in Berlin as Hitler rose to power (see chapter 44), did the arts so overtly engage in social critique.

The 1960s—a decade whose spirit extends well into the 1970s, until the end of the Vietnam War in 1975—was an era with many centers. New York was the center of the art world; Birmingham of the civil rights movement; Berkeley, California, of the student movement. Women began to question their central role as homemakers. And while Washington, DC was the center of government, it was being torn apart, as marchers filled its streets in protest and an embattled president was forced to resign before he could be impeached. Without a well-defined center—geographic or otherwise—the nation seemed to many unmoored and adrift, "blowing in the wind."

The Ongoing Fight for Civil Rights

Martin Luther King's struggle in Birmingham was the culmination of an ongoing fight to desegregate American society. Soon after Reconstruction, the period immediately following the Civil War, Southern states passed a group of laws that effectively established a racial caste system that relegated black Americans to second-class status and institutionalized segregation. In the South, the system was known as Jim Crow, but discrimination against blacks was entrenched in the North as well. At the outset of World War II, A. Philip Randolph (1889–1979) had organized a march on Washington "for jobs in national defense and equal integration in the fighting forces." Ten thousand blacks were scheduled to march on July 1, 1941, when President Roosevelt issued Executive Order 8802 on June 25, banning discriminatory hiring practices in the defense industry and the federal government.

But the momentum of the civil rights movement really began on December 1, 1955, when Rosa Parks (1913–2005) was arrested in Montgomery, Alabama, for refusing to move to the Negro section of a bus. Dr. Martin Luther King, then pastor of the Dexter Avenue Baptist Church in Montgomery, called for a boycott of the municipal bus system in protest. The boycott lasted over a year. In November 1956, the U.S. Supreme Court declared that the segregation of buses violated the Fourteenth Amendment. A federal injunction forced Montgomery officials to desegregate their buses, and Dr. King and a white minister rode side by side in the front seat of a city bus.

Martin Luther King's Message of Resistance

Meanwhile, in Birmingham, the jailed Martin Luther King had written a letter to a group of local white clergy who had publicly criticized him for willfully breaking the law and

promoting demonstrations. Published in June 1963 in *The Christian Century*, what came to be known as the "Letter from Birmingham Jail" became the key text in the civil rights movement, providing the philosophical framework for the massive civil disobedience that King believed was required (**Reading 46.1**):

READING 46.1 **from Martin Luther King, "Letter from Birmingham Jail" (1963)**

You express a great deal of anxiety over our willingness to break laws. . . [but] there are two types of laws. There are just laws and there are unjust laws. One has not only a legal but a moral responsibility to obey just laws. Conversely, one has a moral responsibility to disobey unjust laws. . . . We can never forget that everything Hitler did in Germany was "legal" and everything the Hungarian freedom fighters did in Hungary was "illegal." It was "illegal" to aid and comfort a Jew in Hitler's Germany.

In the days between King's incarceration and the letter's publication, the situation in Birmingham had worsened. A local disc jockey urged the city's African-American youth to attend a "big party" at Kelly Ingram Park, across from the 16th Street Baptist Church (see Map 46.1). It was no secret that the "party" was to be a mass demonstration. At least 1,000 youth gathered to face the police, most of them teenagers but some as young as seven or eight years old. As the chant of "Freedom, Freedom NOW!" rose from the crowd, the Birmingham police closed in with their dogs, ordering them to attack those who did not flee.

Police wagons and squad cars were quickly filled with arrested juveniles, and as the arrests continued, the police used school buses to transport over 600 children and teenagers to jail. By the next day, the entire nation—in fact, the entire world—had come to know Birmingham Police Chief Bull Connor, as televised images documented his dogs attacking children and his fire hoses literally washing them down the streets.

The youth returned, with reinforcements, over the next few days. By May 6, over 2,000 demonstrators were in jail, and police patrol cars were pummeled with rocks and bottles whenever they entered black neighborhoods. As the crisis mounted, secret negotiations between the city and the protestors resulted in change: Within 90 days, all lunch counters, restrooms, department store fitting rooms, and drinking fountains would be open to all, black and white alike. The 2,000 people under arrest would be released.

It was a victory, but Birmingham remained uneasy. On Sunday, September 15, a dynamite bomb exploded in the basement of the 16th Street Baptist Church, a center for many civil rights rallies and meetings, killing four girls—one

11-year-old and three 14-year-olds. As news of the tragedy spread, riots and fires broke out throughout the city and two more teenagers were killed.

The tragedy drew many moderate whites into the civil rights movement. Popular culture had put them at the ready. In June 1963, the folk-rock trio Peter, Paul and Mary released "Blowin' in the Wind," their version of the song that Bob Dylan (1941–) had written in April 1962. The Peter, Paul and Mary record sold 300,000 copies in two weeks. The song famously ends:

How many years can some people exist,
before they're allowed to be free?
How many times can a man turn his head,
Pretending he just doesn't see?
The answer, my friend, is blowin' in the wind,
The answer is blowin' in the wind.

At the March on Washington later that summer—an event organized by the same A. Philip Randolph who had conceived of a similar event over 20 years earlier, this time to promote passage of the Civil Rights Act—Peter, Paul and Mary performed the song live before 250,000 people, the largest gathering of its kind to that point in the history of the United States. Not many minutes later, Martin Luther King delivered his famous "I have a dream" speech to the same crowd. The trio's album, *In the Wind*, released in October, quickly rose to number one on the charts. The winds of change were blowing across the country.

Black Identity

It is probably fair to say that an important factor contributing to the civil rights movement was the growing sense of ethnic identity among the African-American population. Its origins can be traced back to the Harlem Renaissance (see chapter 43), but throughout the 1940s and 1950s, a growing sense of cultural self-awareness and self-definition was taking hold, even though African Americans did not share in the growing wealth and sense of well-being that marked postwar American culture.

Sartre's "Black Orpheus" One of the most important contributions to this development was existentialism, with its emphasis on the inevitability of human suffering and the necessity for the individual to act responsibly in the face of that predicament. Jean-Paul Sartre's 1948 essay "Orphée Noir" [or-FAY nwahr] or "Black Orpheus" was especially influential. The essay defined "blackness" as a mark of authenticity:

A Jew, a white among whites, can deny that he is a Jew, declaring himself a man among men. The black cannot deny that he is black nor claim for himself an abstract, colorless humanity: he is black. Thus he is driven to authenticity: insulted, enslaved, he raises himself up. He picks up the word "black" ["Négre"] that they had thrown at him like a stone, he asserts his blackness, facing the white man, with pride.

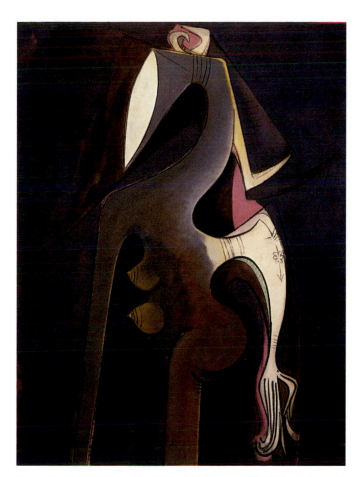

Fig. 46.3 Wilfredo Lam. *The Siren of the Niger*. 1950. Oil and charcoal on canvas, 51″ × 38⅛″. Signed LR in Oil: Wifredo Lam/1950. Hirshhorn Museum and Sculpture Garden, Smithsonian Institution, Gift of Joseph H. Hirshhorn, 1972. © 2009 Artists Rights Society (ARS), New York/DACS. Lam arrived in Paris in 1938 with a letter of introduction to Picasso, who both befriended him and influenced his work.

If, like the Jews, blacks had undergone a shattering diaspora [die-AS-por-uh], or dispersion, across the globe, traces of the original African roots were evident in everything from American blues and jazz to the African-derived religious and ritual practices of the Caribbean that survived as Vodun, Santeria, and Condomblé. For Sartre, these were "Orphic" voices, which like master musician and poet Orpheus of Greek legend, who descended into Hades [HAY-deez] to rescue his beloved Eurydice [yoo-RID-ih-see], had descended into the "black substratum" of their African heritage to discover an authentic—and revolutionary—voice. In works like *The Siren of the Niger* (Fig. **46.3**), Wilfredo Lam, a Cuban-born artist of African, Chinese, and European descent, evokes the "Orphic" voice of Africa, the fertile wellspring of inspiration and creativity. Similarly, the black American writer James Baldwin (1924–1987) would describe the power of the blues in his 1957 short story, "Sonny's Blues." Playing the jazz standard

"Am I Blue," the band "began to tell us what the blues were all about," Baldwin writes (for a longer excerpt see **Reading 46.2**, page 1520):

> They were not about anything very new. He and his boys up there were keeping it new, at the risk of ruin, destruction, madness and death, in order to find new ways to make us listen. For, while the tale of how we suffer, and how we are delighted, and how we may triumph is never new, it must always be heard. There isn't any other tale to tell, it's the only light we've got in all this darkness.

Ralph Ellison's *Invisible Man* Baldwin was, in fact, one of the most influential writers of his generation. *Go Tell It on the Mountain* (1953) and *Notes of a Native Son* (1955), the first a semi-autobiographical account of growing up in Harlem, and the second a collection of deeply personal essays on race, won him great praise. But probably more instrumental in introducing existentialist attitudes to an American audience was the novel *Invisible Man*, published in 1952 by Ralph Waldo Ellison (1913–1984) and written over a period of about seven years in the late 1940s and early 1950s. In part, the novel is an ironic reversal of the famous trope of Ellison's namesake, Ralph Waldo Emerson, in his essay "Nature" (see chapter 33): "I become a transparent eye-ball. I am nothing. I see all. . . ." "I am an invisible man," Ellison's prologue to the novel begins (**Reading 46.3a**):

READING 46.3a | **from Ralph Ellison, *Invisible Man* (1952)**

No, I am not a spook like those who haunted Edgar Allan Poe; nor am I one of your Hollywood-movie ectoplasms. I am a man of substance, of flesh and bone, fiber and liquid—and I might even be said to possess a mind. I am invisible—understand, simply because people refuse to see me. . . . That invisibility to which I refer occurs because of a peculiar disposition of the eyes of those with whom I come in contact. A matter of the construction of their inner eyes, those eyes with which they look through their physical eyes upon reality.

Ellison's story is told by a narrator who lives in a subterranean "hole" in a cellar at the edge of Harlem into which he has accidentally fallen in the riot that ends the novel (Fig. **46.4**). As "underground man" his self-appointed task is to realize, in the narrative he is writing (the novel itself), the realities of black American life and experience. At the crucial turning point of the novel, after seeing three boys in the subway, dressed in "well-pressed, too-hot-for-summer suits. . . . walking slowly, their shoulders swaying, their legs swinging from their hips in trousers that ballooned from cuffs fitting snug about their ankles; their coats long and hip-tight with

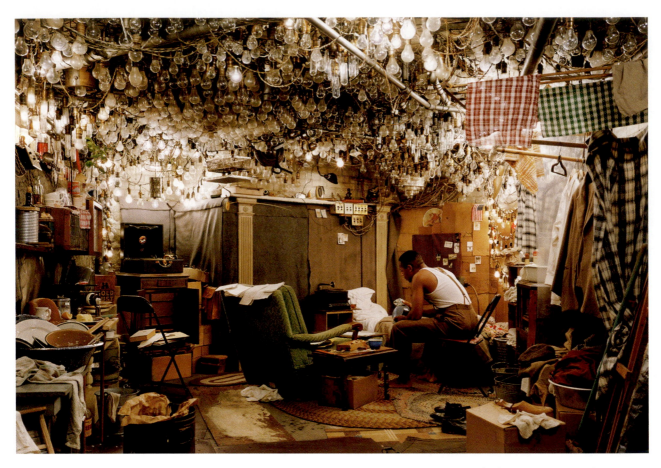

Fig. 46.4 Jeff Wall. *After* Invisible Man *by Ralph Ellison, "The Preface," Edition of 2.* **1999–2000.** Cibachrome transparency, aluminum light box, fluorescent bulbs, 75 1/4" × 106 1/4" × 10 1/4". Marian Goodman Gallery, New York. In his photographic re-creation of the setting of Ellison's novel, Wall emphasizes, as does the novel, the 1,269 light bulbs in the room, all illegally connected to the electricity grid. "I love light," Ellison writes, "perhaps you'll think it strange that an invisible man should need light, desire light, love light. But it is precisely because I am invisible. Light confirms my reality, gives birth to my form." Wall recognizes in these words a definition of photography as well.

shoulders far too broad to be those of natural western men," he muses (**Reading 46.3b**):

<div style="border:1px solid #999; padding:8px;">

READING 46.3b **from Ralph Ellison,**
***Invisible Man* (1952)**

Moving through the crowds along 125th Street, I was painfully aware of other men dressed like the boys, and of girls in dark exotic-colored stockings, their costumes surreal variations of downtown styles. They'd been there all along, but somehow I'd missed them. . . . They were outside the groove of history, and it was my job to get them in, all of them. I looked into the design of their faces, hardly a one that was unlike someone I'd known down South. Forgotten names sang through my head like forgotten scenes in dreams. I moved through the crowd, the sweat pouring off me, listening to the grinding roar of traffic, the growing sound of a record shop loudspeaker blaring a languid blues. I stopped. Was this all that would be recorded? Was this the only true history of the times, a mood blared by trumpets, trombones, saxophones and drums, a song with turgid, inadequate words?

</div>

The blues is not enough. His new self-appointed task is to take the responsibility to find words adequate to the history of the times. Up to this point, his own people have been as invisible to him as he to them. He has opened his own eyes as he must now open others. At the novel's end, he is determined to come out of his "hole." "I'm shaking off the old skin," he says, "and I'll leave it here in the hole. I'm coming out, no less invisible without it, but coming out nevertheless. And I suppose it's damn well time. . . . Perhaps that's my greatest social crime, I've overstayed my hibernation, since there's a possibility that even an invisible man has a socially responsible role to play."

Asserting Blackness in Art and Literature One of Ellison's narrator's most vital realizations is that he must assert, above all else, his blackness, not hide from it. He must not allow himself to be absorbed into white society. "Must I strive toward colorlessness?" he asks.

> But seriously, and without snobbery, think of what the world would lose if that should happen. America is woven of many strands; I would recognize them and let it so remain. . . . Our fate is to become one, and yet many— This is not prophecy, but description.

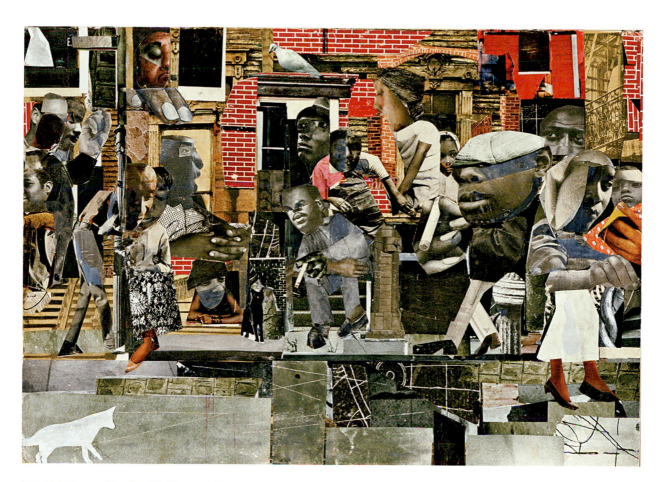

Fig. 46.5 Romare Bearden. *The Dove*. 1964. Cut-and-pasted paper, gouache, pencil, and colored pencil on cardboard, $13\frac{3}{8}'' \times 18\frac{3}{4}''$. Blanchette Rockefeller Fund. (377.1971). The Museum of Modern Art/Licensed by Scala-Art Resource, NY. Art © Estate of Romare Bearden/Licensed by VAGA, NY. The white dog at the lower left appears to be stalking the black cat at the foot of the steps in the middle, in counterpoint to the dove above the door.

There could be no better description of the collages of Romare Bearden (1911–1988), who had worked for two decades in an almost entirely abstract vein, but who in the early 1960s began to tear images out of *Ebony*, *Look*, and *Life* magazines and assemble them into depictions of black experience. *The Dove* (Fig. **46.5**)—named for the white dove that is perched over the central door, a symbol of peace and harmony—combines forms of shifting scale and different orders of fragmentation. For example, a giant cigarette extends from the hand of the dandy, sporting a cap, at the right, and the giant fingers of a woman's hand reach over the windowsill at the top left. The resulting effect is almost kaleidoscopic, an urban panorama of a conservatively dressed older generation and hipper, younger people gathered into a scene nearly bursting with energy—the "one, and yet many." As Ellison wrote of Bearden's art in 1968:

> Bearden's meaning is identical with his method. His combination of technique is in itself eloquent of the sharp breaks, leaps of consciousness, distortions, paradoxes, reversals, telescoping of time and surreal blending of styles, values, hopes, and dreams which characterize much of [African] American history.

The sense of a single black American identity, one containing the diversity of black culture within it that Bearden's work embodies, is also found in the work of poet and playwright Amiri Baraka [buh-RAH-kuh] (1934–). Baraka changed his name from Leroi Jones in 1968 after the assassination of the radical black Muslim minister, Malcolm X, in 1965. Malcolm X believed that blacks should separate themselves from whites in every conceivable way, that they should give up integration as a goal and create their own black nation. As opposed to Martin Luther King, who advocated nonviolent protest, Malcolm advocated violent action if necessary: "How are you going to be nonviolent in Mississippi," he asked a Detroit audience in 1963, "as violent as you were in Korea? How can you justify being nonviolent in Mississippi and Alabama, when your churches are being bombed, and your little girls are being murdered? . . . If violence is wrong in America, violence is wrong abroad."

Baraka's chosen Muslim name, Imamu Amiri Baraka, refers to the divine blessing associated with Muslim holy men that can be transferred from a material object to a person, so that a pilgrim returning from Mecca is a carrier of *baraka*. Baraka's 1969 poem, "Ka'Ba" [KAH-buh], seeks to imbue

baraka upon the people of Newark, New Jersey, where Baraka lived (**Reading 46.4**):

READING 46.4 Amiri Baraka, "Ka'Ba" (1969)

A closed window looks down
on a dirty courtyard, and Black people
call across or scream across or walk across
defying physics in the stream of their will.

Our world is full of sound
Our world is more lovely than anyone's
tho we suffer, and kill each other
and sometimes fail to walk the air.

We are beautiful people
With African imaginations
full of masks and dances and swelling chants
with African eyes, and noses, and arms
tho we sprawl in gray chains in a place
full of winters, when what we want is sun.

We have been captured,
and we labor to make our getaway, into
the ancient image; into a new

Correspondence with ourselves
and our Black family. We need magic
now we need the spells, to raise up
return, destroy, and create. What will be

the sacred word?

The sacred word, the poem's title suggests, is indeed "Ka'Ba." But, despite the spiritual tone of this poem, Baraka became increasingly militant during the 1960s. In 1967 he produced two of his own plays protesting police brutality. A year later, in his play *Home on the Range*, his protagonist Criminal breaks into a white family's home only to find them so immersed in television that he cannot communicate with them. The play was performed as a benefit for the leaders of the Black Panther party, a black revolutionary political party founded in 1966 by Huey P. Newton (1942–1989) and Bobby Seale (1936–) and dedicated to organizing support for a socialist revolution.

Bettye Saar's *The Liberation of Aunt Jemima* (Fig. **46.6**) reflects this thinking, putting a rifle into the hands of the familiar 1950s and 1960s icon used to market syrup and pancakes. Other events, too, reflected the growing militancy of the African-American community. In August 1965, violent riots in the Watts district of South Central Los Angeles lasted for six days, leaving 34 dead, over a thousand people injured, nearly 4,000 arrested, and hundreds of buildings destroyed. In July 1967, rioting broke out in both Newark and Detroit. In Newark, six days of rioting left 23 dead, over 700 injured, and close to 1,500 people arrested. In Detroit, five days of rioting resulted in 43 people dead, 1,189 injured, over 7,000 people arrested, and 2,509 stores looted or burned. Finally, it seemed

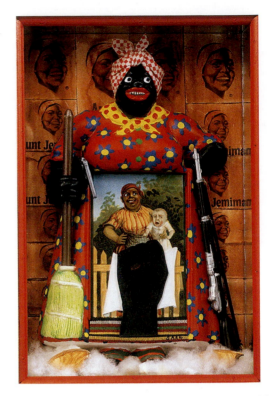

Fig. 46.6 Bettye Saar. *The Liberation of Aunt Jemima.* **1972.** Mixed media, $11^{3}/_{4}'' \times 8'' \times 2^{3}/_{4}''$. Purchased with the aid of funds from the National Endowment of the Arts. Selected by the Committee for the Acquisition of African American Art. Photo Benjamin Blackwell. University of California/Berkeley Art Museum. The black-fisted symbol of Black Power rises in front of the picture of the stereotypical "mammy."

to many that Martin Luther King's pacifism had come back to haunt him when he was assassinated on April 4, 1968.

It was directly out of this climate that the popular poetry/music/performance/dance phenomenon known as rap, or hip hop, came into being. Shortly after the death of Martin Luther King, on Malcolm X's birthday, May 19, 1968, David Nelson, Gylan Kain, and Abiodun Oyewole founded the group the Last Poets, named after a poem by South African poet Willie Kgositsile (1938–) in which he had claimed that it would soon be necessary to put poetry aside and take up guns in the looming revolution. "Therefore we are the last poets of the world," Kgositsile concluded. In performance, the Last Poets were deeply influenced by the musical phrasings of Amiri Baraka's poetry. They improvised individually, trading words and phrases back and forth like jazz musicians improvising on each other's melodies, until their voices would come together in a rhythmic chant and the number would end. Most of all, they were political, attacking white racism, black bourgeois complacency, the government and the police, whoever seemed to stand in the way of significant progress for African Americans. As Abiodun Oyewole put it, "We were angry, and we had something to say."

Equally influential was performer Gil Scott-Heron, whose recorded poem "The Revolution Will Not Be Televised" appeared on his 1970 album *Small Talk at 125th and Lenox* (**Reading 46.5**):

READING 46.5 **from Gil Scott-Heron, "The Revolution Will Not Be Televised" (1970)**

You will not be able to stay home, brother.
You will not be able to plug in, turn on and cop out.[1]
You will not be able to lose yourself on skag[2] and
skip out for beer during commercials because
The revolution will not be televised.

The revolution will not be televised.
The revolution will not be brought to you by Xerox
 in 4 parts without commercial interruptions. . . .
There will be no highlights on the Eleven O'clock News
and no pictures of hairy armed women liberationists
and Jackie Onassis blowing her nose.
The theme song will not be written by Jim Webb or
 Francis Scott Key,
nor sung by Glen Campbell, Tom Jones, Johnny Cash,
Englebert Humperdinck, or Rare Earth.
The revolution will not be televised.

The revolution will not be right back after a message about a
 white tornado, white lightning or white people.
You will not have to worry about a dove in your bedroom,
a tiger in your tank, or the giant in your toilet bowl.
The revolution will not go better with coke.
The revolution will not fight the germs that may cause
 bad breath.
The revolution *will* put you in the driver's seat.

The revolution will not be televised,
will not be televised,
 not be televised,
 be televised.
The revolution will be no re-run, brothers;
The revolution will be LIVE.

[1] **turn on and cop out:** A play on the motto of Timothy Leary (1920–1996), advocate and popularizer of the psychedelic drug LSD, who in the 1960s urged people to "turn on, tune in, drop out."
[2] **skag:** Slang for heroin.

As the next section of this chapter underscores, as angry as Scott-Heron's poem is, the poet's attitude toward American popular culture, which he strongly condemns, is closely aligned with that of Pop artists of the 1960s as well.

Mass Media and the Culture of Consumption

The power of the media—television, particularly—to draw attention to social causes had been demonstrated at Birmingham. It would be cynical to suggest that the race riots in Watts, Newark, and Detroit were staged for the media, but it is true that the media's attention to these events served to further their goals. Following President John F. Kennedy's assassination in 1963, audiences watched again and again the replaying on television of Alexander Zapruder's 26-second film of the events, just as they became obsessed with the image of the Beatles on the *Ed Sullivan Show*, and by the film *Woodstock*. Increasingly, it seemed to many observers, American culture had come to look like a vast array of made-for-television events and advertisements.

"The medium is the message," popular sociologist Marshall McLuhan (1911–1980) declared in 1964. A few years later, he had playfully transformed the phrase to "the medium is the massage," implying, at once, that the media "massage" us into belief ("All media work us over completely," he wrote), and that the media are the primary means of expression in the "mass-age." "Mass communication," he argued, is largely a misnomer—that is, "communication" in the mass media is one-directional, sent over the airwaves to a passive receiver who is, for all practical purposes, unable to respond. McLuhan also understood that the mass media exist to make a profit through the sale of advertising. They do not exist to convey information so much as to stimulate consumption of the products they advertise. As a result, McLuhan wrote, "All media exist to invest our lives with artificial perception and arbitrary values." They create a society of desire—the desire to possess and consume what we do not have.

Pop Art

In the early 1960s, especially in New York, a number of artists created a "realist" art that represented reality in terms of the media—advertising, television, comic strips—the imagery of mass culture. The famous paintings of Campbell's soup cans created by Andy Warhol (1928–1987) were among the first of these to find their way into the gallery scene (Fig. **46.7**).

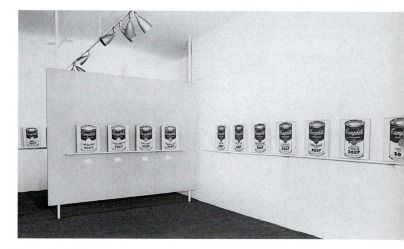

Fig. 46.7 Andy Warhol. Installation view of *Campbell's Soup Cans*, installation at Ferus Gallery. 1962. Founding Collection, The Andy Warhol Museum, Pittsburgh. In order to evoke the way we encounter Campbell's soup on the grocery shelf, Warhol placed the cans on narrow shelves on the gallery walls.

In the fall of 1962, they exhibited 32 uniform 20″ × 16″ canvases, at the Ferus Gallery in Los Angeles. Each depicted one of the 32 different Campbell's soup "flavors." Even as the paintings debunked the idea of originality—are they Campbell's or Warhol's?—their literalness redefined the American landscape as the visual equivalent of the supermarket aisle. The works were deliberately opposed to the self-conscious subjectivity of the Abstract Expressionists. It was, in fact, as if the painter had no personality at all. As Warhol himself put it, "If you want to know all about Andy Warhol, just look at the surface of my paintings and films and me, and there I am. There's nothing behind it."

The term Pop Art quickly became attached to work such as Warhol's. Coined in England in the 1950s (see chapter 45 Focus, pages 1472–1473), it soon came to refer to any art whose theme was essentially the commodification of culture—that is, the marketplace as the dominant force in the creation of "culture." Thus, Still Life #20 (Fig. 46.8) by Tom Wesselmann is contemporaneous with Warhol's Soup Cans, though neither was aware of the other until late in 1962, and both are equally "pop." Inside the cabinet with the star stenciled on it—which can be either opened or closed—are actual household items, including a package of SOS scouring pads and a can of Ajax cleanser. Above the blue table on the right, covered with two-dimensional representations cut out of magazines of various popular varieties of food and drink, is a reproduction of a highly formalist painting by the Dutch artist Piet Mondrian (see Fig. 44.5). The implication, of course, is that art—once so far removed from everyday life, not even, in this case, referring to the world—has itself become a commodity, not so very different from Coke or a loaf of Lite Diet bread. In fact, the structure and color of Wesselmann's collage subtly reflect the structure and color of Mondrian's painting, as if the two are simply two different instances of "the same."

By late 1962, Warhol had stopped making his paintings by hand, using a photo-silkscreen process to create the images mechanically and employing others to do the work for him in his studio, The Factory. One of the first of these is the Marilyn Diptych (Fig. 46.9). Marilyn Monroe had died, by suicide, in August of that year, and the painting is at once a memorial to her and a commentary on the circumstances that had brought her to despair. She is not so much a person, as

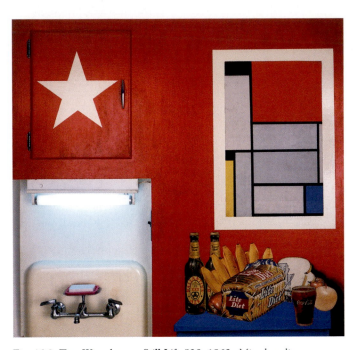

Fig. 46.8 Tom Wesselmann. *Still Life #20*. 1962. Mixed media, 48″ × 48″ × 5½″. Albright-Knox Art Gallery, Buffalo, NY. Gift of Seymour H. Knox, Jr. Art © 2008 Estate of Tom Wesselmann/VAGA, NY. An actual sink faucet and soap dish are incorporated into the composition. Its fluorescent light can be turned on or off.

Warhol depicts her, but a personality, the creation of a Hollywood studio system whose publicity shot Warhol repeats over and over again here to the point of erasure.

The enlarged comic strip paintings of Roy Lichtenstein [LIK-ten-stine] (1923–1997) are replete with heavy outlines and Ben Day dots, the process created by Benjamin Day at the turn of the century to produce shading effects in mechanical printing. Widely used in comic strips, the dots are, for Lichtenstein, a conscious parody of Seurat's pointillism (see chapter 40). But they also reveal the extent to which "feeling" in popular culture is as "canned" as Campbell's soup. In *Oh, Jeff . . .* (Fig. 46.10), "love" is emptied of real meaning as the real weight of the message is carried by the final "But. . ." Even the feelings inherent in Abstract Expressionists brushwork came under Lichtenstein's attack (Fig. 46.11). In fact, Lichtenstein had taught painting to college students, and he discovered that the "authentic" gesture of abstract expressionism could easily be taught and replicated without any emotion whatsoever—as a completely academic enterprise.

One of the most inventive of the Pop artists was Claes Oldenburg (1929–), born in Sweden in 1929, but raised from age seven in Chicago. Inspired by Allan Kaprow's essay, "The Legacy of Jackson Pollock" (see chapter 45), in 1961 he rented a storefront on New York's Lower East Side, and in time for Christmas, opened *The Store*, filled with life-size and over-life-size enameled plaster sculptures of everything from pie à la mode, to hamburgers, hats, caps, 7-Up bottles, shirt-and-tie combinations, and slices of cake. "I am for an art," he wrote in a statement accompanying the exhibition,

that is political-erotica-mystical, that does something other than sit on its ass in a museum.

I am for an art that grows up not knowing it is art at all, an art given the chance of having a starting point of zero.

I am for an art that embroils itself with the everyday crap & still comes out on top. I am for an art that imitates the human, that is comic, if necessary, or violent, or whatever is necessary.

I am for an art that takes its form from the lines of life itself, that twists and extends and accumulates and spits and drips, and is heavy and coarse and blunt and sweet and stupid as life itself.

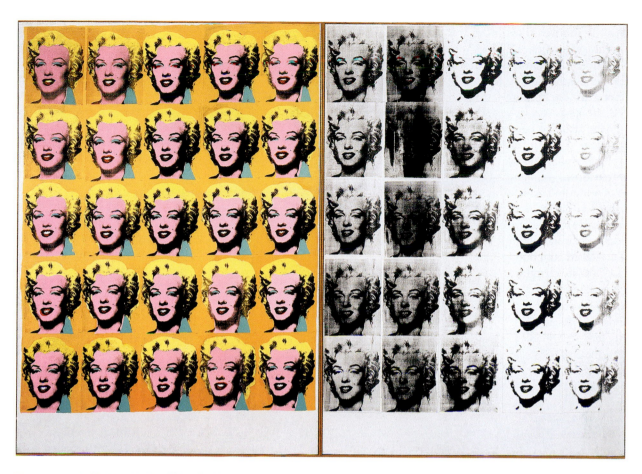

Fig. 46.9 Andy Warhol. *Marilyn Diptych.* 1962. Oil, acrylic, and silk screen on enamel on canvas, 6' 8 7/8" × 4' 9". Tate Gallery, London. Art Resource, NY. © 2003 The Andy Warhol Foundation for the Visual Arts/ARS, NY. ™ 2002 Marilyn Monroe LLC under license authorized by CMG Worldwide Inc., Indianapolis, Indiana 46256 USA www.MarilynMonroe.com. Warhol was obsessed with Hollywood, especially with the false fabric of fame that it created.

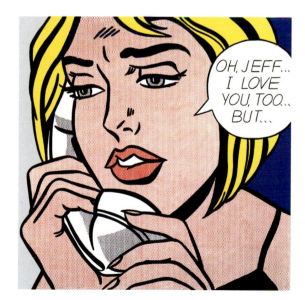

Fig. 46.10 Roy Lichtenstein. *Oh, Jeff . . . I Love You, Too . . . But* 1964. Oil on magma on canvas, 4' × 4'. Private collection. © Estate of Roy Lichtenstein. The large size of these paintings mirrors the scale of the Hollywood screen and the texture of the common billboard.

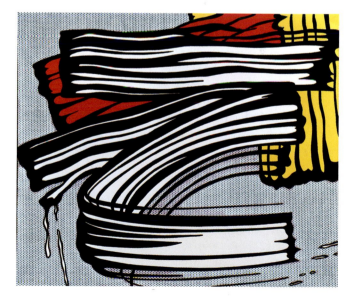

Fig. 46.11 Roy Lichtenstein. *Little Big Painting.* 1965. Oil on synthetic polymer on canvas, 5' 8" × 6' 8". Purchase, with funds from the Friends of the Whitney Museum of America Art. 66.2. Collection of the Whitney Museum of American Art, NY. This "detail" of an imaginary larger painting is nonetheless a giant in its own right.

Admiring the way that cars filled the space of auto showrooms, Oldenburg soon enlarged his objects to the size of cars and started making them out of vinyl stuffed (or not) with foam rubber. These objects toy not only with our sense of scale—a giant lightplug, for instance—but with the tension inherent in making soft something meant to be hard (Fig. **46.12**). They play, further, in almost Surrealist fashion, with notions of sexuality as well—the analogy between inserting a lightplug into its socket and sexual intercourse was hardly lost on Oldenburg, who delighted even more at the image of cultural impotence that his "soft" lightplug implied.

Minimalism in Art and Music

At first it seems that nothing could be further in character from Pop Art than *Pagosa Springs* (Fig. **46.13**), a 1960 painting by Frank Stella (1936–). Stella's work is contemporaneous with Pop, but it seems, in its almost total formality and abstraction—its overtly unsymbolic and minimal means—to turn its back almost entirely on popular culture. It is composed, simply, of copper metallic parallel lines painted carefully between visible pencil marks on an I-shaped canvas. But in its austere geometry and lack of expressive technique, it represents a revolt against the same commodity culture targeted by the Pop artists. In fact, nothing could be further from the onslaught of mass-media images in the culture of consumption than minimal art's almost pure and classical geometries. Cool and severe where Pop is brash and sardonic, minimal art is nevertheless equally concerned with challenging the presumption that art's meaning originates in the "genius" of the individual artist. If Warhol could say, "just look at the surface of my paintings and . . . and there I am. There's nothing behind it," so Stella would say of paintings such as *Pagosa*

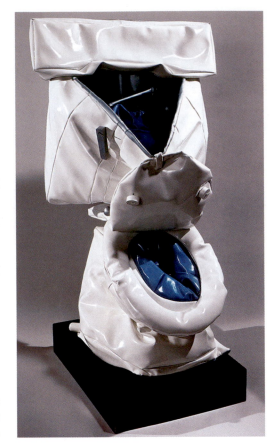

Fig. 46.12 Claes Oldenburg. *Soft Toilet*. 1966. Vinyl, Plexiglass, and kapok on painted wood base, $57\frac{1}{8}'' \times 28\frac{7}{8}'' \times 28\frac{1}{8}''$. Collection, Whitney Museum of American Art, NY. 50th Anniversary Gift of Mr. and Mrs. Victor W. Ganz. 79.83a-b. Oldenburg's art is epitomized by his slightly but intentionally vulgar sense of humor.

Fig. 46.13 Frank Stella. *Pagosa Springs*. 1960. Copper metallic enamel and pencil on canvas, $99\frac{3}{8}'' \times 99\frac{1}{4}''$. Hirshhorn Gallery and Museum, Smithsonian Institution, Washington, DC. Gift of Joseph H. Hishhorn (1972.72.169). © 2009 Artists Rights Society (ARS), NY. The shaped canvas draws attention to one of the fundamental properties of painting—the support.

Springs: "What you see is what you see. Painting to me is a brush in a bucket and you put it on a surface. There is no other reality for me than that."

Like Warhol producing series of silkscreen works at the Factory, minimalist artists were also intrigued with utilizing the processes of mass production, the use of ready-made materials, the employment of modular units. A sculptural piece by Carl Andre (1935–), *10 x 10 Alstadt Copper Square* (Fig. **46.14**), is composed of 100 identical copper tiles. In form, it closely parallels Warhol's 32 *Soup Cans* or the 50 Marilyns that make up the *Marilyn Diptych*, except that it has no imagery.

The ultimate question minimalist art asks is "What, minimally, makes a work of art?" This was not a new question. Marcel Duchamp had posed it with his "ready-mades" (see Fig. 42.5), and so had Kasimir Malevich with his Suprematist paintings (see Fig. 42.8). In many ways Pop itself was asking the same question: What, after all, made a picture of a soup can or a comic strip "art"? But minimalist artists stressed the aesthetic quality of their works; they were confident that they were producing works of (timeless) beauty and eloquence. Perhaps most of all, minimalism invites the viewer to contemplate its sometimes seductively simple beauty. It invites, in other words, the active engagement of the viewer in experiencing it.

Nevertheless, the "art" in works such as Andre's is extremely matter of fact—unmediated, that is, by concerns outside itself. The work is about the simple beauty of its form, drawing specific attention to its order or arrangement. But the order reflected in his pieces does not represent belief in a transcendent, universal order, as the work of Mondrian did. The copper squares are simply a conscious arrangement of parts, without reference to anything outside themselves. To paraphrase Frank Stella: What they are is what they are.

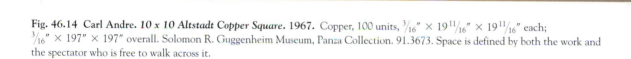

Fig. 46.14 Carl Andre. *10 x 10 Altstadt Copper Square*. 1967. Copper, 100 units, $^3/_{16}$″ × 19$^{11}/_{16}$″ × 19$^{11}/_{16}$″ each; $^3/_{16}$″ × 197″ × 197″ overall. Solomon R. Guggenheim Museum, Panza Collection. 91.3673. Space is defined by both the work and the spectator who is free to walk across it.

György Ligeti and Minimalist Music

Like minimalist artists, minimalist composers emphasized the use of consciously limited means, but rather than creating minimalist art's simple geometric compositions, minimalist musicians transformed the simple elements with which they began into dense, rich compositions. Their music was inspired by advances in new media—particularly electronic recording and production innovations—but their sound was so different that both popular and classical audiences were often put off.

Interest in electronic music was stimulated, in New York, by the Radio Corporation of America's development of the electronic synthesizer in 1955. But Europeans were equally committed to its development, among them Hungarian composer György Ligeti [lih-get-tee] (1923–2006). After World War II, the USSR controlled all of Eastern Europe, and when Hungary tried to break away in 1956, the Soviets sent their tanks into Budapest. Ligeti, then 32 years of age, ignored the gunfire and shellbursts that had sent most fellow citizens into basement shelters to listen to a West German radio broadcast of a piece by German composer Karlheinz Stockhausen [SHTOK-howzun] (1928–) (Fig. **46.15**). Stockhausen had

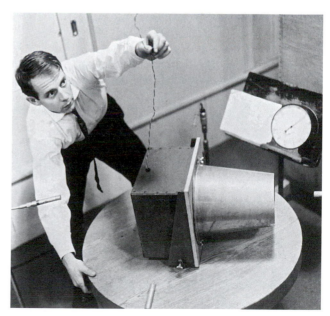

Fig. 46.15 Karlheinz Stockhausen in Cologne. 1958. Photo courtesy Stockhausen-Verlag. Though this picture may not look like musical composition and performance, it is. Note the two microphones, left and bottom, directed at Stockhausen's electronic "instrument."

composed the first piece of music using synthesized tones in 1953, *Studie I*. Its instrumentation consisted of three tape recorders, a sine wave generator, and a "natural echo chamber." Stockhausen felt he was returning to the very basis of sound, which, in his words, rises from "pure vibration, which can be produced electrically and which is called a sine wave. Every existing sound, every noise, is a mixture of such sine waves—a spectrum." For the first time, the musical composition existed entirely on tape and required no performer to produce it.

When Ligeti escaped Hungary late in 1956, he joined Stockhausen at the Studio for Electronic Music in West Germany. Stockhausen was editing tapes of electronically generated sounds—as well as music generated by traditional instruments and voices—in the same way that a filmmaker edits film. And he was experimenting with the ways in which sound was heard by an audience as well. In what is probably the hallmark electronic composition of the era, Stockhausen's *Gesang der Jünglinge* [geh-SAHNG der YOONG-ling-uh] (*Song of the Children*), composed in 1956, was one of the first works to include spatialization as a compositional element, inaugurating the "stereo" and "surround sound" era. Combining taped voices in combination with taped electronic sounds, the original version utilized five loudspeakers, positioned to surround the audience. As Stockhausen describes it: "The direction and movement of the sounds in space is shaped by the musician, opening up a new dimension in musical experience."

Meanwhile, throughout the 1960s, Ligeti was moving in his own direction, developing a rich brand of polyphony—which he called "micropolyphony"—dense, constantly changing clusters of sound that blur the boundaries between melody, harmony, and rhythm. This effect can be heard in Ligeti's 1966 *Lux Aeterna* [luks ee-TER-nuh] (**CD-Track 46.1**) the parts of which seem to blend together in a sort of shimmering atmosphere of overall sound. The piece is actually a canon, an arrangement of theme and variations, except that the entrances are neither contrapuntal nor harmonic, but rather densely compacted and atonal. In 1968, the composition reached a mass audience when American director Stanley Kubrick (1928–1999) used it in the soundtrack of his film *2001: A Space Odyssey*.

Ligeti gradually became aware of the young American "minimalist" composers Terry Riley (1935–), Steve Reich (1936–), and Philip Glass (1937–). Like the minimalist artists, their work relied on repetition of units that differ only slightly or that vary only gradually over extended periods of time. In his ground-breaking *In C* of 1964, Riley created 53 brief thematic fragments, to be played in any combination by any group of instruments. Though each musician plays these fragments in the same sequence, they are free to repeat any fragment as many times as they like. The one constant, providing a foundation for the texture of interweaving fragments in the piece, is a C octave played in a high range of the piano throughout the piece, repeating as many as ten or fifteen thousand times in any given performance (the length of per-

formance will vary depending upon how many times each musician repeats each fragment). Steve Reich's 1965 "It's Gonna Rain" consists of the repetition of a single phrase of text (the title), taken from a tape recording of a street preacher by the name of Brother Walker sermonizing on the subject of Noah and the Flood. Reich spliced together two copies of the same tape played at slightly different speeds, so that they gradually shift, in his words, "out of phase," and the monotony of the repetition is transformed as the original sound of the phrase gradually comes to sound entirely different.

Ligeti's response to these minimalist compositions was the 1968 *Continuum*, a piece for harpsichord based on extremely fast repeating figures of two to eight tones in both hands. Every note is of the same (extremely short) duration, and every pattern is repeated several times before changing.

Other composers began to expand on the possibilities of minimalist music as well. Philip Glass developed a rich, complex minimalist vocabulary to create his full-length opera/performance *Einstein on the Beach* (see chapter 47). John Adams (1947–) echoed Reich's practice in "It's Gonna Rain" to create a composition for the Shaker religion, "Shaker Loops." But in this piece, Adams added a profoundly emotional, almost Romantic dynamic to its minimalist repetition. In 1987 Adams wrote an opera, *Nixon in China* (**CD-Track 46.2**), based on the February 1972 meeting between American president Richard Nixon (1913–1994) and Chinese communist leader Mao Tse-tung. Adams created what he describes as "the first opera ever to use a staged 'media event' as the basis for its dramatic structure." Nixon and Mao were both adept manipulators of public opinion, and in his opera, Adams sought to reveal "how dictatorships on the right and on the left throughout the century had carefully managed public opinion through a form of public theater and the cultivation of 'persona' in the political arena." Nixon made much of his visit, the first by an American president to Communist-controlled China, and the driving propulsion of Adams's repetitive score captures perfectly Nixon's excitement, his passionate desire to leave an indelible mark on history.

The Vietnam War: Rebellion and the Arts

A large part of the reason that President Nixon so desired rapprochement with Mao was that, on almost every other front, his presidency was deeply embattled. The Watergate scandal that would eventually bring his presidency down did not erupt until later in the year, but the Cold War tensions with the Soviet Union had been exacerbated by the United States' involvement in the war in Vietnam. By the mid-1960s, fighting between the North Vietnamese Communists led by Ho Chi Minh and the pro-Western and former French colony of South Vietnam (see chapter 45) had led to a massive troop buildup of American forces in the region, fueled by a military draft that alienated many American youth, the

population of 15-to-24-year-olds that over the course of the 1960s increased from 24.5 million to 36 million.

Across the country, the spirit of rebellion that fueled the civil rights movement took hold on college campuses and in the burgeoning antiwar community. Events at the University of California at Berkeley served to link, in the minds of many, the antiwar movement and the fight for civil rights. In 1964, the university administration tried to stop students from recruiting and raising funds on campus for two groups dedicated to ending racial discrimination. Protesting the administration's restrictions, a group of students organized the Free Speech Movement, which initiated a series of rallies, sit-ins, and student strikes at Berkeley. The administration backed down, and the Berkeley students' tactics were quickly adapted by groups in the antiwar movement, which focused on removing the Reserve Officers' Training Corps from college campuses and helped to organize antiwar marches, teach-ins, and rallies across the country. By 1969, feelings reached a fever pitch, as over a half million protesters, adopting the tactics of the civil rights movement in 1963, marched on Washington.

Kurt Vonnegut's *Slaughterhouse-Five*

Antiwar sentiment was reflected in the arts in works primarily about earlier wars, World War II and Korea, as if it were impossible to deal directly with events in Southeast Asia, which could be seen each night on the evening news. Joseph Heller's novel *Catch-22* (see chapter 45) was widely read, and the Robert Altman (1925–2006) film *M*A*S*H*, a smash-hit satiric comedy about the 4077th Mobile Army Surgical Hospital in Korea, opened in 1970 and spawned an 11-year-long television series that premiered in 1972. But perhaps the most acclaimed antiwar work was the 1969 novel *Slaughterhouse-Five* by Kurt Vonnegut [VON-uh-gut] (1922–2007). It is the oddly narrated story of ex–World War II GI Billy Pilgrim, a survivor, like Vonnegut himself, of the Allied fire-bombing of Dresden [DREZ-den] (where 135,000 German civilians were killed, more than Hiroshima and Nagasaki combined). Pilgrim claims to have been abducted by extraterrestrial aliens from the planet of Trafalmadore. At the beginning of the book, the narrator (more or less, Vonnegut himself) is talking with a friend about the war novel he is about to write (*Slaughterhouse-Five*), when the friend's wife interrupts (**Reading 46.6**):

READING 46.6 **from Kurt Vonnegut,** *Slaughterhouse-Five* **(1969)**

"You'll pretend that you were men instead of babies, and you'll be played in the movies by . . . John Wayne. . . . And war will look just wonderful, so we'll have a lot more of them. And they'll be fought by babies. . . ." She didn't want her babies or anyone else's babies killed in wars. And she thought wars were partly encouraged by books and movies.

In response, Vonnegut creates, in Pilgrim, the most innocent of heroes, and subtitles his novel: *The Children's Crusade: A Duty-Dance with Death*. Pilgrim's reaction to the death he sees everywhere—"So it goes"—became a mantra for the generation that came of age in the late 1960s. The novel's fatalism mirrored the sense of pointlessness and arbitrariness that so many felt in the face of the Vietnam War.

Artists Against the War

In the minds of many, the Vietnam War was symptomatic of a more general cultural malaise for which the culture of consumption, the growing dominance of mass media, and the military-industrial complex (see chapter 45) were all responsible. Among many others, Pop artist James Rosenquist explicitly tied the American military to American consumer culture (see *Focus*, pages 1508–1509).

The establishment itself, especially as embodied by university administrations and their boards of trustees, was often the target of protests. Just such a work was Pop artist Claes Oldenburg's *Lipstick (Ascending) on Caterpillar Tracks* (Fig. **46.16**). The work was pulled into a central square at Yale University, Oldenburg's alma mater, in the fall of 1969 to stand in front of a World War I monument inscribed with the words "In Memory of the Men of Yale who True to her Traditions Gave their Lives that Freedom Might not Perish from the Earth." In Oldenburg's typically audacious way, the piece consists of a three-story-high inflatable lipstick tube mounted on tank-like caterpillar treads. At once a missile-shaped phallic symbol and a wry commentary on the fact that Yale had admitted women to the university for the first time that fall, it was commissioned by the university's architecture graduate students as an antiwar demonstration. Yale authorities were not amused, and had the piece removed before convocation (though it was subsequently reinstalled on campus in 1974).

By the fall of 1969, many other artists had organized in opposition to the war. In a speech at an opening hearing that led to the creation of the antiwar Art Worker's Coalition, art critic and editor Gregory Battcock outlined how the art world was complicitous in the war effort:

The trustees of the museums direct NBC and CBS, The New York Times, and the Associated Press, and that greatest cultural travesty of modern times—the Lincoln Center. They own AT&T, Ford, General Motors, the great multi-billion dollar foundations, Columbia University, Alcoa, Minnesota Mining, United Fruit, and AMK, besides sitting on the boards of each other's museum. The implications of these facts are enormous. Do you realize that it is those art-loving, culturally committed trustees of the Metropolitan and the Modern museums who are waging the war in Vietnam?

Focus

Rosenquist's *F-111*

For Pop artist James Rosenquist (1933–) the society of the spectacle is above all a society of billboards, which, in fact, he once painted for a living. "Painting," he says, "is probably much more exciting than advertising, so why shouldn't it be done with that power and gusto, with that impact?" The mammoth *F-111* possesses precisely the impact Rosenquist was seeking.

The painting was specifically designed as a wraparound work, like Monet's *Water Lilies* murals (see chapter 37), for Rosenquist's first solo exhibition at the Leo Castelli Gallery in New York, where it filled all four walls of the space. It depicts an F-111 fighter bomber at actual scale, "flying," in Rosenquist's words, "through the flack of an economy." In 1964, when Rosenquist was at work on the piece, the F-111, although still in its planning stages, was understood to be obsolete.

James Rosenquist. *F-111*. 1965. Oil on canvas with aluminum, 23 sections, 10′ × 86′. Purchase Gift of Mr. and Mrs. Alex L. Hillman and Lillie P. Bliss Bequest (both by exchange). (00473.96.a-w). Digital Image © The Museum of Modern Art/Licensed by SCALA / Art Resource, NY. © Art James Rosenquist/VAGA Visual Artists Galleries & Association, NY.

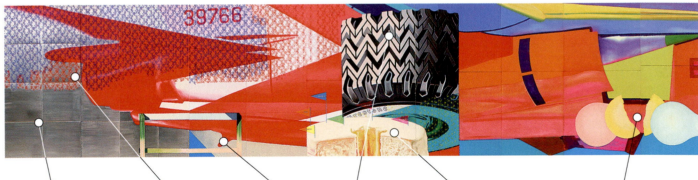

The aluminum panels on this end of the painting would have met up with the strip of aluminum panels at the other end of the painting when installed around the four walls of a gallery. They not only evoke industry, but their reflective quality incorporates viewers into the painting's space, implicating them in the artists' critique of American culture. The scale of the painting makes it impossible to take it all in at once; viewers are always aware that there is more work in their peripheral vision. "I'm interested in contemporary vision," Rosenquist has explained, "the flick of chrome, reflections, rapid associations, quick flashes of light. Bing-bang! Bing-bang!"

The Italian flowered wallpaper, according to Rosenquist, "had to do with atomic fallout."

A runner's hurdle is meant to evoke the arms race.

The Firestone tire, according to Rosenquist, resembles a "crown," becoming a symbol of the supremacy and power of corporate America, the military-industrial complex that Eisenhower warned against. By emphasizing the tire's tread, Rosenquist focuses our attention on the sense of safety that corporate America claimed to provide consumers.

The angel food cake is decorated, stadiumlike, with little pennants listing food additives such as riboflavin and Vitamin D. One even boasts "Food Energy." The chemical manipulation of food is Rosenquist's target here, together with the lack of any real food value in sugar-laden "angel" food.

The three light bulbs can probably best be explained by a comment Rosenquist made in an interview in the *Partisan Review* in 1965: "All the ideas in the whole picture are very divergent, but I think they all seem to go toward some basic meaning . . . [toward] some blinding light, like a bug hitting a light bulb." They also evoke consumer culture and corporations like General Electric or Westinghouse that were also major defense contractors.

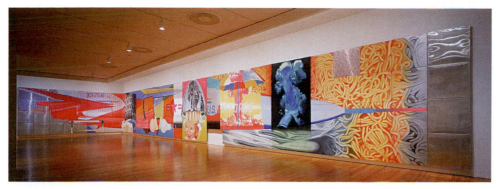

James Rosenquist. *F-111, installation view*. 2000. Oil on canvas with aluminum, 23 sections, 10′ × 86′. Gift of Mr. and Mrs. Alex L. Hillman and Lillie P. Bliss Bequest (both by exchange). (473.1996.a-w) The Museum of Modern Art, NY, U.S.A. Digital Image. The Museum of Modern Art/Licensed by SCALA / Art Resource, NY. Art © Estate of James Rosenquist/VAGA, NY. For its MoMA exhibition in 2000, the painting turned one corner to fill two walls, but did not wrap around the viewer on four walls as originally exhibited.

Nevertheless, production continued on it, by and large to keep those working on it employed and General Dynamics, the company responsible for it, afloat. In his farewell address to the nation in January 1961, President Dwight David Eisenhower (1890–1969) had warned: "This conjunction of an immense military establishment and a large arms industry is new in the American experience. The total influence—economic, political, even spiritual—is felt in every city, every statehouse, every office of the federal government. . . . In the councils of government, we must guard against the acquisition of unwarranted influence, whether sought or unsought, by the military-industrial complex. The potential for the disastrous rise of misplaced power exists and will persist." It is precisely this military-industrial complex and its pervasiveness throughout American consumer culture that Rosenquist's painting addresses. As the Vietnam War escalated, and the painting traveled to eight museums in Europe, the painting became more generally associated with the antiwar movement. It returned to the United States in 1968, and remains on display at New York's Museum of Modern Art.

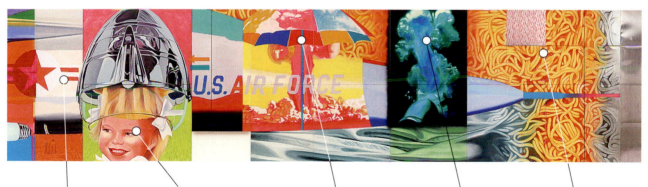

The bars of the Air Force logo, on each side of the hairdryer, function like equal signs in the picture.

"The little girl," Rosenquist says, "was the pilot under a hairdryer." She is also a figure, he says, for "a generation removed, the post-Beat young people. They're not afraid of atomic war and think that sort of attitude is passé, that it won't occur." Thus she smiles happily, her face turned away from the mushroom cloud behind her. She also represents consumer economy, the idea of female beauty, and female passivity in general—the opposite of the phallic jet fighter.

The umbrella, like the Italian flowered wallpaper, is meant to suggest both the defense umbrella of national security and atomic fallout, from which it offers no real protection.

"The swimmer gulping air," Rosenquist explains, "was like searching for air during an atomic holocaust." Visually it echoes the atomic mushroom cloud to its left.

A plate of Franco-American canned spaghetti lies behind the nose of the plane like a pile of entrails. "Franco-American" also suggests French and American involvement in the Vietnam War.

Fig. 46.16 Claes Oldenburg. *Lipstick (Ascending) on Caterpillar Tracks.* **1969–1974.** Cor-Ten steel, steel, aluminum, cast resin; painted with polyurethane enamel, 23′ 6″ × 24′ 11″ × 10′ 11″. Collection Yale University Art Gallery, Gift of Colossal Keepsake Corporation. Photo by Attilio Maranzano. © 2008 Oldenburg Van Bruggen Foundation, NY. Initially made of a soft material that would slowly deflate until someone wishing to speak from the sculpture's platform pumped it up with air to attract attention, the lipstick was constructed of more permanent materials when the piece was reinstalled in 1974.

In other words, the museums embodied, in the minds of many, the establishment politics that had led to the war in the first place. On October 15, 1969, the first Vietnam Moratorium Day, artists managed to close the Museum of Modern Art, the Whitney Museum, and the Jewish Museum, but the Metropolitan and the Guggenheim refused to close. Rather than attacking the museums directly, another strategy designed to undermine the art establishment emerged—making art that was objectless, art which was conceived as either uncollectible or unbuyable, either intangible, temporary, or existing beyond the reach of the museum and gallery system that artists in the antiwar movement believed was, at least in a de facto way, supporting the war.

Conceptual Art

The strategies for creating this objectless art had already been developed by a number of artists who, reacting to the culture of consumption, had chosen to stop making works of art that could easily enter the marketplace. In the catalogue for an exhibition entitled "January 5–31, 1969," a show consisting, in fact, of its catalog but no objects, artist Douglas Huebler (1924–1997) wrote: "The world is full of objects, more or less interesting: I do not wish to add any more." In this way, he sidestepped both the museum and the individual collector. His *Duration Piece #13*, for instance, consists of one hundred $1 bills listed by serial number and put into circulation throughout the world, the serial numbers to be reprinted 25 years later in an art magazine. Each person holding one of the bills would receive a $1,000 reward.

In light of such works, critics began to speak of "the dematerialization of art" and "the death of painting," even as California artist John Baldessari (1931–) destroyed 13 years worth of his paintings, cremating them at a mortuary. The following year, he created a lithograph with the single phrase "I will not make any more boring art" written over and over again across its surface.

Land Art Closely related to both the minimalists and the conceptualists are those artists who, in the 1960s, began to make site-specific art. (Such art defines itself in relation to the particular place for which it was conceived.) One of the most famous of these is *Spiral Jetty* (Fig. **46.17**), created in 1970 by Robert Smithson (1938–1973). Using dump trucks to haul rocks and dirt, Smithson created a simple spiral form in the Great Salt Lake. The work is intentionally outside the gallery system, in the landscape—and a relatively inaccessible and inhospitable portion of the Utah landscape at that. Smithson chose the site, on the shores of the Great Salt Lake about 100 miles north of Salt Lake City and 15 miles south of the Golden Spike National Historic Monument, where the Eastern and Western railroads met in 1869, connecting both sides of the American continent by rail, because, in his mind, it was the very image of *entropy*, the condition of decreasing organization or deteriorating order. For Smithson, the condition of entropy is not only the hallmark of the modern, but the eventual fate of all things—"an ironic joke of nature," as one historian has described the lake, "water that is itself more desert than a desert." Furthermore, humans had already degraded the site: Jetties had once stretched out into

Fig. 46.17 Robert Smithson. *Spiral Jetty,* Great Salt Lake, Utah. April 1970. Art © Estate of Robert Smithson/Licensed by VAGA, New York. Courtesy James Cohan Gallery, New York. Collection: DIA Center for the Arts, NY. Photo: Gianfranco Goroni. Smithson's film of the *Jetty's* construction mirrors the earthwork not only by imaging it, but, as a spiral loop of 16mm film, by formally mirroring its structure.

the lake here to serve now-abandoned oil derricks. As Smithson wrote not long after completing the *Spiral Jetty*, "Across the country there are many mining areas, disused quarries, and polluted lakes and rivers. One practical solution for the utilization of such devastated places would be land and water re-cycling in terms of 'Earth Art.'"

As he was constructing the jetty, Smithson made a film of the event. The typical camera angle is aerial, looking straight down at the surface of the lake from above, so that the spiral seems to lie flat, like a two-dimensional design. The image reinforces the spiral's status as one of the most widespread of all ornamental and symbolic designs on earth, suggesting, too, the motion of the cosmos. The spiral is also found in three main natural forms: expanding like a nebula, contracting like a whirlpool, or ossified as in a snail's shell. Smithson's work suggests the ways in which these contradictory forces are simultaneously at work in the universe.

Fig. 46.18 Bonnie Maclean. *Six Days of Sound*. December 26–31, 1967. Poster. © Bill Graham Archives, LLC. All Rights Reserved. The lineup of artists includes the Doors, Freedom Highway, Chuck Berry, Salvation, Big Brother & the Holding Company, Quicksilver Messenger Service, and Jefferson Airplane.

At the end of the film, a helicopter follows Smithson as he runs out the length of the spiral in a dizzying swirl of cinematography that leaves the viewer unsure which direction is which. When Smithson arrives at the center of the spiral he pauses, then breathless, turns to walk back, a purposefully deflated image of purposelessness, the very image of the tensions between motion and stasis, entropy and creation, expansion and contraction, even life and death, that inform Smithson's work.

The Music of Youth and Rebellion

Given the involvement of American youth in the antiwar movement, it was natural that their music—rock and roll—helped to fuel the fires of their increasingly passionate expressions of dismay at American foreign policy. Rock and roll music had, after all, originated in an atmosphere of youthful rebellion. Beginning at the end of the 1940s, it gained increasing popularity in the 1950s when the gyrating hips and low-slung guitar of one of its earliest stars, Elvis Presley (1935–1977), made the music's innuendo of youthful sexual rebellion explicit. In the 1960s, led by the Beatles, British rock bands (including Led Zeppelin and the Rolling Stones) transformed rock into the musical idiom of a youthful counterculture that embraced sex, drugs, and rock 'n' roll.

Audiences at most concerts openly smoked marijuana, and hallucinogenic mushrooms and LSD, a semisynthetic psychedelic drug which was not made illegal in the United States until 1967, were regularly used by rock groups such as the Beatles, the Doors, Pink Floyd, the Grateful Dead, and Jefferson Airplane. (see *Voices,* page 1513.) The Airplane's "White Rabbit," which appeared on their 1967 album *Surrealistic Pillow,* draws clear analogies between the experiences of Alice in Lewis Carroll's *Alice's Adventures in Wonderland* and the hallucinatory effects of taking LSD. And in their self-titled debut album of 1967, the Velvet Underground describes in dark, almost sardonic terms, which would deeply influence the later punk movement, the heroin addiction of its leader, Lou Reed (1942–).

One of the great promoters of rock in the 1960s was Bill Graham (1931–1991), a refugee from Nazi Germany who was raised by foster parents in New York City. Graham operated two rock venues in San Francisco, the Fillmore West and Winterland, and another in New York, the Fillmore East. Almost every major rock group of the era performed in these halls, and the posters Graham commissioned for these concerts became the emblems of the era.

Bonnie Maclean, a recent graduate of Penn State, was one of the founders of the Fillmore poster "look." Her poster for *Six Days of Sound* (Fig. 46.18), a Christmas to New Year's, celebration in 1967, captures the mood of the era. Deeply indebted to Art Nouveau posters by artists such as Jan Toorop (see chapter 40), many of the posters convey the same sexual energy as Art Nouveau, but combined with a spirit of political protest. In her right hand, the long-haired lady of Maclean's poster carries mistletoe; in her left, the

Voices

San Francisco in the 1960s

The increasing alienation of American youth in the mid-1960s led to the rise of the counterculture. Like the Beat generation of the 1950s, the counterculture movement emphasized nonconformity and the creation of new forms of music, writing, and art. Amplified rock and roll and psychedelic drugs fueled the 1960s-era youth culture with San Francisco as the epicenter. Hundreds of new rock bands such as the Grateful Dead and Jefferson Airplane, and a new "hippie" community, arose in the Haight Ashbury district of the city. The counterculture would decisively influence mainstream American music, writing, film, food, and style. Writer Hunter Thompson remembered the unforgettable Bay Area scene several years later.

I t seems like a lifetime. . . . the kind of peak that never comes again. San Francisco in the middle sixties was a very special time and place to be a part of. Maybe it meant something. Maybe not, in the long run . . . but no explanation, no mix of words or music or memories can touch that sense of knowing that you were there and alive in that corner of time and the world. Whatever it meant. . . .

History is hard to know . . . but even without being sure of "history" it seems entirely reasonable to think that every now and then the energy of a whole generation comes to a head in a long fine flash, for reasons that nobody really understands at the time—and which never explain, in retrospect, what actually happened.

My central memory of that time seems to hang on one or five or maybe forty nights—or very early

> **"There was a fantastic universal sense that whatever we were doing was *right*, that we were winning. . . ."**

mornings—when I left the Fillmore [rock concert hall] half-crazy and, instead of going home, aimed the big 650 Lightning [motorcycle] across the Bay Bridge at a hundred miles an hour . . . booming through the Treasure Island tunnel . . . not quite sure which turnoff to take when I got to the other end but being absolutely certain that no matter which way I went I would come to a place where people were just as high and wild as I was: no doubt at all about that. . . .

There was madness in any direction, at any hour. If not across the Bay, then up the Golden Gate or down 101 to Los Altos or La Honda [the home of Ken Kesey and the Merry Pranksters]. . . . You could strike sparks anywhere. There was a fantastic universal sense that whatever we were doing was *right*, that we were winning. . . .

And that, I think, was the handle—that sense of inevitable victory over the forces of Old and Evil. Not in any mean or military sense; we didn't need that. Our energy would simply PREVAIL. There was no point in fighting—on our side or theirs. We had all the momentum; we were riding the crest of a high and beautiful wave.

peace sign, large and colored red and green, a Christmas ornament that she is about to hang from the branches of a Christmas tree.

The presence of the peace sign in the Fillmore poster is not only appropriate to the season—"Peace on earth, goodwill to men"—but signals the intimate association between rock music and the antiwar movement. As in the Civil Rights March on Washington in 1963, which was highlighted by Peter, Paul and Mary's rendition of Bob Dylan's "Blowin' in the Wind" in front of the Lincoln Memorial, most peace marches concluded in large public spaces where speakers and bands alternately shared the stage. The peace march in San Francisco on Vietnam Moratorium Day, November 15, 1969, concluded at Golden Gate Park, where, among others, Crosby, Stills, Nash & Young performed. A quarter of a million people attended. That same day a half million people marched in Washington, D.C. (and in Columbus, Ohio, Dave Thomas opened the first Wendy's restaurant).

The quartet of David Crosby (1941–), Stephen Stills (1945–), Graham Nash (1942–), and Neil Young (1945–) had come together just months before. Their first performance together was at the Fillmore East in July, their second at Woodstock in August.

The Woodstock Festival, held on a 600-acre dairy farm outside Woodstock, New York, from August 15 to August 18, 1969, known soon after, by the subtitle of the film documenting it, as "3 Days of Peace and Music," has, for an entire generation, become legendary. Approximately 500,000 people attended—and thousands more claim to have been there. On both Saturday, August 16, and Sunday, August 17, bands played all night. Crosby, Stills, Nash & Young began their 16-song set at 3 AM Sunday morning, a marathon evening that concluded on Monday morning with guitarist Jimi Hendrix playing his notorious version of "The Star-Spangled Banner" on a wailing, weeping, whining electric guitar that to conservative ears seemed a direct assault on American tradition.

CULTURAL PARALLELS

Fusing Rock and Japanese Musical Traditions

Just as pioneering musical figures like Elvis Presley and Chuck Berry fused country, folk, and rhythm and blues to create American rock and roll during the 1950s, aspiring musicians across the globe began using rock music as a departure point to create music unique to their own cultures. Beginning in the mid-1960s in Japan, bands strove to imitate the Beatles and other Western pop music. Other Japanese musicians reached back to their own musical traditions and developed a hybrid Japanese folk-rock music. By the mid-1970s, rock musicians like Osamu Kitajima and the members of the Yellow Magic Orchestra were using amplified Japanese instruments—the *biwa* (wooden flute), *shakuhachi* (bamboo flute), and *narimono* (traditional percussion)— combining traditional Shinto music with progressive jazz and rock.

Perhaps as important as the event itself was the release, in March 1970, of the documentary film of the event, with Crosby, Stills, Nash & Young performing "Woodstock," written by Joni Mitchell (1943–), over the closing credits. The last verse makes the politics of the event concrete (**Reading 46.7**):

READING 46.7 from Joni Mitchell, "Woodstock" (1970)

By the time we got to Woodstock
We were half a million strong
And everywhere there was song and celebration
And I dreamed I saw the bombers
Riding shotgun in the sky
And they were turning into butterflies
Above our nation
We are stardust
Billion year old carbon
We are golden
Caught in the devil's bargain
And we've got to get ourselves
Back to the garden

The utopian dream of "Woodstock," the desire to return to "the garden," was quickly shattered. Just days before the November 15 Moratorium Day March, reporter Seymour Hersh (1937–) broke the story of the My Lai [mee lye] massacre in the *New York Times*. On March 16, 1968, the men of Charlie Company, under platoon leader First Lieutenant

William L. Calley, Jr., had rounded up 40 to 45 Vietnamese villagers—women, children, and elderly—herded them into a ditch and mowed them down with machine gun fire. Over 300 other villagers were killed in the action. A stunned America learned every grisly detail of the massacre during Calley's court martial over the course of the following months, and early in March 1970, Calley was sentenced to life imprisonment. (He was paroled by the army in 1974.) A Harris poll conducted just days after Calley's conviction confirmed that, for the first time, a majority of Americans opposed the war in Vietnam.

Just over a month later, on April 30, 1970, President Nixon announced that American troops had begun invading Cambodia five days earlier. Protests erupted on college campuses across the United States. At Kent State University near Akron, Ohio, the governor of Ohio called out the Ohio National Guard, who arrived on campus as students burned down an old ROTC building (already boarded up and scheduled for demolition). On Monday, May 4, some 2,000 students gathered on the school commons. The National Guard ordered them to disperse. They refused. A group of 77 guardsmen advanced on the students, and for reasons that have never been fully explained, opened fire. Four students were killed, nine wounded. Photojournalism student John Paul Filo's photograph of 14-year-old runaway, Mary Ann Vecchio, kneeling over the dead body of 20-year-old Jeffery Miller, became an instant icon of the antiwar movement (Fig. **46.19**). Neil Young quickly penned what would become Crosby, Stills, Nash & Young's most famous protest song, "Ohio," commemorating the four who died. The song quickly rose to number 2 on the charts.

American involvement in Vietnam would not end until January 1973, when a ceasefire was agreed upon in Paris and American troops were finally withdrawn. Two years later, on April 30, 1975, the Viet Cong and North Vietnamese army took control of Saigon, renaming it Ho Chi Minh City, and Vietnam was reunited as a country for the first time since the French defeat in 1954.

High and Low: The Example of Music

Rock and roll's ascendancy as the favorite music of American popular culture in the 1950s and 1960s underscores a shift in cultural values in which the line between "high" and "low" art became more and more difficult to define. By the 1960s, music had become an industry in its own right, perhaps the most fully commercialized medium in the art world. The German company Deutsche Grammophon was dedicated to recording classical music at the highest possible level, and in 1951, it had released the first 33-rpm long-playing records. Now, they owned the Beatles' first recording label, Polydor Records, a company dedicated to recording popular music. Throughout the twentieth century both high and low had stood side by side. Picasso and Braque had incorporated

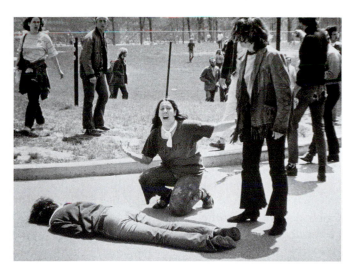

Fig. 46.19 John Paul Filo. *Kent State—Girl Screaming over Dead Body.* **May 4, 1970.** Collection of John Paul Filo. Filo's photograph appeared on the cover of *Newsweek* on May 18, 1970, beside the headline "Nixon's Home Front." Filo was awarded the Pulitzer Prize in photography for his work at Kent State.

images from popular culture into their collages, and popular culture had become the sole theme of Pop Art.

Composers as early as Bach, Haydn, and Mozart had incorporated folk music into their work, but the phenomenon really began to take shape in the nineteenth century, as nationalist composers like Giuseppe Verdi in Italy and Peter Ilyich Tchaikovsky in Russia began to draw on traditional folk songs for their otherwise classical compositions. Over the course of the nineteenth century, classical music was increasingly considered the provenance of elite and intellectual audiences while lighter fare was understood to appeal to wider, more populist tastes. By the jazz era, everyone from the American George Gershwin to the Russian Igor Stravinsky incorporated jazz idioms into their work, and Aaron Copland, as we have seen, looked to the regional traditions of the Appalachian hills and the American West for inspiration. The Boston Pops Orchestra was founded as early as 1885 to present "concerts of a lighter kind of music." Its conductor of over 50 years, Arthur Fiedler (1894–1979), was followed by academy-award winner John Williams (1932–), composer of the soundtracks to the films *Star Wars* and *Indiana Jones and the Raiders of the Lost Ark.*

In this context, one of the most interesting composers of the era was Charles Ives (1874–1954). Ives had been raised in a military family, son of an army bandleader. Working in a decidedly modern vein—often polytonal and polyrhythmic—Ives composed a body of work in the first 20 years of the twentieth century that incorporates patriotic tunes and marches, hymns, and elements of ragtime. The second movement of his *Three Places in New England,* composed between 1903 and 1911, is intended to reflect a child's impression of a Fourth of

July picnic at Putnam's Camp, Redding, Connecticut **(CD-Track 46.3)**. A raucous collage of competing melodies and marches—from "Rally Round the Flag" and "Yankee Doodle" to "The British Grenadiers"—a strand of the national anthem dissolves into a jolting discordance at the end the piece.

The example of Ives is particularly useful because for most of his life his music was largely unknown. Not until after World War II did it begin to attract the attention of an American audience. His third symphony was finally awarded the Pulitzer Prize in 1947, and his second symphony was first performed at last in 1951, when Leonard Bernstein (1918–1980) premiered it conducting the New York Philharmonic Orchestra. It is fitting that Bernstein should have premiered the work since he was himself equally at home in both classical and popular idioms. High and low were distinctions that, in his own work, he tried to ignore, as Mozart had before him. He could write Broadway hit musicals such as *Candide* (1956) and *West Side Story* (1957) and profoundly moving symphonies. His 1963 Third Symphony, *Kaddish,* a musical interpretation of the Jewish prayer for the dead, was written for an orchestra, a chorus, a soloist, a children's choir, and a narrator. At its premier performance, in Tel Aviv, Bernstein conducted the Israel Philharmonic. *Mass,* written in 1971, was a full-fledged 80-minute mass, based on the traditional Catholic liturgy, but which combines Bernstein's classical interpretation of the form with everything from rock-and-roll guitar to a kazoo chorus. Writing in a 1966 book entitled *The Infinite Variety of Music,* Bernstein explained: "As of this writing, God forgive me, I have far more pleasure in following the musical adventures of Simon & Garfunkel . . . than I have in most of what is being written now by the whole community of 'avant-garde' composers. . . . Pop music seems to be the only area where there is to be found unabashed vitality, the fun of invention, the feeling of fresh air." For Bernstein, at least, popular music seemed to have won the day, although the crass commercialization of popular music would later cause him to lose interest in it.

The Birth of the Feminist Era

At the same time that the antiwar and civil rights movements galvanized political consciousness among both men and women, "the Pill" was introduced in the early 1960s. As women gained control over their own reproductive functions, they began to express the sexual freedom that men had always taken for granted. The struggle for gender equality in the United States found greater and greater expression throughout the 1960s until, by the early 1970s, a full-blown feminist era emerged.

The Theoretical Framework: Betty Friedan and NOW

In 1963, a freelance journalist and mother of three, Betty Friedan (1921–2006), published *The Feminine Mystique.* In many ways, hers was an argument with Freud, or at least with

the way Freud had been understood, or misunderstood. While she admits that "Freudian psychology, with its emphasis on freedom from a repressive morality to achieve sexual fulfillment, was part of the ideology of women's emancipation," she is aware that some of Freud's writings had been misused as a tool for the suppression of women (**Reading 46.8**):

READING 46.8 **from Betty Friedan,**
***The Feminine Mystique* (1963)**

The concept "penis envy," which Freud coined to describe a phenomenon he observed in women— that is, in the middle-class women who were his patients in Vienna in the Victorian era—was seized in this country in the 1940s as the literal explanation of all that was wrong with American women. Many who preached the doctrine of endangered femininity . . . seized on it—not the few psychoanalysts, but the many popularisers, sociologists, educators, ad-agency manipulators, magazine writers, child experts, marriage counsellors, ministers, cocktail-party authorities—could not have known what Freud himself meant by penis envy. . . . What was he really reporting? If one interprets "penis envy" as other Freudian concepts have been reinterpreted, in the light of our new knowledge that what Freud believed to be biological was often a cultural reaction, one sees simply that Victorian culture gave women many reasons to envy men: the same conditions, in fact, that the feminists fought against. If a woman who was denied the freedom, the status, and the pleasures that men enjoyed wished secretly that she could have these things, in the shorthand of the dream, she might wish herself a man and see herself with that one thing which made men unequivocally different—the penis. She would, of course, have to learn to keep her envy, her anger, hidden: to play the child, the doll, the toy, for her destiny depended on charming man. But underneath, it might still fester, sickening her for love. If she secretly despised herself, and envied man for all she was not, she might go through the motions of love, or even feel a slavish adoration, but would she be capable of free and joyous love? You cannot explain away woman's envy of man, or her contempt for herself, as mere refusal to accept her sexual deformity, unless you think that a woman, by nature, is a being inferior to man. Then, of course, her wish to be equal is neurotic.

Latent in Friedan's analysis, but central to the feminist movement, is her understanding that in Freud, as in Western discourse as a whole, the term "woman" is tied, in terms of its construction as a word, to man (its medieval root is "*wifman*," or "wife [of] man"). It is thus a contested term that does not refer to the biological female but to the sum total of all the patriarchal society expects of the female, including behavior, dress, attitude, and demeanor. "Woman," said the feminists, is a cultural construct, not a biological one. In *The Feminine Mystique*, Friedan rejects modern American society's cultural construction of women. But she could not, in the end, reject the word "woman" itself. Friedan would go on to become one of the founders of the National Organization for Women (NOW), the primary purpose of which was to advance women's rights and gender equity in the workplace. In this, she dedicated herself to changing, in American culture, her society's understanding of what "woman" means.

Feminist Poetry

The difficulties that women faced in determining an identity outside the patriarchal construction of "woman" became, in the 1960s, one of the chief subjects of poetry by women, particularly in the work of the poets Anne Sexton (1928–1974) and Sylvia Plath (1932–1963). Both investigate what it means *to be*, in an existential sense, "woman."

Plath had famously examined the psychology of being in her poem "Lady Lazarus" (see **Reading 46.9**, page 1521, for the full text). The title alludes to T. S. Eliot's "Love Song of J. Alfred Prufrock," specifically to Eliot's lines: "I am Lazarus, come from the dead, / Come back to tell you all, I shall tell you all." Like Lazarus, Lady Lazarus is reborn in the poem in order to attack the male ego, specifically that of her husband, the poet Ted Hughes (1930–1998). The poem concludes:

> Out of the ash
> I rise with my red hair
> And I eat men like air.

Sexton's marriage was probably more problematic than Plath's. An affluent housewife and mother, she lived in a house with a sunken living room and a backyard swimming pool in the Boston suburb of Weston, Massachusetts. But she was personally at odds with her life, and as her husband saw his formerly dependent wife become a celebrity, their marriage dissolved into a fabric of ill will, discord, and physical abuse. The poem with which she opened most readings, the ecstatically witty "Her Kind," published in 1960 in her first book of poems, *To Bedlam and Part Way Back*, captures the sense of independence that defined her from the beginning (**Reading 46.10**):

READING 46.10 **Anne Sexton,**
"Her Kind" (1960)

I have gone out, a possessed witch
haunting the black air, braver at night;
dreaming evil, I have done my hitch
over the plain houses, light by light:
lonely thing, twelve-fingered, out of mind.
A woman like that is not a woman, quite.
I have been her kind.

I have found the warm caves in the woods,
filled them with skillets, carvings, shelves,
closets, silks, innumerable goods;
fixed the suppers for the worms and the elves:
whining, rearranging the disaligned.
A woman like that is misunderstood.
I have been her kind.

I have ridden in your cart, driver,
waved my nude arms at villages going by,
learning the last bright routes, survivor
where your flames still bite my thigh
and my ribs crack where your wheels wind.
A woman like that is not ashamed to die.
I have been her kind.

Another important poet of the era is Adrienne Rich (1929–), whose poem "Diving into the Wreck" (see **Reading 46.11**, page 1522, for the complete poem) was published in 1973. The poem delves into a metaphoric wreck created by a patriarchal culture that inherently devalues anything female or feminine, a wreck that would include the lives of both Plath and Sexton. Rich's project is to dissolve myth, discover truth, and recover the treasures left by her feminist forebearers:

I came to explore the wreck.
The words are purposes.

The words are maps.
I came to see the damage that was done
and the treasures that prevail.

The first-person "I" of her poem is androgynous, a figure who has given up the sexual stereotyping that constitutes the battered hulk of the wreck. And what Rich discovers in her explorations there is the will to survive.

Feminist Art

It was not a very great reach for feminists to see, in the Vietnam War, the very symbol of male oppression. Nancy Spero [SPEER-oh] (1926–) had lived in Paris from 1959 to 1964, but when she returned to the United States she was, she admitted, "enraged." "I was shocked that our country, which had this wonderful idea of democracy, was doing this terrible thing in Vietnam. I wanted to make images to express the obscenity of war." For Spero the male penis is the very agent of war, the bomb its destructive seed. She describes the images in the resulting *War Series* (Fig. **46.20**) as:

manifestoes against our (the US) incursion into Vietnam, a personal attempt at exorcism. The Bombs are phallic and nasty, exaggerated sexual representations of the penis: heads with tongues sticking out, violent depictions of the human (mostly male) body. The clouds of the Bomb are filled with screaming heads vomiting poison onto the victims below.

Fig. 46.20 Nancy Spero. *Bomb and Victims*. 1965. From *The War Series: Bombs and Helicopters*, 1966–1970. Gouache and ink on paper, 28″ × 35³⁄₄″. © Nancy Spero. Courtesy Galerie Lelong, NY 10001. "The arts," Spero wrote in 1971, "are a territory governed by the laws of male supremacy. . . . The work of successful male artists is coveted, esteemed—prestigious property. The work of a successful woman artist is usually less esteemed."

Fig. 46.21 Eva Hesse. *Ringaround Arosie.* **1965.** Pencil, acetone varnish, ink, glued cloth-covered electrical wire on papier-mâché on Masonite, $26\frac{3}{8}'' \times 16\frac{1}{2}'' \times 4\frac{1}{2}''$. Museum of Modern Art, New York, fractional and promised gift of Kathy and Richard S. Fuld, Jr., 2005. © The Estate of Eva Hesse, Hauser & Wirth Zurich, London. Photo: Abby Robinson/Barbora Gerny, NY. "A woman is side-tracked by all her feminine roles," Hesse wrote in 1965. "She also lacks the conviction that she has the 'right' to achievement."

But as overtly feminist as Spero's work is, it stands out as especially clear in its intentions compared to other work of the late 1960s. As Spero put it in a particularly incisive short paper, "On Feminism," delivered in a panel discussion at the Art Student's League in 1971, "the standards of success in our society . . . force an assertive woman to emulation of the male role."

Thus, many women artists insisted that their work be approached in formal, not feminine terms. Eva Hesse [HESS-uh] (1936–1970), for instance, when asked if works such as *Ringaround Arosie* (Fig. **46.21**) contained female sexual connotations, quickly shot back: "No! I don't see that at all." Of the work's circular forms, she later said, "I think the circle is

very abstract. . . . I think it was a form, a vehicle. I don't think I had a sexual, anthropomorphic, or geometric meaning. It wasn't a breast and it wasn't a circle representing life and eternity."

Even when an artist like Judy Chicago (1939–) would try to invest her work with feminist content, the public refused to recognize it. Her series of 15 *Pasadena Lifesavers* (Fig. **46.22**) exhibited in 1970 at Cal State Fullerton, expressed, she felt, "the range of my own sexuality and identity, as symbolized through form and color." Their feminist content was affirmed by a statement on the gallery wall directly across from the entrance, which read:

> Judy Gerowitz hereby divests herself of all names imposed upon her through male social dominance and freely chooses her own name Judy Chicago.

But male reviewers ignored the statement. As Chicago says in her 1975 autobiography, *Through the Flower: My Struggle as a Woman Artist*: "[They] refused to accept that my work was intimately connected to my femaleness." But, in part, their misapprehension was her own doing. As she explains in *Through the Flower*, "I had come out of a formalist background and had learned to neutralize my subject matter. In order to be considered a 'serious' artist, I had had to suppress my femaleness. . . . I was still working in a frame of reference that people had learned to perceive in a particular, non-content-oriented way."

Fig. 46.22 Judy Chicago. *Pasadena Lifesavers, Yellow No. 4.* **1969–1970.** Sprayed acrylic on Plexiglass (series of 15) $59'' \times 59''$. Whereabouts unknown. © 2008 ARS Artists Rights Society. Photo © Donald Woodman. To many viewers, the geometry of Chicago's forms completely masked their sexual meaning.

Fig. 46.23 Judy Chicago. *The Dinner Party.* 1979. Mixed media, 48′ × 48′ × 48′ installed. Collection of the Brooklyn Museum of Art, Gift of the Elizabeth A. Sackler Foundation. Photograph © Donald Woodman. © 2005 Judy Chicago/Artists Rights Society (ARS), NY. The names of 999 additional women are inscribed in ceramic tiles along the table's base.

Chicago's great collaborative work of the 1970s, *The Dinner Party* (Fig. **46.23**), changed all that. In its bold assertion of woman's place in social history, the piece announced the growing power of the women's movement itself. More than 300 women worked together over a period of five years to create the work, which consists of a triangle-shaped table, set with 39 places, 13 on a side, each celebrating a woman who has made an important contribution to world history. The first plate is dedicated to the Great Goddess, and the third to the Cretan Snake Goddess (see chapter 5). Around the table the likes of Eleanor of Aquitaine (see chapter 13), Artemisia Gentileschi (see chapter 25), novelist Virginia Woolf (see

chapter 42), and Georgia O'Keeffe (see chapter 43) are celebrated. Where the *Pasadena Lifesavers* had sheltered their sexual content under the cover of their symbolic abstraction, in *The Dinner Party*, the natural forms of the female anatomy were fully expressed in the ceramic work, needlepoint, and drawing. But, as Chicago is quick to point out, "the real point of the vaginal imagery in *The Dinner Party* was to say that these women are not known because they have vaginas. That is all they had in common, actually. They were from different periods, classes, ethnicities, geographies, experiences, but what kept them within the same historical space was the fact that they had vaginas."

READINGS

from James Baldwin, "Sonny's Blues" (1957)

Perhaps the best way to introduce this short excerpt from James Baldwin's great short story "Sonny's Blues," is to quote Baldwin on why he was a writer: "You write," he says, "in order to change the world, knowing perfectly well that you probably can't, but knowing that literature is indispensable to the world. In some way, your aspirations and concern for a single man in fact do begin to change the world." That is the effect of music in "Sonny's Blues."

All I know about music is that not many people ever really hear it. And even then, on the rare occasions when something opens within, and the music enters, what we mainly hear, or hear corroborated, are personal, private, vanishing evocations. But the man who creates the music is hearing something else, is dealing with the roar rising from the void and imposing order on it as it hits the air. What is evoked in him, then, is of another order, more terrible because it has no words, and triumphant, too, for that same reason. And his triumph, when he triumphs, is ours. I just watched Sonny's face. His face was troubled, he was working hard, but he wasn't with it. And I had the feeling that, in a way, everyone on the bandstand was waiting for him, both waiting for him and pushing him along. But as I began to watch Creole, I realized that it was Creole who held them all back. He had them on a short rein. Up there, keeping the beat with his whole body, wailing on the fiddle, with his eyes half closed, he was listening to everything, but he was listening to Sonny. He was having a dialogue with Sonny. He wanted Sonny to leave the shoreline and strike out for the deep water. He was Sonny's witness that deep water and drowning were not the same thing—he had been there, and he knew. And he wanted Sonny to know. He was waiting for Sonny to do the things on the keys which would let Creole know that Sonny was in the water.

And, while Creole listened, Sonny moved, deep within, exactly like someone in torment. I had never before thought of how awful the relationship must be between the musician and his instrument. He has to fill it, this instrument, with the breath of life, his own. He has to make it do what he wants it to do. And a piano is just a piano. It's made out of so much wood and wires and little hammers and big ones, and ivory. While there's only so much you can do with it, the only way to find this out is to try; to try and make it do everything.

And Sonny hadn't been near a piano for over a year. And he wasn't on much better terms with his life, not the life that stretched before him now. He and the piano stammered, started one way, got scared, stopped; started another way, panicked, marked time, started again; then seemed to have found a direction, panicked again, got stuck. And the face I saw on Sonny I'd never seen before. Everything had been burned out of it, and, at the same time, things usually hidden were being burned in, by the fire and fury of the battle which was occurring in him up there.

Yet, watching Creole's face as they neared the end of the first set, I had the feeling that something had happened, something I hadn't heard. Then they finished, there was scattered applause, and then, without an instant's warning, Creole started into something else, it was almost sardonic, it was "Am I Blue." And, as though he commanded, Sonny began to play. Something began to happen. And Creole let out the reins. The dry, low, black man said something awful on the drums, Creole answered, and the drums talked back. Then the horn insisted, sweet and high, slightly detached perhaps, and Creole listened, commenting now and then, dry, and driving, beautiful, calm and old. Then they all came together again, and Sonny was part of the family again. I could tell this from his face. He seemed to have found, right there, beneath his fingers, a damn brand-new piano. It seemed that he couldn't get over it. Then, for a while, just being happy with Sonny, they seemed to be agreeing with him that brand-new pianos certainly were a gas.

Then Creole stepped forward to remind them that what they were playing was the blues. He hit something in all of them, he hit something in me, myself, and the music tightened and deepened, apprehension began to beat the air. Creole began to tell us what the blues were all about. They were not about anything very new. He and his boys up there were keeping it new, at the risk of ruin, destruction, madness and death, in order to find new ways to make us listen. For, while the tale of how we suffer, and how we are delighted, and how we may triumph is never new, it must always be heard. There isn't any other tale to tell, it's the only light we've got in all this darkness. ■

Reading Question

What is the narrator referring to when he says, in the next to last paragraph, that "something had happened, something I hadn't heard"?

READING 46.9

Sylvia Plath, "Lady Lazarus" (1962)

Most of Sylvia Plath's best poetry was published posthumously. The major tension of the poem lies in its flippant tone compared with the seriousness of its subject—repeated suicide attempts. Plath wrote the poem and several other of her greatest works in the last month of her life, after her separation from her husband, the poet Ted Hughes, and just before her suicide in London. It establishes her poetic voice as a kind of performance, making light of her desire to die and her failure to succeed in accomplishing the deed. She is, thus, a deeply ironic Lazarus, returned from the dead, resurrected, but not in joy.

I have done it again.
One year in every ten
I manage it—

A sort of walking miracle, my skin
Bright as a Nazi lampshade,
My right foot

A paperweight,
My face featureless, fine
Jew linen.

Peel off the napkin 10
O my enemy.
Do I terrify?—

The nose, the eye pits, the full set of teeth?
The sour breath
Will vanish in a day.

Soon, soon the flesh
The grave cave ate will be
At home on me

And I a smiling woman.
I am only thirty. 20
And like the cat I have nine times to die.

This is Number Three.
What a trash
To annihilate each decade.

What a million filaments.
The peanut-crunching crowd
Shoves in to see

Them unwrap me hand and foot—
The big strip tease.
Gentlemen, ladies 30

These are my hands
My knees.
I may be skin and bone,

Nevertheless, I am the same, identical woman.
The first time it happened I was ten.
It was an accident.

The second time I meant
To last it out and not come back at all.
I rocked shut

As a seashell. 40
They had to call and call
And pick the worms off me like sticky pearls.

Dying
Is an art, like everything else.

I do it exceptionally well.

I do it so it feels like hell.
I do it so it feels real.
I guess you could say I've a call.

It's easy enough to do it in a cell.
It's easy enough to do it and stay put. 50
It's the theatrical

Comeback in broad day
To the same place, the same face, the same brute
Amused shout:

'A miracle!'
That knocks me out.
There is a charge

For the eyeing of my scars, there is a charge
For the hearing of my heart—
It really goes. 60

And there is a charge, a very large charge
For a word or a touch
Or a bit of blood

Or a piece of my hair or my clothes.
So, so, Herr Doktor.
So, Herr Enemy.

I am your opus,
I am your valuable,
The pure gold baby

That melts to a shriek. 70
I turn and burn.
Do not think I underestimate your great concern.

Ash, ash—
You poke and stir.
Flesh, bone, there is nothing there—

A cake of soap,
A wedding ring,
A gold filling.

Herr god, Herr Lucifer
Beware 80
Beware.

Out of the ash
I rise with my red hair
And I eat men like air. ■

Reading Questions

Why does Plath evoke the Holocaust in this poem? What does she see as analogous to her own situation?

READING 46.11

Adrienne Rich, "Diving into the Wreck" (1973)

Adrienne Rich is one of the most politically committed writers of American verse. During the 1960s, family conflicts were a frequent subject of her work. Throughout the decade, her work became politicized, as she explored the question of her own and women's role in society, confronted American racism, and protested against the Vietnam War. "Diving into the Wreck" is an exploration of the question of sexual identity and the damage it has done to both male and female in American society. Her themes include the myths of patriarchy, the understanding of men and woman as inherently different, and the battle of the sexes. The poem is also an investigation of power—who wields it, and why.

First having read the book of myths,
and loaded the camera,
and checked the edge of the knife-blade,
I put on
the body-armor of black rubber
the absurd flippers
the grave and awkward mask.
I am having to do this
not like Cousteau with his
assiduous team 10
aboard the sun-flooded schooner
but here alone.

There is a ladder.
The ladder is always there
hanging innocently
close to the side of the schooner.
We know what it is for,
we who have used it.
Otherwise
it's a piece of maritime floss 20
some sundry equipment.

I go down.
Rung after rung and still
the oxygen immerses me
the blue light
the clear atoms
of our human air.
I go down.
My flippers cripple me,
I crawl like an insect down the ladder 30
and there is no one
to tell me when the ocean
will begin.
First the air is blue and then
it is bluer and then green and then
black I am blacking out and yet
my mask is powerful
it pumps my blood with power
the sea is another story
the sea is not a question of power 40
I have to learn alone
to turn my body without force
in the deep element.

And now: it is easy to forget
what I came for
among so many who have always
lived here
swaying their crenellated fans
between the reefs
and besides 50

you breathe differently down here.
I came to explore the wreck.
The words are purposes.
The words are maps.
I came to see the damage that was done
and the treasures that prevail.
I stroke the beam of my lamp
slowly along the flank
of something more permanent
than fish or weed 60

the thing I came for:
the wreck and not the story of the wreck
the thing itself and not the myth
the drowned face always staring
toward the sun
the evidence of damage
worn by salt and sway into this threadbare beauty
the ribs of the disaster
curving their assertion
among the tentative haunters. 70

This is the place.
And I am here, the mermaid whose dark hair
streams black, the merman in his armored body
We circle silently
about the wreck
we dive into the hold.
I am she: I am he

whose drowned face sleeps with open eyes
whose breasts still bear the stress
whose silver, copper, vermeil cargo lies 80
obscurely inside barrels
half-wedged and left to rot
we are the half-destroyed instruments
that once held to a course
the water-eaten log
the fouled compass

We are, I am, you are
by cowardice or courage
the one who find our way
back to this scene 90
carrying a knife, a camera
a book of myths
in which
our names do not appear. ■

Reading Question

At the end of the poem, the poem's multiple personae—we, I, you—goes back into the wreck with "a book of myths / in which / our names do not appear." Explain.

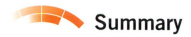

Summary

■ **The Ongoing Fight for Civil Rights** The civil rights movement first regained momentum when, in 1954, the U.S. Supreme Court ruled in the case of *Brown v. Board of Education* that "separate but equal" educational facilities for whites and blacks violated the Fourteenth Amendment to the Constitution, and in 1955, when Rosa Parks refused to move to the Negro section of a Montgomery, Alabama bus. In 1957, tensions erupted over the desegregation of Little Rock, Arkansas, Central High School. And by 1963, the Southern Christian Leadership Conference (SCLC), led by the Reverend Martin Luther King, Jr., had decided that Birmingham, Alabama, would be the focal point of the burgeoning civil rights movement. King provided the philosophical framework for the movement's willingness to engage in civil disobedience in his 1963 "Letter from Birmingham Jail." Meanwhile, in early May, the youth of Birmingham confronted the police at Kelly Ingram Park as horrified Americans watched on television. Negotiations resulted in the desegregation of lunch counters, restrooms, department store fitting rooms, and drinking fountains. In the summer of 1963, 250,000 people marching in Washington, DC, in support of civil rights, heard Martin Luther King deliver his famous "I have a dream" speech, shortly after the folk-rock trio Peter, Paul and Mary sang Bob Dylan's "Blowin' in the Wind." But the dreams of the moment were shattered on September 15, when four young girls were killed by a bomb that exploded at the 16th Street Baptist Church in Birmingham, and riots once again rocked the city.

One of the most important factors contributing to the success of the civil rights movement was the growing sense of ethnic identity among the African-American population. French existentialist philosopher Jean-Paul Sartre had defined "blackness" as a mark of authenticity in his influential essay "Black Orpheus." In its African roots, Sartre argued, the wellsprings of a truly original African-American art might be found, a sentiment realized by black American writer James Baldwin in his evocation of the power of African American music in his short story "Sonny's Blues." Sartre's existentialism, with its emphasis on the inevitability of human suffering and the necessity for the individual to act responsibly in the face of that predicament, found expression in Ralph Ellison's novel *Invisible Man*. The art of Romare Bearden celebrated the diversity of black experience, while the poetry and drama of Amiri Baraka reflected the growing militancy of the age.

■ **Mass Media and the Culture of Consumption** Throughout the 1950s and into the 1960s, the attention given events by the media tended to turn them into spectacles. Artists responded by representing American reality in terms of the media—advertising, packaging, television, and comic strips. Pop Art reflected the commodification of culture and the marketplace as the dominant cultural force. Andy Warhol painted Marilyn Monroe in order to demonstrate that she was not so much a person as a salable product, as commercial as Campbell's soup. Tom Wesselmann included the modernist painting by Mondrian in a still life of household items, suggesting that painting itself was a commodity. In the work of Roy Lichtenstein, the subjective feelings associated with the brushwork of Abstract Expressionist painting were emptied of their "authenticity" and replicated without emotion into a comic strip image. Claes Oldenberg created witty reproductions of American goods, dramatically changing their scale or medium to render them at once monstrous and funny.

■ **Minimalism in Art and Music** Minimal art, meanwhile, turned to almost total formality and abstraction in terms at first diametrically opposed to Pop Art. But like Pop, minimalists were intrigued by the processes of mass production, and they questioned just what it takes to make an image a work of art. In music, minimalism was based on examining the very basis of sound. Karl Hans Stockhausen experimented with the electronic production of sound, and György Ligeti with rich and dense sound patterns that dissolved the difference between melody, harmony, and rhythm. American minimalist composers like Terry Riley, Steve Reich, and Philip Glass relied on the repetition of units or phrases of music that differed only slightly and extended over long periods of time.

■ **The Vietnam War: Rebellion and the Arts** As American involvement in the war in Vietnam escalated throughout the 1960s, artists and writers responded in a number of ways. Kurt Vonnegut's 1969 novel *Slaughterhouse-Five* underscored the sense of pointlessness and futility that many Americans felt in the face of the war. Artworks like Claes Oldenberg's *Lipstick (Ascending) on Caterpillar Tracks* were conceived as antiwar protests. Museums themselves were seen as complicitous in the war effort, and some artists began making art that was objectless, intangible, temporary, or existing beyond the reach of the museum and gallery systems. Both Conceptual Art and Land Art are examples. But it was rock music that most reflected the spirit of rebellion and protest that characterized the antiwar movement. Musicians called for peace at festivals such as Woodstock and wrote songs reflecting the events of the day, such as Crosby, Stills, Nash & Young's "Ohio," written soon after four students were shot down by the Ohio National Guard at Kent State University.

■ **High and Low: The Example of Music** The ascendancy of rock and roll in popular culture underscores the ongoing intrusion of "low" or popular forms into the world of

"high" culture that had begun with nationalist music movements in the nineteenth century. American composer Charles Ives, whose collages of recognizable patriotic and marching tunes were finally appreciated in the 1950s, is a key example of the phenomenon. Leonard Bernstein, who was equally at home writing classical compositions and Broadway musicals, came to believe that popular forms of music were more vital and alive than the music being composed by his avant-garde contemporaries.

■ **The Birth of the Feminist Era** In 1963, in her book *The Feminine Mystique*, Betty Friedan challenged the Freudian understanding of women's desire for equality with men as neurotic "penis envy." Hers was especially an attack on the patriarchal construction of the idea of "woman." Women artists and writers were equally engaged in asserting their place in an art world from which their work was, if not completely excluded, then demeaned as second rate. Poets Sylvia Plath, Anne Sexton, and Adrienne Rich wrote overtly feminist tracks directed against the social institutions that relegated women to second-place status in American society. And painters like Nancy Spero, Eva Hesse, and Judy Chicago fought to find a place in an art world that almost totally excluded women from exhibition and even gallery representation.

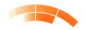 **Critical Thinking Questions**

1. In what ways does Bettye Saar's *The Liberation of Aunt Jemima* (Fig. 46.6) reflect the ideas embodied in Pop Art? What relationship between Pop Art and the civil rights movement does this suggest?

2. What do the civil rights movement, the antiwar movement, and the feminist movement have in common?

3. Many people believe that television has had a greater impact on modern consciousness than any other medium. How did television affect events in the 1960s?

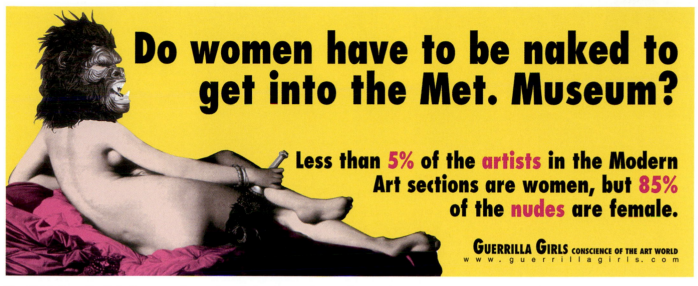

Fig. 46.24 Guerrilla Girls. *Do women have to be naked to get into the Met. Museum? 1989.* Poster. © 1989, 1995 by the Guerrilla Girls, Inc. The figure is a parody of Jean-Auguste-Dominique Ingres's 1814 neoclassical painting, *La Grand Odalisque*, in the collection of the Louvre, Paris.

Despite the advances made by women in the arts in the 1960s, real change was slow in coming. Although in 1976 approximately 50 percent of the professional artists in the United States were women, only 15 in 100 one-person shows in New York's prestigious galleries were devoted to work by women. Eight years later, the Museum of Modern Art reopened its enlarged facilities with a show entitled *An International Survey of Painting and Sculpture*. Of the 168 artists represented, only 13 were women.

Faced with statistics such as these, in 1985 an anonymous group of women that called themselves the Guerrilla Girls began hanging posters in New York City (Fig. 46.24). They listed the specific galleries who represented less than one woman out of every ten men. Another poster asked: "How Many Women Had One-person Exhibitions at NYC Museums Last Year?" The answer:

Guggenheim	0
Metropolitan	0
Modern	1
Whitney	0

One of the Guerrilla Girls' most daring posters was distributed in 1989. It asked, "When racism & sexism are no longer fashionable, what will your art collection be worth?" It listed 67 women artists from Elizabeth Vigée-Lebrun to Frida Kahlo and Georgia O'Keeffe, and pointed out that a collection of works by all 67 artists would be worth less than the art auction value of any *one* painting by Jasper Johns. Its suggestion that the value of Johns's work might be drastically inflated struck a chord with many.

By the late 1990s, the situation had changed somewhat. Many more women were regularly exhibited in New York galleries and more major retrospectives were given their work. But, internationally especially, women continue to get short shrift. Where a retrospective by a major male artist—Robert Rauschenberg, for instance—might originate in New York at the Guggenheim and travel to international venues around the world, most retrospectives of women artists remain much more modest—a single nontraveling show at, say, the New Museum in New York or the Los Angeles County Museum of Art. ■

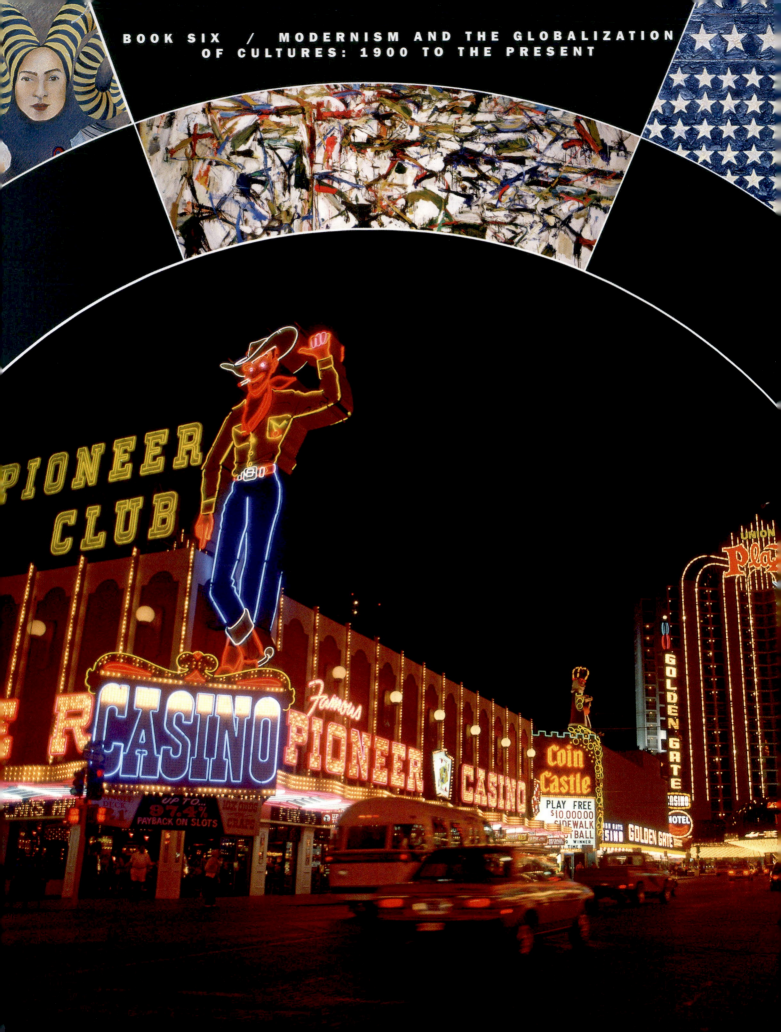

47 The Postmodern Era

Multiple Meanings in a Changing World

Complexity and Contradiction in Postmodern Architecture

Pluralism in the Visual Arts

Multiplicity and Postmodern Literature

The Theatrical and the New *Gesamtkunstwerk*

> **"** *If you take a baroque candelabra and you put it on a baroque table, that's one thing. But if you take a baroque candelabra and you place it on a rock, that's something else. . . .* **"**
>
> Robert Wilson

◄ **Fig. 47.1 Las Vegas, Nevada.** Superstock, Inc. Especially at night, Las Vegas attacks the senses with a profusion of signs and lights. Known as the Strip, it represents the overload of sensory input that has created the postmodern condition. The neon cowboy on the left is known as Vegas Vic. In 1981, Vegas Vickie rose across the street above Glitter Gulch, which took its name from what locals were already calling the four-block length of Fremont Street. This photograph dates from about 1985.

UNTIL THE LATE 1940S, LAS VEGAS, NEVADA WAS A SLEEPY

desert town, home to fewer than 10,000 people. The building of the Hoover Dam in 1931 had stimulated a modest growth, but that same year, two events occurred that would change Las Vegas forever. First, the State of Nevada legalized gambling,

and one month later, Las Vegas issued six gambling licenses. Then, the state liberalized its divorce laws by granting residency to anyone who lived in Nevada for just six weeks. "Dude Ranches" sprang up for those seeking a "quickie" divorce and became the forerunners of the hotels and casinos that would flourish several decades later.

Perhaps the most significant event would occur in 1946 when Bugsy Siegel, a mobster financed by East Coast organized-crime money, opened the Flamingo Hotel. With each of its 105 rooms individually air conditioned, its bathrooms tiled (an almost unheard-of luxury), and swimming pools scattered across its grounds, the Flamingo was the work of a visionary, even if a murderous one. Bring them to the hotel, Siegel reasoned, and they will gamble. At first, the Flamingo flopped, costing Siegel his life—he was murdered in 1947, probably by his unhappy mobster investors. But soon the hotel was turning a healthy profit, and similar establishments quickly appeared along the road from Los Angeles. The Las Vegas Strip was born (see Map **47.1**).

Las Vegas plays a key role in this chapter, which is devoted to the world of postmodern architecture and art. Las Vegas became a mixture of the crassly commercial and the monumental, a stylish successor to the functional Bauhaus style of modernist architecture (see chapter 44). In their seminal 1972 book *Learning from Las Vegas*, architects Robert Venturi (1925–), Denise Scott Brown (1931–), and Steven Izenour (1940–2001) put it simply: "A roadway could become a city. A building could become a sign. In no place at all, someplace could be created. That is Las Vegas' genius." Just as important, on the Las Vegas Strip, "people, even architects, have fun." The desert city's complexity, disorder, and confusion, with each hotel's gigantic neon sign trying to outdo the other (Fig. **47.1**) as they vie for our attention, masked an almost completely artificial landscape.

Robert Venturi, the unofficial dean of postmodern architecture, issued a "Gentle Manifesto" in 1966 which offered his criteria for a new eclectic approach to architecture that abandoned the clean and simple geometries of the International Style (see chapters 44 and 45). For Mies van der Rohe, "less is more" had become a mantra which he used to describe the refined austerity of his designs. Venturi argued for the opposite:

> An architecture of complexity and contradiction has a special obligation toward the whole: its truth must be in its totality or its implications of totality. It must embody the difficult unity of inclusion rather than the easy unity of exclusion. More is not less.

Map 47.1 The Las Vegas Strip. Fremont Street (see Fig. 47.1) lies to the north of the Strip.

In the Las Vegas Strip, Venturi, Brown, and Izenour discovered a new totality: "Although its buildings suggest a number of historical styles," they write,

> its urban spaces owe nothing to historical space. Las Vegas space is neither contained and enclosed like medieval space nor classically balanced and proportioned like Renaissance space nor swept up in a rhythmically ordered movement like Baroque space, nor does it flow like Modern space around freestanding urban space makers.
>
> It is something else again. But what? Not chaos, but a new spatial order. . . . Las Vegas space is so different from the docile spaces for which our analytical and conceptual tools were evolved that we need new concepts and theories to handle it.

If anything, since *Learning from Las Vegas* was first written, the collision of historical styles and commercial architecture in the city has become more pronounced. New York-New York, an enormous hotel and casino, with over 2,000 guest rooms, replicates the New York City skyline (Fig. **47.2**). The Luxor Las Vegas is a model of the pyramid and Sphinx at Giza (Fig. **47.3**). The 24-acre Paris Las Vegas includes replicas of the Eiffel Tower (at 540 feet, more than half as high as the original), the Arc de Triomphe [ark deh tree-OHMF], and Garnier's Opera House. We have come to call the collision of styles and forms epitomized by Las Vegas **postmodernism**.

Similarly, the other postmodern art and architecture examined in this chapter cannot be understood as a product of a single style, purpose, or aesthetic. They are defined by multiple meanings and their openness to interpretation. "Meaning" itself becomes contingent and open-ended, for example, the meaning of the ancient Egyptian Sphinx is transformed when placed in front of a massive twenty-first-century casino and hotel. Indeed, postmodern media art introduces situations in which sight, sound, and text each challenge the "undivided" attention of the audience, sometimes creating a sensory overload in which meaning is buried beneath layers of contradictory and ambiguous information. Confronting the postmodern object, the postmodern mind must ask itself, "How do I sort this out?" But this is a question that, as people living in the postmodern age, we are increasingly adept at answering.

Fig. 47.2 Neal Gaskin, architect. New York-New York. 1997. The interconnected buildings are approximately one-third the size of the actual structures. From left to right are replicas of the Lever House, the Empire State Building, 55 Water Street, the Century Building, Liberty Plaza, the New Yorker Hotel, the Seagram Building, the Chrysler Building, and the CBS Building. In the foreground are a 150-foot-high replica of the Statue of Liberty, a Coney Island-style roller coaster, with other famous but smaller New York buildings forming the lower-level casino facade.

Complexity and Contradiction in Postmodern Architecture

It is difficult to pinpoint exactly when "modernism" ended and "postmodernism" began, but the turning point came in the 1970s and 1980s. Architects began to reject the pure, almost hygienic uniformity of the Bauhaus and International styles, represented by the work of Mies van der Rohe (see Fig. 44.32), favoring more eclectic architectural styles that were anything but pure. A single building might incorporate a classical colonnade and a roof line inspired by a piece of Chippendale furniture. The use of many different, even contradictory elements of design became the hallmark of postmodern architecture. In *Learning from Las Vegas*. Venturi asserted that postmodern design used various, even contradictory strategies to communicate a "difficult whole." The English critic Peter Fuller explained the task of the postmodern artist this way:

> The west front of Wells Cathedral, the Parthenon pediment, the plastic and neon signs on Caesar's Palace in Las Vegas, even the hidden intricacies of a Mies curtain wall, are all equally "interesting." Thus the Post-Modern designer must offer a shifting pattern of changing strategies and substitute a shuffling of codes and devices, varying ceaselessly according to audience, and/or building type, and/or environmental circumstance.

Fig. 47.3 Veldon-Simpson Architect, Inc. The Luxor Las Vegas. 1993. Inside the lobby, a replica of the Great Temple of Ramses II rises 35 feet into the world's largest atrium, measuring 29 million cubic feet. With 4,400 rooms, it is the second largest hotel in America.

The University of Houston College of Architecture

A key example of the kind of "shuffling of codes and devices" that Fuller refers to can be seen in the design for the College of Architecture at the University of Houston (Fig. **47.4**) by Philip Johnson (see chapter 44) and John Burgee (1933–). This school building is in itself a history lesson—a catalog of Western architectural styles from ancient Greece to the present. The building is topped with a Greek temple and immediately below is a large-scale replica of a country villa by Palladio (see Fig. 19.16). It was inspired by an eighteenth-century plan for a House of Education designed by Claude-Nicolas

Continuity & Change
p. 628

Villa La Rotunda

Ledoux [leh-DOO] (1736–1806) for a proposed utopian community that was never built (Fig. **47.5**). The temple at the top of the College of Architecture building is set over a five-story central atrium, an air-conditioned plaza at the heart of the facility.

Students originally protested the Johnson/Burgee plan, calling it a "blatant copy" made by "Xerox, Inc." But the copying was obviously intentional, meant to invoke the utopian aspirations of Ledoux as the ideal of a College of Architecture. Johnson and Burgee also recognized that the building's relocation from France to Houston, Texas 200 years after the original design inherently transformed its meaning as well as its purpose. Overlooking the entire Houston skyline, which is dominated by skyscrapers that are the opposite of its stately traditional forms, the architecture school embodies a tension between the classical and the modern—the very contradiction and complexity that make it a postmodern work.

Fig. 47.4 Philip Johnson and John Burgee. Hines College of Architecture, University of Houston. 1983–1985. Johnson said of the building that it was "the only building in my career that I unashamedly copied from another architect."

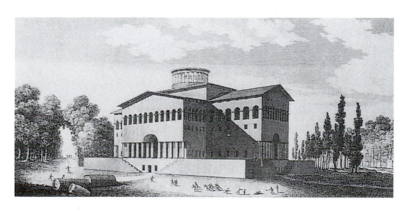

Fig. 47.5 Claude-Nicolas Ledoux. House of Education, plan for Choux, France. 1773–1779. Courtesy of the Library of Congress. Ledoux's plan differs from the Johnson-Burgee design only in the circular form of the temple at its top and the large pediment on which it rests.

Fig. 47.6 Frank Gehry. Residence, Santa Monica, California, and axonometric rendering. 1977–1978. Photograph by Tim Street-Porter. Gehry's neighbors were not at all pleased with his new house, but Gehry claims that he was trying to use "materials that were consistent with the neighborhood." He explains: "When I built that house, that neighborhood was full of trailer trucks in the back yards, and often on the lawn. A lot of old, aging Cadillacs and big cars on blocks on the front lawn, people fixing their cars. A lot of chain link fences, corrugated metal; I know they didn't use it like I did, and that's the difference."

The Gehry House

The home of architect Frank Gehry [GHEH-ree] (1929–) in Los Angeles (Fig. **47.6**) is, on the surface, a collision or eruption of parts. In the mid-1970s, still a young and relatively unknown architect, Gehry and his wife moved into a Santa Monica house that fulfilled their main criterion—it was affordable. "I looked at the old house that my wife found for us," Gehry recalls, "and I thought it was kind of a dinky little cutesy-pie house. We had to do something to it. I couldn't live in it. . . . Armed with very little money, I decided to build a new house around the old house and try to maintain a tension between the two." The new house surrounding the old one is deliberately unfinished, almost industrial. A corrugated metal wall, chain-link fencing, plywood walls, and concrete block surround the original pink frame house with its asbestos shingles. The surrounding wall, with randomly slanted lines and angled protrusions, thus separates not only the "outside" house from the house within, but the entire structure from its environment. The tension established by Gehry between industrial and traditional materials, between the old house and the almost fortress-like shell of his home's new skin, intentionally creates a sense of unease in viewers (one certainly shared by Gehry's neighbors). The sense that they are confronting the "difficult whole" Venturi speaks about defines, for Gehry, the very project of architecture. If Gehry's architecture is disturbingly unharmonious with its surroundings, it cannot be ignored or taken for granted. It draws attention to itself *as* architecture.

The Guggenheim Museum Bilbao

Gehry's use of sculptural frames to surround his house—note the steel and wire fencing that extends over the roof behind the front door, which would be "decorative" or "ornamental" were it not so mundane—has continued throughout his career, culminating in his design for the Guggenheim Museum in Bilbao [bill-BOW ("bow" as in "now")], Spain (Fig. **47.7**). Working on the models with the Catia computer program originally developed for the French aerospace industry, Gehry notes, "You forget about it as architecture, because you're focused on this sculpting process." The museum itself is enormous—260,000 square feet, including 19 gallery spaces connected by ramps and metal bridges—and covered in titanium, its undulating forms evoking sails as it sits majestically along the river's edge in the Basque port city. But it is the sense of the museum's discontinuity with the old town and the surrounding countryside (Fig. **47.8**) that most defines its postmodern spirit. It makes Bilbao, as a city, a more "difficult whole," but a more interesting one, too.

Gehry's design for the Guggenheim in Bilbao was stunningly successful, drawing critical raves, massive numbers of visitors, and even reservations that the architecture was so noteworthy that it overshadowed the priceless art within the structure. One of the key elements of this success was Gehry's ability to ensure that the "organization of the artist" prevailed, as he put it, "so that the end product is as close as possible to the object of desire that both the client and architect have come to agree on." So postmodern architectural design and theory were not necessarily incompatible with the efficient completion of large, complex, and innovative structures like the Guggenheim in Bilbao (or the Experience Music Project museum in Seattle, another large-scale Gehry structure). And it turns out that the digital design models produced by the Catia program were not only useful for envisioning the shapes of "sculpted" buildings. The data produced by such computerized designs was critical in estimating construction costs and budgets.

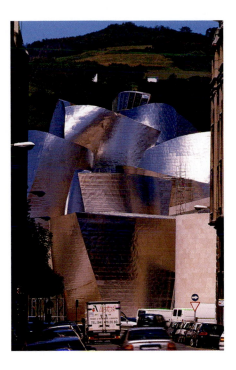

Fig. 47.7 Frank Gehry. Guggenheim Museum Bilbao. 1997. Photo: David Heald. © The Solomon R. Guggenheim Foundation, NY. The official description of the building begins: "The building itself is an extraordinary combination of interconnecting shapes. Orthogonal blocks in limestone contrast with curved and bent forms covered in titanium. Glass curtain walls provide the building with the light and transparency it needs . . . the sinuous stone, glass, and titanium curves were designed with the aid of computers. The glass walls were made and installed to protect the works of art from heat and radiation. The half-millimeter thick 'fish-scale' titanium panels covering most of the building are guaranteed to last one hundred years."

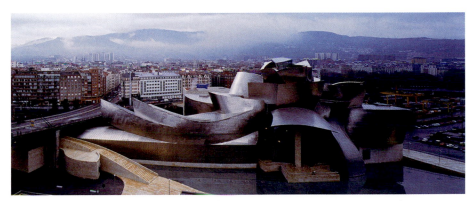

Fig. 47.8 Frank Gehry. Guggenheim Museum Bilbao. 1997. Photo: David Heald. © The Solomon R. Guggenheim Foundation, NY.

Pluralism in the Visual Arts

Despite the apparent plurality of its many "-isms," modern art, from the moment that Braque and Picasso affirmed the primacy of the conceptual over the optical, systematically replaced the representation of the world with the representation of an "idea." This was a process that led to ever greater abstraction. Pop Art offered a different model—works that aimed at inclusion, not exclusion, and the promise that anything might be permissible. A photograph by Louise Lawler (1947–), *Pollock and Tureen* (Fig. **47.9**), summarizes this sense of diversity and multiplicity. Lawler's work attempts to demonstrate how context, from museums to exhibition catalogues to private homes, determines the ways in which images are received and understood. Thus, the Pollock painting in this photograph is transformed into a decorative or ornamental object, much like the tureen centered on the side table in front of it. Lawler both underscores the fact that the painting is, like the tureen, a marketable object and suggests that the expressive qualities of the original work—its reflection of Pollock's Abstract Expressionist feelings—have been emptied, or at least nearly so, when looked at in this context.

New Directions in Painting

By the end of the 1960s artists felt free to engage in a wide spectrum of experimental approaches to painting, ranging from the stylized imagery introduced by Pop artists to the street style of graffiti writers (see the *Focus* on Jean-Michel Basquiat, pages 1534–1535), and from full-blown abstraction to startlingly naturalistic realism. A fascinating new genre developed in this period, seeking to produce the effects

Fig. 47.9 Louise Lawler. *Pollock and Tureen*. 1984. Cibachrome, 28″ × 39″. Courtesy Metro Pictures, NY. The formal parallel of linear rhythm and color harmonies in both the painting and the tureen contradicts their obvious differences.

Focus

Basquiat's *Charles the First*

Charles the First by Jean-Michel Basquiat [bah-skee-AH] (1960–1988) is an homage to the great jazz saxophonist Charlie Parker, one of a number of black cultural heroes celebrated by the graffiti-inspired Basquiat. Son of a middle-class Brooklyn family (his father was a Haitian-born accountant, his mother a black Puerto Rican), Basquiat left school in 1977 at age 17, living on the streets of New York for several years, during which time he developed the "tag"—or graffiti pen-name—SAMO, a combination of "Sambo" and "same ol' shit." SAMO was most closely associated with a three-pointed crown (as self-anointed "king" of the graffiti artists) and the word "TAR," evoking racism (as in "tar baby"), violence ("tar and feathers," which he would entitle a painting in 1982), and, through the anagram, the "art" world as well. A number of his paintings exhibited in the 1981 *New York/New Wave* exhibit at an alternative art gallery across the 59th Street Bridge from Manhattan attracted the attention of several art dealers, and his career exploded.

The price of a halo at 59¢ suggests that martyrdom is "for sale" in Basquiat's world.

Beneath the crown that Basquiat had introduced in his SAMO years is a reference to Thor, the Norse god; below it, the Superman logo; and above it, a reference to the *X-Men* comic book heroes.

The "X" in Basquiat's work is never entirely negative. In Henry Dreyfuss's *Symbol Sourcebook: An Authoritative Guide to International Graphic Symbols*, Basquiat discovered a section on "Hobo Signs," marks left, graffiti-like, by hobos to inform their brethren about the lay of the local land. In this graphic language, an "X" means "O.K.; All right."

This phrase, especially the crossed-out word "young," suggests Basquiat's sense of his own martyrdom. In fact, four months before his twenty-eighth birthday, in 1978, he would become the victim, according to the medical examiner's report, of "acute mixed drug intoxication (opiates–cocaine)."

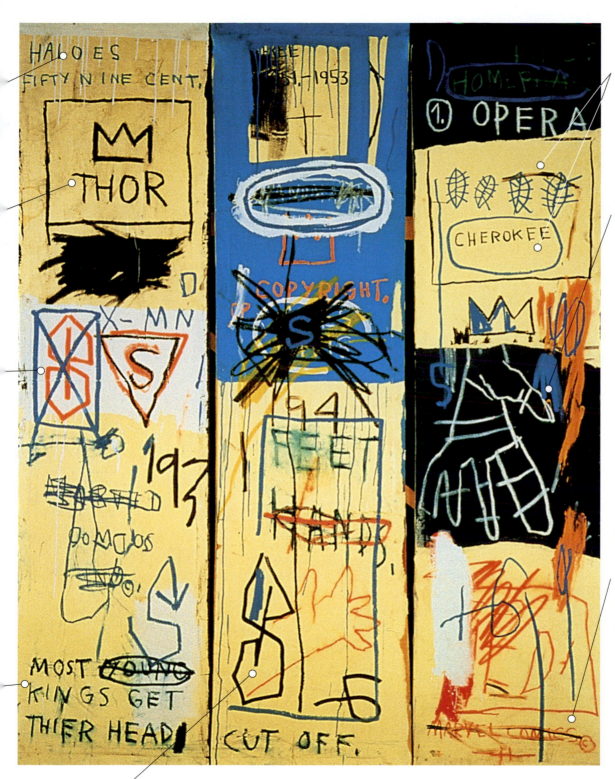

Beneath the word "Opera," and apparently on a par with the most aristocratic of musical genres, is the title of one of Parker's greatest tunes, "Cherokee," topped by four feathers in honor of Parker's nickname, "Bird."

The hand probably represents the powerful hand of the musician, and equally the painter.

Marvel Comics is of course a reference to the king of the superhero comic books. They are also publishers of the *X-Men* series, whom Marvel describes as follows: "Born with strange powers, the mutants known as the X-Men use their awesome abilities to protect a world that hates and fears them."

The "S," especially crossed out, also suggests dollars, $.

Jean-Michel Basquiat. *Charles the First.* **1982.** Acrylic and oil paintstick on canvas, three panels, 78″ × 62 ¼″ overall.
© The Estate of Jean-Michel Basquiat/© 2009 Artists Rights Society (ARS), NY.

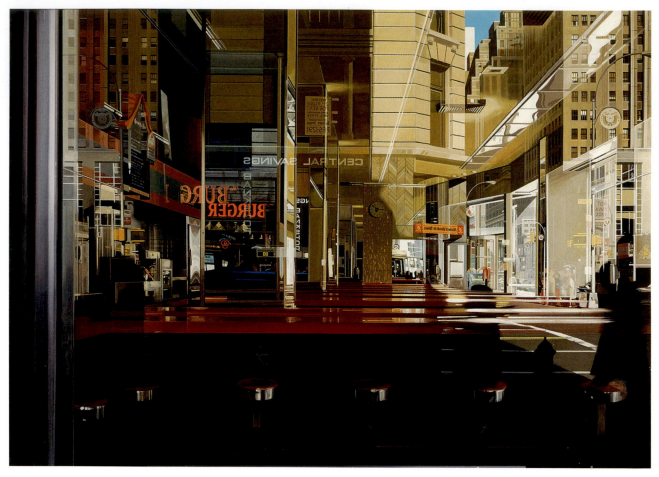

Fig. 47.10 Richard Estes. *Central Savings* 1975. Acrylic and oil on canvas, 36″ × 48″. The Nelson-Atkins Museum of Art, Kansas City, Missouri. Gift of the Friends of Art, P75-13. Photograph by Jamison Miller. Ironically, this painting takes its name not from the diner it depicts, but from the savings bank across the street, behind the viewer.

achieved in photography. The new **photorealist painting**, as it came to be known, was part of a more general acceptance of photography as a mainstream art medium, increasingly an important part of contemporary museum collections. As a rebellion against the prevailing currents of abstract art, photorealism required a high level of technical skill to render photographic-quality work, as well as the use of cameras and photographs to gather images.

The urban still lifes of Richard Estes (1932–) like other photorealist works, are based upon the artist's own photographs, which are then transferred to the canvas through a variety of techniques. But works like *Central Savings* (Fig. **47.10**) differ from actual photographs in a number of ways: most important, the painting's scale, 3 × 4 feet, is much larger than a normal photograph, and its focus is uncannily sharp throughout. Estes is particularly interested in the angles, visual distortions, and clarity inherent in the vast expanses of glass in the contemporary world. In this painting, we peer into the window of a diner, and in its reflection glimpse the Central Savings Bank across the street, an image repeated endlessly because of a mirrored column inside. An important aspect of *Central Savings* as well as Estes's other photorealistic works is

the fleeting nature of the images—dependent on particular lighting, these were mundane moments, frozen in time.

The monumental portraits of Chuck Close (1940–) are of an even larger scale than Richard Estes's Manhattan cityscapes. They also provide evidence of how Close negotiates the contested ground between abstraction and representation. Close overlays an original photograph with a grid—a series of vertical and horizontal lines—and then reproduces it with the same number of squares on a canvas. His nine-foot-high *Stanley* (Fig. **47.11**) illustrates his technique: Within each small square Close executes what amounts to a miniature abstract painting—a small, pointillist target composed of between two and four concentric circles (see the detail, Fig. **47.12**). Viewed up close, it is hard to see anything but the design of each square of the grid. But as the viewer moves farther away, the design of the individual square of the composition dissolves and the sitter's features emerge with greater and greater clarity.

Another approach to the question of the relation between abstraction and representation is seen in the works of Pat Steir [stire] (1940–). In 1989, she adapted Pollock's drip technique to her own ends, allowing paint to flow by force of gravity down the length of her enormous canvases to form

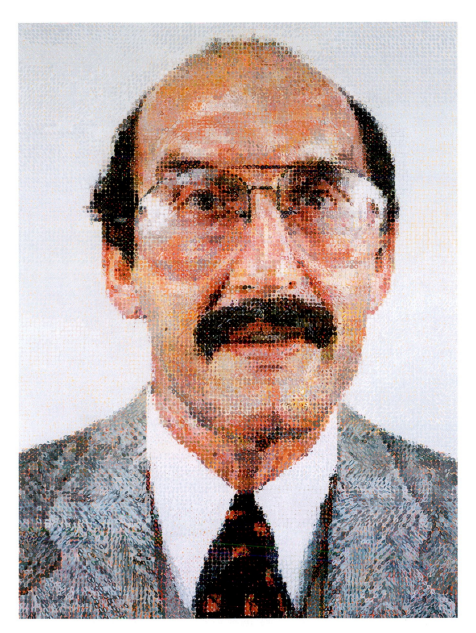

Fig. 47.11 Chuck Close. *Stanley* (large version).
1980–1981. Oil on canvas, 108″ × 84″. Solomon
R. Guggenheim Museum, NY. Purchased with funds
contributed by Mr. and Mrs. Barrie M. Damson,
1981. 81.2839. Photograph by David Heald.
© The Solomon R. Guggenheim Foundation, NY
(FN 2839). Close's work is a radical re-vision of
Seurat's nineteenth-century pointillist canvases
(see Fig. 40.12).

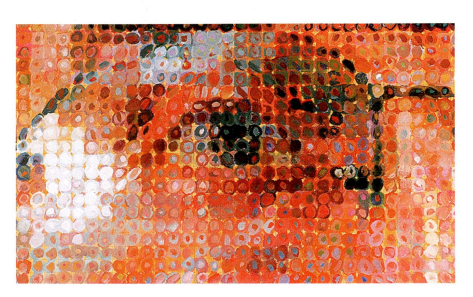

Fig. 47.12 Chuck Close. *Stanley* (large version),
detail. 1980–1981. Oil on canvas, 108″ × 84″.
Solomon R. Guggenheim Museum, NY. Purchased
with funds contributed by Mr. and Mrs. Barrie M.
Damson, 1981. 81.2839. Photograph by David
Heald. © The Solomon R. Guggenheim Foundation,
NY (FN 2839). This is a detail of Stanley's right eye.
In 1987, Close compared his dots to a game of golf,
"the only sport in which you move from the general
to the specific." Each dot is a movement of three or
four strokes (like golf strokes) of paint that create a
complementary color scheme that with each
addition moves closer and closer to the desired color.

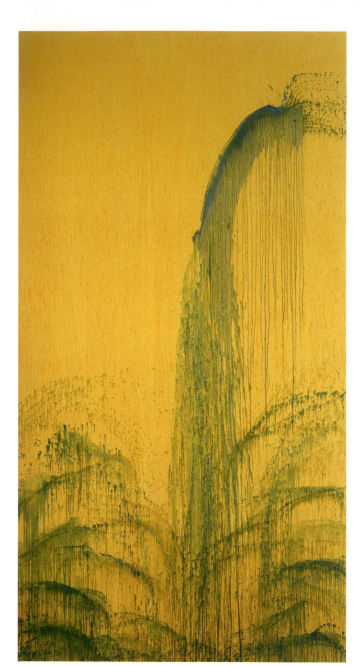

Fig. 47.13 Pat Steir. *Yellow and Blue One-Stroke Waterfall.* **1992.** Oil on canvas, 14′6 1/4″ × 7′6 3/4″. The Solomon R. Guggenheim Museum, NY. Gift, John Eric Cheim, 1999. 99.5288. Steir's work is deeply informed by her interest in Tibetan and Chinese religious lore, and she is interested in creating something of their meditative space.

recognizable waterfalls. *Yellow and Blue One-Stroke Waterfall* (Fig. **47.13**) is 14 feet high, its format reminiscent of Chinese scroll paintings of waterfalls. Steir explained the rationale behind her series of waterfall paintings in a 1992 interview:

> I don't think of these paintings as abstract. . . . These are not only drips of paint. They're paintings of drips which form waterfall images: pictures. . . . [Nor are] they realistic . . . I haven't sat outdoors with a little brush, trying to create the illusion of a waterfall. The paint itself makes the picture. . . . Gravity make the image. . . .

These paintings are, in a sense a comment on the New York School [i.e., the first generation of abstract expressionists, including Pollock and de Kooning], a dialogue and a wink. They [her waterfall paintings] say, "You didn't go far enough. You stopped when you saw abstraction." . . . I've taken the drip and tried to do something with it that the Modernists denied.

The exchange of ideas between proponents of realism and those of abstraction during the post–World War II era had far-reaching effects. Rather than an either/or proposition, there is abundant cross-fertilization between the approaches. We can see this in the work of the contemporary German artist Gerhard Richter [RIKH-ter] (1932–), who moves freely between the two—sometimes repainting photographs, black-and-white and color—and sometimes creating large-scale abstract works. Richter uses photographs, including amateur snapshots and media images, because, he says, they are "free of all the conventional criteria I had always associated with art . . . no style, no composition, no judgment." To him, they are "pure" pictures, unadulterated by the intervention of conscious aesthetic criteria. *Meadowland* (Fig. **47.14**), an oil painting on canvas, might as well have been taken from the window of a passing car. The questions it raises are quite simple: Why did he select this photograph to translate into a painting? How and when does the eye sense the difference between a painted and the photographic surface?

In comparing *Meadowland* to the artist's abstractions, which he concentrated on throughout the 1980s and 1990s, we can begin to answer these questions. Works such as *Ice (2)* (Fig. **47.15**) are obviously paintings. One senses that Richter begins with a realistic image, and before the ground completely dries, he

Fig. 47.14 Gerhard Richter. *Meadowland.* **1992.** Oil on canvas, 35 5/8″ × 37 1/2″. Blanchette Rockefeller, Betsy Babcock, and Mrs. Elizabeth Bliss Parkinson Funds. (350.1985). Digital Image © The Museum of Modern Art/Licensed by SCALA/Art Resource, NY. © Gerhard Richter, Germany. In 1964, Richter began collecting the source photos for all his paintings and arranging them on panels. When the resulting work, *Atlas*, was exhibited in 1995 at the Dia Center for the Arts in New York, it contained 683 panels and close to 5,000 photographs.

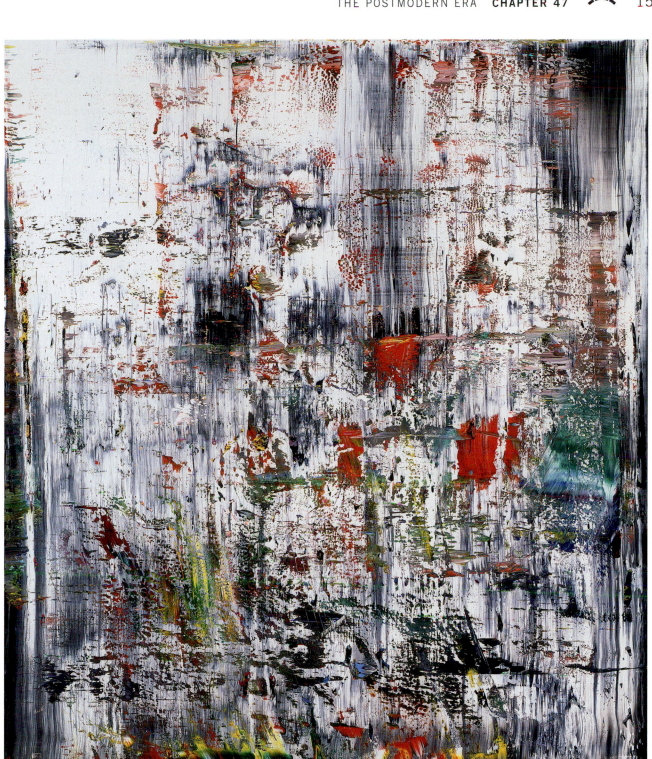

Fig. 47.15 Gerhard Richter. *Ice (2)*. 1989. Oil on canvas, $6'8'' \times 63\frac{7}{8}''$. Through prior gift of Joseph Winterbotham; gift of Lannan Foundation, 1997.188. Reproduction, the Art Institute of Chicago. All Rights Reserved. In the abstractions, the blurred effect of the photograph-based works has been heightened. We seem to be looking at the world through a sheet of ice.

drags another layer of paint through it with a squeegee or palette knife. The result is like viewing an object close up while passing it at high speed. But the resulting work is above all a painterly surface, not a photographic one. Nevertheless, in Richter's words:

> abstract paintings . . . visualize a reality which we can neither see nor describe but which we may nevertheless conclude exists. We attach negative names to this reality; the unknown, the ungraspable, the infinite, and for thousands of years we have depicted it in terms of substitute images like heaven and hell, gods and devils. With abstract painting we create a better means of approaching what can be neither seen nor understood because abstract painting illustrates with the greatest clarity, that is to say with all the means at the disposal of art, "nothing." . . . [Looking at abstract paintings] we allow ourselves to see the un-seeable, that which has never before been seen and indeed is not visible.

Given this artistic strategy, Richter's photograph-based works are paintings of the graspable and visible. Why did he select the photograph upon which *Meadowland* is based? Precisely because it is so mundane, a prospect we have so often seen before. How and when do we recognize *Meadowland* as a painting and not a photograph? When we accept photographic clarity—or photographic blurring, for that matter—as one of the infinite methods of painting. Richter's photographic paintings are thus the very antithesis of his abstractions, except that both styles are equal statements of the artist's vision. Together, in them, Richter explores not only the conditions of seeing but the possibilities of painting. Richter might be the ultimate postmodernist: "I pursue

no objects, no system, no tendency," he writes. "I have no program, no style, no direction. . . . I steer clear of definitions. I don't know what I want. I am inconsistent, non-committal, passive; I like the indefinite, the boundless; I like continued uncertainty."

New Directions in Sculpture

Postmodern sculpture seeks to put its audience in this same space of uncertainty. In his early work of the 1960s, Richard Serra (1939–) utilized minimalist forms—often sheets of lead, each weighing approximately one-quarter ton—that he would position precariously in ways that seemed to threaten viewers' safety. He might, for instance, place a lead sheet high on a wall, holding it in place by a lead pipe propped against it. Or he might arrange four sheets like a house of cards, each supporting the others' weight. But recognizing that viewers would have to maintain their distance from such works, he sought ways, in his words, to "create works that you could walk into, through, and around, to open up the field." A series of such works was inspired by Francesco Borromini's design of the church of San Carlo in Rome (see Figs. 25.10–25.12). After visiting the church in 1993, Serra decided to transform the spatial volume of the nave by rotating it on itself. The result is a series of torqued elliptical works consisting of 20-ton, 2-inch-thick rolled steel plates, each twisted and angled in a unique fashion, and large enough to walk through (Fig. **47.16**). As visi-

Continuity & Change
p. 813

Church of San Carlo

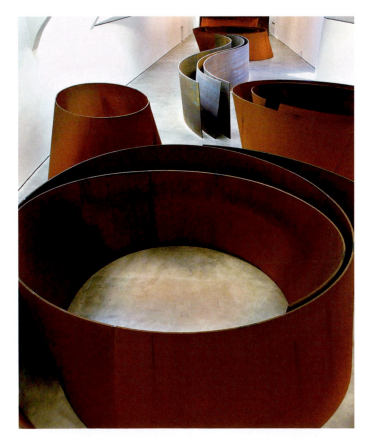

Fig. 47.16 Richard Serra. from front to back, *Tilted Ellipse I*, 1996; *Double Torqued Ellipse*, 1998–1999; *Double Torqued Ellipse II*, 1999; *Snake*, 1996; and two other works. Guggenheim Museum, Bilbao. Gehry designed this space (see Figs. 47.7 and 47.8) specifically for Serra's work, creating a harmonious tie between architecture and art.

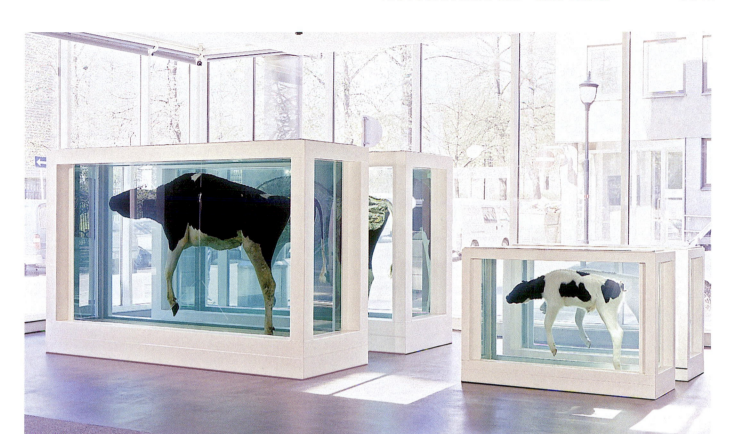

Fig. 47.17 Damien Hirst. *Mother and Child Divided*. 1993. Steel, GRP composites, glass, silicone sealants, cow, calf, formaldehyde solution, 2 boxes, 74³/₄″ × 126³/₄″ × 43″; 2 boxes 40³/₈″ × 66¹/₂″ × 24⁵/₈″. © Damien Hirst/Science, Ltd. The Astrup Fearnley Collection, Oslo, Norway. Photo Credit: Tore H. Royneland, Oslo. When this sculpture was exhibited at the 1993 Venice Biennale it caused an immediate sensation, especially as it resonated with the Mary/Christ theme on view in Venice's many churches.

tors move through the metal ellipses, they feel a destabilizing shift. The nature of space feels uncertain and continues to shift as visitors walk along the torqued wall.

If Serra's work typifies postmodern sculpture because it is physically disorienting, creating an atmosphere of uncertainty, the works of British artist Damien Hirst (1965–) create the same effect, but with a more psychological twist. The central theme of Hirst's work has been an exploration of mortality, realized effectively in the *Natural History* series, in which dead animals are presented in a manner derived from displays at museums of natural history. *Mother and Child Divided* (Fig. **47.17**) presents two adult cows and two calves suspended in formaldehyde solution in four separate boxes. Consisting of actual cadavers of animals that died naturally because of complications during the pregnancy and birth, the work plays off the viewers' initial revulsion at confronting bodies in a formaldehyde solution. The irony of the work soon becomes apparent—the animals float angelically, as if freed from the forces of gravity and life. Yet, preserved in formaldehyde, they refute the transience of life, becoming permanent presences. It is as if the artist and viewer alike deny them the last rite of passage: the passage into eternity. They are an image of purgatory, of some suspended state between life and death.

New Media

Just as the electronic media have revolutionized modern culture, dating from Thomas Edison's first audio recording to the motion picture, radio, television, and digital technologies, from the Internet to the iPod, so too have the arts been revolutionized by these media. This transformation was most fundamentally realized in the visual arts by Korean-born musician and artist Nam June Paik [pike] (1932–2006), whom many consider the father of video art.

In the 1950s and 1960s, Paik studied music in Germany with Karlheinz Stockhausen and John Cage (see chapters 45 and 46), both of whom had encouraged him to pursue electronic-based musical composition. Paik first came to the attention of the art world in 1963 in Germany, where he introduced his *Exposition of Music—Electronic Television*, composed of 13 prepared televisions, three prepared pianos, and various noisemakers. ("Prepared" instruments are those modified to achieve a desired sound, and in Paik's case, images.) It was the first "television"-based art exhibition at the same time that it was the first "television" composition in the history of music.

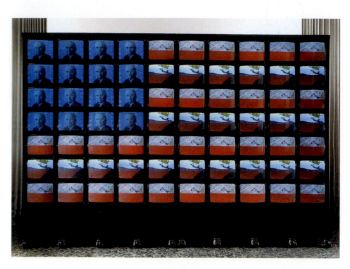

Fig. 47.18 Nam June Paik. *Video Flag*. 1985–1996. 70 video monitors, 4 laser disc players, computer, timers, electrical devices, wood and metal housing on rubber wheels, $94\frac{3}{8}$" × $139\frac{3}{4}$" × $47\frac{3}{4}$". Hirshhorn Museum and Sculpture Garden, Smithsonian Institution, Washington, D.C. Holenia Purchase Fund, in memory of Joseph H. Hirshhorn, 1996 (96.4). The monitors incorporate a face that morphs through every U.S. president of the Information Age, from Harry S. Truman to Bill Clinton.

By the mid-1960s, Paik's "altered TVs" displayed images altered by magnets combined with video feedback and other technologies that produced shifting patterns of shapes and colors. Throughout the 1970s, 1980s, and 1990s, Paik began to produce larger video installations, including the 1995 *Megatron*, which consisted of 215 monitors programmed with both live video images from the Seoul Olympic Games and animated montages of nudes, rock concert clips, national flags, and other symbolic imagery. One of Paik's most distinctive works appeared in 1985–1986, when he used the American flag as the basis for a computer sculpture, making three separate flag sculptures: *Video Flag X*, *Video Flag Y*, and *Video Flag Z*.

As revolutionary as Paik's video art was, the new technology it embraced also brought with it new challenges. Today, one of Paik's most famous works, *Video Flag Z*, a six-foot high grid of 84 monitors that once flashed a pulsating montage of red, white, and blue images across its surface, is packed away in the Los Angeles County Museum's warehouse. "We can't find replacement parts anymore," the museum's curator explains. This problem illustrates the danger most electronic media face as they fall victim to the ever-increasing rate of technological change. John Ippolito, a curator at the Guggenheim Museum in New York, warns that "There's a looming threat of mass extinction on the media-arts landscape." One solution is for media artists to re-engineer their works, which is precisely what Paik has done for his *Video Flag* (Fig. **47.18**) at the Hirshhorn Museum in Washington, DC. Built a decade after the earlier "flags," the newer rendition incorporates what were then (1996) the latest advances

in technology, including automatic switchers and larger monitors. But more than a decade later, it too is threatened by the anachronism of its working parts.

Another answer to the continuing advances in technology is to create works that are designed to last only for a short time. Similar to Jeanne-Claude and Christo's *Wrapped Reichstag* (see Fig. 45.24) but on a smaller scale, the installations of Eleanor Antin (1935–) are designed to be viewed for a specific length of time and then be dismantled. Though they can be reconstructed for a second or third exhibition of limited duration, antiquated hardware can and must be replaced each time the installation is reconstituted.

Antin came to video art through another temporal medium, performance art. Inspired by the example of Allan Kaprow's Happenings (see chapter 45), by the late 1960s many artists began to think that new forms of art might be discovered by blurring the boundaries between media. Performance art, then, is more or less a theatrical work by artists staged in a gallery or a museum. Antin understood that her race- and gender-blurring performances—as the invented persona, Eleanora Antinova, the black ballerina of Diaghilev's Ballets Russes, or as the King of Solana Beach—could be documented by video camera. But she also realized that she could project multiple versions of herself and others simultaneously in installation settings.

An example is *Minetta Lane—A Ghost Story* (Fig. **47.19a, b, c**), first exhibited in New York City in 1995. It consists of a recreation of three buildings on a Greenwich Village (New York) street that runs for two blocks. In the 1940s and 1950s, it was the site of a low-rent artists' community, and Antin's installation recreates the bohemian character of that lost world. The installation itself consists of three narrative films, transferred to video disc, and back-projected onto the tenement windows of the reconstructed lane. The viewer, passing through the scene, thus voyeuristically peers into each window and views what transpires inside. In one window, two lovers play in a kitchen tub. In a second, an Abstract Expressionist painter is at work. And in a third, an old man tucks in his family of caged birds for the night. Ghosts of a past time, these characters are trapped on celluloid, but their world is inhabited by another, unseen ghost. A little girl, who is apparently invisible to those in the scene but clearly visible to us, paints a giant "X" across the artist's canvas and destroys the relationship of the lovers in the tub. She represents a destructive force that, in Antin's view, is present in all of us—and, in fact, present in the very nature of her electronic medium. For the artist, the lovers and the old man represent the parts of us that we have lost—our youth. They represent ideas about art, sexuality, and life that, despite our nostalgia for them, are no longer relevant.

Contemporary video art is, in fact, haunted by ghosts. In a catalogue essay that she wrote for another installation of Minetta Lane, Antin mused, "What I'm after is some image in my mind that I want to make visible, knowable, perceivable. Make the immaterial material, so that someone else can

Fig. 47.19a Eleanor Antin. *Minetta Lane—A Ghost Story.* 1995.
Mixed-media installation. Installation view and two stills from video
projections. Courtesy the artist and Ronald Feldman Fine Arts, NY.
Each of the installation's three films is about ten minutes long.

Fig. 47.19b

Fig. 47.19c

turn it back into some other imma-
terial image that I hope is not too
alien from my own." Antin's films
produce images that are imprinted
on our minds, where they become
immaterial again, summoned by an
act of memory. The filmic image is
the trace—or what remains—of a
lost past. It is, of its nature, inher-
ently "ghostly."

As the "ghost" metaphor suggests,
temporal media like video art are
often concerned with the passing of
time itself, the life cycle from birth to
death. Video artist Bill Viola [vye-
OH-la] (1951–) has been fascinated,
throughout his career, by the passage
of time. His principal metaphor for
this passage is water, which not only
flows, like time, but because it can be

Fig. 47.20 Bill Viola. *Five Angels for the Millennium.* 2001. Video/sound installation, five channels of color video projection on walls in a large, dark room (room dimensions variable); stereo sound for each projection; project image size 7'10½" × 10' × 6" each. Edition of three. Photo: Mike Bruce, courtesy Anthony d'Offay, London.

seen, water seems to make both time and space tangible and palpable. His video installation piece *Five Angels for the Millennium* (Fig. **47.20**) is composed of five individual video sequences that show a clothed man plunging into a pool of water (see also Fig. 36.11). The duration of each video is different, with long sequences of peaceful aqueous landscape suddenly interrupted by the explosive sound of the body's dive into the water. He describes the process of making the piece:

> *Five Angels* came out of a three-day shoot in Long Beach that I had undertaken for several other projects. All I knew was that I wanted to film a man plunging into water, sinking down, below, out of frame—drowning. A year or so later, going through this old footage, I came across five shots of this figure and started working with them—intuitively and without a conscious plan. I became completely absorbed by this man sinking in water, and by the sonic and physical environment I had in mind for the piece.
>
> When I showed the finished work to Kira [Perov], my partner, she pointed out something I had not realized until that moment: this was not a film of a drowning man. Somehow, I had unconsciously run time backwards in the five films, so all but one of the figures rush upwards and out of the water. I had inadvertently created images of ascension, from death to birth.

Because the videos are continuously looped and projected onto the gallery walls, their different durations make it impossible to predict which wall will suddenly become animated by the dive—the one behind you, the one in front of you, the one at your side. The experience is something like being immersed in both water and time simultaneously, in the flow of the moment. For Viola, video differs from film in exactly this sense. The most fundamental aspect of video's origin as a medium is the *live* camera. Video is in the moment. And Viola's installation literally spatializes time, even as time becomes as palpable as the watery surfaces that Viola depicts.

Multiplicity and Postmodern Literature

The pursuit of meaning lies at the heart of postmodern literature, but because meaning is always plural and fleeting, attempting to find any permanent or stable meaning in the postmodern world can only lead to frustration. The postmodern hero seeks meaning, but accepts the fact that the search is never-ending. At the beginning of his study of the Western experience of order, entitled *The Order of Things* (in English translation), French historian Michel Foucault [foo-KOH] (1926–1984) describes the origins of his study (**Reading 47.1**):

READING 47.1 **from Michel Foucault, *The Order of Things* (1966)**

This book first arose out of a passage in Borges, out of the laughter that shattered, as I read the passage, all the familiar landmarks of my thought—our thought, the thought that bears the stamp of our age and our geography—breaking up all the ordered surfaces and all the planes with which we are accustomed to tame the wild profusion of existing things. . . . This passage quotes a "certain Chinese encyclopedia" in which it is written that "animals are divided into: (a) belonging to the Emperor, (b) embalmed, (c) tame, (d) suckling pigs, (e) sirens, (f) fabulous, (g) stray dogs, (h) included in the present classification, (i) frenzied, (j) innumerable, (k) drawn with a very fine camelhair brush, (l) et cetera, (m) having just broken the water pitcher, (n) that from a long way off look like flies." In the wonderment of this taxonomy, the thing we

apprehend in one great leap, the thing that ... is demonstrated as the exotic charm of another system of thought, is the limitation of our own, the stark impossibility of thinking that.

The impossibility of Borges's encyclopedia is based on how impossible it is for contemporary thought to recognize difference with no relation to opposition or relation to a common ground—each element in Borges's taxonomy requires a complete shift in point of view, requiring readers to reposition their viewpoint. There is, as Foucault points out, "no *common locus*" beneath this taxonomy, no *center* around which to organize its elements. But it is precisely this possibility of "thinking *that*" that is the goal of postmodern literature. To this point in this survey of the Western humanities, we have referred to an historical series of shifting geographic centers, each one providing a common cultural locus for thought. Postmodern thought alters the situation. The postmodern world consists of multiple centers of thought, each existing simultaneously and independently of one another.

Jorge Luis Borges's [BOR-hays] (1899–1986) short essay entitled "Borges and I" (see **Reading 47.2**, page 1551) may be the first postmodern exploration of this state of affairs. Borges describes himself as a bodily self divided from his persona as a writer. In the postmodern world, meaning shifts according to place and time and, Borges teaches us, point of view—not only the writer's but our own. Meaning might well be determined by a myriad of semantic accidents or misunderstandings, or by a reader whose mood, gender, or particular cultural context defines, for the moment, how and what he or she understands. Postmodern writing produces texts that willingly place themselves in such an open field of interpretation, subject to uncertainty.

Postmodern Fiction

A working definition of postmodern fiction thus might include any form of writing that defeats the readers' expectations of coherence, that dwells on the uncertainty and ambiguity of experience, and that requires readers who can adjust to that situation. Among its most notable practitioners are Paul Auster (1947–), William Gass (1924–), Don DeLillo (1936–), Donald Barthelme (1931–1989), John Barth (1930–), John Hawkes (1925–1998), Italo Calvino (1923–1985), Umberto Eco (1932–), and Thomas Pynchon (1937–).

Pynchon's 1963 novel *V.* is a good example. Set in the mid-1950s, it takes its title from the ongoing quest of one of its two protagonists, Herbert Stencil, for a woman mentioned in his late father's journals. The journal entry is cryptic: "Florence, April, 1899 ... There is more behind and inside V. than any of us had suspected. Not

who, but what: what is she." She is connected, Stencil understands, "with one of those grand conspiracies or foretastes of Armageddon which seemed to have captivated all diplomatic sensibilities in the years preceding the Great War. V. and a conspiracy." Stencil is convinced that "she" still exists, that she is something of an explanation for World War II, for the bomb, for apartheid in South Africa, for all evil. And, as it turns out, "she" is everywhere. She is Venus, the Virgin, the Vatican, Victoria Wren (who had seduced Stencil's father in Florence in the late nineteenth century), Veronica Manganese (Victoria Wren's reinvention of herself in World War I Malta), and Vera Meroving (her next incarnation in Southwest Africa). Ultimately she is transformed from the animate human being to an inanimate "force" behind Germany's V-1 missiles, which devastated London in World War II. Perhaps most of all, V. is the *vanishing point*, the place on the horizon where two parallel lines appear to converge, but is never reachable. Pynchon's novel ends as a conventional murder mystery, in which the criminal does not turn out to be a person so much as a metaphysical force.

In another metaphysical detective story, *City of Glass* (1985), Paul Auster finds himself a character in his own story, suddenly confronting another of his characters, a mystery writer named Daniel Quinn who writes under the pseudonym William Wilson. Quinn has come to Auster's door (**Reading 47.3a**):

READING 47.3a **from Paul Auster, *City of Glass* (1985)**

It was a man who opened the apartment door. He was a tall dark fellow in his mid-thirties, with rumpled clothes and a two-day beard. In his right hand, fixed between his thumb and first two fingers, he held an uncapped fountain pen, still poised in a writing position. The man seemed surprised to find a stranger standing before him.

"Yes?" he asked tentatively.

Quinn spoke in the politest tone he could muster. "Were you expecting someone else?"

"My wife, as a matter of fact. That's why I rang the buzzer without asking who it was."

"I'm sorry to disturb you," Quinn apologized. "but I'm looking for Paul Auster."

"I'm Paul Auster," said the man.

The elimination of any distance between the author and his work draws attention to the act of writing, a typical strategy of postmodern fiction. In blurring the boundaries between life and art, reality and fiction, Auster's fictional work becomes *real* in some sense. We can thus gain a clue to

Auster's motivation by his character Quinn's explanation early in the novel, about why he writes detective stories (**Reading 47.3b**):

READING 47.3b from Paul Auster, *City of Glass* (1985)

What he liked about these books was their sense of plenitude and economy. In the good mystery there is nothing wasted, no sentence, no word that is not significant. And even if it is not significant, it has the potential to be so—which amounts to the same thing. The world of the book comes to life, seething with possibilities, with secrets and contradictions. Since everything seen or said, even the slightest, most trivial thing, can bear connection to the outcome of the story, nothing must be overlooked. Everything becomes essence; the center of the book shifts with each event that propels it forward. The center, then, is everywhere, and no circumference can be drawn until the book has come to its end.

The detective is one who looks, who listens, who moves through this morass of objects and events in search of the thought, the idea that will pull all these things together and make sense of them. In effect, the writer and the detective are interchangeable. The reader sees the world through the detective's eyes, experiencing the proliferation of its detail as if for the first time. He has become awake to the things around him, as if, because of the attentiveness he now brings to them, they might begin to carry a meaning other than the simple fact of their existence.

By abolishing distinction between detective, writer, and reader, Auster not only highlights the act of writing, but the act of reading as well, with the reader becoming implicated in the novel's intrigues. Literally caught up in his own fiction, Auster's fictional self spins into a life "seething with possibilities, with secrets and contradictions."

The Plural Self and Magical Realism: Latino and Hispanic Literatures of the Americas

Hispanic and Latino literatures of the Americas offer an unsurpassed array of themes relating to the plurality of post-modern selves—as Jorge Luis Borges's essay "Borges and I" demonstrates (see Reading 47.2). As discussed in chapter 23, by the eighteenth century the Hispanic Americas were one of the most diverse cultures in the world, a society composed of *mestizos* [mes-TEE-zohs] (Spanish-Indian), *mulattos* [moo-LAH-tohs] (Spanish-Black), *zambos* [ZAHM-bohs] (Black-Indian), *castizos* [kahs-TEE-zohs] (light-skinned mestizos), and *moriscos* [moh-REES-kohs] (light-skinned

mulattos). As Filipinos [fil-ih-PEEN-ohs] and other Asian populations arrived in Mexico as slaves or indentured servants, a new term came into the language to indicate racial indeterminacy, *tente en el aire* [TEN-tay en el AH-ee-ray], "hold yourself in the air."

The pluralistic identity of Latin America has remained constant, while to the North, North Americans of Hispanic origin have created a distinctive culture group inside the United States (it is estimated that the U.S. Latino population will reach 100 million by the year 2040). The situation has been summed up by Puerto Rico-born poet Aurora Levins Morales [moh-RAH-lays] (1954–), in "Child of the Americas" (**Reading 47.4**):

READING 47.4 Aurora Levins Morales, "Child of the Americas" (1986)

I am a child of the Americas,
a light-skinned mestiza of the Caribbean,
a child of many diaspora, born into this continent at a
 crossroads.

I am a U.S. Puerto Rican Jew,
a product of the ghettos of New York I have never known.
An immigrant and the daughter and granddaughter of
 immigrants.

I speak English with passion: it's the tongue of my
 consciousness,
a flashing knife blade of crystal, my tool, my craft.

I am Caribeña, island grown. Spanish is my flesh,
Ripples from my tongue, lodges in my hips:
the language of garlic and mangoes,
the singing of poetry, the flying gestures of my hands.
I am of Latinoamerica, rooted in the history of my continent:
I speak from that body.

I am not African. Africa is in me, but I cannot return.
I am not taína. Taíno[1] is in me, but there is no way back.
I am not European. Europe lives in me, but I have no
 home there.

I am new. History made me. My first language was spanglish.
I was born at the crossroads
and I am whole.

[1] **Taíno:** The first Native American population encountered by Christopher Columbus (see chapter 22).

Morales's sense of her own plural identities finds its expression in Latin American fiction in the tradition known as **magical realism** (derived from *lo real maravilloso* [loh ray-AHL mah-rah-vee-YOH-soh] or "the marvelous real"), coined by Cuban novelist Alejo Carpentier [kar-pen-tee-AIR] (1904–1980). Magical realism is characterized by two simultaneous perspectives, one based on a rational view of reality

derived from European tradition and the other rising out of a more indigenous belief in the appearance of the supernatural or magical in everyday life. This latter outlook derives from a synthesis of religious mysticism originating in the Catholic, African, and Native American belief systems. Among the chief practitioners of magical realism are Jorge Luis Borges in Argentina, Mario Vargas Llosa [YO-sah] (1936–) in Peru, Isabel Allende [ahl-LEN-day] (1942–) in Chile, and Gabriel García Marquéz [gar-SEE-ah MAR-kays] (1927–) in Colombia. Perhaps the most famous book in the genre is García Marquéz's *One Hundred Years of Solitude*, which tells the story of six generations of the Buendía [bwen-DEE-ah] family and simultaneously the fictional town of Mocondo, from its accidental founding by the patriarch Jose Arcadio Buendía, to its thriving days as a banana plantation, ending in its eventual abandonment. The novel opens with a scene where gypsies introduce *real* objects to the culturally isolated Buendía clan, which they take to be magical, especially a magnet that attracts all the village's metal objects—pots, pans, nails and screws—to itself. "Things have a life of their own," the head of the gypsies explains to the wonderment of all. Of course, the idea that "things have a life" is deeply embedded in the indigenous and African-derived spiritual traditions of Latin America, including the Santeria religion of the Caribbean (which originates in Yoruba beliefs and practices), Palo Monte [PAH-loh MOHN-tay] (of Bantu origin and practiced in Cuba), and Haitian Vodou, which originated in West Africa.

Postmodern Poetry

Because the postmodern self is plural, postmodern literature—including poetry—encompasses a plurality of meanings. Indeed, one of the principal strategies of postmodern poetry is to take advantage of the indeterminacy of certain words—particularly "it," and so-called "pointers," such as "this" and "that"—which, without clear antecedent, might designate anything and everything. This short poem, by David Antin (1932–), is a clear example (**Reading 47.5a**):

READING 47.5a **David Antin, "If We Get It" (1987–1988)**

IF WE GET IT TOGETHER
CAN THEY TAKE IT APART
OR ONLY IF WE LET THEM

To make the point even more indeterminate (and evanescent), Antin's poem was traced out by skywriters in the skies above Santa Monica beach, one line at a time, each line disappearing as the planes circled back to start the next, on Memorial Day, May 23, 1987. Over a year later, on Labor Day weekend, 1988, skywriters wrote the second stanza of Antin's poem over the same beach (**Reading 47.5b**):

READING 47.5b **David Antin, "If We Make It" (1987–1988)**

IF WE MAKE IT TOGETHER OR
FIND IT WILL THEY BREAK IN
OR OUT OF IT OR LEAVE IT
AS THEY FIND IT STRICTLY ALONE

The "it" here is completely imprecise and open to interpretation, but the opacity of its reference was exacerbated by the fact that each line of the poem disappeared from sight before the next was written even as the second stanza followed the first by 15 months. Always in the process of its own dissolution and revision, the poem is never "wholly" present to its audience, its meaning always disappearing.

The abolition of meaning is the express subject of many of the poems of one of America's most prominent—and eclectic—poets, John Ashbery (1927–). As Ashbery relates in "On the Towpath," every time we arrive at meaning, we realize, "No, / We aren't meaning that any more." The poem opens as narrative, but the promise of a story almost immediately recedes (**Reading 47.6**):

READING 47.6 **from John Ashbery, "On the Towpath" (1977)**

At the sign "Fred Muffin's Antiques" they turned off the
road into a narrow lane lined with shabby houses.

If the thirst would subside just for awhile
It would be a little bit, enough.
This has happened.
The insipid chiming of the seconds
Has given way to an arc of silence
So old it had never ceased to exist
On the roofs of buildings, in the sky.

The ground is tentative.
The pygmies and jacaranda that were here yesterday
Are back today, only less so.
It is a barrier of fact
Shielding the sky from the earth.

When Ashbery writes, "This has happened," the reader asks, *what* has happened? Ashbery's "This" is entirely ambiguous. What is "tentative" ground? Muddy? Slippery? Along the "towpath" it might well be, but it is also possible for "the ground" to mean "meaning" itself. Isn't "meaning" frequently tentative and slippery? Similarly, when Ashbery writes "It is a barrier of fact," to what does his "it" refer? Later in the poem, he writes,

The sun fades like the spreading
Of a peacock's tail, as though twilight

Might be read as a warning to those desperate
For easy solutions.

Ashbery's sense of play and experimentalism, along with his subversive humor, deliberately frustrates those who desire closure, or meaning. "No," he writes at the end of the poem:

We aren't meaning that any more.
The question has been asked
As though an immense natural bridge had been
Strung across the landscape to any point you wanted.
The ellipse is as aimless as that,
Stretching invisibly into the future so as to reappear
In our present. Its flexing is its account,
Return to the point of no return.

The pun here involves the elliptical arch of Ashbery's imaginary bridge: "The ellipse is" is also "the ellipsis," literally omitting from a sentence a word or phrase that would complete or clarify its meaning. The poem, finally, returns to the point where we recognize we must go on, "into the future," with however little "meaning" there is. For Ashbery there are only questions, uncertainties, and tentative ground—a concise statement of the postmodern condition.

The Theatrical and the New *Gesamtkunstwerk*

In the nineteenth century, the German composer Richard Wagner had dreamed of making a *Gesamtkunstwerk*, "a total work of art," merging visual art, music, opera, dance, and so on, into a single integrated whole (see chapter 36). Decades later, Bertolt Brecht, the German playwright, warned in response:

So long as the expression "Gesamtkunstwerk" means that the integration is a muddle, so long as the arts are supposed to be "fused" together, the various elements will all be equally degraded, and each will act as a mere "feed" to the rest. The process of fusion extends to the spectator who gets thrown into the melting pot too and becomes a passive (suffering) part of the total work of art. . . . Words, music, and setting must become more independent of one another.

It was this aesthetic philosophy that guided Merce Cunningham, John Cage, and Robert Rauschenberg in their collaborations that combined independent compositions (see chapter 45). In its intentional heterogeneity, the Cunningham, Cage, and Rauschenberg "events" created a clear precedent for postmodern theatrical practice, which sought not to "fuse" the arts but underscored their *difference* within the same stage space.

Robert Wilson and Postmodern Opera

Describing his 1976 postmodern opera *Einstein on the Beach*, innovative director and producer Robert Wilson (1941–) explained:

In making *Einstein*, I thought about gestures or movements as something separate. And I thought about light . . . the decor, the environments, the painted drops, the furniture, and they're all separate. And then you have all of these screens of visual images that are layered against one another and sometimes they don't align, and then sometimes they do. If you take a baroque candelabra and you put it on a baroque table, that's one thing. But if you take a baroque candelabra and you place it on a rock, that's something else. . . .

The music for Wilson's opera is also its own "separate" entity. Created by minimalist composer Philip Glass, *Einstein on the Beach* has a score (see chapter 46) that brims with slowly developing variations that accompany recurring patterns. As Glass himself says, "The difficulty is not that it keeps repeating, but that it almost never repeats." It is thus a fabric composed not of sameness but *difference*. The five-hour opera unfolds, subtly, as in John Ashbery's expression, like "A whispered phrase passed around the room" (**CD-Track 47.1**).

Glass was chiefly inspired by the music of Indian sitarist and composer Ravi Shankar [SHAN-kar] (1920–), whose raga improvisations he had transcribed into Western notation for a soundtrack to the 1966 counterculture film, *Chappaqua*. He was fascinated by the structure of Indian ragas, which he perceived to be made up of small units of notes built up into chains of larger rhythmic patterns. The compositions Glass subsequently created based on this understanding had little in common with Indian music, but they did incorporate the hypnotic, almost mystical, cyclic repetitive patterns that he equated with meditative aural space.

In *Einstein on the Beach*, Wilson sets Glass's music to dance sequences choreographed by Lucinda Childs (1940–) to create contrasting elements (Fig. **47.21**). "I thought of the dances as landscapes, as fields," Wilson said, "And so the space is the biggest. They break apart the space." In much of the opera,

Fig. 47.21 Robert Wilson. *Einstein on the Beach*, Dance, Field. 1976. Performers, Lucinda Childs Company. The dance is almost devoid of the visual resources that dominate the rest of the production, a fact that draws attention to the "openness" of the space in which it occurs, itself a metaphor for the openness of interpretation itself.

Voices

Bohemia Upside Down

New York was a powerful magnet for artists and the art industry from the 1970s into the next century. The postmodern art scene that spawned Laurie Anderson (see page 1550) differed from its predecessors. The new downtown arts community, observed writer Maureen Dowd, had more in common with uptown consumerism than with the anti-materialism of earlier generations of New York artists.

> **"Bohemia used to be a place to hide. . . . Now it's a place to hustle."**

Ann Magnuson sits on a worn couch in her East Village apartment, rummaging in the junkyard of American culture. She talks, with affectionate mockery, about icons and totems and slogans, past and present. Her allusions spill out like the contents of some crazed time capsule—Steve and Eydie, "The Beverly Hillbillies," Patty Hearst, Gidget, Wonder Bread, Amway, TV evangelists, Lawrence Welk, Jim Morrison and the Doors, Chicken McNuggets, high-fiber diets, Mantovani, Mr. Spock, and "Beyond the Valley of the Dolls."

Recently christened the "Funny Girl of the avant-garde" by *People* magazine, the 28-year-old conjures up these spirits in her satirical skits for downtown clubs such as Area, Danceteria, and the Pyramid. Her characters include Mrs. Rambo, who shoots her way through Bloomingdale's to save Nancy Reagan from getting a New Wave makeup job at the Yves St. Laurent counter, and Fallopia, Prince's new protégé . . . a graduate of the Rose-Marie School of Baton and Tap in Duluth.

In the past, Ann Magnuson . . . would have been described as an aspiring actress and her territory would have been called the bohemian part of town. Now she is a performance artist with a cult following and the area where she lives and works is simply called downtown.

She is at the center of the vivid New York arts community that has captured international attention spinning what has come to be known as the "downtown style." The artists cannibalize high art and the mass culture of the last three decades—television, suburbia, pornography, Saturday morning cartoons, comic books, Hollywood gossip magazines, spirituality, science fiction, horror movies, grocery lists. . . . It's everything turned inside of itself, it's sensory over-load, Ann Magnuson says. "It's a postmodern conglomeration of all styles. You steal everything."

. . . Just as irony is the hallmark of the downtown style, the word bohemia takes on an ironic twist when used to describe this arts community. For this is bohemia . . . that is turned inside of itself, different from any that have preceded it. While past bohemians were rebels with contempt for the middle class and the mercantile culture, many of the current breed share the same values as the yuppies uptown. This is a blue-chip bohemia where artists talk tax shelters more than politics, and where American Express Gold cards are more emblematic than garrets. In this Day-Glo Disneyland, the esthetic embrace of poverty has given way to a bourgeois longing for fame and money. It is a world where nightclubs have art curators . . .

"Bohemia used to be a place to hide," says John Russell, the chief art critic of the *New York Times*. "Now it's a place to hustle."

"It's not chic to be a starving artist any more," agreed Joe Dolce, a writer and publicist for the downtown night-club "Area," "it's more chic to be making millions . . ."

The idea of the poor, struggling artist has been rejected and so has the idea of the affinity between art and the common man. Moreover, the attitude of the rest of the society toward Bohemia has changed, as well. People are no longer shocked by it; they're often titillated and desperately seeking its style.

Just as bohemians have grown more like yuppies, so a credit-card culture dizzy with consumption has grown instantly eager for the product of bohemia. . . . Partly, this is because art is now a good investment, and partly it is because the imagery of this arts scene is easier for the average person to understand. . . .

the visual backdrops create a shallow visual field, but the dances occur in a space that is lighted as if receding into the infinite. Each dance sequence occurs twice, the second time to music so distinctly different from the first instance that it is virtually unrecognizable the second time around. This doubling—at once the same and not the same—is another facet of postmodern experience.

Laurie Anderson and Rock Postmodern

While Robert Wilson's *Einstein* remained a relatively "high art" phenomenon, the possibility of creating a work of "total art" that spoke more directly to a popular culture, rock-'n-roll aesthetic, remained an attractive alternative, one addressed first by the rock band The Who when they created the "rock opera" *Tommy* in 1969. However, it was Laurie Anderson, who in 1983 composed a four-part, four-night, eight-hour multimedia *Gesamtkunstwerk* called *United States*, which premiered at the Brooklyn Academy of Music's "New Wave Festival," a year before Wilson's *Einstein on the Beach* was revived there.

Anderson's work was categorized as a "rock" phenomenon, and drew the kind of criticism that rock music has often attracted, especially after a song from *United States, Part II*, "O Superman," became a pop hit in 1981, selling over 1 million records. "O Superman's" eight-minute video version even helped inaugurate MTV, being broadcast during that channel's first year of existence. The song was an indictment of the American dream—"So hold me, Mom, in your long arms, in your petrochemical arms, your military arms, in your arms"—as a mother's arms and the country's armaments combine to form a distinctly chilly postmodern embrace. But despite the song's anti-establishment attitude, Anderson's success was, to many in the avant-garde art scene, a sure sign that she had "sold out," just as many other artists in New York seemed to have submitted to the attractions of postmodern consumer culture. (See *Voices*, page 1549.) After she reached a lucrative agreement with Warner Brothers records and then made a feature-length per-

formance film, *Home of the Brave*, in 1985, their suspicions seemed confirmed.

But Anderson remains one of the most distinctive innovators in the postmodern scene. Early on, in her role as a musician, she began creating new electronic instruments, including a series of electronic violins, called "tape-bow violin," on which a tape playback head has been mounted on the body of the instrument and a strip of recorded audiotape on the bow. She transforms her voice, in the narratives that compose what she calls her "talking operas," by means of a harmonizer that drops it a full octave and gives it a deep male resonance, which she describes as "the Voice of Authority," an attempt to create a corporate voice. She has attached microphones to her body, transforming it into a percussion instrument. And the projected imagery and lighting that provide the backdrop for her performances (Fig. **47.22**) are a combination of pop imagery and cultural critique, which unite the local and the global in an image that underscores the not always positive results of the "American dream."

Fig. 47.22 Laurie Anderson performing "O Superman," from *United States*, II. 1983. Anderson's imagery is almost always ambiguous. Here the projecton of a hand evokes both the authoritative pointing finger of the mother and a gun—the primary themes of "O Superman."

READINGS

from Jorge Luis Borges, "Borges and I" (1967)

Although Jorge Luis Borges published widely in almost every imaginable form, his reputation as one of the leaders of the new Latin-American magical realism rests almost entirely on a series of some forty short stories, tales, and sketches—"fictions," as he called them—the bulk of them published between 1937 and 1955. Many of these sometimes very brief fictions take on a quality of dreamlike mystery. The short fiction, reprinted here in its entirely, "Borges and I," is a late example of the form.

Borges and I

The other one, the one called Borges, is the one things happen to. I walk through the streets of Buenos Aires and stop for a moment, perhaps mechanically now, to look at the arch of an entrance hall and the grillwork on the gate; I know of Borges from the mail and see his name on a list of professors or in a biographical dictionary. I like hourglasses, maps, eighteenth-century typography, the taste of coffee and the prose of Stevenson; he shares these preferences, but in a vain way that turns them into the attributes of an actor. It would be an exaggeration to say that ours is a hostile relationship; I live, let myself go on living, so that Borges may contrive his literature, and this literature justifies me. It is no effort for me to confess that he has achieved some valid pages, but those pages cannot save me, perhaps because what is good belongs to no one, not even to him, but rather to the language and to tradition. Besides, I am destined to perish, definitively, and only some instant of myself can survive in him. Little by little, I am giving over everything to him, though I am quite aware of his perverse custom of falsifying and magnifying things. Spinoza knew that all things long to persist in their being; the stone eternally wants to be a stone and the tiger a tiger. I shall remain in Borges, not in myself (if it is true that I am someone), but I recognize myself less in his books than in many others or in the laborious strumming of a guitar. Years ago I tried to free myself from him and went from the mythologies of the suburbs to the games with time and infinity, but those games belong to Borges now and I shall have to imagine other things. Thus my life a flight and I lose everything and everything belongs to oblivion, or to him.

I do not know which of us has written this page. ∎

Translated by J. E. I.

Reading Questions

In this short parable, the "I" accuses "Borges" of "falsification and exaggerating." Whom are we to trust, or are we to trust anyone, and how would you say that defines the postmodern condition?

 Summary

■ **Complexity and Contradiction in Postmodern Architecture** The 1972 book *Learning from Las Vegas* argued that the visual complexity of Las Vegas, with its competing sign systems, created a condition of contradiction which was inclusive, not exclusive. This new spatial order epitomized the postmodern condition, in which art communicates a plurality of meanings and an openness to interpretation.

■ **Pluralism in the Visual Arts** The postmodern sense of inclusiveness authorized a wide variety of experimentation in painting, from photorealism to pure abstraction. In the work of Jean-Michel Basquiat even graffiti was transformed into high art (see *Focus*, pages 1534–1535). Sculptors sought to place the audience in an environment of instability, uncertainty, and disorientation. Artists have also utilized new electronic media in creating new artistic spaces. Among the first to experiment with television was Korean musician and artist Nam June Paik. His installations of "altered TVs" produce kaleidoscopic realms of luminous color. Both the relatively short life of electronic components, and the fact that industrial advances quickly render them obsolete endanger the long-term viability of such works. Artists like Christo and Eleanor Antin have responded by making works designed to be viewed for a specific length of time and then be dismantled. Bill Viola creates video installations that take advantage of the medium's ability to evoke the world of dreams, memories, and reflections, and Viola's especially immerses the viewer in the flow of time, the cycle of life and death.

■ **Multiplicity and Postmodern Literature** Postmodern literature pursues meaning where meaning is always plural, multiplicitous, and fleeting—frustrating any kind of significant final answer. There is often no common locus around which to organize the world. Multiple, contradictory centers of thought exist simultaneously and independently of one another. In fiction, a novel like Thomas Pynchon's *V.* creates a world of uncertainty and ambiguity, similar to Paul Auster's *City of Glass*, in which the line between fiction and reality totally collapses. Latino and Hispanic literatures, and especially magic realism, underscore the plural identities of South and Latin American peoples. In the novels of Gabríel Garcia Márquéz, ordinary objects are infused with animate life. Postmodern poets take advantage of the indeterminate references of pronouns like "it" and "this" to create poems with an opacity of reference and meaning.

■ **The Theatrical and the New *Gesamtkunstwerk*** Rejecting Richard Wagner's idea of the *gesamtkunstwerk* as a unified, total work of art, postmodern artists have created large-scale theatrical works in which words, music, and setting are independent of one another. The music for Robert Wilson's opera *Einstein on the Beach*, composed by Philip Glass, is totally separate from both the stage effects and the dances choreographed by Lucinda Child that contrast dramatically with the opera's other elements. Laurie Anderson's eight-hour *United States* defined the parameters of a new rock-based postmodern theater.

 Glossary

magical realism A literary tradition characterized by two conflicting but simultaneous perspectives: one based on a rational view of reality that is derived from European tradition; the other rising out of an indigenous belief in the appearance of the supernatural or magical in everyday life.

photorealist painting A type of painting that is based on the representational effects achieved in photography.

postmodernism A term used to describe the collision of art, literary, and musical styles and forms that followed, and often deviated from, those of modernism. Postmodern works often have multiple meanings and are open to interpretation.

Critical Thinking Questions

1. How is postmodernism's sense of uncertainty and ambiguity rooted in Jean-Paul Sartre's existentialism?

2. One useful way to define the "postmodern" is to create a list of words—like "uncertainty"—that define it. What other words help you to define the postmodern?

3. From your own experience, describe an example of what Venturi calls a "difficult whole."

Toward a World Without Boundaries

Continuity & Change

Until recently, most photographs were routinely entered into evidence in most U.S. courtrooms because they were believed to be and could be established as more or less "authentic" evidence of the circumstances surrounding a given set of events. In the last few years, that situation has radically changed. Today, as one expert has recently put it, "the conventional photograph has gone the way of the horse-drawn carriage and the vinyl phonograph record." More and more often, the photograph has been challenged as "admissible evidence."

Digital photography is capable of totally altering the world, presenting an "as if" view of the world. Take, for instance, the photographic work of Andreas Gursky. His photograph *99 Cent* (**Fig. 47.23**) is a digitally composed panorama of corporate commerce which is not literally factual. If its rows and rows of almost wildly attractive color, presented at an almost unbeliev-

able scale for a photograph (nearly 7′ × 11 ½′), seem "true," it is because they are, in essence, "life-size," clear, visible, and almost tangible before our eyes. Yet they are pure deception, an "illusion" every bit as much as any painting. In a certain sense, this makes the photograph more like "art"—more a creation of its maker than a simple record of the visible world. But it is also, as a moment of reflection makes abundantly clear, another, technologically driven instance of the postmodern: what might *seem* authentic as a representation of contemporary culture is a false front, an artistic construction. This is the territory into which we walk, in the twenty-first century—a world where the "truth" is always contingent, often manipulated, digitally or otherwise, and in which we must always tread with doubt and suspicion. It is a world in the "here" that we see before us, that might not really be "there." It is a world, in other words, without boundary or circumference. ■

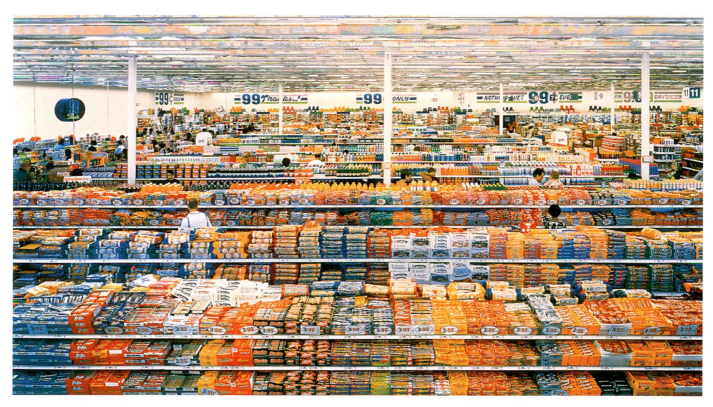

Fig. 47.23 Andreas Gursky. *99 Cent*. 1999. Cibachrome print mounted on Plexiglass in artist's frame, 81 ½″ × 132 ⅝″.
Courtesy Matthew Marks Gallery, New York and Monika Spruth Galerie, Cologne. © 2008 Andreas Gursky/Artists Rights Society (ARS).

48 Blurring the Boundaries

The Global Village in the Information Age

Architecture in the Information Age

East /West: Power and Appropriation

Global Perspectives: The African Double-Bind

The AIDS Pandemic and the Arts

Multiple Identities in a Global World

Recovering Tradition: Contemporary Native American Art

❝ *I plead guilty to the possession of thought. I did not know that it was in me to exercise it, until your Majesty's inhuman commands.* **❞**

Wole Soyinka, *A Dance of the Forests*

◄ **Fig. 48.1 Christo & Jeanne-Claude.** *The Umbrellas, Japan – USA.* **1984–1991.** © 1991 Christo. The yellow umbrellas pictured here, on the Tehon Pass, north of Los Angeles, represent one-half of a global project. Each umbrella could be cranked open in about 45 seconds. Over 4,000 workers opened them in about four hours. They remained on view for 18 days.

O

N THE MORNING OF OCTOBER 9, 1991—A MORNING THAT began 16 hours earlier in Japan than in California—along a stretch of interstate highway in the Tehachapi [ti-HACH-uh-pee] Mountains north of Los Angeles, 1,760 yellow umbrellas, each nineteen feet, eight inches tall, twenty-eight feet, five inches

wide, and weighing 448 pounds, appeared. Each one was slowly opened across the parched gold hills and valleys (Fig. **48.1**). Meanwhile, in the prefecture of Ibaraki [ee-buh-RAHK-eh], Japan, north of Tokyo, in the fertile, green Sato River valley, with its small villages, farms, gardens, and fields, 1,340 blue umbrellas had opened as well (Fig. **48.2**). Built at a cost of $26 million, which the artists Christo (1935–) and Jeanne-Claude (1935–) had raised entirely through the sale of their proprietary work, *The Umbrellas*, blue on one side of the Pacific, yellow on the other, symbolized both the difference underlying global culture and its interdependency. California and Japan were, after all, the two places from which the electronic revolution of the 1970s and 1980s had sprung, California's Silicon Valley providing the innovation and invention and Japan providing the practical application in its massive industrial complex south of Tokyo. Together they changed the world, but their differences were as striking as their interdependence, and Christo and Jeanne-Claude's work underscored this. The landscapes in which the *Umbrellas* rose differed dramatically. In Japan, where less space is available (steep volcanic mountains make most of the land unusable), 124 million people live on only 8 percent of the land. Christo and Jeanne-Claude responded by dense-

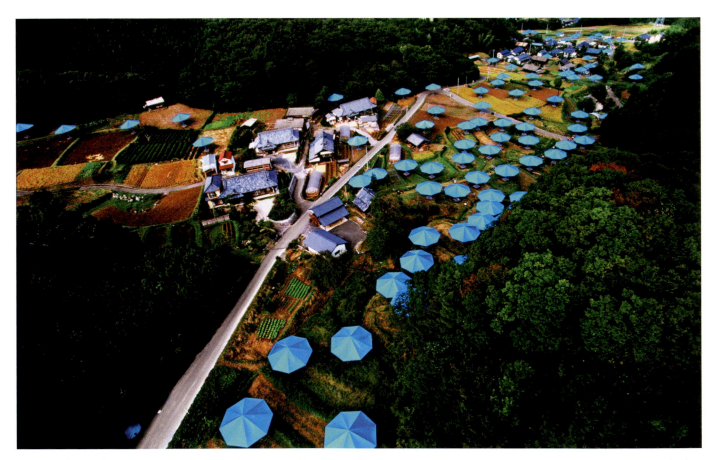

Fig. 48.2 Christo & Jeanne-Claude. *The Umbrellas, Japan – USA.* **1984–1991.** © Christo. As opposed to California, where Christo and Jeanne-Claude had to negotiate with 26 landowners, in Japan they worked with 452 different landowners.

Map 48.1 Widely attended international festivals and fairs celebrating art, music, film, and literature in the early twenty-first century.

ly positioning the *Umbrellas*, sometimes following the geometry of the rice fields. In California, in the vast grazing lands of the Tehachapis, the *Umbrellas* seemed to stretch in every direction, along the ridges, down hills, with great spaces between them. Still, in both cultures, the umbrella is an image of shelter and protection, from both rain and sun, and therefore a symbol of community life. If visitors could never experience the work as a whole, they were always aware that the work continued, in a way, on the other side of the world, that in some sense the umbrellas sheltered a global village.

The term "global village" was coined in 1962 by Marshall McLuhan to describe the way that electronic mass media fundamentally altered human communication, enabling people to exchange information instantaneously, across the globe. In the nearly half-century since then, of course, the introduction of personal computers, cell phones, and pagers has empowered individuals to further expand this communication on an almost unimaginable scale. McLuhan idealistically viewed media as the means of creating a united, global community bridging the gap between the world's haves and have-nots. But because much of the electronic mass media has been controlled by the West, many critics saw it as a new means of asserting commercial and political control over the rest of the world—a new kind of imperialism. But in fact, the globalization of mass media has resulted in a crisis of identity for most world cultures as local values and customs have come into conflict or been assimilated by those of the West.

Global media—whether it be motion pictures, cable television channels such as CNN, or Internet sites like Google and Amazon.com—have also transmitted many elements of popular foreign culture to the West. Asian and Mideastern cuisines, Japanese comic books and video games, along with a vast array of foreign films, fashions, and fads have become popular in the West, aided by the "unlimited bandwidth" of modern telecommunications that offers individuals massive quantities of whatever information or entertainment they desire. International art exhibits, music and film festivals, and book fairs attract visitors and collectors from around the world in search of the latest trends and directions in contemporary art (see Map **48.1**).

Environmental artists Helen Mayer Harrison (1929–) and Newton Harrison (1932–) created a metaphor for the transplantation of foreign cultural elements in their 1982 installation *Barrier Islands Drama: The Mangrove and the Pine* (Fig. **48.3**). They explained:

> Among the things that interested us about the Florida landscape . . . was the pressure we observed of earth and water. That pressure had led to the diminution of habitat for the mangrove. Now one variety or another of mangrove grows worldwide in tropical coastal marshes and shorelines, generating earth, holding land from encroaching waters, and acting as a nursery for a multitude of creatures. The Australian pine was introduced to the Florida coastline early in the century to decorate the landscape.

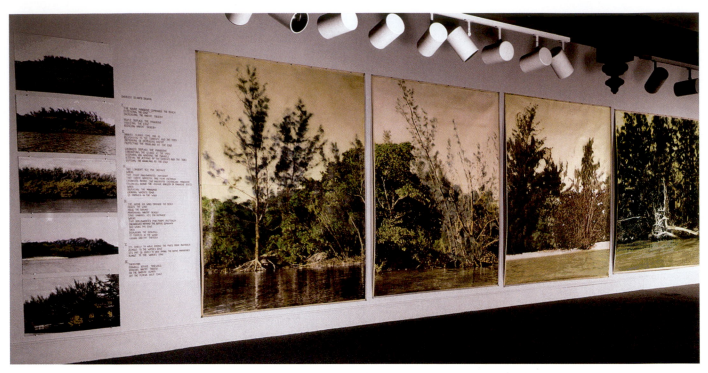

Fig. 48.3 Helen Mayer Harrison and Newton Harrison. *The Pines Colonize behind the Mangrove,* from *Barrier Islands Drama: The Mangrove and the Pine.* **1982.** Hand-colored sepia-toned mounted photo enlargements, 5 panels: 18″ × 28″ each; 4 panels: 98″ × 80″; 97″ × 73″; 98″ × 69″; 96″ × 142″. The Harrisons' work concentrates on ecological issues worldwide.

In its new environment the pine is an exotic, grows like a weed, and has no natural enemies. It colonizes behind the mangrove, spreads until it gains the ocean edge and displaces the mangrove, when, shallow rooted, it topples in the wind, loosing ground thereby. To walk among the graceful pines almost to the water's edge is aesthetically pleasing. To walk among the native mangroves to the water's edge is not. Thus, one can never tell when an aesthetic decision will proliferate and ruin the landscape.

Even as a beautiful pine tree from Australia displaces the native flora of the Florida coast, so too, the Harrisons suggest, pleasing trappings of Western popular culture colonize the world's indigenous cultures, destroying them in the process.

This chapter explores the increasing globalization of the world's cultures, the threat to indigenous cultures that it creates, and the often extraordinarily creative ways in which artists, writers, and musicians have responded to that threat. Perhaps nothing better illustrates this trend than architecture, since the world's leading architects work in all corners of the globe. Both innovative and expensive, their buildings are in many ways symbols of achievement, erected by the world's growing economies. Yet artists increasingly find themselves in a double-bind—how, they ask, can they remain true to their native or ethnic identities and still participate in the larger world market? What happens to their work when it enters a context where it is received with little or no understanding of its origins? How, indeed, does the global threaten the local? Is the very idea of the "self" threatened by technology and technological innovation?

Architecture in the Information Age

Architects and builders exemplify the affluent nomads of the new postmodern society. They, like the people they design and build for, inhabit the "world metropolis," a vast interconnected fabric of places where people do business, and between which they travel, work, and seek meaning. Travel, in fact, accounts for nearly 10 percent of world trade and global employment. As nearly 700 million people travel internationally each year, a half million hotel rooms are built annually across the globe to house them.

Today's architect works in the culture first introduced by the Sony Walkman and carried forward by the iPod and iPhone. These are technologies "designed for movement," as cultural historian Paul du Gay describes their function, "for mobility, for people who are always out and about, for traveling light . . . part of the required equipment of the modern 'nomad.'" And architects also are also responsible for helping to provide the most elusive of qualities in the postmodern world—a sense of meaning and a sense of place.

Architecture in this culture is largely a question of creating distinctive buildings, markers of difference like Frank Gehry's Guggenheim Museum Bilbao (see Figs. 47.7, 47.8) that stand out in the vast sameness of the "world metropolis," so that travelers feel they have arrived at someplace unique, someplace identifiable. In this climate, contemporary architecture is highly competitive. Most major commissions are competitions, and most cities compete for the best, most distinctive architects.

One of the most successful architects in these international competitions has been Spaniard Santiago Calatrava [kah-lah-TRAH-vah] (1951–), who has degrees in both engineering and architecture. Known especially for the dynamic curves of his buildings and bridges, his designs include the Athens Olympics Sports Complex (2001–2004), the Tenerife Opera House in the Canary Islands (2003), and the Turning Torso residential tower in Malmö, Sweden (2005). Based on the model of a twisting body, the 54-story Malmo tower consists of nine cubes, twisting 90 degrees from bottom to top, and rising to a rooftop observation deck with vistas across the Øresund [UR-uh-sun] strait to Copenhagen. More recently, in March 2007, he revealed plans for what will be the world's tallest residential building and the tallest building in North America, the 2,000-foot-high Chicago Spire (Fig. **48.4**). Each of the building's 150 stories will rotate a little over two degrees from the one below with a total 360-degree rotation top to bottom, making it appear to be in motion. The curved exterior reduces the effects of winds on the building, allowing air to flow around the structure. Calatrava has likened the building to a spiral of smoke that he could imagine rising from a Native American campfire. It also reflects, he says, the graceful and "rotating forms" of a snail shell.

Calatrava also won the design competition for the Port Authority Trans Hudson (PATH) train station at the site of the former World Trade Center in New York (Fig. **48.5**). Scheduled for completion in 2009, it is based on a sketch Calatrava drew of a child's hands releasing a bird into the air. Calatrava said that the goal of his design was to "use light as

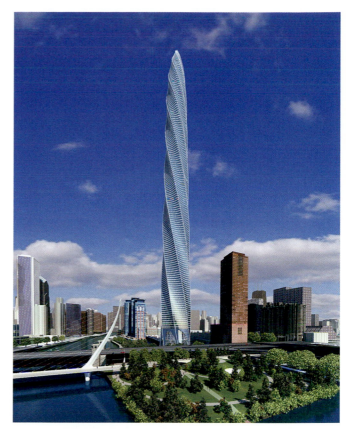

Fig. 48.4 Santiago Calatrava. Chicago Spire. 2007. Courtesy Santiago Calatrava and Shelbourne Development Group, Inc. Containing some 1,300 residential apartments, the tower is scheduled to open for occupancy in the summer of 2010.

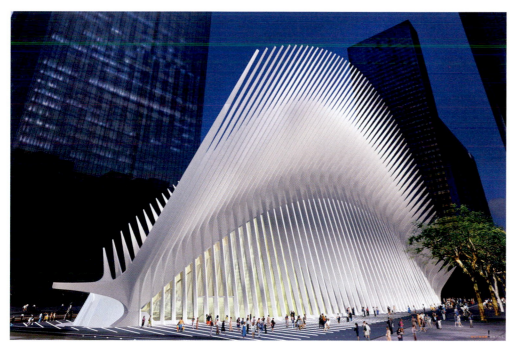

Fig. 48.5 Santiago Calatrava. Port Authority Trans Hudson (PATH) station, World Trade Center Site. 2004. Courtesy Santiago Calatrava/Port Authority of New York. The memorial to those who lost their lives at the World Trade Center lies directly behind the station.

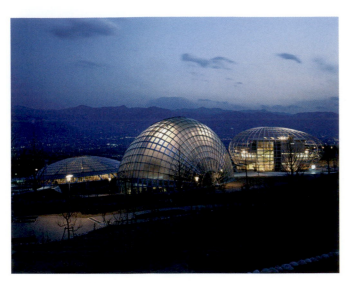

Fig. 48.6 Itsuko Hasegawa. Museum of Fruit, Yamanashi, West Tokyo, Japan. 1996. The greenhouse, Hasegawa says, "represents the memory of the tropical sun," while the museum is "like an alien visitor landing and taking off in the sloped orchard, fus[ing] into one ecological totality of science fiction quality."

a construction material." At ground level, the station's steel, concrete, and glass canopy functions as a skylight that allows daylight to penetrate 60 feet to the tracks below. On nice days, the canopy's roof retracts to create a dome of sky above the station.

Whereas Calatrava's forthcoming Chicago Spire captures the imagination by audaciously designing a building that appears to be in motion, Japanese architect Itsuko Hasegawa [ha-seh-GAH-wah] (1941–) involves the community in her work from the beginning of her projects, a process she calls "participatory architecture." Perhaps her most significant work is the Museum of Fruit (Fig. **48.6**), consisting of three buildings, which rise in the vineyards on the slopes of a river valley below Mount Fuji. They are, in her words, like "seeds jumping out of the ground;" constructed of steel and glass, the buildings test the boundaries between the natural and the artificial. The aim, according to the architect, is to create "a poetic machine" that expresses its "spiritual, social, and environmental context."

Asian cities are particularly challenging to postmodern architects. Unlike American cities, where people tend not to

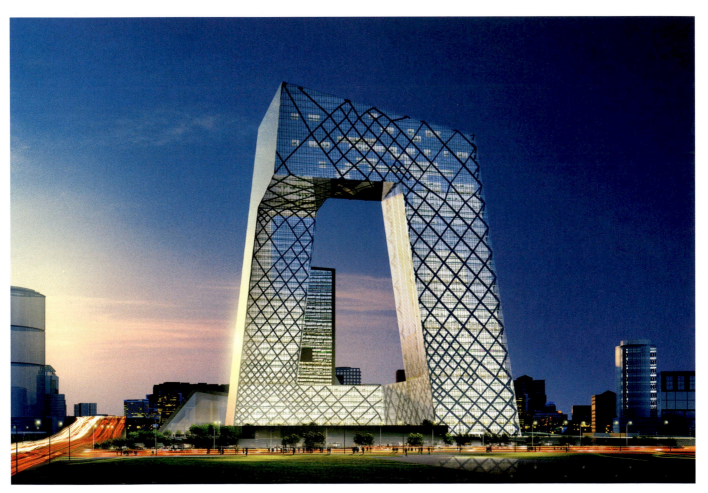

Fig. 48.7 Rem Koolhaas. OMA, New Headquarters, Central Chinese Television CCTV, Beijing, China, competition drawing. 2002. "The irregular grid on the building's facade," according to OMA, "is an expression of the forces traveling throughout its structure," the web of communication that will both feed into and emanate from the building.

Fig. 48.8 Renzo Piano. Jean-Marie Tjibaou Cultural Center in Nouméa, New Caledonia. 1991–1998. The center's namesake, Jean-Marie Tjibaou, was assassinated in 1989 while trying to forge an agreement to free his country of French colonial rule. New Caledonia remains under French control today.

live where they work, Asian cities possess a much greater "mix" of functions. Tall buildings rise in the midst of smaller residential structures. Rem Koolhaas [KOOL-hahs] (1944–), a leading urban scholar and professor at Harvard University, has designed one of the most intriguing new projects in Asia—the headquarters of a Chinese television network (Fig. **48.7**), which will be completed for the Beijing Olympics in 2008. Although 750 feet high, the CCTV tower is, in the words of his architectural firm, "a continuous loop of horizontal and vertical sections that establish an urban site rather than point to the sky."

One of the newest approaches to contemporary architecture takes into consideration the compatibility of the building with its environment. Increasingly, a building's viability—even beauty—is measured by its environmental self-sufficiency. Rather than relying on unsustainable energy sources, architects strive to design sustainable building materials—eliminating steel, for instance, since it is a nonrenewable resource. The other important factor in modern architecture is adapting new buildings to the climate and culture in which they are built. These are the principles of what has come to be known as "green architecture."

One of the more intriguing new buildings to arise in the South Pacific region is the Jean-Marie Tjibaou [jee-bah-OO] Cultural Center in Nouméa, New Caledonia, an island northeast of Australia. It illustrates green architecture at work (Fig. **48.8**). The architect is Renzo Piano (1937–), an Italian, but the principles guiding his design are indigenous to New Caledonia. Named after a leader of the island's indigenous people, the Kanak, the center is dedicated to preserving and transmitting indigenous culture as well as incorporating sustainable environmental principles. The buildings are constructed of wood and bamboo, easily renewable resources, and each of the center's ten pavilions represents a typical Kanak dwelling. Piano left the dwelling forms unfinished, as if under construction, but they serve a function as wind scoops, catching breezes from the nearby ocean and directing them to cool the inner rooms. As in a Kanak village house, the pavilions are linked with a covered walkway. Piano describes the project as "an expression of the harmonious relationship with the environment that is typical of the local culture. They are curved structures resembling huts, built out of wood joists and ribs; they are containers of an archaic appearance, whose interiors are equipped with all the possibilities offered by modern technology."

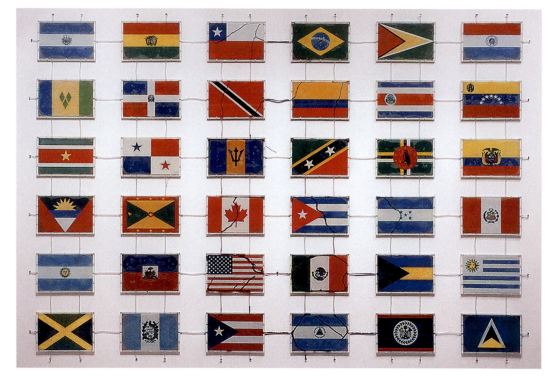

Fig. 48.9 Yukinori Yanagi. America. 1994. Ants, colored sand, plastic boxes, plastic tubes, 36 boxes, each 8″ × 12″. Installation view at Museum of Contemporary Art, San Diego, 1994 collection of artist. "If the travels of the ant show us anything," Yanagi says, "it is that he wanders to resume the task he has been programmed to perform, not to acquire freedom."

Continuity & Change p. 256

Arch of Titus

East/West: Power and Appropriation

Renzo Piano's sensitivity to the indigenous culture of New Caledonia is as admirable as it is atypical. As both Calatrava's Chicago Spire and Koolhaas's Central Chinese Television project make clear, architecture as it is practiced on a global scale is, like the Roman imperial architecture of nearly two millennia ago, about power (see chapter 8). The Central Chinese Television building will be the focus of world attention during the Olympics, and it will function as an advertisement for China's economic might.

While California's Silicon Valley was affected by the economic downturn in 2000 and exacerbated by the tragic events of September 11, 2001, it remains the principal source of global technological innovation. Originally the "the prune capital of America," the 40-mile-long, 10-mile-wide strip of land running from Palo Alto in the north to the southern suburbs of San Jose, was, as one history of the rise of American technology described it in 1984, "the birthplace of pocket calculators, video games, home computers, cordless telephones, laser technology, microprocessors, and digital watches." Its only major competitor was located in the vast industrial center that spreads from Tokyo's southern and eastern sides, including the cities of Yokohama [yoh-koh-HAH-mah] and Kawasaki [kah-wah-SAH-kee]. If the Silicon Valley was the

birthplace of the electronics industry, it was the Tokyo Bay region where Silicon Valley's innovations were realized, principally by three of Japan's giant companies, NEC, Fujitsu [foo-JIT-soo], and Toshiba [toh-SHEE-bah]. It was as if invention were located on one side of the Pacific, among the 8,000-odd high-tech companies in the Silicon Valley, and implemented on the other side, in three giant companies set in the middle of the world's largest urban area. Between them—in fact, like Christo and Jeanne-Claude's Umbrellas—they defined the ability of the new global technology to transform people's lives, individually and collectively.

America, by Japanese artist Yukinori Yanagi [yah-NAH-ghee] (1959–), is an image of this new global power, although the Japanese flag is notably absent from the composition, perhaps suggesting that it has been subsumed by American influence (Fig. 48.9). Creating a grid of plastic boxes, each filled with colored sand in the pattern of a national flag, Yanagi connects each box to the adjacent ones with plastic tubing. When ants were introduced into the system, they immediately began carrying colored sand between flags, transforming and corrupting their original designs. As each flag's integrity is degraded by these "border crossings," a new "cross-cultural" network of multinational symbols and identities began to establish itself. Yanagi's title makes clear that we are witnessing the Americanization of global culture. Yanagi's work directly challenges the traditional Japanese view that Japan is a distinct and isolated culture. Cross-fertilization is everywhere and even Japanese culture is easily permeable in the age of digital technology. (See Voices, page 1563.)

Voices

A Canadian in Tokyo

In the "global village" increasingly large numbers of people are living in foreign countries, drawn by curiosity; artistic, educational, or business opportunities; or adventure. Living in a foreign country offers these sojourners, whether they be Asians, Africans, Americans, or Europeans, the opportunity to form a variety of cross-cultural perspectives. Canadian writer Bruce McCormack spent a decade in Tokyo working for a Japanese company as well as several Japanese universities, and in the following passages offers a Westerner's view of life in the city:

Out in public, on the crowded streets of Tokyo, maintaining a sense of humility works in your favor, because it's a quality people recognize and respect, and they'll sometimes respond in kind—even in Tokyo, where people routinely adopt a big-city surface coldness. For Westerners, learning to bow ever so slightly in your daily encounters is also essential, just as learning to shake hands is necessary for Asian people coming to the West. I've found that it makes a tremendous difference; it's a clear demonstration of your willingness to be culturally sensitive. Obviously, keeping an even disposition also helps a lot. There's an amusing phrase in Japanese I like a lot—*shin denshin*—which loosely means "knowing how other people are feeling without the exchange of words," a kind of psychic or telepathic knowing. . . . When I first arrived in Tokyo, people often wandered up to me and asked if I needed help. After a while, that stopped happening; people knew I wasn't a newcomer anymore. In Japan, there's greater attunement to unspoken signals.

. . . Over these lazy days of the New Year's holiday, we're making space for Japan's English dailies. . . . From the dozens of articles and photos I've perused today, one in particular—in the *Japan Times*—leapt to

> **"The photo conveys a sense of the Rock-of-Gibraltar company solidarity, the extended-family of Japanese life."**

the fore. . . . It's just a black-and-white photo of an orchestra, together with a very large choir, but below the picture is a short descriptive caption . . . : *Japan Air Lines personnel, flight and cabin crew members perform Beethoven's Symphony No. 9 in a concert held Sunday to deepen mutual understanding among them on the occasion of the airline's recent privatization.*

How about that? The photo conveys a sense of the Rock-of-Gibraltar company solidarity, the extended family of Japanese life. I pause and try to imagine a typical North American or European Airline company pulling together to rehearse and perform a piece like this, let alone doing so to "deepen mutual understanding." Somehow, I don't think so.

. . . . The Japanese, however, live with great social pressure to socialize within whatever group they're in, at any given stage of their lives. So if a company forms a choir or a baseball team, employees will join. . . . I readily admit that the benefits of "belonging" often feel very good. My colleagues and I cheered on the Soulful Software rugby team, watching the game in a stadium with a few thousand employees from our company and that of the opposing team. It felt like we belonged to a sports team rather than a company. That's probably all part of the corporate formula for holding everybody tightly together. At times, I felt like I'd been granted extended tenure on my high-school year. It was a happy afternoon out in the sun and away from our desks. . . .

The ability of Western culture to transform other cultures is particularly clear in the way it uses their indigenous arts. In the summer of 1989, for instance, an exhibition opened in Paris that announced itself as "the first world-wide exhibition of contemporary art." Called *Magiciens de la terre* [mah-jee-see-EHN deh lah tair], or *Magicians of the Earth*, the show consisted of works by 100 artists, 50 from the traditional "centers" of Western culture (Europe and America) and 50 from Asia, South America, Australia, Africa, and Native American art from North America. Conceived as a way to show the real differences between and specificity of different cultures, the curators included only the names of each work's creator and its geographical origin in identifying the pieces.

The result was that its audience tended to apply preexisting Western standards to the works. How could one distinguish, for instance, between British environmental artist Richard Long's minimalist "wall painting," composed of mud, and an aboriginal sand painting created by artists from the Australian aboriginal Yuendumu community on the floor in front of it (Fig. **48.10**)? Both were inherently abstract designs that made reference to the natural world. And both were temporary, designed to last only as long as the exhibition itself.

It is remarkable that the aboriginal sand painting should be considered in an artistic context, since it is an example of what the Australian aboriginals call a *Dreaming*—which is the presence, or mark, of an ancestral being in the world.

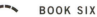
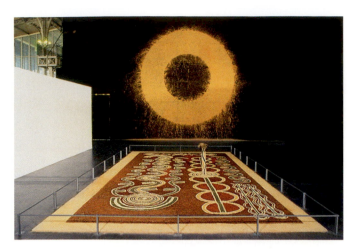

Fig. 48.10 Installation view of *Magiciens de la terre* (*Magicians of the Earth*), La Vilette, Paris. 1989. This exhibition attempted to put works from the "third world" alongside works from the West in a nonjudgmental way. Here a sand painting from the Australian aboriginal Yuendumu community lies on the floor beneath British artist Richard Long's *Red Earth Circle*. It was done on site by Yuendumu artists, as was Long's circle, which is composed of mud applied by hand directly on the wall.

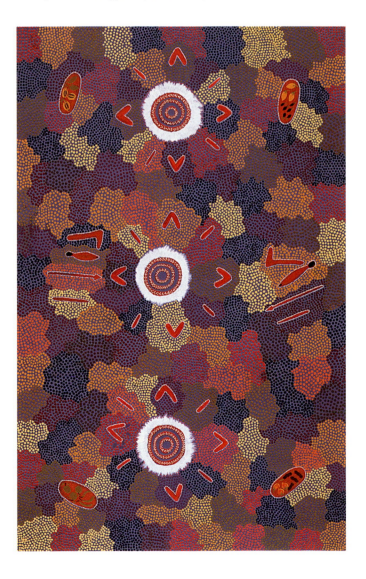

This sand painting is a type of indigenous history, a map of the painters' ancestors' travels, depicting the places and landscapes they inhabited and stories connected with their lives.

Australian aboriginal sand painters inherit the "rights" to a Dreaming image from their fathers, making them *kirda*, or owner, of the image. Every Dreaming is also inherited through the mother's line, and a person who is related to a Dreaming in this way is said to be *kurdungurlu*. *Kurdungurlu* must insure that the *kirda* fulfill their proper social and ritual obligations to the Dreaming. As a result, as in Paris, several people usually work on any given sand painting, and the "artist" is not one person, but several.

The person that Westerners call the "artist"—a distinction not made in aboriginal culture until acrylic paintings such as Erna Motna's *Bushfire and Corroboree Dreaming* (Fig. 48.11) appeared in 1971—is generally the person who has chosen the specific Dreaming to be depicted. The idea of making permanent works was actually that of a young white art teacher named Geoff Bardon, who arrived in 1971 at an aboriginal settlement on the edge of the Australian Western Desert. He encouraged several older Aboriginal men to begin painting with acrylics and in about a year they produced 620 paintings, all of which they subsequently sold. It wasn't long before Aboriginal paintings were a hot international commodity, seeming to mediate, in Western eyes, between folk motifs and high art abstraction.

Motna's painting depicts the preparations for a *corroboree* [kuh-ROB-uh-ree], the general name for all traditional celebration ceremonies. The circular features at the top and bottom represent small bushfires that have been started by women. As small animals run from the fire (symbolized by the small red dots at the edge of each circle), they are caught by the women and hit with digging sticks, and carried with fruit and vegetables to the central fire, the site of the corroboree itself. Motna's acrylic works are permanent and thus not destroyed in the traditional manner after the ceremonial purposes for which they were made.

The subsequent commodification of the paintings/Dreamings has caused conflict in the Aboriginal communities over the potential revelation of secret ritual information and the star status bestowed upon some younger painters. Traditional hierarchies in the community have been disrupted, as has the sense of the Dreamings being a communal, participatory project. Yet, even as Aboriginal art objects are created for individual gain, they have helped revitalize and strengthen cultural traditions that were believed to be doomed to extinction.

Fig. 48.11 Erna Motna. *Bushfire and Corroboree Dreaming*. 1988. Acrylic on canvas, 48″ × 32″. Australia Gallery, NY. Courtesy of Australian Consulate General. Surrounding each of the three fires—the white circles in the painting—are a number of weapons used to kill larger animals: boomerangs, spears, *nulla nullas* (clubs), and *woomeras* (spear throwers).

Global Perspectives:
The African Double-Bind

Aboriginal artists find themselves in a double-bind. Attempting to incorporate their culture's traditions into the contemporary world, they, like many artists and writers from non-Western cultures, struggle with a double identity. Increased mobility between and among cultures reinforces this process. Before World War II, as European colonizers migrated into Africa, for example, Western ideas and values followed them. After World War II, as Africa was quickly decolonized (see chapter 45), many of the leading African intellectuals migrated to Europe in order to receive the education and training they knew they would need as independence was achieved. Most found themselves in a double-bind of their own, caught between their own Africanness and their European educations.

The African Experience in Art

The controversial painting *The Holy Virgin Mary* by Chris Ofili (1968–) (Fig. **48.12**), British-born Nigerian painter, is a case in point. Ofili portrays the Virgin as a black woman, and surrounding her are *putti* (winged cherubs) with bare bottoms and genitalia cut out of pornographic magazines. Two balls of elephant dung, acquired from the London Zoo, support the painting, inscribed with the words "Virgin" and "Mary," a third clump defining one of her breasts. The son of black African Catholic parents, both of whom were born in Lagos [LAY-goss], Nigeria, and whose first language was Yoruba, Ofili has used this West African culture as a source of inspiration for his art.

The display of sexual organs, especially in representations of female divinities, is common in Yoruba culture, and Ofili's putti are meant to represent modern examples of this indigenous tradition, symbolizing the fertility of the Virgin Mary. As for elephant dung, in 1992, during a trip to Zimbabwe [zim-bah-bway], Ofili was struck by its beauty after it was dried and varnished. He also came to understand it was worshiped as a symbol of fertility in Zimbabwe, and he began to mount his paintings on clumps of dung as a way, he said, "of raising the paintings up from the ground and giving them a feeling that they've come from the earth rather than simply being hung on a wall."

The Holy Virgin Mary artwork thus reflects Ofili's African heritage. But he understood that the African association of genitalia and dung with fertility and female divinities would be lost on his Western audience. Indeed it was. When the painting was exhibited at the Brooklyn Museum in late 1999, it provoked a stormy reaction. The Catholic Cardinal in New York called it a blasphemous

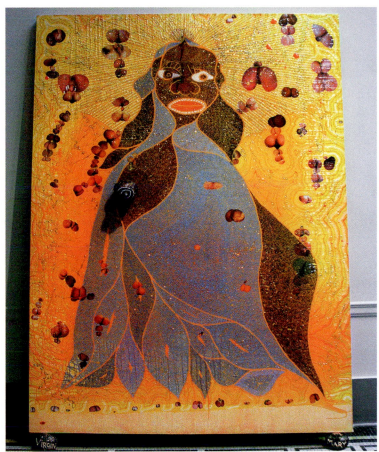

Fig. 48.12 Chris Ofili. *The Holy Virgin Mary.* 1996. Paper collage, oil paint, glitter, polyester resin, map pins, and elephant dung on linen, 8′ × 6′. The Saatchi Gallery, London. Photo: Diane Bondareff/AP World Wide Photos. While on display in Brooklyn, the painting was smeared with white paint by an angry 72-year-old spectator.

attack on religion, and the Catholic League called for demonstrations at the Museum. New York's Mayor Rudolph W. Giuliani threatened to cut off the museum's funding as well as evict it from the city-owned building it leased. (He was forced to back down by the courts.) For Ofili, the conflict his painting generated was itself emblematic of the collision of cultures that define his own identity. At the same time, it can be said that the controversy helped make Ofili even more prominent and did little to diminish the "marketability" of his art. In 2003, he was chosen to represent Great Britain at the Venice Biennale, perhaps the most prominent contemporary global art exhibition.

Like Chris Ofili, Yinka Shonibare (1962–) was born in England to Nigerian parents, but unlike Ofili he was raised in Nigeria before returning to art school in London. In the mid-1990s, he began creating artworks from the colorful printed fabrics that are worn throughout West Africa, all of which are created by English and Dutch designers, manufactured in Europe, then exported to Africa. At that point, they are remarketed in the West as authentic African design

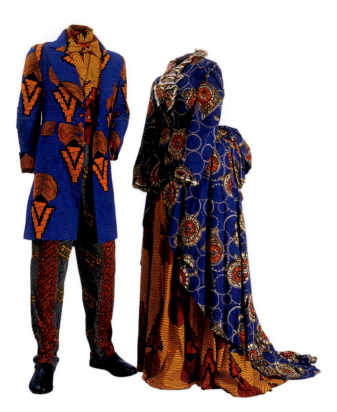

Fig. 48.13 **Yinka Shonibare.** *Victorian Couple.* **1999.** Wax printed cotton textile, left approx. 60″ × 36″ × 36″; right approx. 60″ × 24″ × 24″. Courtesy of the artist, Stephen Friedman Gallery, London, and James Coehn Gallery, NY. Part of the power of these pieces is that they possess no identity—no heads, no hands.

(Fig. **48.13**). "By making hybrid clothes," Shonibare explains, I collapse the idea of a European dichotomy against an African one. There is no way you can work out where the opposites are. There is no way you can work out the precise nationality of my dresses, because they do not have one. And there is no way you can work out the precise economic status of the people who would've worn those dresses because the economic status and the class status are confused in these objects." Sometimes, even the time period of these costumes is drawn into question. They are identified as "Victorian," and indeed the bustle on the woman is a Victorian fashion, but the man's dress seems startlingly hip.

The African Experience in Literature

Ofili and Shonibare represent a striking new presence in the contemporary art scene that is reflected in literature as well. The major authors of the modernist era, writing in English before the 1960s, produced their works in the United States, Britain, and Ireland. In the postmodern era, we must add important writers from South Africa, present-day Zimbabwe, India, Nigeria, Ivory Coast, Kenya, Guyana, Trinidad, and Canada. The oldest of these writers, Doris Lessing (1919–), from Zimbabwe, and Chinua Achebe [ah-CHAY-bay] (1930–), from Nigeria, deal explicitly with the tension between

Western culture (often manifested in the colonial exercise of power) and indigenous values. A 1951 tale by Doris Lessing, "The Old Chief Mshlanga," recounts the gradual awakening of a young Southern Rhodesian girl to the immorality of the white supremacy inherent in colonialism. The chief's words haunt the story: "All this land, this land you call yours . . . belongs to our people."

The 1958 novel, *Things Fall Apart*, by Chinua Achebe, reverts to a time just before colonialism fully impacted Nigeria, telling the story of an Ibo village of the 1890s and one of its great men, Okonkwo. The harmony of village life is disrupted by the appearance of racist colonial officials and the introduction of Christianity, both of which contribute to Okonkwo's killing an African employed by the British in response to a brutal act of injustice.

Achebe's Nigerian colleague Wole Soyinka (1934–) has focused on the differences between African and Western politics and the diversity of the African experience. Like Ofili, Soyinka was raised Christian by Yoruba parents, who nevertheless balanced his Christian training with regular visits to the father's ancestral home in Ìsarà, a small, very traditional Yoruba community. He first gained notoriety in his native Nigeria when he returned in 1960, after studying in England, to produce his play *A Dance of the Forests*, which portrayed post-colonial African politics as helplessly imitating the chronic dishonesty of its colonial heritage. The following short passage demonstrates their aimlessness and corruption (**Reading 48.1**):

READING 48.1　**from Wole Soyinka,**
A Dance of the Forests (1960)

COURT POET Did not a soldier fall to his death from the roof two days ago my lady?

MADAME TORTOISE That is so. I heard a disturbance, and I called a guard to find the cause. I thought it came from the roof and I directed him there. He was too eager and he fell.

COURT POET From favour Madame?

MADAME TORTOISE [eyeing him coolly.] From the roof.

[They look at each other.]

MADAME TORTOISE Well?

COURT POET I forbid him to go.

MADAME TORTOISE I order him to go.

[The novice runs off.]

MADAME TORTOISE And I order you to follow him. When he has retrieved my canary, bring it here to me, like a servant. [The poet bows and leaves. Madame Tortoise and her attendants remain statuesque.] [From the opposite side, a warrior is pushed in, feet chained together. Mata Kharibu leaps up at once. The warrior is the Dead Man. He is still in his warrior garb, only it is bright and new.]

MATA KHARIBU [advancing slowly on him.] It was you, slave! You it was who dared to think.

WARRIOR I plead guilty to the possession of thought. I did not know that it was in me to exercise it, until your Majesty's inhuman commands. [Mata Kharibu slaps him across the face.]

MATA KHARIBU You have not even begun to repent of your madness.

WARRIOR Madness your Majesty?

MATA KHARIBU Madness! Treachery! Frothing insanity traitor! Do you dare to question my words?

WARRIOR No, terrible one. Only your commands.

[Mata Kharibu whips out his sword. Raises it. The soldier bows his head.]

What Soyinka has railed against most passionately is the imposition of Western political solutions on the African continent—whether they be Marxist or capitalist. Instead, he argues for a political system based upon native ritual as part of what he calls an "organic revolution." His model is the Yoruba god Ogun, who moves between the three stages of Yoruba existence—the world of the ancestors, the world of the living, and the world of the unborn. Soyinka recognizes that Ogun is at home in none of these worlds, but only in a borderland world between them where opposites collide without resolution. This, he believes, is the African condition and each local community must act in this state according to its own local needs. There is no one revolution for Africa, only a series of unique revolutions, in which novel and alien forces are regularly and repeatedly integrated into the matrix of tradition and custom. And this is the dwelling place of the African writer as well. Thus, Soyinka displays a talent for multiple styles and effects, genres and pseudo-genres, which embody, he believes, the clash that is the ongoing organic revolution of Africa.

A general feeling exists among African writers that the very survival of their cultures and their peoples is in jeopardy. Illustrating this fear, Ivory Coast author Véronique Tadjo [tah-DJOH] (1955–), who writes in French but translates her work into English, is well known across the continent for her 1992 novel *As the Crow Flies*. Composed of 50 short parables, which can be read independently or as part of a larger whole, the book's female narrator emphasizes the fleeting nature of relationships. The story, "The Betrayal" (see **Reading 48.2**, page 1580), ends with Africa consumed in an atomic explosion, not by forces from the outside, but by the misplaced passions of the African male bent on making love to a woman who asks him to bide his time:

Suddenly, a huge flash of lightning disturbed the clouds. The sky began to flee and the trees to howl. At the same time, an infernal heat descended. A dense and dusty smoke encircled nature and set it aflame. A violent, hot torrent of air scorched people and overturned buildings.

The skin peeled in layers. Eyes dried out. Hair fell in tufts. Everybody died violently. Metal began to melt and trail along the ground. The outline of a gigantic mushroom cloud framed the blazing horizon.

The AIDS Pandemic and the Arts

Because of the brutal impact of AIDS in Africa, it is tempting to read Tadjo's narrative not as a literal description of atomic destruction, but as the figurative account of the continent's destruction by infectious disease. In 2006, there were 2.8 million new infections in sub-Saharan Africa, 2.1 million deaths, and a total of about 25 million people living with HIV/AIDS. A bead-doll tableau by a South African woman (Fig. 48.14) tells part of this story. A young wife, positioned at the top of the human tower, has just learned that her husband is HIV positive. Upon hearing this she runs back to her community, where her sisters, her aunts, and her mother protect her by pushing her up to the top of the human tower—out of the reach of her husband.

Although AIDS originated in Africa, the slowness of the West to use its vast wealth to provide affordable drugs and treatment is viewed by many in Africa as the latest manifestation of the West's imperial supremacy. The 400 years of Western exploitation of African natural resources, and creation of a vast trans-atlantic slave trade, set the stage, it seems, for continued suffering throughout the continent.

The AIDS epidemic is, of course, not limited to the African continent, although more than half the known living victims of the disease are still located there. It is a global

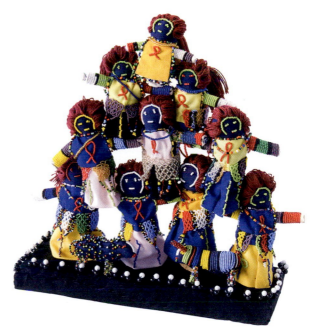

Fig. 48.14 Beauty Ndlovu. *Human Tower*. July 2002. Beaded cloth-doll tableau. Melville J. Herskovits Library of African Studies, Northwestern University, Evanston, IL. Tableaux of the type displayed here are made by women living in the KwaZulu-Natal region of South Africa. Dolls such as this are commonly made, but are arranged in tableaux as a means to engage societal problems.

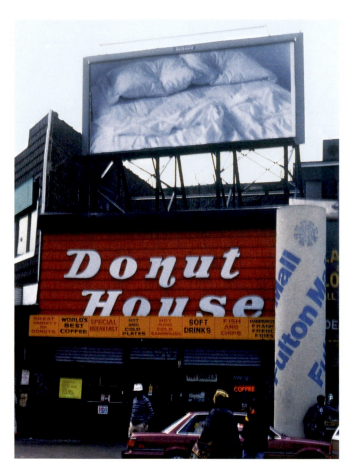

Fig. 48.15 Felix Gonzalez-Torres, *Untitled*. 1991. Printed billboard, 10′5″ × 22′8″. The Museum of Modern Art/Licensed by Scala-Art Resource, NY. © The Felix Gonzalez-Torres Foundation. Courtesy of Andrea Rosen Gallery, NY. The fact that the Museum of Modern Art would sponsor such a project is some indication of how the AIDS epidemic in many ways politicized the American museum as an institution. Given the impact of the epidemic on the art world, museums simply could not ignore the seriousness of the crisis.

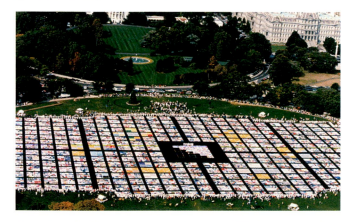

Fig. 48.16 The Names Project, San Francisco, *AIDS Memorial Quilt*, displayed on the Ellipse facing the White House, Washington, D.C., October 6–8, 1989. Each 3′ × 6′ ʻquilt is displayed with three others in 12′ × 12′ groups of four. The dimensions were chosen to resemble a grave, since at the time the project was conceived, in 1987, funeral homes and cemeteries refused the remains of most people who died of AIDS. The quilts, then, are symbolic memorials to loved ones whose lives families and friends could not otherwise celebrate.

pandemic, affecting all segments of the population, but especially the poor. In 1978, gay men in the United States and Sweden and heterosexuals in Tanzania and Haiti began showing signs of what would later be called AIDS. The numbers would soon swell dramatically.

Today, drug therapies are keeping people infected with HIV (the human immunodeficiency virus that causes AIDS) healthy for a longer time and significantly reducing the death rate. But the effects of the disease struck the art world with particular ferocity in the years before treatment became widely available. Virtually everyone working in the arts in America and Europe has lost at least one friend or colleague to the disease.

The year 1989 was a seminal one in developing AIDS awareness. On December 1, 1989, the mounting sense of loss prompted artists in New York to organize the first "Day without Art." Many galleries closed their doors or shrouded paintings in mourning for the day. Theaters were silent and dark. Since then, many museums have followed suit on the Day without Art/World AIDS Day, now observed annually on December 1. Also in 1989, a collaborative team of artists known as Group Material organized an AIDS timeline exhibition at the University Art Museum, Berkeley, California, in order to make visible the course of the epidemic since 1978. Among Group Material's members was Cuban-born and Puerto Rico-raised Felix Gonzalez-Torres, whose own partner, Ross, died of the disease in 1991. A year later, the Museum of Modern Art supported his memorial installation of 24 billboards around New York City showing the crumpled sheets of the bed that he had formerly shared with Ross (Fig. **48.15**). Gonzalez-Torres himself died of AIDS in 1996, at the age of 39.

Finally, the Names Project, a San Francisco-based organization created to make the AIDS crisis more concrete by lending it, as it were, a personal face, organized the display of its *AIDS Memorial Quilt* (Fig. **48.16**) in the Ellipse in front of the White House in Washington, DC. Each panel is a 3- by 6-foot section made by friends and family of an individual who has died from AIDS, and each celebrates that individual's life. When it was displayed in October 1989 in Washington, it consisted of 10,848 panels. Today it consists of over 46,000 panels containing 82,938 names, representing approximately 17.5 percent of all U.S. AIDS deaths.

The AIDS pandemic drew attention not only to the threat that other diseases, such as the flu virus, might quickly spread around the world, but also to the nomadic character of modern life. Other aspects of culture could quickly spread as well.

Multiple Identities in a Global World

"Language is a virus," declared American author William S. Burroughs (1914–1997), referring, at least in part, to the fact that American English had become the international language of business, politics, the media, and culture—a plague upon indigenous languages that threatened their extinction. In this context, the collision of global cultures could hardly

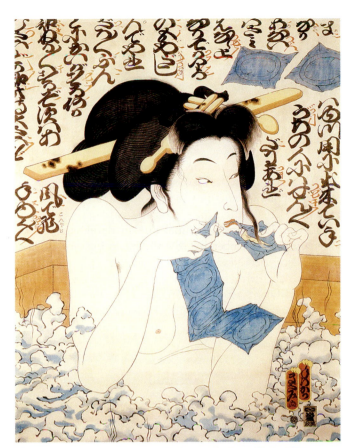

Fig. 48.17 Masami Teraoka. *AIDS Series / Geisha in Bath*. 1988.
Watercolor on canvas, 108″ × 81″. Courtesy of the artist and Catharine
Clark Gallery, San Francisco, CA. In the late 1970s, Teraoka had made
similar works depicting McDonald's hamburgers and Baskin and Robbins'
"31 Flavors" in similar Ukiyo-e contexts.

be ignored. As in Africa, in Asia, Islam, and the Latino and
Hispanic worlds, artists responded by acknowledging that life
in a global world increasingly demanded that they accept
their multiple identities.

The Asian Worldview

Although the Japanese have traditionally considered their
culture as literally "insular," and largely isolated from outside
influence, by the late 1980s, artists like Masami Teraoka [teh-
rah-oh-kah] (1936–) recognized that Japanese artists could no
longer afford to ignore contemporary issues. His 1988 *Geisha
in Bath*, from his *AIDS Series* (Fig. **48.17**), introduced con-
doms into the traditional ukiyo-e [oo-kee-oh-eh] print (see
chapter 39), underscoring the collision of cultures. The work
is not actually a print, but a watercolor on canvas, and its
scale is vastly larger than the more intimate ukiyo-e works it
imitates. The difference underscores the transformation that
Japanese culture's "floating world" has undergone—the urban
world of everyday Japanese life, with its courtesans, actors,
and dancers meets the specter of AIDS. Teraoka has also
moved on to another "floating world," having lived and
worked in Hawaii for decades, alongside the hundreds of
thousands of other ethnic Japanese in the islands.

In *Portrait (Twins)* (Fig. **48.18**), a self-
portrait by Yasumasa Morimura [mor-ih-
moo-rah] (1951–), the artist poses as both
Manet's *Olympia* (see the *Focus*, chapter
36) and her maid, manipulating the pho-
tograph with a computer in the studio,
while subverting the idea of Japanese iso-
lationism even more pointedly. On the
one hand, he copies the icons of Western

Continuity **& Change**
p. 1165

Olympia

culture, but at the same time he undermines them, drawing
attention to the fact that the courtesan and her maid share the
same identity—they are "twins"—slaves to the dominant
(male) forces of Western society. He places Japanese culture as
a whole—and in particular the Japanese male—in the same
position, as prostitute and slave to the West.

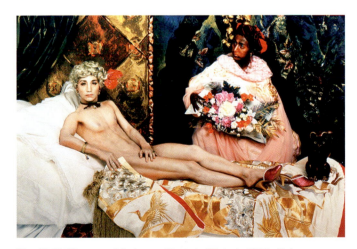

Fig. 48.18 Yasumasa Morimura. *Portrait (Twins)*. 1988. Color
photograph, clear medium, 6′10½″ × 10′. NW House, Tokyo. Courtesy of
the artist and Luhring Augustine, NY. By cross-dressing—and in this image,
un-cross-dressing, Morimura challenges Japanese male gender identity as
well.

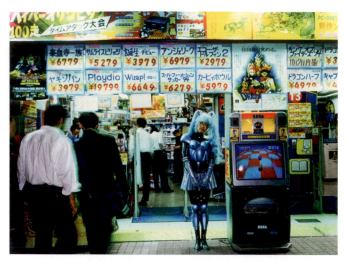

Fig. 48.19 Mariko Mori. *Play With Me.* 1994. Fuji supergloss (duraflex) print, wood, pewter frame, edition of 3, 12′ × 10′ × 3′. Courtesy Deitch Projects, NY. The enormous scale of Mori's photograph lends it a cinematic presence that was also realized in the animated 1996 movie version of Shirow's *Ghost*.

Fig. 48.20 Manga (Graphic Novel) poster page showing the character Major Motoko Kusanagi, from *The Ghost in the Shell,* by Masamune Shirow. 1989–1990.

In Morimura's photograph, transcultural exchange is also a transgendered performance. All boundaries, between East and West, male and female, seem to disintegrate, as does the distinction between humans and machines. In *Play With Me* (Fig. **48.19**), former fashion model Mariko Mori [mor-ee] dresses herself like a cyborg from a Japanese **manga** [MANG-uh]—comic book or graphic novel—the most popular form of reading material in Japanese culture, which often verges toward the pornographic.

Among the most famous manga creators is Masamune Shirow, whose wildly popular graphic novel *The Ghost in the Shell* was originally serialized in 1989–1990 (Fig. **48.20**). Set in the year 2029, when the boundaries between human and artificial intelligence are fading, most people are equipped with microprocessors implanted in their brains so that they can more easily interact with computers. This, of course, leaves them open to manipulation by skilled hackers. The character Major Motoko Kusanagi [koo-sah-nah-ghee] is a cyborg in an elite counter-terrorism group, whose brain—her only human element—is encased in a titanium shell. An entirely nonhuman machine, Kusanagi's cyborg body is capable of enduring sophisticated military assault. In *Play With Me*, Mori assumes a manga identity similar to that of Kusanagi, standing outside a Tokyo toy store in a way that connected her both to the robotic toys inside and to the sexual fantasy world of the manga novels.

Both Morimura's and Shirow's works are parables of the real possibility of the loss of the self—imagined as the loss of the body—in the technological space of the global future. In China, where the government has tightened its control over individual expression during the last six decades, the loss of the self has been taken for granted, and the arts have focused on exposing the mechanisms of repression and overthrowing them. For many, this has meant leaving China. The painter Hung Liu [loo], for instance, born in 1948, worked as a peasant in the fields from 1966 to 1970 during Mao's Cultural Revolution. Since 1984, she has lived in the United States, where she has thought about the nature of her homeland. *Virgin/Vessel* (Fig. **48.21**) considers the origins of Chinese authoritarianism by depicting the almost thousand-year-old practice of binding the feet of China's girls and women which left them unable to walk, totally dependent upon their fathers, brothers, and husbands. After Mao's Communist Revolution, even previously upper-class women who had their feet bound were forced into prostitution after Mao confiscated their possessions, leaving them without servants to transport them. In Liu's painting, the woman's body has become a sexual vessel, like the one in front of her.

In post-Mao China, Chinese artists have been somewhat free to state their opposition to the government's oppression. In 1997, for instance, performance artist Zhang Huan [hwahn] invited 40 peasants who had recently emigrated to Beijing looking for work to stand with him in a pond (Fig. **48.22**). In this way, the city's class of new poor raised the level of the water one meter, an act that Zhang Huan considered a metaphor for raising the government's conscious-

Fig. 48.21 Hung Liu. *Virgin/Vessel* (detail). 1990. Oil on canvas, broom, 72″ × 48″. Collection Bernice and Harold Steinbaum. © Hung Liu. Courtesy Bernice Steinbaum Gallery, Miami, FL. Foot binding originated in China around 900 CE as a means of enforcing the imperial ruler's exclusive sexual access to his female consorts, ensuring their chastity and fidelity.

ness. The performance was, Zhang Huan says, "an action of no avail," and yet as an image of people working together in all their vulnerability, the performance is an image of hope.

Imaging Islam

The tension between political reality, cultural and personal identity is especially evident in the work of Middle Eastern women artists who have moved between their homelands and the West. Shirin Neshat grew up in Iran in an upper-middle-class family, but she moved to the United States after graduating from high school to study art. When the Islamic Revolution overtook her homeland in 1979, 22-year-old Neshat found herself living in exile. When she returned home 11 years later, Iran had completely changed. She recalls:

> During the Shah's regime, we had a very open, free environment. There was a kind of dilution between West and East—the way we looked and the way we lived. When I went back everything seemed changed. There seemed to be very little color. Everyone was black or white. All the women wearing the black chadors. It was immediately shocking. Street names had changed from old Persian names to Arabic and Muslim names. . . . This whole shift of the Persian identity toward a more Islamic one created a kind of crisis. I think to this day there's a great sense of grief that goes with that.

In Neshat's series of photographs, *Women of Allah*, of which *Rebellious Silence* (Fig. **48.23**) is characteristic, many of the women hold guns, subverting the stereotype of women as submissive. At the same time, they bury their individuality beneath the black *chador*, and their bodies are inscribed in Farsi calligraphy with poetry by Tahereh Saffarzadeh, whose verses express the deep belief of many Iranian women in

Fig. 48.23 Shirin Neshat. *Rebellious Silence*, from the series *Women of Allah*. 1994. Gelatin silver print and ink. Photo: Cynthia Preston. © Shirin Neshat, courtesy Gladstone Gallery, NY. "The main question I ask," Neshat has said, "is, what is the experience of being a woman in Islam? I then put my trust in those women's words who have lived and experienced the life of a woman behind the *chador*."

Fig. 48.22 Zhang Huan. *To Raise the Water Level in a Fish Pond*. August 15, 1997. Performance documentation (middle distance detail), Nanmofang Fishpond, Beijing, China. C-Print on Fuji archival, 60″ × 90″. Courtesy Max Protetch Gallery. Though the performance was a political act, Zhang Huan acknowledged that raising the water in the pond one meter higher was "an action of no avail."

Fig. 48.24 Shahzia Sikander. *Pleasure Pillars.* **2001.** Watercolor, dry pigment, vegetable color, tea, and ink on wasli paper, 12″ × 10″. Collection of Amita and Purnendu Chatterjee. Courtesy Sikkema Jenkins & Co., NY. As part of her ongoing investigation of identity, Sikander has taken to wearing the veil in public, something she never did before moving to America, in what she labels "performances" of her Pakistani heritage.

Islam. Only within the context of Islam, they believe, are women truly equal to men, and they claim that the *chador* [CHAH-dor], by concealing a woman's sexuality, prevents her from becoming a sexual object. The *chador* also expresses the women's solidarity with men in the rejection of Western culture. Yet, even as she portrays the militant point of view, Neshat does not blindly accept the Islamic fundamentalist understanding of the *chador*. It is clear that the *Women of Allah* photographs underscore the Islamic world's inability to separate beliefs that focus on religion and spirituality from those that concern politics and violence.

The Pakistani painter Shahzia Sikander addresses her heterogeneous background in works such as *Pleasure Pillars* (Fig. **48.24**) by reinventing the traditional genre of miniature painting in a hybrid of styles. Combining her training as a miniature artist in her native Pakistan with her focus on contemporary art during her studies at the Rhode Island School of Design, Sikander explores the tensions inherent in Islam's encounter with the Western world, Christianity as well as the neighboring South Asian tradition of Hinduism. In the center of *Pleasure Pillars*, Sikander portrays herself with the spiraling horns of a powerful male ram. Below her head are two bodies, one a Western Venus (see Fig. 7.24),

Continuity **&** Change
p. 213

Aphrodite of Knidos

the other Devi, the Hindu goddess of fertility, rain, health, and nature, who is said to hold the entire universe in her womb. Between them, two hearts pump blood, a reference to her dual sources of inspiration, East and West. Eastern and Western images of power also inform the image as a lion kills a deer at the bottom left, a direct artistic quote from an Iranian miniature of the Safavid [sah-FAH-weed] dynasty (1501–1736), and at the top, a modern fighter jet roars past.

The Latino and Hispanic Presence in the United States

The cross-fertilization of traditions so evident in Sikander's work also infuses the art of Latino and Hispanic culture in the United States. From the beginning of the sixteenth century, the Hispanization of Indian culture and the Indianization of Hispanic culture in Latin and South America created a unique cultural pluralism. By the last half of the twentieth century, Latino culture became increasingly Americanized, and an influx of Hispanic immigrants helped Latinize American culture. Chicana muralist Judith F. Baca captured this diversity in a 1990 project created for the town of Guadalupe [GWAHD-ul-oop], California (Fig. **48.25**), in an area whose economy is almost entirely dependent on enormous farms that employ 80 percent of the population of Mexican heritage. The project offers a thought-provoking glimpse of

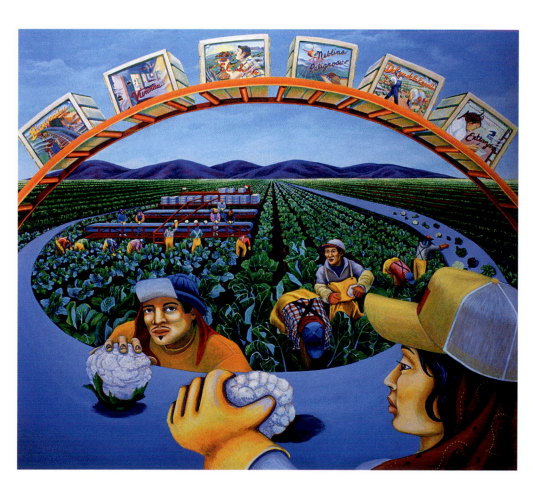

Fig. 48.25 Judith F. Baca.
Farmworkers at Guadalupe. 1990.
One of four murals, 8′ × 7′. Guadalupe, California. © 1997 Judith F. Baca. Courtesy of the artist. To make the murals, Baca hired five local teenagers to construct a town chronology, collected family photos and stories, and called town meetings to discuss her imagery.

the new "Mexican towns" that have become common-place in rural California.

Reflecting the community's pride in its heritage, the mural refers directly to César Chávez's [SHAH-vez] successful efforts to unionize farm workers through the creation of the National Farm Workers Association in 1962 (today known as the United Farm Workers). One of the union's most effective actions was the boycott of table grapes from 1966 to 1970. Beginning with local strikes, marches, and demonstrations, the movement spread across the state and then nationwide. Chávez and a coalition of Hispanic and Filipino farm workers effectively challenged the substandard wages and working conditions imposed by large vineyards. Political and labor activism had cultural consequences, as a vital theatrical tradition developed alongside Chávez's new union.

Luis Valdez was a playwright before joining Chávez to help organize farm workers in Delano, California. There he founded El Teatro Campesino [el tay-AH-troh kahm-pay-SEE-noh] (The Farmworkers Theater) to raise funds for "La Causa" (the cause), the simple but effective term that helped transform a local strike into a broad, instantly identifiable global movement. Combining Italian commedia dell'arte [koh-MEH-dee-ah dell-AR-teh] (improvisational comedy) and Mexican vaudeville [VAWD-vill], by 1968 the Farmworkers Theater had redefined itself as a "teatro chicano" and moved out of the fields and into Los Angeles in an effort to portray a wider range of Chicano experience.

Valdez's national success came in 1978, when he produced *Zoot Suit*, a play that exposed the police brutality and injustices faced by the Chicano community during the "Zoot Suit Riots" and the "Sleep Lagoon" trial of the 1940s. The main character in the play, Henry Reyna, is the leader of the 38th Street Gang. Heading to a party that had been terrorized by rival gang members just moments before, Henry and his friends were mistaken for members of the rival gang and attacked. After a man from the party was killed, the entire gang was indicted on charges of murder. Their identity, both cultural and criminal, was tied to "zoot suits," two-piece suits consisting of a long jacket and pegged pants, accompanied by a long keychain that looped almost to the ankle. The importance of the apparel is expressed by the character El Pachuco [pah-CHOO-koh]—part Aztec god, part quintessential 1940s Zoot Suiter, and part Greek chorus—when he sings the following *corrido* [kor-REE-doh], or traditional Mexican narrative ballad (**Reading 48.3**):

READING 48.3　**from Luis Valdez, *Zoot Suit* (1978)**

Trucha, ese loco, vamos al rorlo
Wear that carlango, tramos y tando
Dance with your huisa

Dance to the boogie tonight!
'Cause the zoot suit is the style in California
También en Colorado y Arizona
They're wearing that tacuche en El Paso
Y en todos los salones de Chicago
You better get hep tonight
And put on that zoot suit!

Valdez's use of "Spanglish" is discussed in Aurora Levins Morales's poem "Child of the Americas" (see Reading 47.4), exemplifying the confluence of cultures that the Latino experience in the United States represents—a plural language for a plural self.

The "World Music" Movement

Of all the technologies that have enhanced cultural diversity, perhaps those that have saturated the music industry—from the phonograph record to the CD, DVD, and iPod—have done most to create a new global fusion of disparate influences. Indian ragas, Arabic chants, American and African music have penetrated every culture. One of the most vibrant pop music scenes in the world, in West Africa, was deeply influenced by Cuban music, which is itself derived from the African traditions brought to the Americas by slaves. Worldbeat music (or ethnopop) emerged during the early 1980s, when Nigerian musician King Sunny Adé [ah-DAY] (1946–), known as the Minister of Enjoyment, released his album *Juju Music*. By combining traditional African drums with electric guitars and synthesizers, Adé's music quickly caught the attention of audiences in the United States and the United Kingdom. Adé would, in turn, introduce the steel guitar, a staple of American country music, to African audiences. Western rock superstars, such as Paul Simon—whose 1985 hit album *Graceland* featured South Africa's Ladysmith Black Mambazo [mahm-BAH-zoh]—played an important role in exposing worldbeat musicians to audiences in the United States and Europe.

One of the most important sources of the world music movement has been Latin and South America, a melting pot of cultural influences, where several popular dances including the *mambo* are derived from a mixture that combines African musical traditions with the eighteenth-century Spanish contradanza, a folk dance in which couples face each other in two long lines. Other popular dances such as the *tango*, the *cha-cha-cha*, the *pachanga* [pah-CHANG-uh], and the *bugaloo* are all derived from or are closely related to mambo forms. And one of today's most popular Latin American musical forms, known as *salsa*, incorporates mambo as the theme played in unison by the rhythm section of the band.

In Jamaica, a similar type of music developed out of West African culture, specifically from drum music traditions of Burru and Kumina as well as Pocomania (meaning "little madness")—the ecstatic, revivalist, Afro-Christian religious movement of the 1860s in which worshipers danced to pow-

erful drums. Combined with a rhythm-and-blues influence from the United States, this indigenous music developed into *reggae*, originally known as *ska* in the early 1960s when its two chief proponents, Jimmy Cliff (1948–) and Bob Marley (1945–1981), first introduced it. Soon after, Cliff's song "Waterfall" (**CD-Track 48.1**) won the International Song Festival in Brazil in 1968, and reggae became a global force in popular music.

Perhaps the most sensual musical form to gain popularity in the world music movement is the Argentinean *tango*. Developed in Buenos Aires in the 1890s, the tango fused musical forms from Spain, Africa, and the Caribbean into a highly charged and aggressively sexual dance accompanied by a narrative music. The most prominent instrument featured in tango is the bandoneón [bahn-dohn-ay-OHN], which is related to the accordion and concertina and is played on the musician's lap. Argentine composer Ástor Piazzolla (1921–1992), who was also one of the great bandoneón players in Argentine history, revolutionized the tango in the 1950s. The *nuevo tango*, as Piazzolla's innovation came to be known, combines elements of both jazz and classical music, particularly in its use of dissonance, Baroque counterpoint, and jazz improvisation. His 1959 composition *Adiós Nonino* [ah-dee-OHSS nohn-EE-noh] established the basic musical structure that his later compositions would follow, a formal pattern of fast-slow-fast-slow-coda (**CD-Track 48.2**). The fast sections display harshly expressive tango rhythms and often dissonant, hard-edged melodies, and the slower sections incorporate lyrical melodies featuring solos by the guitar or Piazzolla's own bandoneón. The quintet featured in this selection would become Piazzolla's favored instrumentation: bandoneón, violin, piano, electric guitar, and double bass.

Meanwhile, two singers from the Brazilian state of Bahia, Caetano Veloso (1942–) and Gilberto Gil (1942–), founded the musical movement known as *Tropicálismo* [troh-pee-kah-LEEZ-moh]. Also known as Tropicalia, this lively genre was named after Tropicália, the Municipal City Hall in Salvador, Bahia, which chose "Tropicálismo" as the theme of its 1967 Carneval, and combines elements of rock and roll, African music (which is powerfully influential in Bahia), folk music, and the bossa nova (itself an early 1960s synthesis of *samba* and jazz). American musician David Byrne (1952–), lead singer of the rock-and-roll band Talking Heads, was attracted to their music when he first heard it in the 1980s, and soon was popularizing it on his own Luaka Bop label, which also presented Cuban music. The many Cuban musical genres had been avidly explored by jazz musicians like Dizzy Gillespie since the 1940s.

Byrne's label also produced a collection of Brazilian samba music (closely related to the Cuban *rumba*), which Byrne sees as intimately related to Candomblé [kahn-dohm-BLAY], the African religion that developed in Brazil after the slave trade. In his essay, "Philosophy of Samba," Byrne explains: "Any activation of the hips-sex-butt-pelvis relates to the source of all life, the womb. This music is definitely a respectful prayer in honor of the sweet, the feminine, the great mother—the

sensuous life-giving aspects of ourselves and our lives—and to the Earth, the mother of us all." Byrne's Luaka Bop project is unique in its determination *not* to present "authentic" world music—that is, music untouched by Western influences. Rather, it focuses on the confluence of Western pop and world musical traditions, the rich intermingling of African, Hispanic, indigenous, blues, and rock traditions that reflects the diversity of the Americas.

Recovering Tradition: Contemporary Native American Art

Native North Americans have been among the most isolated and marginalized of all the world's indigenous peoples. Diverse but sequestered on arid reservations, enmeshed in poverty and unemployment, their traditions and languages on the brink of extinction, Native Americans seemed the consummate "Other." However, in 1968, in Minneapolis, Minnesota, a gathering of local Native Americans, led by Dennis Banks, George Mitchell, and Clyde Bellecourt, decided to address these problems through collective action, and founded the American Indian Movement (AIM). Almost a quarter-century later, Banks recalled what motivated them:

> Because of the slum housing conditions; the highest unemployment rate in the whole of this country; police brutality against our elders, women, and children, Native Warriors came together from the streets, prisons, jails and the urban ghettos of Minneapolis to form the American Indian Movement. They were tired of begging for welfare, tired of being scapegoats in America and decided to start building on the strengths of our own people; decided to build our own schools; our own job training programs; and our own destiny. That was our motivation to begin. That beginning is now being called "the Era of Indian Power."

AIM was, from the outset, a militant organization. On Thanksgiving Day 1970, AIM members boarded the *Mayflower II* at its dock in Plymouth harbor as a counter-celebration of the 350th anniversary of the Pilgrims' landing at Plymouth Rock. A year later, they occupied Mount Rushmore National Monument. In AIM's point of view, the site, which was sacred to their culture, had been desecrated by the carving of the American presidents Washington, Jefferson, Roosevelt, and Lincoln into the mountain. The occupation was designed to draw attention to the 1868 Treaty of Fort Laramie, which had deeded the Black Hills, including Mount Rushmore, to the Lakota Sioux. The U.S. military had ignored the treaty, forcing the Lakota onto the Pine Ridge reservation on the plains south of the Black Hills. There, on December 29, 1890, troops surrounded the Lakota village of Wounded Knee. Conflict erupted, and by the end of the day, 25 soldiers and nearly 300 Lakota men, women, and children were dead. In 1973, AIM militants took control of Wounded Knee and were quickly surrounded by federal marshals. For over two months, they exchanged gunfire, until the AIM

Focus

Bradley's *Indian Country Today*

Contemporary life in the Southwestern pueblos is the subject of *Indian Country Today*, painted by David P. Bradley (1954–), a Native American of Ojibwe [oh-JIB-way] descent. Bradley depicts a traditional kachina [kah-CHEE-nuh] dance taking place in the pueblo. Performed by male dancers who impersonate kachinas, the spirits who inhabit the clouds, the rain, crops, animals, and even ideas such as growth and fertility (see chapter 1), the dances are sacred and, although tourists are allowed to view them, photography is strictly prohibited. The actual masks worn in ceremonies are not considered art objects by the Pueblo. Rather, they are thought of as active agents in the transfer of power and knowledge between the gods and the men who wear them in dance. Kachina figurines are made for sale to tourists, but they are considered empty of any ritual power or significance. This commercialization of native tradition is the real subject of Bradley's painting.

The parking lot of an Indian-run casino is filled with tourist buses. Behind it, in the distance, is the city of Sante Fe, New Mexico, home of the Museum of Indian Arts and Culture.

The train passing behind the pueblo is the Santa Fe Railroad's "Chief"—the very image of Anglo-American culture's appropriation of Native traditions.

The giant mesa overlooking the entire scene is endowed with kachina-like eyes and mouth, suggesting that even in the contemporary world, where tradition and progress appear to be in a state of constant tension, the spirits still oversee and protect their people.

The Four Corners Power Plant in Northwestern New Mexico, one of the largest coal-fired generating stations in the United States and one of the greatest polluters. (Note the smoke reemerging on the far side of the mesa.) Behind the plant is an open-pit strip mine.

Fighter jets rise over the landscape, reminders of the Los Alamos National Laboratory, where classified work on the design of nuclear weapons is performed.

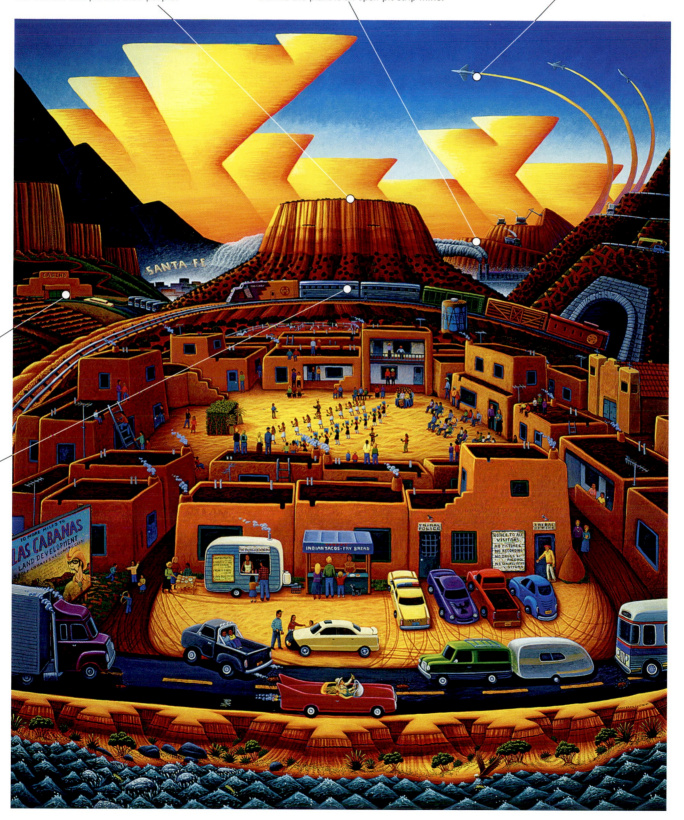

David P. Bradley (White Earth Ojibwe and Mdewakaton Dakota). *Indian Country Today.* **1996–1997.** Acrylic on canvas, 70″ × 60″.
Peabody Essex Museum, Salem, MA. Museum Purchase through the Mr. and Mrs. James Krebs Fund. Photograph courtesy Peabody Essex Museum.

militants surrendered. Of course, not everyone agreed with AIM's tactics, but the group did help to revitalize Native American cultures throughout the hemisphere and furthered an interest in traditional art forms. Two clear examples of this revival are the potters of the Southwest and the revival of native traditions in the Pacific Northwest.

The Potters of the Southwest

The work of the Tewa-Hopi [TAY-wuh HOH-pee] potter Nampeyo [nam-PAY-oh] (ca. 1860–1942) is central to the story of the revitalization of native traditions in the American Southwest. Born in Hano, a village within the Hopi reservation in northern Arizona, she encountered anthropologist J. W. Fewkes (1850–1930) around 1895 when he was excavating at Sikyakti, a site near her village where pottery had been produced in the twelfth century CE. Fascinated by the pottery shards discovered at the site, she began to create original designs based on the Sikyakti prototypes, connecting her work to ancient tradition in a profound way. Her pots (Fig. **48.26**) were quickly popularized by the Sante Fe Railroad, which told her story in their vacation brochures, while her work was sold by a chain of retail shops at lodges, restaurants, railroad stations, and national parks throughout the West.

There are many first-hand accounts of Nampeyo's working methods. In the traditional Hopi manner, she dug for clay, pulverized it by hand, slaked it in water to dissolve the lime it contained, and then removed its other impurities. She fired the pots on a bed of sand overlaid with sheep dung and old shards, creating layers until a mound was formed topped with a final layer of dung. After the fired dung burned for about an hour, the pots were removed with a stick. Finally, she would paint them with natural mineral pigments using brushes made of yucca (a type of agave plant).

Fig. 48.26 Nampeyo of Hano. Black-on-white jar. ca. 1890–1930. Height 17″, diameter 15 ½″. Department of Anthropology, Smithsonian Institution, Catalogue No. 158143. Nampeyo was the oldest of six Navajo and Pueblo women, all born between 1860 and 1920, who revived the pottery-making traditions of the people. The others include Maria Martinez, Lucy Martin Lewis, Margaret Tafoya, Helen Cordero, and Blue Corn.

Nampeyo was the first of six woman potters who raised families in the Southwest pueblos in the early twentieth century and taught their children and grandchildren traditional techniques that have since been passed on to subsequent generations. Their lives span the entire twentieth century, and their influence was enormous. Potters working in the tradition of Nampeyo include Maria Martinez (1887–1980), of San Idelfonso Pueblo [san ill-duh-FAWN-soh PWEH-bloh] near Taos [tous], New Mexico, known for her black-on-black designs; Lucy Martin Lewis (1902–1992), of Acoma [AH-kuh-muh] Pueblo, especially renowned for her "fine-line" or star pattern; Margaret Tafoya [tah-FOY-uh] (1904–2001), of Santa Clara Pueblo, who instead of painting designs on her work, carved them into the clay; Helen Cordero [kor-DER-oh] (1915–1994), of Cochiti [KOH-chih-tee] Pueblo, whose "Storyteller" figures evoke long-standing ceremonial traditions; and Blue Corn (1920–1999), another San Idelfonso potter, who introduced new colors into the traditional Southwestern palette.

The next generation of Pueblo Indians, including Nancy Youngblood Lugo, granddaughter of Margaret Tafoya, further refined their approaches. Like her grandmother, Lugo carves into the clay of her pots, but she combines this carving technique with the black firing processes of Maria Martinez. Her "melon forms" contain deeply carved ribs that swirl around the bowl. Each piece is meticulously polished with river-washed polishing stones (Fig. **48.27**).

The Revival of Northwest Coast Traditions

By the end of the nineteenth century, the long-standing cultural traditions of the tribes along the Northwest Coast of the United States and Canada were nearly extinguished. Most of the tribes of the Northwest Coast had ceased to carve *Gyáa'aang*, meaning "man who stands up" in the Haida [HY-duh] language—the tall red cedar poles carved with images and known as "totem poles" by white society (Fig. **48.28**). ("Totem pole" is in fact a misnomer: a "totem" reflects a clan's belief that it descends from a particular animal; the figures on Northwest Coast "totem poles" depict ancestors or supernatural beings encountered by ancestors. They are thus symbols of family identity and records of the family's history.)

Oral histories among the Haida culture suggest that the custom of carving the poles is very old, and this is correlated by descriptions from the earliest white explorers in the region. According to tradition, the Haida learned to carve the poles from a supernatural being. The poles were raised at potlatches, one of the most significant rituals and social occasions among the Haida. The potlatch is a celebration of its host, his social position and his authority. The

Fig. 48.27 Nancy Youngblood Lugo (Santa Clara Pueblo). Swirled melon bowl. 1996. Ceramic, 5 ½″ × 7 ½″. A 64-ribbed bowl will require five or six 12-hour days to polish. Courtesy of Andrea Fisher Fine Pottery, Santa Fe, NM.

ceremony was declared illegal by the Canadian government in 1883 and remained so until 1951, an example of the destructive force of North American governments on indigenous Americans. Native peoples also began moving from their old multi-family clan houses into Western style single-family residences in areas that were convenient to their jobs.

Although some clans secretly continued to celebrate the potlatch between 1900 and World War II, the artistic styles and craftsmanship of the Northwest Coast tribes were almost forgotten. Yet traditions were carried on in small pockets as elders passed on techniques and styles by example to their heirs.

An important stimulus in revitalizing traditional customs in the Northwest occurred in 1970 when tidal erosion uncovered an ancient Makah [mah-KAW] whaling village on the Olympic Peninsula in Washington, which had been engulfed by a mudslide hundreds of years ago. Over 55,000 artifacts were uncovered, all 300 to 500 years old, and all well preserved. The most spectacular find was a red cedar sculpture, a meter high, carved in the form of a whale's dorsal fin and inlaid with over 700 otter teeth in the shape of a thunderbird holding a snake in its claws. Inspired by the find, a young tribal artist, Greg Colfax, began studying Makah and other Northwest Coast art, using local tribal research resources as well at the University of British Columbia.

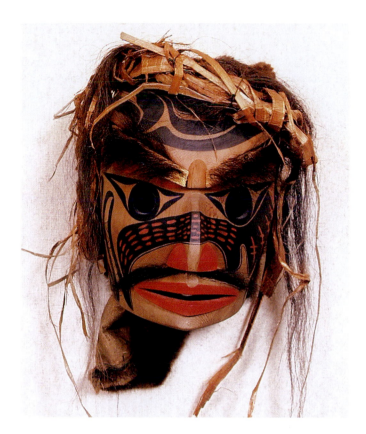

Fig. 48.29 Greg Colfax. *Killer Whaler Mask.* **2003.** Cedar, paint, and other materials, 13″ × 15″. Courtesy the Legacy, Ltd., Seattle, Washington. Such a whaler mask might be worn at a potlatch celebrating a successful hunt.

Crucial to Colfax's art has been the Makah's identity as a whaling people, and he is especially interested in the ceremonial arts associated with whaling (Fig. **48.29**), which the tribe voluntarily gave up in 1920, recognizing that industrial whaling ships had essentially wiped out the gray whale population. Yet their elders continued to pass on whale-hunting traditions, and the Olympic peninsula find provided them examples of traditional tools, techniques, and even boats. Nearly 80 years later, when the gray whale population had recovered to about 26,000 whales globally, the Makah Whaling Commission reinstated the hunt, estimating that this population could provide a sustainable population of whales. In May 1999, amid much controversy and protest, the Makah, using traditional boats and techniques, killed their first whale. The Makah are living proof that the forces of globalization can be overcome at a local level and that indigenous traditions, threatened by the leveling forces of the electronic age, can survive.

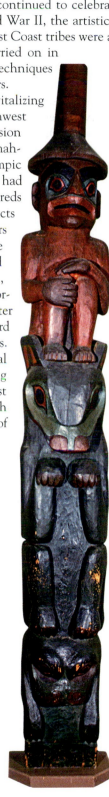

Fig. 48.28 Totem Pole, probably Tlingit peoples, Pacific Northwest. Mid-19th century. Wood and pigment. National Museum of Natural History, Smithsonian Institution, Washington, DC. The figures on this pole represent, from top to bottom, a man, a bear, and a frog, all symbolic of the authority of the family who erected the pole.

READING 48.2

Véronique Tadjo, "The Betrayal" (1992)

Although she was born in Paris, Véronique Tadjo grew up in Abidjan in the Ivory Coast. She studied in both France and America, and she is a widely published poet as well as fiction writer. "The Betrayal" is a short parable from her novel, Au Vol d'oiseau, translated as As the Crow Flies. The novel is composed of some 50 stories of a similar length, which can alternately be read individually or as part of the larger whole.

One day, a woman and a man who were deeply in love decided to have a child.

"We cannot live like this without giving of our own blood," said the woman. "I would like to turn our love into living flesh."

"The child will be a precursor of hope, I'm sure,' agreed the man, nodding his head. 'We will teach him all that we know."

On the following day the woman was pregnant. Before the end of the day, she had given birth to a boy. [10]

Then the man cried out:

"Love has triumphed! We have created life! Our son will be our messenger."

Both father and mother remained close to the child and taught him to love and have faith. They constantly spoke to him. The child listened.

"You will travel through continents, and meet people. Tell them what we have taught you. Rebuild the cities destroyed by violence and oppression. Allow wild plants to grow and do not crush the clouds. Tell [20] them of the water that never dries up. Dip your hand in the soil and inhale its scent, and above all, believe in yourself."

When the child was ready, he bade his parents farewell without looking back. After a while, when there was sufficient distance between them, you could tell that he had grown. By the time he approached the sprawling city, he had already become a man.

Things were not easy. Wherever he went, all he saw was despair. Indeed, the city dazzled with bright lights [30] and shimmered with wonders but just one false move would lead to mud and filth. Although people wore gold, if you just turned your head you would see the poor in tatters and the street children. If you came off the brightly lit streets and ventured further out, you would find yourself choking on the dust of abandoned tracks. All this was nothing, though. The worst part of it was that the inhabitants had lost hope. Some spoke of freedom and change but this was mere empty rhetoric. Nobody believed in it. The harmattan would [40] blow for weeks and dry their skin, but the heat only continued to beat down harder after that and the stench worsened. People dragged themselves along, breathless.

What about him? What was he doing?

He spent his time growing. He looked at life, recorded everything with his eyes. He felt terribly exiled from the others. Communicating with them was so difficult that it became tortuous. What he was looking for seemed to be somewhere else. Sometimes he [50] had an urge to leave, abandon the city in search of something else.

Moreover, he felt that he had changed. Well, not that much, but enough to recognize the difference within himself. He had to make a real effort to continue believing, and although it was true that he could still see his parents in his dreams and hear their gentle words, it was equally true that nightmares left him out of breath in the depth of night. He thought he was falling. His head reeled and he was frightened. He knew [60] only too well that this was caused by anxiety. It was so thick and true he could have held it in his hands.

Anxiety was responsible for his unmaking. It was destroying his spirit and draining his strength. "This has got to stop," he decided. "This has to end."

At about that time he fell in love.

Her eyes were shaped like cowries and her skin was the colour of sand. You could see the city in her gaze.

For her, time was not an obstacle because she considered herself to be without gender. She was a creature [70] in between, ambiguous, who could not care less if she wore a skirt or if she had pointed breasts.

For her, life flowed in regular tides and she knew how to make the most of it. She just got on with it. For her, love was a notion of second degree, like a fly in the ointment. She thought that she had many things to do. Her innocence draped her in an incomparable elegance.

Was this the reason why she was beautiful? The reason why he wanted to possess her? He was not quite [80] sure. All he had was an insatiable desire. Morning and night, her scent stayed with him. For him it was a constant struggle; should he negate this persistent passion, or should he succumb to it?

She agreed to speak to him. She felt in him a strange strength although she was entirely oblivious of its meaning. She hung around listening to him and twisted the white handkerchief that her parents had given her around her finger. She knew that what he said was part of life but she was not ready for it. She needed some more time. Plenty of time, years maybe.

One evening she drank from the glass that he proffered. All of a sudden the light crashed. She felt drowsy. Her eyelids closed.

And so it was thus that he possessed her. In the city, people became petrified. A profound silence settled on the night. The light waned.

When she regained consciousness she was carrying a child in her womb.

"I'm dying," she murmured. "This child is not mine. It will bring misfortune."

Then he realized the enormity of his betrayal, and panic seized him. He wanted to erase what he had done. Deny it. But her belly was round as the globe. He placed his hand on her distended belly to check if the child was still alive.

Suddenly, a huge flash of lightning disturbed the clouds. The sky began to flee and the trees to howl. At the same time an infernal heat descended. A dense and dusty smoke encircled nature and set it aflame. A violent, hot torrent of air scorched people and overturned buildings. The skin peeled in layers. Eyes dried out. Hair fell in tufts. Everybody died violently. Metal began to melt and trail along the ground. The outline of a gigantic mushroom cloud framed the blazing horizon. ■

Reading Question

What is the nature of the betrayal that lends the story its title?

Summary

■ **Architecture in the Information Age** Among the most itinerant artists of our increasingly nomadic postmodern era are its architects. Responding to competitions that will lend individual sites in the "world metropolis" a sense of being unique, they design monuments to national and corporate identity. Community-inspired work is more in harmony with its environmental context, as in Renzo Piano's "green" architectural practice, which takes into consideration a building's environmental sustainability.

■ **East/West: Power and Appropriation** The twin economic engines of the new global economy during the 1980s and 1990s were the Silicon Valley in California, center of research and innovation in microchip electronics, and the vast industrial region that extends down the southern and eastern sides of Tokyo Bay. To many in the non-Western world, it seemed as if the world was becoming Americanized, a fact made particularly clear in the uses the West made of the indigenous art of others. At what was advertised as "the first worldwide exhibition of contemporary art," the 1989 *Magicians of the Earth* exhibition in Paris, works from around the globe were introduced and categorized according to preexisting Western standards on aesthetic rather than social terms.

■ **Global Perspectives: The African Double-Bind** The mobility of modern artisans has led many to feel they have multiple identities. Artists like Chris Ofili and Yinka Shonibare mediate between their British training and their Nigerian roots. Important Asian and African writers have emerged, and many of them continue to explore the enduring consequences of colonialism. Playwright Wole Soyinka articulated the distinctive differences between African and Western politics and centrality of diversity and difference to the African experience.

■ **The AIDS Pandemic and the Arts** The impact of AIDS in Africa has been staggering, where in 2006 approximately 25 million people were living with the disease. African women have engaged the problem with tableaux of beaded-cloth dolls. But AIDS is a global pandemic, and it has impacted the American arts community with particular ferocity, leading to the memorial day of mourning known as the "Day without Art," now an annual event.

■ **Multiple Identities in a Global World** Even cultures traditionally isolated from the West have been forced to face the issues confronting the global community. As national and cultural boundaries collapse—between East and West, male and female—the work of Mariko Mori and Japanese *manga* comics erase the distinctions between the human and the machine. Islamic artists negotiate the limits of their native cultures while exploring the attitudes acquired in the West. In the U.S., the encounters of Hispanic with North American society, especially in California, led to political murals and theater.

The "world music" movement captures the globalization of culture in one of its most energetic and appealing manifestations. In African worldbeat music, Western rock fuses with the African music from which it originally derived. In Latin and South America, the mambo, tango, cha-cha-cha, pachanga, and bugaloo all derived from closely related amalgams of Spanish and African dance forms. Combined with a rhythm-and-blues influence, Afro-Christian religious music was transformed into Jamaican reggae. In Argentina, Ástor Piazzolla forged a *nuevo tango*, a new tango to which he added elements from jazz and classical music. In Brazil, the "Tropicálismo" movement was championed in the United States by David Byrne's Luaka Bop record label.

■ **Recovering Tradition: Contemporary Native American Art** By the beginning of the twentieth century, many Native American cultural traditions were threatened or had already been lost. In the late 1960s, the American Indian Movement (AIM) sought to restore power to Native American peoples, the plurality of whose cultures was itself enormous. Two relevant examples of the recovery of indigenous traditions are the women potters of the American Southwest pueblos and the restoration of tradition among the fishing tribes of the Pacific Northwest.

Glossary

manga Japanese comic books or graphic novels.

Critical Thinking Questions

1. In what ways does the international nomadism of contemporary architects reflect the plurality of global society?

2. Whatever your cultural heritage, in what ways might you consider yourself a "plural self"? How is that different from earlier historical eras?

3. What values in common do the Jean-Marie Tjibaou Cultural Center in Nouméa, New Caledonia, and Native American potters share?

Toward the Future

W e end this book with a look toward the future, at a project that consciously tries to change a nation's conception of its "center" and save it for posterity. This is the goal of Newton and Helen Mayer Harrison's *Vision for the Green Heart of Holland* (Fig. **48.30**). The project was conceived to address the ongoing population growth of the central lowlands of Holland, where officials predict an additional 600,000 homes. At the request of the Cultural Council of South Holland, the Harrisons developed a plan that leaves the existing "green heart" of the central lowlands undeveloped, preserving its mix of parks and farmlands (visible on the right-hand wall in the installation). Emanating from this natural core are ribbons of greenway which serve to separate the sometimes densely populated regions on the periphery and carry fresh water to the urban areas. On the floor below is a walk-on laminated aerial map of central Holland as it appeared in 1994, when the Harrisons first presented the project. It is large enough that residents could find their homes on it, providing them a sense of direct engagement with the work.

Holland's small Green Party immediately embraced the project, but more important political groups soon joined them. The alternative, plotted out on the opposite wall, seemed to them intolerable—the "green heart" missing with, instead, a broad band of housing crossing the entire country, transforming it for all practical purposes into a vast city/suburb. The Harrisons labeled their vision of uncontrolled development "Bad Government," and their vision of the ecologically more responsible plan "Good Government," a reference to Ambrogio Lorenzetti's two frescoes in the Palazzo Publico in Siena, *Allegory of Good Government: The Effects of Good Government in the City and Country* (see Fig. 15.4) and its accompanying *Allegory of Bad Government*.

Initially, the Dutch Ministry of the Environment accepted the plan in its entirety, though subsequent governments have wavered back and forth. Still, its basic goal of preserving the country's center remains a principal Dutch objective, a center conceived through the Harrisons' art. ■

Fig. 48.30 Newton Harrison and Helen Mayer Harrison. *Vision for the Green Heart of Holland,* installation view, Catheren Chapel, Gouda, Holland. **1995.** Maps, drawings, video, text, ceramic titles. Courtesy Ronald Feldman Gallery, NY. The map on the left wall is a mirror image of the map on the right, and hence a reverse image—the west on the right, the east on the left—meant to suggest the "backwardness" of its design.

Index

Boldface names refer to artists. Pages in italics refer to illustrations.

Abolitionist movement, 1014–1015, 1127
Aboriginal rock art, 975–976, *975*
Absolutism, 864–868
Abstract Expressionism
 painting, 1474–1481, *1475–1481*
 sculpture, 1481–1482, *1481, 1482*
Abstraction, Porch Shadows (Strand), 1337, *1338*
Académie Française, 875
Achebe, Chinua, *Things Fall Apart,* 1566
Action painting, 1475–1477, *1475, 1476, 1477*
Adam, Robert, 998
 Kedleston Hall, Derbyshire, England, *1002, 1003, 1003*
Adams, Abigail, 1014, 1037
Adams, Henry, 1217, 1318
Adams, John
 Nixon in China, 1506
 "Shaker Loops," 1506
Adams, John, 1001
Adam style, 1003
Addison, Joseph, 913–915
Adé, King Sunny, *Juju Music,* 1574
Adiós Nonino (Piazzolla), 1575
Adventures of Huckleberry Finn (Twain), 1130–1131
Aedicula window, 814
Aesthete, 1234
Aestheticism, 1234
Africa
 AIDS, impact of, 1567–1568
 diamond mines, 1270–1271
 impact of imperialism on art, 1271–1272
 imperialism, 1269–1271, *1270*
 literature, 1555, 1566–1567
 masks, *1279, 1279*
 painting and textiles, 1565–1566, *1565, 1566*
African American artists
 Bearden, Romare, 1499, *1499*
 Douglas, Aaron, 1397, *1397,* 1441–1442, *1442*
 Harlem Renaissance, 1383, 1388–1389, 1392–1394, 1496
 Lam, Wilfredo, 1497, *1497*
 Lawrence, Jacob, 1383, *1383,* 1398, *1397*
 Ringgold, Faith, 1494, *1495*
 Saar, Bettye, 1500, *1500*
African diaspora, 1015
Afro-American Poetics: Revisions of Harlem and the Black Aesthetic (Baker), 1392
After Invisible Man *by Ralph Ellison, "The Preface," Edition of 2* (Wall), 1497, *1498*
Agee, James, 1444
Agnew Clinic, The (Eakins), 1228, *1229*
Agra, India, Taj Mahal, 983–986, *984, 985*
AIDS, impact of, 1567–1568
AIDS Memorial Quilt (Names Project), 1568, *1568*
"Ain't I a Woman?" (Truth), 1128
Akbar, 982
À la recherche du temps perdu (Proust), 1374
À la recherche Time Regained (Proust), 1374
Albee, Edward, 1469
Albers, Josef (Joseph), 1428, 1457
Alberti, Leon Battista, Santa Maria Novella church, 814, *814*
Alchemist, The (Jonson), 879
Aleichem, Sholem, 1158
Alessandro of Farnese, 836
Alexander I, tsar of Russia, 1125
Alexander II, tsar of Russia, 1206
Alexander Henderson, Presbyterian Divine and Diplomatist (Van Dyck), 877, *877*
Alexandrine meter, 1086
Algeria, 1465
Allende, Isabel, 1547
Alloway, Lawrence, 1472
All Quiet on the Western Front (Remarque), 1353
Altar of the Kings (Balbás), 888–889, *888*
Altarpieces, retablos, 887–889, *888, 889*
Ambassadors, The (James), 1233
America
 Abstract Expressionism, 1474–1482, *1478–1482*
 after World War II, 1471

architecture, International style, 1446–1448, *1447,* 1457, *1457*
architecture, in the 1950s, 1486–1487, *1486, 1487*
architecture, Postmodernism *1526, 1527, 1528–1533, 1528, 1529, 1530, 1531, 1532, 1533*
Armory Show and modern art, 1338, *1339,* 1340, 1341
Bauhaus in, 1457, *1457*
Beat Generation, 1482–1483
civil rights movement, *1492, 1493,* 1494–1501
Civil War and Reconstruction, 1172–1178
frontier and treatment of Native Americans, 1247, 1250–1263
Great Depression, 1440–1448
Great Migration, 1383, 1388
Harlem Renaissance, 1383, 1388–1389, 1392–1394, 1496
Independents, 1471, 1472–1473
Jazz Age, 1386, 1394–1397
land art, 1511–1512, *1511*
literary realism, 1127–1131
literature, black humor, 1474
literature, black identity, 1496–1501
literature, regional, 1446–1448
map of in 1820 and 1860, *1254*
movies, talkies and color, 1448–1452
music, high and low, 1514–1515
music, protest, 1445–1446, 1512–1515
music, rap, 1500
music, rock 'n' roll, 1512, *1513*
New Deal, 1440–1446
painting, Abstract Expressionism, 1474–1481, *1475–1481*
painting, action, 1475–1477, *1475, 1476, 1477*
painting, modern, 1402, 1403–1407, *1404, 1405, 1406*
painting, mural, 1441–1442, *1441, 1442*
painting, Romanticism, 1066, 1068–1069, *1068, 1069*
poetry and the machine aesthetic, 1399–1403
Pop Art, 1501–1504, *1501, 1502, 1503, 1504*
sculpture, Abstract Expressionism, 1481–1482, *1481, 1482*
slavery, 1127–1130
theater, 1407
Vietnam War, 1506–1511, 1514
World War II and, 1462–1463, *1464*
America, in the Gilded Age
 architecture, Chicago School of, 1239–1240, *1239*
 architecture, Woman's Building (Hayden), Chicago, 1237–1238, *1239*
 Central Park, 1240, 1241, *1241*
 Chicago and the Columbian Exposition of 1893, 1236–1241
 economic depression, strikes, and Haymarket Riot, 1224
 literature, 1220–1223, 1230–1232, 1233, 1242–1244
 painting, 1225–1226, *1226,* 1233–1237, *1234, 1235, 1236, 1237*
 ragtime and the beginnings of jazz, 1232
 Statue of Liberty and Tammany Hall, 1223–1224
 women, 1225–1232
America (Yanagi), 1562, *1562*
American Anti-Slavery Society, 1127, 1128
American colonies
 See also Native American art
 architecture, Neoclassicism, 1004–1006, *1004–1006*
 map of in 1763, *999*
 portraiture in the, 878, *878*
 sculpture, Neoclassicism, 1006–1007, *1007*
 slavery, 1008–1015
American Indian Movement (AIM), 1575, 1578
American Museum of Natural History, 1272
American Philosophical Society, 998–999
American Place, An, 1403
American Progress (Gast), 1247, *1247*

American Revolution, 998–1001
Americans, The, 1483
Americas, Baroque in the, 885–889, *886, 888, 889*
"Am I Not a Man and a Brother?" (Hackwood), *1014,* 1015
Amir, Muhammad, *A Horse and Groom,* 1266, *1266*
Amsterdam, 904
 Calvinism, 835–839
 Dutch Reformed Church, 835, 838–839
 map of, *835*
 seventeenth-century, 834–835
 tulipomania, 836–837
Anatomy Lesson of Dr. Tulp, The (Rembrandt), 849, 852, *853*
Anderson, Laurie, *United States,* 1550, *1550*
Anderson, Sherwood, 1336
Andre, Carl, *10 x 10 Alstadt Copper Square,* 1504, *1505*
Animism, 1272
Anna Karenina (Tolstoy), 1207, 1208
Anne, queen of England, 905
Annie G, Cantering Saddled (Muybridge), 1338, *1339,* 1341
"Annus Mirabilis" (Dryden), 900
Antin, David
 "If We Get It," 1547
 "If We Make It," 1547
Antin, Eleanor, *Minetta Lane—A Ghost Story,* 1542–1543, *1543*
Anti-Semitism, 1427–1428, 1435
Antwerp, 836
Apache basketry, 988
Apartheid, 1271
Aphorisms, 919
Apollinaire, Guillaume, 1350, 1355
 "Il Pleut," 1335
 "Lundi, rue Christine," 1334–1335
Apollo Conducting a Choir of Maidens (Guarana), 826
Appalachian Spring (Copland), 1442
Arab on Horseback Attacked by a Lion (Delacroix), 1106, *1107*
Aragon, Louis, 1367
Arcadian Shepherds (Poussin), 872, *872*
Archetypes, 1365–1366
Architecture
 American Neoclassicism, 1004–1006, *1004–1006*
 American in the 1950s, 1486–1487, *1486, 1487*
 Americas Baroque, 886, *886,* 887–889, *888, 889*
 Art Nouveau, 1285, *1285*
 Baroque, Americas, 886, *886,* 887–889, *888, 889*
 Baroque, French, 862, 863–868, *867, 868*
 Baroque, Italian, 806–808, *806, 807*
 Bauhaus in America, 1457, *1457*
 Bayard (Condict) Building (Sullivan), New York City, 1239–1240, *1239*
 Chicago School of, 1239–1240, *1239*
 Crystal Palace (Paxton), London, 1210–1211, *1210, 1211*
 curtain wall, 1239
 Eiffel Tower, Paris, 1280, 1283–1284
 English Enlightenment, 900–901, *901, 902–903, 902, 903*
 English Neoclassicism, *1002, 1003*
 French Baroque, 862, 863–868, *867, 868*
 French Neoclassicism, *1022, 1023, 1024, 1025, 1042, 1042*
 German Rococo, 940–943, *940*
 green, 1561, *1561*
 Houses of Parliament (Barry and Pugin), London, 1119, *1121*
 Indian, Mogul, 983–986, *984, 985*
 in the Information Age, 1558–1561, *1559, 1560, 1561*
 International Style, 1388, 1390, 1428–1432, *1429, 1430, 1431,* 1446–1448, *1447*
 Italian Baroque, 806–808, *806, 807*
 Mikhailovsky Palace (Rossi), Saint Petersburg, Russia, 1126, *1126*
 Neoclassicism, American, 1004–1006, *1004–1006*
 Neoclassicism, English, *1002, 1003*
 Neoclassicism, French, *1022, 1023, 1024, 1025, 1042, 1042*

Opéra (Garnier), Paris, 1167–1168, *1168, 1169*
Postmodernism *1526, 1527, 1528–1533, 1528, 1529, 1530, 1531, 1532, 1533*
Pueblo, 986, *897*
Rococo, German, 940–943, *940*
skyscrapers, 1386–1388, *1386, 1387, 1388,* 1390–1391, *1390, 1391*
Tintern Abbey, England, *1052, 1053,* 1054, *1055*
Woman's Building (Hayden), Chicago, 1237–1238, *1239*
Architecture, elements, facades, 814, *814*
Aria, 825
Arkwright, Richard, 912
Armide, 873–874
Armory Show and modern art, 1338, *1339,* 1340, 1341
Armstrong, Louis, 1396, *1397*
Army of the Potomac—A Sharpshooter on Picket Duty, The (Homer), 1175–1176, *1176*
Arouet, François-Marie. *See* Voltaire
Arp, Jean (Hans), 1355
 Collage Made According to the Laws of Chance, 1356, *1356*
Arrival and Reception of Marie de' Medici at Marseilles, The (Rubens), 869–871, *869*
Arrival of a Train at La Ciotat, 1341–1342
Art brut, 1470
Art criticism, 950–952
Art Deco, 1390
Art Moderne, 1390
Art Nouveau, 1284–1286, *1285, 1286*
Arts and Crafts movement, 1212
Artusi, Giovanni, 824
Ashbery, John, "On the Towpath," 1547–1548
As I Lay Dying (Faulkner), 1446
Asmat, 974–975, *975*
Aspects of Negro Life (Douglas), 1441–1442, *1442*
Astaire, Fred, 1449
Astruc, Zachrie, 1204
Atheistic existentialism, 1468
Atonality, 1333
At the Moulin Rouge (Toulouse-Lautrec), 1289, *1289*
At the Time of the Louisville Flood (Bourke-White), 1444, *1445*
Attucks, Crispus, 1000
Aucassin and Nicolette (Demuth), 1403–1404
Audubon, John James, *Passenger Pigeon,* 1255, *1256*
Auschwitz-Birkenau, *1458, 1459,* 1460
Austen, Jane, *Pride and Prejudice,* 917–918
Auster, Paul, *City of Glass,* 1545–1546
Australia, 975–976
 gold rush in, 1123
Austria, Expressionism, 1333–1334, *1333*
Autobiography of Alice B. Toklas, The (Stein), 1319–1320
Aux Ambassadeurs (Degas), 1203, *1203*
Aux Folies-Bergère (Chéret), 1205, *1205*
Avant-garde, 1167
Avenue de l'Opera, Sunlight, Winter Morning (Pissarro), 1186, 1187, *1189*
Awakening, The (Chopin), 1231–1233

Baby carrier, Native American, 1259, *1259,* 1262
Baca, Judith F., *Farmworkers at Guadalupe,* 1573–1574, *1573*
Bacchus (Caravaggio), 817, *817*
Bach, Johann Sebastian
 instrumental music, 855–856
 vocal music, 854–855
Bachman, John, *View of Central Park,* 1240, 1241
Bacon, Francis, *New Method of Science Novum Organum Scientiarum,* 833, 839, 857
Bahá'í, 1159
Baker, Houston, Jr., 1392
Balbás, Jerónimo de, *Altar of the Kings,* 888–889, *888*
Baldacchino, 809
Baldacchino (Bernini), 808, *809*
Baldwin, James, "Sonny's Blues," 1497, 1520
Ball, Hugo, "Gadji beri bimba," 1355

Balla, Giacomo, 1328
Ballades, 1097
Ballet, Russian (Russes), 1209–1210, 1329–1330
Balustrade, 815
Balzac, Honoré de
 Father Goriot, 1124, 1144–1146
 The Human Comedy, 1123
 Monument to Balzac (Rodin), 1287–1288, 1288
 works of, 1123–1124
Bank of Manhattan Trust Building, New York City, 1390
Banks, Dennis, 1575
Banquet of the Officers of the St. George Civic Guard (Hals), 848, 848
Baraka, Amiri
 Home on the Range, 1500
 "Ka'Ba," 1499–1500
Bar at the Folies-Bergère, A (Manet), 1205, 1205, 1206
Barlow, Joel, 1254
Barnes, Albert C., 1393
Baroque
 dance, 874
 description of style, 808
 difference between Rococo and, 936
 literature/theater, 874–876, 880, 884–885
 music, 822–827, 854–856, 873–874, 880, 886–887
 science, 801, 839–842
 use of term, 801, 806, 808
Baroque architecture
 Americas, 886, 886, 887–889, 888, 889
 Churrigueresque, 887–889, 888, 889
 French, 862, 863–868, 867, 868
 Italian, 806–808, 806, 807
Baroque painting
 Dutch, 842–852, 843–853
 English, 876–877, 876, 877
 French, 869–873, 869–873
 Italian, 815–820, 815–821
 Spanish, 880–882, 881, 883
Baroque sculpture, Italian, 808, 809–815, 809–813
Barr, Alfred H., 1386–1387, 1388, 1401, 1431, 1447
Barricade at the Church of La Madeleine, The, 1152, 1153
Barrier Islands Drama: The Mangrove and the Pine (Harrison and Harrison), 1557–1558, 1558
Barry, Charles, Houses of Parliament, London, 1119, 1121
Barth, John, 1545
Barthelme, Donald, 1545
Bartholdi, Frédéric-Auguste, Statue of Liberty, 1223
Basie, Count, 1396
Basketry
 Apache, 988
 Navajo, 986–988, 987
Basquiat, Jean-Michel, Charles the First, 1534, 1535
Basso continuo, 825
Bataille, Georges, 1470
Bath, The (Cassatt), 1217, 1217
"Batter My Heart" (Donne), 816, 817
Battle of the "Kearsarge" and the "Alabama," The (Manet), 1151, 1151
Battle scene hide painting, 1258–1259, 1259
Battleship Potemkin, The (Eisenstein), 1313, 1361–1363, 1362, 1363
Battock, Gregory, 1507
Baudelaire, Charles
 "Carrion" in Les Fleurs du mal, 1160
 "The Head of Hair" in Les Fleurs du mal, 1160
 "The Painter of Modern Life," 1161
 Portrait of Charles Baudelaire (Nadar), 1159
 "To the Bourgeoisie" in Salon of 1846, 1159
Baudelaire's Mistress Reclining (Study of Jeanne Duval) (Manet), 1160, 1161
Bauhaus art, 1428–1432
 in America, 1457, 1457
Bauhaus Building (Gropius), 1431–1432, 1431
Bay, The (Frankenthaler), 1481, 1481
Bayard (Condict) Building (Sullivan), New York City, 1239–1240, 1239

Bayer, Herbert, 1428
Bayreuth Festspielhaus, 1170, 1171
Bazille, Frédéric, 1194
Beach, Sylvia, 1372, 1372
Beadwork, Native American, 1259, 1259, 1262
Beagle Laid Ashore for Repairs, The (Martens), 1143
Beale, Thomas, 1071
Bearden, Romare, The Dove, 1499, 1499
Beast from 20,000 Fathoms, The, 1467
Beat Generation, 1482–1483
Beat the Whites with the Red Wedge (El Lissitzky), 1360, 1361
Beckett, Samuel, 1469
 Waiting for Godot, 1470
Bed (Rauschenberg), 1484, 1484
Beethoven, Ludwig van
 Eroica, 1091, 1092
 Fifth Symphony, 1092–1093
 Heiligenstadt Testament, 1092
 Ninth Symphony (Choral Symphony), 1093–1094
 Piano Sonata No. 30 in E Major, op. 109, 1093
 Wellington's Victory (Wellingtons Sieg), 1082–1083, 1093
Beethoven (Stieler), 1093
Beggar's Opera, The (Gay), 957
Behn, Aphra, 1011, 1019
Being and Nothingness (Sartre), 1468
Bell, Vanessa, Virginia Woolf, 1373, 1373
Bellay, Jean-Baptiste, 1035–1036, 1035
Bellecourt, Clyde, 1575
Bellini, Gentile, Procession of the Reliquary of the True Cross in Piazza San Marco, 823, 823
Bellows, George, Cliff Dwellers, 1218, 1219, 1220
Belzec, 1460
Benton, Thomas Hart
 America Today, 1441
 The Arts of Life in America, 1441
 A Social History of Indiana, 1441
 A Social History of the State of Missouri, 1441, 1441
Berg, Alban, 1333
Bergson, Henri, 1371
Berkeley, Busby, 1449
Berlin
 Dada, 1355–1359
 in Nazi rally in, 1420, 1421
 theater, 1424–1425
 Wall, 1474
 Weimar Republic, art in, 1422–1425
Berlioz, Hector, 1094–1096
 Symphonie fantastique, 1094–1095
Bernini, Gian Lorenzo
 Baldacchino, 808, 809
 Cornaro Chapel, 809, 809, 810
 David, 810–811, 811
 Ecstasy of Saint Teresa, The, 810, 810
 fireworks and theatrical displays, 812–813, 827
 Four Rivers Fountain, 811–812, 811
 Louvre, East facade (Bernini), 831, 831
 Saint Peter's colonnade, 807
Bernstein, Leonard
 The Infinite Variety of Music, 1515
 Kaddish, 1515
 Mass, 1515
Bessie Smith (Van Vechten), 1395
"Betrayal, The" (Tadjo), 1567, 1580–1581
Beyond Good and Evil (Nietzsche), 1302, 1309
Beyond the Horizon (O'Neill), 1407
Beyond the Pleasure Principle (Freud), 1365
Bianco, Baccio del, Drawing for Andromeda y Perseo by Calderón, 884
Bichitr, Jahangir Seated on an Allegorical Throne, 983, 983
Bierstadt, Albert
 The Last of the Buffalo, 1262, 1263
 The Rocky Mountains, Lander's Peak, 1251–1253, 1251
Big Bend on the Missouri River (Catlin), 1248, 1249, 1262, 1262
"Big Two-Hearted River" (Hemingway), 1370, 1377–1380
Bill of Rights (British), 905
Binary form, 874
Bing, Siegfried, 1284–1285
Biringuccio, Vanoccio, 812

Birmingham, Alabama
 civil rights movement in, 1494–1496
 "Letter from Birmingham Jail" (King), 1493, 1495–1496
 map of, 1495
Birth of a Nation, The (Griffith), 1342–1343, 1342
Birth of the World, The (Miró), 1367–1368, 1367
Birth of Tragedy from the Spirit of Music (Nietzsche), 1302
Birth of Venus, The (Cabanel), 1165
Bismarck, Otto von, 1192, 1270
Bis poles, Irian Jaya, New Guinea, 974–975, 975
Black, White, and Ten Red (Calder), 1481–1482, 1481
Blackburn: Song of an Irish Blacksmith (Smith), 1482, 1482
Black humor, 1474
Black Lines (Kandinsky), 1331–1332, 1332
"Black Orpheus" (Sartre), 1496–1497
Black Panthers, 1500
Black Pirate, The, 1448
Blake, William
 The Little Black Boy, 1012–1013, 1012
 Negro Hung Alive by the Ribs to a Gallows, 1010, 1010
 Songs of Innocence, 1012
 Surinam Planter in His Morning Dress, 1010, 1011
Blériiot, Louis, 1318
Bleyl, Fritz, 1330
Blind Man, The, 1356
Bliss, Lillie P., 1338
Bloody Massacre, The (Revere), 1000, 1000
Bloomsbury group, 1371
"Blowin' in the Wind," 1496
Blue Angel, The, 1449, 1449
Blue Gable, The (Münter), 1332–1333, 1332
Blue note, 1395
Blues, 1395
Boccioni, Umberto, 1350
 Unique Forms of Continuity in Space, 1312, 1328, 1329
Boffrand, Germain, Salon de la Princesse, 932, 933, 934
Bohr, Niels, 1319
Bolsheviks, 1359
Bomb and Victims (Spero), 1517–1518, 1517
Bonheur, Rosa, Plowing in the Nivernais: The Dressing of the Vines, 1134, 1136
Bonparte, Joseph, 1097
Book of History, The (Confucius), 982
Borges, Jorge Luis, 1547
 "Borges and I," 1545, 1551
Borghese, Paolina, 1042, 1043
Boris Godunov (Mussorgsky), 1209
Borromini, Francesco, San Carlo alle Quattro Fontane church, Rome, 813, 813, 815
Bossuet, Jacques-Bénigne, 864
Boston Pops Orchestra, 1515
Boston Tea Party, 1000
Boswell, James, Life of Samuel Johnson, The, 918
Bottle of Suze (Picasso), 1347, 1347
Boucher, François, 937, 950, 950–951
 Le Chinois galant, 976, 977
 Madame de Pompadour, 938, 938
 The Toilet of Venus, 938, 938
Boucher d'Argis, Antoine-Gaspart, 946
Bougainville, Louis-Antoine de, 970
Boulevard des Capucines (Monet), 1196, 1196
Boulton, Matthew, 910
Bouquet, Michel, 1466
Bourgeoisie, 1124, 1189
Bourke-White, Margaret
 At the Time of the Louisville Flood, 1444, 1445
 Chrysler Building: Gargoyle outside Margaret Bourke-White's Studio, 1391
Bradley, David P., Indian Country Today, 1576, 1577
Bradstreet, Anne
 "Here Follows Some Verses upon the Burning of Our House," 879, 892
 Tenth Muse Lately Sprung Up in America, The, 879
 "To My Dear and Loving Husband," 879
Brady, Mathew, 1176–1177
Brahms, Johannes, 1304

Brambilla, Ambrogio, Firework Display at the Castel Sant'Angelo, 812, 812
Braque, Georges, 1350
 Cubism, 1324–1325
 Houses at l'Estaque, 1324, 1324
Brazier's Workshop from Encyclopédie (Diderot), 947
Brecht, Bertolt, 1419, 1548
 Drums in the Night, 1424
 "Theater for Pleasure or Theater for Imagination," 1425
 The Threepenny Opera, 1424
Breton, André, 1440
 Surrealist Manifesto, 1366–1367
Breuer, Josef, 1311, 1364
Breuer, Marcel, 1428
 Breuer Chair, 1432, 1432
 Whitney Museum of American Art, 1457
Bride Stripped Bare by Her Bachelors, Even, The (Duchamp), 1357, 1357
Bridge, first suspension, 1401
Bridge, The (Crane), 1401, 1403
Bridges, iron, 912–913, 912
Brioche, The (Chardin), 951, 951
Britain
 in Africa, 1270
 in China, 1263–1265
 decolonization, 1465
 in India, 1266
 Pop Art, 1472–1473, 1473
 World War II and, 1461–1462, 1463
Brocateado, 886
Brod, Max, 1423
Bronze Horseman, The (Pushkin), 1126
Brooklyn Bridge, 1401
Brooklyn Bridge (Stella), 1402, 1403
Brothers Karamazov, The (Dostoyevsky), 1206
Brown, Denise Scott, Learning from Las Vegas, 1528–1529
Brown, Lancelot, 944, 945
Bruno, Giordano, 842
Brussels, Belgium, stairway (Horta), Tassel House, 1285, 1285
Buchenwald, 1460, 1461
Buffalo, extermination of, 1262
Buñuel, Luis
 L'Age d'or (The Golden Age), 1411
 Un Chien andalou (An Andalusian Dog), 1411, 1411
Bunyan, John, 879
Burgee, John, University of Houston, Hines College of Architecture, 1531, 1531
Burial at Ornans, A (Courbet), 1137, 1138, 1138–1139
Burne-Jones, Edward, 1212
 Laus Veneris (In Praise of Venus), 1213, 1213, 1214
Burroughs, William S., 1568
Bushfire and Corroboree Dreaming (Motna), 1564, 1564
Butler, Theodore Earl, 1217
Byrne, David, 1575
Byron, Lord, 1086, 1087
 Childe Harold's Pilgrimage, 1086
 "Prometheus," 1085

Cabanel, Alexandre, The Birth of Venus, 1165
Cabaret Voltaire, 1355
Cabinet of Dr. Caligari, 1410–1411
Caccini, Giulio, New Works of Music (Le nuove musiche), 824
Cage, John
 4'33" (4 minutes 33 seconds), 1483–1484
 Theater Piece #1, 1484–1485, 1486
Caillebotte, Gustave, 1185
 Paris Street, Rainy Day, 1190, 1191
Calatrava, Santiago
 Chicago Spire, 1559, 1559
 Port Authority Trans Hudson (PATH) train station, 1559–1560, 1559
Calder, Alexander, Black, White, and Ten Red, 1481–1482, 1481
Calderón, Pedro, 884–885
Caldwell, Erskine, 1444
Call-and-response, 1396
Calligrammes, 1335
Calling of Saint Matthew, The (Caravaggio), 815–816, 815
Calotype, 1140
Calvinism, 835–839
Calvino, Italo, 1545

Cameos, *1014*, 1015
Camera obscura, 840, *841*, 842, 1140
Camerata of Florence, 824
Camera Work, 1337
Campbell's Soup Cans (Warhol), 1501–1502, *1501*
"Camptown Races" (Foster), 1174
Camus Albert, *The Stranger*, 1469
Canaletto (Giovanni Antonio Canal),
 London: The Thames and the City of London from Richmond House, 896, 897, 898, 901
Can-can, 1289
Candide (Voltaire), 949–950, 962–964
Cane (Toomer), 1389
Canova, Antinio, 1006
 Napoleon as Mars the Peacemaker, 1021, *1021*
 Paolina Borghese as Venus, *1042*, 1043
Cantata, 854
"Canto 49" (The Seven Lakes Canto) (Pound), 1435, 1454–1455
"Canto 120" (Pound), 1435
Canzona, 823
Canzona Duodecimi Toni (Canzona of Twelve Tones) (Gabrieli), 823
Caprichos (Caprices) (Goya), 1098
Caravaggio (Michelangelo da Caravaggio)
 Bacchus, 817, *817*
 The Calling of Saint Matthew, 815–816, *815*
 Conversion of Saint Paul, 816, *816*
 The Supper at Emmaus, 816, 819, 820, *820*
Cárdenas, Lázaro, 1436
Caricature, 906
Carlyle, Thomas, 1085
 Past and Present, 1116
Carnot, Sadi, 1282
Carpentier, Alejo, 1546
Carrà, Carlo, *Interventionist Demonstration*, 1328, *1328*
"Carrion" in *Les Fleurs du mal* (Baudelaire), 1160
Cartouches, 815, 936
Casablanca, 1452
Cassatt, Mary Stevenson, 1185
 The Bath, *1217*, *1217*
 Gathering Fruit, 1236, *1237*
 In the Loge, 1236, *1236*
 Modern Woman, 1236, *1237*
Castell, Robert, 943–944
Castel Sant' Angelo, Rome, 812
Castiglione, Giuseppe. See Lang Shi'ning
Castrati (castrato), 957
Catch-22 (Heller), 1474, 1488
Catherine the Great, 1125
Catlin, George
 Big Bend on the Missouri River, 1248, 1249, 1262, *1262*
 The Last Race, Part of Okipa Ceremony (Mandan), 1257–1258, *1257*
 Mah-To-Toh-Pa (Four Bears), 1258, *1258*
Cats, Jacob, *Marriage (Houwelick)*, 847
Cavalier, 877
Cayuga, 989
CCTV tower (Koolhaas), Beijing, China, 1560, 1561
Ceiling painting. See Frescoes
Celnart, Elizabeth, 1118
Central Park (Olmsted and Vaux), New York City, 1241
 View of Central Park (Bachman), *1240*, 1241
Central Savings (Estes), 1536, *1536*
Century of Louis XIV, The (Voltaire), 949
Cephale et Procris (Jacquet de la Guerre), 874
Ceramics
 Chinese, Qing dynasty, 980, *980*
 chinoiserie, 976, 978, *978*, *979*
 Wedgwood, 911–912, *911*
Cervantes, *Don Quixote*, 884, 915
Cézanne, Paul, 1291, 1405
 The Gulf of Marseilles, Seen from l'Estaque, 1296, 1297, *1296*
 Mont Sainte-Victoire, 1297, *1297*
 Still Life with Plaster Cast, 1298, *1298–1299*
Chamberlain, Neville, 1461
Chambers, William, 978
Chaney, Lon, 1410
Chaplin, Charlie, 1409, *1409*

Character pieces, 1097
Charcot, Jean-Martin, 1311, 1364
Chardin, Jean-Baptiste-Siméon
 The Brioche, 951, *951*
 Philosopher Occupied with His Reading, A, 946, 946
"Charge of the Light Brigade" (Tennyson), 1352
Charging Chasseur (Géricault), 1047, *1047*
Charles I, king of England, 876, 877
Charles I, king of Spain, 836
Charles I at the Hunt (Van Dyck), 876, 877
Charles II, king of England, 877, 880, 900, 905
Charles III, king of Spain, 1098
Charles IV, king of Spain, 1098
 Family of Charles IV (Goya), 1098, 1100, 1101
Charles X, king of France, 1103, 1132
Charles the First (Basquiat), 1534, *1535*
Chase, William Merritt, *Prospect Park, Brooklyn*, 1226, *1227*
Chattri, 984
Chávez, Carlos, 1442
Chávez, César, 1574
Chelmno, 1460
Chemutengure, 1015
Chéret, Jules, *Aux Folies-Bergère*, 1205, *1205*
Chesneau, Ernest, 1196
Chevreul, Michel-Eugène, 1200, 1292
Chiang Kai-shek, 1474
Chiaroscuro, 816
Chiaroscuro lighting, 1452
Chicago
 Columbian Exposition of 1893, 1236–1238
 Dixieland jazz, 1396
 fire, 1239
 Haymarket Riot, 1224
 Robie House (Wright), 1447, *1447*
 School of Architecture, 1239–1240, *1239*
 Woman's Building (Hayden), Chicago, 1237–1238, *1239*
Chicago, Judy
 The Dinner Party, 1519, *1519*
 Pasadena Lifesavers, Yellow No. 4, 1518, *1518*
 Through the Flower: My Struggle as a Woman Artist, 1518
Chicago Spire (Calatrava), 1559, *1559*
Ch'ien-lung, emperor of China, 1249, 1263
Childe Harold's Pilgrimage (Byron), 1086
"Child of the Americas" (Morales), 1546–1547
Child's Brain, The (De Chirico), 1365, *1365*, 1367
China
 art in post-Mao, 1570–1571, *1571*
 CCTV tower (Koolhaas), Beijing, 1560, 1561
 communist takeover, 1474
 indentured labor and mass migration, 1265–1266
 map of, during 1600–1799, 976
 Nanjing, rape of, 1436
 Opium War, 1263–1265
 Qing dynasty, 977, 980
 revolution of 1911, 1359
 scientific inquiry in, 841
 seventeenth-century, 900
Chinese Exclusion Act, 1265
Chinoiserie, 976, 978, *978*, *979*
Choctaw festival, 1252
Chopin, Frédéric, 1097, 1167
Chopin, Kate, *The Awakening*, 1231–1233
Choreography, or the Art of Describing Dance in Characters (Feuillet), 874
Christaensz-Micker, Jan, *View of Amsterdam*, 834
Christian existentialism, 1467–1468
Christo (Christo Javacheff)
 The Umbrellas, Japan-USA, 1554, 1555, 1556–1557, *1556*
 Wrapped Reichstag, 1491, *1491*
Christ Preaching (Rembrandt), 850, *850*
Christy, Edwin P., 1173–1174
Christy Minstrels, 1173, 1174
Chromatic scales, 1290
Chrysler, Walter, 1390
Chrysler Building (Van Alen), New York City, *1384*, 1385, 1386, 1390–1391, *1390*, *1391*

Church, Frederic Edwin, 1068
 Twilight in the Wilderness, 1069, *1069*
Churches
 See also under name of
 Latin-cross plan, 806–807
Churchill, Winston, 1389, 1461
Church of England, 876
Churrigueresque, 887–889, *888*, *889*
Cinématographe, 1341
Cinna (Corneille), 875
Citizen Kane, 1451–1452, *1452*
City of Glass (Auster), 1545–1546
City Square (Giacometti), 1470, *1470*
"Civil Disobedience" (Thoreau), 1071
Civilization and Its Discontents (Freud), 1365, 1494–1501, 1375–1376
Civil rights movement, in America, 1492, 1493, 1494–1501
Civil War, American, 1172–1178
Classical music, 952–960
Classical unities, 874–875
Classic Landscape (Sheeler), 1404, *1404*
Clavichord, 855
Clay, Henry, 1255
Clemenceau, Georges, 1198
Clemens, Samuel L. See Twain, Mark
Cliff, Jimmy, "Waterfall," 1575
Cliff Dwellers (Bellows), 1218, 1219, 1220
Clooney, Rosemary, 1396
Close, Chuck, *Stanley*, 1536, *1537*
Club, The, 1478
Club Dada, 1359
Colbert, Jean-Baptiste, 831
Cole, Henry, 1210, 1212
Cole, Thomas, 1066
 Kaaterskill Falls, 991, *991*
 The Oxbow, 1068, *1068*
Coleridge, Samuel Taylor, 1054, 1087
 "Rime of the Ancient Mariner," 1057, 1060, 1076–1077
Colfax, Greg, *Killer Whaler Mask*, 1579, *1579*
Collaborative art, 1484–1485
Collage Made According to the Laws of Chance (Arp), 1356, *1356*
Collages, 1325–1327, *1326*, *1327*, 1472–1473, 1473
Collective unconscious, 1365–1366
Columbian Exposition of 1893, 1236–1238
Combine paintings, 1484
Comédie-ballets, 873
Comédie Française, 874, 875
Common Sense (Paine), 1000
Communist Manifest, The (Marx and Engels), 1155, 1179–1180
Como, Perry, 1396
Compagnie des Indes, 1263
Company School painting, 1266, *1266*
Composition with Blue, Yellow, Red and Black (Mondrian), 1428, *1429*
Comte, Auguste, 1115
Concerto, 826–827
Concert of Hector Berlioz in 1846, A (Geiger), 1095
Concerto grosso, 855
Concerto in E minor for Violin and Orchestra (Mendelssohn), 1096
Concert overture, 1096
Confessions (Rousseau), 948, 961–962
Confucius, 982
Congress of Vienna, 1082, *1083*, 1083
Constable, John, 1210
 The Hay Wain, 1062, *1063*, 1064
 Landscape and Double Rainbow, 1059
 The Stour Valley and Dedham Village, 1062, *1063*
 Willy Lott's House, East Bergholt, 1062, *1062*
Constructivism, 1360, *1361*
Consumerism after World War II, 1471
Continuum (Ligeti), 1506
Contrasts (Pugin), 1119, *1120*
Conversion of Saint Paul (Caravaggio), 816, 816
Cook, James, 970, 971–976
Cooper, James Fenimore
 The Leatherstocking Tales, 1255
 The Pioneers, 1255, 1273–1276
Copland, Aaron
 Appalachian Spring, 1442
 El Salón México, 1442

Copley, John Singleton, *Watson and the Shark*, *1014*, 1015
Coram, Thomas, *Mulberry Plantation*, 1015, *1015*
Corday, Charlotte, 1036
Cordero, Helen, 1578
Corelli, Arcangelo, 825–826
Corn, Blue, 1578
Cornaro Chapel (Bernini), 809, *809*, *810*
Corneille, Pierre, 874–875
Cornelia Pointing to Her Children as Her Treasures (Kauffmann), 1032, *1032*
Corot, Camille, 1200
Corps de Dame (Dubuffet), 1470–1471, *1471*
Cotton Club, 1396, *1396*
Council of Trent, 822, 836
Counterpoint, 854
Counter-Reformation, 801, 808
Countess's Levée, The or Morning Party, from Marriage à la Mode (Hogarth), 800, 908, *908*
Country Wife, The (Wycherley), 880
Coup d'état, 1038
Couperin, François, 952
Courbet, Gustave, 1194
 A Burial at Ornans, 1137, 1138, *1138–1139*
 The Stonebreakers, 1137, *1137*
Cowley, Malcolm, 1371
Crane, Hart, 1399
 The Bridge, 1401, *1403*
Crime and Punishment (Dostoyevsky), 1206–1207, 1215
Criollos, 888
Crisis, The, 1389
Critique of Judgment (Kant), 1054
Critique of Pure Reason (Kant), 1066
Cromwell, Oliver, 876–877
Crosby, Bing, 1396
Crosby, David, 1513
Crosby Stills Nash and Young, 1513, 1514
"Crossing Brooklyn Ferry" (Whitman), 1221
Crystal Palace (Paxton), London, 1210–1211, *1210*, *1211*
Cubism
 defined, 1324
 Picasso, work of, 1324–1327, *1325*, *1326*, *1327*
Cubo-Futurism, 1359–1360, *1360*
Cuffe, Paul, 1009
Cullen, Countee, "Heritage," 1392, 1412–1413
Cult of feeling, 1047
Cummings, E. E., 1399
 "she being Brand," 1404
Cunningham, Merce, 1484–1485, *1485*
Cupid and Psyche (Natoire), 934, *934*
Curtain wall, 1239
Cut with the Kitchen Knife through the Last Weimar Beer-Belly Cultural Epoch of Germany (Höch), 1358, 1359
Cuzco school, 885–886

Da capo aria, 957
Dactyl, 1058
Dada, 1355–1359
Daguerre, Louis-Jacques Mandé
 Le Boulevard du Temple, 1140, *1141*
 portrait of, *1141*
Daguerreotype, 1140
d'Alembert, Jean le Rond, 946
Dalí, Salvador
 The Lugubrious Game, 1368, *1369*
 The Persistence of Memory, 1368–1369, 1369
 Un Chien andalou (An Andalusian Dog), 1411, *1411*
Dance
 Cunningham, Merce, 1484–1485, *1485*
 French Baroque, 874
 Graham, Martha, 1442
 minuet, 874
 Russian ballet, 1329–1330
 Wilson, Robert, 1548, *1548*, 1550
Dance Class (Degas), 1202, *1203*
Dancing Couple, The (Steen), 845–846, *845*
Dancing Figure (Rodin), 1288, *1288*
Dance in the Forests, A (Soyinka), 1555, 1566–1569
Dance II (Matisse), 1322, *1323*, 1324
Daniel Gallery, 1403
Danton, Georges-Jacques, 1035

Darby, Abraham, 912
Darby, Abraham III, 912
Darwin, Charles, 1115
 The Descent of Man, 1271
 Origin of Species, 1143, 1271
 The Voyage of the Beagle, 1142–1143
Darwin, Erasmus, 911
Daughters of Edward Darley Boit, The
 (Sargent), 1234–1236, *1235*
Daumier, Honoré
 Gargantua, 1133, *1133*
 Rue Transnonain, 1133–1134, *1134*
 The Third-Class Carriage, 1134, *1135*
David, Jacques-Louis
 Death of Marat, 1036, *1036*
 The General Bonaparte, 1084, *1084*
 The Lictors Returning to Brutus the Bodies of
 His Sons, 1027–1028, *1028*, *1029*
 Marie Antoinette Being Led to Her
 Execution, 967, *967*
 Napoleon Crossing the Saint-Bernard, 1040,
 1041
 The Oath of the Horatii, 1026–1027, *1026*
 Old Horatius Defending His Sons, 1027,
 1027
 The Tennis Court Oath, 1033, *1033*
David (Bernini), 810–811, *811*
Dawes Act, 1262–1263
Day, Doris, 1396
Day, Thomas, 1014–1015
Day without Art/World AIDS Day, 1568
"Dead Man's Dump" (Rosenberg), 1352
Dead Souls (Gogol), 1127
Death of Marat (David), 1036, *1036*
De Beauvoir, Simone, *The Second Sex*,
 1468–1469
DeBeers Mining Co., 1271
Debussy, Claude
 La Mer (The Sea), 1291
 Prélude à l'après-midi d'un Faune,
 1290–1291
De Chirico, Giorgio, *The Child's Brain*,
 1365, *1365*, 1367
Declaration of Independence, The, 997,
 1000–1001
Declaration of Independence, The (Trumbull),
 996, 997
Declaration of the Rights of Man and the
 Citizen, 1034
Declaration of the Rights of Woman and the
 Female Citizen (De Gouges),
 1037–1038
Decolonization, 1463, 1465
Decorative art, Jasperware, 1003–1004,
 1004
Deductive reasoning, 839–840
Defense of Poetry, A (Shelley), 1087
Defoe, Daniel
 Robinson Crusoe, 915–916, *916*
 other works of, 916
Degas, Edgar, 1185, 1194
 Aux Ambassadeurs, 1203, *1203*
 Dance Class, 1202, 1203
 Racecourse, Amateur Jockeys, 1204, *1204*
Degenerate Art exhibition, Munich, 1432
De Gouges, Olympe, *Declaration of the Rights*
 of Woman and the Female Citizen,
 1037–1038
Deism, 840
Deists, 946
De Kooning, Elaine, 1478
De Kooning, Willem, 1475
 Excavation, 1477, *1477*
 Pink Angels, 1476, 1477
 Seated Woman, 1476, 1477
Delacroix, Eugène
 Arab on Horseback Attacked by a Lion,
 1106, *1107*
 Liberty Leading the People, 1132–1133,
 1132
 Mephistopheles Appearing to Faust in His
 Study, 1090
 Scenes from the Massacres at Chios,
 1104–1105, *1105*
Delaroche, Paul, 1140
Delftsche Slaolie (Toorop), 1286, *1286*
DeLillo, Don, 1545
Della Porta, Giacomo, Il Gesù church, 808,
 814, *814*
Del Monte, cardinal, 815, 817
DeMille, Cecil B., 1408
Democratic Vistas (Whitman), 1223
Demuth, Charles

Aucassin and Nicolette, 1403–1404
The Figure 5 in Gold, 1400–1401, *1400*
Incense of a New Church, 1404, *1404*
My Egypt, 1403
De Piles, Roger, 873
Der Blau Reiter, 1330, 1331–1333, *1331*,
 1332
Der Sinn des Hitlergrusses: Kleiner Mann bittet
 um grosse Gaben. Motto: Millonen Stehen
 Hinter Mir! (The Meaning of the Hitler
 Salute: Little Man Asks for Big Gifts.
 Motto: Millions Stand Behind Me!)
 (Heartfield), 1427, *1428*
Descartes, René, 840, 1054
 Discourse on Method, 840, 858
 Mediations on the First Philosophy, 840
 Optics, 840, *841*
Descent from the Cross (Rembrandt), 861,
 861
Descent from the Cross (Rubens), 861, *861*,
 871
Descent of Man, The (Darwin), 1271
De Stijl, 1428–1429, *1429*
Development of Transportation, The Five-Year
 Plan, The (Klucis), 1434
Dewing, Thomas Wilmer, *A Reading*,
 1225–1226, *1226*
Diaghilev, Sergei, 1329
Dialectic, 1085
Díaz, Porfirio, 1436
Dickens, Charles, 1006, 1114
 Dombey and Son, 1121
 Hard Times, 1122–1123
 literary realism, 1114
 The Old Curiosity Shop, 1114
 Sketches by Boz, 1113, 1115–1116
Dickinson, Emily, *1230*
 Poems, 1231, 1243–1244
 "Wild Nights," 1230–1231
Dickson, W. K. Laurie, 1341
Dictionary of the English Language (Johnson),
 918, 919, 947
Diderot, Denis, 970
 Encyclopédie, 946–947
 Paris Salon, 950–951
Dido and Aeneas (Purcell), 880
Dido Elizabeth Belle Lindsay and Lady Elizabeth
 Murray (Zoffany), 995, 995
Die Brücke, 1330–1331, *1330*
Dietrich, Marlene, 1449, *1449*
Dinner Party, The (Chicago), 1519, *1519*
"Disabled" (Owen), 1352
Disasters of War (Goya), 1097
Discourse on Method (Descartes), 840, 858
Discourse on Political Economy (Rousseau),
 976
Discourse on the Origin of Inequality among
 Men (Rousseau), 949
Disney, Walt, 1449, 1471
Disneyland, 1471
Disney Studios, 1449–1450
Divertissements, 873
"Diving into the Wreck" (Rich), 1517, 1522
Dixieland jazz, 1396
Doll's House, A (Ibsen), 1286–1287
Dombey and Son (Dickens), 1121
Don Giovanni (Mozart), 957, 960
Donne, John
 "Batter My Heart," 816, 817
 "The Flea," 828
Don Quixote (Cervantes), 884, 915
Doré, Gustave, *Orange Court—Drury Lane*,
 1115
Dorsey, Tommy, 1396
Dostoyevsky, Fyodor
 The Brothers Karamazov, 1206
 Crime and Punishment, 1206–1207, 1215
 The House of the Dead, 1206
 The Insulted and Injured, 1206
Douglas, Aaron
 Aspects of Negro Life, 1441–1442, *1442*
 "The Prodigal Son," 1397, *1397*
Douglass, Frederick, 1127
 Narrative of the Life of Frederick Douglass:
 An American Slave, 1127–1128,
 11461148
Dove, The (Bearden), 1499, *1499*
Dowd, Maureen, 1549
Downtown Gallery, 1383
Do women have to be naked to get into the Met.
 Museum? (Guerrilla Girls), 1525, *1525*
Doyen, Gabriel-François, 940
Dramma giocoso, 957

Drouais, Jean-Germain, *Marius at*
 Minturnae, 1030, *1030*
Drums in the Night (Brecht), 1424
Dryden, John, "Annus Mirabilis," 900
Du Barry, Madame (Marie-Jeanne Bécu),
 938
Dubbing, 1448
DuBois, W.E.B.
 The Philadelphia Negro, 1388
 The Souls of Black Folk, 1388–1389
Dubuffet, Jean, *Corps de Dame*, 1470–1471,
 1471
Duchamp, Marcel, 1481
 The Bride Stripped Bare by Her Bachelors,
 Even, 1357, *1357*
 Fountain, 1356, *1356*
 Nude Descending a Staircase, No. 2, 1338,
 1339
"Dulce et Decorum Est" (Owen),
 1352–1353
Duncanson, Robert S., *Uncle Tom and Little*
 Eva, 1130
Duration Piece #13 (Huebler), 1511
Dutch Baroque painting, 842–852, *843–853*
Dutch Reformed Church, 835, 838–839
Dylan, Bob, 1496
 "The Times They Are A-Changin'," 1494
Dynamics, 823, 953

Eakins, Thomas
 The Agnew Clinic, 1228, *1229*
 The Gross Clinic, 1228, *1228*
Easter Island, 973–974
East India Co., 971, 983, 1263, 1266
Eastman, George, 1341
Eckford, Elizabeth, *1492*, 1493, 1494
Eco, Umberto, 1545
École des Beaux-Arts, 1194
Ecstasy of Saint Teresa, The (Bernini), 810,
 810
Edison, Thomas, 1283, 1341, 1407
Édouard Manet (Zola), 1163
Education of Henry Adams, The, 1318
Ego, 1365
Eiffel, Gustave, Eiffel Tower, Paris, *1280*,
 1283–1284
Einstein, Albert, 1313, 1319, 1419
Einstein on the Beach (Glass), 1506, 1548,
 1550
Einstein on the Beach (Wilson), 1548, *1548*,
 1550
Eisenstein, Sergei, 1360
 Battleship Potemkin, The, 1313,
 1361–1363, *1362*, *1363*
 11:02—Nagasaki (Tomatsu), 1466–1467,
 1466
Eliot, T. S., *The Waste Land*, 1354–1355,
 1375
Elizabeth I, queen of England, 876
Elizabeth Freake and Baby Mary, 878, 878
Ellington, Duke, 1396
Ellison, Ralph, *Invisible Man*, 1497–1498
El Lissitzky, *Beat the Whites with the Red*
 Wedge, 1360, *1361*
Embarkation from Cythera, The (Watteau),
 936, 937
Embarrassment of Riches, The (Schama), 837
Emerson, Ralph Waldo
 Nature, 1069–1070
 "Self-Reliance," 1070
Émile (Rousseau), 948, 986
Emperor Jones, The (O'Neill), 1407
Empire State Building, New York City, 1390
Empirical method, 839
Encyclopédie (Diderot), 946–947
Engels, Friedrich, *The Communist Manifest*,
 1155, 1179–1180
England
 American colonies and, 999–1000
 architecture, Enlightenment, 900–901,
 901, 902–903, *902, 903*
 architecture, Neoclassicism, *1002, 1003*
 bridges, cast-iron, 912–913, *912*
 conditions and factories of 1898,
 1114–1118
 Crystal Palace (Paxton), London,
 1210–1211, *1210, 1211*
 earthenware (Wedgwood), 911–912, *911*
 gardens, 943–946, *944, 945*
 Great Fire of 1666, London, 898–900,
 899
 Houses of Parliament (Barry and Pugin),
 London, 1119, *1121*

Industrial Revolution, 910–913
jasperware, 1003–1004, *1004*
literature, Enlightenment, 900, 901,
 904–905, 908–910, 913–928
literary realism, 1114, 1115–1116,
 1121–1123
Lunar Society, 910–911, 998–999, 1015
map of, in Romantic Era, *1055*
music, Baroque opera, 880
music, Enlightenment, 913
painting, Baroque, 876–877, *876, 877*
painting, Enlightenment, 906, 907, 908,
 908, 910, 911
painting, Romanticism, 1062, *1062,
 1063*, 1064–1065, *1064, 1065*
science, Enlightenment, 910
sculpture, Neoclassicism, 1003, *1003*
Tintern Abbey, *1052, 1053*, 1054, *1055*
English Factory Act (1833), 1118
Enlightenment
 in America, 986–991, 998
 architecture, 900–901, *901*, 902–903,
 902, 903
 bridges, cast-iron, 912–913, *912*
 in China, 976–982
 earthenware (Wedgwood), 911–912, *911*
 in India, 982–896
 Industrial Revolution, 910–913
 literature, 900, 901, 904–905, 908–910,
 913–928
 map of Europe, 935
 music, 913
 painting, 906, 907, 908, 908, 910, 911
 science, 910
 in South Pacific, 970–976
 use of term, 801, 900
En plein-air, 1194, 1296
Epic theater, 1424–1425
Epistolary novel, 916–917
Equal temperament, 855–856
Equiano, Olaudah, *The Interesting Narrative of*
 the Life of Olaudah Equiano, or Gustavus
 Vassa the African, 1008–1010,
 1017–1019
Ernst, Max, *The Master's Bedroom*, 1366,
 1367
Eroica (Beethoven), 1091, 1092
Essay on Human Understanding (Locke), 904
Essay on Man, An (Pope), 897, 909–910
Essay on the Morals and Customs of Nations
 (Voltaire), 977
Esslin, Martin, 1469
Estates General, 1032–1033
Estes, Richard, *Central Savings*, 1536, *1536*
Esther (Handel), 913
Estípite column, 888–889
Études, 1097
Eugenics, 1271
Europe, maps of
 in Enlightenment, 935
 Napoleonic, 1039
 post-Napoleonic, 1083
 revolutions of 1848, *1154*
Europe, Jimmy, 1394
Evans, Walker, *Washroom and Dining Area of*
 Floyd Burroughs's Home, Hale County,
 Alabama, 1444, *1444*
Evelyn, John, 842, 844, 899
Excavation (De Kooning), 1477, *1477*
Execution of Maximilian, The (Manet), 1192,
 1193
Existentialism
 art, 1470–1471, *1470, 1471*
 atheistic, 1468
 Christian, 1467–1468
 feminism, 1468–1469
 literature, 1469–1470
 philosophy, 1467–1469
Experiment on a Bird in the Air-Pump, An
 (Wright), 910, *911*
Expressionism
 Abstract, 1474–1482, *1475–1482*
 Austrian, 1333–1334, *1333*
 German, 1330–1333, *1330, 1331, 1332,
 1333*, 1425, *1426*

Facades, 814, *814*
Fairbanks, Douglas, 1409, *1409*, 1448
Fallingwater (Kaufman House) (Wright),
 Bear Run, Pennsylvania, 1447–1448,
 1447
Fall into Paradise, The (Viola), *1171*

Fall of an Avalanche in the Grisons, The (Turner), 1065, *1065*
Family of Charles IV (Goya), 1098, 1100, *1101*
Family of Man exhibition, 1483
Fantasia, 1450
Fantasias, 854
Fantasie impromptu (Chopin), 1097
Farewell to Arms, A (Hemingway), 1370
Farmworkers at Guadalupe (Baca), 1573–1574, *1573*
Farnsworth house (Mies van der Rohe), Illinois, 1486–1487, *1486*
Fascism, rise of, 1419, 1425, 1427
Father Goriot (Balzac), 1124, 1144–1146
Faulkner, William, 1371
 As I Lay Dying, 1446
 The Sound and the Fury, 1446
Faust (Goethe), 1081, 1089–1091
Fauvism, 1322, *1323*, 1324
Federalist No. 10 (Madison), 1001–1002, 1016–1017
Federal style, 1004
Feminine Mystique, The (Friedan), 1515–1516
Feminism
 era, birth of, 1515–1519, 1525
 existential, 1468–1469
Ferdinand, Francis, 1350
Fête galante, 937, 938, 976
Fetishes, 1272
Feuillet, Raoul-Auger, 874
Feure, Georges de, 1285
Fickle Type, from *Ten Physiognomies of Women* (Utamaro), 1268, *1269*
Fiedler, Arthur, 1515
Fielding, Henry
 History of Tome Jones, a Foundling, The, 917
 Shamela, 917
Fifth Symphony (Beethoven), 1092–1093
Figure 5 in Gold, The (Demuth), 1400–1401, *1400*
Figurines
 Hawaiian, 974, *974*
 Kongo, *1272, 1272*
 moai, 973–974, *973*
Filo, John Paul, Kent State—Girl Screaming over Dead Body, 1514, *1515*
Fin de siècle, 1284
Firework Display at the Castel Sant'Angelo (Brambilla), 812, *812*
Fireworks, 812
Fitzgerald, Ella, 1396, 1397
Fitzgerald, F. Scott
 The Great Gatsby, 1398–1399
 Tales of the Jazz Age, 1394
Five Angels for the Millennium (Viola), 1544, *1544*
Five Cents a Spot (Riis), 1222, *1222*
Flâneur, 1161
Flaubert, Gustave, *Madame Bovary*, 1124–1125
Flaxman, John, Vase, 1004, *1004*
"Flea, The" (Donne), 828
Flint, F. S., 1336, 1399
Flitcroft, Henry, Stourhead park, Wiltshire, England, 944, *944*
Florence, Santa Maria Novella church (Alberti), 814, *814*
Florida-Bound Blues (Smith), 1395
Flowers in a Wan-li Vase with Blue-Tit (Goedaert), 844, *844*
Folies-Bergère, 1288
F-111 (Rosenquist), 1508–1509, *1508, 1509*
Ford, Henry, 1318
Foreshortening, 819
Foster, Stephen
 "Camptown Races," 1174
 "Oh! Susanna," 1174
 other works of, 1174
Foucault, Michel, *The Order of Things*, 1544–1545
Fountain (Duchamp), 1356, *1356*
Fourier, Charles, 1119
4'33" (4 minutes 33 seconds) (Cage), 1483–1484
Four Rivers Fountain (Bernini), 811–812, *811*
Fox, William (Wilhelm Fried), 1408
Fragonard, Jean-Honoré, *The Swing*, 938, 939, 940

France
 in Africa, 1270
 architecture, Baroque, 862, 863–868, 867, 868
 architecture, Neoclassicism, *1022, 1023, 1024, 1025, 1042, 1042*
 dance, Baroque, 874
 decolonization, 1465
 Eiffel Tower, Paris, *1280*, 1283–1284
 Fauvism, *1322, 1323*, 1324
 French Revolution, 1032–1037
 Haussmann, work of, 1188, 1189–1192
 literary realism, 1123–1125
 literature/theater, Baroque, 874–876
 map of, before and after Constitution of 1791, *1025*
 map of, wars of Louis XIV, 866
 music, Baroque, 873–874
 Opéra (Garnier), 1167–1168, *1168, 1169*
 painting, Baroque, 869–873, *869–873*
 painting, Impressionism, 1194–1206, *1194–1205*
 painting, Neoclassicism, 1026–1032, *1026–1032, 1040, 1041–1042, 1041*
 painting, Realism, 1131–1138, *1132–1139*
 painting, Rococo, 936, 937–940, *937*
 painting, Romanticism, 1102–1106, *1103–1107*
 Paris Commune, 1192, 1194
 Paris Exposition of 1889, *1280, 1281, 1282, 1282*, 1283–1284, *1283*, 1318
 revolution of 1848, 1154–1156
 sculpture, Neoclassicism, 1021, *1021, 1042*, 1043
 World War II and, 1462, 1463
Franco, Francisco, 1435–1436
Franco-Prussian war, 1192
Frank, Robert, 1483
Frankenstein (Shelley), 1038
Frankenstein; or the Modern Prometheus (Shelley), 1087, 1108
Frankenthaler, Helen, *The Bay*, 1481, *1481*
Franklin, Benjamin, 911, 998, 999, 1015
Franz I, Habsburg emperor, 1082
Freake, John and Elizabeth, 878, 878
Frederick I, king of Prussia, 942
Frederick II (Frederick the Great), 942–943
Frederick William (Great Elector), 942
Frederick William I, king of Prussia, 942
Frederick William IV, 1157
Free association, 1311
Free-verse, 1222
French Academy of Sciences, 895
French gardens, 866, 868, 868
French overture, 873
French Revolution, 1032–1037
Frescoes
 Baroque, 819–820, *820, 821*
 Rococo, 940–941, *941*
Freud, Sigmund, 1311, *1311*, 1313, 1419
 Beyond the Pleasure Principle, 1365
 Civilization and Its Discontents, 1365, 1375–1376
 The Interpretation of Dreams, 1364
 Studies in Hysteria, 1364
Friedan, Betty, *The Feminine Mystique*, 1515–1516
Friedrich, Caspar David
 Monk by the Sea, 1066, *1066*
 The Wanderer above the Mists, 1066, *1067*
Friedrich Nietzsche (Stoeving), *1302*
Frontier, American, 1247
Fugue, 856
Fuller, Loïe, 1288, 1290
Fuller, Margaret, 1158
Fuller, Peter, 1530
Furniture
 Art Nouveau, 1285
 Breuer Chair, 1432, *1432*
 chinoiserie, 978, 978
 Morris & Co., 1212, 1214
Futurism, 1328, *1328, 1329*

Gabrieli, Giovanni, 822
Canzona Duodecimi Toni (Canzona of Twelve Tones), 823
"Gadji beri bimba" (Ball), 1355
Gaillard, Eugène, 1285
Galerie Dada, 1355
Galileo Galilei, 840–842
Gallé, Émile, 1285

Gallery 291, 1337, 1403
Galton, Francis, 1271
Gandhi, Mohandas, 1465
Garbo, Greta, 1410, 1448
Garcia, John, 1464
García Márquez, Gabriel, *One Hundred Years of Solitude*, 1547
Gardens
 Chinese, 978
 English, 943–946, *944, 945*
 French, 1190
 Japanese, 944
 of Versailles, 866, 868, 868
Gardner, Alexander, *A Harvest of Death, Gettysburg, Pennsylvania*, 1176–1177, *1177*
Gardner's Photographic Sketch of the War, 1176–1177
Gare Saint-Lazare (Manet), 1185, *1185*
Gargantua, 1133, *1133*
Garibaldi, Giuseppe, 1157
Garland, Judy, 1450
Garnier, Charles
 "History of Habitation" exhibit, *1283*, 1284
 Opéra, Paris, 1167–1168, *1168, 1169*
Gaskin, Neal, New York-New York, 1529, *1529*
Gass, William, 1545
Gassed (Sargent), 1348, 1349, 1350
Gast, John, *American Progress*, 1247, *1247*
Gates of Calais, The (Hogarth), 980, *980*
Gathering Fruit (Cassatt), 1236, *1237*
Gauguin, Paul, 1291
 Mahana no atua (Day of the God), 1303, *1301*
 Vision after the Sermon (Jacob Wrestling with the Angel), 1300, *1300*
Gay, John, 957
Gay, Paul du, 1558
Gay, Peter, 998, 1427
Gay Science, The (Nietzsche), 1302, 1308–1309
Gehry, Frank
 Guggenheim Museum, Solomon R., Bilbao, Spain, 1532, *1533*
 home of, 1532, *1532*
Geiger, Andrew, *A Concert of Hector Berlioz in 1846*, 1095
Geisha in Bath (Teraoka), 1569, *1569*
General Bonaparte, The (David), 1084, *1084*
General Principles of Relativity (Einstein), 1313, 1319
Genet, Jean, 1469
Genre painting, 845–846, *845, 846*
Genres, 1410
Gentileschi, Artemisia, *Judith and Her Maidservant with the Head of Holofernes*, 818–819, *819*
Gentileschi, Orazio, 818
Gentle Art of Making Enemies, The, 1234
Geocentric, 840
Geographer, The (Vermeer), 842, *843*
George I, king of England, 905–906, 913
George II, king of England, 913
George III, king of England, 1001
George Washington (Houdon), 1006–1007, *1007*
Géricault, Théodore
 Charging Chasseur, 1047, *1047*
 Portrait of an Insane Man, 1111, *1111*
 The Raft of the "Medusa," 1103–1104, *1104*
 The Wounded Cuirassier Leaving the Field, 1103, *1103*
Germantown eye-dazzler blanket, Navajo, 987, *987*
Germany
 anti-Semitism, 1427–1428
 architecture, Rococo, 940–943, *940*
 Bauhaus art, 1428–1432
 Bauhaus Building (Gropius), 1431–1432, *1431*
 book burning in 1933, 1419, *1419*, 1428
 concentration camps, 1458, 1459, 1460, 1461
 Dada, 1355–1359
 Degenerate Art exhibition, Munich, 1432
 Der Blau Reiter, 1330, 1331–1333, *1331, 1332*
 Die Brücke, 1330–1331, *1330*

Expressionism, 1330–1333, *1330, 1331, 1332, 1333*, 1410–1411, 1425, *1426*
Fascism, rise of, 1419, 1425, 1427
Hitler, Adolf, 1419, 1422, 1427–1433
Holocaust, 1460, 1465–1466
movies in the 1920s, 1410–1411, *1411*
Nazi rally in Berlin, 1420, 1421
painting, Rococo, 940–941, *941*
painting, Romanticism, 1066, *1066, 1067*
partition into East and West, 1474, 1491
reunification of, 1491
theater in Berlin, 1424–1425
Weimar Republic, art in, 1422–1425
Weimar Republic, map of, *1422*
World War II, 1460–1642
Germinal (Zola), 1167, 1181–1183
Gershwin, George, 1397
Gertrude Stein (Picasso), 1319, *1320*
Gesamtkunstwerk, 1170, 1548
Gettysburg Address (Lincoln), 1177, 1183
Ghost in the Shell, The (Shirow), 1570, *1570*
Ghosts (Ibsen), 1287
Giacometti, Alberto
 City Square, 1470, *1470*
 Suspended Ball, 1369–1370, *1369*
Gibbs, James, 944
Gil, Gilberto, 1575
Gilbert, Cass, Woolworth Building, New York City, 1386, 1388, *1388*
Gilded Age, The (Twain and Warner), 1178
"Gilded Six-Bits, The" (Hurston), 1394
Gin Lane (Hogarth), 906, 907
Ginsberg, Allen, "Howl," 1459, 1483
Girandola, 812
Giraud, Albert, 1333
Girl Before a Mirror (Picasso), 1368, *1368*
Girodet, Anne-Louis, *Jean-Baptiste Bellay, Deputy from Santo Domingo*, 1035–1036, *1035*
Giuliani, Rudolph, 1565
Glass, Philip, *Einstein on the Beach*, 1506, 1548, 1550
Globalization of cultures, 1313
Global village, 1557
Glorious Revolution, 877, 900
Gluck, Christoph Willibald, 957
God Bless America (Ringgold), 1494, *1495*
God's Trombones: Seven Sermons in Verse (Johnson), 1397, *1397*
Godwin, William, 1038
Godzilla, 1467, 1467
Goebbels, Joseph, 1419, 1432
Goedaert, Johannes, *Flowers in a Wan-li Vase with Blue-Tit*, 844, 844
Goethe, Johann Wolfgang, 1088
 Faust, 1081, 1089–1091
 The Sorrows of Young Werther, 1088–1089
Gogol, Nikolai, 1126
 Dead Souls, 1127
 The Inspector General, 1127
Gojira (Godzilla), 1467, 1467
Gold Rush, The, 1409, *1409*
Goldwyn (Goldfish), Sam, 1408
Goncourt, Edmond de, 1192
Gone with the Wind, 1450–1451, *1451*
Gonzalez-Torres, Felix, *Untitled*, 1568, *1568*
Goodman, Benny, 1396
Gorky, Arshile, 1474–1475
Goya, Francisco
 black paintings, 1099, 1022
 Caprichos (Caprices), 1098
 Disasters of War, 1097
 Family of Charles IV, 1098, 1100, *1101*
 Great courage! Against corpses!, 1097–1098, *1099*
 Saturn Devouring One of His Children, 1102, *1102*
 The Sleep of Reason Produces Monsters, 1098, *1099*
 The Third of May, 1808, 1097, *1098*
 Till Death, 1100, *1100*
Goyton, J., *Louis XIV at the Académie des Sciences*, 895, *895*
Grace Abounding (Bunyan), 879
Graceland (Simon), 1574
Graham, Bill, 1512
Graham, Martha, 1442
Grainstack (Snow Effect) (Monet), 1197, *1197*
Grand Prix of the Automobile Club of France (Lartigue), *1316*, 1317, 1318
Grapes of Wrath, The (Steinbeck), 1421, 1443

Great courage! Against corpses! (Goya) 1097–1098, *1099*
Great Depression, 1440–1448
Great Exhibition, 1211
"Great Figure, The" (Williams), 1400
Great Fire of 1666, London, 898–900, *899*
Great Gatsby, The (Fitzgerald), 1398–1399
Great K&A Train Robbery, The, 1410, *1410*
"Great Man" theory, 1085
Great Migration, 1383, 1388
Great Train Robbery, The, 1410
Great Wave, The from Thirty-Six Views of Mount Fuji (Hokusai), 1268–1269, *1269*
Greeley, Horace, 1254
Green architecture, 1561, *1561*
Green on Blue (Rothko), 1479, *1480*, 1481
Green Self-Portrait (Schoenberg), 1333, *1333*
Griffith, D. W., 1409
The Birth of a Nation, 1342–1343, *1342*
Grimke, Sarah, 1128
Gropius, Walter
art school created by, 1428
Bauhaus Building, Dessau, Germany, 1431–1432, *1431*
Harvard Graduate Center, 1457
Gros, Antoine Jean, *Napoleon at Eylau*, 1079, *1079*
Gross Clinic, The (Eakins), 1228, *1228*
Grosz, Georg, *The Pillars of Society*, 1423, *1423*
Group Material, 1568
Group portrait, 848
Guarana, Jacopo, *Apollo Conducting a Choir of Maidens*, 826
Guardians of the Secret (Pollock), 1475, *1475*
Guernica (Picasso), 1438, *1439*
Guerrilla Girls, *Do women have to be naked to get into the Met. Museum?*, 1525, *1525*
Guggenheim Museum, Solomon R. (Gehry), Bilbao, Spain, 1532, *1533*
Guggenheim Museum, Solomon R. (Wright), New York City, 1487, *1487*
Guitar, Sheet Music, and Wine Glass (Picasso), 1327, *1327*
Gulags, 1433
Gulf of Marseilles, Seen from l'Estaque, The (Cézanne), 1296, 1297, *1296*
Gulliver's Travels (Swift), 908–909
Gursky, Andreas, *99 Cent*, 1553, *1553*
Guthrie, Woody, "This Land Is Your Land," 1445–1446

Habeas Corpus Act, 905
Hackwood, William, "Am I Not a Man and a Brother?" *1014*, 1015
Hairy Ape, The (O'Neill), 1407
Hale, Phillip Leslie, 1217
Hall of Mirrors (Le Brun and Hardouin-Mansart), Versailles, 866, 867
Hals, Frans
Banquet of the Officers of the St. George Civic Guard, 848, *848*
Portrait of René Descartes, 840
Hamilton, Alexander, 1001
Hamilton, Richard
Just What Is It That Makes Today's Homes So Different, So Appealing?, 1472–1473, *1473*
"This Is Tomorrow" exhibition, London, 1472, *1472*
Handel, George Frederick, 913
Happenings, 1486
Hardin, Lil, 1396
Hardouin-Mansart, Jules, Hall of Mirrors, 866, 867
Hardenberg, Georg Friedrich Philipp von, 1089
Hard Times (Dickens), 1122–1123
"Harlem" (Hughes), 1414
Harlem Renaissance, 1383, 1388–1389, 1392–1394, 1496
Harlem Shadows (McKay), 1389
Harrison, Helen Mayer and Newton
Barrier Islands Drama: The Mangrove and the Pine, 1557–1558, *1558*
Vision for the Green Heart of Holland, 1583, *1583*
Hart, William S., 1410
Hartigan, Grace, *River Bathers*, 1478, *1479*
Hartley, Marsden, 1400
New Mexico Landscape, 1405, *1405*
Harvard Graduate Center (Gropius), 1457

Harvest of Death, Gettysburg, Pennsylvania, A (Gardner and O'Sullivan), 1176–1177, *1177*
Hasegawa, Itsuko, Museum of Fruit, Japan, 1560, *1560*
Hassam, Childe, *The Manhattan Club*, 1222, *1222*
Haussmann, Georges Eugène, 1185
work of, 1188, 1189–1192
Haussmannization, 1190
Haussmannization of Paris, The, 1191
Hawaii, 974
Hawkes, John, 1545
Hayden Sophia, Woman's Building, 1237–1238, *1239*
Haydn, Joseph, 955
Haymarket Riot, 1224
Hay Wain, The (Constable), 1062, *1063*, 1064
"Head of Hair" in *Les Fleurs du mal* (Baudelaire), 1160
Heartfield, John, *Der Sinn des Hitlergrusses: Kleiner Mann bittet um grosse Gaben. Motto: Millonen Stehen Hinter Mir! (The Meaning of the Hitler Salute: Little Man Asks for Big Gifts. Motto: Millions Stand Behind Me!)*, 1427, *1428*
Heckel, Erich, 1330
Hedda Gabler (Ibsen), 1287
Hegel, Georg Wilhelm Friedrich, 1084
Philosophy of History, 1085
Heiligenstadt Testament (Beethoven), 1092
Heliocentric, 840
Heller, Joseph, *Catch-22*, 1474, 1488
Hemingway, Ernest, 1352, 1419
"Big Two-Hearted River," 1370, 1377–1380
A Farewell to Arms, 1370
A Moveable Feast, 1370
The Sun Also Rises, 1371
Henderson, Alexander, 877, *877*
Hendricks, Jimi, 1513
Hennings, Emmy, 1355
Henrietta Maria, 876
"Here Follows Some Verses upon the Burning of Our House" (Bradstreet), 879, 892
"Heritage" (Cullen), 1392, 1412–1413
"Her Kind" (Sexton), 1516–1517
Heroic couplets, 910
Herrick, Robert, "To the Virgins, To Make Much of Time," 879–880
Hesse, Eva, *Ringaround Arosie*, 1518, *1518*
Hide painting, 1258–1259, *1259*
Hiroshige, Andô, *Ushimachi, Takanawa*, 1204, *1204*
Hiroshima, atomic bombing of, 1463, 1466–1467
Hirst, Damien, *Mother and Child Divided*, 1541, *1541*
Histoire Naturelle (Natural History) (Leclerc), 947
History of Ancient Art (Winckelmann), 1002
"History of Habitation" exhibit (Garnier), 1283, 1284
History of Surrealism (Nadeau), 1370
History of the Revolution of 1848 (Lamartine), 1155
History of Tom Jones, a Foundling, The (Fielding), 1168
Hitler, Adolf, 1171, 1419, 1422, 1427–1433
Mein Kampf, 1427
World War II, 1460–1642
Hoare, Henry, Stourhead park, Wiltshire, England, 944, *944*
Hobbes, Thomas, *Leviathan*, 901, *901*, 904, 920–921
Höch, Hannah, *Cut with the Kitchen Knife through the Last Weimar Beer Belly Cultural Epoch of Germany*, 1358, *1359*
Ho Chi Minh, 1465, 1506
Hodgson, Adam, 1252
Hoffman, Hans, 1475
Hoffmann, E. T. A., 1092, 1209
Hogarth, William
The Countess's Levée or *Morning Party*, from *Marriage à la Mode*, 800, 908, *908*
The Gates of Calais, 980, *980*
Gin Lane, 906, *907*
Hohenzollern family, 941
Hokusai, Katsushika, *The Great Wave* from *Thirty-Six Views of Mount Fuji*, 1268–1269, *1269*
Holiday, Billy, 1396
Holland
Baroque painting, 842–852, *843–853*

Dutch Reformed Church, 835, 838–839
Hollywood
in the 1920s, 1407–1410, *1407*
musicals, 1449
Holocaust, 1460, 1465–1466
Holy Virgin Mary (Ofili), 1565, *1565*
Home on the Range (Baraka), 1500
Homer, Winslow
The Army of the Potomac—A Sharpshooter on Picket Duty, 1175–1176, *1176*
The Life Line, 1226, *1227*, 1230
The Veteran in a New Field, 1178, *1178*
Honda, Ishiro, 1467
Hood, Raymond, 1390
Hooke, Robert, *Micrographia*, 842, *842*
Horace (Corneille), 875
Horse and Groom, A (Amir), 1266, *1266*
Horta, Victor, Stairway, Tassel House, Brussels, 1285, *1285*
Hot Five, 1396
Hot Seven, 1396
Hotter Than That (Armstrong), 1396
Houdon, Jean-Antoine, George Washington, 1006–1007, *1007*
House of Education, Choux, France (Ledoux), 1531, *1531*
House of The Dead, The (Dostoyevsky), 1206
Houses at l'Estaque (Braque), 1324, *1324*
Houses of Parliament (Barry and Pugin), London, 1119, *1121*
Houses on the Hill (Picasso), 1324, *1325*
Howells, William Dean, 1233–1234
"How It Feels to Be Colored Me" (Hurston), 1394, 1414–1416
"Howl" (Ginsberg), 1459, 1483
Howling Wolf, *Treaty Signing at Medicine Lodge Creek*, 1260–1261, *1260*
How the Other Half Lives (Riis), 1222
Hudson River School, 1068
Huebler, Douglas, *Duration Piece #13*, 1511
Huelsenbeck, Richard, 1355, 1359
Hughes, Langston
"Harlem," 1414
"Jazz Band in a Parisian Cabaret," 1393–1394
One Way Ticket, 1383
"Theme for English B," 1414
"Weary Blues," 1393, 1395, 1413–1414
Hughes, Ted, 1516
Human Genome Project, 1569
Human Tower (Ndlovu), 1567, *1567*
Hunger (Kollwitz), 1425, *1426*
Hung Liu, *Virgin/Vessel*, 1570, *1571*
Hurston, Zora Neale, 1394
"The Gilded Six-Bits," 1394
"How It Feels to Be Colored Me," 1394, 1414–1416
Their Eyes Were Watching God, 1394
Huygens, Constantijn, *Autobiography*, 839

Ibsen, Henrik
A Doll's House, 1286–1287
Ghosts, 1287
Hedda Gabler, 1287
The Master Builder, 1287
When We Dead Awaken, 1287
Ice (Richter), 1538, *1539*, 1540
Id, 1365
Idée fixe, 1095
If This Is a Man (Survival at Auschwitz) (Levi), 1465
"If We Get It" (Antin), 1547
"If We Make It" (Antin), 1547
"If We Must Die" (McKay), 1389
Ignatius of Loyola, 808
Spiritual Exercises, 822
Il Gesù church (Della Porta), Rome, 808, 814, *814*
"Il Pleut" (Apollinaire), 1335
Imagism, 1336–1337
Impasto, 1293
Imperialism
defined, 1269
European, 1269–1271
impact of, on African art, 1271–1272
Social Darwinism and, 1271
Impressionism, 1185
French, 1194–1206, *1194–1205*
"Impressionism and Édouard Manet" (Mallarmé), 1194
Impression: Sunrise (Monet), 1194, *1195*

Impression III (Concert) (Kandinsky), 1333, *1333*
"In a Station of the Metro" (Pound), 1336–1337
In C (Riley), 1506
Incense of a New Church (Demuth), 1404, *1404*
Independence Hall, Philadelphia, 999, *999*
Independents, 1471, 1472–1473
India, 1224
architecture, Mogul, 983–986, *984*, *985*
Company School painting, 1266, *1266*
decolonization, 1465
indentured labor, 1265–1266
Islamic art, 982–983, *982*, 983
map of, during 1600–1799, 976
Indian Country Today (Bradley), 1576, *1577*
Indian Removal Act, 1254–1255
Inductive reasoning, 839
Industrial Revolution, 910–913
Infinite Variety of Music, The (Bernstein), 1515
Ingres, Jean-Auguste-Dominique
Madame Rivière, 1106, *1106*
Napoleon on His Imperial Throne, 1041–1042, *1041*
Vow of Louis XIII, 1105–1106, *1106*
Innocent X, pope, 811
Insulted and Injured, The (Dostoyevsky), 1206
Interesting Narrative of the Life of Olaudah Equiano, or Gustavus Vassa the African (Equiano), 1008–1010, 1017–1019
Intermezzi (intermezzo), 873
International Exhibition of Modern Architecture, 1431
International Style, 1388, 1390, 1428–1432, *1429*, *1430*, 1431, 1446–1448, 1447
Interpretation of Dreams, The (Freud), 1311, 1364
Interpretive directions, 953
Intertitles, 1342
Interventionist Demonstration (Carrà), 1328, *1328*
In the Loge (Cassatt), 1236, *1236*
In the Salon of Madame Geoffrin in 1755 (Lemonnier), 950
Intolerable Acts, 1000
Inundation of the Tiber (Bernini), 812–813
Inventions
in cinema, 1341–1343
consumerism after World War II, 1471
Paris Exposition of 1889, 1318
Invisible complement, 811
Invisible Man (Ellison), 1497–1498
Ionesco, Eugène, 1469
Iron Bridge (Pritchard), England, 912–913, *912*
Iroquois Confederacy, 989–990, *989*, *990*
Islamic art, 1571, *1572*, *1573*
in India, 982–983, *982*, 983
Islanders in a Boat off Tahiti, from *An Account of the Voyages ... in the Southern Hemisphere ... by Captain Cook*, 968, *969*
Italy
architecture, Baroque, 806–808, *806*, *807*
Mussolini in, 1434–1435
nationalism in, 1158
painting, Baroque, 815–820, *815–821*
sculpture, Baroque, 808, 809–815, *809–813*
It Don't Mean a Thing (If It Ain't Got That Swing) (Ellington), 1396
"It's Gonna Rain" (Reich), 1506
Ivan I. Shiskin (Kramskoy), 1209, *1209*
Ives, Charles, *Three Places in New England*, 1515
Iwan, 984
Izenour, Steven, *Learning from Las Vegas*, 1528–1529

Jackson, Andrew, 1254
Jacob, Max, 1319
Jacobins, 1035
Jacquet de la Guerre, Elisabeth-Claude, 874
Jade carving, Qing dynasty, 980–982, *981*
Jahan, shah
Peacock Throne Room, 984, *985*
Taj Mahal, Agra, India, 983–986, *984*, *985*
Jahangir, shah, 982–983
Jahangir in Darbar (Manohar), 982, 983

Jahangir Seated on an Allegorical Throne (Bichitr), 983, *983*
James, Harry, 1396
James, Henry, 1217, 1232, 1347, 1371
 The Ambassadors, 1233
 Portrait of a Lady, 1233
James, William, *Psychology*, 1371–1372
James I, king of England, 876, 982
James II, king of England, 877
Janssen, Zaccharias, 842
Japan
 atomic bombing of, 1463, 1466–1467
 gardens, 944
 industrialization of, 1267
 kabuki theater, 880
 manga, 1570, *1570*
 Museum of Fruit (Hasegawa), 1560, *1560*
 music of the 1960s and 1970s, 1514
 Nanjing, rape of, 1436
 opening of, 1266–1269
 painting, 1569, *1569*
 printmaking, 1267–1269, *1267, 1268, 1269*
 shoguns, 868
 Tokyo, description of, 1563
 Umbrellas, Japan-USA, The (Christo and Jeanne-Claude), *1554, 1555, 1556–1557, 1556*
 World War II and, 1462–1463, *1463*
Japonisme, 1204
Jasperware, 1003–1004, *1004*
Jay, John, 1001
Jazz, 1232
 in New Orleans, birth of, 1320
Jazz Age, 1386, 1394–1397
"Jazz Band in a Parisian Cabaret" (Hughes), 1393–1394
Jazz Singer, The, 1448–1449, *1448*
Jean-Baptiste Bellay, Deputy from Santo Domingo (Girodet), 1035–1036, *1035*
Jeanne-Claude (de Guillebon)
 The Umbrellas, Japan-USA, 1554, 1555, 1556–1557, 1556
 Wrapped Reichstag, *1491*, *1491*
Jeanneret, Charles-Edouard. *See* Le Corbusier
Jefferson, Thomas, 1002, 1014, 1026, 1250, 1254
 Declaration of Independence, 998, 100
 Monticello, Virginia, 1004–1005, *1004, 1005*
 Notes on the State of Virginia, 995
 Virginia State Capitol, 1005–1006, *1005*
Jerusalem Liberate (Tasso), 873
Jesuits, 808
"Jewry in Music" (Wagner), 1171–1172
Jews, 1158
 anti-Semitism, 1427–1428, 1435
Jockey Club, The, 1169–1170
Johann Wolfgang von Goethe in the Roman Campana (Tischbein), 1088, *1088*
John Freake, 878, *878*
John Keats (Severn), *1060*
Johns, Jaspar, *Three Flags*, 1485, *1485*
Johnson, Blind Willie, 1395
Johnson, Charles S., 1389
Johnson, Eastman
 Negro Life in the South, 1172–173, *1173, 1174*
 A Ride for Liberty: The Fugitive Slaves, 1174, *1175*
Johnson, James Weldon
 God's Trombones: Seven Sermons in Verse, 1397, *1397*
 "The Prodigal Son," 1397
Johnson, Lonnie, 1396
Johnson, Philip, 1386–1387, 1388, 1401, 1431, 1447
 Seagram Building, New York City, 1457, *1457*
 University of Houston, Hines College of Architecture, 1531, *1531*
Johnson, Samuel, *919, 977*
 Dictionary of the English Language, 918, *919, 947*
 The Rambler, 918–919
Jolson, Al, 1448–1449, *1448*
Jones, Inigo, 879
Jones, Leroi. *See* Baraka, Amiri
Jones, Owen, 1211
Jonson, Ben, 879
Joplin, Scott, *Maple Leaf Rag*, 1232

Journalistic essay, 914
Joyce, James, 1372
 Ulysses, *1372*
Joy of Life, The (Le Bonheur de Vivre) (Matisse), 1322, *1323*
Judgment of Paris, The (Raimondi), 1162, *1163*
Judith and Her Maidservant with the Head of Holofernes (Gentileschi), 818–819, *819*
Judith I (Klimt), 1306, *1306*
Juju Music (Adé), 1574
Julius II, pope, 806
Jullienne, Jean de, 938
Jung, Carl, 1365–1366
Just What Is It That Makes Today's Homes So Different, So Appealing? (Hamilton), 1472–1473, *1473*

Kaaterskill Falls (Cole), 991, *991*
"Ka'Ba" (Baraka), 1499–1500
Kabuki theater, 880
Kachinas, 1576
Kaddish (Bernstein), 1515
Kafka, Franz
 The Metamorphosis, 1424, 1453–1454
 The Trial, 1423–1424
Kahlo, Frida, *Self-Portrait with Monkey*, 1440, *1440*
Kahn, Gustave, 1287, *1288*
Kain, Gylan, 1500
Kaisersaal (Imperial Hall), Residenz (Neumann), Germany, 940, *940*
 frescoes at (Tiepolo), 940–941, *941*
Kalmus, Herbert, 1448
Kamehameha I, 974
Kandinsky, Wassily, 1338, 1428
 Black Lines, 1331–1332, *1332*
 Concerning the Spiritual in Art, 1331
 Impression III (Concert), 1333, *1333*
Kant, Immanuel, 998
 Critique of Judgment, 1054
 Critique of Pure Reason, 1066
Kaprow, Allan
 18 Happenings in 6 Parts, 1486
 "The Legacy of Jackson Pollock," 1486
 Yard, The, 1049, *1049*
Kauffmann, Angelica, *Cornelia Pointing to Her Children as Her Treasures*, 1032, *1032*
Kaufmann, Edgar, 1447–1448
Kaufmann House (Fallingwater) (Wright), Bear Run, Pennsylvania, 1447–1448, *1447*
Kay, John, 912
Keats, John, 1087
 "Ode on a Grecian Urn," 1061
 "Ode to a Nightingale," 1060
Kedleston Hall (Adam), Derbyshire, England, *1002, 1003, 1003*
Keller, Helen, 1419
Kent, William, 944
Kent State—Girl Screaming over Dead Body (Filo), 1514, *1515*
Kepler, Johannes, 840, 841
Kermis (Peasant Wedding), The (Rubens), 870–871, *871*
Kerouac, Jack, *On the Road*, 1483
Key, 823
Keyboard, Baroque, 854–856
Key signature, 953
Kgositsile, Willie, 1500
Kierkegaard, Søren, 1467
Killer Whaler Mask (Colfax), 1579, *1579*
Kinetoscope, 1341
King, Martin Luther, Jr., 1494, 1500
 "Letter from Birmingham Jail," 1493, 1495–1496
Kirchner, Ernst Ludwig, 1350
 Self-Portrait as a Soldier, 1350, *1351*
 Self-Portrait with Model, 1330–1331, *1330*
Kiss, The (Rodin), 1287, *1287*
Kitajima, Osamu, 1514
Klee, Paul, 1428
Klezmer music, 1303
Klimt, Gustav, 1302
 Judith I, 1306, *1306*
 Portrait of Emilie Flöge, 1305, *1305*
 Secession, 1305–1306
Kline, Franz, 1475
Klucis, Gustav
 The Development of Transportation, The Five-Year Plan, 1434

We Shall Repay the Coal Debt to Our Country, 1433
Knobelsdorff, Georg Wenzeslaus von, 942
Kodak camera, 1341
Koehler, Robert, *The Strike*, 1224, *1225*
Koklova, Olga, 1368
Kongo figurines, 1272, *1272*
Koolhaas, Rem, CCTV tower, Beijing, China, 1560, *1561*
Kramskoy, Ivan N., *Ivan I. Shiskin*, 1209, *1209*
Krasner, Lee, *White Squares*, 1478, *1478*
Kubrick, Stanley, 1506
Kukailimoku, Hawaii, 974, *974*
Kulaks, 1433
Kuleshov, Lev, 1360–1361

Lady at the Virginal with a Gentleman (The Music Lesson) (Vermeer), 847–848, *847*
"Lady Lazarus" (Plath), 1516, 1521
Lady Macbeth of the Mtsensk District (Shostakovich), 1434
L'Age d'Or (The Golden Age), 1411
La Goulue (Louise Weber), 1289
La Madeleine (Vignon), Paris, 1042, *1042*
Lamartine, Alphonse de, *History of the Revolution of 1848*, 1155
La Mer (The Sea) (Debussy), 1291
Land art, 1511–1512, *1511*
Landi, Stefano, 827
Landscape and Double Rainbow (Constable), 1059
Landscape painting
 Baroque, 832, 833, 842, 843, 844, 845, 845
 Impressionism, French, 1194–1198, 1195–1199
 Romanticism, American, 1066, 1068–1069, *1068, 1069*
 Romanticism, English, 1062, *1062, 1063, 1064–1065, 1064, 1065*
 Romanticism, German, 1066, *1066, 1067*
 use of term, 1061–1062
Landscape with the Rest on the Flight into Egypt (Noon) (Lorrain), 944, *945*
Lang, Fritz, 1411, *1411*
Lang, Herbert, 1272
Lange, Dorothea, *Migrant Mother, Nipomo, California*, 1443–1444, *1444*
Lang Shi'ning (Giuseppe Castiglione), *The Presentation of Uigur Captives from Battle Scenes of the Quelling of Rebellions in the Western Regions, with Imperial Poems*, 977, *977*
Lanzmann, Claude, 1465
Laocoön: or, An Essay upon the Limits of Painting and Poetry (Lessing), 952
"L'Apres-midi d'un Faune" (Afternoon of a Faun") (Mallarmé), 1290, 1307–1308
La Règle du jeu (The Rules of the Game), 1451
Large Blue Horse, The (Marc), 1331, *1331*
Lartigue, Jacques-Henri, *Grand Prix of the Automobile Club of France*, 1316, *1317*, 1318
Lasky, Jesse, 1408
Last of the Buffalo, The (Bierstadt), 1262, *1263*
Last Poets, 1500
Last Race, Part of Okipa Ceremony (Mandan), The (Catlin), 1257–1258, *1257*
Las Vegas, Nevada, 1526, 1527, 1528–1529, *1528*
Latin cross, 806–807
Latrobe, Benjamin Henry
 Tobacco Leaf Capital, 1006, *1007*
 View of Richmond Showing Jefferson's Capital from Washington Island, *1005*
Laus Veneris (In Praise of Venus) (Burne-Jones), 1213, *1213*, 1214
"Laus Veneris" (Swinburne), 1213
Lawler, Louise, *Pollock and Tureen*, 1533, *1533*
Lawrence, Jacob, *The Migration of the Negro*, 1383, *1383*, 1398, *1398*
Learning from Las Vegas (Venturi, Brown, and Izenour), 1528–1529, *1530*

Le Bonheur de Vivre (The Joy of Life) (Matisse), 1322, *1323*
Le Boulevard du Temple (Daguerre), *1140, 1141*
Le Brun, Charles
 Hall of Mirrors, 866, 867
 Louvre, 831, *831*
Le Chinois galant (Boucher), 976, *977*
Le Cid (Corneille), 874–875
Leclerc, Georges-Louis, 947
Leclerc, S., 895
Lecomte, general, 1192
 execution of, *1193*
Le Corbusier
 Domino House, 1430, *1430*
 The New Spirit movement, 1429
 Towards a New Architecture, 1430
 Villa Savoye, France, 1430, *1430*
Le Déjeuner sur l'Herbe (Luncheon on the Grass) (Manet), 1161–1162, *1162*
Le Docteur Amoureux (The Amorous Doctor) (Molière), 875
Ledoux, Claude-Nicolas, House of Education, Choux, France, 1531, *1531*
Lee, Peggy, 1396
Leeuwenhoek, Antonie van, 842
"Legacy of Jackson Pollock, The" (Kaprow), 1486
Leitmotif, 1170
Lemonnier, Anicet-Charles-Gabriel, *In the Salon of Madame Geoffrin in 1755*, 950
L'Enfant, Pierre-Charles, Plan for Washington D.C., 1006, *1006*
Lenin, Vladimir, 1359
Lenni Lenape, 988, 989
Le Nôtre, André, 866, 868, *868*
Leo Tolstoy Ploughing (Repin), 1208, *1208*, 1209
Le Sacre de printemps (The Rite of Spring) (Stravinsky), 1329–1330
Les Demoiselles d'Avignon (Picasso), 1279, *1279*, 1320, *1321*, 1322
Les Fêtes de Nuit à la Exposition, 1280, *1281*
Les Meninas (Maids of Honor, The) (Velázquez), 881, 882, *883*
Lespinasse, Jeanne-Julie-Eleonore de, 935, 946
Les Poseuses (The Models) (Seurat), 1292–1293, *1292*
Les Précieuses Ridicules (The Pretentious Ladies) (Molière), 875
Lessing, Doris, "The Old Chief Mshlanga," 1566
Lessing, Gotthold Ephraim, 952
Les Temps Modernes, 1469
"Letter from Birmingham Jail" (King), 1493, 1495–1496
Letters on the Equality of the Sexes (Grimke), 1128
Let Us Now Praise Famous Men, 1444
Leutze, Emanuel, *Westward the Course of Empire Takes Its Way (Westward Ho!)*, 1253, *1253*
Le Vau, Louis, Louvre, 831, *831*
Levi, Primo, *If This Is a Man (Survival at Auschwitz)*, 1465
Leviathan (Hobbes), 901, *901*, 904, 920–921
Lewis, Lucy Martin, 1578
Leyster, Judith, *The Proposition*, 846, *846*
Liberalism, 904, 1154, 1155
Liberation of Aunt Jemima, The (Saar), 1500, *1500*
Liberty Leading the People (Delacroix), 1132–1133, *1132*
Libretto, 825
Lichtenstein, Roy
 Little Big Painting, 1502, *1503*
 Oh, Jeff … I Love You, Too … But…, 1502, *1503*
Lictors Returning to Brutus the Bodies of His Sons, The (David), 1027–1028, *1028, 1029*
Lieder, 1096
Life, 1444
Life Line, The (Homer), 1226, *1227*, 1230
"Life without Principle" (Thoreau), 1071
Ligeti, György, 1505
 Continuum, 1506
 Lux Aeterna, 1506
Lincoln, Abraham, *Gettysburg Address*, 1177, 1183
Lin Zexu, 1264–1265
Liotard, Jean-Étienne, *Still Life: Tea Set*, 979

Lippershey, Hans, 842
Lipstick (Ascending) on Caterpillar Tracks (Oldenburg), 1507, *1510*
Lissitzsky, Lazar. *See* El Lissitzsky
Literary realism, 1114, 1115–1116, 1121–1131, 1206–1208
Literature
 African, 1555, 1566–1567
 American, 1220–1223, 1230–1232, 1233, 1242–1244
 American poetry and the machine aesthetic, 1399–1403
 American, regional, 1446–1448
 in the Americas, 887
 Beat Generation, 1482–1483
 black humor, 1474
 black identity, 1496–1501
 Depression era, 1443, 1446–1448
 early twentieth-century, 1334–1336, 1370–1374
 Enlightenment, English, 900, 901, 904–905, 908–910, 913–928
 existentialism, 1469–1470
 free verse, 1313
 French Baroque, 874–876
 Harlem Renaissance, 1383, 1388–1389, 1392–1394, 1496
 Imagism, 1336–1337
 Inundation of the Tiber (Bernini), 812–813
 novels, rise of the English, 915–919
 philosophes, 935–936, 946–952
 Politics Drawn from the Very Words of Holy Scripture (Bossuet), 864
 Postmodernism, 1544–1548
 print culture, new, 913–915
 Puritan and Cavalier, 878–880
 realism, 1114, 1115–1116, 1121–1131, 1206–1208
 Romantic, 1056–1061
 Romantic hero, 1084–1091
 slavery, autobiographical and fictional accounts, 1008–1013, 1017–1019
 Spanish Baroque, 884–885
 stream-of-consciousness, 1371–1372
 Transcendentalism, 1054, 1069–1077
 World War I and, 1352–1355
Literature, readings
 Adventures of Huckleberry Finn (Twain), 1130–1131
 "Ain't I a Woman?" (Truth), 1128
 All Quiet on the Western Front (Remarque), 1353
 The Ambassadors (James), 1233
 "Annus Mirabilis" (Dryden), 900
 The Autobiography of Alice B. Toklas (Stein), 1319–1320
 The Autobiography of William Carlos Williams, 1403
 The Awakening (Chopin), 1231–1233
 "Batter My Heart" (Donne), 816, 817
 "The Betrayal" (Tadjo), 1567, 1580–1581
 Beyond Good and Evil (Nietzsche), 1302, 1309
 "Big Two-Hearted River" (Hemingway), 1370, 1377–1380
 Birth of Tragedy from the Spirit of Music (Nietzsche), 1302
 "Borges and I" (Borges), 1545, 1551
 The Bridge (Crane), 1401, 1403
 The Bronze Horseman (Pushkin), 1126
 Candide (Voltaire), 949–950, 962–964
 "Canto 49" (The Seven Lakes Canto) (Pound), 1435, 1454–1455
 "Canto 120" (Pound), 1435
 "Carrion" in *Les Fleurs du mal* (Baudelaire), 1160
 Catch-22 (Heller), 1474, 1488
 "Charge of the Light Brigade" (Tennyson), 1352
 Childe Harold's Pilgrimage (Byron), 1086
 "Child of the Americas" (Morales), 1546–1547
 "Civil Disobedience" (Thoreau), 1071
 Civilization and Its Discontents (Freud), 1365, 1375–1376
 The Communist Manifest (Marx and Engels), 1155, 1179–1180
 Confessions (Rousseau), 948, 961–962

Crime and Punishment (Dostoyevsky), 1206–1207, 1215
"Crossing Brooklyn Ferry" (Whitman), 1221
A Dance in the Forests (Soyinka), 1555, 1566–1567
Declaration of Independence, The, 997, 1000–1001
Declaration of the Rights of Man and Citizen, 1034
Declaration of the Rights of Woman and the Female Citizen (De Gouges), 1037–1038
Democratic Vistas (Whitman), 1223
Discourse on Method (Descartes), 840, 858
Discourse on the Origin of Inequality among Men (Rousseau), 949
"Diving into the Wreck" (Rich), 1517, 1522
Doll's House, A (Ibsen), 1286–1287
Dombey and Son (Dickens), 1121
"Dulce et Decorum Est" (Owen), 1352–1353
Édouard Manet (Zola), 1163
Encyclopédie (Diderot), 946–947
Essay on Human Understanding (Locke), 904
Essay on Man (Pope), 897, 909–910
Father Goriot (Balzac), 1124, 1144–1146
Faust (Goethe), 1081, 1089–1091
Federalist No. 10 (Madison), 1001–1002, 1016–1017
Feminine Mystique, The (Friedan), 1515–1516
"Flea, The" (Donne), 828
Founding and Manifesto of Futurism (Marinetti), 1317, 1328, 1344
Frankenstein; or the Modern Prometheus (Shelley), 1087, 1108
"Gadji beri bimba" (Ball), 1355
The Gay Science (Nietzsche), 1302, 1308–1309
Germinal (Zola), 1167, 1181–1183
Gettysburg Address (Lincoln), 1177, 1183
"Gilded Six-Bits, The" (Hurston), 1394
"The Great Figure" (Williams), 1400
The Great Gatsby (Fitzgerald), 1398–1399
Gulliver's Travels (Swift), 908–909
Hard Times (Dickens), 1122–1123
"Harlem" (Hughes), 1414
"Head of Hair" in *Les Fleurs du mal* (Baudelaire), 1160
"Here Follows Some Verses upon the Burning of Our House" (Bradstreet), 879, 892
"Heritage" (Cullen), 1392, 1412–1413
"Her Kind" (Sexton), 1516–1517
History of the Revolution of 1848 (Lamartine), 1155
"How It Feels to Be Colored Me" (Hurston), 1394, 1414–1416
"Howl" (Ginsberg), 1459, 1483
"If We Get It" (Antin), 1547
"If We Make It" (Antin), 1547
"If We Must Die" (McKay), 1389
"Il Pleut" (Apollinaire), 1335
"In a Station of the Metro" (Pound), 1336–1337
Interesting Narrative of the Life of Olaudah Equiano, or Gustavus Vassa the African (Equiano), 1008–1010, 1017–1019
Invisible Man (Ellison), 1497–1498
"Jazz Band in a Parisian Cabaret" (Hughes), 1393–1394
"Ka'Ba" (Baraka), 1499–1500
"Lady Lazarus" (Plath), 1516, 1521
"The Lake Isle of Innisfree" (Yeats), 1354
"L'Apres-midi d'un Faune" (Afternoon of a Faun") (Mallarmé), 1290, 1307–1308
"Laus Veneris" (Swinburne), 1213
"The Legacy of Jackson Pollock" (Kaprow), 1486
"Letter from Birmingham Jail" (King), 1493, 1495–1496
"Life without Principle" (Thoreau), 1071
Logan, Speech at the end of Lord Dunmore's War, 969, 990, 992
Leviathan (Hobbes), 901, *901*, 904, 920–921

"Lundi, rue Christine" (Apollinaire), 1334–1335
Lyrical Ballads (Wordsworth), 1056–1057
Madame Bovary (Flaubert), 1124–1125
Mediations on the First Philosophy (Descartes), 840
Mein Kampf (Hitler), 1427
The Metamorphosis (Kafka), 1424, 1453–1454
Moby Dick (Melville), 1071–1073
Modest Proposal, A (Swift), 908, 925–928
"The Moment in Art" (Zola), 1163
Mrs. Dalloway (Woolf), 1372–1373
Narrative of the Life of Frederick Douglass: An American Slave, 1127–1128, 1146–1148
Nature (Emerson), 1069–1070
New Method of Science Novum Organum Scientiarum (Bacon), 833, 839, 857
The New Negro (Locke), 1392
New Works of Music (Le nuove musiche) (Caccini), 824
Night (Wiesel), 1465–1466
No Exit (Sartre), 1468, 1469
"Ode on a Grecian Urn" (Keats), 1061
"Ode to a Nightingale" (Keats), 1060
"Ode to the West Wind" (Shelley), 1087
"On the Nature of Gothic" in *The Stones of Venice* (Ruskin), 1211
"On the Towpath" (Ashbery), 1547–1548
The Order of Things (Foucault), 1544–1545
Oroonoko, or The Royal Slave (Behn), 1011, 1019
"A Pact" (Pound), 1337
"The Painter of Modern Life" (Baudelaire, 1161
Pamela (Richardson), 916–917
Paradise Lost (Milton), 904–905, 923–925
Past and Present (Carlyle), 1116
Philosophy of History (Hegel), 1085
The Pioneers (Cooper), 1255, 1273–1276
Poems (Dickinson), 1231, 1243–1244
Poems on Various Subjects: Religious and Moral (Wheatley), 1011
Pride and Prejudice (Austen), 917–918
"The Prodigal Son" (Johnson), 1397
"Prometheus" (Byron), 1085
Prometheus Unbound (Shelley), 1086–1087
"The Rainbow" (Wordsworth), 1057, 1058
Rambler, The (Johnson), 918–919
"The Red Wheelbarrow" (Williams), 1400
"The Revolution Will Not Be Televised" (Scott-Heron), 1500–1501
"Rime of the Ancient Mariner" (Coleridge), 1057, 1060, 1076–1077
"The Second Coming" (Yeats), 1354
The Second Sex (De Beauvoir), 1468–1469
Second Treatise of Government, The (Locke), 904, 922–923
Shamela (Fielding), 917
"she being Brand" (Cummings), 1404
Sketches by Boz (Dickens), 1113, 1115–1116
Slaughterhouse-Five (Vonnegut), 1507
Social Contract, The (Rousseau), 933, 948–949
"Song of Myself" from *Leaves of Grass* (Whitman), 1221–1223, 1242–1243
"Sonny's Blues" (Baldwin), 1497, 1520
The Sorrows of Young Werther (Goethe), 1088–1089
The Souls of Black Folk (DuBois), 1388–1389
The Sound and the Fury (Faulkner), 1446
Spectator, The, 914–915
Spiritual Exercises (Ignatius of Loyola), 822
The Stranger (Camus), 1469
The Subjection of Women (Mill), 1214
Surrealist Manifesto (Breton), 1366–1367
Swann's Way (Proust), 1374
Taj Mahal inscription, 984
Tartuffe (Molière), 863, 875–876, 890–891

Tender Buttons (Stein), 1336
"Theater for Pleasure or Theater for Imagination," 1425
"Theme for English B" (Hughes), 1414
Thérèse Raquin (Zola), 1167
"Tintern Abbey" (Wordsworth), 1053, 1056, 1974–1075
"To Her Self-Portrait" (Sor Juana), 887
"To Make a Dadaist Poem" (Tzara), 1356
"To My Dear and Loving Husband" (Bradstreet), 879
"To the Bourgeoisie" in *Salon of 1846* (Baudelaire), 1159
"To the Virgins, To Make Much of Time" (Herrick), 879–880
The Trial (Kafka), 1423–1424
Uncle Tom's Cabin (Stowe), 1129–1130
Vindication of the Rights of Woman, A (Wollstonecraft), 1038, 1044–1045
"Visions" (Teresa of Ávila), 805, 810
Voyage of the Beagle, The (Darwin), 1142–1143
Waiting for Godot (Beckett), 1470
Walden, or Life in the Woods (Thoreau), 1070–1071
War and Peace (Tolstoy), 1207–1208
The Waste Land (Eliot), 1354–1355, 1375
"Weary Blues" (Hughes), 1393, 1395, 1413–1414
"Wild Nights" (Dickinson), 1230–1231
"Woodstock" (Mitchell), 1514
Zoot Suit (Valdez), 1574
Lithographs
 Daumier's, 1133–1134, *1133, 1134*
 technique, 1135
Little Big Painting (Lichtenstein), 1502, *1503*
Little Black Boy, The (Blake), 1012–1013, *1012*
Llosa, Mario Vargas, 1547
Locke, Alain, *The New Negro*, 1392
Locke, John, 1054
 Essay on Human Understanding, 904
 The Two Treatises on Government (The Second Treatise of Government), 904, 922–923, 1000, 1001
Logan, Speech at the end of Lord Dunmore's War, 969, 990, 992
London
 conditions and factories of 1898, 1114–1118
 Crystal Palace (Paxton), 1210–1211, *1210, 1211*
 Great Fire of 1666, 898–900, *899*
 growth of, 1720–1820, map, 898
 growth of, 1800–1880, map, *1117*
 Houses of Parliament (Barry and Pugin), 1119, *1121*
 map of 1898, *1115*
 Pop Art, 1472–1473, *1473*
 Saint Paul's Cathedral, 900–901, *901*
 "This Is Tomorrow" exhibition, 1472, *1472*
London, Jack, 1419
London: The Thames and the City of London from Richmond House (Canaletto), 896, 897, 898, 901
Lope de Vega, 884
Lord Byron Sixth Baron in Albanian Costume (Phillips), 1086, *1086*
Lorentz, Pare, 1442, 1443
Lorrain, Claude (Claude Gellé), *Landscape with the Rest on the Flight into Egypt (Noon)*, 944, 945
Lost generation, 1351
Louis XII, king of France, 1105–1106
Louis XIII, king of France, 801, 874
Louis XIV, king of France, 831, 864–876, 931, 934, 949
 as the sun in *Ballet de la Nuit*, 873, 873
Louis XIV (Rigaud), 865, 865
Louis XIV at the Académie des Sciences (Goyton), 895, 895
Louis XV, king of France, 931, 934, 935, 938, 946, 949, 1024
Louis XVI, king of France, 1024, 1032–1035
Louis XVIII, king of France, 1102–1103
Louisiana Territory, 1250
Louis-Napoleon, 1156, 1192
Louis-Philippe, king of France, 1132, 1133, 1134, 1155, 1156, 1170

Louvre
East facade (Bernini), 831, *831*
East facade (Le Vau, Perrault, and Le Brun), 831, *831*
Lugo, Nancy Youngblood, Swirled melon bowl, 1578, *1578*
Lugubrious Game, The (Dalí), 1368, *1369*
Lully, Jean-Baptiste, 873–874
Lumière brothers, 1313, 1318, 1341–1342
Lunar Society, 910–911, 998–999, 1015
Luncheon of the Boating Party (Renoir), 1201, *1201*
Luncheon on the Grass (Le Déjeuner sur l'Herbe) (Manet), 1161–1162, *1162*
"Lundi, rue Christine" (Apollinaire), 1334–1335
Lux Aeterna (Ligeti), 1506
Lyrical Ballads (Wordsworth), 1056–1057

Machine Art Exhibition, 1386–1387, *1387*, *1431*
Macke, Auguste, 1331, 1350
"Mack the Knife," 1425
Maclean, Bonnie, *Six Days of Sound*, 1512–1513, *1512*
Madama Butterfly (Puccini), 1334
Madame Bovary (Flaubert), 1124–1125
Madame de Pompadour (Boucher), 938, *938*
Madame Rivière (Ingres), 1106, *1106*
Maderno, Carlo, Saint Peter's basilica, 806–807, *806, 807*
Madero, Franciso I., 1436
Madison, James, *Federalist No. 10*, 1001–1002, 1016–1017
Magical realism, 1546–1547
Magicians of the Earth (Magiciens de la terre) exhibition, 1563–1564, *1564*
Magnanimous Cuckold: Actor no. 7, The (Popova), 1360, *1361*
Magnuson, Ann, 1549
Magritte, René, *The Meaning of Night*, 1364–1365, *1364*
Mahana no atua (Day of the God) (Gauguin), 1303, *1301*
Mahler, Gustave, 1303
Mah-To-Toh-Pa (Four Bears) (Catlin), 1258, *1258*
Maids of Honor, The (Les Meninas) (Velázquez), 881, 882, 883
Maison Carrée (Square House), France, 1005–1006, *1006*
Majdanek, 1460
Makah whaling village, 1579
Make It New (Pound), 1399
Malcolm X, 1499
Malevich, Kasimir, 1359
Suprematist Composition, Black Rectangle, Blue Triangle, 1360, *1360*
Mallarmé, Stéphane, 1194
"L'Apres-midi d'un Faune" (Afternoon of a Faun"), 1290, 1307–1308
Man, Controller of the Universe (Rivera), 1437, *1437*
Mana, 972–973
Manet, Édouard, 1160, 1194
A Bar at the Folies-Bergère, 1205, *1205*, *1206*
The Battle of the "Kearsarge" and the "Alabama," 1151, *1151*
Baudelaire's Mistress Reclining (Study of Jeanne Duval), 1160, *1161*
The Execution of Maximilian, 1192, *1193*
Gare Saint-Lazare, 1185, *1185*
Luncheon on the Grass (Le Déjeuner sur l'Herbe), 1161–1162, *1162*
Olympia, 1163, 1164, *1165*
Portrait of Émile Zola, 1163, *1166*
Manga, 1570, *1570*
Manhattan Club, The (Hassam), 1222, *1222*
Mann, Thomas, 1419
Manohar, *Jahangir in Darbar*, 982, *983*
Maori, 971–973
Mao Tse-tung, 1474
Mao Zedong, 1506
Maple Leaf Rag (Joplin), 1232
Maps
of Africa, imperial expansion, *1270*
of America in 1763, *999*
of America in 1820 and 1860, *1254*
of Amsterdam, *835*
of Birmingham, Alabama, *1495*

of England, in Romantic Era, *1055*
of Europe, in the Enlightenment, *935*
of Europe, post-Napoleonic, *1083*
of Europe, revolutions of 1848, *1154*
of Far East 1600–1799, *976*
of France, before and after Constitution of 1791, *1025*
of France, wars of Louis XIV, *866*
of German concentration camps, *1461*
of indentured labor in late nineteenth century, *1265*
of international festivals, *1557*
of Las Vegas Strip, *1528*
of London, 1800–1880, *1117*
of London in 1898, *1115*
of London, Great Fire of 1666, *899*
of London, growth of 1720–1820, *898*
of Napoleonic Europe, *1039*
of Native American tribes in the West, *1250*
of Netherlands, United Provinces of, *836*
of New York City from 1870–1900, *1221*
of Paris, grand boulevards, *1189*
of Paris, Picasso's, *1319*
of Paris Exposition, *1282*
of Paris in 1870, *1188*
of Prussia, *941*
of St. Petersburg, Russia, *1125*
of skyscrapers in New York City, *1386*
slave trade triangle, *1008*
of South Pacific islands, *971*
of Spanish civil war, *1436*
of Vatican City, *807*
of Viceroyalty of New Spain, *888*
of Viceroyalty of Peru, *885*
of Vienna, in nineteenth century, *1082*
of Weimar Republic, *1422*
of World War I, *1351*
of World War I, Western front, *1350*
of World War II, Asian and Pacific theaters, *1463*
of World War II, European and Mediterranean theaters, *1462*
Marat, Jean-Paul
Death of Marat (David), 1036, *1036*
The Friend of the People, 1035
Marc, Franz, 1350
The Large Blue Horse, 1331, *1331*
Marey, Étienne-Jules, 1338, 1341
Margaret of Parma, 836
Mariana (Rossetti), 1212, *1213*
Marie Antoinette, queen of France, 967, 967, 1024, 1030–1031, 1034, 1035
Queen Marie Antoinette and Her Children (Vigée-Lebrun), 1031, *1031*
Marie Antoinette Being Led to Her Execution (David), 967, *967*
Marilyn Diptych (Warhol), 1502, *1503*
Marinetti, Filippo, *Founding and Manifesto of Futurism*, 1317, 1328, 1344
Marius at Minturnae (Drouais), 1030, *1030*
Marley, Bob, 1575
Marlow, William, *View of the Wilderness at Kew*, 978, *979*
Marquesas Islanders, 971
Marquise de Pezay and the Marquise de Rougé with Her Two Sons, The (Vigée-LeBrun), 1030–1031, *1031*
Marriage (Houwelick) (Cats), 847
Martens, Conrad, *The Beagle Laid Ashore for Repairs*, 1143
Martinez, Maria, 1578
Marx, Karl, 1359
The Communist Manifest, 1155, 1179–1180
Marxism, 1155
Masks, African, 1279, *1279*
Mason, George, 1000
Masques, 879
Mass (Bernstein), 1515
Master Builder, The (Ibsen), 1287
Master's Bedroom, The (Ernst), 1366, 1367
Matisse, Henri, 1312
Dance II, 1322, 1323, 1324
Le Bonheur de Vivre (The Joy of Life), 1322, *1323*
Maupassant, Guy de, 1284
Maus: A Survivor's Tale (Spiegelman), 1465
Maximilian, 1192, *1193*
Mazarin, Cardinal, 864, 865
Mazzini, Giuseppe, 1157

Mbira, 1015
McClure, Michael, 1483
McCormack, Bruce, 1563
McCrea, Jane, 1254–1255
McKay, Claude
Harlem Shadows, 1389
"If We Must Die," 1389
McLuhan, Marshall, 1328, 1501, 1557
Meade, Charles Richard, *Louis-Jacques Mandé Daguerre*, 1141
Meadowland (Richter), 1538, *1538*, 1540
Meaning of Night, The (Magritte), 1364–1365, *1364*
Mediations on the First Philosophy (Descartes), 840
Medici, Marie de', 869
Meiji, emperor of Japan, 1267
Mein Kampf (Hitler), 1427
Meissonier, Ernest, *Memory of Civil War*, 1156, *1156*
Melanesia, 974–975
Melchior, Friederick, 935
Melville, Herman, *Moby Dick*, 1071–1073
Memory of Civil War (Meissonier), 1156, *1156*
Mendelssohn, Felix, 1096, 1171–1172
Concerto in E minor for Violin and Orchestra, 1096
Menzies, William Cameron, 1451
Mephispheles Appearing to Faust in His Study (Delacroix), 1090
Merisi, Michelangelo. *See* Caravaggio
Merleau-Ponty, Maurice, 1469
Messiah (Handel), 913
Metamorphosis, The (Kafka), 1424, 1453–1454
Metropolis, 1411, *1411*
Metropolitan Life Tower, 1386
Metropolitan Museum of Modern Art, 1338
Mexico
murals, 1436–1437, *1437*
revolution in, 1436
Meyer, Hannes, 1432
Miami Vice, 1530
Michelangelo Buonarroti, Saint Peter's basilica, 807, *807*
Mickiewicz, Adam, 1056
Micrographia (Hooke), 842, *842*
Microscope, 842
Mies van der Rohe, Ludwig, 1428, 1432
Farnsworth house, Illinois, 1486–1487, *1486*
Seagram Building, New York City, 1457, *1457*
Migrant Mother, Nipomo, California (Lange), 1443–1444, *1444*
Migration of the Negro, The (Lawrence), 1383, *1383*, 1398, *1398*
Mikhailovsky Palace (Rossi), Saint Petersburg, Russia, 1126, *1126*
Mill, John Stuart, *The Subjection of Women*, 1214
Miller, Glenn, 1396
Miller, Lee, *Buchenwald, Germany*, 1460, *1461*
Millet, Jean-François
The Gleaners, 1136
The Sower, 1134, 1136, *1136*
Milton, John, *Paradise Lost*, 904–905, 923–925
Mimis and Kangaroo, Aboriginal rock art, 975, *975*
Mimosoidea Suchas (Talbot), 1140, *1140*
Minetta Lane—A Ghost Story (Antin), 1542–1543, *1543*
Minimalism, 1504–1506, *1504, 1505*
Minkisi, 1272
Minstrel show, 1173–1174
Minuet, 874
Miró, Joan, *The Birth of the World*, 1367–1368, *1367*
Miss Loïe Fuller (Toulouse-Lautrec), 1289, *1289*
Mitchell, George, 1575
Mitchell, Joan, *Piano Mécanique*, 1478, *1479*
Mitchell, Joni, "Woodstock," 1514
Mix, Tom, 1410, *1410*
Moai, 973–974, *973*
Mobiles, 1481–1482, *1481*
Moby Dick (Melville), 1071–1073
Modern, use of term, 1154
Modern Chromatics (Rood), 1292

Modernism
Abstract Expressionism, 1474–1482, *1475–1482*
action painting, 1475–1477, *1475, 1476, 1477*
Constructivism, 1360, *1361*
Cubism, 1324–1327, *1325, 1326, 1327*
Cubo-Futurism and Suprematism, 1359–1360, *1360*
Dada, 1355–1359
Der Blau Reiter, 1330, 1331–1333, *1331, 1332*
De Stijl, 1428–1429, *1429*
development of, 1313, 1318–1319
Die Brücke, 1330–1331, *1330*
existentialism, 1470–1471, *1470, 1471*
Expressionism, Austrian, 1333–1334, *1333*
Expressionism, German, 1330–1333, *1330, 1331, 1332, 1333*
Fauvism, 1322, *1323*, 1324
Independents, 1471, *1472–1473*
International Style, 1388, 1390, 1428–1432, *1429, 1430, 1431*
Minimalism, 1504–1506, *1504, 1505*
Pop Art, 1472–1473, *1473*, 1501–1504, *1501, 1502, 1503, 1504*
Surrealism, 1366–1370, *1367, 1368, 1369, 1370*
Modern Woman (Cassatt), 1236, *1237*
Modest Proposal, A (Swift), 908, 925–928
Modulation, 827
Mogul
architecture, 983–986, *984, 985*
painting, miniature, 982–983, *982, 983*
Mohawk, 989
Molière
Le Docteur Amoureux (The Amorous Doctor), 875
Les Précieuses Ridicules (The Pretentious Ladies), 875
Tartuffe, 863, 875–876, 890–891
"Moment in Art, The" (Zola), 1163
Mondrian, Piet, 1429
Composition with Blue, Yellow, Red and Black, 1428, *1429*
Monet, Claude, 1185, 1187, 1194, 1204
Boulevard des Capucines, 1196, *1196*
Grainstack (Snow Effect), 1197, *1197*
Impression: Sunrise, 1194, *1195*
The Regatta at Argenteuil, 1048, 1194, *1195*
Setting Sun, 1198–1199
Water Lilies, 1198, *1198–1199*
Monk by the Sea (Friedrich), 1066, *1066*
Monody, 825
Monroe, Marilyn, 1471
Marilyn Diptych (Warhol), 1502, *1503*
Montage, 1360–1361, *1362*
Montesquieu, 947
Monteverdi, Claudio, 823–825
Orfeo, 825
Monticello (Jefferson), Virginia, 1004–1005, *1004, 1005*
Mont Sainte-Victoire (Cézanne), 1297, *1297*
Monument to Balzac (Rodin), 1287–1288, *1288*
Morales, Aurora Levins, "Child of the Americas," 1546–1547
Mori, Mariko, *Play With Me*, 1570, *1570*
Morimura, Yasumasu, *Portrait (Twins)*, 1569–1570, *1569*
Morisot, Berthe, 1185, 1194
Summer's Day, 1200, *1200*
Morley, Thomas, *Plain and Easy Introduction to Practical Music*, 854
Morozov, Ivan, 1194
Morris, Jane, 1212, 1214
Morris, May, *Bed Hanging*, 1214, *1214*
Morris William, 1211
The Woodpecker, 1212, *1212*
Morris & Co., 1212, 1214
Mother and Child Divided (Hirst), 1541, *1541*
Motion Picture Patents Co., 1407
Motna, Erna, *Bushfire and Corroboree Dreaming*, 1564, *1564*
Mount Tambora, 1084
Moveable Feast, A (Hemingway), 1370
Movement (Marey), 1338
Movements, 825–826

Movies
animation by Disney, 1449–1450
Depression era, 1442–1443
development of, 1313, 1318, 1341–1343
dubbing, 1448
in Europe, 1410–1411
genres, 1410
Hitler's use of, 1432–1433
Hollywood in the 1920s, 1407–1410
musicals, 1449
Russian, 1360–1363, *1362, 1363*
silent, 1407–1411
studios and the star system, 1408–1409
talkies and color, 1448–1452, *1448, 1449, 1450, 1451, 1452*
Mozart, Wolfgang Amadeus, 955–956
Don Giovanni, 957, 960
Symphony No. 40, 956, 958–959
Mrs. Dalloway (Woolf), 1372–1373
Mudendero, 1015
Mulberry Plantation (Coram), 1015, *1015*
Munch, Edvard, 1302
The Scream, 1303–1304, *1305*
Münter, Gabriele, 1331
The Blue Gable, 1332–1333, *1332*
Murals
American, 1441–1442, *1441, 1442*
Mexican, 1436–1437, *1437*
Murder of Jane McCrea, The (Vanderlyn), 1254–1255, *1255*
Murdock, William, 911
Museum of Fruit (Hasegawa), Japan, 1560, *1560*
Museum of Modern Art, New York City
Family of Man exhibition, 1483
International Survey of Painting and Sculpture, An, 1525
Machine Art Exhibition, 1386–1387, *1387, 1431*
Music, 801
Adiós Nonino (Piazzolla), 1575
in the Americas, 886–887
Anderson, Laurie, 1550, *1550*
Armstrong, Louis, 1396
Bach, Johann Sebastian, 854–856
Baroque, 822–827, 854–856, 873–874, 880, 886–887
Beethoven, Ludwig van, 1091–1094
Berlioz, Hector, 1094–1096
Bernstein, Leonard, 1515
birth of jazz in New Orleans, 1320
"Blowin' in the Wind," 1496
blues, 1395
Brahms, Johannes, 1304
Cage, John, 1483–1484, 1485
"Camptown Races" (Foster), 1174
Chopin, Frédéric, 1097
Classical, 952–960
Cliff, Jimmy, 1575
concerto, 826–827
Concerto in E minor for Violin and Orchestra (Mendelssohn), 1096
Copland, Aaron, 1442
Corelli, Arcangelo, 825–826
Debussy, Claude, 1290–1291
Dixieland jazz, 1396
drama, 1170–1171
The 1812 Overture (Tchaikovsky), 1209
Einstein on the Beach (Glass), 1548, *1548,* 1550
electronic synthesizer, 1505–1506
Ellington, Duke, 1396
Eroica (Beethoven), 1091, 1092
Fantasie impromptu (Chopin), 1097
Federal Music Project, 1442
Fifth Symphony (Beethoven), 1092–1093
Florida-Bound Blues (Smith), 1395
Foster, Stephen, 1173–1174
Gabrieli, Giovanni, 822–823
Guthrie, Woody, 1445–1446
Handel, George Frederick, 913
Haydn, Joseph, 955
Hotter Than That (Armstrong), 1396
It Don't Mean a Thing (If It Ain't Got That Swing) (Ellington), 1396
Ives, Charles, 1515
in Japan, in the 1960s and 1970s, 1514
jazz, beginnings of, 1232
Jazz Age, 1386, 1394–1397
keyboard, 854–856

klezmer, 1303
Le Sacre de printemps (The Rite of Spring) (Stravinsky), 1329–1330
Ligeti, György, 1505–1506
Lully, Jean-Baptiste, 873–874
Lux Aeterna (Ligeti), 1506
"Mack the Knife," 1425
Madama Butterfly (Puccini), 1334
Mahler, Gustave, 1303
Maple Leaf Rag (Joplin), 1232
mbira and Shona, 1015
Mendelssohn, Felix, 1096, 1171–1172
minimalism, 1505–1506
modern, 1329–1330
Monteverdi, Claudio, 823–825
Mozart, Wolfgang Amadeus, 955–956, 957–960
Mussorgsky, Modest, 1209
nationalism and opera, 1167–1172
Ninth Symphony (Choral Symphony), (Beethoven), 1093–1094
Nixon in China (Adams), 1506
Offenbach, Jacques, 1171–1172
opera, birth of, 823–825
opera, English, 880
opera, popularization of, 956–957, 960
operetta, 1171–1172
oratorio, 827, 855, 913
Piano Sonata No. 30 in E Major, op. 109 (Beethoven), 1093
Piazzella, Ástor, 1575
Pierrot lunaire (Schoenberg), 1333–1334
plantation melodies, 1174
Prélude à l'après-midi d'un Faune (Debussy), 1290–1291
program, 1094–1096
protest, 1445–1446, 1512–1515
Puccini, Giacomo, 1334
Purcell, Henry, 880
ragtime, 1232
rap, 1500
reggae, 1575
Rigoletto (Verdi), 1168
Ring of the Nibelung, The (Wagner), 1170
rock 'n' roll, 1512, 1513
Rococo, 952–960
Romantic, 1091–1097
Russian nationalist, 1209–1210
Schoenberg, Arnold, 1333–1334
Schubert, Franz, 1096
Schumann, Clara, 1096–1097
Schumann, Robert, 1096, 1097
Smith, Bessie, 1395, *1395*
social realism, 1434
sonata, 825–826
sonata form, 954
Stockhausen, Karlheinz, 1505–1506, *1505*
Stravinsky, Igor, 1329–1330
Sweelinck, Jan Pieterszoon, 854
swing, 1396–1397
symphonic form, 953–955
symphonic orchestra, 952–953
Symphonie fantastique (Berlioz), 1094–1095
symphony, 953–955
Symphony No. 1 (Mahler), 1303
Symphony No. 4 (Brahms), 1303
Symphony No. 5 (Shostakovich), 1434
tango, 1575
Tannhäuser (Wagner), 1169–1170
Tchaikovsky, P. I., 1209–1210
"This Land Is Your Land" (Guthrie), 1445–1446
Three Places in New England (Ives), 1515
Tristan and Isolde (Wagner), 1170
Tropicalia, 1575
Turandot (Puccini), 1334
Verdi, Giuseppe, 1168–1169
Vivaldi, Antonio, 826–827
Wagner, Richard, 1169–1171
"Waterfall" (Cliff), 1575
Water Music (Handel), 1485
Wellington's Victory (Wellingtons Sieg) (Beethoven), 1082–1083, 1093
Widmung (Dedication) (Schumann), 1096
Woodstock Festival, 1513–1514
worldbeat (ethnopop), 1574–1575
Musicals, 1449
Music for the Royal Fireworks (Handel), 913

Mussolini, Benito, 1435, 1460, 1462
Mussorgsky, Modest, *Boris Godunov,* 1209
Mustard Seed Garden, The, 1267
Muybridge, Eadweard, *Annie G., Cantering Saddled,* 1338, *1339, 1341*
My Egypt (Demuth), 1403

Nadar (Gaspard-Félix Tournachon), *Portrait of Charles Baudelaire,* 1159
Nadeau, Maurice, 1370
Nagasaki, atomic bombing of, 1463, 1466–1467
Nahl, Johann August, 943
Names Project, 1568
Nampeyo, Black-on-white jar, 1578, *1578*
Nanjing, rape of, 1436
Napoleon, 1049, *1049,* 1083, 1091, 1097
The General Bonaparte (David), 1084, *1084*
Romantic hero, 1084–1091
Napoleon III, 1156, 1167, 1188
Napoleon as Mars the Peacemaker (Canova), 1021, *1021*
Napoleon Bonaparte, 1037, 1038–1043
Napoleon at Eylau (Gros), 1079, *1079*
Napoleon Crossing the Saint-Bernard (David), 1040, 1041
Napoleon on His Imperial Throne (Ingres), 1041–1042, *1041*
Narrative of a Five Years' Expedition against the Revolted Negroes of Surinam... (Stedman), 1010, *1010, 1011*
Narrative of the Life of Frederick Douglass: An American Slave (Douglass), 1127–1128, 1146, *1148*
Nash, Graham, 1513, 1514
National Association for the Advancement of Colored People (NAACP), 1389
Nationalism
development of, 1083, 1154, 1157–1158
music and, 1167–1172
National Organization for Women (NOW), 1516
National Urban League, 1389
Native American art
Apache basketry, 988
hide painting, 1258–1259, *1259*
Howling Wolf, *Treaty Signing at Medicine Lodge Creek,* 1260–1261, *1260*
Iroquois Confederacy, 989–990, *989, 990*
Navajo weaving and basketry, 986–988, 987
Northeast Woodlands tribes, 988–991
Pueblo architecture, 986, 897
quillwork and beadwork, 1259, *1259,* 1262
Native Americans
American Indian Movement, 1575, 1578
Cherokee, 1255
Choctaw festival, 1252
Cooper's depiction of, 1255
end of an era, 1262–1263
Indian Removal Act, 1254–1255
in myth and reality, 1251–1254
Northwest Coast traditions, 1578–1579, *1579*
painting of, 1254–1255, *1255, 1257–1259, 1257, 1258, 1259,* 1576, *1577*
pottery, 1578, *1578*
tribes in the West, map of, *1250*
Natoire, Charles-Joseph, *Cupid and Psyche,* 934, *934*
Natural History of the Sperm Whale (Beale), 1071
Natural law, 946, 947
Nature (Emerson), 1069–1070
Navajo weaving and basketry, 986–988, 987
Nazi, 1427–1433
rally in Berlin, *1420,* 1421
Ndlovu, Beauty, *Human Tower,* 1567, *1567*
"Negro Art and America" (Barnes), 1393
Negro Hung Alive by the Ribs to a Gallows (Blake), 1010, *1010*
Negro Life in the South (Johnson), 1172–173, *1173,* 1174
Nelson, David, 1500
Nelson, Lord, 1084
Nenzima, queen, 1272, *1272*
necklace made from fingernails, *1272*
Neoclassicism, 998
architecture, American, 1004–1006, *1004–1006*

architecture, English, 1002, 1003
architecture, French, *1022, 1023, 1024,* 1025
decorative art, English, 1003–1004, *1004*
painting, French, 1026–1032, *1026–1032*
sculpture, American, 1006–1007, *1007*
sculpture, English, 1003, *1003*
sculpture, French, 1021, *1021*
Neshat, Shirin, *Rebellious Silence* from *Women of Allah,* 1571, *1571,* 1573
Netherlands
Baroque painting, 842–852, *843–853*
independence from Spain, 836
map of United Provinces of, 836
Tulipomania, 836–837
Neuer Markt (New Market) (Schütz), *1091*
Neumann, Johann Balthasar, Kaisersaal (Imperial Hall) Residenz, Germany, 940, *940*
New Deal, 1440–1446
New Guinea, 974–975
New Harmony, Indiana, 1119
New Method of Science Novum Organum Scientiarum (Bacon), 833, 839, 857
New Mexico Landscape (Hartley), 1405, *1405*
New Negro, The (Locke), 1392
New Orleans, 1232
birth of jazz in, 1320
New Spain, map of Viceroyalty of, 888
Newton, Huey P., 1500
Newton, Isaac, 801, 900
Principia (Mathematical Principles of Natural Philosophy), 910
Tomb for Isaac Newton (Boullée), / 814, 814
New Works of Music (Le nuove musiche) (Caccini), 824
New York City from 1870–1900
See also Museum of Modern Art
Armory Show and modern art, 1338, *1339,* 1340, 1341
Bayard (Condict) Building (Sullivan), 1239–1240, *1239*
Bohemia, 1549
Central Park (Olmsted and Vaux), *1240,* 1241
description of, 1220, 1223–1224
Gallery 291, 1337
Guggenheim Museum, Solomon R., (Wright), 1487, *1487*
Harlem Renaissance, 1383, 1388–1389, 1392–1394, 1496
Jazz Age, 1386, 1394–1397
map of, *1221*
New York-New York (Gaskin), 1529, *1529*
Port Authority Trans Hudson (PATH) train station (Calatrava), 1559–1560, *1559*
Seagram Building (Mies van der Rohe and Johnson), 1457, *1457*
skyscrapers, 1386–1388, *1386, 1387, 1388,* 1390–1391, *1390, 1391*
New Zealand, 971–973
Nicholas I, tsar of Russia, 1125, 1206
Nicholas II, tsar of Russia, 1359
Nickelodeon, 1313, 1318, 1342
Niebuhr, Reinhold, 1467
Nietzsche, Friedrich, 1302–1303, *1302*
Beyond Good and Evil, 1302, 1309
Birth of Tragedy from the Spirit of Music, 1302
The Gay Science, 1302, 1308–1309
Night (Wiesel), 1465–1466
Night and Fog, 1466
Night Café (Van Gogh), 1293, *1293*
Nightingale, Florence, 1225
Nijinsky, Vaslav, 1329, 1330
99 Cent (Gursky), 1553, *1553*
Niño, Luis, *Our Lady of the Victory of Málaga,* 886, *886*
Ninth Symphony (Choral Symphony), (Beethoven), 1093–1094
Nixon, Richard, 1506
Nixon in China (Adams), 1506
Nochlin, Linda, 1293
Nocturne in Black and Gold: The Falling Rocket (Whistler), 1234, *1234*
Nocturnes, 1097
No Exit (Sartre), 1468, 1469
Nolde, Emile, 1330, 1432

Nordau, Max, 1281, 1284
Northeast Woodlands tribes, 988–991
Notes on the State of Virginia (Jefferson), 995
Novalis, 1089
Novels, rise of the English, 915–919
Nude Descending a Staircase, No. 2
 (Duchamp), 1338, *1339*
Number 27 (Pollock), 1475, *1476*
Nutcracker, The (Tchaikovsky), 1209–1210

Oath of the Horatii, The (David),
 1026–1027, *1026*
Object (Luncheon in Fur) (Oppenheim),
 1370, *1370*
Obregón, Álvaro, 1436
Ode, 1060
"Ode on a Grecian Urn" (Keats), 1061
"Ode to a Nightingale" (Keats), 1060
"Ode to the West Wind" (Shelley), 1087
Offenbach, Jacques, 1171–1172
Ofili, Chris, *Holy Virgin Mary,* 1565, *1565*
Oh, Jeff … I Love You, Too … But…
 (Lichtenstein), 1502, *1503*
O'Keeffe, Georgia, 1337, 1405
 Georgia O'Keeffe Museum, 1407
 Red Hills and Bones, 1406, *1406*
Olbrich, Josef, 1305–1306
"Old Chief Mshlanga, The" (Lessing), 1566
Oldenburg, Claes, 1502
 Lipstick (Ascending) on Caterpillar Tracks,
 1507, *1510*
 Soft Toilet, 1504, *1504*
Old Hetton Colliery, Newcastle, 1112, 1113
Old Horatius Defending His Sons (David),
 1027, *1027*
Oliver, Joe, 1396
Ollivier, Michel Barthélemy, *Tea at Prince
 Louis-François de Conti's in the Temple,
 Paris,* 956
Olmsted, Frederick Law
 Central Park, New York City, 1240, 1241
 Prospect Park, Brooklyn, 1227, 1241
 Riverside, Illinois, 1241, *1241*
Olson, Charles, 1484
Olympia (Manet), 1163, 1164, *1165*
Olympia (Riefenstahl), 1433
Olympic games, 1283
*On Colors and Their Applications to the
 Industrial Arts* (Chevreul), 1200
One Hundred Years of Solitude (García
 Márquez), 1547
Oneida, 989
O'Neill, Eugene, 1407
One Way Ticket (Hughes), 1383
Onondaga, 989
"On the Nature of Gothic" in *The Stones of
 Venice* (Ruskin), 1211
On the Road (Kerouac), 1483
"On the Towpath" (Ashbery), 1547–1548
Open Door, The (Talbot), 1140, *1142*
Opera
 birth of, 823–825
 buffa, 936, 957
 giocoso, 936
 nationalism and, 1167–1172
 popularization of, 956–957, 960
 seria, 939, 956–957
Opéra (Garnier), Paris, 1167–1168, 1168,
 1169
Operetta, 1171–1172
Opium War, 1263–1265
Oppenheim, Meret, *Object (Luncheon in
 Fur),* 1370, *1370*
Optics (Descartes), 840, *841*
Opus, 824
Orange Court—Drury Lane (Doré), *1115*
Oratorio, 827, 855, 913
Orchestration, 823
Order of Things, The (Foucault), 1544–1545
Orfeo (Monteverdi), 825
Origin of Species (Darwin), 1143, 1271
Oroonoko, or The Royal Slave (Behn), 1011,
 1019
Orozco, Jose Clemente, 1436
Ospedali musicians, 826–827
Ostinato, 1330
O'Sullivan, Timothy, *A Harvest of Death,
 Gettysburg, Pennsylvania,* 1176–1177,
 1177
Our Lady of the Victory of Malága (Niño),
 886, *886*
Overture, French, 873
Owen, Robert, 1119
Owen, Wildred

"Disabled," 1352
"Dulce et Decorum Est," 1352–1353
Oyewole, Abiodun, 1500
Oxbow, The (Cole), 1068, *1068*

Pace, 953
"Pact, A" (Pound), 1337
Pagosa Springs (Stella), 1504, *1504*
Paik, Nam June
 Exposition of Music—Electronic Television,
 1541
 Video Flag, 1542, *1542*
Paine, Thomas, *Common Sense,* 1000
"Painter of Modern Life, The" (Baudelaire,
 1161
Painting
 See also Landscape painting
 Abstract Expressionism, 1474–1481,
 1475–1481
 action painting, 1475–1477, *1475, 1476,
 1477*
 American, depicting Native Americans,
 1254–1255, *1255, 1257–1259, 1257,
 1258, 1259*
 American, during Gilded Age,
 1225–1226, *1226, 1233–1237, 1234,
 1235, 1236, 1237*
 in the American colonies, 878, *878*
 American Romanticism, 1066,
 1068–1069, *1068, 1069*
 Armory Show and modern art, 1338,
 1339, 1341
 Baroque, Dutch, 842–852, *843–853*
 Baroque, English, 876–877, *876, 877*
 Baroque, French, 869–873, *869–873*
 Baroque, Italian, 815–820, *815–821*
 Baroque, Spanish, 880–882, *881, 883*
 Chinese, Qing dynasty, 977, *977, 980,
 980, 981*
 collages, 1325–1327, *1326, 1327*
 combine, 1484
 Cubism, 1324–1327, *1325, 1326, 1327*
 Cubo-Futurism, 1359–1360, *1360*
 Dutch Baroque, 842–852, *843–853*
 English, Baroque, 876–877, *876, 877*
 English Enlightenment, 906, 907, 908,
 908, 910, 911
 English Romanticism, 1062, *1062, 1063,
 1064–1065, 1064, 1065*
 Enlightenment, English, 906, 907, 908,
 908, 910, 911
 existentialism, 1470–1471, *1471*
 Expressionism, 1330–1334, *1330, 1331,
 1332, 1333, 1425, 1426*
 Expressionism, Abstract, 1474–1481,
 1475–1481
 Fauvism, 1322, *1323, 1324*
 French Baroque, 869–873, *869–873*
 French Impressionism, 1194–1206,
 1194–1205
 French Neoclassicism, 1026–1032,
 1026–1032, 1040, 1041–1042, 1041
 French Realism, 1131–1138, *1132–1139*
 French Rococo, 936, 937–940, *937*
 French Romanticism, 1102–1106,
 1103–1107
 Futurism, 1328, *1328*
 German Baroque, 940–941, *941*
 German Romanticism, 1066, *1066, 1067*
 Impressionism, French, 1194–1206,
 1194–1205
 India, Company School, 1266, *1266*
 Italian Baroque, 815–820, *815–821*
 modern, in America, 1402, *1403–1407,
 1404, 1405, 1406*
 Mogul miniature, 982–983, *982, 983*
 Neoclassicism, French, 1026–1032,
 1026–1032, 1040, 1041–1042, 1041
 photorealist, 1536
 plein air, 1194, 1296
 Post-Impressionism, 1291–1301,
 1291–1301
 Postmodernism, 1533–1540, *1533, 1535,
 1536, 1537, 1538, 1539*
 Realism, French, 1131–1138, *1132–1139*
 Realism, Russian, 1208–1209, *1208, 1209*
 Rococo, French, 936, 937–940, *937*
 Rococo, German, 940–941, *941*
 Romanticism, American, 1066,
 1068–1069, *1068, 1069*

Romanticism, English, 1062, *1062, 1063,
 1064–1065, 1064, 1065*
Romanticism, French, 1102–1106,
 1103–1107
Romanticism, German, 1066, *1066, 1067*
Romanticism, Spanish, 1097–1102,
 1098–1102
Russian Realism, 1208–1209, *1208, 1209*
sand, 1563–1564
Spanish Baroque, 880–882, *881, 883*
Spanish Romanticism, 1097–1102,
 1098–1102
Surrealism, 1366–1369, *1367, 1368,
 1369*
Symbolism, 1288–1290, *1288, 1289*
Palaces
 Kaisersaal (Imperial Hall) Residenz (Neu-
 mann), Germany, 940–941, *940, 941*
 Louvre, 831, *831*
 Mikhailovsky (Rossi), Saint Petersburg,
 Russia, 1126, *1126*
 Sanssouci, Potsdam, 942–943, *942, 943*
 Versailles, 862, 863–868, *867, 868*
Palacio Tore Tagle, Lima, Peru, 886
Pamela (Richardson), 916–917
Panic of 1873, 1224
Panthéon (Soufflot), Sainte-Geneviève,
 Paris, 1022, 1023, 1024, 1025
Paolina Borghese as Venus, 1042, *1043*
Paolozzi, Edouardo, 1472
Papacy. *See under* name of pope
Papiers-collés, 1326
Paradise Lost (Milton), 904–905, 923–925
Paris
 Commune, 1192, 1194
 in the 1850s and 1860s, 1158–1172
 Exposition of 1889, 1280, 1281, 1282,
 1282, 1283–1284, 1283, 1318
 grand boulevards, map of, *1189*
 Haussmann, work of, 1188, 1189–1192
 La Madeleine (Vignon), 1042, *1042*
 Louvre, 831, *831*
 map of, 1870, *1188*
 map of, Picasso's Montmartre, *1319*
 nightlife in the 1920s, 1371
 Opéra (Garnier), 1167–1168, *1168, 1169*
 Panthéon (Soufflot), Sainte-Geneviève,
 1022, 1023, 1024, 1025
 Picasso in, 1319–1322
 revolution of 1848, 1154–1156
 Salon, 950
 Trollope's views of, 1043
Paris Street, Rainy Day (Caillebotte), 1190,
 1191
Parker, Charlie, 1534
Parkinson, Sydney
 Portrait of a Maori, 971–972, *972*
 Three Paddles from New Zealand, 973, *973*
Parks
 American, 1240, 1241, *1241*
 Parisian, 1190
Parks, Rosa, 1495
Parody, 1174
Pasadena Lifesavers, Yellow No. 4. (Chicago),
 1518, *1518*
Passenger Pigeon (Audubon), 1255, *1256*
Passion, 855
Passive resistance, 1465
Passlof, Pat, 1478
Past and Present (Carlyle), 1116
Pastels, 1203
Paul V, pope, 806, 841
Paxton, Joseph, Crystal Palace, London,
 1210–1211, *1210, 1211*
Peacock Throne Room, India, 984, 985
Pearl Harbor, 1462
Pechstein, Max, 1330
Pencil of Nature, The (Talbot), 1140
Pen-grinding factory, 1117
*Penn's Treaty with the Indians When He
 Founded the Province of Pennsylvania in
 North America* (West), 988, 989
Pepys, Samuel, 898
Pepita, Marius, 1209
Perrault, Claude, Louvre, 831, *831*
Perry, Lilla Cabot, 1217
Perry, Matthew, 1266
Persistence of Memory, The (Dalí),
 1368–1369, *1369*
Peru
 Cuzco school, 885–886
 map of Viceroyalty, 885

Peter, Paul and Mary, 1496
Peter and the Wolf (Prokofiev), 1434
Peter the Great, 1125
Philadelphia, 998–999
Philadelphia Negro, The (DuBois), 1388
Philip II, king of Spain, 836, 880
Philip III, king of Spain, 880, 884
Philip IV, king of Spain, 880–881, 884
Phillips, Thomas, *Lord Byron Sixth Baron in
 Albanian Costume,* 1086, *1086*
Philosopher Occupied with His Reading, A
 (Chardin), 946, *946*
Philosophes, 935–936, 946–952
Philosophical Letters (Voltaire), 949
Philosophy, existential, 1467–1469
Philosophy of History (Hegel), 1085
Photogenic drawing, 1140
Photography
 of American Civil War, 1176–1177, *1177*
 Depression era, 1443–1444, *1444*
 development of, 1140, *1140, 1141, 1142*
 digital, 1553, *1553*
 Gallery 291, 1337
 Kodak camera, 1341
Photomontage, 1359, 1427, *1428,
 1433–1434, 1434*
Photorealist painting, 1536
Piano, 953
Piano, Renzo, Jean-Marie Tjibaou Cultural
 Center, New Caledonia, 1561, *1561*
Pianoforte, 953
Piano Mécanique (Mitchell), 1478, *1479*
Piano Sonata No. 30 in E Major, op. 109
 (Beethoven), 1093
Piazza, 808
Piazzolla, Ástor, *Adiós Nonino,* 1575
Picabia, Francis, 1356
Picasso, Pablo, 1319, 1355
 Bottle of Suze, 1347, *1347*
 collages, 1325–1327, *1326, 1327*
 Cubism, 1324–1327, *1325, 1326, 1327*
 Gertrude Stein, 1319, *1320*
 Girl Before a Mirror, 1368, *1368*
 Guernica, 1438, *1439*
 Guitar, Sheet Music, and Wine Glass,
 1327, *1327*
 Houses on the Hill, 1324, *1325*
 Les Demoiselles d'Avignon, 1279, *1279,
 1320, 1321, 1322*
 Violin and Palette, 1324–1325, *1325,
 1326, 1326*
Picasso (Stein), 1336
Pickford, Mary, 1408–1409
*Pièces de clavecin (Pieces for the
 Harpsichord)* (Jacquet de la Guerre), 874
Pierrot lunaire (Schoenberg), 1333–1334
Pietra dura, 984
Pilasters, 814
Pilgrim's Progress, The (Bunyan), 879
Pillars of Society, The (Grosz), 1423, *1423*
Pink Angels (De Kooning), 1476, *1477*
Pinter, Harold, 1469
Pioneers, The (Cooper), 1255, 1273–1276
Pissarro, Camille, 1194, 1204
 *Avenue de l'Opera, Sunlight, Winter
 Morning,* 1186, 1187, 1189
 Red Roofs, 1200, *1200*
Plain and Easy Introduction to Practical Music
 (Morley), 854
Planck, Max, 1318
Plantation melodies, 1174
Plath, Sylvia, "Lady Lazarus," 1516, 1521
Play With Me (Mori), 1570, *1570*
Pleasure Pillars (Sikander), 1572, *1573*
Plein air painting, 1194, 1296
Pliny, 943–944
*Plowing in the Nivernais: The Dressing of the
 Vines* (Bonheur), 1134, *1136*
Plow That Broke the Plains, The, 1442–1443
Poems (Dickinson), 1231, 1243–1244
Poems on Various Subjects: Religious and Moral
 (Wheatley), 1011
Poincaré, Raymond, 1347
Pointilles, 1292
Pointillism, 1291–1293
Poland, nationalism, 1056
*Politics Drawn from the Very Words of Holy
 Scripture* (Bossuet), 864
Pollock, Jackson
 Guardians of the Secret, 1475, *1475*
 "The Legacy of Jackson Pollock"
 (Kaprow), 1486
 Number 27, 1475, *1476*

Pollock and Tureen (Lawler), 1533, *1533*
Polonaises, 1097
Polyeucte (Corneille), 875
Polynesia, 971–974
Polyrhythms, 1330
Polytonal, 1330
Pompadour, Madame de, 935–936, 937, 938
Pop Art, 1472–1473, *1473*, 1501–1504, *1501, 1502, 1503, 1504*
Popé, 889
Pope, Alexander, *An Essay on Man*, 897, 909–910
Popova, Liubov', *The Magnanimous Cuckold: Actor no. 7*, 1360, *1361*
Porgy and Bess (Gershwin), 1397
Port Authority Trans Hudson (PATH) train station (Calatrava), 1559–1560, *1559*
Porter, Edwin S., 1410
Portrait of a Lady (James), 1233
Portrait of a Maori (Parkinson), 971–972, *972*
Portrait of an Insane Man (Géricault), 1111, *1111*
Portrait of Charles Baudelaire (Nadar), *1159*
Portrait of Émile Zola (Manet), 1163, *1166*
Portrait of Emilie Flöge (Klimt), 1305, *1305*
Portrait of Marie Antoinette (Vigée-Lebrun), 967, *967*
Portrait of Nicolaes Ruts (Rembrandt), 848–849, *849*
Portrait of Patience Escalier (Van Gogh), 1294, *1295*, 1296
Portrait of René Descartes (Hals), 840
Portraiture
 in the American colonies, 878, *878*
 Baroque, 848–851, *849–851*
 Baroque group, 848, 848, 852, 853
 Spanish, 880–882, *881, 883*
Portrait (Twins) (Morimura), 1569–1570, *1569*
Positivism, 1115
Post-Impressionism, 1291–1301, *1291–1301*
Postmodernism
 architecture 1526, 1527, 1528–1533, *1528, 1529, 1530, 1531, 1532, 1533*
 literature, 1544–1548
 music, 1548, 1550
 painting, 1533–1540, *1533, 1535, 1536, 1537, 1538, 1539*
 photorealist painting, 1536
 Pluralism, 1533–1544
 sculpture, 1540–1541, *1540, 1541*
 theater, 1548
 video art, 1541–1544, *1542, 1543, 1544*
Postsynchronization, 1449
Pottery
 by Lugo, Nancy Youngblood, 1578, *1578*
 by Nampeyo, 1578, *1578*
Pound, Ezra
 "Canto 49" (The Seven Lakes Canto), 1435, 1454–1455
 "Canto 120," 1435
 Make It New, 1399
 "A Pact," 1337
 "In a Station of the Metro," 1336–1337
 Ta Hsio, translation, 1385, 1399
Poussin, Nicolas, 872–873
 Arcadian Shepherds, 872, *872*
Poussinistes, 872
Pozzo, Andrea dal, *Triumph of Saint Ignatius of Loyola*, 819, 821, 822
Prelude, The (Wordsworth), 1057
Prélude à l'après-midi d'un Faune (Debussy), 1290–1291
Presentation of Uigur Captives from Battle Scenes of the Quelling of Rebellions in the Western Regions, with Imperial Poems (Lang Shi'ning), 977, *977*
Presley, Elvis, 1512
Pride and Prejudice (Austen), 917–918
Principia (Mathematical Principles of Natural Philosophy) (Newton), 910
Principle of Harmony and Contrast of Colors (Chevreul), 1292
Print culture, new, 913–915
Printmaking, Japanese, 1267–1269, *1267, 1268, 1269*
Pritchard, Thomas Farnolls, Iron Bridge, England, 912–913, *912*
Procession of the Reliquary of the True Cross in Piazza San Marco (Bellini), 823, *823*
"Prodigal Son, The" (Douglas), 1397, *1397*
"Prodigal Son, The" (Johnson), 1397
Program music, 827, 1094–1096

Prokofiev, Sergei, *Peter and the Wolf*, 1434
Proletariat, 1117
Promethean hero, 1085
"Prometheus" (Byron), 1085
Prometheus Unbound (Shelley), 1086–1087
Proposition, The (Leyster), 846, *846*
Prospect Park, Brooklyn (Chase), 1226, *1227*
Prospect Park, Brooklyn (Olmsted and Vaux), *1227*, 1241
Protestant work ethic, 878
Proudhon, Pierre-Joseph, 1158–1159
Proust, Marcel
 À la recherche du temps perdu, 1374
 À la recherche Time Regained, 1374
 Remembrance of Things Past, 1374
 Swann's Way, 1374
Prussia
 map of, *941*
 Rococo in, 941–943, *942, 943*
Psychology
 work of Freud, 1364–1365
 work of Jung, 1365–1366
Psychology (James), 1371–1372
Puccini, Giacomo
 Madama Butterfly, 1334
 Turandot, 1334
 works of, 1334
Pueblo people, 889
 architecture, 986, 897
Pugin, Augustus Welby Northmore
 Contrasts, 1119, *1120*
 Houses of Parliament, London, 1119, *1121*
Purcell, Henry, 880
Puritans, 876, 877, 878–880, 905
Pushkin, Aleksandr, *The Bronze Horseman*, 1126
Pynchon, Thomas, V., 1545
Q
Qianlong, emperor of China, 977, 980
Qing dynasty, 977, 980
Quay at Amsterdam (Ruisdael), 832, *833*
Queen Marie Antoinette and Her Children (Vigée-Lebrun), 1031, *1031*
Queen's Ware, 911–912, *911*
Quevedo, Francisco de, 885
Quillwork, Native American, 1259, *1259*, 1262

R
Racecourse, Amateur Jockeys (Degas), 1204, *1204*
Racine, Jean, 876
Radio, Hitler's use of, 1432
Raft of the "Medusa," The (Géricault), 1103–1104, *1104*
Ragtime, 1232
Raimondi, Marcantonio, *The Judgment of Paris*, 1162, *1163*
Rain, Steam, and Speed—The Great Western Railway (Turner), 1122, *1122*
"Rainbow, The" (Wordsworth), 1057, 1058
Rainey, Ma, 1395
Rambler, The (Johnson), 918–919
Rameau, Jean-Philippe, 952
Randolph, A. Philip, 1495, 1496
Rap, 1500
Rational humanism, 947
Rauschenberg, Robert, *Bed*, 1484, *1484*
RCA building, New York City, 1390
Reading, A (Dewing), 1225–1226, *1226*
Ready-mades, 1356
Realism
 literary, 1114, 1115–1116, 1121–1131, 1206–1208
 painting, French, 1131–1138, *1132–1139*
 painting, Russian 1208–1209, *1208, 1209*
 photography, 1140, *1140, 1141, 1142*
Rebellious Silence from *Women of Allah* (Neshat), 1571, *1571*, 1573
Recitativo, 825
Reclining Nude (Venus of Urbino) (Titian), *1164*
Recluse, The (Wordsworth), 1057
Red Hills and Bones (O'Keeffe), 1406, *1406*
Red Roofs (Pissarro), 1200, *1200*
"Red Wheelbarrow, The" (Williams), 1400
Reformists, 1118–1119
Regatta at Argenteuil, The (Monet), 1048, 1194, *1195*
Reggae, 1575
Reich, Steve, 1506
Remarque, Erich Maria, 1352, 1419
 All Quiet on the Western Front, 1353

Rembrandt van Rijn
 The Anatomy Lesson of Dr. Tulp, 849, 852, 853
 Christ Preaching, 850, *850*
 Descent from the Cross, 861, *861*
 Portrait of Nicolaes Ruts, 848–849, *849*
 Self-Portrait, 851, *851*
 Slaughtered Ox, 850, *851*
 The Supper at Emmaus, 849, *849*
Remembrance of Things Past (Proust), 1374
Renoir, Jean, 1451
Renoir, Pierre-Auguste, 1185, 1194
 Luncheon of the Boating Party, 1201, *1201*
Repin, Ilya, *Leo Tolstoy Ploughing*, 1208, *1208*, 1209
Reply to Sor Filotea (Sor Juana), 887
Republicanism, 1000
Resnais, Alain, 1466
Resnick, Milton, 1475
Retablos, 887–889, *888, 889*
Revere, Paul, *The Bloody Massacre*, 1000, *1000*
"Revolution Will Not Be Televised, The" (Scott-Heron), 1500–1501
Reynolds, Joshua, *Samuel Johnson*, 919
Rhapsody in Blue (Gershwin), 1397
Rhodes, Cecil, 1270–1271
Ricci, Matteo, 841
Rice, Thomas Dartmouth, 1173
Rich, Adrienne, "Diving into the Wreck," 1517, 1522
Richards, M. C., 1484
Richardson, Samuel, *Pamela*, 916–917
Richelieu, Cardinal, 872, 874–875
Richelieu, duke (Armand-Jean du Plessis), 872–873
Richter, Gerhard
 Ice, 1538, 1539, 1540
 Meadowland, 1538, *1538*, 1540
Ride for Liberty: The Fugitive Slaves, A (Johnson), 1174, *1175*
Riefenstahl, Leni
 Olympia, 1433
 Triumph of the Will, 1432–1433, *1433*, 1443
Rietveld, Gerrit, Schroeder House, Holland, 1429, *1429*
Rigaud, Hyacinthe, *Louis XIV*, 865, *865*
Riis, Jacob
 Five Cents a Spot, 1222, *1222*
 How the Other Half Lives, 1222
Rilke, Rainer Maria, 1290
Riley, Terry, 1506
"Rime of the Ancient Mariner" (Coleridge), 1057, 1060, 1076–1077
Rimsky-Korsakov, 1371
Ringaround Arosie (Hesse), 1518, *1518*
Ringgold, Faith, *God Bless America*, 1494, *1495*
Ring of the Nibelung, The (Wagner), 1170
Ripieno, 855
Ripieno concerto, 855
Ritornello, 827
Rivera, Diego, 1440
 Man, Controller of the Universe, 1437, *1437*
 Sugar Cane, 1436, *1437*
River Bathers (Hartigan), 1478, *1479*
Riverside, Illinois (Olmsted and Vaux), 1241, *1241*
Robespierre, Maximilien, 1023, 1035–1037
Robie House (Wright), Chicago, 1447, *1447*
Robinson, Theodore, 1217
Robinson Crusoe (Defoe), 915–916, *916*
Rock art, Aboriginal, 975–976, *975*
Rock 'n' roll, 1512, 1513
Rockefeller, John D. II, 1390
Rockefeller, Nelson A., 1437
Rockefeller Center, New York City, 1390
Rocky Mountains, Lander's Peak, The (Bierstadt), 1251–1253, *1251*
Rococo
 architecture, German, 940–943, *940*
 development of, 936
 difference between Baroque and, 936
 music, Classical, 952–960
 painting, French, 936, 937–940, *937*
 painting, German, 940–941, *941*
 philosophes, 935–936, 946–952
 in Prussia, 941–943, *942, 943*
 use of term, 936

The Kiss, 1287, *1287*
Monument to Balzac, 1287–1288, *1288*
Roentgen, David, Desk, 978, *978*
Rogers, Ginger, 1449
Romantic hero, 1084–1091
Romanticism, 1047
 development of, 1054–1055
 literature, 1056–1061
 music, 1091–1097
 painting, American, 1066, 1068–1069, *1068, 1069*
 painting English, 1062, 1063, 1064–1065, *1064, 1065*
 painting, French, 1102–1106, *1103–1107*
 painting, German, 1066, *1066, 1067*
 painting, Spanish, 1097–1102, *1098–1102*
 use of term, 1054
Rome
 See also Saint Peter's basilica; Vatican
 Il Gesù church (Della Porta), 808, 814, *814*
 San Carlo alle Quattro Fontane church (Borromini), 813, *813*, 815
Rood, Odgen, 1200, 1292
Rooney, Mickey, 1450
Roosevelt, Franklin, 1440, 1463, 1465
Rosenberg, Harold, 1475
Rosenberg, Isaac, "Dead Man's Dump," 1352
Rosenquist, James, 1507
 F-111, 1508–1510, *1508, 1509*
Rossetti, Dante Gabriel, *Mariana*, 1212, *1213*
Rossi, Carlo, Mikhailovsky Palace, Saint Petersburg, Russia, 1126, *1126*
Rothko, Mark, *Green on Blue*, 1479, *1480, 1481*
Roundheads, 877
Rousseau, Jean-Jacques, 854
 Confessions, 948, 961–962
 Discourse on Political Economy, 976
 Discourse on the Origin of Inequality among Men, 949
 Émile, 948, 986
 The Social Contract, 933, 948–949, 1000
Rouvroy, Louis de, 865
Royal Academy of Dance (French), 873
Royal Academy of Music (French), 873
Royal African Co., 1008
Royal Society of London for Improving Natural Knowledge, 839, 970
Rubenesque, 870
Rubens, Peter Paul
 The Arrival and Reception of Marie de' Medici at Marseilles, 869–871, *869*
 Descent from the Cross, 861, *861*, 871
 The Kermis (Peasant Wedding), 870–871, *871*
Rue Transnonain (Daumier), 1133–1134, *1134*
Ruisdael, Jacob van
 Quay at Amsterdam, 832, *833*
 View of Haarlem for the Dunes at Overveen, 845, *845*
Rules of the Game, The (La Règle du jeu), 1451
Ruskin, John, 1234
 "On the Nature of Gothic" in *The Stones of Venice*, 1211
Russia
 Ballets Russes, 1329–1330
 collectivization of agriculture, 1433
 Constructivism, 1360, *1361*
 Cubo-Futurism, 1359–1360, *1360*
 literary realism, 1125–1127, 1206–1209
 movies, 1360–1363, *1362, 1363*
 music and ballet, nationalist, 1209–1210
 painting, Realism, 1208–1209, *1208, 1209*
 Revolution of 1917, 1359
 St. Petersburg, 1125–1126, *1125*
 social realism, 1433–1434
 Stalinism, 1433–1434
 World War I and, 1351, 1359
 World War II and, 1462
Russolo, Luigi, 1328
Rutherford, Ernest, 1313

Saar, Bettye, *The Liberation of Aunt Jemima*, 1500, *1500*

Saenredam, Pieter, *St. Bavo's Church at Haarlem, interior of choir,* 838–839, *838*
Safavi, Tamasp, 982
St. Bavo's Church at Haarlem, interior of choir (Saenredam), 838–839, *838*
Sainte-Geneviève, Panthéon (Soufflot), Paris, *1022,* 1023, 1024, *1025*
Saint Paul's Cathedral (Wren), 900–901, *901*
Saint Peter's basilica
 Bernini, 807
 Maderno, 806–807, *806, 807*
 Michelangelo, 807, *807*
St. Petersburg, 1125–1126, *1125*
Salon, 1194
Salon concerts, 1097
Salon de la Princesse (Boffrand), *932,* 933, 934, 940
Salon des Refusés, 1162, 1194
Salonnière, 935
Salon of 1863, 1162
Salons, 931, 934–935
 Carré, 950
 Diderot's, 950–951
Samuel Johnson (Reynolds), 919
San Carlo alle Quattro Fontane church (Borromini), Rome, 813, *813,* 815
Sand painting, 1563–1564
San Francisco, 1238, 1265
 in the 1960s, 1513
Sanssouci Palace, Potsdam
 music room, 942–943, *942*
 plan of, 943, *943*
Santa Maria Novella church (Alberti), Florence, 814, *814*
San Xavier del Bac, 889, *889*
Sargent, John Singer, 1217
 The Daughters of Edward Darley Boit, 1234–1236, *1235*
 Gassed, *1348,* 1349, 1350
Sartre, Jean-Paul, 1313, 1470
 Being and Nothingness, 1468
 "Black Orpheus," 1496–1497
 Les Temps Modernes, 1469
 No Exit, 1468, 1469
Sassoon, Siegfried, "Suicide in Trenches," 1352
Saturn Devouring One of His Children (Goya), 1102, *1102*
Scat, 1396
Scenes from the Massacres at Chios (Delacroix), 1104–1105, *1105*
Schama, Simon, *The Embarrassment of Riches,* 837
Schelling, Friedrich, 1069
Scherzo, 1092
Schiller, Friedrich, 1088, 1094
Schlegel, Friedrich von, 1054
Schmidt-Rottluff, Karl, 1330
Schoenberg, Arnold
 Green Self-Portrait, 1333, *1333*
 Pierrot lunaire, 1333–1334
Schroeder House (Rietveld), Holland, 1429, *1429*
Schubert, Franz, 1096
Schulze, Johann Heinrich, 1140
Schumann, Clara, 1096–1097
Schumann, Robert, 1096, 1097, 1167
Schütz, Carl
 Neuer Markt (New Market), 1091
 View of Vienna from the Josephstadt, 1080, 1081
Science
 Baroque period and, 801, 839–842
 beginning of twentieth century, 1313, 1318–1319
 positivism, 1115
Scientific Revolution, 895
Scott-Heron, Gil, "The Revolution Will Not Be Televised," 1500–1501
Scream, The (Munch), 1303–1304, *1305*
Sculpture
 Aboriginal rock art, 975–976, *975*
 Abstract Expressionism, 1481–1482, *1481, 1482*
 African, 1272, *1272*
 American Neoclassicism, 1006–1007, *1007*
 Baroque, Italian, 808, 809–815, *809–813*
 Chinese jade, 980–982, *981*
 English Neoclassicism, 1003, *1003*
 existentialism, 1470, *1470*
 French Neoclassicism, 1021, *1021, 1042,* 1043

Futurism, 1328, *1329*
Hawaiian, 974, *974*
Italian Baroque, 808, 809–815, *809–813*
Melanesia, 974–975, *975*
moai, 973–974, *973*
Neoclassicism, American, 1006–1007, *1007*
Neoclassicism, English, 1003, *1003*
Neoclassicism, French, 1021, *1021, 1042,* 1043
Postmodernism, 1540–1541, *1540, 1541*
retablos, 887–889, *888, 889*
Surrealism, 1369–1370, *1369, 1370*
Symbolism, 1287–1288, *1287, 1288*
totem poles, 1578–1579, *1579*
Seagram Building (Mies van der Rohe and Johnson), New York City, 1457, *1457*
Seale, Bobby, 1500
Seated Woman (De Kooning), *1476,* 1477
"Second Coming, The" (Yeats), 1354
Second Sex, The (De Beauvoir), 1468–1469
Second Treatise of Government, The (The Two Treatises on Government) (Locke), 904, 922–923, 1000, 1001
Self-Portrait (Rembrandt), 851, *851*
Self-Portrait as a Soldier (Kirchner), 1350, *1351*
Self-Portrait with Model (Kirchner), 1330–1331, *1330*
Self-Portrait with Monkey (Kahlo), 1440, *1440*
"Self-Reliance" (Emerson), 1070
Selznick, David O., 1450–1451
Seneca, 989
Senefelder, Alois, 1135
Serial composition, 1334
Serra, Richard, *Tilted Ellipse I; Double Torqued Ellipse; Double Torqued Ellipse II; Snake,* 1540–1541, *1540*
Setting Sun (Monet), 1198–1199
Seurat, Georges, 1200
 Les Poseuses (The Models), 1292–1293, *1292*
 A Sunday on La Grande Jatte, 1291–1292, *1291*
Seven Years' War, 999
Severance, H. Craig, 1390
Severini, Gino, 1328
Severn, Joseph, *John Keats,* 1060
Sexton, Anne, "Her Kind," 1516–1517
Shaka, 1269
"Shaker Loops" (Adams), 1506
Shamela (Fielding), 917
Shanghai, 1396
Shaving a Boy's Head (Utamaro), 1217, *1217*
Shaw, Artie, 1396
Shchukin, Sergei, 1206
Shebbeare, J., 978
Sheeler, Charles, *Classic Landscape,* 1404, *1404*
Shelley, Mary Godwin, 1086
 Frankenstein; or the Modern Prometheus, 1038, 1087, 1108
Shelley, Percy Bysshe, 1038, 1086
 A Defense of Poetry, 1087
 "Ode to the West Wind," 1087
 Prometheus Unbound, 1086–1087
Shelton Towers, New York City, 1386, 1387–1388, *1387*
Sheridan, Philip, 1262
Shibusawa, Eiichi, 1267
Shimbashi Station, Tokyo, 1267
Shirow, Masamune, *The Ghost in the Shell,* 1570, *1570*
Shiskin, Ivan, 1209, *1209*
Shoah (Lanzmann), 1465
Shoguns, 868
Shona, 1015
Shonibare, Yinka, 1565
 Victorian Couple, 1566, *1566*
Shop of Tingqua, the Painter (Tingqua), 1264, *1264*
Shostakovich, Dimitri
 Lady Macbeth of the Mtsensk District, 1434
 Symphony No. 5 (Shostakovich), 1434
Sibelius, Jean, 1371
Signac, Paul, 1200, 1293
Signboard of Gersaint, The (Watteau), 931, *931,* 937, *937*
Sikander, Shahzia, *Pleasure Pillars,* 1572, *1573*

Silent movies, 1407–1411
Simon, Paul, *Graceland,* 1574
Sinatra, Frank, 1396
Sinclair, Upton, 1419
Singer Building, New York City, 1386
Siqueiros, David, 1436
Sirani, Elisabetta, *Virgin and Child,* 817–818, *818*
Siren of the Niger, The (Lam), 1497, *1497*
Six Days of Sound (Maclean), 1512–1513, *1512*
Sixtus V, pope, 808
Sketches by Boz (Dickens), 1113, 1115–1116
Skyscrapers, 1386–1388, *1386, 1387, 1388,* 1390–1391, *1390, 1391*
Slaughtered Ox (Rembrandt), 850, *851*
Slaughterhouse-Five (Vonnegut), 1507
Slavery, 995
 in America, 1008–1015, 1127–1130, 1172–1174
Slave ship, *1010*
Sleep of Reason Produces Monsters, The (Goya), 1098, *1099*
Smith, Adam, 1014
 Wealth of Nations, 1119
Smith, Bessie, 1395, *1395*
Smith, David, *Blackburn: Song of an Irish Blacksmith,* 1482, *1482*
Smithson, Robert, *Spiral Jetty,* 1511–1512, *1511*
Snow Storm—Steam-Boat off a Harbour's Mouth (Turner), 1065, *1065*
Snow White and the Seven Dwarfs, 1450
Sobibor, 1460
Social contract, 901
Social Contract, The (Rousseau), 933, 948–949, 1000
Social Darwinism, 1271
Social History of the State of Missouri, A (Benton), 1441, *1441*
Social realism, 1433–1434
Société anonyme, 1194
Society of Independent Artists, 1356
Society of Jesus. *See* Jesuits
Soft Toilet (Oldenburg), 1504, *1504*
Sonata, 825–826
 da camera, 825
 da chiesa, 825
 form, 954, *954*
 trio, 825
"Song of Myself" from *Leaves of Grass* (Whitman), 1221–1223, 1242–1243
Songs of Innocence (Blake), 1087
"Sonny's Blues" (Baldwin), 1497, 1520
Sor Juana Inés de la Cruz
 Reply to Sor Filotea, 887
 "To Her Self-Portrait," 887
 villancicos, 887
Sorrows of Young Werther, The (Goethe), 1088–1089
Soufflot, Jacques-Germain, Panthéon, Sainte-Geneviève, Paris, *1022,* 1023, 1024, *1025*
Souls of Black Folk, The (DuBois), 1388–1389
Sound and the Fury, The (Faulkner), 1446
South Pacific, 970
 Australia, 975–976
 Easter Island, 973–974
 Hawaii, 974
 map of, *971*
 Melanesia, 974–975
 New Zealand, 971–973
 Polynesia, 971–974
Sower, The (Millet), 1134, 1136, *1136*
Soyinka, Wole, *A Dance in the Forests,* 1555, 1566–1567
Spain
 Franco and civil war, 1435–1436, *1436*
 Guggenheim Museum, Solomon R. (Gehry), Bilbao, 1532, *1533*
 painting, Baroque, 880–882, *881, 883*
 painting, Romanticism, 1097–1102, 1098–1102
 literature, Baroque, 884–885
Spanish Fury, 836
Spectator, The, 914–915
Spencer Herbert, 1271
Spenserian stanza, 1086
Spero, Nancy, *War Series,* 1517–1518, *1517*
Spiegelman, Art, *Maus: A Survivor's Tale,* 1465
Spiral Jetty (Smithson), 1511–1512, *1511*

Spirit of the Laws, The (Montesquieu), 947
Spiritual Exercises (Ignatius of Loyola), 822
Sprechstimme, 1334
Stained-glass window (Tiffany), 1285, *1285*
Stairway (Horta), Tassel House, Brussels, 1285, *1285*
Stalin, Joseph, 1433–1434
Stamitz, Johann, 952–953, 954
Stamp Act (1765), 999–1000
Stanley (Close), 1536, *1537*
Starry Night (Van Gogh), 1294, *1294*
State and Revolution, The (Lenin), 1359
Statue of Liberty (Bartholdi), 1223, 1225
Stedman, John Gabriel, 1010
Steele, Richard, 913–915
Steen, Jan, *The Dancing Couple,* 845–846, *845*
Steerage, The (Stieglitz), *1337, 1337*
Stein, Gertrude, 1351
 The Autobiography of Alice B. Toklas, 1319–1320
 Gertrude Stein (Picasso), 1319, *1320*
 Picasso, 1336
 Tender Buttons, 1336
Steinbeck, John, *The Grapes of Wrath,* 1421, 1443
Steir, Pat, 1536
 Yellow and Blue One-Stroke Waterfall, 1538, *1538*
Stella, Frank, *Pagosa Springs,* 1504, *1504*
Stella, Joseph, *Voice of the City of New York Interpreted: The Brooklyn Bridge,* 1402, 1403
Sternberg, Josef von, 1449
Stevens, Alfred, *What Is Called Vagrancy,* 1156, *1157*
Stieglitz, Alfred, 1338, 1357, 1403
 Camera Work, 1337
 Gallery, 291
 Shelton Towers, 1387–1388
 The Steerage, 1337, *1337*
Stieler, Joseph Carl, *Beethoven,* 1093
Still life, Baroque, 844, *844*
Still Life: Tea Set (Liotard), 979
Still Life #20 (Wesselmann), 1502, *1502*
Still Life with Plaster Cast (Cézanne), 1298, 1298–1299
Stills, Stephen, 1513, 1514
Stockhausen, Karlheinz, 1505–1506, *1505*
Stoeving, Curt, *Friedrich Nietzsche,* 1302
Stonebreakers, The (Courbet), 1137, *1137*
Stoppard, Tom, 1469
Stourhead park (Flitcroft and Hoare), Wiltshire, England, 944, *944*
Stour Valley and Dedham Village, The (Constable), 1062, *1063*
Stowe, England, gardens at, 945, *945*
Stowe, Harriet Beecher, *Uncle Tom's Cabin,* 1129–1130
Strand, Paul, *Abstraction, Porch Shadows,* 1337, *1338*
Strange Interlude (O'Neill), 1407
Stranger, The (Camus), 1469
Stravinsky, Igor, 1329–1330, 1397
Stream-of-consciousness, 1371–1372
Strike, The (Koehler), 1224, *1225*
String quartet, 955
Stryker, Roy, 1443
Studies in Hysteria (Freud and Breuer), 1311, 1364
Style gallant, 952
Subjection of Women, The (Mill), 1214
Sublimation, 1365
Sublime, 1092
Sueños (Visions) (Quevedo), 885
Sugar Cane (Rivera), 1436, *1437*
"Suicide in Trenches" (Sassoon), 1352
Suite, 874
Sullivan, Louis, 1386
 Bayard (Condict) Bulding, New York City, 1239–1240, *1239*
 Kindergarten Chats, 1239
Summer's Day (Morisot), 1200, *1200*
Summerspace (Cunningham), 1484–1485, *1485*
Sun Also Rises, The (Hemingway), 1371
Sunday on La Grande Jatte, A (Seurat), 1291–1292, *1291*
Superego, 1365
Supper at Emmaus, The (Caravaggio), 816, 819, 820, *820*
Supper at Emmaus, The (Rembrandt), 849, *849*
Suprematism, 1359–1360, *1360*

Suprematist Composition, Black Rectangle, Blue Triangle (Malevich), 1360, *1360*
Surinam Planter in His Morning Dress (Blake), 1010, *1011*
Surrealism, 1366–1370, *1367, 1368, 1369, 1370,* 1411, *1411*
Surrealist Manifesto (Breton), 1366–1367
Survey Graphic, 1389, 1392, *1392,* 1393
Survival at Auschwitz (If This Is a Man) (Levi), 1465
Suspended Ball (Giacometti), 1369–1370, *1369*
Swann's Way (Proust), 1374
Sweelinck, Jan Pieterszoon, 854
Swift, Jonathan
 Gulliver's Travels, 908–909
 A Modest Proposal, 908, 925–928
Swinburne, Algernon Charles, "Laus Veneris," 1213
Swing, 1396–1397
Swing, The (Fragonard), 938, 939, 940
Symbolism
 painting, 1288–1290, *1288, 1289*
 sculpture, 1287–1288, *1287, 1288*
Symphonic form, 953–955
Symphonic orchestra, 952–953
Symphonie fantastique (Berlioz), 1094–1095
Symphony, 953–955
Symphony No. 1 (Mahler), 1303
Symphony No. 4 (Brahms), 1303
Symphony No. 5 (Shostakovich), 1434
Symphony No. 40 (Mozart), 956, 958–959
Symphony No. 94 (Haydn), 955
Syncopation, 1232
Syncretism, 886–887
System of Transcendental Idealism (Schelling), 1069

Tadjo, Véronique
 As the Crow Flies, 1567
 "The Betrayal," 1567, 1580–1581
Tafoya, Margaret, 1578
Tahiti, 970, 972
Ta Hsio, translation (Pound), 1385, 1399
Taj Mahal, Agra, India, 983–986, *984, 985*
Talbot, William Henry Fox
 Mimosoidea Suchas, 1140, *1140*
 The Open Door, 1140, *1142*
 The Pencil of Nature, 1140
Tales of the Jazz Age (Fitzgerald), 1394
Tammany Hall, 1223–1224
Tango, 1575
Tannhäuser (Wagner), 1169–1170
Taos Pueblo, New Mexico, 986, *987*
Tartuffe (Molière), 863, 875–876, 890–891
Tassel House, stairway (Horta), Brussels, 1285, *1285*
Tasso, Torquato, 873
Tatler, The, 913–914
Tattooing, 971–973, *972*
Taylor, Frederick, 1318
Taylor, John, *Treaty Signing at Medicine Lodge Creek,* 1261
Tchaikovsky, Pyotr Ilyich
 ballets, 1209
 The 1812 Overture, 1209
 The Nutcracker, 1209–1210
Tea at Prince Louis-François de Conti's in the Temple, Paris (Ollivier), 956
Telescope, 840–841
Television, 1471
Temple of Ancient Virtue, 944
10 x 10 Alstadt Copper Square (Andre), 1504, *1505*
Tender Buttons (Stein), 1336
Tenebrism, 816
Tennis Court Oath, The (David), 1033, *1033*
Tennyson, Lord Alfred, "Charge of the Light Brigade," 1352
Tenth Muse Lately Sprung Up in America, The (Bradstreet), 879
Teraoka, Masami, *Geisha in Bath,* 1569, *1569*
Teresa of Ávila, 809
 "Visions," 805, 810
Terkel, Studs, 1464
Textiles, eighteenth century, 912
Theater
 of the Absurd, 1469–1470
 American, 1407
 Berlin, 1424–1425
 Cavalier, 880
 El Teatro Campesino (The Farmworkers Theater), 1574

Epic, 1424–1425
French Baroque, 874–876
Japanese kabuki, 880
Piece #1, 1484–1485, 1486
Postmodernism, 1548
"Theater for Pleasure or Theater for Imagination" (Brecht), 1425
Theater Piece #1, 1484–1485, 1486
Their Eyes Were Watching God (Hurston), 1394
"Theme for English B" (Hughes), 1414
Thérèse Raquin (Zola), 1167
Thief of Bagdad, The, 1408, 1409, *1409,* 1451
Things Fall Apart (Achebe), 1566
Third-Class Carriage, The (Daumier), 1134, *1135*
Third of May, 1808, The (Goya), 1097, *1098*
"This Is Tomorrow" exhibition, London, 1472, *1472*
"This Land Is Your Land" (Guthrie), 1445–1446
Thompson, Hunter, 1513
Thompson, J. J., 1313, 1318
Thomson, Virgil, 1442
Thoreau, David, 1465
Thoreau, Henry David
 "Civil Disobedience," 1071
 "Life without Principle," 1071
 Walden, or Life in the Woods, 1070–1071
Thousand Peaks and Myriad Ravines, A (Wang Hui), 980, *981*
Three Flags (Johns), 1485, *1485*
Three Paddles from New Zealand (Parkinson), 973, *973*
Threepenny Opera, The (Brecht), 1424
Three Places in New England (Ives), 1515
Through the Flower: My Struggle as a Woman Artist (Chicago), 1518
Tiepolo, Giovanni Battista, frescoes at Kaisersaal (Imperial Hall), Residenz, 940–941, *941*
Tiffany, Louis Comfort, Stained-glass window, 1285, *1285*
Till Death (Goya), 1100, *1100*
Tillich, Paul, 1467–1468
Tilted Ellipse I; Double Torqued Ellipse; Double Torqued Ellipse II; Snake (Serra), 1540–1541, *1540*
Time signature, 953
Tingqua, *Shop of Tingqua, the Painter,* 1264, *1264*
Tintern Abbey, England, *1052, 1053,* 1054, *1055*
"Tintern Abbey" (Wordsworth), 1053, 1056, 1974–1075
Tischbein, J. H. W., *Johann Wolfgang von Goethe in the Roman Campana,* 1088, *1088*
Titian (Tiziano Vecelli), *Reclining Nude (Venus of Urbino),* 1164
Tjibaou (Jean-Marie) Cultural Center (Piano), New Caledonia, 1561, *1561*
Tobacco Leaf Capital (Latrobe), 1006, *1007*
"To Her Self-Portrait" (Sor Juana), 887
Toilet of Venus, The (Boucher), 938, *938*
Tokyo, modernization of, 1191
Tokyo-Yokohama railway, 1267, *1267*
Toleration Act, 905
Tolstoy, Leo, 1208
 Anna Karenina, 1207, 1208
 War and Peace, 1207–1208
 What Then Must We Do?, 1208
"To Make a Dadaist Poem" (Tzara), 1356
Tomatsu, Shomei, *11:02—Nagasaki,* 1466–1467, *1466*
Tombs, Taj Mahal, Agra, India, 983–986, *984, 985*
"To My Dear and Loving Husband" (Bradstreet), 879
Tonality, 823, 1333
Tone row, 1334
Tonic note, 823
Toomer, Jean, *Cane,* 1389
Toorop, Jan, *Delftsche Slaolie,* 1286, *1286*
To Raise the Water Level in a Fish Pond (Zhang Huan), 1570–1571, *1571*
Torrey, Frank C., 1338
Totem poles, 1578–1579, *1579*
"To the Bourgeoisie" in Salon of 1846 (Baudelaire), 1159
To the Lighthouse (Woolf), 1374
"To the Virgins, To Make Much of Time" (Herrick), 879–880

Toulouse-Lautrec, Henri de, 1290
 At the Moulin Rouge, 1289, *1289*
 Miss Loïe Fuller, 1289, *1289*
Towards a New Architecture (Le Corbusier), 1430
Tragédie en musique, 873–874
Transcendentalism, 1054, 1069–1077
Travelers, 1208–1209
Treaty Signing at Medicine Lodge Creek (Howling Wolf), 1260–1261, *1260*
Treaty Signing at Medicine Lodge Creek (Taylor), *1261*
Treblinka, 1460
Trial, The (Kafka), 1423–1424
Trio sonata, 825
Tristan and Isolde (Wagner), 1170
Triumph of Bacchus, The (Los Borrachos), Velázquez, 881, *881*
Triumph of Saint Ignatius of Loyola (Pozzo), 819, *821, 822*
Triumph of the Will (Riefenstahl), 1432–1433, *1433,* 1443
Trollope, Frances, 1043
Tropicalia, 1575
Trotsky, Leon, 1433
Trumbull, John, *The Declaration of Independence,* 996, *997*
Trump Building, 1390
Truth, Sojourner, *1128*
 "Ain't I a Woman?," 1128
Tulipomania, 836–837
Turandot (Puccini), 1334
Turner, Frederick Jackson, 1247
Turner, Joseph Mallord William, 1210
 The Fall of an Avalanche in the Grisons, 1065, *1065*
 Rain, Steam, and Speed—The Great Western Railway, 1122, *1122*
 Snow Storm—Steam-Boat off a Harbour's Mouth, 1065, *1065*
 Tintern Abbey, interior, *1055*
 The Upper Falls of the Reichenbach, 1064–1065, *1064*
 The Whale Ship, 1071, *1072*
Twain, Mark, 1217, 1224
 Adventures of Huckleberry Finn, 1130–1131
 The Gilded Age, 1178
Tweed, William "Boss," 1223–1224
Twelve-tone system, 1334
Twilight in the Wilderness (Church), 1069, *1069*
Two Treatises on Government, The (The Second Treatise of Government) (Locke), 904, 922–923, 1000, 1001
Tyamzashe, 1271
Tzara, Tristan, 1355
 "To Make a Dadaist Poem," 1356

Ukiyo-e, 1204, 1267–1269, *1268, 1269*
Ulysses (Joyce), 1372
Umbrellas, Japan-USA, The (Christo and Jeanne-Claude), 1554, 1555, 1556–1557, *1556*
Un Chien andalou (An Andalusian Dog), 1411, *1411*
Uncle Tom and Little Eva (Duncanson), 1130
Uncle Tom's Cabin (Stowe), 1129–1130
Unconscious, 1364–1366
Unique Forms of Continuity in Space (Boccioni), *1312, 1328, 1329*
United States (Anderson), 1550, 1550
University of Houston, Hines College of Architecture (Johnson and Burgee), 1531, *1531*
Untitled (Gonzalez-Torres), 1568, *1568*
Upper Falls of the Reichenbach, The (Turner), 1064–1065, *1064*
Urban VIII, pope, 809, 827, 842
Urban music, 822–827
Ushimachi, Takanawa (Hiroshige), 1204, *1204*
Utamaro, Kitagawa
 The Fickle Type, from *Ten Physiognomies of Women,* 1268, *1269*
 Shaving a Boy's Head, 1217, *1217*
 Utamaro's Studio, 1268, *1268*
Utamaro's Studio (Utamaro), 1268, *1268*
Utilitarian theory, 1214
Utopian socialism, 1119

Valdez, Luis, *Zoot Suit,* 1574
Valentino, Rudolph, 1410

Van Alen, William, Chrysler Building, New York City, 1384, 1385, 1386, 1390–1391, *1390, 1391*
Vanderlyn, John, *The Murder of Jane McCrea,* 1254–1255, *1255*
Van Doesburg, Theo, 1428, *1429*
Van Dyck, Anthony
 Alexander Henderson, Presbyterian Divine and Diplomatist, 877, *877*
 Charles I at the Hunt, 876, *877*
Van Gogh, Vincent
 Night Café, 1293, *1293*
 Portrait of Patience Escalier, 1294, *1295,* 1296
 Starry Night, 1294, *1294*
Vanitas painting, 844
Van Vechten, Carl, *Bessie Smith,* 1395
Vases and vessels, Jasperware, 1003–1004, *1004*
Vatican
 map of city, 807
 Saint Peter's basilica (Bernini), 807
 Saint Peter's basilica (Maderno), 806–807, *806, 807*
 Saint Peter's basilica (Michelangelo) 807, *807*
 Square, 804, *805*
Vaughan, Sarah, 1396
Vaux, Calvert
 Central Park, New York City, 1240, *1241*
 Prospect Park, Brooklyn, *1227, 1241*
 Riverside, Illinois, 1241, *1241*
Vauxcelles, Louis, 1324
Velázquez, Diego
 Maids of Honor, The (Les Meninas), 881, *882, 883*
 Triumph of Bacchus, The (Los Borrachos), 881, *881*
Veldon-Simpson Architect, Inc., Luxor Las Vegas, 1529, *1530*
Veloso, Caetano, 1575
Venice, Baroque music, 822–827
Venturi, Robert, *Learning from Las Vegas,* 1528–1529, 1530
Verdi, Giuseppe, 1168–1169
 Il Trovatore, 1169
 Rigoletto, 1168
Verlaine, Paul, 1290
Vermeer, Jan
 The Geographer, 842, *843*
 Lady at the Virginal with a Gentleman (The Music Lesson), 847–848, *847*
 Woman with a Pearl Necklace, 846–847, *847*
Versailles, palace of (Le Vau, Hardouin-Mansart)
 description of, 862, 863–868, *867, 868*
 gardens, 866, 868, *868*
 grand facade, *862, 863*
 Hall of Mirrors, 866, *867*
Veteran in a New Field, The (Homer), 1178, *1178*
Vian, Boris, 1469
Victoria, queen of England, 1264, 1265, 1269
Victorian Couple (Shonibare), 1566, *1566*
Video art, 1541–1544, *1542, 1543, 1544*
Video Flag (Paik), 1542, *1542*
Vienna, nineteenth century, 1080, 1081, 1091
 description of, 1304
 map of, *1082*
 Romantic music, 1091–1097
Vietnam, 1465
Vietnam War, 1506–1511, 1514
View of Amsterdam (Christaensz-Micker), 834
View of Central Park (Bachman), 1240, *1241*
View of Haarlem for the Dunes at Overveen (Ruisdael), 845, *845*
View of Richmond Showing Jefferson's Capital from Washington Island (Latrobe), *1005*
View of Suzhou Showing the Gate of Changmen, 980, *980*
View of the Wilderness at Kew (Marlow), 978, *979*
View of Vienna from the Josephstadt (Schütz), 1080, *1081*
Vigée-Lebrun (LeBrun), Marie-Louise-Élisabeth
 The Marquise de Pezay and the Marquise de Rougé with Her Two Sons, 1030–1031, *1031*

Portrait of Marie Antoinette, 967, 967
Queen Marie Antoinette and Her Children, 1031, 1031
Vignon, Pierre-Alexandre, La Madeleine, Paris, 1042, 1042
Villa, Pancho, 1436
Villancicos, 887
Villa Savoye (Le Corbusier), France, 1430, 1430
Villas of the Ancients Illustrated (Castell), 943–944
Vindication of the Rights of Woman, A (Wollstonecraft), 1038, 1044–1045
Viola, Bill, 1543
The Fall into Paradise, 1171
Five Angels for the Millennium, 1544, 1544
Violin and Palette (Picasso), 1324–1325, 1325, 1326, 1326
Virgin and Child (Sirani), 817–818, 818
Virginia State Capitol (Jefferson), 1005–1006, 1005
Virginia Woolf (Bell), 1373, 1373
Virgin/Vessel (Hung Liu), 1570, 1571
Vision after the Sermon (Jacob Wrestling with the Angel) (Gauguin), 1300, 1300
Vision for the Green Heart of Holland, (Harrison and Harrison), 1583, 1583
"Visions" (Teresa of Ávila), 805, 810
Vitagraph, 1342
Vitebsk Popular Art School, 1360
Vivaldi, Antonio, 826–827
Voice of the City of New York Interpreted: The Brooklyn Bridge (Stella), 1402, 1403
Volpone (Jonson), 879
Voltaire, 942, 949
Candide, 949–950, 962–964
The Century of Louis XIV, 949
Essay on the Morals and Customs of Nations, 977
Philosophical Letters, 949
Volutes, 814
Von Harbou, Thea, 1411, 1411
Vonnegut, Kurt, *Slaughterhouse-Five*, 1507
V. (Pynchon), 1545
Vow of Louis XIII (Ingres), 1105–1106, 1106
Voyage around the World (Bougainville), 970
Voyage of the Beagle, The (Darwin), 1142–1143

Wagner, Richard, 1548
Bayreuth Festspielhaus, 1170, 1171
"Jewry in Music," 1171–1172
The Jockey Club, 1169–1170
music drama, 1170–1171
The Ring of the Nibelung, 1170
Tannhäuser, 1169–1170
Tristan and Isolde, 1170
Waiting for Godot (Beckett), 1470
Walden, or Life in the Woods (Thoreau), 1070–1071
Wall, Jeff, *After* Invisible Man *by Ralph Ellison, "The Preface," Edition of 2*, 1497, 1498
Walpole, Robert, 906
Walter, Marie-Thérèse, 1368
Wanderer above the Mists, The (Friedrich), 1066, 1067
Wang Hui, *A Thousand Peaks and Myriad Ravines*, 980, 981
War and Peace (Tolstoy), 1207–1208
Warhol, Andy
Campbell's Soup Cans, 1501–1502, 1501
Marilyn Diptych, 1502, 1503
Warner, Charles Dudley, *The Gilded Age*, 1178
War of the Worlds, The (Wells), 1452
War Series (Spero), 1517–1518, 1517
Washington, George, 1000, 1006
George Washington (Houdon), 1006–1007, 1007
Washington D.C., plan for (L'Enfant), 1006, 1006
Washroom and Dining Area of Floyd Burroughs's Home, Hale County, Alabama (Evans), 1444, 1444
Waste Land, The (Eliot), 1354–1355, 1375
Waterer and Watered, 1341, 1341, 1342
"Waterfall" (Cliff), 1575
Water Lilies (Monet), 1198, 1198–1199
Water Music, 1485
Water Music (Handel), 913

Watson, Brook, 1015
Watson and the Shark (Copley), 1014, 1015
Watt, James, 910–911
Watteau, Jean-Antoine
The Embarkation from Cythera, 936, 937
The Signboard of Gersaint, 931, 931, 937, 937
Wealth of Nations, The (Smith), 1014, 1119
"Weary Blues" (Hughes), 1393, 1395, 1413–1414
Weaving
Apache basketry, 988
Navajo basketry, 986–988, 987
Webb, Philip, 1212
Weber, Louise, 1289
Weber, Max, 878
Webern, Anton, 1333
Wedgwood, Josiah, 998
cameos, 1014, 1015
Queen's Ware, 911–912, 911
Weine, Robert, 1410
Wellington's Victory (Wellingtons Sieg) (Beethoven), 1082–1083, 1093
Wells, H. G., 1419, 1452
Wells, Ida B., 1238
Wells, Orson, 1451–1452, 1452
We Shall Repay the Coal Debt to Our Country (Klucis), 1433
Wesselmann, Tom, *Still Life #20*, 1502, 1502
West, Benjamin
Penn's Treaty with the Indians When He Founded the Province of Pennsylvania in North America, 988, 989
Westward the Course of Empire Takes Its Way (Westward Ho!) (Leutze), 1253, 1253
Whale Ship, The (Turner), 1071, 1072
What Is Called Vagrancy (Stevens), 1156, 1157
"What Is Enlightenment?" (Kant), 998
Wheatley, Phyllis, 1010–1011
When We Dead Awaken (Ibsen), 1287
Whistler, James Abbott McNeill, 1217
Nocturne in Black and Gold: The Falling Rocket, 1234, 1234
White Squares (Krasner), 1478, 1478
Whitman, Walt, 1220
"Crossing Brooklyn Ferry," 1221
Democratic Vistas, 1223
"Song of Myself" from *Leaves of Grass*, 1221–1223, 1242–1243
Whitney Museum of American Art (Breuer), 1457
Widmung (Dedication) (Schumann), 1096
Wiesel, Elie *Night*, 1465–1466
"Wild Nights" (Dickinson), 1230–1231
William and Mary, 905
William of Orange, 877
Williams, John, 1515
Williams, William Carlos, 1399
Autobiography, 1403
"The Great Figure," 1400
"The Red Wheelbarrow," 1400
Willy Lott's House, East Bergholt (Constable), 1062, 1062
Wilson, Robert, *Einstein on the Beach*, 1527, 1548, 1548, 1550
Winckelmann, Johann, 1002, 1054
Wizard of Oz, The, 1450, 1450
Wollstonecraft, Mary, 1086
A Vindication of the Rights of Woman, 1038, 1044–1045
Woman's Building (Hayden), Chicago, 1237–1238, 1239
Woman with a Pearl Necklace (Vermeer), 846–847, 847
Women
American, 1225–1226
Anderson, Laurie, 1550, 1550
Antin, Eleanor, 1542–1543, 1543
Austen, Jane, 917–918
Baca, Judith F., 1573–1574, 1573
Beach, Sylvia, 1372, 1372
Behn, Aphra, 1011, 1019
Bell, Vanessa, 1373, 1373
Bonheur, Rosa, 1134, 1136
Bourke-White, Margaret, 1391, 1444, 1445
Bradstreet, Anne, 879, 892
Cassatt, Mary, 1217, 1217, 1236–1237, 1236, 1237

Celnart, Elizabeth, 1118
Chicago, Judy, 1518–1519, 1518, 1519
Chopin, Kate, 1231–1233
Cordero, Helen, 1578
Corn, Blue, 1578
De Beauvoir, Simone, 1468–1469
De Gouges, Olympe, 1037–1038
De Kooning, Elaine, 1478
Dickinson, Emily, 1230–1231, 1243–1244
feminist era, birth of, 1515–1519, 1525
Frankenthaler, Helen, 1481, 1481
Friedan, Betty, 1515–1516
Fuller, Loïe, 1288, 1290
Garbo, Greta, 1410
García Márquez, Gabriel, 1547
Gentileschi, Artemisia, 818–819, 819
Girodet, Anne-Louis, 1035–1036, 1035
Grimke, Sarah, 1128
Guerrilla Girls, 1525, 1525
Harrison, Helen Mayer, 1557–1558, 1558, 1583, 1583
Hartigan, Grace, 1478, 1479
Hasegawa, Itsuko, 1560, 1560
Hayden Sophia, 1237–1238, 1239
Hesse, Eva, 1518, 1518
Höch, Hannah, 1358, 1359
Hung Liu, 1570, 1571
Hurston, Zora Neale, 1394, 1414–1416
Jacquet de la Guerre, Elisabeth-Claude, 874
Jeanne-Claude (de Guillebon), 1491, 1491, 1554, 1555, 1556–1557, 1556
Kahlo, Frida, 1440, 1440
Kauffmann, Angelica, 1032, 1032
Kollwitz, Käthe, 1425, 1426
Krasner, Lee, 1478, 1478
Lange, Dorothea, 1443–1444, 1444
Lawler, Louise, 1533, 1533
Lessing, Doris, 1566
Lewis, Lucy Martin, 1578
Leyster, Judith, 846, 846
Lugo, Nancy Youngblood, 1578, 1578
Maclean, Bonnie, 1512–1513, 1512
Martinez, Maria, 1578
Miller, Lee, 1460, 1461
Mitchell, Joan, 1478, 1479
Mitchell, Joni, 1514
Morales, Aurora Levins, 1546–1547
Mori, Mariko, 1570, 1570
Morisot, Berthe, 1185, 1194, 1200, 1200
Morris, Jane, 1212, 1214
Morris, May, 1214, 1214
Münter, Gabriele, 1332–1333, 1332
Nampeyo, 1578, 1578
Native American quillwork and beadwork, 1259, 1259, 1262
Ndlovu, Beauty, 1567, 1567
Neshat, Shirin, 1571, 1571, 1573
O'Keeffe, Georgia, 1337, 1405–1407, 1406
Oppenheim, Meret, 1370, 1370
Ospedali musicians, 826–827
Parks, Rosa, 1495
Passlof, Pat, 1478
Pickford, Mary, 1408–1409
Plath, Sylvia, 1516, 1521
Popova, Liubov', 1360, 1361
Rich, Adrienne, 1517, 1522
Riefenstahl, Leni, 1432–1433, 1433
Ringgold, Faith, 1494, 1495
Saar, Bettye, 1500, 1500
Schumann, Clara, 1096–1097
Sexton, Anne, 1516–1517
Shelley, Mary, 1086, 1087, 1108
Sikander, Shahzia, 1572, 1573
Sirani, Elisabetta, 817–818, 818
Smith, Bessie, 1395, 1395
Sor Juana Inés de la Cruz, 887
Spero, Nancy, 1517–1518, 1517
Stein, Gertrude, 1319–1320, 1320, 1336
Steir, Pat, 1536, 1538, 1538
Stowe, Harriet Beecher, 1129–1130
Tadjo, Véronique, 1567, 1580–1581
Tafoya, Margaret, 1578
Truth, Sojourner, 1128
Vigée-Lebrun, Marie-Louise-Élisabeth, 967, 967, 1030–1031, 1031

Weber, Louise, 1289
Wheatley, Phyllis, 1010–1011
Wollstonecraft, Mary, 1038, 1044–1045
Woolf, Virginia, 1372–1374
Women's Guild of Art, 1214
Women's rights, fight for, 1214
Woodblock prints, ukiyo-e, 1204, 1267–1269, 1268, 1269
Woodpecker, The (Morris), 1212, 1212
"Woodstock" Festival, 1513–1514
"Woodstock" (Mitchell), 1514
Woolf, Virginia
Mrs. Dalloway, 1372–1373
To the Lighthouse, 1374
Virginia Woolf (Bell), 1373, 1373
Woolworth Building (Gilbert), New York City, 1386, 1388, 1388
Word painting, 913
Wordsworth, William, 1087
Lyrical Ballads, 1056–1057
The Prelude, 1057
"The Rainbow," 1057, 1058
The Recluse, 1057
"Tintern Abbey," 1053, 1056, 1974–1075
Works Projects Administration (WPA), 1440–1442
World War I, 1347, 1350
Dada, 1355–1359
literature and, 1351, 1352–1355
maps, 1350, 1351
mustard gas, use of, 1350
World War II
Allied victory, 1463
concentration camps, 1458, 1459, 1460, 1461
in Europe, 1460–1462, 1462
maps of, 1462, 1463
in the Pacific, 1462–1463, 1463
racial identity in U.S. military, 1464
reactions to, 1465–1466
Wounded Cuirassier Leaving the Field, The (Géricault), 1103, 1103
Wrapped Reichstag (Jeanne-Claude and Christo), 1491, 1491
Wren, Christopher, Saint Paul's Cathedral, London, 900–901, 901
Wright, Frank Lloyd, 1446
Fallingwater (Kaufmann House), Bear Run, Pennsylvania, 1447–1448, 1447
Guggenheim Museum, Solomon R., New York City, 1487, 1487
Robie House, Chicago, 1447, 1447
Wright, Joseph, *Experiment on a Bird in the Air-Pump, An*, 910, 911
Wright brothers, 1318
Wycherley, William, 880
Wye Tour, 1054

X-ray style, 976

Yanagi, Yukinori, *America*, 1562, 1562
Yeats, William Butler, 1290, 1353
"The Lake Isle of Innisfree," 1354
"The Second Coming," 1354
Yellow and Blue One-Stroke Waterfall (Steir), 1538, 1538
Yellow Magic Orchestra, 1514
You Have Seen Their Faces, 1444
Young, Neil, 1513, 1514
Yu the Great Taming the Waters, Qing dynasty, 980, 981, 982

Zaire, Ngbandi mask, 1279, 1279
Zapata, Emiliano, 1436
Zhang Huan, *To Raise the Water Level in a Fish Pond*, 1570–1571, 1571
Zoffany, John, *Dido Elizabeth Belle Lindsay and Lady Elizabeth Murray*, 995, 995
Zola, Émile, 1286, 1287, 1288
Édouard Manet, 1163
Germinal, 1167, 1181–1183
"The Moment in Art," 1163
Portrait of Émile Zola (Manet), 1163, 1166
Thérèse Raquin, 1167
Zoot Suit (Valdez), 1574
Zuckmeyer, Carl, 1422–1423
Zukor, Adolph, 1409
Zulu, 1269
Zweig, Stefan, 1422

BOOK 4
1. Detail of Fig. 30.14
2. Detail of Fig. 26.26A
3. Detail of Fig. 27.6
4. Detail of Fig. 27.3
5. Ch. 25: Detail of Fig. 25.7
 Ch. 26: Detail of Fig. 26.21
 Ch. 27: Detail of Fig. 27.27A
 Ch. 28: Detail of Fig. 28.11
 Ch. 29: Detail of Fig. 29.5
 Ch. 30: Detail of Fig. 30.5
 Ch. 31: Detail of Fig. 31.13
 Ch. 32: Detail of Fig. 32.12

BOOK 5
1. Detail of Fig. 39.16
2. Detail of Fig. 40.11
3. Detail of Fig. 40.19
4. Detail of Fig. 35.5
5. Ch. 33: Detail of Fig. 33.3
 Ch. 34: Detail of Fig. 34.8
 Ch. 35: Detail of Fig. 35.12
 Ch. 36: Detail of Fig. 36.36A
 Ch. 37: Detail of Fig. 37.12
 Ch. 38: Detail of Fig. 38.19
 Ch. 39: Detail of Fig. 39.20
 Ch. 40: Detail of Fig. 40.23

BOOK 6
1. Detail of Fig. 48.24
2. Detail of Fig. 45.14
3. Detail of Fig. 45.21
4. Detail of Fig. 44.09
5. Ch. 41: Detail of Fig. 41.3
 Ch. 42: Detail of Fig. 42.2
 Ch. 43: Detail of Fig. 43.43D
 Ch. 44: Detail of Fig. 44.20
 Ch. 45: Detail of Fig. 45.4
 Ch. 46: Detail of Fig. 46.18
 Ch. 47: Detail of Fig. 47.3
 Ch. 48: Detail of Fig. 48.23

Photo Credits

National Portrait Gallery, London, UK. The Bridgeman Art Library; **34-04** Theodor M. von Holst (1810–44). "Illustration from 'Frankenstein' by Mary Shelley (1797–1851)". Engraving. Private Collection. The Bridgeman Art Library; **34-05** Kavaler/Tischbein, Johann Heinrich the Elder (1722–1789), "Goethe in the Roman Campagna". 1787. Location: Staedelsches Kunstinstitut, Frankfurt am Main, Germany. Kavaler/Art Resource, NY; **34-06** Eugene (Ferdinand Victor) Delacroix (1798–1863), "First Meeting between Faust and Mephistopheles: 'Why all this Noise?'". From Goethe's Faust, 1828. Illustration. Lithograph. Private Collection. The Stapleton Collection. The Bridgeman Art Library; **34-07** Erich Lessing/Carl Schuetz (1745–1800), "Neuer Markt (New Market) Vienna". 18th c. Mozart and Haydn lived nearby. Location: Wien Museum Karlsplatz, Vienna, Austria. Erich Lessing, Art Resource, NY; **34-08** Stieler, Joseph Carl (1781–1858), "Ludwig van Beethoven (1770–1827) Composing his 'Missa Solemnis'". 1819. Oil on canvas. Beethoven Haus, Bonn, Germany. The Bridgeman Art Library; **34-09** Andreas Geiger (1765–1856). "A Concert of Hector Berlioz (1803–69) in 1846". Engraving. Musée de l'Opera, Paris, France. The Bridgeman Art Library; **34-10** Oronoz-Nieto/Francisco de Goya, (Spanish, 1746–1828). "The Third of May, 1808". 1814–1815. Oil on canvas, approx. 8'8" × 11'3". Derechos reservados © Museo Nacional Del Prado-Madrid. Photo Oronoz; **34-11** Goya y Lucientes, Francisco Jose de (1746–1828). "A heroic feat! With dead men!, plate 39 of 'The Disasters of War', 1810–14, pub. 1863" Etching. Private Collection, Index. The Bridgeman Art Library; **34-12** Francisco de Goya y Lucientes (1746–1828), "The Sleep of Reason Produces Monsters (El sueño de la razon produce monstruos). Plate 43 of "The Caprices (Los Caprichos)", first edition; etching, aquatint, drypoint and burin; 87/16 × 57/8 in. (21.5 × 15 cm). The Metropolitan Museum of Art. Gift of Knoedler & Co., 1918 (18.64). Photograph © 1994. The Metropolitan Museum of Art; **34-13** Francisco de Goya y Lucientes (1746–1828), "Saturn Devouring One of His Sons", Mural transferred to canvas (146 × 83 cm). Derechos reservados © Museo Nacional Del Prado-Madrid; **34-14** Musée de Louvre/Géricault, Théodore (1791–1824). "The Wounded Cuirassie". 1814. Oil on canvas. Musée du Louvre/RMN Réunion des Musées Nationaux, France. Bridgeman Art Library, NY.; **34-15** Hervè Lewandowski/Théodore Géricault (1791–1824). "The Raft of the Medusa". First oil sketch. Oil on canvas. 37 × 46 cm. Louvre, Paris. Photo: Hervè Lewandowski. Inv.: RF 2229. © Réunion des Musées Nationaux/Art Resource, NY; **34-16** Le Mage/Eugene Delacroix (1798–1863). "Scene from the Massacre at Chios: Greek families awaiting death or slavery". 1824. Oil on canvas. 419 × 354 cm. Louvre, Paris, France. Photo: Le Mage. © Réunion des Musées Nationaux/Art Resource, NY; **34-17** Giraudon/Jean Auguste Dominique Ingres (1780–1867), "The Vow of Louis XIII (1601–43)". 1824. Oil on canvas. Montauban Cathedral, France, Lauros. Giraudon/The Bridgeman Art Library, NY.; **34-18** Ingres, Jean Auguste Dominique (1780–1867), "Madame Philibert Riviere". Oil on canvas, 116 × 90 cm. Musée du Louvre/RMN Réunion des Musées Nationaux, France. SCALA/Art Resource, NY.; **34-19** Eugène Delacroix (French 1798–1863), "Arab Hoseman Attacked by a Loin". 1849–50. Oil on panel, 17 1/4" × 15". Potter Palmer Collection. 1922.403. The Art Institute of Chicago. Photograph © 2008, The Art Institute of Chicago. All Rights Reserved; **34-20** Géricault, Théodore (1791–1824), "Kleptomania: Portrait of a Kleptomaniac". c. 1819–22. Museum voor Schone Kunsten, Ghent, Belgium. The Bridgeman Art Library; **page 1100** Goya y Lucientes, Francisco Jose de (1746–1828), "193-0082155 Until death, plate 55 of 'Los caprichos', 1799". Etching. Private Collection, Index. The Bridgeman Art Library; **page 1101** Arixiu Mas, Barcelona Francisco Goya, "The Family of Charles IV". 1800. Oil on canvas. 9'2" × 11". Museo del Prado, Madrid. Arixiu Mass, Barcelona/Derechos reservados © Museo Nacional Del Prado-Madrid.

Chapter 35

35-01 Anonymous, "Old Hetton Colliery, Newcastle". Beamish, North of England Open Air Museum, Durham, UK. The Bridgeman Art Library; **35-01 Map** Reprinted by permission of Harper Collins Publishers Ltd. © Hugh Cloud (Editor), "The Times History of London New Edition". 1991; **35-02 Map** The New York Public Library, New York, NY USA/Art Resource, NY; **35-02 Map** Penguin Books Ltd. UK; **35-03** The Illustrated London News; **35-04** The Culture Archive; **35-05** Stewart McKnight/Alamy Images; **35-06** Erich Lessing/Joseph Mallord William Turner (1775–1851), "Rain, Steam, and Speed". Oil on canvas. 90.8 × 121.9 cm. National Gallery, London, Great Britain. Erich Lessing/Art Resource, NY; **35-07** The Image Works; **35-08** Robert Harding Picture Library Ltd./Alamy Images; **35-09** National Portrait Gallery, Smithsonian Institution/Art Resource, NY; **35-10** Sojourner Truth (c.1797–1883) (b/w photo), American Photographer, (19th century). Private Collection, Peter Newark American Pictures. The Bridgeman Art Library; **35-11** Robert Scott Duncanson (1821–72), "Uncle Tom and Little Eva". 1853. Oil on canvas. The Detroit Institute of Arts, USA. The Bridgeman Art Library; **35-12** Hervè Lewanski/Eugène Delacroix (1798–1863), "Liberty Leading the People". July 28, 1830. Painted 1830. Oil on canvas, 260 × 325 cm. Musée du Louvre/RMN Réunion des Musées Nationaux, France. SCALA/Art Resource, NY; **35-13** Honoré Daumier (French, 1809–1879), "Gargantua" 1831. Lithograph. Fine Arts Museums of San Francisco, Museum purchase, Herman Michels Collection, Vera Michels Bequest Fund, 1993.48.1; **35-14** Erich Lessing/Honoré Daumier (1808–1879). "Rue Transnonain, 15 Avril 1834. A murdered family". 28.5 × 44.1 cm. Inv. A 1970-67. Kupferstichkabinett, Staatlichen Kunstsammlungen, Dresden, Germany Erich Lessing/ Art Resource, NY; **35-15** Honoré Daumier, "The Third-Class Carriage". c. 1962. Oil on canvas. 25 3/4" × 35 1/2" (65.4 × 90.2 cm). Bequest of Mrs. H. O. Havemeyer, 1929. The Ho. O. Havemeyer Collection. © 1922 The Metropolitan Museum of Art, NY; **35-16** Gerard Blot/Rosa Bonheur, "Plowing in the Nivernais". 1849. Oil on canvas. 5'9" × 8'8" (1.75 × 2.64 m). Musée d'Orsay, Paris, Gerard Blot/Réunion des Musées Nationaux. Art Resource, NY; **35-17** Jean-François Millet (French, 1814–1875), "The Sower". 1850. Oil on canvas, 101.6 × 82.6 cm (40" × 32 1/2"). Gift of Quincy Adams Shaw through Quincy Adams Shaw, Jr. and Mrs. Marian Shaw Haughton, 17.1485. Photograph © 2008 Museum of Fine Arts, Boston; **35-18** Gernaldegalerie Dresden, Germany/Gustave Courbet (1819–1877), "The Stone Breakers". 1849. Oil on canvas. (destroyed in 1945). Galerie Neue Meister, Dresden, Germany. © Staatliche Kunstsammlungen, Dresden. The Bridgeman Art Library; **35-19** William Henry Fox Talbot (English 1800–1877), "Wrack". 1839. Photogenic deawing (salted paper print), 22 × 17.5 cm (8 11/16" × 8 7/8"). Harris Brisbane Dick Fund, 1936 (36.37.20). The Metropolitan Museum of Art, Harris Brisbane Dick Fund, 1936 (36.37.20). Image © The Metropolitan Museum of Art/Art Resource, NY.; **35-20** Louis-Jacques-Mande Daguerre, "Le Boulevard du Temple", 1839, Daguerrotype. Bayerisches Nationalmuseum Munchen; **35-21** Charles Richard Meade (Daguerreotypist) American 1826–1858, "Portrait of Louis-Jacques-Mande Daguerre". 1848. 22.1 × 17.8 cm (8 11/16" × 7"). The J. Paul Getty Museum, Los Angeles; **35-22** J. Paul Getty Museum, Los Angeles/Getty Images, Inc.; **35-23** Scenes of the 'Beagle' being repaired, on the distant cordillera of the Andes, and laid ashore on the Santa Cruz River, engraved by Thomas Landseer (1795–1880) (engraving) (b/w photo), Martens, Conrad (1801–78) (after), Private Collection. The Bridgeman Art Library; **35-24** The

Philadelphia Museum of Art/Édouard Manet (1832–1883) "The Battle of the "Kearsarge" and the "Alabama." 1864. Oil on canvas. 54 1/4 × 50 3/4 in. (137.8 × 128.9 cm). John G. Johnson Collection, 1917. Philadelphia Museum of Art, Philadelphia, Pennsylvania, U.S.A. Art Resource, NY; **pages 1138–1139** Hervè Lewandowski/Gustave Courbet(1819–1877), "Burial at Ornans". 1849–1850. Oil on canvas, 311.5 × 668.0 cm. Hervè Lewandowski/Musée d'Orsay, Paris, France. RMN Réunion des Musées Nationaux/Art Resource, NY.

Chapter 36

36-01 Société Française de Photographie/SFP; **36-02** Ernest Meissonier (1815–1891), "The Barricade, rue de la Mortellerie (Souvenir of the Civil War)." June 1848. Oil on canvas, 29 × 22 cm. Inv. RF1942-31. Location: Louvre, Paris, France. Musée du Louvre/RMN Réunion des Musées Nationaux, France. SCALA/Art Resource, NY; **36-03** Hervè Lewandowski/Alfred G. Stevens (1823–1906), "Those Whom They Call the Vagabonds (The Hunters of Vincennes)". 1855. Oil on canvas, 130 × 165 cm. Musée d'Orsay, Paris, France. Photo: Hervè Hewandowski/Réunion des Musées Nationaux. Art Resource, NY; **36-04** Caisse Nationale des Monuments Historique et des Sites, Paris, France; **36-05** Giraudon/Edouard Manet (1832–1883), "Jeanne Duval (Baudelaire's mistress) reclining". 1862. Location: Museum of Fine Arts (Szepmuveszeti Muzeum), Budapest, Hungary. Giraudon/Art Resource, NY; **36-06** Édouard Manet, "Luncheon on the Grass (Le Déjeuner sur l'Herbe)". 1863. Oil on canvas. 7' × 8'10" (2.13 × 2.6 m). Musée d'Orsay, Paris. RMN Réunion des Musées Natioaux/Art Resource, NY. © 2008 ARS Artists Rights Society, NY; **36-07** RMN/Marcantonio Raimondi (1480–1527/34), "The Judgement of Paris". Inv. 4167LR. Rothschild Collection. Musée du Louvre/RMN Réunion des Musées Nationaux, France. SCALA/Art Resource, NY; **36-08** Hervè Lewandowski/Édouard Manet (1832–1883), "Portrait of Émile Zola". ca. 1868. Oil on canvas, 146.5 × 114 cm. RF2205. Musée d'Orsay, Paris, France. Photo: Hervè Lewandowski. Réunion des Musées Nationaux/Art Resource, NY; **36-09** Robert Harding Picture Library Ltd; **36-10** Gerard Blot/Edouard Detaille (1848–1912), "Inauguration of the Paris Opera House, January 5, 1875: Arrival of Lord Maire (with entourage) from London, Greeted by Charles Garnier". Gouache on paper. Photo: Gerard Blot. Chateaux de Versailles et de Trianon, Versailles, France. Réunion des Musées Nationaux/Art Resource, NY; **36-11** Kira Perov/Bill Viola Studio; **36-12** © 2003 Yale University Press/Spotts, BAYREUTH: A History of the Wagner Festival (1994), image p. 9; **36-13** J. Eastman Johnson (1824–1906), "Old Kentucky Home Life in the South". 1859. Oil on canvas. © Collection of the New-York Historical Society, USA/The Bridgeman Art Library; **36-14** J. Eastman Johnson, (1824–1906), "A Ride for Liberty, or The Fugitive Slaves". c. 1862. Oil on board. © Brooklyn Museum of Art, New York, USA/The Bridgeman Art Library Nationality/copyright status: American/out of copyright; **36-15** Winslow Homer (1836–1910), "The Army of the Potomac—A Sharp Shooter on Picket Duty". 1862. Wood Engraving on paper, 9 1/8 × 13 13/16 in. (23.2 × 35 cm). Gift of International Machines Corp. Location: Smithsonian American Art Museum, Washington, D.C. Art Resource, NY; **36-16** Timothy O'Sullivan (1840–1882), "A Harvest of Death, Gettysburg, Pennsylvania". Location: The New York Public Library, New York, NY/Art Resource, NY; **36-17** Winslow Homer (American, 1836–1910), "The Veteran in a New Field". 1965. Oil on canvas, 24 1/8" × 38 1/8" (61.3 × 96.8). The Metropolitan Museum of Art, NY. Bequest of Miss Adelaide Milton de Groot (1876–1967), 1967 (67.187.131). Image copyright © The Metropolitan Museum of Art; **36-18** Édouard Manet, "The Railway". 1873. Oil on canvas, .933 × 1.115 (36 3/4" × 45 1/8"). Framed: 1.130 × 1.327 × .054 cm (44 1/2" × 52 1/4" × 2 1/8"). Gift of Horace Havemeyer in memory of his mother, Louisine W. Havemeyer. 1956.10.1. Image © 2007. Board of Trustees, National Gallery of Art, Washington, D.C. © 2008 ARS Artists Rights Society, NY; **page 1164** SCALA/Art Resource, N.Y.; **page 1165** (top) Hervè Lewandowski/Édouard Manet (1832–1883), "Olympia". 1863. Oil on canvas, 130.5 × 190.0 cm. Inv. RF 2772. Hervè Lewandowski/ Musée d'Orsay, Paris, France. RMN Réunion des Musées Nationaux/Art Resource, NY. © 2008 Édouard Manet/Artists Rights Society (ARS), NY; **page 1165** (bottom) P. Selert/Alexandre Cabanel (1824–1889), "Birth of Venus". 1863. Oil on canvas, 130 × 225 cm. P. Selert/Musée d'Orsay, Paris, France. Réunion des Musées Nationaux/Art Resource, NY; **page 1170** From Jeremy Yudkin, "Understanding Music," 5/e © 2008, Pearson Education.

Chapter 37

37-01 Erich Lessing/Art Resource, N.Y.; **37-02** Roger-Viollet Agence Photographique; **37-03** Gustave Caillebotte (French 1848–1894), "Paris Street: Rainy Day". 1877. Oil on canvas. 83 1/2" × 108 3/4" (212.2 × 276.2 cm). Charles H. and Mary F.S. Worcester Collection, 1964.336. Photograph © 2006, The Art Institute of Chicago. All Rights Reserved; **37-04** Erich Lessing/Art Resource, N.Y.; **37-05** Henry Guttmann/Stringer/Henry Guttmann/Stringer/Getty Images, Inc.; **37-06** Erich Lessing/Claude Monet (1840–1926), "Regatta at Argenteuil". c. 1872. Location: Musée d'Orsay, Paris, France. Erich Lessing/Art Resource, N.Y.; **37-07** Erich Lessing/Claude Monet (1840–1926), "Impression, Sunrise". 1872. Oil on canvas, 48 × 63 cm. Painted in Le Havre, France. Location: Musée Marmottan-Claude Monet, Paris, France. Erich Lessing/Art Resource, NY; **37-08** Scala/Claude Monet (1840–1926), "Carnival on the Boulevard des Capucines in Paris". 1873. Location: Pushkin Museum of Fine Arts, Moscow, Russia. Scala/Art Resource, NY; **37-09** Claude Monet (French, 1840–1926), "Grainstack (Snow Effect)". 1891. Oil on canvas, 65.4 × 92.4 cm (25 3/4" × 36 3/8"). Gift of Miss Aime and Miss Rosamond Lamb in memory of Mr. and Mrs. Horatio Appleton Lamb, 1970.253. Photograph © 2008 Museum of Fine Arts, Boston; **37-10** Berthe Morisot (1841–1895), "Summer's Day". Oil on canvas. 45.7 × 75.2 cm. © National Gallery, London; **37-11** Erich Lessing/Camille Pissarro (1830–1903), "Red Roofs, a Village Corner, Winter". 1877. Oil on canvas. 54.5 × 65.6 cm. Musée d'Orsay, Paris, France. Erich Lessing/Art Resource, NY; **37-12** The Phillips Collection; **37-13** Hilaire-Germain-Edgar Degas (French 1834–1917), "The Dance Class". 1874. Oil on canvas, 32 7/8" × 30 3/8" (83.5 × 77.2 cm). The Metropolitan Museum of Art. Bequest of Mrs. Harry Payne Bingham, 1986 (1987.47.1). Image copyright © The Metropolitan Museum of Art; **37-14** Erich Lessing/Edgar Degas(1834–1917), "Café Concert aux Ambassadeurs". Musée des Beaux-Arts, Lyon, France. Erich Lessing/Art REsource, NY; **37-15** Utagaawa Hiroshige (Japanese 1797–1858), "Ushimachi, Takanawa; No. 81 from One Hundred Famous views of Edo". Edo Period. Ansei Era, 4/1857. Woodblock print. 13 3/8" × 8 3/4"; 14 3/16" × 9 1/4". Gift of Anna Ferris. Brooklyn Museum of Art; **37-16** Edgar Degas (1834–1917), "The Race Course-Amateur Jockeys near a Carriage". c. 1876-87. Oil on canvas. Musée d'Orsay, Paris, France. The Bridgeman Art Library; **37-17** John Webb/Edouard Manet, "A Bar at the Folies-Bergere", 1881–82. The Courtauld Gallery, London. © 2008 ARS Artists Rights Society, NY; **37-18** Laurent Sully Jalmes/Mention obligatoire Les Arts Decoratifs, Paris (Inv. 7972); Musée de la Publicité (Inv. 10531); Photo: Laurent Sully Jaulmes. Tous droits reserves; **37-19** Bildarchiv Preussischer Kulturbesitz/Ilya Repin(1844–1930), "Tolstoy Ploughing in the Field". 1882. Photo: Roman Beniaminson. Tretyakov Gallery, Moscow, Russia. Bildarchiv Preussischer Kulturbesitz/Art

Resource, NY.; **37-20** © 2009. State Russian Museum, St. Petersburg; **37-21** Burton, Charles (fl.1851-83)/Guildhall Library, Corporation of London, UK/The Bridgeman Art Library; **37-22** Historical Picture Archive/© Historical Picture Archive/CORBIS; **37-23** Morris and Company, "The Woodpecker," 1885. Wool tapestry designed by Morris. William Morris Gallery, Walthamstow, England; **37-24** Aberdeen Art Gallery & Museums Collections; **37-25** Laing Art Gallery, newcastle-upon-tyne/Laurie Platt Winfrey, Inc.; **37-26** R. H. Hensleigh/May Morris (1862–1938), Bed Hangings (Two Curtains), 1917 or earlier. Embroidered wool on linen, each panel 76 3/4 × 27 in. Collection of Cranbrook Art Museum, Bloomfield Hills, Michigan. Gift of George Gough Booth and Ellen Scripps Booth. Photo: R. H. Hensleigh. (CAM 1955.402.); **37-27** Utamuro Kitagawa (1753–1806 Japan), "Shaving a Boy's Head". 1801 (Edo Period). Color woodblock print. 14 15/16" × 9 13/16" (38 × 25 cm). Signed Utamuro hitsu. Bequest of Richard P. Gale. The Minneapolis Institute of Arts; **37-28** Dean Beasom/Mary Cassatt (American, 1844–1926), "The Bath". c. 1891. Drypoint and soft-ground etching in yellow, blue, black and sanguine, (mathews and Shapiro 1989 5.xvi/xvii], Plate: .319 × .249 (12 9/16" × 9 13/16"); Sheet: .367 × .275 (14 7/16" × 10 13/16"). Rosenwald Collection. Photograph © Board of Trustees, National Gallery of Art, Washington, D.C. Photo: Dean Beasom; page 1198 (top) Erich Lessing/Claude Monet(1840–1926), "Waterlilies-Sunset". Oil on canvas. Musée de l'Orangerie, Paris, France. Erich Lessing/Art Resource, NY; page 1198 (bottom) Gerard Blot/Hervé Lewandowski/Claude Monet (1840–1926), "Room 1 of the Waterlilies (Nymphéas)". Photo: Gèrard Blot/Hervè Lewandowski. Musée de l'Orangerie, Paris, France. Réunion des Musées Nationaux/Art Resource, NY.

Chapter 38

38-01 George Bellows, "Cliff Dwellers". 1913. Oil on canvas, 40 3/16" × 42 1/16" (102.07 × 106.82 cm). Los Angeles County Museum of Art. Los Angeles County Fund. Photograph © 2007 Museum Associates/LACMA; **38-02** Childe Hassam, "The Manhattan Club". ca. 1891. Oil on canvas, 18 1/4" × 22 1/8". Santa Barbara Museum of Art, Gift of Mrs. Sterling Morton to the Preston Morton Collection. 1960.62; **38-03** Five Cents a Spot: Lodgers in a Bayard Street Tenement". c. 1899. Museum of the City of New York, Jacob A. Riis Collection; **38-04** Robert Koehler(1850–1917), "The Strike" 1886. Oil on canvas. Deutsches Historisches Museum, Berlin, Germany/The Bridgeman Art Library, N.Y.; **38-05** Thomas Wilmer Dewing (1851–1938), "A Reading". 1897. Oil on canvas, 20 1/4" × 30 1/4" (51.3 × 76.8 cm.). Bequest of Henry Ward Ranger through the National Academy of Design. Smithsonian American Art Museum, Washington, D.C./Art Resource, NY ; **38-06** William Merritt Chase, "Tompkins Park, Brooklyn". 1886. Oil on canvas, 17 3/8" × 22 3/8". Colby College Museum of Art, Gift of Miss Adeline F. & Miss Caroline R. Wing, 1963.040; **38-07** Winslow Homer (1836–1910), "The Life Line". 1884. Oil on canvas, 28 5/8" × 44 3/4" (72.7 × 113.7 cm). The George W. Elkins Collection, 1924. The Philadelphia Museum of Art, Philadelphia/Art Resource, NY.; **38-08** Philip F. Gura; **38-09** Frank Driggs/Frank Driggs Collection/Getty Images, Inc.; **38-10** The Detroit Institute of Arts./James Abbott McNeil Whistler, "Nocturne in Black and Gold: The Falling Rocket". c. 1874. Oil on panel. 23 3/4" × 18 3/8" (60.2 × 46.8 cm). Detroit Institute of Arts. Gift of Dexter M. Ferry, Jr. 46.309. The Bridgeman Art Library Inc.; **38-11** John Singer Sargent (American, 1856–1925), "The Daughters of Edward Darley Boit". 1882. Oil on canvas, 221.93 × 222.57 cm (87 3/8" × 87 5/8"). Gift of Mary Louisa Boit, Julia Overing Boit, Jane Hubbard Boit, and Florence D. Boit in memory of their father, Edward Darley Boit, 19.124 Photograph © 2008 Muscum of Fine Arts, Boston; **38-12** Mary Stevenson Cassatt , American, 1844–1926, "In the Loge", 1878. Oil on canvas, 81.28 × 66.04 cm. (32 × 26 in.). Museum of Fine Arts, Boston. The Hayden Collection-Charles Henry Hayden Fund, 10.35. Photograph © Museum of Fine Arts, Boston; **38-13** Chicago Historical Society; **38-14** Mary Stevenson Cassatt (American, 1844–1926), "Gathering Fruit" about 1893. Drypoint, softground etching, and aquatint printed in color from three plates Catalogue Raisonne: Breeskin 157, ninth state (only known impression of this state, not in Breeskin; cf Mathews and Shapiro cat.15) Platemark: 42.2 × 29.8 cm (16 5/8" × 11 3/4") Sheet: 50.5 × 39 cm (19 7/8" × 15 3/8"). Gift of William Emerson and The Hayden Collection—Charles Henry Hayden Fund, 41.813. Photograph © 2008. Museum of Fine Arts, Boston; **38-15** Charles Graham/The Granger Collection, New York. COLUMBIAN EXPOSITION, 1893. Women's Building, World's Columbian Exposition, Chicago, 1893: water color, 1893, by Charles Graham; **38-16** Vanni/Art Resource, N.Y.; **38-17** John Bachman, "Line Central Park, Summer, Looking South". 1865. Colour Litho. (fl.1850-77). © Museum of the City of New York, USA/The Bridgeman Art Library; **38-18** National Park Service, Frederick Law Olmsted National Historic Site; **38-19** Christie's IMages/John Cast, "American Progress". 1872. Oil on canvas. (fl.1872). Private Collection. Photo © Christie's Images/ The Bridgeman Art Library; page 1128 Thomas Cowperthwait Eakins (1844–1916). "The Gross Clinic". 1875. Oil on canvas. Jefferson College, Philadelphia, PA, USA/The Bridgeman Art Library; page 1129 Thomas Eakins, "The Agnew Clinic". Philadelpia Museum of Art on load from the University of Pennsylvania School of Medicine.

Chapter 39

39-01 George Catlin, (1796–1872), "Big Bend on the Upper Missouri, 1800 Miles Above St. Louis". 1832. Smithsonian American Art Museum, Washington, D.C./Art Resource, NY; **39-02** Albert Bierstadt (American, 1830–1902), "The Rocky Mountains, Lander's Peak". 1863. Oil on canvas, 73 1/2" × 120 3/4" (186.7 × 306.7 cm). The Metropolitan Museum of Art, Rogers Fund, 1907 (07.123). Image copyright © The Metropolitan Museum of Art; **39-02Map** W.W. Norton & Company, Inc.; **39-03** Emanuel Gottlieb Leutz (1816–1868), "Westward the Course of Empire Takes Its Way (Mural Study, U.S. Capitol)", 1861. Oil on canvas, 33 1/4" × 43 3/8" (84.5 × 110.1 cm). Smithsonian American Art Museum, Washington, D.C./Art Resource, NY.; **39-04** John Vanderlyn (American, 1775–1852), "The Murder of Jane McCrea". 1803–1804. 32" × 26 1/2". Courtesy Wadsworth Atheneum Museum of Art, Hartford, Connecticut. Purchased by Subscription; **39-05** Victoria & Albert Museum, London/Art Resource, N.Y.; **39-06** George Catlin (1796–1872), "The Last Race, Mandan O-kee-pa Ceremony". 1832. Smithsonian American Art Museum, Washington, D.C./Art Resource, NY; **39-07** George Catlin (1796–1872), "Mah-to-tohpa, Four Bears, second chief, in full dress (Mandan)". 1832. Oil on fabric; canvas mounted on aluminum, 29 × 24 in. Smithsonian American Art Museum, Washington, D.C./Art Resource, NY.; **39-08** © 2007 Harvard University, Peabody Museum Photo 99-12-10/53121 T4279; **39-09** Smithsonian National Museum of Natural History; **39-10** George Catlin, (1796–1872), "Big Bend on the Upper Missouri, 1800 Miles Above St. Louis". 1832. Smithsonian American Art Museum, Washington, D.C./Art Resource, NY; **39-11** Buffalo Bill Historical Center, Cody, Wyoming; Gertrude Vanderbilt Whitney Trust Fund Purchase; **39-12** Photograph courtesy Peabody Essex Museum; **39-13** Shekh Muhammad Amir, "A Horse and Groom". 1830–1850, Calcutta, India. Pencil and Opaque Watercolor with touches of white and bum Arabic. 11" × 17 1/2". Arthur M. Sackler Gallery, Smithsonian Institution, Washington, D.C. Purchase, S1999.121; **39-14**

Asian Art & Archaeology, Inc./© Asian Art & Archaeology, Inc./CORBIS. All Rights Reserved; **39-15** Kitagawa Utamaro (Japanese, 1754–1806), "How the Famous Brocade Prints of Edo are Produced," (Edo Meibutsu Nishiki-e Kosaku). Ink and color on paper, 38.3 × 74.3 cm. Clarence Buckingham Collection, 1939.2141. © The Art Institute of Chicago. All Rights Reserved; **39-16** Kitagawa Utamaro (1753–1806), "The Fickle Type Uwaki no so 'The fancy-free type'" from the series "Ten Physiognomies of Women," c. 1793. Color woodcut, 14 × 9 7/8 in. (36.4 × 24.5 cm). Print Collection. Miriam and Ira D. Wallach Division. The New York Public Library/Art Resource, NY; **39-17** Historical Picture Archive/Hokusai, "The Great Wave off Kanagawa", from the series "Thirty-Six Views of Mount Fuji". 1823–1829. Color Woodcut. 10' × 15". © Historical Picture Archive/CORBIS; **39-18** Neg./Transparency no. 111806. Photo by Herbert Lang. Courtesy Dept. of Library Services, American Museum of Natural History; **39-19** Neg./Transparency no. 90.1/4180. Courtesy Dept. of Library Services, American Museum of Natural History; **39-20** Female Figure (nksi), Kongo people. Late nineteenth century. Wood. Iron Nails, glass, reson. 20 1/4" × 11". The Stanley Collection. X1986.573. The University of Iowa Museum of Art, Iowa City, IA; **39-21** Pablo Picasso (1881–1973), "Les Demoiselles d'Avignon". Paris. June–July 1907. Oil on canvas, 8' × 7' 8". Acquired through the Lille P. Bliss Bequest. (333.1939). The Museum of Modern Art, New York, NY, U.S.A. Digital Image © The Museum of Modern Art/Licensed by SCALA/Art Resource, NY. © Estate of Pable Picasso/ARS Artists Rights Society; **39-22** The Stanley Collection, The University of Iowa Museum of Art, Iowa City, IA. X1986.591; page 1260 Howling Wolf, "Treaty Signing at Medicine Lodge Creek," 1875–78. Ledger drawing, pencil, crayon and ink on paper, 8 × 11 in. Courtesy, New York State Library, Albany, New York; page 1261 John Taylor, "Treaty Signing at Medicine Creek Lodge," 1867. Drawing for "Leslie's Illustrated Gazette," September–December. 1867, as seen in Douglas C. Jones, "The Treaty of Medicine Lodge," page xx, Oklahoma University Press, 1966.

Chapter 40

40-01 Smithsonian Institution/Office of Imaging, Printing, and Photographic Services; **40-02** Courtesy of the Library of Congress, LC-USZ62-106562; **40-03** Mention obligatoire Les Arts Decoratifs, Paris (Inv. 7972); Musée de la Publicite (Inv. 10531); Photo: Laurent Sully Jaulmes. Tous droits reserves; **40-04** SOFAM, Brussels/Ch. Bastin & J. Evrard; **40-05** Scala/Jan Toorop, "Delftsche Slaolie". Dutch advertisement poster. Scala/Art Resource, NY; **40-06** Philippe Galard/The Kiss, 1888–98 (marble), Rodin, Auguste (1840–1917)/Musée Rodin, Paris, France, Philippe Galard/The Bridgeman Art Library; **40-07** Vanni Art Resource, N.Y.; **40-08** Auguste Rodin, "Dancing Figure". 1905. Graphite and watercolor, .326 × .250 cm (12 7/8" × 9 7/8"). Gift of Mrs. John W. Simpson. 1942.5.36. Image © 2007 Board of Trustees, National Gallery of Art, Washington, D.C.; **40-09** Henri de Toulouse-Lautrec, "Miss Loie Fuller". 1893. Color lithograph. 1947.7.185 Rosenwald Collection. Image © 2007 Board of Trustees, National Gallery of Art, Washington, D.C.; **40-10** Henri Marie Raymond de Toulouse-Lautrec (1864–1901 French), "At the Moulin Rouge". 1892–95. Oil on canvas. 123 × 141 cm. Helen Birch Bartlett Memorial Collection, 1928.610. Photograph © 2006, The Art Institute of Chicago. All Rights Reserved; **40-11** Georges Seurat (French 1859–1891). "A Sunday on La Grande Jatte-1884". 1884-86. Oil on canvas. 81 3/4" × 121 1/4" (207.5 × 306.1 cm). Helen Birch Bartlett Memorial Collection, 1926.224. Combination of quadrant captures F1, F2, G1, G2. Photograph © 2006, The Art Institute of Chicago. All Rights Reserved; **40-12** Georges Seurat (French 1859–1891), "Models". 1886–1888. Oil on canvas. 78 3/4" × 98 3/8". The Barnes Foundation, Merion, Pennsylvania; **40-13** Yale University Art Gallery Vincent van Gogh (1853–1890), "Night Café (Le Café de nuit)". 1888. Oil on canvas, 28 1/2 × 36 1/4 in. 1961.18.34. Yale University Art Gallery, New Haven, Connecticut/Art Resource, NY; **40-14** Vincent van Gogh (1853–1890), "The Starry Night". 1889. Oil on canvas. 29 × 36 1/4 ". Acquired through the Lillie P. Bliss Bequest. (472.1941). Digital Image © The Museum of Modern Art/Licensed by Scala-Art Resource, NY; **40-15** Vincent van Gogh (1853–90), "Portrait of Patience Escalier". 1888. Oil on canvas. Private Collection/Photo © Lefevre Fine Art, Ltd., London/The Bridgeman Art Library; **40-16** Paul Cézanne (French 1839–1906), "The Bay of Marseilles, Sean from l'Estaque". c. 1885. Oil on canvas, 80.2 × 100.6 cm. Mr. and Mrs. Martin A. Ryerson Collection. 1933.1116. Reproduction, The Art Institute of Chicago. All Rights Reserved; **40-17** Graydon Wood/Paul Cezanne, "Mont Sainte-Victoire". 1902–4. Oil on canvas, 28 3/4" × 36 3/16" (73 × 91.9 cm). Photo Graydon wood. Philadelphia Museum of Art: The George W. Elkins Collection, 1936. E1936-1-1; **40-18** Paul Gauguin, French, (1848–1903). "The Vision After the Sermon", 1888. Oil on canvas, 28 3/4 × 36 1/2". The National Gallery of Scotland, Edinburgh, Scotland; **40-19** Paul Gauguin, "Mahana no atua (Day of the God)". 1894. Oil on canvas. 27 3/8" × 35 5/8" (69.5 × 90.5 cm). The Art Institute of Chicago. Helen Birch Bartlett Memorial Collection (1926.198) Photograph © 2007, The Art Institute of Chicago. All Rights Reserved; **40-20** Curt Stoeving (1863–1939), "Friedrich Nietzsche". 1894. Oil on canvas. Stiftung Weimarer Klassik and Kunstsammlungen, Weimar, Germany. Bilderchiv Preussischer Kulturbesitz/Art Resource, NY; **40-21** J. Lathion/Edvard Munch, "Skrik (The Scream)". 1893. Tempera and wax crayon on cardboard. 91.00 × 73.50 cm. Nasjonalgalleriet, Oslo. Photo: J. Lathion © Nasjonalgalleriet 02. © 2008 Artists Rights Society (ARS), NY/ADAGP, Paris; **40-22** Erich Lessing/Art Resource, NY; **40-23** Erich Lessing/Art Resource, N.; **40-24** © Bettmann/CORBIS All Rights Reserved; page 1298 Paul Cezanne (1836–1906), "The Peppermint Bottle", 1893/1895, oil on canvas, .659 ×.821 (26 × 32-3/8); framed: 1.057 × .908 (41 5/8 × 35 3/4). Image © 2007 Board of Trustees, National Gallery of Art, Washington. Chester Dale Collection; page 1299 The Samuel Courtauld Trust, Courtauld Institute of Art Gallery, London.

Chapter 41

Book Opener Yukinori Yanagi, "America". 1994. 12" × 18", each box (36 boxes). Ants, colored sand, plastic box, plastic tube, plastic pipe. Installation view at Museum of Contemporary Art, San Diego, 1994 collection of Artist; **41-01** Jacques-Henri Lartigue (1894–1986), "Course at Dieppe". 1912. Gelatin silver print, 10 × 13 1/2 (25.4 × 34.3 cm). Gift of the photographer. (28.1963). Digital Image © The Museum of Modern Art/Licensed by SCALA-Art Resource, NY. © Copyright Grand Prix of the Automobile Club of France; **41-02** Pablo Picasso (1881–1973), "Gertrude Stein". 1906. Oil on canvas, H. 39-3/8, W. 32 in. (100 × 81.3 cm). Bequest of Gertrude Stein, 1946 (47.106). The Metropolitan Museum of Art, New York, NY, U.S.A. Image copyright © The Metropolitan Museum of Art/Art Resource, NY. © ARS Art Rights Society, NY; **41-03** Pablo Picasso, "Les Demoiselles d'Avignon". 1907. Oil on canvas. 8' × 7'8" (2.44 × 2.34 m). Acquired through the Lillie P. Bliss Bequest. The Museum of Modern Art/Licensed by SCALA-Art Resource, NY. © 2008 ARS Artists Rights Society, NY; **41-04** Henri Matisse, "Joy of Life". 1905–1906. Oil on canvas. 69 1/8 × 94 7/8 in. © 1995 the Barnes Foundation. 2008 Succession H. Matisse, Paris/Artists Rights Society (ARS), New York; **41-05** Henri Matisse, "Dance". Oil on canvas. 260 × 391 cm. Inv. No. 9673. The State Hermitage Museum, St. Petersburg, Russia. © 2008 Succession H. Matisse, Paris/Artists Rights Society (ARS),

New York; **41-06** Georges Braque, "Houses in L'Estaque". 1908. Peter Lauri/Kunstmuseum Bern. Estate of George Braque © 2008 Artists Rights Rights (ARS), NY/ADAGP, Paris; **41-07** Jens Ziehe/Pablo Picasso (1881–1973), "Horta de Ebro-Houses on a Hill". 1909. Oil on canvas. 65.09 × 81.28 cm. Jens Ziehe/Nationalgalerie, Museum Berggruen, Staatliche Museen zu Berlin, Berlin, Germany. Bildarchiv Preussischer Kulturbesitz/Art Resource, NY. © ARS Artists Rights Society, NY; **41-08** George Braque (1882–1963, French), "Violin and Palette". 1909. Oil on canvas. 36 1/2" × 16 1/4". Solomon Guggenheim Museum. 54.1412. George Braque © 2008 Artists Rights Rights (ARS), NY/ADAGP, Paris; **41-09** SCALA/Carlo Carra (1881–1966), "Interventionist Manifesto, or Paintings-Words in Liberty". 1914. Collage on cardboard, 38.5 × 30 cm. Coll. Mattioli, Milan, Italy. SCALA/Art Resource, NY. © 2008 ARS Artists Rights Society, NY; **41-10** The Museum of Modern Art/Boccioni, Umberto (1882–1916), "Unique Forms of Continuity in Space". 1913. Bronze. 43 7/8 × 34 7/8 × 15 3/4". Acquired through the Lillie P. Bliss Bequest. (231.1948). Digital Image © The Museum of Modern Art/Licensed by SCALA/Art Resource, NY; **41-11** Ernst Ludwig Kirchner (1880–1938), "Self-portrait with Model". 1910, reworked 1926. Oil on canvas, 150.4 × 100 cm. Inv. 2940. Photo: Elke Walford. Hamburger Kunsthalle, Hamburg, Germany. Bildarchiv Preussischer Kulturbesitz/Art Resource, NY; **41-12** Franz Marc, "The Large Blue Horses". 1911. Oil on canvas. 3'5 3/8" × 5'11 1/4" (1.05 × 1.81 m). Walker Art Center, Minneapolis, Gift of T. B. Walker Collection, Gilbert M. Walter Fund, 1942; **41-13** Wassily Kandinsky (1866–1944), "Black Lines, December 1913". Oil on canvas. Solomon R. Guggenheim Museum, NY, USA. © DACS. Giraudon/The Bridgeman Art Library. © 2008 ARS Artists Rights Society, New York; **41-14** Krannert Art Museum, University of Illinois at Urbana-Champaign; **41-15** Peter Willi/Wassily Kandinsky (1866–1944), "Impression no. 3 (Concert)". 1911 Oil on canvas. Stadtische Galerie im Lenbachhaus, Munich, Germany. © DACS/Peter Willi. The Bridgeman Art Library. © 2008 ARS Artists Rights Society, NY; **41-16** Arnold Schoenberg, "Green Self-Portrait". 1910. Schoenberg Center, Vienna. Verwertungsgesellschaft Bildener Kunstler (VBK), Vienna; **41-17** Anvil Press Poetry; **41-18** Alfred Stieglitz/Alfred Stieglitz, "The Steerage", 1907. Courtesy George Eastman House. © 2008 ARS Artists Rights Society, NY; **41-19** Paul Strand (1890–1976) © Aperture Foundation "Camera Work". June 1917: Abstraction, Porch Shadows. 24 × 16.5 cm. Inv. Pho1981-35-10. Repro-Photo: Reno-Gabriel Ojoda. Musée d'Orsay, Paris, France. Réunion des Musées Nationaux/Art Resource, NY; **41-20** Graydon Wood, 1994/Marcel Duchamp, "Nude Decending a Staircase No. 2". 1912. 58" × 35". Oil on canvas. Philadelphia Museum of Art: The Louise and Walter Arensberg Collection. Photo: Graydon Wood, 1994. © 2008 Artists Rights Society, NY; **41-21** This article was provided by OldMagazineArticles.com which is from http://www.oldmagazine articles.com/about_us.php; **41-22** Eadweard Muybridge (English 1830–1904), "Annie G. Cantering, Saddled," 1887. Collotype print, Size: sheet: 19 in. × 24 in., image: 7 1/2 in. × 16 1/4 in. Philadelphia Museum of Art: City of Philadelphia, Trade & Convention Center, Dept. of Commerce (Commercial Museum); **41-23** Mary Evans Picture Library/Everett Collection; **41-24** D.W. Griffith/D.W. Griffith, battle scene from "The Birth of a Nation," 1915. The Museum of Modern Art/Film Stills Archive. Courtesy of the Library of Congress; **41-25** Pablo Picasso, "Glass and Bottle of Suze". 1912. Pasted papers, gouache, and charcoal on paper. 25 2/5 × 19 2/3" (64.5 50 cm). Mildred Lane Kemper Art Museum, Washington University in St. Louis. University purchase, Kende Sale Fund, 1946. © Succession Picasso/DACS 1998. © 2008 Estate of Pablo Picasso/Artists Rights Society (ARS), New York; page 1326 CNAC/MNAM/Pablo Picasso (1881–1973), "Violin". 1912. Charcoal and papier colles on paper. Musée National d'Art Moderne, Centre Georges Pompidou, Paris, France. Musée National d'Art Moderne. CNAC/MNAM/Réunion des Musées Nationaux/Art Resource, NY. © 2008 ARS Artists Rights Society, NY; page 1327 (top left) Henry M. Sayre; page 1327 (right) Pablo Picasso, "Guitar, Sheet Music, and Wine Glass". 1912. Charcoal, gouache, and *papiers-collé*, 18 7/8" × 14 3/8". The McNay Art Museum, San Antonio, Texas. Bequest of Marion Koogler McNay. ©2008 Estate of Pablo Picasso/Artists Rights Society (ARS), New York.

Chapter 42

42-01 John Singer Sargent (1856–1925), "Gassed, an Oil Study". 1918–19 Oil on canvas. Private Collection. Imperial War Museum, Negative Number Q1460; **42-02** Ernst Ludwig Kirchner, "Self Portrait as Soldier". 1915. Oil on canvas, 27 1/4" × 24". The Allen Memorial Art Museum, Oberlin College, Oberlin, OH. Charles F. Olney Fund, 1950. 1950.29; **42-03** NMPFT/Daily erald Archive/SSPL/The Image Works; **42-04** SCALA/Jean (Hans) Arp, "Collage Arranged According to the Laws of Chance". 1916–17. Torn and pasted paper, 19 1/8 × 13 5/8". Purchase. (457.1937). Digital Image © The Museum of Modern Art/Licensed by SCALA/Art Resource, NY. © 2008 ARS Artists Rights Society, NY; **42-05** Marcel Duchamp (1887–1968), "Fountain 1917". Replica 1964. Porcelain, unconfirmed: 360 × 480 × 610 mm. Purchased with assistance from the Friends of the Tate Gallery 1999. Tate Gallery, London, Great Britain. © 2008 ARS Artists Rights Society, NY; **42-06** Marcel Duchamp (1887–1968). "The Bride Stripped Bare by Her Bachelors, Even (The Large Glass)". 1915–23. Oil, varnish, lead foil, lead wire, and dust on two glass panels, 109 1/4 × 69 1/4 inches (277.5 × 175.9 cm). Bequest of Katherine S. Dreier, 1952. Philadelphia Museum of Art, Pennsylvania, U.S.A. © 2008 ARS Artists Rights Society, NY; **42-07** Erich Lessing/Hannah Hoch, "Cut with the Cake Knife". 1919. Collage. 44 7/8" × 35 3/8". Staatliche Museen, Berlin. Erich Lessing/Art Resource, NY. © 2008 Artists Rights Society (ARS), New York; **42-08** Erich Lessing/Kasimir Malevich, "Suprematist Painting, Black Rectangle, Blue Triangle". 1915. Oil canvas, 26 1/8 × 22 1/2 in. Stedelijk Museum, Amsterdam. Erich Lessing/Art Resource, NY; **42-09** El Lissitzky, "Beat the Whites with the Red Wedge", 1919. Lithograph. Collection Stedelijk Van Abbemuseum, Eindhoven, Holland. © 2007 Artists Rights Society (ARS), New York/VG Bild-Kunst, Bonn; **42-10** Copyright Cooper-Hewitt, National Design Museum, Smithsonian Institution, New York. Merrill C. Berman Collection, NY; **42-11** The Menil Collection, Houston; **42-12** Giorgio de Chirico, "The Child's Brain". 1914. Oil on canvas. 31 1/8" × 25 5/8". Moderna Museet, Stockholm; **42-13** Letter from Katherine S. Dreyer to Max Ernst, May 25, 1920. Yale Collection of American Literature, Beinecke Rare Book and Manuscript Library. Translation form German by John W. Gabriel. From "Max Ernst, Life and Work" by Werner Spies, published by Thames & Hudson, Page 67. © 2008 Artists Rights Society (ARS), NY; **42-14** Joan Miró (1893–1983) "The Birth of the World". Montroig, late summer-fall 1925. Oil on canvas, 8' 2 3/4" × 6' 6 3/4". Acquired through an anonymous fund, the Mr. and Mrs. Joseph Slifka and Armand G. Erpf Funds, and by gift of the artist. (262.1972). Digital Image © The Museum of Modern Art/Licensed by SCALA/Art Resource, NY. © ARS Artists Rights Society, NY; **42-15** Pablo Picasso (1881–1973) "Girl Before a Mirror". Boisgeloup, March 1932. Oil on canvas, 64 × 51 1/4". Gift of Mrs. Simon Guggenheim. (2.1938). Digital Image © The Museum of Modern Art/Licensed by SCALA/Art Resource, NY. © ARS Artists Rights Society, NY; **42-16** Salvador Dalí (1904–89). "The Lugubrious Game". 1929 Oil & collage on cardboard. Private Collection, Paris, France, © DACS. The Bridgeman Art Library. © 2008 ARS Artists Rights Society, NY; **42-17** Salvador Dalí "The Persistence of Memory" 1931, oil on canvas, 9 1/2 × 13 in. (24.1 × 33 cm). The Museum of Modern Art/Licensed by SCALA-Art Resource, NY. © 1999 Demart Pro

Arte (R), Geneva/Artists Rights Society (ARS), New York; **42-18** Georges Meguerditchian/Alberto Giacometti (1901–1966), "Suspended Ball", 1930–31. Wood, iron and cord, 60.4 × 36.5 × 34.0 cm. Inv. AM 1996–205. Photo: Georges Meguerditchian. Musée National d'Art Moderne. Centre National d'Art et de Culture. Georges Pompidou. CNAC/MNAM/Dist. Réunion des Musées Nationaux/Art Resource, NY. © 2008 ARS Artists Rights Society, NY; **42-19** Merel Oppenheim, "Object". 1936. Fur-Covered Teacup, Saucer and Spoon. D: Cup 4 3/4" (12.1 cm); D: Saucer 9 3/8" (23.8 cm); L: Spoon 8" (20.3 cm). Purchase. The Museum of Modern Art/Licensed by SCALA-Art Resource, NY. © 2008 ARS Artists Rights Society, NY; **42-20** Corbis/Bettmann; **42-21** National Portrait Gallery, London; **42-22** Jacob Lawrence (1917–2000), "The Trains were Packed Continually with Migrants". 1940–41. Panel 60 from The Migration Series. Tempera on gesso on composition board, 12 × 18". Gift of Ms. David M. Levy. (28.1942.30). Digital Image © The Museum of Modern Art/Licensed by SCALA/Art Resource, NY. © ARS Artists Rights Society, NY; page 1362 (top, bottom right) Goskino/The Kobal Collection/Picture Desk, Inc./Kobal Collection; page 1362 (bottom left) Everett Collection; page 1363 Goskino/The Kobal Collection/Picture Desk, Inc./Kobal Collection; Everett Collection; Goskino/The Kobal Collection/Picture Desk, Inc./Kobal Collection; Everett Collection; Everett Collection; Everett Collection; Goskino/The Kobal Collection/Picture Desk, Inc./Kobal Collection.

Chapter 43

43-01 Nathan Benn/Woodfin Camp & Associates, Inc.; **43-02** Installation view of the exhibition "Machine Art," The Museum of Modern Art, New York. March 5, 1934 through April 29, 1934. Photograph by Wurts Brothers, Digital Image The Museum of Modern Art/Licensed by SCALA/Art Resource, NY; **43-03** Alfred Stieglitz (1864–1946) "Looking Northwest from the Shelton, New York". 1932. Gelatin silver print, 24.2 × 19.2 cm (9 1/2 × 7 9/16 in.). Ford Motor Company Collection, Gift of Ford Motor Company and John C. Waddell, 1987 (1987.1100.11). The Metropolitan Museum of Art, New York, NY, U.S.A. Image copyright © The Metropolitan Museum of Art/Art Resource, NY. © 2008 ARS Artists Rights Society, NY; **43-04** Courtesy of the Library of Congress; **43-05** Carl Van Vechten (1880–1964) / Courtesy of the Library of Congress; **43-06** Carl Van Vechten/Courtesy of the Library of Congress/Carl Van Vechten (1880–1964); **43-07** Culver Pictures, Inc. / SuperStock, Inc.; **43-08** Used with Permission of Documenting the American South, The University of North Carolina at Chapel Hill Libraries; **43-09** Lawrence, Jacob (1917–2000), "In the North the African American had more educational opportunities". Panel 58 from The Migration Series. (1940–41; text and titled revised by the artist, 1993) Tempera on gesso on composition board, 12 × 18" (30.5 × 45.7 cm). Gift of Mrs. David M. Levy. The Museum of Modern Art/Licensed by SCALA-Art Resource, NY. © 2007 ARS Artists Rights Society, NY; **43-10** Charles Demuth (American, 1883–1935), "The Figure 5 in Gold". 1928. Oil on cardboard, 35 1/2" × 30" (90.2 × 76.2 cm). The Metropolitan Museum of Art, New York, NY, 1949 (49.59.1). Image © The Metropolitan Museum of Art/Art Resource, NY; **43-11** Joseph Stella (1879–1946), "The Voice of the City of New York Interpreted: The Bridge". 1920–1922. Oil and tempera on canvas, 88 1/2" × 54". Collection of The Newark Museum, 37.288e. Art Resource, NY; **43-12** Charles Demuth (American 1883–1935), "Incense of a New Church". 1921. Oil on canvas, 26 1/4" × 20". Columbus Museum of Art, Ohio: Gift f Ferdinand Howald 1931.135; Courtesy Demuth Museum, Lancaster PA; **43-13** Collection of Barney A. Ebsworth. Image © 2009 Board of Trustees, National Gallery of Art, Washington, DC; **43-14** Marsden Hartley (1877–1943), "New Mexico Landscape". 1919. Oil on canvas, 30 × 36 inches (76.2 × 91.4 cm). The Alfred Stieglitz Collection, 1949. Philadelphia Museum of Art, Philadelphia, Pennsylvania, U.S.A. Art Resource, NY; **43-15** Georgia O'Keeffe (1887–1986), "Red Hills and Bones". 1941. Oil on canvas, 29 3/4 × 40 inches (75.6 × 101.6 cm). The Alfred Stieglitz Collection, 1949. Philadelphia Museum of Art, Philadelphia, Pennsylvania, U.S.A. © 2008 ARS Artists Rights Society, NY; **43-16** Bison Archives; **43-17** Bison Archives; **43-18** United Artists/United Artists/The Kobal Collection; **43-19** United Artists/United Artists/The Kobal Collection; **43-20** Fox Film/Photofest; **43-21** UFA/UFA/The Kobal Collection; **43-22** Bunuel-Dali/The Kobal Collection; **43-23** © Bettmann/CORBIS All Rights Reserved; page 1390 Nathan Benn/Woodfin Camp & Associates, Inc.; page 1391 (top) Margaret Bourke-White/Getty Images, Inc.; page 1391 (bottom left) Solidarity; page 1391 (bottom right) Angelo Hornak/© Angelo Hornak/CORBIS All Rights Reserved; page 1395 (top) From Jeremy Yudkin, "Understanding Music", 5/e © 2008, Pearson Education; page 1395 (bottom) From Jeremy Yudkin, "Understanding Music", 5/e © 2008, Pearson Education.

Chapter 44

44-01 AP Wide World Photos; **44-02** Joerg P. Anders/George Grosz (1893–1959), "Stuetzen der Gesellschaft (Pillars of Society)". 1926. Oil on canvas, 200,0 × 108,0 cm. Inv.: NG 4/58. Photo: Joerg P. Anders. Nationalgalerie, Staatliche Museen zu Berlin, Berlin, Germany. Art © Estate George Grosz/Licensed by VAGA, NY; **44-03** Kathe Kollwitz, "Hunger". 1925. Woodcut on heavy japan paper, 22 7/8" × 16 7/8" (58.1 × 42.86 cm). Los Angeles County Museum of Art, The Robert Gore Rifkind Center for German Expressionist Studies. Photograph © 2009 Museum Associates/LACMA M82.288.185. © 2009 Artists Rights Society (ARS), New York/VG Bild-Kunst, Bonn; **44-04** John Heartfield (German 1891–1968), "Der Sinn Des Hitlergrusses: Kleiner Mann bittet um grosse Gaben. Motto: Millonen Stephen Hinter Mir! (The Meaning of the Hitler Salute: Little man asks for big gifts. Motto: Millions Stand Behind Me!)". 1932. Photomechanical reproduction (Montage on cover of Arbeiter Illustrierte Zeitung, vol. 11, no. 42 16 October 1932). The Metropolitan Museum of Art, NY (1987.1125.8). Image © The Metropolitan Museum of Art/Art Resource, NY; **44-05** Piet Mondrian (1872–1944), *Composition with Blue, Yellow, Red and Black, 1922.* Oil on canvas, 16 1/2" × 19 1/4" (41.9 × 48.9 cm). Minneapolis Institute of Arts. © 2008 Mondrian/Holtzman Trust c/o HCR International, Warrenton, VA, USA; **44-06** Florian Monheim/Florian Monheim/Artur Architekturbilder Agentur GmbH, Cologne, Germany; **44-07** Gerrit Rietveld. Interior, Schroder House, with "Red-Blue" Chair. Photo: Jannes Linders Photography. © 2008 ARS Artists Rights Society, NY; **44-08** French Embassy; **44-09** Anthony Scibilia/Le Corbusier. Exterior. Villa Savoye, Poissy, France. Anthony Scibilia/Art Resource, NY. © 2008 Artists Rights Society (ARS), New York/ADAGP, Paris/FLC; **44-10** Vanni/Art Resource, N.Y.; **44-11** Marcel Breuer, Armchair, Model B3, late 1927 or early 1928. Chrome-plated tubular steel with canvas slings, height, 28 1/8 × width, 30 1/4 × depth, 27 3/4 in. (71.4 × 76.8 × 70.5 cm). Gift of Herbert Bayer. Digital Image © The Museum of Modern Art/Licensed by SCALA-Art Resource, NY; **44-12** NSDAP/The Kobal Collection; **44-13** SCALA/Gustav Klucis (1895–1940), "The Development of Transportation, The Five-Year Plan". 1929. Gravure, 28 7/8 × 19 7/8" (73.3 × 50.5 cm). Purchase fund, Jan Tschichold Collection. (146.1968). Digital Image © The Museum of Modern Art/Licensed by SCALA/Art Resource, NY; **44-14** José Diego Maria Rivera, "Sugar Cane", 1931. Fresco. 57 1/8 × 94 1/8 in. (145.1 × 239.1 cm). Philadelphia Museum of Art. Gift of Mr. and Mrs. Herbert Cameron Morris. 1943-46-2. © Banco de Mexico Diego Rivera & Frida Kahlo Museums Trust. Av. Cinco de Mayo No. 2, Col. Centro, Del. Cuauhtemoc 06059, Mexico, D.F. Reproduction

authorized by the Instituto Nacional de Bellas Artes y Literatura; **44-15** Schalkwijk/Diego Rivera (1866–1957). "Man Controller of the Universe or Man in the Time Machine (El hombre controlador del universo o El hombre en la maquina del tiempo)." 1934. Fresco. 485 × 1145 cm. Palacio de Bellas Artes, Mexico City, D.F. Mexico. © 2003 Banco de Mexico Diego Rivera & Frida Kahlo Museums Trust. Av. Cinco de Mayo No. 2, Col. Centro, Del. Cuauhtemoc 06059, Mexico, D.F. Reproduction authorized by the Instituto Nacional de Bellas Artes y Literatura. Photo Credit: Schalkwijk/Art Resource, NY; **44-16** Frida Kahlo, "Self Portrait with Monkey". 1938. Oil on masonite. 16" × 12" (40.64 × 30.48 cm). Albright-Knox Art Gallery, Buffalo, New York. Bequest of A. Conger Goodyear, 1996. Museo Nacional de Arte Moderno, © 2008 Banco de Mexico Diego Rivera & Frida Kahlo Museums Trust. Av. Cinco de Mayo No. 2, Col. Centro, Del. Cuauhtemoc 06059, Mexico, D.F. Reproduction authorized by the Instituto Nacional de Bellas Artes y Literatura; **44-17** Thomas Hart Benton, "Missouri Mural". 1936 (detail). Oil on canvas. Missouri State Capitol, Jefferson City, Missouri. © T. H. Benton and R/ P. Benton testamentary Trusts/UMB Bank Trustee. Art © Licensed by VAGA, NY; **44-18** Aaron Douglas (1899–1979) "Aspects of Negro Life: The Negro in an African Setting". 1934. Oil on canvas. Arts and Artifacts Collection. Schomburg Center for Research in Black Culture, The New York Public Library, NY, U.S.A. Art Resource, NY; **44-19** Resettlement Administration/The Kobal Collection; **44-20** Courtesy of the Library of Congress; **44-21** Walker Evans (1903–1975) / Courtesy of the Library of Congress, Walker Evans (1903–1975); **44-22** Margaret Bourke-White/Margaret Bourke-White/LIFE Magazine © TimePix; **44-23** Heidrich Blessing/Chicago Historical Society; **44-25** Scott Frances/Esto/Arcaid; **44-26** © Bettmann/CORBIS All Rights Reserved; **44-27** UFA/UFA/The Kobal Collection; **44-28** "The Wizard of Oz" © 1939 The Kobal Collection/ MGM. Warner Brothers Motion Picture Titles; **44-29** MGM/Photofest; **44-30** MGM/Photofest; **44-31** RKO/CITIZEN KANE © 1941 The Kobal Collection/RKO. Warner Brothers Motion Picture Titles; **44-32** Ezra Stoller/Esto Photographics, Inc.; page 1439 (top) Pablo Picasso (1881–1973). "Guernica". 1937. Oil on canvas. 350 × 782 cm. Museo nacional Centro de Arts Reina Sofia, Madrid, Spain. John Bigelow Taylor/Art Resource, NY © 2007 Estate of Pablo Picasso/Artists Rights Society (ARS), NY; page 1439 (bottom) ©Bettmann/CORBIS All Rights Reserved.

Chapter 45

45-01 Philippe Giraud/Good Look/© Philippe Giraud/Good Luck/CORBIS All Rights Reserved; **45-02** © Lee Miller Archives, England 208. All Rights Reserved. www.leemiller.co.uk; **45-03** Shomei Tomatsu (b. 1930), "Senji Yamaguchi of Urakami". 1962. Gelatin silver print, 12 15/16" × 8 13/16" (33 × 22.4 cm). Gift of the photographer. (700.1978). Digital Image © The Museum of Modern Art/Licensed by SCALA/Art Resource, NY; **45-04** TOHO/TOHO/The Kobal Collection; **45-05** Alberto Giacometti (1901–1966), "City Square (La Place)". 1948. Bronze, 8 1/2" × 25 3/8" × 17 1/4". (337.1949). Digital Image © The Museum of Modern Art/Licensed by SCALA/Art Resource, NY; **45-06** Jean Dubuffet, "Corps de Dame", June-December 1950. Pen, reed pen and ink on paper, 10 5/8 × 8 3/8 in. (27.0 × 21.2 cm). The Museum of Modern Art/Licensed by SCALA-Art Resource, NY. The Joan and Lester Avnet Collection. Photograph © 2000 The Museum of Modern Art/Licensed by SCALA-Art Resource, NY. © 2005 Artists Rights Society (ARS), New York/ADAGP, Paris; **45-07** Jackson Pollock, "Guardians of the Secret". 1943. Oil on canvas, 48 3/8" × 75 3/8" (122.89 ×191.47). Albert M. Bender Collection, Albert M. Bender Bequest Fund Purchase © Pollock-Krasner Foundation/ARS Artists Rights Society, NY. SFMOMA Internal Number: 45.1308. San Francisco Museum of Modern Art; **45-08** Jackson Pollock. *Number 57.* 1950. Oil on canvas, Collection, Whitney Museum of American Art, NY. Purchase. © 2008 ARS Artists Rights Society, NY; **45-09** Willem DeKooning (1904–1997), "Seated Woman". c. 1940. Oil and charcoal on Masonite. 54 1/16 × 36 inches (137.3 × 91.4cm); Framed: 54 1/16 × 37 3/4 × 2 1/2 inches (137.3 × 95.9 × 6.4 cm). The Albert M. Greenfield and Elizabeth M. Greenfield Collection, 1974. Philadelphia Museum of Art, Philadelphia, Pennsylvania. U.S.A. Art Resource, NY. © ARS Artists Rights Society, NY; **45-10** Willem de Kooning, "Pink Angels". ca. 1945. Oil and charcoal on canvas, 52" × 40". Frederick P. Weisman Art Foundation, Los Angeles, CA. © 2008 ARS Artists Rights Society, NY; **45-11** Willem de Kooning (American 1904–1997 b. Netherlands), "Excavation". 1950. Oil on canvas, 205.7 × 254.6 cm (81" × 100 1/4"). Unframed. Mr. and Mrs. Frank G. Logan Purchase Prize Fund; restricted gifts of Edgar J. Kaufmann, Jr., and Mr. and Mrs. Noah Goldowsky, Jr., 1952.1 Reproduction, The Art Institute of Chicago. All Rights Reserved. © 2009 ARS Artists Rights Society, NY; **45-12** Lee Krasner 1908–1984. "White Squares". 1948. Oil on canvas, 24" × 30" (61 × 76.2 cm). Gift of Mr. and Mrs. B. H. Friedman. 75.1. Collection of the Whitney Museum of American Art, New York; **45-13** Grace Hartigan (1922–), "River Bathers". 1953. Oil on canvas, 69 3/8 × 7'4 3/4" (176.2 × 225.5 cm). Given anonymously. (11.1954). Digital Image The Museum of Modern Art/Licensed by SCALA/Art Resource, NY; **45-14** Joan Mitchell, "Piano Mecanique". 1958. Oil on canvas, 1.981 × 3.251 cm (78" × 128"). Gift of Addie and Sidney Yates. Image © 2009 Board of Trustees, National Gallery of Art, Washington, D.C.; **45-15** Mark Rothko (American 1903–1970), "Green on Blue". 1956. Oil on canvas, 89 3/4" ×63 1/4" (228.0 × 161.0 cm). Collection of The University of Arizona Museum of Art, Tucson, Gift of E. Gallagher, Jr. Acc. 64.1.1; **45-16** Helen Frankenthaler (b.1928), "The Bay". 1963. Acrylic on canvas. The Detroit Institute of Arts, USA, Founders Society Purchase, Dr. & Mrs. Hilbert H. DeLawter Fund/The Bridgeman Art Library; **45-17** Alexander Calder, "Black, White, and Ten Red", 1957. Painted sheet metal and wire, .838 × 3.658 (33 × 144). Image © 2009 Board of Trustees, National Gallery of Art, Washington, D.C. © 2009 Artists Rights Society (ARS), New York; **45-18** David Smith, "Blackburn: Song of an Irish Blacksmith", front view, 1949–1950. Steel and bronze, 46 1/4 × 49 3/4 × 24 in. Wilhelm Lehmbruck Museum, Duisburg, Germany. Art © Estate of David Smith/Licensed by VAGA, New York, NY; **45-19** Robert Rauschenberg (1925–) "Bed". 1955. Combine painting: oil and pencil on pillow, quilt and sheet on wood supports, 6' 3 1/4" × 31 1/2" × 8". Gift of Leo Castelli in honor of Alfred H. Barr, Jr. (79.1989). Digital Image © The Museum of Modern Art/Licensed by SCALA/Art Resource, NY. © Art Robert Rauschenberg Foundation/VAGA Visual Artists & Galleries Assocition, NY; **45-20** Jack Mitchell/Merce Cunningham, "Summerspace". 1958. Set and costumes by Robert Rauschenberg. Photo by Jack Mitchell. Courtesy of Cunningham Dance Foundation, Inc. © Estate of Robert Rauschenberg/VAGA, NY; **45-21** Geoffrey Clements/Jasper Johns (b. 1930) "Three Flags" 1958. Encaustic on canvas, 30 7/8 × 45 1/2 × 5 in. (78.4 × 115.6 × 12.7 cm). 50th Anniversary Gift of the Gilman Foundation, Inc., The Lauder Foundation, A. Alfred Taubman, an anonymous donor, and purchase. 80.32. Collection of Whitney Museum of American Art, NY. Photo by Geoffrey Clements. Art © Jasper Johns/Licensed by VAGA, NY; **45-22** Bill Hedrich/Ludvig Mies van der Rohe, Farnsworth House, Fox River, Plano, Illinois, 1950. © 2008 Artists Rights Society (ARS), New York/VG Bild-Kunst, Bonn; **45-23** David Heald/Frank Lloyd Wright, The Solomon R. Guggenheim Museum, New York, 1957–59. Photo: David Heald/Courtesy of the Solomon R. Guggenheim Museum. © 2008 Artists Rights Society (ARS), NY; **45-24** Wolfgang Volz/Wolfgang Volz Photography; page 1472 © 2009 Artists Rights Society (ARS), New York/DACS, London; page 1473 Richard Hamilton, "Just What Is It That Makes Today's Home So Different, So Appealing?", 1956, collage on paper, 26 × 25 cm (10-1/4 × 9-1/4"). Kunsthalle Tubingen, Sammlung G.F. Zundel, Germany. © 2007 Artists Rights Society (ARS) New York/DACS, London.

Chapter 46

46-01 © Bettmann/CORBIS All Rights Reserved; **46-02** Faith Ringgold, "God Bless America," 1964. Oil on canvas, 31 × 19 in. © Faith Ringgold 1964; **46-03** Wifredo Lam (Cuban, b. Sagua la Grande, 1902–1982), "Siren of the Niger". 1950. Oil and charcoal on canvas, 51" × 38 1/8" (129.5 × 96.8 cm). Signed LR in Oil: Wifredo Lam/1950. Hirshhorn Museum and Sculpture Garden, Smithsonian Institution, Gift of Joseph H. Hirshhorn, 1972. © 2009 Artists Rights Society (ARS), New York/DACS; **46-04** Jeff Wall/Marian Goodman Gallery; **46-05** SCALA/Romare Bearden (1914–1988), "The Dove". 1964. Cut-and-pasted photoreproductions and papers, gouache, pencil and colored pencil on cardboard. 13 3/8 × 18 3/4". Blanchette Rockefeller Fund. (377.1971). The Museum of Modern Art/Licensed by SCALA-Art Resource, NY. Art © Estate of Romare Bearden/Licensed by VAGA, NY; **46-06** Benjamin Blackwell/Betye Saar, "The Liberation of Aunt Jemima". 1972. Mixed Media. 11 3/4" × 8" × 2 3/4". Purchased with the aid of funds from the National Endowment for the Arts (selected by The Committee for the Acquisition of Afro-American Art). Photo Benjamin Blackwell. University of California/Berkeley Art Museum; **46-07** Andy Warhol Foundation for the Visual Arts; **46-08** Tom Wesselmann, "Still Life #20". 1962. Mixed media. 41" × 48" × 5 1/2" (104.14 × 121.92 × 13.97 cm). Albright-Knox Art Gallery, Buffalo, New York. Gift of Seymour H. Know, Jr. Art © 2008 Estate of Tom Wesselmann/VAGA, NY; **46-09** Andy Warhol, "Marilyn Diptych". 1962. Tate Gallery, London, Great Britain/Art Resource, NY. © 2003 The Andy Warhol Foundation for the Visual Arts/ARS, NY. ™2002 Marilyn Monroe LLC under license authorized by CMG Worldwide Inc., Indianapolis, Indiana 46256 USA www.MarilynMonroe.com; **46-10** Roy Lichtenstein, "Oh, Jeff...I Love You, Too...But...". 1964. © Estate of Roy Lichtenstein; **46-11** Roy Lichtenstein (1923–1997), "Little Big Painting". 1965. Oil and synthetic plymer on canvas. 70" ×82" × 2 1/4" (177.8 × 208.3 × 5.7 cm.) Purchase, with funds from the Friends of the Whitney Museum of America Art. 66.2. Collection of the Whitney Museum of American Art, New York; **46-12** Claes Oldenburg (Swedish b. 01929), "Soft Toilet". Vinyl, Kapok, Liquitex, Wood, 52 × 32 × 30. Collection of Whitney Museum of American Art, NY. **46-13** Frank Stella (American, b. Malden, MA 1936), "Pagosa Springs". 1960. Copper metallic (enamel?) and pencil on canvas, 99 3/8" × 99 1/4" (252.3 × 252.1 cm). Hirshhorn Museum and Sculpture Garden, Smithsonian Institution, Gift of Joseph H. Hirshhorn, 1972. © 2009 Artists Rights Society (ARS), New York; **46-14** Carl Andre, "10 × 10 Altstadt Copper Square". 1967. Dusseldorf Copper. 100-units, each: 3/16" × 19 11/16" × 19 11/16" (.5 × 50 × 50 cm). Solomon R. Guggenheim Museum, New York. Panza Collection, 1991. 91.3673; **46-15** Archive Stockhausen Foundation for Music in Kurten, Germany/Archive Stockhausen Foundation for Music in Kurten, Germany (www.stockhausen.org); **46-16** Attilio Maranzano/Claes Oldenburg, "Lipstick (Ascending) on Caterpillar Tracks". 1969. Cor-Ten stee, aluminum; coated with resin and painted with polyurethane enamel. 23'6" × 24' 10'11" (7.16 × 7.58 × 3.33 m). Collection Yale University Art Gallery, Gift of Colossal Keepsake Corporation Photo by Attilio Maranzano. © 2008 Oldenburg Van Bruggen Foundation, NY; **46-17** Gianfranco Gorgoni/Robert Smithson, "Spiral Jetty". April 1970. Great Salt Lake, Utah. Black rock , salt crystals, earth, red water (algae). 3 1/2' × 15' × 1500'. Art © Estate of Robert Smithson/Licensed by VAGA, New York. Courtesy James Cohan Gallery, New York. Collection: DIA Center for the Arts, New York. Photo: Gianfranco Goroni; **46-18** Bill Graham Archives/Bonnid Maclean, "Six Days of Sound". December 26–31, 1967. Poster. © Bill Graham Archives, LLC/www.wolfgangsvault.com. All Rights Reserved; **46-19** John Paul Filo/John Paul Filo/Getty Images, Inc.; **46-20** © Nancy Spero. Courtesy Galerie Lelong, New York 10001; **46-21** Eva Hesse, "Ringaround Arosie", March 1965. Varnish, graphite, ink, enamel, cloth-covered wire, papier-mâché, unknown modeling compound, Masonite, wood, 67.5 × 42.5 × 11.4 cm/26 5/8 × 16 3/4 × 4 1/2 inch. Museum of Modern Art, NY, fractional and promised gift of Kathy and Richard S. Fuld, Jr., 2005. © The Estate of Eva Hesse, Hauser & Wirth Zurich, London. Photo: Abby Robinson/Barbora Gerny, New York; **46-22** Donald Woodman/Judy Chicago, "Pasadena Lifesavers Red Series #3". c. 1969–1970. Sprayed acrylic lacquer on sheet acrylic. 5' × 5'. © 2008 ARS Artists Rights Society. Photo © Donald Woodman; **46-23** Donald Woodman/Judy Chicago (American, b. 1939), "The Dinner Party", 1979. Mixed Media, 48 ft. × 42 ft. × 3 ft. installed. Collection of The Brooklyn Museum of Art, Gift of the Elizabeth A. Sackler Foundation. Photograph © Donald Woodman. © 2005 Judy Chicago/Artists Rights Society (ARS), New York; **46-24** Courtesy www.guerrillagirls.com; pages 1508–1509 James Rosenquist (b. 1933) "F-111". 1964–65. Oil on canvas with aluminum, 10' × 86' overall. Purchase Gift of Mr. and Mrs. Alex L. Hillman and Lillie P. Bliss Bequest (both by exchange). (00473.96.a-w). Digital Image © The Museum of Modern Art/Licensed by SCALA/Art Resource, NY. © Art James Rosenquist/VAGA Visual Artists Galleries & Association, NY.

Chapter 47

47-01 Ron Dahiquist/SuperStock, Inc.; **47-02** Bob Krist/© Bob Krist/CORBIS All Rights Reserved; **47-03** Richard Klune/© Richard Klune/CORBIS All Rights Reserved; **47-04** Richard Payne/Richard Payne, FAIA; **47-05** Courtesy of the Library of Congress; **47-06** (left) Frank Gehry, Gehry house, 1977–1978, axonometric drawing. Photograph by Tim Street-Porter; **47-06** (right) Tim Street-Porter/Esto/Esto Photographics, Inc.; **47-07** David Heald/The Guggenheim Museum Bilbao, 1997. Photo: David Heald © The Solomon R. Guggenheim Foundation, New York; **47-08** David Heald/The Guggenheim Museum Bilbao, 1997. Photo: David Heald © The Solomon R. Guggenheim Foundation, New York; **47-09** Courtesy of the Artist and Metro Pictures; **47-10** Jamison Miller/Richard Estes American (b 1932). "Central Savings". 1975. Oil on canvas, 36" × 46" (91.4 × 121.9 cm). The Nelson-Atkins Museum of Art, Kansas City, Missouri. Gift of the Friends of Art, P75-13. Photraph by Jamison Miller; **47-11**–**47-12** David Heald/Chuck Close, "Stanley" 1980–1981. Oil on canvas, 274.3 × 213.4 cm (108 × 84 in.) Solomon R. Guggenheim Museum, New York. Purchased with funds contributed by Mr. and Mrs. Barrie M. Damson, 1981. 81.2839. Photograph by David Heald. © The Solomon R. Guggenheim Foundation, New York (FN 2839); **47-13** Pat Steir, "Yellow and Blue One-Stroke Waterfall". 1992. Oil on canvas. 172 5/8" ×91" (438.5 × 231.2 cm). The Solomon R. Guggenheim Museum, New York. Gift, John Eric Cheim, 1999. 99.5288; **47-14** Gerhard Richter (1932–) "Meadowland (Wiesenthal)". 1985. Oil on canvas, 35 5/8 × 37 1/2". Blanchette Rockefeller, Betsy Babcock, and Mrs. Elizabeth Bliss Parkinson Funds. (350.1985). Digital Image © The Museum of Modern Art/Licensed by SCALA/Art Resource, NY. © Gerhard Richter, Germany; **47-15** Gerhard Richter (German, b. 1932). "Ice (2)". 1989. Oil on canvas, 203.2 × 162.6 cm. Through prior gift of Joseph Winterbotham; gift of Lannan Foundation, 1997.188. Reproduction, The Art Institute of Chicago. All Rights Reserved; **47-16** Ander Gillenea/AP Wide World Photos; **47-17** Tore H.Royneland, Oslo/Damien Hirst, "Mother and Child Divided". 1993. Steel, GRP composites, glass, silicone sealants, cow, calf,

formaldehyde solution, 2 boxes. 74 3/4" × 126 3/4" × 43 "; 2 boxes 40 3/8" × 66 1/2" × 24 5/8". © Damien Hirst/Science, Ltd. The Astrup Fearnley Collection, Oslo, Norway. Photo Credit: Tore H. Royneland, Oslo; **47-18** Nam June Paik (American, b. Seoul, Korea, 1932–2006). "Video Flag". 70 Video Monitors, 4 Laser Disc Players, Computer, Timers, Electrical Devices, Wood and Metal Husing on Rubber Wheels. 94 3/8" × 139 3/4" × 47 3/4" (239.6 × 354.8 × 119.9 cm). Hirshhorn Museum and Sculpture Garden, Smithsonian Institution, Gift of Joseph H. Hirshhorn, 1996; **47-19** Eleanor Antin, "Minetta Lane-A Ghost Story". 1995. Mixed media installation. View one of three. Installation view (left), two stills from video projections (below and right). Below: Actors Amy McKenna and Joshua Coleman. Right: Artists's window with Miriam (the Ghost). Courtesy the artist and Ronald Feldman Fine Arts, New York; **47-20** Mike Bruce/Courtesy Anthony d'Offay, London/Bill Viola Studio; **47-21** Jack Vartoogian/Photograph © 1984 Jack Vartoogian/Front RowPhotos. All Rights Reserved; **47-22** Perry Hoberman/Perry Hoberman; **47-23** Andreas Gursky, "99 Cent". 1999. Chromogenic Color Print. 6'9 1/2" × 11' (207 × 337 cm). Courtesy Matthew Marks Gallery, New York and Monika Spruth Galerie, Cologne. © 2008 Andreas Gursky/Artists Rights Society (ARS); page 1535 Jean-Michel Basquiat, "Charles the First". 1982. Acrylic and Oilstick on canvas. Triptych. 6'6" × 5'2 1/4" (1.98 × 1.58 m). © The Estate of Jean-Michel Basquiat/ © 2009 Artists Rights Society (ARS), NY.

Chapter 48

48-01 Wolgang Volz/Wolfgang Volz Photography; **48-02** Wolfgang Volz Photography; **48-03** Harrison Studio; **48-04** Courtesy of Santiago Calatrava and Shelbourne Development Group, Inc./Santiago; **48-05** Port Authority of New York & New Jersey; **48-06** John Edward Linden/Arcaid; **48-07** OMA/Ole Scheeren and Rem Koolhaas; **48-08** Hans Schlupp/Nr. RP2-8 Centre Tjibaou, New Caledonia. © Hans Schlupp/archenova. Architect/Designer: Renzo Piano Building Workshop; **48-09** Yukinori Yanagi, "America". 1994. 12" × 18", each box (36 boxes). Ants, colored sand, plastic box, plastic tube, plastic pipe. Installation view at Museum of Contemporary Art, San Diego, 1994 collection of Artist; **48-10** Benton/Courtesy of AIATSIS Pictorial Collection; **48-11** Erna Motna, "Bushfire and Corroboree Dreaming," 1988, Acrylic on canvas,

48 × 32 in. Australia Gallery, New York. Courtesy of Australian Consulate General; **48-12** Diane Bondareff/Chris Ofili, "The Holy Virgin Mary". 1996. Paper collage, oil paint, glitter, polyester, resin, map pins, and elephant dung on linen. 8' × 6' . The Saatchi Gallery, London. Photo: Diane Bondareff/AP World Wide Photos; **48-13** Yinka Shonibare, "Victorian Couple". 1999. Was printed cotton textile. L: 153 × 92 × 92 cm (60: × 36" × 36"). R: 153 × 61 × 61 cm (60" × 24" × 24"). Courtesy of the Artist, Stephen Friedman Gallery, London, and James Cohan Gallery, NY; **48-14** Courtesy of the Melville J. Herskovits Library of African Studies, Northwestern; **48-15** Peter Muscato/Felix Gonzalez Torres, "Untitled". 1991. Billboard, overall dimensions vary with installation. The Museum of Modern Art/Licensed by SCALA-Art Resource, NY. © The Felix Gonzalez-Torres Foundation. Courtesy of Andrea Rosen Gallery, New York; **48-16** Agence France Presse/Agence France Presse/Getty Images; **48-17** Masami Teraoka, "AIDS Series/Geisha in Bath". 1988. Watercolor on canvas, 108" × 81". Courtesy of the artist and Catharine Clark Gallery, San Francisco, CA; **48-18** Yasumasa Morimura, "Portrait (Futago)", 1988. Color Photograph, 82 3/4 × 118 inches. Courtesy of the artist and Luhring Augustine, New York; **48-19** Courtesy of Mariko Mori and Deitch Projects; **48-20** © 2001 Shirow Masamune. All Rights Reserved. First published in Japan in 2001 by Kodansha Ltd., Tokyo; **48-21** Hung Liu, "Virgin/Vessel," 1990. Oil on canvas, broom, 72 in. × 48 in. Collection of Bernice and Harold Steinbaum. © Hung Liu. Courtesy Bernice Steinbaum Gallery, Miami, FL; **48-22** Zhang Huan; **48-23** Cynthia Preston/Photo: Cynthia Preston. © Shirin Neshat, courtesy Gladstone Gallery, New York; **48-24** Shahzia Sikander, "Pleasure Pillars". 2001. Watercolor, dry pigment, vegetable color, tea, and ink on wasli paper. 12" × 10". Collection Amita and Pumendu Chatterjee. Courtesy Sikkema Jenkins & Co., NY; **48-25** Social and Public Art Resource Center; **48-26** Catalogue No. 158143, Department of Anthropology, Smithsonian Institution; **48-27** Nancy Youngblood (Santa Clara Pueblo), "Black S-swirled melon pot". 2007. Ceramic, 5 1/2" × 7 1/2". Courtesy of Andrea Fisher Fine Pottery, Santa Fe, New Mexico; **48-28** Smithsonian National Museum of Natural History; **48-29** The Legacy, Ltd.; **48-30** Harrison Studio; page 1577 David P. Bradley (white Earth Ojibwe and Mdewakaton Dakota), "Indian Country Today". 1996–97. Acrylic on canvas. Museum Purchase through the Mr. and Mrs. James Krebs Fund. Photograph courtesy Peabody Essex Museum.

Text Credits

Chapter 25

Reading 25.1, page 810: from Teresa of Ávila,"Visions," Chapter 29 of *The Life of Teresa of Ávila* (before 1567), From The Complete Works of Saint Teresa of Jesus, Vol 1. Translated and edited by E. Allison Peers. New York: Sheed and Ward, 1946. Reprinted by permission of Rowman & Littlefield/Continuum International Publishing Group. Page 824: Claudio Monteverdi Appeals for His Salar, From The Letters of Claudio Monteverdi, translated by Denis Stevens. Reprinted with permission.

Chapter 26

Reading 26.2, page 840: from René Descartes, *Meditations* (1641), From "The Seventh Set of Objections with the Author's Replies" by René Descartes. *The Philosophical Writings of Descartes*. Translated by John Cottingham, Robert Stoothoff, Dugald Murdoch. Cambridge: Cambridge University Press, 1985. Reprinted with the permission of Cambridge University Press. **Reading 26.3,** page 858: from René Descartes, *Discourse on Method* (Part IV) (1637), LAFLEUR, LAURENCE J., DESCARTES: DISCOURSE ON METHOD, 1st Edition, © 1956, pages 28-31. Reprinted by permission of Pearson Education, Inc., Upper Saddle River, NJ.

Chapter 27

Reading 27.1 (a), pages 875, 890: from Molière, *Tartuffe*, Act V (1664), Excerpts from TARTUFFE BY MOLIERE, English translation copyright © 1963, 1962, 1961 and renewed 1991, 1990 and 1989 by Richard Wilbur, reprinted by permission of Harcourt, Inc. CAUTION: Professionals and amateurs are hereby warned that this translation, being fully protected under the copyright laws of the United States of America, the British Empire, including the Dominion of Canada, and all other countries which are signatories to the Universal Copyright Convention and the International Copyright Union, are subject to royalty. All rights, including professional, amateur, motion picture, recitation, lecturing, public reading, radio broadcasting, and television, are strictly reserved.

Chapter 28

Reading 28.2, page 920: from Thomas Hobbes, *Leviathan* (1651), HOBBES, THOMAS, LEVIATHAN I & II, 1st Edition, © 1958. Reprinted by permission of Pearson Education Inc., Upper Saddle River, NJ. **Reading 28.4,** page 922: from John Locke, The Second Treatise of Government(1690), PEARDON, THOMAS, P., SECOND TREATISE OF GOVERNMENT: LOCKE, 1st Edition, © 1952. Reprinted by permission of Pearson Education, Inc., Upper Saddle River, NJ. **Readings 28.5 (a, b),** pages 905, 923: from John Milton, *Paradise Lost*, Book 5 (1667), From PARADISE LOST: A Norton Critical Edition, Second Edition by John Milton, edited by Scott Elledge. Copyright © 1993, 1975 by W. W. Norton & Company, Inc. Used by permission of W. W. Norton & Company, Inc.

Chapter 29

Reading 29.3, page 948: from Jean-Jacques Rousseau, *The Social Contract*, Book 1,Chapter 4 ("Slavery") (1762), Reprinted by kind permission of Everyman's Library, an imprint of Alfred A. Knopf. **Reading 29.4,** page 949: from Jean-Jacques Rousseau, *Discourse on the Origin of Inequality among Men* (1755), From A DISCOURSE ON INEQUALITY by Jean-Jacques Rousseau, translated by Maurice Cranston, copyright © 1984 by Maurice Cranston. Used by permission of Viking Penguin, a division of Penguin Group (USA) Inc./Used by permission of Peter Fraser & Dunlop Group Ltd. (Canada). **Reading 29.5,** page 962: from Voltaire, *Candide* (1758), Reprinted by kind permission of Everyman's Library, an imprint of Alfred A. Knopf.

Chapter 32

Reading 32.2, page 1037: from Olympe de Gouges, *Declaration of the Rights of Woman and the Female Citizen* (1791), From Women in Revolutionary Paris, 1789-1795: Selected Documents Translated With notes And Commentary. Translated with notes and commentary by Gay Levy, Harriet Branson Applewhite, and Mary Durham Johnson. Copyright 1979 by the Board of Trustees of the University of Illinois. Used with permission of the editors and the University of Illinois Press. **Reading 32.3 (a),** pages 1038, 1044: from Mary Wollstonecraft, *A Vindication of the Rights of Woman* (1792), From A VINDICATION OF THE RIGHTS OF WOMAN, NORTON CRITICAL EDITION, SECOND EDITION by Mary Wollstonecraft, edited by Carol H. Poston. Copyright © 1988, 1975 by W. W. Norton & Company, Inc. Used by permission of W. W. Norton & Company, Inc.

Chapter 34

Reading 34.7a, page 1089: from Johann Wolfgang von Goethe, *Faust*, Part I (1808), from Faust, Part I (1952) by Goethe, Johann Wolfgang, edited by MacNeice, Louis (trans). By permission of Oxford University Press, Inc.; **Readings 34.7b-c,** pages 1091–1092: from Johann Wolfgang von Goethe, *Faust*, Part II (1832), from Faust, Part II (1954) by Goethe, Johann Wolfgang, edited by MacNeice, Louis (trans). By permission of Oxford University Press, Inc.; **Reading 34.8,** page 1092: from Ludwig van Beethoven, *Heiligenstadt Testament* (1802), FORBES, Elliot; THAYER'S LIFE OF BEETHOVEN 2 VOLUMES. © 1964 Princeton University Press, 1992 renewed PUP Reprinted by permission of Princeton University Press.

Chapter 35

Reading 35.7, page 1126: from Pushkin, *The Bronze Horseman* (1833), Copyright © THE BRONZE HORSEMAN: SELECTED POEMS OF ALEXANDER PUSHKIN, translated by D.M. Thomas, Secker & Warburg UK 1981/Viking US 1982.

Chapter 36

Reading 36.1, page 1179: Karl Marx and Friedrich Engels, *The Communist Manifesto*, Part I, from "Bourgeois and Proletarians" (1848; English edition 1888; trans. Samuel Morse), From THE COMMUNIST MANIFESTO by Karl Marx and Friedrich Engels. Samuel Moore, translator. Edited by Joseph Katz. Copyright © 1964 by Simon & Schuster, Inc. Abridged by permission of Washington Square Press, a Division of Simon & Schuster, Inc.; **Reading 36.4,** page 1160: Charles Baudelaire, "Carrion," in *Les Fleurs du mal* (1857) (translation by Richard Howard), From Les Fleurs du mal by Charles Baudelaire, translated from the French by Richard Howard, Illustrations by Michael Mazur. Reprinted by permission of David R. Godine, Publisher, Inc. Copyright © 1982 by Charles Baudelaire, translated from the French by Richard Howard, Illustrations by Michael Mazur; **Reading 36.5,** page 1160: Charles Baudelaire, "The Head of Hair," in *Les Fleurs du mal* (1857) (translation by Richard Howard), From Les Fleurs du mal by Charles Baudelaire, translated from the French by Richard Howard. Illustrations by Michael Mazur. Reprinted by permission of David R. Godine, Publisher, Inc. Copyright © 1982 by Charles Baudelaire, translated from the French by R; **Readings 36.10 (a),** pages 1167, 1181: from Émile Zola, *Germinal* (1885), Translated by Paul Brains, from *Reading About the World*, ed. Paul Brians et al., vol 2, 3rd edition. Harcourt Custom Publishing, 1999.

Chapter 37

Reading 37.2, page1208: from Leo Tolstoy, *War and Peace*, Part I, Chapter 11 (1869), War and Peace by Tolstoy edited by Aylmer Maude and translated by Louise Maude. By permission of Oxford University Press.